THE OXFORD COMPANION TO

J. M. W. Turner

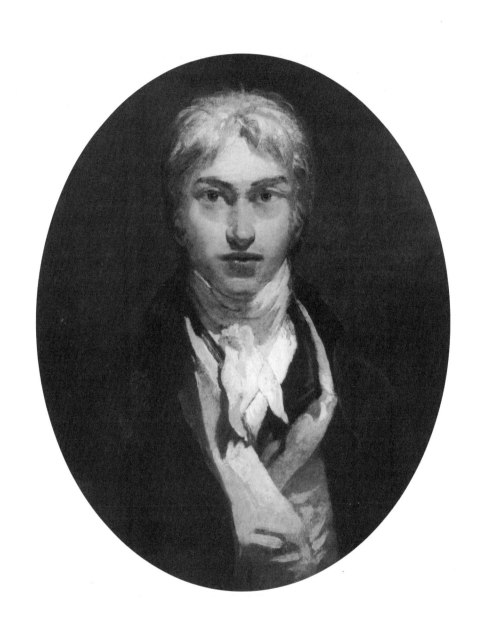

THE OXFORD COMPANION TO

J. M. W. Turner

EDITED BY

Evelyn Joll, Martin Butlin, and Luke Herrmann

OXFORD

UNIVERSITY PRESS

OXFORD
UNIVERSITY PRESS

Great Clarendon Street, Oxford OX2 6DP

Oxford University Press is a department of the University of Oxford.
It furthers the University's objective of excellence in research, scholarship,
and education by publishing worldwide in

Oxford New York

Athens Auckland Bangkok Bogotá Buenos Aires Calcutta
Cape Town Chennai Dar es Salaam Delhi Florence Hong Kong Istanbul
Karachi Kuala Lumpur Madrid Melbourne Mexico City Mumbai
Nairobi Paris São Paulo Shanghai Singapore Taipei Tokyo Toronto Warsaw

with associated companies in Berlin Ibadan

Oxford is a registered trade mark of Oxford University Press
in the UK and in certain other countries

Published in the United States
by Oxford University Press Inc., New York

British Library Cataloguing in Publication Data

Data available

Library of Congress Cataloging in Publication Data

Data available

ISBN 0-19-860025-9

1 3 5 7 9 10 8 6 4 2

Typeset in Bulmer MT
by Alliance Phototypesetters, Pondicherry, India
Printed by Giunti Industrie Grafiche
Prato, Italy

Frontispiece: J. M. W. Turner, *Self-Portrait*, c.1798.
Oil on canvas; 29¼ × 23 in. (74.5 × 58.5 cm.), Tate Gallery.

For Pam, Frances, and Georgina

· PREFACE ·

INITIATED in 1994 with an approach by Oxford University Press to Evelyn Joll, the *Oxford Companion to J. M. W. Turner* has been making slow but steady progress for some five years. Evelyn invited Martin Butlin, his co-author in 'Butlin and Joll', and Luke Herrmann to work with him, and the three of us have had a very harmonious and happy relationship as co-editors of this pioneering and experimental Companion. The first and perhaps most challenging task was compiling the initial Headword List as the essential basis of the whole volume; surprisingly there have been relatively few changes in this over the years. The next stage was selecting and approaching the individual authors. This was again a largely smooth exercise resulting in fifty-three contributors, though it did end up with the three editors themselves writing rather more of the nearly 800 entries than they had anticipated.

As an artist Turner was exceptionally prolific and varied; as a person he was essentially secretive, solitary, and withdrawn. This combination has baffled students and scholars for over a century, and there can probably never be a definitive biography of his life or a really complete catalogue raisonné of his work. There is a remarkable shortage of reliable facts, but this *Companion* brings together a large proportion of the most up-to-date available information, and should remain of value for all interested in Turner and in British painting in the 19th century and above all for every lover of Turner, for many years to come. Research on Turner, and especially on his tours, does, of course, continue, but at a much lesser rate than in the last three decades. The *Companion* will certainly need revision in the improbable circumstance that its publication results in the discovery of hitherto unknown letters, diaries, journals, and the like. There is unlikely to be a flood of lost works by Turner, for the very high auction prices of recent years will already have flushed out most of these, though previously unknown watercolours do continue to appear.

As many reports indicate, Turner often baffled his contemporaries, and he has continued to puzzle scholars and students since his death nearly 150 years ago. The Editors of the *Oxford Companion to J. M. W. Turner* will have succeeded if this volume provides its users with as much reliable information as possible, for, as its publication as the first such Companion devoted to an individual artist indicates, Turner is generally, indeed almost universally, regarded as Britain's greatest painter.

The Editors would first of all like to thank the contributors from both sides of the Atlantic for their co-operation, and for the high standard of their individual entries. The contributors include the majority of the scholars who have published on Turner in recent years, but there are others, not represented here, whose published work has helped in the compilation of this volume, and to whom our thanks are also due. We owe a special debt of gratitude to John Gage, who is also one of the contributors, for his advice in the early stages of planning this book.

Individually Evelyn Joll has made constant use of the library and sales records at Agnew's, and has had helpful answers to his queries from Christie's and Sotheby's. Martin Butlin wishes to acknowledge the practical and secretarial help of Sharon Ives and Averill Zaniboni, and the assistance of his former colleagues and more recent arrivals at the Tate Gallery. Luke Herrmann has made good use of the resources of the Clore Gallery Study Room and of the library at the Paul Mellon Centre.

At Oxford University Press the editors have received most helpful guidance and advice from Pam Coote, and friendly support from her assistants Rebecca Collins and Wendy Tuckey, to all of whom they are very grateful.

EJ, MB, and LH

· CONTENTS ·

· LIST OF PLATES ·

Frontispiece:

*Self-Portrait, c.*1798

Plate section:

Between pages 230–1. An asterisk (*) in front of a word indicates that the picture is the subject of an entry.

· CONTRIBUTORS ·

AGHB Alfred (Fred) Bachrach, CBE, D.Phil. (Oxon.), D.Litt. (Leeds), is Professor Emeritus of the Universities of Leiden and Amsterdam. He is the author of six books on Anglo-Dutch cultural relations in the past. Curator of exhibitions in Leiden, The Hague, Amsterdam, and London, he is a member of the Royal Netherlands Academy of Arts and Sciences.

DLB Dinah Birch is the Stirling Boyd Fellow in English Literature at Trinity College, Oxford. She has published numerous books and articles on Victorian literature, including *Ruskin's Myths* (1988) and *Ruskin on Turner* (1990), and is a regular contributor to the *London Review of Books*.

PB Peter Bower is a forensic paper historian and paper analyst, specializing in the dating, attribution, authentication, and usage of paper. He has written two books on Turner's papers (1990 and 1999), with accompanying exhibitions at the Tate Gallery. He is editor of *The Quarterly*, the journal of the British Association of Paper Historians, and *Studies in British Paper History*. He is a member of the Board of the British Society of Questioned Document Examiners and is registered as an Expert Witness on the UK register.

DBB Dr David Blayney Brown is Curator of the Turner Collection at the Tate Gallery, London. He has written numerous articles on 18th- and 19th-century British art, has lectured widely in the UK and the USA, and organized and wrote the catalogues for a number of exhibitions, including *Turner and Byron* (Tate Gallery, 1991), *Turner* (Vienna, and Yokohama, Fukuoka, and Nagoya, Japan), and *Turner in the Alps* (Tate Gallery and Fondation Pierre Gianadda, Martigny, 1998–9).

MB Martin Butlin read history at Trinity College, Cambridge, and history of art at the Courtauld Institute, London. He became an Assistant Keeper at the Tate Gallery in 1955 and was Keeper of the Historic British Collection there from 1967 until 1989. With Evelyn Joll he is author of *The Paintings of J. M. W. Turner*, a complete catalogue of the oil paintings. As well as other writings on Turner he has catalogued the works of William Blake in the Tate Gallery and compiled a complete catalogue, *The Paintings and Drawings of William Blake*. He has also assisted in the selection and cataloguing of exhibitions on Turner and William Blake. He is a Fellow of the British Academy and was made a CBE in 1990.

MWD Maurice Davies studied pure mathematics at the University of Warwick and then completed a doctorate on Turner's 1811 perspective lectures at the Courtauld Institute. He has been an Assistant Keeper at Manchester City Art Gallery, a Turner Scholar at the Tate Gallery, and the editor of *Museums Journal*. He is currently the Deputy Director of the Museums Association.

GEF Gerald Finley is Professor Emeritus, Queen's University, Canada, and a Vice-President of the Turner Society. His writings on Turner include *Landscapes of Memory: Turner as Illustrator to Scott* (1980); *Turner and George the Fourth in Edinburgh, 1822* (1981); *Angel in the Sun: Turner's Vision of History* (1999); and numerous articles.

GF Gillian Forrester is Assistant Curator of Prints and Drawings at the Yale Center for British Art, New Haven, and a specialist on Turner's graphic work. She was the Volkswagen Turner Scholar at the Tate Gallery, London, 1993–6, and organized the Gallery's 1996 exhibition on Turner's *Liber Studiorum*.

JG John Gage has written *Colour in Turner: Poetry and Truth* (1969), *Turner: Rain, Steam, and Speed* (1972), and *Turner, 'A Wonderful Range of Mind'* (1987), besides editing Turner's *Correspondence* (1980, 1986). He was an editorial board member of *Turner Studies* and a principal organizer of the Bicentenary Exhibition at the R.A., 1974–5, and the *Turner* exhibition, Paris, 1983–4.

JAG Jean Golt has published articles in *Turner Studies* and the *Turner Society News*. She is a guide/lecturer in the Tate Gallery, the Wallace Collection, etc.

JH James Hamilton is the author of the biography *Turner: A Life* (1997), and organized the exhibition *Turner and the Scientists* (Tate Gallery, 1998). He is University Curator at the University of Birmingham, and was the Alistair Horne Fellow at St Antony's College, Oxford, 1998/9. His other books include biographies of Arthur Rackham and William Heath Robinson, and *Wood Engraving and the Woodcut in Britain c.1890–1990* (1994).

RH Robin Hamlyn is a senior curator in the Collections Division, Tate Gallery (Tate Britain). He has curated, written, and lectured extensively on 18th- and 19th-century British art.

LH Luke Herrmann is Emeritus Professor of the History of Art, University of Leicester. He was at the Ashmolean Museum, Oxford, before moving to Leicester in 1967. He is the author of several books on Turner, including *Ruskin and Turner* (1968), *Turner* (1975), and *Turner Prints* (1990). He was on the Editorial Board of and contributor to *Turner Studies*, 1980–91, and is an Honorary Vice-President of the Turner Society.

DH David Hill is Professor of the History of Art at Bretton Hall College (University of Leeds). He is a committee member of the Turner Society and responsible for numerous books, articles, and exhibitions including, most recently, *Turner in the North* (1996) and *Thomas Girtin: Genius in the North* (1999).

JCI Judy Crosby Ivy teaches for Randolph-Macon Woman's College, an American institution affiliated with the University of Reading. She is the author of *Constable and the Critics: 1802–1837* and is currently compiling a catalogue raisonné of the mezzotints engraved by David Lucas after Constable and other artists.

EJ Evelyn Joll is a retired art dealer who worked at Agnew's, 1949–94. He compiled, with Martin Butlin, the catalogue raisonné of Turner's oils (Yale University Press, 1977; rev. edn., 1984), which won the 1978 Mitchell Prize for Art History. An editorial board member of *Turner Studies*, he was Chairman of the Turner Society, 1994–2000.

AK Dr Andrew Kennedy has recently completed a thesis at the Courtauld Institute entitled 'British Topographical Print Series in their Social and Economic Context, c.1720–c.1840'. He teaches at Southampton University, Reading University, and a number of other institutions. He is currently working on Samuel and Nathaniel Buck and William Daniell.

MK Michael Kitson (1926–98) taught at the Courtauld Institute of Art from 1955, and was Deputy Director, 1980–5. He was Director of Studies at the Paul Mellon Centre, London, 1986–92, and Vice-Chairman of the Turner Society, 1984–93. He wrote books on Turner, Rembrandt, and Caravaggio, as well as exhibition catalogues and articles on the Italian baroque, British painting, Salvator Rosa and, above all, Claude Lorrain.

ADL Alastair Laing has been Adviser on Pictures and Sculpture to the National Trust since 1986, and was responsible for the exhibition at the National Gallery celebrating its centenary in 1995, *In Trust for the Nation*. His special field is 18th-century French art, in particular François Boucher (co-organizer of the Boucher exhibition in New York, Detroit, and Paris, 1985/6).

ADRL Andrew Loukes made a special study of Turner as a postgraduate student in art gallery and museum studies at Manchester University. He has worked for several public art museums, including the Tate Gallery and Manchester City Art Galleries, where he contributed to the 1996 catalogue *Turner Watercolours from Manchester*, and to which he returned in 2000.

AL Anne Lyles joined the Tate Gallery in 1987 as an Assistant Keeper in the British Collection, and until 1992 specialized in the art of J. M. W. Turner, curating a number of exhibitions on his watercolours and prints. She now concentrates on the landscapes of Constable and his contemporaries, and has a particular interest in the British watercolour school.

OM Olivier Meslay is Curator in the Department of Paintings at the Musée du Louvre, with responsibility for English and Spanish painting. He has worked at the Louvre since 1993. In 1994 he organized its *Outre-Manche* exhibition, based on the collections of British works in French museums; these collections are currently still mostly unknown. Franco-British artistic relations are at the heart of his work.

PM Paul Mitchell is a frame historian and consultant of international reputation, and has published articles on European frames in

specialist periodicals and exhibition catalogues. He has recently collaborated with Lynn Roberts on *A History of European Picture Frames* (1996) and on *Frameworks: Form, Function and Ornament in European Portrait Frames* (1996), in association with the exhibition of the same name (Paul Mitchell Ltd, November 1996–February 1997).

SM Susan Morris read English at Oxford and studied for a Ph.D. on Thomas Girtin at the Courtauld Institute. While an Andrew Mellon Fellow, 1985–6, she organized a Girtin exhibition at the Yale Center for British Art. A former editor of the *Antique Collector*, she now researches paintings for the Richard Green Gallery.

EN Evelyn Newby took a degree in the history of art at the Courtauld Institute, London University. After a period as Librarian at Colnaghi's, she became Archivist at the Paul Mellon Centre for Studies in British Art in 1975. She compiled the detailed index to the recent edition of the Farington *Diary*, 1998.

MO Mordechai Omer is Director and Chief Curator of the Tel Aviv Museum of Art, Professor of Modern Art at Tel Aviv University, and Curator of the university's art gallery, which he founded in 1974. He has curated exhibitions both in Israel and abroad, and has written widely on artistic topics, including Turner.

LP Leslie Parris (1941–2000), was Senior Research Fellow in the Collections Division, Tate Gallery. He was organizer/co-organizer of Tate exhibitions devoted to British landscape painting (1973–4), Constable (1971, 1976, 1991), the Pre-Raphaelites (1984) and, for Japan, *Masterpieces of British Art from the Tate Gallery* (1998). He was author of *The Tate Gallery Constable Collection* (1981), *John Constable & David Lucas* (1993), *Constable: A New York Private Collection* (1994), and was co-author of *The Discovery of Constable* (1984).

DP Diane Perkins has a BA in Fine Art and an MA in History of Art from Birkbeck College, University of London. She has worked as a curator at the Tate Gallery since 1987, initially specializing in Turner, during which time she organized three Turner watercolour exhibitions. Since 1992 she has been a curator for British 18th-century painting and sporting art.

JRP Jan Piggott teaches at Dulwich College, where for ten years he was Head of English. He studied at Oxford and the University of California, where he wrote a Ph.D. thesis on W. B. Yeats. In 1993 he organized an exhibition at the Clore Gallery, *Turner's Vignettes*.

KIP Khatchick I. Pilikian, sometime university professor of music in the United States, is a performing and recording musician (RAI-TV, RCA, Durium, Poetica), painter (*Gentes Ars*—International Exhibition prize, Rome, 1962), and a lecturer. 'Leonardo da Vinci on voice, music and stage design' was the title of his research as a Fulbright scholar.

CFP Dr Cecilia Powell is the author of four books/exhibition catalogues on Turner and his travels in Europe, including the prize-winning *Turner in the South* (1987), and many articles and reviews, and she has been the editor of *Turner Society News* since 1986.

NRDP N. R. D. Powell is a solicitor, practising in London, and specializing in wills and trusts. Since 1987, he has been Honorary Treasurer of the Turner Society.

TR Terry Riggs received her BA in Art History from the University of Virginia, and her MA from the Courtauld Institute, London. She was a curator of 19th- and 20th-century art at the Tate Gallery, and wrote the catalogue for the major touring exhibition *Masterpieces of British Art from the Tate Gallery*.

LR Lynn Roberts is a frame historian and has written, with Paul Mitchell, *A History of European Picture Frames* (1996) and *Frameworks: Form, Function and Ornament in European Portrait Frames* (1996), in association with the exhibition of the same name (Paul Mitchell Ltd, November 1996–February 1997).

CALS-M Charles Sebag-Montefiore is a director of a City corporate finance house. His particular interest is the history of the British as collectors. He has formed a library of catalogues and manuscript material devoted to this subject, and written several articles. He is Honorary Treasurer of the London Library and a trustee of the Samuel Courtauld Trust.

ES Eric Shanes is a painter, the author of eight books and catalogues on Turner, and was the founding editor of *Turner Studies*. Among his other books are studies of Constantin Brancusi, Salvador Dali, and Andy Warhol.

KMS Kim Sloan has been the curator responsible for the British School in the Department of Prints and Drawings at the British Museum since 1992. She is the author of several exhibition catalogues, including *Alexander and John Robert Cozens: The Poetry of Landscape* (1986), *Vases and Volcanoes: Sir William Hamilton and his Collection* (with Ian Jenkins, 1996), and *J. M. W. Turner Watercolours from the R. W. Lloyd Bequest* (1998).

SS Sam Smiles is Principal Lecturer at the University of Plymouth. He has published on Turner in *Turner Studies* and elsewhere and has made a particular study of Turner's visits to the west of England in the 1810s.

KS Katherine Solender is Coordinator of Exhibitions at the Cleveland Museum of Art, Cleveland, Ohio. She has organized several exhibitions for the museum, including: *Dreadful Fire! Burning of the Houses of Parliament* (1984), *The American Way in Sculpture 1890–1930* (1986), *American Arts & Crafts 1890–1920* (1988), and *The Camera* (1990).

AS Allen Staley is Professor of Art History at Columbia University. He is author of *The Pre-Raphaelite Landscape* (1973) and co-author of *The Paintings of Benjamin West* (1986).

SET Sarah E. Taft is Prints and Drawings Registrar at the Tate Gallery (Tate Britain).

JHT Joyce H. Townsend is Senior Conservation Scientist at the Tate Gallery, where she researches the materials and techniques of 19th-century British artists. Turner's painting materials formed the subject of her doctoral thesis (Courtauld Institute of Art, University of London, 1991). She has written *Turner's Painting Techniques* (Tate Gallery, 1993) and has edited a number of conservation publications.

RMT Rosalind Mallord Turner is an art researcher and bookbinder. She is a direct descendant of John Turner, JMWT's father's eldest brother. She inherited Turner's library in 1979 on the death of her father, C. W. M. Turner. She has transcribed verses for Turner's *Painting and Poetry* (1990).

RU Robert Upstone was at the Ironbridge Gorge Museum, 1984–5, and the National Trust, 1985–6. He has been a curator at the Tate Gallery since 1987. He is the author of *Sketchbooks of the Romantics* (1991) and *Treasures of British Art* (1996). He was curator or contrib-utor to the exhibitions: *Turner: The Second Decade* (Tate Gallery, 1989), *Turner: The Final Years* (Tate Gallery, 1993), *London—World City 1800–45* (Essen, 1992), *Beardsley to Bomberg* (Tate Gallery, 1992), *William Logsdail* (Usher Art Gallery, Lincoln, 1994), *Spencer Gore in Richmond* (Museum of Richmond, 1996), *The Age of Rossetti, Burne-Jones & Watts: Symbolism in Britain* (Tate Gallery, 1997).

WV William Vaughan is Professor of the History of Art at Birkbeck College, University of London. He studied at the Courtauld Institute of Art, became a curator at the Tate Gallery and then taught at University College London before assuming his current post. He has published widely on art in the early 19th century, his books including *German Romanticism and English Art* (Yale, 1978) and *Romanticism and Art* (Thames and Hudson, 1978, 2nd. edn. 1994).

BV Barry Venning was educated at York University, 1974–7, and the Courtauld Institute, 1978–81, where he studied British Romantic Painting with Michael Kitson. His publications include a study of Constable (1992) and a series of articles on wide-ranging aspects of Turner's art. His main research interests lie in Turner's writings and sea paintings.

RW Richard Walker, after active service in the RNVR, was Director of the Government Art Collection, 1949–76, Curator of the Palace of Westminster, 1950–76, and is the author of *Old Westminster Bridge* (1979), *Regency Portraits* (2 vols, 1985), *Royal Collection: the 18th Century Miniatures* (1992) and *The Nelson Portraits* (1998).

RKW Robert K. Wallace is Regents' Professor of Literature and Language at Northern Kentucky University. In addition to *Melville and Turner: Spheres of Love and Fright* (1992), his books include *A Century of Music-Making* (1976), *Jane Austen and Mozart* (1983), *Emily Brontë and Beethoven* (1986), and *Frank Stella's 'Moby-Dick' Series* (forthcoming).

IW Ian Warrell has been a curator at the Tate Gallery since 1985, with a special interest in the work of Turner and 19th-century British painting up to around 1850. He has written several books and catalogues on the artist, including *Turner on the Loire* (Tate Gallery 1997), and *Turner on the Seine* (Tate Gallery

1999), as well as collaborating on the exhibition marking the centenary of Ruskin's death in the spring of 2000.

AW Andrew Wilton was at the Walker Art Gallery, Liverpool, 1965–7, and in the British Museum Department of Prints and Drawings, 1967–76, before becoming first Curator of Prints and Drawings, Yale Center for British Art, New Haven. He returned to the British Museum as Assistant Keeper with responsibility for the Turner Collection in 1981 and became Curator of the Turner Collection in the new Clore Gallery at the Tate Gallery in 1985; Keeper of British Art, 1989–97, and Keeper and Senior Research Fellow from 1998. He has curated and catalogued numerous exhibitions devoted to Turner and other British artists; his books include *Turner in Switzerland* (with John Russell, 1977), *The Life and Work of J. M. W. Turner* (1979), and *Turner in his Time* (1987).

EY Edward Yardley has contributed essays to *Turner Society News* and full-length articles and picture notes in *Turner Studies*. His unpublished research on Turner has centred on the collectors of Turner watercolours. In 1996 he organized and wrote the accompanying publication for an exhibition of the works of the British marine painter Frank Henry Mason (1875–1965).

RY Robert Yardley has an honours degree in Fine Art and has written articles for *Turner Society News* and *Turner Studies*. He has lectured on Turner and his contemporaries and has served on the Committee of the Turner Society for many years.

AY Alison Yarrington is Professor of the History of Art at the University of Leicester. Her research is concerned with the history of sculpture and she is author of *The Commemoration of the Hero 1800–1864*, co-editor of *Reflections of Revolution: Images of Romanticism*, and co-author of *An Edition of the Ledger of Sir Francis Chantrey R.A.* She is currently writing a history of women sculptors.

· CLASSIFIED CONTENTS LIST ·

The following is a complete listing of the entries classified under broad headings. Some entries appear under more than one heading since they relate to more than one topic.

TURNER'S ART

Genre & Content

SUBJECT MATTER

- subject matter, importance for Turner
- agriculture
- architect, Turner as
- biblical
- Carthage and the story of Dido and Æneas
- classical
- contemporary
- convicts
- Fresnoy, Charles-Alphonse du
- Goethe, Johann Wolfgang von
- historical
- literary
- Parliament, Burning of the Houses of
- Plagues of Egypt
- pornography
- science
- seapieces
- Shakespeare, William
- 'Sun is God, The'
- tributes to other artists
- whaling

TOPOGRAPHY

England
- Brighton
- Bristol
- Cambridge
- Canterbury
- Cornwall
- Devon
- Dover
- Durham
- Ely
- Fonthill
- Isle of Wight
- Knockholt sketches
- Lake District
- Lancashire
- London
- Newark Abbey
- Norham Castle
- Oxford
- Peterborough
- Petworth
- Richmond, Surrey
- Richmondshire
- Salisbury
- Sheerness
- Stourhead
- Sussex
- Thames and tributaries
- Thames estuary
- Walton Bridges
- Windsor and Slough
- Yorkshire

Scotland
- Abbotsford
- Clyde
- Edinburgh
- Scotland

Wales
- Caernarvon
- Conway
- Ewenny
- Pembroke
- Snowdonia
- Tintern
- Wales

Belgium
- Antwerp
- Meuse

France
- Bonneville
- Calais
- France
- Loire
- Paris
- Seine

Germany
- Coburg
- Cologne
- Danube
- Ehrenbreitstein
- Germany

CONTEXT

· ABBREVIATIONS ·

ARA Associate of the Royal Academy of Arts.

BI British Institution; the initials with a date imply that a work was included in the summer exhibition of the British Institution that year.

BJ Butlin and Joll 1984 (see bibliography); the number refers to the catalogue entry.

F Finberg 1924; the number refers to Finberg's catalogue of the *Liber Studiorum*.

R Rawlinson 1908, 1913; the number refers to Rawlinson's catalogue of Turner's engravings.

RA Royal Academy of Arts or Royal Academician; the initials with a date imply that a work was included in that year's summer exhibition of the Royal Academy.

TB Turner Bequest; the numbers follow the order in Finberg 1909, the Inventory of the drawings now in the Tate Gallery. Only the first reference to sketchbooks in entries will be prefixed by TB.

W Wilton 1979; the numbers refer to his 'Catalogue of Watercolours'.

· NOTE TO THE READER ·

This book is designed for easy use but the following notes may be useful to the reader.

Alphabetical arrangement Entries are arranged in letter-by-letter alphabetical order following punctuation of the headword, with the exception that names beginning with Mc are arranged as though they were prefixed with Mac, and St is ordered as though it were spelt Saint.

Classified Contents List The list of entries under major themes at the front of the book (see pp. xvi–xxiv) offers an alternative means of access to the material.

Chronology The Chronology (pp. 399–415), which sets the key dates in Turner's career along-side contemporary cultural and political events, offers another starting point to the work. Asterisks within the Chronology signal a cross-reference to the main text.

Cross-references An asterisk (*) in front of a word in the text signals a cross-reference to a related entry. Cross-referencing has been guided as far as possible by common sense and normally occurs only once within any given entry. This means that in some cases asterisks have been added to what are in fact slight variants of the actual headword; it also means that cross-references have been inserted where they seem most likely to assist the reader, rather than mechanically wherever a headword occurs in the text. For this reason locations of paintings have not been asterisked.

Titles of paintings and sketchbooks are given, when this is applicable, as spelt and punctuated by Turner or in original catalogues. Descriptive references to the subject, however, follow modern conventions.

Parenthetic information about individual works is given thus: (date executed or first exhibited; present ownership and location; BJ or W catalogue number—on which see the list of abbreviations on p. xxv). If the ownership of an oil painting is not given, this means that it is in the Tate Gallery, London, as does a TB number.

Street names and institutions are in London, unless otherwise indicated.

Bibliographies Within the text, frequently cited works are referred to in abbreviated form. Their full details can be found in the Select Bibliography at the back of the book (pp. 393–8)

Public Collections A listing of museums and galleries with large groups of Turner works, or with particularly important individual works, appears at the back of the book (pp. 416–19).

Contributors' initials at the end of each entry refer to the list of contributors on pp. xi–xv. Two sets of initials imply joint authorship or the editorial conflation of two overlapping entries.

A

ABBOTSFORD, *Scott's country house on the River Tweed near Melrose. For more than twelve years Scott laboured to transform a modest farmhouse, Cartleyhole, which he had purchased in 1811, into a moderately sized, attractive 'gothick' residence. Renamed Abbotsford, since, in the past, the monks of Melrose forded the Tweed near it, the house displays an array of salvaged or cast parts from celebrated ancient Scottish buildings and was filled by Scott with relics from Scotland's past. It also displayed eight of Turner's watercolours which the artist had prepared to illustrate Scott's *Provincial Antiquities.* Turner visited Scott at Abbotsford for five days in 1831 to collect sketches for illustrations for new editions of the writer's *Poetical Works* and *Prose Works* (see SCOTT). At that time, he sketched the house as well as making studies of its attractive interior (TB CCLXVII, CCLXVIII); he also made sketches in its grounds (CCLXVIII). The house provided the subject of a vignette for the *Poetical Works* (W 1093). Two scenes in its grounds, the Rhymer's Glen and Chiefswood Cottage, furnished designs for the *Prose Works.* There is an unusual painting on a japanned tray of Abbotsford seen from the north bank of the Tweed (*c.*1836) which shows Scott and his family as Turner envisaged them in 1831 (Indianapolis Museum of Art; BJ 524). The tray, in turn, seems to have furnished the design of the watercolour (W 1142) engraved for J. G. Lockhart's *Life of Scott* (1839). GEF

Finley 1980, pp. 103–24, 208–10, 220–2.

ÆNEAS AND THE SIBYL, LAKE AVERNUS, see CARTHAGE.

ÆNEAS RELATING HIS STORY TO DIDO, oil on canvas, 36 × 48 in. (91.5 × 122 cm.), RA 1850 (192); formerly Tate Gallery, London (BJ 430). This was one of Turner's last four exhibits, all with quotations from the *Fallacies of Hope* (see POETRY AND TURNER). The other pictures are *Mercury sent to admonish Aeneas* (BJ 429), *The Visit to the Tomb* (BJ 431), and *The Departure of the Fleet* (BJ 432); these three are in the Tate Gallery whereas the fourth disappeared mysteriously from the record between D. S. MacColl's *National Gallery, Millbank: Catalogue; Turner Collection,* 1920, and the Tate's list catalogue of 1936. Having exhibited a single, overpainted early work in 1847 (*The *Hero of a Hundred Fights*), nothing in 1848, and two early works again in 1849 (one reworked, one left as it was), Turner clearly made a special effort in what was to be the last year in which he exhibited, with an unprecedented group of four paintings devoted to the same theme, Aeneas' stay at Carthage, tempted by the love of Dido until finally persuaded to fulfil his destiny by sailing on to Italy. J. W. Archer, who visited Mrs Booth at Cheyne Walk shortly after Turner's death, stated that Turner had painted there his 'last three [*sic*] pictures which he exhibited at the Royal Academy . . . These pictures were set in a row and he went from one to the other, first painting upon one, touching on the next, and so on, in rotation.'

For *The Times,* 4 May 1850,

It would seem as if Mr. Turner had possessed in youth all the dignity of age to exchange it in age for the effervescence of youth. But to the more practical eyes which still trace through these eccentricities the hand of a great master and a matchless command over the materials of painting, careless of form and prodigal of light, these four pictures are not deficient in beauty and interest.

The *Athenaeum,* 18 May, described the four pictures as 'full of combinations of forms of richest fancy and of colours of most dazzling hue'. Other reviews were more critical, the *Spectator,* 4 May, writing of 'a splendid perplexity, respecting which the name would convey no information to the reader; with a companion, equally brilliant to the eye and dark to the understanding', and 'another picture from his "Fallacies of Hope",—the said fallacy being any hope of understanding what the picture means.' Turner's friend George *Jones wrote to him on 14 April, 'I saw your pictures this morning for the first time, and more glorious effusions of mind have never appeared—*your* intellect defies time to injure it, and I really believe that you never conceived more beautiful, more graceful, or more enchanting compositions, than these you have sent for exhibition.'

See also CARTHAGE. MB

Jerrold Ziff, 'J. M. W. Turner's Last Four Paintings', *Turner Studies*, 4/1 (summer 1984), pp. 47–51.

Nicholson 1990, pp. 285–90.

ÆOLIAN HARP, see *THOMSON'S ÆOLIAN HARP*.

AGNEW'S.

Thomas Agnew (1794–1871) started in business in Manchester in 1817. The firm's records are very sketchy before 1850 so that the first recorded sale of a Turner concerns *Mortlake Terrace* (RA 1827; National Gallery of Art, Washington; BJ 239) bought from the artist Thomas Creswick RA and sold in 1851 for £450 to Samuel Ashton who, in 1850, had bought *Constable's *Salisbury Cathedral* (now on loan to the National Gallery, London) from the firm for £600.

William Agnew (1825–1910), the eldest of Thomas's four sons, opened a branch in Waterloo Place, London, in 1860. In June 1861 Agnew's bought *What You Will!* (RA 1822; private collection; BJ 229) at Lady *Chantrey's sale at Christie's and have since resold it three times. At the *South Kensington International Exhibition in 1862 T. Agnew and Sons lent fourteen watercolours, more than anyone else, but it was the *Bicknell sale in April 1863, where Agnew's bought seven of the Turner oils for a total of £13,971, that, at a stroke, established the firm as the principal dealer in Turner's work. This is confirmed by the provenances in the Wilton and Butlin and Joll catalogues.

Agnew's continued to be major buyers of the Turners collected by *Munro of Novar, *Ruskin, *Dillon, *Gillott, Heugh, *Greenwood, Birchall, and *Leyland which were dispersed during the 1860s to 1880s. There was no shortage of Turners on the market; Redford's *Art Sales*, published in 1918–21, records over 1,500 Turners passing through the salerooms between 1845 and 1912 although not all were authentic. The firm was particularly active in the 1870s, when 313 watercolours passed through their hands.

At the first major dispersal of the *Fawkes collection in 1890 Agnew's bought 23 of the 62 lots sold; they also bought freely at Abel *Buckley's sale in 1904 and at the Acland-Hood sale in 1908 of Turners inherited from Jack *Fuller of Rosehill. But the firm's *mensis mirabilis* occurred in July 1912 when they bought 97 watercolours. Of these 22, including the remaining sixteen of the 1817 *Rhine series, came privately from Frederick H. Fawkes and 75 from the J. E. *Taylor sale on 12 July when Agnew's bought the first 35 lots including both the 'Blue' and the 'Red' *Rigis (1842; private collection and National Gallery of Victoria, Melbourne; W 1524, 1525). In 1917 the firm bought 33 watercolours privately from W. G. *Rawlinson which they sold *en bloc* to R. A. *Tatton a month later. At Captain T. A. Tatton's sale in December 1928, which contained 36 Turners (12

from the Rawlinson collection), the firm bought 23 for stock.

Agnew's occasionally bought Turners in partnership with other dealers, particularly when American buyers were involved. For example, *Venice* and *Keelmen* (RA 1834 and 1835; both National Gallery, Washington; BJ 356/360) were bought by Agnew's with Sulley and Co. in 1910 and sold that year by Sulley to P. A. B. Widener, and the firm's 'first' Turner, *Mortlake Terrace*, was bought in 1920 with Knoedler's, who sold it to Andrew Mellon.

Turner prices increased sharply in the 1920s during which Agnew's paid 29,000 guineas in 1927 for *Dogana, and Madonna della Salute, Venice* (RA 1843; National Gallery of Art, Washington; BJ 403), bought for Governor Fuller of Massachusetts, and 7,900 guineas for the 'Red' Rigi in December 1928. These prices remained records until 1965 and 1959 respectively.

But in the 1930s prices fell dramatically. Unfortunately the firm was then too short of money to take advantage of this, thus missing many opportunities, especially at the Fawkes sale in 1937 where they bought not one of the 23 watercolours on offer despite fine views of the country round Farnley selling for as little as 300 guineas.

Between 1945 and 1970 257 watercolours and 21 genuine oils were sold at auction, Agnew's share being 71 watercolours and 9 oils. By 1970 Paul *Mellon had been buying British pictures and drawings in large numbers for ten years and the firm sold him Turners in both media on a handsome scale.

The great success of the *Turner bicentenary exhibitions (1974–5) led to a marked increase in potential buyers, including new collectors on the Continent. In 1975 Agnew's sold *Ostend* (RA 1844; BJ 405) to the Neue Pinakothek, Munich, the first Turner oil to enter a German museum, and since then Agnew's have sold, among others, *Mainz and Kastell* (c.1820; W 678) to a German private collector and *Falls of the Rhine, Schaffhausen* (c.1841; W 1467) to the museum at Schaffhausen.

In the 1980s Japanese museums entered the field, buying two very late watercolours from Agnew's: *The Descent of the St Gothard* (1847–8; W 1552) and *Pallanza, Lago Maggiore* (1848–50; W 1556). The firm also sold *Seascape with a Squall coming up* (c.1803–4; BJ 143) to the Tokyo Fuji Art Museum and, in partnership with the Marlborough Gallery, *Landscape with Walton Bridges* (c.1845–50; BJ 511) to the Koriyama Art Museum.

Since the early 1980s Agnew's have handled fewer Turners owing to very strong competition from the salerooms, which have greatly increased their share of the market. Their ascendancy has led to clients of Agnew's who, in the

past, would have sold their Turners back to the firm or consigned them to Agnew's for sale on a commission basis, to choose auction instead, with variable results. For example, Agnew's bought *Châteaux de St. Michael, Bonneville, Savoy* (RA 1803; BJ 50; see BONNEVILLE for the confusion over the two 1803 exhibits) at the Pitt Miller sale in 1946 for a client whose son opted for auction in 1984 when it was bought by the Newhouse Galleries, New York, in partnership with Agnew's who then sold it profitably to the Dallas Museum, Texas.

In the 149 years since selling their first Turner, 298 oils and 1,973 watercolours have passed through the firm's hands, although of course this includes many items sold more than once (BJ lists only 221 oils outside the *Tate Gallery including lost or destroyed works).

See also ART MARKET IN TURNER'S WORK SINCE 1851. EJ

AGNEW'S 1951 AND 1967 EXHIBITIONS celebrated, respectively, the centenary of Turner's death and the firm's 150th anniversary. Both were crowded throughout.

The 1951 exhibition, in aid of the *Artists' General Benevolent Institution, consisted of 121 watercolours and four portraits of Turner, all lent privately except *Conway Castle* (c.1800; W 271), given to the *Whitworth Art Gallery in 1948 by the granddaughters of Thomas Ashton, who had bought it from Agnew's in 1863.

Lenders included Sir Edmund Bacon, Stephen *Courtauld, Major Horton-*Fawkes (twelve loans), Lords Harewood and Monk Bretton, Norman Newall, Leslie Wright, and the descendants of those avid Turner collectors J. E. *Taylor and Sir Donald *Currie. Only one loan was refused for the sufficient reason that the drawing in question could not be found.

Above all, on condition Agnew's held the exhibition in February, R. W. *Lloyd, the greatest Turner collector in the first half of the century, agreed to lend 21 drawings (now British Museum). Besides *Zürich* (1842; W 1533) and *Lucerne, Moonlight* (1843; W 1536) Lloyd's loans, especially the *Rhine and *England and Wales* subjects, were the star items in the exhibition.

The 1967 exhibition, in aid of the National Art-Collections Fund, contained 35 oils and 61 watercolours lent from 56 private and eighteen public collections. Exceptionally generous loans to a dealer came from America, including *Slavers* (RA 1840; BJ 385) from Boston, *Snow-Storm, Avalanche . . .* (RA 1837; BJ 371) from Chicago, *Venice* (RA 1835; BJ 362) from the *Metropolitan Museum, New York, *Waves breaking on the Shore* (c.1840–5; BJ 482) from Mr and Mrs Paul *Mellon, and *Venice, the Giudecca* (RA 1841; BJ 391) from Mr William Wood Prince. The *Tate

Gallery lent the recently cleaned *Two Figures in a Building* (c.1830–5; BJ 446), which had never been exhibited before.

The watercolours ranged from *Merton College from the Meadows* (c.1801; private collection; W 408) to *The Descent of the St. Gothard* (1847–8; Koriyama Museum of Art, Japan; W 1552) and *Pallanza, Lago Maggiore* (1848–50; Shizuoka Prefectural Museum, Japan; W 1556) and included five of the 1842 and two of the 1843 sets of Swiss views.

Since 1967 thirteen oils and 22 watercolours among those exhibited have changed hands. EJ

AGRICULTURE AS SUBJECT MATTER, in the sense of arable production and activities associated with it, figures in a relatively small proportion of Turner's oils. As a follower of the classical landscape tradition, Turner usually avoided subjects which tended to degrade rather than elevate landscape painting as a genre. Nevertheless, the important group of *Thames subjects—including both the open-air oil sketches of 1805, and the finished paintings exhibited in 1809–10 at *Turner's gallery—often show agricultural activity in the broader sense. His interest in such topics, as with other artists, was at least partly provoked by the Napoleonic wars, especially the blockade against British goods. In his draft poem of 1811 associated with *Picturesque Views of the *Southern Coast of England*, Turner exhorts his countrymen to 'Urge all our barren tracts by Agriculture skill' in order 'to meet the direfull length | Of continental hatred called blockade' (Wilton 1990, p. 173). That said, the majority of finished Thames paintings of this period, such as *Dorchester Mead* (Turner's gallery 1810; BJ 107), seem to portray a part-pastoral, part-commercial England of cattle, sheep, and barges, with little arable activity. But *Ploughing up Turnips near Slough* (Turner's gallery 1809; BJ 89) depicts hard winter work in progress. Barrell (pp. 152–5) has suggested that, by showing labourers momentarily pausing in their onerous task, Turner avoids depicting them stereotypically as either Georgic automata or indolent Arcadians. The same observation, he suggests, applies to the labourers in *Frosty Morning* (RA 1813; BJ 127).

Turner painted no more agricultural landscapes in oils after 1813, but the subject matter continued to feature in the 'lower' media, that is, watercolour and engraving. Thus, harvesting is taking place in the view of *Hylton Castle* (c.1817; W 556), a watercolour commissioned for engraving in Robert Surtees's *History of *Durham* by the castle's owner, the Earl of *Strathmore. It has been suggested that 'The couple in the foreground appear to be sharing out their gleanings (indicating that charity and benevolence are practised on this estate)' (Payne 1993, no. 61).

There was perhaps more opportunity to be critical of the changes affecting rural society in watercolours made directly for the topographical engravings market, without the involvement of landed patrons. Thus, it has been observed by Payne that certain of Turner's images for *Picturesque Views in *England and Wales*, such as *Valle Crucis Abbey* (c.1826; City Art Gallery, Manchester; W 799) and **Ely Cathedral* (c.1831; private collection; W 845), exhibit a nostalgia for pre-enclosure open fields, in common with images by Peter de Wint (a Tory) and David Cox (a Radical). However, the new debates on industrialism were beginning to marginalize the old debates on the countryside. In a late oil, **Rain, Steam, and Speed* (RA 1844; National Gallery, London; BJ 409), the railway, associated with industrialism, appears as a violent, dynamic element in the hallowed landscape of the Thames valley, in contrast to the tiny, evanescent forms of the plough team on the extreme right of the picture. AK

John Barrell, *The Dark Side of the Landscape*, 1980, pp. 152–5.
Payne 1991, pp. 7–15.
Christiana Payne, *Toil and Plenty: Images of the Agricultural Landscape in England, 1780–1890*, 1993, pp. 52–4 and catalogue entries.

AKENSIDE, Mark (1721–70), didactic and lyric poet and physician, who wrote sensitively (before *Wordsworth) on English landscape, the imagination, and of nature harmonizing the mind. His style was called 'luxuriant' by Dr Johnson and 'gaudy and inane' by Wordsworth, but he was an early favourite of Turner, who quoted him in the *perspective lectures at the Royal Academy. In *The Pleasures of the Imagination* (1744 and 1757) Akenside tunes the 'British lyre' to 'Attic themes' with Platonic discussion of beauty, pleasure, and virtue, and 'the lovely phantoms of sublime and fair'. Turner quotes Book III on the 'association of ideas', a secret union compared to magnetism within the fabric of the mind, which acts like a reflecting lake. The god-like artist creates light, line, colour, and design from chaos. Anticipating Wordsworth and Samuel *Palmer, Akenside describes 'visionary landscape', 'romantic dream', and the 'yellow stream of light' (Book II), the vale of Tempe and Hesperian Isles, ripening clusters, nymphs, and a goddess who holds aloft a branch of fruit, but also Apollo and Python, storms, shipwrecks, and the desolation of the Forum at *Rome. Turner's full title to *The Fall of the Clyde* (RA 1802; Walker Art Gallery, Liverpool; W 343) refers to the *Hymn to the Naiads* (1746), in which Akenside describes the nymphs (pictured by Turner) as elementals of breezes and rivers, favourable to commerce and the navy.

See also POETRY AND TURNER. JRP

Ziff 1964.
Wilton and Turner 1990.

ALBERT, Prince (1819–61), prince-consort of England. Second son of Ernest, Duke of Saxe-Coburg-Gotha, he married Queen *Victoria in 1840, and became a powerful influence on the Queen behind the scenes. His main official activities were concerned with the arts. In 1841 he was made Chairman of the Commission concerned with the rebuilding of the Houses of Parliament, and he was closely involved in the planning of the *Great Exhibition of 1851. He was a considerable collector of early Old Master paintings, and he encouraged the Queen to collect contemporary British art. Victoria retired into deep mourning for several years after Albert's early death from typhoid fever in 1861. LH

ALLEN, Arthur Acland (1868–1939), Liberal MP for Christchurch, 1906–10, and Dunbartonshire, 1911–18. He was one of four brothers, nephews of J. E. *Taylor, who bought watercolours including Turners at his sale at Christie's in July 1912. In his memory they then jointly presented the *Whitworth Art Gallery with *Sunset at Sea with Gurnets* (c.1840; W 1396) and *Sunset on Wet Sand* (c.1845; W 1415), while Arthur Allen alone presented *A Conflagration, Lausanne* (c.1836; W 1455).

Arthur Allen's collection of 143 watercolours was sold at Sotheby's on 4 April 1935. It included ten Turners but the two finest, *Sisteron, Basses Alpes* (?1836; W 1450) and *Town and Lake of Thun* (?1841; W 1505), were both bought in. They were sold later by Allen's widow at Sotheby's on 15 May 1957 and now belong to the *Metropolitan Museum, New York, and to the Cecil Higgins Art Gallery, *Bedford, respectively.

Allen formed a major collection of *Liber Studiorum* prints including many first states, some from the Taylor sale. He was also an acknowledged expert on the series and *Finberg's *History of Turner's* Liber Studiorum (1924) is dedicated to Allen. He donated the bulk of his *Liber* collection to the *Royal Academy of Arts in 1938 and also gave a set of published states to the National Gallery, Millbank, which now forms the basis of the *Tate Gallery's *Liber* collection. His widow presented the residue of his holdings to the National Gallery of New South Wales, Sydney, in 1940. EJ

Forrester 1996, pp. 40–1, 43 n. 9.

ALLEN, James Baylis (1803–76), English engraver, born and trained in Birmingham, who moved to London and worked under the *Findens. Having engraved two copper plates after Turner for the *England and Wales* series, *Stoneyhurst* and the fine *Castle Upnor* (R 244, 271), J. B. Allen was responsible for four of the steel engravings for the *Rivers of France* (1833–5; R 438, 454, 462, 480). He also engraved three of the small plates for *Finden's *Landscape Illustrations of the Bible* (R 574, 578, 587), published in 1836,

and in later years he was responsible for several plates in the *Turner Gallery*. LH

ALLEN, James C. (d. 1831), London-born engraver who specialized in etching, and was a pupil of W. B. *Cooke, in whose studio he continued to work after the expiration of his apprenticeship. His first plate after Turner was the view of *Ivy Bridge* for Cooke's unpublished *'Rivers of Devon' (1816–21; R 139), and in 1824 he engraved *St. Mawes* (R 116) for Cooke's *Southern Coast*, as well as various later plates. The discovery of a letter postmarked '10 Feb. 1819' from Turner to W. B. Cooke (Gage 1980, p. 77) has established that J. C. Allen worked with Turner on the emblematical cover for the *Views in *Sussex* (R 128), which had always been considered as the only finished etching by Turner himself. LH

ALLNUTT, John (1773–1863), wine merchant, collector, and amateur palaeontologist and naturalist, amassed a wide-ranging collection of contemporary British pictures as well as Old Master works. He commissioned portraits from *Lawrence and was an early supporter of *Constable (see *Constable*, exhibition catalogue, Tate Gallery 1991, pp. 152–3). He owned several paintings and drawings by Turner. His name appears in the 'Academies' Sketchbook (TB LXXXIV: 66v.), in use around 1804, and he may have commissioned *The Pass of *St. Gothard* (Birmingham Museums and Art Gallery; BJ 146) and *The Devil's Bridge, St. Gothard* (private collection; BJ 147) after seeing the large watercolours of those subjects in Turner's studio that year. In 1838 Allnutt purchased three major oils: *Newark Abbey on the Wey* (? Turner's gallery 1807; Yale Center for British Art, New Haven; BJ 65), *The *Seat of William Moffatt Esq., at Mortlake. Early (Summer's) Morning* (RA 1826; Frick Collection, New York; BJ 235) and *Mortlake Terrace . . . Summer's Evening* (RA 1827; National Gallery of Art, Washington; BJ 239) at the Harriott sale, Christie's, 23 June. Watercolours in his collection included two views of *Fonthill Abbey (RA 1800; Art Gallery of Ontario and Montreal Museum of Fine Art; W 336–7), *Landscape: Composition of Tivoli* (1817; private collection; W 495), for which Allnutt commissioned the engraving (R 207), and *Leeds* (1816; Yale Center, New Haven; W 544). Allnutt attached a gallery to his house in Clapham which he opened to the public. His collection was sold at Christie's, 18–20 June 1863 and 23 and 25 June 1866. RU

Art Journal, 1863, pp. 160–1.

A. H. Noble, *The Allnutt Family*, 1962.

Macleod 1996, pp. 384–5.

ALLSTON, Washington (1779–1843), American landscape and history painter. He arrived in London in 1801 and enrolled at the Royal Academy; he first exhibited there in 1802. Cultivated and knowledgeable, Allston was uniquely 'international' for his time. He studied in France and Italy, 1803–8, went back to America, and then returned to London 1811–18 before settling in America permanently. Like Turner, Allston set out to emulate the Old Masters—usually with greater success than most of his contemporaries. His comment, prompted by *Snow Storm: Hannibal crossing the Alps* (RA 1812: BJ 126), that Turner was 'the greatest painter since the days of *Claude' carries real authority. Lord *Egremont was a patron and Allston's large painting *Jacob's Dream* (Petworth House) appears in one of Turner's *Petworth gouaches and inspired Turner to rework the subject in another. RH

William H. Gerdts and Theodore Stebbins, Jr., 'A Man of Genius': The Art of Washington Allston 1779–1843, exhibition catalogue, Boston and Philadelphia, 1980.

Butlin, Luther, and Warrell 1989, pp. 48, 53, 146.

ALPS. The great massif of the Alps, stretching from Savoy in eastern France to the Tyrol in Austria and northern Italy, was for Turner the spine of Europe, a 'blanch'd barrier' that had presented an obstacle to man from ancient times to the present. The mountains were there to be crossed, and he nearly always painted them as the context for a journey between the north and south of Europe. Sometimes the journey is a private and personal one, as in his view of a chaise dwarfed by the mountains as it crosses the pass of Faido (1843; W 1538). Sometimes it is historical, even cataclysmic, as in the view of the *Val d'Aosta as the scene of a Napoleonic battle, *The Battle of Fort Rock* (RA 1815; TB LXXX: G; W 399) or his great vision of Hannibal's invasion of Italy, *Snow Storm: Hannibal . . . (RA 1812; BJ 126). The mountains rear up against man and his ambitions; they are a match for any hero, but—the implication is—not for the artist, who conquers them by drawing them.

Turner's first approach to the Alps was from Savoy, and his first oil paintings of them show the range as it appears to a traveller arriving at *Bonneville. Not by chance, perhaps, these two canvases deal in different ways with the problem of recession in landscape: the challenge to represent the process of moving forward through painted space. One employs the device of a broad, curving waterway to lead the eye gently toward the mountains; the other, by contrast, has a dead straight road that precipitates the viewer into the heart of the view. In 1812 Turner published a *Liber Studiorum plate that presents the whole *Chain of Alps from Grenoble to Chambery* (F 49) as seen by the approaching traveller, a frisson of anticipated *Sublimity as he crosses the plain. A somewhat later meditation on the approach to the Alps is the watercolour of *Grenoble Bridge*, (1824; Baltimore Museum of Art, Maryland; W 404), where they loom in the

background of a thriving town dominated by the hotels built for travellers on their way to the mountains.

The dangerous route through the Alps became the subject of two important watercolours, the grand *Passage of Mount *St. Gotthard, taken from the Centre of the Teufels Broch (Devil's Bridge), Switzerland* (Abbot Hall Art Gallery, Kendal; W 366) which appeared at the RA in 1804, and *St. Gotthard: The Devil's Bridge* (Yale Center for British Art, New Haven; W 368), which may not be a finished work. Both subjects were also treated by Turner in oil (Birmingham Museums and Art Gallery and private collection; BJ 146, 147), but it is the watercolours that best convey the vertiginous height and danger of the place. They are based on powerful studies in the 'St Gothard and Mont Blanc' Sketchbook (TB LXXV). The same book provided subjects for watercolours showing parts of the valley of Chamonix, including the boldly composed *Glacier and source of the Arveron, going up to the Mer de Glace* (Yale Center for British Art; W 365), which was shown at the RA in 1803, and reappeared in the *Liber Studiorum* (F 60), together with a plate of the *Mer de Glace* (F 50). A watercolour in a very different vein is the ecstatic view of the *Lake of *Lucerne from the landing place at Fluelen* (c.1807; private collection; W 378), with its mist-wreathed mountains, anticipating the Lake Lucerne subjects that Turner was to execute in the 1840s.

Two subjects dating from after this first sequence of Swiss watercolours record road accidents in bad conditions, experiences that Turner had on his way home from Italy. Both are watercolours. *Snowstorm, Mont Cenis* (1820; Birmingham Museums and Art Gallery; W 402) recalls a difficult crossing of the pass in 1820, while an unusually large work, *Messieurs les voyageurs on their return from Italy (par la diligence) in a snow drift upon Mount Tarrar—22nd January, 1829* (British Museum; W 405), ranks among his most ebullient and cheerful accounts of the dangers of travel. Such was his delight in the adventure that he even exhibited this very personal work at the RA in 1829.

Just as Wales and Scotland had posed new technical problems for him, so the Alps challenged Turner to develop new processes for the expression of vast scale and expansive atmosphere. Initially his responses were governed by the prevailing Neoclassical aesthetic, and in works like *St Huges denouncing vengeance on the Shepherd of Cormayer* (RA 1803; W 364) a *Poussinesque geometry defines recession and the massive blocks of the mountains. The receding road of *Bonneville, Savoy, with Mont Blanc* (RA 1803; Yale Center for British Art, New Haven; BJ 46) reappears here, clearly inspired by the *Landscape with a Roman Road* at Dulwich, long attributed to Poussin but perhaps by a close follower. It was to become a favourite compositional trick,

and recurs in a late Alpine subject, the watercolour of *The Splügen Pass* (1842; private collection; W 1523), which again places special emphasis on the actual process of travel. But the *Splügen* also shows how by the 1840s Turner was concerned with the rendering of atmosphere between the masses of the mountains, rather than with the solid geometry of the rocks themselves. A supreme manifestation of his preoccupation with the free, dynamic atmosphere of the mountain climate is the finished watercolour of *Bellinzona, from the Road to Locarno* (1843; Art Gallery, Aberdeen; W 1539), which is alive with small touches of the brush, enveloping the broad view in a swirl of light and air.

Turner created two definitive statements about the mountains as a geographical and historical phenomenon: his watercolour of *The Battle of Fort Rock, Val d'Aouste 1796* (LXXX: G; W 399), shown in 1815, and *Snow Storm: Hannibal and his Army crossing the Alps*, exhibited in 1812. Already in 1803, in *St Huges*, he had suggested a correlation between the traveller's encounter with the great peaks and the historical and dramatic interrelationship of human beings, though in that watercolour the obscurity of the episode depicted somewhat distracts us from the point he is making. *The Battle of Fort Rock* is another matter. It is a vivid, almost cinematic account of a battle fought on a vertiginous mountain road, ranging in detail from the blowing up of a bastion to the vignette of a peasant woman tending her wounded husband. A deep chasm in the centre of the composition supplies a precise division between this scene of human destruction and the inimical, unscalable cliff of rock that rises opposite. In *Hannibal* the structure is less daringly schematic, but creates one of the most impressive of all images of the mountains. Here, the opposition of Carthaginian army and local tribesmen (we view the battle from the tribesmen's point of ambush) is paralleled by the sweep of the storm which envelops everything in a cataclysmic upheaval that anticipates (and undoubtedly inspired) the apocalypses of John *Martin. AW

Russell and Wilton 1976.
Hill 1992.
Warrell 1995.
Brown 1998.

AMSTERDAM, leading city of Holland, situated at the south-west of the IJsselmeer and the mouth of the River Amstel. Increasingly prosperous after embracing Protestantism in the 16th century, it yet observed a staunch religious tolerance which attracted numerous foreign refugees. A flourishing East India Company, a Stock Exchange, its own Admiralty, a Bank, and the regular extension of concentric canals turning it into 'the Venice of the North' were evidence of its success. Led by *Rembrandt and *Ruisdael, artists

throve, as did scholars and scientists in this richest city of the Dutch Republic. It was made its capital in the time of *Napoleon (1793–1813) and remained so after the creation of the United Netherlands.

Turner first visited the city in 1817 and drew many Amsterdam views (TB CLIX, CLXII, CLXIII, CCXIV), often with interesting inscriptions about curiosities and pictures.

AGHB

D. Regin, *Traders, Artists, Burgers: A Cultural History of Amsterdam in the 17th century*, 1976.

ANCIENT ROME: AGRIPPINA LANDING WITH THE ASHES OF GERMANICUS. *The Triumphal Bridge and Palace of the Caesars restored,* oil on canvas, 36 × 48 in. (91.5 × 122.2 cm.), RA 1839 (66); Tate Gallery, London (BJ 378); and *Modern Rome—Campo Vaccino*, oil on canvas, 35½ × 48 in. (90.2 × 122 cm.), RA 1839 (70); the Earl of Rosebery (on loan to the National Gallery of Scotland) (BJ 379). Germanicus (15 BC–AD 19), nephew of the emperor Tiberius, died in Antioch, possibly poisoned. His widow, Agrippina, brought his ashes home, landing in fact at Brindisi rather than Rome (Turner was probably misled here by Oliver Goldsmith's *Roman History*, 1786). Her arrival is set against a golden vision of the Imperial City which Turner has reconstructed in the manner of J. M. Gandy.

Modern Rome shows the Forum in ruins and the hillside on which Claudian goats feed overgrown. Yet, as Kathleen Nicholson points out, Turner does not present the pair as 'contrasting states of former glory and present decline' but finds a critical rapport between old and new. What endures in Turner's view is nature itself: by choosing a low viewpoint in *Ancient Rome*, the dominant feature is the ever-flowing Tiber while, *Modern Rome* being seen from above, 'nature has begun a gentle reclamation process on the hillside, while, below, a soft mist cloaks the Forum and seemingly heals its decay' (Nicholson 1990, p. 119).

Blackwood's Magazine criticized the pair as 'both alike in the same washy-flashy splashes of reds, blues and whites that, in their distraction, represent nothing in heaven or earth'. Turner had already paired *Modern Italy—the Pifferari* and *Ancient Italy—Ovid banished from Rome* at the RA the previous year, 1838 (Glasgow Art Gallery and private collection; BJ 374, 375).

EJ

Nicholson 1990, pp. 115–23.

ANDERSON DRAWINGS, see FAKES AND COPIES.

ANGEL STANDING IN THE SUN, THE, oil on canvas, 31 × 31 in. (78.5 × 78.5 cm.), RA 1846 (411); Tate Gallery, London (BJ 425). Together with its companion, *Undine giving the Ring to Massaniello, Fisherman of Naples* (BJ 424),

the last of Turner's pairing of contrasted pictures. There was no text for *Undine* in the catalogue but *The Angel standing in the Sun* was accompanied by the lines from Revelation 19: 17, 18, beginning 'And I saw an Angel standing in the sun', and two lines from Samuel *Rogers's *Voyage of Columbus*. In the foreground Adam and Eve lament over the dead body of Abel and Judith stands over the decapitated body of Holofernes. The picture has been seen as a summing up of Turner's career as he approached death, and also as a rather involved attack on the Revd John Eagles, critic of *Blackwood's Magazine*, setting Turner as the Archangel Michael against the humble fisherman Massaniello. Sheila Smith contrasts the destructive lust that corrupts the love of Massaniello and the water nymph Undine with the redemption through love at the Day of Judgement.

The *Spectator*, 9 May 1846, called the two pictures 'tours de force that show how nearly the gross materials of the palette can be made to emulate the source of light', while for *The Times*, 6 May, 'The "Angel standing in the sun" is a truly gorgeous creation . . . It is all very well to treat Turner's pictures as jests; but things like these are too magnificent for jokes'. Ruskin, however, in his notes on the display of Turner's paintings at Marlborough House, 1857, described the two pictures as 'painted in the period of decline' (*Works*, xiii. p. 167).

MB

Smith 1986, pp. 40–50, both pictures repr.

ANGERSTEIN, John Julius (1735–1823), merchant and Lloyd's underwriter. He is renowned in connection with the National Gallery, London, since 38 paintings from his collection of Old Masters were bought by Parliament in 1824 for £57,000 to establish the new gallery, and his house at 100 Pall Mall became its first home.

In 1799 Angerstein paid Turner 40 guineas for a drawing of *Caernarvon Castle*, exhibited at the Royal Academy in 1799 (private collection; W 254). *Farington (*Diary*, 27 May 1799) noted that the price was fixed by Angerstein, and was much greater than Turner would have asked.

CALS-M

ANTWERP, Belgian seaport on the River Scheldt, first visited by Turner in 1817. From the 15th century it was a centre of culture until its fall to the Spanish in 1585 drove its Protestants into exile. In spite of economic stagnation it remained the city of *Rubens, *Van Dyck, Jordaens, and *Teniers, and of many architectural showpieces. Antwerp was treated by *Napoleon as a potential base against England, but after the French retreat and the Articles of London of 1814 it became part of the new Kingdom of the United Netherlands. It joined the Belgian Revolt in 1830 and only in 1839, when the Dutch sovereign finally ceded the South, could a peaceful coexistence with the North be resumed.

Turner's sketchbooks have many Antwerpiana (TB CLXII, CCXIV), but his only Antwerp-based painting was *[Antwerp] Van Goyen, looking out for a Subject* (RA 1833; Frick Collection, New York; BJ 350). When viewed against its companion, *The *Rotterdam Ferry-Boat* (also RA 1833; National Gallery of Art, Washington; BJ 349), his message of reconciliation with its fiercest competitor appears. AGHB

H. Van der Wee, *The Growth of the Antwerp Market*, 1963.

APULLIA IN SEARCH OF APPULLUS VIDE OVID, oil on canvas 57½ × 93⅞ in. (146 × 238.5 cm.), BI 1814 (168); Tate Gallery, London (BJ 128). The reference to Ovid in the title refers to his *Metamorphoses*, Book XIV of which contains the story of the transformation of the Apulian shepherd into an olive tree as punishment for mocking the dancing of the nymphs. In Samuel Garth's translation of 1717 the shepherd became Appullus, for whom Turner invented a mythical wife Apullia who is having Appullus's name pointed out to her on the tree.

The painting is a more or less direct copy of *Claude's *Landscape with Jacob, Laban and his Daughters*, 1654, then as now at *Petworth House, the home of the Earl of *Egremont. It was submitted over a week late to the *British Institution as a candidate for the annual premium for best landscape, a competition designed for young, unestablished artists. An anonymous letter in the *Examiner*, 13 February 1814, attacked Turner's submission as unfair to young artists as well as for being too late and a direct copy of Lord Egremont's Claude. Kathleen Nicholson has untangled Turner's apparently strange motivation (paper delivered at the Turner Symposium, Johns Hopkins University, Baltimore, 18 April 1975; see also Nicholson 1980 and 1990). Turner, although he fully supported the idea that landscape painting was ennobled and made more worthy of attention by being given significant classical or historical subjects, wanted to attack the British Institution and in particular its main supporters, Sir George *Beaumont and Payne *Knight, for supporting the Old Masters and their followers rather than more innovative contemporary painters. In particular the British Institution had scheduled their retrospective exhibitions to coincide with the Royal Academy's exhibitions of contemporary art and had added insult to injury by inaugurating their programme, in 1813, by featuring Sir Joshua *Reynolds, first President of the Royal Academy. Moreover, in 1807, the Institution had started its series of competitions by inviting entries 'proper in point of Subject and of Manner' to be companions to a select list of Old Masters. Turner himself had been particularly heavily criticized by Beaumont because of his 'seducing skill' in influencing younger artists such as A. W. *Callcott and Clarkson *Stanfield. To add to the personal ramifications, the Marquess of Stafford, another patron of the Institution, owned Claude's treatment of the same subject, while Lord Egremont was actually on the jury, though he failed to turn up on the day.

Just as the Apulian shepherd was punished for mimicking a group of nymphs, so Turner was punishing the British Institution for encouraging the imitation of a landscape by Claude. The central nymph who looks out at the spectator (there is no such figure in the original Claude) seems actually to be mocking the Institution, and Turner goes further, subtly modifying Claude's composition by moderating the strong, classicizing horizontal emphasis of the bridge in Claude's picture through the addition of the tower that stresses the recession into depth, by eliminating many of Claude's secondary figures and details, and by enlivening the newly unified space with his more subtle play of light and shade, thus developing the foundations of Claude's reputation, his glowing light and 'softening hue', by making his light still more shimmering and his atmospheric effects still more delicate. *Constable indeed had found the original Claude 'grand and solemn, but cold, dull, and heavy' and Turner seems deliberately to have set out to remedy these defects.

Luckily for the Institution, Turner's late submission spared them the dilemma of awarding or not awarding him the prize, which was instead given to T. C. Hofland's *Storm off the Coast of Scarborough*, a night scene, violently stormy and black throughout, now lost. Turner rammed home his somewhat pyrrhic victory by exhibiting his own personal reinterpretation of Claude, *Dido and Aeneas* (BJ 129), at the same year's Royal Academy exhibition.

William *Hazlitt, in the *Morning Chronicle*, 5 February 1814, found Turner's dependence on Claude an advantage: 'All the taste and all the imagination being borrowed, his powers of eye, hand and memory, are equal to anything', although he attacked the figures as even worse than Claude's. Robert Hunt, in *The Examiner*, 6 February, called the picture 'an exquisite copy of Claude Lorraine'.

There are composition sketches in the 'Woodcock Shooting' Sketchbook and the 'Chemistry and Apuleia' Sketchbook, and a drawing for the main group of figures in the latter (TB CXXIX: 41, and CXXXV: 65–8). MB

Kathleen Nicholson, 'Turner's "Appulia in Search of Appulus" and the Dialectics of Landscape Tradition', *Burlington Magazine*, 120 (1980), pp. 679–84.

Ziff 1988, pp. 16–18.

Nicholson 1990, pp. 179, 227–34.

Shanes 1990, pp. 176–81.

ARCHBISHOP'S PALACE, LAMBETH, THE, pencil and watercolour, 10⅜ × 14⅞ in. (26.3 × 37.8 cm.), RA 1790

(644); Indianapolis Museum of Art (W 10). Turner's first exhibited watercolour, submitted to the Royal Academy in 1790. The work demonstrates advanced technical ability and pictorial conception of great authority for a debutant who was a mere 15 years of age at the time. The painting owes a debt to the stylistic example of Thomas *Malton jun. with its exaggerated linear perspective and animated foreground figures. Turner had briefly studied at evening classes given by Thomas Malton where architectural drawing was the primary subject matter. The watercolour has its origins in a sketch made by Turner during the summer of 1789 contained in the 'Oxford' Sketchbook (TB II: 21).

A further watercolour of this subject was painted by Turner for the architect Thomas Hardwick, but this currently remains untraced. RY

ARCHITECT, Turner as. Turner had trained in his youth in architects' offices, among them Joseph Bonomi (1739–1808), Hardwick, James *Wyatt, and possibly William Porden (1755–1822), and he must also have attended the lectures of Thomas Sandby (1721–98), Professor of Architecture at the *Royal Academy. His formal training probably comprised practical perspective, the drawing of buildings to scale, and making coloured presentation drawings for clients. He may also have learnt how to draw ground plans, but if any of these survive they have not been attributed. Early sketchbooks include perspective exercises ('Oxford' Sketchbook, TB II). He once had the temerity to object to a master architect's instruction to remove reflected light from his window panes because 'it will spoil my drawing' (Redgrave 1866, ii. pp. 83–4). Turner's precise pencil drawings of architecture made in the late 1790s, such as studies of *Fonthill Abbey under construction from the dismembered 'Fonthill' Sketchbook (XLVII), have a clarity and purpose that reflect his professional training.

In his maturity, however, Turner's only client—with the possible exception of Walter *Fawkes—was himself. His first important project was to design and build himself a gallery behind his house in *Harley Street in 1803–4. This building, which he closed for remodelling in 1811, is likely to have been the 16 × 37 ft. (5 × 11 m.) structure named as 'Out Building' on a c.1809 plan of the property, although *Finberg has made other suggestions. Farington, in his *Diary*, 19 April 1804, says '70 feet long and 20 wide'.

Turner's one surviving building that we know he designed (1811–13) is his country house, *Sandycombe Lodge, Twickenham. There are many small sketches of possible plans and elevations for the house in the 'Windmill and Lock', 'Sandycombe and Yorkshire' and 'Woodcock Shooting' Sketchbooks (CXIV, CXXVII, CXXIX). These show how

Turner's ideas evolved from a *cottage-ornée* in the manner of Humphrey Repton, to a style akin to the unadorned manner of *Soane. Turner's technical and aesthetic skill as an architect reveals itself throughout the house—the neat curving stair leading up to a clear glass oval skylight is very similar to the skylight above the stair in Sir John Soane's Museum in Lincoln's Inn; the discreet but deep cupboard in the hall is ideal for storing canvases and paint; and the use of the sloping site is both subtle and clever. The ground falls away from the front of the plot, and this allows Turner to make the house appear from the road to be of a modest two storeys with low wings, while the garden elevation allows it to appear to expand into a rather grander three-storey house. Such public modesty of profile, and private enlargement, parallels the character that Turner himself tended to project.

Turner kept a very careful track of his expenditure while Sandycombe Lodge was being built. There are pages of figures in CXIV and CXXVII which refer to his cash flow, and lists of quantities of fittings he required. He does not appear to have skimped on quality, but ensured that, as architect and client, he got value for money from his builders and suppliers. It may be no coincidence that, on the left-hand side of his *Dido building Carthage* (RA 1815; BJ 131), Turner has painted a pile of bricks and some mason's tools, the kind of things he will have seen whenever he visited the site at Sandycombe.

His third and final major architectural project was to build in 1820 a new house and integral gallery on a plot in *Queen Anne Street West adjacent to his Harley Street house. The site faced north, giving Turner as clear a north light to his first-floor studio windows as was possible in London. The only stipulations that the Portland Estate officials made was that the house was to be built of new stock brick, neatly pointed, and not stuccoed. As client Turner was as concerned with the practical use of the building as with its appearance. Thus he made comparatively large windows for the studio, creating nearly floor-to-ceiling daylight there—a surviving photograph reveals that the studio windowsill was only eight brick courses (about 2 feet—60 cm.) above the floor. Such depth at first-floor level came only at the expense of the ground and second floors, which were correspondingly compressed, as their fenestration shows. The front door lintel, extraordinarily enough, crossed the line of the string-course dividing ground and first floors. The height Turner created at the first floor also benefited his gallery, which ran north–south behind the studio. Thus he could hang his larger paintings without compromising their presentation.

While he remained his own architect, it is possible that Turner also designed a pair of gate lodges at Farnley for

Fawkes *c.*1818, although there is no convincing documentary evidence for this (but see 'Farnley' Sketchbook, CLIII). Stylistically, however, the lodges echo Turner's architectural manner. To *Holworthy Turner gave encouragement and advice while his friend was building his house in Derbyshire, and urged him to 'consider the pleasure of being your own architect day by day, its growing honors hour by hour, increasing strata by strata' (Gage 1980, p. 96).

The friendships Turner maintained all his life with architects, including Thomas Allason (1790–1852), *Cockerell, Thomas L. Donaldson (1795–1885), Philip Hardwick (1792–1870), *Nash, Soane, and Jeffry Wyatville (1766–1840), is a further measure of how deeply involved he was with the art and practice of architecture.

Building construction was so much part of Turner's life that even when he was an old man nearing death he wrote twice to Hawksworth *Fawkes to describe the progress being made on the Crystal Palace, when it was under construction for the *Great Exhibition. In the first letter (27 December 1850) he showed some residual professional concern at the slow progress being made, but later (31 January 1851) reflected with clarity on its construction and appearance: 'it looks very well in front because the transept takes a centre like a dome, but sideways ribs of Glass framework only Towering over the Galleries like a Giant.'

JH

Thornbury 1877, pp. 27–32.
Gage 1980, pp. 224–5, 227.
Youngblood 1982, pp. 20–35.
Warrell and Perkins 1988.
Hamilton 1997, pp. 86–7, 134–9.
Hamilton 1998, ch. 2.

ARMSTRONG, Sir Walter (1850–1918), art critic, from 1880 to 1892, to several papers including the *Pall Mall Gazette* and the *Manchester Guardian*. From 1892 to 1914 he was Director of the National Gallery of Ireland, *Dublin. There he became a prolific author writing books on Alfred Stevens, Velasquez, *Gainsborough, *Reynolds, Raeburn, Turner, and *Lawrence besides co-editing *Bryan's Dictionary of Painters and Engravers* (5 vols., 1920).

Armstrong's *Turner*, published in 1902 and weighing almost six kilos, contains, besides a biography of the artist, the first serious attempt to compile a catalogue raisonné of Turner's works, listing 308 oils (BJ has 541) and 1,220 watercolours but, in this case, excluding the Turner Bequest. Its value lies in the well-researched record from 1851 onwards of the changes of ownership and exhibition history of many of the items listed.

Armstrong died in August 1918 but was not accorded an obituary in the *Burlington Magazine*.

EJ

ARONA. Turner must have visited this small town near the southern end of Lake Maggiore on his way into Italy in 1819. Pencil drawings of the mountains round the lake occur in his 'Turin, Como, Lugano, Maggiore' Sketchbook (TB CLXXIV), and some appear to be taken from the walls of a town which is very possibly Arona (CLXXIV: 76 etc.). In about 1828 Turner made three Italian watercolours, *Florence*, *Lago Maggiore*, and *Lake Albano* (private collections (two) and untraced; W 726, 730, 731), which were engraved for the *Keepsake* annuals for 1828 and 1829. The plate of *Lago Maggiore*, by W. R. Smith (R 321), appeared in 1829 opposite 'Stanzas addressed to J. M. W. Turner, Esq., R.A. on his view of the Lago Maggiore from the Town of Arona', by Robert Southey. Prominent in the foreground of the view is the picturesque town with its bustling crowds seen from a platform on the medieval walls, while the lake and mountains shimmer beyond.

AW

Cecilia Powell, 'Turner and the Bandits: Lake Albano Rediscovered', *Turner Studies*, 3/2 (winter 1983), p. 22.

ARRAN SKETCHES, SEE FAKES AND COPIES.

ARTISTS' GENERAL BENEVOLENT INSTITUTION. Established in 1814 to support artists and their families in times of need. Turner was an enthusiastic founder member who soon became Chairman and Treasurer, active in fund-raising and events (see Bailey 1997, p. 340). In 1818 he successfully arranged a merger with a rival charity, the Artist's Benevolent Fund, but resigned in 1829 following arguments with younger members who wanted a more liberal spending policy. He left £500 to the AGBI in the first draft of his *will (1829) but later revoked this, presumably wanting as much money as possible to go towards his own intended charity for 'Decayed Male Artists'. Nevertheless, he remained a Trustee of the AGBI until 1839 and reintroduced the gift of £500 in the final version of his will (1849). Ironically, the AGBI flourished following Turner's resignation, increasingly attracting subscriptions, while his own charity never came into being. Today the AGBI is based at Burlington House.

ADRL

Cumming 1986, pp. 3–8.
Bailey 1997, pp. 340–2.

ART MARKET IN TURNER'S WORK SINCE 1851. When the confusion over Turner's *will was finally resolved, it resulted in the entire contents of his studio becoming the property of the nation. This meant that there was no studio sale, as for the great majority of artists, or any other dispersals from the collection. Therefore the only works that could circulate after 1851 were those sold in Turner's lifetime. These amounted to about 220 oils, in-

cluding those now untraced or destroyed, and in the region of 2,000 watercolours and drawings. It would be easy to infer from this that the contents of the studio, known as the *Turner Bequest, consisted entirely of the works the artist had been unable to sell. While this is true of a number of major works, a great many more—for example the *Thames, *Roman, and Small Italian sketches (BJ 160–94 and 302–27) plus sketchbooks and other works on paper—were clearly never made available to prospective buyers. Besides these there was also a handful of pictures such as *The *Fighting 'Temeraire'* (RA 1839; National Gallery, London; BJ 377) which Turner resolutely refused to sell.

Very soon after 1851 Turners began to appear on the market and increasingly so during the 1860s to 1880s when collectors like *Munro of Novar, *Bicknell, and *Gillott, among others, sent their Turners to auction. Despite the wide choice available (353 Turners passed through auction in the 1870s), prices soon began to rise: for example *Van Goyen looking out for a Subject* (RA 1833; Frick Collection, New York; BJ 350), which had remained unsold since being shown at the RA in 1833 until bought by Bicknell in 1844, probably for no more than £350, fetched £2,625 at his sale in April 1863. This was more than *Palestrina* (RA 1830; BJ 295) which Bicknell had also bought in 1844 for £1,000. *Van Goyen* was sold again in 1887 for £6,825.

Prices continued to rise and, at the Gillott sale in 1872, *Walton Bridges* (?Turner's gallery 1806; Loyd Collection; BJ 60) was the first Turner to fetch over £5,000 (£5,250). This increased to £7,455 in 1891, whilst in the previous year, *Sheerness* (Turner's gallery 1808; private collection, Japan; BJ 76) had fetched the same amount at the William Wells of Redleaf sale. Other high prices in the 1890s included £7,875 in 1897 for *Mercury and Herse* (private collection; BJ 114, the picture that it was believed that the Prince Regent (see GEORGE IV) might buy at the RA in 1811); in 1899 *Agnew's sold *Purfleet and the Essex Shore* (Turner's gallery 1808; private collection, Belgium; BJ 74) for £9,000 to George J. Gould of New Jersey.

Meanwhile watercolours were also bringing high prices: *Tivoli* (RA 1818; private collection; W 495) fetched £1,890 at John *Allnutt's sale in June 1863. This was more than four times the price that *Pallanza, Lago Maggiore* (1846–50; Shizuoka Prefectural Museum, Japan; W 1556) fetched two years later. This confirms the preference at this time for early and middle-period Turners over late ones. Again, in 1872, *Grenoble Bridge* (1824; Baltimore Museum of Art, Maryland; W 404) was sold for over three times as much as that paid a month later for the oil of *Glaucus and Scylla* (RA 1841; Kimbell Museum, Fort Worth, Texas; BJ 395). However, early watercolours with architecture as the principal

feature fared less well to judge by the series of Salisbury and its Cathedral, commissioned by Colt *Hoare (W 196–213), for two of these went for under £100 when sold in 1883. A late watercolour which proved an exception to what has gone before, *Bamburgh Castle* (c.1840; private collection, USA; W 895), made £3,307 at the Gillott sale, a record so far for a watercolour.

Turners were in plentiful supply from 1900 to 1920. At Stephen Holland's sale in June 1908 *The *Seat of William Moffatt, Mortlake* (RA 1826; Frick Collection, New York; BJ 235) fetched £13,230 and *Heidelberg with a Rainbow* (c.1841; private collection; W 1377) £4,410 (£2,782 at the Gillott sale). In 1909 *The Burning of the House of Lords and Commons* (see under PARLIAMENT; BI 1835; Philadelphia Museum of Art; BJ 359) brought £13,125. Then, in 1910, *Rockets and Blue Lights* (RA 1840; Clark Art Institute, Williamstown; BJ 387) registered a big increase by fetching £25,000 at the Yerkes sale, followed by the two large harbour scenes, now in the Frick Collection, New York: *Harbour of Dieppe* and *Cologne* (RA 1825 and 1826; BJ 231, 232), which were sold privately for £57,000 in 1911.

During the 1914–18 war prices remained surprisingly buoyant, especially for watercolours: at the *Beecham sale in 1917 *Constance* (1842; York City Art Gallery; W 1531) brought £4,252 and this was the period when R. W. *Lloyd was making his collection, paying high prices for drawings from the *England and Wales series including £3,300 for *Windsor Castle* and £3,400 for *Worcester* (both British Museum; W 829, 862), both in 1918, more than several examples in the series brought in the early 1960s (see below). In 1919 *Zürich* (1842; British Museum; W 1533) fetched £6,510 at Sir George Drummond's sale.

During the 1920s prices continued to increase: in November 1922 Henry Huntington bought *The Grand Canal, Venice* (RA 1837; Huntington Art Gallery, California; BJ 368) from Duveen, who had bought it the previous month from Agnew's for £22,000. The saleroom history (all at Christie's) of *Dogana, Madonna della Salute, Venice* (RA 1843; Washington, National Gallery of Art; BJ 403) illustrates how prices rose between Turner's lifetime and the end of the 1920s: bought by Edwin *Bullock at the RA in 1843 for 250 guineas; Bullock sale 1870, £2,688; Sir John Fowler sale 1899, £8,610; James Ross of Montreal sale 1927, £30,450, a record which stood until 1965.

The slump on Wall Street in 1929 affected the art market throughout the 1930s; for example, the great *Dort* (RA 1818; Yale Center for British Art, New Haven; BJ 137) was bought in for only £6,200 guineas at Christie's in 1937 although, in the same year, the enduring demand for Venetian subjects resulted in *Going to* and *Coming from the Ball*,

Venice (RA 1846; private collection; BJ 421, 422) being sold privately for £23,000.

During the 1939–45 war the art market naturally stagnated although Christie's, despite being bombed in 1941, continued to hold sales where, as was to be expected, prices were very low. For example, *The Red *Rigi* (1842; National Gallery of Victoria, Melbourne; W 1525), one of Turner's most celebrated watercolours, which had been sold for 7,900 guineas in December 1928, fetched only 1,100 guineas in July 1942, admittedly a low point in the war for the Allies. In June 1945 *Purfleet and the Essex Shore* fetched 1,700 guineas at Christie's, a sharp reduction compared with its 1899 price mentioned above.

But, when peace came, prices took a long time to rise and there were some extraordinary bargains to be had until, at any rate, 1960. In 1946 *Quilleboeuf* (RA 1833; Fundaçao Calouste Gulbenkian, Lisbon; BJ 353) fetched 3,300 guineas at auction; in 1951 Sir Kenneth *Clark bought *Seascape, *Folkestone* (c.1845; private collection, New York; BJ 472) for £5,500 and, in the same year, Agnew's sold *Mercury and Argus* (RA 1836; National Gallery of Canada, Ottawa; BJ 367) for Lord Strathcona for £7,000, while in 1956 **Staffa, Fingal's Cave* (RA 1832; Yale Center for British Art, New Haven; BJ 347) fetched under £17,000 at auction in New York—a total of around £33,000 for four Turners of the first rank. Three of them have changed hands again since, *Seascape, Folkestone* doing so most sensationally when it brought £7,370,000 at Sotheby's in July 1984; it has been resold since.

When, in 1960, Paul *Mellon began collecting British pictures and watercolours, he bought so much and so rapidly that prices soon began to rise and continued to do so throughout the decade. In 1965 *The *Bright Stone of Honour (Ehrenbreitstein)* (RA 1835; private collection; BJ 361) brought £88,000 at auction and the next year the *Dort* was bought by Paul Mellon for £118,000, having remained in the *Fawkes collection for 148 years.

Then the magnificent *Turner bicentenary exhibition, 1974–5, led to a great surge of interest in—and demand for—the artist's work. This, coupled with favourable economic conditions, led to further price rises so that, in June 1976, the 'Bridgewater Seapiece' (**Dutch Boats in a Gale*, RA 1801; private collection; BJ 14) fetched £373,000 at Christie's, easily a record at the time but doubtless overtaken by the prices Mellon paid for *Staffa* in 1977 and for *Wreckers* (RA 1834; Yale Center for British Art, New Haven; BJ 357) in 1978. But these, too, were eclipsed in 1980 when *Juliet and her Nurse* (RA 1836; BJ 365) was bought by Sra. Amalia Lacroze de Fortabat at auction in New York for $7,040,000 (just over £3 million).

Watercolour prices followed much the same pattern as the oils, being very modest for about fifteen years after the war. The first major rise occurred in March 1959 when the large *Lake of Lucerne, from the landing place at Fluelen* (?1807; Yale Center for British Art, New Haven; W 378) fetched 11,000 guineas at Christie's while, in the same sale, the *Lake of Zug* (1843; Metropolitan Museum, New York; W 1535) brought 10,500 guineas. These figures were almost trebled in 1970 when another early drawing, *Lake of Geneva, with Mont Blanc* (?1805; Yale Center for British Art, New Haven; W 370), was bought on behalf of Paul Mellon for £31,000 at Sotheby's.

The Turner bicentenary exhibition of 1974–5 again sparked off another price increase when *The Dark Rigi* (1842; Nivison Family Trust; W 1532) fetched £75,000 at Sotheby's in 1975, followed in 1979 by *The Lake of Thun* (?1806; private collection; W 373) at £82,500. But the biggest rises took place in the 1980s, when *Venice, the Grand Canal with the Salute* (1840; private collection; W 1368) fetched £440,000 at Phillips in 1989, topped in March 1990 when *Hampton Court Palace* (c.1827; private collection; W 812) was sold for £473,000, an auction record for a British watercolour (since surpassed only by a J. F. Lewis, *Lilium Auratum*, at £826,500 in December 1996). Drawings from the *England and Wales* series, which includes *Hampton Court*, appear with fair regularity on the market, so their price highlights the enormous increase in watercolour prices over the last 35 years: five good examples in the series were sold in the 1960s for prices ranging between 2,600 guineas and £5,500.

After the Goldschmidt sale in 1958 when the price of Impressionist pictures suddenly rocketed, Turner was often erroneously referred to as 'the first Impressionist' and his late work became more highly prized by collectors. In 1966 the exhibition *Turner: Imagination and Reality* at the Museum of Modern Art in New York, arranged by Lawrence *Gowing, presented Turner as the forerunner of Abstract Expressionism. This directed collectors still more firmly towards the late works. Now his name has become associated with—if not besmirched by—the *Turner Prize at the Tate Gallery which has increasingly little to do with the act of painting as practised by Turner. This concentration on the late works received something of a challenge at the Turner Symposium at the Tate Gallery in 1987, reviewed by William Vaughan (*Turner Studies*, 7/2 (1987), pp. 49–50), who noted that more attention was paid in the papers given there to early than to late Turner. Nevertheless the highest price recorded so far is the £11 million paid by the Getty Museum for **Van Tromp going about to please his Masters* (RA 1844; BJ 410) sold in 1992 by Royal Holloway College, although it

is probable that *Seascape, Folkestone* has been privately sold for more.

Of course Turner prices do not go on increasing indefinitely and there have been some failures which show how unpredictable the art market can sometimes be. These have mainly concerned oils, a number of which have been bought in at auction, among them *Cicero at his Villa* (RA 1839; Rothschild Collection, Ascott, Bucks; BJ 381) in 1988, *Fort Vimieux* (RA 1831; private collection; BJ 341) in 1989, and *What You Will!* (RA 1822; private collection; BJ 229) in 1994. The vagaries of the market are nowhere better illustrated than by the saleroom history of *Mercury and Herse*: having sold for £7,875 in 1897 (see above), it next appeared in Lord Swaythling's sale in July 1946 when it was bought in at 2,500 guineas; re-offered in June 1961, it was sold for 7,800 guineas (£8,190) bought by Leggatt's who sold it to a private collector who sent it to Christie's in April 1992 but withdrew it when it appeared that no serious bidders were in the offing.

One of the most notable changes in the demand for Turner's work that has taken place since the 1939–45 war is the spread of his works beyond Britain and America which, up till then, held almost everything of his outside the Turner Bequest apart from a few works in Australia and Canada. Before 1939 the only Turner oils in Continental Europe were the three in the *Groult Collection in Paris. Of these *Landscape with a River and a Bay in the Distance* (c.1845–50; BJ 509) is now in the Louvre after an export licence to Paul Mellon was blocked in 1967, and the other two have since left France. Two oils have gone to Germany: *Ostend* (RA 1844; BJ 407) to the Neue Pinakothek, Munich, in 1975 and *Wreckers on the Coast* (c.1835–40; BJ 477) to a private collector in 1985.

In addition a number of Continental museums and collectors have acquired watercolours, often for reasons of topographical propinquity. These include *Mainz and Kastell* (?1820; W 678) to a German private collector and *Godesberg* (1817; W 668) to the museum in Bonn which already owned the Hochkreuz which appears in the drawing. The museum at Schaffhausen bought *Fall of the Rhine at Schaffhausen* (c.1841; W 1467), the Musée d'Histoire et d'Art, Luxembourg, acquired two small gouaches on blue paper, both c.1839: *Luxembourg from the Fetschenhof* (W 1020) in 1983 and *Luxembourg from the South* (not in Wilton) at Christie's in 1992, and *Nantes* (c.1829; W 1044 as untraced) was bought at an auction in Nottingham in 1994 by the Louvre on behalf of the museum at Nantes. Finally the Rijksmuseum in Amsterdam ignored this topographically related policy by buying *Farnley Hall from above Otley* (c.1815; W 613) at Christie's in 1990.

In the 1980s the Japanese, mostly museums, began to buy both early and late works in both media. Among these were *Seascape with a Squall coming up* (c.1803–4; Tokyo, Fuji Art Museum; BJ 143); *Sheerness* (see above); *Landscape with Walton Bridges* (c.1840–50; private collection; BJ 511); *Calder Bridge* (Turner's gallery 1810; BJ 106) and *The Descent of the *St. Gothard* (c.1847–8; W 1552), both Koriyama Museum of Art; *Pallanza, Lago Maggiore* (1848–50; Shizuoka Prefectural Museum of Art; W 1556); and *Florence* (c.1850–1; W 1568) to a private collector who has since resold it.

The art market suffered a sharp recession between 1992 and 1996 but, during 1998, prices began to stabilize and even to show signs of recovery. This continued in 1999.

As Turner is now universally acknowledged to be one of the supreme landscape painters of all time, his work will surely always be sought after, with the inevitable consequence that, as more goes into public collections, his prices will continue to rise.

See also PRICES FOR TURNER'S PAINTINGS. EJ

Algernon Graves, *Art Sales 1851–1913*, vol. iii, 1921, pp. 218–57. *Art Prices Current*, 1914–1972, *Art Sales Index*, 1973–1998.

ART UNION (1839–48), subsequently the *Art Journal* (1849–1912). Published by the Art Union of London, an institution founded in 1837 to promote art and public taste, the *Art Union* was a monthly periodical aimed at that Victorian readership interested in, if not necessarily knowledgeable about, the decorative and fine arts. Its reviewers, like so many others, admitted Turner's powers but regretted his wilful follies. He could be 'the greatest master of the age' (15 May 1839, p. 67), or a 'madman, who says wonderful things between the fits that place him on a level with creatures upon whom reason never had been bestowed' (15 May 1840, p. 73). *Rockets and Blue Lights* (RA 1840; Sterling and Francine Clark Art Institute, Williamstown, Mass.; BJ 387) and *Snow-Storm, Avalanche and Inundation*; (RA 1837; BJ 371) were 'eccentric flights of genius. They would be equally effective, equally pleasing, and equally comprehensible if turned upside-down' (15 February 1841, p. 29).

The *Art Union*, hoping to influence events as well as report them, kept a watchful eye on individuals and institutions. Worried that Turner might succeed Shee as Academy president, the editor, S. C. Hall, wrote a malicious note in 1845, listing all the merits that Turner lacked: learning, courtesy, polished manners, liberality of mind and feeling, eloquence, and persuasive address. Turner's one qualification was that he was 'prodigiously rich' (Finberg 1939, p. 411).

For the Art Union of London's plans to publish a Turner engraving, see Smith, p. 97, and Finberg 1939, pp. 387–8.

JCI

Roger Smith, 'The Rise and Fall of the Art Union Print', *Print Quarterly*, 3 (June 1986), pp. 94–108.

ASHBY, Thomas (1874–1931), author of *Turner's Visions of Rome*, 1925, which was devoted to Roman drawings and watercolours in the Turner Bequest. Ashby was Assistant Director from 1903 to 1906 of the British School at Rome, and Director from 1906 to 1925. He wrote extensively about the archaeology and architectural legacy of the city in a number of publications. RU

ASHMOLEAN MUSEUM, Oxford. Opened in 1683, in a building designed by Sir Christopher Wren, the Ashmolean Museum in Oxford is the oldest public museum in the British Isles, and one of the oldest in Europe. Based on the 'closet of rarities' collected by John Tradescant the Younger, which had been acquired by the antiquary Elias Ashmole, the original museum was largely scientific in character. It was only when the University's archaeological and art collections were moved in 1845 to the new University Galleries, designed in classical style by C. R. *Cockerell, that the collections of art began to develop. The first Turner drawings to enter the collections, deposited in 1850, were the ten watercolours commissioned for the *Oxford Almanack in 1798 or 1799, and published between 1799 and 1811. In 1861 John *Ruskin presented a selection of 48 of his Turner drawings to the University. Pre-eminent among these is the group of 23 small sheets connected with the *Rivers of France engravings. After his appointment as the first Slade Professor of Fine Art at Oxford in 1869, Ruskin presented another nineteen Turner drawings to the Ruskin School of Drawing which he founded. Since then fourteen more drawings by or attributed to Turner have been added to the collections. The 100 Turner drawings provide an excellent survey of the whole of the artist's career as a draughtsman, and are the outstanding feature of the Ashmolean's important and wide-ranging collection of British watercolours, which can be readily studied in the Department of Western Art's Print Room.

At present (2000) three oils are on long loan from the *Loyd Collection: *Walton Bridges* (?Turner's gallery 1806; BJ 60), *High-Street, Oxford* (Turner's gallery 1810; BJ 102), and *Whalley Bridge* (RA 1811; BJ 117). LH

Herrmann 1968.

ASSISTANTS. Turner's chief assistant for much of his life was his father William *Turner (1745–1829), who took over the job of preparing Turner's grounds from Sebastian Grandi soon after 1802 and carried out this and other relatively menial tasks, including managing Turner's property, until he died in September 1829. In the summer of 1827, for instance, we find Turner writing to his father asking him to send one or if possible two pieces of unstretched canvas, to be used for the *Cowes sketches.

Towards the end of his life, from 1848, Turner employed the young painter Francis Sherrell (c.1826–1916) as an assistant in exchange for lessons. Sherrell seems to have stretched canvases and run errands and may also have cleaned some of the pictures suffering in Turner's gallery. Sherrell seems to have been employed at 6 Davis Place, Chelsea (see CHEYNE WALK), and it could be that he was responsible for some of the small seapieces that escaped from the Turner Bequest through the Pound family (see under BOOTH) and are no longer attributed to Turner (see BJ, p. 284, and nos. 555–7). MB

Gage 1969, pp. 33–4, 171.
Gage 1980, pp. 26, 33–4, 89, 108–10.
Hamilton 1997, pp. 63, 68–9, 302.

ASSOCIATION OF IMAGES AND IDEAS. Turner possessed an unusually associative mind. In daily conversation this often led to a baffling allusiveness, while in art it frequently called forth densities of meaning that can still prove perplexing. However, the painter usually provided clues to his associative intentions, in the form of visual similarities, pictorial connections (especially vertical alignments), historical and geographical incongruities, and emphatic placings of staffage, as well as anomalies in human behaviour. Only on rare occasions did he explain his meanings; more usually he wanted us to puzzle them out for ourselves. As *Ruskin recalled: 'Turner tried hard one day for a quarter of an hour to make me guess what he was doing in the picture of *Napoleon [*War. The Exile and the Rock Limpet, BJ 400] . . . giving me hint after hint in a rough way; but I could not guess, and he would not tell me' (*Works*, vii. p. 435 n.). The artist undoubtedly realized that verbal explanation diminishes the imaginative impact of images, which must communicate their meanings themselves.

On the most basic level Turner's associative propensities led him to play upon similarities of form, and his images abound in such connections. A typical example occurs in the *England and Wales series view of *Chatham* dating from around 1830 (private collection; W 838). Here the X-shape of a marine's webbing is vertically aligned with the adjacent X-shaped vanes of a windmill. Such visual rhyming may have arisen from the desire to achieve a pictorial equivalence to poetic consonance.

On a more demanding level Turner frequently devised visual puns, or plays upon the similarities of represented objects to things unseen. Ruskin (*Works*, iv. p. 261) recognized a particularly ingenious example in the *Liber Studiorum engraving of *Jason* (F 6). Here the artist did not depict the

head of the dragon that Jason is stalking but instead alluded to it by making tree-trunks in the foreground closely resemble writhing dragon's heads.

Many of Turner's historical depictions, treatments of poetic and literary texts, and mature topographical works are imbued with visual metaphors, or employments of staffage, topography, light, and weather effects as associative pointers to meaning. Occasionally these could be direct metaphors, as in the 1844 *Rain, Steam, and Speed* (National Gallery, London; BJ 409). Here Turner portrayed the inner workings (or 'Steam') of a locomotive as viewed through the seemingly transparent front-plate of its boiler.

More usually, however, the artist created indirect metaphors. For example, the placing of storm clouds or violent meteorological outbursts above portrayals of the military or of battlefields became almost a fixed association for him. Obviously these conjunctions were intended to denote the 'storms of war', a trope commonly encountered in the poetry that was known to him, as well as in history painting and military portraiture. In the latter half of his career Turner often also linked the coming of night to the imminence of death, as may typically be seen in The *Fighting 'Temeraire'* (National Gallery, London; BJ 377), where the dying of the day associatively matches the impending destruction of the man-of-war.

Pictorial structures could equally be used to advance meanings associatively. A typical example occurs in the *England and Wales* series view of *Land's End* (Getty Museum, Cal.; W 864). Here oblique lines of headland and sea converge to force the eye to the distant Longships Lighthouse. By doing so they reinforce the moral sentiment of the image, namely that the signal has failed to prevent shipwreck (the forefront of the scene being strewn with wreckage), and that such aspirations often prove fallacious.

Although Turner distrusted fixed colour symbolism, he did occasionally use colour associatively, as with his frequent linkage of crimson with blood, and blood with death. This connection appears very characteristically in the 1840 *Slavers* (Museum of Fine Arts, Boston; BJ 385), in which a flaming sunset both suggests blood and matches the dying of the day to the death of drowning slaves in the foreground.

Turner's use of sunsets as metaphors in The *Fighting 'Temeraire'* and *Slavers* grew out of his known adherence to a Renaissance aesthetic concept, namely Decorum, or the associative matching of staffage, light, and weather effects, and other pictorial components, to meaning. In many pendants, such as the *Carthaginian rise-and-fall paintings of the mid-1810s (*Dido building Carthage*, BJ 131, and The Decline of the Carthaginian Empire*, BJ 135), or the Greek pair of the same period (*The Temple of Jupiter Panellenius*

restored, private collection, New York, BJ 133, and *View of the Temple of Jupiter Panellenius with the Greek National Dance of the Romaika*, Duke of Northumberland, BJ 134), rises-of-empire or rebirths of statehood are associatively linked to sunrises, and declines-of-empire to sunsets. And one of Turner's most ingenious observances of Decorum appears in the 1808 painting *Pope's Villa at Twickenham* (Walter Morrison Picture Settlement; BJ 72) which shows the demolition of the home of the late Alexander Pope. By representing it in evening light in autumn, Turner thereby portrayed the dying house of the dead poet, in the dying part of the day, in the dying part of the year, and with a dead willow-tree lying in the foreground to allude to a tree that was widely associated with the dead poet (a surviving letter from Turner to John *Britton (Gage 1980, no. 43) informs us that the painter intended this allusion to Pope's willow).

Turner also fashioned his figures associatively. From the late 1790s onwards he modelled them principally upon the populace represented by 'low-life' genre painters such as David *Teniers the Younger. Clearly he did so in order to make humanity look as coarse and imperfect as possible. This anti-idealization of the human figure constituted Turner's only departure from the academic, idealizing theory with which he wholeheartedly identified in his *perspective lectures and elsewhere (see IDEALISM), and it was dictated by the moralism that formed a central part of that aesthetic. For Turner as moralist, humankind enjoyed a vain but lowly, brutalized, and extremely finite existence, and by making his figures look as imperfect as possible he maximized our contrast with the surrounding beauty, majesty, and power of external nature.

This conscious fashioning of an imperfect humanity did not work against the idealizing requirement to express the essentials of human behaviour that was commonly encountered in the art theory to which Turner adhered. After the early 1810s, and perhaps stemming from a desire to imbue the *Southern Coast* series with the maximum degrees of significance, such a demand frequently led the artist to articulate his acute awareness of the history, social dimensions, and economic forces of the places he represented, and often to employ associative methods when doing so. Certainly, by the time he came to make sets of drawings such as the *England and Wales* series of the mid-1820s, Turner's expressions of associative meaning had become enormously inventive and profound, extending the significance of his images into areas unmatched by anyone in the history of Western landscape painting. ES

Gage 1969, pp. 132 ff.

Shanes 1990, esp. ch. 2.

ATHENAEUM, THE (1828–1921), a weekly literary review with many of its pages devoted to the visual arts, including prints and illustrated books. Its response to Turner, like that of other periodicals, ranged from thoughtful appreciation to abusive mockery, perhaps because the reviews, published anonymously, were not necessarily penned by the same critic. In 1838, for example, there was scorn for 'the toleration of his admirers, who have followed his genius till they have passed, unknowingly, the bounds between magnificence and tawdriness . . . It is grievous to us to think of talent, so mighty and so poetical, running riot into such frenzies; the more grievous, as, we fear, it is now past recall' (12 May, p. 347). In 1839, however, the *Athenaeum*'s reviewer seemed bewitched by the enchanting brilliance of *The Fountain of Fallacy* (BJ 376; see FOUNTAIN OF INDOLENCE; RA 1834; BJ 354) with its 'ample and delicious repose', 'enormous bubble of painted air', and 'a thousand winged spirits . . . Critics may shake their heads at this picture, but poets will go home from it—to dream' (9 February 1839, p. 117). At times, within a single review, a critic might praise some works while ridiculing others as 'wonderful fruits of a diseased eye and a reckless hand' (5 June 1841, p. 443).

The review sent to Ruskin in Geneva in 1842, which so enraged him that he determined to write a defence of Turner, was possibly from the *Athenaeum* (*Works*, iii. pp. xxiv–xxv). The reviewer, discussing *Snow Storm* (RA 1842; BJ 398), suggested that Turner had formerly 'chosen to paint with cream, *or* chocolate, yolk of egg, or currant jelly,—here he uses his whole array of kitchen stuff.' Derision for *Peace—Burial at Sea* and *War. The Exile and the Rock Limpet* (RA 1842; BJ 399, 400) was followed by sheer wonder that their perpetrator was allocated places of honour (14 May 1842, pp. 433–4). JCI

ATHENAEUM CLUB. When the Athenaeum Club was founded in 1824 for 'Literary and Scientific men and followers of the Fine Arts', Turner, as a Royal Academician, was invited to be a founder member. The Club was formed to create a place of friendly gathering and talk for civilian professional men, following the pattern of the military clubs that had opened in London since 1815. Although it had titled members, it principally embraced men on their merit and achievement, rather than birth or wealth. The initial impetus came from the politician and essayist John Wilson Croker MP (1780–1857), Secretary to the Admiralty. Among the other founder members were *Chantrey, Sir Humphry *Davy, *Lawrence, *Parker, and *Samuel Rogers. *Faraday was the club's first secretary. In 1830 the club moved to new premises designed by Decimus Burton (1800–81) on part of the site of the demolished Carlton House. The exterior of the building, which it still occupies, is adorned with sculpture by Chantrey.

Turner visited the Club regularly, and in the 1840s would sit silently in a dark corner with a bottle of sherry. JH

H. Ward, *History of the Athenaeum 1824–1924*, 1926.
C. Fox, ed., *London: World City 1800–1840*, 1992.

AUSTRALIA, exhibitions in 1960 and 1996; these demonstrated the advances in selection and cataloguing over a generation.

In 1960 sixteen Tate Gallery paintings toured five cities with a three-page catalogue containing one poor colourplate and no information about the exhibits apart from not always accurate dates.

In 1996 36 oils and 63 watercolours from all over the world were shown in Canberra and Melbourne with seascapes strongly represented, ranging from *Fishermen at Sea* (RA 1796; BJ 1) to *Seascape, *Folkestone* (c.1845; BJ 472). Masterpieces included *The *Evening Star* (c.1830; BJ 453), *Keelmen* (RA 1835, BJ 360) and both versions of *The Burning of the Houses of *Parliament* (BI 1835; BJ 359; and RA 1835; BJ 364) together with a wide-ranging survey of watercolours with nine *England and Wales* subjects as a highlight. A scholarly and richly illustrated catalogue contributed to the success of the exhibition, which attracted 430,000 visitors. EJ

AUSTRALIAN ARTISTS INFLUENCED BY TURNER. John *Glover, whose emigration to Australia in 1830 was noted by Turner (Gage 1980, no. 164), is usually credited with introducing there a *Claudian version of landscape painting that was by implication also Turnerian. However, Glover's frequent inclusion of mythological figures in his Tasmanian landscapes is unique and had no followers. It is also difficult to judge what influence, if any, the exhibition of Bishop Nixon's Turners in *Hobart in 1845 had on Australian artists.

Conrad Martens (1801–78) arrived in Australia from England in 1835. Later, as an art teacher in Sydney, he acknowledged Turner's influence on his own development (his painting *Apsley Falls* closely resembles the Falls at Schaffhausen, a favourite subject of Turner's). He also encouraged his students to read *Ruskin's *Modern Painters*.

John Skinner Prout (1805–78), nephew of Samuel, a watercolourist trained in Bristol, spent 1840–8 in Australia. On returning home he noted that, during his visit, taste had become more refined in the colony where 'engravings by *Wilkie, *Landseer and Turner are much more frequently seen than they were'.

Two generations later, Frederick McCubbin (1855–1917) and Arthur Streeton (1867–1943) visited England, where both became fervent admirers of Turner's work which then influenced their own. EJ

Sayers 1996, pp. 203–15.

AUSTRIA. Turner travelled through Austria on at least three of his Continental tours (1833, 1840, 1843). He drew many pencil sketches of its scenery, buildings, and art treasures in both 1833 and 1840 but he made few coloured sketches and did not depict it in any topographical oil paintings. The Austrian capital, Vienna, was the furthest east of all his European destinations. On his way to Venice in 1833 Turner explored Salzburg and its environs and then travelled down the *Danube from Linz to Vienna before revisiting Salzburg and carrying on to Innsbruck. On his return journey he again passed through Innsbruck. Most of the Austrian sketches drawn on this tour are in the small sketchbook which Turner himself named 'Salzburg and Danube' (TB CCC) and in one which he bought on his arrival in Vienna but did not label and which has recently been named 'Vienna up to Venice' (CCCXI). Other sketches, including a dated one in September 1833, were made on some of the small pieces of paper classified by *Finberg simply as 'Miscellaneous: Black and White (a) Grey Paper' (CCCXLI). In 1840 Turner's journey to Venice took him through Bregenz on Lake Constance and Bozen (now known as Bolzano and part of Italy), both of which he sketched in colours on blue or grey sheets of paper. After his time in Venice he left by sea for Trieste, travelling thence through Graz and Vienna and then up the Danube into Germany. During this period he used a sketchbook of Austrian origin, recently renamed 'Trieste, Graz and Danube' (CCXCIX). CFP

Powell 1995, pp. 35–45, 65–9, 114–15, 143, 155–7.

AVALANCHE, see *FALL OF AN AVALANCHE.*

B

BACKGROUNDS LECTURE, see PERSPECTIVE LECTURES.

BACON, Sir Hickman, Bt. (1855–1945). Bacon made an outstandingly fine collection of watercolours. Besides Turner, he assembled major groups of works by J. R. *Cozens, *Girtin, *Cotman, Cox (largest of all), de Wint, and Muller.

Unlike most of his contemporary collectors, Bacon eschewed finished Turner drawings and nearly all his examples are sketchy and difficult to date precisely. Apart from three early drawings dating between 1791 and 1802 and three assigned to the 1820s, the remaining 23 Turners are all dated by Wilton 1979 to the 1830s and 1840s, nine of them from 1844–50, although many dates have *c.* or ? against them and sometimes both. In some cases these dates differ from those in the catalogue of the Turner *bicentenary exhibition, 1974–5, and none more radically than *Rainbow over Loch Awe* (W 1144), then dated *c.*1801 but now advanced to *c.*1831.

Highlights include two groups, each containing six drawings, listed under 'Marine Studies *c.*1830–50' by Wilton, which feature waves breaking, beaches under stormy skies, and sunsets over the sea. The earlier group, dated ?1830s, are mostly on buff paper in watercolour and body-colour (W 1382–7). It contains three studies (W 1383–5) that were originally all on the same sheet, and W 1386–7, both exhibited 1974–5. The second group, all pure watercolour (W 1416–7, 1419, 1422–4) and dated *c.*1845–50, are sketchier still and include the wonderful *Red and Blue Sunset Sky* (W 1416), exhibited 1974–5.

The collection is still privately owned and six watercolours were lent to the 1999 *New York exhibition. EJ

BAIAE, see BAY OF BAIAE.

BANKS OF THE LOIRE, THE, oil on canvas, 27 × 20⅞ in. (68.6 × 52.1 cm.), RA 1829 (19); Worcester Art Museum, Massachusetts (BJ 328a / 329). Turner's only oil painting of a scene on the River Loire, this picture was effectively 'lost' from the Turner literature after its first showing at the Royal Academy. It was commissioned by Sir James Willoughby

*Gordon and his wife (the former Julia Bennet), who seem to have specified the dimensions and the untypical format (TB CCXXXVII: 11), and it remained in the family collection until 1926. The foreground scenery arises from Turner's fancy, but the rocky coteau, with its outcrops of turrets known as the Folies-Siffait, is based on a colour sketch made soon after Turner's 1826 French tour (CCLIX: 138; Warrell 1997, p. 78, fig. 67). The follies lie close to Oudon, down-river from Angers. The upright composition is a conflation of *Claude's *Landscape with Hagar and the Angel*, then a new acquisition by the National Gallery, together with Turner's own experiences in France and Italy. A related, preparatory oil sketch is BJ 281. IW

Powell 1982², pp. 56–8.

Warrell 1997, pp. 181–3, repr. fig. 179.

BANNISTER, Jack [John] (1760–1836). An actor and collector, Bannister entered the Royal Academy Schools in 1777 under de *Loutherbourg, but later withdrew and led a highly successful career as an actor and comedian. He bought Turner's *Seascape with a Squall coming up* (Tokyo Fuji Art Museum; BJ 143) in 1803–4. Turner's 'Academies' Sketchbook (*c.*1803–4; TB LXXXIV: 67v.) is inscribed 'Sea-Piece Mr. Bannister' among a list of pictures in hand. Bannister was a friend of several artists, including Morland, Rowlandson, Beechey, *Gainsborough, *Lawrence, and *Reynolds, and was also on friendly terms with Lord *Egremont. RU

John Adolphus, *Memoirs of John Bannister*, 2 vols., 1839.

BARRY, James (1741–1806), the most formidable of all British Painters in the Grand Style. Solitary but not unsocial, he was Professor of Painting at the Royal Academy from 1782 until 1799, when he was expelled from the Royal Academy for criticizing his colleagues. As a student Turner would undoubtedly have heard Barry lecture and the impact of his injunction to young artists to work hard, found in his sixth lecture (1793), was lasting: 'Barry's words are always ringing in my ears "Get home and light your lamp"' (Turner to James Holworthy, 21 November 1817, Gage 1980, p. 71).

Turner also owned a copy of Barry's *Works*. Barry's most important paintings are the six murals *The Progress of Human Culture* in the Royal Society of Arts, London. Like Turner, he was buried in St Paul's Cathedral. RH

Gage 1969, p. 50.

W. L. Pressly, *The Life and Art of James Barry*, 1981.

BASIRE, James—the Elder (1730–1802) and **the Younger** (1769–1822), English engravers who were father and son and between whose work it is often difficult to differentiate. Both were appointed Engraver to the Society of Antiquaries. The elder James was the son of the engraver Isaac (1704–68) and the younger was the father of another James (1796–1869), who was of the fourth generation of the family to practise as an engraver in London. It has often been claimed that the two older James Basires were both involved, but it is most probable that it was only the younger man who worked for the Delegates of the University Press in engraving between 1799 and 1811 nine of Turner's drawings for the *Oxford Almanack (R 38–46). The first of these, *South View of Christ Church*, was certainly the most impressive print after Turner that had appeared until then, but some of the later plates were less effective. The existence of a number of proofs of these Almanacks touched by Turner, the first for that of 1801, proves that he supervised some of the engraving, a practice which in later years became routine. James Basire was also the engraver of the ten plates after Turner water-colours that illustrated the two volumes of Dr *Whitaker's *History of the Parish of Whalley*, published in 1800–1 (R 52–61). In 1812 he engraved Turner's view of Fountains Abbey for the second edition of Whitaker's *History of Craven* (R 77). LH

BATTLE OF THE NILE, THE, *at 10 o'clock when the L'Orient Blew up, from the Station of the Gun Boats between the Battery and Castle of Aboukir,* size unknown, RA 1799 (275); present whereabouts unknown (BJ 10). Exhibited with seven lines from Book VI of *Paradise Lost*. There is no certain trace of this, Turner's first exhibited painting of a contemporary event, since 1799, although *Bell records it at Christie's in 1864 where, however, the price of 10 guineas argues strongly against it being the Royal Academy picture.

There were four other paintings of the battle in the 1799 RA. Turner's was criticized in the *London Packet* for May because 'it compleatly failed in producing the grand effect which such a spectacle as the explosion of a ship of the line would exhibit'.

In June a display of the Battle of the Nile opened at the Naumachia in Silver Street, 'designed & executed by Mr Turner'. Gage has suggested that this may have referred to

J. M. W. Turner but Richard Spencer has proved that the impresario was William Turner of Shoreditch, a coachmaker and artist who exhibited occasionally at the RA between 1792 and 1816. EJ

John Gage, 'Turner and the Picturesque', *Burlington Magazine*, 107 (1965), pp. 23–5.

Richard Spencer, 'Mr Turner and the Naumachia', *Turner Studies*, 9/1 (1989), pp. 27–31.

BAXTER, George (1804–67). English printer and inventor in 1835 of the 'Baxter' colour printing technique, which used oil colours. Baxter prints became very popular in the mid-19th century, and it is surprising that in a letter written to the poet Charles Ellis in 1845 Turner claimed to know nothing of this new method (Gage 1980, pp. 204–5). LH

BAY OF BAIAE, WITH APOLLO AND THE SYBIL, THE, oil on canvas 57¼ × 94 in. (145.5 × 239 cm.), RA 1823 (77); Tate Gallery, London (BJ 230). This is Turner's second great landscape resulting from his first visit to central Italy in 1819; since *Rome, from the Vatican* he had only exhibited one small painting, *What You Will!* (RA 1822; private collection; BJ 229). The exhibition catalogue included the line, 'Waft me to sunny Baiae shore' from *Horace's 'Ode to Calliope', alluding to the poet's delight in the waters of Baiae, but Turner adds the subject, from Ovid's *Metamorphoses*, of the Cumaean Sibyl who, beloved by Apollo, asked that she might live for as many years as there were grains of dust in her hand. Apollo offered her perpetual youth in return for her love but this she denied him and wasted away until all that was left was her voice; Ruskin sees this as a comment on the decay of the ancient riches of Italy (*Works*, xiii. pp. 132–3). Turner had visited Baiae from Naples in 1819 and there are many sketches, including one of the same view, in his 'Gandolfo to Naples' Sketchbook and 'Pompeii, Amalfi, Sorrento and Herculaneum' Sketchbook (TB CLXXXIV, CLXXXV).

Unlike Turner's pre-1819 classical landscapes this composition is composed in flowing curves rather than the distinct zones with forms parallel to the picture surface of the classical landscape. Most critics agreed that the picture was 'gorgeous' and the *European Magazine*, May 1823, was 'much annoyed by a cold-blooded critic . . . who observed that it was not natural. Natural! no, not in his limited and purblind view of nature. But perfectly natural to a man who is capable of appreciating the value of practical concentration of all that nature occasionally and partially discloses of the rich, the glowing and the splendid.' For the *Literary Gazette*, 17 May,

The seductive influence of colours, and the necessity of painting up to the standard of an exhibition, where the spread of gold is more

than that of canvas [an allusion to the very close hanging of pictures at the Royal Academy], will prevent, if it does not annihilate, the study of nature . . . Though we have no eye for criticism on this splendid piece, it is only when considered as a vision, or a sketch, or as a variety in the large collection—in one word it is not painting.

MB

Powell 1987, pp. 58, 117–21.
Nicholson 1990, pp. 245–9.

BEALE, Thomas, see WHALING.

BEAUMONT, Sir George (1753–1827), English connoisseur, patron and amateur painter. Instinctively conservative and devoted to the Old Masters, he was a severe and influential critic of Turner from about 1803. His most violent attacks were directed at Turner's classical pictures, which he thought travesties of his beloved *Claude, but he also objected to the vivid execution and colouring of his marines, and considered his influence on younger artists pernicious. The designation of Turner and *Callcott as 'white painters' originated with him. He was also critical of *Constable, and bought nothing by him despite taking a friendly interest in his progress. By contrast he helped launch *Wilkie's career and was a long-suffering defender of *Haydon, while his enthusiasm for *Wordsworth and *Coleridge showed an openness to new literary movements not matched in his artistic taste. His partiality, unpredictability, and powerful influence as a director of the *British Institution were resented by many artists, and he was savagely satirized in two anonymous catalogues raisonnés of the Institution's Old Master exhibitions in 1815 and 1816. Chastened, he devoted his later years to realizing his dream of a National Gallery (see LONDON), his gift of sixteen pictures by Old Masters and British artists joining those purchased from John Julius *Angerstein as its foundation collection. Turner's own larger bequest (see WILL), and his stipulation that two of his own pictures should hang with Angerstein's Claudes, can be seen as a belated revenge.

DBB

Felicity Owen and David Blayney Brown, *Collector of Genius: A Life of Sir George Beaumont*, 1988.

BEAUTIFUL, THE, see SUBLIME.

BECKFORD, William (1760–1844), fabulously wealthy builder of *Fonthill Abbey, traveller, connoisseur, author of *Vathek*, and important early patron of Turner, perhaps on the recommendation of Sir Richard Colt *Hoare.

Turner's first visit to Fonthill in 1798 resulted in a drawing in the 'Swans' Sketchbook (TB XLII: 13) and two watercolours painted in collaboration with the architect James *Wyatt (W 332, 333), the latter actually exhibited at the Royal Academy in 1798 under Wyatt's name. Early in 1799 Turner went to Beckford's London house to admire the two great Altieri *Claudes that Beckford had just bought. Soon afterwards Beckford wrote to Turner from Portugal asking him to go to Fonthill again, although *Farington recorded (27 May) that Turner 'does not know what the commission is to be'. Turner then spent three weeks making drawings of the building, still under construction. Many of these drawings are now in the 'Fonthill' and 'Smaller Fonthill' Sketchbooks (XLVII, XLVIII) together with a large watercolour (LXX: P). In 1800 Turner exhibited five large watercolours of Fonthill at the RA (W 335–9) which 'form a classic example of unusual coherence' (Wilton 1979, p. 173). Beckford paid 35 guineas apiece for these but later complained that Turner had over-dramatized the landscape; he subsequently disposed of them. Nearly all are now sadly faded.

Turner also exhibited *The Fifth Plague of Egypt* (Indianapolis Museum of Art; BJ 13; see PLAGUES OF EGYPT) in 1800; however, this depicts the seventh plague, that of hail and fire, rather than the murrain, the subject of the fifth plague. Strongly influenced by *Poussin and Turner's most ambitious painting to date, this was also bought by Beckford for 150 guineas, far more than Turner had received so far for a picture and a great coup for him, although Beckford resold it in 1807.

Beckford did not admire Turner's late pictures: 'He paints now as if his brains and imagination were mixed upon his palette with soap suds and lather; one must be *born again* to understand his pictures' (quoted by Cyrus Redding in *New Monthly Magazine*, 72 (1844), p. 24).

EJ

E. G. Cundall, 'Turner Drawings of Fonthill Abbey', *Burlington Magazine*, 29 (1916), pp. 16–21.
Timothy Mowl, *William Beckford*, 1998.

BEDFORD, Cecil Higgins Art Gallery. The gallery began collecting watercolours in 1952 and now owns 600, ranging in date from Francis Place (1647–1728) to the present day. The nine Turners cover half a century, from *Cote House, near Bristol* (c.1791; W 21) from Turner's very first sketching tour to *The Town and Lake of Thun* (c.1841; W 1505), one of several gems. *Norham Castle on the Tweed, Summer's Morn* (1798; W 226) was painted for Edward *Lascelles. The large *Sublime *The Great Fall of the Riechenbach* (sic) (Turner's gallery 1804; W 367) was bought by Walter *Fawkes, for whom the celebrated A *First Rate taking in Stores* (W 499) was painted 'between breakfast and lunch' at Farnley in November 1818. In 1997 the gallery bought *The Wreck of an East Indiaman* (c.1818; W 500), probably intended as a pendant to the *First Rate*; the colour study (TB CXCVI: N) is inscribed 'Begun for Dear Fawkes of Farnley'. *Rokeby* (W 1053), commissioned by Fawkes in 1822, illustrates *Scott's poem composed at Rokeby in Co. Durham in 1809 describing events after the battle of Marston Moor in 1644.

The other Turners are a blue and grey wash view of *The Coast near Dover* (*c*.1793; not in Wilton) and *The Bishop's Palace, Salisbury* (*c*.1795; W 204) from a series of views of the city commissioned by Sir Richard Colt *Hoare.

Sadly, the most covetable Turner of all, *Bedford* (W 831), has twice eluded the gallery at auction: first, on 30 November 1960 and again at Sotheby's on 8 June 1999 when outbid by an American private collector. EJ

BEECHAM, Sir Joseph (1848–1916), manufacturer, collector, philanthropist, and patron of the arts. Beecham took over and expanded the pharmaceutical business founded by his father, which by the turn of the century was one of the largest in the world. Knighted in 1911 and made a baronet in 1914, he was a notable patron of the arts, who for a time was proprietor of the Aldwych Theatre in London, and was instrumental in the Ballets Russes coming to London. The conductor Sir Thomas Beecham was his son.

Beecham bought Turner's *Walton Bridges (?Turner's gallery 1807; National Gallery of Victoria, Melbourne; BJ 63) sometime between 1909 and 1910.

His sale at Christie's on 3–4 May 1917 included this together with six Turner watercolours, all now part of the Lloyd Bequest in the British Museum, among them *Messieurs les voyageurs . . . in a snow drift upon Mount Tarrar— 22nd of January 1829* (RA 1829; W 405) and a version of *Florence from San Miniato* (*c*.1828; W 728). The sale also included groups of oils by *Constable, Crome, and other British artists. RU

BEGINNINGS or watercolour studies for subsequently developed images. Although Turner made such studies on both sketchbook pages and loose sheets from the 1790s onwards, principally the term 'Beginnings' has been employed historically in connection with the TB CCLXIII 'Colour Beginnings' group of 386 watercolours in the *Turner Bequest, as well as the identically titled but much smaller CXCVI and CXCVII groups.

The term 'Beginning' derives from Turner who wrote the word upon a rough watercolour study (CXCVI: N) he made around 1818 in preparation for the creation of a highly finished watercolour, *Loss of an East Indiaman* (Cecil Higgins Art Gallery, Bedford; W 500, as 'Loss of a Man-of-War'). Quite evidently he used it to denote an imaginative inception of the creative process by means of a rough blocking-out of the fundamental representational, expressive, structural, colouristic, and tonal elements of a planned drawing. However, when A. J. *Finberg titled the CCLXIII group in his 1909 Inventory of the Bequest, he allied the word 'Colour' to 'Beginnings' because he interpreted the

majority of its constituent watercolours as being 'studies of the fundamental colour structures of designs' (vol. ii., p. 814). This is erroneous, as only a small number of watercolours within the CCLXIII section appear to be colour-structure studies.

The principal identifying feature of colour-structure studies is the deployment within them of large areas of relatively flat colour. Evidently such drawings were made to plan the interrelated colouristic, tonal, and compositional underpinnings of subsequently developed, more detailed, and highly finished designs. From the late-1810s colour-structure studies proved necessary to Turner because of a number of related factors: the major, evolutionary shift from tone to colour that took place in his art at that time; the separation of colour from form that could arise from such development; the increasing need to maximize the brilliance of watercolour transparency; and the related wish to organize completed drawings by means of underlying colour areas, rather than merely through overpainted interplays of form. (This is especially true of designs connected with the *England and Wales* series.) Edges, parallels, and similarities of shape maintained their role in creating compositional structure and/or reinforcements of those underpinnings, but increasingly they were matched or even overtaken by the use of formalized areas of colour, to create additional compositional unity. Yet the comparatively small number of colour-structure studies within the CCLXIII group and other sections of the Bequest indicates that Turner must have calculated the colour and tonal organization of most of his finished watercolours during the process of their actual creation, rather than beforehand.

Of the several other types of works in the CCLXIII group some are fully completed watercolours, while a few more are unfinished drawings whose partially developed staffage indicates they were in the process of being taken to completion when abandoned (evidently Turner only added such figuration in the later stages of elaborating an image). Then there are a small number of unfinished, variant versions of known, finished designs, as well as several variant studies or preparations for subsequently developed, known watercolours whose topographical data they exactly replicate but from which they differ significantly in their detailing and/or colouring.

The CCLXIII group also contains many 'beginnings' in the sense in which Turner employed the term. Such studies for known, completed drawings can be connected to the works that were developed from them by similarities of detailing and composition, sheet size, type of paper, occasional watermarks, stylistic traits, and other aids to dating. A marked, general feature of these works dating from between the 1810s

and early 1840s is the fact that they are almost invariably larger than the designs emanating from them. This fixed relationship surely reflects Turner's desire to accord himself the largest possible arena in which to test possible imagery.

Other drawings in the CCLXIII group are test sheets or investigations of brushwork effects, the diffusion of colours, paper characteristics, and the like. Usually these can be identified by their imagery (or lack of it), or by some technical detail that was obviously of primary interest to the artist. The CCLXIII section may also contain some undersheets, or pieces of paper used to support sheets actually being worked on and to prevent the board or table surface beneath them from getting wet. These possible undersheets are covered with randomly distributed smears of paint and rectangular outlines that may have accrued from the masking effects of other sheets placed on top of them. And finally there are large numbers of watercolour sketches or roughly drawn works that were made as expressive and/or exploratory entities in themselves. A significant proportion of these are views of skies and seas, in which Turner simply recorded the passing beauties or sublimities of external nature, and expressed his responses to those phenomena in the process. Such drawings also helped maintain both his observational skills and his idealizing apprehension of the underlying behavioural characteristics of natural forms and forces, as well as occasionally providing effects that could subsequently be deployed within other artistic contexts.

In recent decades proponents of the notion that Turner was a proto-abstract artist have cited many of the cursory, incomplete, intensely coloured, tonally subtle, and often dynamically brushed watercolour 'beginnings' and sketches in the Bequest as evidence to support their case. Certainly, most of the works they have referred to were experimental, for by implication watercolour studies experimentally brought imagery into precise and purposeful focus, while watercolour sketches were experiments with imagery in the widest possible sense. However, recent close analysis has reinforced the view that the imagery of these watercolours was not abstract, but instead was an extremely abbreviated shorthand that served highly representational ends. Such a shorthand is made clear by some key watercolour studies whose comparison with the final works they served to focus establishes the exact and typical degrees of representational attenuation that Turner could employ when making his watercolour studies.

Because many of the watercolour studies and sketches in the Bequest were abandoned in early stages of development, they afford important insights into Turner's technical methods as a watercolourist. For example, it is apparent that he often began his drawings by saturating paper with clear or tinted water, and then immediately added pigment which would instantly be diffused. Increasingly such diffusion came to stand at the very heart of his watercolour practice because it afforded both the creation of enormously delicate interminglings of colour that could not be achieved by any other means, and involved a degree of uncertainty, although in broad terms its effects could be anticipated. Turner welcomed chance effects, for they not only challenged him as a virtuoso but simultaneously they extended and enriched the range of expressive marks that were available to him.

Many other drawings in the CCLXIII and related groups were reduced in colour by means of 'washing-out'. This involves the reactivation and removal of surface colour through the partial or complete submersion of the sheet. Such lessenings of colour could equally be localized by means of a sponge, damp brush, piece of bread, or blotting paper, all of which Turner is known to have used. Upon drying, both the diffused and reduced areas of colour could subsequently be enhanced with scratched and scraped highlights, dragged brushwork, a multitude of crosshatched and stippled marks, or with broader overpaintings.

The very creation of watercolour 'beginnings' and sketches was necessitated by Turner's psychological, technical, and aesthetic approach to the generation of images. From the early 1790s onwards he made large numbers of watercolour studies and sketches in order to give form to a mental image, to narrow down the wide pictorial possibilities that were imaginatively open to him, to explore the pictorial potentialities and demands he faced when developing an image further, and/or to work out what would be needed technically and materially when elaborating that image. Yet the making of such preparatory or exploratory works was simultaneously necessitated by the idealization that governed his art. This improvement upon mundane reality had been recommended by *Reynolds (see IDEALISM), and it dictated that in his many sketchbooks Turner usually outlined in pencil merely the topography, vegetation, buildings, and architectural detailing within a given scene but omitted any figures, shading, and other indications of light and weather. By such means the painter allowed himself the greatest possible freedom to synthesize landscapes and seascapes out of topographical details and lighting effects brought together from differing locations, as well as to populate them with a remembered or invented humanity. Naturally, the making of rough, preparatory watercolour studies and sketches played a crucial role in this pictorial crystallization, especially where colour and tonal dynamics were concerned.

For a breakdown of the CCLXIII group watercolours and related drawings in terms of the definite, probable, or

possible purposes for which they were made, see Shanes 1997. The CCCLXIV 'Miscellaneous: Colour' group and, to a lesser extent, the identically titled CCCLXV section still await detailed investigation. ES

Lindsay 1966, pp. 168–9.
Wilkinson 1975, pp. 99 ff.
Shanes 1997.

BELL, C. F. (1871–1966), museum curator and historian of British art. Appointed to the *Ashmolean Museum, Oxford, in 1896, C. F. Bell was the first Keeper of the museum's Fine (later Western) Art Department from 1908 to 1931. His first publication, in 1901, was *A List of Works Contributed to Public Exhibitions by J. M. W. Turner, R.A.*, a pioneering reference work enriched by his informative notes. Bell did much to develop the collection of English watercolours at the Ashmolean, and he published extensively on the early watercolour artists, in the *Walpole Society, Burlington Magazine*, and elsewhere. LH

BENNET, Julia, see GORDON, SIR WILLOUGHBY AND LADY.

BIBLICAL SUBJECTS first attracted Turner when he was in his twenties, and throughout his career he repeatedly plumbed the Holy Scriptures. His biblical illustrations fall into two distinct categories: the first is dependent on 'pure landscape', closely relating to outdoor sketches of particular views; the second category was a quasi-symbolic, visionary landscape, usually compiled from several tentative studio sketches and often inspired by traditional iconography and literary sources. These two aspects of Turner, his faithful rendering of natural scenes and his romantic dramatization of remote events, may appear to be diametrically opposed, but in fact they are the interrelated poles of a flexible personality who wished to project nature from a naturalistic as well as a poetic perspective.

Turner was greatly influenced by Richard *Wilson, who not only brought historical and ideal landscapes to his attention but also introduced him to the works of Nicolas *Poussin. As early as 1798, Turner copied Poussin's *Exposure of Moses* and *Landscape with a Snake*, whose lessons show clearly in his later work *The Fifth Plague of Egypt* (RA 1800; Indianapolis Museum of Art; BJ 13) and to an even greater degree in *The Tenth Plague of Egypt* (RA 1802; BJ 17; see PLAGUES OF EGYPT). In some of the sketchbooks, for example, the 'Dolbadarn' Sketchbook (TB XLVI), Turner juxtaposes his realistic studies of nature with studies from historical landscapes of the Old Masters. The result is a lofty new conception of landscape.

After Turner visited the Louvre (see PARIS) in 1802, his work bifurcated into two forms: the historical and the sublime. More than half the pictures that Turner studied at the Louvre portrayed biblical subjects, and the biblical paintings that resulted from this first visit to Paris reflected his diligent research. The works of the masters showed him how to transform empirical observations of nature into a non-empirical supernatural content whose biblical-symbolical meaning is clear.

With the first of his three earliest 'historical pictures' he acquired 'new character in his profession'. Between 1800 and 1802 Turner submitted to the Royal Academy each year an example of his historical religious works, all of which related to catastrophic events recorded in the Old Testament. In this group of large paintings, small and helpless figures populate a distant landscape before the fury of God's creation, pointing to the 18th-century aesthetic of the sublime, and the concept of fear as a pleasurable experience. As Edmund Burke says in his study of the origin of ideas of the *sublime, 'whatever is in any sort terrible, or is conversant about terrible objects or operates in a manner analogous to terror, is a source of the *sublime*, that is, it is productive of the strongest emotion which the mind is capable of feeling.'

About 1810, Turner was occupied with biblical subjects that relate to larger themes, most of which, however, he merely mentions by title in his sketchbooks. In the 'Studies for Pictures: Isleworth' Sketchbook (XC: 56a) he suggests three scenes in the life of the patriarch Jacob: *Jacob and Esau, Jacob and Rachel*, and *Laban searching for his Images*.

In the 1830s Turner was once again occupied with biblical subjects and depicted events that took place in Jerusalem: *Pilate washing his Hands* (RA 1830; BJ 332) and the unfinished *Christ driving the Traders from the Temple* (c.1832; BJ 436). A third work, *Burning Fiery Furnace* (RA 1832; BJ 346), depicts Babylon.

Later in his life, as represented in *Dawn of Christianity (Flight into Egypt)* (RA 1841; Ulster Museum, Belfast; BJ 394), *Shade and Darkness—The Evening of the Deluge*, *Light and Colour—The Morning after the Deluge* (both RA 1843; BJ 404–5) and *The *Angel standing in the Sun* (RA 1846; BJ 425), Turner raises to a higher level of consciousness the opposing attitudes that ran parallel throughout his life. The threatening nature of *Shade and Darkness* reflects his pessimistic belief that humanity was doomed as a result of its inner weakness. In the complementary *Light and Colour*, he manifests with equal conviction the belief that the creative process, an artistic view, can give new life to mankind.

Turner's highly dramatized vision of the Bible derives both from his observation of nature (stormy seascapes and architectural ruins), and from his familiarity with the works of other artists, which also dealt with these subjects. He carefully examined the works of the great masters and

particularly strove to understand the means and methods by which to achieve artistic expression. Above all he tried to understand how each subject provoked another use of 'historical colouring'. The 'simplicity' of the parts, the richness of colour, and the brilliancy in effects ('Studies in the Louvre' Sketchbook, LXXII: 28, 60a.) in the works of Old Masters such as *Titian, Poussin, *Rembrandt, and Domenichino enhanced Turner's responsiveness to the 'shades of meaning and feeling' (*Finberg 1961, p. 101) that replaced his traditional mechanical realization which demanded an equal finishing of all objects in the painting, thus giving expression to the 'terrible sublime'. MO

> Edmund Burke, *Philosophical Inquiry into the Origin of Our Ideas of the Sublime and Beautiful*, 1757.
> Mordechai Omer, *Turner und die Dichtkunst*, exhibition catalogue, Munich, Bayerische Staatsgemäldesammlungen, 1976.
> Omer 1979 and 1981.
> Mordechai Omer, 'Turner's Biblical Deluge and the Iconography of "Homo Bulla"', *Comparative Criticism*, 5, 1988, pp. 129–52.
> Herrmann 1990, pp. 209–12.

BICKNELL, Elhanan (1788–1861). Elhanan Bicknell's father, William (1749–1825), ran a successful 'Academy' or school in Lower Tooting, London; he educated Elhanan himself and also passed on to him his own strong Unitarian beliefs. When still a young man Elhanan was offered a partnership by his uncle, who had invented a process of refining spermaceti 'which, figuratively speaking, turned into gold what had previously regarded as mere waste and a nuisance'. Under Elhanan's skilful management, the firm gained substantial interests in the Pacific sperm-whale fishery and, by 1835, despite the introduction of free trade which crippled his business, he had made a considerable fortune which enabled him to begin collecting modern English works of art.

Bicknell married four times and had thirteen children. After his second marriage he moved to Herne Hill, where he enlarged a Georgian villa to accommodate his growing family and, later, to house his pictures and sculpture. Rather than going to dealers, he bought either at auction or directly from artists, many of whom he entertained regularly at his home.

In 1838 he bought his first Turners: two watercolours engraved for *White's *India* (both untraced; W 1293, 1296). He acquired his first oil, *Venice, the Giudecca* (Art Institute of Chicago; BJ 391), at the Royal Academy in 1841 and added the *Campo Santo, Venice* (Toledo Museum, Ohio; BJ 397) the following year. But 1844 was Bicknell's *annus mirabilis* as a Turner collector when he bought eight oils, six of them on one day, and all pictures that had remained unsold for

some time. These probably were: *Calder Bridge* (Turner's gallery 1810; private collection; BJ 106); *Ivy Bridge* (Turner's gallery 1812; private collection; BJ 122); *Port Ruysdael* (RA 1827; Yale Center for British Art, New Haven; BJ 237); *Palestrina* (RA 1830; BJ 295) for which he paid the large sum of £1,050; *Wreckers, Coast of Northumberland* (RA 1834; Yale Center, New Haven; BJ 357); and *Bright Stone of Honour (Ehrenbreitstein)* (RA 1835; private collection; BJ 361). He also bought in 1844 *Helvoetsluys* (RA 1832; private collection; BJ 345) and *Antwerp* (RA 1833; Frick Collection, New York; BJ 350). Finally, in 1851, he bought *Grand Junction Canal* (Turner's gallery 1810; private collection until stolen, 1991; BJ 101) and *Saltash* (RA 1812; Metropolitan Museum, New York; BJ 121) but sold them both later.

Meanwhile Bicknell had ordered, from the 'sample studies' shown him by Thomas *Griffith, two finished watercolours out of the ten 1842 Swiss views: *The Blue *Rigi* (private collection; W 1524) and *Brunnen, Lake Lucerne* (private collection; W 1527). His final purchase in 1854 included four Yorkshire subjects, painted 1809–13 for Sir William *Pilkington (Wallace Collection, London; W 527, 535, 536, 834).

Although Turner was a frequent visitor at Herne Hill, he and Bicknell never became close friends and, in 1845, they fell out over one of the four *whaling pictures Turner exhibited in 1845 and 1846. A letter from Turner, dated 31 January 1845, invited Bicknell to call at *Queen Anne Street 'for I have a whale or two on the canvas'. This refers to *Whalers* (RA 1845; Metropolitan Museum, New York; BJ 415), which Bicknell did acquire although it seems unlikely that he commissioned it. However, in September, *Ruskin's father reported to his son that 'Bicknell is quarelling with Turner . . . he found Water Colour in Whalers and rubbed out some with Handky. He went to Turner who looked Daggers and refused to do anything but at last he has taken it back to alter.' However, the picture was never returned to Bicknell and, to judge from his other Turners, *Whalers*, despite its subject, may not have been entirely to Bicknell's taste.

Bicknell also financed Hogarth's print of 1844 of *The *Fighting 'Temeraire'* (RA 1839; National Gallery, London; BJ 377); this led to a further disagreement between Bicknell and Turner over the latter's fee but Turner is known to have gone on visiting Bicknell, as recorded in the journal of Christine Roberts, wife of Elhanan's son Henry and daughter of David *Roberts, Bicknell's closest friend.

Bicknell died in November 1861; the sale of his extensive collection took place at Christie's on 23 April 1863 and lasted six days. The *Star* (28 April) described the collection as one 'which would have brought no discredit to a LORENZO the MAGNIFICENT' and the total of £75,000 broke all records.

With the exception of *Calder Bridge* all the Turner oils sold very well, especially *Antwerp*, which fetched £2,625, a record for a Turner of that size. The watercolours also went well, *Brunnen* at 680 guineas bringing the most at more than double the price of *The Blue Rigi* (296 guineas). However, the top watercolour price was 760 guineas for Copley Fielding's *Crowborough Hill*.

Despite not buying his first Turner until 1838, Bicknell, who finally owned ten oils and eighteen watercolours, must be included among Turner's half-dozen most important patrons. EJ

Bicknell and Guiterman 1987, pp. 34–44.

BIRCH, Charles (fl. 1825–*c*.1870), mine owner, ironmaster, collector, and amateur picture dealer (not to be confused with the London picture restorer of the same name). Birch had an extensive collection of contemporary British pictures, especially landscapes and idyllic subjects, and also owned many French paintings. Along with works by *Wilkie, *Maclise, Frith, Etty, *Constable, Cox, William Collins, John Linnell, and Edwin *Landseer, he owned a number of important works by Turner, and clearly appreciated his latest style. His collection included *Fishermen upon a Lee-Shore* (RA 1802; Southampton Art Gallery; BJ 16), *Grand Junction Canal at Southall Mill* (Turner's gallery 1810; private collection, stolen 1991; BJ 101), *Mouth of the Seine, Quille-Bœuf* (RA 1833; Gulbenkian Foundation, Lisbon; BJ 353), *Burning of the House of Lords and Commons* (BI 1835; Philadelphia Museum of Art, BJ 359; see PARLIAMENT), *Mercury and Argus* (RA 1836; National Gallery of Canada, Ottawa; BJ 367), *Grand Canal, Venice* (RA 1837; Huntington Library, California; BJ 368), *Rockets and Blue Lights* (RA 1840; Clark Institute, Williamstown; BJ 387), *Depositing of John Bellini's Three Pictures . . .* (RA 1841; private collection; BJ 393), *Van Tromp going about to please his Masters* (RA 1844; Getty Museum, California; BJ 410), and *Approach to Venice* (RA 1844; National Gallery of Art, Washington; BJ 412). Many of these were bought from Joseph *Gillott, the Midlands collector who shared his tastes and enthusiasm for Turner. Birch lived in Dudley, Harborne, Woodfield, and finally Birmingham, where in 1842 he was appointed Secretary of the Birmingham Art Union. He is said to have spent £30,000 on forming the collection of pictures which hung in the picture gallery at Metchley Abbey, Harborne, when he lived there. RU

Macleod 1996, p. 395.

BIRMINGHAM CITY MUSEUMS AND ART GALLERY own eight works by Turner. *The Pass of *St. Gothard* (BJ 146), the only oil, was painted *c*.1803–4 for John *Allnutt with a companion, *The Devil's Bridge, St. Gothard*

(private collection; BJ 147). Allnutt probably ordered them after seeing watercolour sketches of both subjects in the 'St Gothard and Mont Blanc' Sketchbook of 1802 (TB LXXV, repr. Russell and Wilton 1976, pp. 62–3).

The watercolours range from *Salisbury Cathedral from the Bishop's Garden* of 1797–8 (W 200) to *Cochem on the Moselle* (?1844; W 1337) and include a Wharfedale scene with a rainbow (W 621) and *Lancaster Sands* (W 581), both *c*.1818, the latter designed for Whitaker's *Richmondshire* but not engraved. *Blenheim House and Park* (W 846) and *Falls of the Rhine at Schaffhausen* (W 406) were both engraved in 1833, the former for *England and Wales* (R 270), the latter for the *Keepsake* (R 329).

The dramatic *Snowstorm, Mont Cenis* (W 402), inscribed *PASSAGE of Mt Cenis Jan 15 1820*, records an incident on Turner's return from Italy when the coach capsized on top of the pass leaving the passengers to 'flound[er] up to our knees nothing less in snow all the way down to Lancesleyburgh' (Lanslebourg). EJ

Gage 1980, p. 97.

BIRMINGHAM SOCIETY OF ARTISTS' EXHIBITIONS included works by Turner in 1829, 1830, 1834, 1835, and 1847, although neither lender's name nor medium was always given.

In autumn 1829 five *England and Wales* watercolours and *Lake Albano* (untraced; W 731) were shown. All these had been exhibited in June at the *Egyptian Hall, where lenders included *Griffith, *Maw, and *Windus. In 1834 Charles *Birch lent *View of Rye*, probably W 471 (National Museum of Wales, Cardiff), and in 1835 *Allnutt lent 'Landscape', probably one of the '*St Gothard' views (BJ 146–7) he had commissioned *c*.1803–4. In 1847 *Gillott lent *Walton Bridges* (?Turner's gallery 1806; *Loyd Collection, on loan to the Ashmolean Museum, Oxford; BJ 60) which he had recently acquired through *Pennell. EJ

BIRTHDAY, Turner's. Turner died in December 1851 but the year of his birth was uncertain. His coffin recorded his age as 79. After checking the registration of his baptism on 14 May 1775 at St Paul's Church, Covent Garden, his first obituarist suggested age 75/6. Another claimed that Turner was 81. His old housekeeper recalled that Turner said he was born in the same year as Napoleon and the Duke of Wellington—1769. But after noting that Turner had first exhibited at the Royal Academy when 15, in 1790, and had told friends that he was born on St George's Day, and quoting the provision in Turner's first will that the Royal Academy should organize a dinner every year on 'the twenty-third of April (my birthday)', a memoir written in 1877 concluded that Turner was born on 23 April 1775, the date accepted today.

Confirmation of the year appeared when the watercolour *St Erasmus in Bishop Islip's Chapel, Westminster Abbey* (British Museum; W 138), originally exhibited and sold in 1796, was sold again in 1858. In the foreground is painted a slab inscribed 'William Turner Natus 1775'.

After considering these debates Charles Stuckey in 1975 evolved a theory that *England: Richmond Hill on the Prince Regent's Birthday* (RA 1819; BJ 140) was autobiographical, referring to the practice of celebrating the Prince's birthday on the artificial date, St George's Day, that Turner also claimed, rather than on the Regent's natal day, 12 August. As the Prince had not been in Richmond on his birthday in the year before the picture was shown, 1819, Stuckey concluded that the subject was wholly imaginary although in a beautiful real setting. But there was in fact a celebration of the royal birthday in Richmond in August 1817, so Turner was referring to an actual event, unrelated to St George's Day. JAG

Stuckey 1981, pp. 2–8.

Golt 1987, pp. 9–20.

BLACKSMITH'S SHOP, see COUNTRY BLACKSMITH DISPUTING UPON THE PRICE OF IRON.

BLACKWOOD'S (EDINBURGH) MAGAZINE (1817–1980), a monthly forum for anti-Reform Tory views, was a lively, innovative periodical. Primarily a literary journal after 1830, it published anonymous fiction, poetry, humorous (often scurrilous) sketches, topical essays, and critical reviews notorious for their venomous comments. Turner was a target for one of its art critics, 'The Sketcher', whose attack began in his review of the 1835 Royal Academy exhibition (vol. 38, August 1835, pp. 200–1). 'The Sketcher' was the Revd John Eagles (1783–1855), a poet and amateur landscape painter who found little to praise in any exhibition, but was particularly merciless towards anyone he suspected of bravura or unorthodox handling. Eagles's criticism of Turner in the 1836 RA exhibition (especially noteworthy because it directly led to the first personal contact between the young John *Ruskin and the artist) was painfully dismissive: *Juliet and her Nurse* (Sra. Amalia Lacroze de Fortabat, Argentina; BJ 365) was

neither sunlight, moonlight, nor starlight, nor firelight . . . Amidst so many absurdities, we scarcely stop to ask why Juliet and her nurse should be at Venice. For the scene is . . . thrown higgledy-piggledy together, streaked blue and pink and thrown into a flour tub. Poor Juliet has been steeped in treacle to make her look sweet, and we feel apprehensive lest the mealy architecture should stick to her petticoat, and flour it.

Rome, from Mount Aventine (Earl of Rosebery, on loan to the National Gallery of Scotland; BJ 366) was 'a most unpleas-

ant mixture, whereupon white gamboge and raw sienna are, with childish execution, daubed together'. *Mercury and Argus* (National Gallery of Canada, Ottawa; BJ 367) was 'perfectly childish. All blood and chalk' (vol. 40, October 1836, pp. 550–1).

Ruskin, having drafted a letter to *Blackwood's Magazine* in defence of the artist, sent it to Turner for his approval (*Works*, iii. pp. 635–40). Turner's response suggests he was unruffled by Eagles's comments: 'I beg to thank you for your zeal, kindness, and the trouble you have taken in my behalf in regard of the criticism of Blackwoods Mag for Oc[t] respecting my works, but I never move in these matters. They are of no import save mischief and the meal tub which Maga fears for by my having invaded the flour tub' (Gage 1980, pp. 160–1).

Eagles, ever sceptical of Turner's methods and effects, was mischievously inventive in his descriptions of the paintings. He saw 'vitrified tadpoles' (vol. 46, September 1839, p. 314), water 'like hair-powder and pomatum, not over-well mixed' (vol. 48, September 1840, p. 384), 'a wine-swilling pig and a Newfoundland dog chained to a post' (vol. 54, August 1843, p. 192). Yet Eagles could be appreciative: *The *Fighting 'Temeraire'* (BJ 377) was 'a very poetical conception . . . a work of great effect and feeling, and worthy of Turner when he was Turner' (vol. 46, September 1839, p. 313). **Peace* (BJ 399), he said, 'strange as it is, has yet a dash of his genius' (vol. 52, July 1842, p. 30). Eagles expressed reserved praise for Turner in his review of Ruskin's *Modern Painters* (vol. 54, October 1843, pp. 485–503), but was scathing about Ruskin's monomaniacal, even idolatrous, adoration for Turner. JCI

W. E. Houghton, ed., '*Blackwood's Edinburgh Magazine*', in *The Wellesley Index to Victorian Periodicals, 1824–1900*, vol. i, 1966, pp. 7–209.

BLAKE, William, of Newhouse and/or Portland Place, see PUPILS.

BLIGH OR BLYTHE SANDS, see FISHING UPON THE BLYTHE-SAND.

BOARDS AND MILLBOARDS. Besides working on paper Turner also worked on boards for several types of image; most notably some studies for vignettes and a small number of oil sketches. The distinctions between paper and board are based on weight, density, and method of manufacture. Generally sheets below 150 gsm are definitely paper, sheets over 250 gsm are boards, and sheets between 150 and 250 gsm may be either. Paper is generally formed as a single sheet, boards may be formed as a single sheet using a board mould, or may be built up in layers, either on a board machine or as *pasteless* boards where individual handmade

sheets are couched together to form the board. Boards may also be produced by laminating two or more sheets together with glues.

Turner used a variety of prepared boards and millboards for different groups of oil sketches. These heavyweight boards were originally designed for making boxes and in bookbinding, but were later used by artists. The name comes from their method of manufacture, where the thick solid sheets are given a very hard surface by being 'milled' between heavy iron rollers. They were often made from fibre refuse, waste papers, vat ends, etc. In Turner's time the better grades of millboards were produced from hemp and flax fibres only, derived from the same materials used for making strong brown wrapping papers, namely tarred ropes, old sacking, and sailcloth.

The main types of board used by Turner were *Bristol*, *London* and *Superfine Drawing*, although a few examples of other types such as *Ivory* board and millboards can be found amongst his work. Many of these boards were distinguished by the impression of blind-embossed marks in the corner, identifying the type and/or the maker of the board. Typical stamps found in the Bequest include 'BRISTOL [Crown] BOARD', 'EXTRA SUPERFINE [Arms of the City of London] LONDON' and 'EXTRA SUPERFINE [Crown] DRAWING BOARD'. Board makers such as Reynolds, Turnbull, and Creswick produced an increasing variety of products to satisfy a growing sophistication in their trade customers, colourmen like Reeves, Newman, and Winsor and James Newton. Winsor & Newton's earliest Trade Catalogue offers 'Bristol and London Boards, Plain and Coloured'. The earliest catalogue gives no prices but by the mid-1830s two-sheet Foolscap London Boards sold for 2s. 7d. per dozen and the heavier six-sheet board for 7s. 9d. per dozen. Three-sheet Demy boards were for sale from Winsor & Newton in 1840 for 5s. per dozen. In response to increasing demand the price of such boards dropped throughout the 1840s and by Turner's death had fallen to 3s. 6d. a dozen.

Also found amongst Turner's oil sketches are a few examples of Winsor & Newton's 'Prepared Millboards Strained with stout drawing paper', actually designed for use with watercolour but used by him for oils. These boards, made up using two sheets of strong grey wrapping paper covered on each side with either a good-quality watercolour paper or a drawing cartridge, came in a range of sizes from 8 × 6 inches (at 6s. per dozen) up to 24 × 20 inches (at 53s. per dozen). PB

Peter Bower, 'Turner's Use of Papers and Boards as a Support for Oil Sketches', in Bower 1999, pp. 61–78.

BODY-COLOUR, see GOUACHE.

BOHN, Henry George (1796–1884), English bookseller and publisher, who specialized in remainders. As a publisher he is best known for his Library series of English and classical texts. It was Bohn who tried to purchase from *Longman's, who had taken over Charles *Heath's precarious affairs, the remaining stock of the *England and Wales series in 1839, and then declined Turner's offer of part of it after the artist had bought it privately just before it was offered for auction (Herrmann 1990, p. 139). In 1853 Bohn published the impressive reprint of the *Rivers of France, with the title *Liber Fluviorum*, and including a very useful 'Biographical Sketch' by Alaric A. *Watts. LH

BONINGTON, Richard Parkes (1802–28), English landscape painter, influenced by, and influential upon, Turner. A prodigy, he first exhibited at Liverpool in 1813. In 1817 his family moved from Nottingham to Calais, where he studied with Francia, and in 1818 on to Paris, where he studied in the Louvre. In 1821 he made his first visit to Normandy. He exhibited at the Paris Salon from 1822, making his mark with fluent and painterly landscapes in watercolours and from 1824 in oils; he won a Gold Medal at the so-called English Salon in Paris 1824. He also painted romantic literary and historical subjects, partially under the influence of his friend *Delacroix. In 1825 he was in London, gaining first-hand knowledge of Turner's works at the Royal Academy and in the collections of Walter *Fawkes, Sir John *Leicester, and the engravers and publishers George and W. B. *Cooke. At his early death (from consumption) he owned proofs of Turner's *Views in *Sussex* and *Rivers of England*; he would also have seen the original watercolours. Turner's influence can be seen in the *contre-jour* effects and the centrally placed sun of such a work as the *River-Scene—Sunset* (Victoria and Albert Museum). In April 1826 Bonington toured north Italy; his Venetian paintings shown at the British Institution and the Royal Academy in 1828 and included in posthumous studio sales in London, in 1829, 1834, and 1838, almost certainly influenced Turner in his series of Venetian paintings from 1833 onwards, while Turner's *Calais Sands* (RA 1830; Bury Art Gallery; BJ 334) can be seen as a homage to Bonington's scenes on the French coast. Bonington is well represented in the Wallace Collection, London; the most comprehensive exhibition of his work was shown in New Haven and Paris, 1991–2. EJ

Stainton 1985, pp. 19–20, 73–4.

Patrick Noon, *Richard Parkes Bonington*, exhibition catalogue, New Haven, Yale Center for British Art, and Paris, Petit Palais, 1991–2.

BONNEVILLE. Turner visited Bonneville during the early stages of his tour of the Continent in 1802, and it was there

that he gained his first intimation of the true grandeur of the Alps. He made outline sketches in his 'France, Savoy and Piedmont' Sketchbook (TB LXXIII), but also recorded several fully resolved compositions on the larger sheets of the 'St Gothard and Mont Blanc' book, showing the relationship of the town of Bonneville to its mountains setting (LXXV: 7; Courtauld Institute; W 355). He first had cause to use the views of Bonneville for two of the group of five oil paintings that he exhibited a year after his tour (Yale Center for British Art and Dallas Museum of Fine Arts; BJ 46 and 50). There is some confusion about the early histories of these two works, and the identification suggested in the 1984 edition of Butlin and Joll was challenged in a paper by Andrew Wilton (1986, pp. 404–6, based on a lecture of 1977), who thought the title of the picture exhibited as *Châteaux de St. Michael, Bonneville, Savoy* more appropriate to the picture now at Dallas, which must be the work bought by Samuel *Dobree rather than by John *Green and which must now be renumbered BJ 50 rather than BJ 46. Wilton supports this by referring to a third painting of Bonneville that Turner exhibited in 1812 (Philadelphia; BJ 124). This is essentially a repetition of the Dallas picture, and was exhibited under the title *A View of the Castle of St. Michael, near Bonneville, Savoy*, which, as Wilton noted, is a near translation of the earlier picture's title. Part of the debate concerning this group of paintings centres on two letters from Turner to Samuel Dobree about an offending cloud. Whatever his reservations, Dobree seems to have acquired one of the 1803 views of Bonneville; his name is listed with that of John Green of Blackheath in Turner's 'Academies' notebook of 1804 (LXXXIV: 66v.–67).

It is assumed that the 1812 picture arose from Turner's work on the *Liber Studiorum, in which it eventually appeared under the simple title *Bonneville, Savoy* (as plate 64, printed in 1816 but not published until 1819). In the mean time Turner had produced another, smaller oil painting of Bonneville (c.1803–5; untraced; BJ 148). For this he was indebted to a third view from the 'St Gothard and Mont Blanc' Sketchbook (British Museum; W 354). This oil entered the *Fawkes collection, as did a repetition in watercolour of the Dallas painting (?1807; W 381). The Dallas composition was repeated a further time in watercolour in 1808 (British Museum; W 385), bringing the number of works derived from the view of Bonneville on fo. 7 of the 'St Gothard and Mont Blanc' Sketchbook to a total of two oils, two watercolours, and a *Liber* design. Although the other 1803 Bonneville subject is especially interesting in suggesting how closely Turner had looked at the *Landscape with a Roman Road* attributed to *Poussin (then in the Desenfans collection, and now at Dulwich), this composition was

repeated only once: as a watercolour, apparently dated 1817, which was in the collection of Sir John *Swinburne, who favoured Turner's classical subjects (untraced; W 400). It was later engraved for the *Bijou* annual in 1829 (R 313).

IW

Wilton 1986.

BOOTH, Sophia Caroline, née Nolt, formerly Pound (1798–1875), Turner's landlady and companion in later years. After her first husband, Henry Pound, mariner, drowned she married John Booth, who died in 1833, aged over 70, leaving £200 to his stepson, Daniel John Pound, and a house and private income to Mrs Booth, with his physician, Dr Price, as co-executor.

Turner visited Margate occasionally from his schooldays. By 1833 he was using Mrs Booth's lodging-house facing the harbour. He refused to give references or his name but offered payment in advance, asked the landlady her name, and proposed to use it.

Artists who called on Mrs Booth after Turner died at 6 Davis Place (now *Cheyne Walk), Chelsea, found it clean, bright, the walls covered with pictures, and a starling caught by Turner singing in a cage. John *Pye found Mrs Booth, 'about fifty, good looking, dark and kindly mannered but obviously illiterate'. She told him Turner had called her 'old 'un' and she him 'Dear'. She told J. W. Archer that Turner had called her the handmaid of Art. She had acted as studio boy, cleaning his brushes and setting his palette. She described how Turner had made his last four paintings (BJ 434–7; see ÆNEAS RELATING HIS STORY TO DIDO) in her house, going from canvas to canvas in rotation. When he was disturbed or ill in the night she brought him drawing materials. She told of his early rising and long working hours and of his being inspired by dreams, saying there were times when she thought he must be a god.

David *Roberts learned from Dr Price of Mrs Booth's unwearied care of Turner, up night and day so that he wanted for nothing; but Roberts found her garrulous. She claimed she had known Turner's identity from the first, and it seemed they had lived, travelled, and passed together as man and wife. For eighteen years she had apparently provided solely for their maintenance when together and had personally paid for the Chelsea cottage with her inherited money. She showed the two second-floor rooms and small roof terrace Turner had used but Roberts declined her offer to show numerous verses by Turner in honour of herself and her charms. He thought her 'low, vulgar minded and uneducated' but Turner's friends had noticed that he was cleaner and tidier in later years. From her account they had been happy together, although Turner was jealous of anyone

approaching her. Roberts regretted Turner being besotted with someone unsuitable.

Mrs Booth's son, Daniel John Pound, an engraver, lived with her. Roberts met and helped him. *Finberg noted that Turner had interested himself in Pound's education and scandalmongers thought he was Turner's illegitimate son. Monkhouse disbelieved the scandal about a liaison, their only indiscretion being due to Turner's wish for concealment.

Turner's 1846 *will appointed Mrs Booth co-custodian of his gallery, with Hannah *Danby, and bequeathed her an equal annuity of £150. In the subsequent litigation she also sought reimbursement for five years' board (including wine and spirits), lodging, and laundry (fine linen when he went into society and many changes of bedlinen and underwear during illness) towards which Turner had contributed nothing; nor had he paid for his convalescent visits to Margate and to a house she owned in Deal. She got less than half the £1,436 2s. 3d. she claimed.

Mrs Booth or her son later sold several Turner oils (BJ 474–9, 483–4, 511, 513, 557) and watercolours. She left Davis Place in 1867, the end of the lease, and moved to Haddenham, Bucks. She died there, but was buried with John Booth in Margate. JAG

Lindsay 1966.
Guiterman 1989.

BOSTON MUSEUM OF FINE ARTS, Massachusetts, owns *Slavers throwing overboard the Dead and Dying* (RA 1840; BJ 385), the most famous oil outside the Turner Bequest, bought by the museum in 1899 after it had been sold by John *Ruskin in 1872 to America, where initially it met with much adverse comment. *Fall of the Rhine at Schaffhausen* (RA 1806; BJ 61) was bought in 1913 after remaining at *Tabley House from 1807 to 1912. It was the first Turner to be noticed in France, a critic describing it in 1807 as 'n'est vraiment qu'une ébauche au-dessous de la critique'. Boston's third oil, bequeathed by William A. Coolidge in 1993, is the small *View from the Terrace of a Villa at Niton, Isle of Wight, from Sketches by a Lady* (RA 1826; BJ 234). The sketches were by Turner's former pupil, Julia Bennet later Lady *Gordon, whose husband had acquired the villa in question in 1813.

The ten watercolours include *Tintagel Castle, Cornwall* (c.1815; W 463), engraved in the *Southern Coast 1818, *Dover from the Sea*, signed and dated 1822 (W 505), and two of the very rare studies for the *Little Liber* mezzotints: *Catania, Sicily, in a Storm* (W 774), previously mistitled 'Storm over St Peter's', and *Ship and Cutter* (W 777); both were drawn c.1825. *A Jetty: ?Margate* (W 1428) is dated

c.1845–50 and Wilton records that it has been rechristened 'Calais Sands' but he believes without justification.

Boston also owns fine sets of the *Liber Studiorum* and *Little Liber* together with touched proofs collected by Francis *Bullard. EJ

BRABAZON, Hercules Brabazon (1821–1906), British 'amateur' painter, wealthy landowner, and musician, who studied in Rome and elsewhere, but was largely self-taught. He developed a notably fluent, fluid, and colourful watercolour manner, which was much admired by *Ruskin. A prolific artist, also in his later years in pastel, he drew profusely on his many foreign tours, and also made copies from a great variety of artists, including Turner, one of the major influences on him. He exhibited for the first time in 1891, and his work was very well received and often associated with that of the *French Impressionists. LH

BRANDARD, Robert (1805–62), one of three Birmingham-born brothers who were all engravers. He came to London, and studied for a short time with Edward *Goodall, before setting up successfully on his own. Having engraved four copper plates for the *England and Wales* series, including the fine *Lancaster Sands* (R 227), he contributed a total of fourteen steel plates to the *Rivers of France*. An outstanding large copper engraving by Brandard is after the famous painting *Crossing the Brook* (BJ 130), published by Thomas *Griffith in 1842 (R 656). Robert Brandard contributed several plates to the *Turner Gallery, as did his younger brother, Edward. LH

BRIDGE OF SIGHS, DUCAL PALACE AND CUSTOM-HOUSE, VENICE: CANALETTI PAINTING, oil on mahogany, 20³⁄₁₆ × 32⁷⁄₁₆ in. (51 × 82.5 cm.), RA 1833 (109); Tate Gallery, London (BJ 349). Turner's first surviving exhibited oil painting of a Venetian subject (the lost *Ducal Palace*, BJ 352, was also shown at the Royal Academy in 1833) was painted as a tribute to the great 18th-century Venetian artist *Canaletto, who is shown, totally unrealistically, painting a picture in a gold frame in the open air. The choice of a Venetian subject may also have been inspired by the Venetian scenes of *Bonington, and also showed friendly rivalry with *Stanfield, who exhibited *Venice from the Dogana* in the same exhibition. Two contemporary reports suggest, probably exaggeratedly, that Turner painted the picture in two days. The exhibition was also the occasion for Turner's last-minute strengthening of his colours to put down the bright blue of George *Jones's *Gwent*; Jones however won, by toning down his sky.

Jones recommended Robert *Vernon to buy the picture for 200 guineas, 'which was the commencement of his large

prices, for he said to me, "Well, if they will have such scraps instead of important pictures, they must pay for them".' The press gave Turner the victory over Stanfield and indeed over 'every other work in the exhibition' (*Arnold's Magazine*). The *Athenaeum*, 11 May, thought that Turner had worsted Canaletto as well, stating of Turner's picture that it was 'more his own than he seems aware of: he imagines he has painted it in the Canaletti style: the style is his, and worth Canaletti's ten times over.' MB

BRIDGEWATER, Francis Egerton, third and last Duke of (1736–1803), the founder of British inland navigation, amassed great wealth from coal and *canals, and formed a celebrated collection of Old Master paintings, known as the Bridgewater Gallery. The younger son of the first Duke (1681–1745), he succeeded his older brother as Duke in 1748. He made his Grand Tour aged 17, and thereafter devoted himself to developing his coal resources at Worsley. He employed James Brindley to construct a 10-mile canal between Worsley and Manchester (1759–61), which caused the price of coal to halve, greatly increasing the demand. The canal was extended to Liverpool in 1776. The Duke spent £220,000 on construction, which was ultimately to bring him an annual revenue of £80,000.

His earliest recorded purchase was a set of four paintings commissioned in 1759 from Claude-Joseph *Vernet, but the stature of his gallery, hung at Bridgewater House, London, was transformed in 1798 by his involvement with the Italian portion of the picture collection of the Ducs d'Orléans. The Bridgewater share of this harvest included masterpieces by Raphael, *Titian, Tintoretto, and *Poussin.

In 1801 the elderly Duke commissioned (for 250 guineas) the youthful Turner to paint *Dutch Boats in a Gale, better known as the 'Bridgewater Seapiece' (private collection; BJ 14), as a pendant to *Dutch Shipping Offshore in a Rising Gale*, by Willem *Van de Velde the Younger (Toledo Museum, Ohio). Turner's painting was exhibited at the Royal Academy in 1801, at the *British Institution summer exhibition of Old Masters in 1837, and at the Turner *bicentenary exhibition, 1974–5.

The painting descended to the sixth Duke of Sutherland, who sold it at Christie's on 18 June 1976. A British private collector paid £374,000, making the picture at that time the most expensive British picture sold at auction. It is now on long loan to the National Gallery, London. CALS-M

'BRIDGEWATER SEAPIECE', see *DUTCH BOATS*...

BRIGHTON, the favourite retreat of the Prince Regent (see GEORGE IV), was developing rapidly as a seaside resort at the beginning of the 19th century. However, Turner's early watercolour *Brighthelmstone* (c.1796; W 147) focuses on the original picturesque fishing village. In contrast, *Brighthelmston, Sussex* (1824; W 479; made for *Picturesque Views of the *Southern Coast of England*), juxtaposes the improvements of the modern resort with the sublimities of sky and sea. In the background are the Marine Parade, then still under construction, and the Prince Regent's Pavilion, while the new Chain Pier, built to receive steam packets, advances into the blustery foreground. Lord *Egremont helped finance the Pier, which is accordingly also the main motif in the oil *Brighton from the Sea* (c.1829; BJ 291), painted to hang at *Petworth. Here, in a serene *Claudian composition, old Brighton (in the shape of the fishing vessels) harmonizes effortlessly with the new (steamer, Pier, resort). The subject may have been painted in emulation of *Constable's *Beach at Brighton, the Chain Pier in the Distance* (RA 1827; Tate Gallery), which, however, seems to contrast the new unfavourably with the old. AK

Hemingway 1992, ch. 8, esp. pp. 165–6, 185–96.

BRIGHT STONE OF HONOUR (EHRENBREITSTEIN), THE, and *Tomb of Marceau, from Byron's 'Childe Harold'*, oil on canvas, 36¼ × 48½ in. (93 × 123 cm.), RA 1835 (74); private collection, UK (BJ 361). Exhibited with lines from canto iii of *Childe Harold* which pay tribute to the French general Marceau—'He was freedom's champion!'—killed during the siege of the fortress of Ehrenbreitstein in 1796. However, as Powell pointed out (1995, p. 183), 'Ehrenbreitstein' in fact means 'broad', not 'bright', stone.

Turner visited *Ehrenbreitstein in 1834 in connection with a proposed series of engravings of German rivers which, however, never materialized. Several connected drawings occur on a large sheet (TB CCCXLIV: 1–16) and Turner painted many watercolours of Ehrenbreitstein, which became a favourite subject, in the early 1840s.

Most critics praised the picture: the *Athenaeum* (23 May) wrote: 'Imagination and reality strive for mastery in this noble picture', but *Blackwood's Magazine* (vol. 38, p. 201) as usual condemned it, complaining that it contained 'no more poetry than the paring of a toe nail'. The German art historian Dr *Waagen, on seeing Turner's work which, until then, he had known only from 'beautiful steel engravings', wrote 'I could scarcely trust my eyes when, in a view of Ehrenbreitstein, I found such a looseness, such a total want of truth, as I had never before met with.' EJ

Powell 1995, pp. 181–3.

BRISTOL. This south-western port had grown rich in the 18th century on the profits of the slave trade and its associated industries. Turner stayed here in 1791–2 with the *Narraway family, sketching the well-known picturesque

scenery of the Avon Gorge. Two related watercolours were exhibited at the Royal Academy in 1793, including *The Rising Squall: Hot Wells, from St Vincent's Rock, Bristol* (W 18). 'The explicit reference to climatic conditions ushers in a new phase of his development' and the view 'was greeted . . . as something novel' (Wilton 1987, p. 29). Turner also made two views of gentry seats near the town (W 20, 21). However, he took little interest in the town itself, merely executing a large watercolour of *St Mary Redcliffe Church* (c.1791–2; City Museum and Art Gallery, Bristol; W 16) in the style of *Malton and a small prospect of the town for *Harrison's downmarket *Pocket Magazine*, published 1796 (City Museum and Art Gallery, Bristol; W 117, R 30). AK

BRITISH COUNCIL EXHIBITIONS have been the main means of spreading the knowledge of Turner throughout the world since the Second World War, though in recent years the Council's efforts have been augmented by exhibitions organized by important collections of works by Turner such as the Tate Gallery and the City Art Gallery, Manchester, or by important centres abroad such as Hamburg; even such exhibitions are often assisted by the British Council. Mixed exhibitions of British paintings including a considerable representation of Turner were sent to Amsterdam and Berne in 1947, Venice and Rome in 1948, Lisbon and Madrid in 1949, and Hamburg and Scandinavia in 1949–50; among similar exhibitions in later years were those sent to Cologne, Rome, and Warsaw, 1966–7, and Paris, 1972.

Even more important were the exhibitions devoted to Turner alone. These began with that sent to Brussels, Liège, Paris, Rome, and Venice in 1948. This was followed by exhibitions in Germany, 1950–1, the Huntington Art Gallery, California, 1952, Melbourne and Sydney, 1961, Tokyo and Hong Kong, 1963–4, Lisbon, 1973, Leningrad, 1975, Caracas and Mexico City, 1979, Athens, 1981, Paris, 1983–4, Tokyo and Kyoto, 1986, and Madrid, 1993. Some of these are devoted to watercolours alone, others to both oils and watercolours. The British Council has also supported more specialized exhibitions, such as that devoted to Turner and poetry, Germany, 1976, and to Turner and Luxembourg, Luxembourg, 1984. MB

BRITISH INSTITUTION. Founded in London in 1805, the British Institution for Promoting the Fine Arts in the United Kingdom was begun and governed by a group of wealthy and mostly aristocratic collectors, among them Lord Northwick, Sir George *Beaumont, John Julius *Angerstein, and the Duke of Bedford, to rival the virtual monopoly of the *Royal Academy, which was entirely controlled by artists. Its principal object was 'to encourage and reward the talents of the artists of the United Kingdom,

and to open an exhibition for the sale of their productions'. The first exhibition, which opened in February 1806 in its rooms in Pall Mall, previously occupied by Boydell's failed Shakespeare Gallery, was a great success, and sales amounted to about 5,000 guineas. Of some 250 works by living artists half were by members of the Royal Academy, including two by Turner: *Narcissus and Echo* (Petworth House; BJ 53) and *The *Goddess of Discord* (BJ 57), neither of which was sold. The second exhibition, in 1807, to which Turner did not contribute, was even more successful, and the Marquis of Stafford bought fifteen paintings.

The BI also instituted a series of prizes to encourage rising artists, and immediately after the first exhibition of modern pictures, the gallery was re-hung with a small selection of Old Masters (including Richard *Wilson and *Reynolds) which students and artists were permitted to copy undisturbed. In 1813 there was an exhibition devoted entirely to the work of Sir Joshua Reynolds, and in 1815 there was the first of a regular series of larger exhibitions of Old Masters drawn from private collections. This consisted of 146 paintings by Dutch and Flemish masters. Such, as it were 'extramural', activities, which continued until the closure of the BI in 1867, aroused the opposition of the Royal Academicians, who feared the impact on the sale of modern works.

Turner sent two works to the 1808 exhibition; *Jason* (BJ 19, previously shown at the RA in 1802) and *The Battle of Trafalgar* (BJ 58, previously shown in an unfinished state in his own gallery in 1806). Again neither work sold, and nor did his 1809 exhibit, *Sun rising through Vapour* (BJ 69), previously shown at the RA in 1807. Turner did not exhibit again at the BI until 1814, when he submitted his controversial *Apullia in Search of Appullus vide Ovid* (BJ 128), which he submitted, ten days late, for the premium awarded by the Directors for the best landscape 'proper in Point of Subject and Manner to be a Companion' to a work by *Claude or *Poussin. Turner was in fact accused of plagiarism as his work was closely based on Lord *Egremont's famous Claude, *Jacob with Laban and his Daughters*. Turner did not win the prize, designed for young and unestablished artists, but won on this occasion by T. C. Hofland, who was himself only two years younger than Turner. This episode has been considered as a deliberate challenge by Turner against the BI, of which his vocal critic Sir George Beaumont was one of the most influential Directors. Though Turner was not named, he was definitely defended in the two anonymous catalogues raisonnés circulated in 1815 and 1816 with strong attacks on the British Institution.

Turner showed the two large and previously exhibited paintings of the *Temple of Jupiter Panellenius* (private collection, USA, and Duke of Northumberland; BJ 133, 134)

at the BI in 1817, but then there was an interval of nearly twenty years before he exhibited again in 1835. In the previous year the third BI Winter Exhibition had included four early paintings by Turner, of which two were lent by Lord Egremont. The 1835 exhibit was the famous Philadelphia version of the *Burning of the House of Lords and Commons (BJ 359; see PARLIAMENT), which was largely painted on the walls of the gallery on the *Varnishing Days, as vividly recorded by a fellow artist, E. V. Rippingille, and bought at the exhibition by Chambers *Hall. The second version of this composition (BJ 364, now in Cleveland), first shown at the RA in 1835, was one of Turner's two BI exhibits in 1836. At subsequent BI exhibitions Turner continued to show works already exhibited at the RA a year or two earlier. His final BI exhibit was in 1846, when he showed Queen Mab's Cave (BJ 420), which *Ruskin considered one of the 'various failures' of the exhibition. LH

Frank Herrmann, The English as Collectors, 1972, pp. 226–30.

Peter Fullerton, 'Patronage and Pedagogy: The British Institution in the early nineteenth century', Art History, 5/1 (March 1982), pp. 59 ff.

BRITISH MUSEUM. Opened in 1759 in Montague House to display the collections of Sir Hans Sloane bequeathed to the nation in 1753. Today, in its imposing classical building designed by Robert *Smirke, begun in 1823 and enormously enlarged and extended since then, the British Museum is one of the great museums of the world and has some seven million visitors each year. The collections range from the prehistoric to the modern—from Egyptian and ancient sculpture to contemporary Japanese ceramics—and include such treasures as the Rosetta Stone and the Parthenon Marbles. Prints and drawings, but not paintings, have been included from the beginning, but the first Keeper of Prints and Drawings, the artist William Alexander, was not appointed until 1808, when the first separate Print Room was established. The Department now houses some 'two million pieces of paper' as well as an extensive library, and the collection includes prints and drawings of all Western schools, Old Master and modern. For nearly two centuries the Print Room has been open to artists, scholars, students, and connoisseurs, and the attractive watercolour portrait showing Turner studying a sheet in the Print Room (British Museum), drawn by the second Keeper, J. T. *Smith, in about 1830, is proof that the artist was among the visitors. Since 1888 there has been space for exhibitions of prints and drawings, and the present gallery, in which some three temporary exhibitions are held each year, was opened in 1971.

The Department possesses over one hundred drawings and watercolours and a late sketchbook by Turner, most of them coming from four bequests, of which the George Salt-

ing Bequest of 1910 and R. W. *Lloyd Bequest of 1958, consisting largely of finished watercolours, are the most important. The collection of Turner prints is far more extensive, and is the most comprehensive in existence. The unrivalled holding of the *Liber Studiorum includes fifty of the original copper plates and numerous touched proofs. From October 1931, after the flood at Millbank, the Department housed all the works on paper from the Turner Bequest, but these were returned to the *Tate Gallery when the Clore Gallery opened in 1987. LH

A. Griffiths and R. Williams, The Department of Prints and Drawings in the British Museum, 1987, pp. 117–18.

BRITTON, John (1771–1857), antiquarian and prolific writer on topography and architecture, whose works were 'embellished' with 1,866 engravings, knew most of Turner's early patrons. In the British Press for 9 May 1803 Britton wrote the first significant long critique of Turner: he had spoilt a landscape 'by very bad figures', but even his failed attempts at sublimity were 'like the fabulous Phaethon'. Turner designed plates for Britton's Beauties of England and Wales, 1801 (Whitworth Art Gallery, Manchester; W 182; R 63); *Pope's Villa for Fine Arts of the English School, 1811 (BJ 72; R 76); Architectural Antiquities, 1814 (Soane Museum; W 234, R 82), and Cassiobury Park, 1816 (Boston Museum of Fine Arts and untraced; W 189–92; R 818–21). Turner admired the 'depth and well-laid lines' of the engravings in Architectural Antiquities, in which Britton in 1809 had dedicated a plate of Wollaton Hall to Turner, whose paintings 'have exalted his own name & the fine Arts of this country'. In November 1811 Turner wrote shrewdly to Britton criticizing his pompous draft letter-press to accompany Pope's Villa and correcting his term for eel-pots. Britton told *Thornbury that when he forced his way into Turner's bedroom at Maiden Lane by coming up the back stairs Turner covered up his drawings and threw him out. Britton found Turner's manners 'chilling' and 'laconic'; 'blunt, abrupt, unaccommodating and uncourteous'. JRP

John Britton, Autobiography, 1849–56.

Gage 1980, p. 241.

BRITTON AND BRAYLEY. John Britton, FSA (1771–1857), antiquary, topographer, and writer, was in partnership with E. W. Brayley, FSA (1773–1854), also an antiquary as well as archaeologist, for the publication of The Beauties of England and Wales (1801–16), which included one small plate after Turner: Hampton Court, Herefordshire, engraved by J. *Storer (R 63). Britton also edited and partly wrote The Fine Arts of the English School, published in 1812, in which John *Pye's outstanding engraving of Turner's *Pope's Villa was included (R 76), with a lengthy appreciation by

Britton, about which he and Turner corresponded (Gage 1980, pp. 49–51). LH

BROADHURST, John. Broadhurst owned a number of works by Turner: *Guardship at the Great Nore* (Turner's gallery 1809; private collection; BJ 91), **Harbour of Dieppe* (RA 1825; Frick Collection, New York; BJ 231) and **Cologne* (RA 1826; Frick Collection, New York; BJ 232). *Dido directing the Equipment of the Fleet* (badly damaged: RA 1828; BJ 241) may have been painted for him, although he never acquired it. RU

Gage 1980, pp. 108–9.

BROOKE, the Revd Stopford A. (1832–1916), Irish-born preacher, man of letters, and collector. His *Notes on the *Liber Studiorum of J. M. W. Turner, R.A.* was published in 1885 to accompany an edition of Autotypes of the *Liber* and then separately in a small book. Much influenced by *Ruskin, this is one of the most valuable and readable guides to the *Liber*, and includes technical, historical, and descriptive material. Brooke was asked to 'write something on each plate' and states that his 'object has solely been to tell the pleasurable thoughts and feelings these engravings have awakened in me, and the things I have seemed to see concerning their composition and sentiment during a companionship with them of many years'. For long one of the most popular preachers in London, and author of the highly successful *Primer of English Literature*, published in 1876, Brooke was also a considerable collector. A visitor (Sir William Rothenstein) to his Manchester Square house wrote: 'The house had the rich air, the profusion, of the Victorian interior. Prints and drawings covered the walls from top to bottom.' These included works by Turner, Blake, Burne-Jones, Rossetti, Walter Crane, and Alphonse Legros. LH

BRUNNEN. This little town on the eastern shore of the Bay of Uri, the southernmost arm of the Lake of Lucerne, became a tourist centre in Turner's lifetime. Its position is spectacular, with views across the lake to the Uri Rotstock and the historic site of the Rütli, and towering behind it the twin peaks of the Mythen. At the head of the Bay of Uri lies Fluelen, at the beginning of the *St Gotthard Pass. Turner made many drawings of this neighbourhood in the 1840s, including *Brunnen from the Lake* (Clark Art Institute, Williamstown, Mass.; W 1545), done for Ruskin, who however objected to the 'ugly hotels' that Turner characteristically included. Two panoramas of the lake from above the town (private collections; W 1526, 1527) feature in the 1842 set of finished watercolours, based on roll sketchbook studies that are among numerous records of the bay. Another view of the *Bay of Uri from above Brunnen* (Indianapolis

Museum of Art; W 1547) appeared in 1845, accompanied by two views of Fluelen, *Morning, looking towards the Lake* and *Fluelen from the Lake* (Yale Center for British Art, New Haven, and Cleveland Museum of Art; W 1541, 1549).

An unfinished oil in the Tate Gallery of *c*.1840–5 has recently been identified as showing *Lake Lucerne: The Bay of Uri from above Brunnen* (see Warrell 1999², pp. 146–7, repr. in colour pl. 19). AW

BUCKLEY, Abel (1835–1908), banker and 1885–6 MP for Prestwich, Lancashire. Not to be confused with his father of the same name. Buckley owned Turner's *Trout Fishing on the Dee* (Turner's gallery 1809; Taft Museum, Cincinnati; BJ 92), purchased at the Earl of *Essex's sale in 1893, and from 1865–8 *The Beacon Light* (*c*.1835–40; National Museum of Wales, Cardiff; BJ 474). In *Who Was Who 1897–1916* his addresses are given as Ryecroft Hall, Ashton-under-Lyne, and Galtee Castle, Mitchelstown, Co. Cork. RU

BULLARD, Francis (d. 1913). He formed a large collection of *Liber Studiorum proofs and other material which was bequeathed to the Museum of Fine Arts, Boston. Two drawings for the frontispiece were later given to the museum by his daughter. Bullard was the author of 'Thoughts suggested by the Study of Turner's Liber Studiorum', an appendix to the catalogue of *Exhibition of the Liber Studiorum of J. M. W. Turner and a Few Engravings after his Drawings*, Museum of Fine Arts, Boston, 1904. He also wrote *A Catalogue of the Engraved Plates for Picturesque Views in England and Wales, with Notes and Commentaries* (Boston, 1910). RU

BULLOCK, Edwin (fl. 1830–70), ironmaster and collector who lived at Harborne House, Harborne, and Hawthorn House, Handsworth, Birmingham. Bullock bought Turner's *Dogana, and Madonna della Salute, Venice* (National Gallery of Art, Washington; BJ 403) at the 1843 Royal Academy exhibition, and thought of buying a companion work later the same year (Gage 1980, p. 193). A friend of the Midland collectors Charles *Birch and Joseph *Gillott, Bullock would appear to have been on friendly terms with Turner, who wrote to him in May 1843 when he visited London. Macleod states that he generally bought from artists directly, and frequently entertained artists such as Cox, Etty, Rosa Bonheur, and Turner. Bullock originally bought Old Masters, but from the 1820s he formed an extensive collection of contemporary British pictures, including a large number by Cox, seven *Constables, and pictures by Thomas Jones, *Eastlake, Thomas Sidney Cooper, *Wilkie, *Leslie, Pickersgill, Mulready, Roberts, *Callcott, Etty and *Stanfield (see Gage 1980, p. 242). His sales were

at Christie's 21–3 May 1870 (492 lots realizing £42,700), 28 March 1884, and 9 May 1887. RU

Gage 1980, pp. 192–3, 242.
Macleod 1996, p. 398.

BURIAL AT SEA, see PEACE—BURIAL AT SEA.

BURKE, Glendy, a resident of New Orleans who in 1839 bought Wilkie's *Grace before Meat* (Birmingham City Art Gallery). Gage suggests that he is the subject of a letter dated 18 May 1840 to Wilkie in which Turner writes 'I beg to offer you my thanks for the Postscript to Mr Burke's Letter and if it is not troubling you too much to say that I shall be most happy to Paint him a picture upon his favouring me with his wishes regarding the size—price and Subject, and I hope my endeavours will meet his approval and you will much oblige me' (1980, p. 177). However, nothing seems to have come of this possible commission. RU

BURLINGTON FINE ARTS CLUB EXHIBITION, 1872. This pioneering exhibition and its catalogue, organized by the influential London club for art collectors, launched the modern scholarship concerned with Turner's *Liber Studiorum*, and reflected the informed collecting of the *Liber* prints during and immediately after Turner's lifetime. W. G. *Rawlinson in the first (1878) edition of his *Liber* catalogue acknowledged his debt to the BFAC catalogue, and adopted its numerical arrangement of the plates. This was used again in his second edition (1906) and also by A. J. *Finberg in his definitive *History of Turner's* Liber Studiorum *with a new Catalogue Raisonné* of 1924. It is still used today. LH

BURNET, John (1784–1868), Scottish-born painter and engraver and writer on art. He was trained in both painting and engraving in Edinburgh before moving to London in 1806, where he first made his mark as an engraver with prints after his friend and former fellow student David *Wilkie, including *The Blind Fiddler* in 1811. Burnet also exhibited paintings at the Royal Academy and the British Institution, but his principal activity was as an engraver, specializing in figure and historical subjects. In later years he became a prolific writer on art, including such books as *A Practical Treatise on Painting* (1827) and *Rembrandt and his Works* (1849). He also applied himself to improving the mechanical methods of engraving, and he was elected a Fellow of the Royal Society.

Burnet engraved only a few posthumous plates after Turner, foremost among them two large steel plates after The *Shipwreck* of 1805 (BJ 54) and the 'Bridgewater Seapiece' of 1801 (*Dutch Boats in a Gale*; BJ 14) which were published by Henry *Graves in 1853 (R 675, 676). John

Burnet's main connection with Turner is his authorship of the first book on the artist, *Turner and his Works: Illustrated with Examples from his Pictures, and Critical Remarks on his Principles of Painting*, published in 1852. The book opens with a 30-page Memoir by Peter *Cunningham, which is thus the first published biography of Turner. The slim volume is illustrated with ten plates by Burnet, which appear to be a combination of etching and aquatint, and provide very flat and approximate reproductions of the paintings reproduced. Burnet ends his Preface, which is dated 26 April 1852, as follows: 'In describing the particular beauties, and here and there the defects, of Mr. Turner's genius, I have endeavoured to make them in all instances the basis of general instruction in Art.' If John *Ruskin had not been writing at this time, Burnet's pioneering book would have had a far greater impact. LH

BURNING OF THE HOUSE OF LORDS AND COMMONS . . ., THE, see PARLIAMENT, BURNING OF THE HOUSES OF, and Pl. 21.

BUTTERMERE LAKE, with Part of Cromackwater, Cumberland, a Shower, oil on canvas, 36⅛ × 48 in. (91.5 × 112 cm.), RA 1798 (527); Tate Gallery, London (BJ 7). Like *Morning amongst the Coniston Fells* of the same year, this is a personal development of *Wilson's sensitivity to atmosphere. It was exhibited with a quotation from *Thomson's *Seasons*, though Turner omits the immediately succeeding lines that refer to Newton and his 'showery prism', the rainbow; Turner's alteration of the position of the rainbow in the preliminary watercolour in the 'Tweed and Lakes' Sketchbook (TB XXXV: 84), probably worked up in London over an on-the-spot pencil drawing, shows, however, that he was interested in this image. *Hoppner described the two pictures as the work of 'a timid man afraid to venture' (Farington, 5 January 1798). MB

BYRON, Life and Works of Lord. In 1830 the *Findens approached Turner to contribute to a series of *Landscape and Portrait Illustrations* to Byron which ran in monthly numbers from 1832 to 1834 with Murray as half-share partner. These were advertised for binding up with Murray's pocket or 'library' edition of *The Life and Works of Lord Byron* of 1832–4 (also issued in monthly instalments), edited by Thomas Moore. Finden gave Turner a list of Mediterranean settings rather than texts to illustrate; this was originally the work of J. C. Hobhouse who had reneged on his offer to write the letterpress. Murray supplied sketches from travellers and architects of places that were unvisited by Turner (and even of a few that were in his repertory). Turner's colleagues in this venture were *Callcott, *Roberts, *Stanfield,

the *Westalls, J. D. Harding, J. F. Lewis, Samuel Prout, and others. Of Turner's nine landscapes (W 1210–18; R 406–14), five were settings for *Childe Harold* and the others were of Malta, Rhodes, Cephalonia, and Negropont, mostly to illustrate Moore's *Life* of Byron. The series outgrew its proposed fourteen numbers, running to twenty-four. Murray abandoned giving page references for the placing of the plates after the first monthly issue; the series was also issued in three volumes with letterpress by William Brockedon.

Murray intended the seventeen volumes of the Byron *Life and Works* to be uniform with the contemporary edition of *Scott's Waverley Novels published by *Cadell. The last volume (of only the first impression) sold 19,000 copies; Murray claimed that in the history of publishing this success was second only to the Scott series. Each volume carried a vignette for frontispiece and another for title. Stanfield designed eight; nine were by others. Turner designed seventeen (W 1219–35; R 415–31), half of them from his sketchbooks of Italy, Germany, and Switzerland. Murray again provided Turner with sketches to elaborate, by the architect Charles Barry and by William Page. The elegiac *Athens, the Gate of Theseus* (untraced; W 1220; R 416) was frontispiece to the first volume of poems, a Byronic emblem with figures, fallen column, Elgin metope, and thin smoke from the Acropolis. Turner varied his painting of *The *Field of Waterloo* (BJ 138) for the vignette to accompany Byron's account of the battle (private collection, USA; W 1229; R 425). Byron makes a slight reference to Scio in the 'Isles of Greece', the lyric against despotism; Turner, in the foreground of *Scio (Fontana dé Melek Mehmet, Pasha)* (untraced; W 1230; R 426), connotes the appalling Turkish massacres of 1822 at Chios by the casually placed yoke and the Turkish soldiers. His other vignettes are travellers' and not literary images, and John Wright, who edited the *Life and Works*, wrote to Murray anxious lest the chosen images might be too hackneyed. *Ruskin found the Byron illustrations laboured and artificial. Some of them are too detailed, as if they were simply reduced in scale; they do not make enough of the formal potential of the vignette. However, the delicate *Sta. Maria della Spina* (Ashmolean Museum, Oxford; W 1219; R 415) and *The Castellated Rhine* (Beit Collection, Blessington, Eire; W 1235; R 431) are most subtle.

Two important earlier illustrations for Byron were bought or commissioned by Walter *Fawkes. After Turner returned from Waterloo in 1817, he made a watercolour showing *The Field of Waterloo* (W 494) with Highlanders prominent among the carnage, following the tributes in their poems on their visits to the field of battle by Byron, Scott, and Southey (and also, unsurprisingly, by Scott in *Paul's Letters to his Kinsfolk*). In 1822 Turner made for Fawkes a small illustration of the Acropolis in response to Byron's distress at the Turkish suppression of Greece, *''Tis living Greece no more'* (private collection, Greece; W 1055), quoting from *The Giaour*, and figuring two shackled Athenian women and a leering Turk with scimitar.

Turner associated Byron with Italian twilight, using twice as epigraph 'the moon is up' and the 'dispute' between night and day from *Childe Harold*. Another motif of his is a Byronic emblem: an Elgin metope of a centaur (with or without Theseus) and a fallen column or carved anthemion; this features in three pictures—*'Tis living Greece no more*, the *Gate of Theseus*, and the recently rediscovered *Temple of Poseidon at Sunium* (now in the Tate Gallery; W 497, R 673). JRP

Omer 1975, nos. 59–74.
Herrmann 1990, pp. 191–4.
Brown 1991, pp. 40–56, 96–119.
Piggott 1993, pp. 44–9, 93, 99.

BYRON, Lord (1788–1824). George Gordon Byron, sixth Baron, was by far the most famous of Turner's contemporaries among English poets and there is a considerable affinity between them. They had mutual acquaintances such as Hugh Gally Knight (see GREECE) and appeared together in Charles Mottram's engraving after John Doyle of one of Samuel *Rogers' famous breakfasts, that of 1815, though this shows an ideal rather than an actual gathering of notables; there is no definite record of any such meeting, but Turner and Byron could have met in *Venice in 1819 when the British consul was *Hoppner's son Richard, with whom Byron left his daughter Allegra for a time.

Just as canto ii of Byron's *Childe Harold*, 1812, probably inspired, at least in part, Turner's interest in Greece, so canto iv, 1818, shared much of his approach to *Italy, especially Venice. Six of Turner's oils illustrated or were accompanied by quotations from *Childe Harold*. The first, *The *Field of Waterloo* (RA 1818; BJ 138), was accompanied by an epigraph quoting Byron's stanza about the 'one red burial blent' of the slaughtered Scots, British, and Allied soldiers together with the French, and emphasizing Byron's sense of the tragic loss rather than the triumph involved in defeating the scourge of Europe, *Napoleon. That most eloquent tribute to Italian light and landscape, *Childe Harold's Pilgrimage—Italy* (RA 1832; BJ 342), is Byronic by title and epigraph; Turner quotes the lines describing 'fair Italy' as a 'glorious wreck', and 'garden of the world'. John *Murray's *Life and Works of Lord *Byron*, for which Turner made designs, appeared the same year. *The *Bright Stone of Honour (Ehrenbreitstein), and Tomb of Marceau, from Byron's 'Childe Harold'* (RA 1835; private collection; BJ 361)

celebrates the hero Marceau, quoting Byron's tribute to 'Freedom's champion'. The caption to *Modern Rome—Campo Vaccino* (RA 1839; the Earl of Rosebery, on loan to the National Gallery of Scotland; BJ 379; see ANCIENT ROME) misquotes the second of two lines from Byron. These lines appear again, differently misquoted, and accompanying some lines from *Rogers's *Italy*, in the catalogue entry for *Approach to Venice* (RA 1844; National Gallery of Art, Washington; BJ 412). A third Venetian subject, *Venice, the Bridge of Sighs* (RA 1840; BJ 383), was also accompanied by two lines based on Byron's poem. Even the *Shakespearian scene *Juliet and her Nurse* (RA 1836; Sra. Amalia Lacroze de Fortabat, Argentina; BJ 365) was given a Venetian epigraph from *Childe Harold* when it was engraved as 'ST. MARKS PLACE, VENICE (MOONLIGHT)'.

As well as being used in connection with *The Field of Waterloo*, canto iii of *Childe Harold* probably also lay behind the choice of some of the views of ruined castles over-looking the Rhine among the *Rhine drawings of 1817, as well as for later watercolours such as *Oberwesel* (1840; private collection; W 1380), while further watercolours echo canto iv, including *Lake Nemi* (c.1840; British Museum; W 1381).

Although Turner made topographical landscape and vignette illustrations for poems of Byron other than *Childe Harold*, he does not allude to any of these in the pictures made on his own initiative, nor show interest in their characters or narratives. Turner's knowledge of *Childe Harold* can also be inferred from the misquotations in his epigraphs, as if the lines were stocked in his mind rather than selected from a printed text. JRP/MB

Gage 1981, pp. 16–18.
Alfrey 1982, pp. 38–40.
Gage 1987, pp. 50–6, 62, 209.
Powell 1987, pp. 14–17, 187–8.
Brown 1992.

C

CADELL, Robert (1788–1849). Best known as Sir Walter *Scott's Edinburgh publisher during the author's later years, Cadell was instrumental in securing Turner as illustrator of *Scott's *Poetical Works* and *Prose Works*. In 1811, at the age of 23, he was made a shareholder in Archibald Constable's Edinburgh publishing firm and in the next year, a partner. Cadell, Constable, and their printer, James Ballantyne, were forced into bankruptcy by the nation-wide economic crisis of 1826. Their affairs were inextricably intertwined with those of Scott, who was also financially ruined though he refused to declare bankruptcy. However, Cadell, an astute businessman, was determined to extricate himself from these financial difficulties, as was Scott. Their survival was assured when they joined forces. Cadell proposed to publish new works by and about Scott and to prepare illustrated editions of the author's already published work to help reduce Scott's debt and his own. To maximize his profits he began to buy up copyrights in Scott's works. His first publication was a highly successful edition of the Waverley Novels that was referred to as the 'magnum opus' (1829–33). This led Cadell to launch new editions of *Scott's *Prose Works* and of the *Poetical Works* that were to be uniform in size with the 'magnum'. Cadell commissioned Turner to provide illustrations that required him to come to Scotland to collect sketches. This the artist did in the summer of 1831, spending several days at Scott's house, *Abbotsford, with Scott and Cadell. While Turner was there, Cadell documented his activities in remarkable detail in a diary that has shed vivid light on the artist and his sketching procedures. Cadell and Turner, sometimes accompanied by Scott, visited numerous historic buildings in the neighbourhood of Abbotsford. Following this brief sojourn, the artist and publisher departed on an eastern tour of Border abbeys and castles that included *Norham Castle, which Turner sketched, probably from their coach. In 1834, two years after Scott's death, Turner returned to Scotland to confer with Cadell and to collect further sketches, sometimes in the company of the publisher, for the *Prose Works* and other projects the latter had in mind, such as

J. G. Lockhart's *Life of Scott*, a publication that was to be uniform in size with the *Poetical* and *Prose Works*, and a new edition of the Waverley Novels which Cadell wished to be a worthy successor to the successful 'magnum opus'. Cadell first proposed the idea of a new edition of the novels after the completion of the 'magnum opus' but it was not until 1839 that he began to prepare seriously for it. This 'Abbotsford Edition' (1842–7) was to be elaborate and embellished with wood engravings, and for that reason Turner refused the commission, since he did not believe that wood could adequately translate his designs. Cadell eventually secured the artistic services of Clarkson *Stanfield for this final, major publication by him of Scott's works. GEF

Finley 1980, pp. 69–71, 103–29, 171–82, 184–8.

CAERNARVON. Turner first visited Caernarvon in 1798, and the great Crusader castle built by Edward I to guard a natural harbour in the Menai Strait immediately attracted him, as it had others, including Richard *Wilson, before him. He drew it in pencil (TB XXXVIII: 93, 94) and made a small oil study on panel (*c*.1798; BJ 28), which suggests that he first considered painting the subject in oils. Eventually he produced what is effectively a manifesto: a large-scale watercolour (private collection; W 254), topographical in ostensible subject, that vies with oil painting in strength and emulates the composition and mood of one of *Claude's famous seaports, which Turner had admired in the collection of John Julius *Angerstein. The watercolour was shown at the 1799 RA exhibition and Angerstein bought it for 40 guineas. The composition was later adapted for one of the tenderest of all the *England and Wales* subjects (*c*.1833; British Museum; W 857). For another view of Caernarvon, exhibited in 1800, see WALES. AW

CALAIS. As the closest foreign port to England, the French town of Calais often served as the beginning, or end, of Turner's Continental travels. It was there, in 1802, that he arrived in France for the first time during the Peace of Amiens, when he was 'nearly swampt' as he tried to disembark from his packet boat onto the pier (see TB LXXXI: 58–9). This

incident served as the basis for one of the group of ambitious paintings that he exhibited at the Royal Academy the following year, in 1803 (*Calais Pier*; National Gallery; BJ 48), in which the fishwives, with their skate, in the foreground are perhaps an echo of Hogarth's famous depiction of the gate to Calais, where they also feature prominently.

Turner travelled through Calais again in 1819, 1824, 1826, and 1828. During the 1820s he conceived the idea for a project that was to delineate the principal ports on both sides of the Channel, and which would undoubtedly have included a view of Calais if it had been completed. However, his most important depiction of the town to be realized during these years was the view of the town from the sea, titled *'Now for the Painter' (Rope). Passengers going on Board* (RA 1827; Manchester City Art Galleries; BJ 236). This is similar in size to the contemporary views of *Harbour of Dieppe*, *Cologne*, and *Brest* (BJ 231, 232, 527), suggesting that Turner had in mind a series of views of French and European ports comparable with that of Claude-Joseph *Vernet.

It was also during the 1820s that Turner made a series of pen and ink studies on blue paper at Calais and on the coast between there and Boulogne (CCLX). These have been most often dated to 1829, although it is possible they date from at least a year or so earlier. Turner seems to have drawn on these when preparing two oil paintings: *Calais Sands, Low Water, Poissards collecting Bait* (RA 1830; Bury Art Gallery, Lancashire; BJ 334); and *Fort Vimieux* (RA 1831; private collection; BJ 341). In the first of these the influence of *Bonington has frequently been noted as an influence; scenes of the French coast by the younger artist had been exhibited in London in the 1820s, and had also appeared in his studio sale in 1829.

Later sketchbooks in the Turner Bequest contain views of Calais, although these have not always been securely dated. It was also to the coast of Picardy, close to Calais, that the ailing artist returned on his penultimate trip to the Continent in May 1845, sketching predominantly at Ambleteuse and Wimereux. IW

CALAIS PIER, *with French Poissards preparing for Sea: an English Packet arriving*, oil on canvas, 63¾ × 94½ in. (172 × 240 cm.), RA 1803 (146); National Gallery, London (BJ 48); see Pl. 3. When the Peace of Amiens ended the blockade of France in 1802, Turner joined the Britons eagerly flocking across the Channel. As low tide prevented their ferry from crossing the bar at Calais, he and some others tried to land in the ship's boat. This proved hazardous as recorded in 'Our Situation at Calais Bar' and 'Our Landing at Calais. Nearly swampt' ('Calais Pier' Sketchbook, TB LXXXI: 58–9, 74–5, 76–7, 78–9).

The 1803 harbour picture consists of two scenes: top left a near-collision between the English ferry and a Dutch barge, and bottom right French fishermen, straining to avoid having their lugger flung against the pier on their lee while, in Dutch genre style, a fishwife is handing down a bottle. The former demonstrates the *Sublime, the latter the Ridiculous (proverbially 'only one step' away). When compared to the painting, preliminary studies reveal that by nautical dramatization the anti-French message of both scenes was deliberately introduced (LXXI: 3, LXXXI: 102–3).

The picture's reception was mixed, its political atmosphere largely unobserved, and with Sir George *Beaumont sneering 'the water like the veins on a Marble Slab', it remained in Turner's possession—as did the politically equally suggestive *Fishing Boats entering Calais Harbour* (c.1803; Frick Collection, New York; BJ 142). AGHB

R. I. Boireau, *Calais*, 1953.

Bachrach 1994, pp. 13, 30–2.

CALAIS SANDS, *Low Water, Poissards collecting Bait*, see CALAIS, and jacket illustration.

CALIGULA'S PALACE AND BRIDGE, oil on canvas, 54 × 97 in. (137 × 246.5 cm.), RA 1831 (162); Tate Gallery, London (BJ 337). Caligula, of whom it was prophesied that he would no more become Emperor of Rome than he would drive his chariot across the Bay of Baiae, constructed a bridge of boats over the bay (rather than the solid bridge portrayed by Turner) and in due course became Emperor. The architecture, described by Nicholson as 'very much a fragmentary apparition' of the building in *Claude's *Enchanted Castle*, 1664 (National Gallery, London), shows the continuing influence of C. R. *Cockerell and also that of Piranesi's *Opere Varie*, 1750. The ruined bridge is contrasted with the simple pleasures of everyday life on the right, illustrating the moral of the quotation from Turner's *Fallacies of Hope* (see POETRY AND TURNER) with its reference to 'monuments of doubt and ruind hopes'.

This is one of the paintings categorized by *Ruskin as 'nonsense pictures' but was universally praised in 1831, *The Times*, 6 May, describing it as 'one of the most beautiful and magnificent landscapes that ever mind conceived or pencil drew'. *Constable, who was on the Hanging Committee of the Royal Academy that year, moved Turner's picture and replaced it with one of his own, for which Turner teased him unmercifully. MB

Powell 1987, pp. 177–82.

Nicholson 1990, pp. 96, 123, 245, 249–52.

CALLCOTT, Sir Augustus Wall (1779–1844). English landscape and marine painter; Turner's closest follower and rival. Among his first *Royal Academy exhibits were

portraits, and watercolours reflecting the influence of *Girtin; with Turner, he received watercolour commissions from Edward, Viscount *Lascelles. By 1805 his landscapes in oil, in a rustic Picturesque manner (see SUBLIME) dependent on the Dutch tradition, appealed to leading patrons as an alternative to Turner's classicizing manner. From 1806, the two artists drew closer in a mutually influential exploration of atmospheric and tonal effects inspired mainly by Aelbert *Cuyp, prompting Sir George *Beaumont to dub them 'white painters'. Elected ARA in 1806 and RA in 1810, with Turner's support, Callcott suffered sufficiently from Beaumont's criticism to abstain from the RA in 1813 and 1814, in protest as much for Turner and the profession at large as on his own account. From 1815 he showed a series of large marines, of which his masterpiece is *Entrance to the Pool of London* (1816; Bowood House). Turner declared it worth a thousand guineas and responded with his own *Dort Packet-Boat* (Yale Center for British Art, New Haven; BJ 137), a compliment returned when Callcott, who hung the exhibition, gave it precedence over his own contribution to the 1818 RA. Thereafter their styles diverged as Turner became more experimental while Callcott retained his meticulous execution and cooler palette, qualities preferable to many contemporaries—even Turner's friend *Soane exchanging Turner's *Forum Romanum* (BJ 233) for Callcott's *Passage Point* (Soane Museum). Callcott was awarded a knighthood in 1837 and the Surveyorship of the Queen's Pictures in 1843, while his Kensington home, following his marriage to the writer and traveller Maria Graham in 1827, became an important salon. Turner was greatly saddened by his death. DBB

David Blayney Brown, *Augustus Wall Callcott*, exhibition catalogue, London, Tate Gallery, 1981.

CAMBRIDGE. Turner visited this university town on his Midlands tour of 1794, but depicted it rarely, compared to *Oxford. 'This must remain one of the numerous minor mysteries of Turner's career', suggests Patrick Youngblood ('The Stones of Oxford', *Turner Studies*, 3/2 (Winter 1983), p. 3). A watercolour of Clare Hall (untraced; W 75) and three views of King's College Chapel (two untraced, the last King's College, Cambridge; W 76–8) were made c.1794. One of the latter (W 77) was exhibited at the Royal Academy in 1795. The view of the west end of the Chapel (W 78) has the play of light and shadow, derived particularly from *Dayes, that is characteristic of Turner's watercolours at this time. AK

CAMPAGNA. The countryside (*campagna*) round *Rome played a crucial role in the development of British landscape painting in the 18th century, with its blending of topography,

imagination, and the ideal. Taken in its broadest sense (reaching east to the town of Tivoli and south to Lake Nemi), the Roman Campagna is a region of great natural beauty, with spectacular prospects of the winding river Tiber close to Rome itself and—further afield—densely wooded hills, lakes in the craters of extinct volcanoes, and cascades both natural and artificial. It is rich in historical and legendary associations, fine buildings in superb settings contrasting with isolated ruins in areas long abandoned. Tivoli, Albano, and Nemi inspired *Claude Lorrain in the 17th century, Richard *Wilson and J. R. *Cozens in the second half of the 18th, and Turner himself from the mid-1790s onwards as he gradually discovered the work of all these artists. After producing several masterly depictions of the area based on the work of other artists, including *Landscape: Composition of Tivoli* (1817; private collection; W 495), Turner at last explored it for himself in the autumn of 1819, on his first tour of *Italy. He made many records in his sketchbooks, including some in watercolour in the large 'Naples: Rome. C. Studies' Sketchbook (TB CLXXXVII) showing Tivoli and the immediate environs of Rome itself. In c.1827 he showed the desolate, ruin-strewn tracts of land close to Rome in *Campagna of Rome* (W 1168, for *Rogers's *Italy*) and during his second visit to Rome in 1828 he began *Palestrina—Composition* (RA 1830; BJ 295). However, it was not until a decade later that he painted his grandest celebrations of the Campagna: *Modern Italy—the Pifferari* (RA 1838; Glasgow Art Gallery; BJ 374), *Cicero at his Villa* (RA 1839; Rothschild Collection, Ascott, Bucks.; BJ 381) and, in watercolour, *Lake Nemi* (c.1840; British Museum; W 1381). CFP

Powell 1987, pp. 31, 35, 48–50, 72–89, 159, 175, 184–6.

CAMPBELL'S *POETICAL WORKS* (1837), including *The Pleasures of Hope* (1799), were illustrated by twenty vignettes (W 1271–90; R 613–32) commissioned from Turner by Thomas Campbell (1774–1844), in emulation of Samuel *Rogers's editions, with the same publisher (Moxon) and using the same method of printing the engravings with the text, but without such luxurious production. Turner knew Campbell in literary and artistic circles. Campbell visited *Goodall frequently to see the progress of the engraving. The differing accounts of the transactions after the edition was complete when Campbell sold the watercolours back to Turner for 200 guineas are summarized in Lyles and Perkins (all are in the National Gallery of Scotland; preliminary studies in the Bequest, TB CCLXXX). The designs are detailed, and Turner's handling of figures and the vignette form is much more versatile than the designs for Rogers. The subjects are dramatic, with some outlandish settings.

Ironically the 'Bard of Hope' provides cataclysms, drownings, and dispossessions for illustration. Turner responds to Campbell's Continental interests, particularly his German association, and his politics; his strongest design, *Kosciusko* (W 1273; R 615), expresses the 'sacred cause of liberty', showing the Polish romantic hero who opposed Catherine the Great; the vignette shows massacre and fire at Warsaw. There are graphic Napoleonic images such as *Hohenlinden* (W 1279; R 621; preliminary study CCLXXX: 5) and *The Battle of the Baltic* (W 1278; R 620), where Turner adds a boat with white flag that is not in Campbell's text but in Southey's *Life of Nelson*. *The Death-Boat of Heligoland* (W 1288; R 630) and *The Last Man* (W 1282; R 624) are interestingly eldritch fancies. JRP

Lyles and Perkins 1989, pp. 76–8.
Herrmann 1990, pp. 214–19.
Campbell 1993, pp. 53–64.
Piggott 1993, pp. 62–5.

CAMPERDOWN, first Earl of (1785–1867), owner of *Châteaux de St. Michael, Bonneville, Savoy* (Dallas Museum of Art; BJ 50), which he bought from William Young Ottley (d. 1836). (See BONNEVILLE for the confusion over the two views exhibited at the Royal Academy in 1803.) RU

CANALETTI PAINTING, see BRIDGE OF SIGHS . . .

CANALETTO. The paintings of the Venetian artist Giovanni Antonio Canal (1697–1768), generally known by his nickname Canaletto, were highly prized by 18th-century British visitors to Italy, who also gave him commissions during his long residence in England, 1746–55/6. Thanks to the patronage of Grand Tourists, many of his finest views of *Venice are today in British public and private collections, as are related drawings and etchings of great virtuosity, and they have shaped British ideas and expectations of Venice for generations. Both Turner and Thomas *Girtin made copies after Canaletto in the 1790s while seeking to perfect their own drawing skills, an activity that left its mark on both youths, particularly Girtin. In the 18th century the popularity of Canaletto's views of Venice led to the virtual monopolization of this subject by that painter and his followers; British landscape artists in Italy such as Richard *Wilson and J. R. *Cozens made no attempt to compete with paintings of their own. In the 1820s, however, Samuel Prout and R. P. *Bonington turned their backs on this convention and the rapid success of their experiment—closely followed by Bonington's early death in 1828—soon led others, including Clarkson *Stanfield and Turner himself, to take Venice as their subject. A painting by Stanfield for the Royal Academy of 1833 was apparently one of the factors that stimulated Turner to produce his very first painting of Venice in time for the same exhibition. This was *Bridge of Sighs, Ducal Palace and Custom-House, Venice: Canaletti painting* (BJ 349) in which Canaletto is fancifully depicted, standing at an easel in the open air. Over the next decade Turner's many paintings of Venice evoked a city further and further removed from the certainties of 18th-century view-painting which had reached their height in the carefully executed precise vistas of Canaletto. He assumed Canaletto's mantle as the supreme painter of Venice but suggested a very different city: ethereal, ambiguous, and hauntingly fragile. CFP

Stainton 1985, pp. 10–12, 30, 72.

CANALS had been constructed in Ireland since the 1730s but it was not until the 1770s that their value to industry became apparent in England; the great period of 'canal mania' was between about 1800 and 1820. Turner depicted infrastructural links of various kinds, but his images of canals sometimes downplay their modernity and rely on traditional models. His first canal subject in oils, exhibited in his own gallery in 1810, was *Grand Junction Canal at Southall Mill* (private collection; BJ 101); this celebrates the waterway linking London with the Midlands, opened in 1805, which Turner had drawn in the 'Windmill and Lock' Sketchbook (TB CXIV: 71a, 72a, 73); however, the composition is based on *Rembrandt's *The Mill* (National Gallery of Art, Washington).

His second oil depicting a canal, *Chichester Canal* (c.1829; Petworth House; BJ 290), was commissioned by the third Earl of *Egremont, whose investment in the canal, opened in 1823 and linking London with Portsmouth, resulted in great personal financial loss. In this work, Turner perhaps alludes to this misfortune, while the sunset scene reflects the influence of *Claude.

Of the canal subjects executed in watercolour, four feature the Royal Military Canal, completed in 1807. Constructed inshore from the Kent and Sussex coasts to strengthen defences against Napoleon, this was first recorded by Turner in his *Winchelsea, Sussex, and the Military Canal* (c.1813; private collection; W 430). *Hythe, Kent* (c.1823; Guildhall Museum, London; W 475) and *Rye, Sussex* (c.1823; National Museum of Wales, Cardiff; W 471) were later engraved as *Southern Coast* subjects. Another version of the latter (W 486) is now lost.

Two earlier *Rivers of England* designs focus upon canals rather than on rivers, their nominal subjects. These are *More Park* (1822; British Museum; W 734), featuring the Grand Union Canal to the near exclusion of the distant River Colne, and *Kirkstall Lock* (1824–5; British Museum; W 745), where the Leeds and Liverpool Canal has similar prominence over the River Aire.

Canals also provide foregrounds for four *England and Wales* subjects, beginning with *Lancaster, from the Aqueduct Bridge* (c.1825; Lady Lever Art Gallery, Liverpool; W 786), based on sketches of John Rennie's famous canal aqueduct made in 1816 (CXLVIII: 35, 35a, 36). *Nottingham* (1832; Nottingham Museum and Art Gallery; W 850), on the other hand, was derived from a much earlier design for the *Copper-Plate Magazine*, published 28 February 1795 (untraced; W 89); this seems to have been Turner's first representation of a canal. The third subject, *Dudley, Worcestershire* (c.1833; Lady Lever Art Gallery, Liverpool; W 858), emphasizes the industrial importance of canals and their association with other modern improvements by also including the town's chimneys and furnaces as seen from the waterway. A similar device is used in *Exeter* (c.1827; Manchester City Art Gallery; W 807), which adopts the confluence of the newly modified Exeter Canal and the River Exe as a vantage point.

In contrast to the industrial picturesque of Turner's English canal subjects are his more ethereal renditions of *Venice waterways, the majority of which are included in the Turner Bequest. Examples elsewhere include views of the *Grand Canal* in the Huntington Library and Art Gallery, California (RA 1837; BJ 368), and the Ashmolean Museum, Oxford (1840; W 1363). ADRL/AK

Rodner 1997, pp. 95–6, 108–9, 113, 119, 195.

CANOVA, Antonio (1757–1822). Italian sculptor who proposed Turner as an honorary member of the Accademia di San Luca, *Rome, to which he was elected on 24 November 1819 during his first visit to Italy. Canova had been impressed by Turner's work when with B. R. *Haydon he visited the painter's gallery in November 1815, and proclaimed him a 'grand génie'. All three shared an enthusiasm for the Elgin marbles. Canova's visit to England came at a time when his international reputation was well established, demonstrated by the dinner held in Canova's honour by the Royal Academy on 1 December 1815, which Turner attended. It also coincided with his successful mission as papal delegate to the Congress of Paris, when he obtained the restitution of Italian art treasures confiscated by Napoleon. As a consequence he was given the title Marchese d'Ischia by the Pope in 1816. His formulation of exquisite neoclassical beauty, much sought after by discerning British patrons, is exemplified by the *Hebe* (1808–14, marble; Chatsworth House) made originally for John Campbell, first Baron Cawdor and acquired by William, sixth Duke of Devonshire after its exhibition at the RA in 1817. AY

F. Licht, *Canova*, New York, 1983.

Antonio Canova, exhibition catalogue, Venice, 1992.

CANTERBURY, in Kent, abounded with picturesque architecture and historical associations centred on its great cathedral. Turner visited the town in 1792–3 and produced eight watercolours of imposing yet crumbling medieval remains (W 31–4 and 53–6), the largest of which were exhibited at the Royal Academy (W 31, 1793; untraced. W 53, 1794; private collection, Scotland. W 54, 1794; Whitworth Art Gallery, Manchester). Turner's entry was noticed in the press in 1794, probably for the first time, and *St Anselm's Chapel, with Part of Thomas-a-Becket's Crown, Canterbury Cathedral* (Whitworth Art Gallery; W 55), its title evoking the sublime events of Becket's martyrdom, was bought by Dr *Monro. AK

CANVAS. Turner's use of single canvases for a number of compositions is one of the more extraordinary aspects of his working process. There are two known cases of his using large rolls of canvas in this way, differing in their circumstances. The first involved the *Cowes sketches done when Turner revisited the Isle of Wight in July and August 1827 and ordered a canvas, 6 × 4 ft. (1.83 × 1.22 m.) from his father, cut it into two, and painted nine small oil sketches on the two pieces. One of the sketches, *Between Decks* (BJ 266), shows, as Evelyn Joll has pointed out, the possible vantage point from which these sketches were made, a ship anchored off Cowes Roads. The three sketches for *The Regatta beating to Windward* (BJ 260, 261, 262) seem to have been painted alternately on each roll of canvas; this would have allowed an assistant, or Turner himself, to readjust the roll over some form of temporary support for each sketch. The circumstance of Turner being aboard a swaying ship and trying to sketch rapid movement in oils, together with their ready portability, accounts for his practice in this case.

The other case is the group of oil sketches formerly thought to have been done in Rome (but see ROMAN OIL SKETCHES) in 1828. Seven were done on two rolls of canvas, only cut apart in 1913–14 (BJ 302–8). Nine further sketches from the same group are not recorded as having been originally joined but share the peculiarity of having been tacked to some sort of stretcher or support from the front (BJ 309–17). Unlike the Cowes sketches, these have the appearance of composition sketches rather than sketches made from nature; one indeed (BJ 302) is a sketch for *Ulysses deriding Polyphemus* (RA 1829; BJ 330). Some of the sketches are of actual places such as *Lake Nemi* (BJ 304), while at the other extreme is a *Claudian Harbour Scene* (BJ 313). Quite why these works should have been done on rolls of canvas is unclear, unless Turner was already thinking of the easiest way of shipping them back to England.

A similar, if less elaborate, use of a single canvas for three compositions is the *Three Seascapes* of c.1827 (BJ 271) in

which two of the compositions share a single sky. Of about the same date appears to be the *Two Compositions: A Claudian Seaport and an Open Landscape* (c.1825–30; BJ 280).

Some years later Turner used a canvas apparently originally prepared for one of the *Petworth landscapes of c.1828 and perhaps already spoilt by water for six rough sketches in grey paint (BJ 441) for *Dawn of Christianity (Flight into Egypt)* (RA 1841; Ulster Museum, Belfast; BJ 394). Even odder was his use of the back of *The *Vision of Jacob's Ladder* as a palette (BJ 435).

See also SUPPORTS. MB

Reynolds 1969², pp. 67–72.
Butlin and Joll 1984, pp. 159–61, 176–79.
Powell 1987, p. 159.
Warrell 1999, pp. 22–3, 28–30, 268.

CARDIFF, National Museums and Galleries in Wales. All five Turner oils belonged to the Davies sisters, Gwendoline and Margaret, and, before that, to Mrs *Booth. *The Beacon Light* (BJ 474) has been cut down and partly repainted by another hand so is difficult to date but 'late 1830s' seems most plausible, as it is also for *Morning after the Wreck* (BJ 478). The two 'Storm' pictures of c.1840–5 (BJ 480, 481) are considered doubtful by some authorities including Martin Butlin, but the writer accepts them while conceding that they have suffered from harsh relining in the past. The small *A Sailing Boat off Deal* c.1835 (BJ 484) had a companion *Off Deal* (BJ 483), sold at auction from Margaret Davies's collection in 1962 and now in the Nationalmusum, Stockholm. Two similar sketches are in the Tate (BJ 485–6).

The seventeen watercolours naturally feature Welsh subjects including *Llandilo Bridge* (RA 1796; W 140), the Rembrandtesque *Ewenny Priory* (RA 1797; W 227), and *Flint Castle*, c.1834 (W 868), engraved in the *England and Wales series. There are also three 1817 *Rhine watercolours (W 638, 639, 669) and *View of Rye* (W 471) engraved for the *Southern Coast in 1824. *Ehrenbreitstein* (W 1322) seems correctly titled but the more finished version (W 1321) of the Cardiff *Ehrenbreitstein and Coblentz* (W 1322) has recently been identified as *Würzburg*, so both probably date from c.1840. EJ

CARLISLE, Sir Anthony (1768–1840). Turner's physician, and Surgeon to the Westminster Hospital, 1793–1840. He was a Fellow of the Royal Society (1800), a member of the Geological Society, and President of the Royal College of Surgeons (1828 and 1837), and Surgeon Extraordinary to the Prince Regent (1820). He and Turner may have first met at the *Royal Academy when he became the Academy's Professor of Anatomy (1808–24); despite suggestions otherwise, he does not appear to have enrolled as an RA student.

Carlisle was an expert on crustacea, and engaged Turner's interest in the subject which recurs in his lectures and art. On his retirement as Professor of Anatomy Turner presented him with his watercolour *Fishmarket, Hastings*, dated 1824 (private collection; W 510).

See also HEALTH OF TURNER. JH

Gage 1987, pp. 217–18.
E. H. Cornelius, *Annals of the Royal College of Surgeons*, 43 (1968), pp. 39–41.
Brian Hill, 'The Crustacean Knight', *Practitioner*, 201 (1968), pp. 950–5.

CARTHAGE AND THE STORY OF DIDO AND AENEAS preoccupied Turner for much of his life and gave rise to some of his most impressive large paintings. Turner's main source was *Virgil's *Aeneid* in Dryden's translation. Dido, daughter of the King of Tyre, was forced to flee after the murder of her husband Sychaeus and sailed with a few followers to Libya, where she founded Carthage and became its queen. The Trojan hero Aeneas, son of Anchises and Aphrodite, fled from burning Troy with his family, destined to sail to Italy and found what was eventually to become the Roman Empire. After they landed in Carthage, the mutual love of Dido and Aeneas diverted him from his destiny, but eventually Mercury brought a message from the gods and he left; the abandoned Dido died on her funeral pyre. The subsequent, more historical, account of the relations between Carthage and the emergent Rome was a subject of Turner's *Snow Storm: Hannibal and his Army crossing the Alps* (RA 1812; BJ 126) and *Regulus*, painted in Rome 1828 (BJ 294).

Turner's first involvement with Virgil's *Aeneid* was the small painting of *Aeneas and the Sibyl, Lake Avernus* of c.1798 (BJ 34) of which he painted a later version, *Lake Avernus: Aeneas and the Cumaean Sibyl* in 1814–15 (Yale Center for British Art, New Haven; BJ 226); this shows a much later event, set in Italy, when Aeneas was told by the Cumaean Sibyl that he could only enter the Underworld, where he sought the ghost of his father, with a golden bough from a sacred tree, itself the subject of the much later *The *Golden Bough* (RA 1834; BJ 355). The style of the earlier painting already reflects that of *Claude, in this case as seen through the eyes of Richard *Wilson; the association of subjects from the *Aeneid* with Claude was to continue.

Dido and Aeneas, subtitled 'The Morning of the Chase' in the inventory of the Turner Bequest, exhibited RA 1814, is Turner's first large treatment of the theme, measuring 57½ × 93⅜ in. (146 × 238 cm.) (BJ 129). Almost certainly designed by Turner as his own personal reinterpretation of Claude after his teasing repetition of a Claude painting in *Apullia in Search of Appullus*, exhibited at the British Institution

earlier the same year, this was, however, based on a much earlier drawing in the 'Studies for Pictures: Isleworth' Sketchbook of *c*.1804–5 (TB XC: 21); further drawings are in the 'Hesperides (1)' Sketchbook of the same date (XCIII: 4–7). The 'Studies for Pictures: Isleworth' Sketchbook also includes drawings for other subjects to do with Aeneas in Italy, *Aeneas and Evander* and *Pallas and Aeneas, the Parting from Evander* (XC: 58a). A few years later, in the 'Wey Guildford' Sketchbook of 1807, Turner drew two pen and wash landscape drawings of *Dido and Aeneas* (a completely different composition) and *Ascanius*, the son of Aeneas, (XCVIII: 1–2). Turner's interest in the theme had therefore occupied him from soon after his return from his first visit to the Continent in 1802.

Turner's next great picture on the theme was **Dido building Carthage; or the Rise of the Carthaginian Empire* (RA 1815; National Gallery, London; BJ 131). This was the first of Turner's great tributes to Claude's port scenes which included other subjects from the *Aeneid*, *Regulus* and the oil sketch of a *Claudian Harbour Scene* painted in Rome in 1828 (BJ 313). Again, there are what may be early ideas for the composition in the 'Studies for Pictures: Isleworth' Sketchbook of *c*.1804–5 (XC: 11 v., 31 v.).

It was not until two years later, in 1817, that Turner exhibited what, despite a slight increase in size (67 × 94 in./170 × 239.5 cm. compared with 61¼ × 91¼ in./155.5 × 231.5 cm.), seems to have been intended as a companion picture pointing up the moral of the rise and decline of empires, *The Decline of the Carthaginian Empire—Rome being determined on the Overthrow of her Hated Rival, demanded from her such Terms as might either force her into War, or ruin her by Compliance: the Enervated Carthaginians, in their Anxiety for Peace, consented to give up even their Arms and their Children* (BJ 135). John Gage has pointed out that comparisons of the rise and fall of empires, and their applications to contemporary situations, were commonplace in the late 18th and early 19th centuries, as in Oliver Goldsmith's *Roman History* and Edward Gibbon's *Decline and Fall of the Roman Empire* (incidentally both writers had been Professors of Ancient History at the Royal Academy). A contemporary guide to Italy, J. C. Eustace's *Classical Tour through Italy*, 1813, even draws a parallel between Carthage and England. Paintings by Claude had been interpreted in the same way, the two pictures at Longford Castle having been engraved in 1772 as *The Landing of Aeneas in Italy: The Allegorical Morning of the Roman Empire* and *Roman Edifices in Ruins: the Allegorical Evening of the Empire*. A Frenchman had even gone so far as to equate the declining Carthage with Britain (anon., 'Works on England', *Quarterly Review*, July 1816). Interestingly, *The Decline*, newly

treating the later more historical Carthage as an example of political moralizing, was sketched at about this date, 1816, in the 'Yorkshire 1' Sketchbook (CXLIV: 101 v., 102 v.) and the 'Hints River' Sketchbook (CXLI: 32 v., 33).

Contemporary reviews did not, however, see any connections between the two pictures, though on the whole they were in high praise of both. The *Repository of Arts*, June 1817, even praised the verses by Turner that were included in the 1817 catalogue. The critic John Bailey in the *Annals of the Fine Arts*, wrote that 'I wish the Directors of the British Institution would purchase it. When shall we see a National Gallery, where the works of the Old Masters and the select pictures of the British School, may be placed by the side of each other in fair competition, then would the higher branches of painting be properly encouraged?' This was perhaps an encouragement to Turner to bequeath the two large Carthage pictures to the National Gallery in his first **will of 1829 to be 'placed by the side of Claude's "Sea Port" and "Mill"'; in 1831 *The Decline of Carthage* was replaced by the earlier **Sun rising through Vapour* (RA 1807; BJ 69).

In 1828 Turner exhibited, at the RA, *Dido directing the Equipment of the Fleet, or The Morning of the Carthaginian Empire* (BJ 241), his final classical exhibit before he set off again for Rome later the same year. Nicholson suggests that the painting may have been designed as, in a way, a replacement for *Dido building Carthage* which he had by then decided never to part with save to the National Gallery. In the schedule of the Turner Bequest this picture was listed as 'Carthage (Mr. Broadhurst's Commission)' but John **Broadhurst does not seem to have taken the picture; according to a later account Broadhurst disposed of three Turners in his collection, *The Guardship at the Nore* (Turner's gallery 1809; private collection, England; BJ 91), **Harbour of Dieppe* (RA 1825; Frick Collection, New York; BJ 231) and *Cologne* (RA 1826; Frick Collection, New York; BJ 232), in July 1828, just about the time he would have been considering the Dido picture (*Willis's Current Notes*, May 1854). Again the related sketches are more or less contemporary; they occur in the 'River' Sketchbook of *c*.1823–4 (CCIV: 7 v.), among drawings done by Turner while staying with John **Nash at East Cowes Castle in July–September 1827 (CCXXVII(a): 15), and among drawings on blue paper, many connected with the **Rivers of France* series (CCLX: 7, 8); they also possibly include four studies on the back of S. Lovegrove's letter to Turner of 19 November 1827 (CCLXIII(a): 7). The general consensus of critics when the picture was exhibited in 1828 was that it was 'extremely beautiful and powerful' but 'is like nothing in nature' (*The Times*, 6 May). The *Repository of Arts*, June 1828, gives quite a detailed account, not entirely uncritical, of the colouring

and effects of light in the painting, which helps compensate for the fact that the painting is now all but a complete wreck. Interestingly enough, another of the paintings in the same exhibition, *East Cowes Castle, the Seat of J. Nash, Esq.: the Regatta starting for their Moorings* (Victoria and Albert Museum; BJ 243), has also suffered, from an insufficiently prepared ground that gives it a permanent tendency to flake.

Turner returned to the theme of Dido and Aeneas in 1850, the last year in which he exhibited at the RA, when he showed the four paintings *Aeneas relating his Story to Dido* (destroyed; BJ 430), *Mercury sent to admonish Aeneas* (BJ 429), *The Visit to the Tomb* (BJ 431), and *The Departure of the Fleet* (BJ 432), each with a quotation from his own *Fallacies of Hope* (see POETRY AND TURNER); that to the last picture reads 'The sun went down in wrath at such deceit', a suitable comment on the whole sad story. MB

Karl Kroeber, 'Experience as History: Shelley's Venice, Turner's Carthage', *English Literary History*, 41 (1974), pp. 321–39.

Karl Kroeber, 'Romantic Historicism: The Temporal Sublime', in Karl Kroeber and William Walling, eds., *Images of Romanticism: Verbal and Visual Affinities*, 1978, pp. 152–6.

Gage 1987, pp. 211–12.

Powell 1987, pp. 166–89.

Nicholson 1990, pp. 103–10, 138 nn. 39 and 40, 223, 234–7, 276–91.

CATALOGUES, see *ŒUVRE* AND COLLECTION CATALOGUES.

CATHOLIC EMANCIPATION. It would have been surprising if the controversial Catholic Emancipation Act of 1829 had not in some way been reflected in contemporary painting. The Act, allowing Roman Catholics to become MPs and occupy other positions of high office for the first time, enabled Daniel O'Connell to take his seat (Co. Clare); in doing so it averted the potential threat of an uprising in Ireland. Increased public interest in Catholicism was generally mirrored in painting by a curious regard for its more picturesque aspects. Wilkie's *Washing the Pilgrim's Feet* (RA 1829; Glasgow City Art Gallery) has been cited by Powell as one of several manifestations of this trend. *Modern Italy* (RA 1838; Glasgow City Art Gallery; BJ 374), depicting the Pifferari of southern Italy playing bagpipes beside a Roman shrine, might be considered Turner's contribution to the genre. His most poignant reference to Catholic emancipation, however, is made by the *England and Wales* subject *Stoneyhurst College, Lancashire* (private collection; W 820). It has been argued by Shanes that the narrative unfolding in front of the Roman Catholic public school alludes to the passage of the Act and broadly celebrates an era of greater religious freedom in Britain. ADRL

Cecilia Powell, 'Turner and the Bandits', *Turner Studies*, 3/2 (1984), p. 26.

Shanes 1990, pp. 198–9.

CECIL HIGGINS ART GALLERY, Bedford, see BEDFORD.

CHAIN PIER, BRIGHTON, see PETWORTH.

CHANTREY, Sir Francis Legatt (1781–1841), English sculptor, a close friend and angling companion of Turner with whom he shared many social and intellectual interests. Both were members of the Geological Society and it was through Chantrey that Turner met the scientist Mary Somerville, author of *The Mechanism of the Heavens* (1831). They were also members of the Academy Club and were involved in the running of the *Artists' General Benevolent Institution. Chantrey became an ARA in 1816 and an RA in 1818. Turner and Chantrey were both elected to the Council of the Royal Academy on 18 December 1818 and then as auditors to the institution in 1823. In 1822 Chantrey purchased *What you will!* (RA 1822; private collection; BJ 229), but there is no record that he ever made Turner's portrait. Chantrey's career had flourished after his move to London from his native Yorkshire in 1806 and his subsequent advantageous marriage in 1809. His first major success was a portrait bust of the *Reverend Horne Tooke* (1818–21, marble; Fitzwilliam Museum, Cambridge) when the plaster was exhibited at the RA in 1811. It was in this genre that he established his reputation as the leading portrait sculptor of his generation and in 1835 he was knighted. He was in much demand for statues of the famous and a series of commissions for public monuments in the 1820s led him to establish his own bronze foundry c.1827. His statue of *King George IV* (1828; Brighton) exemplifies his work in this medium. Following the popular success of his monument to the *Robinson Children* (marble; Lichfield Cathedral) at the 1817 RA exhibition he was given many commissions for large-scale church monuments. AY

A. Yarrington, I. D. Lieberman, A. Potts, and M. Baker, 'An Edition of the Ledger of Sir Francis Chantrey, R.A., at the Royal Academy, 1809–1841', *Walpole Society*, LVI (1991/2, 1994).

CHARTISM was a mass working-class movement for universal male suffrage that grew out of dissatisfaction at the limited franchise provided by the *Reform Act of 1832, and the exploitation suffered in the new factories. Focused from 1838 around the radical-democratic demands of the People's Charter, it had lost its impetus by 1850. Turner may have lost income as a result of Chartist agitation: the business of one of his patrons, Henry *McConnell, a Manchester cotton manufacturer, was apparently disrupted by Chartist activity between 1837 and 1843, during which time

McConnell bought no Turners. The artist might, indeed, be expected to sympathize with the dynamic entrepreneurial class that had gained politically from the Reform Act, rather than with its working-class opponents. However, Tory campaigners were calling for respectable society to take note of the conditions faced by industrial workers. *Slavers (RA 1840; Museum of Fine Arts, Boston; BJ 385) has been considered as, among other things, a meditation on the ruthlessness of the factory system. AK

CHEYNE WALK. In 1846 Sophia *Booth bought a 21-year lease on a small riverside cottage, 6 Davis Place, Cremorne New Road. At that time, this was a westward extension of Cheyne Walk, Chelsea, and has since been incorporated into it. Mrs Booth took the lease with the express intention of sharing the cottage with Turner, who moved in with her and spent increasingly less time at *Queen Anne Street. The cottage overlooked the river, which was not embanked until the 1870s, and small boats were drawn onto the foreshore on the far side of the road.

Mrs Booth kept the cottage 'clean to a nicety', according to David *Roberts. Its walls were 'covered with pictures, principally engravings from [Turner's] works', and above the parapet was a balcony on which Turner would sit watching the sunrise and the river. The view west he called the English view; east, downriver, the Dutch view. Turner may have tried to live at Davis Place incognito, or as 'Mr Booth', but some of his friends, principally his near neighbour John *Martin, knew of the arrangement, and Turner appears to have been quite open with him about it. Nor did Turner disguise his profession from a local Chelsea barber, who introduced him to Francis Sherrell, an aspiring young artist who became Turner's studio *assistant, and helped him with his last paintings.

His health declining, Turner took boat trips on the river and walked in his small garden. After being bedridden in his last few weeks, he died at Davis Place on 19 December 1851. Latterly the house was the boyhood home of the writers Peter and Ian Fleming, and the painter Augustus John became a frequent visitor. See also DEATH OF TURNER. JH

J. W. Archer, 'Reminiscences' [1862], reprinted *Turner Studies*, 1/1 (summer 1981), pp. 31–7.
Wilton 1987, ch. 6.
Guiterman 1989, pp. 2–9.
Bailey 1997, chs. 20 and 21.
Hamilton 1997, pp. 302–4.

CHICHESTER CANAL, see PETWORTH.

CHILDE HAROLD'S PILGRIMAGE—ITALY, oil on canvas, 56 × 97¾ in. (142 × 248 cm.), RA 1832 (70); Tate Gallery, London (BJ 342). Sometimes known just as 'Italy', this painting was exhibited with a quotation from *Byron beginning 'and now, fair Italy!' The choice of subject may have been influenced by *Eastlake's *Lord Byron's Dream* (RA 1829; Tate Gallery). The still-life detail of a vase was originally stuck on as a piece of paper and subsequently painted over. *Ruskin, in his *Notes on the Turner Gallery at Marlborough House*, singled the picture out as an example of the decay of Turner's later work, a view of this fine, typical panoramic Claudian landscape hardly shared today.

The *Spectator*, 12 May 1832, advised visitors to the Academy to 'look at the way in which it is painted; and then . . . look around at the streaky, scrambled, unintelligible chaos of colour, and see what a scene has been conjured up before him as if by magic'. For the *Morning Chronicle*, 7 May, Turner 'is a sort of Paganini, and performs wonders on a single string—is as astonishing with his chrome, as Paganini is with his chromatics . . . But even now, with all his antics, he stands alone in all the higher qualities of landscape painting.' MB

CHILDREN OF TURNER. Evelina Danby (1800/1–1874) and Georgiana Danby (1811/12–1843) were described in Turner's 1831 *will as 'Evelina and Georgiana T daughters of Sarah *Danby widow of John Danby musician'. Only this initial 'T' gives any hint of their relationship to Turner. The existence of both daughters was kept private, perhaps to protect Sarah's pension from the Royal Society of Musicians, but became public through Turner's will and the subsequent litigation. Archival research has revealed more.

The baptism of 'Evelina, daughter of William and Sarah Turner' was registered on 19 September 1801 at Guestling, Sussex. She died aged 73 in August 1874. Her name was popular from Fanny Burney's 1778 novel *Evelina*. A list of east Sussex place-names in a notebook of this period includes the letter 'G', apparently Turner's code for Guestling to conceal his tracks.

In 1817 the marriage of Evelina Turner to Joseph Dupuis was registered at St James's Church, Piccadilly. Sarah Danby was a witness. Evelina was 16, her husband 29. Dupuis was in the consular service and took Evelina to Ashanti (Ghana), Tripoli, and Tunis before he was somewhat abruptly retired in 1847. In 1824 Dupuis published his *Journal of a Residence in Ashantee* (reprinted 1966). They reared four children of whom two sons also became consuls. One son wrote an account of his own residence as consul in Palestine for which Dupuis wrote a lengthy contribution. An unmarried daughter became a pensioner of the Huguenot Society, claiming that her Dupuis grandfather was a Protestant immigrant from Rouen. Turner's genes survive today in a fourth and a fifth generation.

In 1853 Dupuis applied for the position of custodian of Turner's gallery, vacant since Hannah *Danby's death. He said he had married Evelina Danby, natural daughter of Turner, with his consent and approval. She had been well educated and grew up in the expectation of always enjoying a respectable position in society, and he applied for the post 'to save myself and a child of Mr Turner from absolute destitution'. In 1863 Evelina herself wrote to the family solicitor beseeching him to restore her £150 annuity income, reduced to a third by duty and mortgage payments, to alleviate the sorrows of the great artist's surviving daughter.

Georgiana Danby, under the shortened or pet form of 'Georgia', was the residuary legatee of Turner's 1831 will. In his 1846 codicil he noted that the original residuary legatee had died. In June 1840 the marriage of Thomas James Thompson to Georgiana Danby, 'daughter of George Danby, decd.', was registered at Bermondsey parish church. The Lambeth Lying-in Hospital recorded the admission of 'Georgiana Thompson, married in 1840 as Georgiana Danby', and her death there from puerperal fever in February 1843, aged 31 (and therefore born in 1811/12). Her son survived for five months, his older brother having died at eighteen months. Her death, in the period between Turner's will and codicil, is assumed to be his daughter's. The reference to her father as 'George Danby, decd.', is attributed to her wish to hide her illegitimacy, or 'George' was perhaps a mishearing for 'John'.

It is not known how Evelina and Georgiana were brought up nor how far Turner supported them; Evelina at least visited him at his studio, for *Thornbury reported Trimmer's son saying that the girl with the hare over her shoulders in *Frosty Morning (RA 1813; BJ 127) reminded his father of a young girl whom he occasionally saw at *Queen Anne Street whom, from her resemblance to Turner, he thought a relation; the same female figure appears in *Crossing the Brook (RA 1815; BJ 130). This has led biographers to identify both girls in this painting as Turner's daughters, but recent writers, knowing that Georgiana was merely four, realize that only the younger may be Evelina. Sarah had the Danby girls well taught and the two Turners may have followed them. There may, of course, have been other natural children, who may have died before Turner's first will was drafted. *Falk wrote that Sarah had 'three genuine Turners' and *Roberts had little doubt that Turner 'had family by different women'. Gossip and speculation have suggested other liaisons and unacknowledged offspring, but Evelina and Georgiana remain Turner's only recorded issue. JAG

Powell 1992, pp. 10–14.

CHRYSES, watercolour, 26 × 39½ in. (66 × 100.4 cm.), RA 1811 (332); private collection, England (W492). This work is one of a small number of Turner's watercolours which turns to ancient literature rather than observed topography for its primary subject matter. Like many of his directly allegorical subjects, this work reflects a debt to the example of *Claude Lorrain. Preparatory drawings in the 'Wey and Guildford' Sketchbook (1805; TB XCVIII: 3a, 4, 5a), indicate that Turner had considered this subject some years earlier. Perhaps the realization of the painting of *Apollo and the Python*, also RA 1811 (BJ 115), had prompted this Homeric theme.

Chryses was a priest of the sun god, Apollo, whose daughter had been captured during the Trojan wars. The lines from Alexander Pope's translation of Homer's *Iliad*, which accompanied the RA catalogue entry, focused on the anguish felt by Chryses and his subsequent overtures to Apollo for the safe return of his captive offspring. Turner's composition centres on the setting sun (Wilton suggests '*Chryses* may be an early statement of Turner's apprehension of the sun as God'). RY

Wilton 1979, pp. 193–4.

CHURCH, Frederic Edwin (1826–1900), American landscape painter frequently hailed as Turner's one true heir. A Turnerian dissolution of outline by light and atmosphere is evident in Church's art from the 1850s onward, particularly in his most famous and ambitious paintings such as *Cotopaxi* of 1862 (Detroit Institute of Arts). His knowledge of Turner was primarily via engravings and reading *Ruskin, although he probably did see *Staffa, Fingal's Cave (RA 1832; Yale Center for British Art, New Haven; BJ 347) and *Fort Vimieux (RA 1831; private collection, England; BJ 341), which were in New York by 1851. He first visited England in 1867. AS

Franklin Kelly, *Frederic Edwin Church*, exhibition catalogue, Washington, National Gallery of Art, 1989.

CILGERRAN CASTLE, see KILGARRAN CASTLE.

CIVILIZATIONS, decay of, see CARTHAGE; COMPANION WORKS.

CLARK, Kenneth, 1903–83, Director 1933–45 of the National Gallery, *London, where, in 1939, he rescued from the cellars a rolled-up bundle, thought to be old tarpaulins, which were in fact late Turner paintings.

The two Turners in his own collection were the late oil *Seascape, *Folkestone (private collection; BJ 472), which broke all auction records when sold in 1984, and a small watercolour, *Reapers on a Hillside, c.1832 (not in Wilton).

Clark's opinion that 'Turner must be judged by the pictures which he did not exhibit' is unsustainable in face of the

masterpieces exhibited in the 1830s and 1840s. However, he also wrote, 'I worship Turner', and his championship, especially in *Landscape into Art* (1949), did much to ensure that Turner's genius is now acknowledged internationally. Clark's ideas later reached an enormous audience through his two television series, the hugely popular *Civilisation* (1967) and *The Romantic Rebellion* (1973), both also published as books. He was made a life peer in 1969. EJ

CLASSICAL SUBJECTS, either finished or projected, form an important part of Turner's output, not surprisingly in one for whom *subject matter was of prime importance for exhibited works. Together with *biblical subjects classical subjects account for about a fifth of Turner's finished pictures, distributed over his whole career. They have been thoroughly studied by Kathleen Nicholson. Turner's chief source was Ovid, in particular his *Metamorphoses* as edited and translated by Samuel Garth in numerous editions from 1717 onwards, including 1798 and 1807. He also illustrated the classical epics, the *Iliad*, the *Odyssey*, the *Argonautica* by Apollonius Rhodius, and the *Aeneid*, as well as episodes from ancient history. However, he often amalgamated episodes from a number of sources, transforming them into an individual whole. Turner realized that the early myths expressed the relationship between human activities and the processes of nature, and was able to endow his landscapes with themes of great human significance.

The process of elevating the genre of landscape, low in the Academic hierarchy, was based on the tradition of *Claude and *Poussin, together with elements from Gaspard *Dughet, a tradition developed in 18th-century England, particularly in the works of Richard *Wilson, who had developed the use of actual settings for classical subjects as in his *The Lake of Nemi or Speculum Dianae* of 1758 (on loan to National Trust, Stourhead). Turner actually looked for the site of Wilson's *Cicero and his Friends at his Villa in Arpinum* (at that time thought to be Tusculum), when he made his first visit to Rome in 1819, and exhibited his own version, *Cicero at his Villa*, in 1839 (Rothschild Collection, Ascott, Bucks.; BJ 381). Other important precedents were Alexander Cozens's *Historical Landscape representing the Retirement of Timolean*, exhibited at the Free Society 1761, and J. R. *Cozens's *Landscape, with Hannibal in his March over the Alps showing to his Army the Fertile Plains of Italy* (RA 1776; both now lost). Thus the increasingly representational landscape developed in England during the late 18th and early 19th centuries could still serve as a setting for a meaningful subject from Antiquity. To make Turner's intent clear, new regulations brought in by the Royal Academy in 1798 meant that he was able to place literary quotations in

the catalogues; he later invented his own *Fallacies of Hope* (see POETRY AND TURNER) for this purpose.

Turner's first classical landscape was *Aeneas and the Sibyl, Lake Avernus* of c.1798 (BJ 34), the first of a series of paintings about *Carthage and the story of Dido and Aeneas. Here the stylistic source was Claude as seen through the eyes of Wilson. In 1802 he exhibited *Jason* (BJ 19), probably based on the *Argonautica* rather than Ovid and treated in the manner of Salvator *Rosa. Rosa's style was also prominent in *Apollo and Python* (RA 1811; BJ 115), but after Turner's visit to the Louvre, *Paris, in 1802 his chief influences were Claude, Poussin, Gaspard (in *Narcissus and Echo*, RA 1804; Petworth House; BJ 53) and *Titian. In addition, over the next four or five years, a number of Turner's sketchbooks were filled with sketches and lists of subjects from classical Antiquity (TB LXXXI, XC, XCIII, XCIV, XCVIII); some of these sketches were used as late as 1829, in *Ulysses deriding Polyphemus* (National Gallery, London; BJ 330), and 1837, in *The Parting of Hero and Leander* (BJ 370), though many were never brought to fruition.

The majority of Turner's panoramic landscapes with classical subjects are based, with increasing freedom, on the compositions of Claude, but as early as 1806, in *The *Goddess of Discord . . . in the Garden of the Hesperides* (BI 1806; BJ 57) he set a scene from Greek Antiquity in Alpine scenery very reminiscent of that in *Fall of the Rhine at Schaffhausen* exhibited the same year at the RA (Museum of Fine Arts, Boston; BJ 61). In *Snow Storm: Hannibal and his Army crossing the Alps* (RA 1812; BJ 126) he had historical justification for an Alpine setting which also pressed home the parallel with the fate of *Napoleon, depicted by *David as the modern Hannibal. The distinction between ancient subject and modern landscape was blurred still further if one compares the two large upright compositions of the decade, *Mercury and Herse* (RA 1811; private collection, England; BJ 114) and *Crossing the Brook* (RA 1815; BJ 130), a scene in Devon with genre figures, one possibly based on one of Turner's own illegitimate daughters. Turner even teased his contemporaries with a depiction of a mock-classical subject in a Claudian landscape in *Apullia in search of Appullus* (BI 1814; BJ 128). Possibly also a tease, if not an inept tribute, was Turner's *Bacchus and Ariadne* (RA 1840; BJ 382), the figures in which are clearly taken from Titian's painting of the same subject, purchased by the National Gallery, London, in 1826. Turner's true appreciation of Titian had been shown in his own *Venus and Adonis*, painted c.1803–5 but borrowed from *Munro of Novar for exhibition at the end of Turner's life at the RA in 1849 (private collection, South America; BJ 150).

Turner sketched or listed at least fifteen subjects from Ovid in the sketchbooks of c.1803–7 already mentioned, and two of his exhibited oils of the second decade of the century, *Mercury and Herse* and, in a very special sense, *Apullia in Search of Appullus, vide Ovid*, are illustrations to the *Metamorphoses*. No further subjects from Ovid appeared until the mid-1830s, when Turner began a whole series with *Mercury and Argus* (RA 1836; National Gallery of Canada, Ottawa; BJ 367), continuing with *Story of Apollo and Daphne* (RA 1837; BJ 369), *Pluto carrying off Proserpine* (RA 1839; National Gallery of Art, Washington; BJ 380), *Bacchus and Ariadne* (RA 1840; BJ 382), and *Glaucus and Scylla* (RA 1841; Kimbell Art Museum, Fort Worth, Texas; BJ 395). One of the unfinished pictures of the later 1840s developed from subjects in the *Liber Studiorum* also treats a subject from Ovid, *Europa and the Bull* (Taft Museum, Cincinnati; BJ 514). Another picture in which the forces of nature add expressive effect to a story of amatory relationships is *The Parting of Hero and Leander—from the Greek of Musaeus*, in which, typically, Turner reverses the order of events from the original text so that Leander dies on his way back from visiting Hero. From the same period is the pseudo-historical *Phryne going to the Public Baths as Venus—Demosthenes taunted by Aeschines* (RA 1838; BJ 373). However, for the last year in which he exhibited, in 1850, he returned to the theme of Aeneas at Carthage in no fewer than four oil paintings (BJ 429–32; see ÆNEAS RELATING HIS STORY TO DIDO).

See also CARTHAGE; VIRGIL. MB

Nicholson 1990.

CLAUDE LORRAIN (properly Claude Gellée or Claude le Lorrain; c.1604–82), French landscape painter, born in Lorraine but resident for most of his life in *Rome. Claude was the Old Master who influenced Turner more often than any other. This is not surprising since Claude was not only widely imitated by British painters from the mid-18th century onwards; his work penetrated British culture at every point, from nature poetry to landscape gardening and even architecture. More than half his *œuvre* of almost 300 pictures was in Britain by 1820, and his work appealed strongly to British aristocratic collectors in that period, as it had done on the Continent during his lifetime. This was a similar clientele to that to which Turner aspired in the first half of his career, though the overlap between collectors of the two artists' work was rather small, the third Earl of *Egremont being the chief exception.

In addition, Claude was the greatest exponent of a pictorial type, the ideal landscape, which Turner found himself using again and again throughout his life. Claude's work, that is to say, was the best model for the kind of calm,

spacious landscape or seascape, often showing the sun in the sky (a motif Claude virtually invented), and often containing classical overtones and classical subject matter, which represented for Turner the opposite pole to the dark, stormy landscapes in which he also specialized.

The intensity of Turner's feeling for Claude is best summed up in his own words in the Backgrounds Lecture (1811; see PERSPECTIVE LECTURES): 'Pure as Italian air, calm, beautiful and serene, spring forward the works and with them the name of Claude Lorrain. The golden orient or the amber-coloured ether, the mid-day ethereal vault and fleecy skies, resplendent valleys . . . replete with all the aerial qualities of distance, aerial lights, aerial colour.'

Turner had first encountered Claude's work by spring 1799, when he exhibited at the Royal Academy a large finished watercolour of *Caernarvon Castle* (private collection; W 254), the recession and sunlight effect in which could only have been derived from the French master. Shortly afterwards Turner was among a crowd of visitors to William *Beckford's London house to view the two great Altieri *Claudes* (Anglesey Abbey, Cambridgeshire), recently arrived from Rome. During his visit to Paris in 1802, however, Turner was preoccupied with the work of other Old Masters, and it was not until 1803 that he exhibited his first oil painting in the style of Claude, *The *Festival upon the Opening of the Vintage of Macon* (Sheffield City Art Galleries; BJ 47). Like its successors in the next dozen years— for example, *Thomson's Aeolian Harp* (Turner's gallery 1809; Manchester City Art Gallery; BJ 86) and *Apullia in search of Appullus* (BI 1814; BJ 128)—*Macon* is large in scale, panoramic in composition, and relatively dark in tone. This group of paintings is based on the very grand, highly idealized works of the second half of Claude's career, above all his *Landscape with Jacob, Laban and his Daughters* (1654), which has been at *Petworth ever since the 1680s and which Turner came to know intimately from 1808. Of these paintings by Turner, the *Apullia* is practically a copy of the Petworth Claude, but the finest of them is *Thomson's Aeolian Harp*, precisely because it is the most personal.

In 1815, Turner went further, developing in *Dido building Carthage* (National Gallery, London; BJ 131) those romantic effects of light, space, and splendour which Claude had maintained in classical equilibrium but which Turner exaggerated and which increasingly became the hallmark of his work. The subject matter of *Dido* also has a stronger narrative thrust than Claude ever allowed himself. Yet there is no doubt that this is a profoundly Claude-like picture and perhaps Turner's most important of its kind. It was virtually the first painted *Seaport* by any artist since Claude's own *Embarkation of the Queen of Sheba*, executed in 1648 (in the

intervening years, imitations of his work had been largely confined to landscapes and coast scenes without stately buildings). In his *will of 1831, Turner bequeathed *Dido building Carthage* and **Sun rising through Vapour* (RA 1807; National Gallery, London; BJ 69) to the National Gallery on condition that they be hung next to Claude's *Embarkation of the Queen of Sheba* and its pendant, *The Mill, or the Marriage of Isaac and Rebecca* (though whether this was aesthetically wise appears increasingly doubtful).

Concurrently, Turner was working on a project equally indebted to Claude, at least in its initial idea. This was the **Liber Studiorum*, which he began in 1807: title, medium (etching and mezzotint), proposed number of plates (originally 100 though he gave up in 1819 when he had reached 71), and preparatory drawings (to some extent) are all derived from Earlom's two-volume book of engravings published in 1777 after the 200 drawings in Claude's *Liber Veritatis* (then belonging to the Duke of Devonshire, now in the *British Museum). The main difference between the two undertakings is that Turner's purpose, unlike Claude's or Earlom's, was didactic, that is, it was to show that landscape painting could be enhanced as an art form by conceiving it in categories; to this end Turner devised six different categories identified by initials, for example, H for historical, M for marine, and EP for elevated, or epic, pastoral. The last was based on Claude's landscapes, but in this case the more pastoral and idyllic ones, not the grand canvases that inspired Turner's oil paintings. Another difference between the two projects is that all the drawings in the *Liber Veritatis*, and hence the engravings after them, were records by Claude of his own paintings, whereas the *Liber Studiorum* plates were mostly new compositions specially invented for the publication by Turner.

As is well known, Turner's tonal schemes began to lighten and his colours to become warmer and more intense some two years before he visited *Italy for the first time in 1819. The Claude-inspired paintings that belong to this transitional period are the large finished watercolour, *Landscape: Composition of Tivoli* (1817, RA 1818; private collection; W 495), and two oils, *The *Decline of the Carthaginian Empire* (RA 1817; BJ 135) and **England: Richmond Hill, on the Prince Regent's Birthday* (RA 1819; BJ 140). On his arrival in Italy, however, Turner's interest in Claude temporarily changed emphasis and became more pragmatic. As he travelled down the peninsula towards Rome, remarks in his sketchbooks show that he was constantly on the lookout for sites that reminded him of Claude's pictures. More than this, he made pencil sketches of nine paintings by Claude in *Rome, one in Florence and—on a separate visit to Paris in 1821—eight in the Louvre.

The association of Claude's art with Italian light and Italian scenery was one of the reasons British artists and connoisseurs gave for admiring his work, and Turner was no exception, but, in the event, Claude's style was no help to him when he came to render the Italian landscape; Claude's compositions, that is to say, were too synthetic to be combined with Turner's 19th-century brand of naturalism. Hence, Turner's wonderful ethereal watercolours of Italian subjects made on the spot in and near Rome and Naples owed practically nothing to Claude. Three years after his return to London, however, he reverted to Claude as a model for his oil painting, *The *Bay of Baiae, with Apollo and the Sybil* (RA 1823; BJ 230), and for this he used Claude's grand ideal style once more, but with lighter tones and warmer colouring and a looser form of composition. Waving, stylized pine trees and piles of classical ruins fill the foreground of this painting, while in the sky and distance a sparkling, sunlit effect at once recalls Claude and is beautifully observed from nature.

In subsequent paintings, some executed during a second visit to Rome in 1828, Turner again stretched the Claudian formula, taking it still further away from, rather than closer towards, the real appearance of any actual landscape. Whether or not based on an ostensible topographical location—for example, the Bay of Baiae, Orvieto, or Tivoli—and whether or not furnished with classical subject matter, such as *The *Golden Bough* (RA 1834; BJ 355) or *Mercury and Argus* (RA 1836; National Gallery of Canada, Ottawa; BJ 367), these late Claudian paintings by Turner are dreams of Italy as three centuries of art and literature (not only the pictures of Claude) had taught educated Europeans to experience it. Everywhere Turner makes the forms insubstantial, the colours burn with a gem-like intensity, and skies, distances, water, and foliage partly disappear in the dazzle of light. **Childe Harold's Pilgrimage—Italy* (RA 1832; BJ 342), embodying as it does both gorgeousness and serenity, is perhaps the supreme example. Romantic excess, not classical economy, is the keynote. Indeed, so far from carrying Claude's style to its fulfilment, these late Italian pictures by Turner amount almost to a reversal of what Claude's art had stood for, namely the complete and seemingly effortless fusion of nature and the ideal. With his restless mind and dynamic conception of painting, Turner destroyed the Claudian calm. But in doing so he created something strange and new. MK

Ziff 1965, pp. 51–64.
Kitson 1983, pp. 2–15.
Nicholson 1990, ch. 6.

CLINT, George, ARA (1770–1854). English mezzotint engraver and painter of miniatures, portraits, and theatrical

scenes. He engraved two plates for Turner's *Liber Studi-orum*, *Procris and Cephalus* (F 41) and *Peat Bog* (F 45), which were published in 1812. Clint was a talented engraver, and his plates are some of the most accomplished in the series. According to a letter written to John *Pye in 1850 (Pye and Roget 1879, pp. 65–6), Clint stopped working for Turner 'on account of the inadequacy of the price' paid for his work. His pupil Thomas *Lupton became one of Turner's most celebrated engravers. GF

CLORE GALLERY, see TATE GALLERY.

CLYDE. Scotland's principal river rises south-east of Glasgow and flows in a north-westerly direction through the city to the Firth of Clyde. The falls of the Clyde are located south-east of the city near Lanark and were renowned for their picturesqueness. Turner sketched them twice. The first time in 1801, he produced several watercolours (National Galleries of Scotland, Fogg Art Museum, Cambridge, Mass., and Indianapolis Museum of Art; W 322–4). A version with metaphorical overtones, exhibited in 1802 (National Museums on Merseyside, Liverpool; W 343), formed the basis of a late painting (c.1845–50, Lady Lever Art Gallery, Liverpool; BJ 510). On his second visit to the falls in 1834, Turner made further sketches (TB CCLXIX), probably for a design for an edition of *Scott's Waverley Novels. In this same year he appears to have also sketched the river above Glasgow, including the Firth of Clyde (CCLXX), probably for the same purpose. GEF

Gage 1969, pp. 143–4.
Finley 1980, p. 179.

COBB, George (1799–after 1840), solicitor of Clement's Inn, London, who was acting for Turner by 1823. The son of an Oxfordshire parson, he attended St John's College, Oxford (1814–17), joining Lincoln's Inn in 1817. He left in 1820, giving up the law through ill health, but none the less Turner employed him. Health apparently restored, he joined Clement's Inn in 1828.

He prepared leases for properties in *Harley Street, Wapping, Epping, and perhaps elsewhere for Turner, who was a demanding and exasperating client, as surviving correspondence shows. Nevertheless Turner remained loyal, and their relationship seems to have lasted nearly twenty years. Cobb must have been phlegmatic and adaptable, as Turner gave him brisk instructions, some of them unclear, and went so far as to draft out the wording of documents for him. This legalistic attitude will have contributed to the lack of clarity in Turner's first *will of 1829, which Cobb redrafted two years later.

Cobb had a house in Wilton by 1837, but seems to have moved to Brighton in 1840. He invited Turner to stay at both places, suggesting that a firm friendship existed. JH

Lincoln's Inn Black Books, vol. 20, p. 263.
Finberg 1961, pp. 330–1, 338, 350, 381, 442.
Gage 1980, p. 245.
Bailey 1997, 240–1, 281, 312, 403.

COBURG. Turner visited the German town of Coburg just once, in 1840, when returning from Venice. His visit was clearly prompted by the marriage of Queen *Victoria to her cousin Prince *Albert of Saxe-Coburg-Gotha in February that year and the chance of attracting the patronage of the young couple far outweighed the inconvenience of a slight detour from the direct route home. Dates on some of Turner's Coburg sketches indicate that his visit took place around 17–20 September while the viewpoint of others suggests that he stayed at the White Swan in Spitalgasse. He explored the town and its environs thoroughly, paying special attention to the properties of Prince Albert's family. These included Schloss Ehrenburg in the town centre; the Gothic fortress of Veste Coburg on a hill just outside the town; and—just to the north—Schloss Rosenau, the hunting lodge with an English-style park, where Albert had been born in August 1819. Turner made small pencil sketches of all these in the sketchbook formerly known as 'Coburg, Bamberg, and Venice' but now renamed 'Venice: Passau to Würzburg' (TB CCCX). He also drew four coloured sketches of Coburg on grey paper (originally classified as 'Venice: Miscellaneous (b) Grey Paper', CCCXVII: 7, 8, 9, 11) and three coloured ones on white paper ('Miscellaneous: Colour', CCCLXIV: 49, 105, 329). The last three appear to be preparatory exercises for potential oil paintings, but only one of them resulted in a finished work: *Schloss Rosenau, Seat of H.R.H. Prince Albert of Coburg, near Coburg, Germany* (RA 1841; National Museums on Merseyside, Liverpool; BJ 392). CFP

Powell 1995, pp. 71–2, 168–74.

COCKERELL, Charles Robert (1788–1863), architect, whose early training with *Smirke was enriched by seven years' travel in Turkey, Greece, Asia Minor, and Italy (1810–17) studying and recording classical remains. Cockerell, who came to know Turner in the years after his return to England, became the central figure in the Greek Revival in British architecture. The clarity of his lifetime's production descends directly from the integrity and depth of his studies in the field.

Turner's architectural interests and his coincided, and they had a number of mutual friends including the architects Thomas Allason, Thomas L. Donaldson, Philip Hardwick, and other men of classical taste such as *Holworthy and

Henry Gally Knight. Turner's two paintings *The Temple of Jupiter Panellenius Restored* (RA 1816; private collection, USA; BJ 133) and *View of the Temple of Jupiter Panellenius . . . with the Greek National Dance of the Romaika. Painted from a sketch taken by H. Gally Knight, Esq. in 1810* (RA 1816; Duke of Northumberland; BJ 134) were directly inspired by reports of excavations in Athens which had begun in 1811, and in which Cockerell and Gally Knight were closely involved. The quality of the architectural and incidental detail in the paintings reflects on the importance to Turner of architectural accuracy, and signals a natural affinity with Cockerell.

In the early 1820s the two men pledged to work together. They discovered much common ground between them—Cockerell wrote in his diary 'it was a vast pleasure to me to look over my views with a man who felt them as he did.' Turner agreed to make fifteen watercolours from Cockerell's drawings of the Temple of Jupiter Panellenius for eventual engraving and publication. By 1825, however, only one watercolour had been produced (private collection; W 493), and Turner's connection with the project petered out.

Much of Cockerell's architectural work has been demolished. Among his finest surviving work is the *Ashmolean Museum and Taylor Institution, Oxford.

See also ARCHITECT, TURNER AS. JH

C. R. Cockerell, Diaries 1821–32 (unpublished; RIBA Library).
D. J. Watkin, *The Life and Work of C. R. Cockerell RA*, 1974.
Gage 1981, pp. 14–25.

COLE, Thomas (1801–48), American landscape painter. Basing himself mainly upon Salvator *Rosa and *Claude, Cole was the first significant artist to depict American scenery. He also painted historic landscapes echoing *Martin and Turner, among them *The Course of Empire* (1834–6; New York Historical Society), a five-picture series substantially inspired by *Dido building Carthage* (RA 1815; National Gallery, London; BJ 131) and *The Decline of the Carthaginian Empire* (RA 1817; BJ 135). In 1829 Cole visited Turner's gallery where he praised *Dido building Carthage* and denounced the recent paintings as altogether false, subsequently calling Turner 'the prince of evil spirits'. AS

Ellwood C. Parry III, *The Art of Thomas Cole: Ambition and Imagination*, 1988.

COLERIDGE, Samuel Taylor (1772–1834), theorist of the imagination and literature, who wrote in 1805, 'in looking at the objects of Nature . . . I seem rather to be seeking, as it were *asking* for, a symbolical language for something within me that already and for ever exists, than observing anything new' (*Anima Poetae*). Coleridge knew Thomas *Stothard and *Chantrey, and he and Turner attended Thomas Petti-

grew's *conversazioni*; they were both seen by *Haydon in 1825 at a viewing by candle-light of the Belzoni sarcophagus at *Soane's house. Though analogies have been drawn between the imagery of Turner and Coleridge—for example wrecks in a sea of blood appear in the early poem *Religious Musings*—no real intellectual commerce between them has been demonstrated. JRP

B. R. Haydon, *Correspondence and Table-Talk*, 1876, ii. p. 93.

COLLABORATION WITH OTHER ARTISTS. For an artist as individualistic as Turner collaboration would seem to be unlikely but it did occur. The first known example is in fact of a highly traditional kind, painting the landscape backgrounds for horses or donkeys by the sporting artist Sawrey *Gilpin (1753–1807). One example was exhibited at the Royal Academy in 1799, *Sunny Morning—the Cattle by S. Gilpin, R.A.* (untraced; W 251), and another in 1811, *Windsor Park: with Horses by the late Sawrey Gilpin Esq. R.A.* (probably TB LXX: G; W 414; Upstone 1989, pp. 28–9 no. 28, repr.). Also in the Turner Bequest is *Donkeys beside a Mine Shaft* (LXXI: I; Upstone 1989, p. 31, repr.). The animals in these last two were probably done shortly before Gilpin's death in 1807; Turner did not exhibit watercolours at the RA between 1804 and 1811, hence the delayed exhibition of W 414.

Another form of collaboration is suggested by Wilton as dating from the time that Turner and Charles *Eastlake shared a studio in Rome, to which period can be dated the unfinished oil formerly known as 'The Procuress' but now re-identified as *Judith with the Head of Holofernes* (Wilton 1989, pp. 31–3, repr.) and attributed to both artists. Finally there is a well-known anecdote of Turner during the Varnishing Days at the RA in 1847, when he improved his friend *Maclise's *Sacrifice of Noah* (Leeds Art Gallery) by darkening the area around the lamb and strengthening the rainbow (George *Jones in Gage 1980, p. 8). MB

COLLECTOR, Turner as. Though not a systematic collector, and neither as specialized nor as extravagant in pursuit of particular interests as friends like *Lawrence, *Rogers, or *Soane, Turner acquired numerous works of art. Many of these, mainly drawings, were included in the Turner Bequest; others belong to his descendants. In the Turner sale at Christie's, 25 July 1874, were unidentified subject pictures and a *Death of Abel* by *David's Savoyard follower Jacques (Giacomo) Berger, while he also owned a *Descent from the Cross* and tried to acquire *West's *Cave of Despair* (private collection, USA). A mysterious *Head of an Old Man* (private collection) recorded in his house has been attributed to Thomas Barker of Bath, while the roundel of a classical landscape seen there in the dining room by H. S.

*Trimmer under an attribution to Agostino Tassi (Tate Gallery) is more probably by Goffredo Wals. This last was a gift from his colleague Prince Hoare.

Turner's Old Masters were mainly drawings, two attributed to *Rembrandt (private collection) being bought in the 1833 sale of Dr *Monro—also the source of drawings by *Girtin, *Dayes, and others associated with his own early spell in the Monro 'Academy', by *Wilson (Tate Gallery, TB CCCLXXX: 19), de *Loutherbourg, Samuel Scott, and *Van de Velde. Among his earliest purchases was probably a sketchbook of neoclassical figures by Charles Reuben Ryley (private collection). Though apparently not a bidder at the *Reynolds sale in 1795, in 1821 he is said to have bought portrait sketches by the artist (see BJ 548) and bid unsuccessfully for one of his Italian sketchbooks. Portrait sketches by John Jackson, including studies of the Duke of *Wellington, were bought at that artist's sale in 1831, and Turner also owned examples by William Owen, an early associate of his friend *Callcott, who, as far as is known, was not represented in his collection; other close friends were apparently also absent. While sentimental reasons must have prompted some of his purchases, others seem more random, early French and Dutch drawings as yet unattributed in the Bequest having probably formed part of job lots; and while certain items can be related to work interests, evidence for specific collecting with projects in mind—as when in 1837 he was trying to find views of Continental battlefields and a portrait of *Napoleon for some illustrations to Walter *Scott—is scanty. DBB

COLNAGHI, Dominic (1790–1879). He joined his father Paul (1751–1833) in the firm which has long borne their name although founded in 1760 by an Italian pyrotechnist named Giovanni Battista Torre. The firm specialized in selling prints and Turner is believed to have coloured prints for Paul Colnaghi c.1792. But the relationship did not last for, when publication of the *Liber Studiorum began, Turner proved so stingy about discounts to the trade that a number of printsellers refused to handle the prints. In Colnaghi's case, as Dominic told *Pye, the allowance was reduced over the years from twenty to ten per cent with worse to follow.

In 1834 the firm exhibited Turner's 26 illustrations to *The Life and Works of Lord *Byron* (W 1210–35), engraved 1832–4, but this must have been due to Dominic's friendship with John *Murray who published that edition.

Dominic recalled that, in about 1848, a client wanted a set of the *Liber* (£14) which Dominic obtained from Turner's housekeeper, who reported that she had orders not to allow him more than 5 per cent discount. A few weeks later Turner called on Dominic and went further, telling him that in future he had decided 'no discount to the trade'. Dominic replied, 'In that case how are we to live?' 'That's no affair of mine,' said Turner. Upon which they shook hands and parted. EJ

Pye and Roget 1879, pp. 73–4.
Elfrida Manning, *Colnaghi's, 1760–1960*, 1960.
Finberg 1961, p. 376.
Bailey 1997, pp. 126, 131, 377.

COLOGNE. Turner passed through the historic German city of Cologne on many of his tours of Europe between 1817 and 1844, almost always making quick sketches of its Rhine shore, vast unfinished cathedral, and other imposing buildings such as the Bayenturm and Great St Martin's church. The flying bridge across the Rhine and the bridge of boats (which replaced it in 1822) are also often indicated in these sketches. However, it was only on his first visit that he made any careful drawings away from the waterside.

Cologne was portrayed in two of the fifty *Rhine drawings of 1817 which were sold to Walter *Fawkes. One depicts the Rhine Gate and the riverside busy with people and shipping (National Museums and Galleries of Wales, Cardiff; W 669), while the other shows much more of the river itself, flanked by the Bayenturm and Deutz on the opposite shore and looking north to St Cunibert's (private collection, USA; W 670). About 1820 Turner drew two larger watercolours similar in viewpoint to the second of these (private collection, Tokyo; W 689a; and Seattle Art Museum, Washington, W 690). The popularity of the scene is affirmed by the large engraving published after it in 1824 (R 203).

In 1826 Turner made Cologne the subject of a painting for John *Broadhurst, a companion piece to his *Harbour of Dieppe* (RA 1825; Frick Collection, New York; BJ 231). In this luminous work, *Cologne, The Arrival of a Packet Boat, Evening* (RA 1826; Frick Collection, New York; BJ 232), a few of the famous buildings of Cologne are shown in the middle distance, veiled in a warm haze; they provide a precise topographical setting for a celebration of water, sky, and shipping. It was based on pencil sketches drawn on Turner's visit to Holland in 1825 and reflects his lifelong admiration for the Dutch painter *Cuyp and his abiding appreciation of the Rhineland in equal measure. CFP

Borch 1980.
Stader 1981.
Powell 1991, pp. 44–5, 110–11.

COLOUR BEGINNINGS, see BEGINNINGS.

COMMISSIONED WORKS. Turner was only 15 when he obtained his first watercolour commission from the architect Thomas *Hardwick for a replica of *The *Archbishop's Palace, Lambeth* (Indianapolis Museum of Art; W

10). *Rochester* (untraced; W 87), the first Turner to be engraved, was published in the *Copper-Plate Magazine* on 1 May 1794 and fifteen plates followed between then and 1798 (R 1–15a).

Meanwhile, in 1795, Viscount Malden (later Earl of *Essex) ordered five watercolours of *Hampton Court* (mainly Whitworth Art Gallery, Manchester; W 182–6) and two of *Cassiobury* (private collection and Huntington Art Gallery, California; W 187–8), his seats in Herefordshire and Hertfordshire respectively. Similar commissions followed from 1796 onwards from Sir Richard Colt *Hoare for a series depicting *Salisbury and its cathedral (W 196–213) and, from 1797, Turner began to work at Harewood for Edward *Lascelles. Turner also supplied ten watercolours engraved as headpieces for the *Oxford Almanack (Ashmolean Museum, Oxford; W 295–304), published 1799–1811, as well as some large views of *Fonthill for William *Beckford 1799–1800 (W 335–42).

This success did not escape the watchful pen of *Farington, whose *Diary* (24 October 1798) records that Turner had 'more commissions at present than he could execute' and on 6 July 1799 that Turner had '60 drawings now bespoke by different persons'.

It soon became recognized that if Turner illustrated a publication its success was guaranteed, so a steady stream of orders kept him busy from c.1812 until the mid-1830s. For example, *Cadell, *Scott's shrewd publisher, persuaded the initially reluctant author to employ Turner to illustrate his *Poetical Works (W 1070–93) in 1831 writing: 'With his pencil I shall ensure the subscription of 8,000—without not 3,000'.

Wilton, in 1979, lists all Turner's commissioned watercolours including the numerous topographical series such as the *Southern Coast (1814–26, W 445–84) and *England and Wales (1827–38, W 785–880). One section alone, Turner's 'Book Illustrations' (W 1052–1314), provides evidence of the scope and variety of his work in this field. Besides Scott, Turner illustrated the work of *Byron (W 1210–35), *Rogers (W 1152–1209), *Milton (W 1264–70), *Campbell (W 1271–90), and *Moore (W 1298–1301) as well as providing 26 designs for *Finden's *Landscape Illustrations of the Bible* (W 1236–61) and seven for *White's *Views in India* (W 1291–7).

However, by 1838, the market for even Turner's prints was sated, as over 700 had by then been published so that, after 1840, commissions for watercolours were mainly in the hands of his agent Thomas *Griffith. Turner's final watercolour commission was from *Ruskin for two Swiss views (*The Brunig Pass, from Meiringen* and *The Descent of the *St. Gothard*; both private collections; W 1550, 1552) painted 1847–8.

Turner's first commissioned oil paintings were the two views of *Plompton Rocks* (Harewood House Collection; BJ 26, 27; see LASCELLES) painted for the library at Harewood in 1798. But it was the Duke of *Bridgewater's commission to paint a companion to his *Van de Velde and the picture that resulted (RA 1801; BJ 14) that reinforced Turner's growing reputation. In 1808 Payne *Knight gave Turner a commission that led to a most unusual picture: *The Unpaid Bill, or the Dentist reproving his Son's Prodigality* (private collection, USA; BJ 81), painted as a pendant to Knight's *Alchemist's Laboratory*, attributed then to David *Teniers the Younger but now to the little-known Gerard Thomas (1663–1720). Both pictures show elderly men remonstrating with their families in cluttered interiors.

Also in 1808 Turner painted the two views of *Tabley House* (on loan to Whitworth Art Gallery, Manchester, and Petworth House; BJ 98, 99) which, when shown at the Royal Academy in 1809, led to a whole series of paintings based on patrons' houses which were quite unlike earlier 'house-portraits' (except for a few by Richard *Wilson) in that, although the houses' names feature prominently in the pictures' titles, the houses only appear—if at all—either partly masked by trees or in the distance in the paintings themselves. Examples are *Hurley House on the Thames* for Thomas *Wright of Upton (c.1807–9; private collection; BJ 197), the two pictures of *Lowther Castle* (private collection; BJ 111, 112) for Lord *Lonsdale in 1810, *Raby Castle* (Walters Art Gallery, Baltimore; BJ 136) for Lord Darlington in 1818, the two *Mortlake Terrace* views (Frick Collection, New York, and National Gallery of Art, Washington; BJ 235, 239) for William *Moffatt in 1826–7, and the two pictures of *East Cowes Castle* (Indianapolis Museum, Indiana, and Victoria and Albert Museum, London; BJ 242, 243) painted for John *Nash and exhibited RA 1828.

Turner received few commissions for oils to be engraved, the most successful being the two *Oxford views *High-Street, Oxford* and *Oxford from the Abingdon Road*, BJ 102, 125) commissioned by James *Wyatt, an Oxford picture-dealer, in 1810 and published in 1812. *The *Bright Stone of Honour (Ehrenbreitstein)* (RA 1835; BJ 361) was commissioned by the engraver John *Pye in 1835 but the print was not published until ten years later, by which time *Bicknell had bought the picture.

The only time Turner was accorded royal patronage occurred in 1822 when *George IV commissioned *The Battle of Trafalgar* (National Maritime Museum, Greenwich; BJ 252). The result was Turner's largest painting (102 × 144 in., 259 × 365.8 cm.) but his least successful commission, as criticism by naval pundits at court caused the King to give the picture away to Greenwich Hospital in 1829.

Turner was more fortunate when commissioned to paint four pictures (BJ 288–91) to hang in the Grinling Gibbons panelled dining-room at *Petworth c.1829. Their subjects were two views of *Petworth Park* together with *Chichester Canal* and *Brighton from the Sea* as *Egremont had financial interests both in the Canal and in the Chain Pier at *Brighton. These are more finished, with details such as an added cricket match, and evidently more to Egremont's taste than the freely painted versions that were originally submitted and which are now in the Tate Gallery (BJ 283–6). In the 1820s Turner also painted three oils for Sir Willoughby and Lady *Gordon: *View from the Terrace of a Villa at Niton* (RA 1826; Museum of Fine Arts, Boston; BJ 234), *Near Northcourt in the Isle of Wight* (c.1827; Musée du Québec; BJ 269), and the recently identified *Banks of the Loire* (RA 1829; Worcester Art Museum; BJ 328a, 329).

Turner reduced his prices for commissioned pictures as quoted in his letter of 23 November 1843: 'all of *Venice 200 gns if painted by commission—250 gns afterwards' and continues 'Venice size best 2 feet 3 feet'. Certainly a number of Venetian subjects were commissioned by patrons such as *McConnel (RA 1834; BJ 356), *Sheepshanks (RA 1840; BJ 384), *McCracken, and *Wethered (RA 1846; BJ 421, 422).

Only someone with Turner's energy, application, and speed of execution could have fulfilled all his commissions but it should also be emphasized what great pains Turner took to carry out his patrons' wishes to their complete satisfaction and consequently how high his reputation stood in this respect.

See also COMPANION WORKS; PATRONAGE AND COLLECTING.

EJ

COMPANION WORKS, particularly paired paintings, are a feature of Turner's mature career, especially in his later years. The practice started almost casually. Turner's five exhibits at the Royal Academy in 1803, designed to show the range of his achievement following his first trip to the Continent the year before, included two views at Bonneville in his standard 3 × 4 ft. (91.4 × 122 cm.) *size, *Bonneville, Savoy, with Mont Blanc*, and *Châteaux de St. Michael, Bonneville, Savoy* (Yale Center for British Art, New Haven, and Dallas Museum of Art respectively; BJ 46 and 50; see BONNEVILLE for the confusion over the two 1803 exhibits). Whether deliberately or not, these seem to show Turner demonstrating his ability to compose landscapes in two different manners: the first is designed largely around forms parallel to the picture plane, including a bridge derived from *Claude, while the second is closer to *Poussin with forms thrusting into space, especially the road. More deliberate

seems to have been the pairing of two upright views based on drawings done in the Alps in 1802, and almost certainly commissioned by John *Allnutt, of *The Pass of *St. Gothard* and *The Devil's Bridge, St. Gothard* of c.1803–4 (City Museums and Art Gallery, Birmingham, and private collection respectively; BJ 146, 147).

Another pair of pictures emerged a few years later in the form of two views of *Walton Bridges*, almost certainly exhibited in Turner's own gallery in 1806 and 1807 (Loyd Collection, on loan to Ashmolean Museum, Oxford, and National Gallery of Victoria, Melbourne, respectively; BJ 60, 63). These two views, taken from opposite sides of the river but at roughly the same time of day, may merely reflect the success of the first exhibit, leading to the painting of the second picture. Another possibly casual pairing of works exhibited in Turner's gallery in two successive years, 1809 and 1810, but united by their unusual size, 40 × 51¼ in. (101.6 × 130.8 cm.), and somewhat perverse titles, are *Ploughing up Turnips, near Slough*, a view in fact dominated by the distant Windsor Castle, and *Dorchester Mead, Oxfordshire*, entitled 'Abingdon' when sold to George Hibbert (and bought back by Turner) in 1829 and in the Inventory of the Turner Bequest (BJ 89, 107).

More deliberate pairings of landscapes were the result of commissions. In 1808 Turner painted two paintings for Sir John *Leicester of his house, *Tabley, the Seat of Sir J. F. Leicester, Bart.: Windy Day* and *Tabley, Cheshire, the Seat of Sir J. F. Leicester, Bart.: Calm Morning* (Victoria University of Manchester, on loan to the Whitworth Art Gallery, Manchester, and Petworth House; BJ 98, 99); these were subsequently exhibited at the RA in 1809. Here the obvious point of contrast is the different weather conditions. In the same way two paintings were commissioned by the Earl of *Lonsdale of his house and exhibited at the RA in 1810: *Lowther Castle, Westmorland, the Seat of the Earl of Lonsdale: North-West View from Ulleswater Lane: Evening* and *Lowther Castle, Westmorland, the Seat of the Earl of Lonsdale (the North Front), with the River Lowther: Mid-Day* (private collection, England; BJ 111, 112). Similarly, the fifth Earl of *Essex seems to have commissioned the two contrasting oil paintings on panel, left unfinished, of *Harvest Home* and of his house *Cassiobury Park: Reaping* (c.1809; BJ 209, 209a). There was a tradition of such pairings, involving times of day or the weather, going back to Richard *Wilson, who painted no fewer than five views of Wilton House for the Earl of Pembroke and three of Moor Park for Sir Lawrence Dundas (see Solkin 1982, pp. 195–6, nos. 81a and 81b, and pp. 232–3, no. 126). Slightly different reasons lay behind the two companion pictures of Oxford commissioned for engraving by James *Wyatt: at first he only com-

missioned, in 1809, the *View of the *High-Street, Oxford*, exhibited in Turner's gallery in 1810, but was so pleased by it that he ordered the companion *View of Oxford from the Abingdon Road*; both pictures were exhibited at the RA in 1812 (Loyd Collection, on loan to the Ashmolean Museum, Oxford, and private collection, England; BJ 102, 125).

The first example of Turner's pairing of significant subjects from Antiquity seems to have come about almost by chance. In 1815 Turner exhibited at the RA the first of his grand port scenes of *Carthage, **Dido building Carthage; or the Rise of the Carthaginian Empire*; only two years later was this followed by *The Decline of the Carthaginian Empire* (BJ 131, 135). The second picture is slightly larger than the first, and no contemporary reviews seem to have noticed that Turner was following what had become almost a commonplace in contemporary historical writing, the comparison of the rise and fall of empires. At the RA in 1816, however, Turner did deliberately compare two views of a famous ancient site, then and now: *The Temple of Jupiter Panellenius restored* and *View of the Temple of Jupiter Pannellenius, in the Island of Aegina, with the Greek National Dance of the Romaika: the Acropolis of Athens in the Distance* (the second is signed and dated 1814; private collection, New York, and the Duke of Northumberland respectively; BJ 133, 134). The modern view was based on a drawing by H. Gally Knight, while the reconstruction was based on the work of two architects concerned with the evacuation of the site, C. R. *Cockerell and Thomas Allason. The pictures reflect Turner's sympathy with the cause of Greek liberation, encouraged by the publication of the second canto of *Byron's *Childe Harold* in 1812 (see GREECE).

In the 1820s Turner painted further pairs or groups of views on commission. The first pair, commissioned by William *Moffatt and exhibited at the RA in 1826 and 1827, were *The Seat of William Moffatt Esq., at Mortlake. Early (Summer's) Morning* and *Mortlake Terrace, the Seat of William Moffatt, Esq. Summer's Evening* (Frick Collection, New York, and National Gallery of Art, Washington; BJ 235, 239). These show views from the garden looking up and down river in the evening and morning respectively. Also in 1826 Turner exhibited *View from the Terrace of a Villa at Niton, Isle of Wight, from Sketches by a Lady*; the lady was his former pupil Julia Bennet, now Lady *Gordon (Museum of Fine Arts, Boston; BJ 234). The companion *Near Northcourt in the Isle of Wight* probably resulted from Turner's visit to the *Isle of Wight in 1827 (Musée du Québec; BJ 269). The same visit led to the commission by John *Nash for the two paintings exhibited in 1828, *East Cowes Castle, the Seat of J. Nash Esq.; the Regatta beating to Windward* and *East Cowes Castle, the Seat of J. Nash, Esq.; the Regatta*

starting from their Moorings (Indianapolis Museum of Art, and Victoria and Albert Museum, respectively; BJ 242, 243); these contrast the calm of the estuary of the Medina River with the rougher waters of the Solent. A commission from the Earl of *Egremont led to the four canvases still at *Petworth House (BJ 288–91). Earlier, in 1822, the visit of George IV to Edinburgh had led to four unfinished paintings on panel covering the visit, possibly intended for engraving or a decorative scheme (BJ 247–48b).

Turner's work at Petworth also led to two paired subject pictures exhibited at the RA in 1831, *Lucy, Countess of Carlisle, and Dorothy Percy's Visit to their Father, Lord Percy, when under Attainder upon the Supposition of his being concerned in the Gunpowder Plot* and **Watteau Study by Fresnoy's Rules*, apparently painted on cupboard doors there (BJ 338, 340). The same year saw the exhibit of the first of four paintings of scenes from the career of *Van Tromp, exhibited at the RA in 1831, 1832, 1833, and, returning to the theme much later, 1844 (Sir John *Soane's Museum, London, Wadsworth Atheneum, Hartford, Connecticut, Tate Gallery, and Getty Museum, California, respectively; BJ 339, 344, 351, 410). An RA exhibit of 1832, *Shadrach, Meshech and Abednego in the Burning Fiery Furnace*, seems to have been intended to have a complementary New Testament scene in the finished, but spoiled by splashes of dark paint, *Christ driving the Traders from the Temple* (BJ 346, 436). Two large panoramic landscapes exhibited in 1834 may have been intended as a pair, their compositions being balanced with the framing trees and buildings reversed: *The *Fountain of Indolence* and *The *Golden Bough* (Beaverbrook Foundations, Fredericton, New Brunswick, and Tate Gallery respectively; BJ 354, 355).

The painting of *Venice*, at the RA in 1834, seems to have been done for Henry *McConnel; the following year Turner exhibited **Keelmen heaving in Coals by Night*, which was, according to McConnel, 'painted at my especial suggestion' (National Gallery of Art, Washington; BJ 356, 360). Although there is no actual documentary evidence, it is possible that McConnel, a Manchester textile manufacturer, may have suggested the industrial scene of contemporary prosperous England as a contrast to the decaying beauties of the former empire of Venice. At the Royal Academy in 1838 and 1839 Turner quite deliberately exhibited pairs of pictures conveying the message of the rise and fall of empire: *Modern Italy—the Pifferari* and *Ancient Italy—Ovid banished from Rome* (Glasgow Art Gallery and private collection respectively; BJ 374, 375), and **Ancient Rome; Agrippina landing with the Ashes of Germanicus. The Triumphal Bridge and Palace of the Caesars restored* and *Modern Rome—Campo Vaccino* (Tate Gallery and Earl of

Rosebery respectively; BJ 378, 379). In 1839, for once, the critics actually noticed the message; the *Art Union*, 15 May, recognized 'A fine and forceable contrast to No. 66 [*Ancient Rome*]. The glory has departed. The eternal city, with its splendours—its stupendous temples, and its great men—all have become a mockery and a scorn. The plough has gone over its grandeurs, and weeds have grown up in its high places.'

In the 1840s paired subjects seem to have been particularly associated with square or circular formats (see SIZES AND FORMATS). In 1840 Turner exhibited *Bacchus and Ariadne* (BJ 382) on its own, a square canvas ultimately finished off, probably during the *Varnishing Days, as a circle. What would seem to be the obvious companion to this tribute to *Titian was shown the following year: *Dawn of Christianity (Flight into Egypt)*, again finished as a circular composition (Ulster Museum, Belfast; BJ 394). However, another circular composition exhibited in 1841, *Glaucus and Scylla*, may instead have been intended as the companion to *Dawn of Christianity* of the same year (Kimbell Art Museum, Fort Worth, Texas; BJ 395); their numbers in the exhibition, 532 and 542, are close enough for the pictures to have been juxtaposed in the very crowded hang of the RA at the time.

In 1842 Turner exhibited *Peace—Burial at Sea and *War. The Exile and the Rock Limpet* (BJ 399, 400). The first was a reaction to the death of Turner's friend Sir David *Wilkie and is dark and funereal in colouring, being dominated by blues and blacks. To this Turner juxtaposed *War*, a depiction of *Napoleon on St Helena, which is dominated by reds and oranges. The following year saw the pairing of *Shade and Darkness—the Evening of the Deluge* and *Light and Colour (Goethe's Theory)—the Morning after the Deluge—Moses writing the Book of Genesis* (BJ 404, 405). In this case Turner seems at first to have envisaged the *Evening of the Deluge* as a separate painting, there being what appears to be a preliminary version, close in size and composition, which, however, differs in colouring and would not have illustrated *Goethe's colour theories (National Gallery of Art, Washington; BJ 443).

From 1840 onwards Turner exhibited a whole series of Venetian subjects on a new small format, some at least of which were designed to be seen as companion pairs. However, it was not until 1845 that Turner's titles suggested a deliberate pairing of subjects with *Venice, Evening, going to the Ball* and *Morning, returning from the Ball, St. Martino* (BJ 416, 417). The other Venetian pictures of the same year were probably also designed as a pair, *Venice—Noon* and *Venice—Sunset, a Fisher* (BJ 418, 419). The following year he exhibited another pair, *Going to the Ball (San Martino)* and

Returning from the Ball (St. Martha) (private collection; BJ 421, 422).

These are the last of Turner's Venetian subjects but in 1845 he had also exhibited the first two of what were to be four paintings on *whaling subjects, both entitled *Whalers* (Tate Gallery and Metropolitan Museum, New York; BJ 414, 415). The following year saw '*Hurrah! For the Whaler Erebus! another Fish!*' and *Whalers (boiling Blubber) entangled in Flaw Ice, endeavouring to extricate themselves* (BJ 423, 426). In 1846 Turner also exhibited the rather strange pairing of *Undine giving the Ring to Massaniello, Fisherman of Naples* and *The *Angel standing in the Sun* (BJ 424, 425). These were his last pictures on square canvases. In the last year in which he exhibited, 1850, he capped his career by exhibiting four pictures on the theme of *Aeneas and Dido (BJ 429–32). MB

COMPANIONS ON TRAVELS. Turner has the reputation of a solitary but he greatly enjoyed society at home and abroad when he was not working. He intensely disliked being watched sketching—one of the chief aims of his travels—but he sometimes allowed close friends to be nearby. He rarely made an entire tour with another person, though he did so on a few occasions when it suited him.

In spring 1798 he spent three days on a sketching tour of Kent with the Revd Robert *Nixon and Stephen Rigaud, a fellow pupil at the *Royal Academy Schools, who later recalled Turner's reluctance to drink wine when they stopped for refreshment. He was not so abstemious on his *Devon tour in 1813; one of his companions there, the journalist Cyrus Redding, testified to Turner's generosity as a picnic host while another, the painter Charles *Eastlake, left an account of his secretive sketching habits. In July 1816 Turner spent a week travelling in northern England with the *Fawkes family but he then left them to journey alone and make sketches. In 1831 he explored (and sketched) parts of Scotland under the guidance of Sir Walter *Scott's publisher Robert *Cadell, the writer himself sometimes accompanying them.

Turner's companions on the Continent were extremely diverse in background. He made his first visit abroad in 1802 with the north-country squire Newbey Lowson, a friend of the Earl of *Darlington who was one of the tour's sponsors. In 1819 he travelled to *Italy alone (though an Irishman, Robert James Graves, later claimed to have been with him); in *Rome he was too engrossed in work to see much of his friend *Chantrey and in *Naples he refused to go out sketching in company; however, he was prudent enough to join a party to ascend *Vesuvius, thus meeting the young architect T. L. Donaldson, with whom he also dined with

the British Minister. In the 1820s and 1830s Turner generally travelled through Europe alone but in 1828 he shared rooms and a studio with Eastlake in Rome for some weeks and lived a very sociable life there. The tour through *France to the *Val d'Aosta which he made with H. A. J. *Munro of Novar in 1836 was apparently proposed by the artist as a cure for his patron's low spirits. In 1840 he travelled part of the way to *Venice with an unidentified couple, Mr and Mrs 'E.H.', whose existence is known only from a letter. In 1844 he claimed to have crossed the *Alps with the artist, geologist, and authority on Alpine passes, William Brockedon, but this claim should perhaps not be taken literally. CFP

COMPETITION WITH OTHER ARTISTS. Although Turner assimilated the stylistic influence of many of his artistic forebears and contemporaries, this engagement should not necessarily be interpreted as competitiveness, for clearly it derived from the teachings of *Reynolds, who had recommended such assimilation. However, on occasion Turner did openly compete with other painters, either by means of stylistic emulation, through the adoption of subjects associated with those figures, or by heightening the visual impact of his oils during *Varnishing Days at the *Royal Academy or *British Institution where works were habitually hung frame-to-frame and the colour and tonality of an image could radically affect the appearance of its neighbours.

In 1800 Turner was commissioned by the third *Duke of Bridgewater to paint a pendant to his Willem *Van de Velde the Younger, A Rising Gale (now in Toledo, Ohio). The resulting 'Bridgewater Seapiece' (*Dutch Boats in a Gale, RA 1801; BJ 14) was undoubtedly a competitive response to the earlier master, although any such competitiveness cannot wholly be ascribed to Turner as it was a necessary by-product of the commission.

In 1805 competitiveness also dictated the imagery of Turner's The Deluge (BJ 55), which may have been exhibited in the painter's own gallery that year and certainly was displayed at the RA in 1813. The work was inspired by Nicolas *Poussin's rendering of the same subject which Turner had scrutinized in the Louvre in 1802. We know from a passage in Turner's 'Backgrounds' *perspective lecture manuscript that, although he thought the colouring of Poussin's painting muddily appropriate to its subject, he also found its depiction of natural processes, structures, and effects seriously deficient; by treating those selfsame components in a much more accurate and dramatic fashion, Turner was consciously attempting to improve upon his predecessor.

Between 1807 and 1810 Turner created a small group of paintings in the style of David *Teniers the Younger. These pictures included A *Country Blacksmith disputing upon the Price of Iron (RA 1807; BJ 68), The Unpaid Bill (RA 1808; private collection, USA; BJ 81), and Harvest Home (c.1809; BJ 209). Here Turner not only reworked the types of subject matter explored by Teniers but simultaneously challenged David *Wilkie's (perhaps more successful) post-1806 attempts to build upon the Flemish painter's achievement. Yet this apparent competitiveness with Wilkie may have been dictated not by pique at the latter's success (as is usually argued), but instead by annoyance at the public's failure to recognize that he had been drawing upon Teniers for much longer than Wilkie—indeed, he had done so as early as 1801 for the figures included in the 'Bridgewater Seapiece'.

In 1814 Turner submitted the most *Claudian of all his oil paintings, *Apullia in Search of Appullus (BJ 128), to the annual competition for the Premium or prize for the 'best landscape' painting that was offered annually by the BI. However, he made clear his scorn for the Premium by submitting his work eleven days after the competition deadline had lapsed, while through his underlying choice of subject—the perils of mimicry—he derided three matters simultaneously: the mindless guying of Old Master paintings, as encouraged by the BI; his arch-enemy, Sir George *Beaumont, who was a leading light in the BI and an advocate of such copying there; and art prizes as conferred by dilettanti like Beaumont.

In 1818 Turner exhibited *Dort, or Dordrecht. The Dort Packet-Boat from Rotterdam becalmed at the RA. This oil (Yale Center for British Art, New Haven; BJ 137) may have doubled as a *tribute to *Cuyp (who hailed from Dordrecht) but equally it could have been intended to challenge *Callcott, whose similarly Cuypian Entrance to the Pool of London had been shown on the same walls two years earlier. Moreover, the word 'becalmed' in the title may have alluded to Callcott's difficulties in completing a commissioned view of Rotterdam at the time.

It was frequently related by *Ruskin during and after the 1840s that at the 1826 RA exhibition Turner had purposely darkened his oil painting Cologne (Frick Collection, New York; BJ 232) in order to lessen its visual impact upon adjacent portraits by *Lawrence. However, this seems impossible, given 1826 newspaper reports of the work's brilliance of colouring. On the other hand, in 1827 Turner certainly did brighten parts of Rembrandt's Daughter (Fogg Art Museum, Cambridge, Mass.; BJ 238) in order to put down an adjacent portrait by *Shee, while in that same exhibition a jocular competitiveness entered the title of 'Now for the Painter', (Rope) (City of Manchester Art Galleries; BJ 236). By such means—and in a customarily opaque manner—

Turner referred to similarly titled contemporaneous works by *Stanfield and Callcott.

At the 1832 RA exhibition Turner indulged in what was perhaps his most (in)famous act of competitiveness. On the first of the five Varnishing Days he placed a circular dab of red lead amid the otherwise cool tonalities of *Helvoetsluys* (Tokyo, Fuji Museum; BJ 345) which hung next to *Constable's *Opening of Waterloo Bridge* (Tate Gallery). As C. R. *Leslie commented, 'The intensity of the red lead, made more vivid by the coolness of [Turner's] picture, caused even the vermilion and lake of Constable to look weak.' Constable grumbled, 'He has been here and fired a gun' (Leslie 1860, i. p. 202). Four days later, when the paint had set, Turner shaped the blob into a buoy. But this addition was not merely visual competitiveness on Turner's part—clearly it was also an act of revenge, for in 1831 Constable had sat on the RA hanging committee and replaced Turner's painting *Caligula's Palace and Bridge* (BJ 337) with his own *Salisbury Cathedral from the Meadows* in order to hang the latter in the more advantageous position. When Turner had confronted him over this substitution Constable had been unable to account for it convincingly and, as David *Roberts recorded, 'looked . . . like a detected criminal' (see Guiterman 1989, p. 4).

In the same 1832 exhibition Turner also competed good-humouredly with his friend George *Jones. Ahead of the show both artists had agreed to paint the identical subject of Shadrach, Meshech and Abednego in the burning fiery furnace, and when their efforts were hung Turner attempted to get Jones's painting swapped with his own identically sized panel (BJ 346) in order that it might be seen to better advantage. This lesson in selflessness was surely aimed at Constable. Turner further competed with Jones over a common subject in 1842, when both artists depicted the burial at sea of Sir David Wilkie the previous year; Turner's oil (BJ 399) was acknowledged by Jones to be the better (see *PEACE*).

In the 1833 RA exhibition Turner competed with both Stanfield and Jones. Upon learning that the former was producing a Venetian scene for the show, he too set about creating one, namely *Bridge of Sighs, Ducal Palace and Custom-House, Venice: Canaletti painting* (BJ 349). When this oil was hung Turner heightened the blue of its sky in order to put down the strong blues in an adjacent painting by Jones; the latter, however, cleverly outflanked him by toning down his own blues, thus making Turner's blues appear much too strong. Turner conceded the victory.

Turner also heightened the blue sky in *Undine giving the Ring to Massaniello* (BJ 424), hung at the RA in 1846 next to a work by Roberts that he wished to overpower by such colouring. However, in 1847 Turner may have adjusted the colouring of a rainbow in *Maclise's *Sacrifice of Noah* because it was somewhat overpowered by the intensity of his own, adjacent *Hero of a Hundred Fights* (BJ 427). Clearly, what he took competitively with one hand he could give back with the other.

Turner's last competitive act may have been his bequest of *Dido building Carthage* (BJ 131) and *Sun rising through Vapour* (BJ 69) to the National Gallery, London, to hang alongside two Claudes in perpetuity because he wanted to rival the French master, although his offering could equally have been an act of homage—there is no way of knowing for sure. ES

CONDITION AND CONSERVATION OF TURNER'S OIL PAINTINGS.

Turner's paintings have altered in appearance with time: so have all 19th-century paintings, to a greater or lesser degree. Many of his paintings which were highly regarded when painted have altered more than most. This applies particularly to early ones.

One change in the case of Turner's paintings is loss of colour, notably in red and yellow areas. Examples can be found by examining context, as in the Dutch flags of *Van Tromp going about to please his Masters* (RA 1844; Getty Museum, California; BJ 410), one of which has lost colour in the red portion and another, less usually, in the blue. Another approach is to compare contemporary descriptions with actual appearance, which implies that *Apollo and Python* (RA 1811; BJ 115) appears now to have lost all the 'gleams . . . of blue and gold' which Ruskin praised (*Works*, vii. p. 409). This leaves one wondering how much Turner's sunsets may have lost, for it is much harder to envisage their original appearance. Close examination may reveal that an entire pink sunset has gone, as in *Waves breaking against the Wind* (c.1835; BJ 457), where the pink sunset is preserved on the right side where the frame covered it, and its original extent can be inferred from microscopical examination. Analysis can reveal unusually well-preserved glazes and materials, such as the gum benzoin and iodine scarlet found in glazes on the never-cleaned *The *Fighting 'Temeraire'* (RA 1839; National Gallery, London; BJ 377; see Egerton 1995, pp. 121–3), or their loss from many paintings. For example, traces of copper can be detected in the brownish clouds of *River Scene with Cattle* (?Turner's gallery 1809; BJ 84), which can only represent the base of faded red lake pigments. Unfortunately, the depth and tone of the original colours in such cases are always open to interpretation.

Equally severe, but less readily appreciated, are the changes wrought in the painting by ageing and alteration of the paint medium, and by inappropriate conservation treatments dating from the 19th century. *Ruskin wrote, 'No

picture of Turner's is seen in perfection a month after it is painted. The *Walhalla* cracked before it had been eight days in the Academy rooms. . . . It is true that the damage makes no further progress after the first year or two' (*Works*, iii. p. 249 n.). Yet changes have occurred in the decades since Ruskin wrote this. Turner's *megilps and other modified media such as bitumen with oil darken gradually, and show more contrast with the lighter areas of sky and water than originally they would have done. When this effect is pronounced, a paintings conservator may control the thickness and gloss of a replacement varnish to minimize these differences, or may add a warm glaze on top of that varnish (which ensures it remains easily removable) to modify the unaltered areas which now 'stand out' from the altered ones.

Differential drying rates of Turner's modified oil media (see TECHNIQUES) lead to cracks, both in the days following painting and for many years later, at a rate that is dependent on the painting's history of care. Fine-scale wrinkling can also occur as these materials dry, and this can spoil the effect of a glossy shadow. Turner's finished paintings in the Turner Bequest, that is the ones that stayed in his studio until his death, tend to have wider and more disruptive cracks in the bitumen-rich areas than finished paintings which are now in other collections. In other words, Turner's neglect of the paintings in his studio has adversely influenced their condition today. Some of these cracks continued to grow and change during this century, until the Turner Bequest was moved to air-conditioned galleries, as has been noted for *Interior at Petworth* (*c*.1830–7; BJ 449). They can be seen at their worst in the foreground of *The *Opening of the Wallhalla, 1842* (RA 1843; BJ 401), where they disrupt the group of figures. These could well be the cracks Ruskin meant, though the greater part of the surface has cracks by now. Many of the narrow ones in the sky are ageing cracks, inevitable in a painting of this age and not too disruptive to the viewer. The cracks in the *Wallhalla* are unevenly distributed over the sky though, and this is because Turner added both heat-bodied oil (linseed or walnut oil which has been heated for several hours, to alter its drying time) to lengthen the working time, and oil of turpentine as a thinner, which combined in some proportions to give paint which dried well, while in others it cracked on drying. Not all skies were so badly affected, but this is a very large painting, which may have required these special measures to keep the paint wet over the whole of the sky while Turner was working.

The cracks are rendered more noticeable if they are filled with dirt or deeply yellowed varnish. Generally, such accretions can be removed during removal of the varnish, though for Turner's paintings this is a task which demands skill and judgement out of the ordinary, since different surface layers and underlayers have different solubilities in the solvents used for cleaning, and the varnish removal can be a very slow and painstaking process. It is made much more difficult by the presence of beeswax in the paint, for wax is readily affected by solvents, and areas which might include wax may all have to be cleaned while the conservator views the surface through a microscope.

But damage caused during lining may make all this even more difficult. Lining traditionally involved protecting the paint surface as the painting was laid face down, spreading hot glue over the canvas from the back, placing a new canvas on top, and ironing them together, with irons heated on a stove or fire. This process flattened the paint, and made the whole canvas as stiff as a board. But worse followed for a few of Turner's finished oil paintings, for some of the wax- and bitumen-based paint media softened during lining and trapped dirt and discoloured varnish within existing cracks, an effect which is noticeable in light-coloured passages. This problem is most common in finished paintings of the 1840s, many of which appear to include wax/oil and wax/bitumen/oil mixtures. The earlier paintings tend to suffer more from flattening of the paint during lining: areas of impasto retain the effect of brushmarks only where the paint was stiff and textured originally. Generally the degree of damage varies over a large painting. Details, especially in the foreground, become much harder to interpret. The water in The *Shipwreck* (Turner's gallery 1805; BJ 54) has suffered from this effect.

Even when lining has not had such dire consequences, the yellowing of megilped glazes may make them stand out more than they were intended to. Glazes which should have been subtle now look obvious on close inspection, as in the skies of *Van Tromp* and *Snow Storm—Steam-Boat off a Harbour's Mouth* (RA 1842; BJ 398). These can be compared to *Peace—Burial at Sea* (RA 1842; BJ 399), which was also successfully lined: the corners once protected by an octagonal matt were left unglazed when Turner completed the rest, and can be compared to the highly glazed water. Individual glazes remain too subtle to be differentiated, though they make an impressive collective contribution to the appearance of the sea and the ship. *Venice* (RA 1840; Victoria and Albert Museum; BJ 384) also seems to retain very beautiful glazes, seen as warm reflections of the water on the white buildings and within the watery foreground—yet it was considered to be a damaged painting by the end of the 19th century. So much had it declined from its original splendour, that it was chosen to be preserved in an evacuated case, as a last resort and as an experiment in preventive conservation (British patent no. 6556). It remains there to this day, though surely air must have diffused in by now. A

visual comparison between it and the other Turner oils of that decade now suggests that *Venice* is very well preserved! Yellowing of medium and varnish, traditional glue lining, and removal of the varnish at least once, has been the fate of the others, and these processes have taken a toll.

Unfinished paintings, never varnished by Turner, are still generally close to their original appearance. *Waves breaking against the Wind* has not altered in texture, nor has the medium darkened, though as mentioned earlier one important area has lost colour. This, and others from the 1830s, were not lined until recent decades, when more sympathetic methods, and better means of controlling the lining temperature, had been developed. *The Fighting 'Temeraire'*, with its rare surviving glazes, is one of the better examples of a Turner oil painting which cannot have departed too much from its original appearance, except that its original varnish is much yellowed now. But it remains one of the few examples of a Turner oil where it is clear that none of his subtle glazes can have been removed. JHT

CONDITION AND CONSERVATION OF TURNER'S WATERCOLOURS. A significant minority of Turner's finished watercolours has been damaged by over-exposure to light, probably in the 19th century, but the great majority is in excellent condition, and enable one to envisage how the damaged ones may once have looked. It was the sorry condition of some of Turner's watercolours and oils that prompted the first systematic investigations into the causes of their deterioration in the decades after Turner's death (W. J. Russell and W. de W. Abney, *Action of Light on Watercolours*, 1888). Light causes two main colour changes: yellowing of the paper support, and fading of some pigments. Both effects can be discerned in the early stages if the edges of the watercolour have been covered by a mount, and thus protected from the light. The yellowing of a white paper support, or the fading of a blue paper support followed by yellowing, are irreversible in practice, since the bleaching of the whole sheet would almost certainly damage some of the pigments (H. Norville-Day, J. H. Townsend, and F. Johnston, 'A Study of the Effects of Bleaching Treatments on 19th-Century Pigments, with Special Reference to Turner's Watercolour Palette', *Institute of Paper Conservation '97 post-prints*). The fading of pigments is also irreversible, and it is impossible to judge what nuances of tone may have been lost. For example, Turner rarely painted a grey sky simply with black pigment. He tended to use a mixture of greenish Prussian blue and vermilion, perhaps toned locally with black: the blue can fade, leaving a 'sky' in shades of red and grey. If he used indigo instead of Prussian blue, fading was more likely. Some of the yellow lake pigments (most of

Turner's yellow lakes are based on flavonoid-type dyes such as quercitin), and the madders on a variety of bases are susceptible to fading, but in practice it is not so easy to observe this as it is to note the loss of blue, for these colours are more usually applied as localized washes which do not run out to the edges to be protected by a mount. The yellow lake pigments may also have been mixed with blue pigments such as Prussian blue to form green, in which case the yellow would be expected to fade first, leaving bluish green foliage.

Turner used a great many pigments in watercolour which were traditionally used in oil painting, and most of these do not change colour when exposed to light. No colour change is to be expected to the pale chrome yellows, the natural ultramarine blue used for skies, the emerald green highlights, or the delicate vermilion sunsets so characteristic of his later work. However, it is never advisable to display watercolours continuously, or in stronger lighting than is necessary for their full appreciation, since many will include at least one light-sensitive pigment.

Watercolours are not prone in general to cracking and paint loss, though some of the thicker paint in Turner's gouaches on blue paper has cracked, and in extreme cases flaked off. Nor have past conservation treatments altered the texture of works on paper as badly as lining treatments have done to many oil paintings. Without doubt, many more watercolours survive unaltered than do oil paintings. JHT

CONISTON FELLS, see *MORNING AMONGST THE CONISTON FELLS*.

CONSTABLE, John (1776–1837), English landscape painter and contemporary of Turner. Born at East Bergholt, Suffolk, son of a corn and coal merchant and farmer, Constable worked in the family business before gaining permission to study art. He entered the *Royal Academy Schools in 1799 and first exhibited at the RA in 1802, the year that Turner (only fourteen months his senior) was elected RA. Aiming to introduce a greater degree of naturalism into landscape painting, Constable began making outdoor oil studies in 1802 and by 1810 had developed a new oil sketching style that caught the light, colour, and movement of nature as he perceived it. Outdoor oil sketching (together with drawing) was the basis of Constable's practice, not the intermittent activity it was with Turner. Between 1814 and 1817 Constable went further, painting exhibition pictures largely on the spot. Following marriage to Maria Bicknell in 1816 and a more permanent move to London, he began a series of 6 ft. canvases of River Stour subjects which was to include some of his most famous images (*The White Horse*, 1818–19, *The Hay Wain*, 1820–1, *The Leaping Horse*, 1824–5,

and so on). The full-size studio sketches he made for these were another of his major innovations. Constable continued to paint outdoors, notably at Hampstead, Salisbury, and Brighton, places that provided fresh material for his large studio pictures. He never ventured out of England.

Constable's career, unlike Turner's, progressed slowly. He had to wait until 1819 to be elected an ARA and another ten years for full membership of the RA. Nor did he achieve anything like Turner's reputation or commercial success. The high point of his critical reception came in 1824, when three of his paintings were shown, to much acclaim from *Delacroix and others, at the Paris Salon. Constable was encouraged, telling his close friend Archdeacon John Fisher that he felt 'the honour of having found an original style & independent of him who would be Lord over all—I mean Turner' (Beckett 1968, vi. p. 191). Constable, however, was by no means neglected in the British press and comparisons with Turner were frequent, Constable being seen to represent the outward look of nature, Turner its essence. Constable, in his later works, was also regarded by some reviewers as imitating Turner's eccentricities.

Constable's first recorded reference to Turner is in Farington's diary entry for 29 April 1801: Constable admired *Dutch Boats in a Gale (BJ 14) but said he knew the Van de Velde upon which it was based. Qualified admiration characterizes many of Constable's remarks about Turner. Of his 1826 exhibits Constable wrote, 'Turner never gave me so much pleasure—and so much pain—before' (Beckett, vi. p. 220). But occasionally the praise was more fulsome. 'I remember most of Turner's early pictures,' Constable wrote in 1832, '. . . Amongst them was one of singular intricacy and beauty, it was a canal with numerous boats, making thousands of beautiful shapes, and I think the most complete work of genius I ever saw' (Beckett, iii. p. 58; *Sun rising through Vapour and *Dort, BJ 69 and 137, have both been proposed as the work in question).

Constable appears to have met Turner for the first time on 28 June 1813, when he sat next to him at the annual RA dinner. 'I was a good deal entertained with Turner', he told Maria Bicknell, 'I always expected to find him what I did—he is uncouth but has a wonderfull range of mind' (Beckett, ii. p. 110). From 1818 the two men came across each other at meetings of the *Artists' General Benevolent Institution, of which Turner was Chairman and Constable a Director. It was a cause both believed in passionately. Their personal relations, however, remained ambivalent. When Constable called on Turner in February 1828 to canvass support for election to the RA, Turner 'smiled and shook his head & asked me what I wanted, *angry* that I called on a Monday afternoon' (Beckett, iii. p. 13). Nevertheless, Turner, with

George *Jones, paid a late call on Constable when he was finally elected an RA the following year. 'We parted at one o'clock this morning, mutually pleased with one another', Constable told J. J. Chalon (Beckett, iv. p. 277). Despite this show of friendship, the two men continued to cross swords. There was a row over the hanging of *Caligula's Palace and Bridge (BJ 337) at the RA in 1831, when Constable was on the Hanging Committee and reportedly had given his own Salisbury Cathedral from the Meadows a better position. Similarly, the following year Turner was put out by the unusually high colour key of Constable's The Opening of Waterloo Bridge and reacted by adding an intense red buoy to his otherwise cool Helvoetsluys (Tokyo, Fuji Museum; BJ 345), which hung next to it. The Earl of Egremont tried to get the two artists together at Petworth in September 1834 but Turner arrived after Constable had left. C. R. *Leslie and his family were also staying. Turner rigged out for the young Robert Leslie a model boat which Constable had begun, assuring him that Constable knew nothing about ships. What, more generally, Turner thought of Constable as an artist can only be guessed, but it seems unlikely that he learned anything from him. Equally, Constable's admiration for much of Turner's work did not result in the adoption of Turnerian ideas or methods, though The Opening of Waterloo Bridge—an unusual work for Constable—may owe something to him; connections between the *Liber Studiorum (of which Constable owned a copy) and Constable's own mezzotint series, English Landscape (1830–2), have also been traced.

The majority of Constable's works were still with him when he died and studio sales in 1838 dispersed comparatively few of them. As a result, his last surviving child, Isabel, was able to give or bequeath a large collection to the nation in 1887–8. This is now shared, in London, between the National Gallery, Tate Gallery, Victoria and Albert Museum, and British Museum. Major retrospectives were held at the Tate Gallery in 1976 and 1991. LP

C. R. Leslie, *Memoirs of the Life of John Constable, Esq. R.A.*, 1843, 2nd edn. 1845, ed. Jonathan Mayne 1951.
Beckett, 1962–8.
Graham Reynolds, *The Later Paintings and Drawings of John Constable*, 2 vols., 1984.
Leslie Parris and Ian Fleming-Williams, *Constable*, exhibition catalogue, London, Tate Gallery 1991.
Graham Reynolds, *The Early Paintings and Drawings of John Constable*, 2 vols., 1996.

CONTEMPORARY SUBJECTS. The architectural and picturesque ingredients of Turner's early watercolour topography were soon modified by his sharp observation of contemporary life, whether industrial activity in Wales or the Midlands, or fishing off the Kent coast. If the technologies

he drew were not necessarily new, they were at least current, while in his capacity as an architectural draughtsman he had to render buildings under construction or give a convincing impression of them once finished. His watercolour *The *Pantheon, the Morning after the Fire* (RA 1792; British Museum; W 27) combined his architectural skills with topical reportage, while *Wolverhampton* (RA 1796; Wolverhampton Art Gallery; W 139) is enlivened by a busy fairground scene. Such well-observed activities, characteristic of place and time, are as fundamental to the appeal and message of Turner's topography as its historical allusions, and are related to the wider concern with modern history and experience that increasingly appeared in his work and inspired some of his most important pictures.

Turner's *Views of the *Southern Coast* (R 88–127) marked his first attempt to sustain his documentary approach to his own time across a series of images; they were conceived as an investigation of the condition of a vital maritime frontier during and after the Napoleonic wars. The impact of war on the people and landscape of Britain necessarily sharpened Turner's contemporary sense, and it is significant that it had been in marine subjects that Turner's oil paintings had first acquired a contemporary feel. While its debts to earlier Dutch painting were clear, *Calais Pier* (RA 1803; National Gallery, London; BJ 48) was also topical in its depiction of an English packet arriving in French waters during the Peace of Amiens in 1802, while the patriotic propaganda surely already latent here became more dominant in a series of *Thames estuary oils shown later in the decade in *Turner's gallery, in which the Navy is a reassuring presence in its home waters around the Nore and the very real threat of French incursion up river is implicitly denied. Turner added similar messages to English landscapes; *Ploughing up Turnips near Slough* (Turner's gallery 1809; BJ 89) shows the intensive crop production then being encouraged to serve wartime needs.

Turner's first overt work of modern history had been the lost *Battle of the Nile* (RA 1799; untraced; BJ 10). This was followed by his first treatment of *The Battle of Trafalgar,* (Turner's gallery 1806; BJ 58), and by pictures of the *Victory returning from Trafalgar* (?Turner's galley 1806; Yale Center; BJ 59) and of Danish ships taken at Copenhagen arriving at Spithead (Turner's galley 1808; BJ 80; see DENMARK), informed by his researches and drawings made as the vessels reached Britain. Here the events of the war coincided with his ambitions as a history painter, but his *Field of Waterloo* (RA 1818; BJ 138) was, like the verses by *Byron that he quoted with it—thus adding a further layer of topicality to the work—finely balanced in its sympathies for the dead of both sides, and avoided jingoistic celebration. While

Turner now shared some of the criticism levelled at the supposedly unpatriotic Byron, his lament for the horrors of war rose to the requirements of history as a universal art while being again based on his researches on a visit to Waterloo in 1817 (TB CLX).

The *Dort* (RA 1818; Yale Center for British Art, New Haven; BJ 137) that also arose from that expedition, and the later *Harbour of Dieppe (Changement de Domicile)* and *Cologne. The Arrival of a Packet Boat, Evening* (RA 1825, 1826; both in the Frick Collection, New York; BJ 231, 232), all celebrate the revival of peaceful travel in post-war Europe, while new leisure activity at home was the theme of two oils of the *Cowes regatta (RA 1828; BJ 242, 243) and related oil sketches painted before the motif. These last were commissioned by John *Nash, of whose home and society on the Isle of Wight Turner painted and drew some lively and personal sketches, just as he did at other patrons' houses like Cassiobury (see ESSEX) or *Petworth. For *Fawkes at Farnley, he made more finished subjects of the house, its estate, and social and sporting activities; together with the Petworth sketches, these are unrivalled for their portrayal of early 19th-century country house life. They show the same acute observation that he now brought to topographical projects; series such as the *Rivers and *Ports of England, the *Loire and *Seine views, and especially *Picturesque Views in *England and Wales* are filled with documentary detail and the latest constructions and industries while maintaining an overarching sense of transition and progress in the post-war period.

Turner's continuing ambitions as a painter of contemporary history—and presumably hopes of royal patronage—took him to *Edinburgh in 1822 to witness *George IV's official visit to Scotland; no commission ensued and his oil sketches (BJ 247–48b) remained unfinished, but about this time he began work on his largest oil, *The Battle of Trafalgar* (1824; National Maritime Museum, Greenwich; BJ 252). This was a royal commission, but was widely regarded as a failure. For once Turner seemed overwhelmed by the scale and—by 1824—the relative distance of this great national subject, and achieved none of the impulsive spontaneity that he brought to his two pictures of the *Burning of the Houses of Lords and Commons* (1835; BJ 359, 364; see PARLIAMENT)—an event he witnessed and whose significance as a symbol of the passage of an old order to a new around the time of the *Reform Bill he surely grasped.

Transition was also the theme of *The *Fighting 'Temeraire'* (RA 1839; National Gallery, London; BJ 377), but Turner responded enthusiastically elsewhere to the new steamboats, which he used frequently, as he did to other new technologies such as the Manby apparatus (see LIFE-

BOAT AND MANBY APPARATUS) or improved flares. Ironically *Rockets and Blue Lights* (RA 1840; Sterling and Francine Clark Art Institute, Williamstown, Mass.; BJ 387), showing the latter in action, was to be run into by a train in 1857, but was not damaged. Turner's *Rain, Steam and Speed* (RA 1844, National Gallery, London; BJ 409) is a positive depiction of the Great Western Railway and a work in which he seems already to be assuming a role as a definitive celebrant of modern life comparable to that later claimed by the Impressionists. His outlook on progress was shaped by connections with leading scientists, inventors, and engineers, and contrary attempts by *Ruskin and others to co-opt him into their own retardataire programmes must be regarded with caution. DBB

Shanes 1979, 1981.
Egerton 1995.
Rodner 1997.

CONVICTS AS SUBJECT MATTER. Although Turner painted many serious *contemporary subjects, he made few overt references to convicts: the dismasted ships in his English marine views are rarely, if ever, prison-hulks while the prisoners toiling in his *Forum Romanum* (1818; National Gallery of Canada, Ottawa; W 705) are shown merely as labourers, not as a chain-gang. His most famous denunciation of oppression is his indictment of the slave trade, *Slavers throwing overboard the Dead and Dying* (RA 1840; Museum of Fine Arts, Boston, Mass.; BJ 385), but that painting is not alone in its concern for human rights. He took the equally brutal and inhumane treatment of convicts as his subject after hearing of the wreck of the British female convict-ship *Amphitrite*, which was deliberately allowed to go aground in September 1833, causing the deaths of 125 women and their infant children. The ship was sailing from Woolwich to Botany Bay when it was caught in a violent gale close to the harbour of Boulogne. Its captain refused any assistance from the French, claiming he had no authority to disembark passengers except in New South Wales. In Turner's huge depiction of the ensuing wreck, *Fire at Sea* (? c.1835; BJ 460), a host of women and infants cling pathetically to each other amid turbulent waves or are hideously swept apart. It was never exhibited by Turner himself, who may have felt its subject too controversial for public display, and it was given a title only when catalogued as part of the Turner Bequest; since publication of the above analysis of its content, it has been on show at the Tate Gallery as *A Disaster at Sea*. CFP

Powell 1993, pp. 14–15.

CONWAY. The walled medieval town of Conway, with its many-towered castle, was a focus for Picturesque (see SUB-LIME) tourism in the late 18th century. Turner made several drawings of it in his 'Hereford Court' Sketchbook (TB XXXVIII: 50–4). One of these has inscribed on the back a list of commissions: for 'Revd Mr Lancaster', 'Barrington', 'Revd Mr Dunford', and 'Revd Mr Ogle'. It is not surprising, then, that many watercolour views of Conway exist. They are mostly variants on a standard composition, showing the castle on the left seen across water, as in the sketch on XXXVIII: 52. The grandest of these watercolours, now in the Getty Museum, California, was formerly in the collection of the Viscounts Gage at Firle Place (W 270). A large oil of the same subject was executed for William Leader; Butlin and Joll date this to about 1803 but it was probably begun rather earlier (Trustees of the Grosvenor Estate; BJ 141). AW

COOKE, George (1781–1834), British engraver. His interest in Turner was stimulated by an *Oxford Almanack subject engraved by his master James *Basire, to whom he was apprenticed in 1795. Cooke produced some twenty line-engravings after Turner between 1813 and 1826; his plates appear in *Hakewill's *Picturesque Tour of Italy* (1818–20), Allason's *Antiquities of Pola* (1819), and *Provincial Antiquities of Scotland* (1819–26), but he is chiefly known for his engravings for *Picturesque Views of the *Southern Coast of England* (1814–26), a collaboration between Cooke and his elder brother William Bernard *Cooke. Cooke stopped working for Turner after the two men quarrelled over some *Southern Coast* proofs engraved by Edward *Goodall. GF

COOKE, William Bernard (1778–1855), British engraver and publisher, who collaborated with Turner on several important publishing projects, notably *Picturesque Views of the *Southern Coast of England* (1814–26). The series, a joint venture between Cooke and his younger brother George *Cooke containing 40 plates after Turner and 40 after other artists, was Cooke's first commission for Turner. Cooke subsequently commissioned Turner to produce designs for *Views in *Sussex* (1816–20), the *Rivers of Devon* (1815–23), the *Rivers of England* (1823–7), and *Marine Views* (1824–5). Though often fraught, the relationship between Cooke and Turner was nevertheless fruitful. Cooke organized annual loan exhibitions of drawings and watercolours, mostly by Turner, from 1822 to 1824. He also helped Turner to promote the *Liber Studiorum*; a flysheet advertising the series was inserted in one of the parts of *Southern Coast*, and there are several entries in Cooke's account-books documenting sales of the *Liber*. Sales of Cooke's print holdings, including many proofs after Turner, were held in 1828 and 1830. GF

COPIES AFTER OTHER ARTISTS. One aspect of Turner's respect for tradition and for the traditional ways of

learning to be an artist is his copying of the works of admired precursors, chosen from the wide range of artists who influenced him. The question of Turner's copies after Richard *Wilson is complicated by the possible mix-up at the National Gallery between pictures from the Turner Bequest and the Garnons Bequest of 1854, a group of works from Colommendy House near Mold, Wales, traditionally held to be unfinished works taken there by Wilson when he retired from London c.1780 (see Davies 1946, pp. 153, 167, 177). The arguments for reattributing three such pictures back to Wilson are given under BJ 545-7. Nor indeed is it impossible that Turner actually owned paintings by Wilson; he certainly owned an unfinished *Reynolds which again has been re-established as the work of that artist (BJ 548; see COLLECTOR, TURNER AS). Two paintings are, however, accepted as being by Turner after Wilson, *Diana and Callisto*, c.1796 (BJ 43), and *Tivoli: Temple of the Sibyl and the Roman Campagna*, c.1798 (BJ 44). Both may have links with Turner patrons, Sir Richard Colt *Hoare of Stourhead and the Revd Henry Scott *Trimmer respectively.

Turner also began a copy after *Gainsborough's *Wooded Landscape with Figures, Cows and Distant Flock of Sheep*, c.1746-7 (untraced; J. Hayes, *The Landscape Paintings of Thomas Gainsborough*, 1982, ii. pp. 340-1, no. 15, repr.). However, although the central part of the painting is the same, Turner reduced the trees on each side and added a windmill and a rainbow. Turner's copy has been dated c.1795-1800 (BJ 45). Turner had already copied a plate after Gainsborough from Joshua Kirby's *Dr. Brook Taylor's Method of Perspective Made Easy*, 1754, in about 1790 or possibly 1791 (Princeton University Art Museum; see Robin Hamlyn, 'An Early Sketchbook by J. M. W. Turner', *Record of the Art Museum, Princeton University*, 44/2 (1985), p. 22, no. 79v., repr.; Gage 1987, p. 22, repr.).

Other copies made for study reasons date from as early as 1787 (TB I: A, D, and H; after *Gilpin's *Northern Tour* and J. *Basire). On Turner's visit to *Paris in 1802 his interest in the Old Masters was reflected in copies after Raphael, *Titian, Correggio, Domenichino, *Poussin, *Rembrandt, and *Ruisdael (LXXII). Surprisingly *Claude was omitted, apparently because his works were particularly badly shown; his turn came in 1821 (CCLVIII). Turner's visit to *Rome in 1819 led to much scrappier copies after Titian, Claude, Annibale Carracci, and Bernini. There were also Old Masters at *Petworth and these appear both in Turner's interiors and in the individual copy of Van Dyck's *Portrait of Lucy Percy, Countess of Carlisle* (CCXLIV). The most meaningful of Turner's copies was that after the Petworth Claude, of *Jacob with Laban and his Daughters*, subtly modified in Turner's *Apullia in Search of Appullus* (BI 1814; BJ 128).　MB

Gage 1987, pp. 22, 97-123.
Powell 1987, pp. 65-71.
Butlin, Luther, and Warrell 1989, pp. 47-60.

COPIES AFTER TURNER, see FAKES AND COPIES.

CORN LAWS. Brought in after the defeat of *Napoleon in 1815, these measures imposed restrictions on the importation of foreign corn in order to keep the price of bread high and thus maintain landowners' incomes. The sufferings of the working classes in town and country were exacerbated by the continuance of these price levels. Turner had enjoyed close connections with landowners from early on in his career, and had depicted agricultural prosperity—the result of high prices—during the war years. In *Harvest Home* (c.1809; Tate Gallery; BJ 209), this prosperity is enjoyed by the Earl of Essex and his workers alike. Nevertheless, Turner's depictions of such 'benevolent' practices (see also AGRICULTURE AS SUBJECT MATTER) can perhaps be linked to other imagery suggesting that he was aware of the hard lot of rural labourers. In 1839 the Anti-Corn Law League was founded by manufacturers concerned to promote free trade in corn. They believed that repeal would lower the price of bread, thus alleviating hardship, preventing wage increases, and combating *Chartism among the working class, as well as diminishing the power of the landed interest. Tory followers of Sir Robert *Peel joined with the Whigs to vote for repeal of the Corn Laws in 1846. One of Turner's later patrons, the whaling entrepreneur Elhanan *Bicknell, is known to have been a dedicated free trader, supporting such measures in relation to his own industry in about 1835 even though his finances were adversely affected thereby.　AK

CORNWALL, the most western county of England, was visited by Turner on his tour of 1811 in connection with *Picturesque Views of the *Southern Coast of England*. The county is depicted by him as a combination of the historical and the contemporary, but also as a place where humanity struggles to maintain a foothold amidst economic vagaries and the forces of nature. All these features are present in a watercolour of the fishing village of St Mawes (c.1823; Yale Center for British Art, New Haven; *Southern Coast*; W. 473), which shows the disposal of unsold pilchards for fertilizer (Continental markets were closed owing to the Napoleonic wars when Turner visited), and in a view of St Michael's Mount (c.1836; University of Liverpool; *Picturesque Views in *England and Wales*; W 880), where, ironically, productive work is being performed upon wreck timber. The marine *Sublime, indeed, often triumphs over humanity in the Cornish context, as in *Entrance to Fowey Harbour* (c.1827; private collection, USA; *England and Wales*; W 801), where

shipwreck survivors are about to be washed against the rocks. AK

Shanes 1979, 1981, 1990.

Sam Smiles, 'Picture Notes: St Mawes', *Turner Studies*, 8/1 (summer 1988), pp. 53–7.

COTMAN, John Sell (1782–1842), English landscape painter. The son of a hairdresser, he came to London from Norwich in 1798 and the following year attended Dr *Monro's Academy. Attracted by the 'historical landscape' tradition of *Claude, and Turner's interpretation of it, he attended the Sketching Society, 1802–5. Tours of *Wales in 1800 and 1802 and of *Yorkshire, 1803–5, provided Cotman with a fund of sublime and mountainous subjects to which he returned all his life. In 1806 Cotman returned to Norwich to set up a drawing school; he remained in East Anglia until becoming drawing master at King's College School (possibly with Turner's endorsement) in 1834.

Cotman often made copies from Turner's work, for example *Harvest Dinner, Kingston Bank* (BJ 90), which he surreptitiously sketched when it was on view at Turner's gallery in 1809. Cotman made sketches from Turner's *Liber Studiorum* (issued from 1807) and Turner's printmaking enterprises inspired Cotman's three major excursions into antiquarian topographical printmaking: *Miscellaneous Etchings* (1811), *Architectural Antiquities of Norfolk* (1818), and *Architectural Antiquities of Normandy* (1822). Although more crisply delineated, watercolours like *Domfront*, 1823 (Courtauld Institute Galleries, London), from Cotman's last Normandy tour, vie with Turner in their panoramic breadth, sense of history, geological structure, and picturesque details. Cotman rivalled Turner's watercolours in technical innovation, employing stopping and scratching-out, thickening with gum, and vibrant colours. The interlocked flat washes of his magical Greta period (1805–6) are unique, but he shared Turner's relentless pursuit of new ways of expressing a Romantic vision.

The small oil on panel of *A Scene on the English Coast*, usually accepted as being a work by Turner of *c*.1798, has been tentatively attributed to Cotman by Martin Butlin (Phillips Collection, Washington; BJ 33a). SM

Sydney Kitson, *The Life of John Sell Cotman*, 1937.

Miklos Rajnai, ed., *John Sell Cotman 1782–1842*, exhibition catalogue, London, Victoria and Albert Museum, 1982.

COUNTRY BLACKSMITH DISPUTING UPON THE PRICE OF IRON, and the Price charged to the Butcher for shoeing his Poney, A, oil on pine, 21⅝ × 30⅝ in. (55 × 78 cm.), RA 1807 (135); Tate Gallery, London (BJ 68). Turner's first genre picture, surely designed to rival the young David *Wilkie, who had made a great success at the Royal Acad-

emy the year before with his *Village Politicians*; both ultimately depend upon *Teniers. The subject alludes to the Pig Iron Duty Bill which had caused a political storm in 1806. It was hung next to Wilkie's *Blind Fiddler* and, according to Wilkie's biographer Allan Cunningham, Wilkie's picture was 'flung into eclipse by the unmitigated splendour of a neighbouring picture, hung for that purpose beside it, as some averred, and painted into its overpowering brightness', this being Turner's work. Contemporary accounts were mainly favourable: 'a very clever picture' (Richard *Westall, RA), displaying a 'Considerable share of humour' (*St James's Chronicle*, 9–12 May), and with 'a great variety of appropriate forms managed with infinite skill' (*Cabinet or Monthly Report of Polite Literature*, February–June).

The painting was bought at the RA by Turner's patron Sir John *Leicester for 100 guineas. Sir George *Beaumont said that Turner had told Leicester that 'He understood Wilkie was to have 100 guineas for His *Blind Fiddler* & He should not rate His picture at a less price' (Farington *Diary*, 8 May). Turner bought the picture back at Christie's, 7 July 1827, for 140 guineas.

There is a sketch of a horse being shod in the 'Finance' Sketchbook (TB CXXII: 9) and another drawing in the 'Hesperides (1)' Sketchbook (XCIII: 22 v.). A rebate round the edge of the picture shows that it was finished in its frame.

 MB

Lindsay Errington, *Tribute to Wilkie*, exhibition catalogue, National Gallery of Scotland, Edinburgh, 1985, pp. 58–9, repr. pl. 45.

Whittingham 1986, pp. 26, 28–9, 34 n. 61.

COURTAULD GALLERIES, Somerset House, London, owns seventeen Turner watercolours. Four of these were bequeathed by Mrs Spooner in 1967, including *Drachenfels* (1817; W 667) and *Bregenz* (?1840; W 1350; as 'Locarno'), and thirteen were presented in 1974 in memory of Sir Stephen *Courtauld (1883–1967), Samuel's brother. This group ranges from *Chepstow Castle* (*c*.1793; W 88) to *Brunnen, Lake Lucerne* (*c*.1843; W 1485) and includes *The Upper Fall of the Reichenbach* (1802; W 362) and two later watercolours deriving from the 1802 journey, *Mer de Glace, with Blair's Hut* (1806; W 371) and *Courmayeur* (?1810; W 393).

Also notable are *Crook of Lune* (1816–18; W 575), engraved for *Whitaker's *Richmondshire*; *Colchester, Essex* (*c*.1826; W 789) for the *England and Wales* series, with a hare being chased by dogs across the foreground; two free sketches which belonged to *Ruskin, *Heaped Thunderclouds over Sea and Land* (W 1392) and *A Storm on Margate Sands* (W 1391), which have so far eluded precise dating— Wilton suggests ?1830s; and *Dawn after the Wreck* (*c*.1841; W 1398), with its famous image of the exhausted dog, sole

survivor of the disaster, howling on the shore in mourning for its drowned master beneath a sky flecked with scarlet clouds symbolizing death. This may now be retitled as the beach resembles that at Margate and so sunset not sunrise is depicted. EJ

Michael Kitson, *Turner Watercolours from the Collection of Stephen Courtauld*, 1974.

COURTAULD, Stephen (1883–1967), collector of Old Masters as well as British pictures by *Wilson, *Crome, and Turner, and watercolours by J. R. *Cozens. *Girtin, Turner, and *Cotman.

Andrew Wilton has convincingly suggested that Courtauld's view of *Bonneville (RA 1803; Yale Center for British Art, New Haven; formerly listed as BJ 50) should exchange titles with the former BJ 46 (also RA 1803; Museum of Art, Dallas, Texas) and so now becomes *Bonneville, Savoy with Mont Blanc*, BJ 46.

Courtauld's other oil, *On the River Brent* (c.1807–9; private collection; BJ 198), passed to a relation who sent it to Sotheby's on 13 April 1994 (lot 87), when it was bought in. The composition, apart from minor differences, is identical with a version in watercolour (untraced but sold at Sotheby's 13 November 1980; W 417). The two are virtually identical in size and therefore unique in Turner's œuvre although two versions of *Bonneville* (BJ 148 and W 354) are close.

Besides the Turner watercolours from his collection in the *Courtauld Galleries, Sir Stephen owned *Andernach* (c.1840; W 1319), which he gave to the University of Melbourne in 1947, and a watercolour catalogued by Wilton (W 1349) as 'Heidelberg?', ?1840, but later identified as a view of Bregenz in *Austria, which Turner passed through in 1840; it now belongs to a private collector in Bregenz. EJ

COUSEN, John (1804–80), English line engraver, specializing in landscape and popular as an engraver of book illustrations, including a number after Turner. He engraved five of the steel plates for the *Seine volumes in the *Rivers of France* series, including the dramatic moonlit scene *Light Towers of the Heve* for the frontispiece of the first volume (1834; R 453). Cousen also engraved four of the six plates in the so-called 'Dr. Broadley's Poems' series (R 638–43), which are notable for their lovely light effects. He also contributed several engravings to the *Turner Gallery. LH

COWES SKETCHES. In 1798 the architect John *Nash RA (1752–1835) built a house for himself on the Isle of Wight, East Cowes Castle overlooking the Solent. In 1827 he invited Turner to stay with a view to commissioning two pictures of the castle. Turner stayed for about six weeks, from late July until early September and, while there, wrote

to his father, still acting as his son's assistant aged 82, to send him one or, if possible, two pieces of unstretched canvas, either 'a 6 × 4 feet or a whole-length' (Gage 1980, pp. 108–9). It was on the former, cut in two, that Turner painted the nine Cowes sketches (BJ 260–8), six of which (three for each picture) he was to use as the basis for the two paintings featuring the Regatta, the second year that it had been held at Cowes: *East Cowes Castle, the Seat of J. Nash Esq; the Regatta beating to Windward* (RA 1828; Indianapolis Museum of Art; BJ 242) and *East Cowes Castle, the Seat of J. Nash Esq; the Regatta starting for their Moorings* (RA 1828; Victoria and Albert Museum; BJ 243). After the 1854 Schedule of the Turner Bequest was made, when the sketches were still rolled, they remained unseen until rediscovered in 1905 in the National Gallery, London. They were then divided into the nine separate subjects. One roll contained five sketches and the other four, but no record was kept of how they had been placed on the rolls. However, Martin Butlin has suggested that a plausible reconstruction is possible:

<div align="center">

FIRST ROLL

</div>

Between Decks (BJ 266) upside down	*Moorings 2* (BJ 264)
Windward 1 (BJ 260) upside down	
Study of Sea and Sky (BJ 268)	*Windward 3* (BJ 262)

<div align="center">

SECOND ROLL

</div>

Shipping off East Cowes Headland (BJ 267)	*Moorings 1* (BJ 263)
Moorings 3 (BJ 265)	*Windward 2* (BJ 261)

How and where were these painted? Graham Reynolds plausibly suggests that at least some of them were done on the spot, the *Moorings* sketches probably from somewhere on shore but the racing yachts requiring a different viewpoint; even Turner would have found it difficult to paint them from a vessel which was itself sailing. Perhaps *Between Decks*, which appears to have been painted aboard a man-of-war, provides a clue as to Turner's chosen position, most likely from a ship anchored off Cowes Roads but probably from one further offshore than the guardship clearly visible in the Indianapolis picture and in BJ 262.

It is clear from a study of the six sketches used that Turner painted them alternately on each roll so that Nos. 1 and 3 *Windward* sketches were painted on the first roll and No. 2 on the second, while Nos. 1 and 3 *Moorings* sketches were painted on the second roll and No. 2 on the first. As Butlin suggests, this would give an assistant time to adjust the roll for a new sketch, although the fact that two of the sketches on the first roll are upside down indicates a measure of haste.

While Turner was staying with Nash, he naturally continued his lifelong habit of drawing and the 'Windsor and

Cowes' Sketchbook (TB CCXXVI) contains views of the coast, of yachts racing and at anchor, as well as figure studies; but none of these has a direct link with any of the oil sketches. This would seem to support the theory that they were done on the spot. However, Butlin suggests that *Windward* No. 3, being more highly finished and with a more balanced composition than the earlier two, may have been at least completed back at East Cowes Castle, and the same may well have been the case with *Moorings* No. 3, which contains much more detail and greater emphasis on the figures than the other two.

On page 80 verso of the 'Windsor and Cowes' Sketchbook Turner has listed the names of yachts together with their owners and their colours, showing how involved he became in the Regatta. Indeed this is clearly apparent in the two exhibited pictures where, although 'East Cowes Castle' features prominently in each title, the castle itself is visible only in the distance. The other three sketches on the two rolls were not subsequently used by Turner as the basis for finished works.

On the whole the two Regatta pictures were quite well received by the critics at the Royal Academy, being preferred both to *Boccaccio* (BJ 244) and to *Dido directing the Equipment of the Fleet* (BJ 241). However, the sea in *Windward* was considered 'more like marble-dust than any living waters' by the *Morning Herald* (26 May 1827), which also criticized the picture on technical grounds, finding the yachts 'overmasted and represented as carrying sail such as no vessel of their dimensions could carry in such a wind for a single moment'. EJ

Reynolds 1969², pp. 67–79.
Martin Butlin, 'Cowes Sketches 1827', in BJ, pp. 159–60.

COWPER, Peter Leopold, fifth Earl (1778–1837). He inherited in 1799 Panshanger in Hertfordshire, and the superb paintings, including two by Raphael, collected by his father, who lived in Florence for 30 years. He demolished the old family house at Cole Green, built Panshanger to the design of Samuel Wyatt and William Atkinson, and engaged Humphrey Repton to improve the park.

Cowper bought one oil painting from Turner, *Harlech Castle, from Twgwyn Ferry, Summer's Evening, Twilight* (Yale Center for British Art, New Haven; BJ 9). The painting, which was exhibited at the *Royal Academy in 1799, is based on a watercolour on p. 5 of the 'North Wales' Sketchbook (TB XXXIX). CALS-M

COX, William (?1812–90), a powerful dealer in his day whose place of business changed regularly. He bought *Neapolitan Fisher-Girls* (probably the version in the Huntington Art Gallery, California, BJ 388, sometimes considered a copy; see FAKES AND COPIES), in 1856 and sent *Gillott two Turners, now untraced, in 1870 describing them as 'a great hit' and 'in their dirt as you desired'. EJ

COZENS, John Robert (1752–97), English landscape painter in watercolours whose work was strongly influential upon Turner's. His father was Alexander Cozens (1717–86), a landscape artist who published systems for inventing compositions from loose sketches and blots. The younger Cozens developed his father's systems by applying his various types of composition, intended to evoke specific emotional responses, to views from nature. He used muted colours, mainly blues, greys, and browns, for the sketches he made on his first visit to the Alps and Italy from 1776 to 1779, working them up afterwards for his patron, Payne *Knight, into a series of over fifty subtle but evocative watercolours which were different from anything produced before by earlier artists like Pars, who had concentrated on the topographical aspects of the landscape. Back in England, Cozens produced larger watercolours from his original sketches, using a wider range of colours—pinks, oranges, greens, and yellows—built up on a tonal base. They included classically inspired views of the Italian countryside, of Lakes Albano and Nemi, and the Roman *Campagna; but there were also sublime compositions of steep-sided Alpine passes and views from the mouths of caves.

Incapacitated by mental illness, Cozens was under the care of Dr *Monro from 1794 and Turner seems to have had the opportunity to study and copy Cozens's original sketches from this first tour while working for him in the evenings between 1794 and 1798. Differences in shading and in details may indicate that Turner's sources when copying them with *Girtin were not Payne Knight's versions, but Cozens's own, now lost. They were probably very close in style to the drawings in the seven surviving sketchbooks (Whitworth Art Gallery, Manchester) that Cozens filled on his next trip to Europe, in the company of William *Beckford, in 1782–3—pencil sketches drawn on the spot, quickly washed with greys and blues to record light and shade and atmospheric effects, with pencil notations of colours, locations, and dates. The finished watercolours Cozens produced from these sketches were more highly charged in colour and emotive response than anything he had produced earlier and, as they were sold in 1805, Turner would have had ample opportunity to study them in various collections later in his career.

The remains of Cozens's studio and library were sold at Greenwood's in 1794, and Monro, *Beaumont, and many others bought unidentified bundles of sketches at the sale. These and finished watercolours by Cozens were Turner's

models in the 1790s when he was first learning to interpret landscape. On his own first visit to the *Alps, Turner seems to have viewed them, in works like *The Passage of Mount *St Gothard* (Turner's gallery 1804; Abbot Hall Art Gallery, Kendal; W 366), through Cozens's eyes. Turner, more than any other landscape artist, was the inheritor of the approach to landscape embodied in Cozens's works, some of the most poetic and evocative landscapes ever produced in watercolour. KMS

A. P. Oppé, *Alexander and John Robert Cozens*, 1952.
Andrew Wilton, *The Art of Alexander and John Robert Cozens*, exhibition catalogue, New Haven, Yale Center for British Art, 1980.
Kim Sloan, *Alexander and John Robert Cozens: The Poetry of Landscape*, exhibition catalogue, London, Victoria and Albert Museum, and Toronto, Art Gallery of Ontario, 1986.

CROME, John (1768–1821), English landscape painter, etcher, and teacher. Norwich-based all his life, Crome became a drawing master in 1792, and in 1803 founded the Norwich Society of Artists. He travelled to the Lakes in 1802, Wales in 1804 and Paris in 1814. Like Turner, Crome was influenced by the 17th-century Dutch masters. From them he derived his rich golden-brown tonality and the naturalism of his highly individual studies of the woods and waterways of East Anglia. In 1806 the critic of the *Sun* grouped together Turner and Crome as exponents of the 'new manner [of] . . . scribbling of painting', criticizing their lack of finish (Farington, 5 May 1806). Works like Crome's watercolour *Boat by a River Bank, Evening*, *c*.1805–10 (Clifford Collection), have affinities with Turner's naturalistic oil sketches on the Thames of the same period. Crome was a lifelong admirer of Turner; one of his finest late oils, *The Wensum at Thorpe: Boys Bathing*, 1817 (Yale Center for British Art, New Haven), was his response to seeing Turner's 'poetical feeling, and grandeur of conception' at the Royal Academy. Crome's *Yarmouth Water Frolic*, *c*.1820 (private collection), echoes Turner's *Dort, or Dordrecht. The Dort Packet-Boat from Rotterdam becalmed* (RA 1818; Yale Center for British Art, New Haven; BJ 137). SM

Derek Clifford and Timothy Clifford, *John Crome*, 1968.
Norman Goldberg, *John Crome the Elder*, 2 vols., 1978.

CROSSING THE BROOK, oil on canvas, 76 × 65 in. (193 × 165 cm.), RA 1815 (94); Tate Gallery, London (BJ 130), see Pl. 9. A similar, upright *Claudian landscape to *Mercury and Herse* (RA 1811; private collection; BJ 114), this is in fact a view in *Devon. Cyrus Redding, who was with Turner when he visited Devon in 1813, 'traced three distinct snatches of scenery on the river Tamar' when he saw the picture. Charles *Eastlake identified the bridge as Calstock Bridge

and went on, 'some mining works are indicated in the middle distance. The extreme distance extends to the mouth of the Tamar, the harbour of Hamoaze, the hills of Mount Edgcumbe, and those on the opposite side of Plymouth Sound. The whole scene is extremely faithful' (*Thornbury 1862, i. pp. 210–11, 219). Drawings used for but not actually copied in the picture are in the 'Plymouth, Hamoaze' Sketchbook (TB CXXI) and there is a small composition sketch in the 'Woodcock Shooting' Sketchbook (CXXIX: 52).

Strangely the *Repository of Arts*, 4 June 1815, could see no Claudian elements: 'We perceive no affinity to any style or any school in these works of Mr. Turner [*Crossing the Brook* and *Dido building Carthage*]; we think his manner and execution are as purely original as the poetic forms which create his compositions.' The *Champion* for 7 May described the picture as one of those 'achievements that raise the achievers to that small but noble groupe [*sic*], formed of the masters whose day is not so much of to-day, as of "alltime".' Sir George *Beaumont, however, said of the picture that 'it appeared to Him *weak* and like the work of an Old man . . . it was all of *peagreen* insipidity' (*Farington, *Diary*, 5 June).

The picture failed to sell, perhaps because of Beaumont's criticisms, though Dawson *Turner asked about it in 1818 when the price was 550 guineas. Turner showed the picture again in his own gallery in 1835 when the *Spectator* for 26 April described it as 'a lovely scene of the verdrous valley of the Tamar'.

*Ruskin recalled that, on being shown 'a piece of paint out of the sky, as large as fourpenny piece . . . lying on the floor', Turner replied 'What does it matter? . . . the only use of the thing is to recall the impression' (Ruskin, *Works*, xxxvii. p. 13).

Whittingham has suggested that the picture may have been partly inspired by Henry Thomson's picture of the same subject that belonged to Turner's patron Sir John *Leicester, while David Brown has suggested the influence of *Callcott's *Morning*, exhibited at the Royal Academy in 1805. Shanes adds two further suggestions: an engraving after de *Loutherbourg's *Le Passage du Ruisseau* and *Reynolds's *Crossing the Brook*, included in a major exhibition of Reynolds's works at the British Institution in 1813. MB

Whittingham 1986, p. 25.
Brown 1990, p. 34.
Shanes 1990, pp. 231–8, 269, 290–1, 299.

CUNNINGHAM, Peter (1816–69), author, critic, and civil servant. He was the son of Allan Cunningham, writer on art and secretary for many years to Turner's friend, the sculptor Sir Francis *Chantrey. Peter Cunningham's best-known

book is the two-volume *Handbook of London* (1849), and he was a regular contributor to the **Athenaeum, Household Words*, and other journals. He contributed the 30-page *Memoir* to John **Burnet's *Turner and his Works*, published in 1852, which is thus the first published biography of Turner. This is informative and reasonably accurate, showing the author's close knowledge of both the artist and the artistic environment in which he worked. LH

CURRIE, Sir Donald (1825–1909), chairman of the Union Castle Line, was an avid buyer of Turner's work in both oil and watercolour, especially in the 1890s. His taste was far in advance of his time, for eight of his thirteen oils date from after 1840 and another, *Snow-Storm, Avalanche* (Art Institute of Chicago; BJ 371), from 1837. Among the eight are the circular *Dawn of Christianity* (RA 1841; Ulster Museum, Belfast; BJ 394), *Going to the Ball* and *Returning from the Ball, Venice* (RA 1846; private collection, USA; BJ 421, 422) and *Seascape, *Folkestone* (BJ 472).

His watercolours, well over 50 in number, included all twenty illustrations to **Campbell's *Poetical Works* (National Gallery of Scotland; W 1271–90) drawn *c.*1835. Notable also are two large ex-**Fawkes collection Swiss views: *Mont Blanc from Fort Roch* (private collection; W 369) and *Lake of Lucerne from Fluelen* (private collection; W 378), and three fine **England and Wales* drawings: *Rievaulx Abbey* (private collection; W 785), *Great Yarmouth* (private collection; W 810), and *Gosport* (City Museum, Portsmouth; W 828).

From *c.*1841 are **Falls of Schaffhausen* (Museum der Allerheiligen, Schaffhausen; W 1467) and *Heidelberg, with a Rainbow* (private collection, on loan to National Gallery of Scotland; W 1377) followed by *Brunnen*; 1842 (private collection; W 1527), *The Lake of Zug* (1843; Metropolitan Museum, New York; W 1535), *The Descent of the St. Gothard* (Koriyama Museum of Art, Japan; W 1552) drawn for John **Ruskin 1847–8, and *Pallanza, Lago Maggiore* (1848–50; Shizuoka Prefectural Museum, Japan; W 1556).

Some watercolours remain in family possession but only one oil, *Hurley House on the Thames* (*c.*1807–9; BJ 197).
 EJ

CUYP, Aelbert (1620–91), Dutch 17th-century landscape painter who greatly influenced Turner. Son of a Dordrecht brewer, portrait painter, and half-brother to two fellow artists in the family, Cuyp was called 'the Dutch Claude' because of the delicate glow of his serene landscapes. His style evolved from Van Goyen's exquisite near-monochrome, tonal painting, usually with the addition of well-observed cattle in low-horizon river and coast scenes whose typical Dutchness is sometimes emphasized by contrasting, Italianate backgrounds in the manner of Jan Both and Adam Pijnacker. By 1650 his art was fully developed, soon extended in its repertoire by equestrian portraits. Socially, Cuyp belonged to the 'notables' of Dordrecht, marrying a granddaughter of the renowned Leiden theologian Gomarus and able to afford the delightful country estate Dordtwijk.

From the mid-18th century onwards his pictures, distinguished by their prevailing yellowish light, were extremely popular with English collectors. This resulted in there being more Cuyps in Britain than anywhere else in the world, Holland included. As for Turner, he almost literally took to heart Sir Joshua **Reynolds's exhortation on returning from a trip to Holland in 1781 that 'painters should go to the Dutch School to learn the Art of Painting, as they would go to a Grammar School to learn languages' ('A Journey to Flanders and Holland', *Works*, 1809, ii. pp. 359–64). In Turner's lecture as Royal Academy Professor of Perspective (see PERSPECTIVE LECTURES) on 12 February 1811, he declared, after dealing with two greatly detail-obsessed Dutch painters: 'But Cuyp to a judgement so truly qualified knew where to blend *minutiae* in all the golden colour of ambient vapour' (Ziff 1963, p. 146). It was a conviction which he repeatedly expressed verbally and on canvas. This Master was clearly so potent in his mind and heart that in 1817, on his first Dutch tour, he inscribed a leaf in his 'Itinerary Rhine Tour' Sketchbook 'small Cyp' (TB CLXII: 86); while in 1825 he twice scribbled 'Cyp' on a sketch of Dordrecht meadows and 'Quite a Cyp' underneath a sketch of fields with cows north of Amsterdam (CCXIV: 60a, 117a, 131). In fact, this (consistently misspelled) name recurs in seven of his other travelling sketchbooks (CXIII: 16a, CCCXXVII: 11, CCXLI: 70a, CCXLIX: 39a, CCLVIII: 15, CCLXV: 52a, CCCLXIII: 27a).

In 1818, in his superb **Dort, or Dordrecht. The Dort Packet-Boat from Rotterdam becalmed* (Yale Center for British Art, New Haven; BJ 137) with its clear echo of Cuyp's *The Maas at Dordrecht* (National Gallery, Washington), Turner painted his greatest homage. The Dutch master of luminosity, especially impressive through misty backgrounds, had already inspired him in 1807 to paint **Sun rising through Vapour* (National Gallery, London; BJ 69), *The Forest of Bere* in 1808 (Petworth; BJ 77), and the 'calm morning' of *Tabley, Cheshire* in 1809 (Petworth; BJ 99)—typically Cuypish pictures, followed in 1810 by *Dorchester Mead* (BJ 107), and in 1811 by *Whalley Bridge and Abbey* (Loyd Collection, on loan to the Asmolean Museum, Oxford; BJ 117). Then, after the climax of the *Dort*, his *Entrance of the Meuse: Orange-Merchant on the Bar going to Pieces* (BJ 139) came in 1819.

In this context it is revealing to find so dedicated a champion of Turner's as John **Ruskin writing in 1860 that

'Claude and Cuyp had painted the *sunshine*, Turner alone, the sun *colour*' (*Works*, v. p. 407), while a little earlier he had not hesitated to define Cuyp's work as 'strong, but unhelpful and unthoughtful' even adding 'essentially he sees nothing but the shine on the flap of [the cattle's] ears' (*Works*, vii. pp. 333–4). Turner continued to see more.

Incontestably, the particular quality of Cuyp's light is always poetic in feeling. Directly or indirectly through Turner, it exerted an enormous influence on the development of English landscape painting in the Romantic era. But it was Turner who reinvented Cuyp's spirit. AGHB

S. Reiss, *Albert Cuyp*, 1975.

D

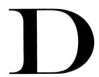

DANBY, Francis (1793–1861), painter of Irish birth whose melodramatic, poetic landscapes and biblical scenes aroused contemporary comparison with Turner. Danby came to London briefly in 1813 and admired Turner's *Frosty Morning* (BJ 127) at the Royal Academy. He spent 1813–24 in Bristol, painting naturalistic local views, before returning to London in 1824 and scoring great success with the Turnerian, sublime *Delivery of Israel out of Egypt* (RA 1825; Harris Museum and Art Gallery, Preston). Danby's *Cleopatra embarking on the Cydnus* (RA 1827; private collection, Worcestershire) owes an equal debt to Turner and to *Claude. The arched, dynamic composition of Danby's biblical epic *An Attempt to Illustrate the Opening of the Sixth Seal* (RA 1828; National Gallery, Dublin) owed much to Turner's *Snow Storm: Hannibal crossing the Alps* (RA 1812; BJ 126). After years of exile in Europe, the result of marital scandal, Danby spent the last years of his life in Exmouth, Devon, painting marines such as *The Evening Gun* (RA 1848; destroyed), which in their intense colours and *Romantic emotion, though not in their precise handling, are influenced by Turner. SM

> Eric Adams, *Francis Danby: Varieties of Poetic Landscape*, 1973. Francis Greenacre, *Francis Danby 1793–1861*, exhibition catalogue, London, Tate Gallery, and City of Bristol Museum and Art Gallery, 1988–9.

DANBY, Hannah (1786–1853), niece of John Danby. She was reported at Turner's death to have been his housekeeper at *Queen Anne Street for 42 years, that is from 1809. As 'Hanah Danby' she signed receipts for Sarah *Danby's monthly allowance from the Royal Society of Musicians on nine occasions between 1810 and 1813 and may have joined Turner's household as a servant in 1801. During Turner's many absences on visits and painting tours in Britain and abroad, and when he lived at Twickenham or Chelsea, Hannah remained alone at Queen Anne Street. In a letter of 1844 Turner mentioned 'the olden days of Hannah's culinary exploits' (Gage 1980, pp. 202–3). This suggests some entertaining. Elsewhere he called her 'my damsel' and *Roberts wrote that she had 'served all the purposes of a wife in her time' but Hannah's main responsibility was to keep Turner's gallery, to which she admitted Turner's guests, 'in a viewable state'.

There are no known accounts of her when young but in later life visitors described her terrifying and pitiful, hag-like appearance, a short woman with an over-large head, draped in dingy, whitish flannel with her face almost covered to conceal some cancerous malady. Her surroundings were equally unpleasant, The dirty skylight admitted little light but much rain into the gallery, the house was dilapidated, and plaster fell on the paintings. Ignorant of Turner's later address, Hannah located but did not see him only days before his death. She was deeply distressed at the funeral, a more genuine mourner than most. Turner included Hannah in all his *wills, at first leaving her £50 a year. Later codicils were concerned with keeping his works as a collection in the National Gallery or, failing this, in his own gallery; Hannah was to be resident custodian with an annuity of £150 but, should she die, another custodian should have £60. If the collection were sold the annuity to 'Hannah Danby residing with me' (codicil of 1849) should continue. Hannah died in 1853. She bequeathed £50 to Evelina, Turner's daughter by Sarah Danby, personally, to exclude her husband, Joseph Dupuis. Her 'dear three cousins Marcella, Caroline Melissa and Theresa' (Sarah Danby's other daughters) were the residuary legatees and eventually shared the net residue of £155 7s. 8d. that would have included two years of the annuity, as this had not been cleared before Hannah died. JAG

> Guiterman 1989, pp. 2–9.

DANBY, Sarah, née Goose (1760/66–1861). That Sarah Danby was the mother of Turner's natural daughters became widely known from his *will and the subsequent litigation in 1852–6. But only after the first publication in 1922–8 of Farington's *Diary* did biographers realize that Sarah might supply the missing love interest in Turner's story. Farington had noted A. W. *Callcott's remark in February 1809: 'A Mrs Danby widow of a musician now lives with him [Turner]. She has some children.' Falk in 1938 embroidered her role, misidentifying her with a younger

actress of the same name. The young, fanciful Sarah recurred in biographies until recent research revealed the facts.

John Danby (1756–98) was a well-known Catholic musician and composer. On his death Sarah applied to the Royal Society of Musicians for a widow's pension and allowances for three daughters under 7 and an unborn child. The Society's archive includes the certificate of her marriage in 1788, receipt books in which monthly payments were recorded, and various notes from her. The Society's rules excluded from benefit any widow found in illicit intercourse. Sarah's pension was paid (with a short, unexplained interruption in 1811) until her death in 1861, aged 100, her family said, although census records suggest she was somewhat younger. The allowances for her four daughters, their school fees, and apprenticeship premiums were paid until each became 14. The monthly receipts were occasionally signed for Sarah by relations or friends, including William *Turner, father of the artist. Sarah's later notes include appeals for additions to her pension during illness when she was living with her unmarried schoolmistress daughter Marcella Danby, her association with Turner having ended in about 1813. Asked by the Society, after Turner's death, she denied being left any annuity or legacy. Although Sarah was asked twice to re-swear her single, impoverished state, there is no reference in these papers to possible cohabitation or illicit intercourse. The un-noted birth of more children, the first possibly within two years of Danby's death, suggests concealment due, perhaps, to Turner's meanness or concern to keep his personal life private. Sarah was eleven or fifteen years older than Turner. She may have met Turner in musical circles during Danby's lifetime or afterwards while staying with friends who shared a house with Turner, before moving to keep house for Turner and his father.

Turner's 1829 will left the interest of £500 to 'Sarah, widow of John Danby musician'—a distancing description. The 1841 will reduced this to £10 a year, which was later revoked. Sarah's parentage is speculative but she had connections with Lincolnshire gentlefolk and her literacy—she helped in the posthumous publication of Danby's works—and the apprenticeship of her daughters as schoolmistresses rather than to manual trades suggest education suitable to Danby's wife. JAG

Jean Golt, 'Sarah Danby out of the Shadows', *Turner Studies*, 9/2 (winter 1989), pp. 3–10.
Powell 1992, pp. 10–14.

DANIELL, the Revd Edward Thomas (1804–42), artist, clergyman, and close friend of Turner who died of malaria while travelling in Syria. Before he left in 1840 he commissioned John Linnell to paint a portrait of Turner, to be drawn surreptitiously (National Portrait Gallery, London; see PORTRAITS OF TURNER). Brought up in Norfolk, Daniell was the son of Sir Thomas Daniell, Bt., a plantation owner. He initially followed an artistic career, and was taught etching by Joseph Stannard, but in 1832 he was ordained. In 1835 he moved from Norfolk to St Mark's Chapel, North Audley Street, living at a house in Green Street, Grosvenor Square. Daniell formed friendships with many artists including John Linnell, David *Roberts, Mulready, Dyce, *Stanfield, *Eastlake, and *Landseer. With Turner he was particularly close. Daniell was touched that of the many artists he knew only Turner ever came to hear him preach. David Roberts recalled that Turner came often to parties given by Daniell, 'an intense lover of Turner. Turner was equally a lover of Daniell . . . Turner told me more than once he would never again form such a friendship as with my friend . . . He adored Turner, when I and others doubted, and taught me to see & distinguish his beauties over that of others' (quoted in Guiterman 1989, p. 4). On being asked how he rated Daniell's artistic work, Turner is reported to have replied 'Very clever, sir, very clever' (Beecheno 1889, p. 13). He was hit hard by Daniell's death. Daniell owned Turner's *Mortlake Terrace* (RA 1827; National Gallery of Art, Washington; BJ 239), which he bought from John *Allnutt. Boxall claimed that *Modern Italy—Pifferari* (RA 1838; Glasgow Art Gallery; BJ 374) was commissioned by Daniell. He could not afford the full price and Turner insisted he had it for £200, but Daniell died before the transaction was completed. Turner then refused to sell it, but eventually sold it to *Munro of Novar, a mutual friend, for the same figure, saying 'I have told you, you shall stand in poor Daniell's shoes. I cannot make money by that picture.' The anecdote is confirmed by a note written by Munro (see BJ 374). RU

F. R. Beecheno, *E. T. Daniell: A Memoir*, 1889.

DANUBE. Turner travelled along the River Danube on two of his tours, enthusiastically sketching the most celebrated stretches of its scenery in both *Germany and *Austria. He recorded it in dozens of small pencil sketches and a handful of larger coloured ones and finally he depicted it in grand style in his huge painting The *Opening of the Wallhalla, 1842 (RA 1843; BJ 401). The verses Turner composed to accompany this work at the Royal Academy in 1843 made specific reference to the powerful flow of the Danube, but he never drew an extensive series of coloured Danube views, either for pleasure or for publication, as he did for several other great rivers of Europe. This was probably because there was simply no market for Danube views as there was for ones of the *Rhine. Far fewer Britons had reason or opportunity to travel this far afield.

On Turner's first journey along the Danube, on his way to Venice in 1833, he drew many tiny pencil sketches recording the succession of ancient castles and the wild and savage scenery between Linz and Vienna (in the 'Salzburg and Danube' Sketchbook, TB CCC). In 1840 he repeated some of these Austrian subjects in summary fashion while travelling by steamer in the opposite direction (in the 'Trieste, Graz and Danube' Sketchbook, CCXCIX). It was probably while staying in Vienna that Turner made his tiny pencil copies—in the second of these sketchbooks—from Jakob Alt's series of lithographs, *Donau-Ansichten* (1819–26); these sketches included sights Turner himself never reached such as Pressburg (today's Bratislava). More importantly, later on that same journey he drew a number of fine coloured sketches in and around the German towns of Passau and Regensburg. These were made in the roll sketchbook recently renamed 'Passau and Burg Hals' (CCCXL) and on various loose sheets of paper, and they capture very diverse aspects of the Danube through an impressive variety of technique and handling. The watercolour sketches on white paper showing the Italianate city of Passau (superbly situated where the waters of the Danube mingle with those of the Inn and the Ilz) are notable for their vaporous fragility, magical colours, and delicate handling. Those of the stern city of Regensburg (with its massive medieval buildings and celebrated stone bridge spanning the broad Danube) were drawn on grey paper, with vigorous passages of ink drawing and broadly applied gouache, and are as sombre in mood as that city itself. CFP

Powell 1995, pp. 35–45, 66–71, 143, 157–68.

DARLINGTON, Earl of, William Harry Vane (1766–1822), Whig MP for Totnes 1788–90 and for Winchelsea 1790–2; created first Duke of Cleveland in 1833. He was probably one of the three noblemen who financed Turner's trip to the Continent in 1802, as Newbey Lowson, Turner's travelling companion, was a Durham man. For nearly 50 years Darlington kept hounds at Raby Castle, Co. Durham, where he 'practically lived in the stables'. He hunted over a vast area and succeeded in having the route of the Stockton to Darlington railway diverted so that it did not cut across his coverts.

Turner arrived at Raby in late September 1817 and stayed until 'Lord Strathmore called at Raby and took me away to the north' (Gage 1980, p. 71). This led to Turner's three watercolours (two Bowes Museum, Barnard Castle and one private collection; W 556–8) which were engraved for Robert Surtees's *History of Durham*, 1819–20 (R 141–3), so perhaps Darlington recommended Turner to Lord Strathmore. A letter from Turner in April 1818 (Gage 1980, p. 72)

implies that he expects Darlington in London before *Raby Castle* (Walters Art Gallery, Baltimore; BJ 136) is due at the Royal Academy exhibition on 1 May but, if Darlington did come, it cannot have been in time for Turner to alter the picture in accordance with Darlington's wishes before the exhibition opened, as explained in the entry for the picture.

EJ

Judy Egerton, *British Sporting and Animal Paintings 1655–1867: The Paul Mellon Collection*, 1978, pp. xii, 156–7.

DART, Miss Ann (1780s–?1861), niece of John *Narraway, with whom *Ruskin corresponded in 1860 after he had bought the early miniature *Self-Portrait* (National Portrait Gallery, London; W 11; see PORTRAITS). She had known Turner briefly in the early 1790s when he stayed with the Narraways in Bristol, and gave Ruskin a largely negative recollection of the young man whom she found to be 'singular and very silent', with 'no faculty for friendship . . . My uncle indeed thought Turner somewhat mean and ungrateful.' However, she noted his self-possession and determination: 'He would talk of nothing but his drawings, and of the places he would go for sketching. He seemed an uneducated youth, desirous of nothing but improvement in his art.' Her recollection, written after Turner's death, is coloured by prejudice born of Turner's apparent slack manners as the Narraways' guest in the 1790s, and may reflect regret that the Narraways terminated the relationship with Turner after the 1798 visit when he was still little known. JH

Finberg 1961, pp. 27–8, 50–1.

DATING OF TURNER'S WORKS. Although Turner's works often bear *signatures, they are rarely dated. However, there are a number of ways of establishing a work's date. For finished works the date of first exhibition, at the Royal Academy, the British Institution, Turner's own gallery, etc. give a close enough indication, though occasionally early works were overpainted or existing *Beginnings finished after an unknown period. Similarly a number of works were engraved with dates.

Sketchbooks and drawings done on the spot can often be dated by building up the itineraries of Turner's journeys; research into these, as by, among others, Cecilia Powell, is continuing to add ever greater precision. Turner did, however, visit many places on more than one occasion; in such cases, as in many others, his *stylistic development and the evidence of one's eye has to be taken into account. Particularly in the case of unfinished works, however, this can be difficult. In the first 1977 edition of Butlin and Joll the *Knockholt sketches were dated to 1806 and numbered 154–9, whereas in 1984 they were brought back to c.1799–1801 and numbered 35 e–j. In both editions *The Procuress?*

and *The Finding of Moses* were dated *c.*1805? (BJ 152–3) but have now been retitled by Andrew Wilton *Judith with the Head of Holofernes*? and *The Rest on the Flight into Egypt* and redated ? and *c.*1828 (Wilton 1989, pp. 28–30, repr.).

More importantly, the group of late unfinished oil paintings based on **Liber Studiorum* subjects, dated to the mid-1830s in the first edition of Butlin and Joll, were redated in the second edition to the next decade on account of a stamp imprinted by the firm of Thomas Brown on the back of the canvas of **Norham Castle, Sunrise* (BJ 152), which includes the last two digits of the date 1844. Even when such digits are not present, the actual form of the stamp, and the address given for such firms as Roberson's, can help in dating (Butlin 1981, pp. 43–5). MB

DAVID, Jacques-Louis (1748–1825), chief French exponent of Neoclassical painting, prominent Revolutionary, and propagandist for *Napoleon. Turner met David in his Paris studio on return from the Alps in 1802. Here he saw *Napoleon on the St Bernard Pass*, *c.*1800 (Château de Malmaison, Paris), representing Bonaparte heroically crossing the Alps in the footsteps of Hannibal (see SNOW STORM: HANNIBAL). Turner paraphrases the painting in *Marengo* (*c.*1827; TB CCLXXX: 146; W 1157), for *Rogers's *Italy*, deflating David's triumphalist composition by ironically locating it before the carnage of battle. Technically, Turner disapproved of David's over-emphasis on draughtsmanship (Finberg 1939, p. 230). ADRL

McCoubrey 1984, p. 4.
Smith 1986, p. 42.
Brown 1998, pp. 17–18.

DAVY, Sir Humphrey (1778–1829), appointed resident lecturer of the Royal Institution in 1801. Davy practised chemistry and lectured on many areas including geology, electricity, and galvanism. Turner and Davy met in Rome during 1819, though they may have already known each other in London. While in Rome both men saw Raphael's frescoes in the Vatican. Davy's interest in the frescoes was in the condition of the pigments. His research into colour chemistry grew from his passion for painting and the ancient world.

Turner and Davy were both visionaries who were driven to explain and interpret what they saw. Davy wrote on a broad range of subjects including the parallels between art and science, on his perceptions of the natural world, and on his own extraordinary visions. The powerful images created in his words may have provided a possible source for such works as Turner's **Hero of a Hundred Fights* (RA 1847; BJ 427). Like Turner, Davy was also an amateur poet. Both men

were very keen fishermen. Davy wrote on angling and took advantage of the opportunities to make scientific studies of fish and the weather. SET

Gage 1987, pp. 219, 225, 254 n. 44.
Hamilton 1998, pp. 14, 17, 65–8, 72, 113–14.

DAWE, Henry (1790–1848), English painter and mezzotint engraver, who studied at the Royal Academy Schools and was taught by his father Philip, also an engraver. He engraved, and in some cases also etched, four published and several unpublished plates for Turner's **Liber Studiorum*. The first of these was *Rivaulx Abbey*, published in 1812 (F 51), and in 1816 he was probably responsible for both the etching and the mezzotint of *Mill near the Grande Chartreuse* (F 54). For Part XIII, published in 1819, Dawe contributed two plates, the tranquil and atmospheric Claudian *Isleworth*, and *Bonneville* (F 63–4). Dawe owned six of Turner's drawings for the *Liber*, which he sold to Charles *Stokes. LH

DAYES, Edward (1763–1804), landscape artist in watercolours and oils, who taught *Girtin from 1788 and was also a strong early influence on Turner. Dayes attended the *Royal Academy Schools, and exhibited landscapes at the RA from 1786. He was best known for his topographical works, which included not only carefully coloured urban views filled with elegant figures similar to the work of Thomas *Malton (e.g. *Greenwich Hospital*, 1788, Victoria and Albert Museum), but also the blue-washed landscapes typical of the work he produced on his annual sketching tours of England and Wales from 1790. Although his foregrounds were mannered and sometimes appeared clumsily sketched, his sense of scale lent a grandeur to his landscape compositions, enhanced by his simple colouring. Turner and Girtin, who came to know his work through Dr *Monro, imitated them in their own early landscapes, and even copied his work, so that it is often difficult to tell which of the three artists has produced a particular view. Attribution of their drawings is further complicated by the fact that Dayes himself copied and re-drew or finished the compositions of other artists, including Thomas Hearne.

Dayes also exhibited ambitious historical compositions, hoping to be accepted into the ranks of the RA; but he was frustrated in his attempts and in 1803 penned the bitter *Professional Sketches of Modern Artists*, which included the earliest biographical notice of Turner, indicating that the latter was largely self-taught. KMS

E. W. Brayley, ed., *The Works of Edward Dayes*, 1805, reprinted with intro. by R. W. Lightbown, 1971.
David B. Brown, 'Edward Dayes: Historical Draughtsman', *Old Water-Colour Society's Club*, 62 (1991), pp. 9–21.

DEATH OF TURNER. The artist died in the river-facing bedroom of his house at 6 Davis Place, New Cremorne Road, Chelsea, at around 10 a.m. on 19 December 1851. He had been getting weaker throughout the autumn, during which period he had been looked after by Sophia *Booth, as well as by Dr David Price, who travelled up to see him every week from Margate. Dr William Bartlett acted as the Kent doctor's locum. Dr Price diagnosed heart disease and on one occasion, some three months before expiration, warned Turner to prepare himself for death. Turner attempted to alter Dr Price's opinion with glasses of sherry but to no avail. Along with Mrs Booth, Dr Bartlett was in attendance when the artist died.

Hannah *Danby had discovered Turner's whereabouts during his last days, and sent his cousin and executor, Henry *Harpur, to see him on her behalf on 17 December. The late-autumn weather was rather gloomy during Turner's final decline but the sun is said to have brightened the artist's bedroom about an hour before the moment of death. Turner's supposed last words, 'The *Sun is God', were probably uttered a few weeks before his demise.

See also HEALTH OF TURNER. ES

DECLINE OF THE CARTHAGINIAN EMPIRE, see CARTHAGE.

DELACROIX, Eugène (1798–1863), French Romantic painter, born in Paris of a wealthy family. He studied under Baron Guérin, who had also taught Théodore Géricault (1791–1824), whose work he greatly admired and who aroused the younger man's interest in English art. Delacroix was an admirer of *Constable and a friend of *Bonington, whom he visited in London in 1825. Here he also met *Lawrence, *Wilkie, and Etty. While in Paris, probably in 1829 or 1832 (see Warrell 1999, pp. 39–42, 54), Turner visited Delacroix, who recorded in his journal in 1855, 'I remember that the only time he came to see me, when I was living on the Quai Voltaire, I was not particularly impressed; he looked like an English farmer with his rough black coat and heavy boots, and his cold, hard expression' (*The Journal of Eugène Delacroix: a Selection*, ed. Hubert Wellington and trans. Lucy Norton, 1951, p. 272). Like Turner in his most poetic works, Delacroix often found his subject matter in the poetry of Lord *Byron, as in *The Death of Sardanapalus* (Louvre, Paris), a dramatic and challenging composition which caused a scandal when shown at the Paris Salon in 1827. However, there is little evidence of any direct influence of Turner on Delacroix, or vice versa. LH

DELAMERE, Lord (d. 1855). Delamere owned two early oils by Turner, *Boats carrying out Anchors and Cables to Dutch Men of War, in 1665* (RA 1804; Corcoran Gallery of Art, Washington; BJ 52) and *A Coast Scene with Fishermen hauling a Boat Ashore* (c.1803–4; Iveagh Bequest, Kenwood; BJ 144), both acquired after the death of Samuel *Dobree.

RU

DELAMOTTE, William (1775–1863), landscape and topographical painter, mostly in watercolours, etcher, and drawing master. An early friend of Turner—they probably met as students in London—and recipient of a letter written in 1800 (Gage 1980, no. 2) in which Turner gives advice for a projected tour in Wales. Delamotte was probably the first owner of Turner's 1799 Royal Academy exhibit *Kilgarran Castle* (National Trust, on loan to Wordsworth House, Cockermouth; BJ 11), and was certainly one of the subscribers in 1806 to the mezzotint plate of *The *Shipwreck* (BJ 54); he bought many later Turner prints. Delamotte worked and taught in Oxford from 1797 to 1803, when he became Drawing Master at the Royal Military College at Great Marlow, a post he held for 40 years. For a few years from 1805 he was, like Turner, painting in oils from nature in the *Thames valley. Delamotte travelled extensively in Britain and later on the Continent, and was one of the British artists in Paris in 1802. He exhibited at the RA from 1793 to 1850, and illustrated several topographical books especially about Oxford. His early drawings were close to *Girtin, but in his later years he adopted a distinctive and effective style of drawing in which pen or pencil outlines were very lightly tinted with pale washes. His son Philip Henry Delamotte was also an artist, and was an early photographer. LH

DE LOUTHERBOURG, see LOUTHERBOURG, PHILIPPE JACQUES DE.

DENMARK. In autumn 1807 Turner went down to Portsmouth to record the arrival of the Danish ships recently captured by the English at Copenhagen (Turner's gallery 1808; BJ 80), but when he exhibited his painting of this subject at the Royal Academy in 1809 he gave it the less controversial title *Spithead: Boat's Crew recovering an Anchor*. He paid his only visit to Denmark itself in September 1835 when he travelled to Copenhagen by sea from Kiel in northern *Germany before visiting Berlin. The Danish capital was his most northerly destination in Continental Europe. Using the small sketchbooks now named 'Hamburg and Copenhagen' (TB CCCV) and 'Copenhagen to Dresden' (CCCVII), he recorded the city's chief sights, from historic palaces to new university buildings and the Church of Our Lady with recent sculptures by Bertel Thorvaldsen. However, he did not develop these tiny pencil sketches into finished compositions. Turner's memories of Copenhagen are reflected in his

vignette *The Battle of the Baltic* (National Gallery of Scotland, Edinburgh; W 1278) for *Campbell's *Poetical Works* (1837) but this is essentially an imagined scene. CFP

Powell 1995, pp. 46–51.

DEPARTURE OF THE FLEET, THE, see ÆNEAS RELATING HIS STORY TO DIDO.

DEVON. 'There is not, perhaps, a single county in the British Islands more replete with picturesque and romantic features, antiquarian remains, geological riches, and . . . maritime relations,' opined John *Britton and Edward Brayley in *Devonshire and Cornwall Illustrated* (1829, Introduction). Turner's first visit to Devon had been made in 1811, in the course of a tour of the West Country to prepare subjects for *Picturesque Views of the *Southern Coast of England*. Four paintings of Devon subjects were exhibited in 1812 (two at Petworth House; BJ 118–20, 122). He also made a tour there in 1813, centred on Plymouth, partly to collect material for the *Southern Coast* and another series, *The *Rivers of Devon* (see also DEVON SKETCHES). His third visit was in 1814. Turner frequently refers to the county's 'maritime relations', as in the views of Plymouth, Devonport, and Dartmouth, made for the *Southern Coast* and *Picturesque Views in *England and Wales*, while 'antiquarian remains' appear, for example, in the view of Okehampton Castle (*c.*1824; TB CCVIII: E; W 738) made for the *Rivers of England* series. One or two of the port scenes, those with drunken and/or licentious sailors and women in the foreground, such as *Plymouth Cove, Devonshire* (*c.*1825–9; Victoria and Albert Museum; W 835), may have offended respectable sensibilities. Generally, though, Devon is represented by Turner as encapsulating national identity in a particularly reassuring way, which encompasses both the modern (especially naval power) and 'unchanging' features (wooded scenery and antiquities), without the necessity of either including or excluding large industrial towns, as in the case of *Yorkshire. Indeed, *Crossing the Brook* (RA 1815; BJ 130), with its Claudian composition, turns the Tamar valley into an English version of Italian 'classic ground' (although, perhaps surprisingly, copper mining is shown in the middle distance). Turner's last oil connected with Devon (RA 1832; BJ 343) once again has a patriotic significance, since it shows the landing of the Prince of Orange at Torbay which heralded the Glorious Revolution (see REFORM BILLS).

AK

Smiles, 1987.
Sam Smiles, 'Turner in the West Country', in J. C. Eade, ed., *Projecting the Landscape*, 1987, pp. 36–53.
Smiles 1989.
Shanes 1990, pp. 10, 37–40.

DEVON SKETCHES. On his second visit to Devon in the summer of 1813 Turner spent much of his time in and around Plymouth and there undertook a campaign of oil sketching from nature. Turner's companion, the local landscape painter A. B. *Johns, had furnished a portable painting box with all the necessary equipment to allow outdoor oil-sketching and Turner produced a large number of studies, although only fifteen of these are extant today, the majority of them in the Tate Gallery (BJ 213–24, 225a–b). With one exception, *The Plym Estuary from Boringdon Park* (BJ 217), all of the sketches are of the same size, approximately 6 × 9 in. (*c.*15 × 24 cm.), and are painted on a heavy paper covered with a greyish ground, presumably prepared by Johns for oil-sketching.

Two eyewitness accounts of Turner's activities at Plymouth survive which suggest that, free of his habitual reserve, he was prepared to sketch in the presence of others and to discuss the results with these attentive local artists and amateurs. Some of the sketches reveal underdrawing, usually in black chalk, others were painted more spontaneously *alla prima*. It was probably a sketch in this latter mode which Turner claimed to have produced in less than half an hour, according to one contemporary witness. All of the sketches that can be identified are of locations within easy reach of Plymouth and it is probable that identifications of the remainder would confirm this pattern of activity. Turner was later to complain that Johns's preparation of the support was defective and that the sketches had deteriorated, which may explain the relative paucity of surviving examples, some of which are poorly preserved. The best of these sketches are, however, in good condition and from them we can understand his practice, which seems primarily to have been an exploration of atmospheric naturalism, capturing effects of light and colour.

Although some of the sketches depict the subdued light of overcast weather, a significant number seem to be responding to the 'Italianate' light and colour presumed by early 19th-century commentators to exist around Plymouth and are chromatically organized around blue and yellow. These experiments seem to have influenced some of Turner's oil paintings of the 1810s, where the same blue–yellow axis can be observed in *Lake Avernus: Aeneas and the Cumaean Sibyl* (1814–15; Yale Center for British Art, New Haven; BJ 226), *Dido building Carthage* (RA 1815; National Gallery, London; BJ 131), and *View of the Temple of Jupiter Panellenius* (RA 1816; Duke of Northumberland; BJ 134). It is with these finished pictures that Turner's seemingly extravagant colour first began to receive sustained comment, three or four years before his first experience of genuine Italian light in 1819. SS

Thornbury 1877, pp. 142–53.

Smiles 1989, pp. 10–26.

Smiles and Pidgley 1995, pp. 99–103.

DIDO AND ÆNEAS, Story of, see CARTHAGE.

DIDO BUILDING CARTHAGE; or the Rise of the Carthaginian Empire, oil on canvas, 61¼ × 91¼ in. (155.5 × 232 cm.), RA 1815 (158); National Gallery, London (BJ 131); see Pl. 8. The first and perhaps the grandest of Turner's great harbour scenes based on similar works by Claude, this picture was bequeathed to the National Gallery, London, to hang next to Claude's *Seaport: The Embarkation of the Queen of Sheba*, originally together with the very slightly larger *Decline of the Carthaginian Empire*, though this was changed in 1831 (see WILL); the two pictures dealt with one of Turner's preoccupations, the rise and decline of empires. However, what seems to be a sketch appears in the 'Studies for Pictures; Isleworth' Sketchbook of as early as *c*.1804–5 (TB XC: 11a). Exhibited with a reference to the first book of Virgil's *Aeneid*, the picture is inscribed 'Sichaeo', identifying the tomb of Dido's murdered husband Sychaeus.

The picture was praised in the press. For the *Morning Chronicle*, 1 May 1815, it was 'one of those sublime achievements which will stand unrivalled by its daring character'. The *Sun*, 16 May, suggests that Turner had toned the picture down on *Varnishing Days: 'When we first saw this Picture, the yellow predominated to an excessive degree, and though the Artist has since glazed it down in the water, it still prevails far too much in the sky.' However, Sir George *Beaumont found it 'in a false taste, not true to nature; the colouring discordant, out of harmony'.

There was a rumour in 1816 that Sir John *Leicester had bought the picture for 800 guineas but in fact Turner always hung onto it, teasing speculation by saying that he wanted to 'Be buried in it, to be sure' (Thornbury 1862, i. pp. 299–300). MB

Kitson 1983, pp. 7, 10–11, repr. pl. 15.

Ziff 1988, pp. 18–22, 25, repr. pl. 7.

Egerton 1998, pp. 272–81, repr. in colour.

Sam Smiles, 'Tales of Mystery and Imagination: Turner's Narratives, Part II', *Turner Society News*, 78 (June 1998), pp. 10–16, repr.

DIDO DIRECTING THE EQUIPMENT OF THE FLEET, see CARTHAGE.

DIEPPE, see *HARBOUR OF DIEPPE*.

DILLON, John, an early collector whose sixteen Turner watercolours, dispersed at Christie's on 17 April 1869, included eleven that were engraved. Among these were *Bay of Naples, Vesuvius Angry* and *Vesuvius in Repose* (*c*.1817;

Williamson Art Gallery, Birkenhead, and private collection; W 698, 699) and three *Southern Coast* views: *Poole Harbour* (*c*.1812; private collection; W 446), *Pendennis Castle* (*c*.1816; private collection; W 458), and *Lulworth Castle* (*c*.1820; Yale Center for British Art, New Haven; W 467). Dillon's *Rivaulx Abbey* (*c*.1826; private collection; W 785) was the first *England and Wales watercolour to be engraved (R 209).

He also acquired three watercolours from Sir William *Pilkington's collection, among them 'Mont Blanc from Aosta' in the sale catalogue but now identified as *Courmayeur* (?1810; Courtauld Institute of Art; W 393), and 'A Landscape' (lot 46 at Christie's), now *Scene in Savoy* (*c*.1816; Wolverhampton Art Gallery; W 401); although listed as untraced by Wilton in 1979, he later published it in *Turner Studies*, 3/1 (summer 1983), pp. 57–8. *Ruskin gave Vokins an 'unlimited commission' to buy it at Dillon's sale and had to pay 1,200 guineas for it—'to my great indignation and disgust', as he wrote later (*Ruskin on Pictures*, 1902, pp. 342, 437). EJ

DISASTERS ON TRAVELS. Turner seems to have enjoyed the risks and challenges presented by *travel, undertaking many difficult and arduous journeys throughout his life and looking back on disasters and near-disasters humorously in his correspondence. He described himself as having been 'nearly swampt' or 'half-drownded' on several different Channel crossings and as 'bogged most compleatly Horse and its Rider' in the *Yorkshire mud in 1816. In one of the sketchbooks used on his tour of the Low Countries and the *Rhine in 1817 ('Itinerary Rhine Tour', TB CLIX: 101r.) he recorded the loss of a bag containing not only clothing and personal effects (shirts, stockings, nightshirt, waistcoat, cravats, razor, guidebook, spare ferrule for his umbrella) but also—more importantly—the very tools of his trade (a sketchbook, half a dozen pencils and a box of colours). Despite this accident, the tour was highly productive in terms of pencil sketches and coloured drawings.

He probably enjoyed his nickname 'Over-Turner', invented by a waggish art critic in 1803 but affectionately used by the *Fawkes family after he took the reins of a tandem and capsized it in the fields. Two coaching accidents that befell Turner in the Alps inspired remarkable watercolours. The first was *Snowstorm, Mont Cenis* (1820; Birmingham City Museums and Art Gallery; W 402), evoking the terrifying and inhospitable scene of his misfortunes on 15 January 1820 as he returned from his first tour of Italy: his carriage capsized on the Mont Cenis Pass, forcing passengers to crawl out of the window and flounder through snow up to their knees to the nearest town, Lanslebourg. His home-

ward journey at the end of his second Italian tour, in January 1829, was a chapter of catastrophes due to ice and snow virtually all the way from central Italy to Paris. Soon after his return he wrote a spirited account of his misfortunes to his recent companion in Rome, Charles *Eastlake, and painted a powerful large watercolour of one of the worst episodes in the Alps, complete with stricken carriage and bivouacking passengers: *Messieurs les voyageurs on their Return from Italy (par la Diligence) in a snow drift upon Mount Tarrar—22nd of January 1829 (RA 1829; British Museum; W 405). The dumpy figure on the left, in top hat and frock coat, is commonly believed to be Turner himself. CFP

Gage 1980, pp. 70, 97, 125–6, 133.

DOBREE, Samuel (1759–1827), City merchant, banker and collector, who lived in Marsh Street, Walthamstow (now Walthamstow High Street). Dobree owned several marine pictures by Turner: *Fishermen upon a Lee-Shore* (RA 1802; Southampton Art Gallery; BJ 16), *Châteaux de St. Michael, Bonneville, Savoy* (RA 1803; Dallas Museum of Art; BJ 50; see BONNEVILLE for the confusion over the two oils of Bonneville exhibited in 1803), *Old Margate Pier*, which Turner gave him (?Turner's gallery 1804; private collection; BJ 51), *Boats carrying out Anchors and Cables to Dutch Men of War in 1665* (RA 1804; Corcoran Gallery of Art, Washington; BJ 52), *Sheerness, as Seen from the Nore* (Turner's gallery 1808; private collection, Japan; BJ 76), *Coast Scene with Fishermen hauling a Boat Ashore* (c.1803–4; Iveagh Bequest, Kenwood; BJ 144), and an impression of *The *Shipwreck*. Dobree also commissioned pictures from George Morland, and *The Letter of Introduction* from *Wilkie. Thomas Frognall Dibdin recalled that Dobree 'loved art in all its varieties, and had been a sort of Maecenas in former days, to *Chantrey, to Turner and to Wilkie . . . Mr Dobree had, of all the men I knew, one of the most pleasant and unaffected modes of address, and reception of his friends' (*Reminiscences of a Literary Life*, 1836, ii. pp. 686–9). Dobree's collection was sold at Christie's on 17 June 1842 and 31 May 1873, and at Foster's on 1–2 July 1889. RU

Gage 1980, pp. 248–9.
Wilton 1986, pp. 404–6.
Gage 1996, pp. 409–10.

DOLBADERN CASTLE, *North Wales,* oil on canvas, 47 × 35½ in. (119.5 × 90.2 cm.), RA 1800 (200); Royal Academy of Arts, London (BJ 12). Exhibited with this quotation:

> How awful is the silence of the waste,
> Where nature lifts her mountains to the sky.
> Majestic solitude, behold the tower
> Where hopeless OWEN, long imprison'd, pined
> And wrung his hands for liberty, in vain.

These are almost certainly the first lines by Turner himself to accompany an exhibited picture and thus forerunners of *Fallacies of Hope* (see POETRY AND TURNER). Turner visited Wales in 1798 and 1799 and drawings of Dolbadern occur in the 'Hereford Court', 'North Wales', and 'Dolbadern' Sketchbooks (TB XXXVIII, XXXIX, XLVI) besides six studies of the castle in the 'Studies for Pictures' Sketchbook of 1799 (LXIX).

This darkly brooding picture was Turner's Diploma Work on being elected RA in 1802. He then submitted a second picture (subject unknown) and offered the RA Council their choice, whereupon they 'unanimously approved' the first painting.

The 'Owen' in the verses refers to Owain Goch, a Welsh prince, who was imprisoned in Dolbadern from 1254 to 1277 by his brother Llewelyn. Dr Holcomb notes that Turner alludes to Owain's captivity by depicting the castle hemmed in by surrounding hills.

The influence of both Richard *Wilson and Salvator *Rosa are apparent in this *Sublime landscape while Wilton points out that 'awful silence' and 'majestic solitude' in Turner's lines also evoke images invested with Sublime connotations by Burke and Payne *Knight.

A small study for the picture (oil on panel, 18 × 13¼ in., 46.5 × 34 cm.) appeared in Sotheby's sale of 15 July 1998 (lot 78), having last been seen in an exhibition in 1937. The first recorded owner was *Munro of Novar; in 1930 it was bought by Percy Moore Turner, whose daughter-in-law was the vendor at Sotheby's in 1998, where it was bought by the National Library of Wales, Aberystwyth. EJ

Holcomb 1974, pp. 31–58.
Wilton 1980–1, pp. 40–2.
Bailey 1997, pp. 49–50, 59.

DORT, OR DORDRECHT. *The Dort Packet-Boat from Rotterdam becalmed,* oil on canvas, 62 × 92 in. (157.2 × 233 cm.), RA 1818 (166); Yale Center for British Art, New Haven, Connecticut (BJ 137); see Pl. 11. Celebrated depiction of the ferry *Zwaan*, anchored for a tide-stop in a complete calm near the confluence of the Rivers Merwede and Noord off Dordrecht. Alongside the somewhat oversized depiction of the vessel facing the distant city's crowded waterfront is a rowing boat with villagers offering fresh eggs and vegetables to the passengers, as was customary. Turner must have delighted in remembering this because of the 'life-giving' metaphor it embodied after his experience of the 'deadness' of the Waterloo battlefield. Even the girl looking straight at the viewer while scooping up water with a spoon seems to be there to emphasize the stillness of the scene.

In September 1817 Turner first visited this most ancient Dutch town which, before the emergence in the 16th century

of the emporia of Antwerp and Amsterdam, was the wealthiest trading centre of Holland and principal link between Germany, Flanders, and England. The blunt tower of its Great Church occurs in many of Turner's sketches, while compositional ideas for the picture are found in two diminutive drawings in the 'Itinerary Rhine Tour' Sketchbook and the 'Guards' Sketchbook (TB CLX: 50, CLXII: 82/83).

Possibly partly inspired by *Callcott's *Entrance to the Pool of London* of 1816 (Bowood Settlement) and certainly modelled on *Cuyp's *The Meuse at Dordrecht* (National Gallery of Art, Washington) exhibited at the *British Institution in 1815, it demonstrates to perfection Turner's alchemy in adapting an Old Master for his own ends and producing an inimitable original that *Constable was to admire for its 'singular intricacy and beauty' after Farington had been told that the *Dort's* colours were so brilliant 'that it almost put your eyes out' (*Diary*, xv. p. 5191). Turner, moreover, had been so fascinated by the town's ambience that subsequently he called the little notebook largely devoted to it his 'Dort' Sketchbook (CLXII).

At the Royal Academy exhibition of 1818, viewing the picture after the harrowing *Field of Waterloo* would, in light of the Burkian characteristics of each, illustrate once again what *Ruskin was to call Turner's 'two strengths, Terror and Repose'. It was bought by Walter *Fawkes, in whose music room at Farnley Hall it occupied a place of honour as shown in Turner's watercolour of 1819 (private collection; W 592).　　　　　　　　　　　　　　　　　　　AGHB

Bachrach 1981, pp. 19–30.

DOUGLAS, the Revd James (1753–1819), soldier, divine, antiquary, and artist. Douglas attended a military academy in Flanders and served as an officer in the Leicester militia, during which time he was appointed to oversee the fortification of Chatham. However, he left the army to take holy orders, and was ordained in 1780. In 1787 he became one of the Prince of Wales's chaplains. Douglas was a member of the Society of Antiquaries and published a number of texts on ancient British archaeology. He was also a gifted artist who both painted portraits of his friends and drew and etched the illustrations to his Sterne-like *Travelling Anecdotes through Various Parts of Europe* (1782). Douglas's connection to Turner is that according to a letter in J. W. Archer's 'Reminiscences' in *Once a Week* (1 February 1862, pp. 162–6; reprinted in *Turner Studies* 1/1 (summer 1981), pp. 31–7), he was the first owner of the early oil of *Rochester Castle* (c.1794; untraced; BJ 21). The anonymous correspondent related how Turner's father dressed Douglas's wig when he was in London to visit the court. Turner's father was late one day, and Douglas visited his shop in Covent Garden, where he discovered the young Turner at work on a drawing. 'So struck by the talent exhibited . . . he took him immediately under his patronage, and . . . invited him to his house at Rochester, where he encouraged him to exercise his talents by painting from nature, which he accordingly did by painting Rochester Castle.' Elsewhere in this article Archer reprints a letter from the picture's current owner, who had asked Turner if he recalled having painted it. Suspecting an attempt to have him authenticate the work, Turner greeted the approach with annoyance and evasion, refusing to comment upon it. Douglas would appear to have had links with the artistic community through his painterly endeavours, and he was clearly on good terms with Lord *Egremont, who recommended him to the Lord Chancellor for the parish of Middleton in Sussex.　　　　　　　RU

DOVER. Turner first visited this port, in Kent, in c.1792, and embarked there for the Continent in 1802, 1819, and on several occasions thereafter. Dover features frequently as the subject of later topographical watercolours, including the patriotically flavoured *Dover from Shakespeare's Cliff* (c.1825; private collection, USA; W 483; made for *Picturesque Views of the *Southern Coast of England*), where the guns of the modern fort fire towards France, presided over by the fortifications of the medieval castle situated on the cliffs in the background. The castle is juxtaposed more emphatically with the modern in *Dover Castle* (1822; Museum of Fine Arts, Boston; W 505; *Marine Views*; see also TB CCVIII: U; W 753). Here, a crowded cross-Channel steam packet forges through the waves while nearby sailing vessels are in evident difficulty. Shanes (1981, p. 33) argues that the steamship even seems to have 'pushed aside' the wrecked brig lying beyond it, thus anticipating the theme of *The *Fighting 'Temeraire'* (the supplanting of the old by the new).　　　　　　　　　　　　　　　　　　　　AK

DUBLIN, National Gallery of Ireland. Established by Act of Parliament 1852, the Gallery opened on 30 January 1864. Thirty Turner watercolours and one drawing were acquired from the Henry *Vaughan Bequest in 1900 (on view only in January); five further watercolours were acquired later. There are no oils. The works range from two of the 1790s up to a wide-ranging group of late Venetian, Swiss, and German views. They include an important sketch for *The Great Fall of the Reichenbach* done in Switzerland in 1802 and originally part of the 'St. Gothard and Mont Blanc' Sketchbook (TB LXXV; W 361), two watercolours for *Picturesque Views of the *Southern Coast* (W 454, 472), and one for *Finden's *Landscape Illustrations of the Bible* (W 1258), a gouache of *Petworth Park (W 908), and a rare signed draw-

ing of shipping done at Cowes (see ISLE OF WIGHT) in 1827. Outstanding among the late works are three watercolours done on Turner's tour of Switzerland in 1836 (W 1441–3) and the brilliant sunset view of *Great Yarmouth Harbour, Norfolk* of *c*.1840 (W 1408); there are also three unfinished *Beginnings of the kind normally only to be found in the Turner Bequest (W 1357, 1475, and 1477). MB

> Barbara Dawson, *Turner in the National Gallery of Ireland*, 1988.

DUCROS, Abraham Louis Rodolphe (1748–1810), Swiss landscape artist, whose work was popular with British collectors. The son of a writing and drawing master, he trained for some years in Geneva, before travelling to Rome in 1776. He visited Naples and Sicily in 1778, and then lived in Rome until 1793, when he returned to Naples, living there and in other parts of Italy and Malta until 1807, before finally returning to Switzerland. Foremost among Ducros's British patrons was Sir Richard Colt *Hoare, who first acquired the artist's work in 1786, and the best collection of his watercolours in England can still be seen at *Stourhead. An often-cited passage in Colt Hoare's 1822 *History of Modern Wiltshire* claims that Ducros's works had a strong influence on the 'rapid improvement in watercolour drawing' in Britain, and it is probable that they made an impact on Turner during his visit to Stourhead in 1798. LH

> Stainton 1985.

DU FRESNOY, see FRESNOY, CHARLES-ALPHONSE DU.

DUGHET, Gaspard (1615–75), also known as Gaspard Poussin; landscape painter, born in Rome of a French father and based in Rome all his life. In 1630, his older sister Anne married Nicolas *Poussin, and for the next few years Dughet studied painting under Poussin, specializing in landscape. Although the two men were not personally intimate, Dughet's style represented a kind of soft, naturalistic classicism compared to Poussin's more heroic and more philosophical forms of expression. Because of the connection, Dughet adopted—or more likely was given—the name 'Gaspard Poussin'. Yet he was a successful artist in his own right. His work was truer to the actual appearance of the Roman Campagna than either Poussin's or *Claude's, and the formulas he devised dominated landscape painting in Rome for 50 years after his death.

His work rapidly became popular and influential in England and by 1750 the bulk of it was in British collections, where it became a point of reference, contrasted with Claude's, in discussions of the picturesque (see SUBLIME). It is difficult to decide, however, whether Turner was influenced by Dughet at all. He nowhere mentions him in his sketchbooks or in the Backgrounds Lecture (see PERSPECTIVE) and there is no indication that he attempted to compete with or emulate Dughet's work as he did that of other Old Masters. There may be a subconscious echo of Dughet's representations of the cascades at Tivoli in Turner's *Morning amongst the Coniston Fells* (RA 1798; BJ 5), and the unusually firmly painted *Windsor Castle from the Thames* (*c*.1805; Petworth; BJ 149) may have been intended by Turner to recall Dughet. Another possibility is *Linlithgow Palace* (Turner's gallery, 1810; Walker Art Gallery, Liverpool; BJ 104), but this is perhaps too linear in handling and too *Wilsonian in feeling to be convincingly Dughet-like. MK

> Anne French, *Gaspard Dughet*, exhibition catalogue, London, Kenwood, 1980.

DUNSTANBOROUGH CASTLE, N.E. COAST OF NORTHUMBERLAND. Sun-Rise after a Squally Night, oil on canvas, 36½ × 48½ in. (92 × 123 cm.), RA 1798 (322); National Gallery of Victoria, Melbourne (BJ 6). Exhibited with lines appended from *Thomson's *Seasons*, the first year this was permitted. At the Royal Academy it was well received, the painting of the water being singled out for praise.

This painting stems from Turner's trip to the North of England in 1797, following *Girtin's visit the previous year. To judge from the amount Turner painted and drew Dunstanburgh, the subject clearly excited him. Studies for this picture occur in the 'North of England' Sketchbook (TB XXXIV) and he also painted a smaller variant in oil (Dunedin Art Gallery, New Zealand; BJ 32) as well as two watercolours, all within three years and all exaggerating the castle's height. *Dunstanborough* was engraved in the *Liber Studiorum* in 1808 and a fine watercolour in the *England and Wales* series (Manchester City Art Gallery; W 814) dates from *c*.1828. Dunstanburgh appears finally in *Wreckers—Coast of Northumberland* (Yale Center for British Art, New Haven; BJ 357), exhibited in 1834, which shows Turner without rival as a painter of the sea. Although the castle is shown in the distance, it dominates the composition as compellingly as it did in 1798. EJ

> Evelyn Joll, 'Turner and Dunstanborough 1797–1834', in Australia 1996, pp. 37–47.

DURHAM, a cathedral city and county in the north-east of England. Turner toured Co. Durham in 1797 (see TB XXXV) and 1817 (see CLVII; also *Whitaker's *History of Richmondshire*). The city was already a favourite with artists and tourists by the 1790s: *Hoppner chose a view of Durham as his present from Turner in 1798. The watercolour that resulted shows the Cathedral and Castle, majestically situated on their hill, with Framwellgate bridge and a picturesque assortment of houses occupying the foreground (*c*.1799;

W 249; based on XXXV: 15). Turner also made sketches of the town *en route* to Scotland in 1801 (see LIII, and the water-colour studies W. 314–16). A later view, made for *Picturesque Views in *England and Wales* (*c*.1834–5; National Gallery of Scotland; W 873), is much more *Claudian than W 249 in its composition and atmosphere: the bridge has been pushed further back and an ethereal Cathedral, its west front improbably turned towards the spectator, is balanced by graceful trees. The high, insecure-feeling viewpoint, however, is not particularly Claudian. AK

Shanes 1990², pp. 99–101, 269.

DUTCH BOATS IN A GALE: Fishermen endeavouring to put their Fish on Board, oil on canvas, 64 × 87½ in. (162.5 × 222 cm.), RA 1801 (157); private collection, England, on loan to the National Gallery, London (BJ 14). Known as the 'Bridgewater Seapiece' because it was commissioned by the Duke of *Bridgewater as a pendant to his Willem *Van de Velde of *A Rising Gale,* now in the Toledo Museum, Ohio. In fact the Turner is larger by 13 inches (33 cm.) each way. Its great success at the Royal Academy was undoubtedly a factor in Turner's election as Royal Academician the following year. Turner was paid 250 guineas for the picture but failed to obtain a further 20 guineas for the frame, as *Farington records, although entitled to do so according to the custom of the day. *Thornbury's claim that Turner began work on the canvas the evening he received the commission is disproved by the numerous studies for the oil in the 'Calais Pier' Sketchbook (TB LXXXI).

Despite its becoming the picture of the year at the RA, the critics were rather grudging in their comments but Turner's fellow artists praised it highly: both *West and *Fuseli compared it to *Rembrandt, West saying it was 'what Rembrandt thought of but could not do'. This suggests that he had in mind Rembrandt's *Christ stilling the Tempest* (1633; Gardner Museum, Boston, until stolen in 1990) which entered the Hope Collection at Deepdene, near Dorking, in the late 18th century, although there is no evidence that Turner knew the picture. Indeed his drawings show how he refined the composition of the Van de Velde, pushing the boats further from the spectator and setting them on a collision course, as noted by Bachrach, who also detects the influence of Jacob *Ruisdael. As Gage has observed: 'the enhanced monumentality of the style makes it clear that he was using the unfamiliar vehicle of a Dutch marine to present a "history" picture in the grand tradition', augmented here by the brilliant deployment of light and shadow over sea and sky.

In 1837 both the Van de Velde and the Turner were exhibited at the British Institution. The critics were divided as to which was the superior but the German critic, Dr *Waagen, condemned the Turner as appearing 'like a successful piece of scene painting' when compared to the Dutch picture. This opinion gave *Ruskin (*Diary,* 21 November 1843) 'the satisfaction of finding Dr Waagen—of such mighty fame as a connoisseur—a most double-dyed ass'. EJ

Bachrach 1981, p. 25.
Gage 1987, pp. 110–11.

E

EAGLES, the Revd John, see *BLACKWOOD'S (EDINBURGH) MAGAZINE.*

EARLOM, Richard (1743–1822), English mezzotint engraver and draughtsman, who studied under the decorative painter Cipriani. His first work was for Alderman Boydell, making drawings of paintings in the Walpole collection at Houghton, and engraving some of these in mezzotint, in which he was self-taught. Earlom also etched and worked in aquatint, and he engraved numerous plates after Old Master and contemporary artists. He is best known for his successful series of mezzotint engravings after the 195 drawings of *Claude's Liber Veritatis*, then in the possession of the Duke of Devonshire. These were engraved between 1774 and 1777, and published in 1777 by Alderman Boydell in two magnificent volumes, and the impressive prints rapidly played an important role in the development of landscape art in Britain. For Turner, Earlom's *Liber Veritatis*, in which the mezzotint was engraved over etched outlines, was a major factor in the planning of, and ultimate choice of mezzotint for, his own *Liber Studiorum.* LH

EAST COAST OF ENGLAND, PICTURESQUE VIEWS ON THE. Watercolour and line-engraving series initiated by Turner around 1827 following the failure to agree terms with the *Cooke brothers in late 1826 for their East coast continuation of the *Picturesque Views of the *Southern Coast* scheme. However, by 1827 Turner no longer had time to act as print-publisher, and he created only four vignettes and six rectangular drawings for the scheme, which was never published. Five of the designs were fully engraved by J. C. *Allen, who left three more plates unfinished when the series was abandoned.

All of the watercolours are drawn in an extremely spontaneously and expressively used *gouache, and are on blue paper. Such a support greatly aided the creation of damp atmospheric effects, while simultaneously differentiating the images from those on white paper that had been contributed to the *Southern Coast* scheme.

The vignette designs are dramatically uneventful, but five of the rectangular drawings portray East Anglian subjects in stormy conditions. One of them (Fitzwilliam Museum, Cambridge; W 904) is a view of the monument at Yarmouth that commemorates the Battle of Trafalgar; in the foreground some figures ingeniously allude to the innovative tactic Nelson employed at that engagement.

A number of gouache sketches in the *Turner Bequest are connected to this scheme by their subjects, medium, support, and sizes (TB CCCLXIV: 366, 394, 407–20). In 1908 Rawlinson (pp. 169–73) misidentified the *East Coast* series, although he corrected that mistake in 1913 (p. 196); unfortunately, the earlier error still leads to extensive confusion in the literature. ES

Shanes 1981, pp. 12, 40–2, 46–7.

Shanes 1990², pp. 14–15, 73, 151–9.

EASTLAKE, Lady, née **Elizabeth Rigby** (1809–93), writer and translator who became a perceptive critic of Turner's later works. She was born and brought up in Norfolk, the daughter of a physician, and after two years living in Germany from 1827 spent a year in London, where she became part of the circles of *Murray, *Munro, *Rogers, and others. Returning to Germany and Russia, she wrote *A Residence on the Shores of the Baltic* (1841). She moved to Edinburgh in the early 1840s, from where she wrote trenchant articles in the *Quarterly Review*. She met Turner at Murray's on a visit to London in 1844, finding him 'a queer little being . . . a cynical kind of body'. After visits to *Queen Anne Street in 1846, she wrote of its dilapidated state in her *Journals*. Turner enjoyed her spirited company, and was particularly happy when she married his friend Charles *Eastlake in 1849. Her observations on Turner's late manner are unprejudiced: '[He] does much as he likes with his brush, and if his likings are sometimes beyond our comprehension that is perhaps our fault. He can never be vulgar.' Her review of *Thornbury in the *Quarterly Review* was merciless. JH

Lady Eastlake, *Journals and Correspondence*, ed. Smith, 1895.

Marion Lochhead, *Elizabeth Rigby, Lady Eastlake*, 1961.

Finberg, 1961, pp. 399, 406–7, 413–15, 429–30.

Gage 1980, pp. 249–50.
Hamilton 1997, pp. 336–8.

EASTLAKE, Sir Charles Lock (1793–1865), English historical and genre painter, scholar, and art-administrator. Born in Devon, he became *Haydon's first student in 1809 and joined the *Royal Academy Schools in the same year. Here he was befriended by Turner, whom he joined on a sketching tour in *Devon in 1813. Eastlake travelled in Italy and Greece, 1818–20, and lived in *Rome from 1821 to 1830. He first exhibited at the RA in 1823, and was elected ARA in 1827 and RA two years later; his most successful exhibits were scenes of contemporary Italian peasant life. Eastlake was a leading figure in the Roman art world, and in 1828, during his second stay in Rome, Turner shared his studio for a time. The two artists remained friends but their relationship never became a close one. After his return to England Eastlake gradually turned from painting to his art-historical studies, collecting and writing, and also devoted ever more time to the politics of art in London. His first major publication was his translation of *Goethe's *Farbenlehre* with the title *Theory of Colours* in 1840, of which Turner owned and annotated a copy. In 1841 Eastlake was appointed Secretary of the newly formed Fine Arts Commission which was concerned with the decoration of the new Palace of Westminster. This work brought him into close contact with the young Prince *Albert, who came to rely on his advice and support. From 1843 to 1847 Eastlake was Keeper of the National Gallery, *London, and after some years as a Trustee was its first Director from 1855 until his death, during which time the collections grew more significantly, mostly by purchase, than at any other time in its history. As Director Eastlake was also responsible for the reception and initial installation of Turner's bequest (see WILL). Eastlake was elected President of the Royal Academy in 1850, an office he filled with distinction, and during the last part of his life he served on numerous committees, including that concerned with the showing of art at the *Great Exhibition of 1851. All these duties and his important art historical writings left Eastlake little time for painting, and he last exhibited at the RA in 1855. LH

David Robertson, *Sir Charles Eastlake and the Victorian Art World*, 1978.

EDINBURGH. The capital of *Scotland, known affectionately as 'Auld Reekie', is topographically striking. Turner made five visits there; in 1801, he sketched the city and prepared large watercolours including a view from Calton Hill (TB LX: H; W 348). In 1818, he collected further studies resulting in another, more dramatic prospect from Calton Hill (National Gallery of Scotland; W 1062) for the *Provincial*

Antiquities. In 1822, he recorded ceremonies of *George IV's visit. In 1831, he sketched a panorama from Blackford Hill which became an illustration for *Scott's *Poetical Works* (private collection; W 1082). In 1834, he drew a view from St Anthony's Chapel (Indianapolis Museum of Art; W 1120) for *Scott's *Prose Works*, and sketched and later prepared a design of Scott's Edinburgh residence (Pierpont Morgan Library, New York; W 1141) for J. G. Lockhart's biography of Scott, 1839. GEF

Finley 1980, pp. 60, 132, 182, 218–20, repr.
Irwin *et al.* 1982.

EDINBURGH, National Gallery of Scotland, founded in 1850, opened in 1859. The original building, which has since been extended, was designed by W. H. Playfair (1789–1857). The collection includes one particularly beautiful house-portrait, *Somer-Hill* (RA 1811; BJ 116), and several important groups of watercolours. The share of the Henry *Vaughan Bequest, 1900, includes *Monro School works, watercolours for the *Picturesque Views in *England and Wales* and for *The Collected Works of Sir Walter *Scott*, as well as one of the *Rhine watercolours of 1817, late *Swiss and *Venetian watercolours, and a signed drawing of shipping done at Cowes in 1827. Twenty watercolours illustrating *Campbell's *Poetical Works* (W 1271–90) were accepted in lieu of inheritance tax in 1988 and a watercolour of *The Bell Rock Lighthouse* (W 502), done for Robert Stevenson in 1819, was purchased in 1989, and a Welsh view of *c.*1799, *Mount Snowdon, Afterglow*, was presented in 1991. Two watercolours of *c.*1818, engraved for Scott's *Provincial Antiquities and Picturesque Scenery of Scotland*, were acquired in 1998; *Edinburgh from Calton Hill* (W 1062) and *Heriot's Hospital, Edinburgh* (W 1064). There is also an important group of engravings after Turner. In addition two oils are at present (2000) on loan from the Earl of Rosebery, *Rome, from Mount Aventine* (RA 1836; BJ 366) and *Modern Rome—Campo Vaccino* (RA 1839; BJ 379). MB

Mungo Campbell, *A Complete Catalogue of Works by Turner in the National Gallery of Scotland*, 1993.

EDWARDS, Edward (1738–1806), painter of various subjects, best known for *Anecdotes of Painters*, published posthumously with a brief biography in 1808. He exhibited prodigiously at the Royal Academy, becoming ARA in 1773 and Teacher of Perspective in 1788, regularly giving private lessons until his death. When Turner succeeded him (1807) the post was re-elevated to 'Professor' in recognition of Turner's full RA status and consequent requirement to deliver public lectures. ADRL

'EGREMONT SEAPIECE', see SHIPS BEARING UP FOR ANCHORAGE.

EGREMONT, third Earl of (1751–1837), magnate, connoisseur, agriculturalist, and racehorse owner and breeder. The third Earl of Egremont's celebrated patronage of Turner was but one—but perhaps the most fruitful and endearing—facet of an endeavour to promote British art and artists through both commissions and hospitality lavishly bestowed on painters and sculptors. The North Gallery at *Petworth (West Sussex) was, and now is again, the memorial to this Maecenas, in all the idiosyncratic profusion of the hang and installation of its singular *mélange* of Old and Modern British Masters, and Antique and Modern Sculpture. But, just as Lord Egremont's interest in art and patronage of artists only seems to have developed in mid-life—almost as if in reaction against the vast sums spent by his contemporaries on the works of dead artists imported into Britain in consequence of the revolutionary upheavals in Europe—so too his patronage of Turner was episodic, and on his own terms: no watercolours; oil paintings all—save *Jessica* (RA 1830; BJ 333)—of conventional character; and with a still unexplained hiatus between the initial purchases and commissions of *c.*1802 to 1812, and the final flourish of the four landscapes painted to be set in the panelling of the Carved Room at Petworth (BJ 283–6—the trial versions at the Tate Gallery; BJ 288–91—the substitutes for these, at Petworth), and the *Jessica*, of *c.*1828–30.

Egremont's early years were conventional. Educated first at Pampellone's school in Wandsworth, and then at Westminster and Christ Church, Oxford, he did not proceed to a degree but went abroad, making a five months' tour of northern Europe in 1770, and another visit in 1772 to Paris, where he ordered two paintings from Vernet and acquired a mistress, Mlle Du Thé. By 1774 possible marriages were being mooted, but nothing came of them. Instead, some time later, he began a liaison with Elizabeth Milbanke, Viscountess Melbourne, which was to result in 1779 in the birth of William, the future second Viscount Melbourne and Prime Minister; and, a year later, in Horace Walpole's niece, Lady Maria Waldegrave, breaking off a three-week engagement to him.

The opprobrium that this incurred appears to have been the decisive factor in removing Egremont from society and any thought of a political career, and in leading him instead to focus his life upon Petworth, the improvement of agriculture on his huge estates, racing, and—ultimately—the encouragement of British art. This retreat was reinforced by his having begun a liaison around 1786 with Elizabeth Ilive or Iliffe, the daughter of a clergyman and master at Westminster, whom he was ultimately to marry, but only after all the six children to reach adulthood that she produced had been born.

It seems, moreover, to have been Elizabeth Iliffe who first prompted the third Earl's interest in art, an interest that was subsequently given focus by William Hayley and his circle. It was she for whom, after the *de facto* separation that took place not long after her marriage, William Blake painted *Satan calling up his Legions*, *c.*1800–5, and *The Last Judgement*, 1808, while *Farington records her interest in art as early as 1798 (entry for 18 December). There is no evidence, prior to that date, of Egremont manifesting any serious interest in art; rather the reverse: when he gave up Egremont House, he sold most of the pictures in it (Christie's, 7–8 March 1794). Nor, despite his subsequently owning over 30 paintings by *Reynolds, half a dozen by *Gainsborough, and three or four by Richard *Wilson, did he commission or buy any of them from these artists, or even in their lifetimes. And, although numerous portraits of him exist, and though he commissioned or obtained portraits of his family and others by leading artists, he never sat to one, preferring artists of the second rank: above all Thomas *Phillips, but also George Clint, William Derby, and John Lucas; so not only no sittings to Reynolds or Gainsborough, but none to Romney (who painted Elizabeth Iliffe, with their children), *Hoppner (who made a lost conversation-piece of his children, and sketch-portraits of his daughters), Beechey (despite his being a regular house-guest and painting a daughter as *Hebe*), or *Lawrence.

It was artists, as much as art, that Egremont loved to assemble, particularly if (unlike the over-obsequious *Haydon) they fell in with his taste for living at Petworth, free of any of the constraints of formal society, like the ruler of a small sovereign state. This informality must have appealed strongly to Turner. As Creevey sardonically noted: 'artists are always allowed to do what they like there' (letter of 18 August 1829); while C. R. *Leslie reports Beechey as saying: 'he has more "put-up-ability" than almost any other man' (1860, i. p. 103). He was keen, above all, that artists should follow their own bent, and not become slaves to the British tyranny of portraiture.

Nevertheless, his earliest patronage, in 1796, seems to have been extended to Thomas Phillips (1770–1845), though at that stage the artist was a stained-glass painter who had taken to subject-painting and was only beginning to paint portraits. Egremont was ultimately to commission some 40 portraits, or copies of portraits, of himself, his family, and friends, from Phillips. It was Phillips who in turn, in 1823, was to introduce C. R. Leslie to Egremont, to paint a posthumous portrait of a grandchild of the Earl which Phillips was unable to execute. Leslie went on to become not only Egremont's favourite painter of literary subjects, but also an intimate of Petworth, whose *Autobiographical Recollections*

give one of the most vivid accounts of Egremont, his tastes, and his patronage.

Egremont was also a major patron of sculptors, although less successful in that field than in painting mainly because many of the finest British sculptors were at work in Rome. Nevertheless he patronized *Chantrey, Nollekens, Rossi, Sir Richard Westmacott, and *Flaxman, to whom he gave his last great commission of *St. Michael crushing Satan* (1819–26), which features prominently in two of Turner's gouache sketches of the North Gallery (TB CCXLIV: 13, 15). However, his chief protégé was the wayward Irishman John Edward Carew (?1785–1868) who, from 1823, was primarily employed by Egremont, who later gave him premises in Petworth. After Egremont's death Carew sued the executors for sums supposedly owing to him, but without success. The evidence of two successive trials, published in 1842, gives one of the most complete pictures of Egremont as a patron. Although bankrupted, Carew survived to sculpt again, including one of the reliefs at the foot of Nelson's Column. In his patronage, first of Flaxman, and then of Carew, it is evident that the third Earl was as deliberately setting himself in opposition to those who went to Rome for their marble sculpture, as he was in the field of painting by giving his custom to contemporary British artists, with Turner foremost among them, instead of conspicuously buying costly imported Old Masters.

In Turner, however, it seems to have been particularly the celebrant of English sites and familiar scenes that Egremont relished, not his painterliness. The exact chronology of his acquisitions, and the point at which these changed from purchases from the artist's stock, through purchases at his exhibitions, to actual commissions, is—in the absence of records of payment—impossible to establish; the most credible sequence is that set out by Evelyn Joll ('Painter and Patron: Turner and the Third Earl of Egremont', *Apollo*, May 1997, pp. 374–9) together with the further arguments of Butlin and Joll 1984. Beginning with the so-called 'Egremont Seapiece' (*Ships bearing up for Anchorage*; BJ 18), which was exhibited at the Royal Academy in 1802 and was acquired by Egremont, if not then, certainly by 1805, the peer went on to make regular acquisitions from the artist and his exhibitions, up to and including 1812. These were mostly views of the Thames and Windsor, or English coastal scenes, but they included two paintings commissioned in 1809—but not, curiously, as pendants—*Cockermouth Castle* (BJ 108) and *Petworth: Dewy Morning* (BJ 113). After the *Hulks on the Tamar* (BJ 119) and *Teignmouth* (BJ 120) of 1812, he does not seem to have acquired anything further of the artist's until 1827, when he bid successfully for *Tabley: Calm Morning* (BJ 99) at the posthumous sale of pictures

from Lord de Tabley's London house (see LEICESTER). It is commonly suggested that this was because Egremont, as one of the Governors of the British Institution, took offence at Turner's flouting of the rules over the submission in 1814 of *Apullia in search of Appullus* (BJ 128)—a picture patently inspired by the Petworth *Claude of Jacob and Laban*; but not only was Egremont not a founder-Governor —and also on occasion himself critical—of the BI, but this was already apparently two years since his last purchase from the artist, whereas he had previously been buying or commissioning pictures at the rate of about two a year with perhaps as many as four in 1808. In the light of the pattern of Egremont's other patronage, he may well have felt that by then Turner was sufficiently well launched to need no further encouragement from him. Similar considerations may have lain behind his not giving a commission to *Constable, despite great hospitableness towards the artist on the latter's two visits to Petworth in 1834.

When his patronage of Turner resumed, after the de Tabley sale, where Turner was also a buyer, its course did not run smooth. We know from Creevey's Diary that by August 1828 Turner had executed at least three paintings for inclusion among the enriched panelling of the Carved Room at Petworth, and that at least one of these, *Petworth Park* (BJ 283), was the version of this subject that remained with Turner, and is now in the Tate Gallery. We know this from Creevey's specific mention of 'Lord Egremont taking a walk with nine dogs that are his constant companions'; and it may have been this detail that Egremont found indecorous for a painting in what was, after all, a show room. This was replaced by *The Lake, Petworth: Sunset, fighting Bucks* (BJ 288). Yet it was into the version accepted for Petworth, *Brighton from the Sea* (BJ 291), replacing *The Chain Pier, Brighton* (BJ 286), that Turner introduced the common vegetables bobbing on the water, over which he and Egremont had a wager as to whether or not they would really float (G. P. Boyce's *Diaries*, 30 June 1857). The differences between the respective versions of this set of pictures are not sufficiently consistent, however, to suggest anything more than that the first set were painted as trial pieces at Petworth itself, and that Turner preferred to keep these, rather than to paint parts of them over, instead executing a second set in London, which deferred to Egremont's wishes in certain respects, notably the inclusion of anecdotal detail and a higher degree of finish.

We are also ignorant as to why the *Palestrina* (RA 1830; BJ 295) that Turner specifically set out to paint '*con amore*' for Egremont in *Rome in 1828, as a pendant to his Claude of *Jacob and Laban*, did not enter the latter's collection, and why instead he acquired the *Keepsake*-style picture of

Jessica, the notorious 'lady getting out of a large mustard pot', a year after Turner exhibited it at the RA in 1830 (cf. Wilton 1991). The *Palestrina*, however, was a romanticized image of a site that Egremont had never seen, whereas he liked concrete evocations of spots that he knew, while the *Jessica* appealed not only to Egremont's taste for theatrical subjects, but also to his notorious fondness for a pretty woman. Most curious of all, perhaps, is the fact that, with Turner as a house-guest, producing in 1828 a unique series of 123 gouache sketches on blue paper of the interiors, picture-hangs, and social life of Petworth together with views of the park and lake, Egremont should not have asked for one for himself. All but seven (W 906–12) are now in the Tate Gallery (CCXLIV). They form, however, a unique memorial to a remarkable episode in British art, of both hospitality and patronage. ADL

Youngblood 1982², pp. 16–33.
Butlin, Luther, and Warrell 1989.

EGYPT. Unlike Greece, Egypt had no Byron to cement Turner's interest in its past and present. His first and most significant treatment was the lost painting The *Battle of the Nile*, one of five pictures of the subject exhibited at the Royal Academy in 1799 (BJ 10). Next year came the first of his two paintings of the *Plagues of Egypt*, with landscapes based on Poussin rather than on any attempt at topographical accuracy (RA 1800 and 1802; BJ 13, 17). Later, in the 1830s, came four illustrations of Egyptian scenes for *Finden's Landscape Illustrations of the Bible*, based on drawings by Charles Barry and others (private collections, Indianapolis Museum of Art; W 1237–9, 1247), and, considerably more imaginative, *Sinai's Thunder* for *Campbell's Poetical Works* (National Gallery of Scotland, Edinburgh; W 1274). MB

EGYPTIAN HALL, Piccadilly, exhibition. In June and July 1829 the engraver Charles *Heath, the publisher of the *Picturesque Views in *England and Wales* series of engravings after Turner, rented the Large Gallery in the Egyptian Hall for an exhibition to promote the sales of the series. Thirty-eight of Turner's watercolours were shown, to which were added three Italian views designed for a similar work on Italy, which was never commenced. By 1829 the first seven parts of this ambitious publication had appeared, but it was not selling at all well, and Heath was in financial difficulties. However, the exhibition was very well received by the critics, one of whom wrote: 'The drawings are splendid specimens of taste and execution, and collected and hung together as they are here, produce an effect beyond expectation, brilliant and beautiful.' LH

Shanes 1979, pp. 12–13.
Gage 1980, appendix II, pp. 237–8.

EHRENBREITSTEIN, the colossal fortress guarding the confluence of the *Rhine and the *Mosel at Coblenz, was one of Turner's favourite German subjects. Always an extraordinarily impressive sight when viewed across the Rhine or from a little way up the Mosel, it is at its most spectacular when it catches the late afternoon or evening sun. In Turner's day it underwent material changes in both war and peace, being besieged by *Napoleon's troops for several years from 1794 onwards and finally surrendering in 1799. Under the terms of the Congress of Vienna (1814–15) the Rhineland fell under Prussian rule; in order to protect the Rhine in the future, Ehrenbreitstein was blown up by its rulers and rebuilt on an even more extensive scale between 1815 and 1832. These developments are reflected in Turner's art, but are often eclipsed by his own sense of Ehrenbreitstein's grandeur and his responses to its superb situation.

Turner first sketched Ehrenbreitstein in 1817 on his first visit to the Rhine and over the next 25 years he sketched it whenever his tours took him through the Rhineland. He also depicted it in every medium. In the *Rhine drawings of 1817 bought by Walter *Fawkes he included four views of the fortress or its environs (Fogg Art Museum, Cambridge, Mass., and untraced; W 656–9). He reused his sketches and memories from 1817 to produce several later watercolours of Ehrenbreitstein, including a fine large one (Bury Art Gallery and Museum; W 1051) which was engraved in the *Keepsake for 1833 (R 328). Soon afterwards he showed it in his oil painting The *Bright Stone of Honour (Ehrenbreitstein) (RA 1835; private collection; BJ 361), painted as a commission from the engraver John *Pye.

Magnificent as that painting and engraving of the fortress undoubtedly are as memorials of recent feats of heroism in this neighbourhood, they are equalled by Turner's celebrated series of watercolour sketches dating from the early 1840s (see Powell 1991, pp. 184–7). These show Ehrenbreitstein not as a formidable military installation but as an almost incidental part of a vast cliff magically transformed by ever-changing veils of light and colour. Turner used a succession of different viewpoints across the Rhine, probably including ones in his own hotel, and showed Ehrenbreitstein and the Rhine in diverse washes of warm and brilliant hues as afternoon turned to evening and sunlight gave way to moonlight. A similarly serene mood and iridescent light effects belong to the preparatory studies for the 1842 watercolour *The Mosel Bridge at Coblenz* (untraced, W 1530) in which part of Ehrenbreitstein forms an ethereal backdrop to the shimmering surface of the Mosel. 'Ehrenbreitstein' does not, in fact, mean 'bright stone of honour' as Turner seems to have believed, but 'broad stone of honour'. His final drawings of the fortress simply as a great mass of glorious

colour are the perfect poetical embodiment both of its real name and of his own mistranslation. CFP

Powell 1991, pp. 111–12, 184–7.
Powell 1995, pp. 188–94.

EHRENBREITSTEIN, see *BRIGHT STONE OF HONOUR*.

ELLIS, Wynn (1790–1875), silk merchant and collector who lived at 30 Cadogan Place, Ponsborne Park, Hertfordshire, and Tankerton Tower, near Canterbury. Ellis was a noted philanthropist who bequeathed 402 Old Master paintings to the National Gallery, whose trustees selected 44. He formed an extensive collection of Old Masters and 18th- and 19th-century British pictures. Ellis owned Turner's *Cilgarran Castle* (c.1799; Viscount Allendale; BJ 36), *Storm in the Mountains* (doubtfully by Turner; BJ 40), **Somer-Hill, near Tunbridge* (RA 1811; National Gallery of Scotland, Edinburgh; BJ 116), *Whalley Bridge and Abbey, Lancashire* (RA 1811; Loyd Collection; BJ 117), *The Temple of Jupiter Panellenius restored* (RA 1816; private collection, New York; BJ 133), and *Conway Castle* (c.1803; Trustees of the Grosvenor Estate; BJ 141). Ellis's collection was sold at Christie's on 6 May, 27 May, 17 June, and 15 July 1875, realizing a total of £56,485. RU

Macleod 1996, p. 413.

ELY, a small cathedral city in Cambridgeshire. Three large, dramatic watercolours of Ely Cathedral (see Pl. 1) were made by Turner from sketches taken in 1794 (W 193–5), including two views of the interior (private collection and Aberdeen Art Gallery; W 194, 195), which were exhibited at the Royal Academy in 1796 and 1797, though there is 'doubt as to which drawing belongs to which year' (Wilton, 1979, p. 321). These latter views, which depict light streaming through the windows, are virtuoso exercises in the architectural **Sublime*, and show the influence of Piranesi and Abraham Louis **Ducros*, whose works Turner would have seen in Sir Richard Colt **Hoare*'s collection. Hoare bought the large view of the exterior (c.1796; private collection; W 193) and may have bought one of the interior views (W 194). The other (W 195) was commissioned by James Yorke, afterwards Bishop of Ely. *Ely Cathedral, Cambridgeshire* (c.1831; private collection; W 845) is an exterior view made for *Picturesque Views in *England and Wales*. AK

ENGLAND AND WALES, PICTURESQUE VIEWS IN. See Pl. 18. Major series of 100 watercolours made for engraving between late 1824 and early 1836, and of 96 line-engraved reproductions of those images published between March 1827 and April 1838. Arguably the original designs constitute the finest set of watercolours Turner ever elaborated for engraving, and they undoubtedly form the largest related series of important drawings created by any leading Western artist.

The series was commissioned by the London print-publisher Charles **Heath*. In a letter now in the Library of Trinity College, Cambridge, Heath wrote to Dawson **Turner* on 19 February 1825 that he had just taken possession of the first four works made for the scheme; that he had paid 30 guineas for each watercolour; that the drawings would fetch upwards of 50 guineas when sold to waiting collectors after their engraving had been completed; and that the funding for the venture was entirely provided by **Hurst*, Robinson, and Co. Turner developed most of the watercolours from sketchbook pencil drawings, some dating from over 30 years earlier. He was not restricted in the dimensions of his designs, which would be scaled down for reproduction but, as with many of his other sets of watercolours produced for engraving, he created them around a distinctive median size, in this case 11×17 in. (27.9×43.1 cm.). The engraving plate-sizes average $6\frac{1}{2} \times 9\frac{1}{2}$ in. (16.5×24.1 cm.). The engraving, on copper plates, was eventually carried out by nineteen engravers, some of whom cut upwards of a dozen plates each. They were paid an average of £100 per plate, which might take up to two years to complete.

Heath planned to publish the initial prints in July 1825 but he was not able to do so until March 1827, a delay that possibly stemmed from Turner's high demands upon the engravers and certainly resulted from the bankruptcy of Hurst, Robinson in January 1826. Subsequently Heath shared financial responsibility for the venture with Robert Jennings, who also marketed and distributed the prints. Initially the engravings appeared in parts about three times a year, with each part comprising four engravings. The prices of the parts ranged from one and a half guineas for those containing proofs on India paper, to 14s. for those made up of ordinary prints.

In early June 1829 Heath exhibited 35 of the watercolours, plus all of the prints produced to date, in the Large Gallery of the **Egyptian Hall*, Piccadilly. By summer 1830, 36 of the engravings had appeared and the first 50 watercolours had probably been completed. In order to obtain new topographical material, that same summer Turner toured the Midlands, subsequently developing thirteen *England and Wales* designs from pencil studies made on the trip. In January 1831 Heath presented a group of watercolours and prints at the Freemason's Tavern, while in June–July 1833 he displayed 66 of the drawings at the **Moon, Boys, and Graves Gallery* at 6 Pall Mall. On Wednesday, 3 July 1833 Turner and 200 artists and *literati* attended a *conversazione* in that gallery, the artist's 'coarse,

stout person, heavy look and homely manners contrasting strangely with the marvellous beauty and grace of the surrounding creations of his pencil' (Revd W. H. Harrison, 'Thomas Stothard', *University Magazine*, Vol 1/5 (1878), p. 301).

In 1831 Robert Jennings sold his half-interest in the scheme to the Moon, Boys, and Graves Gallery, which in May 1835 sold it on to *Longman and Co. However, Longman's involvement did not prevent the subsequent failure of the venture. Principally this was due to the over-saturation of the market for topographical prints—many of them after designs by Turner himself—and also because of the painter's insistence upon using copper plates for printing the engravings, rather than steel plates (copper wears down much more quickly and therefore produces fewer, and necessarily more expensive, impressions than steel). As a result, the engravings could not compete financially with the many cheaper steel engravings that were then flooding the market. Moreover, the public often received merely the poorer, later impressions of the prints, Turner having reserved for himself the best initial proofs in large numbers.

In 1832, Moon, Boys, and Graves had bound the initial 60 engravings (that is, the first half of the scheme as originally envisaged) into a book that enjoyed a letterpress text by H. E. Lloyd, a prolific travel writer, translator, and the author of the catalogue of the subsequent Moon, Boys and Graves Gallery exhibition. By mid-1836 Turner had created 100 drawings but Heath decided to produce only 96 engravings, rather than the 120 originally envisaged. In 1838, after the final part of the scheme appeared, Longman had the 96 engravings re-bound into two volumes with additional letterpress by Lloyd. The market response was negligible and consequently the project was terminated. In order to recoup their losses Longman offered the 96 copper plates and several hundred copies of the bound sets of prints for £3,000 to H. G. *Bohn, a dealer in publisher's remainders and cheap offprints. He was prepared to pay only £2,800, so the stock was advertised for auction at Southgate's, Fleet Street, on 18 June 1839. Turner stepped in at the last moment, buying all the material at the reserve price of £3,000 in order to prevent the plates from being further printed until they were worn out. (He then also had to pay an additional £63 3s. 6d. for transporting the stock to his house in *Queen Anne Street.) The engravings were finally auctioned at Christie's on 24 May 1874, in one of the posthumous sales of works from Turner's studios, at which time the plates were destroyed to preserve the value of the prints.

The total cost of the *England and Wales* series must have been between £15,600 and £17,700. It is unlikely that it broke even, and although Turner's estate eventually gained from the sale of the prints, the artist himself lost on the scheme, for the £3,055 10s. he had been paid over the years at 30 guineas for each of 97 drawings (including an unengraved view of Northampton that was exhibited by Heath in 1833) was outmatched by the £3,063 3s. 6d. he expended to purchase the prints and plates before auction. Heath was financially ruined by the failure of the project, although he was not formally declared bankrupt and probably came to an agreement with his creditors (principally Longman) to pay off his debts gradually. In April 1840 he auctioned off his own sets of *England and Wales* proofs at Sotheby's.

The *England and Wales* series has always been extremely highly regarded. *Ruskin lauded many of its watercolours and engravings in *Modern Painters* and elsewhere, while A. J. *Finberg argued that the prints 'will become the most authentic record of Turner's powers at their highest stretch' (*Life*, p. 376). More recently Andrew Wilton has valued the scheme as 'the central document in [Turner's] art' (1979, p. 186). The drawings not only confirm Turner as the finest of all topographical watercolourists, but equally they reveal him to have been the foremost cultural observer of his age, for clearly he intended the *England and Wales* series to act as a human survey just as much as a group of landscapes and marine prospects. Thus, with the exception of the *railways, in the set he recorded or alluded to every social and technological aspect of his era: the relationship of the social classes; the rise of industry and decline of *agriculture; urban growth and its encroachment upon the countryside; the shrinking powers of the Church and landed aristocracy; the pressure for political change during the crisis years of 1829–32, the period of parliamentary *Reform and its successful outcome; the demand for religious tolerance and education, as exemplified by schools and universities; the army and navy, respectively urgent in wartime and bawdy in peacetime; smuggling and the coastguard; hunting, shooting, and fishing, both as industry and as recreation; the country market and fair; the stagecoach, canal, river traffic, and sea shipping; marine salvage and coastal plunder; and wreck and ruin in frequent, characteristic moralizations upon humanity's vain attempts to achieve some measure of permanence in a beautiful but often hostile environment.

Technically the drawings are unsurpassed, being imbued with the most profound subtleties of draughtsmanship and colouring, and with fine detailing and careful finish often superimposed over extremely spontaneous underpaintings. A mark of Turner's lofty conceptual and creative intentions for the project are the unusually large numbers of watercolour studies and sketches he elaborated in connection with it (see BEGINNINGS). The *England and Wales* series drawings have never been exhibited together, their largest

showings being the 66 displayed in 1833, and the 55 gathered by Evelyn Joll and the present writer at Agnew's in November–December 1979. The outstanding qualities of the watercolours have regularly been reflected by extremely high prices at auction. Sadly, two of the 100 drawings have been destroyed by fire since Turner's day, and several remain untraced. ES

Shanes 1979.

Shanes, 1984, pp. 52–4.

Herrmann 1990, pp. 112–40.

Shanes 1990², pp. 13, 162–261, 273–7.

ENGLAND: RICHMOND HILL, ON THE PRINCE RE-GENT'S BIRTHDAY, oil on canvas, 70⅞ × 131¾ in. (180 × 334.5 cm.), RA 1819 (206); Tate Gallery, London (BJ 140); see Pl. 14. Exhibited with verses from *Thomson's Seasons, 'Summer', ll. 1401–8, referring to the various places that can be seen from Richmond Hill, the picture is a development of the themes of *Pope's Villa (Turner's gallery 1808; BJ 72) and *Thomson's Aeolian Harp (Turner's gallery 1809; BJ 86). The relationship to the Prince Regent's birthday, 12 August, is a complicated one, particularly as it was often celebrated on 23 April, St George's Day and Shakespeare's and perhaps Turner's *birthdays. Golt has pointed to similarities to the description of the unofficial celebration held by Lady Cardigan at her house on the Thames at Richmond on 12 August 1817 despite the fact that Turner seems to have left England for his Rhine tour on 10 April; there were detailed reports in the press.

The picture also alludes to 18th-century pastoral subjects: several of the figures are based on a sketch of c.1815 (TB CXLI: 26v., 27) after *Watteau's L'Île Enchantée. There are also drawings of the view (CXLI: 10v.–13, CXL: 77–82), as well as a number of unfinished watercolours, Colour Beginnings, and later finished watercolours in the Lady Lever Art Gallery, Port Sunlight, the British Museum, and the Walker Art Gallery, Liverpool (W 518, 833, 879).

This was Turner's first oil on this exceptionally large scale, which he was to follow in *Rome, from the Vatican (RA 1820), and the unfinished Rialto, Venice (c.1820; BJ 245). However, the composition follows an unfinished oil in Turner's normal large format, 58 × 93¾ in. (147.4 × 238 cm.), showing Richmond Hill with Girls carrying Corn (c.1819; BJ 227). Turner's new, ambitious format seems to have been inspired by his attempt to obtain royal patronage, by the size, 81 × 121 in. (205.7 × 307.3 cm.), including frame, of T. C. Hofland's View from Richmond Hill shown at the British Institution in 1815, and by the exhibition at the BI from mid-April 1819 of Velasquez's Philip IV of Spain hunting Boar (Martin Butlin, 'Turner and Tradition', Turner

Society News, 74 (December 1996), p. 11, repr.); this is also a panoramic landscape in a wide format with royal associations and shares a small but significant detail in the flag hanging from the branch of a tree.

The Repository of the Arts, June 1819, praises 'the foreground beautifully worked up, and the azure blue of the distances modified in all the gradations of aerial perspective', but the Annals of the Fine Arts wished that Turner had painted another *Dido building Carthage. *Faringdon, 2 May 1819, recorded criticism of 'the flaming colour of Turner's pictures'. MB

Stuckey 1981, pp. 4–6.

Whittingham 1985, pp. 10–12, 16; and 1985², pp. 31, 35, 42.

Golt 1987, pp. 9–20, repr.

ENGRAVERS AND PUBLISHERS. From the age of 19 until the year of his death Turner was almost constantly concerned with the production and publication of prints after his drawings and, less frequently, paintings. Something like a quarter of the more than 300 Turner letters assembled by John Gage (Gage 1980) were written to print-publishers and engravers. These letters form only part of the relatively ample information—there are also Turner's instructions on touched proofs, the notes and reminiscences of engravers, and the like—which we have about Turner's activities connected with the making of prints and of his relationships with the individual engravers. In contrast we have only scant knowledge about his work as a painter and draughtsman, at which he almost invariably worked alone, for on the whole Turner was a very private person. From some of the letters and from the touched proofs we know that Turner frequently controlled the engraving of his work very closely, especially for the plates of the *Liber Studiorum, and also for such series of steel engravings as the *Rivers of France. Indeed the very high standards achieved by the leading British engravers of the 1820s and 1830s is often attributed to the influence of Turner's stimulating and demanding supervision of the engraving of his own work.

The first known surviving proof touched by Turner is for the 1801 *Oxford Almanack, Chapel and Hall of Oriel College, engraved by James *Basire (R 39), and on one of the proofs for the 1811 Almanack, Christ Church Cathedral, is the earliest surviving example of Turner's longer written instructions to the engraver, again Basire (R 47). Publication of the Liber had begun in 1807, and for this mezzotint series Turner himself executed most of the etchings and engraved eleven of the 71 published plates, as well as himself publishing all but the first five parts. There are numerous touched Liber proofs, often with the artist's lengthy written instructions to the engraver in the margins. There are also many

touched and corrected proofs with written instructions for the 40 engravings on copper in the *Southern Coast series, published between 1814 and 1826, in partnership with John *Murray, by the *Cooke brothers, who also did much of the engraving (R 88–127). That Turner was exceptionally closely involved with the engraving, printing, and publication of this beautiful and successful series, for which he provided many outstanding watercolours, is proved not only by the numerous surviving touched and annotated proofs, but also by a considerable group of letters and other records (see Herrmann 1990, pp. 76–90). However, W. B. Cooke clearly found Turner's interference excessive and irksome, and the artist did not collaborate with him again. Turner also quarrelled with his namesake Charles *Turner, who engraved and published the magnificent large mezzotint plate of The *Shipwreck (1807; R 751), and also engraved the first twenty plates of the Liber Studiorum, for which he acted as the publisher of parts II to IV. The two Turners quarrelled in 1809, though a few years later Charles again engraved a plate for the Liber, and then four plates for the *Rivers of England.

On the other hand, several of his other engravers became friendly with Turner, notably John *Pye, whose lovely small plate of *Pope's Villa (R 76) so impressed the painter in 1811. Pye only engraved another twelve plates after Turner during his lifetime, but he assembled an important collection of the Liber Studiorum and his notes on the Liber were edited by J. L. Roget and published in 1879. John *Landseer was another friend and also a neighbour, and, though he engraved little after Turner, his writings on the artist's work have proved of considerable value. Another engraver who wrote about Turner, and who must have known him well, was John *Burnet, though he only engraved posthumous plates after the painter's work. The mezzotint engraver Thomas *Lupton was also on friendly terms with the painter, whom he described as 'always entertaining, quick in reply, and very animated and witty in conversation' (Thornbury 1877, p. 223). On the other hand the younger engraver J. T. *Willmore, who came to be regarded by Turner as one of his six best engravers, and there were some 80 in all, recorded that when he first met the artist, in about 1840, the painter 'with many cordial grunts . . . gave him an hour's lecture, difficult to understand, on the art of engraving' (Gage 1980, p. 299).

Many engravers also acted as publishers of prints, and among these was Charles *Heath, who first worked with Turner in 1811, and who some years later promoted several of the Annuals to some of which Turner contributed plates, including most significantly *Turner's Annual Tour. In 1825 Heath commenced work on the ambitious, artistically highly successful and commercially ill-fated Picturesque

Views in *England and Wales, of which 96 plates were published in parts between 1827 and 1838. At first Heath was in partnership with *Hurst, Robinson, but after their bankruptcy in 1826 they were replaced by Robert Jennings. The expense of the project ruined Heath, and there were several further changes of publisher before the final plates were issued in 1838. A much more successful publishing house, John *Murray, which still exists today, was concerned with several series and books with plates after Turner, including *Hakewill's Italy and Cooke's *Southern Coast. Murray's were famed for their publication of the work of Lord Byron, and among the illustrations of their 1832–4 edition of Life and Works of Lord *Byron in seventeen volumes are 26 small plates and vignettes after Turner.

Other publishing houses involved in publishing illustrations and single plates after Turner included H. G. *Bohn, Henry *Graves, *Longman and Co. and Edward *Moxon. Turner tended to drive harder bargains with the specialist publishing firms than he did with the engravers who also acted as publishers. This could be taken as another indication of how frequently he felt drawn to the engravers, who were mostly members of a closely knit fraternity, and often belonged to families including two or more generations of engravers. LH

Rawlinson 1908 and 1913.
Herrmann 1990.

ENGRAVING AND TURNER. Turner is usually thought of as a painter, and it is his oils rather than his watercolours that most people will know about. However, engraving also played a very important role in his development and activity as an artist, especially in watercolours, but in modern times that aspect of his career has been much neglected. Turner's first experience with engraving was in 1794, when he was only 19, and it continued for over half a century, until the year of his death. During those years nearly 900 prints based on his watercolours, drawings, and paintings were published, and Turner's close involvement with their production must be considered as one of the major factors of his long working life. The entry on *engravers and publishers outlines Turner's relationship with his engravers, and his close supervision of their work, resulting in a much higher standard of engraving in Britain as a whole; the term 'Turner school of engravers' has been used to describe the many outstanding British engravers of the first half of the 19th century who worked with and were directed by Turner. This entry enlarges on that and surveys the importance of his work with and for the engravers in Turner's own development and achievement as an artist, remembering also that on a few occasions he was his own engraver. During the central 25

years of his life the artist must have spent almost as much time dealing with engraving and engravers as he spent painting and drawing.

Turner's early work was as a topographical and architectural draughtsman, and in the late 18th century it was normal for such work to be executed with engraving in mind. Thus between 1794 and 1798 Turner supplied some 30 small watercolours of picturesque views in British towns and cities, which were very mechanically engraved for the *Copper-Plate Magazine* (R 1–15) and other similar modest publications (R 16–31). These tiny engravings and the drawings on which they were based were already old-fashioned at the time of their publication. During the same years Turner was exhibiting large groups of topographical and architectural watercolours at the *Royal Academy each summer; these were impressive and advanced in style and technique, and bore little relationship to his earliest work for the engravers. However, probably because of the success of his RA exhibits, Turner was given one of the most prestigious topographical engraving commissions of the time, when he was engaged in 1799 by the Delegates of the Oxford University Press to produce two drawings to be engraved as headpieces of the annual *Oxford Almanack. In the end Turner produced a total of ten drawings for the Almanack, all of which were engraved by James *Basire, one of the best engravers of the day. Turner's watercolours for this series, which were published between 1799 and 1811 (R 38–47), are still somewhat traditional, but they do illustrate his mastery in depicting light and shade. His concern for this aspect of the compositions is shown by his corrections on a proof of the *Chapel and Hall of Oriel College* (1801; R 39), which is the first known surviving proof touched by the artist.

While his work for the Oxford Almanacks reflected the advances in his watercolours, the contemporary *Liber Studiorum*, which was certainly for Turner the focal engraving venture of his career, was in fact old-fashioned and backward-looking in concept and execution. Inspired by Richard *Earlom's fine mezzotint engravings of the 195 drawings of *Claude's *Liber Veritatis*, published in 1777 by Alderman Boydell, Turner conceived his *Liber Studiorum*, as its title indicates, as a work of instruction or 'drawing book' for other artists, as well as a survey of his own achievements as an artist and a kind of art history of landscape painting. Initially planned as 100 mezzotint engravings to be published in twenty parts, only fourteen parts were, in fact, published, between 1807 and 1819. Despite the total lack of a written text, these 71 plates provided ample material to fulfil Turner's aims. From the start he was deeply involved with the production of the series, supplying not only the drawings for engraving, but also executing nearly all the outline

etchings over which the engravers applied their mezzotint. Turner himself completed the mezzotint engraving of eleven plates, and his constant involvement with this great series is further indicated by the large number of touched proofs which still exist today, many of them also annotated with the artist's detailed instructions to the engraver. Though his work for and on the *Liber* did not herald advances or changes in the development of his art, it did constitute a kind of progress report on his art until then, and as such it provides invaluable insight into the first twenty or more years of Turner's work.

If Turner had died in 1819, when he was 44 years old, he could have been ranked among the 'Old Masters'—as a painter in oils he had shown his ability to emulate and to rival the work of Claude, *Poussin, *Cuyp, *Van de Velde, Richard *Wilson, *Gainsborough, and others, and in watercolours he, for a time alongside Thomas *Girtin, had greatly advanced that medium and taken it to new heights. It was in watercolours that he executed nearly all his drawings made specifically for engraving, and from about 1811 it was the challenge of providing watercolours for engraving that produced many of his further advances in that difficult medium, which in their turn had great effects on the development of his work in oils. It was in 1811, the year in which he had been so impressed by John *Pye's small engraving of his 1808 painting of *Pope's Villa*, that Turner accepted a commission from the *Cooke brothers to contribute 24 watercolours for an ambitious publication entitled *Picturesque Views of the *Southern Coast of England*. In the event Turner provided a total of 40 drawings, which were published between 1814 and 1826 (R 88–127), and many of which were among the finest watercolours that he had produced so far. Ranging in date from 1811 to about 1825, these attractive coastal scenes illustrate his development from the rather dry though sometimes luminous first drawings for the series to the much more informative and lively compositions of the later watercolours of the mid-1820s, such as the dramatic view of Portsmouth on a stormy day (W 477), which was magnificently engraved by William *Miller and published in 1825 (R 120).

As is so clearly seen in the *Southern Coast* drawings, Turner excelled in the depiction of water, both in oils and watercolours, and there are many waterfalls, rivers, and lakes in the twenty views which Turner drew in 1817 and 1818 to illustrate Dr *Whitaker's *History of Richmondshire*, published by *Longman's in 1819–23 (R 169–88). These watercolours, which are all rather larger than the engravings, range from the very direct yet delicate vision of *Weathercote Cave* (British Museum; W 580) to the broad and luminous view of *Simmer Lake, near Askrigg* (British Museum; W 571), and demonstrate Turner's complete mastery of the

medium. *Ruskin, who owned four of them, especially admired these Yorkshire drawings with their 'strong love of place'.

1819 was a critical year for Turner and his art. He had already decided to abandon the publication of the *Liber Studiorum*, and the final two parts were issued on 1 January. Two private London exhibitions of his work—Sir John *Leicester's of eight oils in March and Walter *Fawkes's of his many watercolours in the following month—brought Turner much praise. On 1 August he set out for his long-delayed first visit to *Italy, which made a deep impression on him, though the actual impact on his art was relatively slow. The most dramatic change was seen in the water-colours which he made while there—most of his drawings on this Italian tour were in pencil—especially those of *Ven-ice. These demonstrate an even greater feeling for light and a new fluidity, which had been present only occasionally in previous work. On his return to England early in 1820 it was as if Turner was taking stock—he exhibited only five paint-ings at the Royal Academy from 1820 to 1825. For the first few months of 1820 Turner was probably still working on some of the unpublished plates of the *Liber*, several of which show a new spontaneity of execution, which is also found in the small series of unpublished small mezzotint en-gravings on steel—the so-called *Little Liber* (R 799–809a). During the early 1820s Turner devoted much of his most adventurous creative genius to these somewhat mysterious prints, for which most of the known preliminary drawings are in watercolours. Steel plates for engraving first became available in London in 1820, and it seems possible that Turner was keen to experiment with this new material, which was used for most of the *Little Liber* engravings. As far as we know he alone was responsible for the engraving of the *Little Liber* plates, and, as some of the proofs show, he developed his compositions on the plate. Nine of these fluent compositions feature the sea, and in all cases this reflects the weather in the superbly effective skies.

The importance of the *Little Liber* plates has come to be recognized only in recent years, though there is still very little factual information about them, and the usual dating of *c*.1820–5 is also surmise. However, there can be no doubt that this series, which appears to have no specific theme or subject matter, played an important role in Turner's artistic 'liberation', for from about 1825 his art as a whole became much freer and ever more individual. The *Little Liber* can be thought of as an engraved notebook, in which the very private Turner carried out some of the liberating experi-ments which led to the great art of his later years.

In the meantime Turner had begun working on the most ambitious of his topographical series, the *Picturesque Views in *England and Wales*, initiated by Charles *Heath, who had engraved two of the *Richmondshire* plates. Only 96 of the 120 plates originally planned were published between 1827 and 1838 (R 209–304), and the series was never a com-mercial success. However, Turner was actively interested in the whole project, and again produced some of his out-standing finished watercolours, which have always been among those most coveted by collectors. There are again numerous touched, corrected, and annotated proofs for the *England and Wales* series, as there had been for the *Southern Coast*, and Turner's close supervision often ensured that the impact of his coloured models was surpassed by the effects achieved in black and white. While Turner was at his more 'traditional' best in his watercolours for these publications, the engravers who worked on them were inspired by his en-thusiastic and helpful guidance to achieve new standards of engraving, which had not been seen before in England. An important feature of these basically topographical compos-itions is that they are usually crowded with people and ac-tivity, which play an essential part in harmonizing the scene.

The *England and Wales* prints were engraved on copper, but after 1826 all the plates after Turner, with the exception of some of the later large single plates, were engraved on steel. The greater hardness of the new material meant that far larger impressions could be printed without loss of qual-ity, and thus it was especially suited for engraving book il-lustrations. In the 1830s Turner provided watercolour drawings for over 300 such steel engravings, many of them vignettes on a tiny scale. Producing such minutely detailed small compositions meant a total change of method for Turner, who rose to the challenge magnificently. The water-colours to illustrate the prose and poetry of Samuel *Rogers, Lord *Byron, Walter *Scott, and others are both fluent and precise, and, like the painter, the engravers who interpreted them in black and white worked with excep-tional skill, again often closely supervised by Turner.

One of the outstanding series of his illustrative steel plates was essentially Turner's own, for he chose the sub-jects and the text was written around them; and the plates were based on a totally different type of drawing. This was the topographical *Rivers of France* series, of which three volumes were published in 1833–5, with the title *Turner's Annual Tour* (R 432–92). In these successful books the illus-trations were the important selling point, though they were ably supported by the flowing texts of Leitch *Ritchie. Turner's *Rivers of France* drawings are mostly in gouache on blue paper, and they were executed with much greater spontaneity overall, though in many of them considerable detail of buildings and figures was superimposed on the colours in fine penwork, usually using red ink. Though

again on a small scale, they include some of Turner's most atmospheric compositions, combining, as do the much more finished watercolours of the *England and Wales* series, the 'poetry' of the landscape with the life and activity to be found in that landscape.

The second half of the 1830s saw far fewer illustrative engravings after Turner, and he concentrated again on oil painting for exhibitions and in the early 1840s on finished watercolours for sale, based on the studies he had made during his visits to *Switzerland. His work for and with the engravers had continued for over 40 years, and during those years it played an important part in many aspects of his development as an artist. From the point of view of this development it was certainly the *Liber Studiorum* that was most significant, as is proved by the fact that in the later 1840s the elderly artist painted a considerable number of large unfinished canvases of which the compositions are clearly based on some of the *Liber* plates. The *Liber Studiorum*, and perhaps also the *Little Liber*, were vital elements in the development of Turner's art, and his concern with these and with all the other prints with which he was involved for nearly half a century were an essential part of his art and of his career. LH

Rawlinson 1908 and 1913.
Herrmann 1990.

ENGRAVING TECHNIQUES. The considerable output of graphic work after (and in some cases by) Turner was produced using a range of techniques. With the exception of some lithographs, the prints were made using intaglio methods, where the paper receives the ink from lines incised in the metal plate by hand or acid rather than from the surface of the plate. The term 'engraving' originally referred specifically to line-engraving, a technique used for the majority of the prints after Turner, but from the mid-18th century it was used as a generic description encompassing all intaglio methods, which include aquatint, soft- and hard-ground etching, and mezzotint, as well as line-engraving. W. G. *Rawlinson in his comprehensive survey of Turner's graphic work, *The Engraved Work of J. M. W. Turner* (2 vols., 1908 and 1913), listed all the engravings excluding the *Liber Studiorum* mezzotints, which he treated in a separate volume, *Turner's Liber Studiorum* (1878, rev. edn. 1906). Rawlinson devoted the first volume of his survey to the line-engravings on copper (R 1–312), and in the second listed the line-engravings on steel, the mezzotints, aquatints and lithographs (R 313–867); the techniques are described below in this order.

LINE-ENGRAVING is the most laborious and costly of the intaglio processes. Lines are incised on a metal plate using a sharp tool called a burin or graver, and a burnisher can be used to rub down and lighten areas, and remove unwanted lines. Once the image is engraved, ink is worked into the heated plate, and the surface subsequently wiped with coarse muslin so that the ink remains only in the hollows or lines. A damp sheet of paper is laid over the plate, which is then printed under pressure to force the paper into the grooves to pull out the ink. Rawlinson lists 764 line-engravings after Turner, of which 336 were produced using copper plates, including the earliest plates based on his designs published in the *Copper-Plate Magazine* and the *Itinerant* (R 1–15a). Other notable graphic work in this medium included James *Basire's engravings for the *Oxford Almanack (R 38–47), and several ambitious topographical series such as *Picturesque Views of the *Southern Coast of England* (R 88–127), and *Picturesque Views in *England and Wales*, 1827–38 (R 209–304). Steel plates for engraving were introduced around 1822 by Thomas Goff *Lupton. The new medium had a considerable impact on engraving styles and circulation; the steel plates were more durable than copper, permitting the engraving of very fine closely laid lines, and were capable of printing large editions of 20,000 to 30,000 impressions. Steel plates were particularly appropriate for book illustrations, and during the 1830s Turner was commissioned to produce over 300 designs, including 150 vignettes, which were engraved as illustrations for annuals such as the *Keepsake and the *Literary Souvenir*, and for books, notably Samuel *Rogers's *Italy* (1830) and Walter *Scott's *Poetical Works* (1834).

MEZZOTINT is the only printmaking process which works from dark to light. The plate is grounded using a rocker, a tool like a chisel with a curved and serrated blade which throws up minute points of metal, or 'burr'. If an impression is printed at this stage, the plate will print as a solid dark area. To create light areas, the ground is removed in varying degrees using tools known as burnishers, scrapers, and polishers. Darks can be restored using the rocker or a roulette. The majority of the *Liber Studiorum* plates were engraved using a combination of mezzotint and hard-ground etching (usually known simply as 'etching'), but Turner occasionally used soft-ground etching as a base (F 44, 70, 90, and 91) and some plates incorporate aquatint. Turner mezzotinted some of the *Liber* plates himself, and the twelve mezzotints known as the *Little Liber* (R 799–809a) are also traditionally attributed to him. Other mezzotints engraved after Turner's designs include the plates for the *Rivers of England* (R 752–69), and *Ports of England* series, and the single plate of The *Shipwreck* (R 751; BJ 54). With the *etching* process, the plate is covered while hot with a thin layer of 'ground',

usually composed of gums, waxes and resins, which is allowed to cool and harden. The design is then drawn on the ground with a fine point or etching needle, exposing the metal beneath. The plate is then placed in acid, which 'bites' the exposed lines. *Soft-ground etching* was developed as a means of translating the effect of a pencil or chalk drawing. The ground is a mixture of ordinary etching ground and tallow, and does not harden on cooling. The etcher draws on a piece of thin paper laid over the ground and, when the paper is removed, the ground adheres to the paper where the drawing instrument was pressed, leaving the design exposed on the copper plate. The plate is bitten in the usual way, producing a granular line.

AQUATINT was developed to imitate the effect of watercolour wash. The plate is covered with a ground of powdered particles or resin, which is fused to the surface when the plate is heated. Since this ground is porous, the acid bites tiny uneven pools around each particle. These tiny depressions retain the ink when the plate is wiped, and when printed give the effect of a soft grain. Gradations of tone can be produced either using stopping-out varnish, or by laying grounds which vary in thickness or fineness. Aquatint was used on several *Liber* plates (F 13, 14, 28, 35, 43, 87, and 91), and over twenty plates in pure aquatint were executed after Turner's designs (R 812–32c).

Individual impressions of intaglio prints usually exist in a variety of 'states', each state marking a distinct phase in the development of the print. The earliest are known as 'proofs', a term which generally refers to prints before publication. The impressions taken during the execution of the print to monitor progress are usually known as 'engraver's trial' or 'progress' proofs. Many of the plates executed after Turner went through numerous stages of progress proofs, and proofs annotated with written instructions or marked in pencil or watercolour by the artist are known as 'touched' proofs. The terms 'engraver's proof' or 'proof' are also (confusingly) applied to the earliest, high-quality impressions printed after the plate was considered ready for publication.

LITHOGRAPHY was invented by Alois Senefelder in 1798. An image is drawn in a greasy medium on a stone or plate, which is then dampened with water. Greasy printing ink rolled onto the surface will adhere to the design but be repelled by the damp area. One lithograph, a *View of Leeds* (R 833; W 544), was published in Turner's lifetime and several coloured and chromo-lithographs (using a mechanical process) were made after his death (R 834–67). GF

Anthony Dyson, *Pictures to Print: The Nineteenth-Century Engraving Trade*, 1984.

Bamber Gascoigne, *How to Identify Prints*, 1986.
Carol Wax, *The Mezzotint*, 1990.

ENSOR, James (1860–1949), Belgian artist. He is famed for his pioneering visionary compositions, of which the best-known is the vast *Entry of Christ into Brussels* of 1888–9, now in the Getty Museum. Ensor's father was of British extraction, and the painter, who spent nearly all his life in Ostend, was influenced by various British artists, especially Turner. Ensor visited London for the first time in 1887, and Turner's impact is most significant in the visionary landscapes of the late 1880s and beyond, such as *Christ Calming the Storm* (Museum voor Schone Kunsten, Ostend) of 1891. LH

ESSEX, George Capel Coningsby, fifth Earl of (1757–1839), an early patron of Turner. He lived at Cassiobury Park, near Watford, where the Capel family had been seated since the early 17th century. In 1781 he inherited the Herefordshire estate of Hampton Court from his maternal grandmother, the Countess of Coningsby, and took her surname. He was known as Viscount Malden until inheriting as fifth Earl in 1799.

Cassiobury, described by John Evelyn in 1680 as new and of 'plaine fabric', seemed distinctly old-fashioned to the fifth Earl. In late 18th-century England, there was a growing Gothic taste and the fifth Earl turned to James *Wyatt (1746–1813) to make the house picturesque. In 1801–3 the old house was greatly extended, a cloister introduced, and ogival windows fitted with stained glass; while the exterior, adorned with crenellations, turrets, and huge arched windows, became monastic in character.

The earliest link between the fifth Earl and Turner dates from 1795. The 'South Wales' Sketchbook of that year (TB XXVI) contains a list of 'Order'd Drawings' that includes a set of five views of Hampton Court, Herefordshire, for Viscount Malden (four in the Whitworth Art Gallery, Manchester; W 182–6). Turner made two groups of drawings of Cassiobury, in 1796–1800 and in 1807; the 'Fonthill' Sketchbook (XLVII) has eleven drawings of the house and park, which show its transformation into Gothic. Turner made four finished drawings of Cassiobury (W 189–92), of which *The West Front* was acquired in 1984 by Watford Museum; another is in the *Boston Museum of Fine Arts.

Essex did not buy an oil painting from Turner until 1807, when he bought *Walton Bridges* (National Gallery of Victoria, Melbourne; BJ 63). In 1808 he purchased *Purfleet and the Essex Shore as seen from Long Reach* (private collection, Belgium; BJ 74), and in 1809 *Trout Fishing in the Dee, Corwen Bridge* (Taft Museum, Cincinnati; BJ 92). Two

unfinished oils seem to have been intended for Lord Essex (BJ 209, 209a).

The fifth Earl was a generous patron of contemporary artists, many of whom stayed at Cassiobury. He commissioned views of Cassiobury from William Alexander, Henry Edridge, Thomas Hearne, and William Henry Hunt, and portraits of himself and his wife by *Hoppner. He bought pictures and watercolours by Bone, *Callcott, Clint, Collins, *Jones, Edwin *Landseer, *Leslie, and *Wilkie, and owned twenty 'most picturesque views' of Paris, drawn in watercolour by Thomas *Girtin in 1802.

Engravings from drawings of Cassiobury by Turner and other artists were included in John *Britton's *History and Description of Cassiobury Park*, published in 1837 (R 818–21). By then, Turner was no longer a regular visitor. At the age of 80 (1838), after the death of his first wife, the fifth Earl married Kitty Stephens (1794–1882), singer and actress. He died on 23 April 1839, and was succeeded as sixth Earl by his nephew. The seventh Earl sent for sale at Christie's on 22 July 1893 nine paintings collected by the fifth Earl, including the three by Turner. Cassiobury itself survived until 1922, when the entire contents were sold by auction, and the house was demolished. CALS-M

EVENING OF THE DELUGE, see *LIGHT AND COLOUR.*

EVENING STAR, THE, oil on canvas, 36¼ × 48¼ in. (92.5 × 123 cm.), *c.*1830; National Gallery, London (BJ 453). An exquisite, unfinished evocation of *Bonington's coastal scenes, perhaps associated with some draft verses on 'The first pale Star of Eve ere Twylight comes' ('Worcester and Shrewsbury' Sketchbook, *c.*1829–30; TB CCXXXIX: 70), and perhaps painted in rivalry to Etty's *Venus, the Evening Star* (RA 1828), a figure subject. For a similar but exhibited picture see *Calais Sands* (RA 1830; BJ 334). MB

Egerton 1998, pp. 290–2, repr. in colour.

EWENNY. The Benedictine Priory at Ewenny, a Romanesque foundation that was in ruins when Turner visited it in 1795, inspired him to one of the grandest of his early architectural interiors. His drawing is in the 'Smaller South Wales' Sketchbook (TB XXV: 11). The watercolour was exhibited at the Royal Academy in 1797 (National Museum of Wales, Cardiff; W 227), and with its bold, arched composition and brooding light effects reflects the interest in the etchings of Giovanni Battista Piranesi (1720–78) and the watercolours of Abraham Louis Rodolphe *Ducros (1748–1810) that had been awakened in him by visits to Sir Richard Colt *Hoare at Stourhead, Wiltshire, where goodly collections of their work were to be seen. The resulting design anticipates the *Rembrandt-inspired compositions of arched interiors in

dramatic lighting of the years around 1830 (BJ 445, 446, 450). Turner drew at Ewenny again in 1798, in his 'Swans' Sketchbook (XLII: 54, 58/9). AW

EXHIBITED WATERCOLOURS. From the outset of Turner's career as a professional artist the need to produce finished work for public exhibition became a crucial element in his driving ambition to achieve professional recognition from fellow artists and critics alike. It was the route to patronage and the means to creating a ready market for his paintings. As watercolour was the primary medium for his output during the first decade of his professional career and the *Royal Academy was regarded as the primary and most prestigious institution for public exhibition, it was Turner's exhibited works at the annual exhibition that were to represent the foundation of his early reputation.

Turner made his debut at the RA in 1790 with the watercolour of the *Archbishop's Palace, Lambeth* (Indianapolis Museum of Art; W 10). From that year until 1804 he regularly exhibited watercolours, along with an increasing proportion of oil paintings. In the early years of the decade the exhibited watercolours were the immediate manifestations of Turner's increasing appetite for travel in search of the Picturesque (see SUBLIME) subject matter which could fire his imagination.

The watercolours exhibited at the RA in 1792 and 1793 were produced from sketches made in Malmesbury and *Bristol during the previous year. The sites earmarked for study were the castles, country houses, and ecclesiastical architecture which formed the staple diet of most of the topographical draughtsmen in whose manner Turner shaped his watercolour style. Paul *Sandby, Thomas *Malton, Edward *Dayes, Thomas Hearne, and Michel 'Angelo' Rooker were his primary sources but the developing rivalry with Thomas *Girtin, and his own desire to achieve a higher platform for his art, resulted in mature works which extended beyond the mere recording of topographical subjects.

The exhibited watercolours were the means to demonstrate the rapid technical advances Turner was making in the watercolour medium and also the picture-making qualities that only Girtin could begin to rival. His architectural subjects became bolder in design and more daring in their conception. In such works as *Transept of Tintern Abbey, Monmouthshire* (RA 1794; Ashmolean Museum, Oxford; W 58) and *Cathedral Church at Lincoln* (RA 1795; British Museum; W 124) Turner purposely created an exaggerated scale and a sense of enormity specifically designed to create a sense of wonderment in the viewer. The watercolour of *St. Erasmus in Bishop Islip's Chapel, Westminster Abbey* (RA

1796; British Museum; W 138) may be regarded as the consummate achievement of his early architectural works. The fact that Turner 'signs' this work by way of an inscription on one of the tombs 'WILLIAM TURNER NATUS 1775' indicates not only his innate ambition but also the confidence he had that he was destined to achieve recognition and immortality through the avenues of public exhibition.

However, those artists who held serious ambitions of professional status at the turn of the 18th century were painters in oils, watercolour being considered an inferior medium. At the RA exhibitions the scale of works was also a factor in endorsing serious aspirations to the realms of high art, and watercolour, conditioned partly by the nature of the medium, did not readily lend itself to the production of large-scale works. Consequently, at the exhibitions, watercolours were often placed in ante-rooms or dwarfed among the larger oil paintings which were hung from floor to ceiling at that time.

By 1797 Turner had reached a watershed for an artist of ambition who had worked primarily in watercolour but had, the previous year, exhibited his first oil painting at the RA, *Fishermen at Sea* (BJ 1), to some critical acclaim. It was this growing ambition which had prompted Turner to make his landmark tours in 1797 to the North of England and the *Lake District followed in 1798 by a lengthy excursion to *Wales in search of the scenery that had inspired Richard *Wilson.

The exhibited watercolours emanating from these two major excursions were on an altogether more *Sublime plane and both the realization of dramatic effect and their comparatively large scale required considerable technical repositioning. This move saw Turner begin to transcend the previously clear distinction between paintings in watercolour and works in oil. By achieving these technical advances Turner was able to present his watercolours shown at the RA in the context of the revered Old Masters rather than reworking the traditional sources, embedded in the Picturesque, which was the province of most of his contemporary exponents of the medium.

The manner of Richard Wilson is evident in the exhibited works of 1798–9 in both oil and watercolours. However, the watercolour of *Caernarvon Castle* (private collection; W 254), exhibited at the RA in 1799, transcends the Wilsonian theme to depict the castle silhouetted against a deep, rich sunset reflected in the calm waters which clearly evokes the harbour scenes of *Claude Lorrain.

In 1798 the RA revived the custom whereby exhibitors were able to include quotations in the catalogue entries to their works. Turner responded immediately and five of his exhibits in 1798 were accompanied by passages from familiar poetry. These included the watercolours of *Norham Castle on the Tweed, Summer's Morn* (Cecil Higgins Art Gallery, Bedford; W 225) and *The Dormitory and Transept of Fountains Abbey—Evening* (City Art Gallery, York; W 238), both of which were accompanied by passages from *Thomson's *Seasons* in the catalogue. Thomson's texts, which refer specifically to the times of day echoed by Turner in his titles, were clearly recognized by the artist as a vehicle for enhancing the sentiments and emotive context of the pictures. He continued to append literary texts to embellish selected exhibits for the remainder of his career.

At the exhibition of 1800 Turner submitted five large watercolours, commissioned by William *Beckford, portraying his new Gothic abbey then under construction at *Fonthill (W 335–9). The benefit of increasing recognition was also bringing the rewards of significant patronage. *Caernarvon Castle, North Wales* (TB LXX: M; W 263), also exhibited at the RA in 1800, was his first watercolour which addressed a specifically historic theme. The subject of the Welsh bard, forlorn in contemplation of his impending exile in the face of defeat by the armies of Edward I, was also well known through Gray's celebrated ode 'The Bard' of 1757. The lines which Turner appended to this work mark a further development in the partnership of painting and poetry, as they appear to be by Turner himself. An overtly Claudian composition, in which the castle is a distant appendage but a vital indicator to the historic context, this work is the consummate achievement of Turner's moves to create an equal platform for the appreciation of watercolour to that accorded to oil painting.

A further dimension was embraced in the finished watercolours which stemmed from the material gathered on his first visit to the *Alps in 1802. Works such as *Glacier and source of the Arveron, going up to the Mer de Glace* (Yale Center for British Art, New Haven; W 365) and *St. Huges denouncing vengeance on the shepherd of Cormayer in the valley of d'Aoust* (Soane Museum, London; W 364), both exhibited RA 1803, address the notion of the Sublime, constructed around feelings of drama and horror experienced in mountains which were of an altogether more dramatic dimension than the uplands of Wales or *Scotland. The latter work includes reference to historical incident which, although its source is not known, provides the opportunity to embrace a foreground drama which evokes the example of Nicolas *Poussin, set within an essentially Turnerian experience.

Turner was not alone in advancing the position of watercolour painting. It became common practice to produce large-scale works for exhibition purposes, often displayed in ornate frames and gold mounts, purposely presented to

mirror the appearance of oil paintings. Increasing recognition of the achievements of painters in watercolour not unnaturally prompted moves for the establishment of a breakaway 'Academy' and in 1804 the Society of Painters in Watercolour was established, the cornerstone of which was its own annual public exhibition. One of the leading protagonists in the formation of this new society was William Frederick *Wells, a close friend of Turner to whom is credited the idea for the creation of his *Liber Studiorum. However, Turner did not ally himself with this new venture, preferring to concentrate on the opening of his own gallery in *Harley Street where, although the majority of the works exhibited were oil paintings, a number of important watercolours were also shown. These were primarily finished works emanating from his tour of the Alps. Walter *Fawkes, who had acquired the *Source of the Arveron* from the RA the previous year, purchased over twenty finished watercolours during the next ten years, several from *Turner's gallery.

By 1819 Fawkes had established a unique collection of Turner's watercolours, as well as other works by contemporary artists. On 13 April that year he opened his London house in *Grosvenor Place for the public to view the collection. Although other artists were represented, a large group of watercolours by Turner were on show. It was effectively the first 'retrospective' of his work and included former RA exhibits, a number of the great Swiss watercolours, as well as twenty sketches, not originally intended for public show, of scenes in Wharfedale and the environs of Farnley Hall. As if to endorse this significant event and the public access to his works, Turner was often to be seen in attendance at the show, which won critical acclaim.

Turner's focus up to 1810 was essentially on the exhibitions at his own gallery. However, in 1811, he returned to the RA with exhibits including the watercolours of *Chryses (private collection; W 492) and *Scarborough Town and Castle: Morning: Boys catching Crabs* (private collection; W 528). Apart from showing four Swiss watercolours in 1815 Turner concentrated on submitting his oil paintings to the RA from this point onwards. The most notable exception, however, was the memorial picture *Funeral of Sir Thomas Lawrence, a sketch from memory* (RA 1830; CCLXIII: 344; W 521). Turner's finished watercolours began to take on a different role in his output, being the basis of an increasing body of work for engraving. Through his engraved work Turner was able to reach a much wider audience than the more transient exposure of the exhibition. The work was also lucrative for Turner, if not always for his engravers or the publishers. It was the need to revive the sales of some of the engraved projects which prompted the main public displays of his watercolours in the latter part of his career.

The *England and Wales project was an artistic triumph but after a steady launch in 1827 the publisher, Charles *Heath, soon recognized the need to revive flagging interest in the publication. In 1829 he arranged an exhibition, at the *Egyptian Hall in Piccadilly, of some 40 watercolours of which 35 were from the *England and Wales* series. These were accompanied by the engravings from them which had already been published. It was similar motives which encouraged new publishers who had taken over the project from Charles Heath to hold a similar, but more comprehensive, exhibition at the galleries of *Moon, Boys, and Graves located at 6 Pall Mall in June and July 1833, when 63 watercolours were loaned to the show. But, despite the support of Turner himself, the project was eventually to cease publication prematurely.

Excepting works loaned by his patrons and collectors, most notably a group from the Fawkes collection shown at the Music Hall in *Leeds during 1839, Turner did not choose to exhibit any more of his watercolours publicly before his death. RY

EXHIBITIONS of Turner's Works, see:

CONTEMPORARY
Birmingham Society of Artists' exhibitions
British Institution
Egyptian Hall, Piccadilly, exhibition
Great Exhibition of 1851
Grosvenor Place exhibition, 1819
Hill Street exhibition, 1819
Hobart, Tasmania, 1845 exhibition
Leeds exhibition, 1839
Liverpool Academy
Moon, Boys, and Graves
Munich, Congress of European Art, 1845
Royal Academy of Arts, London
Royal Hibernian Academy exhibition, Dublin, 1846
Royal Manchester Institution exhibitions
Royal Scottish Academy exhibitions, Edinburgh
Turner's gallery and exhibitions

POSTHUMOUS
Agnew's, 1951 and 1967 exhibitions
Australia, exhibitions in 1960 and 1996
British Council exhibitions
Burlington Fine Arts Club exhibition, 1872
Exhibitions outside Britain since 1950
Fine Art Society
Grosvenor Gallery Winter exhibitions, 1888 and 1889
Hamburg
Indianapolis, *Turner in America* exhibition, 1955

EXHIBITIONS OUTSIDE BRITAIN SINCE 1950. In Britain it has rarely been necessary to make a special case for the significance of Turner, but his reputation abroad has suffered from the long-held assumption, once voiced by Courbet's friend Champfleury, that 'England is artistically marginal'. Since 1950, however, some of the most influential exhibitions of Turner's work have been held outside Britain. In the last two decades their number has increased so sharply that this brief survey must be selective, focusing on the most significant or representative examples.

Foreign exhibitions of Turner's work have generally been of two kinds: either didactic, proposing a specific view of the artist or correcting common misunderstandings about his art, or of specific national or local interest, often drawing upon his incessant travels. But one aim the various exhibitions hold in common is to foster an international awareness of his status as a master of European *Romanticism*.

Turner in America, held in 1955 at the John Herron Art Museum, Indianapolis, was not a thematic exhibition, unless its theme was the rich variety of his work in American collections. Among the most important exhibits were the *Bonneville painting from Philadelphia (RA 1812; BJ 124), *Staffa, Fingal's Cave (RA 1832; Yale Center for British Art, New Haven; BJ 347), and three works that now belong to the renamed Indianapolis Museum of Art: *The Fifth *Plague of Egypt* (RA 1800; BJ 13), *Abbotsford (1834–6; BJ 523), and *East *Cowes Castle; the Regatta beating to Windward* (RA 1828; BJ 242). More recently, the collection of Turner watercolours in Indianapolis was combined with loans from Manchester to mount a significant exhibition in 1997.

Turner's travels provided the theme for an exhibition held at the Kunsthaus, *Zurich, in the winter of 1976–7. Entitled *Turner und die Schweiz*, it assembled a significant collection of watercolours and oils which vividly illustrated Turner's changing responses to the Swiss landscape, from the earlier exercises in the *Sublime which followed his visit in 1802, to the radiant watercolours of the 1840s.

One of the oils to feature prominently in Zurich was *Bonneville, Savoy with Mont Blanc* (RA 1803; Yale Center for British Art, New Haven; BJ 46), which had been seen a few months earlier in a more wide-ranging exhibition at the Kunsthalle, *Hamburg. *Turner und die Landschaft ihrer Zeit* (May–July 1976) also contained *The *Fall of an Avalanche in the Grisons* (RA 1810; BJ 109), which had been conspicuously absent in Zurich. The selection of exhibits at Hamburg, including *The *Bright Stone of Honour* (RA 1835; private collection, London; BJ 361), the *Guardship at the Great Nore, Sheerness, &c* (Turner's gallery 1809; private collection, England; BJ 91), and the peerless *Frosty Morning* (RA 1813; BJ 127), was a judicious one, for it embraced every category of the *Liber Studiorum and helped to place Turner within the landscape art of his era.

Andrew Wilton's exhibition, *Turner and the Sublime, had a more specific scholarly theme. It was shown in three countries from November 1980 to September 1981: at the British Museum, London, the Yale Center for British Art, New Haven, and the Art Gallery of Ontario, Toronto. Wilton sought to relate Turner's art to 18th-century theories of the Sublime and further attempted to identify its various modes (architectural, historical, terrific, etc.) in the prints, drawings, and watercolours he selected from Yale and the Turner Bequest.

Turner en France, which was held in *Paris at the Centre Culturel du Marais during the winter of 1981–2, was another self-contained exhibition that drew substantially upon the research of Nicholas Alfrey. At its heart was an impressive attempt to assemble a sizeable body of works associated with the *Rivers of France series. They were accompanied by oils with a French subject such as *The Mouth of the Seine, Quilleboeuf* (RA 1833; Fundaçao Calouste Gulbenkian, Lisbon; BJ

353). While the overall quality of the works was beyond doubt, the exhibition as a whole was compromised by idiosyncratic presentation, evincing a nervousness that the art would not stand by itself.

The exhibitions held since 1950 have also reflected changing interpretations of Turner's work. Perhaps the most influential of all post-war shows was organized by Lawrence Gowing in 1966 at the Museum of Modern Art, *New York, with the title *Turner: Imagination and Reality*. At first sight MOMA seems an unlikely venue for a Turner exhibition, since its own collection is exclusively drawn from the modern period. As the chief institutional stronghold of Modernist art history and criticism it provided, through its publications and exhibitions, a formalist interpretation of modern art which tended to exclude discussion of subject matter or social context. The works selected by Gowing, however, included many oil sketches, studies, and unfinished paintings: these supported a view of Turner as a 'pure' painter for whom the subject matter was a pretext for revelling in the qualities of paint itself. At MOMA Turner was removed from his own era and comparisons drawn with the work of post-war American artists. It was an unexpected juxtaposition which endorsed the critical status of abstract expressionism while simultaneously presenting a fresh reading of Turner. Late, unfinished works also formed the theme of *Exploring Late Turner*, Salander-O'Reilly Galleries, *New York, 1999.

In 1983 the most ambitious display of Turner's work since the *Turner bicentenary show of 1974/5 was held at the Grand Palais, Paris. In its size, in the range and quality of its exhibits (some of them rarely seen), it provided a strong contrast with Gowing's brilliant but partial selection in New York. Visitors to the Grand Palais could not doubt Turner's range of interests or the significance of his subjects. The exhibition also made a powerful case for his status in a country where his achievements were often undervalued: the Louvre, for example, did not acquire one of Turner's oils until 1967. If Parisians were unprepared for the beauty of *Juliet and her Nurse* (RA 1836; Sra. Amalia Lacroze de Fortabat, Argentina; BJ 365) or *Mortlake Terrace: Early (Summer's) Morning* (RA 1827; National Gallery of Art, Washington, DC; BJ 235; see WILLIAM MOFFATT), the exhibition also redressed the scandalous neglect to which *The *Field of Waterloo* (RA 1818; BJ 138) had been subject, even in Britain.

More recent exhibitions around Turner's travels in Belgium and Germany were curated by Cecilia Powell. From the Tate Gallery they have travelled to Brussels (1992), and to Mannheim and Hamburg (1995–6). Larger exhibitions of Turner's work outside Britain, such as those held in Tokyo and Kyoto in 1986 and in Canberra and Melbourne, Australia, in 1996, have generally respected the approach taken at the Grand Palais: a broad and representative set of exhibits is used to support a view of the artist as someone whose ambitions were formed by the culture of his own epoch.
See also BRITISH COUNCIL EXHIBITIONS. BV

EXILE AND THE ROCK LIMPET, THE, see *WAR*.

FAKES AND COPIES are common, not altogether surprisingly, in view of the fact that even Turner's later works, though criticized and ridiculed in the press, were never ignored and continued to be purchased. Copies were made after Turner's exhibits and engravings of his works in his own lifetime, and fakes from at least the middle of the century onwards. As Egerton (1998, p. 306) notes, numerous copies of *The *Fighting 'Temeraire'* were made after the picture entered the National Gallery collection in 1856. More interesting is the fact that, on average, there are more copies of pictures exhibited by Turner at the British Institution than at the Royal Academy; this is because the BI kept its exhibitions open after they had closed to the general public so that students could study and copy pictures without interference. *Queen Mab's Cave* (BI 1846; BJ 420) is an example of this, as is *Wreck of a Transport Ship*, painted *c*.1810 but not exhibited until the *Old Masters* exhibition at the BI in 1849 (Fundaçao Calouste Gulbenkian, Lisbon; BJ 210). Many copies were made, both during Turner's lifetime and later, as exercises in the manner of the artist or for educational reasons. Other copies had a more sinister motive.

As well as the cases in which a supposed signature has been added to a landscape more or less (and often very much less) resembling a work by Turner, there are deliberate imitations of his style. Following the rule that a fake or imitation echoes the appreciation of the original artist's work as seen in the period during which the imitation is made, those from the later 19th century are now easier to spot and are indeed so prevalent that three different hands among the imitators have been detected (by Martin Butlin; see BJ, p. xx), as well as individual imitations. 'Hand A' is the most interesting in that it appealed to the taste of the new collectors who were the chief purchasers of Turner's later oil paintings. The subjects are usually Italian, though pitchpines appear in Venice and other topographical inaccuracies make one wonder whether the imitator had ever been to Italy. The superficial characteristics of Turner's late style are imitated: free brushwork, heavy impasto (often contrasting with the skimpiest of applications of paint to other parts

of the canvas), over-attenuated and wispy trees, azure skies and disc-like suns; there is a prevalence of hot, foxy colour. One example is, perhaps significantly, on a canvas bearing a French linen stamp. 'Hand B' is distinguished by a tendency to paint compositions that resemble those of Turner's watercolours while actually being in oils; this factor, difficult to define, is perhaps illuminating for the light it shows on Turner's sense of scale (see SIZES AND FORMATS). 'Hand C' is distinguished by the small size of the paintings, in oils, and by an over-delicate prettification of Turnerian style and motifs.

Two further groups of imitations are those associated with the dealer, auctioneer, and author John Anderson and with the collection of the fourth Earl of Arran. The first is a large collection of drawings and watercolours mainly by a single amateur hand, often inscribed with a place name and dated, on the basis of which Anderson seems to have convinced himself that Turner made a number of visits to places abroad not otherwise recorded. He also convinced himself that these works bore hidden signatures, and one can often detect little arrows pointing to such 'signatures' in, for instance, the pupil of a bird's eye. (See John Anderson Jr., *The Unknown Turner*, 1926.)

The Arran sketches, more interestingly, are a group of oil sketches on board, freely painted and in Turner's general manner. One indeed is clearly based on one of the so-called *Roman oil sketches of *c*.1828 (BJ 302–17) which could only have been seen in Turner's studio or gallery; once in the National Gallery Turner's sketches were not even given inventory numbers until well into the 20th century. They bear a certain similarity to the oil paintings of Peter de Wint (1784–1849). (For a characterization of this group see BJ 526.)

Outside these groups, and putting aside actual misattributions (for instance works now attributed to Richard *Wilson (BJ 545–7), the *Bath Abbey* and *Edinburgh and Calton Hill from St. Anthony's Chapel* by unknown artists (BJ 549 and 554), and the *George the Fourth leaving Ireland and Embarking at Kingstown on 3rd September 1821* (exhibited at

Leggatt's, 1960; see cat. no. 8) by the elusive William Turner de Lond (or 'of London')), there are other close imitations such as *Old London Bridge* and *Caernarvon Castle* (BJ 553 and 559) and the puzzling group of apparently late unfinished seapieces some of which may have originated in the collection of Mrs *Booth's son John Pound and may be by the hand of Turner's *assistant Francis Sherrell (BJ 555–8); the last of these, *The Shipwreck* in the National Gallery of Canada, Ottawa, is of considerable size, 46 × 56¼ in. (117 × 143 cm.) (BJ 558). There are also a number of individual imitations of Turner's later Venetian paintings, for instance that in the Beaverbrook Foundations (BJ 560) and one formerly in the Thyssen Collection.

Most likely to deceive, even when placed next to the originals, are the straight copies of Turner's later watercolours that Ruskin encouraged his pupils and assistants to execute. The authors of some of these are known, for instance William Ward (1829–1908), of whom Ruskin said 'I have been more than once in doubt, seeing original and copy together, which was which'. The detailed, almost pointillist technique of the originals, particularly the vignettes, makes the copies very difficult to identify, and Ruskin made a practice of dating and authenticating these 'facsimiles'; examples are in the Tate Gallery, the Museum of Fine Arts, Boston, the Fogg Museum, Harvard University, and the Indianapolis Museum of Art (some repr. in Goldyne, 1975, nos. 78 and 79, and Krause 1997, pp. 258–63, nos. 83–6). Other copies from Ruskin's circle are by Isabella Jay (?–1919; an example in the Indianapolis Museum of Art is reproduced Goldyne no. 80 and Krause p. 257), Arthur Severn, William Hackstoun, F. T. Underhill, and Major-General Sir Herbert Jekyll. (For this group of copyists see Ruskin, *Works*, xiii. pp. 507, 514–15, 530, 575–8; xx. pp. 463–76; xxi. p. 170; xxx. pp. 37–8; and *Ruskin and his Circle*, exhibition catalogue, Arts Council, 1964, p. 80, no. 362.)

See also REPLICAS AND VARIANTS. MB
 Forgeries and Deceptive Copies, exhibition catalogue, London, British Museum, 1961.

FALK, Bernard (1882–1960), journalist and writer, the author of *Turner the Painter: His Hidden Life* (1938). This was subtitled 'A Frank and Revealing Biography', and made use of material relating to Turner's family life, litigation over his will, and his perspective lectures belonging to C. Mallord *Turner. However, while stating in the introduction that he wished to correct some of the elements of Thornbury's biography, Falk was equally sensationalist and speculative. His book appeared shortly before Alexander *Finberg's biography (1939), but was not of the same high order. Falk's other books on art included a biography of Rowlandson

(1949). He published two volumes of autobiography, *He Laughed in Fleet Street* (1933) and *Five Years Dead* (1938).
 RU

FALL OF AN AVALANCHE IN THE GRISONS, THE, oil on canvas, 35 × 47¼ in. (90 × 120 cm.), Turner's gallery 1810 (14); Tate Gallery, London (BJ 109). This was by far Turner's most bold and dramatic picture to date. He may have visited the Grisons in 1802 but the immediate occasion for this picture was probably news of the avalanche at Selva in the Grisons in December 1808. Turner was probably also emulating two paintings of avalanches by P. J. de *Loutherbourg, one of *c*.1800 in the collection of Lord *Egremont (Petworth House), the other dated 1803 belonging to Sir John *Leicester (now Tate Gallery).

Turner's catalogue included the following lines, anticipating those in Turner's *Fallacies of Hope* (see POETRY AND TURNER) and influenced by *Thomson's *Seasons*:

> The downward sun a parting sadness gleams,
> Portenteous lurid thro' the gathering storm;
> Thick drifting snow on snow,
> Till the vast weight bursts thro' the rocky barrier;
> Down at once, its pine clad forests,
> And towering glaciers fall, the work of ages
> Crashing through all! extinction follows,
> And the toil, the hope of man—o'erwhelms.

The picture marks a new boldness of execution for Turner's exhibited work. As the *Sun* of 12 June 1810 noted, 'the picture is not in his usual style, but is not less excellent'; for Ruskin (*Works*, xii. pp. 122–3), 'No one ever before had conceived a stone in flight'. MB

FALL OF THE RHINE AT SCHAFFHAUSEN, oil on canvas, 57 × 92 in. (144.7 × 233.7 cm.), RA 1806 (182); Museum of Fine Arts, Boston (BJ 61). Connected drawings are in the 'Fonthill' Sketchbook (TB XLVII), dating from 1803. It was bought by Sir John *Leicester in February 1807 in exchange for *The *Shipwreck* and 50 guineas.

Badly hung at the Royal Academy, it attracted savage criticism from reviewers and artists alike, *West saying that Turner had become 'intoxicated and produced extravagancies' while, when two journalists met in front of the picture, one said: 'That is Madness' and the other agreed 'He is a madman' (*Farington *Diary*, 5 May 1806).

The *Star* (8 May) considered that the figures looked as though 'they were dressed from a book of Swiss costumes' while 'the spray from the cataract more resembles a cloud of stone dust than water'.

The subject remained a favourite with Turner, who painted it frequently in watercolour in the 1840s. EJ

Marjorie Munsterberg, 'J. M. W. Turner's *Falls at Schaff-hausen*', *Record of the Art Museum Princeton University*, 44/2 (1985), pp. 24–31.

FALLACIES OF HOPE, see POETRY AND TURNER.

FARADAY, Michael (1791–1867) One of the leading chemists of his day, Faraday was an assistant to Humphrey *Davy before succeeding him as Professor of Chemistry at the Royal Institution in 1827. His experiments into the relationship between electricity and magnetism culminated in the discovery of electromagnetic induction, and led to the development of modern techniques of electricity generation and storage.

Turner came to know Faraday through attending *conversazioni* in London during the 1820s and 1830s; Turner and Faraday also met at boating parties held by C. J. *Hullmandel. Faraday shared with Turner his theories and the developments he was making in his experiments. John Gage suggests that Turner's knowledge of these ideas contributed to some of the 'eccentric features' introduced into Turner's later style. Turner was fascinated by magnetism as a phenomenon and James Hamilton suggests that Turner was subtly giving graphic expression to the lines of force demonstrated in Faraday's magnetic field experiments with iron filings in his painting *Snow Storm—Steam-Boat off a Harbour's Mouth* (RA 1842; BJ 398). SET

H. Bence Jones, *The Life and Letters of Faraday*, 1870.
Gage 1987, pp. 225–8, 230.
Hamilton 1998, pp. 16, 19, 126–8.

FARINGTON, Joseph (1747–1821), English landscape painter and pupil of Richard *Wilson; ARA (1783), RA (1785). From 1793 until his death, he kept a detailed diary charting the important role he played in the affairs of the *Royal Academy and the London art world.

It is difficult to gauge Farington's reaction to Turner, as he mostly recorded the opinions of others, but one can trace a development from benevolent interest to genuine approbation, gradually evolving into puzzled incomprehension. In his earliest mention of Turner, concerning the works shown at the RA in 1795, Farington merely described Turner as a pupil of *Malton, an architectural draughtsman. During these early years, Farington was generous with both general advice and professional support at the time of Turner's first attempt at election as ARA in 1798 and his second, successful attempt the following year, though later Farington came to regret Turner's lack of strong commitment to the RA.

Whereas Farington thought Turner's RA exhibits for 1798 fine pictures (they included *Morning amongst the Coniston Fells* (BJ 5) and *Dunstanborough Castle* (National Gallery of Victoria, Melbourne; BJ 6), by 1803 he was beginning to feel uneasy at Turner's influence over younger artists such as *Callcott. Farington's first personal, adverse comment appeared as late as 1806 when he described Turner's two landscapes exhibited at the RA, one of which was *Fall of the Rhine at Schaffhausen* (Museum of Fine Arts, Boston; BJ 61), as false and presumptuous, thereby echoing the criticisms of others. In 1806 Farington was noting a lack of finish (*Battle of Trafalgar*, Turner's gallery 1806; BJ 58), and in 1815 he recorded criticisms of *Dido building Carthage* (BJ 131) as painted in a false taste and showing no comprehension of art. In 1819, the last year in which he mentions Turner's RA exhibits, Farington thought the flaming colours of *Entrance of the Meuse* (BJ 130) and *England: Richmond Hill* (BJ 140) quite unacceptable within the confines of the exhibition rooms.

At the start of Turner's career, Farington had been helpful and well disposed. Invited to Turner's first private exhibition in 1804, Farington persevered with yearly visits, but without recording any comments. The two artists met quite frequently at the houses of connoisseurs and at the various RA meetings. In 1802 they had also met in *Paris during the lull afforded by the Peace of Amiens. It was in Paris that Farington, a founder member of the exclusive St Peter Martyr Society, registered with some dismay Turner's comment that the sky of *Titian's St Peter Martyr altarpiece, then part of the Napoleonic booty exhibited in the Louvre, was too blue.

Farington often recorded his interest in the picturesque values of natural scenery though this remained strongly tempered by his search for accuracy. Although he was never as venomous in his criticisms of Turner as were some of his contemporaries, it was inevitable that he could never fully comprehend Turner's vision. EN

FARNLEY HALL, see FAWKES, WALTER RAMSDEN, and Pl. 12.

FATHER'S FAMILY. They were self-made craftsmen and petty bureaucrats, most of whom remained in their native Devon. Turner's grandfather John Turner (1715–62) was a wig-maker and barber, latterly a saddler, in South Molton. By his wife Rebecca Knight (d. 1802) he had five sons and two daughters who survived to adulthood. William *Turner was the third born. Of his four other sons, John (1742–1818) was a saddler and woolcomber who became governor of Barnstaple workhouse by 1802; Price (1746–1831) became a saddler in Exeter; Joshua (1757–1816) a customs official in London; and Jonathan (1760–1831) owned a bakery in Walcot, Bath. The eldest child Eleanor (1740–84) married Ralph Harris, while the fifth, Mary (d. *c.*1805), married John Tucker. All the children had issue. John Turner senior provided equally for each of his children, but on his widow's death the

siblings fell out, and legal action threatened. By 1811 the dispute was apparently not settled, for Turner called on John and Price, evidently to discuss his grandmother's effects.

Turner had little feeling for his father's family, and maintained no social contact with them. This contrasts with the attachment he felt for his cousin on his mother's side, Henry Harpur, his executor and solicitor. When Price's son Thomas Price Turner (1790–1868), a musician, called on Turner in 1834 he was received coolly and not invited back. Though quick to aggression and boastful, the family was close-knit and tended to support each other's endeavours. When Mary *Turner was committed to Bethlem Hospital in 1800 her papers were signed, *inter alia*, by Joshua; and on Turner's death the family came together in a skilled, spirited, and ultimately successful contest of the *will and bequest. Gossip among the Turner family averred that the artist had abandoned his mother in her final years.

John Turner jun., who married Catherine Widgery (d. 1817), had seven children who survived infancy. His grandson, Jabez Tepper (1815–71), became a solicitor and organized the legal challenge of Turner's trustees from 1853. Turner's dismissal of his father's family in his life and his ignoring of them in his will fired their enthusiasm to take their case to the Court of Chancery. In preparing the family's case Tepper amassed papers, later organized by his cousin C. W. M. *Turner, which laid the foundations of the dossier on which the research of Bernard *Falk, A. J. *Finberg, Jack *Lindsay, and later biographers has been based. As a result of their victory, members of the family built two large houses at Paradise Lawn, South Molton. JH

Finberg 1961, pp. 8–13.
Lindsay 1966, 12, 21, 75–7, 110, 115–16.
Bailey 1997, pp. 3, 52, 57–9.
Hamilton 1997, pp. 7–8, 61–2, 66–7, 71–2, 147.

FAWKES, Francis Hawksworth (1797–1871), second child of Walter *Fawkes and his wife Maria, née Grimston, who became heir to Farnley after the suicide of his elder brother Walter in 1811. From 1811 to 1814 he was at Eton, and in 1815 briefly at Trinity College, Cambridge. Of all the Fawkes children, Turner made a special bond with 'Hawkey' as he was known in the family. He told *Thornbury that he had witnessed Turner's excitement at seeing a thunderstorm over Wharfedale, which gave Turner immediate inspiration for his *Snow Storm: Hannibal and his Army crossing the Alps* (RA 1812; BJ 126). So comfortable was Turner in Hawkey's presence that in 1818 he painted the watercolour *First Rate taking on Stores* (Cecil Higgins Art Gallery, Bedford; W 499) with the young man sitting beside him. Hawkey's account of the event is one of the most vivid eyewitness in-

sights we have into Turner's practice of watercolour painting. He became himself an amateur watercolour painter. An album of his caricature portraits of guests at Farnley survives.

In 1825 he married Elizabeth Anne Pierce Butler, his stepmother's daughter. They had no children. He cared for and catalogued the large Farnley collection, arranging exhibitions of Turner's watercolours in Leeds in 1826 and 1839, and added to the collection by buying *Rembrandt's Daughter* (RA 1827; Fogg Art Museum, Cambridge, Mass.; BJ 238). Hawkey maintained his close friendship with Turner until the artist's death, keeping up the family tradition of sending the artist Christmas fare from Farnley. The pair met often in London in the 1830s and 1840s. *Ruskin visited Hawkey at Farnley soon after Turner's death, and dedicated *Pre-Raphaelitism* (1851) to his host. JH

Thornbury 1877, pp. 237–42.
Gage 1980, p. 253.
Hamilton 1997, pp. 127–9, 191–2, 224–5, 231, 309.

FAWKES, Walter Ramsden (1769–1825), politician, collector and landowner, whose close friendship with Turner developed in the 1800s and lasted until his death. He was born Walter Ramsden Hawksworth, and brought up at Hawksworth Hall, near Guiseley, Yorkshire. He moved to Farnley Hall, near Otley, when his father inherited it in 1786, and he in turn inherited Farnley and its 15,000-acre estates in 1792. On receiving the bequest, he changed his surname to Fawkes, as his father had done before him.

He attended Westminster School (1781–6) and Trinity College, Cambridge (1786; did not graduate), and subsequently embarked on a Continental tour. Personal experience of the *Alps and Lake Geneva, which he sketched 'with magic skill' according to his school and college friend the Revd Henry F. Mills, will have drawn him towards Turner's watercolours of the Alps made after his 1802 tour, of which he ordered 30. Indeed, although Fawkes was not himself a 'nobleman', it is just possible that he was one of the three, with Lord *Yarborough, who subscribed to send Turner to the Continent in 1802 to study the Old Masters. He certainly led at this time the style of life of one who might help to send an artist abroad: in addition to the Farnley estates he kept a London house in Grosvenor Place, and, as a tax bill for 1802 reveals, he employed in that year 14 male servants, kept 25 horses, 15 dogs, and 6 carriages, and paid tax on 135 windows.

Fawkes had been a schoolfriend of the radical reformer Francis Burdett, and this early brush with dissent was to have a lifelong effect. He first put himself forward as MP for Yorkshire against the Tory Henry Lascelles in 1796 with the

words 'I am connected with no party . . . my country's good is my only aim; the only qualifications I can boast of are my honest intentions and entire independence.' Although he was persuaded to withdraw because his fortune was no match for that of Lascelles, he stood in 1802 and again, this time successfully, in 1806. By now he had joined the Whigs, later telling the political diarist Thomas Creevey that 'I have been a Whig, a *Great big* Whig all my life, ever since I was a reasonable being, in defiance of *advice, or persecution*, of hostility of every kind, I have stuck to my text.' Fawkes's patriotism prompted him also to serve in and raise local militias during the *Napoleonic wars, being Brevet Colonel of the 4th West Riding of Yorkshire militia in 1797–8, and Colonel of the Wharfedale Volunteers in 1803–4.

Fawkes campaigned in 1806 with his fellow candidate William Wilberforce on the anti-*slavery platform, but gained decisive support from West Riding cloth and iron manufacturers who believed that Lascelles had neglected them as MP. The 1806 parliament lasted barely six months, but Fawkes nevertheless made a maiden speech advocating control of sinecures, and pledging to maintain his election promise of a 'watchful jealousy over public expenditure'. The election campaign cost Fawkes dear, and he did not stand again, ostensibly out of duty to his family. A deeper reason, however, was that he was closer to Burdett than his Yorkshire patrons could bear. The botanist Charles Lyell (1767–1849), staying three days at Farnley in 1815, reported to Dawson *Turner that there was much to admire at Fawkes's 'magnificent seat', and 'nothing to regret but his being a furious *Burdettite*!!' This radical allegiance was well advertised at Farnley. Fawkes owned a plaster cast of *Chantrey's over-lifesize bust of Burdett (1810), inscribed 'Sacred to Public Principle and Private Friendship'. This is just visible in Turner's gouache of the drawing-room at Farnley (1818; private collection; W 592). Other indications are the large collection of Cromwellian relics that Fawkes had inherited with the house, and prominently displayed (see W 593), which had come down in the family from General Thomas Fairfax, a hero of the Parliamentary cause in the English Civil War. These became a touchstone for Fawkes himself, and the inspiration for *Fairfaxiana* (*c*.1815–20; private collection; see W 582), Turner's series of heavily inscribed narrative watercolours that trace the history of political reform in England, and advocate its need.

After he left Parliament, Fawkes employed his considerable powers of oratory as an advocate for reform, in uncompromising support of Burdett. He was a founding member and first chairman of the Hampden Club (1812), and spoke at the Crown and Anchor Tavern in the Strand the same year at a meeting celebrating the tenth anniversary of Burdett's

election as MP for Middlesex. Fawkes also became a political writer in these years, with his *Chronology of the History of Modern Europe* (1810) and *The Englishman's Manual; or, A Dialogue between a Tory and a Reformer* (1817).

Although Turner and Fawkes may have met in the late 1790s in London, or when the artist was working nearby at Harewood, the first of Turner's regular visits to Farnley most probably took place in 1808, immediately after the completion of interior decoration to the extensive new south wing. This had been designed by John Carr of York, as an addition to the existing Jacobean manor house, and completed in 1788. Already, Fawkes had bought Turner's *Portrait of the 'Victory', in Three Positions* (?Turner's gallery 1806; Yale Center for British Art, New Haven; BJ 59), and he was a considerable collector of the artist's watercolours. Over the previous two decades Fawkes had bought widely of Old Master and contemporary paintings alike, and the friendship between politician and painter flourished on a basis of mutual generosity, trust and common allegiances.

Fawkes and Turner generally sat together at Royal Academy dinners in the 1810s. Their friendship by this time was well known, leading to the suspicion voiced by *Farington that Fawkes was the author of the eloquent but devastating pair of pamphlets, the *Catalogues Raisonés* (1815 and 1816). These attacked the *British Institution and rallied to the defence of Turner, though he was unnamed. The authorship is not proven, but the style and substance of the *Catalogues* reflected Fawkes's views and recall his manner as a polemical writer.

By 1810 Fawkes had four sons and seven daughters by his first wife Maria, née Grimston. Farnley at this time was a happy, lively country house, well staffed, and with much family activity. Fawkes himself brought a modern outlook to the management of the Farnley estates, being a co-founder of the Otley Agricultural Society, and an advocate of cooperation between landowners and tenants. The series of intimate gouaches Turner made *c*.1815–20 of the interiors and exteriors of the house and surrounding landscape (W 582–631) bears witness to shooting parties, country jaunts, and quiet domesticity. Fawkes was a generous and genial host. Among the indoor pastimes in which the family and visitors took part was the making of the Farnley *Ornithological Collection*, five volumes of specimens of plumage and watercolour studies of birds and their eggs. A number of the bird studies were painted by Turner (Leeds Art Galleries). Fawkes's passion for natural history reveals yet another facet of a remarkable man. This took further practical form in his introducing zebra, wild hogs, and deer onto the estates, and culminated in his writing a four-volume *Synopsis of Natural History* (1823).

Such apparently incessant activities masked a succession of family tragedies. Fawkes's eldest child, named Walter after his father, committed suicide by drowning in 1811; his wife died in 1813; his brother, Richard, was killed in a shooting accident at Farnley in 1816; and Fawkes himself slipped inexorably towards bankruptcy during the early 1820s as his fortune ebbed away through political and publishing expenses, and his expansive style of living. This came to a head in 1824, the year in which Fawkes held the honorary (and expensive) post of Sheriff of Yorkshire. His accounts for that year reveal that his expenditure had been £11,355, against an expendable income of £6,055, and that in addition he owed the total capital sum of £69,734. His debts derived from long-standing insurance and mortgage interest payments on his estates, and loans from friends and neighbours. Among these was £3,000 lent by Turner himself in 1818, both as cash and uncollected debts for pictures.

Fawkes's lifelong collecting habits had also fuelled the debts. Of the *Swiss watercolours he ordered from Turner in 1802, twenty had been delivered by 1815. He bought Turner's complete production of 50 *Rhine watercolours after the artist's 1817 tour, and commissioned the series of some 50 views of Farnley and the surrounding country, the 'Wharfedales', in addition to the *Fairfaxiana* and the bird studies. After buying *Portrait of the Victory* from Turner's gallery, he added four further oils to his collection up to 1810, including **Bonneville* (c.1803–5; untraced; BJ 148) and **London* (Turner's gallery 1809; BJ 97). **Dort, or Dordrecht* (RA 1818; BJ 137) arrived at Farnley in 1818, but it is not certain that this was ever paid for, coming as it did when Turner made his loan to Fawkes.

Turner was always welcome both at Farnley and Grosvenor Place. He took part in family activities, and became a popular and much-loved guest. This was reflected in the annual Christmas gift of a goose pie from the family, which continued until the artist's death. Fawkes's son Hawksworth *Fawkes became greatly attached to him, though the daughters showed some nervousness of the famous painter in their midst. He earned family nicknames—'Overturner', after he had apparently crashed a carriage at Farnley, and, perhaps patronizingly, 'little Turner' in a diary kept by Fawkes's second wife, also named Maria, formerly Mrs Pierce Butler, whom he married in 1816.

Despite his activities as a collector and countryman, Fawkes's root instincts were political. He spoke strongly at Yorkshire county meetings against income tax (1816) and the Peterloo Massacre (1819), and promoted a petition for reform which attracted 17,000 signatures in Yorkshire in 1823. The reformer Francis Place called him 'a man of weight and character', while from the art world Thomas

Uwins saw him as 'a man of good sense, with a long purse and a noble soul'. Recalling his long association with Turner, Fawkes praised his friend in 1819, writing of the 'delight I have experienced, during the greater part of my life, from the exercise of your talent and the pleasure of your society'. During Fawkes's final illness, Turner was one of the very few people he wanted to see. Turner dined with his friend twelve times during the early months of 1825, and on the eve of Turner's departure for Holland on 27 August they dined together for the last time. Fawkes died at his London home, and was buried at All Saints, Otley, where there is a memorial. Despite his continuing friendship with Hawksworth Fawkes, Turner never returned to Farnley. The bulk of Fawkes's papers were destroyed by his heirs. Those that survived are now in the West Yorkshire Archaeological Society, Leeds,

See also ARCHITECT, TURNER AS; GROSVENOR PLACE EXHIBITION, 1819; PRIVATE LIFE OF TURNER. JH

Thornbury 1877, pp. 236–42.
Gage 1980, pp. 253–4.
Hill 1984, pp. 16–22, 36.
Lyles 1988.
Hill 1988.
Bailey 1997, ch. 12.
Hamilton 1997, pp. 39–40, 46, 94–7, 110–13, 126–30, 147, 151, 155, 160, 169–71, 178, 180, 184–6, 191–2, 206–7, 223–6, 251, 266, 333.

FESTIVAL UPON THE OPENING OF THE VINTAGE OF MACON, THE, oil on canvas, 57½ × 93½ in. (146 × 237.5 cm.), RA 1803 (110); Sheffield City Art Galleries (BJ 47). Hamilton has discovered that, although the festival was indeed of Macon, the place shown here is Tournus, 20 miles further north on the Saône, which Turner sketched in July 1802, then mistakenly inscribing it 'Macon' (TB LXXIII: 19).

The most Claudian of Turner's landscapes to date, but it owes less to his visit to the Louvre, where the *Claudes were so ill-lit as hardly to engage his attention, than to Lord *Egremont's Claude, *Jacob, Laban and his Daughters* or, more likely, the engraving of it by Woollett (1783). The 'Calais Pier' Sketchbook (LXXXI) contains drawings for the picture, one inscribed in 1805 by Turner 'Ld Yarborough's picture'. Lord *Yarborough (the referee for Turner's passport in 1802) had bought it in 1804, reputedly for 300 guineas, although Turner had previously asked Sir John *Leicester for 400 guineas.

The restorer William Seguier reported that Turner had the greatest horror of the picture being relined, as he had 'commenced it with size colour on an unprimed canvas'. Seguier remembered that 'when first painted it appeared of the most vivid greens and yellows' although, when shown at the *British Institution in 1849, it was of 'a deep rich tone'.

At the Royal Academy *Farington reported that *Opie thought it 'very fine' and *Fuseli also praised it, whereas *Beaumont said that 'the subject was borrowed from Claude but the colouring forgotten'. EJ

Hamilton 1997, pp. 73, 80.

FIELD OF WATERLOO, THE, oil on canvas, 58 × 94 in. (147.5 × 239 cm.), RA 1818 (263); Tate Gallery, London (BJ 138). Turner's moving anti-war picture after the British Institution's competition for a 'Grand Historical Painting' to commemorate *Napoleon's defeat on 18 June 1815. By August 1817, free to visit the battlefield, he used the 'Waterloo and Rhine' Sketchbook for locations and his 'Guards' Sketchbook for uniforms (TB CLX, CLXIV). They testify to his topographical accuracy and emotional response, both in the sites selected and inscriptions such as '4,000 killed here', or 'hollow where the great carnage took place of the Cuirassiers by the Guards' (CLX: 21a–24a).

The setting of Turner's picture is the burning ruin of Hougoumont, the fortified farm where the fiercest fighting took place. Rather than any sabre-flashing daytime engagement, the centre of attention is a mound of dead and dying in the evening, grieved over by women who when the battle was lost and won had rushed to the site, a cynical note being the flare fired in the background to frighten off marauders.

In the catalogue Turner underlined the message of his indiscriminate depiction of casualties by lines from *Byron's description of the field at the end of the day when

> The thunder clouds close over it, which when rent,
> The earth is covered thick with other clay,
> Which her own clay shall cover, heaped and pent,
> Rider and horse—friend, foe, in one red burial blent.
> (*Childe Harold's Pilgrimage*, iii, 1816, ll. 33–6)

The *Field of Waterloo* was badly received, the press calling it an 'abortive attempt', a 'failure', an 'error' (*Literary Chronicle*, 22 June 1818), even 'a drunken hubbub on an illumination night' (*Annals of the Fine Arts*, 1818). Only one or two reviews expressed a certain openness to its Rembrandtesque grandeur.

Variations on *Waterloo* were four watercolours of many years later, engraved as illustrations to the 1832 edition of *The Life and Works of Lord *Byron* and the 1835 edition of *Scott's *Life of Napoleon*. In none of these were self-righteous pomp and circumstance even hinted at, the scenes being perceptibly less desolate and more like post-war landscapes, one showing a distant view of La Belle Alliance, the inn outside which *Wellington and Blucher met. AGHB

D. Howarth, *Waterloo: Day of Battle*, 1968.

A. G. H. Bachrach, 'The Field of Waterloo and Beyond', *Turner Studies*, 1/2 (1981), pp. 4–13.

FIGHTING 'TEMERAIRE', THE, *tugged to her Last Berth to be Broken up, 1838*, oil on canvas, 35¾ × 48 in. (90.7 × 121.9 cm.), RA 1839 (43); National Gallery, London (BJ 377). Turner's most evocative picture of a contemporary event, this was exhibited in 1839 with the following lines paraphrased from Thomas Campbell's 'Ye Mariners of England': 'The flag which braved the battle and the breeze, | No longer owns her.' The *Temeraire* was towed up the Thames to the Beatson ship-breaking yard at Rotherhithe on 5 and 6 September 1838. Accounts that Turner actually witnessed the scene have been discounted by Judy Egerton, who suggests that Turner may even have been out of England at the time. Certain apparent inaccuracies, such as the position of the tug's mast and funnel, were deliberate; corrected in Willmore's engraving of 1845, they were changed back in the reissue of 1851. The unlikely position of the vessel as seen with the sun setting behind it is, however, possible. Various details, such as the broken dolphin-striker and the absent jackstaff, allude to the decommissioning of the ship.

The *Temeraire*, named after *Le Téméraire*, a French ship captured at Lagos Bay in 1759, was a Second Rate warship of 98 guns, launched in 1798. She played a distinguished part at the Battle of Trafalgar, and Hawes has shown that Turner's picture was in part a symptom of the interest that grew up in the late 1830s in the dwindling number of veteran ships from the *Napoleonic wars, and also a portrayal of the more general theme of the decline of Britain's mercantile power.

Several reviewers noticed the symbolic content of the picture. The *Morning Chronicle*, 7 May, remarked: 'There is something in the contemplation of such a scene which affects us almost as deeply as the decay of a noble human being.' For the *Athenaeum*, 11 May, 'A sort of sacrificial solemnity is given to the scene', in which the steam-boat 'almost gives to the picture the expression of such malignant alacrity as might befit an executioner'. For the *Literary Gazette*, 11 May, 'The sun of the glorious vessel is setting in a flood of light, such as we do not remember ever to have seen represented before, and such as, we think, no one but Mr. Turner could paint.' *Thackeray, writing as Michael Angelo Titmarsh in *Fraser's Magazine* for June, described the picture as being 'as grand a painting as ever figured on the walls of any academy, or came from the easel of any painter'. For *Ruskin this was the last picture Turner 'ever executed with his *perfect* power'. He also stated that 'the Old Temeraire is nearly safe in colour'. Even *Blackwood's Magazine* for July–December 1839 found the picture 'very beautiful—a very poetical conception; here is genius', but wished it had 'been more true'.

The picture is indeed one of the best preserved of Turner's works. X-rays show a largish boat with a single sail

just to the left of the centre of the picture; whether this was originally part of the composition, which seems unlikely, or whether Turner reused a canvas that he had already worked on, is unclear. MB

Louis Hawes, 'Turner's *Fighting Téméraire*', *Art Quarterly*, 35 (1972), pp. 23–48.

Eric Shanes, 'The Fighting "Téméraire", tugged to her Last Berth to be broken up, 1838', *Turner Studies*, 8/2 (winter 1988), p. 59.

Egerton 1995.

Egerton 1998, pp. 306–15, repr. in colour.

FINANCE AND PROPERTY. Turner sprang from a modest class of tradesmen but died owning a great fortune. This was almost entirely the result of his professional success. It owed little to speculation in property or other investments, let alone inheritance. It owed much to a temperament which has traditionally been described as parsimonious and was certainly businesslike in money matters. His financial acumen was put to use by the *Royal Academy and the *Artists' General Benevolent Institution (of which he served as Chairman and Treasurer).

At Turner's birth, his father was a 29-year-old barber in Covent Garden, the third child in a family of seven produced by John Turner, a Devon saddler, who had died in 1762 worth very little. Turner's grandmother died worth under £300. Turner's uncle, Jonathan, a baker, wrote in 1811 that he had done well in business during the previous twelve years. 'I have a house worth £700 and built a flour loft, cost me £160, and some money besides to carry on trade.' Turner's maternal family was slightly better off. His mother's grandfather and brother were butchers; her sister married a clergyman. Although never impecunious, Turner's parents provided the artist with little in the way of worldly substance, save perhaps for vital early connections with his father's customers.

The value of Turner's fortune at his death can only be estimated. The executors declared his estate to be worth 'not more than £140,000', roughly equivalent to £4 million today. Although some £70,000 of this was in quantifiable Government Funds, the declaration made for the purpose of probate was low in the values attributed to the paintings, watercolours, drawings, and engravings owned by the artist at his death. No painter of his generation equalled Turner's accumulation of wealth.

Part of Turner's earnings was derived from watercolours made for engraving. He contributed work for the *Copper-Plate Magazine* and the annual *Oxford Almanack. Some engraved series, like his own *Liber Studiorum*, brought in little financially, but other commissions were remunerative. In 1816 Longman's ordered 120 drawings at 25 guineas each

to illustrate *Whitaker's proposed *History of Yorkshire*, by far the most valuable commission to that date, although the project collapsed after publication of the very first part (*Richmondshire*). Charles *Heath's *Picturesque Views in *England and Wales* was also a commercial failure, but this did not stop Turner receiving a handsome fee for 96 watercolours. The introduction of steel plates for engraving about 1820 transformed publishing economics by multiplying the number of impressions that could be taken, and making possible mass production for the benefit of the prosperous middle classes. Prices for Turner's contributions seem, nevertheless, to have remained little altered: 25 guineas each for 24 designs for the frontispieces and title-page vignettes to *Scott's *Poetical Works*, for example. Sometimes, as for the illustrations to Samuel *Rogers' *Italy*, a much lower fee was charged for the loan of watercolours to be returned to the artist after engraving. In the 1840s there was a good market for engravings after his oil paintings.

In the spring of 1791, the 16-year-old student was earning about four guineas a week as a scenery painter in the *Pantheon opera house, Oxford Street. A few shillings per night and a meal was the reward for his regular copying work, with *Girtin, for Dr *Monro in the 1790s. But from the middle of that decade he had wealthy patrons, and in October 1798 told Farington that 'he had more commissions at present than he could execute and got more money then he expended'. In the summer following his election as a full Academician in 1802, patrons financed the cost of his first Continental tour. That same year he purchased the lease of a house on the corner of *Harley Street and *Queen Anne Street, where he built a picture gallery to display his work. The lease cost £350, but Turner had charged 250 guineas the previous year for the 'Bridgewater Seapiece' (*Dutch Boats in a Gale*, BJ 14) and was to earn 300 guineas in 1804 for his *Macon (BJ 47). By 1811 he was noting payments of over £400 each from various noble patrons and valuing his total assets at over £12,000.

Turner held no bank account. Surplus funds were invested in Government securities by his broker, William Marsh of 5 Sweetings Alley. A sketchbook note of 17 August 1810 (see Bailey 1997, p. 108) shows Turner's investments as:

	£	s.	d.
Reduced 3% Annuities	2,283	9	3
Consolidated 3% do.	823	5	7
Navy 5%	4,110	1	4
	7,216	16	2

Apart from his successive homes, Turner sank only modest amounts into real property. He bought a cottage in Buckinghamshire, land in Twickenham, four acres of marshland

in Essex, and, apparently, houses at St Margaret's-at-Cliffe and Deal. In 1820 he inherited from his mother's brother a share in four houses at New Gravel Lane, Wapping, dividing them with his cousins, and converting his allotted pair of cottages to an inn, the Ship and Bladebone. Turner managed the Wapping properties and may have visited them regularly, indulging in low life. The erotic works destroyed by Ruskin after Turner's death may have been drawn here.

Turner's mercenary nature was notorious, but it is uncertain how far this reputation was justified. He lived very frugally, disliked waste, and demanded meticulous performance of all bargains and contracts. In 1819 Sir Walter *Scott wrote, 'Turner's palm is as itchy as his fingers are ingenious and he will, take my word for it, do nothing without cash, and anything for it. He is the only man of genius I ever knew who is sordid in these matters' (Finberg 1961, p. 257). But Henry *McConnel, who commissioned two oils in the 1830s, was one of many who complained that Turner's first biographer, *Thornbury, exaggerated such reports. McConnel wrote, 'No one could have behaved with less parsimony—I may almost say with greater generosity—than did Turner in his transactions with me' (Bailey 1997, p. 111). See also PRICES. NRDP

Finberg 1961, pp. 8–13, 41–55, 107, 164–73.
Bailey 1997, pp. 106–20, 238–42, 403.
Hamilton 1997, pp. 100, 119, 186, 188–9, 232–3.

FINBERG, Alexander Joseph (1866–1939), writer on the history of British art and pioneering expert on the work of J. M. W. Turner. Born in London on 23 April (Turner's birthday) 1866, he was educated at the City of London College and King's College, London, and studied painting in Paris. He worked as an illustrator for the *Graphic* and the *Illustrated London News*, and became art critic for several papers, including the *Manchester Guardian* and the *Saturday Review*. In 1905 Finberg, already long a student of the work of Turner, was commissioned by the Trustees of the National Gallery to complete the arrangement of the sketches and watercolours in the Turner Bequest (see WILL AND BEQUEST), which had been begun in the 1850s by *Ruskin. During this work Finberg rediscovered numerous, mostly unfinished, Turner canvases, which were transferred to the *Tate Gallery in 1906. The interest arising from their exhibition moved Sir Joseph Duveen to present a new Turner Wing to the Gallery, which was opened in 1910. Finberg devoted four years to his work on the Bequest, making a careful study of all the sketchbooks, elucidating much new topographical information and arranging the drawings as far as possible in chronological order. The resulting *Complete Inventory of the Drawings of the Turner Bequest* was pub-

lished in two volumes in 1909, and 90 years later it has not been superseded and remains in constant use by all scholars and students of Turner. Other less ambitious publications on Turner followed, and then, in 1924, the definitive *History of Turner's* Liber Studiorum *with a New Catalogue Raisonné* (reprinted 1988) replaced the catalogues of W. G. *Rawlinson. It took many years of meticulous research and constant revision for Finberg to complete his final, and also still largely definitive, contribution to our knowledge and understanding of Turner, *The Life of J. M. W. Turner, R.A.*, published in 1939 a few weeks after the author's death. A second edition, revised by his widow and his son, the historian H. P. R. Finberg, appeared in 1961.

Finberg's work on the Turner Bequest, which included a considerable number of drawings by other artists, made him realize the almost total lack of reliable reference material on British art, and led to his founding in 1911, with a small group of fellow spirits, the Walpole Society, created 'to provide for the publication of materials for the study of the history of British art' in an annual volume. Until 1922 he himself acted as honorary secretary and as editor of the volumes of the society devoted to 'original documents and the results of research', and during these years he personally contributed six articles. The society continues to publish its annual volumes, and these are recognized as the principal source of such material for students of British art history. LH

FINDEN, William (1787–1852) and **Edward Francis** (1791–1857), London-born brothers who were both engravers trained by James Mitan, and worked together as print-publishers. They established their reputations with small but effective book illustrations and most of their work after Turner was in that category. Between them they engraved on steel all but one of the 26 plates after Turner illustrating John *Murray's edition of *The Life and Works of Lord *Byron* (1832–4), with William responsible for 23 of them. William engraved four and Edward twelve of the 28 illustrations after Turner in *Landscape Illustrations of the Bible*, which they published in 1836, with further illustrations after *Callcott, David *Roberts, Clarkson *Stanfield, and other eminent artists. The brothers went bankrupt in 1842 because of their over-ambitious 'Royal Gallery of British Art', a collection of 48 plates, including three after Turner (R 659–61). For Turner's reaction to this 'mishap', see his letter to Clara *Wells (Gage 1980, no. 249). LH

FINDEN'S *LANDSCAPE ILLUSTRATIONS OF THE BIBLE* (1835–6), for which Turner illustrated 26 out of the hundred landscapes (W 1236–61; R 572–597), was the joint venture of the *Findens with John *Murray, concurrent with their *Byron illustrations; Turner in some cases used

sketches by the same travellers to work up. (Another version, *The Biblical Keepsake* (1835–7), with the same illustrations and text was published by Murray as an annual.) The series was topographical in intention, contrasting with the wood-engraved narrative Bible illustrations from designs by Richard *Westall and John *Martin published the same year. The Revd Thomas Hartwell Horne in his cautionary text emphasizes the selection of scenes of the desolation of megalopolitan cities at the height of their prosperity. Turner took turns with *Callcott, *Stanfield, and the other artists in selecting sketches to work up: many images came from the architect Charles Barry (sketches in the Royal Institute of British Architects Drawings Collection). *The Pools of Solomon* (Fitzwilliam Museum, Cambridge; W 1244; R 580) lay on Turner's breakfast-table for a month before he decided to give the geometrical design a sunset and turbaned horsemen tilting at a ring. Turner added staffage of pilgrims in oriental dress bound for the River Jordan, monks, and Arabs. Turner chafed at the literal-mindedness of Barry and Murray, who complained about his placing the sun in impossible positions and adding symbolic wolves. Turner said that *Mount Sinai* (untraced; W 1238; R 574) and *Mount Lebanon* (Ashmolean Museum, Oxford; W 1248; R 584) represented the Law and the Gospel, and gives symbolic allusions in other designs. JRP

 Omer 1985.

 J. Piggott, 'Turner and the Bible at Boston', *Turner Society News*, 76 (August 1997).

FINE ART SOCIETY, founded in 1876 with premises in New Bond Street which it still occupies. It has mounted an intensive programme of exhibitions, over 150 being held in the first 21 years.

 In 1878 the Managing Director, Marcus Huish, persuaded *Ruskin to lend for exhibition 114 of his Turner watercolours. These were accompanied by Ruskin's extensive commentary together with an epilogue describing the genesis of the 1842 and 1843 series of Swiss views. Published as *Ruskin's Notes on Turner*, this went through thirteen editions in 1878 with a fourteen in 1900 when a smaller exhibition, including many items for sale, was held to commemorate Ruskin, who had died in January that year.

 The Fine Art Society aided both Ruskin and *Whistler after their celebrated lawsuit, acting as bankers for Ruskin's legal fees and commissioning a series of Venetian etchings from Whistler, exhibited in 1883 and entitled *Arrangement in White and Yellow*.

 The gallery now specializes in art of the period from the Aesthetic Movement to the present day. EJ

FINGAL'S CAVE, see STAFFA.

FIRE AT SEA, oil on canvas, 67½ × 86¾ in. (171.5 × 220.5 cm.), *c.*1835; Tate Gallery, London (BJ 460). This large unfinished picture has recently been identified as showing the wreck in the English Channel on 1 September 1833 of the *Amphitrite*, a female convict-ship, in which 125 women and children died. It is now displayed under the title *A Disaster at Sea*. The ship went aground close to Boulogne but, despite prompt offers of assistance by the French, the captain and surgeon of the *Amphitrite* claimed they had no authority to land their charges other than in New South Wales; nor did they attempt to use their own longboats. This, as Cecilia Powell points out, makes it one of the great disaster pictures of European *Romanticism, worthy to rank beside Turner's *Slavers* and Géricault's *Raft of the Medusa* of 1819.

 There are three sketches of a ship on fire in the 'Fire at Sea' Sketchbook, hitherto dated, by *Finberg, to *c.*1834 (TB CCLXXXII: 3, 4, 5). Despite being unfinished, the picture was given an inventory number by the National Gallery, London, immediately on acquisition in 1856 and it seems to be referred to by *Thornbury when he speaks of Turner 'studying a burning ship at sunset (unfinished oil picture)' (1862, i. p. 325; 1877, p. 451).

See also CONVICTS AS SUBJECT MATTER. MB

 Powell 1993, p. 15

FIRST RATE TAKING IN STORES, A, pencil and watercolour, 11¼ × 15⅝ in. (28.6 × 39.7 cm.), 1818; Cecil Higgins Art Gallery, Bedford (W 499). The watercolour which accounted for one of the most comprehensive contemporary anecdotes relating to Turner's working methods in the watercolour medium. It was painted while Turner was staying with Walter *Fawkes at Farnley Hall, probably in November 1818. A typescript account made by Edith Mary Fawkes (now in the Library of the National Gallery, London) describes the genesis of the picture:

One morning at breakfast Walter Fawkes said to him, 'I want you to make me a drawing of the ordinary dimensions that will give me some idea of the size of a man of war'. The idea hit Turner's fancy, for with a chuckle he said to Walter Fawkes's eldest son, then a boy of about fifteen, 'Come along Hawkey and we will see what we can do for Papa' and the boy sat by his side the whole morning and witnessed the evolution of *The First Rate taking in stores*. His description of the way Turner went to work was very extraordinary; he began by pouring wet paint onto the paper till it was saturated, he tore, he scratched, he scrubbed at it in a kind of frenzy and the whole thing was chaos—but gradually and as if by magic the lovely ship, with all its exquisite minutia, came into being and by luncheon time the drawing was taken down in triumph.

The finished work demonstrates what a virtuoso performance it must have been. Another account suggests the work was complete within three hours and that Turner was

'tearing up the sea with his eagle-claw thumbnail and working like a madman' (*Thornbury 1877, p. 239).

A companion work, also at Bedford, *Loss of an East Indiaman* (c.1818; W 500) was also painted for Fawkes, the sketch (TB CXCVI: N) being inscribed 'Beginning for Dear Fawkes' (see Shanes 1997, pp. 33–5, both repr. in colour).

RY

FISHERMEN AT SEA, oil on canvas, 36 × 48⅛ in. (91.5 × 122.4 cm.), RA 1796 (305); Tate Gallery, London (BJ 1). Turner's first exhibited oil painting shows the Needles off the western point of the Isle of Wight; Turner had been there in 1795. A watercolour from the 'Cyfarthfa' Sketchbook (TB XLI: 37), apparently done on the same trip, is directly related to the painting. The picture is typical of the Picturesque movement (see SUBLIME) and depends on the moonlit, marine paintings of Claude-Joseph *Vernet, *Wright of Derby, and P. J. de *Loutherbourg, the last of whom had depicted the Needles in a watercolour of 1794; the treatment of the water and the contrasting of the cold light of the moon with the warm glow of the lantern in the boat are particularly characteristic of these models. Turner adapted the composition for an unpublished plate of his *Liber Studiorum* in 1817 or later (F 85).

The painting was bought at the Royal Academy by 'General Stewart' for £10, apparently before the opening. It was reviewed in the *Companion* to the exhibition: 'As a seapiece, this picture is effective. But the light on the sea is too far extended. The colouring is, however, natural and masterly; and the figures, by not being more distinct and determined, suit the obscure perception of the objects, generally seen through the gloom of night, partially illumined.'

This painting was bought by the Tate Gallery in 1972. It is the only oil by Turner to have been purchased, rather than acquired by bequest or gift, by one of the English national collections.

MB

FISHERMEN CLEANING AND SELLING FISH, see *SUN RISING THROUGH VAPOUR.*

FISHING was Turner's most productive form of relaxation. On the river bank, whether in London, Petworth, or other parts of England and Wales, he would use the stillness of fishing to reflect on light and landscape, to make notes, to paint, and to write poetry. His love of fishing, and his skill at it, was another manifestation of Turner's fascination with water and its changing colour and surfaces. Thus, sitting or standing beside water with a fishing rod in his hand was as much research as relaxation. There were times, however, when the fish were safe from him. In one poem he wrote:

Below the Summer Hours they pass
The water gliding clear as Glass
The finny race escapes my line
No float or slender thread entwine.
('Perspective' Sketchbook, TB CVIII: 13)

Sitting on the river bank, with his shadow falling behind him on a sunny day so he was concealed from the fish, he was also, *ipso facto*, looking towards the sun, and aware of the weather. On one trip to the River Dee in 1808 he wrote his observations about the optics of reflections in water ('Tabley 2' Sketchbook, CIV: 24). On this, as on other trips, he combined fishing with painting, and listed his various needs: 'Fishing Rod, Great Coat, Box Coat, Painting Box, Canvas' and 'Large Eel Hooks, Patent Yellow' (CIV: 5a, 55a).

Turner often fished in company, with *Chantrey, *Holworthy, *Howard, *Jones, *Trimmer, and other friends, and he noted down advice from one of these on the supply and care of maggots ('Worcester and Shrewsbury' Sketchbook, CCXXXIX: 68a–69). Trimmer related that Turner 'threw a fly in first-rate style', and caught trout in the River Brent to stock his pond at *Sandycombe Lodge. Many of his most lyrical paintings, such as *Trout Fishing in the Dee* (Turner's gallery 1809; Taft Museum, Cincinnati; BJ 92) and *Fishing upon the Blythe-Sand* (Turner's gallery 1809; BJ 87), take fishing, both river and maritime, as their subject, and others such as *Fishermen upon a Lee-Shore, in squally Weather* (RA 1802; Southampton Art Gallery; BJ 16) show how aware he was at an early age of the dangers of sea-fishing.

Among his watercolours are a number of colourful still-lifes of fish painted with clarity and truth to nature (e.g. CCLXIII: 339). From the late 1820s he transforms the imagery of fish into a more exotic language, for example the flying fish in the foreground of *Ulysses deriding Polyphemus* (RA 1829; Boston, Museum of Fine Arts; BJ 330) and the creatures in the foreground of *Slavers* (RA 1840; BJ 385). The subject reaches its climax in Turner's *whaling pictures and in *Sunrise with Sea Monsters* (c.1845; BJ 473). Turner's surviving fishing rod is in the Tate Gallery.

JH

Thornbury 1877, p. 120.
Lindsay 1966, pp. 18–19.
Bailey 1997, pp. 96, 97, 176–82, 207, 279, 316, 326.
Hamilton 1997, pp. 108–10, 117.

FISHING UPON THE BLYTHE-SAND, *Tide setting in,* oil on canvas, 35 × 47 in. (89 × 119.5 cm.), Turner's gallery 1809 (7); Tate Gallery, London (BJ 87). Perhaps the most evocative of Turner's views of the Thames estuary, showing Blythe, Blyth, or Bligh Sands off *Sheerness, facing Canvey Island. There is a similar oil of a *Coast Scene with Fishermen and Boats* (BJ 176) among the large *Thames sketches of c.1805–6 but the composition is different. A wash drawing in

the Tate Gallery (TB cxx: Q) is closer but again not an actual sketch for the oil.

The picture is one of four mentioned in a letter to Sir John *Leicester of 12 December 1810, presumably as for sale, but this did not eventuate. Thornbury reports that Turner also had 'the proud pleasure of refusing to sell' this picture 'to his old enemy Sir John [sic] *Beaumont'. Thornbury also records that Turner used this picture as a cat-door and indeed the canvas has been torn in five places; these tears have now been restored. Thornbury claims that 'the sky was painted in perishable sugar of lead, and has quite altered', but no evidence of this remains today. MB

Thornbury 1862, i. pp. 179, 297, ii. pp. 155, 173; 1887, pp. 304, 317, 432.

Joll 1983, pp. 82–3, no. 24, repr.

FITZWILLIAM MUSEUM, Cambridge. Founded by the 1816 bequest of Richard, seventh Viscount Fitzwilliam of Merrion, of his collections, which included 144 paintings, and £100,000 for the building, the Fitzwilliam is the University of Cambridge's principal museum. It was opened in 1848 in a classical building designed by George Basevi and completed by C. R. *Cockerell. Turner is well represented by some fifty works in the Fitzwilliam's important collection of British watercolours and drawings. As at the *Ashmolean, the core of the Turner collection came in 1861 as the gift of John *Ruskin, who presented 25 carefully selected sketches and drawings to the University of Cambridge for the Fitzwilliam Museum. The earliest is a very detailed watercolour of *Christchurch Gate, Canterbury*, dating from about 1793 (W 34), and the latest is the wonderfully economical *Schaffhausen* of some fifty years later (W 1468). This is one of eight late Swiss drawings in the gift, and there are three fine views of *Venice, also dating from the early 1840s (W 1353, 1361–2). The other half of the Turner drawings collection has come from various gifts, bequests, and purchases, including a group given by T. W. Bacon in 1950. The most recent Turner watercolour acquisition, purchased in 1979, is the beautiful *Vale of Pevensey* (W 432), executed for John *Fuller of Rosehill Park in about 1816. There are three early Turner oil paintings in the Fitzwilliam. A pair of small studies of *A Beech Wood* (BJ 35a and b; see KNOCKHOLT SKETCHES), purchased in 1981, dates from about the same time, 1799–1801, as the rather weak *Mountain Landscape with a Lake* (BJ 38), from the *Munro of Novar Collection, purchased in 1925. LH

Malcolm Cormack, *Catalogue of Turner Drawings and Watercolours in the Fitzwilliam Museum*, 1975.

FLAXMAN, John (1755–1826), English sculptor. His *St. Michael Overcoming Satan* (1819–24, marble, 132 in., 335.3 cm., *Petworth House), commissioned by the third Earl of *Egremont, was the subject of Turner's *Petworth: The Gallery, with Flaxman's St. Michael* (?1827; TB CCXLIV: 25). The dramatic focus of this work, installed in 1826, is emphasized by the light streaming in from the windows before they were blocked in on the advice of *Chantrey and Thomas *Phillips in 1830. Flaxman's *Pastoral Apollo* (1813–24, marble, 33 in., 83.5 cm., Petworth House), exemplifying his particularly eviscerated form of *Neo-classicism, was also commissioned by Egremont. Flaxman had entered the Royal Academy Schools in 1769 and had made his first designs for Wedgwood in 1775. In 1787 he travelled to Italy and it was here that he made his first major ideal works. However, it was his illustrations to the *Iliad*, *Odyssey*, and Dante, engraved by Piroli in 1793, that made his European reputation. After his return to England in 1794 recognition came when he was elected ARA (1797), RA (1800), and then the first Professor of Sculpture at the RA (1810). AY

David Irwin, *John Flaxman 1755–1826: Sculptor, Illustrator, Designer*, 1979.

FLORENCE, with its beautiful setting and many celebrated art treasures, has long been an essential ingredient in any serious tour of *Italy. Turner first depicted the city in c.1818 in three of his watercolours for James *Hakewill's *Picturesque Tour of Italy* (W 713–15). He visited Florence twice: when returning north from Rome in December 1819–January 1820, at the end of his first Italian tour; and nearly nine years later, on his way to Rome at the start of his second visit, in October 1828. On both occasions he sketched only in pencil in small sketchbooks ('Rome and Florence', TB CXCI, in 1819–20; and 'Genoa and Florence', CCXXXIII, in 1828). His main study of the city and its environs took place in 1819, when he made notes on a wide range of paintings in the Uffizi and elsewhere by artists including Dürer, Simone Martini, Baldovinetti, Pontormo and *Claude Lorrain. He visited the cathedral, Santa Croce, and other famous Florentine churches, studying and making a few quick sketches of architecture, monuments, and frescoes. He also made many sketches of Florence as a whole from viewpoints that had long been popular with artists and travellers and were already known to him from his work for Hakewill: Fiesole; the river banks; the hillside close to San Miniato al Monte looking down on the Arno and the Ponte Vecchio. This last viewpoint was particularly well suited to Turner's genius. When his dazzling finished watercolour (1827; private collection; W 726) was engraved in the *Keepsake* for 1828, the scene was so popular that three repetitions were commissioned very soon afterwards. CFP

Powell 1987, pp. 90–103.

FOLKESTONE, SEASCAPE, oil on canvas, 36¾ × 46¼ in. (88.3 × 117.5 cm.), *c*.1845; private collection, USA (BJ 472). Formerly called 'Storm off the Forelands'; neither title is secure and no history is known before 1894. Similarities with watercolours in the 1845 'Ambleteuse and Wimereux' Sketchbook (TB CCCLVII) make that date and a view somewhere in the Channel most likely. Whether it was sold in Turner's lifetime or removed afterwards from the studio remains unknown.

In pristine condition, 'the peculiarly iridescent quality of the paint, and the lightness of touch, are hard to match and in many respects the picture stands alone' (David Blayney Brown, *Turner and the Channel*, exhibition catalogue, London, Tate Gallery, 1987, p. 7).

It broke all auction records for a painting when it fetched £7,370,000 in July 1984. EJ

FONTHILL, in Wiltshire, was the seat of the author, collector, and patron William *Beckford who, inheriting his father's immense West Indian plantation wealth, had commissioned a massive neo-Gothic Abbey from James *Wyatt (1746–1813) in 1793 to replace the old family mansion. Wyatt engaged Turner to make a large watercolour depicting a romanticized conception of the finished building (Yale Center for British Art, New Haven; W 333), which was exhibited at the Royal Academy in 1798 as by the architect. Turner further assisted Wyatt in his publicity efforts on Beckford's behalf: with other artists, he was a guest at the half-completed house in the summer of 1799 and exhibited five views at the 1800 RA exhibition (W 335–9), showing the Abbey in its picturesque grounds at different times of day. Hamilton (1998, pp. 23–5) points out, however, that Turner also made a series of close-up pencil sketches of the Abbey, including the then unfinished tower (see XLVII, XLVIII). These are very different from the watercolours that Beckford received, which view the Abbey from afar, 'with the details of the tower fudged by the distance'. He suggests that Beckford or Wyatt may have wanted views that showed the tower as finished, which Turner was unable or unwilling to provide. The exhibited views, then, would represent a compromise between the wishes of artist and commissioner. AK

FORMATS, see SIZES AND FORMATS.

FORNARINA, LA, see ROME, FROM THE VATICAN.

FORT VIMIEUX, oil on canvas, 28 × 42 in. (71.1 × 106.7 cm.), RA 1831 (406); private collection, England (BJ 341). The second Turner oil to go to America, bought in 1850 by Colonel *Lenox, who already owned *Staffa (RA 1832; Yale Center for British Art BJ 347). Both were auctioned in New York in 1956, when *Fort Vimieux* returned to England.

Identical in format to **Calais Sands* (RA 1830; BJ 334) and also *Bonington-influenced, the composition is developed from *A Ship aground* (*c*.1828; BJ 287; see PETWORTH). It was exhibited without a title, but with a paraphrased account of a wartime incident in which a Royal Navy cruiser reconnoitring the French coast ran aground, enduring enemy fire from 'the Fort of Vimieux' until the rising tide enabled her to warp off. Turner gives the year of this incident as 1805, and his source as 'Naval Anecdotes'. In a lecture at the *Turner* symposium, Canberra, 1996, Judy Egerton suggested that Turner was in fact recollecting (but modifying) a widely reported incident which occurred on 23 October 1804, when the *Conflict* gun-brig, stationed off Ostend, chased and engaged an enemy flotilla, but ran aground in shoal water, becoming a target for enemy fire until eventually captured. In the *Naval Chronicle* for 1804, this incident was indexed under 'Naval Anecdotes'. 'Vimieux' may be Turner's version (or a Royal Academy catalogue misprint) of Wimereux, some 50 sea miles from Ostend. EJ

FORUM ROMANUM, *for Mr. Soane's Museum,* oil on canvas, 57⅜ × 93 in. (145.5 × 237.5 cm.), RA 1826 (132); Tate Gallery, London (BJ 233). The second of Turner's great tributes to Rome, following **Rome, from the Vatican* (BJ 228). The picture was originally designed for the museum built by the architect Sir John *Soane in his home in Lincoln's Inn Fields; the painting's depiction of some of the most important ancient ruins in Rome would have particularly suited him. However, presumably because space was very constricted, Soane did not in fact take the picture. Instead, much later, Soane bought *Admiral *Van Tromp's Barge at the Entrance of the Texel, 1645* in Turner's standard 3 × 4 ft. (91.4 × 122 cm.) *size (RA 1831; BJ 339). There are two sketches in the 'Small Roman Colour Studies' Sketchbook and the 'Rome Colour Studies' Sketchbook (TB CXC: 1, CLXXIX: 43).

The *Literary Gazette*, 13 May 1826, noted that 'The artist, we can readily perceive, has combated a very difficult quality of art, in giving solidity without strong and violent opposition of light and shade . . . Mr. Turner . . . seems to have sworn fidelity to the *Yellow Dwarf*, if he has not identified himself with that important necromancer.' MB

Powell 1987, pp. 56–7, 121–6.

FOUNTAIN OF INDOLENCE, THE, oil on canvas, 42 × 65½ in. (106.5 × 166.4 cm.), RA 1834 (52); Beaverbrook Art Gallery, Fredericton, New Brunswick (BJ 354). The title is taken from James *Thomson's poem *The Castle of Indolence*

(1748). Turner's dream-like fantasy of idle pleasure was reworked to an unknown extent and exhibited again at the *British Institution (58) five years later as *The Fountain of Fallacy* (BJ 376), accompanied by four lines from *Fallacies of Hope* (see POETRY AND TURNER). Although Turner did sometimes exhibit at the BI pictures previously unsold at the Royal Academy, this is a unique case of his changing the title; this misled *Ruskin into believing that two pictures existed.

Gage, while admitting that Turner's lines are 'not altogether transparent', suggests they mean that 'science, or thought, is capable of measuring, although it is itself immeasurable', thus marking 'Turner's deepening involvement with science' due to his contacts with scientists such as *Faraday and Mary *Somerville. EJ

Gage 1987, pp. 224–5.

FRAMES. The picture frames chosen by Turner have proved extremely vulnerable to later tastes, and few survive. His career coincided with the change from hand-carved frames to machine-turned wooden mouldings and applied composition ornament; thus his frames may have been seen as disposable packaging rather than as carefully judged foils for his work. Study of remaining authentic examples, of paintings showing Turner's pictures, and of contemporary comments indicate, however, that he employed well-considered solutions to the question of presentation.

The earliest frame which is certainly Turner's choice surrounds his Diploma Work, *Dolbadern Castle* (RA 1800; Royal Academy; BJ 12). Its main feature is a wide concave (scotia) moulding, bordered on the top edge by reeds or fasces bound with a ribbon, and inside by acanthus and tongue ornament. It was originally water-gilded. This basic structure, varied by more or less decoration, was one of two main types of frame used by Turner throughout his career. It is a variant of a late 18th-century Neoclassical pattern, known as a 'Morland' frame by association with the artist George Morland; versions were used by *Constable, among others. The deep hollow is a device for focusing upon the image, and also helps to diffuse light onto the painted surface, while the overall weight of the frame makes it particularly suitable for large landscapes, isolating the image from the surrounding wall.

A similar design, the hollow decorated with cross-cut acanthus leaves in composition, was used for the 'Bridgewater Seapiece' (*Dutch Boats in a Gale*, RA 1801; BJ 14). When newly gilded, the decoration would have created an aureole of flickering light around the painting, perhaps justifying Turner's demand of 20 guineas extra for the frame (Farington *Diary*, vi. p. 2380). The ray-like effect of the leaf-veins helps to enhance the spatial depth of the seascape; and besides its richness and adaptability to different subjects, the pattern has a Classical resonance which Turner would have appreciated.

Plain scotia frames with small Classical ornament—supplied by the framemaker C. Gerard—surround Turner's work in Petworth House, ordered by the third Earl of *Egremont, although Turner would have approved this type of design. Both plain and acanthus versions also remain in the Tate and National Galleries, although it is unclear to what extent these survivors are authentic. The Turner Bequest arrived at the National Gallery in 1856 without frames. Permission had to be granted to the Gallery's Trustees by the lawyer for Turner's legatee, allowing them to take 'all or any of the Picture frames' left at Turner's house (National Gallery Archives). How many they may have taken is unrecorded; nor is it known how many were subsequently discarded as the pictures moved from gallery to gallery. Certainly, some frames were badly damaged.

E. R. Taylor's painting, *'Twas a Famous Victory* (Birmingham Art Gallery), shows one of the Turner rooms at the National Gallery in 1883, with *The Battle of Trafalgar* (Turner's gallery 1806; BJ 58) prominently displayed. This and all the larger Turners are in wide scotia frames with a convex leaf and berry ornament on the top edge, effectively isolating each painting from its neighbours. H. E. Tidmarsh's *grisaille* of the other Turner room (c.1883; Guildhall Library and Art Gallery) shows similar frames. The present setting for *Trafalgar* is based on the heavily restored central section of such a frame, the carved leaf and berry and inner gilt cuff having been lost. So, apparently, have all save two of the other frames in this pattern.

Scotia frames can also be seen in G. *Jones's *Interior of Turner's Gallery* and its pendant (c.1852; Ashmolean Museum). The paintings are shown hung or propped edge to edge, the frames acting like gold mortar. As well as scotia frames, however, Jones has shown Turner's other favoured design—a centre and corner frame loosely modelled in Louis XV style.

This may have been adopted as a 'patron's frame'. It appears in Turner's depictions of his own work: *Walter Fawkes's Exhibition at Grosvenor Place* (c.1819; private collection; W 498), full of Turner watercolours; and *Drawing-Room, Farnley* (1818; private collection; W 592), where his oil painting *Dort* (RA 1818; Yale Center for British Art, New Haven; BJ 137) hung in a straight-sided frame with prominent corners (now lost). B. G. *Windus's collection of Turner watercolours, painted in 1835 by John Scarlett Davis (British Museum), had uniform swept Louis XV-style settings with projecting corners.

Turner himself used a Louis XV-style design, notably in the ornate swept frame of *Admiral *Van Tromp's Barge* (RA 1831; Sir John Soane's Museum; BJ 339); see Pl. 25. Soane bought this picture from the RA, and there is no record of its being reframed. Although the curvilinear forms echo the billowing sails, it is an unlikely setting for a marine; it was presumably intended as a dramatic complement to a 'grand machine'. A similar frame was used for *Regulus* (1828; BI 1837; BJ 294): see T. Fearnley's *Turner Painting Regulus* (1837; N. Young Fearnley Collection); and in 1840–1 Turner used a square rococo frame with circular sight to exhibit first *Bacchus and Ariadne* (RA 1840; BJ 382), and then *The Dawn of Christianity* (RA 1841; Ulster Museum; BJ 394), on which it remains.

Versions of both the scotia and Louis XV style were used as 'close frames' (i.e. without mounts) for his watercolours. Unfortunately, these have succumbed in even greater numbers to changing tastes. Both private and museum collections have been stripped of their original frames, mounted with acid-free board, and set in plain pine mouldings. This does much for their preservation but nothing for their presentation.

A rare surviving 'close' concave frame, ornamented with acanthus leaves and egg and dart, defined by an inner gilt flat and knurled top edge, can be seen on the *St Huges denouncing vengeance . . . valley of d'Aoust* (RA 1803; Sir John Soane's Museum; W 364); see Pl. 2, which was bought by Mrs Soane from Turner's gallery. There is no record of *Soane reframing it; and it escaped an attempt in the 1880s to provide it with a card mount and simpler frame. It has also been protected from light, so that the intensity of colour survives, showing why Turner chose—like many of his contemporaries—to treat his watercolours as oil paintings and give them opulent golden borders. Comparable examples of 18th-century close frames survive at *Stourhead House, Wiltshire.

In 1857 a writer in the *Builder* (Gage 1969, p. 163) observed that Turner anticipated 'the union of the gold of his colour with the gold of his frame . . . [He urged] the hanging of frames containing his drawings in groups, without intervals between the frames, so that nothing but gold might be seen in connection with the drawing.' Institutions such as the Royal Academy and Old Water-Colour Society favoured this method of hanging for both media, producing exhibition walls resembling secular polyptychs; and Turner's patrons (Windus and Walter Fawkes) also imitated it.

However, after Turner's death fashion veered towards plainer frames and pale card mounts for watercolours. The National Gallery, London, bequeathed thousands of his unframed drawings, set only three of the largest in close gilt frames similar to the originals. A committee decided that a selection of the rest should be set in flat oil-gilded frames 2 inches (5 cm.) wide with 'a French mount . . . a sheet of thick paper of a tint agreed on' (National Gallery Archives). Only the *Liber Studiorum* drawings retained Turner's own mounts. The frames were designed by a Trustee, Russell, and the work carried out by Colnaghi, at £116 12s. for 67 watercolours.

John *Ruskin campaigned for this method of framing. His fantasy was a national gallery for Turner's watercolours with each in a 'golden case and closing doors', like a medieval triptych; but he settled for light-excluding mahogany cabinets containing cases of framed and mounted paintings. The mount was to be white, and 'the frame of white pine; because the whiter the wood, the less it hurts the colour of the sketch' (National Gallery Archives). Arthur Severn's *View of Ruskin's Bedroom, Brantwood* (1900; Ruskin Foundation, Brantwood, Coniston) shows his own Turner drawings in white mounts and narrow gilt frames; these became the standard treatments for Turner's watercolours in public and private collections.

In the 20th century the Farnley series of watercolours was reframed in this way, losing their original 'deep gilt frames, some decorated with the family crest, in which Fawkes and the painter had had them put' (MS annotation by C. F. *Bell in his *Exhibited Works of J. M. W. Turner*, 1901, Victoria and Albert Museum copy). This action probably destroyed the only intact collection of Turner's paintings framed by the artist. Other groups—such as the R. W. *Lloyd Bequest in the British Museum—tend to have uniform settings and mounts chosen by the purchaser; often, as here, produced by the firm of *Agnew, which also seems to have reframed many of the Turners which have passed through its hands. Even the frame for *Bell Rock Light House* (1819; National Galleries of Scotland; W 502), for which we have the only extant Turner sketch of a frame section (Gage 1980, p. 79), has apparently vanished. When we look at Turner's work, therefore, it is important to remember that the way it is now presented is often far from the way in which the artist expected it to be seen. PM/LR

National Gallery Archives, London: NG5/129/1856 and NG/220/1857.
Gage 1969, p. 163.
Gage 1980, p. 79.

FRANCE. Throughout his career Turner was stimulated by both the landscape and the art of France. His many Continental tours are neatly framed by those of 1802 and 1845, which took him across the Channel to France for the first and last times. Even before his first trip, he was familiar with

French scenery as a result of making copies of views by other artists, along the same lines as his vicarious study of Italian scenes at the *Monro Academy. Among those artists that he most admired and attempted to emulate, the majority were French, including *Claude Lorrain, *Poussin, *Vernet, and *Watteau. As well as these established names, he seems to have been conversant with his French contemporaries, visiting the studios of Guérin, *David, and *Delacroix. His first visit in 1802 was clearly prompted by the opportunity of seeing the Napoleonic booty gathered from across Europe in the Louvre, *Paris, although this was perhaps secondary to his chief concern with the scenery of the *Alps. His direct experience of art and landscape was combined in the pictures of *Bonneville and elsewhere sent to the Royal Academy in 1803 (BJ 46–8, 50). The route he had taken southwards in 1802, via Lyons, was repeated on his second trip to France in 1819, but this time he pushed on to Italy.

Turner's first tour devoted solely to French scenery occurred in 1821 at a time when there was considerable interest in Normandy and its architecture. In 1824, at the end of his *Meuse and *Mosel tour, he spent several days on the coast between *Calais and Dieppe, which resulted in the large oil painting *Harbour of Dieppe (Changement de Domicile)* (RA 1825; Frick Collection, New York; BJ 231). This was the first of a group of port subjects modelled on the famous series by Vernet. His tour of 1825 again took him through France, this time to Boulogne, as well as to Calais, but is less significant than that of 1826, during which he travelled extensively through Normandy, Brittany, and along the *Loire. Two years later, he delayed his arrival in Italy by making a leisurely exploration of the Rhone and the coast between Marseilles and Genoa.

In 1829 Turner returned once again to the *Seine. Another lengthy French tour took place in 1832, focusing chiefly on Paris and sites connected with *Napoleon. The repeated visits to France in the late 1820s and early 1830s gave rise to four oil paintings exhibited at the Royal Academy between 1829 and 1833 (BJ 329, 334, 341, 353), as well as designs for the *Keepsake* annual. In 1836 Turner once more travelled through France, making a tour, partly in the company of *Munro of Novar, of the Alps and the south; and in the two following years he may have returned again to this area. His final French visits both occurred in 1845: in May he went to Ambleteuse and Wimereux; and in September he visited Dieppe and Eu, where he was invited to the château by *Louis-Philippe.

See also REPUTATION DURING TURNER'S LIFETIME. IW

Paris 1981.
Alfrey 1983, pp. 35–41.
Gage in Paris 1983, pp. 43–55.

Warrell 1997.
Warrell 1999.

FRENCH IMPRESSIONISTS. It has often been stated that Turner's later work was a formative influence in the development of French Impressionism. There is some truth in this, for several of the major French Impressionists, especially Claude Monet and Camille Pissarro, were great admirers of Turner's paintings. Both these artists studied the work of Turner during their stays in London at the time of the Franco-Prussian War in 1870, and were thus familiar with it when moving into their true Impressionist manner in the early 1870s. However, at that time few if any of Turner's most 'impressionist' paintings, such as the now famous *Norham Castle, Sunrise* (BJ 512), were on view in London. Most of these late 'unfinished' canvases were only rediscovered in store at the National Gallery, *London, from 1901 onwards. On the other hand many of the Turner Bequest paintings exhibited in his lifetime, such as *Rain, Steam, and Speed* (RA 1844; National Gallery, London; BJ 409), which were certainly on view, had sufficiently 'impressionist' characteristics to influence the French painters. The same was, of course, true of the Turner watercolours which they studied in the Print Room of the *British Museum. Some of Turner's pioneering oil and watercolour techniques will certainly have had an impact on the French Impressionists, but it must be remembered that there was one essential difference between the working methods of Turner and the Impressionists. Except for some on-the-spot sketches, especially earlier in his career, Turner painted his oils in the studio; it was a basic tenet of the Impressionists that they painted their 'finished' canvases in the open, thereby achieving the same wonderfully natural effects of light, colour, and atmosphere as Turner did when painting in his studio.

See also POSTHUMOUS RECEPTION ABROAD. LH

FRESNOY, Charles-Alphonse du (1611–68), French painter and poet. His Latin poem *De Arte Graphica*, translated into English variously by Dryden and William Mason, was highly influential, and particularly admired and propagated by *Reynolds. Turner owned a copy of Mason's translation (*The Art of Painting*) annotated by Reynolds (1783), and referred to it frequently and sometimes critically in his *perspective lectures.

Du Fresnoy lived in Rome 1634–53, where he painted *Poussinesque subjects and began his poem. He spent 25 years perfecting the 549 hexameters of *De Arte Graphica*, which proclaimed the sisterhood of painting and poetry. He introduced musical terminology to describe colour, and thus initiated a language of metaphor which enabled

discussion of the nature of colour to progress in the late 18th and 19th centuries.

Turner's interest in Du Fresnoy came to a focus in 1830–1 when he painted *Watteau Study by Fresnoy's Rules* (RA 1831; BJ 340). This small oil on panel was made at *Petworth, with its companion *Lord Percy under Attainder* (RA 1831; BJ 338), perhaps as a result of a technical discussion among artists staying at the house with Lord *Egremont. Turner had great affection for and understanding of the paintings of *Watteau, and by depicting the artist's studio in the setting of a crowded room at Petworth, he translates the bustling creativity of Petworth into 17th-century costume. In the background Turner has transcribed Watteau's *Les Plaisirs du Bal* (enlarged and reversed; Dulwich Picture Gallery) and *La Lorgneuse*, then owned by *Rogers.

Turner's leading intent with the painting was to demonstrate the power of black and white, following Fresnoy's dictum:

> *White*, when it shines with unstain'd lustre clear,
> May bear an object back or bring it near.
> Aided by *black*, it to the front aspires;
> That aid withdrawn, it distantly retires;
> But black unmix'd of darkest midnight hue,
> Still calls each object nearer to the view.

Turner quoted the first two lines of this passage in the 1831 *Royal Academy exhibition catalogue.

The painting has darkened considerably, obscuring the bright colours which themselves made further tribute to Watteau, and scrambling Turner's point about Du Fresnoy. What remains clear, however, is that Turner has used two strong areas of white, one in the foreground, the other in the background. Despite the fact that the darker figure of Watteau stands in front of the background white, this does nevertheless obtrude strongly. The *Library of the Fine Arts* (June 1831) understood Turner's argument in the picture, 'with its almost impossible effects produced on principles directly opposed to those generally adopted'. The *Athenaeum* (21 May 1831) wrote of 'the wildest of the artist's colouring fancies . . . What a trifle in the tone would destroy the beauty. We have not seen this picture commended, but to our taste it is full of delicacy and beauty and is a rich gem.'

JH

Gage 1969, pp. 89–90, 92, 205, 223.
Whittingham 1985², pp. 31–5.
Butlin, Luther, and Warrell 1989, pp. 90–1.
Davies 1992, pp. 38–9.

FRICK COLLECTION, New York, owns five Turners, all acquired by Henry Clay Frick between 1901 and 1914. The earliest is *Fishing Boats entering Calais Harbour*—on a very breezy day (BJ 142), painted *c*.1803. Turner apparently still owned it when it was engraved for the *Liber Studiorum* in 1816 (F 55) but it is not known who bought it subsequently.

The large *Harbour of Dieppe* and *Cologne* (RA 1825 and 1826; BJ 231, 232) were apparently painted for Mr John *Broadhurst, which argues against the suggestion in the Frick Catalogue that Turner intended them to follow the *Dort, thus forming a trio of northern Continental ports. A more convincing companion for the Frick pair is the unfinished harbour scene (BJ 527) recently identified as *Brest*.

Mortlake Terrace . . . Early (Summer's) Morning (see MOFFATT, WILLIAM, also exhibited at the Royal Academy in 1826 (BJ 235)), was bought in 1909 surprisingly from Andrew Mellon, who evidently regretted having parted with it, as he subsequently bought the companion *Mortlake Terrace . . . Summer's Evening* (RA 1827; National Gallery, Washington; BJ 239) when it became available in 1920.

Van Goyen looking out for a Subject (RA 1833; BJ 350) is often referred to as 'Antwerp', as that city appears in the distance. Its cool tonality was welcomed by the critics after the too-prevalent yellow they had deplored in such pictures as *Cologne*.

EJ

FROSTY MORNING, oil on canvas, 44 × 68¾ in. (113.5 × 174.5 cm.), RA 1813 (15); Tate Gallery, London (BJ 127). Exhibited with the line 'The rigid hoar frost melts before his beam' (*Thomson's *Seasons*). The picture, reputedly one of the artist's own favourites, records a scene Turner sketched when travelling by coach in Yorkshire and, according to the younger *Trimmer, thereby immortalized Turner's 'old crop-eared bay horse, or rather a cross between a horse and a pony'. The girl with the hare round her neck is thought by some to portray Evelina, Turner's elder daughter (see CHILDREN OF TURNER), who also appears in *Crossing the Brook* (BJ 130). David Hill (*Country Life*, 1980, pp. 2402–3) suggests that the man with the gun—who hardly looks like a prosperous squire—is Walter *Fawkes and the boy his son Francis Hawkesworth, but Turner is unlikely to have shown his patron next to his illegitimate daughter.

The picture was highly praised by *Constable's patron, Archdeacon Fisher, who preferred it to anything in the exhibition by Constable but consoled him by writing: 'You are a great man like Buonaparte, and are only beaten by a frost' (Beckett 1968, vi. p. 21). In 1818 Turner offered it to Dawson *Turner for 350 guineas but without success while, according to *Thornbury, Turner had once considered giving it to Trimmer but never did so. Monet, who saw it in 1870, described it enthusiastically as 'peint les yeux ouverts' (quoted by Gage 1983, p. 50). The painting has lost some glazes. EJ

FULLER, Jack [John] (d. 1834), Member of Parliament for East Sussex, self-styled 'Honest Jack' Fuller but usually dubbed 'Mad Jack' by contemporaries. He was a notable patron of Turner's in the years following 1810. Fuller's first commission was for four watercolours of Sussex in 1810: *The Vale of Pevensey from Rosehill Park* (Fitzwilliam Museum, Cambridge; W 432), *The Vale of Ashburnham* (University of Liverpool; W 433), *Beauport* (Fogg Art Museum, Cambridge, Mass.; W 434), and *Battle Abbey* (private collection; W 435). These were privately printed as coloured aquatints by J. C. Stadler (R 822–5), and distributed to Fuller's friends and neighbours. Originally Fuller was to have paid Turner just to borrow the watercolours for printing, but in the event he purchased them. Around this time he also commissioned an oil of *Rosehill Park* (c.1810; private collection; BJ 211), completed in 1811, which Fuller considered also having aquatinted. The oil commission gave birth to one of the famous anecdotes about Turner's character, for when he delivered it to Fuller's London home in Devonshire Place he charged him three shillings for the Hackney cab, a story Fuller repeated with delight. Turner's *Fishmarket on the Sands—Hastings?* (Turner's gallery 1810; William Rockhill Nelson Gallery and Atkins Museum of Fine Arts, Kansas City; BJ 105) was also acquired by Fuller.

From about 1816 Turner executed a further series of watercolour views of Sussex scenery for Fuller. These comprised: *The Observatory at Rosehill Park, the Seat of John Fuller Esq* (untraced; W 424), *The Vale of Ashburnham* (British Museum; W 425), *Pevensey Bay from Crowhurst Park* (private collection; W 426), *The Vale of Heathfield* (British Museum; W 427), *Bodiam Castle* (private collection; W 428), *Hurstmonceaux Castle* (private collection; W 429), *Winchelsea, Sussex, and the Military Canal* (untraced; W 430), *Pevensey Castle* (private collection; W 431), and *Rosehill, Sussex* (British Museum; W 438). Some of these, along with Turner's earlier watercolours for Fuller, were published by W. B. *Cooke between 1816 and 1820 as *Views in *Sussex* (R 128–36). Originally intended to run to three parts, the first part remained incomplete, largely due to the distribution problems Cooke faced after the withdrawal of John *Murray.

Fuller's fortune was built on iron smelting and his sugar plantations in the Caribbean, where he owned many slaves. He was reputedly a volatile and sometimes eccentric man, who was locked up for two days by the Speaker of the Commons for his bad behaviour during a debate on the abolition of *slavery. A number of follies were commissioned for the park of Rosehill, along with a large pyramid under which he is buried in Brightling churchyard. However, he was also a member of the Royal Institution, and had an observatory installed at Rosehill which was filled with scientific instruments. A portrait of him by Henry Singleton is held by the Royal Institution, and a plaster bust by *Chantrey is in the Ashmolean Museum, Oxford. Many of the works commissioned from Turner passed down to Sir Alexander Acland-*Hood and were sold at Christie's on 4 April 1908.

RU

FUNERAL OF SIR THOMAS LAWRENCE, A sketch from memory, watercolour and body-colour on paper, 24½ × 32½ in. (61.6 × 82.5 cm.), RA 1830 (493); Tate Gallery, London (TB CLXIII: 344; W 521). The last watercolour Turner exhibited at the Royal Academy, it was his tribute to an event which affected him deeply. The work combines a mood of personal loss while portraying a theme of public mourning of a great national figure. The composition is the artist's spontaneous impression of the scene outside the west front of St Paul's Cathedral as the funeral procession enters the cathedral.

Turner's friendship with *Lawrence spanned much of his career and he was much saddened when the RA President died at the comparatively early age of 60. The mood and inspiration of this watercolour can be gleaned from a letter Turner wrote to his fellow Royal Academician George *Jones: 'Alas! only two short months Sir Thomas followed the coffin of Dawe to the same place. We then were his pall-bearers. Who will do the like for me, or when, God only knows how soon. My poor father's death proved a heavy blow upon me, and has been followed by others of the same dark kind' (Gage 1980, p. 137).

EY

FUSELI, Henry (1741–1825), Swiss-born history painter who worked in London from 1779 and was Professor of Painting at the Royal Academy 1799–1805 and 1810–25 and Keeper 1804–5. Fuseli's art possesses an energy and eroticism unique for its time. Although not close friends, Fuseli and Turner had a mutual respect for the intellect and physicality in each other's work: Fuseli felt that Turner was 'the only landscape painter of genius in Europe' (Finberg 1961, p. 343); in Italy in 1828 Turner referred to Fuseli as 'a departed spirit, whose words and works will long dwell in [our] remembrance' (Turner to Thomas *Lawrence, 15 December 1828; Gage 1980, pp. 122–3). The close attention paid by Turner to Fuseli's lectures can be seen in his annotations to *Goethe. The early praise Fuseli gave the 'Bridgewater Seapiece' (*Dutch Boats in a Gale*, RA 1801; BJ 14)—he thought it the 'best picture' in the exhibition, with the figures 'very clever', the whole 'quite Rembrantish' (Farington, iv. p. 1541)—made it quite natural for him to vote for Turner as an RA the following year. In 1803 he admired *Calais Pier*

(National Gallery, London; BJ 48) and *The *Festival upon the Opening of the Vintage of Macon* (Sheffield City Art Galleries; BJ 47) though he thought the foregrounds 'too undefined'. An eccentric colourist himself, he clearly admired Turner's skills in this department but could be critical of him, as he was of the *Holy Family* (BJ 49; Farington, vi. p. 2023).

RH

Gert Schiff, *Henry Fuseli 1741–1825*, exhibition catalogue, London, Tate Gallery, 1975.
Gage 1984, pp. 35, 41, 42.

G

GAINSBOROUGH, Thomas (1727–88). With Richard *Wilson, Gainsborough was one of the founding fathers of the British landscape school, and also an accomplished portrait painter, a rival to *Reynolds. His pastoral landscapes were highly influential on Turner during his early career. Turner would have known Gainsborough's work through various friends or patrons, notably Dr *Monro, W. F. *Wells, H. S. *Trimmer (the grandson of Gainsborough's associate, Joshua Kirby), and Sophia Lane (Gainsborough's niece). An early sketchbook by Turner of *c*.1790–1 (Princeton Art Museum) includes a copy in monochrome washes of Gainsborough's etching, *Wooded Landscape with Church, Cow and Figure* (taken from a manual about perspective published by Kirby in 1754), while oil sketches made in the vicinity of *Knockholt *c*.1799–1801 (BJ 35a–j) and a painting of *The Forest of Bere* (Turner's gallery 1808; Petworth House; BJ 77) recall Gainsborough's woodland subjects. One early oil, *Landscape with Windmill and Rainbow* (BJ 45), is in parts even directly copied from a (now lost) painting by Gainsborough. *Sand Bank with Gipsies*, *c*.1815–20, an unpublished plate for the *Liber Studiorum (F 91), transposes one of Turner's own Gainsborough-like oils (?Turner's gallery 1809; BJ 82), and was also engraved by him in soft-ground etching, a medium favoured by Gainsborough for his own prints, thus reinforcing the source of his inspiration. Gage argues that it may have been Dr Monro who introduced Turner to the idea, adopted by Gainsborough in the 1770s, of displaying drawings like oils rather than storing them in portfolios. Turner also created landscapes in watercolour by experimenting with Gainsborough's famous 'mopping' technique. AL

John Hayes, *The Drawings of Thomas Gainsborough*, 2 vols., 1970.

John Hayes, *The Landscape Paintings of Thomas Gainsborough*, 2 vols., 1982.

Gage 1987, pp. 22, 78, 115–16, 139.

Forrester 1996, pp. 9–10, 32–3, 47–8, 53, 152, 157.

GAMBART, Ernest (1814–1902), a Belgian by birth who settled in London in 1840. Initially a printseller in a small way, he became a British citizen in 1846 and soon prospered. He then branched into modern pictures but retained his highly profitable print business. Although nicknamed 'Gamble-Art', he was extremely shrewd with a prodigious appetite for pictures, 'engulfing them', in Maas's simile, 'like a whale swallowing plankton'.

Gambart's only reported contact with Turner rests on *Falk's story that Gambart arranged with the dying Turner to publish one of his *Southern Coast views but that Turner was too far gone to touch the proofs when shown to him. As Gambart's two *Southern Coast* engravings were published early in 1850, this story seems highly dubious. In 1856 Gambart reissued the incomplete *Ports of England* of 1826–8 as 'Harbours of England' with six additional plates and an introduction by John *Ruskin.

Gambart bought only one Turner painting during the artist's lifetime: *Dunstanborough Castle* (RA 1798; National Gallery of Victoria, Melbourne; BJ 6), sold at Christie's, 10 July 1851, as 'Corfe Castle from the Sea'. Other purchases followed in the 1850s and at *Munro's sale at Christie's, 26 March 1860, Gambart bought *Venice, from the Porch of the Salute* (RA 1835; Metropolitan Museum, New York; BJ 362) for 2,400 guineas. Afterwards John James *Ruskin suggested to Gambart that, if he would forgo his commission and find twenty gentlemen to subscribe £100 each, 'I will subscribe £500 towards buying the picture . . . for presentation to the Louvre' (see PARIS, LOUVRE). Gambart collected eight potential subscribers but nothing further resulted and the Louvre did not acquire a Turner oil until 1967 (*Landscape with a River and a Bay in the Distance*, *c*.1845–50; BJ 509; see GROUT). Gambart bought no more Turners after 1860 and left England in the early 1870s. EJ

Falk p. 221.

Maas 1975.

GARDEN OF THE HESPERIDES, see GODDESS OF DISCORD.

GEDDES, Andrew (1783–1844), Scottish painter of portraits and history subjects. Although not a successful artist

commercially, Geddes was admired by other painters, including Turner, who got to know him in *Rome during 1828. According to David *Wilkie, Turner spoke highly on his return of a copy which Geddes had made after Paul Veronese. In a letter of 1829 to Charles *Eastlake, still in Rome, Turner also included Geddes in a list of 'friends' to whom he wished to be remembered. Geddes's interest in *Watteau, whose paintings he collected, would certainly have corresponded with, if not encouraged, Turner's own. The principal anecdote concerning Turner and Geddes, however, comes from Thomas *Lupton via *Thornbury and refers to an incident at an 1839 *Varnishing Day (Whittingham 1985, p. 6). According to this account, Turner felt inclined to heighten the reds of The *Fighting 'Temeraire' (RA 1839; National Gallery, London; BJ 377) after seeing the brightly coloured carpet represented in an adjacent portrait group by Geddes. This was probably The Daughters of Charles Arbuthnot Esq., a Group in the Costume of the Time of Charles I (private collection). ADRL

Finberg 1961, pp. 272, 293, 297, 314, 317.
Whittingham 1985, pp. 6–7, 9, 20, and 1985², pp. 43–4.

GENEVA. From 1814 the capital of the small French-speaking canton of Geneva, the city was the largest in Switzerland, a natural point of entry to the country from the west. Standing at the foot of Lake Geneva, it is divided by the River Rhone whose famously blue waters are joined by the Arve close by. In the Romantic period it was associated particularly with Voltaire and Jean-Jacques Rousseau. After his first Continental tour, Turner made a large watercolour, in his most *Neoclassical vein, of the lake looking towards Geneva and Mont Blanc (?1805; Yale Center for British Art, New Haven; W 370), and in 1810 an oil painting (Lake of Geneva from Montreux, Chillion, &c, Turner's gallery 1810; Los Angeles County Museum; BJ 103) recorded his interest in the eastern end of the Lake. He returned to Geneva on his tours of 1836 and 1841, in the latter year making several roll-sketchbook studies of the city from a viewpoint above Fort l'Écluse, or of the lake and the Jura range (TB CCCXXXII); but he was not inspired to realize any finished works as he was at *Zurich. In the 1840s he made many studies of Lake Geneva itself, centred on Lausanne. AW

GEOLOGY. Turner had access to the Geological Society, founded in 1807, through his friendships with Charles *Stokes and Francis *Chantrey, who were both prominent members. He also knew the distinguished descriptive geologist John MacCulloch (1773–1835), from whom he acquired two volumes of Geological Society Transactions. Accounts in these volumes possibly prompted Turner to tackle such subjects as The Eruption of the Souffrier Mountains, in the Island of St. Vincent (RA 1817; University of Liverpool; BJ 132) and *Staffa, Fingal's Cave (RA 1832; Yale Center for British Art, New Haven; BJ 347).

Turner's view of the rock face in the *St Gotthard Pass (W 1499) and watercolours of Lulworth Cove (W 449, 467) and Land's End (W 447, 864; see also Shanes 1997, pp. 78–81) reveal his understanding of geological form. He made studies of Stonehenge and the Isle of Staffa and wrote verses using technical geological language in his 'Devonshire Coast No. 1' Sketchbook (TB CXXIII). Turner's geologist friends respected his ability to spread scientific knowledge through his work. Charles Stokes owned a number of Turner's works that contained a geological element. SET

Gage 1987, pp. 218–22.
Hamilton 1998, pp. 115–26.

GEORGE III (1738–1820). King of Great Britain and Ireland (1760–1820) and Elector of Hanover, he was the first Hanoverian monarch to be born in England, becoming heir to the throne on the death in 1751 of his father, Frederick, Prince of Wales, who had been a noted collector and patron of the arts. The young George's interest in art was much encouraged by his mother, Princess Augusta of Saxe-Gotha, and by his influential 'favourite', Lord Bute. He was taught drawing by Joshua Kirby, Joseph Goupy, and the architect William Chambers, and was a competent landscape and architectural draughtsman. Unlike his grandfather, George II, who was totally uninterested in art, George III, who married the art-loving Princess Charlotte of Mecklenburg-Strelitz in 1761, was warmly welcomed in cultured circles. From the beginning of his reign he encouraged the arts, especially by his active support of the *Royal Academy of Arts, founded in 1768. The King's most notable act of collecting was his purchase in 1762 of Consul Smith's great collection with its unrivalled group of paintings and drawings by *Canaletto. However, George III never patronized Turner, who was anxious for royal recognition. Among the King and Queen's favoured painters were Zoffany, Allan Ramsay, *Gainsborough, and Benjamin *West. LH

GEORGE IV (1762–1830), Prince Regent 1811–20, was typically Hanoverian in his creation of his own court in opposition to that of his father George III. There were hopes that he would play an active role in the promotion of the arts, particularly British art: in 1804 he expressed support for a national collection of British art and in 1810 talked of making his own collection of contemporary British art (Whittingham 1986, p. 24). He collected Dutch paintings and certain British artists such as *Wilkie and was patron of John *Nash, but Turner's attempts to gain royal patronage were not very successful. In 1811 a rumour that the Prince was

going to buy Turner's *Mercury and Herse* (BJ 114) effectively prevented Turner from selling it at the Royal Academy. The Prince's purchase of *Cuyp's *Passage Boat* in 1814 may have led Turner to paint the highly Cuypian **Dort* (RA 1818; BJ 137) with him in mind. The circumstances behind **England: Richmond Hill, on the Prince Regent's Birthday* (RA 1819; BJ 140) suggest a more overt attempt at royal patronage, as do the four unfinished paintings depicting the by now King George IV's visit to Edinburgh in 1822 which may have been designed for engraving or sale to the monarch (BJ pp. 152–3, nos. 247–8b). Turner's only actual success at gaining royal patronage was the King's commission of the large *Battle of Trafalgar* (BJ 252) in 1822 to hang as a pendant to P. J. de *Loutherbourg's *Glorious First of June* in one of the state rooms in St James's Palace; the picture was completed in 1824 but sent off to Greenwich Hospital with its pendant in 1829, partly as a result of criticism of its accuracy and, in particular, the rigging. MB

Finley 1981.
Stuckey 1981, pp. 2–8.
Hichberger 1983, pp. 16–17.
Galt 1987, pp. 9–20.

GEORGE IV IN EDINBURGH. In August of 1822 the newly crowned monarch, encouraged by his ministers and by Sir Walter *Scott, came to *Scotland. Scott, who had been placed in charge of the visit, devised processions and ceremonies that were rich in pageantry and, commensurably, in historical allusion. Though some scoffed at the pageantry (especially the spectacle of the obese king parading the kilt), others were enthralled by it and considered the visit a significant, national event. Many spectators, including artists, had come from England to witness this special occasion. Among them was Turner. It is not known whether Turner's presence had been requested by Scott who, at that time, was employing him to complete illustrations for his *Provincial Antiquities*. However, since Turner's final illustrations for this publication were two vignettes of events of the visit, Scott's influence on the artist's decision to come north seems possible, even likely. Yet Turner would not have needed much encouragement to visit *Edinburgh since he appears to have been anxious to contact the physicist Sir David Brewster about his experiments with light. And the King's visit certainly provided a splendid opportunity for him to record the ceremonial welcome of the first Hanoverian monarch to set foot on Scottish soil. Turner recorded events of the royal visit and an ambitious proposal for nineteen paintings based on them in two sketchbooks (TB CC, CCI), with the probable intention of using these pictures as a bid for royal favour. Although this series was never realized, he did undertake four oil compositions, probably dating from about 1823, which

are in different stages of completion (BJ 247–48b). The first two are sketchy, the second two are more finished. The first represents the King's yacht, the *Royal George*, in Leith Roads shortly after its arrival on 14 August, when Scott was transported to the royal yacht to welcome the King (BJ 248a); the second seems to depict the King in his barge leaving the royal yacht, heading towards the quay at Leith (15 August; BJ 248b); the third picture depicts the King at the provost's banquet in parliament house (24 August; BJ 248), and the fourth represents the King attending the service at St Giles Cathedral (25 August; BJ 247). There are also three watercolours associated with this proposed series. The first of the two vignettes for the *Provincial Antiquities* represents the King's procession with the regalia to Edinburgh Castle on 22 August (volume 1; *c.*1825; CLXVIII: A; W 1058); the second, Scott's visit to the *Royal George* to welcome the King on 14 August (volume 2; *c.*1825; CLXVIII: B; W 1063). The third watercolour, *Edinburgh: March of the Highlanders* is associated with the laying of the foundation stone of Edinburgh's national monument and represents highlanders ascending the Calton Hill (27 August). This watercolour (*c.*1835; W 1134), embellished *Fisher's Illustrations to the Waverley Novels* (1836–7). GEF

Gerald Finley, 'Turner's Colour and Optics: A "New Route" in 1822', in 'Two Turner Studies', *Journal of the Warburg and Courtauld Institutes*, 36 (1973), pp. 285–90, repr.
Gerald Finley, 'J. M. W. Turner's Proposal for a "Royal Progress"', *Burlington Magazine*, 117 (1975), pp. 27–35.
Finley 1981.

GERMANY. The Germany that Turner knew was composed of numerous kingdoms, states, and principalities, each with its own ruling family and regional traditions and varying in size from minute states to huge and powerful ones like Prussia. Relations between Britain and the various German states were excellent throughout Turner's lifetime. Social and political relationships were underpinned by numerous dynastic marriages between Protestant royal families over the centuries and further strengthened by a new military alliance against the common enemy, *Napoleon. At the time of Turner's birth in 1775, *George III, King not only of Britain but also of the substantial German state of Hanover, had been on the throne for fifteen years. His numerous children married into princely families in many parts of Germany. In 1837 his 18-year-old granddaughter *Victoria became Queen and herself made one of the most important matrimonial alliances in the history of Britain: at the beginning of 1840 she married her first cousin, *Albert of Saxe-Coburg-Gotha, who dedicated himself conscientiously to his role as Prince Consort until his early death in 1861, ten years after that of Turner himself.

Germany was a natural destination for Turner to explore as early in his career as he could, since it possesses Picturesque scenery (see SUBLIME) of the highest quality on its western side. The mere accident of proximity to England inevitably contributed to the growing British popularity of the *Rhine just south of Cologne, while its aesthetic appeal was boosted through the publication of Mrs Ann Radcliffe's book, *A Journey made in the Summer of 1794 . . . with a Return down the Rhine* (1795). Between 1817 and 1844 Turner probably passed through this part of Germany more often than any other area of the Continent, for he regularly used the Rhine valley as a route through Europe on his visits to Italy or Switzerland. Twice he made use of the *Danube valley in similar fashion. Germany thus played a major part in several of his tours even when it was not his principal destination. He owned one excellent guidebook to Germany, the first English edition of Alois Schreiber's *The Traveller's Guide down the Rhine*, published in 1818, and in the later 1830s would certainly have known the *Handbooks for Travellers* issued by John *Murray for both northern Germany (1836) and southern Germany (1837). He became the owner of two phrasebooks, but never became proficient in German, and he acquired, borrowed, or made his own copies of maps as the necessity arose.

While Turner's main interest in Germany lay, inevitably, in its landscape, he was also concerned with its art and architecture. Around 1810, while preparing his first course of lectures as Professor of Perspective (see PERSPECTIVE LECTURES) at the Royal Academy, he studied Dürer's ideas on that subject published three centuries previously. Three of Turner's closest friends among his RA colleagues—*Callcott, *Wilkie, and *Eastlake—had extremely close connections with contemporary German artists and art institutions throughout the period of Turner's visits; their knowledge, advice, and recommendations must have played an important part in shaping Turner's expectations of Germany and his travel plans. In several German cities (including Munich, Berlin, and Dresden) he visited celebrated art galleries and museums as well as cathedrals, palaces, and churches, and he made notes and sketches to record paintings, sculpture, and buildings alike. On his visits to *Rome in 1819 and 1828 he probably met members of the Nazarene community of German artists who were then practising there and he must certainly have seen examples of their work thanks to the international contacts of Eastlake, himself a well-established resident in Rome by 1828. Turner became acquainted with some of *Goethe's aesthetic ideas through Eastlake's translation of his *Farbenlehre* (*Theory of Colours*), 1840, of which he owned and annotated his own copy, but he did not accept much of what he read there. Within a few years he exhibited

two paintings in response to Goethe: *Shade and Darkness—the Evening of the Deluge* and **Light and Colour (Goethe's Theory)—the Morning after the Deluge—Moses writing the Book of Genesis* (RA 1843; Tate Gallery until stolen in July 1994; BJ 404, 405).

An account of Turner's travels in Germany shows him gradually discovering different areas in turn until he had visited almost every region of natural beauty in the country. In 1817 he spent ten days following the Rhine between Cologne and Mainz as part of a northern tour that also took him to the Low Countries. Like many other Britons of his day, he did this immediately after a pilgrimage to the *Field of Waterloo, south of Brussels, where the allied forces of Britain and Prussia had finally defeated Napoleon on 18 June 1815. The grandeur of the Rhineland, with its bleak and ruinous castles, many newly blackened and gutted in recent struggles, provided a perfect epilogue to this solemn experience. Turner himself made a note in one of his sketchbooks ('Itinerary Rhine Tour', TB CLIX: 100r.) outlining the itinerary of this entire tour and its timetable—10 August to 15 September. Seven years later, in 1824, he explored the region to the south and west of Cologne and discovered two stretches of river landscape with scenery similar to that of the Rhine but on a much smaller scale and a far more cheerful mood: the *Meuse and the *Mosel. Once again he recorded the overnight stops along his route and his timetable in a sketchbook ('Rivers Meuse and Moselle', CCXVI: 270r.) and once again his tour lasted from 10 August until mid-September.

In the 1830s Turner's travels took him much further afield. His sketchbooks contain no notes of dates, but his movements are sometimes traceable through the custom, then widespread in European towns, of recording the arrivals and departures of visitors in the appropriate local newspaper. Such reports often name the hotels at which visitors lodged and in several cities in Germany and Austria Turner's own sketches provide confirmation of official announcements. In 1833 he used the Rhine valley in Germany and the Austrian part of the Danube on his way to Venice, passing through Ulm, Augsburg, and Munich on his way from Stuttgart to Linz. In 1835 he made a long tour in northern Europe which included his only visits to the cities of Hamburg, Copenhagen, Berlin, Dresden, and Prague. South of Dresden he travelled through the extraordinary rock scenery of the Elbe valley in Saxon Switzerland. On his final visit to Germany during this decade, in 1839, he used a very similar itinerary to that of 1824 along the Meuse, Mosel, and Rhine, but explored the terrain much more thoroughly, often leaving the road or the river for sights that demanded a detour or simply for enjoyable rambles.

Turner's travels in the 1840s again introduced him to spectacular new German cities and scenery. Returning from Venice in 1840 he followed the German part of the Danube between Passau and Regensburg and then made a detour to *Coburg, birthplace of Prince Albert, before returning home down the Rhine. In the 1840s his visits to Switzerland took him regularly through Germany, that of 1844 being notable for his extensive study of *Heidelberg and the Neckar valley. On the 1844 tour he also explored the valley of the Nahe, which joins the Rhine at Bingen, a few miles west of Mainz.

On all Turner's visits to Germany he sketched constantly in pencil in small sketchbooks, using larger sketchbooks and colours only occasionally. On several tours he either lost or ran out of sketchbooks and had to buy notebooks or sheets of *paper locally. He followed up several of his tours with superb watercolours or oil paintings based on his recent on-the-spot records, but sadly this was not always the case and one of his most fascinating tours—that of 1835—resulted in no finished works at all. His first German subjects were those of the series of fifty *Rhine drawings of 1817, completed and sold immediately after the tour itself to his friend and patron Walter *Fawkes. His travels along other German rivers in the 1820s and 1830s were clearly made with a view to producing similar series, either for a patron or to be engraved in a 'landscape annual' like those featuring his views of the *Loire and *Seine. This, however, did not occur and Turner's many small coloured drawings of the Mosel remained unengraved and in his possession. A larger watercolour of Bernkastel on the Mosel, datable on stylistic grounds to c.1830 (Stadt Bernkastel-Kues; W 1378a), was probably produced as a sample for a Continental sequel to the Picturesque Views in *England and Wales but this proposed series did not materialize either. Individual engravings were, however, made in the 1820s and 1830s from some of his watercolours of *Cologne and *Ehrenbreitstein. There were also several German subjects, both topographical and imaginary, among Turner's numerous watercolour vignettes engraved in the works of *Byron, *Scott, and *Campbell in the 1830s and in some in the 'annuals'. All these publications reached a widespread readership in Germany, where the poets were held in high regard, while the 'annuals' were themselves a German invention, introduced into England by the émigré publisher Rudolph Ackermann in the 1820s.

Turner exhibited only four oil paintings depicting Germany at the RA, all of high quality and produced under very diverse circumstances. Their subjects are equally wide-ranging, embracing the scenery of both of Germany's greatest rivers, the Rhine and the Danube, and touching on various aspects of peace and war, heroism and ambition. In 1826 he showed the very large Cologne. The Arrival of a Packet Boat, Evening (Frick Collection, New York; BJ 232). This depicts the Rhine front at Cologne, looking upstream, with a few venerable towers, including that of Great St Martin's Church, veiled in a rosy mist. However, its main focus is on a large and crisply painted sailing ship bursting with passengers, its angular sails sharp against an ethereal sky and its bulk exaggerated by widely spreading reflections in the gleaming Rhine. It was painted for the collector John *Broadhurst, as a pendant for the *Harbour of Dieppe exhibited in 1825 (Frick Collection, New York; BJ 231). Both works pay homage to the great northern master of light and marine or river views, Aelbert *Cuyp.

In 1835 Turner showed The *Bright Stone of Honour (Ehrenbreitstein) and Tomb of Marceau, from Byron's 'Childe Harold' (private collection; BJ 361). This was painted expressly for John *Pye the engraver, whose engraving (R 662) did not, in the end, appear until 1846. The viewpoint of the painting is a short way west of the confluence of the Rhine and the Mosel and it shows the great fortress of Ehrenbreitstein rising in the distance above the pyramid-shaped tomb of the young French general Marceau, killed at the Battle of Altenkirchen in 1796. It was exhibited with nine lines from canto iii of Byron's epic which paid tribute to the youth whom even his enemies acknowledged as a hero. Turner had intended that three further lines from the same source, on the fortress itself, should also be included in the RA catalogue, but these did not appear.

Six years later, in 1841, Turner exhibited a very different German scene, depicting a princely hunting lodge with its park and gentle stream rather than a fortress on a mighty river, and with two young children at play rather than a general's tomb. This was *Schloss Rosenau, Seat of H.R.H. Prince Albert of Coburg, near Coburg, Germany (Walker Art Gallery, Liverpool; BJ 392), conceived and executed in the hope of catching the attention of Queen Victoria or Prince Albert himself, who had been born in this very castle in August 1819 and had spent many childhood summers there. Turner's attempt at attracting royal patronage was unsuccessful but he soon found a buyer for the painting, his patron Joseph *Gillott acquiring it in c.1844.

Turner's last exhibited depiction of Germany was a vast one, painted not on canvas but on a mahogany panel. The *Opening of the Wallhalla, 1842 (BJ 401) was shown in 1843, the same year as the two paintings responding to Goethe's Farbenlehre. Exhibited with a quotation from Turner's own unpublished verse epic, Fallacies of Hope (see POETRY AND TURNER), the painting marked the completion of the *Walhalla on the banks of the Danube near Regensburg, which he had seen under construction in 1840. Like that temple

itself, it celebrated the crushing of Napoleon's hopes of domination and the return of peace and independence. The painting did not find a buyer and remained in Turner's possession. A fifth painting of Germany, *Heidelberg (BJ 440), was never exhibited by Turner but may have been intended as a pendant to the *Wallhalla*. Similar in dimensions but painted on canvas, this celebrates both the flowering of culture in an age of peace and an Anglo-German royal alliance, though the 17th-century court in question (that of the Elector Palatine Friedrich V and his bride Elizabeth, daughter of the English king James I) was sadly short-lived.

The Opening of the Wallhalla, 1842 is notable for being the only painting that Turner ever sent from London for exhibition abroad. In August 1845, he sent it to the Congress of European Art in *Munich, where he was the sole British artist represented. The painting was badly received by German critics, who were appalled at its loose handling and lack of form, unable to understand its subject matter, and intensely disappointed at what they believed to be the complete degeneration of the famous artist's powers. The work was returned damaged, with carriage to pay. The spectacular theft of Turner's two Goethe paintings from an exhibition in Frankfurt, almost 150 years later, which made newspaper headlines across the world, provides an ironic sequel to this slight which would surely have amused him.

CFP

Powell 1991.
Powell 1995.

GIBBONS, John (1777–1851), ironmaster and collector. He was Francis *Danby's chief patron, and also acquired works by C. R. *Leslie, Clarkson *Stanfield, John Linnell, Mulready, and Frith. He was the first owner of Turner's *View of the Castle of St Michael, near *Bonneville* (RA 1812; John G. Johnson Collection, Philadelphia; BJ 124), and sometime after the sale of Jack *Bannister's collection in 1849 he bought *Seascape with a Squall coming up* (c.1803–4; Tokyo Fuji Art Museum; BJ 143). Gibbons also owned Holman Hunt's *Rienzi*, which he reportedly kept in a cupboard. He lived in Bristol until the mid-1820s, Edgbaston by 1843, and Hanover Terrace in London 1845–51. His Edgbaston house was bought by Joseph *Gillott.

RU

Macleod 1996, p. 420.

GILLOTT, Joseph (1799–1872), steel pen manufacturer and important collector of Turner's works. Gillott developed a new method of producing steel pen nibs that helped him form a formidable fortune: he employed 450 people, and the items sold at Christie's in 1872 after his death realized £170,000. His collection embraced a number of contemporary British artists and included works by Etty (with whom he was on particularly friendly terms), Müller, John Linnell, *Maclise, Mulready, *Roberts, and Prout, displayed in top-lit picture galleries at his homes in Edgbaston and Stanmore. Gillott collected Turner oils of all periods, his collection comprising: *Kilgarran Castle (RA 1799; National Trust, Wordsworth House, Cockermouth; BJ 11), *Cilgarran Castle* (c.1798; Leicester Museum and Art Gallery; BJ 37), *Walton Bridges (c.1806; Loyd Collection; BJ 60), *Sheerness and the Isle of Sheppey ('The Junction of the Thames and Medway')* (Turner's gallery 1807; National Gallery of Art, Washington; BJ 62), *View of the Temple of Jupiter Panellenius* (RA 1816; Duke of Northumberland; BJ 134), *Calais Sands, Low Water, Poissards collecting Bait (RA 1830; Bury Art Gallery and Museum; BJ 334), *Mercury and Argus* (RA 1836; National Gallery of Canada, Ottawa; BJ 367), *The Grand Canal, Venice* (RA 1837; Huntington Library and Art Gallery, San Marino, California; BJ 368), *Snow-Storm, Avalanche and Inundation* (RA 1837; Art Institute of Chicago; BJ 371), *Cicero at his Villa* (RA 1839; Rothschild Collection, Ascott, Bucks.; BJ 381), *Schloss Rosenau* (RA 1841; Walker Art Gallery, Liverpool; BJ 392), *Depositing John Bellini's Three Pictures in la Chiesa Redentore, Venice* (RA 1841; private collection; BJ 393), *Van Tromp going about to please his Masters (RA 1844; Getty Museum, California; BJ 410), *Going to the Ball* (RA 1846; private collection; BJ 421), *Returning from the Ball* (RA 1846; private collection; BJ 422), and perhaps *Coast Scene* (Birmingham Society of Artists 1830; untraced; BJ 534). Gillott also amassed a number of Turner's watercolours, and these included: *The Thames* (c.1806; British Museum; W 415), *Dartmoor: The Source of the Tamar and the Torridge* (c.1813; Yale Center for British Art, New Haven; W 443), *Hastings: Fish Market on the Sands* (1824; private collection; W 510), *Patterdale Old Church* (c.1810–15; Yale Center for British Art, New Haven; W 547), *Brinkburn Priory, Northumberland* (c.1830; Graves Art Gallery, Sheffield; W 843), *Powis Castle, Montgomery* (c.1834; Manchester City Art Gallery; W 861), *Winander-Mere, Westmoreland* (c.1835; Manchester City Art Gallery; W 874), *Bamborough Castle* (?c.1840; private collection, USA; W 895), *Ehrenbreitstein* (c.1832; Bury Art Gallery and Museum; W 1051), *Heidelberg, with a Rainbow* (c.1841; private collection; W 1377), and *Zürich: Fete, Early Morning* (1845; Kunsthaus, *Zürich; W 1548). Gillott's collection was disposed of at Christie's 19 April–3 May 1872; Cheshire and Gibson, Westbourne Road, Edgbaston, 4–11 June 1872; The Grove, Stanmore, 29–31 July 1872; and Christie's, 30 April 1904. His papers are in the Getty Archive, Santa Monica, California.

RU

Chappell 1986, pp. 43–50.
Macleod 1996, pp. 420–2.

GILLRAY, James (1756–1815), caricaturist chiefly remembered for viciously lampooning both King *George III and *Napoleon. His cartoons were produced in broadsheet form and circulated widely throughout Britain and Europe. Although his principal targets were the political and social life of his day, he also ridiculed what he took to be the follies of the *Royal Academy (where he had once been a student). His *Titianus Redivivus* of 1797 satirized the obsession of Benjamin *West and others with discovering the 'secret' of Venetian oil painting. Gillray represents Turner, then at the outset of his career, as a sceptic in the matter. BV

GILPIN, Sawrey (1733–1807). English sporting artist who supported Turner's first attempt to become an Associate of the Royal Academy in 1798 and contributed to his work in watercolour on three known occasions. Bailey has suggested that Gilpin's influential writing on landscape colouring possibly influenced Turner during the late 1790s. His first project with Turner was *Sunny Morning—The Cattle by S. Gilpin R.A.* (RA 1799; untraced; W 251). A second, *Windsor Park; with horses by the late Sawrey Gilpin* (RA 1811), is probably the Turner Bequest sheet now known as *A Group of Horses in Windsor Park* (c.1805–7; TB LXX: G; W 414 repr.). The third collaboration, *Donkeys beside a Mineshaft* (c.1805–7; LXX: I; see Upstone, p. 31, repr.), is unfinished.
 ADRL

Upstone 1989, pp. 28–9, 31.
Bailey 1997, p. 48.

GILPIN, the Revd William (1724–1804), author, amateur artist, schoolmaster, and parish priest. He was a formative figure in the Picturesque movement (see SUBLIME), who did much to popularize domestic travel in Britain. From 1752 to 1777 Gilpin was the innovative headmaster of Cheam School, and then became vicar of the large rural parish of Boldre in the New Forest. He was a prolific author, first of theological works, and then of books explaining and illustrating his Picturesque theories. The basis of these were his own reed pen and wash landscape drawings, in a broad and individual style, which were the result of sketching tours in various parts of Britain. For some years his illustrated descriptions of these were circulated in manuscript, and in 1783 the first of his 'Picturesque Tours', devoted to *The River Wye and Several Parts of South Wales*, was published and was very well received. Seven further *Tours* followed, the most popular being the *Lakes Tour*, published in 1786. All of these were illustrated with aquatint engravings after Gilpin's drawings. In 1792 *Three Essays* elucidated Gilpin's Picturesque theories, while in *Two Essays* (1804) he described his methods of drawing, long much used by amateur artists. One of Turner's earliest surviving drawings (TB I:

D) is copied from Gilpin's plate of 'Dacre Castle' in the *Lakes Tour*. LH

C. P. Barbier, *William Gilpin*, 1963.

GIRTIN, James [or Jack or John] (1773–c.1820). English engraver, printer, and publisher, and a brother of Turner's friend and fellow artist Thomas *Girtin. An undated letter from Turner to James Girtin relating to a trial engraving plate may refer to an early experiment with a *Liber Studiorum* subject (Gage 1980, pp. 28–9), and it is possible that Turner may have been considering a collaboration, with Girtin acting as publisher for the series, as he had for his brother's *Views in Paris and Environs*, issued posthumously in 1803; however, this unidentified project evidently failed to materialize. GF

GIRTIN, Thomas (1775–1802), English landscape watercolourist and contemporary whose short career paralleled and influenced the early years of Turner. Girtin, the son of a brushmaker, was born in Southwark on 18 February 1775, two months before Turner. In 1788 he was apprenticed to the topographical watercolourist Edward *Dayes and was also influenced by the architectural watercolours of *Canaletto and Thomas *Malton, which he copied. From 1794 to 1797 Girtin was employed with Turner by Dr *Monro to copy watercolours by J. R. *Cozens, Thomas Hearne, etc.: 'Girtin drew in outlines and Turner washed in the effects' (*Farington, 11 November 1798).

From 1794 Girtin made summer tours every year to gather material for topographical watercolours. His series of cathedral facades, like *Peterborough Cathedral*, dated 1794 (Ashmolean Museum, Oxford), closely parallel such Turner drawings as *West Entrance of Peterborough Cathedral* (RA 1795; Peterborough Art Gallery; W 126). Both invest a traditional topographical subject with a sense of awe and grandeur by choosing a low viewpoint and filling the picture frame with a close-up of the facade.

In 1796 Girtin first visited the North of England. His watercolour palette became more rich and sonorous, his compositions spare and panoramic. Girtin's response to rugged, romantic northern ruins such as *Dunstanborourgh* and *Lindisfarne Castle* (Metropolitan Museum of Art, New York) influenced Turner's treatment of 'Sublime' castle subjects in the years 1796–1800.

Turner and Girtin's watercolour style was closest in 1798, when they both adopted a palette of rich browns, gold, and russet and a broken, exuberant touch which dissolves form and sweeps up sky, land, and architecture into a vibrant celebration of nature. By that date they had both gained a patron in Edward *Lascelles, son of the first Earl of Harewood. Girtin stayed at Harewood for the first time in 1798,

producing portraits of the house in its rolling parkland (1798–1801) which are more austere and dramatic than Turner's more picturesque views. Girtin vied directly with Turner's pair of oils of *Plompton Rocks* (c.1798; Earl of Harewood; BJ 26, 27) by producing a large-scale watercolour of the same subject (Victoria and Albert Museum).

By 1799 patrons were setting up a rivalry between the two innovative watercolourists; Farington reported 'Mr Lascelles as well as Lady Sutherland are disposed to set up Girtin against Turner . . . the former more genius—Turner finishes too much' (9 February 1799). By that year their styles were diverging; in his late watercolours, such as *The White House at Chelsea* (1800; Tate Gallery) or *The Abbey Mill, Knaresborough* (c.1801; Yale Center for British Art, New Haven), Girtin obtains a monumental power through spare, panoramic compositions in broad watercolour washes, with only minimal human presence. The complex interweaving of landscape, architecture, history, and modern life, which fills Turner's paintings, never much interested Girtin. However, he did experiment with 'literary landscape', from 1799 to 1800 attending a Sketching Society which met to make monochrome drawings inspired by the evening's set poetic passage.

Girtin's most radical works are pure watercolour sketches like *Estuary of the River Taw, Devon* (c.1801; Yale Center for British Art, New Haven) and *Storiths Heights* (1802; private collection, England) which simplify landscape forms almost to the point of abstraction.

In 1801, five years after Turner, Girtin exhibited his first oil painting at the *Royal Academy, a now-lost view of *Bolton Bridge*. That year he started making watercolour studies for his *Eidometropolis* or panorama of *London, which opened in August 1802. In these studies (British Museum) Girtin's understanding of urban atmosphere surpassed anything that Turner had achieved to date.

In late 1801, taking advantage of the Peace of Amiens, Girtin went to *Paris, Turner following in July 1802. The immediate fruits of the entrepreneurial Girtin's journey were a series of softground etchings, *Twenty Views in Paris*, published from June 1802 and still being issued after Girtin's early death from consumption on 9 November 1802.

Girtin's genius remained unfulfilled, but at the time of his death he was the acknowledged leader, with Turner, of the watercolour school (though far less precocious in oil, and consequently never elected to the RA). The strength and daring of Girtin's watercolours, and his early achievements as a printmaker, strongly influenced Turner, as did his technical genius. Turner almost certainly never made the famous remark, 'If Tom had lived, I should have starved', but he did write on an 1840 Alpine sketch (TB CCCXLII: 66v.), to remind himself of the superb use of a single white highlight: 'Girtin White House'. SM

Thomas Girtin and David Loshak, *The Art of Thomas Girtin*, 1954.

Francis Hawcroft, *Watercolours by Thomas Girtin*, exhibition catalogue, Manchester, Whitworth Art Gallery, and London, Victoria and Albert Museum, 1975.

Susan Morris, *Thomas Girtin*, exhibition catalogue, New Haven, Yale Center for British Art, 1986.

GLAZES are transparent layers which intensify or modulate surface colour. Traditional glazes generally contain pigments which are almost transparent in the medium used for the glaze. Turner often added small amounts of pigments such as Mars orange (a synthetic and brightly coloured form of earth colour) which are more opaque in the natural resins or *megilps which he used for glazing. His glazes are usually more subtle than deeply coloured.

A good example of Turner's glazing can be seen in *Peace—Burial at Sea* (RA 1842; BJ 399), since he applied glazes to the area not covered by an octagonal framing mat. The painting is now displayed with the unglazed corners visible. The depth of colour in the sea shows clearly what can be achieved by numerous layers of resinous glazes, each one covering a limited area of paint. Thornbury (1862, ii. p. 167) wrote of Turner on the *Varnishing Days at the Royal Academy: 'His touches were almost imperceptible, yet his pictures were seen at the end to have advanced wonderfully', which neatly summarizes the effect of his glazes. JHT

GLOVER, John (1767–1849), English landscape painter, regarded by some as Turner's chief rival and known as the 'English Claude'. He was the teacher of Turner's friend James *Holworthy and provoked the resignation of another friend, W. F. *Wells, from the Old Water-Colour Society (see WATERCOLOUR SOCIETIES) by his introduction of oils to its exhibitions. His watercolours—the highest-priced in the Society's first show in 1805—were collected by Walter *Fawkes and included with Turner's in Fawkes' exhibition in 1819. He resigned from the Water-Colour Society in 1817 and travelled to Italy. Having painted a landscape between a *Claude and a *Poussin in the Louvre in 1814, he introduced works by Claude and *Wilson into his one-man exhibitions in London in the early 1820s, his invitation to Turner to join him bringing the reply, 'If you are so confident, try it yourself' (J. L. Roget, *History of the Old Water-Colour Society*, 1891, i. p. 405). With Turner he contributed to Surtees' *History and Antiquities of Durham*, 1820. In 1830 he emigrated to Van Diemen's Land (Tasmania), sending 68 pictures to London for exhibition in 1835 and six to King *Louis-Philippe in the early 1840s; the two pictures chosen

by the king (Louvre, Paris) were at Château d'Eu when Turner visited it in 1845. DBB

John McPhee, *The Art of John Glover*, 1980.

GODDESS OF DISCORD CHOOSING THE APPLE OF CONTENTION IN THE GARDEN OF THE HESPERIDES, THE, oil on canvas, 61⅛ × 86 in. (155 × 218.5 cm.), BI 1806 (South Room 55); Tate Gallery, London (BJ 57). This was Turner's most ambitious landscape with a classical subject to date. The landscape was based on the mountainous scenery of *Switzerland, visited by Turner in 1802 and also to be seen in his grand watercolour of *The St Gothard Road between Amsteg and Wassen* (?c.1803; TB LXXX: D; W 363), and the oils of *Fall of the Rhine at Schaffhausen* (RA 1806; Museum of Fine Arts, Boston; BJ 61) and *The *Vision of Jacob's Ladder* (BJ 435). The subject is Turner's own reworking of the classical story, related to his own 'Ode to Discord' in his Verse Notebook (see POETRY AND TURNER): Discord is shown choosing the apple that was eventually awarded by Paris to the goddess Aphrodite, leading to the Trojan War. *Ruskin, who points out the influence of *Poussin, gives a long analysis of the subject (*Works*, vii. pp. 392–408, and xiii. pp. 113–19), as do John Gage (1969, pp. 137–9) and Kathleen Nicholson (1990, pp. 76–83). Turner priced the picture at £400 in his 'Finance' Sketchbook of c.1810 (CXXII: 36).

Sir George *Beaumont said of Turner's British Institution exhibits of 1806 that 'they appeared to him to be like the works of an *old man* who had ideas but had lost his power of execution', but the painter William Havell spoke 'of Turner as being superior to *Claude . . . Poussin, or any other' (*Farington, 5 April 1806). In 1808 Turner re-exhibited the picture in his own gallery when it was praised by John *Landseer, who suggested the inspiration of Poussin's *Landscape with Polyphemus* (Hermitage Museum, St Petersburg). See also LITERARY SUBJECTS. MB

GOETHE, Johann Wolfgang von (1749–1832), the most prominent European literary personality of his time, several of whose works had been translated into English by the year of his death. Although he is best known as a novelist (e.g. *The Sorrows of Young Werther*, 1774) and a poet (e.g. *Faust*, 1808, 1832), Goethe was also an active art critic, art sponsor, and art collector, whose collection included a group of English landscape drawings which he characterized as 'nebulous but estimable'. The authors of these works are not known, but the description suggests affinities with the style of Turner; and certainly among the many drawings which Goethe made himself are several atmospheric studies of moonlight and mountains which indicate a sensibility akin to that of Turner himself. Affinities in their approach to

landscape are also suggested in the letters and diary Goethe wrote on his visit to Italy in 1786. Turner, however, came to Goethe not through his most imaginative literary works but through his scientific writing, specifically the *Theory of Colours*, first published in 1810 and which, paradoxically, the poet regarded as his most important book.

Turner's close interest in Goethe's theory of colour emerges both in notes to the 1840 English translation by *Eastlake of part of this book and in two paintings of 1843, *Shade and Darkness—the Evening of the Deluge* and *Light and Colour (Goethe's Theory)—the Morning after the Deluge—Moses writing the Book of Genesis* (BJ 404, 405; stolen from the Goethe exhibition in Frankfurt in 1994). Goethe had cited a range of empirical evidence in support of the ancient Greek notion that colours were generated by the interaction of darkness and light, and in opposition to the theory of Sir Isaac Newton, who had argued in the late 17th century that they were functions of variable refractions of light alone. Goethe supposed that darkness seen through a turbid medium (even a prism) produced blue, which might be intensified to violet by increasing the opacity of the medium, and that light seen through this same medium showed yellow, which might be intensified to red. Blue and yellow were thus the 'primary' colours and red the product of what Goethe called 'augmentation' (*Steigerung*).

Elements of this ancient doctrine had long been familiar to Turner in the *Treatise on Perspective* (1775) of the elder Thomas Malton and in the writings of the colour-technologist and theorist George Field; Goethe's version had met with a mixed reception in England, and had been opposed particularly vehemently by the Scottish scientist Sir David Brewster, with whom Turner was in touch in the 1830s. So it is not surprising that Turner's response to Goethe's ideas was far from clear-cut. The *Theory of Colours* had been translated by Turner's friend Charles Lock Eastlake, who had argued that it was more useful to artists than Newton's in its elucidation of colour-harmony and the principles of contrast and gradation, 'the chief elements of beauty' (pp. xxxi, xxxiii). In his marginal notes, Turner generally ignored Goethe's discussion of harmony and disputed his views on gradation (§615); but he was certainly concerned with Goethe's polar contrasts of dark and light (§696), which play a key role in his *Deluge* pair, and had already formed the basis of *Peace and *War* (BJ 399, 400) in 1842. But in a note on the complementary colour-circle (§815) Turner adopted the Newtonian position that the prismatic hues are 'the product of light', a view which, as Lawrence *Gowing has proposed, may have been suggested to him by the circular system of the English theorist Moses Harris (c.1776), and may account for the play on the names 'Moses' and 'Genesis'

in the title of BJ 405. Since John *Martin's *Eve of the Deluge* (1840) had been acquired by Prince *Albert, who had also accepted the dedication of a mezzotint reproduction in 1842, it seems likely that the immediate stimulus for Turner's 1843 pair was less theoretical than pragmatic, part of his continuing—and fruitless—pursuit of royal patronage. JG

Gage 1969, ch. 11.

Gage 1984, pp. 34–52.

Gerald Finley, 'Pigment into Light: Turner and Goethe's Theory of Colours', *European Romantic Review*, 2/1 (1991), pp. 49 ff., and in F. Burwick and J. Klein, eds., *The Romantic Imagination: Literature and Art in England and Germany*, 1996, pp. 357–76.

Finley 1997.

GOETHE'S THEORY, see *LIGHT AND COLOUR.*

GOLDAU. The village of Goldau (now Arth-Goldau) lies on the road between Arth on the Lake of Zug and the Löwerzersee, at the foot of the eastern slopes of the *Rigi. It was famous in the 19th century as the scene of a catastrophic landslide: on 2 September 1806 457 people were killed when Goldau and three neighbouring villages were buried under an avalanche from the slopes of the Rossberg to the north. Turner visited the place in 1842 and one of his grandest late watercolours resulted. *Goldau* (1843; private collection, USA; W 1537) is flooded with crimson and gold from a spectacular sunset. In the foreground, boys fish from the huge boulders that lie strewn over the site of the village. The work is an elegy conceived on a monumental, not to say operatic, scale. Another watercolour, *The Lake of Zug, Early Morning* (1843; Metropolitan Museum, New York; W 1535), in which Arth is seen from the water, suffused with a deep blue shadow, may have been conceived as a pendant to *Goldau*. AW

GOLDEN BOUGH, THE, oil on canvas, 41 × 64½ in. (104 × 163.5 cm.), RA 1834 (75); Tate Gallery, London (BJ 355). Turner's original title for this appropriately Claudian panoramic landscape was 'The Sibyl gathering the golden bough', an allusion to the Cumaean Sibyl carrying the golden bough and guiding Aeneas into the Underworld, and the subject of two earlier pictures of *c.*1798 and 1814–15, both also showing Lake Avernus (BJ 34, 226).

The painting was bought by Robert *Vernon before the 1834 exhibition. Two or three years later it was noticed that a figure in the foreground was coming away because it was painted on paper. Turner stated that he had used a nude study made at the Life School at the *Royal Academy. A fragment in the British Museum (TB CCCLXIV: 395), in fact showing three figures, has been identified by Gage (1974, pp. 74–5, repr. pl. 17) with this piece of paper and as show-

ing the Fates. There is also a large colour sketch for the composition (CCLXIII: 323).

The *Athenaeum*, 10 May 1834, attacked 'the slight and slovenly handling', and the *Morning Chronicle*, 26 May, the picture's yellowness. However, the *Literary Gazette*, 31 May, praised the picture as 'when viewed at proper distance, assuming shape and meaning, and delighting the eye with the finest poetical and pictorial beauty'. MB

Powell 1987, pp. 170, repr. in colour pls. 34 and, details, 9 and 36.

GOODALL, Edward (1795–1870), self-taught English painter and line engraver. He is said to have attracted Turner's attention by the painting he exhibited at the Royal Academy in 1822, and to have been invited by him to engrave as many plates after his work as he could undertake. His first engraving after Turner was the view of Tantallon Castle, dated 1 June 1822, and published in *Scott's *Provincial Antiquities of Scotland* (R 198). From then on Goodall was one of the most prolific engravers after Turner, at first on copper, including three plates for Cooke's *Southern Coast* (R 114, 121, 126) and four for the *England and Wales* series, but from 1826 usually on steel, a medium in which he became one of the most effective engravers of his day. He engraved ten of the vignettes for the 1830 edition of *Rogers's *Italy* and 26 of those illustrating *Rogers's *Poems* in 1834, quickly proving his exceptional skill in translating the intricate detail of Turner's brilliant watercolours into black and white with great delicacy and clarity. Later in the 1830s Goodall contributed plates to *Scott's *Poetical* and *Prose Works*, and he engraved all but three of the twenty vignettes in the 1837 edition of *Campbell's *Poetical Works*. In the 1840s Goodall was responsible for two of the large single plates after Turner (R 651 and 653), and he also contributed three plates to the *Turner Gallery*. LH

GOODWIN, Albert (1845–1932), British landscape painter, mostly in watercolours. He was an ardent follower of Turner, was taught by Arthur Hughes and Ford Madox Brown, and was patronized and influenced by *Ruskin. He travelled widely in Europe and the East, and many of his works featured Turnerian effects of light and atmosphere. LH

GORDON, Sir Willoughby and Lady. Julia Bennet, afterwards Lady Gordon (1775–1867), became a pupil of Turner in 1797 and two watercolours by her from this date are recorded: one is a copy of Turner's *Cowes Castle* (TB XXVI: F) inscribed: 'First with Mr Turner 1797'. Now untraced, it was seen in 1939 by Paul Oppé, who considered it was almost all Turner's work although Turner had allowed Julia Bennet 'to put in a few touches'. The second example, *Llangollen*

Bridge (*Burlington Magazine*, 94 (1957), p. 48, fig. 21), is inscribed on the back: 'Julia Bennet with Mr Turner May 1797'.

In 1805 Julia Bennet married Colonel James Willoughby Gordon, Military Secretary to the Commander-in-Chief and Quarter-Master General of the army from 1811 until his death in 1851. In 1818 he was promoted major-general and given a baronetcy. No correspondence between Turner and Julia Bennet/Gordon survives but they must have kept in touch after 1797 for Sir John *Swinburne, who married Julia Bennet's sister, bought *Mercury and Herse* (private collection; BJ 114) in 1813 and Turner also painted some *Rhine watercolours for him in 1820 (W 691, 692). Furthermore Colonel Gordon regularly attended the RA dinners and patronized *Callcott, *Stanfield, and *Wilkie among Turner's fellow artists.

In 1813 Colonel Gordon bought a villa at Niton in the Isle of Wight named The Orchard, to which he made extensive alterations. Around 1826 Lady Gordon thought of giving her husband a painting of his villa by Turner but, as Turner had never seen the villa, she lent him her own sketches on which to base his picture. The result was exhibited at the RA in 1826 (297) entitled *View from the Terrace of a Villa at Niton, Isle of Wight, from sketches by a Lady* (Museum of Fine Arts, Boston; BJ 234). This small picture, Turner's masterly transformation of very amateurish material, shows that, in undertaking such an unusual commission, he must have retained an affectionate regard for his former pupil.

Turner's visit to East *Cowes Castle in the summer of 1827 gave him a chance to visit the Gordons in person and led to a further commission. In 1818 Lady Gordon and her sister had become co-heiresses of a Jacobean manor, Northcourt, at Shorwell in the Isle of Wight and, as the Swinburnes lived in Northumberland, the Gordons bought their share of the property. Sir Willoughby then evidently asked Turner to paint a picture the same size as *View from a Terrace* to include a view of his wife's property. The result was *Near Northcourt in the Isle of Wight* (c.1827; Musée du Quebec; BJ 269).

The Gordons must then have decided to commission a third oil and chose an upright format to hang between their two Isle of Wight views. This was correctly identified by Ian Warrell only in 1997 as *The *Banks of the Loire* (RA 1829; Worcester Art Museum, Worcester, Mass.; BJ 328a, 329). This had been entitled *A View overlooking a Lake* until 1983 when a note of the commission in the 'Roman and French' Sketchbook of 1828 (CCXXXVII: 11) was read by Cecilia Powell as 'Sir Willoughby; 28 Inches by 21 High' (*Finberg had read the name as 'Sir Woulsey' but the size fits); this led to the picture being tentatively rechristened 'A View on the

Rhone?' as Turner went down the Rhône on his way to Rome in 1828 (see Powell 1982, pp. 56–8). Ian Warrell has also discovered that a colour sketch in the Loire series, CCLIX: 138, deriving from Turner's visit in 1826, is directly related to the Gordons' oil and depicts a group of follies near Oudon on the north bank of the river between Angers and Nantes (1997, pp. 181–3). The foreground, however, is Turner's own invention in which the seated woman suggests a link with the woman washing clothes in the view of Northcourt. The composition also echoes that of *Claude's *Landscape with Hagar and the Angel*, given to the National Gallery in 1828 by Sir George *Beaumont, and perhaps also owes something to *Mercury and Herse*. Whether the subject was selected by the Gordons after being shown the colour sketch or by Turner himself is not known but the picture was probably painted between Turner's return from Rome in February 1829 and the opening of the Royal Academy exhibition two months later.

After Lady Gordon's death in 1867 the three pictures disappeared until they were exhibited at Burlington House in 1912, each simply entitled 'Landscape'. As the Niton view had been mistakenly omitted from C. F. *Bell's *A List of Works*, it was given no provenance in the catalogue, which caused the critic of the *Daily Telegraph* (2 February 1912) to doubt the authenticity of all three pictures. However, the Gordons' granddaughter, Mrs Disney Leith, then established this by providing details of the commissions. EJ

GOUACHE is also known, less correctly, as 'body-colour'. Gouache is water-based paint made opaque by the addition of a white pigment, used with or instead of transparent watercolour washes. In watercolours, it was traditionally used sparingly for highlights. Chalk was commonly used for gouache, and its application required some skill, for a wet brushstroke of chalk in gum is almost transparent, and the artist has to anticipate its effect when it will have dried white. Turner used chalk, magnesium carbonate, and even zinc white in early years, when he applied gouache in the traditional way, and examples can be seen throughout his life. In addition, he used both white and coloured gouache extensively in the 1820s and 1830s, most notably in *Petworth scenes and the *Rivers of France* series, both painted on blue paper. This gouache was truly opaque, and consisted of lead white combined with the pigments used elsewhere in watercolour washes, particularly yellow ochre or ultramarine blue. These areas of gouache are as extensive as the watercolour washes. In *Rouen Cathedral* (1830; TB CCLIX: 109) the entire building was painted first in white gouache, with watercolour washes used afterwards for the foreground, the blue sky, and for shadows and details of the

cathedral. X-radiographs of these works show the presence of lead white gouache with great clarity, because lead white absorbs X-rays very strongly; hence each brushstroke is revealed, even when Turner added transparent washes on top. These gouache layers are several times thicker than watercolour washes, and Turner had to use more gum than usual, to prevent them from cracking. He might well have added sugar or honey, or even drying oil, to make the gouache more flexible and less prone to crack, but analysis thus far has revealed only the presence of unidentified additives in thick dark brown washes in the drawings for the *Liber Studiorum* (Townsend 1996, pp. 376–80). Fine cracks which could lead to flaking of the gouache and paint loss can be seen in some of the *Rivers of France* series: Turner did not completely resolve the difficulties of working with lead white gouache. JHT

GOWING, Sir Lawrence (1918–91), painter, art scholar, curator, teacher; writer on Vermeer, Cézanne, Turner, and others. He was a pupil at the Euston Road School in the 1930s, and his works are in many public and private collections. He was a Trustee of the British Museum, the National Portrait Gallery, and the Tate Gallery, where he was Keeper of the British Collection and Deputy Director, 1965–7. He was elected ARA in 1978, RA in 1989, and was knighted in 1982. Gowing's 1966 exhibition *Turner: Imagination and Reality*, at *New York's Museum of Modern Art, approached Turner's painting as the forerunner of modernism, emphasizing the abstract elements in his work. His articles include 'Turner's "Pictures of Nothing"' (*Art News*, 62, Oct. 1963, pp. 30–3). The BBC 2 television series *Three Painters*, which Gowing presented 1984–8, included a programme on Turner. TR

 Lawrence Gowing, exhibition catalogue, London, Serpentine Gallery, 1983.

GRAVES, Henry (1806–92), London printseller and publisher. His father, Robert, was a printseller, while his elder brother, also Robert, was a successful engraver. Henry's first job was as assistant to Samuel Woodburn, the art dealer. Later he joined the firm of *Hurst, Robinson, and Co., as manager of their print department. He then became a partner in *Moon, Boys, and Graves, and in 1844, after various changes of partnership, he became sole proprietor, renaming the firm Henry Graves and Co.; the premises were at 6 Pall Mall. In 1831 Moon, Boys and Graves had taken over the publication of the *England and Wales* series, of which three further parts were published in 1832, the year in which the first 60 plates were issued as a single volume. Henry Graves's principal contact with Turner was through the publication of many of the best large single plates of his works issued in the artist's later years and posthumously. The first of these, published in 1838 by Hodgson and Graves, was the lively view of the *Grand Canal, Venice* (RA 1837; Huntington Art Gallery, California; BJ 368) engraved by William *Miller (R 648). In 1853 Graves, now on his own, published the very large pair of plates after two of Turner's early marine masterpieces—The *Shipwreck* of 1805 (BJ 54) and *Dutch Boats in a Gale* (the 'Bridgewater Seapiece' of 1801, BJ 14)—both engraved by John *Burnet (R 675 and 676). In the following year Graves issued another notable pair of prints—*Lake of Lucerne* and *Zurich*—after two of Turner's latest, large Swiss watercolours, both owned by B. G. *Windus (R 671 and 672). Henry Graves's initiative and enterprise are demonstrated by the publication in consecutive years of two such very different pairs of prints after the recently deceased artist. In the following years he continued to publish imposing single prints after Turner, by engravers who had worked with him, the last in 1873 (R 686). Graves also published fine plates after many other recent and contemporary British artists, including *Wilkie, *Constable, *Landseer, Frith, and Millais, and he was one of the founders of the *Art Journal*. The Graves papers in the Department of Western Manuscripts in the British Library provide valuable insight into the affairs of the firm.

LH

GREAT EXHIBITION OF 1851. Opened by Queen *Victoria on 1 May 1851 and closing five and a half months later, the Great Exhibition of the Works of Industry of All Nations was the most important happening in London, and indeed in Europe, in the last year of Turner's life. The principal engineers of 'one of the outstanding success stories of the nineteenth century' were Prince *Albert and Henry Cole, who had already been involved with a series of much smaller annual British industrial exhibitions under the auspices of the *Society of Arts in the later 1840s. It was decided that the 1851 exhibition was to be 'International'—it was the first international exhibition ever held—and that the site was to be Hyde Park. A Royal Commission was established early in 1850, with Prince Albert as President, and a distinguished Executive Committee, which included Henry Cole. There was strong opposition to the scheme, especially from *The *Times*, and many crises; a competition for designs for the exhibition building produced 245 entries, not one of which was felt to be usable. The same applied to the Building Committee's official design, and it was the inspired proposal for a glass building made by Joseph Paxton, who had gained experience of such structures designing huge greenhouses for the Duke of Devonshire at Chatsworth, that saved the day.

The famous 'Crystal Palace', which covered about 19 acres (7 hectares), was completed in under eight months; during construction the committees successfully undertook the awsome task of organizing the vast number of exhibits—there were nearly 14,000 exhibitors—grouped into six major divisions, of which the last was 'Fine Arts'. This was dominated by sculpture, with many large-scale marble statues and groups displayed throughout the exhibition. Decorative and applied arts of every type, and especially furniture, were well represented, with an accent on highly ornate design and intricate manufacture and craftsmanship. One of the most lasting results of the exhibition was the establishment of the taste for the ornate in Victorian Britain—indeed the term 'Victorian' first came into use in 1851. The exhibition was visited by over 6 million people—the largest attendance on any one day being 109,915—and made a profit of £186,437, much of which was used to buy the land in South Kensington, London, on which the great concentration of museums and colleges has been developed.

Turner visited the Crystal Palace under construction in January 1851, and in one of his last surviving letters, to Hawksworth *Fawkes (Gage 1980, no. 323), he described it with approval. There is no evidence that Turner, who was unwell throughout much of the year, visited the exhibition itself, though in a letter written to Thomas *Griffith on 19 May (Gage 1980, no. 325), he complained of the effect of the 'worlds fair' on the sale of his own prints. LH

GREECE. Turner never visited Greece, though in 1799 there was a plan that he should go to Istanbul with Lord Elgin, as his draughtsman. However, he became friends with at least two of the architects who had explored the ancient sites in the 1810s, Thomas Allason and C. R. *Cockerell, whose studies helped Turner in the first of his great pairs of paintings comparing the past with the present, *View of the Temple of Jupiter Panellenius in the Island of Aegina . . . Painted from a sketch taken by H. Gally Knight Esq., in 1810*, dated 1814, and *The Temple of Jupiter Panellenius restored* (both RA 1816; Duke of Northumberland, and private collection, New York; BJ 134, 133). Turner also used the drawing by the amateur H. Gally Knight for two contrasted views of the temple in its contemporary state for the *Liber Studiorum* (Forrester 1996, pp. 140–1, no. 77, repr.).

Turner had already used subjects from ancient Greece for the oil paintings *Jason* (RA 1802; BJ 19), *Narcissus and Echo* (RA 1804; Petworth House; BJ 53), *The *Goddess of Discord choosing the Apple of Contention in the Garden of the Hesperides* (BI 1806; BJ 57), *Mercury and Herse* (RA 1811; private collection, England; BJ 114), and *Apollo and Python* (RA 1811; BJ 115); for the watercolour *Chryses* (RA 1811;

private collection, England; W 492); and for the drawing (TB LXXI: 57) used much later for *The Parting of Hero and Leander* (RA 1837; National Gallery, London; BJ 370). His interest in Greek sculpture was also fuelled by works seen in the collections of Lord Elgin, the Earl of *Egremont and, on his first visit to *Rome in 1819, the Vatican.

Interest in contemporary Greece was particularly aroused by the publication of *Byron's *Childe Harold's Pilgrimage* in 1812. In 1822, the year after the outbreak of the Greek War of Independence, Turner painted for Walter *Fawkes the watercolour of *The Acropolis, Athens* with the caption ''Tis living Greece no more' from Byron's *Gaiour*, with its direct allusion to the sufferings of the Greeks (private collection, Greece; W 1055). The watercolour *Hastings: Fish-Market on the Sands* of 1824 (private collection; W 510) may also allude to the war (see Shanes 1981, pp. 47–8; this is disputed in David Hill's review of Shanes 1990 in *Turner Studies*, 10/2 (winter 1990), pp. 53–4). Of Turner's 26 illustrations to Byron nine are Greek scenes (W 1212–13, 1215, 1217–18, 1220, 1224, 1228, 1234) as are two of his contributions of 1832–4 to *Finden's *Landscape Illustrations of the Bible* (W 1257, 1259); these are topographical illustrations, typical of the growing interest in the Greek landscape by visiting artists in the 1820s and 1830s. MB

Gage 1981, pp. 14–25.

Fani-Maria Tsigakou, *The Rediscovery of Greece: Travellers and Painters of the Romantic Era*, 1981.

Brown 1992, pp. 21–4, 27–8, 40–3, 57–60, 87–9, 96–7, 100–7, 113, 115, 118.

GREEN, John, of Blackheath. Green commissioned or bought from Turner *Bonneville, Savoy, with Mont Blanc* (RA 1803; Yale Center for British Art, New Haven; BJ 46; see BONNEVILLE for the mix-up over the two oils exhibited in 1803), and was the first recorded owner of *Venus and Adonis* (RA 1849; private collection, South America; BJ 150). Green's pictures were sold by Christie's on 26 April 1830 at his Blackheath house and *Munro of Novar bought both the Turners. RU

Gage 1980, p. 272.

Wilton 1986, pp. 404–6.

GREENWICH, see LONDON [FROM GREENWICH].

GREENWOOD, Thomas, collector of Turner's watercolours, lived at Sandfield Lodge, Hampstead. His collection of 53 Turner watercolours included *Grenoble Bridge* (1824; Baltimore Museum of Art; W 404), *Castle of Chillon* (?1836; Whitworth Art Gallery, Manchester; W 1456), *Ehrenbreitstein and Coblenz* (c.1840; private collection; W 1321), *Venice: San Giorgio Maggiore and the Zitelle from the Giudecca* (1840; private collection; W 1367), *Yarmouth*

Sands (?1840; Yale Center for British Art, New Haven; W 1406), *The *Rigi, Lake Lucerne, Sunrise* (c.1841; private collection; W 1473) and *Steamboat in a Storm* (?1841; Yale Center for British Art, New Haven; W 1484). Sales of his collection took place at Christie's on 8 March 1872, 12–13 March 1875, and 10 April 1878, and also included works by Panini, Boucher, *Sandby, *Girtin, *Bonington, Cattermole, *Callcott, Müller, Prout, Clarkson *Stanfield, and Cox. RU

GRIFFITH, Thomas (1795–?), Turner's dealer perhaps from 1827 but especially after 1840. After Cambridge, Griffith was admitted to the Inner Temple in 1827 but never practised. In the same year it appears from a letter from Turner to Charles *Heath (Gage 1980, no. 128) that Griffith had been entrusted with the sale of the **England and Wales* watercolours made for Heath. Griffith lent thirteen *England and Wales* subjects to Heath's exhibition at the **Egyptian Hall* in 1829 and 29 to the exhibition at *Moon, Boys, and Graves in 1833. In 1834 Griffith was reported to have bought many of the Turner watercolours illustrating **Byron's Works* on exhibition at *Colnaghi's and, in the same year, *Cotman wrote to Dawson *Turner that Griffith had 'behaved to me like a prince—A name known to you as a large collector, and a purchaser of the *best works* of modern art'.

Griffith lived at Norwood in Surrey and it was at dinner at his house on 22 June 1840 that *Ruskin first met Turner and, on reaching home afterwards, jotted down in his diary his now famous first impression of the artist. Later that year a group of artists including Turner, *Stanfield, *Roberts, Harding, and Copley Fielding presented Griffith with a suitably inscribed piece of plate in recognition of his services to art. On that occasion the **Athenaeum* (1840, p. 893) described Griffith as 'an amateur of pictures, whose fortune places him above the necessity of dealing, engaged in the delicate task of smoothing the difficulties which occasionally arise between painters and their patrons'. This contradicts Ruskin's mother who in 1838 described Griffith as 'dishonest in the common acceptation of the word' but without producing any evidence to support her opinion.

From 1840 Turner employed Griffith to sell his oils as well as watercolours and Griffith handled the sale of, among others, **Slavers* (Boston Museum of Fine Arts; BJ 385) and *Rockets and Blue Lights* (Clark Art Institute, Williamstown, Mass.; BJ 387), both unsold at the Royal Academy that year. Griffith played a major part in marketing the 1842 and 1843 sets of Swiss watercolours, taking *Constance* (York City Art Gallery; W 1531) as his commission for finding buyers for the other nine drawings in the 1842 group. In February 1844 Turner consulted Griffith about his pictures for the forthcoming exhibition, writing 'Pray tell me if the new Port Ruysdael [BJ 408] shall be with fish only and if the new *marines* are to have Dutch Boats only?' These must refer to *Ostend* (Neue Pinakothek, Munich; BJ 407) and *Van Tromp going about* (Getty Museum, California; BJ 410) and the letter shows how much Turner had by then come to rely on Griffith's advice.

In 1845 Griffith opened a gallery in Pall Mall where he advertised the large engravings (R 652–6) after five Turner oil paintings that he was publishing, an enterprise that Turner seems to have financed himself. Griffith collected an exceptionally fine group of about 60 **Liber Studiorum* proofs for himself.

Griffith attempted to form a syndicate to purchase **Dido building Carthage* (RA 1815; BJ 131) for £2,500 or £3,000 to present it to the National Gallery, London, but without success. In 1848 he took James *Lenox to Turner's studio where Lenox wanted to buy *The *Fighting 'Temeraire'* (RA 1839; BJ 377). Lenox offered first £5,000 and then a blank cheque but to no avail. Also in 1848 Turner made Griffith an executor of his will but, after Turner's death, Griffith resigned, apparently because of a conflict of interest with his art dealing. EJ

Gage 1980, p. 258.
Bailey 1997, pp. 346–7, 371, 375–6, 380–1, 393, 402.

GROSVENOR GALLERY WINTER EXHIBITIONS, 1888 and 1889, surveyed 'British Art 1737–1837'. In 1888 eleven Turners included **Festival upon the Opening of the Vintage of Macon* (RA 1803; BJ 47) and **Wreck of a Transport Ship* (c.1810; BJ 210) from Lord *Yarborough.

In 1889 four oils included **High-Street, Oxford* (Turner's gallery 1810; BJ 102) and *Whalley Bridge and Abbey* (RA 1811; BJ 117) from Lord Wantage (pictures still belong to the descendants; see LOYD), brother of Coutts Lindsay, who founded and ran the palatial Grosvenor Gallery at 135 New Bond Street. The gallery flourished from 1877 to 1890, although *Ruskin considered Lindsay 'an amateur both in art and shop-keeping'. EJ

Virginia Surtees, *Coutts Lindsay, 1824–1913*, 1993.

GROSVENOR PLACE EXHIBITION, 1819. In spring 1819 Walter *Fawkes opened his London house to the public to display his watercolour collection. Amongst these were more than 60 works by Turner; but other artists included Cristall, Fielding, Sawrey *Gilpin, and *Glover. The exhibition was well attended and warmly appreciated by public and press. Thomas Moore (1779–1852) wrote: 'Went to see Mr Fawkes's drawings; chiefly Turner's, and very beautiful' (*Diaries*, 11 May 1819), while one press report, reprinted later by Fawkes in the souvenir catalogue, said

'Turner is perhaps the first artist in the world in the powerful and brilliant style peculiar to him; no man has ever thrown such masses of colour upon paper.' A report in the *Literary Gazette* (22 May 1819) described the colourful crowds attending the exhibition in 'Mr Fawkes's elegant mansion', and the crush on the stairs, where 'rouge melted, teeth dropped, feathers broken, bonnets crushed' as the crowds tried to circulate.

Although it was not solely Turner's exhibition, he nevertheless seems to have treated it as such. '[He] generally came alone, and while he leaned on the centre table in the great room, or slowly worked his rough way through the mass, he attracted every eye in the brilliant crowd, and seemed to me like a victorious Roman General, the principal figure in his own triumph' (Carey).

Turner designed the cover of the catalogue, which Fawkes dedicated to him: 'first, as an act of duty; and, secondly, as an offering of Friendship; for, be assured, I can never look at it without intensely feeling the delight I have experienced, during the greater part of my life, from the exercise of your talent and the pleasure of your society.'

The following year Fawkes's collection was open once more, but Fawkes was then unwell and only family and friends were invited. JH

W. Carey, *Some Memoirs of the Patronage . . . of the Fine Arts*, 1826, p. 147.
Gage 1980, pp. 78, 81, 253–4.
Bailey 1997, pp. 217–18, 221.

GROULT, Camille (1837–1908), a wealthy miller and industrialist who was virtually the only collector of Turner in France. Having created, between 1860 and 1890, one of the most important collections of French 18th-century art, ranging from *Watteau to Fragonard, he then devoted himself almost exclusively to collecting British art, and especially that of Turner. An eccentric personality, who also collected insects and butterflies, he created a short-lived museum of British art in 1905 in the Château de Bagatelle, which had previously housed the Wallace Collection. His son kept this collection almost intact until after the Second World War. However, it remained practically unknown; there were few visitors and hardly any descriptions.

An entire room in his Paris mansion on the Avenue Malakoff was devoted to Turner. In 1967 the Louvre acquired from this remarkable collection the painting *Landscape with a River and a Bay in the Distance* (*c*.1845–50; BJ 509). This is still the only painting by Turner in a French public collection. It was one of the first works by Turner acquired by Groult. In his *Journal* for 18 January 1890 Edmond de Goncourt described it as follows: 'Among these canvases by Turner there is an ethereal blueish lake with vague outlines. . . . My God, this outdoes the originality of Monet.' Among the other Turner paintings in the collection there were also *Ancient Italy—Ovid banished from Rome* (RA 1838; private collection, USA; BJ 375) and *The Val d'Aosta* (*c*.1845–50; National Gallery of Victoria, Melbourne; BJ 520). The presence of two unfinished late paintings in this exceptional collection was remarkable, but Camille Groult also owned several manifest fakes, some of which he was said to have painted himself. In 1905 he presented one of these fakes, a view of the Pont Neuf in Paris, to the Louvre.

See also PARIS, EXHIBITIONS OF 1887 AND 1894. OM
 (trans. LH)

Gage 1983, pp. 52–3, 149–51.

H

HAKEWILL'S *PICTURESQUE TOUR OF ITALY*. James Hakewill (1778–1843) was trained as an architect, though no building designed by him is known today. His reputation rests on his work as an author and topographical artist, and by far the most successful of his books is the splendidly illustrated *Picturesque Tour of Italy*, published by John *Murray in 1820, with an anonymous text. The 63 plates, of which 36 are topographical views and the remainder plans and outline engravings of interior views of museums, had previously appeared in parts, the first of which is dated 18 May 1818. These engravings were based on pencil drawings made by Hakewill during his tour of Italy in 1816 and 1817, of which most of the originals form part of the collection of over 300 of his drawings now in the Library of the British School at Rome. Turner was one of eight artists commissioned by Hakewill to produce finished watercolours for the engravers based on his own drawings, though John Murray refused to accept any of these except those by Turner. Eighteen of the twenty watercolours which he produced, and for which he was paid the exceptionally high fee of 20 guineas each, were engraved for the book (W 700–17). These attractive and convincing drawings pre-date Turner's first visit to Italy, and indeed it can be argued that one of the factors that finally persuaded Turner to set off for Italy in August 1819 was his work for Hakewill's book, and Hakewill helped Turner in preparing for his tour. LH

> Cecilia Powell, 'Topography, Imagination and Travel: Turner's Relationship with James Hakewill', *Art History*, 5/4 (1982), pp. 408–25.
>
> Powell 1987, pp. 14–15, 17–18, 34–5, 88, 92–5, 134–6.
>
> Tony Cubberley and Luke Herrmann, *Twilight of the Grand Tour: A Catalogue of the Drawings by James Hakewill in the British School at Rome*, 1992.

HALL, Chambers (1786–1855), collector who bought Turner's *Burning of the House of Lords and Commons* (Philadelphia Museum of Art; BJ 359; see PARLIAMENT) at the 1835 British Institution exhibition. Later he is reported to have sold it to a Mr Colls. It was to Hall that Turner supposedly remarked that he would have given his little finger to have made a watercolour like *Girtin's *White House at Chelsea* (Tate Gallery). Chambers had an extensive collection of works of art and antiquities. A few months before his death he presented to the British Museum 66 drawings by Girtin; at the same time he gave the rest of his collection to the Ashmolean Museum, Oxford, including drawings by Raphael and Leonardo. RU

HAMBURG, *William Turner und die Landschaft seiner Zeit*, 1976, was one of a series of innovative exhibitions in the Hamburger Kunsthalle entitled 'Kunst um 1800', which were arranged and largely curated by the Director, Werner Hofmann. The smaller half of the exhibition—some twenty paintings, and over 130 watercolours, drawings, and engravings, of which the majority were lent from the *British Museum—was devoted to Turner. The other half showed the work of nearly 100 contemporary landscape artists ranging from Thomas Jones to Camille Corot, providing a rare opportunity to study the work of Turner in its broader European context. LH

HAMERTON, Philip Gilbert (1834–94), critic, author, and etcher, much influenced by *Ruskin and an admirer of Turner. He described Turner as 'a most instructive subject for the student of art, because he is always and above all things the *artist*', and he published his *Life* in 1879. This presents Turner critically in a much broader context than *Thornbury. Trained as an artist in London, Hamerton spent some years living in the Scottish Highlands and France. The publication of the successful *A Painter's Camp in the Highlands* in 1862 launched Hamerton's career as an author, and he was appointed art critic of the *Saturday Review*. In 1868 his book *Etching and Etchers* helped established the revival of etching, which he himself practised with some success. In the following year he launched the *Portfolio*, a well-illustrated art journal, which he edited until his death and which became a leader in its field. Among his many books one of the most impressive was the folio volume *Landscape* (1885), a beautifully produced and illustrated

survey of landscape art in Europe, in which seven of the 43 plates reproduce works by Turner. LH

P. G. Hamerton, *An Autobiography and a Memoir by his Wife*, 1897.

HAMMERSMITH. Turner rented 6 West End, Hammersmith, from the autumn of 1806, directly after he left *Sion Ferry House, Isleworth. A hearsay report (1880s) describes it as a white house 'of a moderate but comfortable size, and its garden, intersected by the Church Path, extended to the water's edge'. Turner entertained the *Trimmer family here, and painted in the summerhouse at the river's edge. West End, being adjacent to Hammersmith Terrace, where de *Loutherbourg lived, and which *Farington referred to as 'sociable and neighbourly . . . very desirable', was ideal as a base for Turner to paint river subjects and to court patrons. However, his stay there was short-lived, for almost as soon as he had moved in work began on the construction of the West Middlesex Water Works directly behind his house. This must have made life intolerable, and by late 1811 he had moved out. He retained an interest in Hammersmith, however, making studies of the suspension bridge (opened in 1827) in the 'Birmingham and Coventry' Sketchbook (TB CCXL). JH

W. T. Whitley, *Artists in England 1800–20*, 1928, pp. 195–6.
Lindsay 1966, pp. 99–101.
Wilton 1987, ch. 2.
Bailey 1997, pp. 102–5.
Hamilton 1997, pp. 99–100, 148–9.

HANDS A, B, AND C, see FAKES AND COPIES.

HANNIBAL AND HIS ARMY CROSSING THE ALPS, see *SNOW STORM: HANNIBAL . . .*

HARBOUR OF DIEPPE (CHANGEMENT DE DOMI-CILE), oil on canvas, 68½ × 88¾ in. (173.7 × 225.4 cm.), RA 1825 (152); Frick Collection, New York (BJ 231); see Pl. 16. The words 'Changement de Domicile' remain obscure but may indicate that Turner's first lodgings proved unsatisfactory. A date in the right foreground can be read as either 1825 or 1826. The latter looks more convincing, in which case Turner may have touched the date again when painting the companion picture of *Cologne* (BJ 232).

Based on sketches made on Turner's visit to Paris in the late summer or autumn of 1821 in the 'Paris, Seine and Dieppe' Sketchbook (TB CCXI) and also in the 'Dieppe, Rouen and Paris' Sketchbook (CCLVIII); drawings of Dieppe harbour occur in the 'Rivers Meuse and Moselle' Sketchbook (CXVI), watermarked 1822. The picture received mixed reviews: a general criticism condemned the colours as too bright and 'more suited to a seaport of a southern clime than to one on the northern coast of France' (*European Maga-*zine, May 1825), although the same critic also praised the picture: 'Not even *Claude in his happiest efforts, has exceeded the brilliant composition before us'. The harshest words appeared in the *New Monthly Magazine* (15 (1825), p. 300), which called it 'perhaps the most splendid piece of falsehood that ever proceeded from the pencil of its author'.

The Frick Collection catalogue suggests that *Dieppe* and *Cologne* form a trio with the *Dort* (BJ 137), representing northern Continental ports, but there seems no evidence that Turner connected them in this way. A more plausible companion to the Frick pair is the unfinished harbour scene of identical size recently identified as *Brest* (BJ 527). EJ

'HARBOURS OF ENGLAND, THE', see PORTS OF ENGLAND, THE.

HARDWICK, Thomas, see TRAINING AND APPRENTICE-SHIP.

HARLEY STREET. Turner lived at 64 Harley Street from 1800, having moved from *Maiden Lane. The house, in which he rented rooms, was on the corner with *Queen Anne Street West in the heart of the fashionable Portland Estates north of Oxford Street. He initially shared the house with others including John *Serres, but their partnership was short-lived, and, in the light of rate returns which show him to be the sole tenant from 1803, Turner may have eased out the other tenants. He bought the lease for the garden and outbuildings in 1802, and the following year began to build his own gallery directly behind the house. *Turner's gallery opened in April 1804. Among his neighbours were Jeffry Wyatt (presumably the architect, later named Jeffry Wyattville, 1766–1840) at no. 65, and Sir William Beechey RA (1753–1839) diagonally opposite at no. 13.

Turner remained at this address until 1809, when he sublet it to Benjamin Young, a dentist. He retained access to the gallery, and became a co-tenant in 44 Queen Anne Street West, the property which backed on to 64 Harley Street from the north. The gallery access may have been a cause of problems with Young, who appealed annually for rate reductions during the early years of his tenancy, and in 1811 Turner brought builders in to create a new gallery entrance on Queen Anne Street West. In 1819 Young's lease on 64 Harley Street was reassigned to Turner as occupier, and in 1822 it appears that he took a 60-year lease on numbers 65 and 66. The properties Turner leased in Harley Street were demolished at the end of the 19th century. JH

Howard de Walden Estates papers.
Finberg 1961, pp. 267–70.
Lindsay 1966, pp. 44, 100, 112.
Bailey 1997, pp. 50, 57, 59, ch. 5, and *passim*.
Hamilton 1997, pp. 59–60, 86–7, 189.

HARPUR FAMILY, see MOTHER'S FAMILY.

HARRIS, G., London platemaker, of 4 Harp Lane, Shoe Lane, who made all the 49 surviving copper plates used for the first parts of the *Liber Studiorum*. Now cancelled, these were presented to the Department of Prints and Drawings at the British Museum by C. W. Mallord *Turner in 1945 (1945-12-8-321). Harris was one of several copper plate manufacturers centred on Shoe Lane in the first half of the 19th century, and is known to have supplied many plates for William Daniell's *Voyage Round Great Britain* (1814-25).

LH

HARRISON AND CO., London print-publisher, of 18 Paternoster Row, who published the topographical series which included the first small and rather crude engravings after drawings by Turner. The first of these was the *Copper-Plate Magazine*, of which five volumes with sixteen plates after Turner (R 1–15a) were published between 1794 and 1798, in which year they were reissued as *The Itinerant*. Harrison also published, in 1795-6, the *Pocket Magazine*, again with sixteen plates after Turner (R 16–31). This publication was later reissued as the *Ladies' Pocket Magazine* and the *Pocket Print Magazine*.

LH

HART, Solomon Alexander (1806-81), English painter of portraits and history subjects. He lifted Turner's spirits during his final year by introducing him, to a hero's welcome, as a mystery guest at a Royal Academy Club dinner. In 1847, Turner had improved Hart's *Milton visiting Galileo when a Prisoner to the Inquisition* (Wellcome Institute, London) at an RA *Varnishing Day. Onto a blank area of canvas, behind Galileo's head, Turner chalked in the astronomer's map of the solar system. This strengthened the painting's impact compositionally and, in explicitly referring to Galileo's chief scientific discovery, enhanced its meaning. Hart later wrote, 'Turner was upon the point of effacing his addition but *Stanfield . . . hastened to me to preserve the lines . . . All thought that Turner's suggestion had much improved my picture' (Shanes 1990, pp. 22-3, repr. pl. 8).

ADRL

Bailey 1997, pp. 290-1, 393.

HASTINGS, VIEWS AT, see SUSSEX, VIEWS IN.

HAYDON, Benjamin Robert (1786-1846), English historical painter, teacher, and writer. His dedication to large-scale history painting against the current of contemporary taste and his quarrels with patrons marginalized him and led, by way of impoverishment and imprisonment for debt, to his suicide. His disputes with the *Royal Academy provoked

Turner's verdict, 'He stabbed his mother', but there had been mutual regard, Haydon exempting Turner from his published satires on his colleagues and bringing *Canova to Turner's gallery, while Turner admired his *Judgement of Solomon* (private collection) in 1814 and attended the private view of drawings by Haydon's pupils in 1819. Turner's *War. The Exile and the Rock Limpet* (RA 1842; BJ 400) probably alluded to Haydon's innumerable paintings of *Napoleon in exile (see Gage 1987, p. 150, repr.)

DBB

Willard Bissell Pope, ed., *The Diary of Benjamin Robert Haydon*, 5 vols., 1960-3.

David Blayney Brown, Robert Woof, and Stephen Hebron, *Benjamin Robert Haydon*, exhibition catalogue, Grasmere, Wordsworth Trust, Dove Cottage, 1996.

HAZLITT, William (1778-1830), English essayist and critic. The son of an Irish-born Unitarian minister, he was educated for the Unitarian ministry. However, inspired by his artist brother, he decided to become a painter and painted some portraits, exhibiting one of his father at the Royal Academy in 1802. Much influenced by *Coleridge, whom he first met in 1798, as recounted in one of his outstanding essays, 'My First Acquaintance with Poets' (1822). Though still doing some painting and visiting art galleries and collections, Hazlitt moved towards a literary career, publishing his first book in 1805. He became a respected and prolific writer and critic, contributing to the *Examiner*, the *Edinburgh Review*, and many other journals and newspapers. He also gave courses of lectures in London and elsewhere, one of which, on the English Poets, Turner attended with *Soane in 1818. Hazlitt's art criticism included frequent references to Turner, the earliest some critical comments on *Dido and Aeneas* (RA 1814; BJ 129) in the *Morning Chronicle*. On the whole, however, Hazlitt approved of Turner's work, and described him in the *Examiner* in 1816 as 'the ablest landscape-painter now living'. This was the year when Turner exhibited his two large *Claudian pictures of *The Temple of Jupiter Panellenius* (BJ 133, 134), of which Hazlitt wrote with remarkable prescience, 'They are pictures of the elements of air, earth and water. . . . All is "without form and void". Some one said of his landscapes that they were *pictures of nothing and very like.'

LH

Tom Paulin, *The Day-Star of Liberty: William Hazlitt's Radical Style*, 1998.

HEALTH OF TURNER. Living as he did to the age of 76, and travelling for thousands of miles over a lifetime, Turner had a supremely healthy constitution. He was robust and stocky, and his rate of work and the physical labour it required further indicates prolonged strength of body as well as of character. However, notes in sketchbooks and remarks

in letters and elsewhere give some clues to the nature of his illnesses when these struck him.

He spoke of being 'weak and languid' to *Farington in June 1801, but the first evidence of significant illness comes in the 'Hastings and Oxford' Sketchbook, c.1809–11 (TB CXI: 2a, 8a–8), where Turner makes notes about the smoking of stramonium (thornapple), a narcotic used for the treatment of asthma or bronchitis, and a recipe for a solution of the powerful emetic blue vitriol. The side-effects of stramonium are hallucinations and disorientation. In April 1812 Farington reported Turner complaining of 'want of strength in the stomach', and that autumn of 'a nervous disorder, with much weakness in the stomach. Everything . . . disagreed with him,—turned *acid*. He particularly mentioned an aching pain in the back of his neck.' His illness at this time may have been Malta Fever, a form of brucellosis carried in goats' milk, for in the 'Chemistry and Apuleia' Sketchbook of 1813 (CXXXV) he lists the symptoms of 'Maltese Plague' with a note of a remedy using ipecacuanha, calomel, jalap, and sal mandeveri.

Around 1826/7 Turner found himself to be losing weight. He described himself to *Holworthy as being 'as thin as a hurdle or the direction post', and indeed a caricature by Richard Dighton (1827, Victoria and Albert Museum) of his uncharacteristically thin figure supports this description (see PORTRAITS OF TURNER). Although he showed great anxiety to Robert *Cadell lest he catch cholera, Turner appears to have avoided the national epidemic of 1831/2. His home and studio in *Queen Anne Street West was in a modern and airy part of London, with good drains and wide streets, and he had himself installed a water closet in 1820. Thus, by absorbing himself in his work indoors, as he appears to have done that winter, Turner kept himself away from the infection.

In the mid-1830s Turner suffered from a complaint that required cinnamon, ipecacuanha, laudanum, and tincture of rhubarb for treatment. This points to acute diarrhoea. Two sketchbooks, 'Guernsey', ?1832 (CCLII) and 'Brussels up to Mannheim', 1833 (CCXCVI), contain similar remedies, suggesting that the complaint was chronic—the 'Guernsey' recipe has the direction 'within an hour of the attack'. For Turner, these were the years of gathering ailments, for during the winter of 1836/7 he succumbed to 'the baneful effects of the *Influenza*', from which he felt a 'lassitude' and a 'sinking down'. Some months later he suffered 'a very sharp touch of fever' in the winter of 1837/8, and consulted his physician, Sir Anthony *Carlisle. Evidence suggests that Turner swung from rude health to debilitating illness and back again, and may have had a lifelong stomach condition and some breathing difficulties. When healthy, he was variously described as having ruddy or weather-beaten features, the look of a farmer or a sea-captain; but when ill he had a tendency to complain to his friends, which is largely how we know about the pattern of his sicknesses.

Turner's doctor after Carlisle's death was Dr David Price (1787–1870) of Margate, Sophia *Booth's doctor. Price claimed unpaid fees for 1850–1 from Turner's trustees in 1853 in an affidavit in which he laid out his visits to Turner, and revealed that Turner suffered from a 'severe attack of cholera and a serious illness consequent upon it'. Although the attentive nursing care of Mrs Booth kept him alive longer than might otherwise have been the case, the cholera will have weakened Turner, and probably hastened his death. JH

Hamilton 1997, pp. 65, 141, 155–6, 231–2, 273, 307–9, 339–45.

HEATH, James (1757–1834) and **Charles** (1785–1848). James trained in London, and quickly became one of the leading engravers of his day. He was elected ARA in 1791, and in 1794 was appointed historical engraver to *George III. He engraved three small topographical plates after Turner in 1805 (R 73–5). Charles trained under his father and quickly established his reputation as the engraver of fine small illustrative plates. He added the figures in John *Pye's two important engravings, *Pope's Villa* (1811; R 76) and *High-Street, Oxford* (1812; R 79). In the 1820s and 1830s Charles Heath became one of the principal promoters of the popular and fashionable annuals, such as the *Keepsake*, to which Turner contributed seventeen plates between 1828 and 1837 (R 319–35), *Heath's Picturesque Annual* and *Heath's Book of Beauty*, which combined engravings of fetching portrayals of beauteous women with literary and poetic contributions from a variety of authors, edited by the Countess of Blessington. Heath was the promoter of *Turner's Annual Tour*, the three *Rivers of France* volumes published in 1832–4, for which Turner provided all the illustrations (R 432–92). Charles Heath's most ambitious project, which was overshadowed by financial difficulties, was the great *Picturesque Views in *England and Wales* series, which was to consist of 120 engravings on copper after specially commissioned watercolours by Turner, to be published in parts of four plates at the rate of three a year. In the event the sales of the engravings were disappointing, and only 96 plates, published between 1827 and 1838, were completed (R 209–304). Publication of the individual parts was often delayed, partially because of frequent changes of the partners in the project. LH

HEIDELBERG. In the 19th century most travellers in the Rhineland paid a visit to the famous old town of Heidelberg, situated a short distance along the valley of the Neckar, one of the *Rhine's most attractive tributaries. With its imposing

old stone bridge and the red sandstone ruins of its extensive and ornate castle magnificently situated against a backdrop of wooded hills, the town is one of the most picturesque in Germany and has been painted by countless artists of many nationalities. Heidelberg enjoys a royal connection with Britain which inevitably contributes to its attraction for British visitors: Elizabeth, daughter of James I, married the Elector Palatine Friedrich V in 1613 and for a few years resided in Heidelberg Castle before moving to Prague for a brief reign as Bohemia's 'Winter Queen'. One of her grandsons became the first of Britain's Hanoverian monarchs, George I.

Turner first visited Heidelberg on his tour of 1833 when travelling from the Rhine towards Austria and Venice. He bought two of the sketchbooks used on that tour ('Heidelberg up to Salzburg', TB CCXCVIII, and 'Salzburg and Danube', CCC) on his arrival there, using the former for over 50 pencil sketches of the town, chiefly focusing on the castle and views from the river. He passed through Heidelberg again on his 1840 tour, when he made just one sketch, from the Prinz Carl hotel. Despite the town's attractions, however, it was not until the early 1840s that Turner depicted it in either watercolour or oils. In c.1841 he produced a large watercolour of Heidelberg with a rainbow from across the Neckar (private collection, on loan to the National Gallery of Scotland; W 1377); this was commissioned by the engraver T. A. *Prior, whose fine large engraving of 1846 (R 663) met with Turner's approval. The first Heidelberg watercolour was soon followed by another with a very similar composition but different meteorological effects (c.1842–3; Manchester City Art Galleries; W 1376). In the early 1840s Turner planned a further Heidelberg watercolour and executed a 'sample study' (CCCLXIV: 325) similar to those of Swiss subjects made around this time, but it failed to attract a patron.

On his way to Switzerland in 1844 Turner again stayed at the Prinz Carl hotel in Heidelberg and drew a series of watercolour sketches not only of Heidelberg itself but also of the towns and castles along the Neckar as far as Heilbronn. These were drawn in two roll-sketchbooks of white Whatman paper ('Rheinfelden', CCCXLIX, and 'Heidelberg', CCCLII) and are notable for their magical effects of light and atmosphere. The unfinished oil painting *Heidelberg (BJ 440) may have been begun around the time of this visit, when Turner was clearly more inspired by Heidelberg and the Neckar than ever before. CFP

Powell 1995, pp. 74–5, 113–14, 196–202, 208–20.

HEIDELBERG, oil on canvas, 52 × 79½ in. (132 × 201 cm.), c.1844–5; Tate Gallery, London (BJ 440). This unexhibited,

not quite finished canvas may have been intended as an 'ancient' pendant to The *Opening of the Wallhalla, alluding to the glamorous but short-lived court of the 'Winter Queen', Charles I's sister Elizabeth, who married the Elector Palatine Friedrich V in 1613. It was probably inspired by Turner's last visit to *Heidelberg, 24–7 August 1844, and based on such a watercolour sketch as TB CCCLII: 9 (repr. Powell 1995, p. 209). MB

Whittingham 1985[2], pp. 40–2, repr.
Powell 1995, pp. 59, 201–2 no. 131, repr. in colour p. 201.

HENDERSON, John, amateur artist and early patron of Turner. He lived next door to Dr Thomas *Monro at Adelphi Terrace, and presumably through him met Turner. The *Dictionary of National Biography* entry for Henderson's son, also named John, suggests that Turner and *Girtin made drawings in the Henderson house, as they did for Monro. In 1794 Henderson commissioned two watercolour views of Oxford, *Magdalen Tower and Bridge* (British Museum; W 70) and *Christ Church, Oxford* (British Museum; W 71). Monro and Henderson were clearly on friendly terms, for Monro commissioned a replica of the Magdalen watercolour from Turner (Whitworth Art Gallery, Manchester; W 69). John Henderson jun. (1797–1878) was also a collector and artist, and made watercolours in the style of Turner. He bequeathed his watercolour collection to the British Museum, including the Turners and Girtins that had belonged to his father. RU

HERO OF A HUNDRED FIGHTS, THE, oil on canvas, 35¾ × 47¾ in. (91 × 121 cm.), RA 1847 (180); Tate Gallery, London (BJ 427). Exhibited with the explanation, 'An idea suggested by the German invocation upon casting the bell: in England called tapping the furnace—*Fallacies of Hope*' (see POETRY AND TURNER). Turner shows the breaking away of the mould at the casting of M. C. Wyatt's bronze statue of the Duke of Wellington in September 1845. However, the picture is superimposed on a much earlier picture of c.1800–10 showing an interior with large pieces of machinery similar to a drawing in the 'Swans' Sketchbook of c.1798 (TB XLII: 60, 61); this is left partly uncovered, Turner adding the great bursts of light on the left and highlighting the still life in the foreground. The reworking may well have been done during *Varnishing Days as a result of Turner's picture having been hung next to *Maclise's *Sacrifice of Noah*, on which Turner heightened the colouring of the rainbow; it has resulted in considerable drying crackle.

Reviews were mainly critical, though nobody seems to have noticed the stylistic dichotomy between the original painting and the superimposed glow that so dazzled them. Cruellest was the *Illustrated London News*, 8 May: 'This

kind of painting is not the madness of genius—it is the folly and imbecility of old age.' MB

Alfrey 1988, pp. 33–8, repr.
Hamilton 1998, pp. 9–10, 49–51, 111–14, repr. in colour.

HESPERIDES, THE, see GODDESS OF DISCORD, THE.

HIBBERT, George. Hibbert was the first recorded owner of Turner's *Dorchester Mead, Oxfordshire* (Turner's gallery 1810; BJ 107). Included in his sale at Christie's, 13 June 1829 (lot 24, as 'Abingdon'), it was bought back by Turner for £120 15s. Hibbert was also a subscriber to Turner's print of The *Shipwreck* (R 751). RU

HIGH-STREET, OXFORD, *View of the,* oil on canvas, 27 × 39½ in. (68.5 × 100.3 cm.), Turner's gallery 1810 (3); The *Loyd Collection, on loan to the Ashmolean Museum, Oxford (BJ 102). Signed: 'JMW Turner RA' bottom right. Commissioned by James *Wyatt, an Oxford picture dealer and frame-maker, to be engraved. Much of the correspondence between Turner and Wyatt still exists. This shows that Turner visited Oxford in late December 1809 to make a drawing of the subject, which he is said to have done from inside a hackney coach. This has disappeared but Turner told Wyatt he already had a sketch of the scene (TB CXX: F), taken from a spot slightly to the west of that of the painting.

On 14 March 1810 Turner reported the picture was finished; it was sent to Oxford but returned in time to be exhibited in Turner's gallery on 7 May. Afterwards it was handed over to the engravers and the print was published by Wyatt on 14 March 1812 (R 79).

The correspondence shows that a few alterations to the oil were made at Wyatt's request, some women being introduced 'for the sake of colour' and the spire of St Mary's Church raised.

Wyatt was so pleased with the result that he commissioned a companion painting: *Oxford from the Abingdon Road* (private collection; BJ 125). This was completed in time for both Oxford views to be sent to the Royal Academy in 1812 where, however, they were hung so unfavourably that not one reviewer mentioned them. EJ

Finberg 1961, pp. 169 ff., 186–9.
Gage 1980, pp. 35–53.

HIGHAM, Thomas (1795–1844), English engraver. His work was usually on a small scale, and was exceptional in its convincing depiction of intricate detail. This is seen in his first plate after Turner, *Egglestone Abbey,* engraved in 1822 for *Whitaker's *Richmondshire* (R 174). Turner's fine watercolour of *Ely Cathedral* (private collection; W 845) is reproduced with the same confident delicacy for the *England and Wales* series (R 269), but it is in his three engrav-

ings on steel for the *Rivers of France* (R 433, 467, 489) that Higham is at his most skilful. The *Rouen Cathedral,* in which the intricate facade and the great crowd below it are so beautifully engraved, is one of the most memorable small prints after Turner. LH

HILL STREET EXHIBITION, 1819, was held at the London house of Sir John Fleming *Leicester (1762–1827), fifth baronet, created Lord de Tabley in 1826. Leicester acquired the lease of 24 Hill Street in March 1805, and added a picture gallery, designed by Thomas Harrison of Chester. The additional hanging space stimulated the growth of the collection and over three years he was active in buying pictures from Turner and other contemporary artists.

Leicester decided to open his London gallery to the public on a certain day in each week, experimentally in 1818, but again in 1819 during the season. William Carey, his eventual biographer, was commissioned to prepare a printed catalogue of the collection, and two versions were published during 1819, with a preface by Sir Richard Colt *Hoare (1758–1838). The success of the exhibition encouraged Walter *Fawkes in April 1819 to allow the public to see his collection of watercolours at 45 *Grosvenor Place.

The Hill Street exhibition took place before the founding of the National Gallery (see under LONDON) in 1824, and at a time when the collecting of Old Masters was given an unprecedented stimulus by the continual arrival in London of Old Master pictures from the Continent. These formed the basis of new British collections, and certain aristocratic collectors opened their galleries to the public. The Hill Street exhibition had considerable impact in promoting the reputation and patronage of British artists. CALS-M

HILLS, Robert (1769–1844), watercolour painter and etcher. For many years he was secretary to the Society of Painters in Watercolours (see WATERCOLOUR SOCIETIES). He was an avid traveller on the Continent from which he wrote many 'Letters to a Friend' illustrated by engraved 'Plates'. In 1815 he crossed over to Ostend only a few weeks after the Battle of Waterloo for a trip through the Low Countries which in 1816 resulted in *Sketches in Flanders and Holland* with meticulous descriptions of country and people in ten letters and 36 etchings after special pages devoted to the battlefield.

When Turner disembarked in 1817 he followed in Hills's footsteps; this is apparent in many a detail recorded in the 'Itinerary Rhine Tour' Sketchbook and even in the verbatim copy of almost a whole page (p. 195) of Dutch phrases and numerals (TB CLIX: 14v.). AGHB

A. G. H. Bachrach, 'New Light on Turner's Travel Preparations in 1817', *Turner Studies*, 11/1 (1991), pp. 32–5.

HILTON, William (1786–1839), history painter, elected RA 1820 and Keeper 1827–39. Hilton was friendly enough with Turner to persuade him to help W. F. Witherington (1785–1865) improve one of his exhibits on a Varnishing Day. In 1828 Hilton and Turner (with J. C. Rossi) and then again in 1837 (with William Etty) were hangers of the Royal Academy exhibition. Hilton was highly admired by colleagues though his adherence to the Grand Style bought him few patrons. C. R. *Leslie claimed that *Chantrey's indignation at this led him to create the Chantrey Bequest: Hilton's career is thus perhaps linked with Turner's shaping of his own *will. Hilton's studio sale was held at Christie's in 1841. The auctioneer's copy of the catalogue is inscribed 'Sold for Nothing! Oh! Shame upon the Taste of Connoisseurs of 1841'. RH

Jones 1980, pp. 1–10.

G. D. Leslie, *The Inner Life of the Royal Academy*, 1914.

Finberg 1961.

HISTORICAL SUBJECTS. As a student at the Royal Academy Turner was taught to place a premium on history painting for its moral dimension. A work of art, by the actions it depicted, should function as an 'exemplum virtutis'. Academic theory gave lower priority to portraiture or landscape as merely imitative forms, without conceptual value. Turner's own predilection for landscape led him to claim for it an equal status, but certainly not to reject history itself. The recognized mode of 'historic landscape', whose most distinguished British practitioner to date had been *Wilson, proved a fruitful one, and in this and other forms he painted history all his life.

His *Lake Avernus with the Cumaean Sibyl* (*c*.1798; BJ 34) was a first and faithful—if anodyne—essay in Wilson's manner and in the historical associations, mythic or real, that accrued to particular places. Patrons encouraged this trend while fostering his knowledge of its sources and subjects. His first major historical landscape, *The Fifth *Plague of Egypt* (RA 1800; Indianapolis Museum of Art, Indiana; BJ 13), bought by William *Beckford, combined the contemporary aesthetics of the *Sublime with the style of *Poussin; actually representing the biblical seventh plague, it was a foretaste of Turner's cavalier attitude to accuracy, but also of his own—or the patron's—shrewd eye for contemporary allusion, the thunder and hail invoked by Moses upon the tyrannical Pharaoh echoing the tribulations of *Napoleon's army in *Egypt, and Nelson's defeat of the French fleet at Aboukir Bay, already the subject of Turner's first picture from contemporary history, *The *Battle of the Nile* (RA 1799; untraced; BJ 10).

Following his visit to the Louvre in 1802, Turner assimilated a range of Old Masters into a series of exhibition pictures on historical themes; these laid claim to the same moral high ground that *Reynolds had reserved for the historical 'Grand Style' descended from Renaissance masters. Turner had for some time been noting ideas or sketches for subjects, mainly from classical myth or literature, that could inform his landscapes (for example in the 'Calais Pier' Sketchbook; TB LXXXI). These were interpreted with increasing grandeur and bravura, emphasis on mere storytelling diminishing to allow the exposition of larger themes literally analogous to the processes of nature, which were understood from the first as essentially poetical. *Apollo and Python* (RA 1811; BJ 115) equates the victory of good over evil with that of light over darkness as the god of art and poetry vanquishes his serpent adversary, and can also be read as a personal allegory of creative progress and self-renewal. This was how *Ruskin saw Turner's historical masterpiece, **Ulysses deriding Polyphemus* (RA 1829; National Gallery, London; BJ 330), whose dazzling colour and play of elemental forces mark his liberation from the more faithful imitation of *Claude that had characterized earlier pictures such as *Mercury and Herse* (RA 1811; private collection; BJ 114) or *Dido and Aeneas* (RA 1814; BJ 129).

By now steeped in ancient history, and preoccupied with the Trojan and Punic Wars (see CARTHAGE) that seemed to parallel the contemporary Napoleonic conflict, Turner had brought his earlier academic phase to a magnificent conclusion with **Dido building Carthage* (RA 1815; BJ 131) and *The Decline of the Carthaginian Empire* (RA 1817; BJ 135), surpassing their Claudian models in splendid lighting and their inspired reconstructions of an ancient city; their visions of the cyclical trends of history had complex messages for his modern audience, still celebrating Waterloo. Turner had already implicitly forecast Napoleon's defeat—in the year of his disastrous Russian campaign—by depicting Hannibal's tribulations during his invasion of Italy, but **Snow Storm: Hannibal and his Army crossing the Alps* (RA 1812; BJ 126) was no less prophetic of Turner's own development, its acknowledged subject being so overwhelmed by a mountain blizzard as to be invisible, leaving the picture poised ambiguously between the genres of history and landscape—a distinction that Turner must by now have believed irrelevant.

While they continued to be drawn from often familiar episodes of Greek and Roman history, Turner's historical subjects now increasingly rejected conventional narrative strategies, subjecting the individuals or events described in their titles to an evident eclipse—literally so in *Regulus* (Rome 1828–9; BI 1837; BJ 294), where the viewer who confronts the painted sun seems to take the place of the blinded hero. Although *Hero and Leander* (RA 1837; National

Gallery, London; BJ 370) sustains a more expository approach, Turner's histories were as likely to be inventions or combinations of his own drawn from his vast if undisciplined reading, as in *Phryne going to the Public Baths as Venus—Demosthenes taunted by Aeschines* (RA 1838; BJ 373); they variously provided the excuse for a display of his powers of historical reconstruction or stylistic parody, or to release the play of natural forces, the source of all mythology, but have often a serious relevance to the artist's creativity itself. Thus late subjects from Ovid inspired by his love for the *Metamorphoses* (see CLASSICAL SUBJECTS) seem playful, but have a more thoughtful counterpart in *Ancient Italy—Ovid banished from Rome* (RA 1838; private collection, USA; BJ 375), nature's cycle of decay and renewal being echoed by the cultural process of rejection and rediscovery.

Turner had often enhanced his landscapes by unseen historical presences such as the poets *Thomson and *Pope, their ghosts, figured by a monument or a house, hinting at vicissitudes in reputation. *Cicero at his Villa* (RA 1839; Rothschild Collection, Ascott, Bucks.; BJ 381), while showing the philosopher and his estate at their zenith, inevitably reminds us of his subsequent downfall—and that of *Wilson, who had painted the same subject. But in exploiting a new fashion for subjects of historical artists themselves, Turner was usually more positive, *Rome, from the Vatican: Raffaelle and the Fornarina* (RA 1820; BJ 228) celebrating a painter who had enjoyed unbroken admiration up to his current tercentary; he could also be frivolous, *Rembrandt's Daughter* (RA 1827; Fogg Art Museum, Cambridge, Mass.; BJ 238) imagining a fraught moment in the master's domestic life, and *Bridge of Sighs . . . Canaletti painting* (RA 1833; BJ 349) showing that artist in the equally unlikely act of *plein air* painting. In these last two canvases, quasi-historical subject matter is combined with an appropriate historical style. Similarly, the most innovative of Turner's late historical pictures were also the most stylistically reactionary. Scenes supposedly from the life of Admiral *'Van' Tromp (e.g. *Admiral Van Tromp's Barge at the Entrance of the Texel*; RA 1831; Sir John Soane's Museum, London; BJ 339) introduce a new genre, the historic marine, but were faithful essays in the style of Dutch masters. By a final contrast, Turner's last exhibited historical subjects, revisiting the story of Dido and Aeneas (see AENEAS RELATING HIS STORY TO DIDO, RA 1850; BJ 429–32), were reworkings of Claudian compositions in his most diffuse late manner.

DBB

Nicholson 1990.

HOARE, Sir Richard Colt (1758–1838), antiquarian and partner in the family bank. He inherited *Stourhead in Wilt-shire in 1785 and became a major early patron of Turner about ten years later. Turner's 'Isle of Wight' and 'South Wales' Sketchbooks (TB XXIV, XXVI), both in use in 1795, have notes of orders for Colt Hoare; the first for two views of *Salisbury Cathedral and the second for two views of Hampton Court, Herefordshire (seat of Viscount Malden, later Lord *Essex), although these two were not painted until *c.*1806 (Yale Center for British Art, New Haven; W 215–16).

The Salisbury commission was to become much more extensive, consisting of two sets each of ten drawings (of which seventeen were completed); these occupied Turner *c.*1796–1805. The larger-sized set concentrated on the cathedral, the smaller on views and buildings in the city together with one of Wilton House (W 196–214).

Colt Hoare considered that 'the advancement from *drawing* to *painting* in watercolours did not take place till after the introduction into England of the drawings of Louis *Ducros' (1748–1810), thirteen of which he bought in Italy between 1787 and 1793 to hang at Stourhead. He mentions Turner among several artists influenced by Ducros and this is confirmed by Lindsay Stainton, who notes that the 'monumentality and dramatic atmosphere' in Ducros's watercolours 'exactly coincided with Turner's developing taste for sublime subjects'. The watercolours of Salisbury Cathedral certainly provide evidence of this.

Turner's few letters to Colt Hoare (Gage 1980, pp. 25, 27–30) are all strictly about business but the two must have been on good terms, as it seems likely that Colt Hoare recommended Turner both to his friend Sir John *Leicester and to his neighbour William *Beckford.

On 4 February 1786 Colt Hoare, an enthusiastic amateur artist, made a drawing of Lake Avernus near Naples which was afterwards copied by Turner. This formed the basis of *Aeneas and the Sybil, Lake Avernus* (*c.*1798; BJ 34), perhaps intended as a pendant to *Wilson's *Lake Nemi* at Stourhead. It is a conscious exercise in Wilson's manner and, Woodbridge believes, no longer to Colt Hoare's taste. So the Turner did not remain at Stourhead but, in 1814, Colt Hoare commissioned a second version of the subject (Yale Center for British Art, New Haven; BJ 226), an extremely rare event in Turner's *œuvre* (see REPLICAS AND VARIANTS) and Colt Hoare's final Turner purchase. The long gap between the two can perhaps be explained by Colt Hoare, having admired Turner's classical subjects exhibited about this time, realizing that Turner could now represent this subject in Claudian terms, thus complementing his own antiquarian interests. Turner must have had much advice from Colt Hoare when he visited Italy in 1819, and he certainly owned the latter's *Hints to Travellers in Italy* (1815).

At the Stourhead Heirlooms sale in 1883, all the Turners were dispersed but six of the Salisbury Cathedral watercolours remain in English museums. EJ

Woodbridge 1970.
Gage 1974, pp. 71–5.
Stainton 1985².

HOBART, Tasmania, 1845 exhibition. This consisted of two Turner oils, three watercolours, and some prints, belonging to Francis Russell Nixon, Bishop of Tasmania, who had inherited them from his father, the Revd Robert *Nixon, an early friend of Turner.

Shown in the Legislature Council Chambers, Hobart, from 6 January to 15 February, the Turners were catalogued as *Landscape* and *View of Snowdon, North Wales* (oils) with the watercolours *Ruins of Sir Gregory Page Turner's House, Blackheath*, *View on the Dee*, and *Shakespeare's Cliff, Dover*, the latter two described as 'early drawings'.

The catalogue noted that the *View of Snowdon* was 'Turner's first production in oils' (this is now considered to be *Watermill and Stream*, c.1792; TB XXXIII: a, BJ 19a). The description of *Snowdon* in the *Hobart Town Advertiser* (14 February) identifies it with *Snowdon: Waggoners, Early Morning* (Wedmore 1900, vol. i, repr. facing p. 14; Armstrong 1902, p. 232), which is certainly not by Turner and is now attributed to George *Jones. As the present whereabouts of the four other exhibits is unknown, this places a query over them also despite their apparently irreproachable provenance.

After this earliest exhibition of Turner's work outside Britain, the bishop's wife wrote: 'Alas, the Hobartians have proved themselves very unworthy of such an intellectual treat.' Bishop Nixon's Turners were shown again in the *Art Treasures* exhibition in Hobart in 1858 before they returned to England with him in 1862. EJ

Sayers 1996, pp. 209–11.

HOGARTH, William (1697–1764), the most important British painter of the early 18th century. He was trained as an engraver but built up a successful career as a portrait painter. His reputation lies primarily in his highly original narrative compositions, which became universally popular through the sale of engraved reproductions.

Hogarth's preoccupation with portraiture and wry observations of contemporary life made him a somewhat unlikely model for Turner. The closest attempt Turner made at Hogarthian satire was *The Garreteer's Petition* (RA 1809; BJ 100), and two associated pen and ink studies of c.1808, the preliminary study for the painting (TB CXXI: A), and its companion, *The Amateur Artist* (CXXI: B). *The Garreteer's Petition* seems to have been closely modelled on Hogarth's *The Distressed Poet*, 1736 (Birmingham City Art Gallery), which was published in engraved form in 1736/7: the poetic inscriptions on the plate were adapted by Turner for the verse he exhibited with the picture at the Royal Academy in 1809 and, more closely, for the lines he inscribed on the sketch of the subject. In *The Amateur Artist* Turner's use of symbolic pictures is a device characteristic of Hogarth.

Hogarth's importance to Turner was more personal than artistic. Turner may have identified with Hogarth's forceful and somewhat boorish character: like his predecessor, Turner achieved artistic and financial success, despite a lowly upbringing. Hogarth's sense of patriotism and belief in the abilities of British artists had caused him to be regarded as the founder of a British School of painting—a role which Turner himself sought to emulate. DP

Ronald Paulson, *Hogarth's Graphic Works*, 1965, rev. 1970.
Ronald Paulson, *Hogarth: His Life, Art, and Times*, 1971.

HOLLAND. In Turner's time the Netherlands (often simply referred to as 'Holland' after its main province) consisted of territories comparable to those of the Benelux countries in the 20th century. Turner first set foot on 'Dutch' soil at Ostend on the Belgian coast in the summer of 1817, three years after Belgium, the Dutch Republic, and the Grand Duchy of Luxembourg had jointly been created the 'Kingdom of the United Netherlands' under William I, formerly the exiled Stadtholder Prince William VI of Orange.

In 1793 the Low Countries had been invaded by the French revolutionary armies and renamed the Batavian Republic. In 1806 *Napoleon had turned this new republic into a kingdom under his brother Louis with *Amsterdam as capital. When Louis abdicated in 1810, the Netherlands were annexed to France until the French retreated in 1813 and Orange was proclaimed king by the Allies in London, their object being to ensure a 'balance of power' in Europe. They failed because Belgian nationalists soon started agitating; by 1830 this resulted in the Belgian Revolt and in 1839 in the definitive split into the two present kingdoms, the Belgian and the Dutch.

When in 1825 Turner toured the United Netherlands again, he might have observed that the cities in the North were making only moderate progress commercially, but those in the South were doing extremely well industrially. He would not have noticed any political unrest at the time, but the conflict of the 1830s and what seemed the British government's betrayal of their own creation did not leave him indifferent, interested as he had long been in Dutch art and artists—and hence in their history.

From Roman times onwards, waterways and sea-defences had been crucial for the prosperity of the north where people had always depended on their wide-ranging shipping for survival. Also, they had always lived in small units. In the South settlements had grown during the feudal Middle Ages into cities of ever-increasing wealth and beauty, particularly in Flanders, where there was no land to be drained or reclaimed as in the lake-studded North. And in the meantime marriage, conquest, purchase, and inheritance had resulted in all the Low Countries being gradually brought under the rule of the Dukes of Burgundy, whose Charles V in 1519 even became Holy Roman (Catholic) Emperor. Under his son Philip II, who had also inherited Spain, the inevitable struggle for regional autonomy came to a head, and in 1568 the Dutch Insurrection began. A Spanish army under the cruel Duke of Alba was dispatched to subdue 'provinces' which now gave their allegiance to William the Silent, Prince of Orange, who in a time of bitter religious conflict—with the Inquisition as a terrible weapon—was one of the first European champions of genuine toleration.

Eleven years after the outbreak of the fighting, the Union of Utrecht banded the Northern provinces together against the Spanish king, who was solemnly abjured in 1581. Orange defiantly kept his title as Royal Stadtholder or 'Lieutenant', a fiction still preserved in the Dutch national anthem, the 'Wilhelmus'. In 1594 Prince William I was assassinated, but his sons Maurice and Frederic-Henry succeeded by exemplary military campaigns in driving the Spaniards from the mainly Protestant Northern Netherlands. At the same time Dutch squadrons won many sea-battles culminating in 1588 in the combined Anglo-Dutch victory over the Spanish Armada after Queen Elizabeth had earlier sent auxiliary troops to Holland.

Economically thriving as the 'carriers of Europe' and by their colonial trade, the Provinces were able to conclude a Twelve Years' Truce in 1609. Upon the war's resumption they proved so effective that in 1648, at the Peace of Munster, their 'Republic of the Seven United Provinces' was born and internationally recognized.

If the 17th century was the Golden Age for the North, there was decline in the South, where *Rubens and *Van Dyck had shone before each in turn went over to England. Admittedly, after being provoked by England's crippling Act of Navigation of 1651, the North had to fight a succession of Anglo-Dutch sea wars. But in Stadtholder William III who, like his father, had married a Stuart princess, a Prince of Orange emerged who saw fit to accept the invitation of a number of prominent Englishmen to the country from their Catholic and French-dominated sovereign James II. It was a chain of events which after the fateful year of 1830 furnished Turner with the inspiration for half a dozen historical compositions with a pro-Dutch message. Such were for instance *The Prince of Orange . . . landed at Torbay* (RA 1832; BJ 343), *Helvoetsluys. The City of Utrecht, 64, going to Sea* (RA 1832; Tokyo Fuji Museum; BJ 345; see SEAPIECES), and the early *Van Tromp* pictures (RA 1831, 1832, and 1833; Soane Museum, Wadsworth Atheneum, Hartford, Conn., and Tate Gallery; BJ 339, 344, 351). Now that the British-born Kingdom of the United Netherlands was left to fend for itself, these were so many implied reminders of an indebtedness to Dutch political initiative and of the beginning of the end of Louis XIV's expansionism which in 1672 had already pushed his armies as far as Utrecht.

But in spite of the not unfavourable Peace of Rijswijk in 1697, the period of Netherlands greatness was over. In 1702 William III died without issue. The Republic became involved in the War of the Spanish Succession which ended with Belgium being allocated to Austrian overlordship. In Holland, from 1780 to 1784, the fourth trade war with the English tolled the death-knell for the navy. Party strife between 'Patriots' and 'Orangists' did not help the worsening economy which greatly suffered from the country's physical decline through the costly decay of the dykes and a shrinking population.

Turner's last visits date from 1840 to 1841 when he paid special attention to *Rotterdam. In 1840 the enterprising Dutch 'Merchant King' William I resigned in favour of his son and the Netherlands evolved towards a constitutional monarchy. Culturally, after *Neoclassicism and scientific progress, the country had fully embraced *Romanticism— which brought a renewed discovery of the past and its great artistic and scholarly achievements. The Dutch landscapists, seapainters, and portraitists left an indelible imprint on the civilization of the Netherlands from which Turner derived a special inspiration. Quite irrespective of his art, this has been testified by writers who recount how, towards the end of his life when sitting on his Chelsea roof-terrace, he would point to the view inland as 'my English Prospect' and to the view downriver as 'my Dutch Prospect'.

AGHB

Y. Schoffer, *A Short History of the Netherlands*, 1973.
Bachrach 1994.
J. A. Kossmann-Putto and E. H. Kossmann, *The Low Countries*, 1997.

HOLWORTHY, James (1781–1841), collector, teacher and watercolour painter, whose long friendship with Turner bred a revealing correspondence. He was taught watercolour by John *Glover (1767–1849), with whom he shared a house in Mount Street in 1804, and was a founder member

with Glover of the Old Water-Colour Society (see WATER-COLOUR SOCIETIES) and an exhibitor until 1824. From about 1814 he lived in York Buildings, New Road, near his and Turner's friend W. F. *Wells. He moved in the circles of watercolourists, architects, and collectors of classical taste, including Thomas Allason, Henry Gally Knight, *Munro, *Phillips, and W. F. Wells and his family, all of whom are discussed in Turner's letters to him.

He built a fine painting and print collection, including *Liber Studiorum proofs and over 200 prints after *Teniers. He was probably the 'Holworthy Junr' who subscribed to the engraving of Turner's *Shipwreck in 1805. Turner gave him two watercolours on his marriage. Among his paintings was *Watteau's L'Île enchantée, which had once belonged to *Reynolds, and which was a source for the figures in *England: Richmond Hill (RA 1819; BJ 140).

Turner's letters to Holworthy, and the confidences they contain, suggest that their friendship was close and mutually understanding. They went on fishing trips together, and Holworthy gave Turner lodgings in New Road when the latter's house in *Queen Anne Street was being rebuilt. He vainly urged Turner to visit when in 1822 he moved to Derbyshire, but Turner took close interest in the progress of construction of the Holworthys' house near Hathersage, and proffered advice.

See also ARCHITECT, TURNER AS; FISHING. JH

Gage 1980, pp. 260–1.
Shanes 1990, p. 315.
Hamilton 1997, pp. 147, 174, 207, 210, 224, 227, 333.

HOLY LAND. Turner had already collaborated with William and Edward *Finden, owners of one of the main printing houses in London, and publisher John *Murray over illustrations for The Life and Works of Lord *Byron when he accepted their commission for Landscape Illustrations of the Bible, published in 1836. Murray and the Findens knew that guidebooks in the early 19th century neglected the Holy Land, writing in their Introduction: 'how much more worthy of awakening the strongest emotions in the mind of a Christian must be the country whose history far transcends in interest that of any other'.

Never having visited the Holy Land, the illustrators relied on sketches made on the spot by more adventurous travellers, such as Sir Charles Barry (1785–1860), which became the Findens' primary source for their publication. They selected 25 sketches by Barry and nearly 75 by 30 other travellers. Eleven other artists took part in the project, Turner receiving the largest assignment.

Whenever he could, Turner chose sketches that presented open panoramas and of the 26 designs he contributed

fourteen were after Barry. He picked sketches such as Mount Moriah, Jerusalem, Pool of Bethesda, and Jerusalem from the Mount of Olives (all 1819; British Architectural Library Drawings Collection, Royal Institute of British Architects) and passed over sketches portraying particular buildings which were drawn by *Roberts and Clarkson *Stanfield.

*Ruskin so admired Turner's treatment of the sky in Pools of Solomon (Fitzwilliam Museum, Cambridge; W 1244) that, in Modern Painters, he makes it an example of his careful study of Turner's sky perspective.

Turner never reached the Holy Land but he heard the echoes of his admirers who had. In April 1841 *Wilkie wrote from Jerusalem: 'I thought of him [Turner] when I passed the ancient city of Jericho. I can fancy what our friend would make of this and the Vale of Jordan . . . above all the Mount of Olives, Mount of Ascension, with all the mystery associated with it' (Finberg 1961, p. 188). MO

Omer 1975.
Omer 1979 and 1981.
Mordechai Omer, J. M. W. Turner and the Romantic Vision of the Holy Land and the Bible, exhibition catalogue, Boston College, McMullen College of Art, 1996.

HOOD, Sir Alexander Acland- (d. 1909), the descendant of Turner's patron Jack *Fuller of Rosehill Park, Sussex. He inherited most of the works by Turner that had belonged to Fuller with the exception of the oil of Rosehill Park, Sussex (c.1810; private collection; BJ 211) that went to Fuller's grandson Owen Fuller-Meyrick. These were all sold at his sale at Christie's on 4 April 1908, when they were bought by *Agnew's. RU

HOPPNER, John (1758–1810), leading pupil of Reynolds, portrait painter to the Prince of Wales, and prominent Royal Academician (ARA 1793; RA 1795). Impressed by Fishermen coming ashore at Sun Set (RA 1797; untraced; BJ 3), Hoppner visited Maiden Lane in 1798, subsequently describing Turner as 'a timid man afraid to venture' (Finberg 1939, p. 45). He also claimed to have advised Turner that his pictures were too brown, leading him to pay closer attention to nature. Turner saw the *Van de Veldes in Hoppner's collection, and it has been suggested that the latter's A Gale of Wind (Tate Gallery) possibly influenced the early marines (Wilton 1979, p. 86). Hoppner's long-standing friendship with the *Lascelles family could have been a factor in the Harewood commissions (Gage 1987, p. 157), and around this time Turner made him a present of Durham Cathedral (c.1798; Royal Academy, London; W 249), subsequently benefiting from his vote in becoming ARA (1799). Hoppner's regard for Turner turned sour after 1803, when he complained of a new indistinctness in his painting and a

slump in his manners (Bailey 1997, p. 74). Later detractions included an 1805 assertion that Turner's gallery was 'like a Greens stall, so rank, crude, & disordered were his pictures' (ibid., p. 77). Despite this change of heart, Turner bought a group of studies by Hoppner at the *Monro sale of 1833 and evidence of his continuing influence has been noted in *Reclining Venus* (1828; BJ 296; see Butlin, Luther, and Warrell 1989, pp. 53–5) and in Turner's later use of wax (Lindsay 1966, p. 176; Gage 1969, p. 33). ADRL

John Human Wilson, 'The Landscape Paintings of John Hoppner', *Turner Studies*, 7/1 (summer 1987), pp. 15–25.

HORACE (65–8 BC). At Turner's death his travelling-box contained Young's *Night Thoughts*, Izaak Walton, and 'some inferior translation of Horace'. Turner surely responded to Horace's praise of the Italian countryside and frugal rural retirement, his descriptions of cascades, fountains, rivers and their banks, verdure, dances of youths and nymphs, the cycle of the seasons, mountains, and shipwrecks. The 'Devon Rivers, No. 2' Sketchbook (TB CXXXIII) contains a translated stanza from Ode ii. v, describing ripe youths and virgins carrying grape-clusters for festal vintage. Although humbly born, Horace associated with the great. Turner quoted from Horace's *Ars Poetica* an aphorism about the genius and eloquence of Greek civilization when writing to Lord Elgin in 1806 to congratulate him on the Parthenon Marbles. Horace refers frequently to the wars between Rome and *Carthage; in Ode III. v, he praises the 'high soul' of *Regulus. Turner alludes lyrically to Horace in *The *Bay of Baiae, with Apollo and the Sybil* (RA 1823; BJ 230): 'liquidae placuere Baiae' from Ode III. iv is incised on foreground masonry. This ode addresses the celestial muse, Calliope; blest by bright Apollo, 'parent of sacred song and guardian of the Muse', and driven by love of the Muses, Horace seeks Tivoli, cool Palestrina and 'famed Baia's warm salubrious rills'. Horace's Epistle I also claims that the Bay of Baiae is nowhere outshone. Turner shows the ruins of the elaborate buildings of the rich at Baiae with their 'fickle luxury' (Ode II. xviii). Turner as a literary traveller doubtless associated Tivoli with Horace who often celebrates (as *Tibur*) its 'cool sequestered shade', not far from his Sabine villa. JRP

Powell 1987, pp. 6–8, 72–4, 78, 118–19.

HORSBURGH, John (1791–1869), Scottish engraver, born and trained in Edinburgh, where he lived and died. His first print after Turner was the dramatic *Bell Rock Light House*, published in 1824 as the frontispiece to Robert Stevenson's *Account of the Bell Rock Light House* (R 201). Turner was recommended to Stevenson by Walter *Scott. Horsburgh contributed two plates to the *England and Wales* series, in-cluding the powerful *Malvern Abbey and Gate* (R 258). On steel Horsburgh engraved three of the vignettes for *Scott's *Poetical Works* and seven for *Scott's *Prose Works*, among them that of *Napoleon's Logement, Quai Conti* (R 526).

LH

HOWARD, Henry (1769–1847), portrait and history painter now largely forgotten but undoubtedly respected by Turner as a 'labourer in the same Vineyard' (Gage 1980, p. 136). Elected RA in 1808 (Turner voted for him), in 1811 he became Royal Academy Secretary (again supported by Turner), a post he successfully filled until just before his death. As Secretary he often had contact with Turner. In 1833 Howard became Professor of Painting: his lectures were later described as 'scarcely worthy of mention' (*Art-Union*). Close to Henry *Trimmer, Howard had Turner's help in finishing a portrait of one of Trimmer's children (Thornbury 1862, pp. 37–8). He is represented in the Tate Gallery and the Soane Museum in London, and at Petworth.

RH

'Henry Howard RA', *Art-Union*, 9 (1847), p. 378 (obituary).
Frank Howard, 'Memoir', in H. Howard, *Lectures*, 1848.

HUDSON RIVER SCHOOL, American landscape artists active from c.1825 to c.1875, who initially drew subject matter from upstate New York. Thomas *Cole is usually considered the school's father, and Asher Brown Durand (1796–1886) his chief disciple. Their approach to American scenery grew out of English picturesque sketching and travel (see SUBLIME). Younger associates such as Frederic *Church and Sanford Gifford (1823–80), who were influenced by the light, colour, and atmospheric effects of later Turner, are now often referred to as 'Luminists'. AS

K. Avery *et al.*, *American Paradise: The World of the Hudson River School*, exhibition catalogue, New York, Metropolitan Museum, 1987.

HUGHES, John Newington (d. 1848). A resident of Winchester, Hughes owned Turner's *Sheerness and the Isle of Sheppey* (Turner's gallery 1807; National Gallery of Art, Washington; BJ 62) and *Whalley Bridge and Abbey, Lancashire* (RA 1811; Loyd Collection; BJ 117). Both were sold at his sale at Christie's, 15 April 1848, the year in which he is believed to have died. RU

HULLMANDEL, C.J. (1789–1850), pioneer of lithography in England. He set up a lithographic press in 1817–18 and published his technical treatise, *The Art of Drawing on Stone*, in 1824. Only one lithographic plate after Turner was produced during his lifetime (R 833), but a considerable number of usually large lithographs and chromo-lithographs were issued posthumously in the 1850s (R 834–67). LH

HUNT, Alfred William (1830–1896), landscape artist born in Liverpool. His watercolours combined the detail of the Pre-Raphaelites with the atmosphere of Turner, and won the admiration of *Ruskin. He found some of his favourite subjects in North Wales, Scotland, and the Lake District, and also travelled in Italy and Switzerland.　　　LH

HUNTINGTON ART GALLERY, San Marino, California. The railway magnate Henry E. Huntington (1850–1927) formed his collection between 1908 and 1927 and the gallery was opened in 1934. Huntington bought only one Turner: *The Grand Canal, Venice* with a quotation from *The Merchant of Venice* (RA 1837; BJ 368) and based on two pencil drawings in the 1819 'Milan to Venice' Sketchbook (TB CLXXV: 72a, 73). Dr Wark has suggested that Turner may have intended it as a sunlit pair to the moonlit **Juliet and her Nurse* (Sra. Amalia Lacroze de Fortabat, Argentina; BJ 365) of 1836. *Neapolitan Fisher-Girls surprised bathing by Moonlight* (BJ 388), acquired in 1981, has recently been adjudged a copy by Andrew Wilton but this is disputed by Martin Butlin and the matter is still being investigated (see REPLICAS AND VARIANTS).

Four of the seven watercolours date from the 1790s (W 86, 150, 172, 188) and *Ludlow Castle* (W 264) is *c.*1800. *St Goarhausen* (W 676) belongs to the 1817 *Rhine drawings, while *Beaumaris Castle* (*c.*1835; W 865) from the **England and Wales* series is a puzzle, as no evidence exists that Turner ever visited Anglesey.　　　EJ

Robert Wark, *Ten British Pictures 1740–1840*, 1971, pp. 123–34.

HURST, Robinson, and Co., London print-publishing and -selling business. In 1818 it bought the business and stock of Boydell's, the leading London print-publisher of pre-Napoleonic years. In 1822 J. O. Robinson approached Turner with an ambitious scheme to publish three or four large single plates after specially painted important pictures. Turner's response to the idea is recorded in a letter, originally published by *Thornbury but now lost, dated 'June 28 1822' (Gage 1980, pp. 86–8), which provides fascinating, and rare, insight into the artist's positive attitude towards engravings after his work. We know nothing more about these proposals; Hurst, Robinson went bankrupt in the financial turmoil of 1826.　　　LH

I

IDEALISM, the central aesthetic determinant of Turner's art. As he made clear in his *perspective lecture manuscripts, the painter wholeheartedly subscribed to the academic, idealizing doctrine of 'poetic painting' as promulgated by *Reynolds, and by the latter's predecessors, Bellori, de Piles, du *Fresnoy, Dryden, Richardson, and Algarotti. This theory holds that painting and poetry are 'Sister Arts', and that it is the duty of visual artists to attain the idealized beauty, humanistic universality, moral elevation, epic scale, consonance, and inventiveness of form and imagery that are commonly encountered in major poetic and dramatic works.

For Reynolds and his forerunners, the loftiest levels of artistic expression were attainable through the use of *historical, allegorical, *biblical, *classical, and *literary subject matter. In such content an Ideal Beauty of human physical perfection could be united with the most universalized moral statements regarding human behaviour. Reynolds accorded landscape painting a fairly lowly place aesthetically because he felt it was over-particularized or beholden to what de Piles had termed the 'accidents of nature'. (If, for example, a landscapist arbitrarily witnessed a scene in bad weather, then presumably that was how it would just as arbitrarily be depicted.) However, Reynolds did accept that *Claude Lorrain had overcome this limitation by attaining perfected form and greater universality through synthesizing his images from diverse observations, bringing together, say, 'scenes and prospects' viewed in one place, with light-effects, vegetation, and staffage witnessed elsewhere. The resulting composites overcame arbitrariness and attained idealized expression through the amalgamation and intensification of beauties.

That Turner fully agreed with such an idealizing method is proven by a passage in one of his perspective lecture manuscripts:

To select, combine and concentrate that which is beautiful in nature and admirable in art is as much the business of the landscape painter in his line as in the other departments of art. (British Library, Add. MS 46151, P, p. 2v.)

In a paraphrase of Reynolds he also defined the imaginative precondition of this practice:

it is necessary to mark the greater from the lesser truth: namely the larger and more liberal idea of nature from the comparatively narrow and confined, namely that which addresses itself to the imagination from that which is solely addressed to the eye. (British Library, Add. MS 46151, AA, p. 3)

The lecture manuscripts also make clear Turner's identification with the Platonic idealism of the poet Mark *Akenside, and that very possibly he was introduced to such metaphysics at an extremely early age by Thomas *Malton jun. (see Shanes 1990, pp. 254-7).

Throughout his maturity Turner gave expression to his idealism, almost always synthesizing his landscapes and frequently doing so from memory, a highly idealizing faculty that sorts out the essential—and thus more universal—from the inessential. Equally, the desire to communicate essentials was arrived at by means of the apprehension and expression of the underlying dynamics of natural process, structure, and behaviour, or what the artist characterized as the 'qualities and causes' of things (annotation to *Opie; see Venning). Indeed, it is surely Turner's unmatched expression of the fundamental dynamics of architectural, geological, and arboreal structure, and of meteorological, hydrodynamic, and aerodynamic behaviour, that makes him arguably the finest landscapist and marine painter in the history of Western art (and it was not least of all for these very attainments that *Ruskin eloquently claimed him to be just that in *Modern Painters* and elsewhere).

The expression of universal human behaviour was central to the academic idealism of Reynolds and his predecessors. As the majority of Turner's publicly displayed or engraved images make clear, locating humanity within its environment was of overriding importance to the painter. The desire to do so received expression both through his staffage—few of Turner's works lack figures—and through the adoption of historical and similarly humanistic subject matter. More subtly, in his maturity the artist frequently alluded to the underlying economic, historic, and social

verities of the places he represented (see ASSOCIATION OF IM-AGES AND IDEAS).

Naturally, because Turner accepted the linked, moralizing purpose of art as dictated by art theorists such as Reynolds, he often projected his moral viewpoint regarding the place of humanity within the universal scheme of things, although this necessitated his only major departure from idealizing theory. Instead of representing his staffage in the perfected, heroicized manner recommended by Reynolds and his predecessors, Turner imitated the stylized renderings of people by *Teniers, *Rembrandt, and others to make his populace look as imperfect and puny as possible. By doing so he maximized their physical contrast with the overwhelming beauty, immensity, or physical force of their surroundings, and thereby projected the central moral and dramatic point of his art: humanity does not rule the natural world but is a relatively insignificant part of that domain, and our vain notions to the contrary are a mere 'fallacy of hope'. ES

Venning 1982, pp. 38–9.

IMPASTO is the term used to describe paint which is applied more thickly than elsewhere on the paint surface. Areas of white or light highlights in Turner's oils are often applied with impasto, by means of a localized brushstroke or palette knife of thick, densely coloured paint. Drying oils such as linseed and walnut can absorb only a limited amount of pigment as they are ground with it, and can provide impasto of a limited thickness. Paint made from pure drying oils, and used with the maximum amount of pigment possible, tends to retain brushstrokes, and to have a crisp outline when dry. Turner, and many of his contemporaries, modified pure oil paint in order to achieve a greater variety of impasto. The addition of *megilp to the oil paint on the palette gave impasto which was less sharp-edged, but which could dry without slumping very much, even when it was applied over larger areas than mere highlights. A combination of linseed oil, beeswax, and, on occasion, spermaceti wax gave a softer impasto which slumped to a considerable extent as it dried, and which was used to good effect in soft clouds applied with a long, soft brush. Turner often applied pure oil paint with a palette knife, as impasto for stormy skies. JHT

IMPRESSIONISTS, see FRENCH IMPRESSIONISTS.

INDIA. Turner never visited India but did two sets of Indian subjects based on drawings by others. In about 1800 he did three views of Seringapatam probably based on drawings made on the spot by Thomas Sydenham during the siege of 1799; one, showing the siege from afar, is in the Tate Gallery (T 04160; see *Turner Studies*, 8/1 (Summer 1988), p.

59; and Lyles 1989, pp. 41–2, repr.). The commission probably came through the Daniells, Thomas (1749–1814) and William (1769–1837); the three watercolours were attributed to the latter until 1985. A drawing in the Turner bequest (TB CXCVI: Z) appears to be a design for a fourth Seringapatam subject. The second group, seven watercolours, done *c.*1835 for Lieutenant George Francis *White's *Views in India, chiefly among the Himalaya Mountains* (W 1291–7), were based on Lieutenant White's sketches (Herrmann 1990, pp. 213–14). MB

INDIANAPOLIS, *Turner in America* exhibition, 1955. All lent by American museums and private collectors, the 60 or so paintings and drawings in this exhibition provided a chronological survey of Turner's work. Shown at the John Herron Art Museum (as the *Indianapolis Museum of Art was then called) and then at the Dayton Art Institute, the exhibition had as its focal point 'a group of four notable works by Turner which have just come to America' as a gift to the John Herron Art Museum in memory of Evan F. Lilly. This included the 1800 Fifth *Plague of Egypt* (BJ 13) and a complete set of the *Liber Studiorum*, which was shown in the exhibition. An enthusiastic supporter of the exhibition was Kurt *Pantzer, the Indianapolis collector of Turner. LH

INDIANAPOLIS MUSEUM OF ART, Indiana, now owns the largest collection of Turner's work in America after the *Yale Center for British Art, New Haven. This is largely due to the enthusiasm, generosity, and contacts of Kurt *Pantzer. Encouraged by Pantzer, two friends and clients each bought a Turner oil in 1955: *The Fifth *Plague of Egypt* (RA 1800; BJ 13) and *East Cowes Castle, the Regatta Beating to Windward* (RA 1828; BJ 242; see NASH); the former was given to the museum (then called the John Herron Museum of Art) before it staged the *Turner in America* exhibition that same year, and the latter in 1971.

Pantzer's 38 Turners, covering a wide range in date and subject matter, were given to the museum in several groups. Highlights include two of the 1817 *Rhine drawings (W 653, 665), *Borthwick Castle* (W 1060) and *Roslyn Castle* (W 1065), which had belonged to Sir Walter *Scott, two vignettes (W 1102, 1115) illustrating Scott's *Life of Napoleon*, the fine *England and Wales watercolour *Llanthony Abbey* (W 863), *Falls of the Rhine, Schaffhausen* (*c.*1841; W 1461) and, from Turner's final years, *Lake Lucerne from Brunnen* (W 1547) and *Oberhofen on Lake Thun* (W 1557). EJ

Krause 1997.

INFLUENCE ON LATER ARTISTS. Turner is often described as too isolated a genius to have had followers. That is not entirely true, but he had less obvious influence on later

painting than less radically individual artists such as *Constable and David Cox.

In 1851, three years after the formation of the Pre-Raphaelite Brotherhood, when John *Ruskin took John Everett Millais under his wing, Millais pointedly rejected his new champion's admiration for Turner, and indeed nothing appears further from the visionary breadth of late Turner than the myopically detailed background of Millais's *Ophelia* (Tate Gallery), painted in 1851–2. Yet in August 1851 Ruskin published *Pre-Raphaelitism*, a pamphlet chiefly about Turner that links Turner and Millais in their defiance of false teaching and equates 'Turnerism' and Pre-Raphaelitism. Justifying Ruskin's defence of the Pre-Raphaelites was his belief that they observed the principle of 'rejecting nothing, selecting nothing' enunciated in the first volume of *Modern Painters*, and, however different the art, early Pre-Raphaelitism was undoubtedly influenced by arguments developed in a book about Turner. As the initial impulse waned, several Pre-Raphaelite artists ventured onto more recognizable Turnerian terrain: most notably, John William Inchbold (1830–88) in paintings of Venice and the Lagoon done in 1862–4 and watercolours of the Lake of Geneva from 1877–88, and William Holman Hunt (1827–1910) in watercolours made in Italy in 1868. Two other artists who went through Pre-Raphaelite phases and were befriended by Ruskin, Alfred William *Hunt and Albert *Goodwin, devoted their mature careers to painting watercolours strongly influenced by Turner. For Edmund Gosse, Hunt was Turner's one Victorian heir, and Hunt's elaborately wrought watercolours probably do represent the most ambitious attempt by any artist to equal Turner's virtuosity in the medium. Goodwin painted in a sketchier manner modelled upon Turner's unfinished later drawings.

Turner's importance for *Whistler has often been asserted. Around 1855 Whistler did copy a chromolithograph of *Rockets and Blue Lights* (RA 1840; Clark Art Institute, Williamstown, Mass.; BJ 387), but in later life, perhaps out of hostility to Ruskin, his comments about Turner were consistently negative. Whistler's *Nocturnes* from the 1870s owed debts to Inchbold's Venetian pictures of the 1860s, which were influenced by Turner, but, while the *Nocturnes* may recall Turner's atmospheric and tonal effects, they are products of an aestheticizing denial of the natural world, which seems the antithesis of Turner's concerns. Nevertheless, for younger generations, Whistler stood for rejection of Pre-Raphaelite detail and elaboration. The rejection accompanied renewed appreciation of earlier English landscape painting and, by the end of the century, numerous claims about the importance of some English painting for *French Impressionism. In those claims, Constable rightly assumed

greater prominence than Turner, but the 'discovery' in about 1890 of watercolour sketches by the amateur Hercules Brabazon *Brabazon provided a Turnerian link. Brabazon, who painted some 400 free 'translations' after Turner, was hailed as his disciple, as England's best watercolour painter since Turner (according to D. S. *MacColl), and as an indigenous natural Impressionist.

Claude Monet (1840–1926) and Camille Pissarro (1830–1903) saw Turner's work in London in 1870, but the importance of that exposure for the development of Impressionism is now generally considered slight, contrary to assertions by MacColl and others. Nor, with one significant exception, were the Impressionists' main English followers directly influenced by either Constable or Turner. The exception was Philip Wilson Steer (1860–1942), who about 1893 began to imitate both, even basing subjects on sites depicted in Turner's *Liber Studiorum*. In doing so, Steer abandoned a precocious early style inspired by French art for a consciously conservative English one. By 1893 the once too radical Turner had become a respectable model.

Constable had greater influence than Turner upon 19th-century French painting, but the opposite was true in America. Turner conspicuously influenced two Philadelphia artists, James Hamilton (1819–78) and Thomas *Moran, who both gained sobriquets as 'the American Turner', but he was also important for another Philadelphian, William Trost Richards (1833–1905), and for the younger *Hudson River School 'Luminists', Sanford Gifford (1823–80) and Frederic *Church. The Americans initially knew and emulated Turner from engravings and reading Ruskin, but all made pilgrimages to London to study him at first hand. What they absorbed runs the gamut from subject matter (in Hamilton), to effects of light, colour, and atmosphere (particularly in Gifford and Church), and audacity and grandeur of vision (in paintings of Ecuador by Church and of the American West by Moran), sinking to pale imitation in late watercolours by Richards and Venetian views by Moran.

See also AUSTRALIAN ARTISTS. AS

Allen Staley, *The Pre-Raphaelite Landscape*, 1973.

J. Wilmerding *et al.*, *American Light: The Luminist Movement 1850–1870*, 1980, exhibition catalogue, Washington, National Gallery of Art.

Kathleen A. Foster, 'The Pre-Raphaelite Medium: Ruskin, Turner, and American Watercolour', in Brooklyn Museum, *The New Path: Ruskin and the American Pre-Raphaelites*, 1985, pp. 79–107.

Scott Wilcox and Christopher Newall, *Victorian Landscape Watercolors*, exhibition catalogue, New Haven, Yale Center for British Art, 1992.

Kenneth McConkey, *Impressionism in Britain*, exhibition catalogue, London, Barbican Art Gallery, 1995.

INTERIOR AT PETWORTH, see PETWORTH.

ISABEY, Eugène (1803–86), French painter of landscapes, marines, history and romantic genre subjects, the son and pupil of the renowned miniature artist Jean-Baptiste Isabey. He was on friendly terms with and much influenced by *Bonington and *Delacroix, and Turner's influence, probably through his prints, can be seen in some of his marines. Isabey paid several visits to England, and was there in 1825 at the same time as Bonington and Delacroix. He was one of the official artists at the court of *Louis Philippe, and painted many of the events in his reign. LH

ISLE OF WIGHT. Situated across the Solent off the south coast of England, the island was particularly popular with Picturesque artists and tourists from the 1790s onwards. Turner visited the island in 1795 and two related subjects were exhibited at the Royal Academy in 1796: *Fishermen at Sea* (BJ 1), which shows the rocks called the Needles in the background, and the watercolour of a picturesque subject, *Chale Farm* (private collection; W 142). Turner revisited the Isle of Wight in 1827, in connection with a commission to paint the seat of his friend the architect John *Nash. Two oils, both entitled *East Cowes Castle, the Seat of J. Nash, Esq.,* were exhibited at the RA in 1828 (Indianapolis Museum of Art, and Victoria and Albert Museum; BJ 242, 243). One, subtitled *the Regatta beating to Windward* (Indianapolis Museum of Art; BJ 242), shows a Royal Yacht Club race on a windy day, the other, subtitled *the Regatta starting for their Moorings* (Victoria and Albert Museum; BJ 243), is a calm sunset scene, recalling a Claudian seaport; *Watteau-esque figures crowd the shore on the right, giving an air of the *fête galante* to the depiction of genteel leisure. The compositions are similar to the pair of views of *Tabley*, (RA 1809; BJ 98, 99) in that the primary emphasis is upon the contrasting atmospheric conditions, while the house is relegated to the background. In the images of East Cowes, however, the house is even less prominent (as in the two paintings of Mortlake Terrace (see MOFFATT), RA 1826 and 1827; BJ 235, 239).

See also COWES SKETCHES; *MUSIC AT EAST COWES CASTLE.*

AK

ITALY. Like countless other British artists both before and since, Turner was deeply inspired by Italy: by the legacy of ancient *Rome, with its history, literature, and awe-inspiring monuments; by the glorious cities of *Florence and *Venice with their art and architecture of the Renaissance and the 17th century; by the intoxicating beauty of its landscape (most notably the countryside round Rome, the Roman *Campagna) and of its coast (especially the Bay of *Naples crowned by the peaks of the volcano *Vesuvius); and, last but not least, by Italy's brilliant light and colours.

Although he was in many ways a revolutionary artist, both Turner's art and thought were firmly rooted in tradition. From his earliest years, his education and artistic training were shaped by the civilization of Italy that had long dominated every aspect of British culture, and in his very last exhibited paintings he returned to one of his favourite themes, *Virgil's story of Dido and Aeneas, the founder of Rome (RA 1850; BJ 429–32; see *ÆNEAS RELATING HIS STORY TO DIDO*). But Turner could never have achieved the extraordinary feats of imagination, subtlety of colouring, and brilliance of light of his later years without first-hand experience of Italy itself on many occasions during his career. Of all his destinations in Continental Europe, Italy was not only the most distant but the most significant in artistic terms; and, just as it involved him in the longest and most arduous of his journeys, so, too, it provided him with the greatest rewards.

Despite the acknowledged importance of a visit to Italy, Turner was not able to visit Rome until 1819, when he was 44 and well established in his career. The outbreak of war with France in 1793 made travelling abroad either impossible or inadvisable for over two decades and, although he managed a Continental tour in 1802, during the Peace of Amiens, this took him no further into Italy than the Alpine towns of Courmayeur and Aosta. However, Turner did not lack opportunities to study Italy at second hand during his early years. As a student at the *Royal Academy Schools from 1789 onwards he began by learning to draw the human figure from plaster casts of the most famous sculptures of the ancient world, housed in the Vatican and Capitoline museums in Rome and in other Italian collections. He studied engravings and copies of celebrated Italian paintings and he heard lectures extolling Italian art by senior members of the RA including its first President, Sir Joshua *Reynolds. In the 1790s Turner also studied and copied Venetian views by *Canaletto and etchings of Roman buildings and antiquities by G. B. Piranesi in the collections of patrons such as Sir Richard Colt *Hoare of Stourhead, where he would also have seen a variety of other Italian works of art ranging from *Titian and *Reni to Salvator *Rosa.

Another important development in this period—perhaps even more crucial to Turner's future vision than seeing paintings by the revered Italian masters themselves—was that he became familiar with the work of landscape artists from northern Europe whose style and careers had been transformed by residence in Italy. He spent many winter evenings *c.*1794–8 at the house of Dr Thomas *Monro, copying Italian views by the watercolourist J. R. *Cozens. He became captivated by the work of *Claude Lorrain which had

already played a significant role in the development of the first major British landscape painter, Richard *Wilson.

After the return of peace in 1815 Turner did not immediately start planning a tour of Italy, hindered perhaps by diffidence, perhaps by existing commitments. However, each year of delay merely produced further pressure to make the long journey south. In 1817–18 he was commissioned to make a series of watercolours to illustrate James *Hakewill's *Picturesque Tour of Italy*; in 1818 the poet *Byron published the fourth canto of *Childe Harold's Pilgrimage* with memorable passages on Italy which were soon on everyone's lips. By 1819 it was clear Turner could tarry no longer and on 31 July he set forth. As usual he was well prepared for *travel, on this occasion being armed with one recent pocket guide-book (Reichard's *Itinerary of Italy*, 1818), a small notebook of memoranda and thumbnail sketches copied from well-known books on Italy ('Italian Guide Book' Sketchbook, TB CLXXII), and another filled with advice by Hakewill ('Route to Rome' Sketchbook, CLXXI). Turner's first tour lasted exactly six months overall, including the long journeys through France and Switzerland at either end. During this time he visited all the major cities and popular beauty spots of Italy, visiting Turin, Milan, Como, Venice, Bologna and Ancona on his way to Rome, which he probably reached by late September. He explored Tivoli and the Campagna on excursions from Rome soon after his arrival; Naples and southern Italy as far as Paestum on a tour in late October–early November; and finally Florence on his way home in December. He filled 23 sketchbooks with records and studies, on his travels mostly using pencil in small sketchbooks of about 5 × 7 in. (13 × 18 cm.), but also using colours in a few larger ones, up to about 10 × 16 in. (26 × 41 cm.), when he was settled in Venice, Rome, and Naples. He sketched and wrote notes on every type of subject: the countryside; cities and their buildings ancient and modern; art treasures in museums and galleries; Italian life with all its unfamiliar labours and recreations. He worked so intensively that there are few *witnesses to his activities, only one known extant letter from the tour, and few definite dates. His initial attempt at keeping a diary (in the 'Paris, France Savoy 2' Sketchbook, CLXXIII) petered out almost immediately. However, he was sighted in Naples by the son of John *Soane who reported to his father that Turner had brusquely refused another Briton the pleasure of his company on a proposed sketching expedition. It is known that he had contact in Rome with the great Italian Neoclassical sculptor Antonio *Canova, who took a party of visiting Britons (Turner, Sir Thomas *Lawrence, Francis *Chantrey, Thomas *Moore, and John Jackson) to observe drawing classes at two art academies on 15 November. He was elected an honorary member of the *Roman Academy of St Luke on 21 November. Regarding *disasters on his travels as yet more grist to his artistic mill, he commemorated the snowstorm which capsized his carriage in the *Alps and recorded its date, 15 January 1820; and he was back in London on 1 February.

Over the next nine years Turner's memories of Italy and his huge store of sketches inspired him to produce a steady stream of paintings and watercolours of the highest quality. However, none of the three large paintings—*Rome, from the Vatican* (RA 1820; BJ 228), The *Bay of Baiae* (RA 1823; BJ 230), and *Forum Romanum* (RA 1826; BJ 233)—found a purchaser. Of the watercolours, the first series (1820–1; W 402, 718–24; now in several public and private collections) were bought (and presumably commissioned) by his friend and patron Walter *Fawkes. The second series (c.1826–8; in CCLXXX, W 1152–76) were commissioned to be engraved as illustrations to the 1830 edition of Samuel *Rogers's poem sequence *Italy*; they thus reached a huge and appreciative public, including the young John *Ruskin, who received a copy of the book for his thirteenth birthday in February 1832 and became Turner's champion for life. While the Fawkes watercolours were factual and topographical in nature, those for Rogers were imaginative recreations of Turner's experiences and miraculously captured the spirit and grandeur of each scene in an unbelievably tiny format; in the published book some scenes are no more than 2 or 3 inches (5–8 cm.) high. Their delicacy and exquisite taste led to Turner receiving many further commissions for illustrations to *literature throughout the 1830s.

Turner's work on Rogers's *Italy* led his mind and his footsteps back to the south and he paid his second visit to Rome in 1828, again making it the destination of a tour that lasted six months (August 1828–January 1829). He now adopted a different route from that of 1819, travelling out via the south coast of France, Genoa, Florence, and Pisa, and went on to have a wholly different lifestyle in Rome itself. Here he shared rooms and a studio with his friend Charles *Eastlake at 12 Piazza Mignanelli, close to the Spanish Steps, and he devoted himself to painting in oils indoors (using canvases and other materials assembled for him by Eastlake) rather than travelling round Italy and making on-the-spot pencil sketches. It was the only occasion in his life when he is known to have worked in oils on canvas anywhere abroad. Also thanks to his association with Eastlake, Turner was far more sociable on his 1828 visit to Rome than he had been in 1819, mingling with artists of many different nationalities, and he even found time to write to friends and associates back home (Chantrey, Charles *Heath, George *Jones, Lawrence, Charles *Turner). Turner's Roman paintings in-

clude three large landscape studies (BJ 299–301) and three female nudes (BJ 296–8), an unusual subject for him but on this occasion prompted by his recent study of *Titian in the Uffizi and his visits to contemporary artists' studios in Rome. However, most of Turner's energies were directed towards producing three finished paintings which he exhibited in the city in December, shortly before his departure. These were *View of Orvieto* (BJ 292) and *Regulus* (BJ 294), both measuring some 3 × 4 ft. (*c.*90 × 120 cm.), and one of about 6 × 8 ft. (*c.*175 × 250 cm.), *Vision of Medea* (BJ 293). The first celebrates Turner's delight at the famous medieval hill town which he had recently seen for the first time on his journey to Rome; the second took a well-known episode from Roman history and set it in a luminous seaport after the manner of Claude; the third was inspired by the outstanding London performances of an Italian *opera—Mayr's *Medea in Corinto*—with the greatest Italian soprano of the age, Giuditta Pasta, in the title-role (see also ROMAN OIL SKETCHES).

Despite all these overt forms of homage to Italy, Turner's Roman exhibition was not a success; the paintings attracted much attention but critics and public alike were either hostile to them or simply perplexed. Another frustration for him was that when his paintings were sent home to London, they did not arrive in time for the RA in April 1829 and he had to produce substitute exhibits at short notice. A final endeavour that did not proceed as planned was the painting of an Italian landscape for the Earl of *Egremont. Turner had intended that an 8 ft. (250 cm.) work he began in Rome should be a companion piece to the Claude in the Earl's collection at Petworth, *Landscape with Jacob, Laban and his Daughters*. However, Lord Egremont decided not to acquire Turner's *Palestrina—Composition* (1828, RA 1830; BJ 295) and it remained in the artist's hands until 1844, when he sold it to another patron, Elhanan *Bicknell.

Turner's 1828 visit to Italy did not include a return to either Venice or the south and, wary of political instability in Europe around the time of the revolutions of 1830, he did not make another extensive Continental tour for several years. However, he did pay a visit to Venice in 1833, financed by his patron H. A. J. *Munro of Novar, who hoped for a Venetian watercolour in recompense. After travelling along the *Danube through *Austria, Turner crossed the Alps into Italy through the Brenner Pass. He carried on through Bolzano (Bozen), Trento, Verona, and Padua and is recorded as arriving in Venice on 9 September 1833; he probably stayed there for about a week, making small pencil sketches. In 1836 Munro financed another tour that reached into northern Italy, and this time himself accompanied Turner to the *Val d'Aosta. In 1840 Turner was in Venice for his third and probably final visit which was also his longest

so far; it lasted from 20 August to 3 September. During this time he painted many watercolour studies, including ones of *Venetian theatres, and his memories inspired a number of late Venetian paintings, both exhibited and unfinished. His outward journey took him through the Tyrol, where he made Bolzano the subject of two coloured sketches (Powell 1995, nos. 83–4). He avoided returning home from Venice through the Alps (which had caused major difficulties in 1829 as well as in 1820) and instead sailed to Trieste and then travelled by carriage to Graz and Vienna. In the early 1840s Turner made annual visits to *Switzerland, his tours taking him to Lake Maggiore and Lake Como in 1842 or 1843. The watercolour sketches inspired by this mountain scenery (see Warrell 1995, nos. 49, 50) are characterized by the same ethereal power as Turner's sketches of Switzerland made on the same tours.

Italy influenced Turner's art at every level and throughout his life in a way that no other country did, including his own homeland. The visible splendours of its dazzling skies, sparkling water, and sun-burnished buildings fostered the luminosity, heightened range of colour, and golden tone of his maturity and late career, making his vision personal and unique. Prolonged first-hand study of the Italian Old Masters with their sublime themes and rich colouring provided him with new revelations and challenges. The wealth of associations that enrich every step of a journey through the cities and countryside of Italy inspired him with many *classical, *historical, *literary, and *contemporary subjects in which past and present are blended or contrasted in a nostalgic or moralizing way. Grandeur is followed by ruin and decay, but, on the other hand, the oppression and intolerance of the ancient world are replaced by greater liberty and enlightenment. In the 1830s Turner painted Italian scenes and themes on a variety of pretexts, but in the ultimate analysis it mattered very little whether his declared point of departure was a Roman emperor, as in *Caligula's Palace and Bridge* (RA 1831; BJ 337), or a modern poet, as in *Childe Harold's Pilgrimage—Italy* (RA 1832; BJ 342), or ancient myth and legend, as in *The *Golden Bough* (RA 1834; BJ 355). For Turner, as for so many other travellers to Italy, its landscape and ruins, like its pearly dawns and fiery sunsets, are the perfect embodiment of the cycle of rise and decline that are the lot of every individual and every civilization. CFP

Ashby 1925.
Finberg 1930.
George 1971.
Gage 1980, pp. 80–1, 118–32.
Stainton 1985.
Powell 1987.

J

JACOB'S LADDER, see *VISION OF JACOB'S LADDER*.

JESSICA, oil on canvas, 48 × 36 in. (122 × 91.5 cm.), RA 1830 (226); Tate Gallery, London, and the National Trust (Lord Egremont Collection), Petworth House (BJ 333). The twentieth and final oil bought by Lord *Egremont, perhaps as a substitute for *Palestrina* (BJ 295).

Exhibited with the words: 'Shylock—"Jessica, shut the window, I say"', which does not occur in Shakespeare's *The Merchant of Venice* although other lines have been proposed as running through Turner's mind. Ziff has suggested that Turner may have remembered *Rogers' Italy, which mentions 'a Jessica . . . at her half-open window'. Turner is here reinterpreting *Rembrandt, who painted several pictures of girls at windows, while *Jessica*'s jewel-like colours recall Rembrandt's *Jewish Bride* (Rijksmuseum, Amsterdam).

Jessica was greatly abused at the Royal Academy: *Wordsworth said, 'It looks to me as if the painter had indulged in raw liver until he was very unwell,' while the *Morning Chronicle* (3 May) thought it showed 'a lady getting out of a large mustard-pot'. EJ

Ziff 1980, pp. 166–71.
Gage 1984, p. 105.
Butlin, Luther, and Warrell 1989, pp. 55, 89–90, 92, repr. in colour, fig. 92.
Wilton 1989, pp. 14–20, 26–7.
Wilton 1990, p. 56.

JOHNS, Ambrose Bowden (1776–1858), Plymouth landscape painter and contemporary of Turner. Johns was at the centre of that circle of artists and amateurs who befriended Turner on his visits to *Devon in the 1810s. Johns made oil sketches from nature and was instrumental in encouraging Turner's production of oil sketches at Plymouth in 1813, accompanying him to local sketching grounds with pre-prepared equipment. His teaching inspired B. R. *Haydon, Samuel Prout, and Edward Calvert's student work at Plymouth, and he was closely involved with the emergence of the city as a provincial centre of art. Johns owned a version of *Girtin's *White House at Chelsea* and later acted as John Linnell's agent in promoting sales of Blake's *Job* in Devon. Thanks to Johns and others' welcome at Plymouth, Turner lent *Fishing upon the Blythe-Sand* (Turner's gallery 1809; BJ 87) and *Jason* (RA 1802; BJ 19) to the first Plymouth Institution exhibition in 1815. Johns worked predominantly in a poetic and classical idiom, and his work was sometimes confused with Turner's, which apparently ended their friendship. In fact, although Turner still seems to have valued Johns's friendship into the 1820s, his artistic maturity was incomprehensible and threatening to the Plymouth artist's more timid explorations of landscape. SS

George Pycroft, *Art in Devonshire*, 1883, pp. 77–81.
Julian Faigan, *Ambrose Bowden Johns, Family and Friends*, exhibition catalogue, City of Hamilton Art Gallery, Victoria, Australia, 1979.
Smiles 1987, pp. 11–14.

JONES, George (1786–1869), painter of battle scenes and historical subjects. He was a close friend of Turner, and writer of an important memoir (reprinted in Gage 1980, pp. 1–10). The son of the mezzotint engraver John Jones, he was a student at the *Royal Academy from 1801 and exhibitor at the RA from 1803 and at the British Institution from 1807. In his early work, he was quick to seize fashionable literary sources, becoming among the first to illustrate new works by *Scott and *Byron (see Brown 1992, nos. 10–14), at the same time developing a taste for more obscure classical subjects. Alongside his artistic pursuits, he was involved in the military, joining the South Devon Militia, and was later a captain of the Montgomeryshire Militia. In 1815 he was part of the army of occupation in Paris. Though he did not serve at Waterloo, he became closely associated with the battle, not least because he was said to resemble the Duke of *Wellington (though the Duke claimed never to have been mistaken for Mr Jones), but chiefly because he was a joint winner (with James Ward) of a competition mounted in 1816 by the BI for a picture to celebrate the famous victory. He went on to repeat the subject on numerous occasions, and also published a book on the battle (1817).

In 1822 he received a commission from *George IV for two battlepieces as part of the scheme to decorate the public rooms at St James's Palace, and it may have been through this project that he came to know Turner. As well as the King, they had many patrons in common, including *Leicester, *Egremont, and *Soane, for whom Jones painted the *Opening of New London Bridge, 1831*, which includes an incidental portrait of Turner. The two men were both keen fishermen, a passion they shared with their mutual friend *Chantrey, the subject of a biography by Jones (1849). They also shared a deep respect for the RA, where Jones was later to serve as Librarian (1834–40), Keeper (1840–50), and with Turner as acting President during the illness of *Shee (1844–50). By 1831 Turner had nominated Jones as a trustee of his proposed charitable institution, and as one of his executors.

In later life, Jones was a respected figure of the London art world. It was he who encouraged Robert *Vernon to buy Turner's work, and thereafter acted as Vernon's chief adviser. He was also present on the occasion that *Ruskin was first introduced to Turner in 1840. Throughout his life he travelled extensively, covering very similar ground to Turner: his sketches are now dispersed between the Ashmolean Museum, Oxford, the Fitzwilliam Museum, Cambridge, and the Tate Gallery. As one of Turner's executors, his signature of endorsement can be found in many of the sketchbooks in the Bequest. The small oil pictures he produced after Turner's death are apparently the only visual records of the interior of Turner's gallery and of his funeral (Ashmolean Museum, Oxford).

Professionally there was a jocular rivalry between the two, most famously resulting in their exhibits in 1832 of pictures on the subject of the *Shadrach, Meshech and Abednego in the Burning Fiery Furnace* (BJ 346; both now in the Tate Gallery) and in their parallel attempts in 1842 to commemorate the death of *Wilkie (see PEACE—BURIAL AT SEA, BJ 399; Jones's picture is now untraced). IW

Hichberger 1983, pp. 14–20.

JONES, Walter H., collector of Turner watercolours. His outstanding collection of drawings included *West Entrance of Peterborough Cathedral* (RA 1795; Peterborough City Museum and Art Gallery; W 126), *Ludlow Castle* (1800; Barber Institute of Fine Arts, University of Birmingham; W 265), *Aysgarth Force* (1817; private collection; W 570), *Mainz and Kastel* (c.1820; private collection; W 678), *Cologne from the River* (Cooke's Gallery 1822; Seattle Art Museum; W 690), *Cascade of Terni* (c.1817; Blackburn Museum and Art Gallery; W 701), *Shoreham* (c.1830; Blackburn Art Gallery and Museum; W 883), *Barnard Castle* (?c.1825; private collection; W 890), *Schloss Eltz on the Moselle* (?1844; private collection; W 1333), *Venice: The Mouth of the Grand Canal* (1840; Yale Center for British Art, New Haven; W 1360), *Looking towards Brunnen* (?1840s; Hinderton Trust, Wirral; W 1517), *The Blue *Rigi* (1842; private collection; W 1524), and *The Red Rigi* (1842; National Gallery of Victoria, Melbourne; W 1525). These passed to his wife on his death; her sale was at Christie's, 3 July 1942. RU

JUDKIN, the Revd Thomas J., the first recorded owner of Turner's *The Evening of the Deluge* (c.1843, National Gallery of Art, Washington; BJ 443). This is a variant of *Shade and Darkness—Evening of the Deluge* (RA 1843; BJ 404; see LIGHT AND COLOUR; REPLICAS AND VARIANTS). Judkin was a friend of *Constable, and seems to have been acquainted with Turner as well, featuring in a number of anecdotes related by *Thornbury (e.g. 1862, i. pp. 223, 316–17). One of these involves Turner refusing to pay his fare on an omnibus. RU

JULIET AND HER NURSE, oil on canvas, 36½ × 48½ in. (92 × 123 cm.), RA 1836 (73); Sra. Amalia Lacroze de Fortabat, Argentina (BJ 365). Of all Turner's works this, one of his most visionary views of Venice, had the most far-reaching effects, for it was the criticism that *Juliet* attracted at the Royal Academy that caused the 17-year-old *Ruskin to rush to Turner's defence. This defence, although unpublished at the time, was later expanded into the five volumes of *Modern Painters* (1843–60). These established Ruskin as the most influential critic of his time while also giving a considerable boost to Turner's reputation.

This criticism was certainly partly due to Turner transferring Juliet to Venice from Verona where *Shakespeare had set the scene. However, at the RA not all reviews were hostile: the *Morning Post* (25 May) described it as 'one of those magical pictures by which Mr Turner dazzles the sense and storms the imagination', while the *Spectator* (28 May) considered it and *Mercury and Argus* (National Gallery of Canada, Ottawa; BJ 367) 'visionary and poetical, but Turner's dreams are finer than the waking moments of many, for, in spite of his exaggerations, he cannot forget nature'.

The *Literary Gazette* (4 February 1837) could not discover Juliet and her nurse until coming across them 'perched, like sparrows, on a house-top' while *The Times* (6 May) disbelieved the subject: 'Shakespeare's Juliet! Why it is the tawdry Miss Porringer, the brazier's daughter of Lambeth and the Nurse is that twaddling old body Mrs MacSneeze who keeps the snuff-shop at the corner of Oakley Street', and, in a second review (11 May), compared Turner's work unfavourably with *Callcott's picture of Murano.

But the harshest criticism appeared in *Blackwood's Magazine* (October 1836) written by the Revd John Eagles (1783–1855) of Wadham College, Oxford, who considered the picture 'a strange jumble . . . confusion worse confounded':

It is neither sunlight, moonlight, nor starlight, nor firelight . . . the scene is a composition as from models of different parts of Venice, thrown higgledy-piggledy together, streaked blue and pink, and thrown into a flour tub. Poor Juliet has been steeped in treacle to make her look sweet, and we feel apprehensive lest the mealy architecture should stick to her petticoat and flour it.

It was this notice that raised Ruskin to the height of 'black anger', whereupon he wrote an answer to *Blackwood's*. On his father's advice he sent it first for approval to Turner who, however, in a kind letter, advised against sending it as 'I never move in these matters. They are of no import save mischief and the meal tub which Maga [*Blackwood's Magazine*] fears for by my having invaded the flour tub.' He then asked permission to send the manuscript to *Munro of Novar, who had bought the picture, and this was granted.

Ruskin's reply to *Blackwood's*, published in the Library Edition of Ruskin's *Works* (iii. pp. 635–40), in which he claimed that Turner's imagination was 'Shakespearean in its mightiness', was thus the beginning of his lifelong championship of Turner. The publication of the first volume of *Modern Painters* in 1843 certainly led to increased interest in Turner's work among collectors, resulting in a number of important sales in 1844. EJ

K

KEELMEN HEAVING IN COALS BY NIGHT, oil on canvas, 35½ × 48 in. (90.2 × 121.9 cm.), RA 1835 (24); National Gallery of Art, Washington (BJ 360); see Pl. 24. Signed: 'JMWT' on the buoy. This rare night scene is based on the watercolour *Shields on the River Tyne* (British Museum; W 732), dated 1823, but the oil has a greatly increased sense of space.

It was painted for the Manchester merchant Henry *McConnel as a *companion to his *Venice* (National Gallery of Art, Washington; BJ 356) exhibited in 1834. The pair contrast Venice, a city declining in power but shown here nevertheless *en fête*, with the English working even at night, as Turner implies they need to do in order to maintain Britain's industrial supremacy and thus avoid the fate of Venice.

On going abroad, McConnel sold both pictures to John *Naylor and then, on his return, tried unsuccessfully to buy them back. At the Royal Academy the reviews were mixed, but more than one criticized the sky for being too blue for a night scene. EJ

KEEPSAKE, THE, a Christmas annual, launched by Charles *Heath in 1827. Heath ran into financial difficulties, editors and proprietors changed, but it ran until 1856. Annuals, miscellanies of prose and verse, were the coffee-table or 'boudoir' books of their day. With many aristocratic contributors this was the superior series, selling at a guinea rather than 12s. Lamb, George Eliot, and *Thackeray mocked the productions; *Scott wrote of the 'uncommon splendour' of the engravings. Turner (Gage 1980, p. 138) seemed dismayed at appearing in annuals, but as Alaric *Watts observed, he reached a vast public who had not seen his large prints; from 1828 to 1837 seventeen plates after Turner were published in the *Keepsake* (R 319–35).

Italian scenes originally intended for Heath's unpublished *Picturesque Views in Italy* were now accompanied by commissioned texts: a story by Mary Shelley for *Lake Albano* (private collection; W 731; R 320), figuring Turner's bandit, hunter, and *contadina*, and a vapid poem praising Turner by Southey, the Laureate, for *Lago Maggiore* (private

collection; W 730; R 321). Other Continental scenes have commentary by Leitch *Ritchie or others, a poem by Miss Landon, or an ardent romantic story. Caroline Norton wrote a poem to accompany *Destruction of both Houses of *Parliament by Fire* (private collection; W 1306; R 332). The pair of images of *Virginia Water* (private collections; W 519–20; R 322–3) was painted by Turner for George IV, who did not buy them. Three sea-disaster vignettes (private collections; W 1303–5; R 333–5) illustrate details of the stories; in *Fire at Sea* young women in night attire escaped from a fire on an Indiaman in a sinking cuddy.

Andrew Wilton has pointed out that the publication in the *Keepsake* of examples of historical genre by artists such as George Clint, C. R. *Leslie, William Linton, and especially *Bonington seems to have influenced certain of Turner's works in the 1820s and early 1830s such as *What You Will!* (RA 1822; private collection; BJ 229), *Rembrandt's Daughter* (RA 1827; Fogg Art Museum, Cambridge, Mass.; BJ 238), *Boccaccio relating the Tale of the Birdcage* (RA 1828; BJ 244), *Jessica* (RA 1830; Petworth House; BJ 333) and some of the interiors associated with *Petworth. JRP/MB

Lyles and Perkins 1989, pp. 63–5.

Wilton 1989.

Lyles 1992, pp. 42–3.

Piggott 1993, pp. 51–2, 91, 100.

Warrell 1999, pp. 65–6, 104–5, 215–16.

KILGARRAN CASTLE ON THE TWYVEY, *Hazy Sunrise Previous to a Sultry Day,* oil on canvas, 36 × 48 in. (92 × 122 cm.), RA 1799 (305); National Trust (on loan to Wordsworth House, Cockermouth) (BJ 11). Turner visited Cilgerran (as it is now spelled) in 1798, perhaps after seeing *Wilson's picture of the subject (repr. Constable 1953, pl. 30a) or an engraving of it.

The 'Hereford Court' Sketchbook (TB XXVIII) contains a study for the oil on page 88 while a watercolour version of *c*.1798–9 is in the City Art Gallery, Manchester (W 243).

Four other views of Cilgerran exist: one, identical to the Royal Academy picture, is, despite a *Munro of Novar provenance, almost certainly an early copy (private collection,

England; BJ 550). The other three compositions are smaller and all differ; one, ex-*Gillott collection, which may precede the RA picture although not accepted by Herrmann, is in the Leicester Art Gallery (BJ 37). Lord Allendale's version (BJ 36) is so closely linked to a composition by William Havell (1785–1858) in the National Museum of Wales that its status remains unclear until it is cleaned. The last, BJ 541, is untraced, having been exhibited last at the Guildhall, 1899 (5), when it was accepted by both *Bell and *Armstrong.

EJ

R. B. Beckett, '"Kilgarran Castle": A Link between Turner and Wilson', *Connoisseur*, 120 (September 1947), pp. 10–15.

KINGSLEY, the Revd William (1815–1916), friend of Turner and *Ruskin, and collector. Kingsley, of Sidney Sussex College, Cambridge, was the source, usually via Ruskin, of much anecdotal information about Turner. Kingsley went up to Cambridge in 1834, and possibly first met Turner about 1845. According to Ruskin, Turner told Kingsley that he had learnt more from *Watteau than from any other painter. A letter Ruskin wrote to Kingsley provides dating for Turner's *Self-Portrait* (c.1793; Indianapolis Museum of Art, Indiana; BJ 20; see PORTRAITS). Ruskin also relayed a story—possibly apocryphal—which Kingsley told him about *Snow Storm—Steam-Boat off a Harbour's Mouth* (RA 1842; BJ 398). Turner told Kingsley he had depicted an actual event during which he had been lashed to the mast of a ship.

Kingsley made notes on Ruskin's drawings collection in 1878 (published 1904). In these, he spoke of Turner's weakening powers, attributing the artist's condition to his loss of teeth and his inability to use the false teeth made for him by Cartwright. Kingsley said Turner's digestion suffered and forced him to take recourse in alcohol. An unpublished letter from Kingsley to Ruskin written in April 1872 corroborates this (see HEALTH). He was one of the mourners at Turner's funeral.

Kingsley was the owner of *Distant View of Lowther Castle* (1809; Ashmolean Museum, Oxford; W 524), *Prudhoe Castle, Northumberland* (c.1826; British Museum; W 798), *Dawn after the Wreck* (c.1841; Courtauld Institute of Art; W 1398), and *Falls of the Rhine, Schaffhausen* (?1841; Courtauld Institute of Art; W 1462). The Kingsley sale was held at Christie's on 14 July 1916. TR

Finberg 1961, pp. 390, 416, 437–9.
Whittingham, 1985², p. 47, no. 129.

KNIGHT, John Prescott (1803–81), portrait and subject painter who succeeded Turner at the *Royal Academy as Professor of Perspective (see PERSPECTIVE LECTURES) in 1837. He also served with Turner on the Academy Council 1845–6 and the Hanging Committee 1845. A note from

Turner, dated 1846, apparently requests Knight's assistance in securing RA pensions for two artists' relatives (Gage 1980, p. 215). In 1856, together with *Eastlake, he sifted the pictures remaining in Turner's studio, deciding which were by his hand and, therefore, to be included in the Bequest.

ADRL

KNIGHT, Richard Payne (1751–1824), collector, philologist, numismatist, connoisseur, poet, philosopher, and Greek scholar. A keen collector of Old Master paintings, as well as drawings and paintings by British artists, he commissioned Turner's *The Unpaid Bill, or the Dentist reproving his Son's Prodigality* (RA 1808; private collection, USA; BJ 81), possibly to hang with *Rembrandt's *The Cradle* (now called *The Holy Family*, Rijksmuseum, Amsterdam) or, more plausibly, as a pendant to the *Alchemist's Laboratory* (now attributed to Gerard Thomas, but at that time to David *Teniers the Younger).

Payne Knight's grandfather was a Herefordshire industrialist whose second son, Thomas, was domestic chaplain to Francis, Lord Deloraine. Thomas married a milkmaid, Ursula Nash, and lived at Wormsley Grange in Herefordshire. Their first child was Richard Payne Knight. Eminent in many fields, Richard Payne Knight suffered from poor health as a child and was mainly self-educated. He made the Grand Tours to France and Italy in 1772 and 1773, and in 1776 toured Switzerland with the painter John Robert *Cozens. He travelled to southern Italy and Sicily the following year, interested chiefly in Greek remains. In 1781 Payne Knight was elected to the Society of Dilettanti, a dining club for cultivated gentlemen who had travelled to Italy. He completed for the Dilettanti Society the first volume of the folio *Specimens of Antient Sculpture Selected from Several Collections in Great Britain*, with illustrations of masterpieces in the collections of Payne Knight and Charles Townley. Payne Knight was among those most responsible for the successful negotiations to leave Townley's collection of ancient art to the British Museum. He was appointed a Trustee of the British Museum in 1814, with the result that he decided to bequeath his own collection to that institution. His collection was housed in the museum and library at his house at 3 Soho Square, which was built to be safe from fire. His country house, Downton Castle, near Ludlow, was architecturally significant. In 1794 he published *The Landscape*, an attack on the landscape gardening style of 'Capability' Brown. His *Analytical Inquiry into the Principles of Taste* was published in 1805. His controversial advice to the Government not to buy the Elgin Marbles added fuel to an attack on Payne Knight for his reverence of Old Masters. The attack, published in 1815 in an anonymous

pamphlet entitled *A Catalogue Raisonné of the Pictures now Exhibiting at the British Institution*, included a defence of Turner. TR

Finberg 1961, pp. 221–5.
Clarke and Penny 1982.

KNOCKHOLT SKETCHES. A group of ten small sketches in oil and mixed media on sized paper (BJ 35a–j) associated with visits to the village of Knockholt in Kent, *c.*1799–1801. The majority depict woodland scenes but three are of interiors or furniture. Five (BJ 35e–i) bear inscriptions linking them with Knockholt and other places nearby, while three (BJ 35a–c) show beechwoods in autumn suggesting a connection with the note in *Farington's *Diary* (30 October 1799) that Turner 'Has been in Kent painting from Beech Trees'. The group as a whole has been associated with Turner's visits to his friend W. F. *Wells at his Knockholt cottage. However, Wells did not move into it until 1801, so that the work described by Farington must have been done in other circumstances or company— perhaps on visits to another friend, Henry Fly, curate of the village church of St Katherine. Whatever their exact date, the Kent subjects represent Turner's first sustained attempt at outdoor sketching in oils, perhaps encouraged by similar experiments by William *Delamotte. They tend to an unaffected naturalism that anticipates the later *Thames sketches, though the gipsy figures included in two of them show the impact of the Picturesque (see SUBLIME), and there may also be an echo of woodland subjects by *Gainsborough, whose drawings Wells collected and engraved. In the following years Turner became a frequent visitor to Wells's cottage; other artist visitors in this period included Joshua Cristall, William Alexander, Robert Ker *Porter, and John Byrne.

See also OPEN AIR, WORKS IN. DBB/AK

D. Chittock, 'Detective Work at Knockholt', *Turner Society News*, 5 March 1977, pp. 92–4.
Brown 1991, pp. 17–18, 45–7.

KOCH, Josef Anton (1769–1839), Austrian landscape painter, resident in Rome during Turner's second visit to the city of 1828–9. Koch was one of the leading Continental advocates of an elevated style of landscape that challenged the Academic hierarchy of genres. Although their ambitions might seem broadly comparable, Koch was repelled by the pictures Turner exhibited in Rome, which included *Regulus* (BJ 294) and the *Vision of Medea* (BJ 293). They appeared to him and his circle of German painters as idiosyncratic and perverse. In his *Kunstchronik* (1834) he described *Medea* as incomprehensible, whichever way it was hung—a remark which becomes a commonplace of later Turner criticism. BV

L

LADY LEVER ART GALLERY, Port Sunlight, see LIVER-POOL.

LAHEE, James (fl. 1810–52), copper-plate printer, with a workshop in Castle Street, off Oxford Street in London, who was used by Turner for the printing of plates of the *Liber Studiorum*. A brief note from Lahee to Turner, dated 'Feby 2nd 1811', records his sending pulls of two plates from Part V (F 23 and 25) to Turner, who recorded a payment to Lahee on the first page of the 'Hastings' Sketchbook (TB CXI). Lahee formed a celebrated collection of proofs of the *Liber*, which he sold to Thomas *Lupton in 1852 for 200 guineas, and which is now in the John Rylands Library, Manchester. LH

LAKE AVERNUS: AENEAS AND THE CUMAEAN SIBYL, see CARTHAGE.

LAKE DISTRICT, a mountainous region in the north-west of England, and a destination for Picturesque tourists from the 1760s onwards (see SUBLIME). It was described by numerous authors, including Thomas Gray (1775) and William *Gilpin (1786), and was generally agreed to unite '*beauty, horror* and *immensity*' (Dr John Brown, 1767). Turner first visited the area in 1797, during his tour of the North. This visit provided subject matter for two oils, *Morning amongst the Coniston Fells, Cumberland* (BJ 5) and *Buttermere Lake, with part of Cromackwater, a Shower* (BJ 7), both exhibited at the Royal Academy in 1798, and for a number of watercolours. Turner made sketches in and around the popular tourist locales, but invariably selected his own viewpoints, rather than the standard recommended ones. Likewise, David Hill has been unable to connect any of Turner's subjects with specific passages in the contemporary topographical and picturesque literature (1996, p. 8). Turner may have depended more upon the recommendations of fellow artists like Joseph *Farington, to whom he presented a watercolour entitled *Head of Derwentwater with Lodore Falls* (private collection; W 282) in 1801. This may have been in large part a study from nature, painted on his return from Scotland in that year (Hill 1996,

pp. 106–8). A related, almost-complete watercolour of the subject from 1797 (TB XXXVI: H) is close to *Girtin in its dramatic evocation of the Sublime forms of mountain, lake, and cloud. Indeed, larger traces of human presence, such as towns, or the antiquities that he focused on in *Yorkshire and Co. *Durham in 1797, are suppressed or excluded in these early images of the Lakes. Turner was, however, attentive to the Lake District as a working landscape, although it is arguable that the corn mill and bark mill at *Ambleside* (RA 1798; University of Liverpool; W 237) are depicted as picturesquely flimsy in comparison to the mountainous sublimities above them (Hill 1996, p. 130).

Later watercolours of the area are less faithful to the topography. An instance would be the view of *Windermere* (1821; W 555) made for Walter *Fawkes, which is none the less convincing in its portrayal of sunny, breezy weather, such as a tourist out on the lake might experience. The view of Windermere at sunset in *Picturesque Views in *England and Wales* (c.1835–6; City Art Gallery, Manchester; W 874) is much more explicit in its representation of tourism— boats throng the lake while 'On the shore the less affluent gather to enjoy the spectacle' (Hill 1996, p. 132). Turner may have revisited this spot on his travels from Kendal to Keswick in 1831 to collect material for his illustrations to the works of *Scott. By contrast, the view of Ullswater on a warm evening (c.1833–4; W 860), in the same series, is devoid of tourists, the foreground being populated instead by female bathers and by cattle. Shanes (1990[2], p. 239) suggests that the bathers could equally well be milkmaids or naiads; Hill (1996, p. 124) argues that their 'nakedness seems . . . waifish' and that we are meant to reflect on the presence of poverty amid so much scenic beauty. AK

Wilton 1980, pp. 35–6.
Hill 1996, pp. 2, 5–8, 103–37, 181–3, 187.

LANCASHIRE, a north-western English county. Turner sketched in and around Lancaster, the picturesquely situated county town, on his 1797 tour of the North. In 1799 he toured further south, in Ribblesdale, in connection with a

commission to illustrate the Revd Dr T. D. *Whitaker's *History of Whalley* (1800–1). In 1808 he again toured Ribblesdale, one result of which was the oil *Whalley Bridge and Abbey, Lancashire: Dyers washing and drying Cloth* (RA 1811; Loyd Collection, on loan to Ashmolean Museum, Oxford; BJ 117). This painting may originally have been commissioned by Thomas Lister *Parker of nearby Browsholme Hall. Here, industrial drying is carried on in what is otherwise a scene of classical serenity. Lancashire, like *Yorkshire, was a cradle of the Industrial Revolution, but Turner never expressed this with a panorama of Liverpool or Manchester or any other industrial town, as he did for Yorkshire with his view of Leeds (1816; W 544). None the less, several Lancashire watercolours depict the circulation of people and goods that was held by economists to be the basis of a commercial nation. These works derive from the northern tour of 1816, undertaken in connection with Whitaker's *History of *Richmondshire* (see Hill 1984). Two watercolours show people and stagecoaches hurriedly negotiating Lancaster Sands at low tide (c.1826; W 803, *Picturesque Views in *England and Wales*; also W 581, of c.1818). There is also a view of Lancaster as seen from John Rennie's impressive canal aqueduct over the river Lune (c.1825, *England and Wales*; W 786; see CANALS), in which the modern transportation route, with its barge traffic, gives a novel viewpoint of the countryside below. Turner's views of the upper Lune valley for the *History of Richmondshire*, however, represent it as a quasi-paradisiacal realm, neither too desolate nor too cultivated, and untouched by industry.

AK

LANCASTER, the Revd Thomas, cleric and Turner collector. Lancaster was Perpetual Curate of Merton in Surrey from 1801 to 1827. He was the first owner of Turner's *Newark Abbey* (c.1807–8; formerly Loyd Collection; BJ 201). There appear to be two references to him in Turner's sketchbooks. On the back of a view of *Conway Castle in the 'Hereford Court' Sketchbook (TB CCCVIII: 52) Turner wrote 'Revd Mr. Lancaster, 45 Gower Street'. In his 'Academies Sketchbook' (LXXXIV: 66v.) Turner notes that he has painted a small view of Conway for 'Rd. Mr Lancaster'. RU

LANDSEER, Sir Edwin (1803–73), one of John *Landseer's three artist sons. He studied in the Royal Academy Schools and also under B. R. *Haydon. Like Turner before him and then J. E. Millais (1829–96) after, Landseer showed youthful brilliance that was early on seen as hugely important for the future of the British School: all three became ARAs at the earliest age possible (24 years). Landseer went on to become the most famous animal painter of his time with his *The Monarch of the Glen* internationally known

through its use on a whisky bottle label and his portrait of Prince Albert's greyhound *Eos* one of the very best of all dog portraits. According to Frederick Goodall, Landseer applied the black dog, as a paper cut-out, to *Mortlake Terrace, Summer's Evening* (RA 1827; National Gallery of Art, Washington; BJ 239; see MOFFATT). Turner's example on *Varnishing Days led Landseer to describe him as 'the best teacher I ever met with' (quoted in Gage 1969, p. 172) and on one such occasion in the 1840s he made two slight sketches of Turner at work (see PORTRAITS OF TURNER). Landseer was buried near Turner in St Paul's Cathedral. RH

Richard Ormond, Joseph Rishel, and Robin Hamlyn, *Sir Edwin Landseer*, exhibition catalogue, Philadelphia Museum of Art and London, Tate Gallery, 1981.

Walker 1983, p. 30.

LANDSEER, John (1769–1852), engraver, occasional landscape painter, and author. Trained by William Byrne, John Landseer was one of the least productive but most vocal engravers of his day, especially in the struggle for proper recognition by the *Royal Academy, of which he was elected an Associate in 1806, though he never became a full Member. In 1804 he gave a series of three lectures on engraving at the Royal Institution in London, and he was invited to give a second series in the winter of 1805–6, when he delivered lectures on engraving (published as *Lectures on the Art of Engraving* in the following year), in which he presented a strong case for raising the status of the engraver and his art. However, the lectures were stopped after his notorious attack on the print-publisher Alderman Boydell in the sixth lecture. After this setback Landseer devoted much of his time to the encouragement and training of his three artist sons, the most successful of whom was Edwin, the animal painter. Landseer also developed a growing interest in archaeology.

Landseer and Turner were close neighbours in London, but little is known about their relationship, and Landseer engraved only two published plates after Turner, the dull *Cascade of Terni* (R 145) for *Hakewill's *Picturesque Tour of Italy* in 1819, and the equally uninspiring *High Force or Fall of the Tees* (R 173) for Dr. *Whitaker's *Richmondshire* two years later. Much more important were Landseer's critical writings about Turner, most notably his review of the 1808 exhibition in *Turner's gallery, in the second of the four issues of his short-lived *Review of Publications of Art* (reprinted in Herrmann 1987, pp. 27–33). This informative review provides the most detailed description that we have of any of the exhibitions in Turner's gallery, and proves Landseer to have been one of the most perceptive critics and admirers of Turner's work. The appreciative tone is set by the opening paragraph:

In the Exhibition which Mr Turner thus liberally throws open to the eye of the public, the genuine lover of Art, and the faithful observer of Nature in her broader purposes, will find himself very highly gratified. The shew of landscape is rich and various, and appears to flow from a mind clear and copious as that noble river on whose banks the artist resides, and whose various beauties he has so frequently been delighted to display.

Landseer himself occasionally painted and drew landscape, and his comments on Turner's 1808 paintings reveal his close knowledge of the problems and challenges facing the landscape artist. He particularly emphasizes the poetic qualities of Turner's work, and his mastery of colour and light. A footnote in the review provides the only surviving contemporary reference to the otherwise lost 'Prospectus' for Turner's *Liber Studiorum, of which the first plates had been published in 1807, and its proposed 'classification of the various styles of landscape, viz. the historic, mountainous, pastoral, marine, and architectural'.

Just over thirty years after his 1808 review the elderly Landseer again took up his pen to write about Turner's work. In 1839 he launched the *Probe*, another short-lived critical review largely written by himself, which included reviews of the 1839 and 1840 RA summer exhibitions. These were vintage years for Turner, in which his exhibits included *The *Fighting 'Temeraire'* (National Gallery, London; BJ 377) and *Slavers* (Boston Museum of Fine Art; BJ 385). Landseer's comments (all of which are reprinted in Herrmann, 1987[2], pp. 21–8) were again largely laudatory and very perceptive, particularly stressing the 'poetry' of Turner's later canvases. They comprise the most telling discussion of the later work of Turner recorded by a fellow artist of his own generation, but have been largely forgotten until recent times.

Nothing is known about Turner's own reactions to his neighbour's reviews, but it has been suggested by John Gage ('Turner and John Landseer: Translating the Image', *Turner Studies*, 8/2, winter 1988, pp. 8–12) that in his almost lifelong involvement with engraving the painter was strongly influenced by Landseer's Royal Institution lectures and by the engraver's constant battle for the status of his art within the RA. In his lectures, of which he presented a copy to Turner, Landseer stated:

Engraving is no more an art of *copying* Painting than the English language is *an art of copying* Greek or Latin. Engraving is a distinct language of Art: and though it may bear such resemblance to painting in the construction of its grammar, as grammars of languages bear to each other, yet its alphabet and idiom, or mode of expression, are totally different.

Gage argues convincingly that the importance of engraving for Turner, expressed especially in his *Liber Studiorum*, owed much to the influence of Landseer's 'political' activities on behalf of the art of engraving. LH

Herrmann 1987, pp. 26–33, and 1987[2], pp. 21–8.

LASCELLES, Edward, senior (1740–1820) and **junior** (1764–1814), father and eldest son, of Harewood House, Yorkshire, and Hanover Square, London, can be counted among the more important of Turner's early patrons. Edward sen. inherited the Harewood estates and fortune in 1795 and in the following year was created Lord Harewood. In 1812 he became first Earl of Harewood, whereupon Edward jun. became Viscount Lascelles. The son is of the greater interest in the context of Turner, since he was one of the leading collectors of young British artists of his time. Between 1796 and 1808 he assembled an outstanding collection which included watercolours by Turner, Thomas *Girtin, John Varley, John Sell *Cotman, Peter de Wint, and Augustus Wall *Callcott. Turner was probably introduced to Edward jun. by Viscount Malden (see ESSEX) about 1795, and Lascelles's first purchase from Turner was the *St. Erasmus in Bishop Islip's Chapel, Westminster Abbey* (RA 1796; British Museum; W 138), for which Lascelles paid 3 guineas on 17 May 1797. The payments of both father and son (together with a fascinating picture of their daily lives and indulgences) are recorded in their personal account books at Leeds City Archives.

Turner visited Harewood House in 1797 when Edward jun. commissioned a series of four watercolours of the house and two of the castle nearby. Turner's sketches of the house are mostly on loose sheets (TB LI: L,R,S,X,W); another is in the 'North of England' Sketchbook (XXXIV: 76) following a series of studies of the castle (67–74). On 21 November 1797 Lascelles paid Turner 10 guineas for each of two views of the house (W 218, 219), and on 15 March 1798 the same sums for two further views of the house (W 217, 220) and two of the castle (W 221, 222); all these are still at Harewood House. In addition Edward sen. commissioned two oil paintings of the nearby picturesque garden and Lascelles property *Plompton Rocks* (BJ 26, 27). These were required to fill spaces created by alterations in the saloon. The paintings were evidently toned and coloured to harmonize with their setting, and they hang in their original positions to this day. Lord Harewood paid Turner 15 guineas for each on 14 June 1798, plus 19s. for their packing case, and they can thus be seen to be Turner's first *commissioned landscapes in oil.

Turner visited Harewood during his formative tour of the north of England in 1797 and Lascelles bought two more finished watercolours from that tour, *Kirkstall Abbey* (Fitzwilliam Museum, Cambridge; W 224) and *Norham Castle* (Cecil Higgins Art Gallery, Bedford; W 226). In addition he

also bought watercolours of *Llyn Cwellyn* (Whitworth Art Gallery, Manchester University; W 267), *Lake *Geneva* (Yale Center for British Art, New Haven; W 370) and *Pembroke Castle* (private collection, USA; W 280), the last two being among the largest of Turner's early career. The last record of Lascelles patronage is in the 'Greenwich' Sketchbook of 1808–9 (CII: 1) in which Turner recorded a commission for 60 guineas of a picture of 'Fort Rock'. This is identifiable with the watercolour of *Mont Blanc from Fort Roch in the Val d'Aosta* (private collection; W 369), which does not ever seem to have entered the Lascelles collection, but which was bought instead by Lascelles's Wharfedale neighbour, Walter *Fawkes of Farnley Hall.

The Harewood Turners remained together until 1 May 1858 when the fourth Earl of Harewood consigned his whole collection of watercolours for sale at Christie's, but divided the Turner Harewood subjects among his sisters. The four watercolours of the house, plus one of the castle, together with several Girtins and Varleys, have subsequently found their way back to Harewood. The house is open to the public between March and November when the oils may always be seen, and the watercolours whenever conservation regimes will allow. DH

Hill 1984², pp. 24–32, and 1985, pp. 30–46.

David Hill, *Harewood Masterpieces: English Watercolours and Drawings*, Harewood House Trust, 1995.

Hill 1996, pp. 2 ff., 152 ff.

LAWRENCE, Sir Thomas (1769–1830), English portrait painter and friend and patron of Turner. Born in Bristol, he was a child prodigy; after a spell drawing portraits of the fashionable in Bath during the 1780s, he arrived in London in 1787, when he also made his début at the Royal Academy. His handling of paint was brilliant; he was a superb draughtsman, comparable to Ingres, and a perceptive catcher of likeness and character. All this and his ease in high society helped him to the Presidency of the RA in 1820. Lawrence's bravura portraits of allied sovereigns and military leaders painted 1815–19, some produced during a triumphant European tour, confirmed his status as Europe's leading portraitist. With Turner the greatest landscapist of the day, the two men were central to the pre-eminence of the English School in Europe in the early 19th century.

Lawrence, who occasionally drew and painted landscape and historical subjects, was a consistent, though not entirely uncritical, admirer of Turner's work from early on. In 1798 he supported Turner's election as an ARA and at about the same time commissioned a watercolour, *Abergavenny Bridge* (RA 1799; Victoria and Albert Museum; W 252). One of Turner's RA 1803 exhibits, *Châteaux de St Michael *Bonne-*

ville, Savoy, with Mont Blanc (Yale Center for British Art; BJ 50) Lawrence thought 'remarkably fine' but qualified his view of all seven of the Turners on show as 'showing his usual faults, but greater beauties'—an echo, perhaps, of a current criticism of Turner's pictures that their foregrounds were blotty and the figures featureless (*Farington vi. p. 2024).

By 1809, having visited *Queen Anne Street and then recommending *Near the Thames Lock, Windsor* (Petworth House; BJ 88) to a possible patron, he judged that Turner was 'indisputably the first landscape painter in Europe' (Finberg 1961, p. 156). He bought *Newark Abbey* (Yale Center for British Art; BJ 65) at the de Tabley sale (see LEICESTER). As Principal Painter in Ordinary to the King, Lawrence helped Turner obtain his only royal commission in 1822, *The Battle of Trafalgar* (National Maritime Museum; BJ 252), and advised him on the fee he should charge.

In February 1830 Turner wrote to Eastlake 'what a loss we and the arts have in the death of Sir Thos Lawrence' (Gage 1980, p. 136). Turner's tribute to the President of the RA and friend (comparable with his later one to *Wilkie) can be seen in his watercolour of *The *Funeral of Sir Thomas Lawrence* with its procession by the snow-covered steps of St Paul's Cathedral (RA 1830; TB CCLXIII: 344). RH

Kenneth Garlick, *Sir Thomas Lawrence: A Complete Catalogue of the Oil Paintings*, 1989.

'LEADER SEAPIECE', THE, size unknown, c.1807–9; present whereabouts unknown (BJ 205). This is known only through the *Liber Studiorum print, published in March 1809 (F 20). William *Leader was in touch with Turner by 1798. He bought watercolours besides commissioning the oil of *Conway Castle* (c.1803; Trustees of the Grosvenor Estate; BJ 141). Leader's son had two sales containing Turners at Christie's in 1840 and 1843 but neither included this seapiece.

However, Gillian Forrester suggests that, rather than being lost, the picture may never have existed, citing the difference between the lettering on the etching: 'Possession of Wm Leader Esq' and that on the print: 'Original Sketch of a Picture for W Leader Esq'. She interprets this to mean either that the print and picture differed considerably or even that the picture 'had not progressed beyond the *Liber* design'. She further speculates that the picture may be identified with *Sheerness as seen from the Nore* (Turner's gallery 1808; private collection, Japan; BJ 76), which is similar in composition to a watercolour (Tel Aviv Museum) which was linked to the 'Leader' print by 19th-century *Liber* connoisseurs. EJ

Forrester 1996, pp. 68–9.

LEADER, William. Leader either commissioned or bought directly from Turner *Conway Castle* (Trustees of the Grosvenor Estate, BJ 141). The subject must have held special significance for him, as he also owned two watercolours of it by Turner, which were sold in his son J. T. Leader's sale at Christie's, 18 March 1843 (lots 50 and 57; one is W 268, untraced, but Wilton does not list the other). The study for W 268 in Turner's 'Hereford Court' Sketchbook (TB XXXVIII: 50v.) is inscribed 'Mr. Leader'. However, the first recorded owner was William Blake of Newhouse (see PUPILS), for whom the watercolour was made, and his name too is written on the back of the same sketchbook page. This implies that Turner may, in this case at least, have kept track of the owners of the finished designs in the pages of his sketchbooks. One of the *Liber Studiorum* plates is inscribed 'Original Sketch of a Picture for W Leader Esq.,' and dated 1809 (F 20) but there are no other references to such a picture (see LEADER SEAPIECE). RU

LEEDS CITY ART GALLERY has ten Turner watercolours, five bequeathed by Agnes and Norman Lupton in 1953, and the *Farnley Book of Birds* acquired in 1985 after a successful public appeal following an export stop.

The watercolours range in date from *View of *Fonthill from a Stone Quarry* (W 340), commissioned by William *Beckford in 1799, to *Grey Sea—a Boat coming Ashore* (c.1845–50; W 1421). Notable are *Durham Castle* (1801; W 315) from the 'Smaller Fonthill' sketchbook (TB XLVIII), *A Rocky Pool with Heron and Kingfisher* (c.1815; W 542), probably a scene in Wharfedale, *The Lurleiberg* (1817; W 648), and *Part of the Ghaut at Hurdwar* (c.1835; W 1291), one of seven designs for *White's *Views in India*. Late drawings include *The Foot of the St. Gothard* (c.1842; W 1522) and *Traben Trarbach on the Moselle* (identification not confirmed; ?1844; W 1338).

The twenty drawings in the *Book of Birds* come from the five-volume *Ornithological Collection* still at Farnley. Several drawings including two of the finest, Jay and Kingfisher, depict dead birds, while others are of heads only, among them a cuckoo—Turner's 'first achievement in killing on Farnley Moor in ernest [sic] request of Major *Fawkes to be painted for the Book' (Gage 1980, p. 227). Other heads depict Green Woodpecker, Owl, Peacock, Heron, and a 'Moor Buzzard' now correctly identified as a Marsh Harrier. Robin and Goldfinch, both shown alive, are noticeably weaker, causing Hamilton (1997, p. 323 n. 33) to doubt their authenticity, among several others including the cuckoo. EJ

Hill 1988.
Lyles 1988.

LEEDS EXHIBITION, 1839. This took place in the Music Hall and consisted of miscellaneous works of art and other objects. Francis Hawkesworth *Fawkes lent 42 Turner watercolours from Farnley Hall. Of these 27 had been shown in the *Grosvenor Place exhibition in 1819. About half the additions were the products of Turner's visit to *Italy of 1819–20 although *Eruption of Vesuvius* (Yale Center for British Art, New Haven; W 697) is inscribed and dated 1817 so must be based on another artist's drawing (?*Hakewill). There were two views of *Venice: *The Rialto Bridge* (Indianapolis Museum of Art; W 718) and *Venice from Fusina* (1821; private collection; W 721) and three of *Rome including *The Colosseum* (1820; British Museum; W 723) and *Interior of St Peter's* (1821; private collection; W 724) but the finest of this group is *Snowstorm, Mont Cenis* (City Museums and Art Gallery, Birmingham; W 402) which shows Turner's coach just before it turned over on the top of the pass on 15 January 1820 resulting in the travellers having to flounder up to their waists through snow down to Lanslebourg (see DISASTERS ON TRAVELS).

Among the others, three are still at Farnley: *Lake Tiny, Farnley Park* (W 606) and *Farnley in Olden Time* (W 629), both c.1818, catalogued as *Old Farnley Hall* at Leeds. Also, *Drawings of the Swords of Cromwell, Fairfax, Lambert &c.*, one of the watercolours Turner made c.1815 of the relics, belonging to the Fawkes family, of the Cromwellian general Thomas Fairfax (1612–71) to commemorate his part in the Civil War (see W 583).

A catalogue of the exhibition is in the library of the Leeds Philosophical Society. EJ

LEEDS NATIONAL EXHIBITION, 1868. This enormous survey included eleven oils and nineteen watercolours by Turner. At least two oils: *View near Lucerne* and *Embarkation of George IV from Ireland* (possibly the picture by William Turner de Lond, exhibited at *Leggatt's in 1960) cannot have been genuine while two others, each entitled 'Sea Piece', lent by Henry Bucknell (surely *Bicknell) cannot be identified with any pictures known today. But J. G. Marshall of Leeds lent *Burning of the Houses of Lords and Commons* (see PARLIAMENT; RA 1835; Cleveland Museum of Art, Ohio; BJ 364), Miss Miller lent *Saltash* (Turner's gallery 1812; Metropolitan Museum, New York; BJ 121), and Joseph *Gillott lent *Junction of the Thames and Medway* (Turner's gallery 1807; National Gallery of Art, Washington; BJ 62).

John Edward *Taylor lent seven watercolours including two *England and Wales* views of c.1835: *Llanthony Abbey* (Indianapolis Museum of Art; W 863) and *Derwentwater* (British Museum; W 871) and, appropriately, *Leeds*, but apparently not W 544 (1816; Yale Center for British Art, New

Haven) unless Taylor owned it between Vokins and John Knowles. F. Craven lent *Longships Lighthouse, Land's End* (c.1835; Getty Museum, California; W 864) and William Quilter lent two of Turner's three last watercolours of c.1850–1, *Lake of Thun* (Taft Museum, Cincinnati; W 1567) and *Geneva*, now retitled *Genoa* (City Art Gallery, Manchester; W 1569). EJ

LEGGATT'S *J. M. W. Turner* exhibition, 1960 (seventeen oils, 21 watercolours) was something of a curate's egg. The catalogue included an Introduction by Basil Taylor. Among doubtful works were two views of *Hornby Castle* probably by John *Glover, some Arran sketches which are no longer accepted as by Turner (see FAKES AND COPIES), and *George the Fourth leaving Ireland and embarking at Kingstown on the 3rd September, 1821* by William Turner de Lond.

Outstanding private loans included *Temple of Jupiter Panhellenius* (RA 1816; Duke of Northumberland; BJ 134), Sir Kenneth Clark's *Seascape, *Folkestone* (BJ 472), *Lake Lucerne from Fluelen* (?1807; Lord Wharton; W 378), the **Splügen Pass* (1842; F. Nettlefold; W 1523), and *Lake Nemi* (c.1848–50; Mrs C. W. Garnett; W 1560).

Leggatt Brothers, dealers in St James's Street, London, were founded in 1820 but ceased trading in 1992. EJ

LEICESTER, Sir John Fleming (1762–1827), fifth baronet, created Lord de Tabley in 1826, a leading patron of contemporary British artists. He formed a collection of exclusively British paintings, which he displayed in galleries in Tabley House in Cheshire, and in his London house, 24 *Hill Street, to which he admitted the public.

The Leicester family had lived at Tabley since the 13th century. Tabley House was built by John Carr of York (1762–7) for Sir Peter Byrne Leicester (1732–70), fourth baronet, who commissioned Richard *Wilson to paint the house and, in 1769, Francis Cotes to paint portraits of himself and his wife Catherine, daughter of Sir William Fleming of Rydal Hall. Sir Peter died in 1770, leaving his 7-year-old son to be brought up by his mother (d. 1786); her sister Barbara Fleming was the grandmother of Thomas Lister *Parker.

Leicester had a conventional upbringing, including the Grand Tour (1785–6). He befriended Sir Richard Colt *Hoare (1758–1838), but unusually brought no paintings home. According to William Carey, his biographer, Leicester 'returned to England with the unpretending merit of having reserved his fortune for the encouragement of British artists'. He sat to *Reynolds in 1789, and bought the unfinished portrait in 1794 from the artist's executors, sending it to Northcote for completion. Also in 1789 he bought *Gainsborough's large *Greyhounds Coursing a Fox* (Kenwood). He commissioned two paintings of horses from

George Garrard (dated 1791–2). Between 1800 and 1820, Leicester acquired fourteen paintings by Northcote, an artist also much patronized by Parker.

In 1803 Leicester tried to buy Turner's **Festival upon the Opening of the Vintage of Macon* (Sheffield City Art Galleries; BJ 47), exhibited at the Royal Academy. He offered 250 guineas, but failed to agree a price with Turner, who asked 400 guineas. Between 1804 and 1808, he bought **Kilgarran Castle* (National Trust, on loan to Wordsworth House, Cockermouth; BJ 11), exhibited at the RA in 1799 (305), from the painter William *Delamotte.

In March 1805 he acquired the lease of 24 Hill Street, London. He immediately added a picture gallery designed by Thomas Harrison of Chester, and the additional hanging space stimulated the growth of his collection. In 1806 he bought pictures by *Opie, James Ward, Henry Thompson, and three landscapes by Augustus Wall *Callcott. Subsequent purchases from artists other than Turner also included works by Romney (April 1807), James Ward (February 1808), Benjamin *West (March 1808), Opie (May 1808), Owen (October 1808), and *The Cottage Door* by Gainsborough (April 1809). He continued to buy pictures until the 1820s.

The key position in the gallery at the centre of the end wall was in 1806–7 occupied by Turner's **Shipwreck* (BJ 54), which Leicester bought at the opening of the exhibition at Turner's gallery in 1805 for 300 guineas. In February 1807 he part-exchanged the painting with Turner for the **Fall of the Rhine at Schaffhausen* (Museum of Fine Arts, Boston; BJ 61). Peter Cannon-Brookes has noted that this purchase may have been made to counter-balance de *Loutherbourg's *Avalanche*, bought in March 1805.

In 1807–8 Leicester added five paintings by Turner. **Walton Bridges* (Loyd Collection, on loan to the Ashmolean Museum, Oxford; BJ 60), possibly exhibited at Turner's gallery in 1806, was bought for £280: the receipt is dated 18 Jan. 1807. *The *Country Blacksmith* (BJ 68), exhibited at the RA in 1807 (135), followed in January 1808 for 100 guineas. The *View of *Pope's Villa at Twickenham* (Trustees of the Walter Morrison Picture Settlement; BJ 72), exhibited at Turner's gallery in 1808, cost Leicester 200 guineas; this acquisition received much favourable comment from contemporary writers, and at Leicester's posthumous sale it was bought by James *Morrison for 210 guineas.

In the summer of 1808 Turner and Henry Thompson both stayed at Tabley. The 'Tabley' Sketchbooks date from this time. Sketchbook no. 1 (TB CIII) contains pencil drawings in Lancashire especially around Whalley, where Turner made studies for his illustrations to *Whitaker's *History of*

Whalley. Leicester commissioned views of Tabley from both artists. Turner painted two views, *Tabley, Windy Day* (Victoria University of Manchester, on long loan to the Whitworth Art Gallery; BJ 98), and *Tabley, Calm Morning* (Petworth House; BJ 99). *Farington (*Diary*, 11 February 1809) recorded that Callcott told him that Turner 'painted two views of Tabley of his 250 *guineas size*, yet Thompson who was there said that His time was occupied in *fishing* rather than painting'.

In 1818, the year Leicester first opened his gallery to the public, he added paintings by Collins, *Fuseli, *Hilton, West, and his last Turner, *Sun rising through Vapour: Fishermen cleaning and selling Fish* (National Gallery, London; BJ 69), exhibited at the RA in 1807 (162).

In 1823 Leicester formally offered to sell his entire collection to the nation to form a Gallery of British Art, but the Prime Minister, Lord Liverpool, rejected this offer. Leicester died in June 1827, less than a year after becoming Lord de Tabley. His executors offered the Hill Street collection for sale at Christie's in July 1827, at which Turner bought back two of his pictures (BJ 68 and 69). A substantial part of Leicester's collection remains on view to the public at Tabley House, now belonging to Manchester University.

CALS-M

William Carey, *Some Memoirs of the Patronage and Progress of the Fine Arts . . . with anecdotes of Lord de Tabley*, 1826.
Peter Cannon-Brookes, *Paintings from Tabley*, exhibition catalogue, Heim Gallery, London, 1989.

LE KEUX, John (1783–1846) and **Henry** (1787–1868), London-born brothers, who both trained as engravers under James *Basire, and became specialists in architectural subjects. Each engraved a few plates after Turner; John only two in the early 1820s (R 150 and 171) and Henry a total of eight, including two for *Rogers's *Italy* (R 354 and 361) and one, the luminous moonlit view of St Herbert's Chapel, for the *Poems* (R 379). Henry also engraved the well-known vignette with a distant view of *Abbotsford on the title-page of the twelfth and final volume of *Scott's *Poetical Works* (R 516). LH

LENOX, Colonel James (1800–80), New York lawyer, art collector, bibliophile, and philanthropist. Lenox was a lifelong bachelor of Scottish Presbyterian descent, who inherited a large fortune from his father's commercial import business augmented by astute real estate investments. In 1840 Lenox retired from business to oversee his investments and devote himself to his true passions: bibliography and his book and art collections. With philanthropic spirit Lenox decided to create a 'public' library for New York. Originally named the Lenox Library, this opened in 1870 with an endowment from him of $300,000. Eventually it became the New York Public Library. His entitlement in the Turner literature as 'Colonel' seems to be mistaken. The New York Public Library has no information that he ever held military rank, nor was he from the Southern United States where such a title might be honorary. In his autobiography C. R. *Leslie dubs him simply 'Mr Lenox'.

In 1845 Lenox commissioned Leslie to buy him a picture by Turner. Leslie related the story in detail in his *Autobiographical Recollections*:

Lenox . . . who knew his [Turner's] works only from engravings, wished very much to possess one, and wrote to me to that effect . . . Mr. Lenox expressed his willingness to give £500, and left the choice to me. I called on Turner, and asked if he would let a picture go to America. 'No; they won't come up to the scratch.' . . . I told him a friend of mine would give £500 for anything he would part with. His countenance brightened, and he said at once, 'He may have that, or that, or that,'—pointing to three not small pictures.

Eventually *Staffa, Fingal's Cave*, sold by the New York Public Library in 1956 (RA 1832; Yale Center for British Art, New Haven; BJ 347), was decided upon. 'When it went to New York', Leslie continued,

Lenox was out of town; and we were in suspense some time about its reception. About a fortnight after its arrival he returned to New York, but only for an hour, and he wrote to me, after a first hasty glance, to express his great disappointment. He said he could almost fancy the picture had sustained some damage on the voyage, it appeared to him so indistinct throughout . . . I met Turner, at the Academy . . . and he asked me if I had heard from Mr Lenox. I was obliged to say yes. 'Well, and how does he like the picture?' 'He thinks it indistinct.' 'You should tell him,' he replied, 'that indistinctness is my fault.' (1978 edn, pp. 205–7)

Butlin and Joll attribute the charge of indistinctness to a bloom on the varnish, something Turner's advice to wipe it with a silk handkerchief seems to have cured. Lenox came to admire the picture, and in 1850 bought at Christie's *Fort Vimieux* (RA 1831; private collection; BJ 341). In 1848, when he came to London, Lenox had tried to buy The *Fighting 'Temeraire'* (RA 1839; National Gallery, London; BJ 377) through *Griffith but was unsuccessful, as by then Turner had decided never to part with it. Lenox owned works by a number of other British artists, notably *Constable. RU

LESLIE, Charles Robert (1794–1859), genre and portrait painter. Born in London of American parents, Leslie spent his childhood in Philadelphia before returning to England in 1811. He first exhibited at the Royal Academy in 1813, was elected ARA in 1821, RA in 1826, and served as Professor of Painting from 1847 to 1851. He became a close friend of *Constable, whose biography he published in 1843. At the same time he also greatly admired Turner's work and was

instrumental in securing Turner's first American sale, that of *Staffa, Fingal's Cave (RA 1832; Yale Center for British Art, New Haven; BJ 347) to James Lenox in 1845. Leslie visited Turner at his gallery many times and they were fellow guests at *Petworth in the 1830s. Two visits by Turner to Leslie's house are recorded: one in 1840, when Turner amused himself by trying on the Lord Chancellor's wig (Leslie was engaged on his portrait), and the other in 1850, to discuss the vacant presidency of the Royal Academy. In his *Hand-Book for Young Painters* (1855), based on his RA lectures, Leslie replied to *Ruskin's attacks on Constable in *Modern Painters*. Ruskin responded by blaming Leslie for promoting Constable 'as a great artist, comparable in some kind with Turner' (*Works*, v. p. 423). Leslie made two portrait sketches of Turner from memory in 1816 (Walker 1983, p. 25; see PORTRAITS). Nineteen prints after Turner were included in the Leslie sale in 1860. LP

C. R. Leslie, *A Hand-Book for Young Painters*, 1855.
Leslie 1860.
Beckett Vol. III, 1965.

LEWIS, Frederick Christian (1779–1856), English engraver and landscape painter. He engraved one plate for the *Liber Studiorum*, *Bridge and Goats* (F 43), published in 1812 but traditionally regarded as the first executed for the series. Turner and Lewis disagreed over the division of labour and the fee, and the engraver did no further work for the *Liber*. Lewis subsequently engraved two mezzotints after Turner, *Colebrook Dale* (*c*.1797; Yale Center for British Art, New Haven; BJ 22; R 775) and *New Weir on the Wye* (R 776), and collaborated with his son, Charles George Lewis (1808–80), on an unpublished mezzotint after Turner's painting The *Field of Waterloo* (RA 1818; BJ 138; R 795). GF

LEYLAND, Frederick Richard (1831–92), shipowner and art collector. Leyland is best known for his patronage of *Whistler, Moore, Rossetti, and Burne-Jones; he also collected early Renaissance art. He owned two late works by Turner, clearly attractive to him because of their advanced style. These were *Whalers (RA 1845; Metropolitan Museum, New York; BJ 415), bought from *Agnew's in 1867 and sold in 1874, and *Margate Harbour* (*c*.1835–40; Walker Art Gallery, Liverpool; BJ 475), perhaps also bought around 1867, and sold in 1872. Leyland also apparently owned *Emigrants embarking at Margate* (Walker Art Gallery, Liverpool; BJ 556), which is no longer attributed to Turner. Whistler called Leyland 'the Liverpool Medici', while Margaret MacDonald described him as 'a ruthless and ambitious man, impatient, quarrelsome, and unforgiving: and on the other hand, hardworking, meticulous, just, a generous patron and friend. Self-educated, he was fluent in several languages, and was a talented musician . . . he was essentially isolated' (*James McNeill Whistler*, exhibition catalogue, Tate Gallery, 1994–5, p. 155, no. 68). RU

LIBER STUDIORUM. An unfinished series of engravings after Turner's designs, supervised and published by the artist. Considered for half a century to be one of the most significant achievements of his career, the *Liber Studiorum*, or 'Book of Studies', consumed a great deal of Turner's energies for nearly twenty years, and became a lifelong preoccupation. According to a letter written two years after Turner's death by Clara Wheeler, the daughter of Turner's friend William Frederick *Wells, the project was suggested to Turner by Wells when the artist was staying at his house at *Knockholt in the autumn of 1806. Clara Wheeler's account of the *Liber*'s genesis recalled Wells's concern that Turner's work would be travestied after his death by inferior engravings, as *Claude Lorrain's *Liber Veritatis* drawings had been by Richard *Earlom's uninspired renderings in etching and mezzotint. Wells may have spurred Turner into embarking on the series, but it seems likely that Turner, who had produced designs for engraving from the start of his career, would already have had such an enterprise in mind as a means of disseminating his work to a wider public.

A number of details concerning the *Liber*'s protracted and involved publication history remain unresolved. Turner's intention was to publish the *Liber* in twenty parts of five plates, with a frontispiece (F 1), which was issued to subscribers with the tenth part in 1812. The plates published in the first number were undated. In the early *Liber* literature the initial publication date was given as 20 January 1807, but Turner's contemporaries Charles *Turner and John *Pye in later unpublished manuscripts alluded to the start of publication as 1808; however an entry in Joseph *Farington's diary for 13 June 1807 mentioning 'the first number of His [Turner's] publication of prints etched and acquatinted from his designs, which was published on Thursday last' almost certainly referred to the *Liber*. Turner initially may have considered collaborating with a publisher to share the burden of finance and administration. An undated letter from Turner to James *Girtin, who had published his brother Thomas's *Views in Paris and Environs* posthumously in 1803 (Gage 1980, pp. 28–9), may refer to an early experiment with a *Liber* subject; no such collaboration materialized, however, and Turner published the first part himself.

Turner's dealings with Girtin may have prompted the artist to approach Frederick Christian *Lewis, the principal engraver of *Views in Paris*, who had been commissioned to produce a series of aquatints after Claude for the Royal Collection. According to some of the early literature on the

Liber, Lewis's single plate for the *Liber Studiorum*, known as *Bridge and Goats* (F 43), and engraved in a combination of aquatint and mezzotint, was the first to be put in hand by Turner, although it was not published until later in the series. This theory was subsequently disputed, but it is probable that the traditional account is correct. In any event, Turner's collaboration with Lewis, documented in three letters from the artist to the engraver (Gage 1980, pp. 31–4), was fraught and short-lived, and the twenty plates included in the first four published parts were engraved by Charles Turner, who briefly assumed the role of publisher after the first part appeared. The two Turners quarrelled around 1810 after publication of the fourth part; three plates engraved by Charles Turner (F 26, 57, 65), probably executed before the rift, appeared subsequently, but otherwise Turner commissioned several different professional engravers, including Henry *Dawe, George *Clint, Thomas *Lupton, and William *Say, to work on the plates, and also engraved some himself (F 28, 35, 39, 44, 50, 55, 58, 60, 66, 70; in addition, possibly the unpublished plates F 81, 84, 85, 87, 88, 89, 91). The parts appeared at erratic intervals, and the publication dates inscribed on the plates are often inconsistent and misleading; Part 8, for example, contained a mixture of plates dated variously 1, 11, and 14 February 1812.

The process of producing the *Liber* plates was arduous and complex. Turner made preliminary designs in watercolour as guides for his engravers. These studies are generally described in the literature as being executed in sepia, but technical analysis carried out for the *Tate Gallery's 1996 *Liber Studiorum* exhibition revealed that Turner used a range of pigments, including umbers, siennas, ochres, and sepia. Drawings are now known for 57 of the published and fifteen of the unpublished plates, and a large proportion of these are in the Turner Bequest at the Tate Gallery. Of the nineteen untraced subjects, one was last recorded in 1921, two are known only through anecdotal evidence, and two others may correspond to works recorded in 19th-century sales catalogues. Turner derived his subjects from a variety of sources, including his own finished oil paintings and watercolours, as well as works by other artists, and he also made use of topographical material gathered on his sketching-tours. It seems unlikely that Turner would have produced drawings for all subjects, especially for the plates closely based on works which would have been in his studio, and for some of his own engravings he may have worked directly on the plate. Turner's handling of the practical aspects of publishing and marketing of the *Liber* was disorganized, but his approach to planning the contents of the first ten parts seems to have been quite systematic, as evidenced by a number of sketchbooks in the Turner Be-

quest containing notes relating to the subject matter and progress of the series ('Tabley', TB CIII; 'Hastings', CXI; 'Liber Notes (1)', CXLIII; 'Farnley', CLIII; 'Liber Notes (2)', CLIV(a)).

The majority of the *Liber* plates were executed in a combination of hard-ground etching and mezzotint, but several incorporate aquatint, and Turner occasionally used soft-ground etching as a base, or dispensed with etching altogether, his choice of medium presumably dictated by the different effects of painting and drawing he wished to translate (see ENGRAVING TECHNIQUES). As a rule Turner provided the etched outline, and the engraver added tone. Although Turner's knowledge of the mezzotint process was slight at the start of the project, he quickly assimilated the technical principles, and from an early stage began to supervise his engravers' work closely by annotating their progress proofs. Preserved by 19th- and early 20th-century *Liber* enthusiasts, notably A. A. *Allen, John Pye, W. G. *Rawlinson, Charles *Stokes, and Henry *Vaughan, and now largely held in public collections such as the *British Museum, the *Boston Museum of Fine Arts, the *Royal Academy of Arts, and University College London, these proofs provide invaluable insights into Turner's methods of working out his compositions. For some plates, such as George Clint's virtuosic *Peat Bog* (F 45), Turner was apparently content to let the engravers produce direct transcriptions of his drawings and required few progress proofs, but for other subjects, notably *Norham Castle* (F 57), the preliminary study functioned simply as a point of departure, and the image underwent a powerful transformation as the engraving progressed. Turner learnt much from his engravers, and in return, he taught them how they could apply their technical skills to the interpretation of visual images; one engraver who particularly benefited from this process was Thomas Lupton, who engraved his first mezzotint plate, *Solway Moss* (F 52), for the *Liber* under Turner's tutelage. The plates were printed by James *Lahee, and according to John Pye, who carried out extensive research into the *Liber* after Turner's death, the artist supervised the printing, amending the plates between impressions. Turner continued to rework the plates after publication, in part to counteract the effect of wear and tear of printing on the plates, but also in order to develop the images further. The total number of impressions printed is uncertain. Turner's only known notes related to print runs, made in his 'Hastings' Sketchbook (CXI), probably around 1809–10, indicate that he was hoping to sell 190 sets, although he only had 120 subscribers at that point. Over 30 sets from the early printings were included in the Turner Sale, however, which suggests that fewer than 160 sets were sold.

Turner experienced difficulties with promoting the *Liber* from the start, and he provided little information to help his audience interpret this ambitious publication. No printed prospectus, if any did exist, is known to have survived, but when the engraver and critic John *Landseer visited Turner's gallery in 1808, he saw an account of the project—whether in printed or manuscript form is uncertain—which he published in *Review of Publications of Art*: 'Proposals for publishing one hundred Landscapes, to be designed and etched by J. M. W. Turner R.A. and engraved in Mezzotinto. It is intended in this publication to attempt a classification of the various styles of landscape, viz., the historic, mountainous, pastoral, marine and architectural' (Herrmann 1987, p. 28 n.). Turner's list of classifications was printed on the blue paper wrapper into which each part was stitched, and each plate was inscribed with an initial letter denoting a different category of landscape subject. From the outset, however, Turner disregarded his chosen classification system, and in the very first issue he omitted an example of Mountainous landscape, replacing it with a composition in the spirit of Claude's *Liber Veritatis*, inscribed with the letters 'EP'. Turner never glossed this acronym, but it seems most likely that it stood for 'Elevated Pastoral', and was intended as a counterpart to the Pastoral category, which generally included examples of unidealized rural subjects.

It seems clear, in any case, from Turner's system of categories, and his designation of the series as a 'book', that he intended the *Liber* to have a didactic function. At the time of the *Liber*'s conception, Turner indeed was preoccupied with teacherly concerns. He was elected to the post of Professor of Perspective (see PERSPECTIVE LECTURES) at the Royal Academy on 10 December 1807, and probably had been contemplating such a role for some time before his application. Turner's approach to the subject was eclectic, covering broader artistic issues than required, and the day after Turner gave his first lecture Joseph Farington noted in his diary entry for 8 January 1811 that 'Turner is desirous of having a Professorship of Landscape Painting established in the Royal Academy'. The last perspective lecture of the inaugural series, given five weeks later, and entitled 'Backgrounds: Introduction of Architecture and Landscape', took issue with the accepted notion of relegating landscape to the lowly status of a 'background' for history painting, arguing instead for the acceptance of landscape painting as a separate genre in the hierarchy of art. If 'Backgrounds' could be interpreted as Turner's first step to achieving his ambition to be Professor of Landscape Painting, the *Liber* can be read as its counterpart, a portable visual history of European landscape painting, with illustrations alluding both to Old Masters such as *Claude, *Poussin, *Rembrandt, and *Rubens, and to artists of the British School, including *Gainsborough, Morland, *Wilson, and, of course, Turner himself.

Publication ceased in 1819, the year of Turner's departure for Italy, after only 71 plates had appeared. The limited evidence relating to the finances of the series suggests that it was unremunerative, and Turner's decision to abandon publication may have been partly due to its lack of commercial success. The print market had been at a low ebb when he had embarked on the project, and his unsystematic marketing strategy would hardly have helped to bring the series to the attention of potential subscribers. Moreover, it is likely that the prices—initially 15*s*. per part for print impressions, and 21*s*. for proofs (that is, the earliest, high-quality, impressions printed after the plate was considered ready for publication), and rising in about 1810–14 to 1 and 2 guineas respectively for new subscribers—would have seemed high in comparison with similar publications on the market. The complex task of co-ordinating and publishing the *Liber* clearly overstretched Turner's organizational competence, and his notes relating to the planning of the last ten parts indicate that he was adding subjects in a piecemeal fashion. Turner's manuscript lists of subjects also show that there was an acute shortage of subjects for the Architectural category. Twenty unpublished plates exist in the form of engraver's proofs (F 72–91), some not begun until the 1820s, and work may have continued on the plates as late as 1825. Turner may have found his self-imposed combination of etching and mezzotint restrictive, however, and three of the unpublished plates, *Stonehenge* (F 81), *Moonlight on the Medway* (F 86), and the *Deluge* (F 88), which have close affinities with the *Little Liber* engravings, are executed in pure mezzotint. A number of copper plates of the same size and make as the *Liber* plates were discovered in Turner's studio after his death, implying his intention to complete the series. The *Liber* clearly had lasting significance for Turner. In 1845 he had the plates for the published subjects reprinted by *McQueen's, probably in response to an order for a set by John James *Ruskin. About this time, Turner also produced a group of oils based on *Liber Studiorum* subjects (see next entry; BJ 509–19); nine have been firmly identified as corresponding to *Liber* compositions, mainly in the 'EP' category, and a further two may relate to the series.

The *Liber* received considerable critical attention between the 1860s and 1920s, and the total output of publications devoted to the subject, comprising catalogues for exhibitions and private collections, catalogues raisonnés, and drawing manuals, is larger than for any other aspect of Turner's art. Two early collectors, Charles *Stokes and John

Pye, who knew Turner personally, conducted investigations into the *Liber*; their researches remained unpublished, but passed in manuscript to other *Liber* enthusiasts after their deaths, and formed the basis for subsequent publications, notably the catalogues raisonnés compiled by W. G. *Rawlinson (1878; revised 1906) and A. J. *Finberg (1924). For a full bibliography of publications on or related to the *Liber*, see Forrester 1996, pp. 42–3. The *Liber* played an important role in the British art curriculum in the latter half of the 19th century under the influence of John *Ruskin, who promoted the series as a practical drawing manual in his *Elements of Drawing*. Ruskin's teachings inspired several portfolios and books intended for students of drawing. Landmark exhibitions were held at the *Burlington Fine Arts Club in 1872, and the National Gallery at Millbank (later the Tate Gallery) and the Whitworth Galleries, Manchester, in 1921–2. Interest in the series, and in Turner's prints in general, declined at the end of the 1920s, and prices fell sharply. Few *Liber* exhibitions took place over the next fifty years, but there was a revival of interest in the 1980s, marked by the *Liber* exhibitions at Nottingham University Art Gallery in 1986 and the Ruskin Gallery, Sheffield, in 1988, the publication of Luke Herrmann's *Turner Prints* in 1990, and the Tate Gallery's 1996 exhibition devoted to the series. GF

Rawlinson 1878, 2nd edn. 1906.
Pye and Roget 1879.
Finberg 1924.
Herrmann 1990, pp. 24–71.
Forrester 1996.

LIBER STUDIORUM, oils based on. Ten late paintings possibly or definitely derive their imagery from drawn and engraved images made years earlier. Although they might all appear to be unfinished pictures, of the kind that Turner frequently sent to the Royal Academy for completion on *Varnishing Days, eight of them contain figures, animals, architectural and arboreal detailing, and because Turner usually added such subsidiary components only when finalizing an image, such inclusions strongly suggest that these eight works were taken to completion. Moreover, the formal sophistication, tonal subtlety, and intensity of colouring of every one of the paintings makes it equally evident that they were either finished or developed to some advanced state. Arguably these pictures form the most impressive of the late groups of related images by Turner, as well as perhaps the supreme expression of the artist's *Idealism.

In June 1845 Turner had fifteen new sets of the *Liber Studiorum* printed (see Pye and Roget), and it seems possible that this reprint led him to create the ten or so oil reworkings of *Liber* designs. Some of the canvases bear manufacturer's stamps that can be ascribed to 1838 or later, and one of them—*Norham Castle on the Tweed* (BJ 512)—has '[18]44' stamped on its verso, thereby establishing that the picture was painted in or after that year (see Butlin 1981). If the artist began that work before the 1845 reprint of the engravings (by developing its imagery from an earlier print), such an inception may have inspired the reprinting of the mezzotints; if he started the oil after that date, then it may have been inspired by the reprinted image. Given that all the canvases are in the artist's favoured 3 × 4 ft. (91.4 × 122 cm.) *size, it seems highly likely they were intended to form a group and one possibly intended to summarize his *œuvre*. Turner is known to have undertaken a stocktaking of his studio in 1845, and it has plausibly been suggested that such an activity hints 'at a concern to resolve unfinished business', with the 'Late Liber' series consequently being 'a final attempt to achieve some kind of completion or closure' in his art (Forrester 1996, p. 22).

The present writer has argued (1984) that the pictures were painted consecutively between 1844 and 1848 (or even later). This view was based upon the discernment of a gradual diminution of refinement from one work to the next, a decline that could have stemmed from the artist's known physical deterioration in his final years. However, upon further consideration it seems dangerous to posit such a creative progression and decline upon the immensely subtle painterly differences between these works. In all of them subtle glazes were employed over fairly non-absorbent grounds, as were small touches of heavy impasto, and such close technical correspondences between the canvases strengthen the likelihood that they were all painted at around the same time, with any necessarily subtle differences between them stemming from Turner's fluctuating strength in old age.

In the following listing of the 'Late Liber' group oils, their titles correspond to those of the prints, rather than to those given in inconsistent forms in the Butlin and Joll catalogue. The canvases are:

- *Inverary Pier. Loch Fyne. Morning* (BJ 519, Yale Center for British Art, New Haven, derived from *Liber Studiorum* plate 35, published 1811).
- *Norham Castle on the Tweed* (BJ 512, derived from *Liber Studiorum* plate 57, published 1816).
- *The Clyde* (BJ 510, Lady Lever Gallery, Port Sunlight, derived from *Liber Studiorum* plate 18, published 1809).
- *The Woman and Tambourine* (BJ 513, Tochigi Prefectural Museum, Japan), derived from *Liber Studiorum* plate 3, published 1807).

- *The Bridge in the Middle Distance* (BJ 511, private collection, derived from *Liber Studiorum* plate 13, published 1808).
- *Solitude* (BJ 515, derived from *Liber Studiorum* plate 53, published 1814).
- *The Bridge and Goats* (BJ 518, derived from *Liber Studiorum* plate 43, published 1812).
- *Europa and the Bull* (BJ 514, Taft Museum, Cincinnati, derived from the *Liber Studiorum* Frontispiece, published 1812).
- *Junction of the Severn and Wye* (BJ 509, Louvre, Paris, derived from *Liber Studiorum* plate 28, published 1811).

The final two paintings on this list are less highly developed than the others and they may well have remained unfinished. Additionally, BJ 517, titled by Butlin and Joll *Landscape with River and Distant Mountains*, may comprise the rudimentary beginnings of a reworking of plate 8 in the *Liber Studiorum*, *The Castle above the Meadows*, which was published in 1808. ES

Pye and Roget 1879, p. 71 n.

Butlin 1981.

Eric Shanes, 'The True Subject of a Major Late Painting by J. M. W. Turner Identified', *Burlington Magazine*, 126 (May 1984), pp. 284–8.

LIBRARY, Turner's. The library is best reviewed in two parts; first, Turner's collection of books, a few sketches and prints, his poetry, and personal documents, and, secondly, the books and articles about Turner himself and his work, published after his death. The items have remained in the family, as a privately held collection, and have come to be referred to collectively as the 'Turner Library'.

In the inventory of Turner's house in *Queen Anne Street, taken at the time of his death for payment of legacy duties, was recorded: 'small bookcase with glazed door in dining room on ground floor'. There followed a list of books (see Wilton 1987, pp. 246–7). Many of the titles were mentioned individually, 130 were recorded as 'various', there were six books of music and sundry pamphlets. The collection is no longer complete as some books have been lost.

The most important books are those annotated by Turner, some including lines of his own poetry with occasional sketches and pertinent remarks, all of which give an invaluable insight into his thoughts on various subjects. The main annotations appear in his copies of *Goethe's *Theory of Colour*, *The Artist's Assistant (author unknown)*, Goldsmith's *Roman History*, *Opie's *Lectures on Painting*, and *Shee's *Elements of Art*. Turner's verse book, written in his own hand, is a unique item, displaying his tireless attempts at writing poetry to complement many of his paintings (see Lindsay 1966, and POETRY AND TURNER).

Though art, architecture, and poetry predominate, the subjects of Turner's books reveal his wide interests apart from art—from Macquer's *Chemistry* to Hansard's *Report on the Mode of Preventing Forgery of Bank Notes*. His books were extensively used for both reference and pleasure, his thirteen well-worn leather-bound volumes of *British Poets* sustaining this theory. Topography in connection with his travels, together with dictionaries and maps, are also to be found. Some books were presented to him for his work on the illustrations—such volumes as Samuel *Rogers' *Poems*. Other books, given to him by friends, included inscriptions, for example John *Ruskin's *Stones of Venice* and Sir John *Soane's *Designs for Public Improvements*.

Mentioned in the inventory, and still held in the library, are a few sets of original prints, some having been touched by Turner himself. Also retained are letters written either to or by Turner, many having been discovered inside his books. Other documents include indentures of leases on properties which he had owned, and his notes for lectures given at the Royal Academy.

Over the years copies of most newly published books and catalogues about Turner have been added to the library, making it an up-to-date and comprehensive reference centre for academic research. Works by *Finberg and *Rawlinson are well represented. C. M. W. *Turner, a descendant of Turner's cousin William (son of Turner's father's eldest brother John), who inherited the majority of his books, accomplished invaluable work on the family history. In 1902 he collected together numerous documents relating to the Turner family and to Turner's controversial *will, and had them bound, thereby preserving them for posterity.
 RMT

Wilton 1987.

Wilton and Turner 1990.

***LIFE-BOAT AND MANBY APPARATUS* *going off to a Stranded Vessel making Signal (Blue Lights) of Distress*,** oil on canvas, 36 × 48 in. (91.4 × 122 cm.), RA 1831 (73); Victoria and Albert Museum, London (BJ 336). Captain George William Manby (1765–1854), a versatile inventor, developed this apparatus after witnessing a shipwreck off Great Yarmouth, Norfolk, in 1807. It provided a lifeline to a ship in trouble by firing a stone at the end of a rope from a mortar on shore.

Turner was closely associated with Manby at this period and Gage considers that the 'uncharacteristically circumstantial title' indicates that Manby had commissioned the painting to add to his collection of sea pictures but, owing to

financial difficulties, could not finally afford it. Gage further notes how the anxious attitudes of the onlookers underline the hazardous nature of such rescue operations.

Although it was scarcely noticed at the Royal Academy, the few mentions were favourable. EJ

Gage 1987, pp. 229–33.
Rodner 1997, pp. 68, 75.

LIGHT AND COLOUR (GOETHE'S THEORY)—THE MORNING AFTER THE DELUGE—MOSES WRITING THE BOOK OF GENESIS, oil on canvas, 31 × 31 in. (78.5 × 78.5 cm.), RA 1843 (385); Tate Gallery, London (BJ 405). Exhibited as a companion to *Shade and Darkness— The Evening of the Deluge* (RA 363, BJ 404), both with lines of verse attributed to the *Fallacies of Hope* (see POETRY AND TURNER). There is an earlier version, *Shade and Darkness* (*c.*1843; National Gallery of Art, Washington; BJ 443), probably done before Turner decided to illustrate *Goethe's theory of colour, seen as a product of both light and darkness as opposed to Newton's theory that it proceeded from light alone, and of a colour-circle divided into 'plus' and 'minus' colours: the former, reds, yellows, and greens, were to be associated with gaiety, warmth, and happiness, while the latter, blues, blue-greens, and purples, were seen as productive of 'restless, susceptible, anxious impressions'. Both sets of accompanying verses from the *Fallacies of Hope* are in fact pessimistic, attacking hope as 'ephemeral as the summer fly'. However, both Noah and Moses are forerunners of Christ. Twelve years earlier Turner had alluded to another theory of colour, C. A. du *Fresnoy's *De Arte Graphica* in his *Watteau Study by Fresnoy's Rules* (RA 1831; BJ 340). Turner also seems to be alluding to the various accounts of geological evolution common at the time, 'vulcanist', 'neptunist', 'uniformitarian', and 'catastrophic'.

Wilton has suggested the influence of baroque painted cupolas on these centrifugal compositions (1979, p. 216). Both pictures were painted up to the edge of the square canvas but were finished, almost certainly in their frames, with the corners cut across, as octagons, though *Light of Colour* also shows signs that at one time Turner considered finishing it as a circular composition.

Both pictures were stolen from the Schirn Kunsthalle, Frankfurt, on 28 July 1994 and have not yet (2000) been recovered. MB

R. D. Gray, 'J. M. W. Turner and Goethe's Colour Theory', in *German Studies Presented to Walter and Horace Bruford*, 1962, pp. 112–16.
Gage 1969, pp. 173, 185–8, 190, 194, colour pls. 21–2.
Gage 1984, pp. 34–52.
Finley 1997.

LINDSAY, Jack (1900–90), writer on Turner. Born in Melbourne, but spending most of his life in Britain, Lindsay was the author or editor of some 170 books. These included novels, biographies, plays, poetry, art history, books about the ancient world, and four volumes of autobiography. In 1981 he was created an Officer of the Order of Australia. Throughout his life Lindsay was a committed Marxist, and during the 1930s wrote for *Left Review* and the *Daily Worker*; his historical novels, all popularly received, were often on movements for democracy such as the *Chartists and the Levellers. His art books included studies of Cézanne, *Hogarth, William Morris, Courbet, and *Gainsborough. Lindsay's *J. M. W. Turner: His Life and Work: A Critical Biography*, 1966, to some degree pre-empted tendencies in modern study of the artist's life. Previous biographers, with the notable exception of *Finberg, had been less rigorous in their analysis of Turner's life and work, and the relationship between the two. In 1966 Lindsay also published *The Sunset Ship*, a volume devoted to Turner's poems, which showed the link between the artist's painting and *poetry. His *Turner: The Man and his Art* was published in 1985 to celebrate the building of the Clore Gallery. RU

LITERARY SUBJECTS. Turner's art was associative and literary: 'We cannot make good painters without some aid from poesy,' he declared in one of his *perspective lectures at the *Royal Academy. The RA appointed a professor of ancient literature; an RA dinner in 1804 featured Shakespearian recitations from the actor Philip Kemble. 'Historical' painting on literary subjects was encouraged: *Barry, in a lecture of 1793, told the students, 'Go home from the Academy, light your lamps, and exercise yourself in the creative power of your art, with Homer, with Livy, and all the great characters, ancient or modern, for your companions and counsellors'; Turner wrote to *Holworthy in 1817 that these words were 'always ringing' in his ears. *Girtin's Sketching Club, founded in 1799, took for subjects 'original ideas from poetick passages'. At the same period Boydell's Shakespeare Gallery and *Fuseli's Milton Gallery exhibited paintings with literary subjects, most of which were engraved as prints; this was the great age of English book illustration, to which many Academicians contributed. The conjunction of art and literature can never have been closer; there were theatrical presentations of moving painted scenery at the Sans Souci in Leicester Place, called 'Dioramas', 'with voices issuing from behind, reciting descriptions of the scenes that were passing'.

In addition to his commissioned illustrations to *literature, Turner himself celebrated the writers Pope and *Thomson in oil paintings: *Pope's Villa* (Turner's gallery

1808; Trustees of the Walter Morrison Picture Settlement; BJ 72) and *Thomson's Aeolian Harp* (Turner's gallery 1809; City Art Gallery, Manchester; BJ 86). Even in his own day the public misunderstood what Alaric *Watts called 'the odd-looking figures in the foreground', that spoiled a landscape 'by way of dignifying it with a sounding name', whether literary or mythological. Many modern scholars, especially Wilton and Gage, take the literary subject matter and the poetic passages applied by Turner from poets or from his own poems by epigraphs as significant to Turner's meanings. In *Chryses* (RA 1811; private collection; W 492) from Pope's translation of the *Iliad*, the Priest of the Sun prays to Apollo. *The *Goddess of Discord* (BI 1806; BJ 57) is best understood by the unpublished poem written to accompany it, for which Turner made many drafts in the *Verse Book* (private collection): by its Miltonic phrasing it connotes ideas of the Christian Fall of Man and makes an analogy between the Garden of Eden and the Hesperides. Even in lesser compositions Turner expects allusions to be taken up as part of what he has to say. The vignette of *Rhymer's Glen* (National Gallery of Scotland; W 1119) shows the bench, open book, and walking-stick of the recently dead poet *Scott where he meditated at *Abbotsford; these details create Turner's elegy. In addition the numinous large rock in the foreground is the 'Edgeworth Rock' on which the writer had once sat, as Lockhart described in his *Life* of Scott. In the stormy watercolour *Temple of Poseidon at Sunium* (now Tate Gallery; W 497) Turner connotes *Byron, who refers to the temple in *The Giaour, Childe Harold*, and *Don Juan*, by placing sculpted reliefs in the foreground showing the anthemion and Parthenon metope which he had made elsewhere a kind of *leitmotiv* of Byron; a sinking ship recalls the popular poem *The Shipwreck* (1762) by William Falconer, who describes in canto iii the ship lost below that very temple and the companions divided by death.

Compared with the careful historical accuracy and details in literary paintings by more literal artists of the day, such as *Leslie, Turner's own references in titles and epigraphs seem vague. The untraced Scottish scene (RA 1802; W 346) whose title included '*vide* Ossian's War of Caros' showed little more, we are told, than a 'wild Ossianic effect' in the landscape; scholars have not identified the exact subject intended by Turner in the mezzotint *From Spenser's Fairy Queen* in the *Liber Studiorum* (R 36), although there are affinities with the description of the Cave of Despair in canto i. With *Boccaccio relating the Tale of the Birdcage* (RA 1828; BJ 244) one may look in vain for such a story in the *Decameron*: Turner has invented it—the illustrations by *Stothard to an edition of Boccaccio from which Turner took some of his imagery in this painting merely featured many wild and tame birds; the edition was, significantly, in Italian, which Turner did not read. On the other hand the emblematical details in the fantastic painting *The *Fountain of Indolence* (RA 1834; Beaverbrook Art Gallery, Fredericton, New Brunswick; BJ 354) can only be understood by reference to its source in Thomson's poem. Turner's Byronic subjects, all with epigraphs from Byron, are perhaps his most realized 'literary subjects': *The *Field of Waterloo* (RA 1818; BJ 138), *Childe Harold's Pilgrimage—Italy* (RA 1832; BJ 342), and *The *Bright Stone of Honour* (RA 1835; private collection; BJ 361). With *Shakespeare the two smaller paintings from the comedies, *Jessica* (RA 1830; Petworth House; BJ 333) and *What You will!* (RA 1822; private collection; BJ 229) interpret character and situation, while the Shakespearian figures in the large Venetian subjects *Juliet and her Nurse* (RA 1836; Sra. Amalia Lacroze de Fortabat, Argentina; BJ 365) and *Grand Canal, Venice* (RA 1837; Huntington Art Gallery, California; BJ 368), showing Shylock, are comparatively marginal.

Where Turner gives paintings literary quotation by way of epigraph, he sets up relations between picture and text. In his early epigraphs, such as from Thomson and Milton from 1798 onwards, he seems more interested in the time of day or weather, or in adding an acoustic element to the image by quoting descriptions of sounds, for example Miltonic cannon for *Battle of the Nile* (RA 1799; untraced; BJ 10); towards the end of his career the epigraphs, particularly when they are from his own poetry, give the images further literary connotations. Turner quotes from 18th-century writers, Thomson, Langhorne, Gisborne, Mallet, and *Akenside; from classical translations by Pope, Addison, and Dryden; and from his contemporaries, principally Byron, Southey, *Campbell, *Rogers, and Scott. The context of the quotation is often important, as in *Dawn of Christianity* (RA 1841; Ulster Museum, Belfast; BJ 394) where Gisborne's exclamation on the risen Star quoted by Turner is from a passage where Gisborne describes vernal renewal, which endorses Turner's image of a world restored after the receding Deluge. See also POETRY AND TURNER. JRP

Ziff 1964.
Lindsay 1966.
Gage 1969.
Paulson 1982.
Gage 1987.
Wilton and Turner 1990.

LITERATURE, illustrations to. In a sense many of Turner's works illustrate *literary subjects; however, by the 1830s most of his work for engravings consisted of commissions for frontispieces, title-pages, and vignettes for editions of literature, mostly by his contemporaries. The new

process of very fine line-engraving on steel also made mass production possible. This greatly increased his fame and fortune. The publisher Robert *Cadell told *Scott that illustrations by Turner would increase the sales of his collected poems by almost three times. *Ruskin assumed that Turner's most famous illustrations, those for the very large printings and reprintings of Samuel *Rogers's *Italy* (1830) and *Poems* (1834), were in every educated household, and uses them as references in making his points.

In the 18th century there had been some fine copper-engraved work in book-illustration, such as Bentley's edition of Gray of 1753, and in the latter part of the century there was a vogue for large engraved plates with scenes from *Shakespeare and *Milton. At the time when Turner began to illustrate editions of poetry, smaller series of books with larger issues using good paper and with finely designed and engraved plates were very popular. F. J. Du Roveray also published 'British Classics' commissioning designs for plates from *Fuseli and other Academicians. *Stothard, Blake, and many other contemporaries of Turner designed illustrations for what were known as 'embellished' editions.

In 1822 Turner made for Walter *Fawkes (according to Mrs Ayscough Fawkes, for an unrealized 'edition' of *Modern Poets*) some small watercolour designs to illustrate Scott, *Byron, and *Moore (W 1052–7); there was a frontispiece of a stela with the three poets' signatures on it and Loch Katrine behind. The best of the four Scott illustrations was a romantic miniature of Melrose Abbey by the pale moonlight. Moore's *Lalla Rookh* showed 'a lady reclining on couch under Persian portico'. All were illustrations to particular lines, presumably Fawkes's choice, which were written by Turner onto the design, for example on fallen masonry.

For the two volumes of poems by Rogers Turner developed the miniaturist skill of the vignette form, which originated in medieval book-illustration—a *vignette* is literally a vine ornament. In the 18th century it came to mean an unbordered illustration. The Rogers vignettes tended towards rectangles with circular corners and shading edges, but the later vignettes (freed from Rogers's fastidious control) for Milton, *Campbell, and Moore became bolder and the edges more shadowy. The vignettes were engraved by a school of engravers supervised by Turner. The vignettes for Rogers and for Campbell were printed by a technically difficult method: instead of the tradition of illustrations on separate pages, vignettes were printed for head- or tail-pieces, and the pages of letterpress thus had to be passed through the press a second time. Wood-engravings can be 'locked up' with type and printed at the same time, but Turner firmly resisted Cadell's invitation to design wood-engraved illustrations for the Waverley Novels, since they would lack

the sophistication necessary to translate more subtle effects of light and shade. Turner drove a hard bargain with the publishers, insisting in a letter of 1834 (Gage 1980, p. 151) on 25 guineas for each drawing, 50 proof impressions of each plate, a presentation copy of the book, and a guarantee that neither drawing nor plate was to be used for any other work.

Turner's thirty contributions to Annuals from 1826 to 1837 were topographical and accompanied by ephemeral texts, mostly written to accompany the illustrations, with the exception of the four sea-vignettes from the *Keepsake*. In the 1830s there was a vogue for 'Landscape Illustrations' to writers. Turner's illustrations to Byron and Scott generally illustrate setting rather than text; however, the desolate frontispiece *Loch Coriskin* (National Gallery of Scotland; W 1088; R 511) and its pair the vignette *Fingal's Cave* (private collection; W 1089; R 512) connote mood and idea as well as place.

Turner renders few figures in illustrating the narratives of the poems; several figures were drawn in by Stothard for Rogers's *Poems*, and *Goodall had to supply some angels for a Milton illustration. On the other hand the six 'landscape-historical' illustrations made for the Waverley Novels for the publisher Henry Fisher in 1836–7 (W 1134–9; R 560–5) show much drama and some humour in the small figures. In the elaborate emblematical title-page for *The Pilgrim's Progress* (W 1302; R 605), also made for Fisher in 1836, the figures of the Evangelist, Christian, and the others are facile and wooden, but the image contains an eloquent juxtaposition of a barren and gloomy landscape with Turner's architecture of the Celestial City, including the dome of St Paul's. The pair of designs for Milton's *War in Heaven* (W 1264–5; R 598–9), and the two series for Rogers's *Voyage of Columbus* (W 1202–8; R 398–404) and Scott's *Life of Napoleon* (W 1102–17; R 525–40) are extraordinarily successful. Turner's landscape vignettes in watercolour for *Scott's *Poetical Works* (W 1070–89; R 493–512) were originally enclosed by architectural cartouches with characters from the poems drawn outside them, but only one of these was actually engraved with the figures. For the editions of Campbell and Moore Turner's later vignettes (at their best) use figures, landscape, and form in highly dramatic combination.

In the 1840s Turner prepared 'illustrations' for the poems of C. B. Broadley, a don at Trinity College, Cambridge, and a friend of William *Kingsley. The work was never published, but the plates, including a fine vignette, *Lake Nemi* (Taft Museum, Cincinnati, Ohio; W 1311; R 638), appeared in a portfolio *Gems of Art* in 1843–4, republished in *Art and Song* in 1867.

*Finberg said that Turner's art in general was spoiled by his catering to the middle-class reading public and by being influenced by the 'dreamy voluptuousness and vulgarity of the contemporary phase of Romantic poetry'. This is for the most part unfair to his art and to his contribution to English book-illustration. The engravings and their watercolour originals should be seen for what they are—particularly the vignettes, which are masterpieces of compression and delicacy for meditation: the world seen in a grain of sand— richly extending the act of reading and, as was recognized in their day, as visual 'poems' in themselves.　　　　JRP

Rawlinson 1908, 1913.
Lyles and Perkins 1989.
Herrmann 1990.
Piggott 1993.

LITTLE LIBER. A group of mezzotints after sketches by Turner, acclaimed for their expressive, *Romantic qualities. Little is known about the circumstances surrounding the production of these beautiful unpublished engravings, which exist only in the form of a handful of rare engraver's proofs preserved in the 19th century by assiduous collectors, notably Charles *Stokes and Henry *Vaughan, and now largely owned by public institutions including the *British Museum, the *Museum of Fine Arts, Boston, University College London, and the *Yale Center for British Art. W. G. *Rawlinson in *The Engraved Work of J. M. W. Turner* listed twelve plates under the heading of 'The socalled Sequels to the Liber Studiorum' (R 799–809a): *Paestum, The Evening Gun, Shields Lighthouse, St. Michael's Mount, Ship in a Storm, The Mew-Stone, Catania, Sicily, Study of Sea and Sky, Bridge and Monument, Ship and Cutter, Gloucester Cathedral*, and *The Medway—Thunderstorm with Rainbow*. Although it is unknown whether Turner intended to publish the engravings as a series, similarities in technique, size, and subject matter (all the plates depict dramatic natural lighting conditions) suggest that they constitute a group. The dating is also uncertain, but it seems likely that the engravings were produced from the early or mid-1820s. The plates, in terms of handling and subject matter, have affinities with some of the unpublished *Liber Studiorum* mezzotints, notably *Stonehenge* (F 81), *The Felucca* (F 82), *The Lost Sailor* (F 84), and *Moonlight on the Medway* (F 86); two of these were executed in pure mezzotint, like the *Little Liber* engravings, rather than the combination of etching and mezzotint generally used for the *Liber*, and since Turner was still occupied with *Liber* plates in the 1820s, he may have been working on both groups of engravings simultaneously. Several printing plates for *Little Liber* subjects were found in Turner's studio after his death, and dispersed at the Turner sale; three in copper and four in

steel are still known. Steel engraving plates were first introduced in the early 1820s, their use pioneered by the engraver Thomas *Lupton, who first worked for Turner on the *Liber*, and in the mid-1820s engraved mezzotints for the *Rivers of England*; Turner would have been interested in the new medium, and the use of steel indicates a possible dating of the early to mid-1820s for at least those subjects (see ENGRAVING TECHNIQUES).

The traditional and accepted view is that Turner engraved the *Little Liber* plates himself, but there is no documentary evidence to support this attribution. Turner engraved several *Liber* subjects, and undoubtedly possessed sufficient skill to produce the *Little Liber* mezzotints, but some progress proofs have been touched with corrections, and it remains questionable whether Turner would have annotated proofs if he were engraving the plates himself—no touched proofs are known for his own *Liber* subjects. However, the preliminary drawings, the majority of which are at the Tate Gallery, are broader in handling than the detailed studies Turner customarily made for engravers, and this argues for Turner's authorship of the engravings.　　GF

Marcel-Étienne Dupret, 'Turner's "Little Liber"', *Turner Studies* 9/1 (summer 1989), pp. 32–47.

LIVERPOOL, National Museums and Art Galleries on Merseyside, incorporating the Walker Art Gallery, Sudley House, and the Lady Lever Art Gallery, Port Sunlight. The Walker Art Gallery, which in its turn incorporated the collection of the Liverpool Royal Institution, founded in 1814, was built 1874–7. The collection of Turner's oil paintings is usually divided between the Walker and Sudley Hall (the Holt Collection) and includes *Linlithgow Palace, Scotland* (Turner's gallery 1810; BJ 104), *Schloss Rosenau, Seat of H.R.H. Prince Albert of Coburg, near Coburg, Germany* (RA 1841; BJ 392), *The *Wreck Buoy* (RA 1849; BJ 428), and two of the late oils of *Liber Studiorum* subjects of *c*.1845–50, *The Falls of the Clyde* (BJ 510) and *Landscape with River and Distant Mountains*, now identified by Ian Warrell as being after *The Castle above the Meadows, Liber* no. 8 (BJ 517; see Forrester 1966, p. 55 under no. 8). Of the 24 watercolours, 17 originally presented by the first Viscount Leverhulme to the Lady Lever Art Gallery, most are normally available in the print room in the Walker, though some may be on display at Port Sunlight. They include topographical works of the 1790s, *The Fall of the Clyde, Lanarkshire: Noon* (RA 1802; W 343); works for *Picturesque Views of the *Southern Coast of England*; a version of *Richmond Hill* engraved for the *Literary Souvenir*, 1826 (W 518); works for *Whitaker's *History of Richmondshire*; *Ports of England*; and *Picturesque Views in *England and Wales*, including another view of

Richmond Terrace, Surrey (W 879); studies for *Turner's Annual Tour: the Seine*, 1834; *The Bass Rock* for *Scott's Provincial Antiquities of Scotland* (W 1069); and watercolours from the 1840s of English, Venetian, and Swiss views.

Also in Liverpool, at the University, are the oil of *The Eruption of the Souffrier Mountains, in the Island of St. Vincent . . . 1812* (RA 1815; BJ 132) and five watercolours. MB

Frank Milner, *Turner Paintings in Merseyside Collections*, 1990.

LIVERPOOL ACADEMY exhibited five works by Turner during his lifetime. Three were watercolours engraved in *Hakewill's *Picturesque Tour of Italy*: *Roman Forum from the Capitol* (private collection; W 704), *Forum Romanum* (National Gallery of Canada, Ottawa; W 705), both shown in 1831, and *The Rialto* (untraced; W 700) shown in 1845.

The oils were one of the views of *Tabley Hall* (RA 1809; BJ 98, 99), lent by Sir John *Leicester in 1811, and *Van Tromp, going about . . .*(RA 1844; Getty Museum, California; BJ 410) lent in 1850 by John *Miller of Liverpool, who lent it again to the *Royal Scottish Academy in 1852. EJ

LLOYD, Mrs Mary (*c.*1810–1880s), a young friend of Turner. She was probably introduced to the painter by Sarah *Rogers, the sister of Samuel *Rogers, in the early 1820s. She greatly admired Turner, who responded by giving her little confidences such as the secrets of his sunsets (they were, he told her, in fact sunrises), and special tips on painting.

She came from a medical family, her mother's uncle being Dr Skey, possibly Dr Joseph Skey, inspector-general of army hospitals, and they moved in the circles of the Carrick Moores, *Eastlakes, Rogers, *Somervilles, Charles Babbage, and others in which the arts and sciences met.

She first married a Mr Robinson in the 1830s, and lived with him in Hertford Street, where the couple habitually entertained Turner to dinner. After her husband's death in the 1850s Mary Robinson lived with her parents and sister in Richmond. She suffered from ill health and depression, but was greatly relieved by a friendship and regular correspondence with Babbage, who sent her copies of his and other scientists' books, and discussed philosophical ideas with her. She was a regular attender at Royal Institution lectures.

Mary Robinson married her cousin Captain Lloyd in 1864. The couple continued to live in Richmond, where Mary Lloyd wrote a collection of memoirs of her older contemporaries, such as Turner, Babbage, and Eastlake, which were published as *Sunny Memories*. JH

Babbage Correspondence, British Library.

Mary Lloyd, *Sunny Memories*, 2 vols., 1879 and 1880 (memoir of Turner), reprinted in Lloyd 1984.

LLOYD, Robert Wylie (1868–1958), businessman and collector, notably of Turner watercolours, bequeathed to the *British Museum. Born in Lancashire, Lloyd came to London to live as a child, and there began a lifelong passion for collecting, starting with insects and becoming the youngest member of the Royal Society of Entomologists. Chairman of Nathaniel Lloyd and Co., printers in Blackfriars, Lloyd became chairman of a number of other companies, including Christie's in 1939. An active member of the Alpine Club from 1901, he assiduously collected images of the Alps in the form of Swiss prints (eventually owning 5,000, also bequeathed to the British Museum). He extended his collecting to British watercolours with his first purchase, of a de Wint, at *Agnew's in 1912. A week later he returned to buy Turner's *Marxburg* (W 692) and thus became a regular customer at a time when fine Turners from the J. E. *Taylor, *Fawkes, and *Swinburne collections were steadily passing through their hands.

Between 1912 and 1936, Lloyd purchased 110 British watercolours, drawings, and oils at Agnew's, building a representative collection but focusing his activities on acquiring examples of Turner's watercolours which were in fine condition and with impeccable provenances. His collection represented every period of the artist's work, but the real strengths of his collection were five watercolours commissioned by the Swinburne family, seven of the 50 *Rhine drawings of 1817 once belonging to Walter Fawkes, twelve stunning watercolours from the *Picturesque Views in *England and Wales* series once owned by *Windus of Tottenham, John *Ruskin, and *Munro of Novar, and several late Continental works, including two from Ruskin's favourite series, the late Swiss watercolours (*Zurich* and *Lucerne by Moonlight*; W 1533, 1536). He also owned one of Turner's largest and most spectacular watercolours, *Messieurs les voyageurs on their return from Italy* (RA 1829; W 405).

Lloyd was one of the earliest collectors to have roller blinds inserted into the frames provided by Agnew's in his rooms in Albany, where the blinds on the Turners remained drawn, and visitors were required to admire the antiquities, insects, and Swiss prints before the blinds were raised. Lloyd had a reputation for driving a hard bargain, but was a philanthropic supporter of the many societies of which he was a member, and he was a generous lender of his Turner watercolours. Lloyd had begun to collect Turner watercolours just after George Salting's generous bequest to the British Museum in 1910 and the nature of his collection, mainly highly finished works in marvellous condition, was closer to the type of work bequeathed by Salting than the loose watercolour sketches and 'Colour *Beginnings' in the Turner Bequest, housed at the British Museum from 1931 to

1987. Lloyd obviously felt his collection would complement the British Museum's own and the bequest of his Turners and English watercolours was on the condition that they never leave the building, that they be stored as a group apart from the rest of the collection, and that they be shown only in the first two weeks of February. Modern lighting controls enable Lloyd's bequest to be exhibited outside of February, but they are still never lent. KMS

Kim Sloan, *J. M. W. Turner Watercolours from the R. W. Lloyd Bequest to the British Museum*, exhibition catalogue, London, British Museum, 1998.

LOCK, William, of Norbury (1732–1810), an early patron of Turner, and a neighbour and friend of Dr *Monro. Turner visited Lock's house, Norbury Park, near Dorking, Surrey, in 1797 and painted a watercolour of the Fern House there (RA 1798; location unknown; W 239). At or about the same time, he made a group of watercolours in the vicinity (W 153–9, 161, 163), some of which were acquired by Monro.

Lock went on the Grand Tour in the early 1750s, accompanying Richard *Wilson from Venice to Rome, and on this journey developed a taste for the antique and old masters. He began his art collection in Rome, buying antique sculpture and Old Master paintings, including *Claude's *Seaport with the Embarkation of St Ursula* (National Gallery, London). Over the following years he developed an extensive collection of drawings and watercolours. He built Norbury Park, designed by Thomas Sandby, in the late 1770s, and commissioned George Barret Sen. to paint decorations in the house. It is possibly through Lock that Turner came to know *Angerstein. Norbury was a focal point for artistic and literary society, and among Lock's visitors were *Fuseli and Fanny Burney. Lock was himself an amateur sketcher with pronounced views on art theory. JH

Duchess of Sermonetta, *The Locks of Norbury*, 1940.
Finberg 1960, p. 44.
Lindsay 1966, p. 108.

LOIRE. Turner made an extensive tour of north-western France in 1826, which culminated in his journey up the River Loire. At that date Brittany and the Loire had not received the same kind of attention from British topographers as Normandy, so Turner's itinerary was ground-breaking, even though he seems to have arrived at it in a rather haphazard way. While the whole journey kept him away from London for over a month and a half, he seems to have spent scarcely two weeks travelling from Nantes (where he was on 1–2 October) up the Loire to Orléans, whence he continued to Paris. Such a hasty visit really permitted him to focus only on the principal riverside towns of Nantes, Angers, Saumur, Tours, and Orléans. It was in these centres that he had time

to sketch in pencil on the sheets of blue *paper made by Bally, Ellen & Steart that he had taken with him for perhaps the first time on any of his travels, as well as in his customary sketchbooks (TB CCXLVII, CCXLVIII, CCXLIX). The fleeting nature of his brief acquaintance with his motifs did not prevent him from subsequently working up nearly 80 views in watercolour and gouache on sheets of the blue paper. Twenty of these were engraved and published at the end of 1832 in the first of three volumes issued as *Turner's Annual Tour*. This first edition of the annual, that designated for 1833, which also has the title *Wanderings by the Loire*, was devoted exclusively to the river, and was the first set of his prints to be published complete in one volume.

Most of Turner's journey was carried out using the public vehicles known as *diligences*, but between Nantes and Angers he evidently took advantage of one of the steamboats, which had only recently been introduced on the Loire. This part of the journey was especially significant for him, accounting for the subjects of 22 (over a quarter) of the series of *gouache studies. In these he charted the gradual progress of his day on the river, beginning with a hazy sunrise at Nantes. This was also the part of the river he chose to depict in his only oil painting commemorating the Loire journey (The *Banks of the Loire* (RA 1829; Worcester Art Museum, Massachusetts; BJ 329, now equated with BJ 328a), although he also embarked on an ambitious view of Brest soon after the trip (BJ 527; see Warrell 1997, p. 175, for this recent identification). Unlike the subsequent views of the *Seine, the drawings for the published Loire series left Turner's own collection. Though some of the group were dispersed, the majority remained together and were owned by Charles *Stokes, passing then to his niece Hannah Cooper, who sold them to John *Ruskin, by whom they were given to the museum in Oxford, now the *Ashmolean, in 1861 (he also gave some unpublished views of the Loire to the *Fitzwilliam Museum, Cambridge, in the same year). Ruskin's admiration for the set brought them to the attention of his and the next generation, during which time they were frequently copied. IW

Alfrey 1981, pp. 187–258.
Herrmann 1990, pp. 167–71.
Warrell 1997.

LONDON. A number of important oils and watercolours depict aspects of Turner's native city—including *Archbishop's Palace, Lambeth* (RA 1790; W 10), The *Pantheon, the Morning after the Fire* (RA 1792; W 27), *Funeral of Sir Thomas Lawrence* (RA 1830; TB CCLXIII: 344; W 521); and, in oils, *London* (Turner's gallery 1809; BJ 97), *The Burning of the House of Lords and Commons, 16th October, 1834* (BI

1835; Philadelphia Museum of Art; BJ 359) and *The Burning of the Houses of Lords and Commons, October 16, 1834* (RA 1835; Cleveland Museum of Art, Ohio; BJ 364; see PARLIAMENT). However, unlike some of his contemporaries, Turner 'was never to make the commercial heart of London the subject of [a major oil]' (Hemingway 1992, p. 237). Indeed, his fragmentary verses on London follow *Thomson's *Seasons* in depicting the city as a 'World of Care | Whose Vice and Virtue so commixing blends', in contrast to the generally positive portrayal of the countryside around London in his *Thames series of c.1805–10. Nevertheless, there exists an unfinished oil, *The Thames above Waterloo Bridge* (c.1830–5; BJ 523), possibly begun in emulation of *Constable's *Opening of Waterloo Bridge* (RA 1832; Tate Gallery), which suggests that Turner's aesthetic of London underwent some development: the image includes not only industrial emissions, but also a steam-boat and its dark plume of smoke (see Hamilton 1998, pp. 103–5). In topographical work for engraving, urban modernity was more easily admissible: four finished watercolours, of which three show the bustling Pool of London, are probably connected with W. B. *Cooke's abortive series *Views in London and its Environs* (W 513–16; R 205–6; see Shanes 1990[2], p. 11, nos. 100–1, 246–7). One of these images juxtaposes the Tower of London with two cross-Channel steamers (c.1825; W 515; see Egerton 1995, p. 57), while in *View of London from Greenwich* (1825; W 513), three more paddle steamers invade the classic vista depicted in the 1809 oil *London*.

AK

Shanes 1990[2], pp. 128–9, 271–2.

LONDON, Corporation of, Art Gallery, Guildhall, 1899 exhibition. *Loan Collection of Pictures and Drawings by J. M. W. Turner, R.A., and of a Selection of Pictures by some of his Contemporaries* was the title of the eighth in an annual series of free exhibitions organized by the Corporation of London and devoted to British, Dutch, Flemish, and French art, which had attracted nearly one and a half million visitors so far. Both in design and content the catalogue of the 1899 exhibition, which had 223,132 visitors, shows the strong influence of John *Ruskin, who himself lent nine of the 79 watercolours. In addition there were 38 oil paintings, and a selection of *Liber Studiorum* plates (mostly lent by W. G. *Rawlinson) and a few other prints were also shown. The exhibition provided a succinct and impressive survey of Turner's work. The 35 paintings by other British artists ranged from Richard *Wilson's *Snowdon* to works by John Linnell and William Mulready.

LH

LONDON, National Gallery. Founded in 1824 with the promise of the *Beaumont Collection and the purchase of the *Angerstein Collection, and initially displayed in Angerstein's former Pall Mall house, it moved to the present building in Trafalgar Square, designed by William Wilkins, in 1838. Originally the building also housed the *Royal Academy. One of the last 'national' collections to be established in the major European capitals, the National Gallery has continued and expanded on that site since then to become one of the outstanding paintings collections in the world. All Western schools are represented, and the collection is especially strong in Italian paintings, many of the most important of which were acquired during the Directorship of Sir Charles *Eastlake. The British School was represented from the start, and greatly strengthened by the Robert *Vernon Gift of 1847, which, except for one painting by Turner, was not, however, displayed in Trafalgar Square, for lack of space, until 1876.

Turner must have approved of the new National Gallery, for in 1829 in his first will he bequeathed to it two of his paintings—*Dido building Carthage; or the Rise of the Carthaginian Empire* (BJ 131) and *The Decline of the Carthaginian Empire* (BJ 135)—on condition that they were hung beside two of the Angerstein *Claudes. In his new will in 1831 the second painting was replaced by the rather earlier *Sun rising through Vapour* (BJ 69). This bequest was not changed again in the various codicils to his will, and in December 1852 the two works were hung at Trafalgar Square between the two largest Claudes from the Angerstein Collection—as they are still hung today—within a few days of the time-limit set by the will. As is recorded elsewhere (see WILL AND BEQUEST) the artist's rather confused plans 'to keep my Pictures together' and to create a gallery for the rest of his work in his possession at the time of his death were overturned after a long Chancery suit initiated by distant relatives, resulting in the unexpected 'Turner Bequest' to the nation in 1856. Nearly 300 paintings and 19,000 drawings became the responsibility of the National Gallery, and underwent a very chequered and contentious existence until the opening of the Clore Gallery at the *Tate Gallery well over a century later in 1987.

At first a small selection of paintings and drawings was shown at Marlborough House; then a larger one at South Kensington in what is now the Victoria and Albert Museum, until finally in 1876 the Bequest was moved to the National Gallery, where over 100 paintings were exhibited. With the opening in 1897 of the Tate Gallery on Millbank, until 1954 controlled by the Trustees of the National Gallery, all of the Turner Bequest except for a small selection of paintings was moved there. In 1997 nine paintings remain at Trafalgar Square, including such famous works as *Calais Pier* (BJ

48), *The *Fighting 'Temeraire'* (BJ 377), and **Rain, Steam, and Speed* (BJ 409). LH

Davies 1946, pp. 146–69, 185–91.
Finberg 1961, pp. 441–52.
BJ, pp. xxii–iv.
Egerton 1998, pp. 11–17, 260–325.

LONDON [from Greenwich], oil on canvas, 35½ × 47¼ in. (90 × 120 cm.), signed and dated 'JMW Turner RA PP [?]' and '1809', Turner's gallery 1809 (16); Tate Gallery, London (BJ 97). This view from Greenwich was a favourite one for British artists from the late 17th century. By the time it was published in the *Liber Studiorum* as 'London from Greenwich' (F 26) on 1 January 1811 it belonged to Walter *Fawkes; according to *Thornbury it was later exchanged for another work.

The 1809 catalogue includes the following verses:

Where burthen'd Thames reflects the crowded sail,
Commercial care and busy toil prevail,
Whose murky veil, aspiring to the skies,
Obscures thy beauty, and thy form denies,
Save where thy spires pierce the doubtful air,
As gleams of hope amidst a world of care.

The date, in a different colour from the signature, may have been added after the picture's return to Turner. The letters 'PP' refer to Turner's position as Professor of Perspective at the Royal Academy (see PERSPECTIVE LECTURES).

There are related drawings in the Tate Gallery (TB CXX: N and XCV: 43–4) as well as studies for a *Liber Studiorum* plate (CXVII: D and, a variant, in the Whitworth Art Gallery, Manchester). MB

Forrester 1996, pp. 75–7, repr.

LONGMAN AND CO. London publishing house founded in 1724 by the first Thomas Longman, and continuing for over 250 years. The firm achieved particular renown under Thomas Longman III (1771–1842), who 'reigned' for 48 years, in a variety of partnerships, each lasting a few years. During that period Longman's published *Whitaker's *History of Richmondshire* (1819–23), and in 1835 the firm took over the publication of the problematic *England and Wales*, and saw the project through to its end. Longman's were also concerned with another of the best-known series of engravings after Turner, the three volumes of *Rivers of France*, which they published for Charles *Heath. LH

LONSDALE, Earl of (1757–1844). He commissioned two views of Lowther Castle near Penrith in Cumbria from Turner in 1809 although the castle was not completed until 1811. The commission was probably due to Lonsdale having admired Turner's two pictures of *Tabley House (on loan to Whitworth Art Gallery, Manchester, and Petworth House; BJ 98, 99) at the Royal Academy in 1809.

The two pictures, which remain in family possession, were exhibited at the RA in 1810, where they were well received although unusual in having no figures. One depicts *Lowther Castle . . .: North-West View from Ulleswater [sic] Lane, Evening* (BJ 111) and the other *(the North Front), with the River Lowther* (BJ 112). The 'Lowther' Sketchbook (TB CXIII) contains some architectural details of the castle but nothing connected with the oils. However, there are three drawings of Lowther in the *Ashmolean Museum, Oxford, given to *Ruskin by the Revd William *Kingsley, two of which are studies for the oils.

Page 59 of the 'Hastings' Sketchbook (CXI) notes a payment on 18 June 1810 from Lonsdale of almost £600. This is mystifying, for Turner would have charged 200 guineas each for the views of Lowther and there is no record of any other commission from Lonsdale. EJ

Herrmann 1968, pp. 91–2, Ashmolean drawings repr. pls. XV, XLVA.

LOST, STOLEN, AND DESTROYED WORKS. Given the fact that Turner exhibited most of his finished oil paintings and that all of his unfinished works should have formed part of the Turner Bequest (see WILL), one has a fairly good idea of what is missing among his oil paintings. In the case of finished watercolours many more examples were not actually exhibited, having been given away, commissioned, or sold through dealers, and may not therefore be recorded.

Two oil paintings have definitely been destroyed but luckily are preserved in black-and-white photographs: *Fish-Market on the Sands—the Sun rising through a Vapour* (RA 1830; BJ 335), a standard 3 × 4 ft. (91.4 × 122 cm.) picture destroyed in a fire in New York in 1956, and *The Mouth of the Thames* (?Turner's gallery 1807; BJ 67), a small picture destroyed during the last war.

Three oil paintings are at present (1999) missing having been stolen: *Grand Junction Canal at Southall Mill* (Turner's gallery 1810; BJ 101) in 1991, and *Light and Colour (Goethe's Theory)—the Morning after the Deluge* and *Shade and Darkness—the Evening of the Deluge* (RA 1843; BJ 405, 404) in Germany in 1994.

Of lost paintings the most mysterious is *Aeneas relating his Story to Dido*, one of Turner's last four exhibits in 1850, untraced since it was lent to a provincial gallery by the Tate Gallery soon after 1905 (BJ 430). Other oils remain untraced since their first exhibition. Two of these are recalled in engravings in the *Liber Studiorum*: *Fishermen coming ashore at Sun Set, previous to a Gale*, the *'Mildmay Seapiece' (RA 1797; BJ 3), and the *'Leader Seapiece', engraved for the

Liber 29 March 1809 (BJ 205). *Ducal Palace, Venice*, interesting as one of Turner's first two exhibited Venetian oils (RA 1833; BJ 352), may be the work recorded in W. Miller's engraving of 1854 as 'The Piazzetta Venice'. Certain pictures exhibited in Turner's gallery may now be works known, with greater or lesser degrees of doubt, by different titles: the two pictures of 'Fishing Boats in a Calm' and 'Bilsen Brook', exhibited in 1809 (BJ 93, 94, 96), and 'The River Plym' in 1812 (BJ 118), perhaps to be equated with *Hulks on the Tamar* (Petworth House; BJ 119). *Rosllyn*, exhibited in Turner's gallery 1810, may just be a watercolour though this is doubtful (BJ 110), as may *Storm off the Farne Island* of *c*.1825, traced up to 1919 and known from a photograph but sold twice at Christie's as a monochrome oil (BJ 259a; W 783). Other lost early exhibits are *Winesdale, Yorkshire, an Autumnal Morning* (RA 1798; BJ 4), the title most likely a mistake for Wharfedale (see Hill 1996, p. 182), *Fishermen becalmed previous to a Storm, Twilight* (RA 1799; BJ 8), known from contemporary descriptions and apparently a small work approx. 15 × 20 in. (38 × 51 cm.), and *Scene in Derbyshire* (RA 1827; BJ 420), sadly recalled in the *Literary Magnet* as 'a bit of unrivalled richness and beauty'.

More importantly, three large pictures appear to be missing. The first, **Battle of the Nile, at 10 o'clock when the L'Orient blew up, from the Station of the Gun Boats between the Battery and Castle of Aboukir* (RA 1799; BJ 10), would be Turner's first attempt at such an ambitious and dramatic scene. *The Army of the Medes Destroyed in the Desart by a Whirlwind—Foretold by Jeremiah, Chap xv. ver 32, and 33* (RA 1801; BJ 15), probably a painting of the type of those depicting **Plagues of Egypt*, may be lurking under the later painting of *The *Vision of Jacob's Ladder* (BJ 435). A large seapiece of 'Gravesend—5 ft. long 3¾ high' is known only from a letter including a sketch written 12 December 1810 to Sir John Leicester (BJ 206).

Other pictures thought to be probably by Turner on account of their early provenance are *Rochester Castle with Fishermen drawing Boats ashore in a Gale* (*c*.1794; BJ 21), and *Fishing Boats in a Stiff Breeze* and *Coast Scene* (of unknown date, BJ 533-4).

Further works have been lost since they were recorded in the art trade earlier in the 20th century, for instance a small version of *Bonneville, Savoy* (*c*.1803-5; BJ 148) last recorded in 1935. Works in private collections have a tendency to go to ground, particularly nowadays when owners are more security (and tax) conscious. Luckily some works reappear. *Knockholt Park, Kent* (*c*.1799-1801; BJ 35d) has re-surfaced twice during the last ten years and is still in a private collection. *Châteaux de St. Michael, *Bonneville, Savoy* (RA 1803; BJ 50) has now found a permanent home in the Dallas

Museum of Art after being confused for years with *Bonneville, Savoy, with Mont Blanc*, also at the RA in 1803 (Yale Center for British Art, New Haven; BJ 46). Two distinct entries in BJ, 539 and 540, have, as was already suspected, turned out to be the same work from the **Rogers Collection, sold at Sotheby's New York on 13 December 1991. The mysterious **Banks of the Loire* (RA 1829; BJ 329) has been shown to be a picture painted for Sir James Willoughby **Gordon and to be the work tentatively entitled 'A View on the Rhone?', BJ 328a, in the Worcester Art Museum, Worcester, Mass. (see Warrell 1997, pp. 181-3, repr. in colour).

Watercolours, much more likely to disappear or to be totally unrecorded, reappear rather more frequently in the salerooms or dealers' galleries. From 1981 to 1991 they were recorded in *Turner Studies* and since then in the *Turner Society News*, usually with the endorsement 'not in Wilton', that is, Wilton 1979. MB

LOUIS-PHILIPPE, King (1773-1850), eldest son of the Duke of Orleans and pretender to the French throne who in 1789 assumed the name of Egalité. Although he affected revolutionary sympathies, his father's execution in 1793 caused him to flee to Austria, Switzerland and America before settling in England. There, at Highshot House, Twickenham, with Turner as a near neighbour from 1805, he lived from 1800 to 1807, travelling to Italy in 1809 and marrying Ferdinand IV's daughter, Maria Amelia. After **Napoleon's defeat at Leipzig, he returned to France, where in 1814 Louis XVIII had become King. But when Napoleon escaped from Elba in March 1815 and the King fled to Ghent, he returned to England with his family, this time renting 'Orleans House' on the Thames at Twickenham but returning to France in 1817. After the July Revolution of 1830 he became the 'Citizen King' of France, demonstratively modest and approachable as none of his predecessors were.

Louis Philippe was a great art-lover and befriended Turner probably as early as 1806. In 1837 he attended Queen **Victoria's coronation and presented his old friend with a gold snuff box. Hearing in the autumn of 1845 that the painter was sketching on the coast, he invited him to Eu Palace in Picardy (see the 'Eu and Tréport' Sketchbook, TB CCCLIX). In 1848, however, another revolution brought his abdication; he fled again to England and in 1850 died at Claremont, Surrey. AGHB

A. de Castries, *Louis Philippe*, 1980.

LOUTHERBOURG, Philippe Jacques de (1740-1812), Alsatian painter of landscapes, naval battles and historical subjects, whose work Turner imitated in his early career. He moved to London in 1771, and became a designer of

theatrical scenery for the actor-manager David Garrick. In 1781 he invented the 'Eidophusikon', a sort of miniature theatre with sound and lighting effects used, above all, to present *Sublime landscape phenomena. An early sketchbook by Turner of c.1790–1 (Princeton Art Museum) contains details copied from de Loutherbourg's *Cottage in Patterdale*, while a group of watercolours of c.1792 showing rocky coastlines (TB XXIII: Q, R, V) recalls his stormy marines, and also reflects his handling of figures and foliage. Furthermore, just as Turner's *Limekiln at Coalbrookdale* of c.1797 (Yale Center for British Art, New Haven; BJ 22) may have been inspired by de Loutherbourg's small watercolour cards of industrial subjects in Shropshire (including some of Coalbrookdale), then owned by Dr *Monro and which Turner later purchased at Monro's sale in 1833 (CCCLXXII), so also his *Fall of an Avalanche in the Grisons* (BJ 109) recalls avalanche subjects by de Loutherbourg in the collections of the Earl of *Egremont and Sir John *Leicester. Given Turner's admiration for the older artist, it seems unlikely that the principal figure in a satirical drawing by him, *The Artist's Studio*, c.1808 (CXXI: B), depicts de Loutherbourg, as John Gage has suggested (1969, pp. 136–8). About 1810, the two artists became neighbours at Hammersmith. Turner's *Battle of Trafalgar* (BJ 252) was commissioned by *George IV in 1822 as a pendant to de Loutherbourg's *Glorious First of June 1794* (London, National Maritime Museum).　　AL

Gage 1969, pp. 29–30, 50, 137–8, 181–2, 229 n. 53, 255 n. 14.

R. Joppien, *Philippe Jacques de Loutherbourg, RA*, exhibition catalogue, London, Kenwood, 1973.

LOYD OF LOCKINGE. The first Lord Loyd of Lockinge was born Robert James Lindsay (1832–1901). He was one of the great heroes of Victorian England, the first man to win the Victoria Cross, for gallantry that won the day at the Battle of Alma in the Crimea. He was the first Chairman of the Red Cross Society, personally distributing aid during the siege of Paris in 1870. He had a successful political career under Disraeli, becoming Financial Secretary to the War Office in 1877. From 1859 he played a prominent part in first forming and then running the Volunteer Movement. In 1885 he was created Baron Wantage of Lockinge. He married Harriet Loyd, the only child of Lord and Lady Overstone in 1859, and adopted the name Loyd-Lindsay.

The picture collection was housed at Lockinge House, which was demolished in 1944, and subsequently at Betterton House, Lockinge, in Berkshire. The diverse collection includes works by both British painters and the Old Masters. The collection has been published by Leslie Parris, *The Loyd Collection of Paintings and Drawings*, 1967; revised edition by Francis Russell, 1990.

Of the five Turners in the collection, three were bought by Lord Overstone: *Newark Abbey* (c.1807–8; BJ 201), *View of the *High-Street, Oxford* (Turner's gallery 1810; BJ 102), and *Whalley Bridge and Abbey, Lancashire: Dyers Washing and Drying Cloth* (RA 1811; BJ 117). Lord Wantage bought *Walton Bridges* (?Turner's gallery 1806; BJ 60) and *Sheerness as Seen from the Nore* (Turner's gallery 1808; BJ 76). All were acquired through Agnew's. *Newark Abbey* and *Sheerness* have now been sold; the latter is in a private collection in Japan. *Whalley Bridge*, *High-Street, Oxford*, and *Walton Bridges* are on loan to the Ashmolean Museum, Oxford.　　RU

LUCERNE. Turner first visited Lucerne in 1802, and made drawings and watercolours in the area; but it was not until the 1840s that he celebrated the town and its lake in detail. He took to staying at a waterside hotel, the Swan, with views over the lake to the *Rigi, which he often drew. He also made sketches of Mont Pilatus, opposite Lucerne to the south, and of the shores and villages round the lake, from Küssnacht to Fluelen. The town itself also preoccupied him, standing as it does at the heart of an impressive complex of lakes, fortified by a splendid half-circle of 14th-century walls punctuated with watch-towers, and straddling the River Reuss, crossed by the covered wooden Kapellbrücke. Next to the Kapellbrücke rises the Wasserturm, supposed originally to have been a lighthouse (*lucerna*). Three views of the town appear among the late finished Swiss watercolours: *Lucerne from the Walls* (1842; Lady Lever Art Gallery, Liverpool; W 1529), *Lucerne: Moonlight* (1843; British Museum; W 1536), and *Lucerne Town* (1844; private collection, Germany; W 1544). In addition to three finished views of the Rigi, there are no fewer than eight (possibly nine) of the villages and hills round the lake. In addition there are a large number of colour studies, some of which served as 'samples' from which the finished views were realized. It is in these lake views, both studies and finished works, that Turner's art as a painter of the ineffable atmosphere of Swiss mountain scenery reaches its apogee, with exquisite manipulation of technical effects, relying particularly on contrasts between fine hatching and broad, wet washes of soft colour.

See also BRUNNEN.　　AW

LUPTON, Thomas Goff (1791–1873), English mezzotint engraver, known for his pioneering use of steel plates for engraving in the 1820s, and his skilful interpretation of Turner's work. Lupton was apprenticed to George *Clint, who engraved two plates for Turner's *Liber Studiorum, and under Turner's close supervision Lupton produced for the *Liber* his first mezzotint plate, *Solway Moss* (F 52), one of the most spectacular engravings of the series. Lupton also

engraved the published plates of *Dumblain Abbey, Scotland* (F 56), *Water Cress Gatherers* (F 62), and *Ben Arthur, Scotland* (F 69), as well as the unpublished subjects *Dumbarton* (F 75) and *Ploughing Eton* (F 79), and may have also worked on *Stonehenge* (F 81), although this plate is traditionally attributed to Turner. Lupton engraved five plates on steel after Turner's designs for the *Rivers of England* in the 1820s (R 753, 755, 757, 762, 766). In 1826 he collaborated with Turner on the *Ports of England*, acting as engraver and publisher, but by 1828 only six mezzotints of the proposed twelve had been published (R 779–84), and the remaining six (R 785–90) did not appear until 1856, when the complete series was published as the *Harbours of England*. Lupton's single large mezzotint plates of *Calais Pier* (R 791; BJ 48) and *Folkestone* (R 798) remained unpublished. Between 1858 and 1864 Lupton re-engraved fifteen of the *Liber* subjects on steel for a projected series to be published by *Colnaghi and dedicated to John *Ruskin, but the plates were never issued.

GF

LUXEMBOURG. Turner travelled twice through the small Duchy of Luxembourg, which lies between the valleys of the *Meuse and the *Mosel. On his first tour of this area, in 1824, he made just a few swift pencil sketches of Luxembourg (in the 'Rivers Meuse and Moselle' Sketchbook, TB CCXVI) but his second tour, in 1839, inspired more concentrated sketching on the spot. After returning home, he produced over twenty coloured drawings of Luxembourg on blue *paper similar in style and technique to those depicting the Meuse and Mosel created around the same time (catalogued in Powell 1991, pp. 173–83).

Prior to 1991, when the chronology of both Meuse–Mosel tours was finally established, the Luxembourg drawings were variously dated by Turner scholars but they can now be firmly dated thanks to their consistent stylistic characteristics and their similarities to the pencil sketches in one of the sketchbooks known to have been used in 1839 ('Givet, Mézières, Verdun, Metz, Luxembourg, and Trèves,' CCLXXXVIII). Turner's sudden interest in Luxembourg in 1839 may have been prompted in part by the signing—in April of that year—of the Treaty of London, a diplomatic triumph for the British Foreign Secretary Lord Palmerston. In settling the dispute between Belgium and the Netherlands, this treaty adjusted the borders of Luxembourg and confirmed the Dutch king as its Grand Duke. But other factors obviously played a major part also: the innate appeal of Luxembourg as a subject for a landscape painter and its proximity to the two great rivers in which Turner was currently interested.

All Turner's Luxembourg drawings show its capital city, also named Luxembourg, a complex ensemble including not only a castle and cathedral but the most massive fortifications in northern Europe with towers, bridges, and castellated walls, situated above tortuous valleys and precipitous wooded gorges. Such a wealth of spectacular views—uniting natural features and staggering feats of ingenuity on the part of architects and builders over the centuries—inspired Turner to paint some of the most dynamic of all his scenes on blue paper. Indeed, their atmospheric effects, visionary exaggeration of scale, and virtuoso colouring show his genius at its height. Although most of the drawings are in the Turner Bequest, several are in public and private collections (two are in the Musée d'Histoire et d'Art in Luxembourg itself) and previously unknown works in the series continue to be discovered.

CFP

J. M. W. Turner in Luxembourg and its Neighbourhood, exhibition catalogue, Luxembourg, Musée de l'État, 1984.
Powell 1991, pp. 52, 127–8, 173–83.

M

McADAM, John Loudon (1756–1836), developed a smooth, hard-wearing surface for roads, based on layers of small stones, thus helping to establish the network of fast mail-coach routes upon which Turner depended so much during his sketching tours of Britain. A letter by Turner of 1826 (Gage 1980, p. 97), which describes the overturning of his stagecoach during its negotiation of the Alpine pass of Mont Cenis in 1820, asserts the superiority of the British McAdam, 'the Colossus of Roads', over that other road-builder, *Napoleon. The incident is depicted in *Snowstorm: Mont Cenis* (1820; Birmingham Museums and Art Gallery; W 402). On Napoleon and Alpine passage, see *SNOW STORM: HANNIBAL AND HIS ARMY CROSSING THE ALPS*.

See also TRAVEL; DISASTERS ON TRAVELS. AK

MacCOLL, D. S. (1859–1948), artist and critic; Keeper of the *Tate Gallery from 1906 to 1911, and Curator of the Wallace Collection from 1911 to 1924. When MacColl became Keeper of the Tate in 1906, the conditions of Turner's *will had not yet been fulfilled. A great admirer of Turner, he was instrumental in soliciting benefactors and acquiring land for a building to house the Turner Bequest; the new Turner wing opened in 1910. He controversially campaigned for permission to sell what he saw as 'superfluous' works from the Turner Collection in 1916: the House of Lords rejected the bill. MacColl's 'Notes on English artists 2: Turner's Lectures at the Academy' was published by the *Burlington Magazine*, 12 (March 1908), pp. 343–6. TR

Maureen Borland, *D. S. MacColl: Painter, Poet, Art Critic*, 1995.

McCONNEL, Henry (1801–71), textile manufacturer and collector of contemporary British art, who was Governor of the Royal Manchester Institution from 1831. He commissioned work from *Callcott, Edwin *Landseer, and Turner, and also owned works by *Constable, Mulready, William Collins, *Wilkie, *Eastlake, Morland, Millais, and *Wright of Derby. Three letters to him from Turner are recorded (Gage 1980, pp. 154, 156, 159). He owned several Turner oils: *Venice* (RA 1834; National Gallery of Art, Washington; BJ 356), *Keelmen hauling in Coals by Night* (RA 1835; Na-

tional Gallery of Art, Washington; BJ 360), *Rockets and Blue Lights* (RA 1840; Clark Institute, Williamstown, Mass.; BJ 387), *Neapolitan Fisher-Girls surprised bathing by Moonlight* (?RA 1840; private collection, USA; BJ 389; see REPLICAS AND VARIANTS) and *Campo Santo, Venice* (RA 1842; Toledo Museum of Art, Ohio; BJ 397). McConnel stressed in a letter to John *Naylor that both *Venice* and *Keelmen* were painted 'at my especial suggestion'. McConnel formed his collection mainly in the 1830s, and in 1839 the *Art Union* described it as 'unrivalled out of London' (p. 5). Part of his early collection was sold to John Naylor when his business was going badly. This included his first two Turners, which he later tried to buy back, but Naylor refused to part with them. His purchases in the 1850s and 1860s were partly guided by *Agnew's. McConnel lent a number of British pictures to the *Manchester *Art Treasures* exhibition in 1857 and the International Exhibition, *South Kensington, in 1862. His collection was sold at Christie's on 27 March 1886. RU

Julian Treuherz, 'The Turner Collector: Henry McConnel, Cotton Spinner', *Turner Studies*, 6/2 (winter 1982), pp. 37–42. Macleod 1996, pp. 446–7.

McCRACKEN, Francis (fl. 1840–64), Belfast cotton spinner and collector. He commissioned Turner's *Morning, returning from the Ball* (RA 1845; BJ 417) either *Going to the Ball (San Martino)* or *Returning from the Ball (St. Martha)* (RA 1846; private collection; BJ 421, 422), but rejected them. His chief artistic interest seems to have been the Pre-Raphaelites: he bought Ford Madox Brown's *Pretty Baa Lambs* and *Wycliffe*, Millais's *Othello*, and Arthur Hughes's *Ophelia*, along with Rossetti's *Annunciation*. It was through McCracken that *Ruskin developed an enthusiasm for Rossetti's work after the Ulsterman sent him this last work for his opinion. There has been considerable confusion over McCracken's background. Macleod gives his occupation as cotton spinner, having consulted Belfast directories from 1843 to 1863. His traditional designation as a shipowner seems unsure. He corresponded with Rossetti and Ruskin,

who both wrongly connected him with James and Richard McCracken, the Royal Academy packing and shipping agents. McCracken's policy of paying in instalments for his pictures, or offers of payment in kind, suggests that Macleod's characterization of him as a humble but enthusiastic collector is correct. RU

Macleod 1996, pp. 447–8.

MACLISE, Daniel (1806–70), Irish painter of portraits and history subjects. His *Caxton's Printing Office* (RA 1851; Knebworth House; Arts Council 1972, no. 100, repr.) was much admired by Turner. Earlier, Maclise's *Sacrifice of Noah* (Leeds City Art Gallery; Arts Council 1972, no. 98, repr.) had hung next to Turner's **Hero of a Hundred Fights* (BJ 427) at the Royal Academy in 1847. According to George *Jones, 'Turner encouraged Maclise to darken his background to heighten the effect of the burning lamb. After his attempt, Turner said "It is better but not right" and accomplished the effect himself as well as adding to the rainbow. Maclise was pleased with it and left it untouched' (Finberg 1991, p. 416). *Ruskin complained that the juxtaposition of the two paintings detracted from the Turner. This is not surprising given his assertion that *Modern Painters* had been written to educate 'the class of people who admire Maclise' (Hamilton 1997, p. 294). ADRL

Finberg 1961, pp. 352, 395, 416–18, 431.
Arts Council, *Maclise*, exhibition catalogue, 1972.
Hamilton 1997, pp. 266, 294, 299.

MACON, see *FESTIVAL UPON THE OPENING OF THE VINTAGE.*

McQUEEN, J., London family printing and publishing firm founded by William Benjamin McQueen in 1816, which merged with Thomas Ross and Son in 1956. Turner had the copper plates for the **Liber Studiorum* reprinted by McQueen's in 1845. According to a letter written to John *Pye in 1852 by one of the McQueen family, the firm printed fifteen sets (Pye and Roget 1879, p. 71 n.); however, seventeen sets were included in the Turner sale, together with a large number of loose impressions from that printing. In the 1850s McQueen's published two series of lithographs after Turner's works (R 842–7b, 854, 857, 859). GF

MAIDEN LANE. The street of Turner's birth, running east–west about half-way between the Strand and today's Covent Garden Piazza. William *Turner had lived at no. 21, at the south-west end of the street, since March 1773, and took his bride to live there after their marriage. Their rooms, from which William Turner worked as a barber and wig-maker, were above a rowdy drinking place, the Cider Cellar, and the house had previously been used as auction and exhibition rooms. Turner was born at no. 21, but, probably in the early 1780s, the family moved to no. 26, directly opposite.

Turner's first drawings were displayed in the barber's shop at no. 26, and it was in rooms at the back of the house that he drew and painted as a boy. This house backed onto Hand Court, a small enclave off Maiden Lane, where Turner took rooms 1793–9. Although presumably he had more space in Hand Court, it was nevertheless dark and restricting, as the *Self-portrait* (c.1798; BJ 25; see PORTRAITS) with its close top light and claustrophobic air suggests. The largest works he painted here were the pair of canvases for Edward *Lascelles, *Plompton Rocks* (c.1798; 48 × 54¼ in. (122 × 137.5 cm.); Harewood House; BJ 26, 27). *Thornbury described Hand Court as 'a sort of gloomy horizontal tunnel, with a low archway and a prison-like iron gate of its own'.

Maiden Lane, being close to the Covent Garden market and Bow Street magistrates court, was populous, lively, and probably dangerous. Its name derives either from the fact that it had traditionally been the haunt of prostitutes, or had been near a convent—both, indeed, are true. Having two large theatres nearby, and the *Society of Arts and Somerset House, the home of the *Royal Academy, *Royal Society, and the Society of Antiquaries, it had long been geographically at the heart of London's artistic and intellectual life. Turner left Maiden Lane in 1800 for *Harley Street. On 2 June 1999 a plaque was placed on 21 Maiden Lane by the Westminster City Council and the Turner Society, commemorating Turner's birth on the site. See also TURNER, MARY; TURNER, MARY ANN; TURNER, WILLIAM. JH

Thornbury 1877, pp. 1–2, 9.
Lindsay 1966, pp. 12–13.
Bailey 1997, ch. 1.
Hamilton 1997, ch. 1.

MALDEN, Viscount, see ESSEX, EARL OF.

MALLORD FAMILY, see FATHER'S FAMILY.

MALTON, Thomas, junior (1748–1804), architectural draughtsman, from whom Turner took his first professional drawing lessons. The son of an architectural artist and lecturer on perspective, the younger Malton first studied as an architect before entering the *Royal Academy Schools in 1773. He worked as a topographical artist in Bath and as a scenery painter at Covent Garden before setting himself up as a drawing master specializing in perspective in 1783. Turner started to work in Malton's studio in 1789, the year he was admitted to the Royal Academy Schools. The first watercolour he exhibited in 1790, *The *Archbishop's Palace, Lambeth* (Indianapolis Museum of Art; W 10), shows how

quickly he absorbed Malton's tuition. Twenty years later, when he himself was Professor of Perspective at the RA (see PERSPECTIVE LECTURES), Turner praised his early teacher's skill, describing him as 'my real master' (Thornbury 1862, i. p. 47).

Malton published many of his designs as aquatints (e.g. *A Picturesque Tour through London and Westminster*, 2 vols., 1792) and exhibited mainly architectural subjects, enlivened with elegantly drawn groups of figures, at the RA from 1773 to 1803. His drawn outline was coarse, but he frequently etched his compositions in outline and coloured them with delicate washes by hand, enabling him to create multiple versions of his most successful works (e.g. *King's Mews, Charing Cross*, c.1792; British Museum). He often employed a low vantage point, an imaginative approach to depicting architecture, taken up by Turner to the greatest effect in his views of ruins (as in *Tintern Abbey*, 1794; British Museum; W 59, 60). KMS

Andrew Wilton, *British Watercolours, 1750 to 1850*, 1977, p. 191.
Wilton 1987, pp. 21, 28, 45.

MANCHESTER, see ROYAL MANCHESTER INSTITUTION EXHIBITIONS.

MANCHESTER, *Art Treasures* exhibition, 1857. Made up of loans from private collections and held in a temporary glass building on the scale of the Crystal Palace, the exhibition of *Art Treasures of the United Kingdom* was opened by Prince *Albert and visited by over 1,300,000 people, including Queen *Victoria. Turner was by far the best-represented artist, with 22 oils, 84 watercolours, and over 150 prints. Among the oils, shown as part of 689 'Paintings by Modern Masters', were *Dolbadern Castle* (RA 1800; Royal Academy; BJ 12), *Cologne* (RA 1826; Frick Collection, New York; BJ 232), and *'Now for the Painter'* (RA 1827; Manchester City Art Gallery; BJ 236). Included with the 969 'Drawings in Watercolours' were *The Mewstone* (c.1814; National Gallery of Ireland, Dublin; W 454) and *Ely Cathedral* (c.1831; private collection; W 845). Within the considerable showing of prints after Turner in the 'Engravings—Line' section were examples from the *Southern Coast, the *Liber Studiorum*, and a number of literary illustrations. To mark the occasion of the exhibition, John *Ruskin delivered two lectures to large audiences in the city's Athenaeum Club. These encouraged the patronage of young British artists, advocating freedom of artistic licence and fair prices for good work. Reports of the lectures appeared in the Manchester press and they were jointly published under the title *The Political Economy of Art* (1857). ADRL

Catalogue of the Art Treasures of the United Kingdom, 1857.
Timothy Clifford, Introduction, *A Century of Collecting 1882–1982: A Guide to Manchester City Art Galleries*, 1983, pp. 11–14.
Croal and Nugent 1996, p. 15.

MANCHESTER CITY ART GALLERY has two Turner paintings: *'Now for the Painter' (Rope), Passengers going on Board* (RA 1827; BJ 236), whose punning title aimed to cap both *Stansfield and *Callcott, who had recently painted pictures which included 'painter' in their titles (the kind of joke Turner enjoyed); and the Claudian *Thomson's Aeolian Harp* (BJ 86), exhibited in 1809.

The 35 watercolours, which range from 1795 to 1850–1, were nearly all bequeathed by two brothers, James and Beatson Blair, and by Dr Lloyd Roberts. Among seven *England and Wales* drawings are two in pristine condition, *Dunstanborough Castle* (c.1828; W 814) and *Malvern Abbey and Gate* (W 834). *Rouen, a Distant View* (c.1834, engraved for *Scott's *Poetical Works*; W 1130) belonged to *Ruskin, who described it as 'exquisitely finished'. Later drawings include the large *Oxford from Boar's Hill* (c.1835–40; W 889), the much-exhibited *Heidelberg with a Rainbow* (c.1840–2; W 1376), *Kussnacht* (W 1534) from the 1843 set of Swiss views, *Sion near the Simplon Pass* (c.1846; W 1533), described by Wilton as 'a restatement of the principal motif of the great *Splügen* [W 1523] of 1842', and *Genoa, Italy* (1850–1; W 1569), the very last drawing in Wilton's catalogue. Two watercolours for *Scott's *Provincial Antiquities and Picturesque Scenery of Scotland, Tantallon Castle* (W 1067) and *Linlithgow Palace* (W 1068), were acquired in 1998. EJ

Timothy Clifford, ed., *Turner at Manchester*, 1982.
Croal and Nugent 1996.

MARSHALL FAMILY, see MOTHER'S FAMILY.

MARTIN, John (1789–1854), English painter and mezzotinter influenced by Turner but who also influenced him. He specialized in apocalyptic subjects in which tiny figures are overwhelmed by cataclysmic events, sometimes under a vortex of storm clouds inspired by *Snow Storm: Hannibal crossing the Alps* (RA 1812; BJ 126). Unlike Turner's art, the 'mapwork' of Martin's landscapes and architectural motifs leaves little to the imagination. This, together with his enormous popular success, meant he always remained outside the high-art establishment of Turner's world. Martin was a superb mezzotinter after his own work; the first public exhibition of some of his prints in 1824 possibly inspired the *Little Liber*. Martin and Turner were both interested in securing a just print copyright law. *Shade and Darkness* and *Light and Colour* (RA 1843; BJ 404–5) perhaps owed a debt to Martin's *Eve of the Deluge* (Royal Collection, London) and *The Assuaging of the Waters* (Fine Arts Museums

of San Francisco), exhibited at the Royal Academy in 1840. Martin seems to have visited Turner at Chelsea (see Finberg 1961, p. 376) and after 1848 also lived nearby. In 1844 one of Martin's sons made a small sketch of Turner at work (Walker 1983, pp. 28–9; see PORTRAITS). RH

Michael J. Campbell *et al.*, *John Martin: Visionary Printmaker*, exhibition catalogue, York City Art Gallery, 1992.

William Feaver, *The Art of John Martin*, 1975.

MATISSE, Henri (1869–1954), French painter, who in 1905 was the leading artist of the Fauve group, with its bold use of violent colours. He continued to be one of the most adventurous and influential of French post-Impressionist artists. Camille Pissarro had advised the young Matisse to look at Turner, and Matisse did so when on his honeymoon in London in 1898. He was never strongly influenced by Turner's work, but 'found a great similarity between his watercolours and Claude Monet's paintings in the way they were constructed with colour' (N. Watkins, *Matisse*, 1984, p. 34).

 LH

MAUCLAIR, Camille (1872–1945), French writer, artist. In his book *Antoine Watteau* (1920), Mauclair saw *Watteau as the originator of the Impressionist style, and Turner as the link between Watteau and Monet. In his later book *Turner* (1939), he perceived Turner as an individualist, an isolated figure in British art, influenced by *Titian, *Claude, *Ruisdael, and *Rembrandt. Turner's landscapes, Mauclair felt, anticipated Corot, Manet, Boudin, and Sisley, and he discussed the impact Turner must have had on Monet during the latter's 1870 visit to London. TR

Camille Mauclair, *Turner*, trans. from French by Eveline Byam Shaw, 1939.

Whittingham 1985², pp. 42, 84 n. 134.

MAW, John Hornby (1800–85), pharmaceutical chemist and surgical instrument maker. He inherited his father's surgical instrument business in 1828, and developed it into one of the most successful companies supplying medical equipment. He gathered a wide circle of artist friends, including *Cotman, David Cox, William Henry Hunt, Samuel Prout, Turner, and Peter de Wint, and entertained them in London and at his estate near Roydon, Essex. Turner attended Maw's daughter's fifth birthday party in 1835, when he sat her on his knee 'with a pencil and envelope provided by him and sharpened by him. He remarked: "bless me, the child draws crows a great deal better than I do."'

Maw built up an important watercolour collection, and had bought four *England and Wales* drawings by 1833. He became an accomplished amateur watercolourist himself, making sketching tours with Cox, and exhibited at the *Royal Academy in 1840–8. By 1837, having made enough

money to retire, he moved to Hastings, but in 1850 he began a second career, buying up a Shropshire tile-making company and developing it into Maw and Co., the largest decorative tile company in the world. Part of his extensive correspondence with artists is in the British Library. JH

Gage 1980, p. 269.

J. G. L. Burnby, 'Pharmaceutical Connections: The Maw's Family', *Pharmaceutical Historian*, 15/2 (1985), pp. 9–11.

MAYALL, John Jabez Edwin (1813–1901), daguerrotypist and photographer whose studio Turner visited regularly, apparently incognito, from 1847. He was born near Huddersfield, but emigrated in the early 1840s to Philadelphia, where he did pioneering work in photography and set up in business. Returning to London in 1846, Mayall worked briefly for Claudet before opening his own studio early in 1847 at 433 Strand. This he called the 'American Daguerrotype Institution', which he ran initially under the sobriquet 'Professor Highschool', specializing in portraits. Turner discovered Mayall shortly after the business opened, and talked with fascination 'about light and its curious effects on films of prepared silver'. Mayall claimed he took several daguerrotype portraits of Turner, though none has been traced. He introduced vignetted photographs and the photographic carte-de-visite and was patronized by public figures and royalty. Daniel Pound (see BOOTH) engraved many of his portraits. The business expanded to further addresses in London, and to branches in Melbourne, Australia, and Brighton, where Mayall retired and became active in local politics. He was Mayor of Brighton at his death. See also PHOTOGRAPHY. JH

Thornbury 1877, pp. 348–52.

H. Gernsheim, *The Origins of Photography*, 1982, pp. 141–4.

L. L. Reynolds and A. T. Gill, 'The Mayall Story', *History of Photography*, 9 (1985), pp. 89–107.

MEGILP was a term which became widely used following the publication of *Reynolds's notebooks after his death in 1792. It was used by Turner and his contemporaries to describe paint which is thixotropic. Thixotropic paint can be used for raised impasto which does not slump before it dries, but which can be brushed out thinly as a glaze as well. The megilps of the 19th century were glossy even after drying, and imparted depth and beauty when they were used as transparent or coloured glazes. They also extended the range of texture achievable in impasto with unmodified oil paints. They had two serious drawbacks as well: paintings with megilp tended to crack when they were varnished with mastic spirit varnish, and the areas of megilp darkened as the painting grew older.

Megilps were made by combining mastic spirit varnish (mastic is a natural resin) and linseed drying oil which had been previously cooked with a lead compound. The two liquids could be combined as required, then mixed into ready-ground oil paint. Megilp could also be bought ready-prepared, at least from 1835 which is the earliest date from which London colourmen's records survive (Leslie Carlyle, personal communication), and presumably from earlier decades also. Many of the megilps discussed in manuals on painting were named after the individual inventors. The proportion of resin to drying oil varied from recipe to recipe, and so did the method of preparing the lead-based drying oil. Practical experiments (J. H. Townsend, M. Odlyha, L. Carlyle, A. Burnstock, and J. J. Boon, '19th century paint media part I: The formulation and properties of megilps', in *Painting Techniques: History, Materials and Studio Practice* pre-prints, International Institute of Conservation, 1998) have shown that a range of colours and viscosities of megilp result as the preparation is varied.

Lead acetate was used to prepare 'white megilp', while litharge was used to prepare 'brown megilp'. The latter was used extensively by house-painters and coach-painters, which is to say whenever the colour of the pigment was strong enough to mask its deep yellow colour. Analyses of Turner's paint all indicate that he used megilps based on lead acetate. There are many references to his use, and over-use, of lead acetate, in *Thornbury. Even a megilp based on lead acetate was straw-coloured when fresh, and tended to darken with time. Yellowed glazes of megilp-like material can be seen in many of Turner's later works, and notably in the sky of *Van Tromp, going about to please his Masters* (RA 1844; Getty Museum, California; BJ 410). Lead acetate-based megilps have been detected in glazes in The *Opening of the Wallhalla, 1842* (RA 1843; BJ 401; see J. J. Boon, J. Pureveen, D. Rainford, and J. H. Townsend, 'The Opening of the Wallhalla, 1842: the molecular signature of Turner's paint as revealed by temperature-resolved in-source pyrolysis mass spectrometry', in *Turner's Painting Techniques in Context*, United Kingdom Institute of Conservation, 1995, pp. 35–45), and in *Dawn of Christianity (Flight into Egypt)* (RA 1841; Ulster Museum, Belfast; BJ 394; Jaap Boon, personal communication). To date, no litharge-based megilps have been found. JHT

MELLON, Paul (1907–99), son of Andrew Mellon, founder of the *National Gallery of Art, Washington. Already the owner of major Impressionist pictures, Paul Mellon, a confirmed Anglophile, began in 1959 to assemble, at a prodigious pace, the most comprehensive collection of British art outside the UK, including fourteen oils and over

50 watercolours by Turner. The collection, given to the *Yale Center for British Art in 1977, aimed at depicting a more informal side of British life than that shown in the full-length portraits bought by his father, *Frick, and *Huntington.

The greatest gem among the oils is the *Dort* (RA 1818; BJ 137), closely followed by *Staffa* (RA 1832; BJ 347) which, in 1845, was the first Turner to go to America, and by *Wreckers—Coast of Northumberland* (RA 1834; BJ 357). Notable also are the Poussinesque *Bonneville, Savoy, with Mont Blanc* (RA 1803; BJ 50; see BONNEVILLE for the identification of the two Bonneville oils exhibited in 1803), the stormy *Port Ruysdael* (RA 1827; BJ 237) and the very late *Inverary Pier, Loch Fyne* (BJ 519), based on a *Liber Studiorum* subject.

There is a wide variety of watercolours from the 1790s including *Newark Castle* (c.1796; W 168), followed by the dramatic *Mer de Glace, Chamonix* (RA 1803; W 365) and *The Lake of Lucerne* (c.1805; W 370, perhaps Turner's largest watercolour, 28¼ × 44½ in./71.5 × 113 cm.), both resulting from Turner's 1802 journey to the Continent.

There are fine examples of the *Southern Coast* and *England and Wales* views, the 1817 *Rhine series, *Yorkshire subjects of 1815–18 and illustrations to *Byron and *Scott. The storm-tossed *Yarmouth Sands* (W 1406) and the calm *Mouth of the Grand Canal, Venice* (W 1360) date from 1840, while the latest watercolour, *Fluelen: Morning* (W 1541) comes from the 1845 set of Swiss views.

Among many munificent bequests, Mellon left $75 million and over 300 pictures to the *Yale Center for British Art, New Haven. EJ

Paul Mellon with John Baskett, *Reflections in a Silver Spoon*, 1992.

MERCURY SENT TO ADMONISH AENEAS, see ÆNEAS *RELATING HIS STORY TO DIDO*.

MERSEYSIDE, National Museums and Galleries, see LIVERPOOL, . . .

MESSIEURS LES VOYAGEURS ON THEIR RETURN FROM ITALY (PAR LA DILIGENCE) in a snow drift upon Mount Tarrar—22nd of January, 1829, watercolour on paper, 21⅜ × 29⅛ in. (54.5 × 74.7 cm.), RA 1829 (520); Trustees of the British Museum, Lloyd Bequest (W 405). This watercolour is specifically autobiographical and was painted after Turner's return over the Alps in January 1829. During his journey Turner's coach had overturned in heavy snow. He later related the events on which the watercolour is based in a letter to Charles Lock *Eastlake written on 16 February 1829 (Gage 1980, pp. 125–6): 'the snow began to

fall at Foligno, tho' more of ice than snow, [so] that the coach from its weight slide [sic] about in all directions . . . till at Sarre-valli the dilegence zizd into a ditch and required 6 oxen, sent three miles back for, to drag it out.' Turner has portrayed himself wearing a top hat, sitting in the foreground, while the rest of the entourage attempt to dig out the stranded coach. As an example of Turner's story-telling of the perils he encountered while travelling in winter it can be linked to *Snowstorm, Mont Cenis* (1820; City Museums and Art Gallery, Birmingham; W 402) and **Snow Storm— Steam-Boat off a Harbour's Mouth* (RA 1842; BJ 398). EY

METROPOLITAN MUSEUM, New York, owns three Turner oils (acquired by 1900) and three watercolours (acquired since 1958). *Saltash with the Water Ferry* (Turner's gallery 1812; BJ 121) derives from a drawing in the 'Devonshire Coast No. 1' Sketchbook (TB CXXIII) used in 1811. *Venice from the Porch of the Madonna della Salute* (RA 1835; BJ 362) resulted from Turner's 1833 visit to *Venice, financed by *Munro, who had commissioned a watercolour and only reluctantly bought this oil instead. *Whalers* (RA 1845; BJ 415), the only one of four exhibited *whaling subjects to sell, caused a disagreement with *Bicknell, who owned it briefly but returned it to Turner on discovering that it included soluble watercolour.

The watercolours are *View of *London from Greenwich* (1824–5; W 513), one of several London subjects apparently destined for engraving but never carried out, *Sisteron, Basses Alpes* (?1836; W 1450), and *Lake Zug* (W 1535) from the 1843 set of Swiss views. EJ

MEUSE. Turner depicted many different aspects of the River Meuse (known in Holland as the Maas), from the French fortress town of Verdun down to its mouth in the North Sea. He first saw the most northerly part of the river on his tour of the Low Countries in 1817 and depicted it shortly afterwards in two important large oil paintings: **Dort or Dordrecht. The Dort Packet Boat from Rotterdam becalmed* (RA 1818; Yale Center for British Art, New Haven; BJ 137) and *Entrance of the Meuse* (RA 1819; BJ 139). Twenty years later, after further explorations of the river, he celebrated the beauties of its winding course and wooded scenery many miles to the south in a series of tiny but dramatic gouache drawings (catalogued in Powell 1991, pp. 151– 72).

All Turner's paintings and drawings of the Meuse were firmly based on his own experiences and their genesis may be traced through the relevant drawings in his sketchbooks. However, the paintings are not merely river views. The *Dort* is indisputably a homage to the 17th-century master *Cuyp, whose *The Maas at Dordrecht* had been exhibited in London in 1815. On the other hand, *Entrance of the Meuse* had a

topical relevance to 1818–19 when the Dutch 'Merchant King' (of the House of Orange) was in as much trouble financially as Turner's vessel (an Orange-Merchant) among the waves. Turner's long subtitle to his painting (*Orange-Merchant on the Bar, going to Pieces; Brill Church bearing S.E. by S., Masensluys E. by S.*) provided an exact topographical reference to a notorious danger-spot in the Meuse estuary.

Turner made his first close study of the valley of the Meuse in 1824, during the earlier of his two Meuse-*Mosel tours. According to his own sketchbook timetable ('Rivers Meuse and Moselle' Sketchbook, TB CCXVI: 270r.) he spent ten days travelling up the river from Liège to Verdun; the small pencil sketches in the same book and in a somewhat larger sketchbook ('Huy and Dinant', CCXVII) record his progress stage by stage. Since his boat was drawn by horses against the current, there was abundant time to record all the scenery, castles, and fortresses he wished but sometimes he made his own way on foot to achieve better viewpoints. These sketches did not lead to any paintings or watercolours.

Turner revisited the same stretch of the Meuse on his second Meuse–Mosel tour of 1839 when he studied it in even greater detail, recording it in two sketchbooks ('Spa, Dinant and Namur', CCLXXXVII, and 'Givet, Mézières, Verdun, Metz, Luxembourg, and Trèves', CCLXXXVIII). From the pencil sketches in these and other sketchbooks used on the tour he later made an outstanding series of over a hundred coloured scenes on small sheets of blue paper depicting not only the Meuse and the Mosel themselves but also two areas visited immediately before and after the Meuse. The fifteen Belgian subjects include Brussels, Louvain, Franchimont, and Spa, while over twenty drawings show *Luxembourg. About 25 drawings show the Meuse, its rocky eminences and the fortress towns of Huy, Dinant, and Namur receiving special attention. Turner evidently worked on the series as a complete project, rather than on a strictly topographical basis. Several of the Meuse scenes resemble the Mosel or Luxembourg subjects in their handling or colouring but others are notable for their vigorous pen drawing, a characteristic rare in the German scenes. CFP

Powell 1991, pp. 36–54, 106, 122–3, 127, 151–72.
Bachrach 1994, pp. 17–19, 42–5.

MIDDIMAN, Samuel (1750–1831). English topographical draughtsman and engraver, who studied under William Byrne. His first work after Turner was as one of the three engravers—the others were John *Pye and Charles *Heath—on the large plate of **High-Street, Oxford*, published in Oxford in 1812 by James *Wyatt (R 79). Middiman

was responsible for the open etching, which was his speciality and an essential factor in the high quality of this engraving. Other Middiman plates after Turner were two in *Hakewill's *Italy* (R 146 and 155), and two, including the outstanding *Weathercote Cave*, for *Whitaker's *Richmondshire* (R 181 and 188). Middiman worked extensively for Alderman Boydell and other publishers. LH

MILDMAY, Sir Henry Paulet St John, third baronet (1746–1808), the probable owner of Turner's *Fishermen coming ashore at Sun Set, previous to a Gale* (The 'Mildmay Sea Piece'; RA 1797; untraced; BJ 3). When the picture was sold at G. R. Burnett's sale at Christie's 24 March 1860, the catalogue stated, 'this grand work was painted for Sir John Mildmay', suggesting that this was Turner's earliest commissioned oil of any importance. The picture is now known only through the mezzotint in the *Liber Studiorum* (1812, F 40), which was inscribed 'Picture in the possession of Sir John Mildmay Bart. . . . *3 Feet × 4 Feet*'. There seem, however, to have been no Sir Johns in the family during these years; perhaps 'Sir John' was a mistake for 'St. John'. The vendor in 1860 would have been the fifth baronet, Sir Henry Carew St. John Mildmay (1810–1902), the fourth baronet, yet another Sir Henry, having lived from 1787 until 1848.

RU

MILLBOARDS, see BOARDS.

MILLER, John, of Liverpool (1798–1876). Tobacco, timber and cotton merchant, shipowner and collector. Miller owned a number of Turner's oils, including important works from his mature career: *Tummel Bridge, Perthshire* (*c*.1802–3; Yale Center for British Art, New Haven; BJ 41), *Saltash with the Water Ferry* (Turner's gallery 1812; Metropolitan Museum of Art, New York; BJ 121), *Hurley on the Thames* (*c*.1807–9; private collection; BJ 197), *Van Tromp's Shallop, at the Entrance of the Scheldt* (RA 1832; Wadsworth Atheneum, Hartford, Conn.; BJ 344), *Cicero at his Villa* (RA 1839; Rothschild Collection, Ascott, Bucks.; BJ 381), *Neapolitan Fisher-Girls surprised bathing by Moonlight* (?RA 1840; Huntington Library, San Marino, Calif.; BJ 388; see REPLICAS AND VARIANTS), *Van Tromp, going about to please his Masters* (RA 1844; Getty Museum, California; BJ 410), *Whalers* (RA 1845; Metropolitan Museum of Art, New York; BJ 415) and *Cilgerran Castle* (?*c*.1799; untraced; BJ 541; see KILGARRAN CASTLE). Miller started his collection in the 1840s, initially buying works by Turner, Etty, *Constable, and John Linnell. However, in the early 1850s he became deeply interested in the Pre-Raphaelites, and became one of their major patrons. He owned Millais's *Blind Girl* and *Autumn Leaves*, and Holman Hunt's *Eve of St Agnes*.

Miller was responsible for introducing Rossetti's work to F. R. *Leyland. He held a weekly salon at his house for artists and patrons, and became President of the Council of the Liverpool Academy in the 1850s. Parts of Miller's collection were sold during his lifetime at Christie's on 21 June 1851 and 20–22 May 1858. After his death works were sold at Branche & Leete, Liverpool, on 6 May 1881. RU

Macleod 1996, pp. 451–2.

MILLER, William (1796–1882). Edinburgh-born engraver. He trained in both Edinburgh and London, and became the most prolific engraver of the work of Turner, producing some 70 plates, many of them of vignettes. The first were three for the *Southern Coast* in 1824–5, including the dramatic stormy view of *Portsmouth* (R 120), on one of the touched proofs of which (untraced today) Turner wrote lengthy and revealing instructions which show how carefully he was guiding his 'new' engraver. Miller engraved 30 of the minutely detailed illustrations for *Scott's *Prose Works*, published in 1834–6, and these vignettes are among the outstanding steel engravings of their time. Miller also engraved several of the best of the later large single plates after Turner, including *Modern Italy* (BJ 374; R 658), a wonderfully atmospheric plate published in 1842. A number of Turner's letters to Miller concerning the progress of this plate survive today (Gage 1980, pp. 184–5, 187–8, 190). LH

MILTON'S *POETICAL WORKS*, with seven illustrations by Turner (W 1264–70; R 598–604), published in a small octavo six-volume edition, was the first venture of John Macrone (friend of Dickens and *Moore), May–October 1835. The editor, Egerton Brydges, praises Turner's unrivalled imagination as equal to Milton's. The first edition listed Milton's lines accompanying the illustrations. Turner shows greater confidence with figures and devices. *The *Athenaeum* called the vignettes 'Sublime', but in general they were not admired. Turner said in a lecture of 1812 that Milton was too 'pictorial' for illustration; however, inspired by genuine interest and knowledge—Turner had taken epigraphs from *Paradise Lost* for two early oil paintings—he designed two powerful visionary images for the War in Heaven. *The Mustering of the Warrior Angels* (untraced; W 1264; R 598) is a complex design drawing on several lines in Books VI and VII of *Paradise Lost* and showing the triumph of light over dark, with globes of 'liquid light' and columns of angels crossing the interstellar spaces. Gabriel stands on the sun, anticipating the late *Angel standing in the Sun* (RA 1846; BJ 425). For *The Fall of the Rebel Angels*, with the damned hurled headlong flaming to the abyss with Lucifer, a falling star (untraced; W 1265; R 599), Turner told *Goodall to engrave innumerable figures in the sky. Turner

responded warmly to the other texts with the shipwreck of Lycidas, phosphoric nymphs rising for *Comus*, and a snake from *Poussin's *Deluge* in the *Temptation on the Mountain* (private collection, New York; W 1267; R 601). JRP

Omer 1975, nos. 149–52.
Herrmann 1990, pp. 212–13.
Piggott 1993, pp. 60–2, 86–7, 100.

MODERN ROME—CAMPO VACCINO, see ANCIENT ROME.

MOFFATT, William (1758/9–1831). He commissioned a pair of oils from Turner, both views of his house: *The *Seat of William Moffatt, Esq., at Mortlake. Early (Summer's) Morning* (RA 1826; Frick Collection, New York; BJ 235) and *Mortlake Terrace, the Seat of William Moffatt, Esq. Summer's Evening* (RA 1827; National Gallery of Art, Washington; BJ 239). Moffatt's house was The Limes at Mortlake, where he lived from 1812 until his death in 1831; it survives today as 123 Mortlake High Street. Turner made a number of drawings for the paintings in his 'Mortlake and Pulborough' Sketchbook (TB CCXIII).

The first picture has an intimate feel, the trees preventing the public riverscape from dominating the private house and grounds. In the second picture, the public sphere impinges far more, since the artist has turned away from the house to focus directly into the evening sun on the Thames, and his treatment of this spectacle is itself a bravura, public performance. The silhouette of the dog increases the sense of dazzle and recession and draws our attention to the river vessels, which include what appears to be a State barge (part-hidden by a tree), commercial sailing barges, and pleasure parties in smaller boats. The theme of outdoor pleasure extends back into the garden in the forms of a parasol (stuck on) and a child's hoop. In this depiction of luxury and commerce combined, Turner perhaps anticipates the theme of the Thames as the Grand Canal in England's new Venice, as embodied in *Constable's *Opening of Waterloo Bridge* (RA 1832; Tate Gallery). The *Morning Post*, however, criticized the painting for its 'yellow fever', and *John Bull's* reviewer became possibly the first to allege a decline in Turner's powers.

The second oil was the subject of a noted Turnerian anecdote. *Thornbury claimed he was told by the Scottish painter Sir George Harvey that Turner had realized that a dark object against the setting sun would emphasize the sense of recession, and painted a black dog on a piece of paper and stuck it to the canvas (1877, p. 438). However, Frederick *Goodall, whose father was one of Turner's engravers, recalled it was the work of Edwin *Landseer:

He cut out a little dog in paper, painted it black, and on *Varnishing Day, stuck it upon the terrace . . . all wondered what Turner

would say and do when he came back from the luncheon table at noon. He went up to the picture quite unconcernedly, never said a word, adjusted the little dog perfectly, and then varnished the paper and began painting it. And there it is to the present day. (Frederick Goodall, *Reminiscences*, 1902, p. 124)

The dog is certainly stuck on, as is the parasol nearby, and Turner made additions in this manner to other paintings, such as *Childe Harold's Pilgrimage* (RA 1832; BJ 342) and The *Golden Bough* (RA 1834; BJ 355). Eric Shanes believes it unlikely Landseer would have teased Turner in the way Goodall describes. In view of Turner's use of stuck-on elements elsewhere, he ingeniously suggests that Landseer may have helpfully picked up the dog after it had fallen off and stuck it back on. Witnesses may have misinterpreted what he was doing, and this explanation would also explain Turner's lack of surprise. RU/AK

Eric Shanes, 'The Mortlake Conundrum', *Turner Studies*, 3/1 (summer 1983), pp. 49–50.
Wilton 1987, p. 149.

MONRO SCHOOL. Dr Thomas Monro (1759–1833) was a leading London physician specializing in mental illness, one of those who treated *George III during his bouts of porphyria, and a Principal Physician at the Bethlem Hospital in which Turner's mother died in 1804. He was a keen amateur artist and a collector of drawings and watercolours by Old Masters and contemporaries. His own work consists principally of small landscape drawings, executed in charcoal or india ink and stump, vaguely in the manner of Thomas *Gainsborough, whom he had known. He owned drawings and prints by Dutch, Flemish, and Italian masters, and admired the work of many modern topographers, among them Edward *Dayes, Michael 'Angelo' Rooker, and Thomas Hearne, together with a number of watercolours and studies by John Robert *Cozens, another sufferer from mental instability, who died in 1798. It was these landscape drawings that he proposed should be copied, once a week, on his premises, by young artists to whom he gave 2s. 6d. (or by other accounts 3s. 6d.) an evening, with a supper of oysters.

In the course of the 1790s, after Monro had moved from his father's house in Bedford Square into 8 Adelphi Terrace, there grew up what came to be referred to as an 'Academy', and over a decade or so several young artists who were to become celebrated enjoyed the benefit of Monro's encouragement and hospitality. But the 'students' can never have been many at any one time, and at first it seems likely that the only two were Turner and his close contemporary Thomas *Girtin. It may well have been through Monro's ministrations to Turner's mother that the two became acquainted, and in about 1793 Turner made a watercolour featuring one of Monro's properties at Monk's Hadley (see

W 40). By 1794 he and Girtin were definitely installed on Friday evenings, two to a desk and sharing a candle. As they told *Farington, 'Girtin drew in outlines and Turner washed in the effects.' A very large number of their drawings survives; they were sold in several lots at Monro's sales at Christie's, 26 to 28 June, and 1 and 2 July 1833. All of them were attributed simply to Turner, and on 27 June Turner himself bought four lots (24, 96, 97, 99). His agent Thomas *Griffith bought other lots, and two albums which subsequently entered Turner's possession and remain in the Turner Bequest alongside those Turner himself acquired. He evidently intended to build up a sizeable representation of this body of his early work. Many more examples are scattered elsewhere. Their authorship has presented problems, but a very considerable bulk of them can fairly confidently be assigned to the collaboration of Girtin and Turner. With their pale washes of blue watercolour and grey ink they resemble a type of drawing that occurs frequently in the output of Edward Dayes, whose Lake District subjects often appear to have been models. Many of Dayes's drawings of this type have been thought to be by Turner. A large number of Italian and Swiss subjects derive from the sketchbooks of John Robert Cozens, then in Monro's possession. The crisp assurance of Girtin's pencil-work is usually distinguishable from the more fussy drawing of Dayes, while Turner's washes are less mechanical than Girtin's, and economically suggest the variegated sparkle of light on rough surfaces. We may trace a development over the period that Girtin and Turner worked for Monro: the earliest drawings, of about 1794, are small in size and simple in technique; larger, more elaborately washed subjects probably date from 1796. Some others, which retain the general air of the 'Monro School' grey-and-blue wash drawings, are executed in an altogether broader, freer manner and look like Turner's work of 1797; they suggest a continuing connection with Monro even after the three-year stint was up.

A neighbour of Monro's in the Adelphi, John *Henderson, joined in the patronage of the young artists, and gave them subjects to copy which he appears to have drawn himself, many of them at Dover. Other hands are also involved; of slightly older artists, Henry Edridge and William Alexander were particularly close to Monro, and in due course John Sell *Cotman, John and Cornelius Varley, Louis Francia, Peter de Wint, and William Henry Hunt all passed through Adelphi Terrace. Monro's three sons, Henry, Alexander, and John, were also enthusiastic copyists and their work is sometimes close to the standard 'Monro School' style—though Henry (1791–1814) was an original talent in his own right and was on his way to making a considerable mark when he died at the age of 23.

Monro has been claimed as one of the crucial influences on the development of watercolour in the 1790s, when it was evolving into a principal channel for *Romantic ideas. This claim can hardly be sustained, despite his obvious ability to pick talent and provide it with exercise. There is indeed something slightly ludicrous in the idea of young men as gifted as Girtin and Turner being retained at a weekly desk making mechanical copies over a period of three years or more. The exercise was an elementary one for these two budding geniuses, who by 1794 were experimenting with adventurous watercolour techniques and must have found the repetitive copying and adapting irksome. The question arises, why did they endure it? Monro had some personal hold over Turner, in that he was superintending his increasingly distressed and distressing mother as she descended into incurable lunacy. But the opportunity to get to know such a large number of the works of the most admired watercolourists of the day must have struck him and Girtin as a benefit in itself; the direct link with a hero of theirs, John Robert Cozens, may have exerted a certain glamour, and it can certainly be affirmed that the intimate knowledge of Cozens's art that these sessions made possible forged a link between his pioneering achievements and the high point of Romantic landscape which was of vital importance in the development of modern European art. AW

Andrew Wilton: 'The Monro School Question: Some Answers', *Turner Studies*, 4/2 (winter 1984), pp. 8–23.

MONUMENTS TO TURNER. Following Turner's death on 19 December 1851, the Pre-Raphaelite sculptor Thomas *Woolner, a friend of the artist, is attributed with making his death mask (white plaster, glazed, National Portrait Gallery, London). Despite Turner's close friendship with *Chantrey no sculpted portraits of him seem to have been made during his lifetime. Turner's *will made provision of £1,000 for a monument to be erected in St Paul's Cathedral near to those of his 'Brothers in Art', but with no stipulation that it should be a portrait statue. The monument (marble, 1857–62, St Paul's Cathedral) by Patrick MacDowell (1799–1871) was finally raised in 1862 after the long-drawn-out Chancery case was resolved. In December 1856 it was announced that the design was to be chosen from those submitted by 14 January 1857 to Turner's Queen Anne Street gallery. The competition was restricted to the five sculptors who were then Royal Academicians. MacDowell's design is a quintessentially *Romantic image where Turner, rather more handsome than in life and dressed in outdoor clothing, is shown leaning against a rocky outcrop, as though pausing in the process of making a sketch from nature. A model for a statue of Turner (untraced; possibly a competition design)

by Edward Hodges Baily (1788–1867) exhibited at the Royal Academy in 1858 was promoted in the *Art Journal*. Later a relief portrait of Turner (*c*.1876) by H. H. Armstead was placed amongst the pantheon of great artists forming part of the 'Painters' frieze on the Albert Memorial, London.

Turner's place in the history of British art was further recognized by the inclusion of a portrait medallion on the exterior of the Stroud College of Science and Art, Gloucestershire (1890–9) by J. P. Seddon and W. H. C. Fisher. Here he was placed in the company of Faraday, Huxley, Kelvin, Barry, Rossetti, and Leighton. His statue (stone, *c*.1906–8) by Ernest George Gillick (1874–1951) also appears among the statues to painters, sculptors, architects, and craftsmen on the Cromwell Road facade of the Victoria and Albert Museum, London. It was much later that the RA commemorated Turner's contribution to its own institution when in 1935 a bronze portrait statue by William McMillan (1887–1977) was placed in Burlington House, Piccadilly.

AY

MOON, BOYS, AND GRAVES, print-publishers in London, at 6 Pall Mall, whose principal partner until 1835 was Francis *Moon. They were first involved with the publication of a print after Turner in 1828. This was John *Pye's large copper plate of the *Temple of Jupiter* (R 208), originally commissioned by *Hurst, Robinson, and Co. In 1831 they took over the ambitious but unprofitable *England and Wales* series from Jennings and Chaplin, who had themselves replaced Charles *Heath as its publisher in 1830. In the summer of 1833 the firm held a large exhibition of Turner's drawings—66 for *England and Wales* and twelve for *Scott's *Poetical Works*, published in the following year (Finberg 1961, pp. 494–8 and 514–15). The exhibition was well received by the critics, and in 1834 Turner's drawings for the *Seine tour in the *Rivers of France* series were also exhibited at Pall Mall.

LH

MOON, Sir Francis Graham (1796–1871), leading London printseller and publisher, who became Lord Mayor of London in 1854 and was created a baronet in 1855. He began working as a book and print seller with Mr Tugwell of Threadneedle Street, and took over the business on his death. He then began publishing prints, for some years as a leading partner with *Moon, Boys, and Graves, but mostly on his own. He published many of the more important later single plates after Turner, and also prints after many other leading artists, including *Wilkie, *Eastlake, Edwin *Landseer, and David *Roberts, on whose famous *Sketches in the Holy Land* (1842–9) he is said to have spent £50,000. Moon frequently entertained artists, and arranged exhibitions of their work in London and provincial cities to boost the sales of their prints. He enjoyed an international reputation, especially in France.

LH

MOORE'S *EPICUREAN* was the remnant of a scheme proposed to the poet Thomas Moore (1779–1852) by John Macrone for Turner to illustrate a collected edition of his works and to make sketches in Ireland, but which was abandoned over copyright problems; Macrone died before *The Epicurean* appeared in 1839 under his widow's supervision. Turner and Moore first met in Rome in 1819 in company with *Canova, *Chantrey, and *Lawrence. Moore's bizarre and febrile 'Egyptian' novella *The Epicurean* (1827), combined with its earlier verse form, *Alciphron*, was illustrated by four plates after Turner's designs (untraced; W 1298–1301; R 634–7). (*Alciphron* appeared separately in the same year with three of the plates.) These figure some elaborate Grecian and Egyptian architecture and one splendid moonlit sky (*The Nile*, W 1300; R 636). Moore, a great admirer of Turner, visited *Goodall, the engraver; unsurprisingly, he liked the three more theatrical and luxurious designs, but he took against the one brilliant design, *The Ring* (W 1299; R 635), a nightmare image of the Epicurean, Alciphron, falling from a crumbling balustrade and clutching at a ring among ghouls. This was a subject later illustrated by Gustave Doré (1865). As many as seven fine unused finished designs and some sketches (TB CCLXXX: 126/34, and Victoria and Albert Museum; W 1312) were left on Turner's hands; in 1842 Moore noted in his diary that at a dinner with Samuel *Rogers' sister, Sarah, Turner was trying to persuade him to take them up again.

JRP

Omer 1975, nos. 176–9.
Herrmann 1990, pp. 219–23.
Piggott 1993, pp. 65–7, 90–2, 100.

MORAN, Thomas (1837–1926), American landscape painter and lifelong admirer and imitator of Turner. In England in 1862 he copied paintings by Turner and made a sketching tour to the sites of Turner's *Southern Coast. His best-known works are two large panoramic views, both purchased by the American government: *Grand Canyon of the Yellowstone* (1872) and *Chasm of the Colorado* (1873–4), which bring a *Sublime Turnerian vision to spectacular and heretofore virtually unknown scenery. In late career he painted numerous pastiches of Turner's Venetian pictures.

AS

Nancy K. Anderson, *Thomas Moran*, exhibition catalogue, Washington, National Gallery of Art, 1997.
Richard P. Townsend, ed., *J. M. W. Turner: 'That Greatest of Landscape Painters'; Watercolours from London Museums*, exhibition catalogue, Tulsa, Oklahoma, Philbrook Museum, 1998.

MORNING AFTER THE DELUGE, see LIGHT AND COLOUR.

MORNING AMONGST THE CONISTON FELLS, CUMBERLAND, oil on canvas, 48⅜ × 35⁵⁄₁₆ in. (123 × 89.7 cm.), RA 1798 (196); Tate Gallery, London (BJ 5). Exhibited in 1798, the first year verses were allowed in the Royal Academy catalogue, with four lines from Milton's *Paradise Lost* describing Adam and Eve in Paradise. The quotation demonstrates Turner's determination to raise the status of his landscapes (see SUBJECT MATTER).

The picture shows the mountain known as the Coniston Old Man, in Lancashire, which Turner visited in 1797; a pencil drawing inscribed 'Old Man' is in the 'Tweed and Lake' Sketchbook of that year (TB XXXV: 57). There are also one or two watercolour beginnings in oblong format (XXXVI: L and ?U), and a finished watercolour of *c*.1797 (private collection; W 230). The more dramatic upright composition of the oil may have been suggested by Gaspard *Dughet's *Falls of Tivoli*, engraved in 1744 (Wallace Collection, London), but the overall treatment is developed from Richard *Wilson. MB

Hill 1996, pp. 136, 201 n. 46, repr. in colour p. 137.

MORNING CHRONICLE, THE (1769–1862), a daily, London newspaper with coverage of the arts confined to exhibition reviews and occasional articles or gossip about artists and their institutions. Turner was noticed from the beginning of the 19th century, but early reviews functioned more as guides to exhibitions than reasoned analyses. Although anonymity prevailed, *Hazlitt is recognized as the critic who, in 1814, praised Turner's 'powerful execution' but found his pictures 'a waste of morbid strength' and his figures 'execrable' (5 February). In his Royal Academy review later that year, he declared that *Dido and Aeneas* (BJ 129), 'powerful and wonderful as it is, has all the characteristic splendour and confusion of an eastern composition. It is not natural nor classical' (3 May). In 1815, however, another critic praised *Dido building Carthage* (BJ 131) as 'one of those sublime achievements which will stand unrivalled by its daring character' (1 May); and *Dort* (BJ 137) was hailed in 1818 as 'one of the most magnificent pictures ever exhibited' (4 May).

The caustic criticism of Edward Dubois (1774–1850) is recognizable from at least 1829 until 1834, when he so overstepped the bounds of propriety with his review of a portrait of Harriet Martineau that the *Chronicle* dropped him. A lawyer, he was lively and learned; but his lethal sarcasm was aimed at artists' integrity, manners, and physical impairments as well as at their artistic merit. The vocabulary of subsequent critics reflects the widespread ambivalence accorded Turner's art: it was gorgeous, poetic, magnificent; it was insane, incomprehensible, capricious. JCI

J. C. Ivy, *Constable and the Critics 1802–1837*, 1991, pp. 15–24.

MORRISON, James (1789–1857). From a modest background Morrison made a large fortune as a draper on the principle of small profits and quick returns. He was Member of Parliament for Ipswich for many years and acquired Fonthill Pavilion, Basildon Park, a house in Harley Street, and the island of Islay.

He bought *Constable's *Lock* in 1824 and Turner's *Rise of the River Stour at *Stourhead (W 496), probably at the RA in 1825, followed by *Pope's Villa* (Turner's gallery 1808; BJ 72) at the de Tabley sale in 1827 (see LEICESTER), paying 5 guineas more than Turner had sold it for in 1808. He also acquired **Thomson's Aeolian Harp* (Turner's gallery 1809; City Art Galleries, Manchester; BJ 86) but at what date is unknown, as well as pictures by, among others, *Wilkie, William Collins, *Poussin, *Claude, *Rembrandt, and *Rubens, sometimes in partnership with the dealer William Buchanan. The remains of his collection (including BJ 72 and W 496) is now at Sudeley Castle, Gloucestershire.

A letter from Turner (not in Gage) to Mrs Morrison in 1845 or 1846 accepts her invitation to visit Basildon 'and hopes he may bring his fishing tackle'. Morrison and his son Alfred visited Turner shortly before he died and were much struck by the contrast between the beauty of his paintings and the squalor in which he lived. EJ

Richard Gatty, *Portrait of a Merchant Prince, James Morrison 1789–1857*, n.d.

MORTLAKE, see MOFFATT, WILLIAM.

MOSEL. The most important of the *Rhine's many tributaries, the Mosel (or Moselle, as it is known in France) provided Turner not only with inspiration but with relaxation from the rigours of travel on several occasions and seems to have been regarded with special affection. The German reach of the Mosel strongly resembles the Rhine in its winding course, ruined castles picturesquely perched on rocky eminences, and abundance of vineyards on steep slopes. However, all is on a much smaller scale, giving the Mosel a more tranquil, domestic, and charming character than its great neighbour. In Turner's day it was only just becoming popular as a destination for British artists and travellers; *Stanfield depicted some of its beauties in the lithographs in his *Sketches on the Moselle, the Rhine, & the Meuse* of 1838, which may have acted as a catalyst for Turner's interest.

Turner first saw the Mosel on his Rhine tour of 1817 when he passed through Coblenz, situated at the confluence of the two rivers beneath the great fortress of *Ehrenbreitstein (see

BRIGHT STONE OF HONOUR). One of the grandest architectural subjects among the *Rhine drawings of 1817 shows the Mosel bridge at Coblenz with Ehrenbreitstein beyond and the Rhine itself merely a gleam in the middle distance (private collection; W 659). He returned to the Mosel in 1824, when he recorded two stretches of its scenery in his sketchbooks: a small portion of its course in France between Metz and Thionville and then a far longer one in Germany, its final and most celebrated reach between Trier and Coblenz ('Rivers Meuse and Moselle', TB CCXVI; 'Trèves and Rhine', CCXVIII; 'Moselle (or Rhine)', CCXIX). In 1839 he followed the identical stretches of the river, sketching it in greater detail and diversity of viewpoint, surveying it not only from the water and the shore but sometimes also from the surrounding hills ('Givet, Mézières, Verdun, Metz, Luxembourg, and Trèves', CCLXXXVIII; 'Moselle and Oxford', CCLXXXIX; 'Trèves to Cochem and Coblenz to Mayence', CCXC; 'Cochem to Coblenz—Home', CCXCI). In 1840 he revisited the part of the Mosel closest to Coblenz while using the Rhine as his highway through Europe and he did so again on other occasions in the early 1840s. The Mosel bridge at Coblenz was the subject of an outstanding watercolour in 1842 (untraced; W 1530).

About 1830 Turner painted a large watercolour of Bernkastel (Stadt Bernkastel-Kues; W 1378a), probably for an unrecorded publishing project, but his most important depictions of Mosel scenery are the series of over 40 gouache and watercolour drawings on small pieces of blue paper inspired by his visit of 1839 (catalogued in Powell 1991, pp. 130–49). These bear close resemblances to the pencil sketches made between Trier and Coblenz in the last two of the sketchbooks listed above and were probably produced over the winter of 1839–40. They form about a third of a series of similar works depicting places sketched on the 1839 tour which include views of the *Meuse and elsewhere in Belgium, and many of *Luxembourg. The group has much in common stylistically and technically with the *Loire and *Seine drawings of the early 1830s, but are generally less detailed. They are, however, in a class of their own in their brilliant colouring and dynamic atmospheric effects. Most of Turner's coloured Mosel views from 1839–40 remained in his possession and are now in the Turner Bequest. They were never engraved and the extent and importance of the series has only recently been recognized. Several of their subjects are found again in a separate, smaller, series of coloured sketches on grey paper dating from 1840.

CFP

Powell 1991, pp. 36–54, 122–50.
Powell 1995, pp. 30–4, 61–4, 106–9, 122–54.

MOSES WRITING THE BOOK OF GENESIS, see LIGHT AND COLOUR.

MOTHER'S FAMILY. On her mother's side, Mary *Turner came from a long line of London butchers, traceable back four generations to John Mallard (first half of the 17th century), a skinner of St Botolph-extra-Bishopsgate. His son Joseph (d. 1688) became apprenticed as a butcher in 1663, gaining his freedom to practise in 1670, and settled in St Leonard's, Eastcheap. His will names him as a 'Citizen and Butcher of London', and names only his wife Martha and son Joseph Mallard as beneficiaries. The younger Joseph (d. 1741) duly became a citizen and butcher in St Mary's, Islington, but also enriched himself by acquiring property. His will lists four houses at 'Wapping New Crane', Middlesex, four acres of 'Marsh Sand' in Barking, Essex, and a 'Messuage or Tenement' near 'New Chappel', Essex. This property he left to his wife Sarah and after her death to their daughter 'Sarah Marshall wife of William Marshall Salesman of . . . St Mary Islington'. It is in this will that the spelling of the family name is defined as 'Mallord'.

The roots of William Marshall's family are not known, although *Thornbury raises the suggestion that he came from the Marshall family of Shelford Manor, Nottinghamshire. Women named Marshall appear to have married tenants of Shelford in the 18th century, but the family connection is not proven. The description of William Marshall's occupation in his father-in-law's will as 'salesman' suggests that, following Dr Johnson's definition, he may have traded in ready-made clothing. The Marshalls had one son and three daughters. The eldest child, Joseph Mallord William (d. 1820), became a butcher in Brentford, while the second, Sarah (d. 1809), married the Revd Henry Harpur, Curate of St Mary's, Islington. Turner's mother, Mary, was the third child.

Although they were not gentry, Turner's mother's family were from a higher social class than his *father's family, and this may have encouraged Turner to show a greater warmth towards them than to the Turners in Devon. They were, moreover, closer at hand in London. Turner's cousin Henry Harpur, son of Sarah and Henry Harpur, became the artist's solicitor and executor, visiting him 'many times', according to Sophia *Booth, during his final illness. Harpur read the will after Turner's funeral. In 1785 Turner stayed for a few months with his uncle Joseph Marshall and his wife Mary in Brentford, where his lifelong friendship with Henry Scott *Trimmer began. In the later 1780s he stayed with his uncle and aunt when they moved to Sunningwell, near Abingdon, whence he made his first architectural studies, and came to know *Oxford. He maintained contact with the Marshalls

["

his Villa, exhibited at the RA in 1839 and bought by Munro after 1848 (Rothschild Collection, Ascott, Bucks; BJ 381).

Munro's interest in British art led him to buy landscapes by *Wilson, Bonington (12 paintings), *Constable (6 works), *Landseer (7 works, one a sketch depicting Novar), and subjects by Etty (56 pictures), *Stothard (27 works), *Fuseli, *Hilton, Maclise, Ward, and *Wilkie. Many of these were illustrations for novels or poetry.

Old Master paintings were an abiding interest, and among the auctions at which he bought pictures were those of Lord Northwick (1838), the Duke of Lucca (1840), Stowe (1848), and Samuel *Rogers (1856). The picture of greatest repute in his day was *The Madonna dei Candelabri*, then attributed to Raphael (Walters Art Gallery, Baltimore, as by Giulio Romano), and his very large collection included works by *Titian, Veronese, *Rembrandt, *Rubens, and *Claude.

Munro died unmarried on 23 November 1864, leaving an illegitimate son also called H. A. J. Munro (1819–95), a classical scholar. Novar was entailed and passed through his uncle to Col. Robert Fergusson of Raith. Munro left his other property to his sister Isabella Munro-Johnstone (d. 1873). She married the Hon. Henry Butler (1809–79). Their only surviving son, Henry Alexander Munro-Butler-Johnstone (1837–1902) sold the collection gradually at Christie's. The sales took place in May 1867 (364 pictures from Hamilton Place), June 1877 (55 watercolours), April 1878 (104 lots including 32 watercolours and 9 oils by Turner), and June 1878 (153 Old Masters). The final part of the collection was sold by auction in 707 lots in March 1880.

CALS-M

MURRAY, John. Major London publishing house founded in 1768 by the Edinburgh-born John (Mac)Murray I (1745–93), when he bought the business of William Sandby. He was succeeded by his son, John II (1778–1843), who started the *Quarterly Review* in 1809, and moved the firm to Albemarle Street in 1812, where it still remains. John Murray III (1808–92), who again succeeded his father, was a keen traveller and the author of the first of the Murray *Handbooks*, published in 1836; he may have travelled with Turner on the Continent in 1843 (Gage 1980, p. 274). Murray's were the publishers of several books illustrated by Turner, of which the first, with the *Cooke brothers, was the *Southern Coast* in 1814–26. They also published *Hakewill's *Picturesque Tour of Italy* in 1819, having quarrelled with the author over the illustrations, allowing him to retain only those after Turner (R 144–61). Murray's established a reputation as publishers of poetry, most famously that of Lord *Byron, and Turner was employed to illustrate their

1832–4 seventeen-volume *Life and Works of Lord Byron* (R 406–31). LH

MUSIC played a significant role in Turner's life and work. The overall number of works with specific musical references exceeds 100, of which 38 are paintings out of a total of 541. The rest are watercolours and sketches.

Some references to musical notation indicate Turner's interest in singing and flute-playing. Most musical references depicted consist of musical instruments, the range of which is impressive. The most frequently depicted musical instruments are: flute, tambourine, lute, and lyre. Considering their symbolic significance, such as the flute's phallic connotations, the tambourine denoting feminine erotic impulses, the lute personifying love and courtship, and the lyre as an attribute of poetry, dance, and song, they emerge as the dominant quartet displaying Turner's musical obsessions, rendering him as the favourite of Erato, the muse of love and erotic poetry.

Turner's amorous relations with Sarah *Danby, an actress and a singer, is common knowledge, especially after her husband's sudden death. John Danby (1757–98) was a well-known organist, singer, and composer of glees. Perhaps Sarah or Danby himself had given Turner some preliminary instructions in part-singing, a style of delivery impossible to tackle without learning notation. Turner's desire to learn proper singing may have been an attempt to come closer to Sarah and join her also in singing. The earliest record of this is a music phrase with numbers indicating duration; flat, natural, and sharp signs; the range of a tetrachord for each level of the human voice; and clefs ('Colour Bill' Sketchbook, 1801; TB LXII).

Elsewhere ('Swiss Figures' Sketchbook, 1802; LXXVIII), Turner has written down the words of the song 'I am a Friar of Order's Gray' from the popular pantomime of the day, *Merry Sherwood*, first performed at Covent Garden on 21 December 1795, with music by the prolific composer William Reeve (1757–1815). The vocal range needed to sing 'The Friar' is two octaves, with an interlude for German flute, ending in a flourish. This would imply Turner had a wide-ranging musical voice and some training.

As to Turner's interest in flute-playing, it is worth mentioning that most of the pantomime songs of the period included short interludes with harp, guitar, or most frequently the German flute—the transverse flute as it was known.

The auction of Turner's belongings documents among others '6 Books of Music' and 'Scotch Airs', all of which, alas, are now lost. It is tempting to presume that at least two or three of those books were Reeve's *Merry Sherwood*, both

the vocal and the German flute scores (published in *c*.1796), plus his selection of 'Scotch Airs' of 1793.

'Tabley No. 2' (CIV: 52) and 'Tabley No. 3' (CV: 24), both sketchbooks of 1808, contain diatonic scales and four-bar melodies. The scales are notated on a six-line staff with cluster of dots corresponding to each degree of the scale. Thus they are merely 'touch tables', the fingerings to play the flute, or the recorder, and not 'complementary chords' as Livermore thought.

In the second of the *Carthage pictures (*Dido building Carthage*, RA 1815; National Gallery, London; BJ 131) there is no musical instrument in sight. But the presence of music can be detected in the carving on the left side entablature, in the metope, up on the column of a palace. The carving is in the shape of the two joined arms of a lyre-kythara used as an abstract sign of the instrument, symbolizing the efforts of building an empire, reflecting the archaic notion of music's power to make or break the whole structure of a society.

More than 40 years after first drawing the subject of *Woman and Tambourine* (*c*.1806–7; CXVI: B), Turner returned to it and painted his last picture with musical connotations, namely *Landscape: Woman with Tambourine* (*c*.1845–50; Tochigi Prefectural Museum, Japan; BJ 513). The source of the painting has been noted to be the etching by Earlom after *Claude's *Landscape with River and a Peasant Milking a Goat*, 1774. The metamorphosis of the Claudian figures in the Turner picture illuminates a profound Turnerian message—no more the Claudian milking male peasant, nor the prominence of a goat at the centre; instead a woman plays the tambourine with hands raised, while dancing and probably even singing. Her whole musical performance is directed towards a child and a seated couple dressed in archaic outfits. The child is obviously attempting to dance, helped by one of the couple holding his hands. Music not milk is providing the nourishment of the child. The painting is an allegory of music as spiritual nourishment providing the well-being of mankind's childhood, at all ages, in all time.

Turner's interest in *opera resulted in large canvases, with subject matter referring to well-known operas of the time, retelling the legends of Medea, Dido, and Massaniello. Furthermore, Turner's bardic pictures may have received a major and direct impetus not only from the ode 'The Bard' of 1757 by Thomas Gray (1716–71) but from a contemporary production of an opera, namely *Cambro-Briton*, first performed on 21 July 1798, with music by Samuel Arnold (1740–1803). The Welsh subject matter, thought to be the first of its kind, treated the legend of the invasion of Wales by Edward I, the main theme of the bardic pictures including the watercolour *Scene in the Welsh Mountains with an Army on the March* (1799–1809; LXX: Q).

On the other hand, the verse accompanying *Carnarvon Castle, North Wales* (RA 1800; LXX: M; W 263) refers to the same legend, but underlining the savage extermination of the Welsh bards by Edward I's army:

> The Bard the song of pity pours, . . .
> Tyrant drench'd with blood the land, . . .

The unceasing struggle of the Bard (music–poetry–history–memory) against tyranny (savagery–indignity–inhumanity–oblivion) is a leitmotiv of Turner's poetic ethos. Despite his occasional intellectual pessimism expressed characteristically in the *Fallacies of Hope* (see POETRY AND TURNER), Turner's fertility in visual narratives, woven with colourful threads of dance and music, makes him undoubtedly a Bard of Hope and Visual Culture for our own times and the millennium to come. KIP

Ann Livermore, 'Turner and Music', in *Music and Letters*, 38 (1957), pp. 170–9.

Edward Lockspeiser, *Music and Painting: A Study in Comparative Ideas from Turner to Schoenberg*, 1973.

Malcolm Budd, *Values of Art, Painting, Poetry and Music*, 1995.

MUSIC AT EAST COWES CASTLE, oil on canvas, 47¾ × 35⅝ in. (121 × 90.5 cm.), *c*.1830–35; Tate Gallery, London (BJ 447). Formerly grouped with *Petworth subjects, the picture has been shown by Patrick Youngblood to depict the Octagon Room at East Cowes Castle. Turner apparently first visited John *Nash in the late summer of 1827 but this seems too early for this picture. Whittingham has shown that Turner made at least one other visit to East Cowes Castle, at Christmas 1832. There is a sketch for one of the figures in the 'Seine and Paris' Sketchbook (TB CCLIV: 24) of 1829 or, perhaps, 1832. Nash died in 1835 but Youngblood dates the picture as late as *c*.1837. In any case, it was presumably painted back in the studio using the sketch of 1829 or 1832. It is one of the thickly textured, highly coloured pictures associated with *Rembrandt and Petworth and is close to the small figure scenes in bodycolour on blue paper done there. MB

Youngblood 1983, pp. 615–19, repr.

Whittingham, Selby, 'Turner's "Music Party"', *Burlington Magazine*, 126 (1984), p. 92.

Butlin, Luther, and Warrell 1989, pp. 92–3, 148, colour repr. fig. 95.

MUSIC AT PETWORTH, see MUSIC AT EAST COWES CASTLE.

N

NAPLES, superbly situated on a bay in southern *Italy overlooked by the volcano *Vesuvius, has attracted countless artists and travellers over the centuries. Thanks to its long-standing popularity with the British, it is one of the few places on the Continent that provides us with reliable evidence from *witnesses to Turner abroad and *companions on his travels. Turner visited Naples in autumn 1819, during his first tour of Italy, and explored not only the city itself but also the many celebrated beauty spots and ancient sites in its neighbourhood. These included Lake Avernus (which he had already depicted in two early oil paintings of *classical subjects), *Virgil's tomb and the ruins discovered in the 18th century at Pompeii, Herculaneum, and Paestum. He made pencil sketches of southern Italy in three small sketchbooks ('Gandolfo to Naples', TB CLXXXIV; 'Pompeii, Amalfi, Sorrento and Herculaneum', CLXXXV; 'Naples, Paestum, and Rome', CLXXXVI) and used a larger sketchbook, 'Naples: Rome. C. Studies' (CLXXXVII) in which he drew not only informative pencil records but a few expressive colour studies also. After his return home, he included watercolours of the region in a group made for his friend Walter *Fawkes in 1820–1 and among his vignettes to *Rogers's *Italy*, published in 1830. The Neapolitan coast and countryside, with their spectacular combination of natural beauty and the remains of antiquity, inspired four highly poetical oil paintings: *The *Bay of Baiae, with Apollo and the Sybil* (RA 1823; BJ 230); **Caligula's Palace and Bridge* (RA 1831; BJ 337); *The *Golden Bough* (RA 1834; BJ 355); and *Neapolitan Fisher-Girls Surprised Bathing by Moonlight* (RA 1840; Huntington Art Gallery, California; BJ 388; see REPLICAS AND VARIANTS). CFP

Powell 1987.

NAPOLEON BONAPARTE (1769–1821), general and Emperor of France. Born in Corsica, he rose rapidly in the French revolutionary army, was promoted brigadier-general in 1793 and given command of the army in Italy in 1796, winning several victories against Austria. However, he was defeated by the British in the Egyptian campaign and, returning to France in 1799, he carried out a coup against the Directory and set up the Consulate, becoming First Consul. After his victory at Marengo in 1800 he steadily enhanced his powers, and finally crowned himself Emperor of the French in 1804. Military victories over Russia, Austria, Prussia, and others resulted in French rule in most of Europe, with only the British holding out and defeating him at sea. After the disastrous invasion of Russia in 1812 Napoleon abdicated in 1814, and was confined on the island of Elba. He soon escaped and was triumphant for a Hundred Days, which ended with his final defeat at Waterloo in June 1815, commemorated by Turner in *The *Field of Waterloo* (RA 1818; BJ 138). Napoleon was exiled to St Helena, where he died. Turner's **War. The Exile and the Rock Limpet* (RA 1842; BJ 400) is a telling evocation of the defeated Emperor. LH

NAPOLEONIC WARS (1793–1815). Turner's first confrontation came during the short-lived Peace of Amiens in 1802 when he produced his 'Studies in the Louvre' Sketchbook (TB LXXII) with written and drawn impressions of 32 pictures in the Paris exhibition of Napoleon's art loot. To the same context belong the two 'Calais Pier' Sketchbooks (LXXI and LXXXI) and the large picture of **Calais Pier* of 1803 (BJ 48). After a decade, the theme of the inevitable downfall of the power-obsessed, particularly with classical *Carthage as example, was painted many a time, not merely in **Snow Storm: Hannibal . . . crossing the Alps* (BJ 126) of 1812—the year of Napoleon's retreat from Moscow—and *The Battle of Fort Rock, Val d'Aosta*, a watercolour of 1815 (LXXX: g). But only in 1842, in **War. The Exile and the Rock Limpet* (RA 1842; BJ 400), did Turner portray Bonaparte himself against a dark red sunset. The ex-Emperor is here shown as an elongated giant rather than a shrunken figure as in the relevant vignettes engraved in 1832 for *The Life and Works of Lord *Byron* and in 1833 for *Scott's *Life of Napoleon*. In one he represented the fallen leader's dramatic farewell from his staff officers on the terrace of Fontainebleau; in another as prisoner on the deck of HMS *Bellerophon* looking down on

the countless sightseers being rowed past the English warship in Plymouth harbour.

Turner had long had a *Romantic, if ambivalent, admiration for the French dictator (to whom, as 'the King of Roadmakers', were owed the ease and speed with which it was now possible to travel on the Continent). That he also ridiculed the numerous productions of his old rival B. R. *Haydon's sentimental *Napoleon at St. Helena* is apparent from his adding to the catalogue entry for the 1842 picture from the *Fallacies of Hope* (see POETRY AND TURNER) the lines:

> Ah thy tent-formed shell is like
> A soldier's nightly bivouac, alone
> Amidst a sea of blood—
> —but you can join your comrades.

Turner's feelings were expressed in a number of paintings, all directly or metaphorically connected with England's involvement in the French Revolutionary wars which lasted from February 1793 to June 1815. These 'Napoleonic' wars greatly influenced British people's thoughts and movements, both positively and negatively, for several generations. The connection between *Peace—Burial at Sea* and its companion *War. The Exile and the Rock Limpet* (both RA 1842; BJ 399, 400) in their special format is particularly telling because of the almost over-emphatic use of symbolic colour: red and orange for blood in the latter and blackest black for the sails in the former. *Wilkie's burial at sea after self-chosen exile in peacetime must have recalled for Turner the many losses in that same Mediterranean as a result of the long years of war, the outcome of which had been for their instigator no more than humiliating, solitary exile.

AGHB

D. G. Chandler, *Dictionary of the Napoleonic Wars*, 1979.
A. Horne, *Napoleon: Master of Europe*, 1980.

NARRAWAY, John (d. ?1837), leather-dresser and gluemaker of Broadmead, Bristol, first recorded by *Thornbury as a friend of William *Turner. It is likely that the friendship began in North Devon, and that both men moved east in the 1770s. Many Narraways are listed in Barnstaple in this period, and an affidavit and warrant (1767) naming 'John Narraway, Leather dresser' is held in North Devon Record Office. He appears first in the 1794 *Bristol Directory* as 'Leather-dresser, Broad-mead', and in the 1810 edition as 'Leather Dresser and Glue maker, Broadmead'. His final business entry is in the 1828 *Matthew's Directory*. Thereafter, to 1837, his address is variously 7, 8, and 9 St James's Square, Bristol. Turner stayed with him in Bristol in 1791, 1792, and 1798, *en route* for Wales, and gave drawings to him or his family, notably *Self-Portrait* (1791; London, National Portrait Gallery; W11; see PORTRAITS); and *Archbishop's Palace, Lambeth* (RA 1790; Indianapolis Museum of Art; W 10). The family nicknamed Turner 'The Prince of the Rocks', a reference to his energy in climbing in the Bristol Gorge, but Narraway appears to have remarked that Turner had 'crooked legs' ('Turner at Bristol', *Portfolio*, 1880, pp. 69–71).

See also DART, MISS ANN. JH

Thornbury 1877, p. 23.
Finberg 1961, pp. 21, 27–8.
Hamilton 1997, pp. 25–7, 43.

NASH, John (1752–1835). Architect, urban planner, landscape designer. As architect to the Prince Regent (later *George IV), Nash extended the Royal Pavilion at Brighton, designed London's Regent's Park and Carlton House Terrace, planned Regent Street, and transformed London's West End. Turner found great affinity with Nash's *Neoclassical style. He visited Nash at the architect's mansion, East Cowes Castle, on the Isle of Wight, in late July and August 1827, where Nash provided him with a special painting room. During his stay, he made nine sketches, now in the Tate Gallery (see COWES SKETCHES). Six of these (BJ 260–5) were used for two pictures commissioned by Nash and exhibited at the Royal Academy the following year: *East Cowes Castle, the Seat of J. Nash, Esq.; the Regatta beating to Windward* (Indianapolis Museum of Art, Indiana; BJ 242), and *East Cowes Castle, the Seat of J. Nash, Esq.; the Regatta starting for their Moorings* (Victoria and Albert Museum; BJ 243). The other three sketches, *Between Decks* (BJ 266), *Shipping off East Cowes Headland* (BJ 267), and *Study of Sea and Sky, Isle of Wight* (BJ 268), did not result in more finished paintings. In a letter possibly written in August 1827 (Gage 1980, pp. 108–9), Turner wrote to his father from the Isle of Wight, requesting one or two pieces of unstretched canvas and further supplies of paint to be sent him. He wanted either a piece measuring 6×4 ft. (1.83×1.22 m.) or a 'whole length'; the nine sketches were painted on a 6×4 ft. canvas cut into two.

This was only the second Regatta to be held at Cowes, and Turner's interest in it is evidenced by his drawings and notes in the 'Windsor and Cowes, Isle of Wight' Sketchbook (TB CCXXVI). This contains drawings of boats racing, boats at anchor, views of the coast, and figure studies, and a list of boats with names, names of owners, and colours. Turner probably painted *Near Northcourt in the Isle of Wight* (*c*.1827; Musée du Québec; BJ 269) during the same trip, and he used the exterior of East Cowes Castle in the background of *Boccaccio relating the Tale of the Birdcage* (RA 1828; BJ 244).

Patrick Youngblood (1983, pp. 615–19) identified East Cowes Castle as the setting for another picture, *Music at East Cowes Castle*, previously known as *Music Party, Petworth* (c.1835; BJ 447). One of the ladies shown is possibly Mrs Nash. Turner may have begun this painting while staying with Nash at Christmas 1832, although it seems likely that the work was painted from recollection rather than on the spot.

Nash also acquired *Life-Boat and Manby Apparatus going off to a Stranded Vessel making Signal (Blue Lights) of Distress* (RA 1831; Victoria and Albert Museum; BJ 336). The Nash sale was held at Christie's on 11 July 1835. TR

Finberg 1961, pp. 302–3, 307, 326.

Reynolds 1969².

Michael Mansfield, *John Nash: A Complete Catalogue*, 1991.

NAYLOR, John (1813–89), banker and collector. On his marriage in 1846 Naylor bought Liscard Manor, but in 1851 he built the neo-Gothic Leighton Hall at Welshpool. Naylor predominantly collected earlier 19th-century British art, including works by *Leslie, Frith, *Eastlake, and Edwin *Landseer, but also acquired pictures by *Reynolds and *Gainsborough. In Paris in 1850 he bought pictures by Delaroche, Scheffer, and Horace Vernet. Naylor owned several oils by Turner, who was a particular favourite, often acquired for considerable sums of money: *Harbour of Dieppe* (RA 1825; Frick Collection, New York; BJ 231), *Cologne, arrival of a Packet Boat. Evening* (RA 1826; Frick Collection, New York; BJ 232), *'Now for the Painter' (Rope). Passengers Going on Board*, acquired from Turner in 1851 for £1,276 (RA 1827; Manchester City Art Gallery; BJ 236), *Venice*, bought from *McConnel and which he refused to sell back to him (RA 1834; National Gallery of Art, Washington; BJ 356), *Keelmen heaving in Coals by Night*, from the same source (RA 1835; National Gallery of Art, Washington; BJ 360), *Mercury and Argus*, bought for 1,300 guineas (RA 1836; National Gallery of Canada, Ottawa; BJ 367), *Fishing Boats with Hucksters bargaining for Fish*, bought from Turner in 1851 for £1,276 (BI 1838; Art Institute of Chicago; BJ 72), and *Rockets and Blue Lights* (RA 1840; Clark Institute, Williamstown, Mass.; BJ 387). RU

Macleod 1996, pp. 456–7.

NEOCLASSICISM. During Turner's lifetime the term 'classical' was often used in opposition to 'Romantic', as it is today. In reality the two were inextricably linked. In the mid-18th century the unearthing of Herculaneum and Pompeii gave vivid relevance to the understanding of Roman architecture that had been received through the writings of Andrea Palladio. By the 1760s, architects and designers visiting Italy on the Grand Tour could study many newly ex-

cavated sites and incorporate the Roman language of decoration into their buildings. At the same time the discovery of early Greek temples at Paestum and in Sicily drew attention to a more primitive and robust style of ancient architecture. James Stuart and Nicholas Revett's survey of *The Antiquities of Athens*, published by the Society of Dilettanti in several volumes from 1762, was the first scientific account of the monuments of Periclean Athens, though attempts to describe them had recently also appeared on the Continent. Many country houses and public buildings in Britain erected in the period 1780–1840 reflect these innovations.

In the 1760s and 1770s Rome became a centre for artists pioneering the new aesthetic. They were guided by the writings of the German antiquary Johann Joachim Winckelmann (1717–68), whose *Gedanke über die Nachahmung der griechischen Werke*, 1755, and *Geschichte der Kunst des Alterthums*, 1764, provided an aesthetic codification of the masterpieces of Greek sculpture. Winckelmann exalted the high seriousness of Greek art, emphasizing the purity of white marble sculpture, and, incidentally, the visual importance of the varied outlines of a carved image. The English sculptor John *Flaxman was among many who evolved a refined style based on these precepts; he also illustrated Homer, Hesiod, Aeschylus, and Dante in outline drawings which, engraved by Tommaso Piroli, were influential throughout Europe. When Lord Elgin brought the Parthenon marbles from Athens to London in 1801 it gradually became clear that Winckelmann's 'Greek' sculpture was in fact Roman, copied often at a distant remove from the originals. The ensuing controversy ushered in a last phase of Neoclassicism, in which Greek, as opposed to Roman, prototypes were favoured, and architects like Charles Robert *Cockerell sought a sophisticated archaeological accuracy in their work.

Neoclassical ideas briefly influenced landscape painting in the first decade of the 19th century when painters adopted formal rules derived from the 'intellectual' art of *Poussin, emphasizing especially orthogonals and firm perspective lines. Even wild, Romantic scenery could be treated in this rigorous way. Neoclassicism pervades the work of some topographical watercolourists like Thomas *Girtin, whose pared-down, austere designs owe much to its influence. A number of Turner's compositions from this decade share similar characteristics; notably the large watercolour *Lake *Geneva with Mont Blanc* (?1805; Yale Center for British Art, New Haven; W 370) with its nude bathers, and the remarkable oil composition of *Windsor Castle from the Thames* (c.1805; BJ 149). Turner's deliberate pastiche of *Claude, *Appulia in Search of Appullus* (BI 1814; BJ 128), stands in complete contrast to the entirely 'Turnerian' and

Neoclassical landscape of the same year, *Dido and Aeneas* (RA 1814; BJ 129). AW

David Irwin, *English Neoclassical Art*, 1966.

Hugh Honour, *Neo-classicism*, 1968.

The Age of Neo-classicism, exhibition catalogue, London, Arts Council of Great Britain, 1972.

NEWARK ABBEY. These medieval ruins, in west Surrey, are on the River Wey, a tributary of the *Thames. They were sketched in pencil by Turner in 1805 (TB xcv, xcviii; see also THAMES SKETCHES), and later sketched in oil (*c*.1805; BJ 191–2). In an oil painting (?Turner's gallery 1807; Yale Center for British Art, New Haven; BJ 65) that was bought by Sir John *Leicester before 1821, the abbey is a distant silhouette in the evening light, seen between trees to the left of centre and the shapes of a lighter, a lock, and riverside buildings to the right of centre. As one of the few prominent ecclesiastical ruins along the Thames or its tributaries, the subject perhaps offered a rare opportunity in this region of juxtaposing England's medieval past with its commercial present, thus enhancing the area's intended status as 'classic ground'. However, the abbey did not have the weighty associations or, indeed, the physical impressiveness of that other medieval structure depicted by Turner in his Thames paintings, the royal seat of *Windsor Castle. Moreover, unlike the river Medway, for instance (see THAMES ESTUARY), the Wey itself had no especially strong associations, so it is not surprising that the painting was not commented upon. The abbey features more prominently in a modest-sized oil (*c*.1807–8; ex-Loyd Collection; BJ 201), probably painted for the Revd Dr Thomas *Lancaster, curate of Merton, in Surrey, and intended to induce a mood of elegiac contemplation: a roofless gable with its gaping window space is shown frontally against the sky and isolated in the landscape, recalling *Girtin's *Kirkstall Abbey* (1800–1). AK

NEWSPAPERS AND JOURNALS, that 'fugitive writing' so aptly described by Leigh Hunt in *The Examiner* (1808), provide vast documentation for Turner's life and work. They chronicle his activities and place him in a wide cultural context with a vivacity and immediacy unrivalled by any other single source. He and his works were discussed relentlessly throughout his life by critics and reviewers with an insatiable curiosity about his unorthodox methods, dazzling effects, and enigmatic subject matter. There was a constant and ever-increasing fascination with Turner as the number of daily, weekly, monthly, and quarterly periodicals multiplied during the first half of the 19th century in response to the rapid expansion of the reading and viewing public (many reviews of Turner's oil paintings are quoted in BJ, *passim*). Although some of these publications were devoted solely to the visual arts, the majority slotted their coverage into designated sections which were sacrificed, when necessary, to more newsworthy political, commercial, or criminal reports.

Writing for this wide range of newspapers and journals was a motley crew of critics, most still veiled in anonymity. Those who are identifiable, such as *Hazlitt, Robert Hunt, Edward Dubois, W. H. Leeds, J. H. Reynolds, or William Carey, seem to have had some connection with the arts, however tenuous, and thereby felt themselves equipped to mete out praise or blame, approval or correction. Many of those who chose to use pseudonyms revealed their light-hearted eagerness to entertain as well as instruct: T. G. Wainewright as Janus Weathercock and Cornelius van Vinkbooms; W. H. *Pyne as Ephraim Hardcastle; John Williams as Anthony *Pasquin; or W. M. *Thackeray as Michael Angelo Titmarsh. But whoever the critics were, however serious or jocular their comments, whatever the political bias of their publications, none could remain silent when confronted by Turner's works.

The range of responses was enormous. Indeed, the ambivalence represented by that range is what characterizes Turner criticism. From the outset, he was hailed as a genius possessing powers of imagination and originality; but he was forever being warned against the excesses of his methods and effects. Critics increasingly found his subject matter unintelligible, his titles inexplicable, and his images impenetrable. Many measured him against nature and found him wanting, though they could not deny his poetic vision. The inevitable comparison to the northern and Italian Old Masters was marked by that same ambivalence: for some reviewers, he was their equal or superior; for others, he was embarking on a path destined to lead to the death of landscape painting as they knew it.

Most of the critics, perhaps because they were themselves artists or had at least had some relevant training, were knowledgeable about the history of art and conversant with its materials and techniques. Yet, faced with Turner, they seemed perplexed. Unable to distinguish objects (they were particularly critical of Turner's figures), they saw only the colours: paintings *were* vermilion or crimson or ochre. The more facetious reviewers were endlessly inventive about Turner's painting materials: mustard, saffron, eggs and spinach, soapsuds, or blood. But there were always critics sensitive to the underlying mystery of Turner's understanding and treatment of the natural world. Turner, they reasoned, might be mad, but he was brilliant, his works always hovering somewhere between the *Sublime and ridiculous. Occasionally musical analogies were applied when there was no other way to explain his magical and visionary images.

It was not only an artist's work that was discussed in the critical arena of the popular press. A widespread antipathy to the privileges of the *Royal Academy infected many reviews and articles and led to scurrilous attacks not only on Turner's art, but on his character and personal habits. His physique, his lack of articulate and refined address, his wealth and coarse living style made him a victim of ridicule and ribald humour.

It is not evident that Turner amended his art or his life to appease his critics, but he certainly was aware of his reputation and the public's perception of him. In 1836, after a particularly unkind review in *Blackwood's Magazine*, he informed *Ruskin that he never responded to such attacks. But Ruskin and *Trimmer both record Turner's sensitivity to censure; and in a marginal note to *Shee's *Elements of Art*, Turner made clear his views about critics: 'It is not the love of arts that prompts a critic but vanity and never ceasing lust to be thought a man of superior taste' (Lindsay, 1966, pp. 129–30). JCI

W. T. Whitley, *Art in England 1800–1837*, 2 vols., 1928 and 1930.

Helene E. Roberts, 'Exhibition and Review: The Periodical Press and the Victorian Art Exhibition System' in Joanne Shattock and Michael Wolff, eds., *The Victorian Periodical Press: Samplings and Soundings*, 1982.

Hemingway 1992, pp. 105–54.

NEW YORK, *exploring late Turner* exhibition, 1999, at the Salander-O'Reilly Galleries, East 79th Street. Like the 1966 *New York, Museum of Modern Art show, this exhibition concentrated on the very late, mainly unfinished works. It centred on sixteen small oil sketches on millboard or pasteboard of c.1840–5 of shore scenes or studies of sea and sky (BJ 485–500) discovered in a parcel in the *British Museum in about 1960; they were joined here by BJ 483 (Nationalmuseum, Stockholm) and BJ 484 (National Museum of Wales, Cardiff) from the same series.

The other oils were *Europa and the Bull* after the frontispiece to the *Liber Studiorum* (Taft Museum, Cincinnati; BJ 514), two depicting rough seas and waves breaking (Yale Center for British Art, New Haven; BJ 476, 482) and two from the Tate Gallery both newly identified: BJ 521 as *Lake *Lucerne: The Bay of Uri from above *Brunnen* and BJ 522 as *Sunset from the *Rigi*.

The sixteen watercolours came from the Rhode Island School of Design, the Tate Gallery, and two private collections. The fully illustrated catalogue, edited by Leslie Parris and designed by his wife, contained essays by Peter Bower, Martin Butlin, Kenneth Clark, Robin Hamlyn, Evelyn Joll, Graham Reynolds, Lawrence Salander, and Ian Warrell.
 EJ

NEW YORK, Museum of Modern Art, *Turner: Imagination and Reality* exhibition, 1966. Pioneering exhibition of 99 paintings and watercolours, mostly dating from after 1828 and unfinished, selected and catalogued by Lawrence *Gowing. In his catalogue foreword Monroe Wheeler wrote that at MOMA there was 'no precedent for a one-man show of an artist who died more than a century ago', but that the programme occasionally included 'exceptional productions of other periods of art in which the modern spirit happened to be foreshadowed'. The exhibition coincided with the peak of Abstract Expressionism, and had a great impact. LH

NIXON, the Revd Robert (1759–1837), clergyman and amateur artist; curate of Foot's Cray near Sidcup from 1784 to 1804. Nixon exhibited watercolours at the Royal Academy from 1790 until 1818. He saw Turner's drawings pinned up in his father's barber's shop and, impressed by the young artist's ability, he introduced him to John Francis Rigaud, Visitor of the Academy Schools (see W. L. Pressly, ed., 'Facts and Recollections of the XVIIIth Century in a Memoir of John Francis Rigaud . . .', *Walpole Society*, 50 (1984), pp. 105–6). Rigaud subsequently recommended Turner as a probationary student at the Schools. Turner and Nixon became friends, and in about 1798 Nixon sent him one of his drawings which Turner returned annotated with helpful technical suggestions (Tate Gallery Archive, 941–1). In 1798 Turner visited him in Kent and along with Stephen Rigaud they went on sketching expeditions together. Rigaud recalled that Turner refused to go to church on Sunday morning, preferring to work, and that he also refused wine at an inn while out sketching. While Rigaud attributed this to parsimony, it might seem just as likely to have been due to Turner wanting to keep a clear head. Thornbury suggests that it was in Nixon's house that the young Turner completed his first painting in oils (but see BJ 21).

See also HOBART, TASMANIA, 1845 EXHIBITION. RU

Thornbury 1877, pp. 45–6.

Lionel Cust, 'J. M. W. Turner: An Episode in Early Life', *Burlington Magazine*, 21 (1912), pp. 109–10.

Finberg 1961, pp. 17, 46–7.

Sayers 1996, pp. 209–11.

NORHAM CASTLE is a medieval ruin situated on the English bank of the Tweed, the river that forms part of the border between England and Scotland (see Pl. 19). Turner first visited this site in 1797, during his tour of the North (see pencil sketches, TB XXVII: U and XXXIV: 57), and it became one of his favourite subjects throughout his career. He made it the subject of two ambitious watercolours (private collection; Cecil Higgins Art Gallery, Bedford; W 225 and 226, the latter painted for Edward *Lascelles, jun.; see also the related colour studies: L: B, C). One of these (probably W

225) was exhibited at the *Royal Academy in 1798 under the title *Norham Castle on the Tweed, Summer's morn*, accompanied by lines describing daybreak from *The Seasons*, by James *Thomson, a Scot who grew up in the Tweed valley. This pairing of image and text implied, among other things, that the watercolour 'constituted a response to nature of the same merit and profundity as the greatest poetry' (Hill 1996, p. 183), a quality which Turner also claimed for his oils at the same exhibition (see *Morning amongst the Coniston Fells*, BJ 5; and *Buttermere Lake*, BJ 7). One critic, indeed, described the view of Norham Castle as having 'the force and harmony of oil painting' (ibid.). The image was also compositionally adventurous, thus asserting its author's originality. Another writer described the work as 'rather nature in miniature than a transcript' (ibid.), implying that Turner possessed not merely an imitative talent, but the mysterious creative power that distinguished genius.

Turner represented the subject in three other finished watercolours, a *Liber Studiorum* plate (1816; F 57) and a valedictory oil (see NORHAM CASTLE, SUNRISE). By the 1820s the site had acquired associations with Sir Walter *Scott as well as with Thomson. A small drawing of *c.*1822 (private collection; W 1052), commissioned by Walter *Fawkes, illustrates the first line of canto I of Scott's poem *Marmion* (1808), being inscribed 'Day sat [set] on Norham's Castled steep'. The image accordingly depicts sunset rather than dawn, as previously. The poem ends with the destruction of the Scots army by the English on Flodden field. A watercolour of *c.*1824 (CCVIII: O; W 736) seems to suggest continuing differences between Scots and English, this time in the form of wealth: the Scottish side of the Tweed (indicated by a plaid-clad figure) exhibits only rowing boats and a small bothy; the English side has the castle, sailing boats, and cattle (Hill 1996, p. 92).

Turner made a last visit to Norham in 1831, *en route* to Scotland to make illustrations for the works of Scott. One result of this visit was the vignette *Norham Castle—Moonrise* (*c.*1833; untraced; W 1099; engraved for *Scott's *Prose Works*). Travelling with Turner was Scott's publisher Robert *Cadell, who was puzzled to see the artist doff his hat and bow towards the castle. He was told: 'Oh, I made a drawing or painting of Norham several years since. It took, and from that day to this I have had as much to do as my hands could execute.' AK

NORHAM CASTLE, SUNRISE, oil on canvas, 35¾ × 48 in. (91 × 122 cm.), *c.*1845–50; Tate Gallery, London (BJ 512). This is one of the group of late unfinished oils based on the *Liber Studiorum*. On the back of the original canvas is a stamp incorporating the initials of the colourman Thomas

Brown and the date '[18]44'. It is based on the *Liber* plate 57, catagorized as 'P' for 'Pastoral' and inscribed as being from 'the Drawing in the Possession of the late Lord Lascells' or *Lascelles (Cecil Higgins Art Gallery, Bedford; W 226). Another version of this finished watercolour of *c.*1798 was probably exhibited at the Royal Academy in that year (private collection; W 225) and there are two large watercolour studies (TB L: B and C) and sketches in the 'North of England' Sketchbook of 1797 (XXXIV: 57). There are later sketches of 1801 (LIII: 42v.–50) and further finished watercolours of *c.*1800 (Whitworth Art Gallery, Manchester; W 277), *c.*1823 for the *Rivers of England* (CCVIII: O; W 736) and other less closely related depictions (W 1052, 1099) and also later Colour *Beginnings (CCLXIII: 22 and 72); the subject clearly fascinated Turner throughout his life. MB

Butlin 1981.

Hill 1996, pp. 88–93, repr. in colour.

NORTHUMBERLAND, Algernon, fourth Duke of (1792–1856), purchaser in 1856 of Turner's *View of the Temple of Jupiter Panellenius . . .* (RA 1816; Duke of Northumberland; BJ 134). According to the catalogue of the Northumberland collection, around the time of his accession in 1847, the fourth Duke had tried to buy from Turner *The *Fighting 'Temeraire'* (RA 1839; National Gallery, London; BJ 377), but the artist refused. The Duke then asked Colnaghi's to let him know of the first Turner to come on the market. This part of the story seems doubtful, as there were several other Turners available before BJ 134. RU

NORTON, Charles Eliot (1827–1908), member of an established Boston family and Professor of Fine Art at Harvard. He first met John *Ruskin when he visited Denmark Hill to see the Turners in 1855. In the following year a chance meeting on a steamer on Lake Geneva (movingly recalled in *Praeterita*) led to a lasting and warm friendship between the already renowned but increasingly insecure English critic and 'savant' and the learned and confident younger American scholar, to whom Ruskin referred as 'my first tutor'. They met only rarely, but corresponded regularly, with Norton filling the role of confessor for Ruskin, while Ruskin's art theories and teaching had a profound influence on Norton. The American based much of his work at Harvard on Ruskin's example, and thus encouraged the study and admiration of Turner, whose drawings and prints he himself collected. As a result of Norton's influence Boston became a centre for the collecting of Turner's work, especially his prints, of which one of the outstanding collections is in the *Boston Museum of Fine Arts. In 1899 the Museum acquired *Slavers (RA 1840; BJ 385), which had belonged to Ruskin. The Boston Public Library has an impressive stock

of books and catalogues relating to Turner and Ruskin. Norton edited American editions of Ruskin's work, and in 1879 he organized the showing of the 1878 *Fine Art Society exhibition of Ruskin's Turner drawings, with numerous additions including some from his own collection, in Boston and New York. Ruskin and Norton frequently exchanged presents, and Ruskin often turned for advice and comfort to Norton, who was certainly one of his closest friends and became one of his literary executors. LH

C. E. Norton, ed., *Letters from John Ruskin to Charles Eliot Norton*, 1904.

NORTON STREET (now Bolsover Street) was in the Portland Estates, half a mile west of *Upper John Street. '—Danby', presumably Sarah *Danby with her children, is listed in the St Marylebone rate returns as living at 75 Norton Street from 1800. For 1802–4 the ratepayer is named as 'William *Turner', the painter's father. Turner himself used the address while alterations to 64 *Harley Street were under way, and submitted work to Royal Academy exhibitions from there (1801–3). Although their name disappears from Norton Street rate returns from 1804, Turner evidently retained property interest there until the end of the decade, when he noted a leasehold sale in Norton Street in the 'Hastings and Oxford' Sketchbook (TB CXI: 62a–63). JH

Finberg 1961, p. 107 n.
Lindsay 1966, pp. 74, 112–13, 124.
Bailey 1997, pp. 57, 59, 63, 77.
Hamilton 1997, pp. 62–3, 88.

ŒUVRE AND COLLECTION CATALOGUES. The earliest published lists of Turner's work were the Appendices at the end of Walter *Thornbury's *Life* (1861; 2nd edn. 1877). These comprised 'A Complete Catalogue of all Turner's Engraved Works', based on the papers of Charles *Stokes; a 'Catalogue of all the Pictures Exhibited by Turner in the *Royal Academy and the *British Institution'; lists of works in 'Miscellaneous Collections'; and, finally, lists of works by Turner, with prices, sold at Christie's between 1833 and 1873. The first *catalogue raisonné* of any of Turner's work was W. G. *Rawlinson's *Turner's *Liber Studiorum: A Description and a Catalogue*, published in 1878 with a greatly revised second edition in 1906. This pioneering book set the standard for the collecting and study of the *Liber*.

The first 20th-century catalogue was C. F. *Bell's thorough and informative *List of Works Contributed to Public Exhibitions by J. M. W. Turner, R.A.*, published in 1901. In the following year the last 70 pages of Sir Walter *Armstrong's imposing large folio volume *Turner* were devoted to an extensive 'List of the Works of J. M. W. Turner, R.A.', in which 'an attempt is made, it is believed for the first time, to give an exhaustive list of Turner's works, both in oil and water-colour'. These lists remained authoritative for many years, as still do the two volumes, published in 1908 and 1913, of W. G. Rawlinson's invaluable catalogue of *The Engraved Work of J. M. W. Turner, R.A.* This ambitious survey of all the prints by and after Turner up to about 1860 remains the only such catalogue, and references to Turner prints in subsequent publications (including this one) include their R (Rawlinson) number. Also unsuperseded to this day are the two volumes published in 1909 by A. J. *Finberg, entitled *The National Gallery: A Complete Inventory of the Drawings of the Turner Bequest: with which are Included the Twenty-three Drawings bequeathed by Mr. Henry *Vaughan*. This put in chronological order the great quantity of sketchbooks and drawings of the Turner Bequest. Finberg's second major contribution to catalogues of Turner's work followed in 1924, when his *History of*

Turner's Liber Studiorum with a New Catalogue Raisonné was published. This superseded the Rawlinson *Liber* catalogue referred to above, and today references to *Liber Studiorum* engravings usually include their F (Finberg) number.

For over 40 years no catalogue exclusively devoted to collections of the work of Turner was published, and it was not until 1968 that the first catalogue raisonné of the Turners in a public collection appeared. This was Luke Herrmann's *Ruskin and Turner*, which is a detailed and fully illustrated catalogue of the hundred or so Turner drawings in the *Ashmolean Museum, Oxford. More recently other similar catalogues of the Turner watercolours and drawings in a number of British public collections have appeared; of those in the *Fitzwilliam Museum Cambridge, by Malcolm Cormack, in 1975; *Turner at Manchester* of drawings in *Manchester City Art Gallery was produced in connection with exhibitions in Italy in 1982; *Turner Watercolours in the *Whitworth Art Gallery*, Manchester, by Craig Hartley, appeared in 1984; Barbara Dawson's *Turner in the National Gallery of Ireland* (see under DUBLIN) came out in 1988, and Mungo Campbell's *Turner in the National Gallery of Scotland*, *Edinburgh, in 1993. Thus the principal collections of Turner's work in British museums outside London have now all been catalogued.

The most noteworthy and influential catalogue devoted to Turner published in modern times is certainly *The Paintings of J. M. W. Turner* by Martin Butlin and Evelyn Joll, which first appeared in 1977, with a revised edition in 1984. Usually referred to as 'Butlin and Joll', abbreviated in references, as in this Companion, to BJ, this is in two volumes, the first devoted to the very detailed and informative catalogue entries, and the second to the plates, with almost all the paintings discussed reproduced on a large scale, many of them in excellent colour. 'Butlin and Joll' gives the fullest possible information about all aspects of each painting, and also quotes extensively from contemporary criticism. What Butlin and Joll have done for Turner's paintings, Andrew Wilton has done, though less comprehensively, for the artist's finished watercolours in his pioneering 'Catalogue of

Watercolours' at the end of his *The Life and Work of J. M. W. Turner*, published in 1979. The volume also includes a greatly abbreviated version of Butlin and Joll's paintings catalogue. Another abbreviated version of that catalogue, for which the authors' names are reversed and they were assisted by Gemma Verchi, was published in Italian in 1982 in the Rizzoli Classici dell'Arte series. This is in two volumes, the first covering the period from 1790 to 1829 and the second the years 1830 to 1851, and with two new introductions by Evelyn Joll on Turner and Italy and Turner and his patrons.

Turner in Indianapolis by Martin F. Krause was published in 1997, and provides a handsome survey of the *Pantzer Collection of drawings and watercolours by Turner and his contemporaries in the Indianapolis Museum of Art. In 1998 the British Museum published another most attractive volume devoted to Kim Sloan's very thorough catalogue of the Turner watercolours from the R. W. *Lloyd Bequest. Each of the 47 watercolours of this outstanding collection is reproduced in colour, and a few of them are shown in their original frames. Since the opening of the Clore Gallery in 1987 a large number of watercolours and drawings from the Turner Bequest have been shown in a considerable number of survey and topic exhibitions, which have usually been accompanied by excellent catalogues. Thus full information about these Turner drawings, often the result of new research, is now available in printed form. There are still thousands of drawings which have so far escaped being included in one of these exhibitions, and it is hoped to publish a replacement for Finberg's 1909 *Complete Inventory* in due course; work on this has been in progress for some years. LH

OPEN AIR, work in. In about 1808, in his copy of *Opie's *Lectures*, Turner wrote, 'every glance is a glance for study', and a number of anecdotes record his acuity of vision and his willingness to expose himself to bad weather to memorize its effects. His ability to observe accurately and to store that information until needed was a vital part of his work in the open air and it complemented and extended the sketches and studies he made throughout his career. Turner was an inveterate sketcher and the Turner Bequest, now at the *Tate Gallery, holds upwards of 19,000 leaves of drawings and watercolours; however, within this mass of work careful discrimination is required to separate sketches produced in the open air from experimental or preparatory work done away from the motif. The bulk of the material contained in Turner's sketchbooks, of which almost 300 exist, comprises pencil sketches, and this was his most favoured method of working from the motif in the open air.

As he was noted to have remarked, talking to a fellow artist in *Rome in 1819, 'it would take up too much time to colour in the open air—he could make 15 or 16 pencil sketches to one coloured' (Gage 1969, p. 35). None the less it is clear that many of the Italian watercolour sketches made on that trip were in fact produced in front of the motif; and throughout his career, and especially in his younger years, Turner used a variety of media when working in the open, not just pencil.

The majority of his sketches were made when on tour, either in Britain or in Europe, and the exigencies of travel determined his methods. When actually on the move he tended to employ a pocket-sized sketchbook, roughly $4\frac{1}{2} \times 7\frac{1}{2}$ in. (11.5 × 19 cm.) in size, which he would fill with pencil sketches and memoranda, sometimes working across both pages, sometimes subdividing each page into separate areas for a sequence of different aspects. Colour notes might sometimes be added as verbal information, but no actual colour studies would be included. As *Ruskin later observed of Turner's avoidance of colour sketching: 'before the deliberate processes necessary to secure the true colours could be got through, the effect would have changed twenty times over. He therefore almost always wrote the colours down in words, and laid in the effect at home' (Powell 1987, p. 50). When based in one place for a more protracted campaign, Turner also made use of larger sketchbooks up to 16 × 10 in. (40.5 × 25.5 cm.) in size, and it is these larger sketchbooks which tend to include colour sketches alongside pencil studies. Many of these would have been worked up away from the motif but equally, and notwithstanding his attested reluctance to do so, some of these colour sketches evidently result from Turner working in the open air.

His pencil sketching can be roughly divided into two main stylistic modes. One is a relatively tight handling, where a hard pencil allows a precision of notation capable of recording highly specific and accurate information, especially of architectural detail. These drawings are often complemented with verbal annotations whose purpose is to recall additional details not depicted on the page. The other is more summary, set down much more rapidly and more concerned with the overall disposition of masses and the interrelations of parts than with detail. The journalist Cyrus Redding, who witnessed Turner making pencil sketches in *Devon in 1813, described this latter technique as 'a kind of shorthand . . . slender graphic memoranda . . . writing rather than drawing . . . such outlines were to him what the few heads of a discourse would be to a person who carried them away with a good memory' (Thornbury 1877, pp. 143–9). These graphic memoranda contain the essence of a subject and could be worked up in the studio often years later to produce finished pictures, as witnessed by the watercolour

of *Boscastle, Cornwall* (*c*.1824; Ashmolean Museum, Oxford; W 478) painted thirteen years after Turner visited the spot.

Many of his sketchbooks also include work in other media: wash, pastel, and watercolour. While most of these studies were produced away from the motif, as elaborations of the visual data already captured in pencil and in memory, some of them were made in the open air. In 1798 he showed Joseph *Farington 'two books filled with studies from nature—several of them tinted on the spot, which he found were much the most valuable to him' (Gage 1969, p. 34). His *Welsh tours of the 1790s, for example, included watercolour sketches made from nature dated from 1792 to the late 1790s; sketchbooks relating to tours to *Scotland and the North of England in 1801 contain watercolour studies probably made from the motif and there are nineteen coloured studies of *Alpine scenery, produced on his first tour to *Switzerland in 1802, which were almost certainly finished on the spot.

Throughout his career Turner often used larger, 'roll sketchbooks', allowing him greater latitude to explore natural phenomena, as seen in the watercolours contained in his 'Thames from Reading to Walton' Sketchbook (*c*.1805; TB xcv) which appear to have been painted on the spot. Although he does not seem to have shared *Constable's interest in scientific approaches to cloud formations, Turner's investigations of meteorological phenomena are evident in his finished pictures and his 'Skies' Sketchbook of *c*.1818–22 (CLVIII) contains 65 watercolour studies of cloud formations studied from nature. A related interest in recording atmospheric effects explains the appearance of a number of watercolours comprising sky studies and sunrises/sunsets dated to the mid-1820s among the Colour *Beginnings. The six-month *Italian tour of 1819–20 resulted in nineteen sketchbooks and also produced a number of watercolour sketches made on the spot, despite Turner's protestations against the slowness of colour sketching. This is borne out by the amateur artist R. J. Graves, who is recorded sketching in Italy with Turner:

At times . . . when they had fixed upon a point of view, to which they returned day after day, Turner would content himself with making one careful outline of the scene, and then, while Graves worked on, Turner would remain apparently doing nothing, till at some particular moment, perhaps on the third day, he would exclaim 'there it is' and, seizing his colours, work rapidly until he had noted down the peculiar effect he wished to fix in his memory. (Gage 1969, p. 35)

Another fellow traveller, the architect T. L. Donaldson, recorded Turner making a coloured sketch of the sky as they ascended Vesuvius.

If open-air colour sketching was relegated to an increasingly rare position in his work of the 1820s and 1830s, it did not disappear completely. The nine watercolours of 1834 apparently documenting the burning of the Houses of *Parliament (CCLXXXIII) may be studies from nature and *Munro of Novar recorded a sketching tour with Turner in the *Val d'Aosta in 1836 which indicates that Turner made direct watercolour sketches of Swiss and Italian scenes then (Thornbury 1877, p. 104). Although there is no compelling argument one way or the other, it is possible that even in the last decade of his career Turner was still prepared to sketch in the open air. Evidence for this can be found among the summary studies of light and architecture produced in a roll sketchbook in *Venice in 1840 (CCCXV) and in the sketches made in northern France in September 1845 (CCCLX) at the very end of his activities as a tourist.

Turner's interest in oil sketching from nature may owe something to his acquaintance with William *Delamotte, who was sketching in oils in the Thames valley from at least 1806, and certainly Turner's *Thames and *Devon sketching campaigns might be regarded as participating in the naturalist preoccupation of sketching from nature also seen in the work of John Constable and the Varley circle in the first two decades of the 19th century. Turner was later to complain to Munro of Novar that he was loath to sketch in oils because 'he always got his colours too brown' (Gage 1969, p. 39), but notwithstanding his reservations he produced a significant body of oil sketches. These fall into four major groups: ten sketches made at *Knockholt in Kent, dated to *c*.1799–1801 (BJ 35a–j); some 35 studies of the Thames and the Wey produced *c*.1805 (BJ 160–94); fifteen sketches in Devon of Plymouth and environs produced in 1813 (BJ 213–25b); and nine painted at *Cowes on the Isle of Wight in 1827 (BJ 260–8).

Four of the Knockholt sketches are in oil alone, the remainder being painted in a mixed method of oil and watercolour with the addition of size on paper. Most of them depict beech woods and trees in Chevening and Knockholt Parks; two of them are cottage interiors with additional work in ink. These studies range in effect from naturalistic studies of trees to more conventionally Picturesque, even artificial, compositions with gypsies among trees and figures in cottage settings.

The Thames studies are more resolutely naturalistic in effect and are complemented by a group of Thames watercolours also probably painted in front of the motif and dated to *c*.1805. Seventeen of the Thames oils are on canvas and may have been at least begun out of doors; a second group of eighteen smaller oils, painted on mahogany veneer, were probably produced entirely out of doors. According to a

contemporary, Turner painted the Thames studies from his own boat: 'He had a boat at Richmond . . . From his boat he painted on a large canvas direct from Nature. Till you have seen these sketches, you know nothing of Turner's powers' (Gage 1969, p. 37).

The oil sketches produced around Plymouth were produced on Turner's second trip to Devon in the summer of 1813. Not all of them survive, but those that do are more uniform in size and less wide-ranging in subject than the Thames sketches, lacking the vigour and ambition of the earlier set and replacing it with a more studied examination of summer light. Their origins are well recorded in two contemporary accounts which suggest that Turner undertook this campaign because a local landscape painter, A. B. *Johns, had prepared special equipment for outdoor oil-sketching.

It has been suggested that the nine oil sketches made at Cowes, on the Isle of Wight, in the summer of 1827 may also have been painted on the spot. Six of them are concerned with two pictures commissioned by the architect John *Nash, *East Cowes Castle, the Regatta* (Indianapolis Museum of Art and Victoria and Albert Museum; BJ 242, 243), and may possibly have been painted from a boat on the open sea. Turner requested his father to send him some unstretched *canvas and on a 6 × 4 ft. (1.83 × 1.22 m.) piece, cut in two, he painted these nine sketches, five on one roll of canvas, four on the other. There are a few further oil sketches of the later 1820s in the Turner Bequest (BJ 271, 276) which may perhaps have been painted in the open air, as well as ten *Small Italian Sketches* (BJ 318–27), painted on millboard and originating either in Turner's first Italian visit of 1819 or, more probably, his second of 1828.

As John Gage has noted, Turner's relatively infrequent use of direct sketching from the motif, in oil or watercolour, owes much to his growing understanding of painting as a distillation of visual experience rather than being a simple record or direct transcription of observable reality. Work in the open air could illustrate and even capture natural appearances but it could never penetrate nature itself.

See also PAPER; SKETCHBOOKS; SKETCHES, USE OF. SS

Thornbury 1877, pp. 104, 143–9.
Gage 1969, pp. 34–41.
Wilkinson 1974.
Wilkinson 1975.
Brown 1991[2].

OPENING OF THE WALLHALLA, 1842, THE, oil on mahogany, 44⁵/₁₆ × 79 in. (112.5 × 200.5 cm.), RA 1843 (14); Tate Gallery, London (BJ 401). This grand late picture of a contemporary event was exhibited with lines from the *Fallacies of Hope* (see POETRY AND TURNER) alluding to *Napo-

leon's victory at Ratisbon in 1809 and to the return of peace typified by the *Walhalla (*sic*), 'reared to science, and the arts, | For men renowned of German fatherland.' The Walhalla, designed like a Doric temple by Leo von Klenze, lies on the Danube about six miles downstream from Regensburg (Ratisbon). It was opened by Ludwig I of Bavaria on 18 October 1842 but Turner based his painting on sketches which he made when at the site on 12 or 13 September two years earlier (TB CCCX: 70).

The picture was generally well received: 'One of the most intelligible pictures he has exhibited for many years' (*Morning Chronicle*, 9 May 1843), 'A superb landscape composition' (*Spectator*, 13 May), and 'It has its beauties; distances are happily given: most absurd are the figures, and the inconceivable foreground' (*Blackwood's Magazine*, August 1843). However, when Turner sent the picture to the Congress of European Art exhibition at *Munich in 1845, 'it was seen as a pure satire on this kind of celebration' (G. K. Nägler, *Neues Allgemeines Künstler-Lexicon*, 1849). Injury was added to insult when the picture returned damaged and with £7 to pay. MB

Powell 1995, pp. 18–19, 39, 49, 70, 179–80 no. 109, 201–2, repr. in col. p. 179.

OPERA. Born within a stone's throw of Covent Garden and Drury Lane, Turner had a lifelong love of *music and drama which inspired some of his most original and arresting paintings. His first drawing master, Thomas *Malton, was a scene painter at Covent Garden Theatre; in 1791 he himself spent several weeks as a *scene painter at the Pantheon opera house in Oxford Street, which provided him with exciting back-stage experience of theatrical life; and a pencil sketch shows that by his early 20s he had discovered the joys of being high up in the gods for performances in London's grandest theatres (TB XLIV: W). Later on, he also attended plays and operas abroad: in 1819 he made a sketchbook note of the names of theatres in Milan ('Milan to Venice', CLXXV: 1a) and in 1840 he painted watercolour sketches of *Venetian theatres.

Operas with famous *classical subjects played an important role in the genesis of some of Turner's oil paintings, including those inspired by the story of Dido, queen of Carthage. Her love for Aeneas and its tragic aftermath were related by the Latin poet *Virgil but the story was also adapted by a host of composers and librettists in Turner's own day; one of many operas entitled *Didone abbandonata*, which was shown in London in 1827, inspired him to take up the theme again, after an interval of thirteen years, with *Dido directing the Equipment of the Fleet* (RA 1828; BJ 241).

Another vast painting of 1828, *Vision of Medea* (RA 1831; BJ 293), was also inspired by the sufferings of a classical heroine abandoned by her lover which had recently been presented on the London stage with the same internationally acclaimed soprano, Giuditta Pasta (1797–1865), in the title-role. The tragic opera *Medea in Corinto* by Giovanni Simone Mayr (1763–1845) took London by storm in 1826–8 with critics (including William *Hazlitt) likening Pasta's dramatic powers to those of Sarah Siddons. Turner took for his subject the incantation scene in which Medea uses her magic powers to devise revenge on her unfaithful husband Jason, summoning up the Furies from the Underworld, and he produced a painting dominated by unusually large, well-drawn, and expressive figures whose grand gestures are echoed in a windswept landscape. He painted it during his second visit to *Rome in October–December 1828, exhibiting it there shortly before his return home; though probably intended as a tribute to Italy's supremacy in the field of opera, it was not well received. He exhibited it in London in 1831, when Pasta was again appearing in *Medea*, and now accompanied it with verses from his own unpublished epic *Fallacies of Hope* (see POETRY AND TURNER).

A much later (and more complex) painting, *Undine giving the Ring to Massaniello, Fisherman of Naples* (RA 1846; BJ 424), was partly inspired by a contemporary opera or musical drama with a revolutionary hero. With the increasing rise of nationalism in the 19th century, Turner's lifetime saw the staging of many works about Masaniello, leader of a Neapolitan revolt in 1647; the most famous of these was the opera *La Muette de Portici* by Daniel-François-Esprit Auber (1782–1871), the Brussels première of which sparked off the Belgian revolution of 1830. Other elements, however, were introduced into Turner's *Undine* from a multiplicity of sources, as was also the case with its pendant, *The *Angel standing in the Sun* (RA 1846; BJ 425). CFP

Powell 1987, pp. 151–6.

OPIE, John (1761–1807), English painter of portraits, history, and rustic genre and Academic colleague of Turner. He arrived in London in 1781 and his brilliant use of colour and chiaroscuro soon led *Reynolds to liken him to Caravaggio. His reputation faded though his burial in St Paul's Cathedral reflected his undoubted impact on his contemporaries.

In 1803 he generously felt the *Festival upon the Opening of the Vintage of Macon* (Sheffield City Art Galleries; BJ 47) 'perhaps the finest work' in a room which included eight of his own pictures (Farington, vi. p. 2023). In 1804 Opie, sharing others' doubts about Turner's depiction of water, thought that the sea in *Boats carrying out Anchors* (Corcoran Gallery, Washington; BJ 52) 'looked like a *Turnpike*

Road over the sea' (ibid., p. 2307). Opie became Professor of Painting in the Royal Academy in 1805. His lectures were published in 1809; Turner's annotations in his copy throw light on his own thinking on art. RH

Mary Peter, *John Opie*, exhibition catalogue, Arts Council tour, 1962–3.
Venning 1982, pp. 36–46.

OTHER ARTISTS, Turner's works based on. In 1815 Turner exhibited at the Royal Academy *The Eruption of the Souffrier Mountains, in the Island of St. Vincent, at Midnight, on the 30th of April, 1812, from a Sketch taken at the time by Hugh P. Keane, Esqre* (University of Liverpool; BJ 132). The only other exhibited painting based on another artist's sketch was *View of the Temple of Jupiter Panellenius, in the Island of Aegina . . . Painted from a sketch taken by H. Gally Knight, Esq. in 1810* (Duke of Northumberland; BJ 134), shown in 1816. However, as Turner's outstanding reputation resulted in a growing demand from print and book publishers for topographical watercolours for engraving, he based a considerable number of these on sketches by other professional and amateur artists. The earliest of these were after James *Hakewill for that artist's *Picturesque Tour of Italy* (1818–20; R 146–61). A number of artists, including T. Allason and W. Page, provided the drawings for Turner's illustrations of scenes in *Greece and the Near East, which he himself never visited, for John *Murray's edition of *The Life and Works of Lord *Byron* (1832–4; R 406–31). For *Finden's *Landscape Illustrations of the Bible* (1835–6; R 572–97) Turner based his watercolours on drawings by Charles Barry, Gally Knight, Sir Robert Ker *Porter, and others. Lieutenant George Francis White himself provided the drawings for Turner's seven illustrations for *White's *Views in India, Chiefly among the Himalaya Mountains* (1836; R 606–12). In all his watercolours for engraving based on the work of other artists Turner succeeded in concealing the fact that he himself had not seen the place depicted.
 LH

OVERSTONE, Lord; see LOYD OF LOCKINGE.

OXFORD. Turner depicted this university town many more times than he did *Cambridge. He apparently first visited the town in 1789, and it was a natural stopping-off point on his early tours of Wales, the English Midlands and North, and Scotland (1794–1801). Hamilton (1998, p. 23) has described Turner's Oxford subjects of the late 1790s and the early 1800s (many of them for the *Oxford Almanack) as 'the first tokens of Turner's life-long romance with learning and with . . . a town where he might always be welcome but never became fully a part of'. In *Christ Church, Oxford*

(*c*.1832; private collection; W 853), made for *Picturesque Views in *England and Wales*, there is a table on the right on which prize cups and rosettes, denoting educational achievement, are set out. Moreover, the depictions of building work in several of these views may not only reflect the frequency with which the soft stone had to be repaired, but may also indicate the constructive process of education. In the view just mentioned, however, the demolition of the wall on the left possibly rather suggests the ceaseless change associated with modernity. In Turner's last view of the town, the prospect entitled *Oxford from North Hinksey* (*c*.1835–40; Manchester City Art Gallery; W 889), Oxford's towers and spires are visible in the distance, beyond the happy harvest scene in the foreground. The juxtaposition of two strolling dons with the female agricultural workers indicates, perhaps, that learning does not develop in cloistered isolation, but in the wider national context. In oils Turner painted *View of the *High-Street, Oxford* (Turner's gallery 1810; Loyd Collection, on loan to the Ashmolean Museum, Oxford; BJ 102) and *View of Oxford from the Abingdon Road* (RA 1812; private collection; BJ 125). AK

OXFORD ALMANACK. The University's annual Calendar, first published by the Clarendon Press in 1674. For the first century the subjects of the engraved headpieces were largely allegorical or historical, many featuring an aerial view of a college. From 1767 the subject matter became consistently topographical, normally taking the form of views of a single college or building. To provide the drawing for the Oxford Almanack became one of the most prestigious commissions for topographical artists, and the Almanack's renown is shown by the fact that one of Turner's earliest surviving drawings is a copy, dated 1787, of the 1780 Almanack headpiece (TB I–A; W 5). Eleven years later Turner's rapidly rising reputation is demonstrated by his being commissioned in 1798 to produce the first two of his ten drawings that were published as the headpiece, all but one

engraved on copper by James *Basire, between 1799 and 1811. For these two the Delegates of the Clarendon Press paid Turner 20 guineas in 1799; he received a further payment of 10 guineas for one drawing in 1800–1, and he was also paid 10 guineas each for the remaining seven watercolours in 1804. By that time Turner was an RA, and it is noteworthy that the artist's rate of remuneration did not alter despite his greatly enhanced status.

While Turner's watercolour for the 1799 headpiece, *South View of Christ Church, &c. from the Meadows* (W 295), is itself masterly, the engraving after it by James Basire was certainly the most impressive print after Turner that had appeared so far. Except for the 1808 headpiece, which was a *View of Oxford from the South Side of Headington Hill* (W 302), the other Turner subjects are all detailed views of buildings. One of these is an interior, the impressive *Inside View of the Hall of Christ Church* (W 301), published in 1807. The others are external views of college and other Oxford buildings, of which the most attractive is the beautifully lit *View of Worcester College, &c.* (W 298), which is further enlivened by the considerable road-mending activity shown in the foreground. Much has been made of the fact that the Delegates did not accept Turner's watercolour of *Part of Balliol College Quadrangle* (W 303), because one of them, the Master of Balliol, disapproved of the placing of the shadows. The composition was redrawn by a minor local artist, H. O'Neill, and published in 1810 under his name, an indication of how little respect Oxford worthies had at this time for a member of the *Royal Academy. Turner's Balliol drawing is with his other Oxford Almanack watercolours in the *Ashmolean Museum, where they were deposited by the Clarendon Press in 1850 and can now be seen in the Print Room. They show him at the height of his powers as a topographical draughtsman in the later 18th-century tradition in which he grew up. LH

Herrmann 1968, pp. 45, 55–63.
Helen Mary Petter, *The Oxford Almanacks*, 1974.

P

PALMER, Samuel (1805–81). English landscape painter, mainly in watercolour. He was influenced at first by William Blake and, especially in his later work, by Turner, whom he greatly admired. Palmer was a master of romantic and pastoral landscape, but struggled for recognition. Rediscovered in the 1920s, he is now one of the most popular of British 19th-century artists. LH

Raymond Lister, *Samuel Palmer*, 1987.

PANTHEON, THE MORNING AFTER THE FIRE, THE, watercolour on paper, 15½ × 20¼ in. (39.3 × 51.5 cm.), RA 1792 (472); Tate Gallery, London (TB IX: A; W 27). This large architectural watercolour depicts the scene outside the facade of the Pantheon concert and assembly rooms in Oxford Street after it was gutted by fire during the night and early morning of 14 January 1792. Turner was on hand to sketch the ruins the following morning and he took the trouble to make a small-scale preliminary study of his finished composition which was squared up for transfer (CXCV: 156) to achieve an accurate and balanced design.

In this carefully composed watercolour, Turner combines skilful architectural draughtsmanship of the ruined facade of the Pantheon in the style of his early mentor Thomas *Malton with lively figures in the foreground which show the influence of Edward *Dayes. EY

PANTZER, Kurt (1892–1979), a successful lawyer in Indianapolis who decided that, when he had made his first $100,000, he would buy a watercolour by Turner. He began in 1937 as inauspiciously as possible: his first purchase was a watercolour copy of *The Prince of Orange landing at Torbay* (RA 1832; BJ 343) followed by a dozen spurious drawings from the collection of the charlatan John Anderson jun. (see FAKES AND COPIES). Although unaware of these errors for several years, Pantzer then fortunately transferred his buying to the London salerooms acting mainly through John Mitchell and occasionally through *Agnew's.

From 1955 to 1975 Pantzer collected steadily, eventually owning 38 Turner watercolours and pencil drawings, which he gave or bequeathed to the *Indianapolis Museum of Art

together with watercolours by Turner's predecessors, contemporaries, and successors chosen to illuminate Turner's own work. Among these artists were J. R. *Cozens, *Dayes, *Girtin, Clarkson *Stanfield, *Roberts, Samuel *Palmer, and John *Ruskin, as well as J. T. *Smith (1766–1833), whose drawing shows Turner looking at a watercolour in the *British Museum's Print Room of which Smith was then the Keeper. Pantzer also gave the museum a dozen Turner letters, 3,000 Turner prints, 500 books, and many 19th-century manuscripts relating to the artist.

Pantzer, aged 82, visited London for the *Royal Academy *Turner bicentenary exhibition (he was a lender) and afterwards made a most handsome donation to the newly founded *Turner Society, which honours his memory annually with a lecture given on Turner's birthday. EJ

Martin Krause, *A Passionate Eye and a Public Spirit: Kurt F. Pantzer and the J. M. W. Turner Collection*, Indianapolis, 1992.

PAPERS, Turner's. Late in his life on being asked by Mary *Lloyd for his advice on watercolour painting, Turner gave a deceptively simple reply: 'First of all, respect your paper!' (Lloyd 1984, p. 23). With one or two exceptions, such as this remark, there is very little direct evidence of Turner's actual thoughts or feelings about paper in general, or the particular papers that he used, other than the papers themselves, where his actual use of individual papers is perhaps the most eloquent testimony that we could have.

Paper is simply macerated and hydrated cellulose fibre, derived from plant material, held in suspension in water, and formed by one of three different methods: into individual sheets either by hand or on a cylinder mould machine (invented by John Dickinson in 1809), or formed as a continuous web on a Fourdrinier machine (developed by Bryan Donkin in 1804 from an original invention by Nicholas Louis Robert in 1798). Paper is made either *laid* or *wove*, regardless of the method of manufacture. Laid paper is formed on a surface made from thin parallel wires held together every inch or so by chain wires, while wove paper is formed on a woven wire cloth.

During Turner's lifetime the cellulose used in paper-making was generally derived from old waste rags, ropes, and sailcloth made from linen, hemp, and cotton. The rags are pulped in water and, in handmade papermaking, formed into sheets by dipping a mould into a vat of the pulp and lifting it out, allowing the water to drain away. As the water drains through the mould surface the mould is shaken to distribute the fibres and consolidate the surface of the sheet. The newly formed sheets are then pressed and hung up to dry. After drying the sheets are coated with animal gelatine to stop inks or watercolours soaking into the surface and to increase the surface strength of the sheet. Local and regional variations in raw material supply and papermaking practice led to rich varieties of papers that were nominally the same colour. Preparation of the pulp, rather than the formation of the paper, by hand or by machine, is the major influence on the life and durability of the sheet.

Paper was traditionally made in a range of sizes based on local measurements that varied slightly from country to country: in Britain the most common artists' papers sizes were: Foolscap (16½ × 13½ in.; 42 × 34.3 cm.), Crown (19 × 15 in.; 48.3 × 38.2 cm.), Demy (20 × 15½ in.; 50.8 × 39.4 cm.), Large Post (21 × 16½ in.; 53.3 × 42 cm.), Royal (24 × 19 in.; 61 × 48.3 cm.), Super Royal (27½ × 19½ in.; 69.8 × 49.5 cm.), Imperial (30 × 22 in.; 76.2 × 55.8 cm.), Colombier (34½ × 23½ in.; 87.6 × 59.7 cm.), Atlas (34 × 26 in.; 86.4 × 66 cm.), and Antiquarian (53 × 31 in.; 134.6 × 78.7 cm.). Paper qualities were quite simply described as superfine, fine, and retree; bulk and weight as thick, thin, stout. The surfaces of handmade sheets were described as: *rough*, produced by the weave of the wet press felt; *not*, the same surface but further smoothed by pressing the sheets again against each other; and *hot pressed*, glazed by means of metal plates, although heat was rarely used. Later refinements included calendered surfaces produced by passing sheets through sets of rollers. Throughout his life Turner seems to have preferred lighter weight (by modern watercolour paper standards very lightweight) *not* and *hot pressed* surfaces.

One of the most distinctive characteristics of European paper since its earliest days has been the incorporation within the sheet of images, words, letters, and dates. The term watermark is somewhat misleading as water plays no particular part in the formation. The French term *filigrane* or earlier English terms such as *papermark* and *wiremark* are more accurate descriptions. The marks are created by wires, bent and shaped into the desired form, and sewn down onto the surface of the papermaking mould. During the formation of a sheet the pulp lies in an even thickness on the mould's surface. Variations in the surface, such as the watermark wires, produce differences in the amount of pulp

at that point in the sheet. After pressing the sheet appears flat, but the pulp is less dense where the wires are: held up to the light, the image shows as lighter lines within the sheet.

The earliest watermarks date from late 13th-century Italy and were all pictorial: images of animals, birds, suns, moons, stars, human figures, coats of arms, pots, hands, waterwheels, even abstract patterns. Gradually the initials of individual makers began to be included. Particular makers gained reputations for quality and their marks passed into general use among other makers. By the end of the 18th century watermarks were quite simply trade marks.

In laid papers the watermark image is usually centred within one half of the sheet and, by the 18th century, was generally indicative of a particular sheet size: Posthorn (Post or Large Post), Fleur-de-Lys (different designs for Demy, Medium, Imperial), Britannia (Foolscap, Double Foolscap, etc.). The watermark is often accompanied by a countermark, centred in the other half of the sheet, which consists of the maker's name, initials, and often a date. After 1794 in Britain most fine papers were dated in the watermark. Watermarks in wove papers are usually found along the bottom edge of the sheet, either centred or in the bottom right corner.

The study of watermarks is increasingly used in the dating and attribution of works of art on paper, but great care must be taken in understanding what is seen: watermarks were often copied, even deliberately forged, by other makers, moulds changed hands, dates were not changed for years. For this reason simple descriptions of papers, such as 'Whatman paper' or 'paper watermarked 1794 / J WHATMAN' should be treated with caution. One must be wary of assuming that all the different examples of the papers watermarked '1794 / J WHATMAN' used by Turner are the same paper. Known '1794 / J WHATMAN' papers found in the Turner Bequest (see WILL AND BEQUEST) include 28 different varieties, some of which are found in three different finishes and all in different weights.

On the other hand, the preparation of the pulp used, the skill of the papermaker, and seasonal variations in the speed of drying of paper can all lead to subtle differences in appearance of watermarks in sheets made on the same mould. The lettering styles of watermarks changed, regional and local traditions affected the design, as the form and composition of the papers themselves changed. The study of watermarks in conjunction with the analysis of the make-up of the sheet itself alone provides powerful evidence for the authenticity or otherwise of works of art on paper.

Turner's working life covered a period of great change in papermaking history: developments in new raw materials and production methods, and increasing competition from

the newly developed papermaking machine, forced the handmade mills into an increased specialization in order to survive. The production of papers specifically for drawing began sometime in the 1770s but was not to become a major part of the handmade paper industry until the early years of the 19th century. Until this time 'drawing' papers, which included papers for watercolour as well as those for pencil, chalk, and ink, were quite simply those papers which artists found they could work on, regardless of the use for which papermills had made them.

From the 1780s onwards, a complex web of technical, cultural and economic influences operating on papermakers, paper merchants, artists' colourmen, and artists themselves, led to the evolution of papers designed and made specifically for watercolour. The effects of the introduction of such papers coupled with new sensibilities and aspirations in the artists themselves had a dramatic effect on the working practices of individual artists and their expression of their visions.

Watercolour, in particular, depends for its success on a deep and vivid understanding of the nature of particular surfaces and the ways that those surfaces can be worked. The ability of particular papers to satisfy the changing demands that artists now began to make on them was much influenced by the increasingly sophisticated technology of papermaking. The rapid introduction and exploitation of the paper machine by an increasing number of papermakers had made those who continued to make by hand change both their working practices and their concepts of papermaking itself, forcing them to produce papers of increased quality and range. They explored new raw materials and production methods, developed new qualities and characteristics, and produced new surfaces, sizings, strengths, tones, and colours. Watercolour artists seized on these new developments, not always using the new papers in the ways the makers expected, but grateful for the opportunities they provided.

It is no accident that the advent of a generation of 'greats' amongst watercolourists, such as Turner, *Girtin, and *Cotman, coincides with a period of papermaking when very specific drawing papers began to be made, but before such papers had become so specialized as to lose much of their potential. Much of this increasing specialization was due to the activities of merchants and colourmen, but artists themselves contributed to the process, by telling the colourmen what they wanted. Many of these 'drawing' papers were actually designed and produced for various kinds of more technical drawing, rather than for the fine artist. The market for fine artists' papers has always been relatively small, but by the early years of the 19th century the market for engin-

eering, architectural, surveying, and map-making papers was enormous. It was this market that made the development of such papers economically viable for the mills.

A noticeable feature of Turner's work on paper throughout his working life is his almost instinctive understanding of and constant exploration of surface strengths and textures. From his very earliest years, he appears to have made very distinct choices in his papers. Growing up around the Strand and Covent Garden, he was surrounded by stationers and artists' colourmen selling a wide range of very good-quality papers. Being accustomed to seeing good-quality paper from a very young age must have played some part in training his naturally 'good' eye. A roll-call of the papermakers, both English and Continental, whose papers can be found in the Turner Bequest lists many of the finest makers of the day: from Britain, James Whatman, William Balston, the Hollingworth Brothers, Edmeads & Pine, Hayes & Wise, Smith & Allnutt, Ansell, Bally Ellen & Steart, Joseph Ruse, Gater, and William Alley; from the Continent, Almasso, Fabriano, Montgolfier, Marias, Dupuy, and Richard.

Later in Turner's career, the papers are not as obviously different from each other as those he had been working on earlier, but as his techniques developed he came to focus more on very specific details of the papers that might suit his needs. The London colourmen and stationers were handling a greater variety of sizes, weights, and textures of paper, of increasing quality, and sometimes made specifically for drawing. He must have been shown many of these new papers, and the Bequest (see TATE GALLERY; WILL) includes isolated sketchbooks, individual sheets, and various small groups of sheets that were probably obtained for trials.

Many of the changes in papermaking were 'invisible'. Technical innovations and increasing skill among papermakers produced some profound changes in the ways sheets behaved in use. Many of these changes were not always obvious to the uninitiated, although artists such as Turner, Girtin, and Cotman show a deep understanding of the possibilities of these new surfaces. The development of new types of presses, primarily to speed up production and to give greater strength for writing papers (which had had to change with the introduction of the steel nib, which demanded a much greater surface strength) also gave greater pressure and compacted the surface of the sheet differently, allowing an artist to work the colour more vigorously.

What differentiates Turner's use of paper from the usages of many other artists is the sheer number of different papers that he actually used. Besides the wealth of papers available to him in London, every journey out of town on his constant travels throughout Britain and on the Continent shows him

acquiring new papers, either as whole sheets or as pages of sketchbooks. The Turner Bequest contains hundreds of different papers from hundreds of different makers in practically every country he visited. Few other artists use so many different papers from so many different sources.

Throughout his career Turner made very deliberate choices in the sheets of paper he used but, as with all artists, there were also occasions when he worked on whatever was to hand, from backs of letters to scraps of wrapping paper. Moreover, much of the paper Turner used, even when made by the most illustrious makers of his day, was actually *retree* paper that was sold at a slightly lower price because of some visible fault, but not one sufficient to make the whole sheet useless. Most of the paper Turner used was handmade but there are examples of him working on machine-made papers, one of the earliest being a sheet of 'Eliot's paper' made about 1810. He also used part of a roll of Winsor and Newton's 'Colossal Continuous Drawing Paper' (which one could buy 4 ft. (1.22 m.) wide and any length one required) for a series of vignette studies, and a Swiss machine-made lightweight writing paper for a series of watercolours in the early 1840s.

One indication of the often deliberate nature of his choices could be seen in those papers he used for his 'finished' works where he constantly relied on papers from very few makers. The three main ones were, for white paper, William Balston at Springfield Mill, Maidstone, the Hollingworth Brothers at Turkey Mill, also at Maidstone, both of whom produced paper with the Whatman watermark, and George Steart of Bally, Ellen & Steart at the De Montalt Mill, Bath, who, besides providing white paper, also produced much of the blue, grey, and buff papers used by Turner later in his career. Although he continued to buy new papers throughout his life, he sometimes returned to using papers which he had first worked on many years before, a particularly good example being a batch of Super Royal Whatman that he had bought and first used in 1794 but continued to use off and on until the early 1840s, some 50 years after he first bought it.

Artists have always chosen what suits their particular needs. If they cannot find what they want, they treat the sheet themselves. Prepared grounds are found throughout Turner's career. While it was possible to buy toned and coloured grounds, such as *Bistre* papers, from the colourmen, the highly individual nature of many of Turner's prepared papers suggest that he was preparing them himself. It was just this kind of individual usage that gradually filtered back to the papermakers, through the colourmen and merchants, and would eventually lead to some of the changes in papermaking practice.

Turner often produced several different works on the same sheet of paper. From the 1820s onwards he had the habit of folding Royal, Super Royal, or Imperial sheets in quarters, eighths, or sixteenths and sketching on the resulting pad in pencil, unfolding and refolding the sheet as necessary to give a new surface. These drawings were often later worked up as watercolours. In the studio he worked slightly differently, using the whole sheets flat but producing, say, four works on the same sheet, only tearing it down after the entire sheet was done.

Many of the papers found in Turner's British-made sketchbooks come from the same papermakers and mills found in the loose sheets that he used, but a greater variety of paper types, papermills, and papermakers is found in those sketchbooks that he bought on the Continent. The blank books available to Turner came in a wide range of sizes and formats, and many of his sketchbooks were in fact designed for other purposes: ordinary notebooks, commonplace books, ladies' pocket books, and even bankers' books. Although he did buy very good-quality books designed specifically for drawing and watercolour, his main criteria often seem to have been availability and portability. He bought books off the shelf from colourmen and stationers and also, particularly earlier in his career, had books made up to his own specification, often using sheets of paper he had prepared with toned and coloured washes.

Throughout his life he took sketchbooks with him on his tours as well as acquiring others *en route* as and when he needed them. Many of these books contained ordinary, often relatively low-quality, writing papers rather than papers designed for watercolour: most of Turner's work in sketchbooks is simply drawing and such papers were often admirably suited for quick sketching in graphite. When travelling Turner also on occasion made up his own small books, sometimes just a few sheets of writing paper simply stitched or pinned together.

From the 1820s onwards there is a much larger proportion of sketchbooks actually made for watercolour, particularly the so-called roll-sketchbooks, soft covered and designed to be carried rolled-up, something that is not actually very practical: paper, when it spends much time rolled, is actually very difficult to flatten out properly for use, the resulting undulations in the pages making it difficult to paint in watercolour. Some of the confusion about Turner's use of roll-sketchbooks has arisen because of the similarity between true roll-sketchbooks, supplied with ties to keep them rolled, and ordinary soft-covered sketchbooks, cheaper and lighter than hardbacked books and not specifically designed to be rolled up: both are commonly found in Royal quarto and Super Royal quarto formats in the Turner Bequest.

One thing emerges very strongly from any examination of Turner's use of paper: as he explored the possibilities of various surfaces, he moved away from merely superimposing his vision onto a paper surface towards a full maturity where, in every work, the paper is integral to the expression of his vision.

See also BOARDS AND MILLBOARDS; SKETCHBOOKS; SUPPORTS.

PB

W. A. Churchill, *Watermarks in Paper*, 1935.
E. Heawood, *Watermarks, Mainly of the 17th and 18th Centuries*, 1950.
Bower 1990.
Peter Bower, 'The Evolution and Development of "Drawing Papers" and the Effect of this Development on Watercolour Artists, 1750–1850', in *The Oxford Papers: Studies in British Paper History*, vol. I, 1996, pp. 61–74.
Bower 1999.

PARIS. Turner made more visits to Paris than to any other European city (1802, 1819, 1820, 1821, 1826, 1828, 1829, 1832). Yet surprisingly he produced only eight finished watercolours of the city itself, and no works in oil. Five of these were for **Turner's Annual Tour*, 1835 (TB CCLIX: 117–20, and private collection; W 987). The other three appeared in **Scott's Prose Works*, 1834–6 (Indianapolis Museum of Art and untraced; W 1102, 1103, 1113). These numbers are somewhat deceptive because Turner recorded the external features of Paris in hundreds of sketches over the years, culminating in his most thorough survey of the city and its environs in 1832 (CCXLIX, CCLIV, CCLVII). Curiously, almost no sketches survive from the earliest of his visits in 1802, when he seems to have spent most of his time in the Louvre (see PARIS, MUSÉE DU LOUVRE). However, this may also reflect an awareness of *Girtin's plan to produce a series of views of Paris (the latter had returned to London just prior to Turner's departure for France).

IW

Paris 1981, pp. 257, 360, 374, 378–9.
Warrell 1999, pp. 14–24, 27–8, 35–43, 52–60, 228–46.

PARIS, Centre Culturel du Marais, *Turner en France*, 1981–2. The first Turner exhibition in France since that in Paris in 1948 (see PARIS, MUSÉE DE L'ORANGERIE), this focused on the artist's tours in France, and made a great impact. The 200 works—a few oils, watercolours, and drawings—were a revelation. In addition the unique design of the exhibition, with its striking and luminous setting, was epoch-making in the history of exhibitions, and provided the subject of lively debate among French curators. The study of Turner's visits to France was revitalized by the exhibition and its informative catalogue, with contributions by Nicholas Alfrey, John Gage, Jacqueline and Maurice Guillaud, Robin Hamlyn,

David Hill, Michael Kitson, Lindsay Stainton, and Andrew Wilton.

OM

(trans. LH)

PARIS, Grand Palais, *J. M. W. Turner*, 1983–4. This exhibition was organized by the *British Council to mark its 50th anniversary, and remains today the most important Turner exhibition shown in France. Of all the exhibitions devoted to English painters at this time—*Gainsborough, *Reynolds, and *Wright of Derby—it was the outstanding success. There were 257 items in the catalogue, 79 of which were paintings, illustrating all aspects of Turner's work. Important essays by Nicholas Alfrey, John Gage, Evelyn Joll, Andrew Wilton, and Jerrold Ziff, especially those on Turner and the Old Masters, and on Turner's reputation in France, provided a new insight into the artist's work for the French public.

OM

(trans. LH)

PARIS, Musée de l'Orangerie, *Turner*, 1948. This was the first Turner one-man exhibition in France. It was organized by the *Tate Gallery for the *British Council, and the selection was made by Sir John *Rothenstein and Humphrey Brooke. There were 66 exhibits, of which 41 were oils, and 15 sketches or unfinished studies; the catalogue stressed this aspect of Turner's work. The exhibition had a considerable influence on the French perception of Turner in relation to the *Impressionists and certain abstract painters.

OM

(trans. LH)

PARIS, Musée du Louvre. At the time of Turner's first visit to Paris in 1802 the Musée du Louvre, situated in a former royal palace and based on the royal collection, was greatly augmented by the artistic riches gathered together in the wake of Napoleon's military campaigns. There are comments on a couple of pictures in the 'Small Calais Pier' Sketchbook (TB LXXI) and a copy of Mola's *Vision of St Bruno* in the 'France, Savoy, Piedmont' Sketchbook (LXXIII: 2), which suggest that Turner made a preliminary survey of the Louvre before heading south to the Alps. But it was only when he returned to Paris at the end of September that he was able to concentrate more fully on the paintings. Some of his remarks on the collection were noted by *Farington, whom he met there. But his more personal reflections were committed to a book wholly devoted to the purpose; the 'Studies in the Louvre' Sketchbook (LXXII). In this small notebook his written observations are frequently supplemented with copies of specific pictures. Though the focus of his critical analysis was *Poussin, the majority of his copies are of works by *Titian, presumably partly prompted by the controversy then surrounding the supposed secret techniques used by Venetian artists. Altogether his com-

ments encompass about 40 works by some sixteen artists (some attributions have since changed, consequently swelling this number). The works are as follows (the relevant pages of Turner's sketchbook are given in parentheses): Correggio, *Saint Jerome*, restored to Parma in 1815 (33v.–34, 64); Domenichino, *Hercules and Cacus* (75v., 76v.) and *Hercules and Acheloüs* (76, 77); Giorgione-Titian, *Le Concert champêtre* (56v.–57v.); Guercino, *Mars and Venus* (identified by Turner as a Domenichino), returned to Modena in 1815 (35–36v.), and *The Resurrection of Lazarus* (52v.–54v.); La Haye, *Suzanna bathing* (60v.–61); Le Brun, *The Death of Cato*, sent to the Musée d'Arras (69v.); Lievens, *The Visitation* (68); Lotto, *The Adoration of the Infant Jesus* (63); Mola, *St John the Baptist preaching* (18), *Tancredie and Erminia* (78v.–79), and *Erminia guarding her Flock* (78v., 80); Poussin, *Baptism of Jesus* (27), *Christ and the Woman taken in Adultery* (27, 90), *Death of Saphire* (or the *Wife of Ananias*) (27, 90), *The Deluge* (41v.–42, 74), *Landscape with Diogenes* (25v), *Eliezer and Rebecca* (27, 71, 72, 90), *The Israelites gathering Manna* (26v., 27, 90), *Plague at Ashdod* (27, 73, 90), *Landscape with Orpheus and Eurydice* (26, 71), and *Saint John baptizing the People* (73); Raphael, *The Holy Family* (17); Rembrandt, *The Angel Raphael leaving Tobias* (60v.); (Student of) Rembrandt, *The Good Samaritan* (59v.–60); Rubens, *The Rainbow* (77v.–78) and *The Tournament* (78); Ruisdael, *The Tempest* (14v.–15, 23) and *The Ray of Sunlight* (22v., 18); Titian, *Woman at her Toilet* (23v.–24, 25), *The Entombment* (29v.–31v., 32), *The Crowning with Thorns* (51–51v., 52), and *The Death of St Peter Martyr*, returned to Venice in 1815, where it was destroyed by fire in 1867 (27v.–28v.); Van Dyck, *Venus and Vulcan* (16).

The most obvious omission in this list is any work by *Claude Lorrain, especially as there may have been up to fifteen works by him hanging, though it is not possible to prove exactly which works were on display. In 1811 Turner remembered only two canvases by Claude in the Louvre, which he felt should more properly be attributed to Swanevelt (in his 'Backgrounds' lecture: Ziff 1963, pp. 145, 129 n. 18). To remedy his neglect of 1802, he paid much closer attention to Claude when he revisited the Louvre in 1821, making thumbnail copies of eight compositions, which he annotated with notes on the colour, light, and shadows used in each (CCLVIII: 19v., 20, 32v., 34). The only other picture to catch his attention during this trip seems to have been Poussin's *Diogenes*, which he had also examined in 1802.

The Louvre itself appears in one of the group of Paris subjects that was engraved in the 1834 edition of *Turner's Annual Tour* (CCLIX: 117; R 485). As well as this distant view, there are three pencil sketches on sheets of blue paper showing the Grande Galerie (with artists making full-scale copies), which are difficult to date, but most probably relate to the 1826 trip (or to that of 1832) (CCLX: 88, 90, 125). IW

Ziff 1965, pp. 51–64.

Jean-Pierre Cuzin and Marie-Anne Dupuy, *Copier Créer: De Turner à Picasso: 300 œuvres inspirées par les maîtres du Louvre*, exhibition catalogue, Paris, Musée du Louvre, 1993, pp. 80–4.

Warrell 1999, pp. 15–18.

PARIS EXHIBITIONS OF 1887 AND 1894. The first, entitled *Exposition de tableaux de mâitres anciens au profit des inondés du midi*, held at the École des Beaux-Arts in 1887, included a *Paysage* by Turner lent by 'M. G.ˣˣˣ'. To judge by the long and enthusiastic description by J. K. Huysmans (*Certains*, 1889, pp. 201 ff., reprinted in Gage 1983, p. 52) this seems to have been *Landscape with a River and Bay in the Distance*, one of the late unfinished oils based on the *Liber Studiorum*, at that time in the possession of Camille *Groult (Musée du Louvre, Paris; BJ 509). The same picture was also praised by Maurice Hamel (*Gazette des Beaux-Arts*, 2nd ser., 35/1 (1887), p. 251).

In 1894 the Galerie Sedelmeyer held at exhibition of 100 Old Masters including *Ancient Italy—Ovid banished from Rome* (RA 1838; private collection, USA; BJ 375); efforts were made to secure this for the Louvre but it finished up in the collection of Camille Groult. Among the twelve pictures by or attributed to Turner it seems likely that one or both of the two unfinished oils belonging to Groult were also included, BJ 509 and *The Val d'Aosta* (c.1840–50; National Gallery of Victoria, Melbourne; BJ 520); Camille Pissarro, writing to his son Lucien in June 1894, mentions 'two Turners belonging to Groult, which are quite beautiful' (C. Pissarro, ed. Bailly, *Lettres à son fils*, vol. i. 1980, pp. 345–6).

It is extraordinary to think that the late unfinished oils BJ 509 and 520 could have been exhibited in Paris as early as 1887 and 1894, before such works from the Turner Bequest (see WILL) were even given inventory numbers by the National Gallery in *London. The same works, and others attributed to Turner, were seen in the Groult collection by such connoisseurs as Edmond de Goncourt (*Journal*, 18 January 1890). MB

Gage 1983, pp. 52–3, 149.

PARKER, Thomas Lister (1779–1858), an early patron and friend of Turner. Parker was first cousin once removed to Sir John *Leicester of Tabley; Walter *Fawkes of Farnley was a friend and neighbour. Turner drew Browsholme in 1799, and his subsequent watercolour (private collection, England; W 291) was engraved for the *History of Whalley* 1801, written by Parker's friend Thomas Dunham *Whitaker.

Parker was an enthusiastic collector of contemporary British painting. His *Catalogue of Paintings in the Gallery at Browsholme* of 1807 listed over 50 paintings, chiefly Dutch

and Italian, and including Velasquez's *Juan de Parera*. It also recorded four British paintings: pictures by *Gainsborough, *Wilson, and *Callcott, and Turner's *Sheerness and the Isle of Sheppey*, usually known as *The Junction of the Thames and the Medway* (Turner's gallery 1807; National Gallery of Art, Washington; BJ 62).

In 1808 Parker sold most of his Old Masters, partly owing to financial pressures, and thereafter concentrated on patronage of contemporary British artists. In 1811 Parker sold his Turner but commissioned a copy from Callcott, still at Browsholme. CALS-M

PARLIAMENT, Burning of the Houses of. On the night of 16 October 1834 the Palace of Westminster, a complex of buildings on the bank of the Thames that served as the seat of the Houses of Parliament, was consumed by flames. The destruction of the Houses of Parliament was a devastating loss to the British nation for the complex of buildings at Westminster had enormous historical significance. It was not only the centuries-old home of the Houses of Parliament and the principal courts of justice, from about 1017 to 1529 it had also been the London residence of the sovereign. Despite this historical legacy, as it stood in 1834 the Palace of Westminster was not noted for its architectural beauty. Numerous restorations and enlargements had produced an eclectic architectural complex, both confusing and inconvenient. By the early 19th century the palace had become a labyrinth of chambers linked by narrow, gloomy passages. Much of it comprised brick and stone, but a significant portion was wood, covered with lath and plaster. Members of Parliament complained that they could not adequately perform their duties in this environment and in the early 1830s two parliamentary committees concluded that new accommodation was essential. But the need for a new Bankruptcy Court at Westminster was even more immediate. Thus the Board of Works undertook to refurbish part of the Exchequer Offices, including an office known as the tally-room. From the 12th to the 19th century, wooden sticks called 'tallies' were a recognized form of receipt for payments into the Royal Treasury. Although the wooden tally system was abolished in 1826, about two cartloads remained. On the morning of 16 October 1834, at a time when Parliament was not in session, two labourers began burning the tallies in the stoves of the House of Lords. Despite indications throughout the day (a considerable amount of smoke and a higher-than-normal temperature in the Lords' chamber), no action was taken and Mrs Wright, the housekeeper, locked everything up at five o'clock, as usual. Shortly after six o'clock the building was on fire and the battle to save Westminster began.

Within two hours, both the Houses of Parliament were engulfed by flames and the roofs of both chambers collapsed. Attention was then directed to the fate of Westminster Hall, the oldest and most historic structure on the site. Fire engines were moved inside to hose down the interior while others saturated the exterior and roof. Thanks to the changing direction of the wind, the flames were blown away from the roof and Westminster Hall was saved.

By midnight the fire's worst damage had been done, although the flames were still burning furiously. At about half past one the floating fire engine finally arrived and pumped enough water to confine the remaining flames. By five o'clock the site was a smouldering ruin.

When the fire broke out an excited throng of Londoners converged on the neighbourhood, jamming the surrounding streets, the bridges, and even the river to witness the awe-inspiring sight. Given the commanding visual drama of billowing smoke and flames bursting forth against the moonlit sky, it is not surprising that numerous artists were in the crowd. The porter of the *Royal Academy is said to have announced the event to students in the library.

The destruction of the Houses of Parliament triggered a deeply felt response in Turner. Also an eyewitness to the fire, Turner spent part of the night intently observing the historic disaster. The results appear to have been a significant body of work including two sketchbooks, one containing very slight pencil notations and the other nine watercolour studies; an unfinished watercolour; a vignette illustration engraved for the *Keepsake* in 1835; and two major oil paintings exhibited the following year. The drawings and paintings Turner produced in the aftermath of the Parliament disaster reveal not only the profound impact that it had on him, but also the very process through which he arrived at an expressive union of experience and imagination.

Such focused concentration on a single theme was not unusual for Turner, who habitually explored the imaginative use of cataclysmic phenomena—fire, flood, blizzard, and avalanche—in paintings that reveal nature's elemental beauty as well as her fearful power. But most of these works, though frequently informed by personal experience (the storms in *The Fifth *Plague of Egypt* (RA 1800; Indianapolis Museum of Art; BJ 13) and *Snow Storm: Hannibal and his Army crossing the Alps* (RA 1812; BJ 126), or the fire in *Shadrach, Meshech and Abednego in the Fiery Furnace* (RA 1832; BJ 346), for example), depict incidents Turner did not see himself. Since the opposite was true for the scene at Westminster, in the two oil paintings of the Parliament fire Turner was able to create images of astonishing power and originality. He used the historic conflagration as the starting

point for a painterly dissolution of the material reality of the natural world into its basic components—earth, air, fire, and water—which he then reconstituted on canvas in terms of brilliant, evanescent colour. The pictures raise the Parliament disaster to a level of cosmic significance, becoming universal statements rather than mere records. Comparing them with the widely circulated prints of the fire emphasizes the telling differences between journalistic documentation and Turner's personally expressive interpretation.

Proof of Turner's presence at Westminster on the night of the fire is provided by the unpublished diary of John Green Waller, a student at the Royal Academy, who recorded that Turner, along with Clarkson *Stanfield and a group of Waller's fellow students, observed the fire from a boat on the Thames. Turner may have recorded his impressions at the scene, either from the river or from various vantage points along its banks. The pencil studies (TB CCLXXXIII) are quite summary and rather ambiguous. Indeed, they may have nothing to do with the fire at all, although two pages (CCLXXXIV: 7, 9) contain images that could be construed as brief, rapidly recorded observations of a great blaze. It is plausible that they were made at the scene for later reference.

Turner's watercolour studies (CCLXXXIV) present a more complex problem, however. Once bound together in a sketchbook but now mounted separately, they do not record specific detail, thus engendering varied interpretations. Because the back of the page facing each watercolour was blotted, it has been argued that these watercolours were also made at the scene of the fire. Certainly this would have been extremely difficult, given both the darkness and the general chaos at the scene. Alternatively, the blotting may have occurred in Turner's studio, where, working from memory with great imaginative fervour, he wasted no time waiting for the colour on each sheet to dry and quickly turned to the next to capture his thoughts while they were still fresh in his mind. Even more likely, the blotting occurred in the *Tate Gallery during the Thames flood of 1928. Regardless of where they were made, the sketches themselves reveal a fascination with colour, smoke, and contrasts of light and dark, and are sufficiently varied in composition that they may simply represent the artist's musings on possible compositions for a nocturnal scene of fire reflected in water. The connection with the fire at Westminster remains inconclusive for in none of the watercolours can any of the Parliament buildings be clearly identified.

In contrast to the sketches, the more finished watercolour (CCCLXIV: 373; W 522) is an explicit, close-up depiction of the fire that seems to prove that Turner spent at least part of the evening on the Westminster side of the Thames. Showing the interior of Old Palace Yard, the central portion of the composition is filled with spectators, held in check by soldiers. Water from the firemen's hoses shoots up towards the flaming buildings and gushes from a pump in the foreground. Of all Turner's works relating to the fire, this watercolour conveys the clearest sense of the noise and confusion at the heart of the disaster. The drawing may have been intended for engraving, perhaps as an illustration for a pamphlet such as William Manby's *Plan for the Establishment of a Metropolitan Fire Police*, published in 1835. Here the Parliament fire was used to bolster an argument for an organized fire-fighting force, since at the time, such services were performed by the individual insurance companies.

During the next six months, as Turner continued to deliberate on the Parliament conflagration, he produced the two powerful oils, each taken from a different viewpoint and recording a different moment of the fire, which now reside in American collections. The Philadelphia painting (BJ 359) is the earlier version, shown in 1835 at the *British Institution's February exhibition as *The Burning of the House of Lords and Commons, 16th October, 1834*. With the canvas hung on the gallery wall, as recorded by the genre painter E. V. Rippingille in his vivid account of the artist at work on 2 February, one of the *Varnishing Days, Turner created the picture using not only brushes but his fingers and palette knife in an assured, spontaneous display of painterly bravado.

In the Philadelphia painting Turner presented the fire from the Surrey side of the Thames, looking directly across at the Houses of Parliament. The glowing inferno and its reflection in the water illuminate the left half of the canvas and Westminster Bridge, jammed with onlookers, dominates the right. Greatly exaggerated in scale, it rises towards the centre of the picture, apparently permanent and stable, but then seems to collapse abruptly before the far bank, as if its massive structure is dissolving in the heat of the blaze. Across the river, St Stephen's Chapel (which housed the Commons, and which was one of the first buildings destroyed) is clearly visible at the centre of the flames, glowing as if molten, and flanked on either side by disintegrating buildings. In the background can be seen the towers of Westminster Abbey, illuminated by the flaring radiance before them.

This chronicle of the fire also shows the river teeming with boats and a watchful multitude in the foreground. Like the chorus in an opera, these figures not only frame and balance the lower half of the composition, they also convey the conflicting emotional responses of the fire's witnesses. Many stare outward, inviting the viewer into the picture as fellow participants in the spectacle. Turner rendered the assembled spectators in the second, Cleveland version (BJ 364) in a similar manner, although he confined them almost entirely to the outermost edges of the picture. He thus left

open an expanse of canvas for the flaming apparition in the centre, which threatens to consume the entire scene. Here, too, a number of wide-eyed, open-mouthed faces turn away from the inferno towards the viewer.

The second oil rendering, entitled *The Burning of the Houses of Lords and Commons, October 16, 1834*, was exhibited at the Royal Academy in May 1835. This version presents a panoramic view of the fire, from the south end of Waterloo Bridge, looking upstream towards Westminster. While the closer vantage point of the Philadelphia picture allows the viewer an almost direct confrontation with the blaze itself, the distant prospect provides more scope for Turner's characteristic obliteration of the distinction between material, man-made monuments and nature's elements.

In the Cleveland painting everything seems to merge in the centre of the flames. Westminster Bridge, relatively substantial at the left in tones of blue and green, appears to dissolve into the burning yellows, ochres, and oranges in the centre of the composition. The Parliament buildings are nearly impossible to identify with the exception of Westminster Hall, which seems to coalesce with the surrounding glow. Once again those symbols of English pride—the towers of Westminster Abbey—stand by like paired sentinels, reflecting the intense light, but remaining unscathed by the fire itself. The great arc of thickly painted flames sweeping across the night sky is magnified to a grander scale by its reflection in the river below. As in Turner's portrayals of shipwrecks or snowstorms, there is a certain measure of irony in both Parliament oils, for on the one hand the fire was a national tragedy, but on the other it presented a magnificent visual experience. Simultaneously attracted and repulsed, he projected in these paintings both the terror and the fascination of the disaster.

To achieve this pictorial splendour and convey a universality of meaning, Turner sacrificed topographical accuracy in the Cleveland version, even more than he had in the Philadelphia painting. Here, for example, he straightened the curve of the Thames between the Waterloo and Westminster bridges. In the two oils Turner did, however, pay close attention to other specific details. Responding to the historic importance of Westminster Hall and the crowd's concern for its safety (widely reported by the press), Turner took care to highlight its presence at the centre of the inferno in the Cleveland painting. In the Philadelphia version the prominence of St Stephen's Chapel serves as a reminder of Parliament's medieval foundations, recently shaken by the *Reform Bill of 1832 and now literally going up in smoke. In the centre foreground of the Philadelphia painting is another telling detail—a sign protruding above the crowd,

facing the viewer, on which a large 'NO' appears. Perhaps this refers to the opposition expressed by the crowd that night (again, confirmed by press accounts) to the Poor Law—legislation Parliament was considering at the time of the fire.

In the Cleveland painting Turner also took special care to include, at the lower right, a floating fire engine that did not arrive at Westminster until almost 1.30 a.m. Earlier in the evening the very low tide had impeded the engine's progress from the Rotherhithe docks. It was thus too late to save the day and came to be viewed by many as a metaphor for lethargic parliamentary action. While Turner must have been aware of such political interpretations, he is likely to have intended another sort of allegorical statement as well, emphasizing the futility of humanity's efforts to control the relentless forces of nature.

In both these paintings Turner's characteristically energetic brushwork is employed to great effect. The contrast between the relative precision of foreground details and the less distinct handling of the flames and burning structures gives these representations a convincing air of truth, even if they lack journalistic detail. The *Athenaeum* (14 February) critic described the Philadelphia picture as a 'splendid impossibility' and commented that 'the sky is of noon-day blue, and truth is sacrificed for effect which, however, is in parts magnificent'. The *Athenaeum* reviewer of the 1835 Royal Academy exhibition (23 May) did not appreciate Turner's enhancement of meaning through technique, however, and described the Cleveland picture as 'extravagant'. The writer would have preferred to see 'the accuracy of a district survey'. The *Times* (23 May) observed that Turner's 'fondness for exaggeration' had here 'led him into faults which nothing but his excellence in other respects could atone for'.

The Cleveland and Philadelphia paintings represent Turner's grandest thoughts on the subject of the Parliament fire, but he took up the theme on at least one further occasion. Later in 1835 he produced a completely new rendering of the subject—a watercolour vignette (1835; Museum of Outdoor Arts, Englewood, Colorado; W 1306)—to illustrate a poem entitled 'The Burning of the Houses of Lords and Commons' by the Hon. Mrs Norton, editor of the *Keepsake*, a popular annual. The engraved version, produced by J. T. *Willmore, appeared in the 1836 edition. KS

Gowing 1966, p. 33, repr.
Gage 1969, pp. 35, 117, 169; pls. 10 and 11 (reversed).
Wilton 1979, pp. 218, 220, 226–7, 250; pl. 215.
John McCoubrey, 'Parliament on Fire: Turner's Burnings', *Art in America*, 72/11 (December 1984), pp. 112–25.
Solender 1984.
Gage 1987, p. 233; repr. pls. 318–20.

PASQUIN, Anthony (John Williams) (1754–1818), author and critic whose satirical writings frequently resulted in litigation. Pasquin fled to America in 1798, but returned to England on several occasions. His art criticism, published in newspapers and pamphlets, was facetious and unfriendly towards the *Royal Academy; his early reviews of Turner, however, were free of satire and full of encouragement. *Fishermen at Sea* (BJ 1), though 'managed in a manner somewhat novel', was proof of 'an original mind' (*Critical Guide to the Exhibition of the Royal Academy for 1796*, pp. 15–16). His lengthy, even more effusive review in 1797 of *Fishermen Coming Ashore at Sun Set* (the lost '*Mildmay Seapiece'; BJ 3) praised Turner's 'genius and judgement', extolling his 'peculiar vision', his adroit 'singularity of perception', and his 'grace and boldness in the disposition of his tints and handling'; he was particularly impressed with Turner's depiction of the sea, 'that inconstant, boisterous, and ever changing element' (*Morning Post*, 5 May; reprinted in *A Critical Guide to the Present Exhibition at the Royal Academy*, 1797, pp. 10–11). Aware of Turner's reputation for 'bold eccentricities', he was none the less full of praise for *Spithead* (Turner's gallery 1808; RA 1809; BJ 80) and *Tabley . . .: Calm Morning* (RA 1809; BJ 99), but puzzled by Turner's attempt to rival *Wilkie in *The Garreteer's Petition* (RA 1809; BJ 100): why 'squat himself uninvited in an orchestra where he can play only a very subordinate violin' (*Morning Herald*, 4 May 1809). JCI

R. W. Lightbown, 'John Williams alias Anthony Pasquin', pp. 1–72 in facsimile reprint of Pasquin's *An Authentic History of Painting in Ireland*, 1970.

PASSAVANT, Johann David (1787–1843), German scholar and artist. He was a childhood friend and supporter of the Romantic painter Franz Pforr and a correspondent of *Goethe. Passavant visited England during the years 1831–2 and subsequently published an account of his experiences in 1836 with the title *Tour of a German Artist in England*. He was struck by the speed with which Turner finished his pictures just in time for the opening of the Royal Academy exhibition. He may have been referring to Turner's increasing practice of elaborating or completing his RA submissions during the *Varnishing Days allotted to artists for the final retouching of their work. BV

PATRONAGE AND COLLECTING IN TURNER'S LIFETIME. Royal and aristocratic collecting in Britain, focusing on Italian, French, and other Continental artists, began in the early 17th century with Charles I and his court, and reached fruition in the 18th century as an array of superb collections displayed in both London and country houses, a tradition which continued on a reducing scale until the early

20th century. The Industrial Revolution brought economic supremacy to 19th-century Britain and led to the formation of another multitude of collections. Some were motivated by connoisseurship as, for example, the taste for Italian primitives pioneered by the artist, dealer, and collector William Young Ottley and the Liverpool banker William Roscoe. However, the century was characterized by the rise of new collectors, whose fortune did not derive from land, and who preferred to collect British pictures. These were the inventors and industrialists, merchants and manufacturers, engineers and spinners, brokers and bankers, not only from London but also from Liverpool, Manchester, Newcastle, and other northern cities.

Turner's lifetime touched the earlier of these traditions, but coincided mainly with the later. In 1775 *George III had reached the 15th year of his reign and Sir Joshua *Reynolds was President of the recently founded *Royal Academy. When Turner died in 1851, Queen *Victoria was in the 14th year of her reign and the Presidency of the Royal Academy had passed to Sir Charles *Eastlake, a central figure of the Victorian art world.

Throughout the 18th century young men who had made their Grand Tour returned home from France, Switzerland, and above all Italy with vast quantities of paintings, sculpture, prints, drawings, and other works of art. British collections which may have comprised no more than family portraits and sporting pictures were transformed by the arrival of pictures by Raphael, *Titian, and many other Old Masters.

In the last quarter of the 18th century, and in the aftermath of the Napoleonic wars, the flow of works of art reaching London appeared apparently inexhaustible, making this period one of the most favourable in the history of both art-dealing and collecting. Artists and dealers speculated in works of art: James Irvine (?1759–1831), William Buchanan (1777–1864), and Andrew Wilson (1780–1848) travelled on the Continent and returned to London with individual works and whole collections for sale. The Calonne, Fagel, and Vitturi collections were notable among those then dispersed in London, but the greatest collection was that of the Duc d'Orléans, sold in the late 1790s chiefly to aristocratic collectors. The principal portion was acquired by the third Duke of *Bridgewater (1736–1803). Among other prominent purchasers were the fourth Earl of Darnley (1767–1831), who bought fine Venetian works by Titian, Tintoretto, and Veronese, and the seventh Viscount Fitzwilliam (1745–1816), founder of the *Fitzwilliam Museum, Cambridge.

By the mid-19th century, many owners of fine collections opened their London houses to members of the public on certain days of the week, a concession of particular

importance before 1824, the year of the foundation in *London of the National Gallery. The Bridgewater House collection, inherited in 1833 by the first Earl of Ellesmere, numbered (1851 catalogue) 302 paintings, and included four superlative works each by Raphael, *Rembrandt, and *Claude, five by Titian, and eight by *Poussin. Another collection formed in the same tradition was founded by the first Earl Grosvenor (1731–1802) and extended by his son the second Earl (1767–1845), created first Marquess of Westminster in 1831. The Grosvenor House gallery was catalogued by John Young in 1820: it contained 143 paintings, including a portrait by Velasquez, three paintings by Murillo, four by Poussin, five by Guido *Reni, six by Rembrandt, and no fewer than ten by Claude, and eleven by *Rubens. The collection included works commissioned by the first Earl from *Gainsborough, Northcote, Reynolds, Stubbs, *West, and *Wilson, all 18th-century British painters. Other significant 19th-century collections in this tradition include those belonging to the first Duke of *Wellington (1769–1852) at Apsley House and Stratfield Saye, Robert Stayner Holford (1808–92) at Dorchester House and Westonbirt, and those formed by members of the Baring, Hope, and Rothschild families.

Patronage of British painters of portraits, landscapes, and sporting art had increased steadily throughout the 18th century. Artists were attracted to London to live and work there: Reynolds (1723–92) in Leicester Fields, Gainsborough (1727–88) in Pall Mall, and Romney (1734–1802) in Cavendish Square. The classical landscapes of Richard Wilson (1714–82) secured his reputation as an artist in the Grand Style, and demonstrated that a British painter was as capable as any Continental painter of producing a serious work of landscape art. Stubbs (1724–1806) won early aristocratic patronage from the Dukes of Grafton and Richmond, the Marquess of Rockingham, Earl Grosvenor, and Earl Spencer.

Turner was born at an auspicious time for living British artists. The long-held prejudice that British painters were unequal to the challenge of historical painting had been largely overcome by the activities of Alderman John Boydell (1719–1804). Boydell began to publish historical engravings c.1751, and established a lively and profitable industry: his profits from one print alone, William Wollett's engraving after West's *Death of Wolfe*, amounted to £15,000. In 1786 Boydell embarked on his project to publish by subscription a series of prints illustrating scenes from the plays of *Shakespeare. For this immense enterprise Boydell commissioned over 300 pictures from well-known artists, and among the names listed in the catalogue are Hamilton (23 pictures), Smirke (26), *Westall (22), Downman, *Fuseli, Northcote,

*Opie, Reynolds, Romney, *Stothard, West, and *Wright of Derby. The printseller Thomas Macklin (d. 1800) closely followed Boydell with two noteworthy publications—the *Poet's Gallery* and *Macklin's Bible*, for which he commissioned 100 pictures and 60 pictures respectively.

The cause of contemporary British artists was enthusiastically taken up by Sir John *Leicester (1762–1827), created Lord de Tabley in 1826. A leading patron, he unusually brought home no paintings from his Grand Tour (1785–6), but formed from 1800 onwards a collection of exclusively British paintings, which he displayed in galleries in Tabley House in Cheshire, and in his London house, 24 *Hill Street, which he opened to the public in 1818. Leicester bought his first oil painting by Turner between 1804 and 1808, *Kilgarran Castle* (National Trust, Wordsworth House, Cockermouth; BJ 11), exhibited at the RA in 1799 (305), and was to acquire eight more paintings by Turner by 1818. The London collection was auctioned in 1827, soon after de Tabley's death. One of Leicester's paintings by Opie, *Damon and Musidora*, had been commissioned by Macklin for his *Poet's Gallery*, and was bought at the Tabley sale by the third Earl of *Egremont for the *Petworth collection, as was one of the Turners.

Some aristocratic collectors readily became patrons of British artists. In 1801 the elderly Duke of Bridgewater commissioned (for 250 guineas) the youthful Turner to paint *Dutch Boats in a Gale*, better known as the 'Bridgewater Seapiece' (BJ 14), as a pendant to *Dutch Shipping Offshore in a Rising Gale*, by Willem *Van de Velde the Younger. In 1795 Turner drew five views of Hampton Court, Herefordshire for the fifth Earl of *Essex, who in 1807–09 bought three fine Turner oils: Essex was a generous patron of contemporary artists, commissioning views of Cassiobury from Alexander, Edridge, Hearne and W. H. Hunt, and portraits of himself and his wife by *Hoppner.

Essex was seven years older than the sixth Duke of Bedford (1766–1839), who actively patronized contemporary artists and sculptors, although not Turner. He commissioned sculpture from *Chantrey, *Flaxman, Thorwaldsen, and Westmacott, but his most celebrated statue was *The Three Graces* commissioned from *Canova in 1814. The sixth Duke sent 44 paintings by Flemish and Dutch Old Masters to Christie's for sale in June 1827 to make room for works by living artists, among whom were Sir William Allan, President of the Royal Society of Arts, *Bonington, Collins, Sir Charles Eastlake, Sir George Hayter, Sir Edwin *Landseer, F. R. Lee, C. R. *Leslie, J. C. *Schetky, and James Ward.

The first Marquess of Westminster added several contemporary British pictures to the Grosvenor House gallery. This collection was recorded in 1844 in its entirety by Mrs

Jameson (*Private Galleries of Art in London*, pp. 227–84). In 1831 the Marquess commissioned Leslie to paint the group portrait of his family, depicted in the gallery at Grosvenor House, in which pictures by Rubens and Velasquez can clearly be seen.

For the emerging Victorian middle class, with fortunes built on industrial success, the current fashion of picture collecting had changed from Continental Old Masters, usually acquired from dealers, to 'modern', mainly British, art, often commissioned from the artist. Robert *Vernon (1774–1849) made a fortune as a hackneyman and stable owner, which enabled him to live in Pall Mall, two doors from the *British Institution, whose annual winter exhibitions he had patronized from at least 1826. It is not surprising that Vernon bought five British pictures in 1827 at the Tabley sale. In 1847 Vernon presented 157 paintings, including four by Turner, and eight sculptures by British artists to the National Gallery with the aim of establishing a Gallery of British Art.

Another public benefactor was John *Sheepshanks (1787–1863), a Leeds clothing manufacturer who settled in London by 1827. He became a friend of a wide circle of contemporary artists, and bought works not only from *Constable and Turner but also from Collins, Leslie, Landseer, Mulready, Richard *Redgrave, and Wilkie. In 1857 he presented 233 oil paintings and 298 watercolours to the South Kensington Museum for the same purpose as Vernon, but it was not until the gift in the 1890s from Sir Henry Tate (1819–99; see TATE GALLERY) that the intention of creating a National Gallery of British Art was fulfilled.

Among the host of private collectors of this period, many of whom lived in suburban houses which were not grand, four may serve as examples. John *Allnutt (1773–1863), a wine merchant, lived on Clapham Common: he patronized Constable and *Lawrence and owned oils by several contemporary artists and watercolours by Turner. In 1833 he built a picture gallery onto his house, drawn in watercolour by David Cox in 1845.

James *Morrison (1789–1857), draper and subsequently banker, bought Constable's *The Lock* at the opening day of the RA exhibition of 1824 (180) for 150 guineas and hung it in his house at Basildon with his three oils by Turner, and his collection of other living artists. Morrison turned to Old Masters in the 1830s, and like Samuel *Rogers (1763–1855), the second Lord Northwick (1769–1859), and Wynn Ellis (1790–1875) mixed Old Masters with contemporary paintings.

Elhanan *Bicknell (1788–1861), a sperm whale oil merchant, spent over £25,000 on oils, and gave commissions to *Callcott, Eastlake, Etty, Frost, Landseer, *Roberts, *Stanfield, and Turner. His death was deplored by the *Athen-

aeum as a very great loss to the arts. His British pictures were sold in 1863: his seven Turner oils brought £17,150, and the collection as a whole fetched the then huge sum of over £58,600.

Joseph *Gillott (1799–1872) made his fortune as a manufacturer of steel pens in Birmingham. He patronized Turner and Etty, and owned works by David Cox, William Hunt, Linnell, *Maclise, Muller, Roberts, and Prout. His collection was sold in April and May 1872. The 527 lots brought the gigantic sum of £164,500: the highest individual price was paid for a Turner oil painting, *Walton Bridges* (?Turner's gallery 1806; Loyd Collection, on loan to the Ashmolean Museum, Oxford; BJ 60), which fetched £5,250.

The changes in both collectors and collections between the Orléans generation and the mid-Victorian era were momentous. Reporting on the Bicknell sale, the *Star* of 28 April 1863 recorded that:

the collection of paintings thus sold had been gathered together by a private Englishman, a man of comparatively obscure position, a man engaged at one time in mere trade; a man not even pretending to resemble a Genoese or Florentine merchant-prince, but simply and absolutely a Londoner of the middle-class, actively occupied in business. . . . He had been the patron of some of the very greatest of modern artists, and formed a collection which would have brought tourists from all parts of the world. . . . Offered for sale in the auction-room on Saturday . . . the collection realised a sum of money only wanting a few hundreds of £60,000. The artists whose work was thus purchased, were, for the most part, too, our own. It was no mere competition of fashionable pretenders, feeling themselves secure to praise and purchase so long as 'your Raphaels, Correggios and stuff' were in question. English money was being spent on English art.

See also COMMISSIONED WORKS. CALS-M

John Young, *A Catalogue of the Pictures at Grosvenor House, London*, 1820.
Mrs Jameson, *Private Galleries of Art in London*, 1844.
Catalogue of the Bridgewater Collection of Pictures, Belonging to the Earl of Ellesmere at Bridgewater House, St. James's, 1851.
William Roberts, *Memorials of Christie's: A Record of Art Sales from 1766 to 1896*, 1897.
Francis Haskell, *Rediscoveries in Art*, 1976.
A. E. Santaniello, ed., *The Boydell Shakespeare Prints*, 1979.
Hamlyn 1993.

PEACE—BURIAL AT SEA, oil on canvas, 34¼ × 34⅛ in. (87 × 86.5 cm.), RA 1842 (338); see Pl. 30; Tate Gallery, London (BJ 399). Exhibited as a pendant to *War. The Exile and the Rock Limpet* with the following lines from the *Fallacies of Hope* (see POETRY AND TURNER): 'The midnight torch gleamed o'er the steamer's side | And Merit's corse was yielded to the tide', in memory of Turner's friend and erstwhile rival *Wilkie who had died on board the *Oriental*

on 1 June 1841 on the way back from the Middle East and had been buried at sea off Gibraltar. The picture was done in friendly rivalry with George *Jones who reported that Clarkson *Stanfield objected to the darkness of the sails: 'I only wish I had any colour to make them blacker,' replied Turner. The presence of a mallard, a pun on Turner's second name, stresses his involvement.

Turner contrasts the contributions of his two heroes, Wilkie and *Napoleon, and their respective burial places (Napoleon's ashes had just, in 1840, been given state burial in Paris at Les Invalides) by making this painting predominantly blue, *War* predominantly red. Both pictures were painted to the full extent of the square canvas but were finished off, presumably on *Varnishing Days, as octagons (they are now displayed with the corners uncovered).

The critics scorned these two paintings in comparison with Turner's Venetian exhibits: 'He is as successful as ever in caricaturing himself, in two round blotches of *rouge et noir*' (*Spectator, 7 May 1842). The *Athenaeum, 14 May, could 'not endure the music of Berlioz, nor abide Hoffmann's fantasy-pieces. Yet the former is orderly, and the latter are commonplace, compared with these outbreaks.' Even *Ruskin felt that *Peace* was 'Spoiled by Turner's endeavour to give funereal and unnatural blackness to the sails.' MB

Wallace 1979, pp. 112–13, repr.

McCoubrey 1984, pp. 2–7, repr.

Alfrey 1988, pp. 33–4, repr.

Shanes 1990, pp. 100–4, 219, repr. in colour pl. 54.

PEEL, Sir Robert (1788–1850), Tory politician, who was twice Prime Minister (see CORN LAWS). Peel was a significant patron of contemporary British art and, from 1827, a Trustee of the National Gallery (see under LONDON). He apparently wanted to buy *Dido building Carthage; or the Rise of the Carthaginian Empire* (RA 1815; BJ 131) for the original price of 500 guineas, but was deterred when Turner increased his price first to 600 and then to 700 guineas (F. C. Goodall, *Reminiscences*, 1902, pp. 45–6). Later, Peel was among the subscribers who unsuccessfully sought to buy both *Dido building Carthage* and *The Decline of the Carthaginian Empire* (RA 1817; BJ 135) from Turner for £5,000, and present the pictures to the National Gallery (Thornbury 1862, i. pp. 394–5). Peel also commissioned a version of Benjamin *Haydon's *Napoleon Musing on St Helena* (first version exhibited 1830), thus ensuring the saleability of further treatments of this subject, including Turner's *War. The Exile and the Rock Limpet* (RA 1842; BJ 400). AK

PEMBROKE. The early 13th-century castle at Pembroke was one of several in South *Wales that provided subjects for small watercolours after Turner's 1798 tour (see TB XLIV:

A). A little later, when he was planning subjects for large-scale watercolours, its massive walls encircling the 75-foot (23 m.) high cylindrical Great Tower caught his imagination and he made expressive sketches for a composition in his 'Studies for Pictures' Sketchbook (LXIX: 88, 89). Two large watercolours resulted, almost indistinguishable except for a few details. In them, Turner distorts the configuration of the castle while transforming the quiet inlet of Milford Haven that it dominates into a rough sea, yet preserves quite recognizably the essential character of the place. One of them, *Pembroke Castle, South Wales: thunder storm approaching*, was shown in 1801 (private collection, USA; W 280), the second in 1806 with the subtitle *Clearing up of a thunder storm* (Art Gallery of Toronto; W 281). He adapted the design again for the *England and Wales* series in a drawing of about 1829 (Holburne of Menstrie Museum, Bath; W 832). AW

PENN, John (1760–1834), collector and writer, the grandson of William Penn, the Quaker founder of Pennsylvania. Penn was the probable first owner of Turner's *Dunstanborough Castle* (RA 1798; National Gallery of Victoria, Melbourne; BJ 6). When Turner published this picture in the *Liber Studiorum* in 1808 he described it as 'in the possession of W. Penn Esq.' (F 14). However, John Gage has suggested this is likely to be a mistake (*Turner Studies*, 4/2 (winter 1984), p. 56). Farington's diary entry for 17 July 1813 records that he met Turner at a dinner given by John Penn at New Street, Spring Gardens. That evening Turner sat next to John Penn's brother Granville, who subsequently seems to have owned *Dunstanborough Castle*. RU

PENNELL, George (d. 1866), art dealer at 18 Berners Street. Pennell enjoyed a close relationship with Joseph *Gillott, whose correspondence contains 107 letters from Pennell, who addressed him as 'Old Guv' or 'Friend G'.

All seven Turners handled by Pennell in the 1840s were either sold directly to Gillott as with *Walton Bridges* (?Turner's gallery 1806; Loyd Collection, on loan to the Ashmolean Museum, Oxford; BJ 60) or sold on his behalf to collectors such as Charles *Birch or John *Miller of Liverpool. In return Pennell, who lived with an extravagant actress, often needed—and obtained—financial help from Gillott. Pennell also had Turner dealings with both *Gambart and *Agnew's.

In 1855 Christie's were considering accepting a private offer for the 'Iveagh Seapiece' (*c*.1803–4; Iveagh Bequest, Kenwood; BJ 144) and *Boats carrying out Anchors* (RA 1804; Corcoran Gallery of Art, Washington; BJ 52), whereupon Pennell objected and insisted that they should come under the hammer. EJ

Chapel 1986, pp. 44–6, 48.

PERSPECTIVE LECTURES AT THE ROYAL ACADEMY. Turner was the *Royal Academy's Professor of Perspective for thirty years. He was elected unopposed to the post on 10 December 1807 and delivered a course of six lectures at least a dozen times: in 1811, 1812, 1814, 1815, 1816, 1818, 1819, 1821, 1824, 1825, 1827 (four lectures only), and 1828. He did not lecture after 1828 and resigned in December 1837 after a parliamentary select committee the previous year had been critical of the sorry state of the Royal Academy's lecture programme, particularly Turner's failure to lecture for the previous eight years.

Perspective was one of five professorships at the Royal Academy (the others were anatomy, architecture, painting, and sculpture). Apart from the Professor of Anatomy, the professors had to be elected from among the Academicians. Turner's duties were to present annually six public lectures 'in which the most useful propositions of geometry, together with the principles of lineal and aerial perspective, shall be fully and clearly illustrated'. He was fairly well qualified for this task as a result of his training in perspective in the late 1780s by Thomas *Malton jun., whose father Thomas sen. had written perhaps the 18th century's most comprehensive perspective treatise. Turner also had experience of perspective from his work as a draughtsman for architects Thomas Hardwick and James *Wyatt.

In preparation for his lectures Turner made notes from around thirty perspective treatises, ranging in date from 1505 to 1800, and books such as Junius's *The Painting of the Ancients*. He owned copies of many treatises and consulted others at the British Museum. However, he studied his sources erratically. He did not often read books through from beginning to end; his notes show that he usually jumped about, often only copying occasional diagrams or jotting down footnotes or other peripheral material. This caused him problems: he made notes on some subjects several times, but apparently missed other material of great importance.

Perhaps not unexpectedly, in view of his rather chaotic note-taking, he found it hard to finalize his lecture scripts and worked his way through three complete drafts of all six lectures before eventually giving his first course in early 1811. A summary of this 1811 course gives a flavour of his interests and approach.

His introductory lecture began by regretting the nature of his duties as Professor of Perspective: 'The task must be entered upon; however arduous, however depressing the subject may prove, however trite, complex or indefinite, however trammelled with the turgid and too often repelling recurrence of mechanical rules, yet those duties must be pursued.'

He then praised the Royal Academy and Sir Joshua *Reynolds and embarked upon the first lecture's main task: to link perspective to the subjects of the four other Royal Academy professors. This required the adoption of a rather generous conception of perspective and, strictly speaking, the lecture was mainly concerned with geometry. For example, his discussion of 'perspective' and anatomy was largely about the way in which basic shapes, such as triangles, can be found in the human body. In covering sculpture, architecture, and painting, Turner discussed a wide range of subjects, including: the proportioning of sculpture as evidenced in attempts of Phidias and Alcamenes to make statues of Minerva, the bas reliefs on Trajan's column, the 'flaming ball' on the Monument, and the statue of George I on the top of the steeple of St George's Bloomsbury; architectural drawings of Carlton House and the Admiralty; the early history of perspective by artists and the perspective of pictures by Raphael, particularly his tapestry cartoons, in which the subtle use of perspective had not been adequately recognized: 'The lights and shadows have received their share of praise . . . but the lines . . . as lines have never had a line of praise'.

The second lecture began by setting out the basic geometry of linear perspective and then defined some of perspective's specialist terminology. Many of the definitions were presented in such a way that they made little sense; indeed, some were inaccurate. Little of the terminology given here related to that used by Turner in the third and fourth lectures when he explained practical perspective techniques, where he prided himself on his ability to avoid what he saw as unnecessary technical jargon. In fact, in general Turner did not approve of the highly abstract, theoretical approach of most perspective treatises. He noted that while their mathematics may be 'a useful and well beaten road to science' it is 'circuitously cautious for a painter's pursuit'. As the Royal Academy's professor, it was Turner's task to bridge the gap between practising artists and the published literature on perspective. In contrast to perspective treatises, Turner's lectures did not include rigorous proofs of theorems; rather they concentrated on straightforward 'rules' that artists (and architects) could use in their day-to-day practice.

Lecture 2 continued with a detailed and well-informed discussion of some of the shortcomings of linear perspective, particularly ways in which distorted images can result when short viewing distances are used. This subject fascinated Turner—and he returned to it in other lectures. His overall conclusion was that, while a knowledge of the basic rules of perspective is essential for an artist, there are occasions when the rules cannot be relied upon. When this

happens the artist should judiciously ignore them: 'the true artist must poise all the mechanical excellence of rules and the contrarieties which are to [be] found in nature, with them to balance well the line between deformity and truth.'

The third and fourth lectures represent a thorough attempt to teach techniques of perspective that would be relevant to artists. After a rather eccentric and inaccurate historical survey of different perspective techniques for depicting squares and cubes, reviewing treatises as old as 1505, the third lecture was taken up with a fairly straightforward introduction to practical linear perspective, including a variety of methods for depicting simple buildings, circles, and the architectural orders. This material continued into the fourth lecture, where, among other things, Turner brought together a variety of techniques to demonstrate how to depict Pulteney Bridge in Bath.

In lectures 3 and 4 the methods Turner used were often complex. He presented them with an authoritative tone, tending to outline the key characteristics of a procedure in rather broad terms, rather than giving a great amount of detail. His explanations generally give a fairly adequate overview, but he did make occasional errors. One of the mistakes he made—to do with locating vanishing points—is so fundamental that it is scarcely credible that he made it.

In 1811 the fifth lecture was the 'Reflexes' lecture, which looked at the way in which opaque, polished, and transparent bodies reflect light; reflections from different metals; reflections in water; colour in reflections; differences between natural and artificial light; the effect of multiple light-sources; and reflections in different types of globes.

The 1811 course concluded with the lecture commonly known as 'Backgrounds, Introduction of Architecture and Landscape' that discusses landscape painting in general. This bears little obvious relationship to the rest of the lectures in the course (although there are a small number of references to perspective).

The above summary covers the 1811 course. After that, Turner seems to have revised his lectures fairly extensively each time he gave them, often writing entirely new lectures. The surviving lecture scripts (now mostly in the British Library) include texts for over 40 separate lectures. Some lecture scripts seem to have been used only once, but others were extensively revised for reuse on several occasions. For example, at least one page includes passages written as early as 1810 and was still being revised in 1827. Turner often added material on slips of paper or changed the sequence of material: it is not uncommon for a single sheet now to bear five different page numbers. Some texts have been so heavily amended that it is impossible to reconstruct the contents of a lecture at each stage of its development. Occasionally it

is not even possible to determine where a particular version of a lecture was intended to begin or end.

This means that the lecture scripts present great problems of interpretation. Several factors, particularly the existence of three separate drafts, one of which is dated, mean that it is possible to be fairly confident about the contents of the 1811 course, as set out above, but most later material has not been comprehensively studied or even dated.

In addition to the lecture scripts, there are almost 200 accompanying large diagrams (TB CXCV), the largest of which are about 31 × 52 in. (79 × 132 cm.). Other source material includes notes in several sketchbooks (also in the Turner Bequest; see TATE GALLERY; WILL), annotations that Turner made in books, and press reviews of the lectures.

A significant proportion of the reviews record that Turner was a bad lecturer. For example, he 'mumbled', had many 'unhappy pauses', was 'scarcely audible', and sometimes left the audience 'completely at a loss'. Generally Turner's lectures are badly written and he seems to have been a poor public speaker (some parts of the lectures are embellished with huge numbers of large red commas that may have been intended to help his delivery). Furthermore the extensive revisions add to the general confusion of the texts.

However, some critics evidently understood what Turner said, for they managed to write extensive summaries of it and even wrote, for example, that he 'manifested diligent enquiry and accurate knowledge'. Thomas *Stothard, who was nearly deaf, reputedly attended the lectures because 'there is so much to *see*' in Turner's diagrams.

A considerable amount of the lecture texts is based fairly closely on published treatises, but in places Turner explores complex and subtle ideas about perspective from slightly unusual angles. This latter type of material does not appear to be based on published treatises and seems to represent new thinking. It is often not fully resolved and does not reach clear conclusions.

Turner's lectures are generally disappointing to those looking for clear statements of his attitudes to picture-making and explanations of individual works of art. Indeed, they are surprisingly uninformative. They do, however, offer some hints about what he may be trying to do in a small number of pictures, particularly those in which he experimented with perspective.

The lectures show that, like most artists, Turner was not aiming to produce a mathematically precise representation of what he saw. It is not, therefore, appropriate—or possible—to analyse the geometry of his pictures to determine the exact size and position of objects (as one can in the case of, for example, Vermeer or Piero della Francesca).

Indeed, Turner wrote in his lectures that there is a 'distinction between the geometric laws of perspective regulating the parts, and the rules of perspective influencing the design'. The designs of Turner's pictures were influenced by perspective in two main ways: his creation of complex picture spaces and his attempts to break down the barrier between the viewer and the picture space.

The overall composition of pictures such as *Palestrina—Composition* (1828, RA 1830; BJ 295) or *Frosty Morning* (RA 1813; BJ 127) are largely determined by the way in which recession into space is organized. In these works 'the rules of perspective' certainly influence the design. Note, too, that although the picture spaces are fairly complex, they are internally consistent and perfectly stable. As is often said of *Claude's landscapes, it looks possible to walk into Turner's pictures and count the miles. Most of his late works, too, have a perfectly coherent picture space.

All this is to say little more than that Turner was skilled enough in using perspective to construct convincing picture spaces. More interesting are the relatively few pictures in which he deliberately manipulated the conventional rules of perspective to produce unusual spatial effects.

Consider, for example, *Petworth Park: Tillington Church in the Distance* (c.1828; BJ 283). This picture seems to be an attempt to reflect Turner's assertion that the limit of the field of view is a circle, all around the viewer's body: 'The theory of vision is to take into view comparatively all objects. The eye can only be said to receive portions of an extended sight . . . which must form an entire circle.' If pictures are 'portions of an extended sight', then Petworth Park is a more extended portion than normal. The scene depicted is extensive and broad and does not appear to be restricted by the edges of the canvas: it seems to be possible to see things that would be outside the field of view of a more conventional picture. In part this effect is created by the subtle curving of the sky and foreground; note in particular the way in which the curving path leads the eye to the far edges of the picture and then pulls it back in again. Note, too, the way that the paving in the left foreground almost invites the viewer to step into the picture space. Indeed, at the far left Turner has provided a chair and a bottle of something to drink so that viewers of the picture who make the imaginative leap into the picture can sit and rest as they contemplate the sunset. In these and many other details, Turner's skill in controlling perspective allowed him to create a picture space that is innovative and experimental, but remains coherent.

Perhaps the most extreme example of an experimental picture space is *Rome, from the Vatican* (RA 1820; BJ 228)—an approach repeated on a smaller scale in *George IV at St Giles's, Edinburgh* (c.1822; BJ 247). In *Rome, from the Vatican*, Turner has given the foreground loggia a great twist and to further confuse the viewer has depicted the key players in the picture—Raphael and La Fornarina—as diminutive, doll-like figures that seem to be acting out their roles on a stage. There is not the space here to discuss Turner's intention in this picture in detail, but clues to his approach can be found in rather obscure passages in the lectures such as 'as every line is more or less elevated, so it must partake of a parabolic curve'.

Analysis of the picture's perspective and of preparatory studies shows that when spectators view this picture they must, by implication, be standing in the loggia, with a vault of the loggia soaring above their heads. *Rome, from the Vatican* is perhaps the most extreme example of Turner creating a picture space that offers an alternative to the conventional view-through-a-window of conventional perspective. In many other less extreme works he tries the same, often providing a clear and solid foreground onto which the spectator could take an imaginative step. Examples include *The Parting of Hero and Leander* (RA 1837; BJ 370) and *The Decline of the Carthaginian Empire* (RA 1817; BJ 135).

Turner's perspective lectures are undoubtedly a relatively peripheral part of his output, but they can give an insight into his thought processes and, of course, show that he had a perhaps unexpectedly deep interest in perspective and related matters. MWD

Ziff 1963.
Gage 1969, ch. 6.
Davies 1992.

PETERBOROUGH. Turner visited this Cambridgeshire town on his Midlands tour of 1794. In a view of the Cathedral for John Walker's *Copper-Plate Magazine* (W 94; R 8; published 1796), the emphasis is on topographical detail and context—hence the building is shown in its entirety. However, the artist also exhibited a large close-up view, *West Entrance of Peterborough Cathedral* (RA 1795; Peterborough City Museum and Art Gallery; W 126), which shows the influence of *Dayes in its concern for tonal effect. The watercolour was once in the collection of Dr *Monro, who had introduced Turner to Dayes. AK

PETERLOO MASSACRE (1819), so called in bitter parody of Waterloo. Eleven were killed and some 400 wounded when magistrates ordered cavalry to attack a peaceful Radical demonstration in St Peter's Fields, Manchester. In the subsequent national outcry, Turner's patron Walter *Fawkes was reported by Lord Castlereagh to have declared that 'he would rather perish in the temple of liberty than see it converted into a barrack' (Hansard, 23 November 1819, col. 104). Elizabeth Helsinger (*Rural Scenes and National*

Representation: Britain 1815–1850, 1997, p. 32) sees Turner's depiction of 'transgressive' working-class activities in *Picturesque Views in *England and Wales* as a response to such seminal events in the *Reform agitation. AK

PETWORTH, country house and park situated in West Sussex, north-east of Chichester. Ancestral home of George O'Brien Wyndham, the third Earl of *Egremont, it is also home of the largest group of oil paintings by Turner put together during his lifetime, with the added significance of having remained in its original setting.

Although its origins lie in the 12th century, when it was part of the Percy estates, the external form of Petworth House was not really completed until the first years of the 18th century, probably to a design by the Huguenot Daniel Marot. The building work, along with formal gardens and the foundations of the picture collection, were paid for by the sixth Duke of Somerset (third husband of the Percy heiress). After his death, his son became first Earl of Northumberland and Earl of Egremont, but the second title soon passed to his nephew, the owner of the Petworth estates. During the 1750s the second Earl of Egremont paid 'Capability' Brown to provide a natural landscape in the park surrounding the house, and it was the mature form of this setting that Turner later celebrated in his oil and gouache studies. During the life of the third Earl, Petworth had its golden era, after which it passed to the line of his natural son, George, later Lord Leconfield. After a long period of decline, his grandson gave the house and park to the National Trust in 1947. All of the Turner paintings were accepted by the Treasury in part-payment of death duties in 1957, responsibility for which was transferred to the Tate Gallery in 1984.

It has been generally thought that Turner made his first visit to the house in 1809, but there are two early watercolours of Petworth Church dating from about 1792, when he was 17, which prove a much earlier connection (TB XXIII: E, and private collection). The second of these was used as a model for his pupils to copy (see XXVIII: I). It may be that this early visit was made in order to see the picture collection at a time when there was no National Gallery from which to learn.

Egremont was among the most important patrons to acquire works by Turner in the first decade of the 19th century, but his taste was quite domestic and not as wide as that of Sir John *Leicester. However, it was presumably the latter collector's commission of two views of his home at *Tabley (BJ 98 and 99) that prompted Egremont to get Turner to paint his residences in Sussex and Cumberland (*Cockermouth Castle*; Turner's gallery 1810; BJ 108) to join the group of

Thames scenes and seascapes that he already owned. The sparkling view of *Petworth, Sussex*, from the lake, exhibited with the subtitle *Dewy Morning* (RA 1810; BJ 113), was one of a series of estate views in which Turner introduced a lighter ground. Such works led the critics to mock him, and those who imitated the effect, as 'White Painters'.

The *Dewy Morning* picture arose from a stay at Petworth in 1809 (see CIX), but it is not clear when Turner became a regular visitor. (After the death of the third Earl, many of his papers were destroyed, which makes it now impossible to document fully this important period in the history of Petworth.) The Earl's patronage of Turner, however, seems to have come to an abrupt end in about 1814, following the controversy surrounding the aims of the new *British Institution, and it is very likely that Turner did not return to Petworth for at least a decade (see APULLIA IN SEARCH OF APPULLUS).

Evidence for a renewed familiarity with Petworth comes in the so-called 'Mortlake and Pulborough' Sketchbook (CCXIII), which contains a series of views of the house and lake made from the Upperton Monument. Since the rest of this book appears to have been in use in 1825, it is reasonable to assume that these sketches were also made that year. The actual date of the visit is not recorded, but, as Egremont was never at home for more than a few days at a time during that summer, Turner could have been there without actually seeing his host.

A more significant visit occurred in the early autumn of 1827, during which Turner completed the final designs for *Rogers's *Italy* (1830). This was also the occasion when he painted the large group of watercolour and gouache studies of Petworth on small sheets of blue *paper (CCXLIV, etc.); see Pl. 20. As well as capturing the Liberty Hall atmosphere of the house, some of these colour sketches appear to be preliminary designs for the panoramic canvases he soon afterwards painted of the view towards the lake, two of which were installed in the Carved Room by August 1828 (BJ 283 and ?284). Ultimately four landscapes were actually installed (BJ 288–91), for which Turner made four closely related studies (BJ 283–6). As well as two views from the house towards the lake, there are also views of *The Chain Pier, Brighton* and *Chichester Canal*, and, among the sketches, *A Ship aground* (BJ 287).

The 1827 visit marks the beginning of a decade of regular sojourns at Petworth, so that it effectively replaced Farnley (see FAWKES, WALTER) as Turner's retreat from London. The surviving records in the Petworth Archives demonstrate that he was there on the following dates: 23–9 June 1832; 28 October–5/6 November 1834; 24 October–3 November 1836. But he is also known to have been there in 1829 and twice in

1837 (just prior to the death of Egremont and for his fu-
neral), and he may also have stayed there in 1830 and 1831
(see Gage 1980, p. 251, and Whittingham 1985², p. 43).
Sketches from such visits are scattered throughout his note-
books (see CCXLIII, CCXXXVII, CCXLV, CCLXXXVI, CCXCII:
58–9), and some of the erotic sketches remaining in the Be-
quest have also been associated with Petworth (CCXCI: b, c).

*Constable referred to Petworth as 'that House of Art',
which was in part a tribute to Egremont's fairly comprehen-
sive patronage of important contemporary artists, but also a
recognition of the longer historical perspective of painting
and sculpture represented in the collection. The import-
ance of the Petworth picture collection for Turner's art can-
not be understated, stimulating him to produce pastiches in
the manner of *Claude, *Van Dyck, *Watteau, *Reynolds,
*Gainsborough, de *Loutherbourg, and *Allston, while the
works by, or then attributed to, *Rembrandt called forth a
series of brooding, dark interiors. Some of this series, how-
ever, have now been related to East Cowes Castle (see NASH).
Another possible casualty of recent writing on this group is
the canvas known as *Interior at Petworth* (BJ 449); see Pl.
22, which has been interpreted as a recollection of the house
after Egremont's death, when his body lay in a coffin in the
Marble Hall. This appealing theory, however, has been chal-
lenged by Andrew Wilton, who has retitled the picture
Study for the Sack of a Great House (1989, pp. 26–8); Patrick
Youngblood, however, defends the interpretation (letter to
the Editor, *Turner Studies*, 10/1 (summer 1990), p. 51).
See also EGREMONT, THIRD EARL OF. IW

Youngblood 1982², pp. 16–33.
Butlin, Luther, and Warrell 1989.
Wilton 1989.
Wilton 1990².
Alun Howkins, 'J. M. W. Turner at Petworth: Agricultural Im-
provement and the Politics of Landscape', in John Barrell, ed.,
*Painting and the Politics of Culture. New Essays on British Art
1700–1850*, 1992, pp. 231–51.

PETWORTH, MUSIC AT, see MUSIC AT EAST COWES CASTLE.

**PETWORTH, SUSSEX, the Seat of the Earl of Egremont:
Dewy Morning**, oil on canvas, 36 × 47½ in. (91.4 × 120.6
cm.), RA 1810 (158); Tate Gallery and the National Trust
(Lord Egremont Collection), Petworth House (BJ 113); see
Pl. 7. Commissioned by Lord *Egremont, together with a
smaller picture of *Cockermouth Castle, Cumberland*
(Turner's gallery 1810; BJ 108). The 'Petworth' Sketchbook
(TB CIX), in use in 1809, contains a pencil sketch for this
picture (repr. Wilkinson 1974, p. 98) and also drawings of
Cockermouth Castle.

Following Turner's experiments in using a white ground
in his *Thames sketches of *c*.1805, this may be the first

exhibited oil to employ this method, thus attaining a high
key throughout. This surprised the critic of *La Belle Assem-
blée* (vol. 1, 1810, p. 250) so much that he would have
doubted Turner's authorship but 'for the information in the
catalogue'. He criticized the lack of contrast between lights
and darks which resulted in 'a mere flimsy daubing'. But the
British Press (13 June) disagreed, calling it a 'most beautiful
landscape . . . in clearness and brilliancy, we have never seen
it excelled'.

Youngblood considers that the long, almost featureless,
facade of the house caused Turner 'to call upon every pic-
torial device at his disposal to rescue the composition from
stagnation'. EJ
Youngblood 1982, p. 17.

PHILADELPHIA MUSEUM OF ART. Legally the
museum owns only one Turner, the earlier of the two paint-
ings of the *Burning of the House of Lords and Commons* (BI
1835; BJ 359; see PARLIAMENT). However, *A View of the Cas-
tle of St Michael, near *Bonneville, Savoy* (RA 1812; BJ 124)
has hung in the museum since the early 1930s as part of the
John G. Johnson Collection which was bequeathed to the
City in 1917. In all but minor details it repeats the composi-
tion of *Châteaux de St. Michael, Bonneville, Savoy* (RA 1803;
Dallas Museum, Texas; BJ 50), so rare an occurrence in
Turner's œuvre that it is difficult to account for why Turner
painted a second version or for the nine-year gap between
them. Perhaps Turner, whose sales had been disappointing
lately, hoped that, as both BJ 50 and another Bonneville sub-
ject, also RA 1803 (Yale Center for British Art, New Haven,
BJ 46), had sold quickly, a third might also attract a buyer.
See also REPLICAS AND VARIANTS, and BONNEVILLE for the
confusion over the 1803 RA exhibits. EJ
Richard Dorment, *British Paintings in the Philadelphia
Museum of Art from the Seventeenth through the Nineteenth Cen-
tury*, 1986, pp. 392–405.

PHILLIPS, Sir George (1789–1863), baronet and Member
of Parliament. Phillips commissioned Turner's *Linlithgow
Palace, Scotland* (Turner's gallery 1810; Walker Art Gallery,
Liverpool; BJ 104). The commission was noted by David
*Wilkie in his diary: 'Had a call from a Mr Phillips (now Sir
George), who commissioned me to paint him a picture, for
he was making a Collection of the English School, he resides
in Lancashire' (7 May 1810); 'went to see Turner's Gallery:
he has . . . a view of Linlithgow Castle; the latter painted for
the Mr Phillips who called on me yesterday. I thought this
one of his best pictures' (quoted in BJ, p. 104). RU

PHILLIPS, Thomas (1770–1845), English portrait and his-
tory painter, Royal Academician and admirer of Turner. A

prolific and good portraitist, patronized by the nobility in-cluding Lord *Egremont, he was overshadowed by Thomas *Lawrence. He was Professor of Painting at the Royal Academy 1825–32.

He was among those contemporaries of Turner who appear to have accepted his art unreservedly, thinking it not in any way 'extreme' (Farington, vi. p. 2034); Sir George *Beaumont, an outspoken Turner critic, in 1812 was aware that Phillips thought him 'the greatest Landscape painter that ever lived' (Farington, xii. p. 4224). The clearest expression of his regard for Turner is seen in his recommendation to Constable in 1819 that he should study the *Liber Studiorum 'to learn how to make a whole' (Farington, xv. p. 5422). RH

'Thomas Phillips, Esq. RA', obituary, *Gentleman's Magazine*, 23 (June 1845), pp. 54–7.

PHOTOGRAPHY. The techniques that led to photography evolved in the 1820s and 1830s. The first fixed photographs were made in France in 1826 after years of experiment by Nicephore Niepce (1765–1833) on pewter plates, and were named by him *heliographs*. He went into partnership with Louis Daguerre (1787–1851), who launched his much improved *daguerreotypes* in 1839. Meanwhile in England William Henry Fox Talbot (1800–77) had produced the earliest surviving camera negative, on paper, in 1835, and then went on to produce positives as well as negatives, which he named *photogenic drawings* in a paper given to the *Royal Society in London on 31 January 1839. Another important pioneer at this time was the astronomer Sir John Herschel (1792–1871), who invented the use of glass negatives. Talbot rapidly improved his own process, renamed it the *calotype*, and patented it in 1841, thereby greatly slowing down the development of professional photography. However, in 1851 F. S. Archer (1813–57) invented the collodion process, which in a short time supplanted all the earlier methods. In the same year the *Great Exhibition included a display of photographs, which aroused great popular interest, and from then on nothing could hold back the rapid development and widespread use of photography.

One of the early professional photographers in London was the American-born J. J. E. *Mayall (1810–1901), who set up a studio in the Strand in 1847. Here, as the photographer recounted to *Thornbury, he was frequently visited by an 'inquisitive old man', whom he later discovered to be Turner, with whom he had long discussions about light and the spectrum and of whom he 'took several admirable daguerreotype portraits', none of which are known today. Among accounts of Turner's concern of the possible effects of photography on art is a report by *Ruskin of an occasion in the house of the banker, poet, and collector, Samuel *Rogers:

Soon after the discovery of the Daguerrotype Mr. Rogers brought some from Paris . . . he was showing them to several artists who had never seen them before, and they considered the discovery would injure Turner particularly. When he came they said, 'Our profession is gone.' On looking at them he answered 'We shall only go about the country with a box like a tinker, instead of a portfolio under our arm'.

A decade later many of the first professional photographers were men who had been trained or practised as painters, especially of landscape. LH

Helmut and Alison Gernsheim, *A Concise History of Photography*, 1965.

PICKERSGILL, Henry (1782–1875), portrait painter and, from 1826, Royal Academician. He was a pupil of the landscape painter George Arnald (1763–1841). Pickersgill was quite close to Turner socially and in Royal Academy life. They sometimes took sherry together, were both visitors in the Life Academy in 1830–1 and the Painting School in 1842, and along with J. P. *Knight were 'hangers' of the 1845 RA exhibition. In 1844 Pickersgill supported Turner in successfully opposing a move to reduce the number of works which RAs had the right to hang in the exhibition from eight to six. Pickersgill's portraits were faithful rather than brilliant. His portrait of Robert *Vernon, exhibited in 1847, is in the Tate Gallery. RH

Finberg 1961, pp. 407, 432.
Gage 1980, pp. 174, 191, 234–5, 275.

PICTURESQUE, THE, see SUBLIME.

PIGMENTS IN OIL PAINTINGS AND WATER-COLOURS. During Turner's lifetime there were many advances in the manufacture of artists' pigments. He made good use both of new materials and of improved traditional ones. Turner was particularly fascinated by yellows. Even before the production of chrome yellow, he was using traditional yellows as he would immediately use the new pigment, in spots of concentrated colour, or as large areas of sky applied over white underpaint. Turner's notes in the 'Chemistry' Sketchbook (1808; TB cv; see J. H. Townsend, 'Turner's Writings on Chemistry and Artists' Materials', *Turner Society News*, 62 (1992), pp. 6–10) refer many times to yellow pigments and their properties. He made lifelong use of Mars colours, brighter versions of earth colours, and possessed and used a larger range of red laked pigments than have been found in the palettes of his contemporaries or successors.

Turner quickly began to use brightly coloured details, applied in opaque pigments, in his watercolours, in addition to

the more muted shades previously used in the 18th century. There is no obvious time lag between his use of a new pigment in oil and watercolour. In the later watercolours he made great use of natural ultramarine, pale chrome yellow, and Mars red. Many also include vermilion, emerald green, Prussian blue, cobalt blue, Mars yellow, and a range of ochres and siennas (Townsend 1993², pp. 244–5), as do the oil paintings (ibid., pp. 242–3). There are more red and yellow laked pigments in the watercolours than the oils, but otherwise the pigment range is the same at each stage of his career, and Turner never entirely abandoned any material. See also TECHNIQUES IN OIL AND WATERCOLOUR. JHT

PILATE WASHING HIS HANDS, oil on canvas, 36 × 48 in. (91.5 × 122 cm.), RA 1830 (7); Tate Gallery, London (BJ 332). This is the first of three paintings of biblical subjects owing a lot to *Rembrandt, both in technique (but with much stronger colour) and subject; the others are *Shadrach, Meshech and Abednego* (RA 1830; BJ 346) and, unfinished, *Christ driving the Traders from the Temple* (c.1832; BJ 436). *Pilate*, like *Jessica*, was violently attacked by the critics: 'wretched and abortive' (*Literary Gazette*, 8 May 1830). However W. H. *Pyne, in an article on Turner in *Arnold's Magazine of the Fine Arts*, August 1833, praises *Pilate* and similar pictures for adventurously advancing into a style close to pure historical painting and for being 'imbued with the highest feelings of poetry'; in *Pilate* Turner 'Like Rembrandt, by the mere power of light and shade and harmonious colouring . . . can rouse the sublimest feelings of our mind' (see Ziff 1986, pp. 20, 22).

The *Morning Chronicle*, 3 May 1830, describes *Pilate* and *Orvieto* (RA 1830; BJ 292) as pictures completed during the *Varnishing Days at the Royal Academy. MB

Kitson 1986, pp. 10, 12, 14, 16, repr. pl. 24.

PILKINGTON, Sir William, eighth baronet (baptized 1775; d. 1850). Amateur artist and patron of Turner. Pilkington, of Stanley Chevet, Wakefield, was a close friend of Walter *Fawkes (to whom he was related by marriage) and Edward *Swinburne. Turner executed for Pilkington numerous views of Yorkshire and Switzerland. Among these were four works now in the Wallace Collection, London: *Scarborough Castle: Boys Crab-fishing* (1809; W 527); a pair of pictures, *Woodcock Shooting on the Chiver* (1813; W 534) and *Grouse Shooting* (c.1813; W 535); and *Mowbray Lodge, Ripon, Yorkshire* (c.1815; W 536); and also *On the Washburn, under Folly Hall* (c.1815; British Museum; W 538). In addition Pilkington was probably the first owner of *Scene in the Savoy* (c.1815–20; Wolverhampton Art Gallery; W 401).
 TR

Lyles 1988, pp. 28, 46 n. 65.

PLAGUES OF EGYPT. *The Fifth Plague of Egypt* (RA 1800; Indianapolis Museum of Art; BJ 13) was Turner's first treatment of an Old Testament subject, as well as his first work in the Grand Manner influenced by two of the painters he admired most: Richard *Wilson and Nicolas *Poussin. However, the painting depicts the seventh plague, that of hail and fire, and not the fifth which was the murrain or pestilence. Visible in the lower right corner is Moses, who during the seventh plague reaches forth towards heaven immediately before the onslaught of the hail and fire that destroyed the livestock of Egypt.

Turner's 'Dolbadarn' and 'Studies for Pictures' Sketchbooks (TB XLVI, LXIX) contain several studies for the picture. In the *Liber Studiorum* the biblical landscapes were categorized as 'historical' and the engraving of *The Fifth Plague* was published in June 1808 (F 16).

Turner used landscape as an open stage for biblical scenes of death and destruction at several stages in his career. In 1802 he exhibited five paintings including *The Tenth Plague of Egypt* (BJ 17), the slaughter of every first-born. *Finberg (1961, p. 79) quotes one critic who declared that *The Tenth Plague* was 'the first picture in the present Exhibition, in sublimity of conception, in the harmony, or rather discord, of its parts and in a bold and masterly execution'.

It is noteworthy that among Turner's early studies that remain in his sketchbooks as unrealized intentions are two large grey pages that depict the First Plague. The artist's inscription identifies them as 'The Water Turn'd to Blood' ('Calais Pier' Sketchbook, LXXXI: 42–3, 152–3).

Turner continued to follow the tradition of idealized nature imitation. As also seen in the *Liber* engraving made in 1816 after *The Tenth Plague* (F 61), lightning leads the eye deep into the composition through a series of systematic and clearly constructed linear planes. The tiny human figures (weeping mothers) within the symbiotic relationship between the landscape and the architecture confirm the influence of Wilson and Poussin, who inspired Turner to create a magnificent fusion of biblical-historical and landscape painting.

See also BECKFORD, WILLIAM; BIBLICAL SUBJECTS. MO

Ziff 1963².

Nicholson 1990, pp. 54–7.

POETRY AND TURNER. Even for an era when painting and literature kept close company, Turner is an extraordinarily literary painter. A profound interest in literature and ideas informs his work; in addition to overtly *literary subjects, the associational process by which he creates complex meanings is expressed by direct quotation from poets or his

own verses in epigraphs and by poetic allusions in the paintings themselves. Interpretation can be more difficult than in Renaissance mythological and religious iconography. A fairly straightforward early example of association is *Dolbadern Castle (RA 1800; Royal Academy; BJ 12): Turner's verses indicate that the castle has long imprisoned the Welsh prince Owen, who wrings his hands in longing for liberty, giving the landscape a further sonority resembling Beethoven's Fidelio. Turner's ideas and aims in The *Goddess of Discord (BI 1806; BJ 57) are better understood in the context of the manuscript poem 'Ode to Discord', of which there are several drafts in the sketchbooks. In 1809 *Thomson's Aeolian Harp (City Art Galleries, Manchester; BJ 86) was accompanied at Turner's gallery by the painter's 32-line poem printed in his catalogue. Turner can be shown to be a highly verbal, even lexical type; his letters contain puns and his paintings visual puns. His more ambitious images connote abstract ideas. In the second Battle of Trafalgar (1822–4; National Maritime Museum, Greenwich; BJ 252) Turner actually introduces into the painted waters the words of Nelson's motto—'Palmam qui meruit ferat'—to convey the idea of the irony of the palm of martyrdom also being implicit in the palm of victory.

At the Royal Academy *Reynolds had stressed in the Discourses (especially III, XIII, and XV) the analogies and relations of poetry and painting, the 'sister arts', and the importance of reading 'to exercise, warm, invigorate and enrich the imagination, and excite noble and daring conceptions'. This was endorsed by the later lectures of *Barry, *Fuseli, and *Opie, and in a letter of 1817 Turner wrote how Barry's words were 'ringing in his mind': 'Go home from the Academy, light your lamps, and exercise yourself in the creative power of your art, with Homer, with Livy and all the great characters, ancient and modern, for your companions and counsellors'. His fellow Academicians *Westall and *Shee published volumes of verse. The Sketching Club of 1799, to which *Girtin and F. L. T. Francia belonged, used to compose 'historic Landscapes' stimulated by 'poetic passages'. Turner's own lectures quote liberally from Milton, *Akenside, and other writers; in a reworking of ideas from some lines by Akenside describing a stream of consciousness, Turner wrote in 1812: 'Painting and Poetry flowing from the same fount mutually by vision, constantly comparing Poet's allusions by natural forms in one and applying forms found in nature to the other, meandering into streams by application, which reciprocally improved reflect and heighten each others beauties like . . . mirrors'.

Turner was known to be fond of discussing poetry; we can deduce much of what he read from his epigraphs. From 1798 the RA encouraged the printing of epigraphs in the annual catalogue. The appendix to both editions of Finberg's Life transcribes Turner's epigraphs chronologically. Turner altered or misquoted from memory some verses from the poets. He owned the thirteen-volume edition by Robert Anderson of British Poets (1795), which also included translations from the classics. He studied Addison's and Dryden's versions of Ovid (see CLASSICAL SUBJECTS); Pope's Homer and Dryden's *Virgil; pastoral, mythological, and topographical verse; and didactic poems about art and nature. Pope and *Thomson both received homage from him by the title of a painting; Milton, Akenside, Mallet, Gray, Gisborne, and Langhorne supplied epigraphs, along with Callimachus and Pope's Iliad. Among modern poets he knew and illustrated *Rogers, *Campbell, *Moore and *Scott; he quoted *Byron, Rogers, Southey, and Scott in epigraphs. Among the Romantics he obviously preferred Byron (who admired Pope and Dryden and held the 'Lakers' in contempt), not just from temperamental affinity, but from his loyalty to the tastes of his early manhood. There is no firm evidence of Turner reading *Wordsworth, *Shelley, *Coleridge, or Keats, though obviously parallels can be made in feeling and description of nature. Wilton (1987, pp. 246–7) prints a list of books known to have been in Turner's library. The letters give further clues of the range of his reading, with their many detailed references to *Shakespeare and some to Scott. He also writes to *Soane and to the pianist Moscheles, sending quotations from Churchill and Dryden.

From 1793 to 1847 Turner wrote many lines of verse in his sketchbooks; significantly these were often in the margins of sketches. In 1957 Ann Livermore and in the earlier 1960s Jerrold Ziff wrote articles on Turner's poetry; the relevance of his poems to the paintings was early recognized by Kenneth *Clark. In 1966 Jack *Lindsay published an interesting but unreliable selection of Turner's poems in The Sunset Ship. In 1990 Andrew Wilton published a study of Turner's verse from 1804 to 1819, Painting and Poetry, and with Rosalind Turner made a transcription of the twenty-page Verse Book belonging to Turner's descendants. It is unlikely that all of Turner's verse drafts will ever be published, as much is indecipherable and some were further damaged by the Thames flood of 1928 (see TATE GALLERY). Much of the writing is admittedly clumsy, confused, and frustrated at the limits of verbal expression. It shows Turner sensitive to sounds and scents as well as sights. After some verses he notes, 'Written at Purley on the Thame. rainy morning. no fishing'. The subjects are as one would expect: nature, weather, the seasonal cycle, gilded mornings; disasters, ordeals at sea; fishing; the wrong of shooting the 'winged quarry'; discord, worldly futilities, and 'delusive hope'; amorousness,

PLATE 1

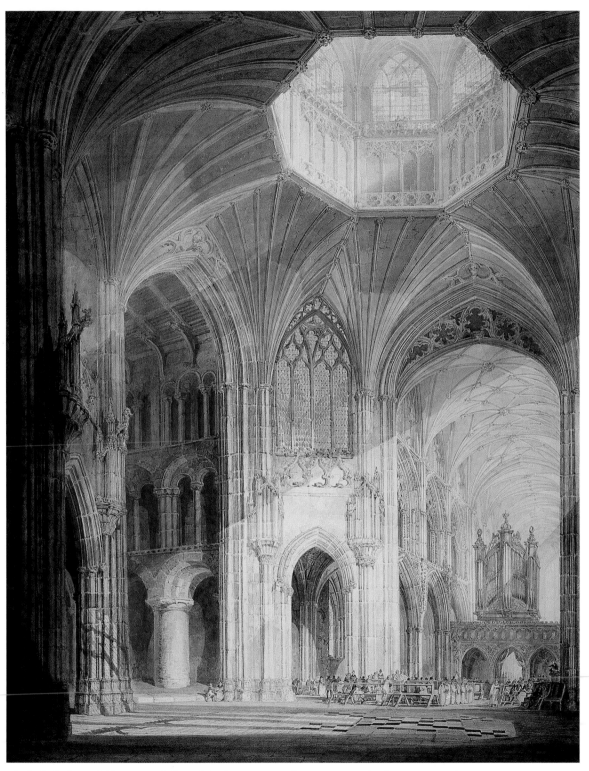

Ely Cathedral, North Transept and Chancel, ?RA 1797. Watercolour; 24¾ x 19¼ in. (62.9 x 48.9 cm.).
Aberdeen Art Gallery and Museums.

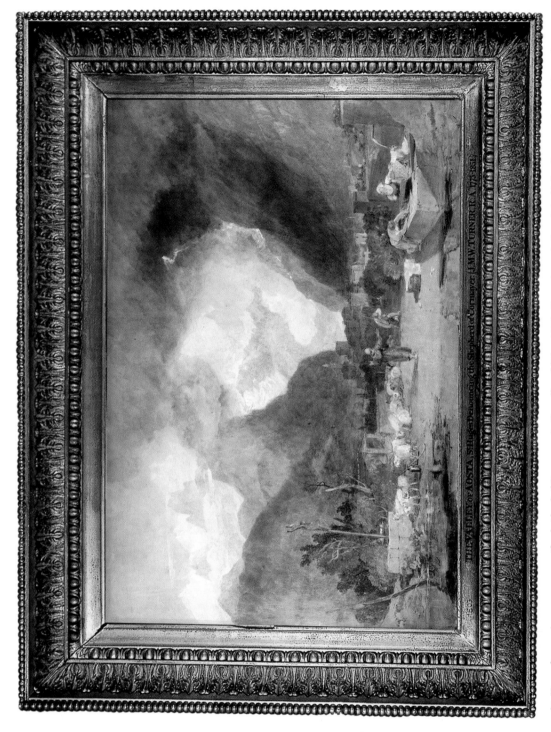

PLATE 2

St. Huges denouncing vengeance on the shepherd of Cormayer, in the valley of d'Aoust, RA 1803—shown in its original 'close' concave frame. Watercolour; 26½ x 39¾ in. (67.3 x 101 cm.). Sir John Soane's Museum, London.

PLATE 3

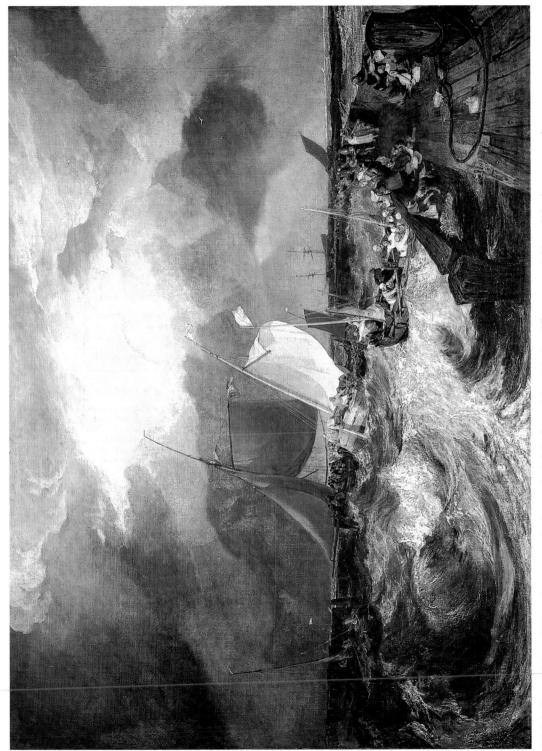

Calais Pier, with French Poissards preparing for Sea: an English Packet arriving, RA 1803. Oil on canvas; 67¾ x 94½ in. (172 x 240 cm.). National Gallery, London.

PLATE 4

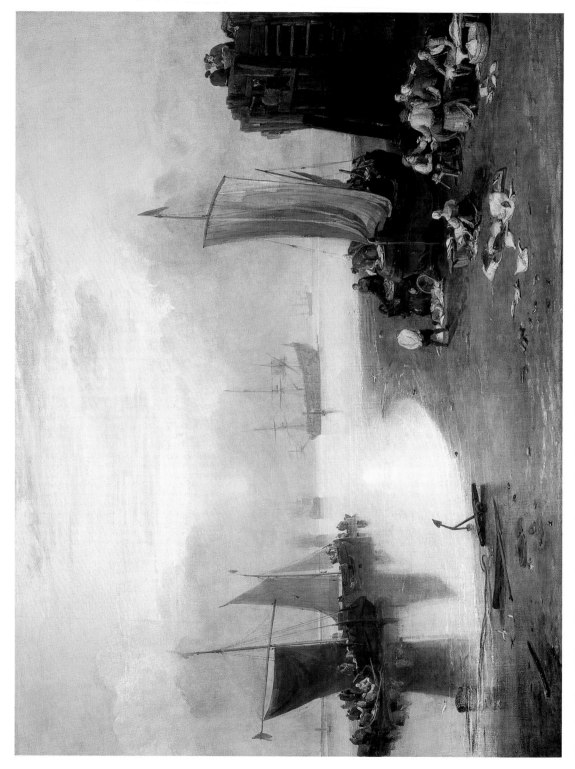

Sun rising through Vapour; Fishermen cleaning and selling Fish, RA 1807. Oil on canvas; 53 x 70½ in. (134.5 x 179 cm.). National Gallery, London.

PLATE 5

The Thames near Walton Bridges, 1805. Oil on mahogany veneer; 14⅝ x 29 in. (37 x 73.5 cm.). Tate Gallery, London.

PLATE 6

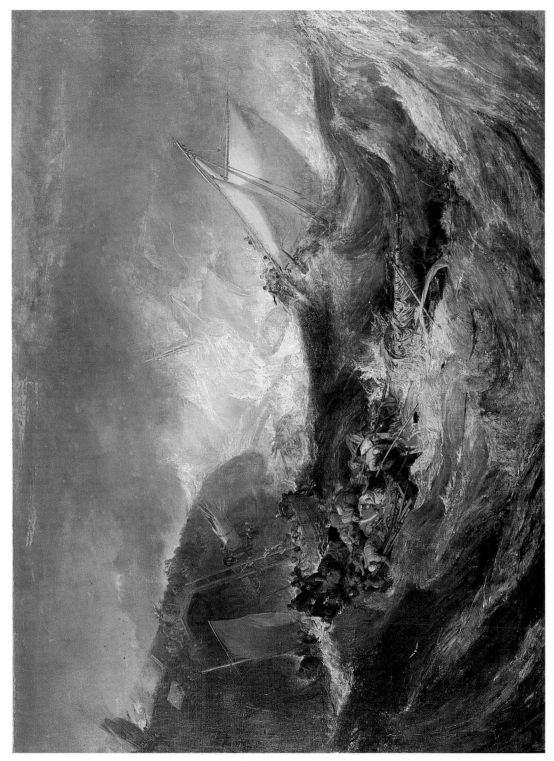

The *Wreck of a Transport Ship*, c.1810. Oil on canvas; 68 x 95 in. (172.7 x 241.2 cm). The Fundaçao Calouste Gulbenkian, Lisbon.

PLATE 7

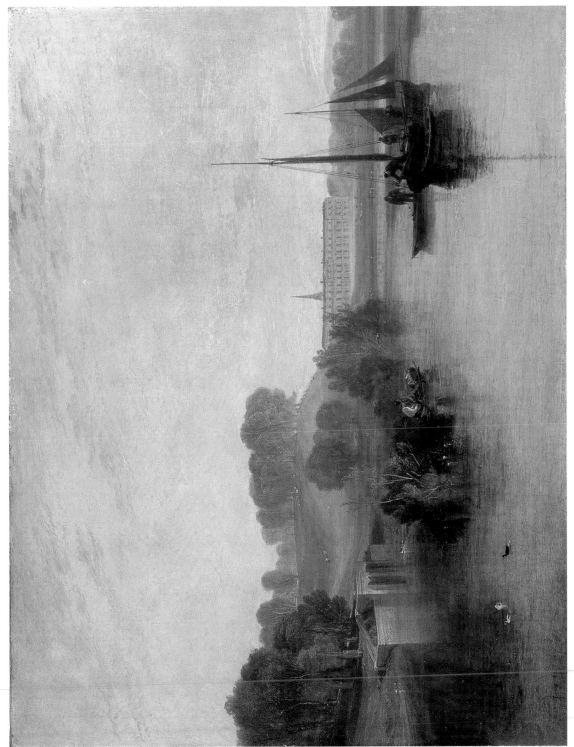

*Petworth, Sussex, the Seat of the Earl of Egremont: Dewy Morning, RA 1810. Oil on canvas; 36 x 47½ in. (91.4 x 120.6 cm.). Tate Gallery and the National Trust (Lord Egremont Collection), Petworth House.

PLATE 8

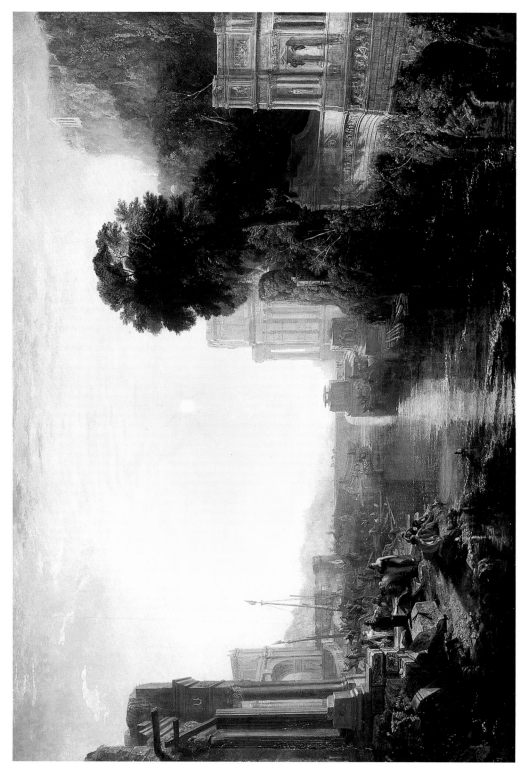

Dido building Carthage; or the Rise of the Carthaginian Empire, RA 1815. Oil on canvas; 61¼ x 91¼ in. (155.5 x 232 cm.). National Gallery, London.

PLATE 9

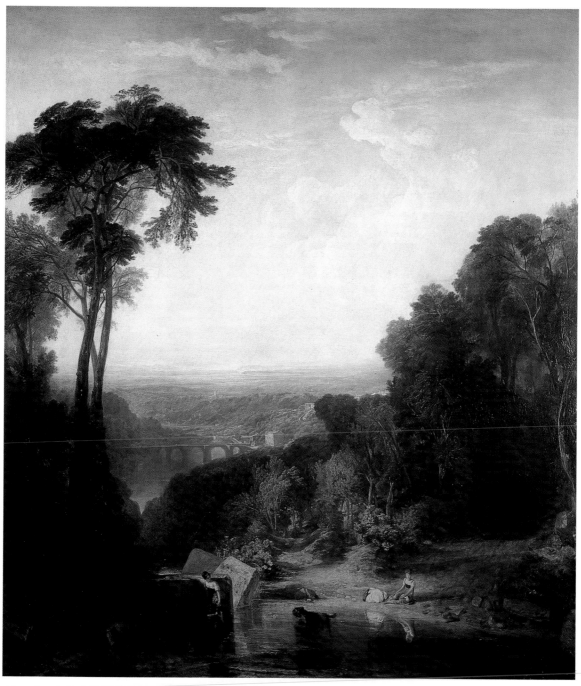

Crossing the Brook, RA 1815. Oil on canvas; 76 x 65 in. (183 x 165 cm.). Tate Gallery, London.

PLATE 10

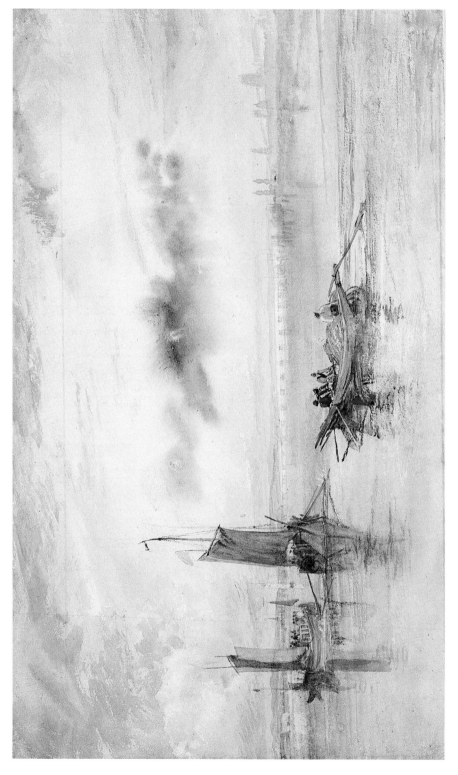

*Mainz and Kastell, c.*1820. Watercolour and bodycolour; 8¼ x 14⅜ in. (20.8 x 36.5 cm.). Private Collection, Germany.

PLATE 11

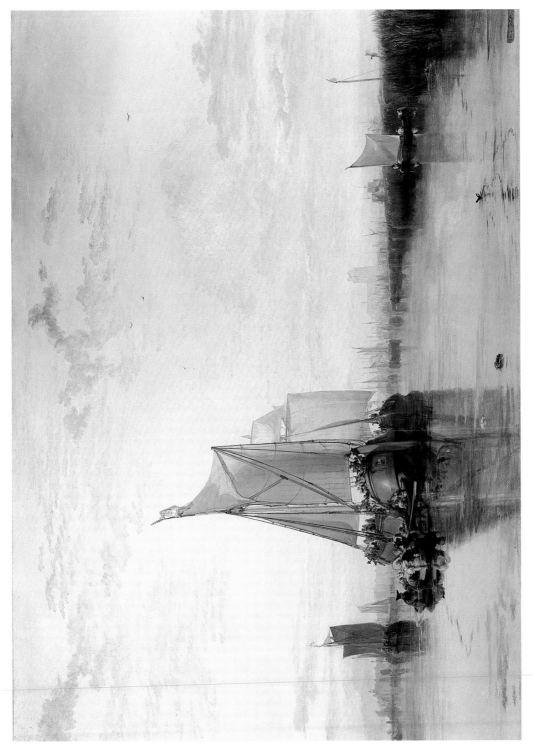

Dort, or Dordrecht. The Dort Packet-Boat from Rotterdam becalmed, RA 1818. Oil on canvas; 62 x 92 in. (157.5 x 233 cm.). Yale Center for British Art (Paul Mellon Collection), New Haven.

PLATE 12

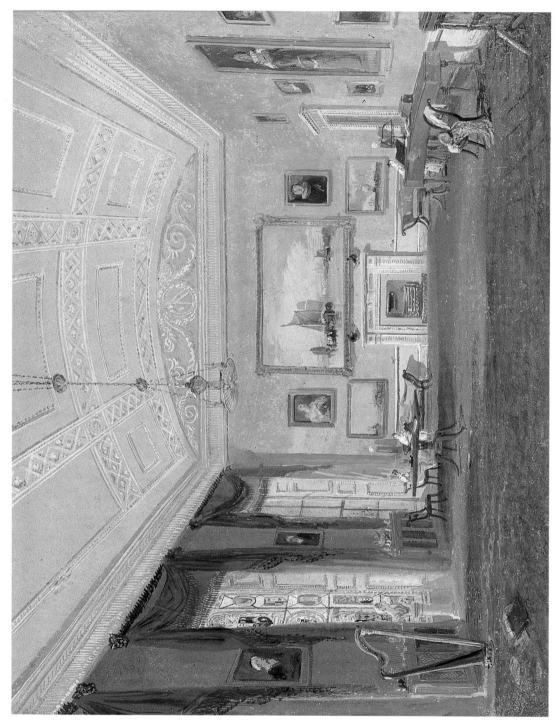

The Drawing Room, Farnley Hall, 1818. Bodycolour on buff paper; 12⅜ x 16¼ in. (31.5 x 41.2 cm.). Private Collection, England.

PLATE 13

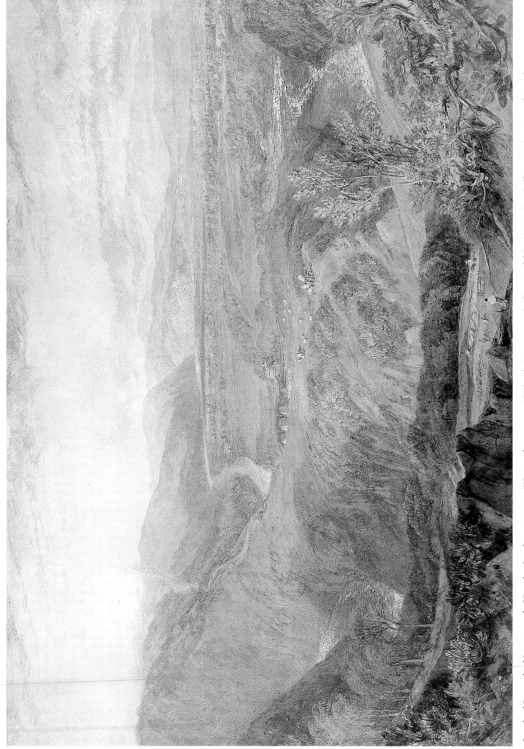

Crook of Lune, looking towards Hornby Castle, c.1816–18. Watercolour; 11 x 16½ in. (28 x 41·7 cm.). Courtauld Institute Art Gallery, University of London.

PLATE 14

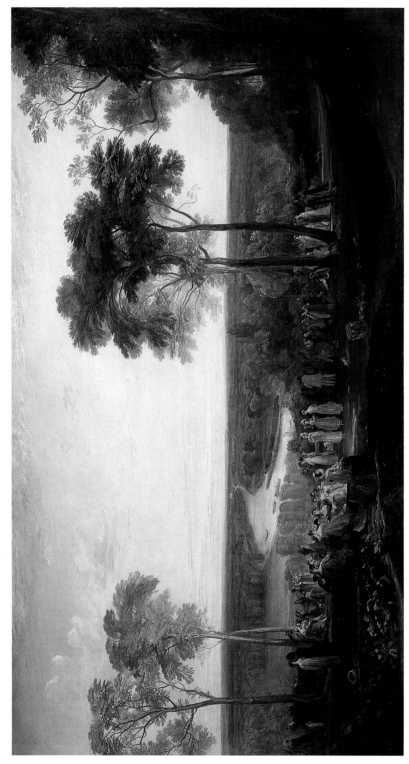

England: Richmond Hill, on the Prince Regent's Birthday, RA 1819. Oil on canvas; 70⅞ x 131¾ in. (180 x 334.5 cm.). Tate Gallery, London.

PLATE 15

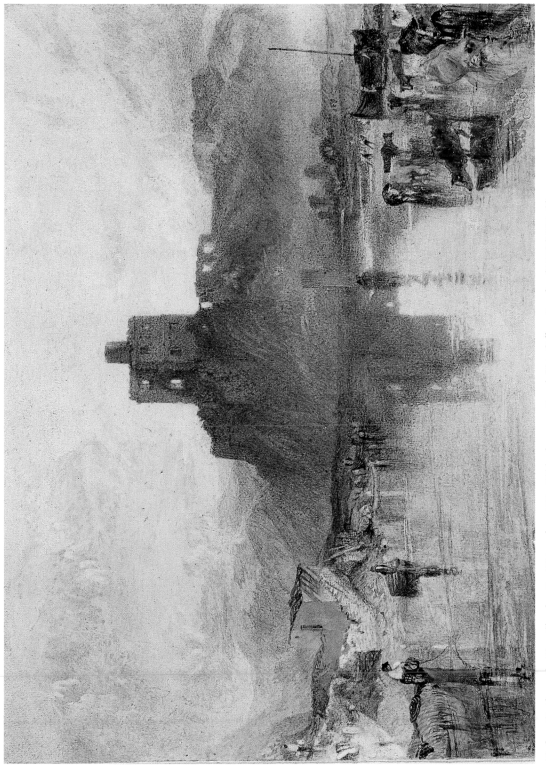

Norham Castle, on the River Tweed, c.1824. Watercolour; 6⅛ x 8½ in. (15.5 x 21.6 cm.). Tate Gallery, London (TB CCVIII- O).

PLATE 16

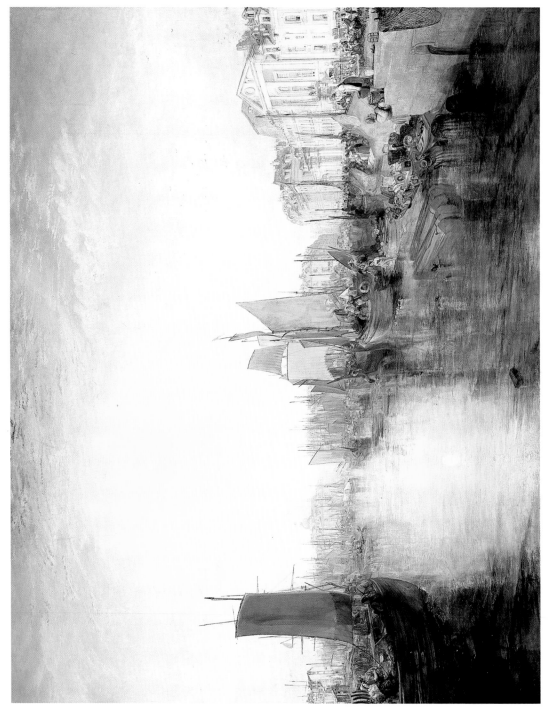

Harbour of Dieppe (Changement de Domicile), RA 1825. Oil on canvas; 66⅜ x 88¾ in. (173.7 x 225.4 cm.). The Frick Collection, New York.

PLATE 17

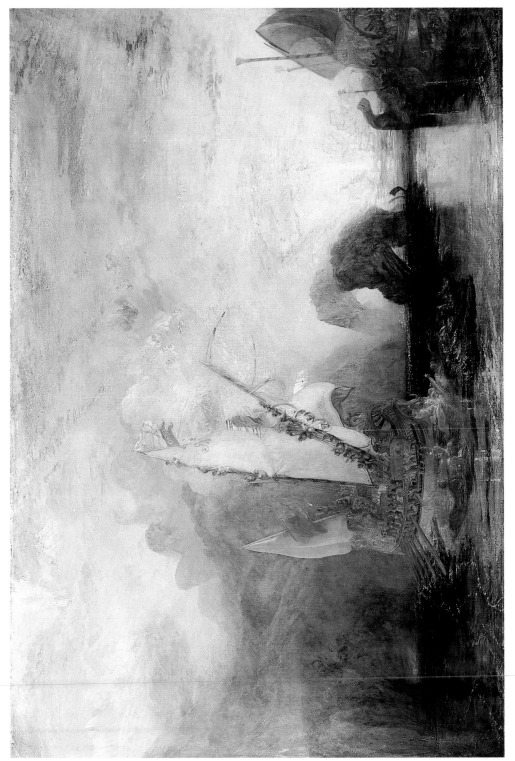

Ulysses deriding Polyphemus—Homer's Odyssey, RA 1829. Oil on canvas; 52¼ x 80 in. (132.5 x 203 cm.). National Gallery, London.

PLATE 18

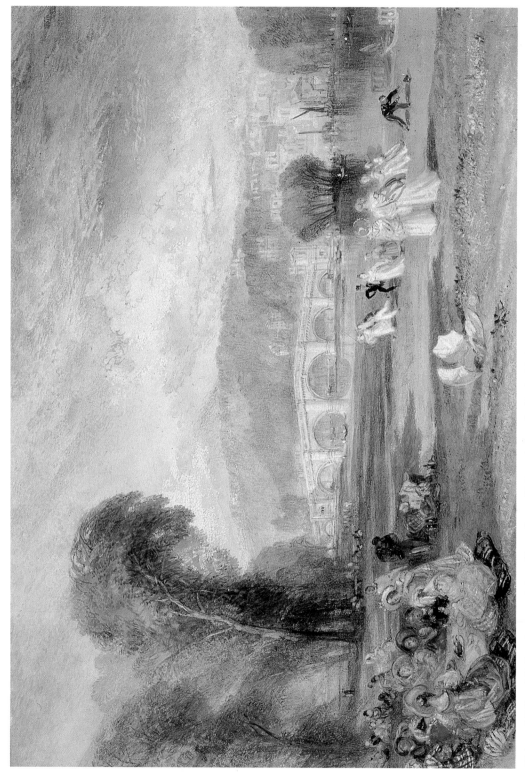

Richmond Hill and Bridge, Surrey, c.1828–9. Watercolour, with boycolour and white highlights; 11½ x 17⅞ in. (29.1 x 43.5 cm.). British Museum, London.

PLATE 19

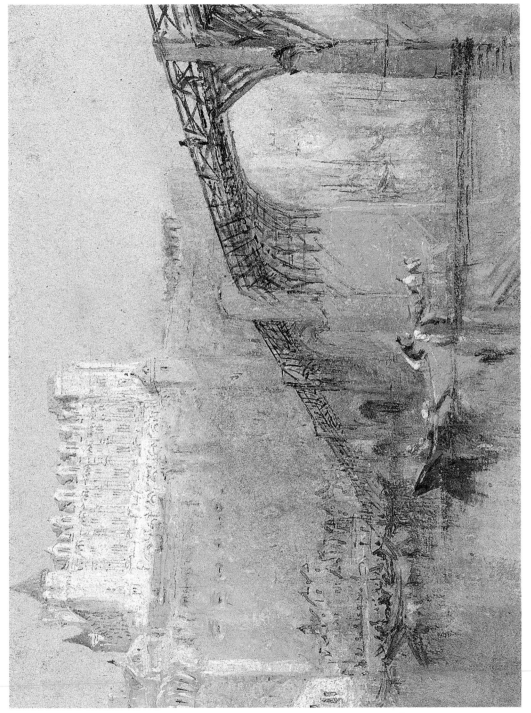

Château of Amboise, c.1830. Watercolour and bodycolour, with pen and black ink, on blue paper; 5¾ x 7⅞ in. (13.6 x 18.8 cm.). Ashmolean Museum, Oxford.

PLATE 20

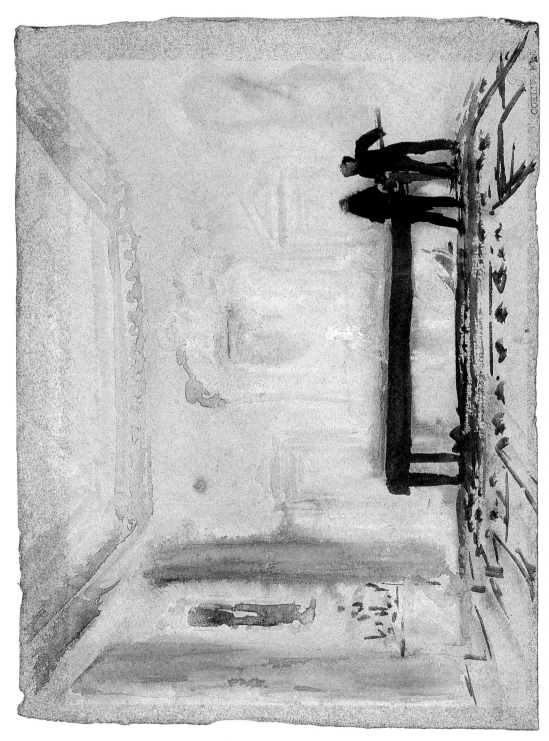

The Billiard Players, Petworth, 1827. Watercolour and bodycolour on blue paper; 5½ x 7½ in. (14 x 19 cm.). Tate Gallery, London (TB CCXLIV - 116).

PLATE 21

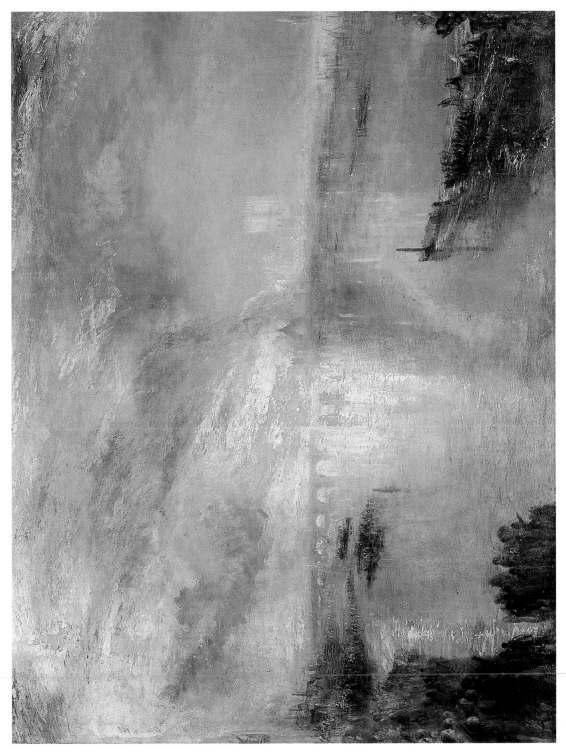

*The *Burning of the Houses of Lords and Commons, October 16, 1834*, RA 1835. Oil on canvas; 36½ x 48½ in. (92.5 x 123 cm.). The Cleveland Museum of Art, Ohio.

PLATE 22

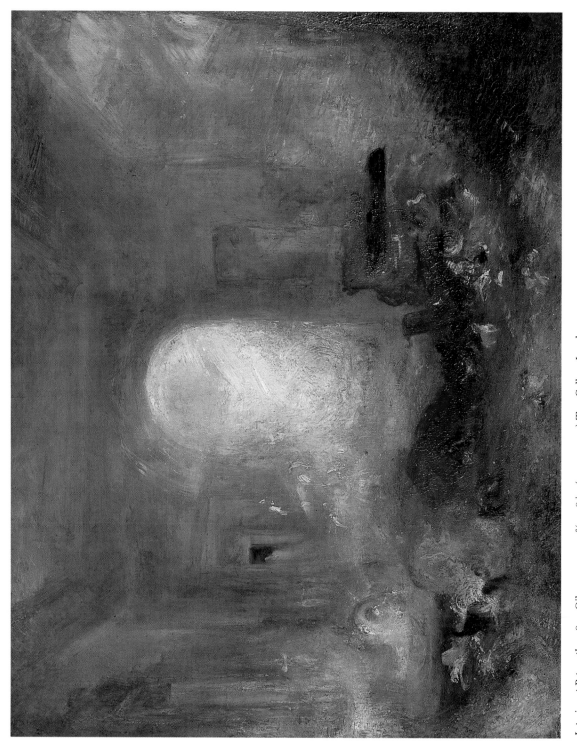

Interior at Petworth, c.1837. Oil on canvas; 35¾ x 48 in. (91 x 122 cm.) Tate Gallery, London.

PLATE 23

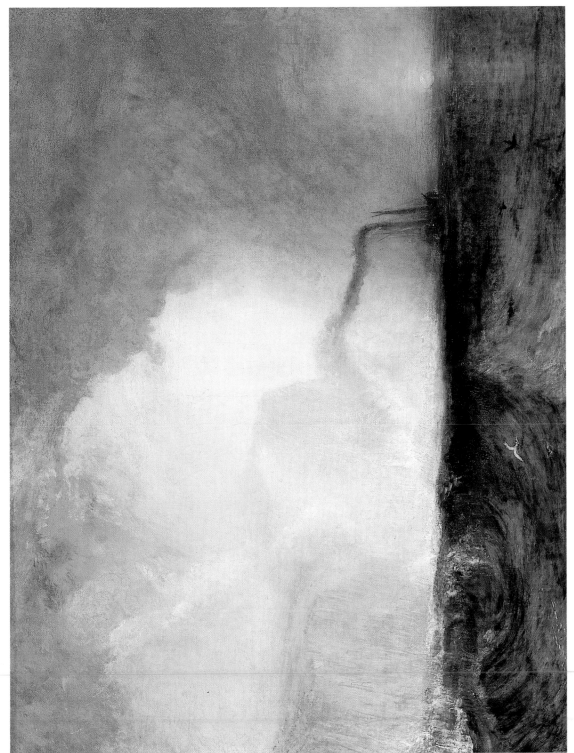

Staffa, Fingal's Cave, RA 1832. Oil on canvas; 36 x 48 in. (91.5 x 122 cm). Yale Center for British Art (Paul Mellon Collection), New Haven.

PLATE 24

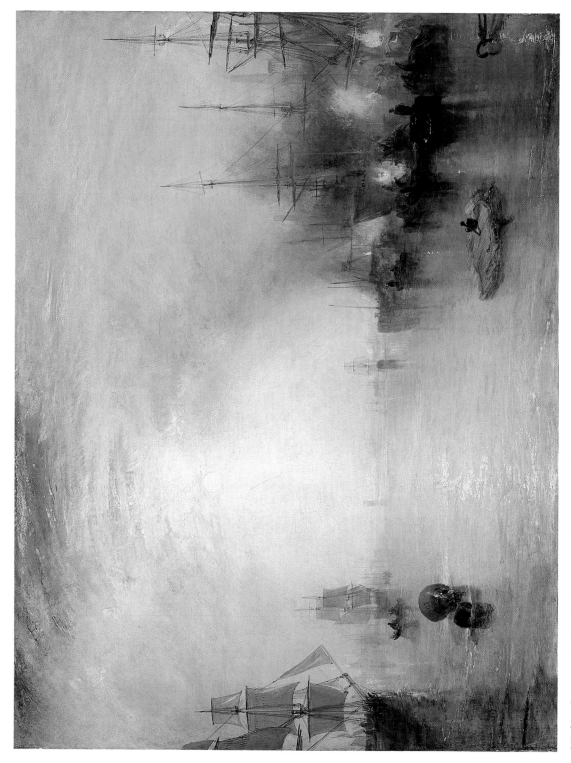

Keelmen heaving in Coals by Night, RA 1835. Oil on canvas; 35½ x 48 in. (90.2 x 121.9 cm.). National Gallery of Art, Washington DC.

PLATE 25

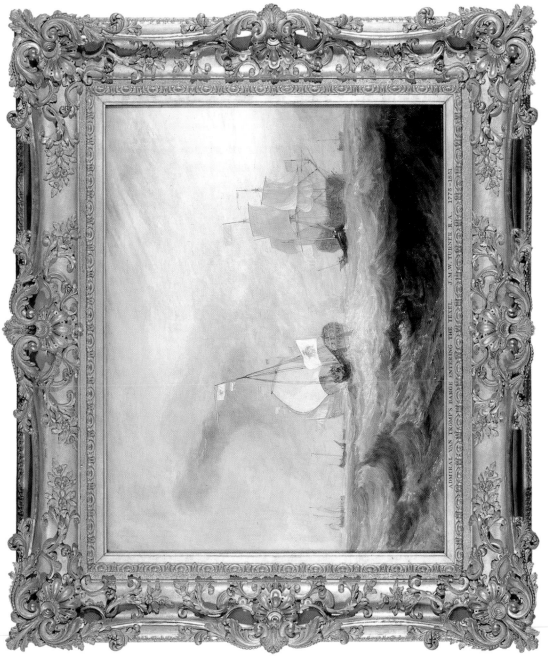

Admiral Van Tromp's Barge at the Entrance of the Texel, 1645, RA 1831—shown in its original Louis XV-style frame. Oil on canvas; 35½ x 48 in. (90.2 x 121.9 cm.). Sir John Soane's Museum, London.

PLATE 26

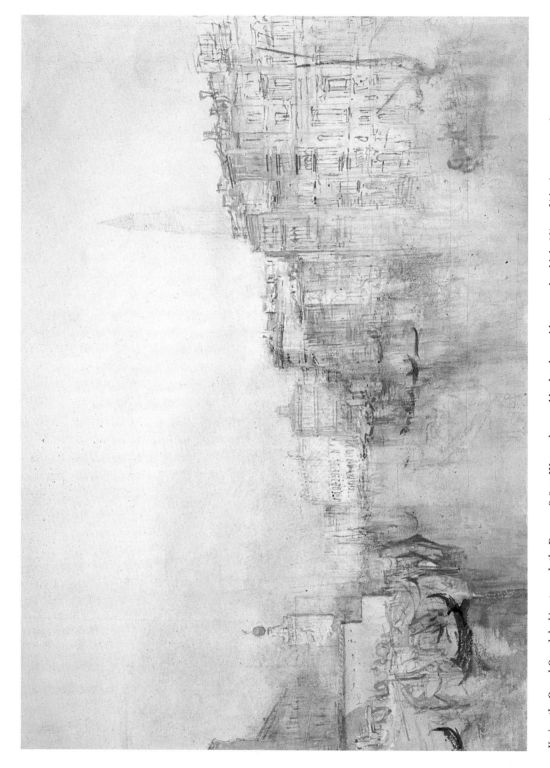

Venice, the Grand Canal, looking towards the Dogana, ?1840. Watercolour and bodycolour with pen and red ink; 8¾ x 12⅝ in. (22.1 x 32 cm.). British Museum, London.

PLATE 27

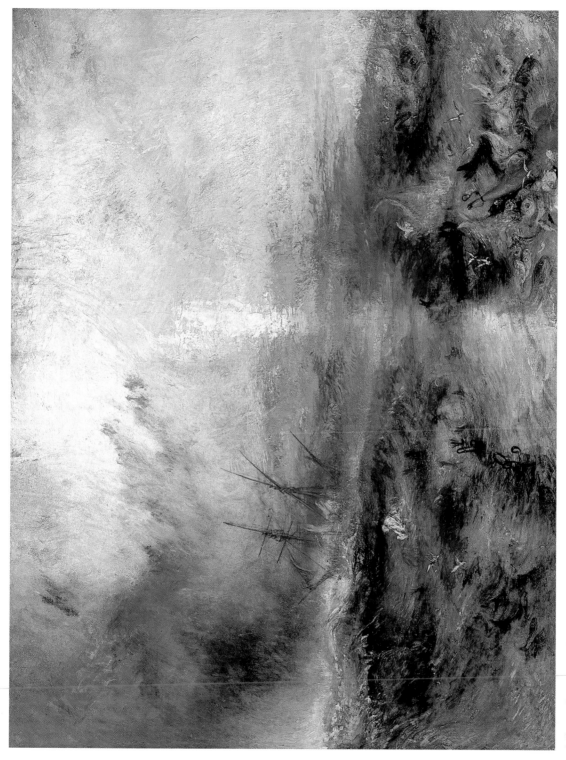

Slavers throwing overboard the Dead and Dying—Typhon coming on ('The Slave Ship'), RA 1840. Oil on canvas; 35¾ x 48 in. (91 x 138 cm.). Museum of Fine Arts, Boston, Mass.

PLATE 28

'*The Red Rigi*', 1842. Watercolour; 12 x 18 in. (30.5 x 45.8 cm.). National Gallery of Victoria, Melbourne.

PLATE 29

Campo Santo, Venice, RA 1842. Oil on canvas; 24½ x 36½ in. (62.2 x 92.7 cm.). The Toledo Museum of Art, Toledo, Ohio.

PLATE 30

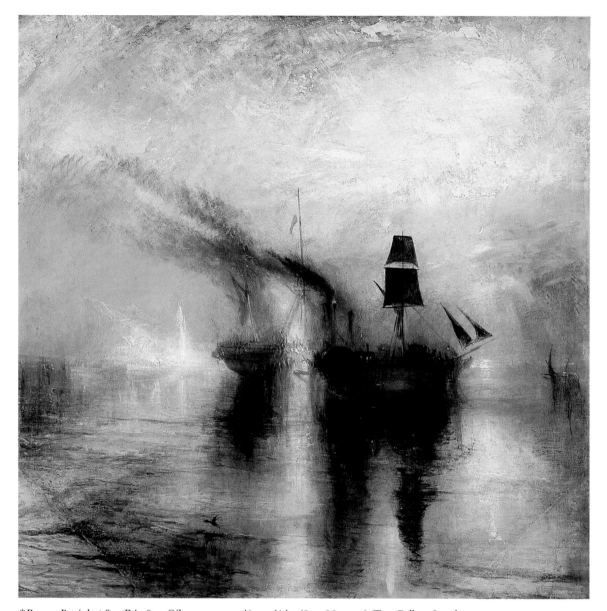

Peace—Burial at Sea, RA 1842. Oil on canvas; 34¼ x 34⅛ in. (87 x 86.5 cm.). Tate Gallery, London.

PLATE 31

Rain, Steam, and Speed—the Great Western Railway, RA 1844. Oil on canvas; 35¾ x 48 in. (91 x 122 cm.). National Gallery, London.

PLATE 32

*Seascape, *Folkestone, c.1845. Oil on canvas; 34¾ x 46¼ in. (88.3 x 117.5 cm.). Private Collection, New York.*

woman's temper ('Love is like the raging Ocean'), and frustrated love; solitude; Runic spells, mythology—Jason, Dido, Hero and Leander, *Regulus, Medea; 'the Origin of Vermilion'; struggling poets; the navy—'British oak'—and Nelson; *Napoleon, 'the scourge of Europe'; and also the ordinary people and their occupations that figure in the foregrounds of his *England and Wales series. There is mention of Girtin and *Wilkie. A long geographical verse letter about the Devon coast of 1811, the 'Itinerary Poem', was rejected by the *Cookes as text for the *Southern Coast. The poems contain recurrent motifs, such as Pope's Villa or Apollo and Python, and important phrases such as the 'ensanguined sun'; there is even an unfinished dialogue for the shepherd and daughter in *Pope's Villa (Turner's gallery 1808; Trustees of the Walter Morrison Picture Settlement; BJ 72). Into the sketchbooks he also copied ballads and poems from magazines.

As poet Turner is capable of flashes of brilliance, such as the phrase describing the zodiacal Sagittarius and late November, 'the fierce archer of the downward year', or the couplet

> Bind not the Poppy in thy golden Hair,
> Autumn, kind giver of the full Ear'd Sheaf.

Some sustained passages, such as the epigraphs to *Battle of Fort Rock* (RA 1815; British Museum; W 399) and *Slavers* (RA 1840; Museum of Fine Arts, Boston; BJ 385), are strong and eloquent. That he can write prose with marvellous literary expressiveness is clear from the paragraph of homage to Claude and the 'amber-coloured aether' in the RA lecture of 1811 (see PERSPECTIVE LECTURES). When writing to *Britton about the text that Britton proposed to accompany the engraving of Turner's *Pope's Villa* in *Fine Arts of the English School* (1812), Turner shrewdly criticized Britton's vapid reference to Pope's 'mellifluous lyre' as denying Pope's 'power of thought'.

The 'unpublished poem', *Fallacies of Hope*, to which Turner ascribed many of his epigraphs from 1812 onwards, does not exist in manuscript or in drafts; it is very unlikely to have been a complete or continuous poem. It may be studied in Wilton and Turner 1990, pp. 180–1. ('Fallacious Hope' is a phrase that occurs in Thomson's *Autumn*; it is of course also the name for the tormenting Fairy that after old age, penury, and other ills was the last spite to issue from Pandora's box.) *Punch* twice published parodies of it, *Thackeray referred to 'that sybilline book of mystic rhymes', and Alaric *Watts dismissed it as 'crazy-crambo'. Even so, there is some sequence to the extracts, and the series is unified by its high common factors of large historical gestures and ironies of fate and ambition. Human hope is mocked by the faithlessness of Aeneas and the atrocities of man's

destructiveness—Hannibal (see CARTHAGE), Napoleon, Caligula, slave-ships; there are images of apocalypse and cataclysm, seas of blood. Queen Mab and Medea figure as occult powers. Natural forces oppose man's struggles: the fisher of Venezia is hunted by the storm. It is perhaps helpful to think of *The Fallacies of Hope* as anticipating the method of Pound's *Cantos*, part of a process of allusion, analogy, and levels of abstract and emotional expression of his consciousness to accompany the paintings, issued in series, and containing some private symbolism. Thus the poet and painter combine in the process that Turner described in a lecture (see Wilton and Turner 1990, p. 88) as 'calling upon those mysterious ties which appear wholly to depend upon the association of ideas'. JRP

Livermore 1957.
Ziff 1964.
Gage 1987, pp. 181–205.
Lindsay 1966, pp. 16, 55, 57–69, 73, 104–6, 118, 123–9, 131–2, 136–7, 145, 156, 162, 172, 189, 203, 212.
Lindsay 1966².
Wilton and Turner 1990.

POLITICS AND SOCIETY, Turner's views on. Although the artist very rarely articulated his political sympathies—possibly to avoid alienating an important section of his clientele—none the less he openly expressed his views on liberty and social responsibility many times. And one important image not only precisely fixes his political outlook around 1830–1 but also perhaps indicates his more abiding political beliefs.

Turner was an ardent libertarian, as a host of paintings and watercolours make directly or indirectly clear. The earliest expressions of this conviction appeared in 1800 when he exhibited three works whose underlying theme is the curtailment of liberty (*Dolbadern Castle, North Wales*, Royal Academy; BJ 12; *The Fifth *Plague of Egypt*, Indianapolis Museum of Art; BJ 13; and *Caernarvon Castle, North Wales*, British Museum; W 263; see WALES). Given the contemporaneous extent of such suppression both domestically and abroad, such a statement may simultaneously have been a protest and a subtle form of appeal to an influential pro-democratic, libertarian grouping within the *Royal Academy, to which Turner was seeking full election at the time (see Shanes 1990).

The painter returned to the theme of liberty and its constraint a great many times, as in the 1838 picture of *Ancient Italy—Ovid Banished from Rome* (private collection, USA; BJ 375); the exile and death paintings of 1842 (*War and *Peace*; BJ 400, 399); and two paired oils of 1846 (*Undine* and *The *Angel standing in the Sun*; BJ 424–5, for which also see Smith 1986). Linked to these themes were the numerous

*Greek, *Carthaginian, *Roman, and *Venetian rise-and-fall of empire depictions, with their reiterated, implied statements concerning the need to place common interests above those of the individual, and duty above pleasure. Such moral points may well have derived from Augustan poetry, in which they had frequently received expression.

Turner first articulated his keen opposition to slavery in 1800, when he portrayed the Israelites in Egypt (BJ 13; see PLAGUES OF EGYPT); he last did so in the 1840 *Slavers (Museum of Fine Arts, Boston; BJ 385). Nor was he merely opposed to the denial of personal freedom; the lack of political freedom mattered to him equally. In a long inscription he added to four proofs of an 1822 engraving of *Wycliffe, near Rokeby* (R 177), Turner convolutedly expressed his belief that liberty of thought and action was as much threatened in his own day as it had been in Wyclif's time. Almost half of the inscription derived word-for-word from a banned pamphlet reporting the contemporary trial of a political Radical. Because the inscription also refers to another, similar trial, simultaneously it therefore indirectly expressed Turner's identification with parliamentary reform, the major political issue of the day (see Shanes 1990).

Turner's sympathy with Reform was openly articulated in the most explicitly political image he ever created. This is an unengraved *England and Wales* series watercolour of *Northampton* (private collection; W 881) probably dating from the winter of 1830–1. In the drawing Turner celebrated the re-election to Parliament of Lord Althorp, a member of the Whig pro-Reform administration of Earl Grey that would eventually force Reform through parliament. Turner also surely alluded to this legislative revolution in his 1832 painting *The Prince of Orange, William III, embarked from Holland, and landed at Torbay, November 4th, 1688, after a Stormy Passage* (BJ 343; see also HOLLAND) which both commemorated the 'Glorious Revolution' and anticipated by a few weeks the approval of parliamentary reform 'after a Stormy Passage'. And in further *England and Wales* series watercolours Turner alluded to *Catholic emancipation (a contributory factor in parliamentary reform), hinted at the dire consequences of opposition to political change, and referred to the final enactment of Reform in 1832.

The latter allusion occurs in a view of Nottingham that includes a Greek flag just two years after Greece had attained its independence (c.1831; City Museum and Art Gallery, Nottingham; W 850). In a number of the *Byron illustrations of the early 1830s, as well as earlier paintings and drawings, Turner openly or covertly expressed his support for Greek freedom. Given that Greece was generally considered the cradle of both liberty and democracy, such an identification again points to the painter's innate libertarianism.

During the early 1830s Turner illustrated the poems of the Whig banker Samuel *Rogers. Because he enjoyed complete freedom of depiction, several of his designs might well indicate his political sympathies, especially two prospects of the former home of the late Whig politician Charles James Fox.

Turner was not very close to Rogers, but his friendship with Walter *Fawkes was profound, and their intimacy from about 1808 until the latter's death in 1825 suggests they might have held similar or identical political beliefs. The Yorkshireman was widely known for his Whig radicalism, especially after the French Revolution when he was an ardent republican (see *Farington, 10 July 1796). Turner was also friendly with *Louis-Philippe, the 'citizen-king' of France. Naturally, such friendships are not proof of parallel political sensibilities but certainly it seems possible that a similarity of views existed. In any event, there is more than enough evidence to reveal Turner's political progressiveness. Such an outlook is surely unsurprising, given the artist's humble beginnings and refusal ever to lose sight of those origins.

See also CHARTISM; CORN LAWS; REFORM BILLS; SLAVERY. ES

Lindsay 1966.
Smith 1986.
Shanes 1990.
Shanes 1990².
Shanes 1990, pp. 40–6.

POLYPHEMUS, see *ULYSSES DERIDING POLYPHEMUS*.

POPE'S VILLA AT TWICKENHAM, oil on canvas, 36 × 47½ in. (91.5 × 120.6 cm.), Turner's gallery 1808; Trustees of the Walter Morrison Picture Settlement (BJ 72). Signed: 'IMW Turner RA PP' lower left. Turner was elected Professor of Perspective at the Royal Academy in December 1807 so this must be a very early example of this form of signature.

The picture refers to the demolition of Pope's villa in 1807 on Baroness Howe's orders. Turner, who had bought land himself in Twickenham in 1807, clearly deplored this destruction and wrote a poem on the subject in his verse-book of 1808.

*Lindsay suggests that the two 'pastoral lovers' in the foreground were the forerunners of *Dido and Aeneas*, exhibited in 1814 (BJ 129).

The Examiner (8 May 1808) reported that Sir John *Leicester had bought the picture for 200 guineas. It was engraved by John *Pye in 1811 (R 76). Turner was so struck by the result that he wished he had employed Pye earlier. EJ

Lindsay 1966, p. 128.

PORNOGRAPHY AS SUBJECT MATTER. To his dismay, *Ruskin discovered while cataloguing the Turner Bequest a large number of pornographic drawings which he

considered had been 'assuredly drawn under a certain condition of insanity'. The exact quantity of these is unknown; Ruskin describes them as a 'parcel'. With no guidance forthcoming from the National Gallery, *London, or Turner's trustees, he and *Wornum burned the drawings in December 1858.

Enough, however, slipped through the net to give an idea of their standard and ubiquity. They include pencil drawings of figures copulating (e.g. 'Finance' Sketchbook, TB CXXII: 37), some lyrical sketches in 'Colour Sudies 1' Sketchbook (CCXCI(b)) in which the subject looms out of colour wash, and a detailed pen and ink drawing (CCCLXV: A) reminiscent of a Cupid and Psyche. Additionally, there are in the 'Academies' (LXXXIV) and 'Paris, Seine and Dieppe' Sketchbooks (CCXI) female nude studies in which the genitalia are highlighted. The subjects appear to date from c.1810–1840s.

Not able to bring himself to wholesale destruction of Turner's pornography, Ruskin annotated some sketchbooks (e.g. CCLXXIX(b)) 'Kept as evidence of the failure of mind only'. Turner's sexual nature found expression also in his verse, notably the poem 'Molly' which he drafted in the 'Perspective' Sketchbook (CVIII). The character trait that led him to draw pornographic subjects was touched upon delicately immediately after his lifetime by William Havell who wrote to John *Pye of the 'reality' of Turner's 'habits and conduct' being 'the reverse of what one would wish to know or commemorate' (National Art Library, Victoria and Albert Museum, 86. FF. 73, p. 11). *Thornbury wrote of Turner's 'excesses'. JH

> Thornbury 1877, p. 313–14.
> Lindsay 1966, pp. 161–2.
> Hamilton 1997, pp. 118–19, 230, 301, 337.

PORTER, Sir Robert Ker (1777–1842). History painter, early friend of Turner. Porter entered the *Royal Academy Schools in 1790 and became friendly with Turner when the latter began to attend the Life Academy in 1792. That summer Porter introduced him to the landscape watercolourist William Frederick *Wells, who was to become one of Turner's closest friends. Porter exhibited panoramic battle paintings in London with great success. In 1804 he was appointed Historical Painter to the Tsar and began his career as traveller and diplomat, eventually becoming British Consul in Venezuela (1826–41). KMS

> Wilton 1987, p. 21.
> *Sir Robert Ker Porter*, exhibition leaflet, London, Department of Manuscripts, British Library, 1993.

PORTRAITS OF TURNER. The question is often asked, why are there no portraits of Turner? No major portraits of him emerged from one of the great sources of British portraiture—Regency London. *Lawrence, a kind and appreciative friend, described him as 'indisputably the first landscape painter in Europe', yet produced not even a drawing. *Hoppner, Nollekens, Beechey, Raeburn, Smart, Cosway, Engleheart, among portrait painters and sculptors of the period, left no record of sittings. Even one of those arid *camera lucida* profiles by *Chantrey would have been a godsend. No doubt his fellow artists respected his well-known reluctance to sit. There is no shortage of verbal descriptions, some vivid and illuminating, stressing his helpfulness and friendliness; others are snide caricatures of his physical unattractiveness—'a shabby Bacchus' (Wilkie Collins), 'short stout and bandy-legged with covetous eyes' (Cunningham), 'a vulgar-looking man with coarse pimply face' (Rippingille). The nearest approaches to a straight portrait are 'Rainy Day' J. T. *Smith's watercolour drawing of Turner looking at prints in the British Museum (British Museum), the 'reminiscence' by John Linnell (National Portrait Gallery, London), or perhaps the stubby figure in George *Jones's *Turner's gallery* (Ashmolean Museum; Oxford). We are left therefore with the three self-portraits, a number of surreptitious sketches, and some caricatures.

SELF-PORTRAIT, *c*.1791, watercolour on paper, 3¾ × 2¾ in (9.5 × 7.1 cm.); National Portrait Gallery, London (W 11; RW 1, number from Walker 1983). This attractive and rather childish figure, dressed in a striped blue-green jacket and orange waistcoat, shows Turner aged about 15, with a shy, friendly expression. It was painted when the boy was staying with his father's friend, John *Narraway, in about 1791, immediately given to the family and purloined by Narraway's niece, Ann *Dart, who sold it to *Ruskin in about 1860. She described from memory Turner's reluctance to paint his own portrait. 'How am I to do it?' he asked; 'in your bedroom with a mirror.' She continued to stress his diffidence. 'When asked to make the portrait you have just purchased,' she told Ruskin, 'he said it is no use taking such a little figure as mine; it will do my drawings an injury; people will say such a little fellow as this can never draw. When the portrait was given to us it was hung on the stairs, my cousin saying he would not have the little rip hung in the drawing-room' (Ruskin, *Works*, xiii. p. 473). Miss Dart's guess of 1791–2 (inscribed on the back) is probably not far out. The childish face may be compared to a drawing of a boy with hat and old bearded man of about this date (TB XXIX: 0).

SELF-PORTRAIT, *c*.1793, oil on canvas, 20½ × 16½ in. (52 × 42 cm.); Indianapolis Museum of Art (BJ 20; RW 2). There is doubt about the authenticity of this portrait, mainly because of its poor quality and the unreliable accounts of its provenance. There is a story, probably apocryphal, that

Turner himself was dissatisfied, even to the extent of knocking his fist through the canvas (*Thornbury 1862, i. p. 7). Turner is believed to have given it to his housekeeper, Hannah *Danby, who bequeathed it to Ruskin in 1854. It was then described as aged 16 to 19, from an inscription on the frame, J M W TURNER SUA MANU LUSTRO ETATIS QUARTO, suggested by Ruskin himself. Ruskin declared his belief in it: 'The likeness must have been a striking one, for all who knew Turner well can trace the features and the glance of the old man through the glow of youth; and recognise the form of the grey forehead under the shadow of the long flowing chestnut hair.' Ruskin later, in characteristically elliptical phraseology, emphasized his conviction: 'it is to me who knew him in his old age, entirely the germ and virtually capable contents of the man I knew' (*Works*, xiii. pp. 156, 473). Today many of us are sceptical, but I am inclined to agree with Ruskin that this is indeed a likeness of the great artist, concealed beneath the camouflage of youth.

SELF-PORTRAIT, 1798–1800, oil on canvas, 29¾ × 23 in. (79.5 × 58.5 cm.); Tate Gallery, London (BJ 25; RW 7); see Frontispiece. Again opinions differ about Turner's exact age in this portrait. The Tate Gallery Catalogue suggests 25, which seems a reasonable compromise. It shows a young man, a bit of a dandy but still aloof, of growing self-confidence, and with the piercing blue-grey eyes 'like lanterns', observed by Frederick Goodall. By this time Turner had travelled widely in England and Wales, and had become a well-known exhibitor of watercolour drawings, many engraved. He was fully conscious of being no longer a beginner but a professional exponent of the topographical landscape. His first oil, *Fishermen at Sea* (BJ 1), had appeared at the Royal Academy in 1796; his first *child, Evelina, was born; and he was elected ARA in November 1799 at the age of 24, possibly the very occasion for this striking self-portrait.

DRAWINGS AND SKETCHES BY OTHER ARTISTS

Because of Turner's well-known diffidence and dislike of sitting, most portraits of him that have come down to us are no more than surreptitious sketches, taken by stealth. He may have posed obligingly to his fellow students at the *Monro Academy, perhaps even to Monro himself (Indianapolis Museum), and he certainly must have given a sitting for the profile, dated 31 March 1800, for George Dance's *Collection of Eminent Characters* (RW 3–6, 9). And someone must have posed at length for the Sheffield portrait, drawn by Cornelius Varley in his 'Patent Graphic Telescope', but today most scholars are sceptical of its identity as our Turner (RW 14).

We are therefore left with the thumbnail sketches, almost doodles, mostly achieved by trickery and without Turner's knowledge, by fellow artists. Charles *Turner, no relation but a lifelong friend, made a very attractive pencil drawing (British Museum) in which he wears the same elegant clothes as he does in the self-portrait of c.1800, though with a smiling expression and less well-groomed hair. Charles Turner also made another drawing (British Museum), inscribed caustically: *A Sweet Temper*, but showing a scowling angry figure with unkempt hair, possibly reflecting his refusal to sit for a serious portrait (RW 8, 11). The two Turners quarrelled over the price of engravings, but eventually made it up and Charles produced a brilliant mezzotint in 1856, showing his great namesake holding a sketchbook open at *Mercury and Argus* (RA 1836; BJ 367). The head, in reverse, had been used earlier for a delightful whole-length drawing of Turner in his studio, with a print of *The *Shipwreck*, 1807, on a chair (RW 30–3).

A younger artist, C. R. *Leslie, later author of *A Handbook for Young Painters* and a *Life of Constable*, wrote a series of gossipy letters to his sister describing life as a Royal Academy student in 1816. He illustrated them with tiny pen and ink sketches (National Portrait Gallery, London, 4084), two of them of Turner lecturing, one annotated: 'have this time succeeded; the above is a good deal like him'. It shows Turner nattily dressed but hairy and bewhiskered (RW 16–17). Leslie has left an even more vivid verbal portrait: 'Turner was short and stout, and he had a sturdy sailor-like walk. There was in fact nothing elegant in his appearance, full of elegance as he was in art; he might have been taken for the captain of a river steamboat' (Leslie 1860, p. 205). The 'captain' appears briefly in an imaginary breakfast with Samuel *Rogers, accompanied by *Byron, *Wordsworth, *Coleridge, and other literary figures (mezzotint by C. Mottram).

One of the most revealing of all the portraits is a watercolour and wash drawing by J. T. Smith of a smiling Turner leafing through prints in the British Museum. 'Rainy Day Smith' is said to have used this drawing to show the Trustees the vulnerability of drawings in general, and the Print Room was organized accordingly (RW 25).

A number of whole-length drawings make fun of Turner's diminutive figure and, as he grew older, increasingly shabby clothes and top hat. One is by his young friend Hawksworth *Fawkes who, as a boy in 1818, had watched Turner at work on *A *First Rate taking on stores* (W 499). Hawksworth's father held an exhibition of Turner's drawings in his *Grosvenor Place house in 1819, and the whole family came to London for Hawkey's wedding in 1825, perhaps the occasion for this cheerful little figure (RW 19). One of Turner's favourite places to stay was the Fawkes's house, Farnley Hall near Leeds, where he became almost one of the family,

enjoying the pleasures of the country, especially fishing and shooting. Turner's first bag was a cuckoo.

Another whole-length drawing, a watercolour by Richard Dighton of 1827, shows an elderly figure with beaky nose, immaculately dressed in frock coat, top hat, furled umbrella under arm (Victoria and Albert Museum; RW 20). He seems to be frozen with cold, uneasy at some social function, his hands clasped in front for warmth. But a more familiar image is an oil sketch by C. W. Cope, c.1828 (National Portrait Gallery, London; RW 22). He wears a rusty black coat and shabby black hat, and stands, a stumpy figure on a bench painting an oil (perhaps *Regulus*, BJ 294), surrounded by a varnish jar, paint rags, and admiring spectators. Sir Arthur Cope described this as

a little oil sketch, painted by my father . . . when he was a student, of Turner at work on a picture of his own, in one of the empty rooms of the RA Schools with some of the porters or sweepers looking on. He used to do this when he was a 'Visitor' in the Schools. Being a bit of a pincher, he did not wish to forgo the fees that were then paid for the teaching Visitors gave to the students, but spent most of his time there in the manner depicted. (MS in NPG)

Sir John Gilbert's drawing, *Varnishing Day at the British Institution*, is another sketch (Courtauld Institute Collection) made surreptitiously while Turner was absorbed in repainting *Regulus*. It shows him faintly smiling, palette and brush at the ready, and with a paint rag stuffed into his tailcoat pocket. It was engraved for Cassell's *Illustrated Exhibition and Magazine* (1837) and numerous copies and versions exist. 'My portrait', wrote Gilbert, 'that is the one in Cassell's book has been copied over and over again, and engraved' (RW 26). An oil version, inscribed, 'Gilbert's 2nd study of Turner (the 1st 1841)', was sold at Sotheby's, 8 April 1992.

John Linnell's oil head and shoulders (National Portrait Gallery, London; RW 37) was painted from memory in 1838, and in a letter to Thornbury, describing this portrait, Linnell mentions his drawing of Turner's eyes at the foot of a sketch of Turner's father listening to his son's lecture (Tate Gallery; Wilton 1987, Pl. 140). Charles Martin's pencil drawing (National Portrait Gallery, London 1483) was published as a cut in the *Illustrated London News* in 1846, Martin being a regular contributor. He stands, a prim little figure, in much the same pose as the Gilbert drawing of 1837, the familiar paint rag in his pocket. The drawing has had the strangest attributions, including Thomas *Girtin, who had of course died 40 years before. The ascription to Charles Martin was confirmed by his son Carew, who visited the National Portrait Gallery in 1907. Here again the drawing has been much copied (RW 34).

CARICATURES

Turner's bizarre figure, paint-stained clothes, and sometimes morose expression, probably due to indigestion or depression, lent themselves to caricature. C. H. Lear's pencil drawing of 1847 (National Portrait Gallery, London; RW 38) was made for a gallery of similar sketches of prominent Academicians. It was accompanied by a vivid verbal portrait in Lear's diary for 3 May 1847:

he is a little man dressed in a long tail coat, thread gloves, big shoes, and a hat of a most miserable description, made doubly melancholy by the addition of a piece of broad shabby dingy crape. . . . There is no evidence of unhealthy biliousness in his face; it is red and full of living blood. . . . They talk about his pictures being the wreck of a great mind. They are the glorious setting of a glorious sun. (Transcript in National Portrait Gallery archive)

John Phillip's pencil and watercolour profile of c.1850 (National Portrait Gallery, London) exaggerates the parrot nose and sour expression, and was probably inspired by James Cassie, a friend of Phillip and an avid collector of Turner watercolours. A similar profile of c.1850 is by Frederick Goodall, another enthusiastic admirer (RW 42–3). In the main, however, Turner was a cheerful soul—Clara Wells spoke of him as light-hearted and merry and described the uproar he and her sisters made in the cottage at *Knockholt—and most caricaturists emphasized this side of his nature. A parody of the Cope sketch, by the Norwegian artist Thomas Fearnley (private collection, Oslo), shows the sunlight in Turner's picture brilliant enough to illuminate its surroundings, and in fact to cast shadows from the spectators (RW 23). William Parrott produced a close variant, *Turner on Varnishing Day* (Ruskin Gallery, Sheffield City Art Galleries; RW 37). John Jackson's ink drawing c.1830 (Fitzwilliam Museum, Cambridge), another grimly smiling profile, was probably intended to be worked up into an oil for Jackson's collection of portraits of his fellow Academicians (RW 24). Ruskin's black paper silhouette of c.1840 (private collection) is inscribed by Ruskin himself: 'J. M. W. Turner as he was dressed for a visit to the Royal Academy' (RW 29). Dicky Doyle's famous cartoon, in the *Monthly Almanac* for June 1846, shows the great master of atmospheric painting at work with a large mop and a bucket of chrome yellow wash (RW 36).

One of the most famous caricatures, by Count D'Orsay, has Turner stirring his tea in a grand drawing-room, probably Lady Blessington's or Elhanan *Bicknell's. This was lithographed and a copy, brought to the National Portrait Gallery, was annotated in pencil: 'in Mr Bicknell's house'. Another impression is annotated (probably by W. G. *Rawlinson): 'From a drawing by Count D'Orsay, said to have been touched by *Landseer'. This is quite possible; Edwin

Landseer was a frequent visitor to both houses (RW 35). Landseer's own sketch, painted rapidly in oils on his palette, shows Turner's backview, with a silk handkerchief over his head and hat to keep off the draught (RW 40). The sketch was taken off on a piece of blotting-paper and sent to Redleaf, where Mr Wells put it in the Scribblers' Book, now in the British Museum (Goodall 1902, p. 53). Some drawings by Millais (RW 44–6) and a caricature by *Maclise with Turner balanced on a high stool in a blaze of sunshine (Victoria and Albert Museum) conclude this brief survey of the cheerful Turner in benevolent mood.

Turner lived well into the age of photography and pronounced on this new science: 'Thank God I have had my day!' However, he delighted to visit *Mayall's Regent Street studio, where he 'repeatedly sat in all sorts of Rembrandtic positions' (Thornbury 1862, p. ii. 263), though no photographs are believed to survive today.

Finally we have the tragic *memento mori* of the death mask (National Portrait Gallery, London), probably taken by Thomas *Woolner, a friend, admirer, sculptor, and expert practitioner in this lugubrious technique (RW 48–9). On a happier note is a pencil caricature by Sir William Richmond, 'drawn from memory about 1884', with gently smiling expression and the famous parrot beak directed towards a glass of champagne (National Portrait Gallery, London, Reserve Collection)—a poor substitute for this greatest of all landscape painters. But then, there really are no portraits of Turner. See also MONUMENTS. RW

Lionel Cust, 'The Portraits of J. M. W. Turner RA', *Magazine of Art*, 1895.

Cosmo Monkhouse, 'Some Portraits of J. M. W. Turner', *Scribner's Magazine*, 1896.

Goodall 1902.

Walker 1983, pp. 21–32 (numbered 1 to 51 and referred to here as RW).

PORTS OF ENGLAND, THE. Watercolour and mezzotint engraving scheme initiated in summer 1825 by Thomas *Lupton. Since 1822 Lupton had been engraving designs for the *Rivers of England* series on behalf of the *Cooke brothers. In order to become a publisher himself, he invited Turner to create a set of 25 marine watercolours for mezzotint reproduction. The prints were to have appeared in twelve parts, with two prints per part. In the event Turner made only thirteen of the designs (including a vignette to adorn the wrapper), as well as three or four drawings that can possibly be connected with the scheme.

Originally *The Ports of England* was to be entitled 'The Harbours of England' but the name was changed when the first part of the work appeared in May 1826. The project was dedicated to *George IV. The second and third parts

followed in 1827 and 1828. However, in 1828 Turner quarrelled with Lupton over delays and faults he found in other reproductions of his works by the engraver. Finally he broke off relations, making further publication of the *Ports* series impossible. Lupton then carefully stored all twelve of the mezzotint plates he had begun or completed, and in 1856 he reprinted them, including the six unfinished plates exactly as he had abandoned them in 1828. This reprint was produced in collaboration with *Ruskin, who wrote a commentary for it, reverting to Turner's original title of 'The Harbours of England' in the process.

Turner hired all of the *Ports* watercolours to Lupton, and after the first seven had been reproduced (including the wrapper vignette), six were returned to him; as a consequence they have remained in the Turner Bequest (TB CCVIII: I, J, Q, S, T, and U). However, as the unfinished prints make apparent, at the time of his break with the painter Lupton was still transcribing the six further designs. He also seems to have held onto the wrapper vignette drawing. Probably because he felt Turner owed him compensation for his labours he sold all seven watercolours, and now they are dispersed around the world (see W 750–68). (This sale explains why he could not complete the unfinished engravings in 1856—he had nothing to work from.)

The *Ports* drawings have much in common with the *Rivers of England* watercolours, being equally concentrated in size, scale, and pictorial dynamism. Both groups are on sheets of fine white paper averaging $6\frac{3}{8} \times 9$ in. (16 × 23 cm.). They enjoy similar felicities of detailing and finish, with stippling employed extensively to lend textural vivacity and tonal variety, although the three or four further drawings that were possibly made in connection with the *Ports* series are sometimes more freely elaborated (see Shanes 1990). In three of the *Ports* scenes—views of Falmouth, Sidmouth, and Portsmouth—the artist may have alluded respectively to peace celebrations, to contemporary politics, and to recent advances in naval communications. ES

Shanes 1981, pp. 11–12, 34–40, 153.

Herrmann 1990, pp. 159–62.

Shanes 1990², pp. 13–14, 130–50.

POSTHUMOUS RECEPTION ABROAD. In 1860 John James *Ruskin proposed that twenty English subscribers purchase a Turner for the Louvre, but nothing came of the scheme. Thirty-four years later, after *Ancient Italy—Ovid Banished from Rome* (RA 1838; private collection, USA; BJ 375) was bought by the Sedelmeyer Gallery in Paris, a French effort to buy it for the Louvre (see under PARIS) was opposed by several artists, including Camille Pissarro and Alfred Stevens, and also failed. Only in 1967 did the Louvre acquire its first Turner, and until 1955 there were no

paintings by him in any European museum. Also, few pictures have been privately owned or sold on the Continent. The appearance of two paintings in a French auction in 1874 was sufficiently remarkable to elicit their descriptions in 1882 in *La Peinture anglaise* by Ernest Chesneau. In 1894 an exhibition of English painting (see PARIS, EXHIBITIONS OF 1887 AND 1894) organized by Sedelmeyer included two late unfinished paintings belonging to Camille *Groult (BJ 509, 520). Their exhibition, a dozen years before similar paintings from the Turner Bequest were visible in London, was significant, but until the 1970s other European showings of Turner were scarce.

French opinion of Turner in the 19th century was not uniform, but most writers described him as isolated and inimitable, unlike *Constable, who was ascribed major influence in France. One analogous French artist suggested by Chesneau was Gustave Moreau, and, according to Edmond de Goncourt in 1891, Moreau did become an admirer when he saw Groult's pictures.

In 1870 Claude Monet and Camille Pissarro took refuge in London from the Franco-Prussian War. Writing in 1902 to the painter Wynford Dewhurst, Pissarro recalled admiring Turner with Monet, and he acknowledged English importance for Impressionism. But in 1904, when Dewhurst published a book proclaiming Impressionism's British origins, Pissarro objected, telling his son Lucien that Constable and Turner 'had no understanding of the analysis of shadow' (*Letters to Lucien*, 1943, pp. 355–6). In 1918 Monet told a visitor, 'At one time I greatly admired Turner; today I care less for him. . . . He didn't shape the colours sufficiently, and he put on too much: I've studied it quite carefully' (René Gimpel, *Diary of an Art Dealer*, 1966, p. 73).

The first Impressionist exhibition in 1874 included an etching after *Rain, Steam, and Speed* (RA 1844; BJ 409) by Félix Bracquemond. In 1882–3 several Impressionists, including Pissarro, Monet, and Degas, related their treatment of nature to 'the illustrious Turner' in an unsuccessful effort to exhibit at the *Grosvenor Gallery in London. In 1894, while disparaging *Ancient Italy*, Pissarro praised Groult's two paintings, and these quasi-abstract works evidently did attract younger French artists. Paul *Signac and Henri *Matisse visited London to see Turner, and the former in *D'Eugène Delacroix au Néo-Impressionnisme* (1899) and other writings, while reiterating claims about *French Impressionist debts, stressed the freedom of colour in late Turner, formulating a generally shared 20th-century French view.

In Germany, Turner got off to a bad start by sending *The *Opening of the Wallhalla* (RA 1843; BJ 401) to Munich in 1845, where it was ridiculed. German disapproval persisted as late as 1904, when he was the object of a sixteen-page critical dissection by Julius Meier-Graefe, who rejected claims for any Impressionist derivation, decried his formlessness, and finally turned with relief to Constable, dismissing Turner as 'the most bewildering result' of England's 'fundamentally erroneous conception of art' (*Entwicklungsgeschichte der modernen Kunst*, 1904, i. pp. 212 ff.). Two years later, however, Josef Strzygowski saw the first exhibition of 26 late unfinished paintings at the Tate Gallery and, after mentioning Turner in *Die bildende Kunst der Gegenwart* (1907), in March 1908 in the *Burlington Magazine* praised the newly visible *Interior at Petworth* (BJ 449) as his ultimate achievement and linked him with Arnold Böcklin as the 19th-century's two most significant *Inhaltskünstler* (artists of meaning). Earlier, in evoking Gustave Moreau, Chesneau created a French Symbolist Turner; Strzygowski found a German Expressionist.

James *Lenox bought two oils, *Staffa* and *Fort Vimieux* in 1845 and 1850; and in 1855/6 an American Baptist clergyman, Elias Magoon, bought five watercolours, which in 1864 went to Vassar College as the first Turners to enter American museums. By 1874 enough work was in America for Charles Eliot *Norton to organize an exhibition of drawings and prints in Boston to accompany a series of lectures. A picture already famous from *Ruskin's writing, *The *Slavers* (RA 1840; BJ 385), came to America in 1872 and in 1876 was the star attraction of the opening exhibition of the *Boston Museum of Fine Arts. Soon after, the great migration of paintings from English to American collections began to include numerous Turners. The *Metropolitan Museum's three paintings arrived in New York between 1889 and 1899, and many other American holdings are almost as venerable.

Ruskin's claims for Turner were widely accepted in America as gospel in the mid-19th century but, as the century progressed, Ruskin's authority was undermined by attitudes shaped in France. In 1878, when *Harper's New Monthly Magazine* asked George Inness, 'Is Turner as great a painter as Mr. Ruskin pronounces him?', he responded: 'His *Slave-Ship* is the most infernal piece of clap-trap ever painted. . . . The color is harsh, disagreeable, and discordant.' For artists of Inness's generation the Barbizon school had displaced Turner. Their views did not inhibit their wealthy compatriots' acquisitive instincts, but Turner was now bought to hang in collections either mainly of 18th-century British paintings (the McFadden collection in the *Philadelphia Museum of Art) or of Old Masters (the *Frick Collection), not of up-to-date art. In America he became another Old Master, removed from contemporary artistic concerns.

In 1956 a modern Turner was rediscovered for Americans in the Museum of Modern Art's *Masters of British Painting 1800–1950*, an exhibition dominated by the unfinished

Norham Castle, Sunrise (BJ 510) and *Interior at Petworth*, discovered by Strzygowski in 1906. In 1966, updating Signac, the Museum of Modern Art's *Turner: Imagination and Reality* (see under NEW YORK) appropriated Turner as forerunner of the most recent colour-field abstraction. AS

A. Haus, 'Turner im Urteil der deutschen Kunstliteratur', in *J. M. W. Turner: Maler des Lichts*, exhibition catalogue, Dresden, Gemäldegalerie Neue Meister, 1972.

Joseph R. Goldyne, 'Criticism and Collecting: Nineteenth-Century American Response to Turner's Achievement', in *J. M. W. Turner: Works on Paper from American Collections*, exhibition catalogue, Berkeley, Calif., University Art Museum, 1975, pp. 19–38.

Gage 1983.

POUND, Daniel John, see BOOTH, SOPHIA CAROLINE.

POUSSIN, Nicolas (1594–1665), French artist born in Normandy but resident for most of his life in *Rome. Ever since his death, Poussin has been recognized as the greatest of classical history painters, the heir to Raphael and the ancients, the subtlest of pictorial story-tellers and, in his use of painting as a vehicle for ideas, the exemplar of the painter-philosopher. His work first began to be appreciated in England early in the 18th century, when Jonathan Richardson wrote a perceptive account of *Tancred and Erminia* (Barber Institute, Birmingham). Thenceforth, the number of Poussin's paintings in British collections steadily grew, until by 1800 almost half his surviving *œuvre* of just under 250 pictures was in Britain; they included such masterpieces as both sets of *Sacraments* (now owned respectively by the Dukes of Rutland and Sutherland), the two great *Phocion* landscapes (Earl of Plymouth and Walker Art Gallery, Liverpool), and *Landscape with a Man killed by a Snake* (National Gallery, London). The other important surviving group, a good many of which Turner saw in *Paris in 1802, were the 40 or so paintings in the Louvre.

The principal English 18th-century comments on Poussin are in *Reynolds's *Discourses*. Turner's were next and are to be found, first, in his notes in the 'Studies in the Louvre' Sketchbook (TB LXXII) and secondly in the 'Backgrounds' lecture of 1811 (see PERSPECTIVE LECTURES). In the former, Turner concentrated on technical questions of colour and composition; he found Poussin's distribution of primary colours to be too often 'spotty' but praised his use of broad areas of grey to suggest the *Sublime. Generally he admired the discipline of Poussin's compositions but thought that in one case, *The Deluge* from the *Seasons*, such discipline was inappropriate to the violence of the subject matter. He pointed out that the figures in the upturned boat in this picture were at the wrong end to convey the sensation of falling, that the waterfall was descending placidly into another pool,

'artificially, not tearing and desolating', and that the figures on the rocks and in the water were too unconcerned to suggest terror. 'But the colour is sublime', added Turner. 'It is natural—is what a creative mind must be imprest with by sympathy and horror.' This was a new and significant *Romantic criticism of Poussin, and, when Turner came to paint his own *Deluge* (?Turner's gallery 1805; BJ 55), he treated it as a critique of Poussin's version; he made both the composition and the figures more turbulent and retained only the 'Sublime' grey and lurid lighting of Poussin's picture.

Turner's 'Backgrounds' lecture was a more formal context than his sketchbook notes and required him to give a more rounded assessment of Poussin as of other Old Masters. As usual, he took his cue from Reynolds, though Turner's observations were by no means merely second-hand. Like Reynolds, he judged Poussin's qualities to spring principally from his love of the Antique. This included a use of colour 'that often removes his works from truth'—a strength, not a weakness, in both Reynolds's and Turner's view. Once again, Turner remarked on Poussin's mastery of the Sublime (as had Reynolds), citing in the 'Backgrounds' lecture the *Landscape with Pyramus and Thisbe* (Frankfurt am Main), then in the collection of Lord Ashburnham.

To judge from two pen and watercolour sketches in his 'Dolbadarn' Sketchbook (XLVI), Turner first encountered Poussin's paintings in 1798 or 1799. During the next seven years he executed half a dozen pictures influenced in varying degrees by the French artist; these show that Poussin's example was the principal factor in Turner's endeavour to establish himself as a historical landscape painter in the early 1800s (though he soon exchanged the solidly architectonic compositions of Poussin for the more ethereal ideas of *Claude).

Remarkably, Turner's finest, best executed, and most faithful essay in the style of Poussin was his first, *The Fifth *Plague of Egypt* (RA 1800; Indianapolis Museum of Art; BJ 13). Bought by William *Beckford (itself a major coup for the artist), this was not only Turner's most Poussinesque but also his largest and most ambitious painting of any kind to date, and was highly praised by the critics. The pictorial source in Poussin was the already mentioned *Landscape with Pyramus and Thisbe*. The compositions of both paintings consist of a rolling panoramic landscape extending deep into space and swept by a violent storm, with confused areas of dark in the foreground broken by patches of light and, in the sky and background, searing flashes of lightning (Poussin) or rolling clouds of fire (Turner) illuminating the surfaces of classical buildings. (As is well known, Turner miscounted the plagues of Egypt, which are not numbered in the Bible, and seems to have represented either a

combination of the fifth and sixth plagues—the murrain and the boils—or possibly the seventh, that of hail and fire.)

In 1802 Turner followed this picture with another, even more menacing, storm-filled plague scene inspired by Poussin, *The Tenth Plague of Egypt* (BJ 17), illustrating the destruction of the Egyptian first-born. In this the handling is broader and the space more enclosed, with the architecture possibly suggested by a copy or engraving of Poussin's *Saving of the Infant Pyrrhus* (Louvre), the original of which Turner saw in Paris later the same year. Lastly, he painted a third cataclysmic picture, *The Destruction of Sodom* (?Turner's gallery 1805; BJ 56), the composition of which is still more turbulent and more coarsely handled; indeed it is no longer strictly Poussinesque at all.

A more genuine, though quieter, tribute to Poussin was the *Bonneville, Savoy with Mont Blanc* (RA 1803; Yale Center for British Art, New Haven; BJ 46; see BONNEVILLE for the confusion between the two Bonneville pictures exhibited in 1803). Even though this site had been sketched from nature by Turner during his trip to Switzerland in 1802, he reworked it in terms of calm, sunlit Poussinesque mountains in the background and, in the left foreground, a road leading straight into depth as in *The Roman Road*, a painting which he could have seen when it was bought in London in 1802 by Noel Desenfans, from whose collection it eventually went to Dulwich. (Praised in the 'Backgrounds' lecture and famous as a Poussin at the time, this picture is now considered to be a copy.)

Effectively Turner's last Poussinesque picture was another calm but very grand painting, with an imaginary landscape and mythological subject matter: *The *Goddess of Discord choosing the Apple of Contention in the Gardens of the Hesperides* (BI 1806; BJ 57). There the idealized plain with its trees, river, and female figures (the Hesperides), backed by massive mountains, is inspired by Poussin's *Landscape with Polyphemus* (which Turner must have seen in a copy or an engraving, as the original was already in St Petersburg). Fittingly, a dragon occupies the place on top of the mountain in Turner's painting where Poussin had situated Polyphemus. MK

Ziff 1963, pp. 315–21.
Nicholson 1990, *passim*.

PRICES FOR TURNER'S PAINTINGS AND WATER-COLOURS DURING HIS LIFETIME.

Turner fixed the prices for his oil paintings according to *size, an arrangement that came into force after he was elected ARA in 1799. Before that, his first exhibited oil, **Fishermen at Sea* (BJ 1), shown at the Royal Academy in 1796, was sold to General Stewart for only £10, while on 14 June 1798 Lord Harewood

paid Turner £32 9*s.* for '2 Views of Plompton & Case for Do' (BJ 26, 27). But in 1800 William *Beckford bought *The Fifth *Plague of Egypt* (Indianapolis Museum of Art; BJ 13; 49 × 72 in., 124 × 183 cm.) for 150 guineas and in 1801 Turner charged the Duke of *Bridgewater 250 guineas for *Dutch Boats in a Gale* (BJ 14; 64 × 87½ in., 162.5 × 222 cm.). Turner decided early in his career that his standard exhibition size would be 36 × 48 in. (91.4 × 122 cm.) and, in the early 1800s, the price for a picture of this size was 200 guineas, while *A *Country Blacksmith* (BJ 68; 21½ × 30½ in., 57.5 × 80.5 cm.), being smaller, cost £100 when sold in 1807.

Turner's prices naturally increased as his reputation grew but the rise was less than one might expect: in 1835, for example, when Mr Marshall called on him in *Queen Anne Street, Turner told him that he 'could have anything in his studio for £350' (his standard size being understood), only a moderate increase in 30 years. In any case he was not always consistent for Gage quotes a note from Turner to Edward Carey in 1837 stating that 'he cannot undertake a picture of less size than three feet by four and that his price will be 200 guineas for that size'. That Turner charged less for commissioned works than for those painted as speculations is evident both from this and from a letter he wrote in November 1843 (Gage 1980, pp. 192–3) to an unknown correspondent which quoted: 'all of Venice 200 gns if painted by commission—250 gns afterwards' (by then he had decided 'Venice size best 2 feet 3 feet').

There were some wide variations but these were exceptional: according to David *Roberts Turner refused an offer of £1,600 from *Bicknell in 1844 for *Sun rising through Vapour* (RA 1807; BJ 69; 53 × 70 in., 134.5 × 179 cm.) but this was because he had already included it in his *will as a specific bequest to the National Gallery. In 1848 Colonel *Lenox was reported to have offered Turner a blank cheque for *The *Fighting 'Temeraire'* (RA 1839; BJ 377) without success. Turner is also said to have refused offers of £5,000 for his two *Carthage pictures (BJ 131, 135) and £100,000 for the entire contents of his studio (Bailey 1997, p. 381).

The highest recorded price during Turner's lifetime was when John *Naylor bought, directly from Turner in 1851, *Pas de Calais* (RA 1827; Manchester City Art Gallery; BJ 236) and *Fishing Boats with Hucksters bargaining for Fish* (BI 1838; Art Institute of Chicago; BJ 372), unsold since 1827 and 1838 respectively. Each cost £1,276 and measured 68 × 88 in. (174 × 224 cm.). The next highest price appears to be £1,050, paid in 1844 by Bicknell for *Palestrina* (RA 1830; BJ 295; 55 × 98 in., 140.5 × 249 cm.) which had remained unsold for fourteen years.

When, late in 1810, Turner totted up his assets he was realistic about the value of pictures that had not sold,

depreciating them quite ruthlessly, in some cases by as much as 75 per cent of their original asking prices. For example, these eight large paintings: 'Nelson' (*Battle of Trafalgar*, BJ 58), *Calais Pier* (BJ 54), *Spithead* (BJ 80), *Shipwreck* (BJ 54), *Tenth Plague* (BJ 17), *Hesperides* (*Goddess of Discord*, BJ 57), *Holy Family* (BJ 49), and *Sodom* (BJ 56) were lumped together at £800 while *Narcissus and Echo* (Petworth House, BJ 53), *Richmond* (BJ 73), 'Ploughing' (BJ 89), and 'Cows', probably *Dorchester Mead* (BJ 107), were valued at £200 for the four. Turner's shrewdness was confirmed later as *Narcissus and Echo* was the only one of the twelve that was subsequently sold.

At first Turner's watercolours were very modestly priced to judge by the 3 guineas that Edward *Lascelles paid for an interior view of Westminster Abbey (RA 1796; British Museum; W 138), but the price rose to £10 the following year and Lascelles eventually owned eleven Turner watercolours at a total cost of £168 including 60 guineas for the very large *Lake Lucerne with Mont Blanc* (Yale Center for British Art, New Haven; W 370), bought in 1806.

Caernarvon Castle (RA 1799; private collection; W 254) was bought by *Angerstein for 40 guineas; 'the price was fixed by Mr A. and was much greater than Turner would have asked' (Farington *Diary*, 27 May), more also than the *two* oils of *Plompton Rocks* had cost the previous year. This windfall enabled Turner to obtain 35 guineas each for the watercolours of *Fonthill commissioned by Beckford in 1800 (W 335–42). But W. B. *Cooke, who ordered 40 small watercolours to be engraved in *Views of the *Southern Coast* (W 445–89), published 1814–24, paid Turner only £7 10s. each for the first 24 drawings although this increased to £10 for the final sixteen. Meanwhile Walter *Fawkes had bought the entire 1817 *Rhine series (W 636–77, 679–86) for £500 or £10 each, but he was doubtless offered special terms.

In 1825 Charles *Heath commissioned 120 watercolours for the *Picturesque Views in *England and Wales* at 30 guineas each although only 96 were published 1826–38 (W 785–929). In 1842 *Griffith obtained 80 guineas each for nine of the set of ten *Swiss views. But the highest prices for watercolours were the 100 guineas each, paid in 1848 by *Ruskin sen., for *Brunig* (private collection, USA; W 1550) and *The Descent of the *St. Gothard* (Koriyama Museum of Art, Japan; W 1552), both of 1847–8.

Although these prices seem low compared to those for oils, they more than hold their own when converted into todays' values: £1,276 in 1851 = £35,547 today, or 27.8 times as much; while £105 in 1848 = £3,539, or 33.7 times as much.

See also ART MARKET . . . SINCE 1851; COMMISSIONED WORKS.

EJ

Hill 1984, pp. 24–33.

Hill 1985, pp. 30–46.

Shanes 1984, pp. 52–4.

PRINCE REGENT'S BIRTHDAY, see ENGLAND: RICHMOND HILL.

PRIOR, Thomas Abiel (1809–86), English line-engraver. Prior made his name in 1846 through the success of his impressive large steel engraving, which he himself published, of *Heidelberg*, after a drawing by Turner (now in Edinburgh; W 1554), based on his own sketch. After Turner's death Prior was one of the engravers who produced several large-scale steel plates after well-known works by Turner, including, in 1854, *Zürich* (R 672) after the 1845 watercolour now in Zurich (W 1548), and, in 1863, *Dido building Carthage* (R 683), after the painting exhibited in 1815 (BJ 131). Prior spent his last years in Calais. LH

PRIVATE LIFE. Turner tended to clothe his activities in mystery, or so his contemporaries and later historians have asserted. Sometimes, but not always, this is with justification. But so much of the documentation of Turner's daily life has been lost that, the more we accept that he did have 'mysterious' ways, the more we must also accept that his private life was rich and fulfilling. What we know of his private friendships suggests that they were uncommonly deep and in some cases lifelong. Turner's private life became a foundation from which his work as an artist could grow, and into which he could withdraw at will.

Turner was never frustrated during his childhood in his natural desire to become an artist by alternative parental ambitions. His father supported and promoted him from earliest youth and was visibly proud of his achievements. As a consequence Turner never became embittered, nor did childhood hardship have critical effects on him. His father was naturally thrifty, a trait which the son inherited, and seems to have prospered as a barber in Covent Garden, to the extent that what hardships there may have been were less financial than emotional. Mary *Turner's troubles, however, were of a kind which, before the age of psychoanalysis, could be ignored once she was immured in St Luke's and subsequently Bethlem Hospitals. Although he acquiesced at the very least in her confinement, Turner may have suppressed all memory of his experience of his mother.

His sojourns with the Marshall family (see MOTHER'S FAMILY) and the *Narraways in the 1780s and 1790s is, despite Mary's absence, evidence of the importance to Turner's father of their extended family network, and the security that followed from it. Such emphasis on roots gives reason for Turner's maintaining many long-term friendships

outside his profession, the lengthiest being with the Revd H. S. *Trimmer and Philip Hardwick, and, no less important, with the Revd E. T. *Daniell, the Earl of *Egremont, Walter and Hawksworth *Fawkes, Samuel *Rogers, Mary *Somerville, Charles *Stokes, and W. F. *Wells and his daughters.

The nature of Turner's education determined the development of his private life. His *œuvre* reveals his deep knowledge of the classics and the Bible which grew from multifarious roots. As a boy in *Maiden Lane he cannot have avoided Richard Porson's well-attended recitations from Shakespeare and classical authors in the Cider Cellar opposite his house. Trimmer's mother, the educationalist Sarah Trimmer, used classical and biblical imagery to illustrate her writings, while biblical imagery was dominant in the sermons of Thomas Coleman, Turner's putative schoolmaster in Margate. Trimmer, and the friend of later years, Edward Daniell, both became classics scholars and entered the church. Being surrounded from his early age by the living narratives of the classics and the Bible, he became engrossed in them, and they transformed his art, his outlook on life and, particularly from the 1820s, the way in which he presented himself to the world.

Turner's early training as an *architect, and contact in 1792/3 with the *Society of Arts, introduced him to the world of the technical and practical, and fostered his latent interest in how things worked. This lasted a lifetime, and drew him towards a fondness for modern gadgets, such as a swivelling painting table, an umbrella concealing a dagger, a water closet, and an enjoyment of the equipment in *Mayall's studio. It also catalysed his interest in *science as subject matter, and imbued his own architecture with a sense of order and discretion. All this suggests an instinctive appreciation of the moral foundation of classicism, and an understanding of rectitude in form and image.

Though coolly determined in the way he approached his work, Turner was restless in his attitude to property, and where he should settle. His move from Maiden Lane in 1800 for more spacious rooms in *Harley Street was a sensible professional step. He took additional lodgings at Isleworth (see SION) in 1804, and two years later moved to another Thames-side property in *Hammersmith. Having invested creative energy, time, and money in building his gallery in Harley Street in 1804, he tore it down and in 1811, reoriented it to face *Queen Anne Street. Then in 1820 he rebuilt his house and gallery once more. Having created *Sandycombe Lodge in Twickenham as his country haven, he was weary of it by 1815, and considered giving it up. In addition, he bought and inherited properties in Wapping, Epping, Great Missenden, and possibly Deal, St Margaret's-at-Cliffe, and

elsewhere. Owning and managing property amounted to an obsession with him, and coloured his private life. Perhaps he saw it as active relaxation, taking his mind off painting while continuing to earn him money as investment. Whatever the motive force, it indicates that Turner was immersed lifelong in bourgeois practicalities, and that it was an imperative for him to have a comfortable income.

Throughout his life Turner had somebody to run his domestic affairs. Until he died in 1829, his father was a 'willing slave', and managed Turner's studio, stretching and priming canvases and running out for supplies, manning the gallery, and cooking. At Sandycombe he did much the same, as well as cultivating the garden. Once established and famous, Turner had his father at his beck and call. Hannah *Danby was housekeeper at Queen Anne Street from *c.*1809, and may have relieved old William Turner of most domestic responsibility as far as her own health would allow. Such assistance enabled Turner to entertain, as he could at Sandycombe and Queen Anne Street, though he was much more frequently and enthusiastically a guest than a host.

Through clothes lists and the *c.*1798 *Self-Portrait* (see PORTRAITS; BJ 25) there is early evidence of Turner's dandyishness and swagger. It may be that his father, as a retired barber, helped keep him neat and tidy; indeed after his father's death Turner declined into genteel shabbiness in both person and property, despite Sophia *Booth's best efforts to rescue him. Remembering him as he was in the 1810s, Redding compared him to a sea-captain, while *Delacroix in 1832 recorded that Turner had the 'look of an English farmer'. These independent reports agree that years of travel and of working in the open air had had the inevitable physical effect on Turner's appearance. However, the need to keep up appearances among the passing crowd, must have determined him to instruct his father to send some natty clothes down to him at East Cowes when staying with John *Nash in 1827. A report from John *Martin's son suggests that in the late 1840s he sometimes managed to start his day in Chelsea bright and clean-shaven and with shiny boots.

Such natural tidiness extended into his concern to keep his dozens of *sketchbooks in order. By 1820, when he returned from his first visit to Italy, he had about 170 that we know of, and it is likely that it was then that he carefully numbered and titled them on their covers and spines so that he could refer to them the more easily and shelve them methodically. *Finberg recorded, but did not follow, Turner's numbering system, while the titles Turner gave to the books aided *Ruskin when he came to make the first list of the Turner Bequest in 1856–7. Such tidiness extended to Turner's practice of planning his tours more or less pre-

cisely. Little was left to chance, and sketchbooks reveal the advice that he sought from friends and fellow travellers as to the best routes and accommodation.

Turner seems to have been reluctant to have his portrait painted. There are few posed portraits such as his artist friends Francis *Chantrey, Thomas *Lawrence, or Thomas *Phillips would have been eager to make. This apparent shyness may not have developed until middle life, for there is no evidence for it during his young manhood. There are two confirmed youthful self-portraits (W 11 and BJ 25), and one early portrait which belonged to Ruskin (c.1793, Indianapolis Museum of Art; BJ 20), and which is certainly of him, but may not be by him. In addition, *Monro seems to have drawn him in full face in the 1790s (Indianapolis Museum of Art), as did Charles *Turner (c.1800, British Museum). All these address the spectator boldly. There exists also a posed portrait of c.1800 by Masquerier (private collection, USA), and a composed profile, one of a series, which George Dance drew for engraving in 1800 (Royal Academy). Turner was no reluctant sitter for any of these. Later portraits, however, catch Turner fleetingly, and in the case of John Linnell's portrait for Daniell (National Portrait Gallery, London) the likeness was taken by subterfuge. The new technology in Mayall's studio in the late 1840s may have seduced him into sitting happily, indeed regularly, in front of the camera, echoing in his last years his youthful dandyishness.

Running counter to the latent dandy in Turner's character was a roughness of speech that he did nothing to improve. His was the accent of the London streets, his aspirated 'h' being very occasionally audible in the sketchbooks—in a recipe in the 'Rhine, Moselle and Aix-la-Chapelle' Sketchbook (TB CCXCI(a)), for example, he writes of boiling '2 quarts of Strongs Hale'. His womanizing tendencies also find expression in sketchbook drawings, in the drafted and redrafted poem 'Molly', as well as in an oblique reference in one letter to *Holworthy (Gage 1980, no. 122). Before he left for Italy, Turner made a careful note in the 'Italian Guide Book' Sketchbook (CLXXII) of where prostitutes might be found in Paestum. Whatever the nature or extent of their mutual affection, it is likely that Sarah *Danby, who habitually held her hair in a turban, was one of the models for groups of explicit nude studies in the 'Academies' (LXXXIV) and 'Lowther' (CXIII) Sketchbooks. Some of these figures have turbaned hair.

Turner's relationship with Sarah may have produced two daughters that we know of—Evelina (b. 1800/1) and Georgiana (b. ?1811). Even this statement is riddled with doubt, as there is only fragmentary documentary evidence to go on (see below). But we have to take into account the significant timing of *Holy Family* (RA 1803; BJ 49). Although this was painted directly after Turner had seen works by *Titian and Giorgione in the Louvre, *Paris, it is nevertheless a blind alley, and there is nothing like it subsequently in Turner's art. Moreover it was made when Turner was the father of a 2- or 3-year-old child, and when he may have been living some semblance of a family life with Sarah.

According to *Farington the couple were living together in 1809, and Trimmer reported that he saw a young girl in Turner's house, presumably Evelina. Trimmer's surmise suggests that Turner kept what passed for a family life very much to himself, even to the extent of not being frank about it to so old a friend as Trimmer. By about 1814 the relationship with Sarah seems to have been at an end, but in his will of 1831 he left her £10 a year for life, which indicates that affection lingered at the very least. This, however, was revoked in the 1848 codicil. Evelina married the diplomat Joseph Dupuis in 1817, and left with him shortly afterwards for West Africa and a subsequent peripatetic life. There is no known record of any further contact between Evelina and her father during his lifetime, despite the fact that the family returned periodically to England, and that Evelina had four children who survived infancy. Turner did, however, leave Evelina £50 a year for life in the 1832 codicil, which suggests some empathy with her parental burdens. This bequest was revoked in 1848, by which time her children had grown up. Knowledge of Turner's relationship with Georgiana is shadowy, not to say non-existent. When in 1840 the child came to marry, she gave her father's name as 'George [sic] Danby, deceased', suggesting that she may never have known that Turner was her father, if indeed he was. As with Evelina, Turner left Georgiana £50 in the 1832 codicil, revoked 1848—a formality, for she had died in 1843. He never explicitly claimed either girl as his daughter. (See also WILL.)

This attitude seems to run against Turner's known affection for children. Clara *Wells saw how hearty and amusing he was when playing with her younger sisters. The Fawkes children, too, enjoyed his company, as did Trimmer's boys and *Maw's daughter. Such fondness had its roots in Turner's innate soft-heartedness and humanity, better able to express itself when he had no parental responsibilities. But like a sword his emotional nature had two edges to it. He could be great fun with children, or be moved to tears by *Claude, or generous and giving to brother artists and their widows; but he nevertheless drove a hard bargain with patrons and demanded payment to the penny, insisted on tough agreements with his engravers which led some business ventures to collapse, and would hound a tenant through the courts for apparent rent-evasion. His was a mercurial temperament, fearful of being done down, but crossed with kindness.

The generosity that infused his private life led him to direct his executors to set up alms houses for 'decayed artists', and to many other intentions for the public good, above all the bequest of his paintings to the nation. Some of these intentions were explicitly aimed at achieving the immortality that he sought, deserved, and has. The hardness in his nature, however, and indeed his loose sexual morals as perceived in the Victorian era, led to scandalized rumours being magnified into character traits that biographers such as *Thornbury, *Falk, and Finberg found regrettable. While showing the greatest reverence for his work, these earlier biographers felt the need to apologize for, or to gloss over, aspects of his private life with which they were uncomfortable.

Turner was the life and soul of parties, as reports from *Roberts, Ruskin, Clara Wells, and others attest. He could also be morose and difficult, as records show, but that he was regularly invited back by these and very many others, including the Maws, the Carrick Moores, the *Eastlakes, Fawkes, Holworthy, Redding, and Rogers, indicates that conviviality was dominant in him. Walter Fawkes was perhaps the greatest of his friends—closer even than the faithful Trimmer or George *Jones, who worshipped him. Of all Turner's friends, Fawkes was the only one who matched him in strength of character, to the extent that Fawkes might be considered to have dominated even Turner. Certainly, with a dog-like devotion Turner made painting after painting for Fawkes, down to the watercolours for the Farnley bird albums and the minuscule (and still scarcely known) *Fairfaxiana*. It is not clear exactly how much of this was ever paid for. Turner had a radical streak of his own—expressed widely but obliquely in his exhibited paintings—but Fawkes's own activist politics may have temporarily heightened Turner's beliefs and converted what was an abstract desire for welfare and natural justice for all into a campaigning attitude. Fawkes was a zealot, whose beliefs, eloquently expressed in public and private, may actually have swayed Turner. (See POLITICS.)

It is noteworthy that for his closest friends beyond artistic circles Turner chose not only a zealous politician, but also two ordained ministers, Trimmer and Daniell. The lives of each of these were guided by ineradicable beliefs and convictions which it was their duty to convey to others. In Turner's surviving writings, sketchbooks, and exhibited paintings there is strong evidence of his own religious feelings, and in the 'Wilson' sketchbook (XXXVII) and elsewhere direct indication of church attendance. Roberts wrote of how Daniell watched proudly as Turner took his seat in church, and of how devastated Turner was at Daniell's premature death. Having evolved throughout a lifetime, religious sensibilities may have been the driving force behind

such paintings as *Angel standing in the Sun (RA 1846; BJ 425) and *Light and Colour (Goethe's Theory) ... (RA 1843; BJ 405).

Being driven by his genius, Turner found the relaxation he needed in his work and in the travel required to accomplish and feed it. His vast output directs us to the obvious conclusion that he spent most of his private life painting in the quiet of his studio. His private life and his work were essentially two ends of the same stick. An upbringing in Covent Garden, and experience in the 1780s of painting theatrical backdrops (see SCENE PAINTER), gave him an interest in the theatre, and a knowledge and experience of contemporary theatre and *opera spilled out into correspondence and paintings such as Vision of Medea (1828; BJ 293). He almost certainly enjoyed *music, if the reported presence of a flute and sheet music among his effects is sufficient evidence, and was aware of what was going on musically in London. His favourite country relaxation was *fishing, and with rod in hand he would watch the landscape and the changing colours of the sky, and draw and make written notes. Much of his *poetry was, it seems, written on the river bank.

During his life with Sophia *Booth in Margate and later Chelsea, Turner allowed himself to be mothered and cared for. Sophia kept a tidy house, as Roberts observed, and in taking what he needed from life, as he always had, Turner found with Sophia the attention that Hannah Danby may no longer have been well enough to give him at Queen Anne Street. He had recurrent chest and possibly heart illnesses at this time, and appears to have contracted cholera in 1848/9, and it must have been through Sophia's care that he was kept alive and working. Though death was creeping up, he continued to experiment in both watercolour and oil. There is a growing sense of peace in many late works—such as The New Moon (RA 1840; BJ 386) and *Norham Castle, Sunrise (c.1845–50; BJ 512)—that must be a product of final contentment with Sophia. He repaid this by giving Sophia and her son Daniel Pound paintings, which they later sold, and by helping Pound to establish himself as a wood-engraver. Turner may, indeed, have been instrumental in introducing Pound to Mayall, catalysing the relationship that led to Pound engraving many of Mayall's portrait photographs.

An inventory made of the contents of 47 Queen Anne Street in 1854 suggests that there was very little in Turner's life that was not directed towards painting and the furtherance of his art. Apart from the good-quality furniture, ornaments, and painting equipment, portfolios and clothing, there were ship models (now in the Tate Gallery) to aid his composition, telescopes, a pair of table globes, a model church monument in the studio and odd bits of plaster or

'compo' sculpture. A plaster skull in the parlour was said to have been cast from Raphael's. Turner's *library, which descended to C. W. M. *Turner, and was first catalogued as found by Falk in 1938, comprised many books on perspective and painting, on mainstream English poetry—Burns, *Byron, *Campbell, Crabbe, *Milton, *Moore, Rogers, *Scott, and others—and books of topographical illustrations by himself and contemporaries. For an artist so immersed in the classics, however, there were surprisingly few volumes of the classical authors. Only Livy, Plutarch, and Pope's *Iliad* translation appear to be present, though there have undoubtedly been losses. Presentation copies from authors including Edward Bulwer-Lytton, Chambers *Hall, and Mary Somerville reflect the esteem in which Turner was widely held.

We know less than we should about Turner's private life not so much because he was purposely secretive, but because through coincidence and ill-luck so much correspondence and other papers have been destroyed. Turner's surviving letters are loquacious and informative, and so no doubt would be much of the lost correspondence. The papers of Egremont, Fawkes, and Trimmer were all destroyed in bulk by heirs, and in the few years between Turner's own death and the proving of his *will, his papers too vanished. All that survived were letters and envelopes addressed to him that he happened to have drawn or painted upon, clearly indicating that the whole lot was picked over by his executors and, like some of his erotic drawings, deliberately destroyed. These destructions took with them large quantities of evidence about Turner's private life, and bolstered the myths of his love of mystery, his reclusiveness, and his apparent inability to express himself in words.

See also CHILDREN OF TURNER; HEALTH OF TURNER; MUSIC AND TURNER; PORNOGRAPHY AS SUBJECT MATTER; PORTRAITS OF TURNER; SCIENCE AS SUBJECT MATTER; TURNER, MARY; TURNER, WILLIAM. JH

Thornbury 1877.
Falk 1938.
Finberg 1939.
Lindsay 1966.
Wilton 1987.
Bailey 1997.
Hamilton 1997.

PROFESSOR OF PERSPECTIVE, see PERSPECTIVE LECTURES.

PUBLICATIONS ON TURNER—1900–74. Relatively few books exclusively devoted to Turner were published in the years before 1939. The years after the Second World War

saw an ever-growing number of books and exhibitions up to the watershed of the *Turner bicentenary in 1975. The even greater number of publications that appeared in and after that year are described in a separate entry. The pre-1975 publications—excluding exhibition catalogues and journal articles—are listed here in the chronological order of their appearance.

The long-lived John *Ruskin died in the first month of the new century, and it is fitting that the only Turner publication in 1900 celebrated and commemorated his great influence on the reputation and study of Turner. Beautifully produced and printed by Ruskin's publishers, George Allen, whose address was Ruskin House, *Turner and Ruskin: An Exposition of the Work of Turner from the Writings of Ruskin* is edited and introduced by Frederick *Wedmore. Its two handsome folio volumes are illustrated by some 90 photogravure plates of paintings and watercolours, arranged in chronological order and mostly printed in sepia. The text is 'drawn from all periods' of Ruskin's writings, 'from works familiar and unfamiliar'.

The one publication of 1901 was C. F. *Bell's scholarly *A List of the Works Contributed to Public Exhibitions by J. M. W. Turner, R.A.*, a very useful reference book, of which only 350 copies were printed. In 1902 the principal Turner dealer, Thos. *Agnew & Sons, published the most luxurious volume, again a folio, ever devoted to the artist. *Turner*, by Sir Walter *Armstrong, is a richly illustrated biography, which ends with two informative lists, of 'Oil Pictures' and of 'Water-colour Drawings'. Largely because of these lists Armstrong remained the principal authority for Turner until 1939, when, as we shall see, *Finberg's biography was published. Also dating from 1902 is C. A. Swinburne's largely forgotten *Life and Work of J. M. W. Turner*, unillustrated except for a frontispiece of William Parrott's *Varnishing Day* (see PORTRAITS).

The following year, 1903, saw the appearance of the first four of the 39 volumes of George Allen's Library Edition of *The Works of John Ruskin*, edited by E. T. Cook and Alexander Wedderburn. Volumes iii and iv are devoted to *Modern Painters*, completed in the next three volumes in the following two years. The excellent and essential 'General Index' fills the whole of volume xxxix, published in 1912. In 1904 George Allen published a pocket edition of *Modern Painters* in six volumes, and there were numerous other Ruskin reprints in the early years of the century.

One of the best collections of accurate colour reproductions of Turner's watercolours that has appeared was also one of the first, T. A. Cook's *The Water-Colour Drawings of J. M. W. Turner, R.A. in the National Gallery*. This large quarto volume has 58 excellent plates of drawings for the

Rivers of England and *Rivers of France*, and the *Harbours of England* (see PORTS), and, appearing in 1904, was an early example of 'colour-printing by photography'.

In 1906 a new and greatly revised edition of W. G. *Rawlinson's pioneering *Turner's* Liber Studiorum: *A Description and a Catalogue*, first published in 1878, was issued, and remains today a valid authority on the *Liber*. Only two years later Rawlinson published the first volume of *The Engraved Work of J. M. W. Turner, R.A.*, devoted to the line-engravings on copper, 1794–1839. The second volume, which lists all the other Turner prints, was issued in 1913. These two invaluable volumes list the prints in considerable detail in chronological order, and remain unsuperseded to this day. References to Turner's prints in subsequent publications usually include their R (Rawlinson) number. Another unsuperseded and vital catalogue was published by A. J. Finberg in 1909. The two volumes of *The National Gallery: A Complete Inventory of the Drawings of the Turner Bequest: with which are included the Twenty-three Drawings bequeathed by Mr. Henry *Vaughan*, provide the systematic inventory that its title suggests. The research for this scholarly record of the multitude of drawings found in Turner's studio was originally begun by John Ruskin soon after their transfer to the National Gallery. During the time that the Bequest drawings were preserved in the Print Room at the *British Museum and since their transfer to the Clore Gallery (see TATE GALLERY), the task of revising Finberg's *Inventory* has been in hand, and much will be contributed towards this by the researches that have gone into the succession of Clore Gallery exhibition catalogues in the last ten years.

In 1909 the two outstanding Turner scholars of the day, Rawlinson and Finberg, collaborated to produce a special number of the *Studio* with excellent colour reproductions, on *The Water-Colours of J. M. W. Turner*. In the following year the hard-working A. J. Finberg published *Turner's Sketches and Drawings* (second edition 1911) in which, with the aid of 100 black and white illustrations, he planned to 're-study the character of Turner's art in the light of his sketch-books and drawings from nature'. Yet another Finberg volume appeared in 1912, the undated *Turner's Water-Colours at Farnley Hall*, a valuable record, with excellent colour plates, of Walter *Fawkes's collection before it was further broken up. It was not until 1920 that a catalogue of the oil paintings of the Turner Bequest was published, D. S. *MacColl's rather basic *National Gallery, Millbank: Catalogue; Turner Collection*, which includes a list, based on Finberg's *Inventory*, of several hundred exhibited drawings and watercolours.

A. J. Finberg's second major contribution to Turner scholarship, *The History of Turner's* Liber Studiorum *with a New Catalogue Raisonné*, was published in 1924. Though retaining the Rawlinson numbering, this added an enormous amount to our knowledge and understanding of the *Liber*, and it remains the 'standard' work on it. In 1929 Finberg's own Cotswold Gallery published his exemplary *An Introduction to Turner's *Southern Coast, with a Catalogue of the Engravings*, and in the following year his *In *Venice with Turner*, which remains useful for its illustrations, though it has been significantly overtaken by later scholarship. Five years earlier, in 1925, the Director of the British School in Rome, Dr Thomas *Ashby, had produced *Turner's Visions of *Rome*, a somewhat chatty volume in which the colour plates are disappointing.

The 1930s saw the publication of several new biographies of Turner, the first, in 1931, being *Turner: A Speculative Portrait*, by the watercolour artist Walter Bayes, who asked the reader, in his Introduction, not to take it 'too seriously'. This was followed in 1938 by Bernard *Falk's *Turner the Painter: His Hidden Life*, described as a 'frank and revealing biography'. It is largely fictional, but includes a list of books that Turner had in his own 'small but usefully varied' library. From the same year (new edition 1951) is Kenelm Foss's *The Double Life of J. M. W. Turner*. It is described by the author as 'not about a gentleman, but about a man' who bequeathed to 'posterity . . . imperishable work of unimaginable beauty'. These three quirky biographies were fortunately joined in 1939 by what remains the modern 'standard biography', A. J. Finberg's *The Life of J. M. W. Turner, R.A.*, of which a second edition, revised by Hilda F. Finberg, was published in 1961. Sadly the author had died some weeks before the appearance of the first edition, and his widow also died before her revision was printed. Finberg's *Life* at last replaced totally the problematic *Life and Correspondence* (1862 and 1877) by Walter *Thornbury, and immediately became the basis for all future Turner scholarship.

In the post-war years a considerable number of 'picture books'—some large, some small, some scholarly, and some general—were produced, including ones by John *Rothenstein (1949), Charles Clare (1951), Martin Butlin on *Turner Watercolours* (1962), Luke Herrmann (1963), Michael Kitson (1964), John Rothenstein and Martin Butlin (1964), and William Gaunt (1971). In 1965 the Tate Gallery first published two booklets, Mary Chamot's *Turner Early Works* and Martin Butlin's *Turner Later Works*, which provided a useful introduction to the paintings in the Turner Bequest. The year 1966 saw two books by Jack *Lindsay, *J. M. W. Turner: A Critical Biography*, which approaches the artist from a rather psychological point of view, and stresses the importance of poetry and literature in Turner's work, and *The Sunset Ship: The Poems of J. M. W. Turner*, edited and

with an essay by Lindsay. This brings together Turner's verses, many of them originally printed in exhibition catalogues, including *Fallacies of Hope (see POETRY). Another 1966 publication, which was the book rather than the catalogue of the important exhibition at the Museum of Modern Art, *New York, is Lawrence *Gowing's Turner: Imagination and Reality. This argues the case for Turner, especially in his later more abstract work, as a pioneer of 'modern' art.

Turner by Graham Reynolds, published in the World of Art series in 1969, is a readable, balanced, and well-illustrated account of the artist's life and work. Also published in 1969, and probably the most influential Turner book of the decade, is Colour in Turner: Poetry and Truth by John Gage. This densely written book provided much new material and thinking. The same author's Turner: *Rain, Steam and Speed is an equally illuminating and scholarly in-depth study of this famous masterpiece.

The first catalogue raisonné of the Turners in a public collection is Luke Herrmann's Ruskin and Turner, published in 1968. This provides full details and reproductions, some in colour, of all the hundred or so drawings and watercolours by Turner in the *Ashmolean Museum, Oxford, the majority of which were the gifts of John Ruskin. The book includes a study of Ruskin as a collector of Turner's drawings, and a review of Turner's development as a draughtsman.

Gerald Wilkinson published the first of his three very personal selections of sheets from sketchbooks in the Turner Bequest in 1972. Entitled Turner's Early Sketchbooks, it includes some 200 illustrations, many of which are sadly misleading colour reproductions. The second and more ambitious volume, The Sketches of Turner, R.A., 1802–20: Genius of the Romantic, appeared in 1974, with nearly 450 reproductions, again mostly of poor quality. The third, and final volume, Turner's Colour Sketches, 1820–34, dates from 1975 and is strictly speaking outside the scope of this survey.

It is a thought-provoking reflection of the insularity of the interest in British art in the first three-quarters of the 20th century that, apart from Lawrence Gowing's 1966 MOMA catalogue, there is only one book in this survey published outside Britain. This is Turner and Rotterdam by A. G. H. Bachrach, which was published in Holland in 1974. This very specific study reproduces 125 leaves from sketchbooks that Turner used on three tours in the Netherlands, in 1817, 1825, and 1841, and many are identified in detail for the first time. Since this attractive small book appeared, there have been numerous books devoted to the work of Turner in specific areas of Britain and countries abroad. However, all these post-date 1975 and will be discussed in the entry

devoted to later 20th-century publications on Turner, which follows. LH

PUBLICATIONS ON TURNER—later 20th century. The remarkable spate of books, articles, and exhibition catalogues on Turner produced in the last third of the 20th century can be matched for few other artists before the *French Impressionists. Of earlier masters perhaps only Caravaggio and *Rembrandt attracted greater attention during that period.

The upsurge of scholarly interest in Turner began, not in 1975, the year of the great *Turner bicentenary exhibitions at the Royal Academy and British Museum, but in the previous decade, with intimations still earlier. Until the 1960s the principal book on the artist was A. J. *Finberg's Life of J. M. W. Turner, R.A., first published in 1939 and reissued with some revisions in 1961. Arid, not as unbiased as it purported to be, and superficial in its account of Turner's art, this book nevertheless established for the first time the sequence of events which made up the painter's career, and thus supplied the groundwork for future research.

The first signs of a new approach came with the growth of an interest in Turner's mind—or perhaps one should say, with the recognition that he had a mind at all. In 1963, Jerrold Ziff usefully published in the Journal of the Warburg and Courtauld Institutes the text of Turner's 'Backgrounds' lecture—that discourse in which, at the end of his series of lectures at the Academy as Professor of Perspective (see PERSPECTIVE LECTURES), Turner gave his interpretation of the great poetic landscapists of the past. Ziff was also one of those who, with Ann Livermore and Jack *Lindsay, first drew attention in this period to Turner's interest in *poetry, both as a prolific writer of verses himself and as an admirer of such earlier poets as Milton, *Thomson, and *Akenside. Livermore's publication of Turner's 'verse book' together with her account of the influence on him of Thomson's Liberty in the Connoisseur Year Book for 1957 was indeed striking for its time. In 1966 Lindsay published The Sunset Ship, containing all the poetry by Turner which he thought worth preserving, and in the same year he also published a stimulating biography, Turner: His Life and Work. However, the former of these books has now largely been superseded by Andrew Wilton's Painting and Poetry: Turner's 'Verse Book' and his Work of 1804–1812, an exhibition catalogue with a long analytical essay (London, Tate Gallery, 1990), which is typically more penetrating and more scholarly than anything Lindsay wrote. Lindsay's biography of Turner is also uneven, especially as regards the artist's work—for example, it almost totally ignores Turner's travels and his output as a topographer. However, the author gave a livelier, more com-

plete, and more 'democratic' portrait of Turner the man than Finberg, and the place of his book in the literature has surely been underrated.

The year 1966 also saw the emergence of a very different type of approach: Lawrence *Gowing's *Turner: Imagination and Reality*, which accompanied an exhibition of the artist's work at the Museum of Modern Art, *New York. As the venue indicates, this was a deliberate move to align Turner with the then most prominent trend in modern painting, American abstract expressionism and abstract impressionism, and only two works by Turner dating from before 1828 were included. It is true that since the 1930s Kenneth (Lord) *Clark had frequently stressed Turner's late work, especially the unfinished pictures, which he claimed to have partly rediscovered and whose painterly freedom he much admired, but Gowing went further. He treated watercolours as the equals of oil paintings and included examples of Turner's colour diagrams. In his catalogue essay, Gowing also wrote with a descriptive freshness and verve almost worthy of *Ruskin. Here at last, one might say, was an account of Turner to appeal to a wide public, and not least to a young public. There can be little doubt that *Turner: Imagination and Reality* helped to prepare the ground for the rapturous public response to Turner's art at the bicentenary exhibitions of 1975, although the Museum of Modern Art show never travelled to Britain.

For all its brilliance, Gowing's evocation of Turner's innovative handling of light and colour remained just that—an evocation. It was left to John Gage, in *Colour in Turner: Poetry and Truth* (1969), to explore the roots of the artist's attitude. Bringing to bear a more broadly based and more scrupulous scholarship than anyone had applied to Turner before, Gage showed, for a start, that Turner's attention to colour and colour theory began much earlier in his life than had previously been supposed and that his work, so far from falling into two distinct, successive parts, in fact exhibited a continuous development, a development that was experimental at every stage. Moreover, where Gowing had done ample justice to 'imagination' in Turner but had somewhat lost sight of 'reality', Gage showed an equal grasp of both, insisting as Ruskin had done on Turner's never-ending quest for visual truth. Though not the easiest book to read—for its author never cuts intellectual corners—*Colour in Turner: Poetry and Truth* is highly interesting throughout and is probably the most profound and original book on Turner to have been written in the 20th century. It has also been one of the most influential. At all events, no subsequent scholar has attempted to deny Gage's central perception: that the key to Turner's art lies in the power, energy, and range of his intellect, unsystematic and sometimes confused though that

intellect was. In the 19th century that quality was better understood than in the first two-thirds of this, and *Constable as well as Ruskin was aware of it. 'A wonderful range of mind' was Constable's (now well-known) phrase, and it was fitting that Gage took this as the title of his 1987 book on Turner, in which he extended the approach of *Colour in Turner: Poetry and Truth* into most other areas of the artist's achievement. With these two books and with *Turner: *Rain, Steam, and Speed* (1972) and his invaluable edition of the *Collected Correspondence of J. M. W. Turner* (1980), as well as numerous periodical articles, John Gage's contribution to Turner studies in our time has been second to none.

The 1970s were marked above all by advances in the documentation of Turner's work. The catalogues of the two bicentenary exhibitions—*Turner, 1775–1851* at the Royal Academy, by Martin Butlin, Andrew Wilton, and John Gage, and *Turner in the British Museum*, by Andrew Wilton—were quite slim by modern standards, but they proposed an ordering of Turner's work which was usefully coherent without obscuring its complexity. The RA exhibition also had the invaluable merit of bringing together not only a large number of Turner's oil paintings, watercolours, pencil sketches, and some prints, but also of showing representative examples in all these categories of works both from inside and outside the Turner Bequest. There, for the first time, Turner was seen 'in the round' on a massive scale. No wonder the impression on everyone who saw the exhibition was overwhelming.

In addition, this exhibition helped, through the research done for it, to give birth to the great catalogue of the artist's oils, *The Paintings of J. M. W. Turner*, by Martin Butlin and Evelyn Joll, first published in 1977 and reissued in a second, revised edition in 1984. Every lover of Turner knows this book, familiarly referred to in other publications as 'BJ', and most possess it—it achieved the unusual distinction for an expensive art book, albeit one magnificently illustrated, mostly in colour, of being a best-seller. It included, among other things, comments by contemporary critics that had never been reprinted before, and in its provision of factual information it is quite simply definitive—in so far as any catalogue can be definitive—and indispensable.

In the mean time, Andrew Wilton was working on the catalogue of the watercolours appended to his *Life and Work of J. M. W. Turner* (1979). Although one of the worst produced books, physically speaking, in the history of scholarly publishing, in content it is of the highest distinction and of lasting importance. Dealing as the text does with the artist's oils as well as watercolours, it remains to the present writer's mind the best medium-length introduction there is to Turner's art for the serious, but not necessarily

specialized, reader. In it, Wilton solves the problem, which undid Finberg and which continues to bedevil some later Turner scholars, of writing a rounded, satisfying, and refined study of Turner's life and art without becoming bogged down in detail. Wilton was the most penetrating analyst of the visual qualities of Turner's art writing in the late 20th century, a scholar who perceived the force of the artist's intellect not, as Gage perhaps did, as a quality antecedent to the art but as embedded in the act of painting itself. *The Life and Work of J. M. W. Turner* is only the first of a stream of studies by Wilton, shorter in length, devoted to selected aspects of the artist's activity and often cast in the form of exhibition catalogues. Notable titles, besides *Painting and Poetry*, already mentioned, are: *Turner and Switzerland* (with John Russell, Zurich, 1976), *Turner and the Sublime* (1980), *Turner Abroad* (1982), *Turner in Wales* (1984), and *Turner in his Time* (1987), though the last is once again a more general study, designed as a semi-popular overview to coincide with the opening of the Clore Gallery.

Three of the above titles deal with the artist's travels, and Turner the traveller is one of the principal themes of the literature of the 1980s. Of course, there were examples earlier than this, including a short article by Hardy George in the *Art Bulletin* for 1971 demonstrating fairly conclusively that the artist's second visit to Venice occurred in 1833, not 1832 or 1835 as had previously been thought. There was also a series of studies beginning in 1974 by A. G. H. ('Fred') Bachrach concerned with Turner in Holland; these culminated in Professor Bachrach's scrupulously researched and thoughtful exhibition catalogue, *Turner's Holland* (London, Tate Gallery, 1994). But it was in 1980 that the interest in Turner the traveller, and hence in Turner as a topographical artist, really took off, initially with David Hill's exhibition catalogue of that year, *Turner in Yorkshire* (York City Art Gallery; this coincided with the first one-day symposium dedicated to Turner, organized by Selby Whittingham, the founder of the *Turner Society, at York University; the second, organized by the present writer, was at the Clore Gallery in 1987). Hill has an extraordinary capacity for putting himself in Turner's shoes, eating his breakfasts, squelching with him through streams, and scrambling up mountainsides and over moors in the rain, the experiences of which he conveys to the reader with infectious enthusiasm, and his book on Turner in Yorkshire in 1816 (1984) was appropriately called *In Turner's Footsteps*. He followed this in 1992 with a study of Turner in France and Switzerland in 1802, and in 1993 with another devoted to *Turner on the Thames* in 1805. In each case, Hill personally retraces the artist's journeys, identifies the viewpoints of his sketches, and takes useful photographs of the sites.

All studies of Turner's travels involve the minute examination of his sketchbooks as well as physically repeating his itineraries, and no one has been more indefatigable in doing both than Cecilia Powell, the most profound and intelligent scholar in the field. In her major book, *Turner in the South: Rome, Naples, Florence* (1987), she not only reconstructed the artist's journeys and identified the sites of his sketches in pencil and watercolour but also showed how his experiences of the Italian landscape fused with his sense of history to create oil paintings as poetic as any he produced. From the point of view of discovering new facts, Powell's exhibition catalogue, *Turner's Rivers of Europe: The Rhine, Meuse and Mosel* (London, Tate Gallery, 1991) was perhaps even more valuable as it encompassed a more elusive and (apart from the Rhine) less familiar aspect of the artist's activity. The author's subsequent exhibition at the Tate Gallery, *Turner in Germany* (1995), covered some of the same ground but also followed the artist into Central Europe as far as Berlin, a city which none of his British contemporaries visited.

While David Hill and Cecilia Powell made themselves into Turner's constant travelling companions, so to speak, there have also been useful single studies, notably *Turner en France* by Nicholas Alfrey (Paris, 1981), *Turner's Venice* by Lindsay Stainton (1985), and *Turner on the Loire* by Ian Warrell (1998; a similar study of the Seine followed in 1999). The research done for these publications on Turner's travels, apart from being interesting in itself, will have provided useful new information for the comprehensive revision of Finberg's *Inventory of the Drawings of the *Turner Bequest* of 1909, a long-term project at the *Tate Gallery. The same purpose was served by the six 'Decade' shows in the Clore Gallery at the Tate Gallery (1988–94) of drawings and watercolours from the Bequest, which were organized by the gallery staff, notably David Blayney Brown and Anne Lyles.

Besides books, catalogues, and articles that may be called 'Turner in . . .', there have been others classifiable as 'Turner and . . .'—for example, Turner and the Old Masters ('Turner and Claude', 'Turner and Rembrandt', both by the present writer in *Turner Studies*), Turner and the poets (for example, *Turner and Byron* by David Blayney Brown at the Tate Gallery, 1992), and Turner and his patrons. Concerning the latter, Gerald Finley wrote exhaustive studies covering Turner's professional relationship with Sir Walter *Scott in 1980 and 1982, and Martin Butlin, Mollie Luther, and Ian Warrell produced a detailed book on *Turner at Petworth: Painter and Patron* (1989), which incidentally provided another contribution to the revision of the Finberg *Inventory*. There have also been articles in *Turner Studies* on such early collectors as Joseph *Gillott (by Jeannie Chapel, 1986) and Elhanan *Bicknell (by Peter Bicknell and

Helen Guiterman, 1987). Ruskin's gift to Oxford University of watercolours and drawings by Turner was catalogued by Luke Herrmann as long ago as 1968 (*Ruskin and Turner*). Apropos of this, a recent book by Dinah Birch, *Ruskin on Turner* (1990), attempts to assess Ruskin's interpretation of the artist, but this is too slight to be useful, and a proper analysis of this challenging topic for both Turner and Ruskin studies remains to be written.

In addition to 'Turner in . . .' and 'Turner and . . .', the other main theme of the 1980s and early 1990s was the study of Turner's iconography, that is, essentially the figurative content of his landscapes. Eric Shanes was a major explorer of this, above all in his *Turner's Human Landscape* (1990). In this rich and stimulating book, he made good use of Turner's fragments of poetry and his lecture notes to present him as in some ways a traditional history painter, though a history painter who vitally extended the genre into areas of modern history. Turner also delighted in verbal and visual puns, though whether he did so in every instance proposed by Shanes is disputable. The same tendency to let ingenious connections run away with him also sometimes spoils the author's earlier *Turner's Picturesque Views in *England and Wales* (1979), which is also, and rightly, more about the human content of these views than about their characteristics as topography. However, he later corrected and greatly amplified the topographical side of this book in *Turner's England* (1990).

The other leading scholar to have concentrated on Turner's iconography is Kathleen Nicholson, whose *Turner's Classical Landscapes: Myth and Meaning* (1990) displays a greater depth of conventional learning than Shanes's book and is also very interesting but shows less awareness of Turner the living and breathing artist. Nor should one forget Ursula Seibold's published Tübingen dissertation, *Zum Verständnis des Lichts in der Malerei J. M. W. Turners* (1987). It is hardly an accident that the two most strictly philosophical studies of Turner yet written are both by authors whose nationality is not English.

During the 1990s it became increasingly difficult to identify a dominant theme in Turner studies; it seemed rather that the literature was dividing into distinct areas, mainly represented by Clore Gallery exhibition catalogues, each devoted to a range of relatively limited, miscellaneous subjects. The largest of these areas related to Turner's concern with science and technical questions, with works by Peter Bower (1990) on Turner's drawing papers, by Maurice Davies (1992) on Turner's attempts to explain the mathematics of linear perspective, on *Turner's Painting Techniques* by Joyce Townsend (1993), on *Turner's Watercolour Explorations, 1810–1842* by Eric Shanes (1997), and, the

most extensive of them, *Turner and the Scientists* (1998), by the artist's biographer, James Hamilton. One aspect of Hamilton's field of interest, Turner's depictions of early steamboats, industrial towns, and early railways, has also been the subject of a medium-length book by William S. Rodner, *J. M. W. Turner: Romantic Painter of the Industrial Revolution* (1997). Two other exhibitions of a different kind were also held in the 1990s: *Making and Meaning: Turner, The Fighting Temeraire* by Judy Egerton, at the National Gallery, London (1995), and *Italy in the Age of Turner: 'The Garden of the World'* by Cecilia Powell, at Dulwich Picture Gallery, London (1998). The latter was the more original of the two and pointed the way to a new direction in Turner studies, hitherto neglected: the discussion of his work alongside that of his contemporaries.

The prints after Turner's work, whose execution he often supervised closely (as well as occasionally wielding the etching needle himself, as in his *Liber Studiorum* designs), also re-attracted attention in the 1990s. After being first comprehensively listed by W. G. *Rawlinson and A. J. Finberg at the beginning of the 20th century, they were then largely forgotten and there has never been a major exhibition of them in Britain (though there has in America). In 1990 this situation was rectified by Luke Herrmann's *Turner Prints: The Engraved Work of J. M. W. Turner*, which the author described as 'not a catalogue and . . . not written primarily for the collector of prints, but . . . intended as a contribution to the study of the artist as a whole'. In addition, Jan Piggott devoted detailed study to the late vignette illustrations after Turner's watercolour drawings (exhibition in the Clore Gallery, 1993–4), and Gillian Forrester discussed Turner's 'Drawing Book' the *Liber Studiorum* in a new analysis in the same gallery in 1996.

Perhaps the most striking phenomenon of the decade, however, was the simultaneous appearance in 1997 of two new full-length biographies, by Anthony Bailey (*Standing in the Sun: A Life of J. M. W. Turner*) and James Hamilton (*Turner: A Life*). Both are serious, workmanlike, straightforward, informative, up-to-date, and well written—Bailey's being slightly smoother than Hamilton's, which probes more deeply. They resemble each other more than they differ, and either can be read as a useful replacement for Finberg, on which they are mainly based; where they depart from him is chiefly in that area which has become fashionable recently: Turner's supposed abuse of women.

In addition to his books and articles, Eric Shanes is known as the distinguished founder and editor of the periodical *Turner Studies*, which ran from 1981 to 1991 in 11 volumes, each containing two issues, and the present review may fittingly conclude with a brief account of this publication.

That it existed at all is a reflection of the astonishing wave of interest in Turner which reached its height in the 1980s, as well as of the energy of its editor and the generosity of the Tate Gallery in subsidizing it throughout most of its run. It is difficult to do justice to *Turner Studies* in the brief space available here. The comprehensive index, published as vol. 11, no. 2, in 1993, includes the names of no fewer than 86 separate authors, many of whom wrote for the journal several times. Not surprisingly, the most frequent contributors were those who figure most prominently in the paragraphs above: Shanes himself, Gage, Joll (for exhibition reviews), Powell, Wilton, and Ziff. Special mention should also be made of Luke Herrmann, who was a major writer of articles and reviews. Among others not so far mentioned was Sam Smiles, who contributed valuable notes on pictures and watercolours by Turner representing scenes in Devon and also wrote one of the few articles incorporating—most intelligently—attitudes developed by the 'new' art history ('Splashers, Scrawlers and Plasterers: British Landscape Painting and the Language of Criticism, 1800–40', 10/1 (summer 1990)). However, the only contributor to have sounded the new art historical trumpet at full blast is Albert Boime, 'Turner's Slave Ship: the Victims of Empire', in the same issue—the wording of its title testifies to the drift of this article. Mention may also be made here of a book by a new art historian which gives a central place to Turner in a thoughtful discussion of the notion of genius in British aesthetics during the Romantic period: *The Idea of the English Landscape Painter: Genius as Alibi in the Early Nineteenth Century* (1997), by Kay Dian Kriz.

When *Turner Studies* ceased publication in 1991, the number of articles submitted had begun to decline. Nevertheless, almost as many books and exhibition catalogues appeared after 1991 as before, and there was little or no sign of a falling-off in quality. Indeed, the two biographies published in 1997 are likely to have brought new readers to a love of Turner. What happened, rather, is that some of the urgency and sense of direction went out of Turner studies. He was no longer the object of a campaign, since this had now been won, and he had become an artist to be examined in context, although that process has hardly (in 1998) been begun. Meanwhile all those interested in Turner have a superb thrice-yearly journal in *Turner Society News*, edited since 1986 by Cecilia Powell, which combines scholarly articles and reviews with up-to-date information on current events in the Turner world.

See also OEUVRE AND COLLECTION CATALOGUES.　　MK

PUPILS. As a young man Turner gave drawing lessons although he did not much care for it and did so for only a few years: 1793/4–1799. He told *Farington that 'he first taught drawing at 5 shillings an hour and never had more than 7s. 6d.', whereas Bailey quotes 'between five and ten shillings a lesson'.

The earliest reference to pupils occurs in the 'Marford Mill' Sketchbook of 1794 (TB xx: 17) where 'Major Frazer April 6 1 Hour & Half 8 Lessons' is noted in pencil. Then on fo. 1 of the 'Small South Wales' Sketchbook of 1795 (xxv), in a bracket inscribed 'Teaching', are listed 'Mr Murwith, Mr Jones of Lewisham, Mr Davis ditto, Miss Palin, Miss Hawkins and Mr Goold'. None of these names occurs elsewhere and nothing more is known about them although the possible intrusion of pupils' work in the Bequest has been raised by Gage's suggestion that Llanthony Abbey (xxvii: Q) is a pupil's copy of xxvii: R.

But we do have information about three pupils: first, William Blake (not the poet-painter), whose name crops up initially in an inscription on the verso of *A Fishing Boat in a Choppy Sea* (private collection: W 149) of c.1796 which reads 'Drawn by JMW Turner when giving a lesson to Wm Blake (probably at the end of the 18th century)'. This was exhibited at the Royal Academy, 1974 (36), as was a watercolour, *Mountainous Landscape with Cattle* (B 18), catalogued as by William Blake of Newhouse although other authorities, including Hill, refer to him as Blake of Portland Place. Perhaps he was both at different times.

Blake commissioned several watercolours from Turner in 1797 including *Harewood Castle* (Harewood Collection; not in Wilton) and *Norham Castle* (Cecil Higgins Art Gallery, Bedford; W 226) although, having agreed a price of 8 guineas for the latter, Turner told him he had been offered 12 guineas for it, upon which Blake refused to pay any extra and so gave up the drawing. However, he was more fortunate over *Conway Castle* (W 268) of 1798–1800. This was sold at Christie's, 30 June 1981 (lot 55).

The second pupil was Julia Bennet, later Lady *Gordon, whose lessons with Turner in 1797 are discussed in her entry.

Thirdly, the Revd Robert *Nixon, who lived at Foots Cray in Kent, took lessons in landscape from Turner and in figure painting from J. F. Rigaud whose son, Stephen, accompanied Turner and Nixon on a three-day sketching tour in Kent in the spring of 1798, when Turner displeased his companions by refusing to share the expense of a bottle of wine.

On 28 November 1798 Turner told Farington that he was 'determined not to give any more lessons in drawing' and that his charge per session was 5s. However, he evidently continued to teach, for on 12 October 1799 he told Farington that 'His practice was to make a drawing in the presence of a pupil and leave it for Him [or her] to imitate'; his charges

had risen to 7s. 6d. This accords with his habit later in his career of helping other artists to correct faults in their pictures by touching on them himself rather than by explaining what they themselves should do. EJ

Finberg 1961, p. 62.
Bailey 1997, pp. 35–7.

PYE, John (1782–1874), leading English landscape engraver, and major figure in the struggle by engravers for proper recognition. Born in Birmingham, where he trained before moving to London in 1801 to work under James *Heath, who engraved the figures in Pye's fine plate of *Pope's Villa at Twickenham after Turner's painting of 1808 (BJ 72); this was published in John *Britton's *Fine Arts of the English School* in 1811 (R 76). Turner especially approved of this luminous engraving and it was said that it altered his then somewhat negative attitude towards line-engravings after his work. He expressed his satisfaction with one of the proofs, and was reported as saying to Pye, 'This will do! you can see the lights; had I known that there was a man who could do that, I would have had it done before' (Rawlinson 1908, p. xxvi).

Turner and Pye became friends, and in the next twenty years Pye engraved a number of plates after Turner, on some of which he worked together with Samuel *Middiman, who was his father-in-law. The first of these was the large *High-Street, Oxford, published in 1812 (R 79); the second the *Lake Nemi*, one of the best plates in *Hakewill's *Italy*, for which Pye also engraved the plate of *La Riccia* (R 154); and the third, and most impressive, the large plate after the 1816 Royal Academy exhibit *The Temple of Jupiter Panellenius Restored* (R 208; BJ 133), published in 1828 by Moon, Boys, and Graves. Other series for which Pye made engravings after Turner were *Whitaker's *Richmondshire*, 1819–23 (R 175 and 182), *Rogers's *Italy*, 1830 (R 365 and 369) and Walter *Scott's *Poetical Works*, 1834 (R 509). Pye contributed illustrations to many of the popular annuals of the day, and was one of the most highly regarded engravers of his time. He spent much time in France in his later years.

As part of his sustained campaign to attain greater recognition for engravers from the *Royal Academy in particular and the world of art in general, John Pye published in 1845 his informative but confusing book *Patronage of British Art* (reprinted 1970), which severely criticizes official patronage in Britain. Pye assembled an important collection of Turner's *Liber Studiorum, which he sold to the *British Museum in 1869, and his *Notes and Memoranda Respecting the* Liber Studiorum *of J. M. W. Turner, R.A., Written and Collected by the late John Pye*, was edited by J. L. Roget and published in 1879. Pye's notes and materials for this and other potential writings on the art of his time are now in the National Art Library at the *Victoria and Albert Museum. LH

PYE AND ROGET. John *Pye, who had a long association with Turner as an engraver, wrote and collected, and John Lewis Roget edited, *Notes and Memoranda Respecting the* *Liber Studiorum of J. M. W. Turner, R.A.*, published in 1879. Pye did not engrave the *Liber Studiorum*, but greatly admired it and collected progressive states of the plates. His notes, entrusted to Roget, resulted in an invaluable record of Turner's working methods and other details on the *Liber*.
 TR

PYNE, James Baker (1800–70). Born in Bristol, Pyne first studied law but soon abandoned it to become an artist, moving to London in 1835 where he exhibited at the *Royal Academy between 1836 and 1852. He became a member of the Society of British Artists in 1842 and later its Vice-President.

He travelled widely in Britain and visited *Switzerland, *Germany, and *Italy in 1846. In the late 1840s he was commissioned by *Agnew's to paint a series of *Lake District views which proved highly popular when published as coloured lithographs in 1851.

Pyne greatly admired Turner who, in turn, according to *Thornbury (1877, p. 209) considered Pyne's work 'poetic', although his most Turneresque pictures contain a marked element of pastiche. These were criticized in *Blackwood's Magazine as belonging 'to the white school, we are sorry to find him "following the leader" [Turner] in this faulty course'. This has led to some Pynes being attributed to Turner in the past. It was to Pyne that Turner, whose least favourite colour was green, said 'I wish I could do without trees'.

The Victoria and Albert Museum library contains Pyne's ledgers; these record titles and sizes of his oils which were often also numbered. EJ

Art Journal, 1856, pp. 205–8.
Ziff 1986, pp. 18–25.

PYNE, William Henry (1769–1843), watercolourist, writer, and publisher. He knew Turner as early as 1805 and remained a lifelong admirer. Pyne was a founder of the Society of Painters in Water-Colours (see WATERCOLOUR SOCIETIES) but his art was eclipsed by his later career as an author and critic. In 1833 he published, in *Arnold's Magazine of the Fine Arts*, an article on Turner whose depth of insight and breadth of sympathy was unequalled until *Ruskin published *Modern Painters*. Unlike most reviewers he admired the early and later Turner in equal measure and he mounted a spirited defence of paintings from the early 1830s that were generally vilified as incomprehensible. BV

Q

QUEEN ANNE STREET WEST. Turner is first listed in Queen Anne Street West in 1809, the year in which Benjamin Young became tenant of 64 *Harley Street. Rate returns name Turner and two others, Robert Bennett and John Jones, as co-ratepayers for no. 44, a 'house and shop', with land running towards the corner of Harley Street. The following year they were joined by the Earl of Effingham and William Brown. When in 1818 Turner took on a 35-year lease for a property in Queen Anne Street, it referred to this same site, land and outbuildings adjoining the western end of the garden of 64 Harley Street. It was here that Turner was directed by the Portland Estates in July 1820 'to rebuild before Michaelmas 1821 in a workmanlike manner . . . the part of the premises being about 20 feet in depth, the front wall of which is to be built with new picked stocks neatly pointed it is not to be stuckoed. 35 years from 1818.' The rate returns list it as 'empty and in building' at Christmas 1819.

This building, which has been variously numbered 44c and 46a, was known by Turner as 47 Queen Anne Street West. It became his home, studio, and gallery for the rest of his life, although in practice he ceased to live there after 1846 when he moved to *Cheyne Walk. It faced north, and was built to Turner's design, with abnormally large windows to the first-floor studio to gather as much clear north light as possible. In the entrance hall Turner displayed casts from the Elgin Marbles, and although William Leighton Leitch reported in 1842 that the hall had a 'square empty appearence; no furniture in it, a dingy brown colour on the walls', it is likely that Turner originally set it out in a welcoming manner with mahogany hall chairs and table, a clock, and some decorative ceramics. The parlour and dining room were similarly well furnished, as the inventory (1854) of the house reveals. Some of Turner's furniture has found its way by bequest to the Mayor's Parlour in Hastings Town Hall. Turner's parlour was hung with yellow morine curtains, and it is possible that the walls also were painted a fashionable yellow to match.

In the basement was the kitchen and scullery, and on the first floor the gallery (about 55 × 19 ft., 16.8 × 5.8 m.) top-lit on a north–south axis behind the studio. From here there was probably a connecting door, and certainly a peep-hole. At the end of the gallery the building extended to the east, and it was likely that there was a back staircase and storage room for paintings and frames here. Below the gallery there must have been further extensive storage. The gallery was lined with Indian red fabric, as the Revd William *Kingsley, who had seen it in the early 1820s, reported. 'It was the best lighted gallery I have ever seen, and the effect got by the simplest means; a herring net was spread from end to end just above the walls, and sheets of tissue paper spread on the net, the roof itself being like that of a greenhouse. By this the light was diffused close to the pictures.' The interior of the gallery can be seen in two paintings by George *Jones (Ashmolean Museum, Oxford). On the second floor there were two bedrooms, and in the yard an outbuilding with rooms over.

Turner lived at the address with his father, and with Hannah *Danby and her many Manx cats. The property deteriorated in the 1840s, when Leitch had to keep his umbrella up when standing in the gallery, 'no sound to be heard but the rain splashing through the broken windows onto the floor'. The paintings suffered heavily under these conditions, but the storage space below may have remained dry. Turner did not wholly neglect the property, however, but tried to spruce it up by having its windows cleaned, as a journalist noted in September 1850. Nevertheless, its decline was inexorable and its appearance forbidding by the time Turner died, when it was described as looking like a place where some great crime had been committed. It was demolished in 1882.

See also ARCHITECT, TURNER AS; TURNER'S GALLERY AND EXHIBITIONS. JH

Finberg 1961, pp. 267–70.
Lindsay 1966, 159, 215–17 and *passim*.
Selby Whittingham, '47 Queen Anne Street West', *Turner Society News*, 39 (February 1986), pp. 8–11.
Wilton 1987, ch. 4 and p. 248.
Bailey 1997, ch. 5 and pp. 417–18.
Hamilton 1997, pp. 100, 189, 208, 211–13, 304–8.

R

RABY CASTLE, the Seat of the Earl of Darlington, oil on canvas, 46¾ × 71¼ in. (119 × 180.6 cm.); Walters Art Gallery, Baltimore (BJ 136). Turner was invited to Raby in Co. Durham by Lord *Darlington (1766–1842) in the autumn of 1817 and studies for the picture occur in the 'Raby' Sketchbook (TB CLVI). Lord Darlington was a passionate foxhunter and X-rays reveal that Turner originally introduced large-scale mounted figures in the foreground. Lord Darlington evidently objected to these when he first saw the picture (a rare instance, therefore, of Turner misinterpreting a patron's wishes), for Turner later relegated the hunting scene to the background, which ensured that the castle became the focal point of the composition as the owner wished.

The critics concentrated on The *Field of Waterloo (BJ 138) and the *Dort (Yale Center for British Art, New Haven; BJ 137) but the Literary Chronicle (22 June) referred to Turner's 'still more detestable [than Waterloo] fox hunting picture', which proves that it was then still unaltered. EJ

RADCLYFFE, William (1783–1855), English line-engraver. He was born, trained, and largely working in Birmingham, where he formed a school for engravers, producing some of the leading practioners of the day. Radclyffe's first plate after Turner was of a view of Deal (R 124) published in 1826 in Cooke's *Southern Coast of England. In the 1830s he was responsible for seven engravings in the *England and Wales series (R 233, 254, 260, 264, 270, 281, 295). Radclyffe also engraved three steel plates after Turner, two for the *Seine tour of 1835 (R 478, 487) and one, of Nineveh (R 585), in *Finden's Landscape Illustrations of the Bible, also published in 1835. LH

RAFFAELLE, ACCOMPANIED BY LA FORNARINA . . ., see ROME, FROM THE VATICAN . . .

RAILWAYS. Horse-drawn carts on wooden rails had been used to carry coal to ports and rivers since the early 17th century. These were gradually replaced, from 1804, by steam locomotives on wrought iron tracks, and it is this later system which Turner represented in his *Rivers of England design Shields, on the River Tyne, 1823 (TB CCVIII: V; W 732). Here, a coal-wagon is seen on cliffs above a line of sea-going collier-brigs, some of which were still in the practice of taking their loads from the barges which had long operated on the Tyne. Turner's prominent placement of a full moon, symbolic of death, perhaps emphasizes the demise of the keelmen's vocation.

While the industrial value of railways was fully apparent by the 1820s, the following decade witnessed a boom in their significance as a mode of public transport. This was underpinned by massive commercial speculation, which by 1840 had seen 2,400 miles of track laid in Britain. The subsequent 'railway mania' of the 1840s was reflected upon by Turner in his principal statement on the subject, *Rain, Steam, and Speed (RA 1844; National Gallery, London; BJ 409). The painting represents the Great Western Railway crossing the Thames at Maidenhead on Isambard Kingdom Brunel's bridge, famously incorporating the largest elliptical brick arches in the world. Brunel had masterminded the entire line, begun in 1836, which by the exhibition of Turner's painting ran from London to Exeter and was the fastest in Britain. Aside from Lady Simon's possibly dubious anecdote, related both to *Ruskin and to George Richmond (Gage 1972, p. 16), there is no evidence that Turner actually used the Great Western. A letter of 1840, however, demonstrates the painter's general enthusiasm for rail travel (ibid., p. 43), although his adoption of it as subject matter went largely without parallel among artist contemporaries; a series of watercolours and a lost oil, Wind, Rain and Sunshine, 1845, by David Cox being notable exceptions. In general, railways elicited a negative response from the cultural élite; John *Martin, *Wordsworth, Dickens, and Ruskin, who never discussed Rain, Steam, and Speed in later volumes of Modern Painters, all spoke out against their destructive impact on the landscape. While some writers have acknowledged Turner's more positive stance, ambiguously expressed through Rain, Steam, and Speed (e.g. Gage and

Hamilton), others have argued for a more negative reading of the painting (e.g. McCoubrey). ADRL

Gage 1972.

McCoubrey 1986, pp. 33–9.

Hamilton 1998, p. 300.

RAIN, STEAM, AND SPEED—*The Great Western Railway,* oil on canvas, 35¾ × 48 in. (91 × 122 cm.), RA 1844 (62); National Gallery, London (BJ 409); see Pl. 31. According to both George Richmond and John *Ruskin, Lady Simon, returning from Devonshire in a storm, either by train or coach, saw Turner put his head out of the window to observe the effect and get drenched; encouraged by his example she did the same and recognized the effect at the next Royal Academy exhibition. George Dunlop Leslie, RA, thought that the painted-out hare running for its life in front of the locomotive represented speed rather than the train itself, while the man ploughing on the right alluded to the saying 'Speed the plough'. The picture reflects both Turner's interest in up-to-date imagery and in the symbolic contrast between the train and the countryside. The picture was also inspired by the *railway mania of the late 1830s and early 1840s. The site of the picture has been identified as a railway bridge over the Thames at Maidenhead looking east towards London.

According to Ruskin, who otherwise hardly mentions the picture, Turner only painted it 'To show what he could do even with an ugly subject' (*Works,* xxxv. p. 601 n. 1). The press, however, was torn between amazement and admiration. For *The Times,* 8 May 1844, 'The dark atmosphere, the bright sparkling fire of the engine, and the dusty smoke, form a very striking combination', while for *Fraser's Magazine,* June, Turner 'has out-prodigied almost all of former prodigies. He has made a picture with real rain, behind which is real sunshine, and you expect a rainbow every minute'. *Fraser's Magazine* also noted the technique: 'The rain . . . is composed of dirty putty *slapped* on to the canvass with a trowel; the sunshine scintillates out of very thick, smeary lumps of chrome yellow. The shadows are produced by cool tones of crimson lake and quiet glazings of vermillion . . . The world has never seen anything like this picture.'

The picture made a great impression on Monet and Pissarro when they visited London in 1870–1 and it became almost an icon for the *French Impressionists, an etching of the picture by Félix Brachquemond being included in their first exhibition in Paris in 1874. MB

Gage 1972.

McCoubrey 1986, pp. 33–9, repr.

Egerton 1998, pp. 316–25, repr. in colour.

RAWLE, Samuel (1771–1860), topographical engraver and draughtsman working in London. From 1798 he engraved many plates for the *European* and *Gentleman's* magazines. In 1800 he engraved and published the earliest views after Turner issued separately, two views of Dunster Castle in Somerset (R 48–9). Two decades later, in 1819–20, Rawle engraved three plates after Turner in Robert Surtees's *History of the County of Durham* (R 141–3), and in 1818 he also engraved one of Turner's drawings for *Hakewill's Picturesque Tour of Italy* (R 157). His plates were often rather hard and grey. LH

RAWLINSON, William George (1840–1928), silk merchant, art collector, and Turner scholar. He was born at Taunton, Somerset, the only son of William Rawlinson, who owned a silk mill there. Nothing is known of his education, and in about 1865 young Rawlinson joined a London silk firm, James Pearsall & Co., which handled the produce of the mill at Taunton. Later, as a partner in that business he helped to create the English embroidery-silk trade, until then a German monopoly. In conjunction with Sir Thomas Wardle, of Leek, he reintroduced old methods of dyeing silk with the natural dyes of the East. He retired from this business in 1908.

Rawlinson is chiefly remembered for his scholarly publications on the engraved work of Turner, of whose drawings and prints he was an assiduous collector. In 1878, he published *Turner's *Liber Studiorum: A Description and a Catalogue,* which he described as 'mainly compiled—a labour of love indeed—in such intervals as I have been able to snatch from City work'. Based on the pioneering catalogue of the *Burlington Fine Arts Club 1872 *Liber* exhibition, and much influenced by the writings of John *Ruskin, this was the essential guide for all students and collectors of *Liber* prints. A second, much revised, edition appeared in 1906, and was only superseded in 1924 by the more exhaustive catalogue of A. J. *Finberg.

However, Rawlinson's other major Turner publication, the two-volume *The Engraved Work of J. M. W. Turner, R.A.* (1908 and 1913), remains the only extensive catalogue of the nearly 900 prints, in addition to the *Liber Studiorum,* by and after Turner. The researches that led to these invaluable catalogues were based on Rawlinson's own extensive collection of Turner prints. His collecting of the artist's watercolours is reflected in his contributions to a special number of the *Studio* on Turner's watercolours published in 1909. His choice collection of 33 Turner watercolours was sold in 1917 to R. A. *Tatton, after whose death it was dispersed at Christie's on 14 December 1928. Rawlinson's collection of *Liber* proofs, of which he had issued a privately printed catalogue in 1887, with a revised edition in 1912, was sold late in that year to Francis *Bullard, of Boston, Massachusetts, and

formed part of that collector's great bequest to the *Boston Museum of Fine Arts, in 1913. Rawlinson's unrivalled collection of other Turner engravings was bought, as a whole, in 1919 by Mr Stephen *Courtauld, and is now in the *Yale Center for British Art, New Haven, Conn. Late in his career as a collector Rawlinson also became interested in coloured aquatints of the early 19th century and in blue and white Chinese porcelain. LH

RECREATIONS, see PRIVATE LIFE.

REDGRAVE, Samuel (1802–76) and **Richard** (1804–88), co-authors of *A Century of Painters of the English School* (1866), a valuable source of first-hand, anecdotal information about Turner's life and art. Samuel, whose career with the Home Office did not interfere with his lifelong commitment to the arts, was an architecture student in the *Royal Academy Schools. He arranged the British watercolour paintings in the International Exhibition of 1862, compiled a catalogue of watercolours in the South Kensington Museum, and wrote *A Dictionary of Artists of the English School*. Richard, a Royal Academician noted for narrative scenes depicting the poor and oppressed (*The Governess*, Victoria and Albert Museum), was also an avid landscape painter. Contemporaries of Turner, the Redgrave brothers had personal knowledge of his working methods and materials; they shared his interest in colour theory and, as their writings confirm, were particularly sensitive to his innovative contributions to the development of watercolour painting. Richard's diary, on which his *Memoir* was based, records recollections of Turner, including his lectures and funeral; there are two sketches of Turner by Richard (Victoria and Albert Museum; see PORTRAITS OF TURNER). JCI

F. M. Redgrave, *Richard Redgrave, A Memoir*, 1891.

Susan P. Casteras and Ronald Parkinson, eds., *Richard Redgrave 1804–1888*, exhibition catalogue, London, Victoria and Albert Museum, 1988.

REFORM BILLS. The Whig Government that took office in 1830 introduced a Parliamentary Reform Bill widening the franchise and eliminating some of the worst electoral corruption in 1831. This was defeated by the Tories in committee, and after a general election a second Bill was brought forward, only to be defeated in the House of Lords. The subsequent outcry persuaded the Lords to let a third Bill go through in 1832. This Bill extended the vote to many middle-class males, but large sections of the working class remained disenfranchised (hence *Chartism). Turner evidently supported Reform, having been close friends with the Whiggish (i.e. moderate) Radical MP Walter *Fawkes since c.1808. A watercolour of *Northampton* (c.1830–1;

W 881), probably made but never engraved for *Picturesque Views in *England and Wales*, shows the chairing of Lord Althorp, the Whig Chancellor of the Exchequer, after his re-election in December 1830; a triumphal procession carries banners with constitutional slogans. Before the final Bill had been passed, Turner exhibited *The Prince of Orange, William III, embarked from Holland, and landed at Torbay, November 4th, 1688, after a Stormy Passage* (RA 1832; BJ 343) This picture further situates the artist within Whiggism, celebrating as it does the inauguration of the Glorious Revolution, and inviting parallels between William III's 'stormy passage', and that of the Reform Bills. In 1835, Turner exhibited two paintings of *The Burning of the Houses of Lords and Commons* (see PARLIAMENT), an event which he had witnessed the previous year (Philadelphia Museum of Art, BJ 359; Cleveland Museum of Art, Ohio; BJ 364). It is likely that he intended a parallel between the purging of ancient parliamentary buildings by fire and the purging of Britain's ancient parliamentary system by Reform.

 AK

Solender 1984.
Shanes 1990, pp. 16–20.
Shanes 1990², pp. 222–3.

REGENCY STYLE. Technically this term relates to the style in architectural and decorative work dominant between 1811 and 1820, the period in which George, Prince of Wales, was Regent before becoming *George IV. In practice, however, it is applied to the late phase of the *Neoclassical movement in Britain running from the late 1790s to the 1830s. While the underlying design of Regency works was based on classical simplicity, these were often adorned with sumptuous decoration—something that reflected the lavish taste of the Prince Regent himself and which echoed the 'Empire' style promoted at the same time by the Emperor *Napoleon in France. It was during this period that the archaeological tendencies of the Neoclassical movement reached their height. As well as Greek and Roman forms, there was also a taste for Egyptian motifs, stimulated by Napoleon's Egyptian expedition of 1798. There was interest, too, in exotic 'oriental' forms based on Chinese and Indian art. These can be seen in the building that epitomizes the Regency style at its most exotic—the Brighton Pavilion, a remodelling of an earlier building for the Prince Regent by the architect John *Nash, begun in 1815.

Nash is the architect most frequently associated with the Regency style. Since he was the principal architect for the Prince Regent, this is highly appropriate. A brilliant and showy designer, he created a flamboyant form of classicism—incorporating dramatic moments of simplicity. Apart from the Brighton Pavilion, this can be seen at its best

in his metropolitan improvements to the West End of London. The more complex work of Turner's architect friend John *Soane is less frequently associated with the Regency style, although it reveals a similar interest in classical simplicity and archaeological reconstruction. The Regency style is most evident in the decorative arts. The furniture of C. H. Tatham and Thomas Sheraton showed a new archaeological purity of design, to be contrasted to the earlier more decorative use of classical motifs by Robert Adam and Hepplewhite. The purest work of this kind was that designed by the influential patron and arbiter of taste, Thomas Hope.

Regency style is not a term normally applied to painting. However, the Regency style had its impact on architectural reconstructions in history paintings, most notably in the fantastic biblical scenes of John *Martin. WV

John Fleming and Hugh Honour, *The Penguin Dictionary of Decorative Arts*, 1977.

REGULUS, oil on canvas, 35¼ × 48¾ in. (91 × 124 cm.), 1828, BI 1837 (120); Tate Gallery, London (BJ 294). A typical *Claudian port scene, painted and exhibited in Rome in 1828 but considerably reworked before being exhibited again in 1837. The particular model is Claude's *Seaport with the Villa Medici* in the Uffizi, Florence (copied by Turner in 1828 in the 'Rome and Florence' Sketchbook, TB CXCI: 60); Turner sketched another *Claudian Harbour Scene* on a roll of canvas in Rome (BJ 313; see ROMAN OIL SKETCHES). The title alludes to the fact that Regulus, having deliberately failed to arrange an exchange of prisoners with the Carthaginians, was punished by having his eyelids cut off and was then exposed to the sun which blinded him; the spectator stands in the position of Regulus (see Gage 1969, p. 143; Wilton 1980, pp. 142–3, points out, however, that the picture was engraved in 1840 as 'Ancient Carthage—the Embarkation of Regulus').

The young Sir John Gilbert (1817–97) noted Turner at work on the picture in the British Institution in 1837 (see VARNISHING DAYS): there were ruled lines from the sun, 'I suppose to guide his eye', and most of his time was occupied by 'scumbling a lot of white into his picture—nearly all over it'; 'the sun was a lump of white standing out like the boss on a shield'. As the *Literary Gazette*, 4 February 1837, pointed out, the 'sun absolutely dazzles the eyes'. However, for the *Spectator*, 11 February, 'Turner is just the reverse of Claude; instead of the repose of beauty . . . here all is glare, turbulence, and uneasiness'. MB

REMBRANDT VAN RIJN (1606–69). The greatest painter of the Dutch Golden Age was a miller's son from Leiden who after various local apprenticeships moved to

*Amsterdam in 1631. In 1632 he made his name with *The Anatomy Lesson of Dr Tulp* (Mauritshuis, The Hague); Turner, following the guidebook notes in his 'Itinerary Rhine Tour' Sketchbook, saw this unique medical group portrait together with the world-famous militia-picture *The Company of Capt. Banning Cocq* or 'Nightwatch' of 1642 (Rijksmuseum, Amsterdam) on 7 September 1817 (TB CLIX: 10 and 100).

As an artist, Turner was first associated with Rembrandt in 1801 when Benjamin *West, President of the Royal Academy, commented that *Dutch Boats in a Gale* (BJ 14) was 'what Rembrandt thought of but could not do' while *Fuseli found it 'quite Rembrandtish'. As to his own feelings, these first appear in the 'Studies in the Louvre' Sketchbook (LXXII) of 1802, the year of his election to full Royal Academician status. In these memoranda, both sketched and written, he brashly dealt with the 'Good Samaritan', 'The Angel Departeth from Tobit Family', and 'Susanna' successively (LXXII: 59a, 60, 60a, 61) as 'rather monotonous' about the first; 'rich in colour and brilliant in effect but hard' about the second; and 'miserably drawn and poor in expression' about the third. Six years later, however, he noted in his 'Greenwich' Sketchbook 'Rembrandt is a strong instance of reflected light', calling the celebrated *Mill* 'an instance of the strongest class' (CII: 17, 19). Subsequently, lecturing on 'Backgrounds' in 1811 (see PERSPECTIVE LECTURES), he emphasized Rembrandt's 'negative quality of shade and colour' and 'aerial perspective enwrapt in gloom' before the intensity of his feeling prompted him to the profound, poetic passage:

Rembrandt depended upon his chiaroscuro, his bursts of light and darkness to be *felt*. He threw a mysterious doubt over the meanest piece of Common; nay, more, his forms, if they can be called so, are the most objectionable that could be chosen, namely, the Three Trees and the Mill, but over each he has thrown that veil of matchless colour, that lucid interval of Morning dawn and dewy light on which the Eye dwells so completely enthrall'd, and it seeks not for its liberty, but as it were, thinks it a sacrilege to pierce the mystic shell of colour in search of form. (p. 145)

Turner's relationship with Rembrandt knew three phases, although in each the Dutch Master's handling of light was the chief attraction after that of space and colour. Early examples are *Limekiln at Coalbrookdale* of *c*.1797 (Yale Center for British Art, New Haven; BJ 22), *The Garreteer's Petition* (RA 1809; BJ 100), and *The Grand Junction Canal at Southall Mill* (Turner's gallery 1810; private collection; BJ 101).

By 1818, Rembrandt's *chiaroscuro* and his use of several sources of light in the same composition reappear in Turner's *Field of Waterloo* (RA 1818; BJ 138). But it was not until 1827 when painting his possibly semi-autobiographical

Rembrandt's Daughter (Fogg Art Museum, Cambridge, Mass.; BJ 238) and thereby echoing the Dutch Master's *Joseph and Potiphar's Wife* (Staatliches Museum, Berlin) at a time when widespread interest in Rembrandt's art and life had become a British phenomenon, that Turner openly demonstrated his personal allegiance.

In 1830, with the Belgian Revolt front-page material in the press, he exhibited the seemingly enigmatic *Pilate washing his Hands* (BJ 332) as well as the glowing *Jessica* (BJ 333); the former evidently a deliberate exercise in Rembrandtesque crowd management with a political message, the latter a successful following of the popular genre of half-length portraits of young women in the opening of a window or door.

Typically, Turner's next and last directly Rembrandt-inspired compositions, his *Shadrach, Meshech and Abednego in the Fiery Furnace* of 1832 (BJ 346) and the unfinished *Christ driving the Traders from the Temple* (BJ 436), were less successful. But, taken all in all, what Rembrandt had come to mean for Turner was unique light effects based on an unequalled handling of colour in consistently unorthodox, dramatic compositions. In his early criticism he had followed the spirit of his time in rejecting anything that ignored the classical rules in choice of subject and composition.

Parallel to his daring artistic emancipation, Turner often took over from the Old Masters what suited his creative purpose while at the same time undertaking again and again to outpaint them. After the Italians, Rembrandt may be said to head the list of his Dutch models.

This characteristic also manifested itself in pastiche, as in *The Unpaid Bill* (RA 1808; private collection, USA; BJ 81), *The Garreteer's Petition*, and *The Artist's Studio*, extant only as a watercolour (c.1809; CXXI: B). In the unfinished *Christ driving the Traders from the Temple*, the last irrefutably Rembrandtesque composition after *The Fiery Furnace*, the diagonal flow of largely female figures from top right to bottom left may seem to detract from the seriousness of the subject, but this is merely a detail. And perhaps the most fascinating side to Turner's relationship with the rule-defying Master is that this link remained alive with him to the end—even where 'indistinctness' was his defiant 'fault', as he snorted after complaints about *Staffa, Fingal's Cave* of 1832 (Yale Center for British Art, New Haven; BJ 347).

This lends to both the interiors and the landscapes and seascapes of his last phase an emotional tension all of their own, as recognizable even in pictures like *Rain, Steam, and Speed* of 1844 (National Gallery, London; BJ 409) and even certain drawing-room scenes at *Petworth which might be called 'Rembrandt reinvented'. Of course, whether

the Dutch Master's dramatic life—leading from opulence with a rich wife to bankruptcy with a son and servant-mistress while nevertheless remaining immensely productive—also touched Turner's capacity for empathy can only be surmised, *pace* his 'vide *Lives of the Dutch Painters*' as appended to the catalogue entry for *Van Tromp going about to please his Masters* of 1844 (Getty Museum, Malibu, California; BJ 410).　　　　　　　　　　　　　　　　　　AGHB

Kitson 1988, pp. 2–19.

Christopher Brown, with Jan Kelch and Pieter Van Thiel, *Rembrandt: The Master and his Workshop*, 1992.

RENI, Guido (1575–1642), Bolognese painter. He was greatly admired by 18th- and early 19th-century British visitors to Italy for his graceful and idealizing classical style though he was criticized by Sir Joshua *Reynolds for monotony of expression in his dramatic subjects. One of Reni's most celebrated and best-preserved works is the huge fresco *Aurora*, painted on the ceiling of the Casino Rospigliosi, Rome, in 1613–14. Turner studied this in a line-engraving in 1812 and mentioned it in one of his *perspective lectures in 1818. When he first visited Rome in 1819 he wrote detailed notes on its colouring and perspectival effects in his 'Remarks (Italy)' Sketchbook (TB CXCIII: 3–3v.), the fullest analysis of any painting he studied there. Reni's depiction of the torch-bearing boy Phosphorus accompanying his mother, the dawn goddess Aurora, may have contributed to Turner's inclusion of phosphorescent nymphs in his own most gorgeously coloured dawn scene, *Ulysses deriding Polyphemus* (RA 1829; National Gallery, London; BJ 330).

CFP

REPLICAS AND VARIANTS are relatively rare in Turner's work, unlike other artists such as Richard *Wilson, who spoke of a successful composition as a 'good breeder' and painted well over twenty versions of *The White Monk* over a number of years (W. G. Constable, *Richard Wilson*, 1953, pp. 227–30). Though they do occur in Turner's work, there is usually a special reason.

In oil paintings replicas or variants are particularly rare. Among early works the small *Caernarvon Castle* of c.1798 (BJ 28) seems to be an alternative in oils to a watercolour sketch (TB XLIII: 39v.) eventually used for a large finished watercolour exhibited at the Royal Academy in 1799 (private collection; W 254). Of finished works, the smaller oil of *Dunstanborough Castle* (c.1798; Dunedin Public Art Gallery, New Zealand; BJ 32) is close to the watercolour of much the same date (Laing Art Gallery, Newcastle upon Tyne; W 284). Other similarities between oils and watercolours occur later in Turner's career, as in the oil of *Teignmouth* (Turner's gallery 1812; Petworth House; BJ 120) and the more detailed

watercolour from the *Southern Coast series (engraved 1815; Yale Center for British Art, New Haven; W 452). What was once thought to be Turner's own replica of Kilgarran Castle on the Twyvey, Hazy Sunrise (RA 1799; National Trust, on loan to Wordsworth House, Cockermouth; BJ 11) is now usually thought to be a copy (BJ 550); two other Turner oils of Cilgerran Castle, as it is now spelled, are from different viewpoints (the Viscount Allendale, and the Leicestershire Museum and Art Gallery; BJ 36, 37). Another painting of the late 1790s, Aeneas and the Sibyl, Lake Avernus (c.1798; BJ 34), was repeated in a version painted for Colt *Hoare in 1814–15 (Yale Center for British Art, New Haven; BJ 226), possibly a replacement for the earlier version, though there is no evidence for this; this is much more 'advanced' and *Claudian than the early, Wilsonian version (see Woodbridge 1970, pp. 89, 183, 243, 270).

In the case of another composition repeated a number of years later there is much less difference in stylistic character: Châteaux de St. Michael, Bonneville, Savoy, exhibited at the Royal Academy in 1803 as one of the first results of Turner's first visit to the Alps (Dallas Museum of Art; BJ 50; see BONNEVILLE for the confusion over the two pictures of Bonneville exhibited in 1803) was closely followed in the work exhibited at the RA in 1812 as A View of the Castle of St. Michael, near Bonneville, Savoy (John G. Johnson Collection, Philadelphia; BJ 124). There is hardly any difference between the two pictures, not even in the two figures in the left-hand foreground, though there is an additional suggestion of cloud between the two ranges of mountains on the right. Turner had already repeated the composition in two watercolours of probably 1807 and a year or two later (W 381, 385), and one can only suppose that each was done on commission for somebody who particularly liked the subject.

In the late 1820s the relative closeness in compositions as between the first and second versions of the four subjects of *Petworth and nearby (BJ 282–6, and, at Petworth, BJ 288–91) may have been the result of Lord *Egremont's preference for slightly greater finish or merely because Turner had got his measurements wrong for the earlier series.

Among later works there seems to be only one genuine replica, that of Shade and Darkness—Evening of the Deluge (RA 1843; BJ 404) in The Evening of the Deluge of the same date now in the National Gallery of Art, Washington (BJ 443). The exhibited work was paired with *Light and Colour (Goethe's Theory)—the Morning after the Deluge (BJ 405) specifically to contrast the 'plus' and 'minus' aspects of *Goethe's theory; the Washington version would seem to have been painted before Turner thought of this contrast. In the case of Neapolitan Fisher-Girls surprised Bathing by Moonlight, RA 1840, and Schloss Rosenau, RA 1841, the replicas are not now usually accepted as genuine. In the case of the former both the version in the Henry E. Huntington Library and Art Gallery, San Marino, Calif. (BJ 388) and that in a US private collection (BJ 389) have their champions though this writer prefers the former. In the case of *Schloss Rosenau the version in the Walker Art Gallery, Liverpool (BJ 392) is generally accepted in preference to that in the Yale Center for British Art (BJ 442).

Among Turner's watercolours there are a number of replicas, particularly of earlier works. A typical example is *Norham Castle, of which Turner did various versions for exhibition, patrons, the *Liber Studiorum, and finally as one of the late oils based on a Liber Studiorum subject (c.1845–50; BJ 512). In the case of some of the watercolours resulting from Turner's *Rhine journey of 1817, the replicas of a year or so later are more finished, presumably resulting from the more conventional tastes of the people who commissioned them in comparison with that of Turner's regular patron Walter *Fawkes. Late in his life, Turner produced sample watercolours, mainly of *Swiss subjects and all but finished in technique, from which patrons could commission final versions.

See also FAKES AND COPIES. MB

REPUTATION DURING TURNER'S LIFETIME.
From early on Turner's outstanding abilities as a landscape painter were recognized. Already in 1797, the second year in which he exhibited oil paintings at the *Royal Academy, his work was praised in the press as showing 'undeniable proof of the possession of genius and judgement' and for being original in its perception of nature. But this recognition was followed very soon by frustration and confusion about what seemed to be the artist's waywardness. As early as 1799 critics were beginning to complain about his lack of finish and pictorial excesses. This mixture of praise and exasperation continued throughout his life, with varying degrees of emphasis. On the whole journalistic criticism became increasingly negative in the artist's last years. On the other hand he did receive in 1843 the most powerful support from the young John *Ruskin in the first volume of that critic's book Modern Painters. Ruskin saw Turner as the greatest landscape painter who had ever lived. He argued that the apparent excesses of his manner were the outcome of an unusually penetrating perception of the workings of nature, and of the workings of the presence of the Divine through these. While this interpretation may be wide of the mark in some aspects, it did manage to sustain Turner's reputation at a highly critical moment in the artist's career.

Turner's earliest reputation was gained for his watercolours at a time when this medium was achieving a new

prominence. The Academician Joseph *Farington noted the artist's watercolours exhibited in 1797 as ingenious, but possessing a 'mannered' harmony. Much early criticism was directed towards comparing him with *Girtin. Some patrons—such as Edward *Lascelles—considered the latter to have more 'genius' and originality. Turner himself acknowledged the power of Girtin's achievement, though significantly his generous remarks come from after 1802, the year in which his rival died.

By this time, however, Turner was well established as an oil painter as well, and had been elected a full Academician. His sea pieces were responded to particularly favourably at this time. There was almost universal applause for his 'Bridgewater Seapiece' (*Dutch Ships in a Gale; BJ 14), when it was exhibited in 1801. *Fuseli, an exacting critic, regarded it as the best in the show and even Sir George *Beaumont—later to become one of Turner's fiercest opponents— admired it. Perhaps the fact that such sensationalist work was aimed at rivalling the Dutch in naturalistic effect made it easier to appreciate the technical advances incorporated in it. There was less approval when Turner came to challenge the values of classical landscape, particularly those of *Claude, since here it was commonly believed that an unbeatable standard of ideality had already been obtained.

Turner's innovatory use of colour in this context first brought him up against the most powerful of contemporary connoisseurs, Sir George Beaumont, in 1803. According to Farington, the classicizing *Festival upon the Opening of the Vintage of Macon (RA 1803; Sheffield City Art Galleries; BJ 47) was described by Sir George Beaumont as 'borrowed from Claude but the colouring forgotten'. Beaumont—normally a generous patron of contemporary artists—took a dislike to Turner's art that seems strangely personal. He particularly attacked him on pictures that were in the Claudian mode. Turner's great modern masterpiece in this genre, *Crossing the Brook (RA 1815; BJ 130), was dismissed by him as showing the 'insipidity' of the work of an old man. Some contemporaries thought that Beaumont's opposition did Turner damage, but most conceded that Turner was really too secure in his reputation to suffer from such attack. Turner had, moreover, the support of several powerful and wealthy patrons—such as Walter *Fawkes and the Earl of *Egremont—which more than compensated for Beaumont's attacks.

Most journalistic criticism of Turner was relatively episodic. Yet it was far from being consistently trivial. While there was a constant string of insults—such as the jibe in 1803 that the sea in *Calais Pier (RA 1803; BJ 48) was like 'soap and chalk'—there was often generous recognition of the artist's stature. In 1815 the *Champion* presciently observed that *Crossing the Brook* and **Dido building Carthage* (RA 1815; BJ 131) were 'achievements that raise the achiever to that small but noble group, formed of the masters whose day is not so much today as of "all time"'. Such an observation was well in advance of the judgement of the leading art journalist of the day, the essayist William *Hazlitt, who simultaneously acknowledged and censured Turner's atmospheric virtuosity. Writing in the *Examiner* in 1816 he called him the 'ablest landscape-painter now living', but criticized his tendency to make 'too much abstraction of aerial perspective' and concluded that he made 'pictures of nothing, and very like' (Bailey 1997, p. 187). Like so many critics, Hazlitt seemed incapable of appreciating that Turner's amazing atmospheric effects could not have been achieved had a laborious attention to detail predominated in his work.

Censure in this direction was as nothing compared to the disbelief that Turner encountered on most occasions when he exhibited his work abroad. In 1828, during his second visit to *Rome, Turner staged a showing of his *Vision of Medea* (BJ 293) and other works which filled the visitors with 'wonder and pity'. The ultimate débâcle came for Turner when he sent his **Opening of the Wallhalla* (RA 1843; BJ 401) to the Congress of European Art at *Munich in 1845. Local connoisseurs were so shocked by the treatment of this national event that they thought that the British artist was having a joke at their expense. Germans seem to have been particularly troubled by Turner's manner, perhaps because the tendency of art in their own country at the time emphasized meticulous detail so much. In *France—where there had been something of a vogue for the spirited naturalistic manner then associated with British art in the 1820s—there was more appreciation. In 1858, when asked for his views on the British school by Théodore Silvestre, the painter Eugène *Delacroix wrote of *Constable and Turner that they 'were real reformers. They broke out of the rut of traditional landscape painting. Our school, which today abounds in men of talent in this field, profited greatly by their example' (Jean Stewart, ed., *Eugene Delacroix: Selected Letters*, 1971, p. 352). On the other hand, Delacroix had not been impressed by the person of Turner. In 1855 he recalled that when the latter had come to see him in his Paris studio 'I was not particularly impressed; he looked like an English farmer with his rough black coat and heavy boots, and his cold, hard expression' (ibid., p. 10). In fact Delacroix like most of his French contemporaries was more impressed by the naturalism of Constable. It was a later generation—that of the Goncourt brothers and the Symbolists—who seriously began to establish an interest for Turner in France (see POSTHUMOUS RECEPTION ABROAD).

Turner's main Continental reputation came in fact from the detailed steel engravings that were made after his works and published in profusion after the *Napoleonic wars (see ENGRAVING). It is perhaps revealing from this point of view that the 'fantastic' British landscapist most valued abroad at the time was John *Martin, who managed to combine spatial exaggeration and dramatic atmospherics with a detailed, tinselly, manner of painting. Prince *Albert shared this preference, and was presumably to a large extent responsible for the lack of recognition that Turner received from royal quarters in his later years.

Turner did achieve some success in the New World, however, selling *Staffa, Fingal's Cave (RA 1832; Yale Center for British Art, New Haven; BJ 347) to Colonel James *Lenox of New York in 1845 through the good offices of the Anglo-American painter C. R. *Leslie. Although Lenox expressed some misgivings about the 'indistinctness' of Turner's painting, he did also buy *Fort Vimieux (RA 1831; private collection; BJ 341).

By the 1840s, attitudes were in general hardening, and even sympathetic critics were assuming that the artist was misusing his talent, either through wilfulness or through loss of mental faculties. 'Who will not grieve at the talent wasted upon the gross outrage of nature?' wrote the *Art Union of the *Slavers (RA 1840; Museum of Fine Arts, Boston; BJ 385). It was in this period, in 1843, that John Ruskin came to Turner's defence in the first volume of his book Modern Painters, his brilliant and sustained argument being that Turner's apparent 'abstraction' was in fact the most profound and visionary form of naturalism. For a time Ruskin appears to have been influential in turning the tide of criticism in Turner's favour and even in improving the saleability of his work. But after 1845 Ruskin himself began to consider that Turner was losing his powers. Sadly Turner ended his life with almost all commentators, sympathetic or hostile, considering him a brilliant landscapist who had lost his faculties. Yet this negative situation may have had an advantage. For it was his sense of the lack of appreciation of his achievement that undoubtedly spurred him to make provision in his *will for his works to be preserved together (ultimately and fortuitously in the national collection) rather than to leave them at the mercy of the judgements of his contemporaries. See also PASSAVANT; WAAGEN. WV

Butlin and Joll 1984, passim.

REWORKING OF OIL PAINTINGS BY TURNER.
Turner's practice of finishing paintings during the *Varnishing Days at the Royal Academy is well documented. Not all of these paintings sold, and he returned to those in his studio from time to time, strengthening clouds in The Story

of Apollo and Daphne (RA 1837; BJ 369), for example, after the paint had dried so thoroughly that it formed drying cracks. Quite possibly he regarded a painting as complete only when no time was left for further work, or when an even better idea had occurred to him and demanded to be put down in paint immediately.

It is not possible to distinguish work which Turner carried out on the Varnishing Days from earlier or subsequent work, unless such a time elapsed between paint applications that the paint surface had gathered a coat of dust before he reworked it. Even then, careful examination with a microscope, or the making of a cross-section, would be required to prove this.

There were many unfinished works in Turner's studio, some of which look very promising. We cannot tell how many similar ones became the annual RA painting, or how many more Turner would have completed had he lived long enough. At the very end of his life, he drastically reworked a number of paintings which had previously been finished rather than merely advanced. One such is The *Hero of a Hundred Fights (begun c.1800-10 and exhibited after reworking in 1847; BJ 427). It is an extreme example, for Turner did not cover the whole canvas in the reworking, and seems to have ignored the mismatch. He also reworked several paintings during visits to *Petworth, but here the reason seems more obvious: he had no new canvases left there, and perforce worked over an old one. Interior at Petworth (c.1830-7; BJ 449; see Wilton 1989, pp. 26-7) and Two Women with a Letter (c.1835; BJ 448; see J. H. Townsend, 'Two Women with a Letter' by J. M. W. Turner', Turner Studies, 9/2 (1989), pp. 11-13) remain unresolved after more than one reworking.

Apart from scraping off any loose and damaged paint, Turner simply painted on top of the old image. Two Figures in a Building (c.1830; BJ 446; see J. H. Townsend and I. J. Warrell, 'Two Figures in a Building' by J. M. W. Turner', Turner Studies, 11/1 (1991), pp. 54-7) was worked over an earlier image which was so damaged it could never have been displayed. Turner's unsold paintings were never varnished, so the new paint adhered well enough to the old for him to proceed, and even exhibit the reworked painting on occasion. Conventional wisdom would have said that Turner should have rubbed down the paint to give tooth to the new layers, then oiled out the surface, or even applied a new priming, but he did none of these in the course of reworking. Nor did he in the normal course of painting. The reworked paintings are hardly more prone to flake and crack than the finished ones. JHT

REYNOLDS, Sir Joshua (1723-92), founder member and first President of the *Royal Academy. Reynolds was the

most important British painter during the latter half of the 18th century; his highly accomplished portraits were widely imitated, although his most pervasive influence lay in his writings on the theory of art, especially his *Discourses* (1769–90).

Reynolds's preoccupation with portraiture meant that his direct artistic influence on Turner was limited. Contemporary critics, however, occasionally commentated on Turner's paintings being imitative of Reynolds, examples being *Venus and Adonis* (c.1803–5; private collection; BJ 150) and the *Holy Family* (RA 1803; BJ 49). An unfinished oil sketch, *Portrait of a Lady* (BJ 548), was included in Turner's collection and was formerly attributed to him working in the manner of, or copying, Reynolds; it is now, however, considered to be by Reynolds or his studio. Turner had paid homage to Reynolds by purchasing the picture (along with two others by the artist) at Christie's in 1821.

The impact of Reynolds's theories on Turner was wide-reaching and can be traced in his imitations of Old Masters admired by Reynolds, in his notions of historical landscape, and in his own attempts at lecturing on matters of art, when Professor of Perspective (see PERSPECTIVE LECTURES). Reynolds's importance to Turner was primarily as the first truly intellectual artist of the British School, a position Turner strove to emulate. As a lifelong committed Academician, Turner greatly admired its first President. His esteem is evident in his panegyric upon Reynolds included in his first perspective lecture of 1811. As he had wished, Turner's body was buried at St Paul's beside the tomb of Reynolds.

DP

REYNOLDS, Samuel William (1773–1835), English mezzotint engraver and landscape painter. He engraved two plates (F 67, 71) for the final Part of the *Liber Studiorum*, published in 1819. Reynolds was one of the leading mezzotint engravers of his day, and it was he who pioneered the use of etching as the basis of a mezzotint plate, which was an essential element in Turner's production of his *Liber*. Between 1820 and 1826 he issued, in four volumes, 357 small engravings after his namesake, Sir Joshua *Reynolds. In his later years he enjoyed considerable success in Paris. LH

RHINE. The Rhine valley, some 850 miles (1,350 km.) in length, provides not only a route from the Alps to the North Sea but also a host of spectacular and popular sights. In Turner's day it was regularly used by British travellers, especially those returning from Switzerland or the Grand Tour. The Picturesque (see SUBLIME) beauties of the Rhine in Germany became widely known in Britain after the publication of *A Journey Made in the Summer of 1794, through Holland and the Western Frontier of Germany, with a*

Return down the Rhine by Mrs Ann Radcliffe (1795). Its tortuous bends, angry torrents, treacherous whirlpools, fantastic rocks, precipitously sited vineyards, and gloomy ruined castles were here made the subject of Romantic descriptions which shaped the expectations of many a British traveller in search of sensation and fashionable Sublimity. During the *Napoleonic wars this stretch of the Rhine was the scene of many struggles between invading French forces and German states, with the French eventually dominating most of the region for some two decades. In 1816, a year after the expulsion of the French and the return of peace, *Byron celebrated both the scenery and the history of the German Rhineland in part of his *Childe Harold's Pilgrimage* (canto iii, verses 46–61). His lines evoked a landscape rich in natural beauty but strewn with bleak reminders of ambition, war, and heroism and they appealed strongly to many British travellers including Turner himself.

Turner first studied the Rhine in 1802, ending the earliest of his many tours of *Switzerland with visits to *Schaffhausen, Laufenburg, and Basel. In 1817, during his first European tour after the Napoleonic wars, he spent ten days exploring the most celebrated German stretch of the river, the 120 miles between Mainz and Cologne. He subsequently travelled along this and many other parts of the river on his various tours, making use of both sailing boats and steamboats as the latter were gradually introduced in different regions. He also explored several of the Rhine's tributaries in *Germany, most notably the *Mosel in 1824 and 1839; the Neckar between *Heidelberg and Heilbronn in 1844; and the Nahe in 1844.

Turner depicted the Rhine many times and in every medium, capturing all the diverse aspects of its course from icy Alpine streamlets down to the mighty river at Rotterdam. In 1806 he exhibited the oil painting *Fall of the Rhine at Schaffhausen* (Museum of Fine Arts, Boston; BJ 61) and twenty years later an oil painting showing the Rhine at *Cologne (RA 1826; Frick Collection, New York; BJ 232). In 1807 and 1811 Basel and Laufenburg featured in his *Liber Studiorum*. Turner's most important watercolours of the river are his series of fifty *Rhine drawings of 1817, completed immediately after his tour of that year. His subsequent depictions of the Rhine were the result of a variety of commissions and included, in the 1830s, several tiny watercolour vignettes to illustrate the works of Byron, *Scott, and *Campbell. The fortress of *Ehrenbreitstein, which guards the confluence of the Rhine and the Mosel at Coblenz, inspired many works; these included an important oil painting in 1835 and a series of vaporous coloured sketches in the early 1840s. Finally, in 1842, Turner painted a magnificent watercolour of the Rhine pouring out of the shimmering

expanse of Lake Constance while men work on rafts and platforms of logs in the foreground (York City Art Gallery; W 1531). Here, as so often in Turner's Rhine works, his concern is with man's relation to his natural surroundings and not simply with nature itself. CFP

Borch 1980.
Stader 1981.
Powell 1991.

RHINE DRAWINGS OF 1817. See Pl. 10. One of Turner's grandest series of watercolours, the Rhine drawings of 1817 (W 636–77, 679–86) were the fruit of his ten days' intensive study of that river as part of his first Continental tour after the end of the *Napoleonic wars. In late August he had travelled upstream from *Cologne to Mainz along the west bank of the Rhine, for the most part on foot and using the newly constructed *route Napoléon*; he immediately returned downstream, chiefly by boat. The series depicts the most celebrated sights between Mainz and Cologne as Turner himself had recently experienced them from road or river, and his subjects seem to have been dictated by personal choice rather than a commission for specific views. Some sights were idiosyncratic discoveries of his own; some subjects (including the popular one of the Lorelei) he painted several times from different viewpoints; other notable ones were omitted. Turner sold the drawings to his friend Walter *Fawkes for £500 in the autumn of 1817, apparently arriving at Farnley Hall in Yorkshire and pulling them out of his breast-pocket before he had even taken his coat off. The series has traditionally been regarded as consisting of fifty-one works, as stated by Turner's first biographer *Thornbury, but it is more likely that there were fifty. Thornbury could mistakenly have included a slightly later Turner Rhine view (*Mainz and Kastel*; W 678; see Evelyn Joll, 'Watercolour', *Agnew's 1982–1992*, 1992, p. 162, repr. in colour) in the Fawkes collection in his tally of the 1817 series.

All Turner's subjects in this group are derived from his recent pencil sketches in two sketchbooks. Most are based on those in the small upright book, 'Waterloo and Rhine' (TB CLX), which are often very schematic or minute in size: when Turner was travelling by boat he sometimes crammed numerous sketches onto a single page, hastily subdividing it into minute strips or boxes as he worked. A handful of the finished drawings are based on the more detailed and well-composed scenes in the large 'Rhine' Sketchbook of horizontal format (CLXI). The marked similarities between on-the-spot pencil sketches and final coloured drawings demonstrate that the latter were neither composed nor painted in front of their subjects, as was once believed. It is, however, possible that they were begun during Turner's

time abroad. They were probably finished while he was at *Raby Castle in Co. Durham, where he stayed on his way to Farnley Hall; a third sketchbook ('Itinerary Rhine Tour', CLIX) was used both on the Rhine and at Raby, which may be taken as an indication that Turner carried all his Rhine material with him throughout the autumn of 1817.

The *paper Turner used for this series was a white writing paper, light in weight but heavily sized. Some sheets bear a Whatman 1816 watermark. The drawings are not of uniform size or shape but most of them fall within certain parameters; it is likely that Turner bought a quire of twenty-four foolscap sheets (each measuring 17 × 13½ in., 43.3 × 34.3 cm.) from which he created 48 of 8½ × 13½ in. (21.6 × 34.3 cm.). He prepared these with a wash of grey which provided a neutral but sombre background for his work in pencil, watercolour, and gouache. While the grey wash was an inspirational shortcut to Turner's swift evocations of overcast skies and the treacherous bends of the river beneath ancient ruined castles, rocky crags, and shadowy hills, it also meant that highlights could be created with equal ease by scratching through to the white paper beneath. The washes of colour were mostly applied in a magnificently free and fluid manner, suggestive not only of ever-changing atmospheric effects but also of spontaneity on the part of the travelling artist. All the techniques employed in the series were thus ideally suited both to the nuances of its grand subject matter and to Turner's own need to record as much of it as possible soon after his tour.

The Rhine series remained with the descendants of Walter Fawkes until June 1890 when the Revd Ayscough Fawkes sold 35 of the drawings through Christie's, having exhibited the entire series the previous year at the Royal Academy winter exhibition of *Works by the Old Masters, and by Deceased Masters of the British School*. All the remaining Rhine drawings were sold by Frederick Fawkes, Ayscough's nephew, to *Agnew's in July 1912. Today the drawings are scattered around the world in many different public and private collections, the largest single group being the seven in the bequest of R. W. *Lloyd in the British Museum which cannot be lent for exhibition elsewhere. Selections from other sources have, however, been displayed together in recent exhibitions in both Germany and England.

Around 1818–20 Turner repeated several of the scenes in his Rhine series on a slightly larger scale and with a higher degree of finish (W 678, 687–93, 689a). Some were intended for patrons other than Fawkes, some for the purpose of engraving. Sadly, however, his projected series of 36 Rhine watercolours, agreed in 1819 with John *Murray, W. B. *Cooke, and J. C. *Allen, was never executed. A few engravings deriving from scenes in that series appeared individually

through different publishers, some in the 1820s (R 202, 203, 317a), two not until 1852, the year after Turner's death (R 669, 670). CFP

Borch 1980.
Stader 1981, pp. 17–31.
Powell 1991, pp. 20–36, 98–105.
Powell 1995, pp. 26–8, 91–103.
Sloan 1998, pp. 60–79.

RICHMOND, Surrey, a town on the *Thames. The prospect from Richmond Hill had been celebrated as a microcosm of the nation by James *Thomson, as it is in Turner's *England: Richmond Hill* (RA 1819; BJ 140). The varied social make-up of the spectators in that painting is accentuated in the foreground of the watercolour *Richmond Terrace, Surrey* (c.1836; Walker Art Gallery, Liverpool; W 879; for *Picturesque Views in *England and Wales*), which is read by Shanes (1979, no. 85) as a survey of British society. There is more contrast, however, between Turner's oil and watercolour depictions of Richmond Hill and Bridge than there is between the two foregoing images. The eponymous oil (Turner's gallery 1808; BJ 73) gives Richmond 'a pastoral character', as John *Landseer commented, by 'obscuring the town in the mistiness of morning; [and] by introducing sheep and . . . a woman bathing a child near the foreground'. Conversely, in the later watercolour (c.1825–9; British Museum; W 833; for the *England and Wales* series) such associations are banished by the presence of a lively party of fashionable picnickers, not to mention the steamboat in the background. AK

RICHMOND HILL, see ENGLAND: RICHMOND HILL . . .

RICHMONDSHIRE is the historic name of an area of North *Yorkshire, centred upon the picturesquely situated town of Richmond, which Turner first visited in 1797. He subsequently made watercolours of the town (e.g. W 248, c.1799) and of St Agatha's Abbey at nearby Easby (c.1799–1800; W 272–4), all from a low viewpoint. His next visit was in 1816 in connection with a commission to make views for *Whitaker's *History of Richmondshire* (see Pl. 13). The resulting depictions all show the town from a high viewpoint; two of these images are in *Picturesque Views in *England and Wales*. A milkmaid is prominent in the foreground of *Richmond Castle and Town* (c.1824–5; British Museum; W 791) and a shepherdess or reaper plays with her dog in a view of *Richmond from the Moors* (c.1828; Fitzwilliam Museum, Cambridge; W 808). There is a marked tendency in the latter series for working-class figures to occupy the commanding viewpoints previously monopolized by their social superiors. However, Turner also 'makes pastorality seem [the town's] principal base' (David Hill, 'Turner in York-

shire', London Ph.D. thesis, 1991, p. 159) while downplaying Richmond's commercial and industrial activities. Hence the modern mill in *Richmond Castle and Town* (W 791) is partially obscured by graceful trees, whereas in the corresponding image (R 170, 1820) in Whitaker's *History of Richmondshire*, our view of the mills is relatively unobstructed. AK

Hill 1984, pp. 60–7.
Hill 1996, pp. 40–5.

RICHMONDSHIRE, HISTORY OF, see WHITAKER.

RIGI. This famous mountain, 5,905 feet (1,780 metres) high, rises gently from the shore of Lake Lucerne opposite the town of *Lucerne, its ridge sloping up to a peak—the *Rigi-kulm*—at its eastern end. By the middle decades of the 19th century it had become a spot peculiarly beloved of tourists, who would gather to watch the sun rise over the grand panorama visible from its relatively accessible summit. As far as we know, however, Turner never climbed it. Its northern slopes faced the Swan hotel, also known as Le Cygne et Righi, built in 1836, in which he stayed on his visits to Lucerne in 1841 and 1842. From there he was able to observe the mountain and draw it in many different lights, and it became an object of special significance for him, inspiring a sequence of sketches and finished works which anticipate the habit of making series of studies of changing light effects on a single object that we particularly associate with Monet. The Rigi was a mountain peculiarly suited to Turner's preoccupations in his later years: viewed, as it was from Lucerne, rising above a tranquil expanse of water, its inherent *sublimity was transcendental rather than terrific. The mountain mass was inseparable from the atmospheric conditions in which he saw it, and it was these that he recorded with a passionate but meditative intensity. Some are vivid or melting colour notes in the roll-sketchbooks that he favoured at that period; one (TB CCCLXIV: 196) is a mere wraith of pale grey wash touched with yellow, an impression almost oriental in its distilled quietness.

Others are more elaborate studies which he evidently conceived as embodying ideas for finished watercolours. These are the 'sample studies' that he was to show to his agent in London, Thomas *Griffith, and, having procured commissions, 'realize' as elaborately completed watercolours. The 1842 set of ten Swiss subjects (two of them—*Constance* and *Coblenz Bridge*—were actually German) included the *Blue Rigi: Lake of Lucerne, Sunrise* (W 1524) the *Red Rigi* (W 1525; see Pl. 28); and *Dark Rigi* (W 1532). The *Red Rigi* and *Dark Rigi* were both acquired by *Munro of Novar, though the former shortly after entered *Ruskin's collection. The *Blue Rigi* was bought by Elhanan *Bicknell.

Each of the three retains much of the character of its 'sample' study, although Turner invests the finished works with an ecstatic atmosphere, hushed and expectant, as though the onlooker were breathlessly awaiting the next subtle change in the effect of light. In the *Dark Rigi*, as Ruskin observed, Turner shows 'the dawn of a lovely summer's morning; a fragment of fantastic mist hanging between us and the hill'; while in the *Blue Rigi* the expansive calm of sunrise is rendered more intense by the interruption of two dogs, who bark as they jump off a small boat, alarming a family of ducks. The Rigi also figures faint in the distance of his 1842 view of *Lucerne from the Walls* (W 1529). There is a further sequence of studies of the Rigi in the 'Lucerne' Sketchbook which Turner may have used on his last visit to Switzerland in 1844 (CCXLV).

Recently an unfinished oil in the Tate Gallery of *c*.1840–5 (BJ 522) has been identified by Ian Warrell as showing *Sunset from the Summit of the Rigi* (1999², pp. 146–50, repr. in colour, pl. 20). AW

RISE OF THE CARTHAGINIAN EMPIRE, see DIDO BUILDING CARTHAGE.

RITCHIE, Leitch (1800?–65), author and editor, born in Scotland. He was employed by Charles *Heath to write the text for several landscape annuals, including the three volumes of *Turner's Annual Tour*, also known as the *Rivers of France*, published in 1833–5. Ritchie's first success, *The Romance of History, France*, published in three volumes in 1831, brought him recognition and ample further work. He wrote a number of novels and contributed to various reviews. He returned to Scotland in the later part of his life, and edited *Chambers's Journal*. LH

RIVERS OF DEVON, THE. In 1815 W. B. *Cooke, the publisher of the *Southern Coast*, commissioned Turner to undertake a smaller but similar venture which would capitalize on the growing popular enthusiasm for Picturesque (see SUBLIME) tourism in *Devon. Although the envisaged scale of the project is not clear, Turner appears to have produced at least six watercolours for it in the years immediately following his Devon tours of the 1810s: *Plymouth Citadel, Plymouth Sound, Ivy Bridge, Dartmoor: the Source of the Tamar and the Torridge, Sunshine on the Tamar* (W 440–4) and *Eddystone Lighthouse* (W 506) (reallocated to the *Marine Views* series). The proposed publication did not appear, however, largely because W. B. Cooke was overcommitted with producing the *Southern Coast*, and these Devon landscape subjects were published separately or elsewhere in the 1820s and later. Given the abortive nature of the

enterprise, speculation on its possible range and ambition is necessarily tentative, but it is evident that these identified subjects offer a very limited selection of Devon rivers and make no reference to Turner's most recent exploration of the River Dart in 1814. Three of them indeed stretch the whole concept of 'river' by dealing with Plymouth Sound and the open sea, the result perhaps of Turner's *Southern Coast* work being too limited to provide enough fresh material to repackage as the *Rivers of Devon*. SS

Shanes 1990², pp. 10, 37–40, 262–3.
Smiles and Pidgley 1995.

RIVERS OF ENGLAND, THE, a watercolour and mezzotint engraving series initiated in 1822 by W. B. *Cooke to exploit the economic benefits of steel-faced mezzotint engraving. This process had recently been developed by Thomas Goff *Lupton, who was to reproduce several of the *Rivers* designs. Images by the late Thomas *Girtin and by William Collins were also included in the scheme.

Between 1822 and 1825 Turner produced seventeen or more drawings for the project, two of which are predominantly *canal-scenes (W 734, 745). All the watercolours are on sheets of white paper averaging 6⅛ × 8¹¹⁄₁₆ in. (15.5 × 22 cm.). Turner hired his drawings to Cooke (for 8 guineas), and consequently they have remained in the Turner Bequest. One of his much earlier watercolours, a 1799 view of Warkworth Castle (Victoria and Albert Museum; W 256) provided the basis for the untraced work (W 742) which was also engraved in the scheme, possibly to accompany the Girtin images and thereby make them appear less singularly old-fashioned. Additionally, Turner proofed the reproductions of the Girtin designs, commenting 'Poor Tom, Poor Tom' in the process (see Miller).

Turner's participation in the *Rivers* series ended when relations with the Cooke brothers collapsed in late 1826. In 1827 W. B. Cooke bound together all the unsold prints and published them under the title *The River Scenery of England*. By then the work included fifteen engravings after watercolours by Turner (R 752–66). Three more prints were left unfinished or their plates cancelled owing to imperfections in the metal (R 767–9).

Like the similarly sized *Ports of England* drawings, the *Rivers* watercolours are jewel-like in their intensity of colour and sharp detailing, with stippling employed extensively throughout. It has been suggested (Gage 1987, p. 89) that Turner appropriated the latter technique from portrait-miniature painting, and it certainly boosts the textural vivacity and tonal variety of the drawings. ES

T. Miller, *Turner and Girtin's Picturesque Views Sixty Years Hence*, 1854.
Shanes 1981, pp. 9–11, 14–16, 29–33, 152–5.

Herrmann 1990, pp. 153–9.

Shanes 1990², pp. 11–12, 102–18.

RIVERS OF EUROPE, see *TURNER'S ANNUAL TOUR.*

RIVERS OF FRANCE, THE. This is the usual title given to *Turner's Annual Tour,* the series of three volumes illustrating 'Wanderings by the *Loire' (1833) and 'Wanderings by the *Seine' (two volumes, 1834 and 1835). These books with their impressive small steel engravings after drawings by Turner (R 432–92), and texts by Leitch *Ritchie, were the most successful and popular publications with which the artist was involved. LH

ROBERTS, David (1796–1864), Scottish landscape painter and friend of Turner. The self-taught son of a shoemaker, from 1816 Roberts made a career as a scene painter in Edinburgh and Glasgow, and from 1822 in London. Turner praised Roberts's oil *A View of Rouen Cathedral* (RA 1825; untraced) and by 1830 he was able to give up scenery design. Roberts was one of the first British artists to visit Spain (in 1832–3) and the Near East, including Egypt (in 1838); paintings and prints from these journeys brought him great success. His love of exotic, dramatic architecture and sweeping panoramic views owes much to Turner, whom he admired deeply; however, Roberts was more precise and topographical. From the 1840s Turner was a frequent visitor to Roberts's house at 7 Fitzroy Square and Roberts wrote a memoir of him (manuscript in private collection). They had a mutual patron in Elhanan *Bicknell, whose son married Roberts's daughter. Roberts was appointed to the Royal Academy Turner Bequest committee (see WILL), but resigned when paintings were exhibited against his advice. SM

Katharine Sim, *David Roberts,* 1984.

Helen Guiterman and Briony Llewellyn, *David Roberts RA, 1796–1864,* exhibition catalogue, London, Barbican Art Gallery, 1986.

Guiterman 1989, pp. 2–9.

ROCK LIMPET, see WAR. *THE EXILE AND THE ROCK LIMPET.*

ROGERS, Samuel (1763–1855), poet, banker, collector, friend and executor of Turner. He inherited wealth in 1793 and became well known for his breakfast parties, where Turner often appeared at his best. Rogers had a caustic tongue, remarking of Turner's dining table: 'It was wonderful . . . but how much more wonderful it would be to see any of his friends around it.'

Turner's illustrations to *Rogers's Italy* (1830) and *Poems* (1834) increased their sales considerably and also first made the young *Ruskin aware of Turner's existence.

Rogers owned *Study of the Quarter-Deck of the 'Victory'* (1805; TB CXXI: S; Vaughan Bequest); also *Stonehenge*

(*c.*1827; Salisbury and South Wiltshire Museum; W 811) and an early oil, inherited from his sister Sarah *Rogers, *Seapiece with a Fishing Boat off a Wooden Pier* (?*c.*1800–5; BJ 539, 540 but the same picture; see LOST . . . WORKS). It appeared at Sotheby's, New York, on 20 February 1991 (lot 28) but was bought in.

Hamilton (1997, p. 337) suggests that Rogers, aged 88 in 1851, had the knowledge and the ability to have written Turner's first biography but failed to do so. EJ

ROGERS, Sarah (1772–1855), sister of Samuel *Rogers and like her brother a friend of Turner's. She was an amateur artist, and supervised the publication of the 1822 edition of her brother's *Italy.* Sarah Rogers lived with her brother Henry until his death in 1832, when she moved to 5 Hanover Terrace, Regent's Park, where Turner appears to have been a regular guest. Here were displayed her collection of curios and pictures, many of which were inherited from Henry Rogers. The collection included pictures by *Reynolds, *Gainsborough, *Wilson, *Stothard, *Leslie, *Bonington, and *Wilkie. Sarah accompanied Samuel Rogers on his Continental tour in 1814. Mrs A. Jameson's *Companion to the Most Celebrated Private Galleries of Art in London* (1844) lists in Sarah Rogers's collection a picture by Turner entitled *A Storm* (BJ 539), described as 'treated almost entirely in brown. A spirited but very mannered sketch'. This can now be identified with the *Seapiece, with Fishing Boats off a Wooden Pier, a Gale coming on* (BJ 540), which she must have bequeathed to her brother Samuel who died later the same year; the picture itself reappeared in the United States and was offered at Sotheby's, New York, on 20 February 1991, bought in. The picture, which is unfinished, probably dates, very roughly, between 1800 and 1810. RU

Gage 1980, pp. 185, 208, 235, 279–80.

ROGERS'S ITALY, commissioned 1826, published 1830, with 25 vignettes by Turner and other designs by Thomas *Stothard and Samuel Prout: a sensational success, remaining one of Turner's most famous productions. Samuel *Rogers (1763–1855), collector, wit, banker, and patron of Turner, *Moore, and *Campbell, was an important and hospitable figure in the world of art and literature, and executor of Turner's second will. His anecdotal travel poem *Italy* was first published in 1822. Rogers invested a great deal of money in the printing, illustration, and engraving of the new deluxe edition, which sold 6,800 copies by 1832. Rogers supervised Turner in subjects and their character; he told *Ruskin that Turner was responsive and pliant. Many of Turner's designs are from his sketches of the Alps, Rome, and the Campagna; *Marengo* (TB CCLXXX: 146, W 1157;

R 353) quotes *David's equestrian portrait of *Napoleon, seen by Turner in Paris at David's studio in 1802. Turner here generally designed vignettes of place, the graceful Stothard of people. Edwin *Landseer drew the dogs for *Hospice of the Great St. Bernard II* (Vassar College Art Gallery, Poughkeepsie, New York; W 1156; R 352). All the watercolours except the last are in the *Turner Bequest (CCLXXX; W 1152–77). The moonlight scenes, designed in blues and with black ink, especially *A Villa* (W 1165; R 361) and *A Villa. Moon-light* (W 1175; R 371), are particularly subtle. The vignettes suggest the ruins of Time and intimations of death and beauty. JRP

Cecilia Powell, 'Turner's Vignettes and the Making of Rogers' *Italy*', *Turner Studies*, 3/1 (summer 1983), pp. 2–13.
Lyles and Perkins 1989, pp. 65–8.
Herrmann 1990, pp. 182–8.
Warrell 1991, pp. 13–14, 53–7.
Piggott 1993, pp. 35–9, 81–2, 98.

ROGERS'S *POEMS*, including *The Pleasures of Memory* (1792), issued by the poet with 33 Turner vignettes (others by *Stothard) in 1834. Samuel *Rogers invested £15,000 on *Italy* and *Poems* together. *Poems* was more than four years in preparation by Rogers, Turner, and the engravers, and even eclipsed *Italy* in popularity. Turner said to Rogers that no lady's boudoir would be complete without it; 50,000 copies of the two books had sold by 1847. Turner's highly finished watercolours (W 1177–1209) are all in the Turner Bequest (TB CCLXXX; studies also, and sketches in an edition of 1827, CCCLXVI); many of these were bolder in design and form than those for *Italy*, such as *The Alps at Daybreak* (W 1199; R 395) and the vortical *Hurricane in the Desert* (W 1189; R 385). Stothard 'improved' several figures: the hero in *Land Discovered by Columbus* (W 1205; R 401), the boat and figures in *Traitor's Gate* (W 1187; R 383), and two figures in *Venice* (W 1190; R 386). *A Garden* (W 1177; R 373) is an elaborate emblem of Time. Many vignettes derive from the English and Scottish sketchbooks. The *Napoleonic wars figure in the *Old Oak* pair (W 1195–6; R 391–2) with village green and shipyard. The great series for *The Voyage of Columbus* (unified by motifs of the cross and conflict of light and dark) rises to heights of drama and vision, such as the phantasmagoric *A Vision* (W 1204; R 400) and *A Tempest* (W 1207; R 403). The series influenced Turner's visionary images in his late religious paintings; *The *Angel standing in the Sun* (RA 1846; BJ 425) was given an epigraph from Rogers's *Columbus*. JRP

Lyles and Perkins 1989, pp. 65–6, 68–71.
Herrmann 1990, pp. 188–90.
Lyles 1992, pp. 13, 48–52.
Piggott 1993, pp. 39–44, 82–5, 98.

ROMAN ACADEMY OF ST LUKE. The Accademia di San Luca was founded in *Rome in the late 16th century, incorporating the painters who met in the church of San Luca, and it soon became famous for its teaching and prizes and for the prestige and influence it enjoyed in a wide range of artistic matters. In Turner's day it was still situated adjacent to the church of SS. Luca e Martina, north of the Forum. Some notable British artists who visited Rome in Turner's lifetime (including John *Flaxman and Sir Thomas *Lawrence) were elected full members of the academy. However, when Turner himself visited Rome there were no vacancies, so he was elected an honorary member instead. Soon after Turner's arrival in Rome, in October 1819, he called on the academy's Perpetual President Antonio *Canova, bearing letters of introduction from both Lawrence and the collector Thomas Hope. On 15 November he visited the academy with Canova, Lawrence, and other Britons, and saw a life class with about 100 students drawing and modelling from a naked figure. Turner's election took place on 21 November and he wrote to Canova a few days later (in the only extant letter from the 1819 tour) to thank him for his supportive role. Turner's friend the sculptor Francis *Chantrey and the portrait painter John Jackson, who were also visiting Rome at the time, were similarly elected a week earlier. Turner took great pride in his membership of such a distinguished academy: he described himself as 'Member of the Roman Academy of St Luke' when he exhibited *Rome, from the Vatican* (BJ 228) at the Royal Academy in 1820 and he also used the title when advertising his own small exhibition of paintings in Rome in December 1828 at the conclusion of his second (and last) visit to that city. CFP

Gage 1980, pp. 80–1.
Powell 1987, pp. 70–1.

ROMAN OIL SKETCHES. Turner's second visit to *Rome, from early October 1828 to early January 1829, was largely devoted to painting in a studio, an activity he is not known to have practised in any other foreign city. The studio, at 12 Piazza Mignanelli, was that of his friend Charles *Eastlake, by now an established resident in Rome, who assembled all the painting materials Turner had requested by letter so that he could start work there as soon as he arrived. He had decided to begin by painting a companion to Lord *Egremont's celebrated *Claude, *Landscape with Jacob, Laban and his Daughters*, and embarked on an 8-ft. (250-cm.) Claudian landscape which, in the event, was neither completed in Rome nor acquired by its intended patron: *Palestrina—Composition* (RA 1830; BJ 295). However, he did manage to complete three oil paintings in Rome which were put on show in the city for just one week in a small

one-man exhibition: *View of Orvieto* (BJ 292; later shown at the Royal Academy in 1830), *Vision of Medea* (also RA 1831; BJ 293), and *Regulus* (also BI 1837; BJ 294). Six further works, all large, can also be definitely assigned to Turner's 1828 visit to Rome on grounds of similarity to the exhibited works in respect of their coarse canvas, form of original stretcher, and idiosyncratic mode of attachment of canvas to stretcher by means of upholsterer's springs. These works are the female nude studies (BJ 296–8) and landscape studies (BJ 299–301).

Turner's well-documented use of a studio in Rome in 1828 has led to a widespread presumption that a number of oil sketches in the Turner Bequest with seemingly Italian or Italianate subjects were also produced on the same occasion: the sixteen catalogued by Butlin and Joll as 'Roman Sketches, 1828' (BJ 302–17) and a group of ten smaller ones catalogued as 'Small Italian Sketches, 1828?' (BJ 318–27). However, recent research has shown this assumption to be seriously flawed as far as the first group goes, as will be shown below.

The sixteen 'Roman sketches'—to use the misnomer prevalent until 1999—were painted one by one on rolls of canvas about 4 ft. (122 cm.) wide. Turner evidently tacked an area of the canvas—24 in. (61 cm.) by from about 30½ in. (77.5 cm.) to 40 in. (101.5 cm.)—onto a small stretcher or other support each time he wanted to paint a scene; he knocked in the tacks from the front and painted over them in the course of his work. At least seven (BJ 302–8) were not separated until 1913–14 (by which time they were in the National Gallery, London). The technique, canvas, and appearance of the other nine sketches (BJ 309–17) indicate a similar or identical history, while the themes and concerns of the sixteen sketches themselves suggest a concentrated body of work, created over a relatively short time span. The arguments for assigning the group of sketches to the autumn of 1828 seemed very reasonable: the coarse canvas of BJ 302–17 'would seem to be Italian in origin, presumably purchased in Rome' (BJ, p. 170); they are marked by vertical craquelure, a sign of their having been rolled, presumably for dispatch on a long journey; two of the group (BJ 304, 311) show Lake Nemi and Tivoli, famous beauty spots near Rome; many of the seaports and landscapes employ the same Claudian vision and types of composition as *Orvieto*, *Regulus*, and *Palestrina*, with clearly articulated planes and sidescreens; one sketch (BJ 302) is unmistakably a preparatory study for the celebrated *Ulysses deriding Polyphemus—Homer's Odyssey* (RA 1829; National Gallery, London; BJ 330), a relationship that suggested a likely date for the entire group. However, it was revealed in 1999 by Ian Warrell that several of the scenes have very close similarities to pencil sketches drawn by Turner on a visit to France in 1821: for example, BJ 307 and 312 are views of the aqueduct at Arcueil just south of Paris; BJ 315 and 317 depict Rouen on the River Seine; BJ 316 shows the port at Dieppe on the northern French coast.

This discovery necessitates a radical revision of the estimated date and place of execution of the oil sketches but probably does not affect our conception of their status and function. Whatever the origins of their canvas, they were possibly painted in England during the 1820s, presumably in Turner's own studio where he could consult his French sketchbooks. In view of the similarities in mode of production with the *Cowes oil sketches of 1827 (BJ 260–8), Warrell has suggested a date of ?1827–8. According to this scenario, Turner's plans for his forthcoming visit to Italy would have stimulated him to start painting Italian subjects before his departure, just as travel plans inspired him on other occasions; and it should be remembered that he was also engaged in drawing on his Italian memories and sketchbooks of 1819 for his vignette illustrations for *Rogers's *Italy* at this precise moment. One of his 1828 RA exhibits was the Claudian harbour scene *Dido directing the Equipment of the Fleet* (BJ 241). Work on this (including the oil sketches BJ 308 and ?313), together with his ambition to produce a companion piece to Lord Egremont's Claude, must have led him to refer to his own small pencil sketches of Claude's paintings in the Louvre, made in 1821. Searching through his 1821 'Dieppe, Rouen and Paris' Sketchbook (TB CCLVIII), he found not only these but the Arcueil, Rouen, and Dieppe sketches as well. Soon he was experimenting with a wide range of subjects both topographical and imaginary for, as Warrell has shown, the important French connections in this group of oil sketches include not only Claude's ideal landscapes but *Watteau's *fêtes galantes* as well. It would also appear that he was already planning to paint *Ulysses deriding Polyphemus* at this stage and may even have begun work on the exhibition picture itself before leaving for Italy.

The ten 'Small Italian sketches' (BJ 318–27) form an entirely separate group from those discussed above, being calmer in mood, less colourful, and very much less energetic in handling. They mostly measure about 16 × 24 inches (40 × 61 cm.) and are painted on a comparatively rare support for Turner oil sketches: millboard or millboard resurfaced with muslin (see BOARDS). Two types of millboard were used—both heavyweight, being really intended for bookbinding, and of Italian manufacture—and the muslin used on five of the boards must have been laid down by Turner himself. One of this group of sketches (BJ 318) shows a hill town sited above a meandering river with a range of distant

hills, a characteristic prospect in the *Campagna round Rome. Two (BJ 319–20) include features from the neighbourhood of *Naples, the scenery which inspired Turner to paint The *Bay of Baiae (RA 1823; BJ 230); this is not known to have been visited in 1828 but could have been painted from memory. Two (BJ 321, 324) include lofty Claudian trees and the subjects of the remaining five are indistinct and probably unidentifiable. Some scholars believe that this group of sketches may have been painted in the open air on Turner's first tour of Italy in 1819 while others have favoured their traditional dating of ?1828. With BJ 302–17 removed from Turner's 1828 studio output, it becomes increasingly questionable whether BJ 318–27 really belong there either; they, too, may turn out to have been painted in England in the years between Turner's two visits to Rome. CFP

Joll 1983, pp. 109–11.

Warrell 1999, pp. 23, 28–30, 119–20, 170–6, 202, 254 nn. 88 and 95, 268.

ROMANTICISM. Turner's career spanned almost exactly the period usually identified as the era of Romanticism, and his art exemplifies much of what the Romantic movement involved. This was never a self-conscious or coherent development, but it can best be summed up as an intensifying of individual and personal values in art and life, a process intimately bound up with the optimistic belief in human perfectibility that characterized the Enlightenment. A sense of the creative importance of personal experience, and especially of the power of the individual imagination, emerged gradually, but there is a memorable moment in literature that seems to define the shift. In 1751 Thomas Gray (1716–71) published his Elegy Written in a Country Churchyard, which begins with a description of twilight in which 'The ploughman homeward plods his weary way, | And leaves the world to darkness and to me.' The poet himself is identified as the source of a subjective response to the world, and especially to nature.

The new value placed on emotion as a creative force was exemplified in The Sorrows of Young Werther (1775) by the youthful *Goethe. This novel epitomized the German Sturm und Drang ('Storm and Stress') movement, giving the expression of 'sentiment' or strong feeling international currency as appropriate subject matter for art. On a wider front the American War of Independence, and, more significantly still, the French Revolution, signalled a new confidence in man's ability to change the world, while confronting contemporaries, in the Terror of 1792–3, with the horrors of unrestrained feeling on a public scale. In this more politicized climate both modern and historical heroes acquired popular respect and inspired much imaginative art. The new emphasis on the genius of the artist gave him the status of hero, too, and the creative imagination was seen as a force with the potential to enlighten and govern mankind.

William *Wordsworth famously celebrated the excitements of revolution for a young mind, but was also the supreme exponent of an almost solipsistic nature poetry, in which 'the still, sad music of humanity' is apprehended at a distance through an intensely perceived and understood natural world. With Samuel Taylor *Coleridge he published in 1798 the Lyrical Ballads which introduced a new simplicity of utterance, sweeping away the circumlocutions of 18th-century verse. Also in 1789 and 1794 William Blake (1756–1827) produced his Songs of Innocence and Experience, which have a comparable vernacular immediacy. Among painters, John *Constable shared Wordsworth's retiring, inward response to nature, but it is Turner who more completely parallels the poet's broader awareness of life in the context of creation as a whole. Lord *Byron (1788– 1824), the archetypal Romantic, in his long poem Childe Harold (1812–18), surveyed Europe in the aftermath of revolution, and meditated on the growth and passing of civilizations, encouraging Turner among many others to see history from Antiquity to the present as a great morality, teaching the fallacy of men's aspirations to power and immortality. AW

Hugh Honour, Romanticism, 1979.

ROME had been attracting artists from north of the Alps for many generations by Turner's day, lured by its incomparable wealth of art and architecture from classical and Renaissance times alike. Admiration for the city and interest in its history and civilization underpinned virtually every aspect of British taste and education. The *Napoleonic wars prevented Turner from travelling to Rome until he was in his 40s; he first became familiar with its most celebrated sights and monuments through studying the 18th-century etchings of G. B. Piranesi in the 1790s and later through making watercolours from the sketches of James *Hakewill in c.1818.

Turner at last departed for his first tour of *Italy in 1819 and was absent from London for exactly six months. Between October and December 1819 he was chiefly resident in Rome, leaving it for excursions to the nearby *Campagna and south to *Naples. He applied himself wholeheartedly to sketching Rome: he studied its ancient sites and monuments, churches, streets and squares, paintings and sculptures, and he viewed the city from many fine vantage points outside the walls. For the most part he sketched in pencil in small sketchbooks but he sometimes employed colours and larger books as well; the sketchbooks which he himself named 'Naples: Rome. C. Studies' (TB CLXXXVII), 'Rome: C. Studies' (CLXXXIX), and 'Small Roman C. Studies' (CXC) all contain watercolour and gouache studies of Rome and its

environs; the letter 'C' perhaps stands for 'Colour'. Apart from his visits to the *Roman Academy of St Luke, he apparently mixed little in society in Rome, which aroused some disappointment.

By contrast, in October 1828, when he returned for a second sojourn of nearly three months, he devoted far less time to study and led an extremely sociable life. He made few pencil sketches but painted indoors, producing three finished oil paintings, *View of Orvieto, painted in Rome* (RA 1830; BJ 292), *Vision of Medea* (RA 1831; BJ 293), and *Regulus* (BI 1837; BJ 294), and several unfinished ones (see ROMAN OIL SKETCHES). He shared rooms and a studio with his friend Charles *Eastlake, long resident in the city, at 12 Piazza Mignanelli, by the side of the Spanish Steps; he mixed with other artists both native and foreign; and finally, in December, he held an exhibition in the via del Quirinale of three brand-new paintings created in Rome itself. The exhibition attracted over 1,000 visitors but it aroused much criticism and, although Turner paid subsequent visits to Italy, he never returned to Rome.

Turner's first visit to Rome inspired two very grand paintings which blend topography with imagination: *Rome, from the Vatican* (RA 1820; BJ 228) was painted partly as a tercentenary tribute to the great painter Raphael (1483–1520), while *Forum Romanum* (RA 1826; BJ 233) was intended for the museum of his friend John *Soane, though the architect ultimately declined it. Turner depicted Rome in four topographical watercolours for Walter *Fawkes in 1820–1 and in tiny vignette illustrations for both the 1830 edition of Samuel *Rogers's *Italy* and the works of *Byron. In the late 1830s he contrasted ancient and modern Rome and Italy in *companion works of moralizing paintings partly inspired by James *Thomson's poem *Liberty*. At the RA in 1838 *Ancient Italy—Ovid banished from Rome* (private collection, USA; BJ 375) was exhibited with *Modern Italy—the Pifferari* (Glasgow Art Gallery; BJ 374); in 1839 *Ancient Rome; Agrippina landing with the Ashes of Germanicus* (BJ 378) was shown with *Modern Rome—Campo Vaccino* (Earl of Rosebery; BJ 379). In these works, with their exaggerations of scale and heightened colouring, Turner left faithful topography far behind him and produced visions of Rome rather than views, but visions that many travellers can recognize as their own. CFP

Ashby 1925.

Powell 1987, chs. 3–5, 9.

ROME, FROM THE VATICAN. RAFFAELLE, ACCOMPANIED BY LA FORNARINA, preparing his Pictures for the Decoration of the Loggia, oil on canvas, 69¾ × 132 in. (177 × 335.5 cm.), RA 1820 (206); Tate Gallery, London (BJ

228). This is the second of three vast landscapes, exceptional in size; the first was *England: Richmond Hill* (RA 1819; BJ 140) while the third was the unfinished *Rialto, Venice* of c.1820 (BJ 245). The Rome picture, the only work Turner exhibited in 1820, was the first public demonstration of what he had learned from his first visit to Rome in 1819. Exhibited on the 300th anniversary of Raphael's death, it also represents Turner's tribute to the great artist of the Renaissance, here shown with his mistress, La Fornarina. As John Gage has shown, Turner here identifies himself with the universal artist of the Italian Renaissance, incorporating sculpture, a surprisingly *Claudian landscape, and, anachronistically, Bernini's colonnades in front of St Peter's, which were not built until a century after the scene depicted. The vaults of the Loggia had been painted by Raphael and his pupils, and the other easel pictures shown include Raphael's *Madonna della Sedia* (Pitti Palace, Florence). Studies for the general composition, details of the Logge and the snow-capped Apennines in the distance are found in the 'Tivoli and Rome' Sketchbook of 1819 (TB CLXXIX) and there is a finished composition study in the 'Rome Colour Studies' Sketchbook (CLXXXIX: 41).

As well as the historical inaccuracies there are exaggerated effects of *perspective that incorporate a number of different viewpoints and, the result of Turner's experience of Mediterranean light, much stronger colour than in his earlier works. This may be partly the result of haste—Turner had only returned to London from Italy at the end of January 1820 and the exhibition opened at the beginning of May, but the result is an almost vertiginous approach to a classical landscape. Nevertheless, the *British Press*, 2 May 1820, described the picture as 'an exquisite composition. The perspective and colouring are beautiful'. *The Repository of Art* for June describes it as 'a strange and wonderful picture' and, while criticizing 'the crossing and recrossing of reflected lights about the gallery', the figures and 'the perspective of the fore-ground', praises the distance and the 'richness and splendour of the colouring'. MB

Gage 1969, pp. 92–5.

Powell 1987, pp. 98, 110–17, 198–9.

Nicholson 1990, pp. 219–23.

ROSA, Salvator (1615–73), Neapolitan painter. Rosa was noted in Britain in the 18th and early 19th centuries for his paintings of harsh and desolate landscapes, often peopled by soldiers or brigands. These led to his famous sobriquet 'savage Rosa' in 'The Castle of Indolence' (1748) by one of Turner's favourite poets, James *Thomson, and his predilection for evoking wild and hostile scenery was one of many ingredients in the complex aesthetics of the Picturesque (see

SUBLIME) in the following decades. Rosa's influence on the young Turner is well seen in his *Dolbadern Castle, North Wales (RA 1800; Royal Academy of Arts, London; BJ 12), with its small figures dwarfed by rugged mountains and a lonely tower. It also contributed much to The *Vision of Jacob's Ladder (probably begun c.1800; BJ 435) and to one of the most savage scenes by Turner himself, *Snow Storm: Hannibal and his Army Crossing the Alps (RA 1812; BJ 126).

CFP

ROSENAU, see SCHLOSS ROSENAU.

ROTHENSTEIN, Sir John (1901–92), writer, art historian. Rothenstein was the son of the painter Sir William Rothenstein (1872–1945). After a short spell as a teacher, he became Director of first Leeds and then Sheffield City Art Galleries (1932–8) and then the Director and Keeper of the *Tate Gallery (1938–64). He was knighted in 1952. A prolific writer, he published his series Modern English Painters, 1952–73, and a three-volume autobiography, 1965–70. He wrote three books on Turner, in 1949, 1960 and, with Martin Butlin, in 1964. He also wrote introductions to several Turner exhibition catalogues.

TR

John Rothenstein, Brave Day, Hideous Night, 1966.

ROTTERDAM. The biggest port of the Netherlands, prominent in Turner's 'Rotterdam' and 'Rotterdam and Rhine' Sketchbooks of 1835 and 1841 (TB CCCXXI and CCCXXII). The only picture showing Rotterdam is his Rotterdam Ferry-Boat (RA 1833; National Gallery of Art, Washington; BJ 348), which is intriguing because of the curious group of women and children in the diminutive ferry crossing the river between a big merchantman under full sail and a 17th-century warship at anchor. It is a *companion work to [Antwerp] Van Goyen looking out for a Subject (RA 1833; Frick Collection, New York; BJ 350) and thereby embodies a political message.

From small beginnings Rotterdam grew in the 17th century, but real prosperity started only in the 19th after the decline of *Antwerp. Turner was fascinated by the patterns produced by moored barges in front of the gabled architecture in its harbours and canals, or by ships sailing out into the Meuse. In his Dutch sketchbooks the city is consistently given the greatest number of topographical pages.

AGHB

H. Reinhardt, The Story of Rotterdam, 1955.
Bachrach 1974.

ROUGHT, Thomas (d. 1872), a dealer in Regent Street. Generally well respected although William *Wethered, another dealer, found him at times 'very queer, very nasty'.

Like *Pennell, Rought sold several Turners in the 1840s mainly either to *Gillott or for him. These included Sheer-

ness and the Isle of Sheppey, also known as Junction of the Thames and Medway (Turner's gallery 1807; National Gallery of Art, Washington; BJ 62), *Calais Sands (RA 1830; Bury Art Gallery; BJ 334) and Depositing of John Bellini's Pictures, referred to as 'Jean Bellini' (RA 1841; private collection; BJ 393). Rought also sold The Grand Canal, Venice (RA 1837; Huntington Art Gallery, California; BJ 368) to John James *Ruskin in April 1847. When many dealers faced ruin in 1858 only *Gambart and Rought were expected to survive.

EJ

Maas 1975, pp. 44–5, 98.
Chapel 1986, pp. 43–50.

ROYAL ACADEMY OF ARTS, London. This was the central educational, exhibiting, creative, cultural, and economic institution of Turner's life. It occupied the northern, Strand block of Somerset House until 1837, after which it moved to the eastern half of the National Gallery, *London building in Trafalgar Square. Turner's involvement in the body was wholehearted and diverse.

Having made a drawing 'from Castes' that was approved by the Academy's President, Sir Joshua *Reynolds, and its Keeper, Agostino Carlini, on 11 December 1789, Turner gained admission to the Royal Academy Schools. At the time these constituted the sole art school in Britain, and only drawing was taught there. Turner had been encouraged to apply by the painter and Academician J. F. Rigaud. From early 1790 to the end of 1793 he drew fairly regularly from plaster models in the Antique or 'Plaister' Academy, and from June 1792 until mid-October 1799 he studied intermittently in the Life Academy. It seems very likely that he attended the delivery of Reynolds's final Discourse on 10 December 1790, and all of those lectures crucially influenced his aesthetic development (see IDEALISM).

Turner made his debut at the 1790 RA exhibition with a watercolour, The *Archbishop's Palace, Lambeth (Indianapolis Museum of Art; W 10), and he showed watercolours in the annual exhibitions regularly throughout the 1790s and early 1800s. Subsequently he displayed them in decreasing numbers and with declining frequency until 1830. He exhibited an oil painting for the first time in the 1796 exhibition (*Fishermen at Sea; BJ 1) and thereafter showed them regularly until 1850. He failed to participate in the annual exhibitions only in 1805, a year of troubles and intrigues at the RA during which James *Wyatt temporarily replaced Benjamin *West as President (see also below); in 1821, when he was immersed in building work; in 1824, when he was preoccupied with a royal commission; and in 1848 and 1851, in which years he was apparently too weakened by age to repaint something old or complete anything new. By the end

of the 1790s he was already obtaining extremely high *prices for his oils and watercolours (especially the former). In general his works were favourably hung, although in 1812 he threatened to withdraw *Snow Storm: Hannibal and his Army crossing the Alps (BJ 126) because its display above a doorway countered the internal perspective of the painting; accordingly it was rehung at eye level in another room.

In 1798 the RA permitted the quotation of verse beneath the titles of works in the annual exhibition catalogues, and subsequently Turner often took advantage of that change. Principally he did so as part of a larger response to Reynolds's demands for visual artists to match painting to its 'Sister Art' of *poetry, in terms of imagery, metaphorical suggestion, scale, visual consonance, and moral elevation. Turner explored the possibilities of equating the two arts for the rest of his career, having tested them in a particularly methodical way between 1798 and 1800 (see Ziff 1982, Shanes 1990[1], pp. 51 ff.). Naturally, the poetic texts afford great insight into Turner's visual meanings. Until 1812 such verses were by others (except perhaps in 1800, when lines that the painter may have composed himself were appended); after that date the majority of poetic subtexts are those constituting Turner's Fallacies of Hope.

At the end of the 1790s the painter began actively canvassing for election as an Associate Academician, a necessary step to becoming a full Academician. He was successful, being elected an ARA on 4 November 1799. The huge success of *Dutch Boats in a Gale (BJ 14) in the 1801 exhibition contributed greatly to his election as a full Academician on 10 February 1802 (and not 12 February as usually stated—see *Farington Diary). He was the youngest person to have been accorded that status to date. As a necessary condition of election he had to present the RA with a Diploma work, and he offered two choices, the first of which was accepted. This was the oil painting *Dolbadern Castle, North Wales (BJ 12), which had been exhibited in 1800.

Not long after Turner was voted an Academician he became a member of the Academy Council and thus was a close witness to a series of related disputes that both divided the RA and had important repercussions for his career as an exhibitor (see Shanes 1990, pp. 40–6). Fundamentally the conflicts stemmed from contention between two factions: the 'Academical' party, whose aim was to maintain RA autonomy from the monarch; and the 'Court' party, which wanted to increase royal control. Turner allied himself to the former group but eventually the squabbling became so bitter that he feared for the future of the RA. Consequently, in April 1804 he opened his own gallery at 64 *Harley Street so that if the institution dissolved he would have an alternative venue in which to exhibit. Possibly his 1806 painting The *Goddess of

Discord choosing the Apple of Contention in the Garden of the Hesperides (BJ 57) was a vehicle for expressing his revulsion at the divisiveness and envy within the RA, a 'disgust' he still felt as late as 1807 (see Farington, 12 January).

From the very beginning of his career Turner engaged in a visual discourse on the walls of the RA with artists past and present. This dialogue is often cited as proof of his sense of 'inferiority' to other painters, and a resulting need to upstage them, but surely it was inspired by Reynolds's demand that artists should respond in this way. Over the years Turner enhanced his art by drawing stylistically upon Rooker, de *Loutherbourg, *Rembrandt, *Van de Velde the Younger, *Teniers the Younger, *Claude, Reynolds, *Rosa, *Titian, *Poussin, *Canaletto, and *Watteau, as well as a host of lesser practitioners from *Wilkie to George *Jones.

Although in his early days as an Academician Turner was occasionally thought to be 'presumptive & arrogant' (*Hoppner, quoted by Farington, 30 April 1803) or 'uncouth' (*Constable, letter to Maria Bicknell, 30 June 1813), the superiority of his creative powers and his 'wonderful range of mind' (ibid.) usually sufficed to excuse him. However, this was sadly not the case with a leading collector, Sir George *Beaumont, whose disparagement of Turner in the 1800s and early 1810s proved especially damaging professionally. But press criticism was frequently favourable in the 1810s and 1820s, although by the 1830s Turner's annual RA offerings became the subject of much derision. Fortunately, by that time the artist had become largely impervious to criticism. In any event, he surely valued the fact that he was never neglected by the press.

Turner served the Royal Academy in a number of capacities:

- Acting President between February 1845 and December 1846, when he stood in for the President, Sir Martin Archer *Shee, who was ill. Turner was officially elected Deputy President in June 1845.
- Member of the Academy Council in 1803, 1804, 1812, 1819, 1820, 1828, 1829, 1837, 1838, and 1845.
- Member of the Hanging Committee in 1803, 1828, 1837, 1838, and 1845.
- Professor of Perspective, in which office he mounted a course of six lectures in most years between 1811 and 1828. No lectures were given in 1813, 1817, 1820, 1822, 1823 and 1826. In 1827 two lectures were dropped from the course.
- Auditor of Accounts annually between 1824 and 1839, and again between 1841 and 1846.
- Inspector of the Library in 1819 and 1838.
- Inspector of the Cast Collection in 1820, 1829, and 1838.

- Annual Visitor or instructor in the Life Academy in 1812, 1813, 1822, 1823, 1825, 1830, 1831, 1834, 1835, and 1837.
- Visitor in the Painting School in 1816 (the year it opened), **1830, 1831, 1835**, 1836, 1838, 1839, 1842, and 1843. (The dates given in bold indicate the years in which Turner combined this post with Visitorship in the Life Academy—see above.) Although Turner lacked verbal skills, he usually made himself understood and was an extremely popular teacher; attendances rose when he was scheduled as Visitor.

Turner was a very active member of the Academy Club, whose gustatory gatherings he first attended on 4 November 1799, and to which he last inched his way on 7 May 1851. He was also the moving spirit behind a farewell dinner that was held in December 1836 just before the RA moved from Somerset House. He presented the RA with a dozen dessert spoons in 1802; Hogarth's palette in 1832; a cast of the Apollo Belvedere in 1842; and some silver sugar-tongs in 1850. He also bequeathed the institution £20,000. This was to be spent on grants to needy artists of repute who were not Members of the RA; on a biannual *Turner Medal and scholarship in Landscape Painting; and on annual contributions to the RA Schools. Turner's desire to create a Professorship of Landscape Painting (see Farington, 8 January 1811) was never realized.

See also PERSPECTIVE LECTURES; VARNISHING DAYS.　　ES

Farington *Diary*, especially vols. v, viii.
Sidney C. Hutchison, *The History of the Royal Academy*, 1986.

ROYAL ACADEMY OF ARTS, *Bicentenary Exhibition, 1768–1968*, 1968–9. Celebrating the bicentenary of the Foundation of the *Royal Academy in 1768, this enormous exhibition provided a broad survey of the exhibits at the annual summer exhibitions during the previous two centuries. There were more works by Turner—fifteen paintings, 21 watercolours, and one etching—than by any other artist.　　LH

ROYAL ACADEMY OF ARTS, *Exhibition of British Art*, 1934. A survey covering from c.1000 to 1860 with 1,632 exhibits including such diverse items as funerary helms, tulip watches, and maidenhead spoons.

Turner was represented by eighteen oils including fourteen from private collections and ranging from 1803 (*Bonneville, BJ 46) to 1849 (The *Wreck Buoy; BJ 428).

The 32 watercolours (27 loaned privately) admirably demonstrated Turner's variety of subject matter and technical mastery culminating in five of the ten famous 1842 Swiss views: *Brunnen* (private collection, UK; W 1527), *Constance* (York City Art Gallery; W 1531), *Zürich* (British Museum; W 1533), and both the 'Blue' and 'Red' *Rigis (private col-

lection, and National Gallery of Victoria, Melbourne; W 1524, 1525).　　EJ

ROYAL ACADEMY OF ARTS, *First Hundred Years* exhibition, 1951–2. Turner figured largely in this exhibition of *The First Hundred Years of the Royal Academy, 1769–1868*, held in the winter of 1951–2. With 21 oil paintings and fifteen watercolours he outnumbered even the first President, Sir Joshua *Reynolds.　　MB

ROYAL ACADEMY OF ARTS, Winter exhibitions of *Works by the Old Masters* began as a regular series in 1870. Most included between one and twelve works by Turner, though from the 1890s onwards the exhibitions were increasingly devoted to a single artist or group of artists. In certain years Turner was specially featured: 1886 (with one oil and 53 watercolours), 1887 (two and 72 respectively), 1889 (five oils and 73 watercolours including the 50 *Rhine drawings from the *Fawkes Collection), 1892 (seven oils; 38 watercolours), 1906 (five oils; 15 watercolours), and 1907 (3 oils and 25 watercolours mainly from the *Currie Collection); the 1912 exhibition of 'Graphic Artists' included sixteen *Liber Studiorum* prints. This meant that finished oil paintings and watercolours from outside the national collection were repeatedly before the public in the later 19th and early 20th centuries.　　MB

ROYAL HIBERNIAN ACADEMY EXHIBITION, Dublin, 1846. This included *Whalers* (RA 1845; BJ 414) and *Saltash from the Water Ferry* (Turner's gallery 1812; Metropolitan Museum of Art, New York; BJ 121) still belonging to Turner and for sale, showing that, even aged 71, Turner was ready to explore new selling venues. *Saltash* must then have passed to the dealer J. Hogarth, as it appears in his sale at Christie's on 13 June 1851 (lot 50a).　　EJ

ROYAL MANCHESTER INSTITUTION EXHIBITIONS. Founded in 1823, the RMI showed five Turner oils during his lifetime which were generally well received by the Manchester press. Sir George *Phillips, who commissioned *Linlithgow Palace* (Turner's gallery 1810; Walker Art Gallery, Liverpool; BJ 104), lent it in 1829. Henry *McConnel lent *Venice* and *Keelmen* (RA 1834, 1835; both National Gallery of Art, Washington; BJ 356, 360) in the same year that each was at the RA; *Keelmen* was catalogued merely as 'Moonlight' causing *Finberg to identify it as *Alnwick Castle* (Art Gallery of South Australia, Adelaide; W 818) but McConnel referred to *Keelmen* as 'the Moonlight' in a letter to *Naylor in 1861. In 1845 Joseph *Gillott lent *Schloss Rosenau* (RA 1841; Walker Art Gallery, Liverpool; BJ 392) and *The Temple of Jupiter Panellenius* (RA 1816; Duke of Northumberland; BJ 134).

Several Governors of the Institution were Turner collectors including Sir John *Leicester, McConnel and Sir George Phillips. ADRL/EJ

Manchester City Art Galleries 1983, pp. 11–14.

Croal and Nugent 1996, p. 15.

ROYAL SCOTTISH ACADEMY EXHIBITIONS, Edinburgh. Ten Turner paintings were lent to the RSA exhibitions by collectors between 1845 and 1851: three by John *Miller of Liverpool (in 1845, *Neapolitan Fisher-Girls*, Huntington Art Gallery, California, or private collection, USA, BJ 388 or 389, see REPLICAS AND VARIANTS; in 1847, *Hurley House*, private collection, BJ 197; in 1848, *Cicero's Villa*, Rothschild Collection, Ascott, Bucks.; BJ 381); three by *Bicknell (in 1845, *Palestrina*, BJ 295; in 1846, *Ivy Bridge*, private collection, England, BJ 122; in 1849, *Wreckers*, Yale Center for British Art, New Haven, BJ 357); one each by Charles *Birch (1846, *Mercury and Argus*, National Gallery of Canada, Ottawa; BJ 367), and by Joseph *Gillott (1847, *Temple of Jupiter*, Duke of Northumberland, BJ 134), and two by the Earl of *Yarborough (1851, *Macon*, Sheffied City Art Galleries, BJ 47, and *Wreck of the Minotaur*, now retitled *Wreck of a Transport Ship*, Fundaçao Calouste Gulbenkian, Lisbon, BJ 210). EJ

ROYAL SOCIETY, founded by scholars in 1660 and granted its Charter in 1662, which defined the Society's responsibility for 'improving naturall Knowledge'. From 1781 to 1837 the Royal Society made Somerset House its home alongside the Royal Academy. The close proximity of these learned bodies conveniently gave Turner and other artists the opportunity to meet and exchange ideas with prominent scientists. The Journal Books of the Royal Society, however, do not confirm his attendance at any lectures. Turner attended Royal Society soirées in the 1840s although he was not a Fellow. SET

James Hamilton, *Turner and the Scientists*, 1998, pp. 22–3.

ROYAL SOCIETY OF ARTS, see SOCIETY OF ARTS.

RUBENS, Peter Paul (1577–1640), greatest exponent of the Northern baroque. The son of an old *Antwerp family, he was taught by various reputable artists and entered the Guild at 21. After working in Italy and Spain he was appointed Court Painter to the Spanish Governor of the Netherlands in 1608. He settled in Antwerp and after a rich marriage became uniquely successful in his palatial workshop with *Van Dyck and Jordaens as young assistants. Apart from executing important commissions abroad, he also acted as a diplomat and in 1629 was knighted by King Charles I, for whom he painted the ceiling of the Banqueting House in Whitehall.

The colourful, self-assertive opulence of his figures and the grandeur of his designs, both religious and secular, impressed Turner strongly enough to make him repeatedly mention the Flemish Master in his lectures, although in 1802 he had written in his 'Louvre' Sketchbook (TB LXXII: 58) of Rubens's *Tournament* and *Landscape with a Rainbow* (Wallace Collection, London): 'the sun [was] ill-judged and misapplied . . . one continual glare of colour and absurdities when investigated by [the] scale of Nature, but captivating.' In fact, in his 'Backgrounds' lecture of 1811 (see PERSPECTIVE LECTURES) he called him 'Master of every power of handicaft and mechanical excellence . . . disdained to hide, but threw around his tints like a bunch of flowers' (p. 145). Rubens was his model for handling the three-colour conception of the primaries despite alleged ignorance and neglect of natural effect. In his 'Reflexes' lecture of 1818 he singled Rubens out for his capacity to use white as a colour—which in Turner's context was to be a subject in itself. AGHB

Christopher White, *Peter Paul Rubens: Man and Artist*, 1987.

Michael Jaffé, *Peter Paul Rubens*, 1989.

RUISDAEL, Jacob van (1628–82), supreme 17th-century Dutch landscape and marine painter. Born in 1628 at Haarlem, the early centre of Dutch realism, this great discoverer of his countryside's individuality, after travels in East Holland and West Germany, settled in *Amsterdam in 1655. There he also appears to have practised as a surgeon after obtaining a degree from Caen.

His atmospheric views—at first mostly of the dune and forest dominated environs of his birthplace—were widely imitated, his closest follower being Hobbema. In Ruisdael's landscapes symbolic elements are not lacking. First among such are the almost ubiquitous *vanitas* effects of trees struck by lightning with their attention-catching, white, barkless trunks. Another characteristic which found much popular appreciation was the upright format of his many delightful *Haerlempjes*, the little Haarlem panoramas viewed from the top of a dune.

All this implied huge skies with dramatic cloud formations which in turn allowed an unsurpassed handling of light in a highly original development of vista painting, often with the city silhouette as background and the St Bavo Church as the dominant landmark. It was connected with another distinguishing feature which became apparent halfway through his career: an obsession with the single tree as a personality, dignity, and majesty of its own. In his marines, too, Ruisdael's chief concern is atmosphere, with the dramatic effect of wind and waves emphasized by dark foregrounds against almost aggressively lit-up backgrounds in wide strips.

Turner drew and criticized two Ruisdaels in the 'Studies in the Louvre' Sketchbook, a landscape and a marine. His comments contain sharp reactions to colouring and composition, praising the landscape but judging the depiction of surf breaking on 'a lee-shore embanked' in the seapiece to be badly deficient—a judgement obviously based on the fact that, since he had not yet been to Holland, he was still ignorant of the difference in the effect on wave-formation of English shingles and Dutch sandbeaches (TB LXXII: 14–15).

In 1827 stricture gave way to admiration to the extent of Turner now painting a stormy seapiece with a sailing-boat likewise approaching a lee-shore and calling it *Port Ruysdael* (RA 1827; Yale Center for British Art, New Haven; BJ 237). Such a port does not exist; what does is merely the spaced-out superscription of his Louvre comment of 25 years before, reading 'Sea Port R[u]ysdael' (LXXII: 23). In 1844, after another seventeen years and having in the mean time made a faint sketch of a landscape at Dresden in 1836 inscribed 'Rysdael' (CCCXLI: 427), he repeated this eccentric form of homage in a no less dramatic *Fishing-Boats bringing a Disabled Ship into Port Ruysdael* (RA 1844; BJ 408) with, in light of his advanced age, its clearly symbolic overtones. Turner's respect for the several masterpieces by Ruisdael in British collections may have grown as he himself felt confronted by similar if not identical challenges. As a result came his impressive evolution from merciless critic to lifelong liegeman. AGHB

Jacob van Ruisdael, exhibition catatalogue, Cambridge, Mass., Fogg Art Museum, 1981.

RUSKIN, John (1819–1900), English art and social critic, whose extensive writings on Turner have been widely influential in shaping public perceptions of his achievement. Ruskin was the only child of John James *Ruskin and his wife Margaret, who had moved from Edinburgh to London in 1818. Precociously talented, Ruskin acquired a taste for literature and painting from his father, who was a prosperous wine merchant with an active interest in the arts. His first encounter with Turner came in 1832, when he was given a copy of Samuel *Rogers's poem *Italy* as a thirteenth-birthday present. The book was illustrated with vignette engravings, including several after Turner. Ruskin was captivated. The family soon ventured on its first Continental journey in order to see for themselves what Turner had drawn. Throughout his lifetime's work on Turner, Ruskin's dedication to the pictures was closely bound up with his attachment to the places Turner painted.

In 1833 Ruskin saw his first original Turners, exhibited at the *Royal Academy. It was not long before he was prompted to write on the artist's behalf. Turner exhibited

Juliet and her Nurse in 1836 (Sra. Amalia Lacroze de Fortabat, Argentina; BJ 365), and the picture was contemptuously reviewed by the Revd John Eagles in *Blackwood's (Edinburgh) Magazine*. Ruskin immediately composed a long and passionate defence, describing Turner's imagination as 'Shakespearian in its mightiness'. His essay was sent to Turner, who thanked Ruskin for his efforts but expressed no wish to see the piece published. Though it did not appear in print until 1903, this essay is important as the earliest germ of *Modern Painters* (1843–60), the monumental five-volume study of landscape painting in which Ruskin developed his championship of Turner to the point at which it can be seen as a foundation for his art criticism as a whole. Ruskin's writings on Turner are by no means confined to *Modern Painters*, but it was the intensity and commitment of his characterization of the artist in that work which made the deepest impression on the standing of Turner in the Victorian period and beyond.

Written over a period of seventeen years, *Modern Painters* is an immensely varied and wide-ranging work. The first volume, which Ruskin published anonymously at the age of 24, is more directly concerned with Turner than the four which followed. For all its ardour and confidence, this volume draws on a limited experience of painting. Ruskin had had little opportunity for serious work in the art galleries of Europe. He had studied the Turners owned by B. Godfrey *Windus, whose house on Tottenham Green contained probably the largest collection of Turner watercolours then in existence as well as several oils, alongside pictures by other contemporary artists. This collection, together with paintings he had encountered elsewhere in London—especially in the Dulwich Picture Gallery, close to his home in south London, and in the exhibitions of the Old Water-Colour Society (see WATERCOLOUR SOCIETIES)—provided Ruskin with the foundation of his knowledge of landscape art. Turner towers above his fellow 'modern painters' in the pages of this volume, but he does so in close association with Ruskin's parallel passion for nature. Each of the succeeding volumes of *Modern Painters* is prefaced with a quotation from *Wordsworth's *Excursion*:

> 'Accuse me not
> Of arrogance,
> If, having walked with Nature,
> And offered, far as frailty would allow,
> My heart a daily sacrifice to Truth,
> I now affirm of Nature and of Truth,
> Whom I have served, that their Divinity
> Revolts, offended at the ways of men,
> Philosophers, who, though the human soul
> Be of a thousand faculties composed,

And twice ten thousand interests, do yet prize
This soul, and the transcendent universe,
No more than as a mirror that reflects
To proud Self-love her own intelligence.
(Ruskin, *Works*, iii. p. vii)

In both tone and substance, this epigraph provides a key to Ruskin's understanding of Turner. He was formed by his reading in English *Romanticism, and the influence of Wordsworth's philosophical poetry on his early work was especially profound. Wordsworth had argued that nature could teach the disciplines of spiritual humility, and that true wisdom was a product of that lesson. This conviction became the basis of Ruskin's interpretation of Turner. *Modern Painters* has many claims to be seen as the last great work of English Romanticism, and Turner is the focus of that identity. Ruskin justifies his claims for the painter's transcendent greatness by pointing to what he sees as his incomparable 'truth to nature'. In Ruskin's eyes, the pictures are so faithful to nature that they are almost natural phenomena in themselves. In fact, the first volume of *Modern Painters* has rather more to say about the natural world—mountains, clouds, trees, and water—than about Turner's pictures. Nature, and Turner's visions of nature, are perceived as sources of moral energy. What is odd, and perhaps misleading, is that Turner emerges from Ruskin's compelling analysis as a painter whose primary motive is to serve. As Ruskin saw it, Turner's greatness lay in his acknowledgement that nature was greater still.

Yet Ruskin was not simply the painter's critical acolyte. For all his devotion to Turner, he came of a different generation and background, with very different aspirations. Turner was 44 years old when Ruskin was born. Though both can be seen as Romantic figures, Ruskin's later Romanticism did not, as Turner's did, lead him to reject Christian traditions of thought. This was a crucial distinction between them. As *Modern Painters* moved towards its conclusion, the exuberant celebration of the first volume darkened into a more mature and sober homage. In 1860, when the fifth and final volume was published, Ruskin had come to see a depth of meaning that approached tragedy in the painter's work. Turning increasingly to the mythological paintings, he saw in them emblems of the failing civilization of Victorian England. In the last chapter, he spoke of what he had come to feel as despair in the painter: 'And all his failure and error, deep and strange, came of his faithlessness' (*Works*, vii. p. 444). Much had happened to change Ruskin's view of the painter in the years between 1843 and 1860, including the loss of his own early Christian certainties. Though Turner remained in his estimation without question the greatest modern painter, in his later years he no longer spoke of him as the semi-divine figure that emerges from the enthusiastic pages of the first volume of *Modern Painters*.

Ruskin's personal relations with Turner were always complicated, and contributed to his changing view of the painter's work. He first met Turner in the house of Thomas *Griffith, on 22 June 1840. He recorded the occasion in his diary:

Introduced to-day to the man who beyond all doubt is the greatest of the age; greatest in every faculty of the imagination, in every branch of scenic knowledge; at once *the* painter and poet of the day, J. M. W. Turner. Everybody had described him to me as coarse, boorish, unintellectual, vulgar. This I knew to be impossible. I found in him a somewhat eccentric, keen-mannered, matter-of-fact English-minded-gentleman: good-natured evidently, bad-tempered evidently, hating humbug of all sorts, shrewd, perhaps a little selfish, highly intellectual, the powers of the mind not brought out with any delight in their manifestation, or intention of display, but flashing out occasionally in a word or a look. (*Works*, xxxv. p. 305)

The two men were never close friends, though they continued to meet intermittently, both in Turner's studio and in Ruskin's home at Denmark Hill, in London. Much that passed between them remains obscure. Though Ruskin repeatedly calls attention to the painter's kindness, which was evidently extended to the eager young author of *Modern Painters*, Turner seems to have given his admirer some obscure cause of offence for which he was never quite forgiven. Turner may have felt an understandable resentment of the power with which Ruskin had represented, or occasionally misrepresented, his motives as an artist. Perhaps there was a disagreement over money, for many of Ruskin's dealings with the painter involved the purchase of pictures. Whatever happened, relations between the two were always a little distant, though never hostile. In his late autobiography, *Praeterita* (1885–9), Ruskin muses on their first meeting:

If he had but asked me to come and see him the next day! shown me a pencil sketch, and let me see him lay a wash! He would have saved me ten years of life, and would not have been less happy in the close of his own. One can only say, Such things are never to be; every soul of us has to do its fight with the Untoward, and for itself discover the Unseen. (*Works*, ibid., p. 306)

As his knowledge of Turner deepened, Ruskin became an important collector of his work. More than 300 pictures passed through his ownership. They were mostly watercolours, though in January 1844 his father gave him *Slavers* (RA 1840; Museum of Fine Arts, Boston; BJ 385), the picture of which he had said (in *Modern Painters*, i) that 'if I were reduced to rest Turner's immortality upon any single work, I should choose this' (*Works*, iii. p. 572). It hung in

Denmark Hill until he sold it to America in 1872. Later, *The Grand Canal, Venice: Shylock* (RA 1837; Huntington Art Gallery, California; BJ 368) also became part of the Denmark Hill collection, also to be sold in 1872. As a young man, Ruskin was dependent on his father's generosity for all his acquisitions of Turners. There was no initial thought of establishing a collection when the first drawing (*Richmond Hill and Bridge, Surrey*; British Museum; W 833) was bought for Ruskin in about 1837, 'for a specimen of Turner's work'. But it was followed in 1839 by the *Gosport* (Portsmouth City Museum; W 828) and in 1840 the *Winchelsea* (British Museum; W 821), also from the series *Picturesque Views in *England and Wales*, was purchased. It was then that, as Ruskin was to recall in *Praeterita*, the first division of opinion between father and son over Turner began to emerge. The *Winchelsea* was not wholly to Ruskin's taste: 'I was disappointed, and saw for the first time clearly that my father's joy in *Rubens and Sir Joshua [*Reynolds] could never become sentient of Turner's microscopic touch' (*Works*, xxxv. p. 256). Collecting Turners became a source of family friction. John James Ruskin was divided between his wish to gratify his son and his reluctance to supply the increasing sums of money needed to buy the pictures. Perhaps he also felt some degree of jealousy of his son's adulation of the painter. He was dismayed by Ruskin's willingness to pay £70 for *Harlech Castle* (untraced; W 867), the next purchase, also from the *England and Wales* series. Feelings came to a head over the *Splügen* (private collection; W 1523), a late (1842) Swiss drawing that Ruskin longed for, and failed to acquire. Ruskin calls the *Splügen* 'the best Swiss landscape yet painted by man' (ibid., p. 309), and its loss became an emblem of frustration that haunted him for years. In 1878, after his first bout of serious mental illness, friends subscribed money to buy the picture for Ruskin, a gesture of loyalty that meant much to him.

Turner's death in December 1851 marks a new phase in Ruskin's relations with his work. He had been named among Turner's executors, and though he withdrew from the task when the *will was disputed, there is no doubt that he had come to feel a more professional measure of responsibility to the painter's legacy. He was no longer a fervent youth eulogizing the work of a living painter, but an acknowledged author in his early 30s, assessing and recording Turner's completed career. He laid glowing plans for a gallery that would be worthy of the pictures: 'Each picture with its light properly disposed for it alone—in its little recess or chamber. Each drawing with its own golden case and closing doors—with guardians in every room to see that these were always closed when nobody was looking at *that* picture . . . Room for everybody to see everything' (*Works*, xiii.

pp. xxviii–ix). It was not to be. Nor was John James Ruskin prepared to open his purse to buy large numbers of new Turners, though Ruskin's wish to own them grew even keener after the painter's death. Ruskin's work on the painter continued on a quieter note, in the succeeding volumes of *Modern Painters*, and in less celebrated works like the 'Illustrative Text' to a series of engravings after Turner published in 1856 as The *Harbours of England.

In late 1856, when the National Gallery, *London, at last received the pictures that Turner had bequeathed to the nation, Ruskin offered to sort and arrange all of the drawings and sketches. His magisterial *Notes on the Turner Gallery at Marlborough House* (1857) confirmed his claims as the best man to do this work, and he was given the authority to proceed. The task was immense. There were more than 19,000 items to be set in order, and Ruskin worked steadily throughout the winter of 1857–8. His understanding of the painter was renewed, and changed. The experience had much to do with the richer, but more shadowed, view of Turner that develops in Ruskin's writings in the later 1850s and beyond. Most painful, perhaps, was the discovery of a group of drawings that he thought obscene. He agreed that they should be destroyed. It may be that Ruskin's sense of the darkness in Turner's late art was partly derived from this experience, though he rarely spoke of it and it is hard to estimate how much it mattered to him. (See PORNOGRAPHY.)

After the completion of *Modern Painters* in 1860, Ruskin's interests diversified widely. His later writings on Turner are scattered among texts which deal with many other subjects, and his changing views are difficult to disentangle from what he has to say about politics, the teaching of art and science, economics and history, national responsibility and national decline, and his own haunted sense of the past. He continued to acquire Turner drawings, and also to dispose of them. He gave valuable groups of drawings to Oxford (see ASHMOLEAN) and Cambridge (see FITZWILLIAM) in 1861. His *Lectures on Art* (1870), delivered after his election as Oxford's first Slade Professor of Fine Art in 1869, speak of Turner as belonging to what he termed the 'School of Light': 'being throughout a school of captivity and sadness, but of intense power' (*Works*, xx. p. 153). His earlier gift to Oxford was enriched by further Turner drawings, given to endow the new Ruskin School of Drawing which he founded in association with the Professorship. Ruskin's last sustained statement on Turner came in 1878, as he prepared *Notes* for an exhibition of his collection of Turner's drawings to be held at the *Fine Art Society's Galleries in Bond Street. The work was interrupted by the first of the attacks of mental illness that were to cloud his later years. Sombre and elegiac, this catalogue is a reminder of how much had

changed for Ruskin since he had composed the dizzy pane-
gyrics of the first volume of *Modern Painters*. But his rever-
ence for Turner remains constant. 'As in my own advancing
life I learn more of the laws of noble art, I recognize faults in
Turner to which once I was blind; but only as I recognize
also powers which my boy's enthusiasm did but disgrace by
its advocacy' (*Works*, xiii. p. 405). DLB

Wedmore 1900.

Herrmann 1968.

Tim Hilton, *John Ruskin: the early years*, 1985; *John Ruskin: the
later years*, 2000.

Dinah Birch, *Ruskin on Turner*, 1990.

Ruskin, Turner and the Pre-Raphaelites, exhibition catalogue,
London, Tate Gallery, 2000.

RUSKIN, John James (1785–1864), wine merchant (Ruskin,
Telford & Domecq), father of John *Ruskin, and collector
with his son of Turner's works. Born in Edinburgh, the son
of a grocer, Ruskin studied art under Alexander Nasmyth.
In 1807 he moved to London and worked as a clerk before in
1814 founding what was to become a thriving wine mer-
chant's business. Ruskin began to collect pictures in *c.*1832
with a seapiece by Copley Fielding. In January 1839 he
bought the first of the long series of works by Turner for his
son John. Together they formed an extensive collection of
works, and while John Ruskin seems always to have made
the greatest critical contribution, John James generally only
funded the acquisition of works he also liked. John James's
dedication to Turner above almost all other painters is
evident from a letter dated 11 April 1842 when he wrote to
his son: 'I find I see every day less of the Red and Yellow of
Turner & More of his Beauty. I never find my Eye remains
on any picture if I am leaving it to take its own way except
Turner and Lewis. Ergo other pictures are rubbish nearly
to me' (Gage 1980, p. 282). John James Ruskin's addresses
were 54 Hunter Street, Brunswick Square (1818–23),
28 Herne Hill (1823–42), and Denmark Hill (1842–64).
 RU

Macleod 1996, p. 471.

RUSKIN SCHOOL COPIES, see FAKES AND COPIES.

ST GOTTHARD. The St Gotthard pass was a principal route over the **Alps* into Italy; although Turner did not plan an Italian tour in 1802, he was obviously interested enough in the possibility to make a considerable detour to inspect such a road. In any case, the pass offered some of the most dramatic of Alpine scenery, in a context that he relished: the harsh conditions of travel. He followed the route from Fluelen on Lake Lucerne, through Altdorf, legendary scene of William Tell's exploits, to the Devil's Bridge before turning back. The narrow mountain road and vertiginous bridge over which travellers had to pass, and which had been the site of a battle between the French and the Austrians as recently as 1801, were the subject of two fine studies in the 'St Gothard and Mont Blanc' Sketchbook (TB LXXV: 33, 34), which became the bases for a pair of small oil paintings of *c*.1803–4 (City Museums and Art Gallery, Birmingham, and private collection; BJ 146, 147), a watercolour (Abbot Hall Art Gallery, Kendal; W 366), and a **Liber Studiorum* plate (F 19). A further plate was designed but never published (F 78). One of the paintings and the watercolour show the narrow gorge from a viewpoint on the bridge itself, emphasizing the dizzying drop over which one had to walk. Another large watercolour, recently rediscovered and now in the Yale Center for British Art, New Haven (W 368), which may not be finished, is an imaginary view taken from higher up the pass, with the bridge almost lost in the cloud-filled gulf.

Among the late Swiss watercolours the two views of Fluelen (Yale Center for British Art, New Haven, and Cleveland Museum of Art, Ohio; W 1541, 1549) and *The First Bridge above Altdorf* (Whitworth Art Gallery, Manchester; W 1546) all record episodes on the route up to the St Gotthard. One of Turner's two last **commissions*, from **Ruskin*, was *The Descent of the St. Gothard (Valley of the Ticino)* (1847–8; Koriyama Museum of Art, Japan; W 1552). AW

SALISBURY. Turner made a number of views of the Cathedral and other antiquities of this Wiltshire town between *c*.1796 and *c*.1805 (W 196–212), mostly for Sir Richard Colt **Hoare* of Stourhead. In one view, part of a cloister window frames the Cathedral spire, giving it a strikingly **'Sublime'* quality (*c*.1802; Victoria and Albert Museum; W 202). In the later *Salisbury, from Old Sarum Intrenchment* (*c*.1828–9; and Salisbury and South Wiltshire Museum; W 836; for *Picturesque Views in **England and Wales*) the shepherd who is protecting children from the rain may be the counterpart of the 'native' in Turner's verses of *c*.1811 (Wilton and Turner 1990, p. 170) who no longer acknowledges the competing 'feudal' claims of 'Priests and Soldiers'—the dominant factions in the medieval city of Old Sarum, before the present Cathedral and town were founded. As a rotten borough, Old Sarum further symbolized feudal tyranny. Moreover, the Church hierarchy supported the unreformed parliamentary system, which may explain why the Cathedral in the image, though bathed in light itself, offers no protection from the elements to the foreground figures (see Elizabeth Helsinger, 'Turner and the Representation of England', in W. J. T. Mitchell, ed., *Landscape and Power*, 1994, p. 124 n. 27.

See also REFORM BILLS. AK

SANDBY, Paul (1730–1809), English landscape artist in oils, gouache, and watercolour. Born in Nottingham, Paul Sandby spent his early years in the shadow of his elder brother, Thomas, architect and draughtsman. He was appointed draughtsman to the Survey of the Highlands in 1747, and there he began his career as a topographical artist and also learnt the art of etching. Returning to London in about 1752, he spent much time at Windsor, where Thomas was employed by the Duke of Cumberland. Paul's outstanding watercolours of Windsor Castle and its surroundings date from these years, and he also developed his skills in the drawing of figures, often in a French rococo manner. He was also painting landscapes in oils and gouache, and established his reputation as one of the leading landscape and topographical artists of the day, becoming a founder member of the **Royal Academy* in 1768, the year in which he was appointed Chief Drawing Master at Woolwich Military Academy. Paul Sandby made great advances in the tech-

niques of watercolour and pioneered the use of aquatint. Through his teaching and engravings Sandby was very influential in the development of the English watercolour school, and Turner's earliest exhibited watercolours, such as *The *Archbishop's Palace, Lambeth* (RA 1790; Indianapolis Museum of Art; W 10), owe much to his example. LH

Luke Herrmann, *Paul and Thomas Sandby*, 1986.

SANDYCOMBE LODGE. The country house which Turner designed and built for himself at 'Sand pit Close', Twickenham. He had bought the land in 1807, near property lived in during his exile by *Louis Philippe, with the intention of building a house there. He had been establishing himself in country properties on the western fringes of London, at *Sion Ferry House, Isleworth, and at *Hammersmith, since 1805, and although Sandycombe Lodge was not directly on the River Thames, it was on high ground within the landscape that *Thomson and Alexander *Pope had immortalized in their poetry and *Wilson had painted, and in the view from *Reynolds's country house on Richmond Hill. Every acre in that vicinity was for Turner redolent with poetry and art.

Early architectural sketches and ground plans (c.1811–13) in the 'Windmill and Lock', 'Sandycombe and Yorkshire', and 'Woodcock Shooting' Sketchbooks (TB CXIV, CXXVII, CXXIX) show the house evolving from a *cottage-ornée* to the more urbane manner of *Soane, with large windows and overhanging eaves. Turner designed the house during the period of his early *perspective lectures at the Royal Academy, when architecture was in the forefront of his mind. Although since altered, Sandycombe Lodge remains a neat, elegant building, with an inventive use of the sloping site, and a formal kinship with the much admired Pope's Villa at Twickenham. This was demolished after Turner had bought the land, and its memory may have directed the form of Sandycombe Lodge. From the road (Sandycombe Road), it is a modest two-storeyed house with low wings which have since been raised. On the garden front, however, the sloping site enables it to expand into three storeys with a diocletian window to the kitchen and dentilation (missing) at first-floor level. Its fine detailing, inside and out, shows Turner to have been a sensitive and accomplished architect, economical in the use of space.

Turner and his father used Sandycombe Lodge as a haven from London. They entertained there, but by 1815 Turner became frustrated that he had not been able to spend much time at Sandycombe, and he considered selling up. In the event he kept the property until 1826, when his father's health had begun to deteriorate, and managing the house and garden was becoming too much for him.

For a brief period, Turner referred to the house as 'Solus Lodge'. This has been taken to suggest that he wanted to be alone there; but it may equally be a misunderstanding of *Solis*—'of the sun'.

See also ARCHITECT, TURNER AS. JH

Youngblood 1982, pp. 20–35.
Wilton 1987, pp. 118–20.
Bailey 1997, ch. 13.
Hamilton 1997, 135–8, 157, 162–4, 174–5, 188, 232.

SAY, William (1768–1834), English mezzotint engraver born in Norfolk, who moved to London in about 1798 and trained under James Ward. Say became a highly successful and industrious engraver, working only in mezzotint and producing 335 plates between 1801 and 1834, most of them of portraits after artists such as *Lawrence and *Hoppner. Between 1811 and 1819 Say was responsible for mezzotinting eleven of the published *Liber Studiorum* plates (F 22, 24, 27, 29, 30, 34, 38, 49, 53, 61, and 68), a total only exceeded by Charles *Turner. A few years later Say engraved two outstanding plates for the *Rivers of England*, the vivid *Brougham Castle* (R 760), and the crowded and lively *Kirkstall Lock* (R 765). LH

SCENE PAINTER, Turner as. Shortly after Turner's sixteenth birthday, in April 1791, he abandoned his drawing classes at the *Royal Academy for several weeks and was employed as a scene painter at the Pantheon in Oxford Street, an experience that fuelled his love of *opera, *music, and drama as well as increasing his confidence in painting on a large scale. The London Pantheon, designed by the architect James *Wyatt with features inspired by its ancient namesake in Rome, had originally housed assembly rooms. It was converted into an opera house in 1790 and its chief scene painter was William Hodges, RA (1744–97). The last RA class in spring 1791 that Turner attended was on 26 March and he did not return until 4 July; records from the Pantheon, including signed bills and receipts, show that he was employed there from 22 April to 18 June.

At first he performed menial tasks with other boys, painting clouds and decorative borders, and earned 15s. a week. However, he was soon promoted to more responsible work and painted the scenery on the backcloths with complete set-pieces like cityscapes or storms at sea. From 1 May to 18 June he earned 4 or 5 guineas a week, charging a guinea extra for working on Sunday and overtime. Seven months later, on 14 January 1792, a disastrous fire swept through the theatre which Turner immediately hastened to sketch and commemorated in his watercolour *The *Pantheon, the Morning after the Fire* (RA 1792; TB IX: A; W 27). CFP

Price 1987, pp. 2–8.

SCHAFFHAUSEN, see *FALL OF THE RHINE AT SCHAFF-HAUSEN.*

SCHETKY, John Christian (1778–1874), Scottish marine painter and contemporary of Turner. After studying in Edinburgh under Alexander Nasmyth, he became drawing master at the Royal Military College, Great Marlow (1808–11), then Professor of Drawing at the Royal Naval College, Portsmouth (1811–36), and exhibited regularly at the *Royal Academy between 1805 and 1872, especially ship portraits, royal embarkations, and historic naval battles. A lifelong friend of Sir Walter *Scott, by 1818 he was also in touch with Turner, who breakfasted that year with Schetky's family during a visit to Scotland in search of subjects for Scott's *Provincial Antiquities.* In 1820 Schetky became Marine Painter in Ordinary to the King, *George IV, and in 1822 went to Edinburgh to record the latter's visit to *Scotland, especially his disembarkation at, and departure from, the port of Leith. Turner also attended the royal visit, and when subsequently planning four commemorative oils, intended to borrow Schetky's detailed study of the Royal Barge (for BJ 248b). However, in a letter to Schetky of December 1823 (Gage 1980, p. 90) Turner turned down the loan, the project having now been abandoned. Turner had meanwhile been commissioned by the King to paint a picture of the Battle of Trafalgar (BJ 252), and in the same letter he asked if Schetky could make him a fresh study of the *Victory* and also advise him on the appearance of other ships engaged in the battle, such as *Neptune* and *Redoubtable.* He returned Schetky's sketches nine months later (Gage 1980, p. 93). AL

W. Greenaway, 'The Marine Man, J. C. Schetky', *Turner Studies,* 7/2 (winter 1987), pp. 42–8.

SCHEVENINGEN. Now it is a modest fishing village west of The Hague, but in the 17th century ships with important passengers from England, such as ambassadors bound for the seat of the Dutch government or vice versa, would regularly anchor off Scheveningen beach for landing or embarkation by boat. Charles II on his way to Restoration in 1660 used this route, as did the Princes William II and William III in 1641 and 1677, respectively, to their marriages with Stuart princesses.

Turner visited Scheveningen in 1817 drawing some twenty sketches of fishing-boats and fisherfolk, both men and women, on and near flat-bottomed 'pinks' either drawn up on the beach or being rolled back into their element on poles. They form a unique group in the 'Dort' Sketchbook (TB CLXII: 24–37a), yet curiously enough neither boats nor figures seem ever to have been used by Turner for pictures. AGHB

SCHLOSS ROSENAU, *Seat of H.R.H. Prince Albert of Coburg, near Coburg, Germany,* oil on canvas, 38¼ × 49¼ in. (97 × 124.8 cm.), RA 1841 (176); Walker Art Gallery, Liverpool (BJ 392). Turner made a detour to *Coburg in September 1840 on his way back from Venice in order to visit Prince *Albert's birthplace. Studies for the picture occur in his 'Coburg, Bamburg and Venice' Sketchbook (TB CCCX).

If Turner hoped that the picture might be bought for the royal collection, he was to be disappointed, for Queen *Victoria did not even mention it in her *Journal* after visiting the exhibition. But the royal connection ensured handsome press coverage—mainly abusive: 'a picture that represents nothing in nature beyond eggs and spinach' (*The Times,* 4 May) or 'among the fruits of a diseased eye and a reckless hand' (*Athenaeum,* 5 June). *Ruskin countered these criticisms with extravagant praise in *Modern Painters* but qualified this considerably in the third edition (1846).

A version, catalogued with reservations as BJ 442, is now no longer considered genuine. EJ

SCIENCE AS SUBJECT MATTER. Scientific events or paraphernalia are rarely direct subjects in Turner's work, but scientific ideas, which he received from conversations with scientists and through his own observations, are frequently present as catalysts. His practical interest in science was slight, though he transcribed many pigment and varnish recipes in his 'Chemistry and Apuleia' Sketchbook (TB CXXXV), perhaps to save tradesmen's fees.

During his early travels in the Midlands and South Wales Turner found subjects in which the results of scientific discovery had been harnessed into industrial techniques. In *Limekiln at Coalbrookdale* (*c.*1797; Yale Center for British Art, New Haven; BJ 22) he has depicted the dramatic moment of the opening of a furnace at night, couching it deliberately, and fashionably, in the visual language of *Rembrandt. A commission from a former ironmaster, Anthony Bacon, caused him to begin the series of unfinished drawings of Cyfarthfa Ironworks near Merthyr Tydfil (1798, XLI: 1–4). His interest in these is not the nature of the iron-making process, but the creation of a set of picturesque landscapes.

The root of his interest in science as subject matter lies in his innate curiosity. He told how, as a boy, he would lie for hours on his back watching the skies, and then go home and paint them. Such resolution led directly to the observations of sky effects over a short period in the 'Skies' Sketchbook (?1818; CLVIII) and elsewhere, and studies of the stages of an eclipse of the sun (1804; 'Eclipse' Sketchbook; LXXXV). Most weather effects in Turner are drawn from direct observation.

Some, however, for example the stormy vortex in *Rockets and Blue Lights. . .* (RA 1840; Clark Art Institute, Williamstown, Mass.; BJ 387), may have developed out of acquaintance with the writings of the scientist David Brewster. Friendship with Mary *Somerville further fostered Turner's curiosity, while Somerville, as a popularizer of science, had in him the perfect audience.

The development of geology as a scientific discipline in the 1810s engaged Turner deeply. His verses in the 'Devonshire Coast No. 1' Sketchbook (1811; CXXIII) use geological vocabulary that can only have come from conversations with geologists, of whom the Revd William Buckland, John MacCulloch, and *Stokes were among his friends. In many of the watercolours from the *Southern Coast* series, such as *Lulworth Cove* (*c*.1811; untraced; W 449) and *Tintagel Castle, Cornwall* (*c*.1815; Museum of Fine Arts, Boston; W 463), the accurate depiction of geological form is paramount.

Although he may have known Humphry *Davy, a flourishing social link between the two is not proven. Davy's late writings, however, with their chromatic visionary imagery, may have been a catalyst for such paintings as *Angel standing in the Sun* (RA 1846; BJ 425) and *Hero of a Hundred Fights* (RA 1847; BJ 427).

The opinions of his contemporaries are crucial to an understanding of Turner's engagement with science. The Revd James Skene wrote of Turner's 'scrutinising genius' in the context of discoveries in the science of colour; while John MacCulloch was 'delighted' with Turner's 'clear, intelligent, piercing intellect'.

See also FARADAY; FRESNOY; GOETHE. JH

 Gage 1987, ch. 8.
 Rodner 1997.
 Hamilton 1998.

SCOTLAND. Turner journeyed to Scotland in 1797, 1801, 1818, 1822, 1831, and 1834. These six visits are documented, in part, by approximately 26 *sketchbooks, almost 100 watercolours, and about ten oil paintings. While it is possible from these to determine many of the localities he visited, one must frequently speculate about the routes followed and the direction in which he travelled, since he did not often use the pages of his sketchbooks sequentially, nor did he date his sketches. What makes the reconstruction of his routes still more difficult is that he not only employed more than one sketchbook at a time but sometimes reused sketchbooks on subsequent trips, making it, on occasion, hopeless to distinguish between journeys. This present reconstruction of the Scottish tours is based primarily on the locations identified in the sketches, on other documentary evidence relating to Turner, such as the paintings and watercolours mentioned above, on diaries and correspondence,

and on established travel routes, many of which are in existence today. Evidence indicates or suggests that he travelled at different times by regularly scheduled coach, hired or private two- or four-wheeled carriage, steamer or on foot. Almost all of these trips appear to have been undertaken alone.

THE 1797 VISIT. Turner first set foot on Scottish soil in 1797. His visit was brief, almost incidental to a North of England tour for which he had brought with him two large sketchbooks. However, he did cross the border into Scotland and recorded ancient architecture along the Borders (TB XXXIV, XXXV). He seems to have crossed into Scotland from Berwick-upon-Tweed, travelled south-west along the River Tweed, sketching the abbeys of Kelso, Dryburgh, and Melrose, and then journeyed south to Jedburgh. From Jedburgh, *Finberg suggests that he probably travelled to Hawick to catch the coach south to Keswick in the English Lake District.

THE 1801 TOUR. Before beginning this trip Turner consulted his friend *Farington, who had already visited Scotland twice. This visit lasted more than four weeks during which he filled eight sketchbooks (XLVIII, LII, LIII, LIV, LV, LVI, LVII, LIX). He travelled from London to Berwick-upon-Tweed, where he crossed the Tweed into Scotland. He stopped to sketch at Dunbar and then travelled on to Tantallon and Bass Rock. From there he went to North Berwick, south-east to Haddington, stopping at Dalkeith, and from there proceeded to *Edinburgh. He took sketching outings within the capital, short jaunts to Queensferry and Leith and a longer one south to Roslin Castle, which he sketched before he left Edinburgh. From the capital he journeyed west to Linlithgow and south-west to Glasgow, then northwest, down the *Clyde to Dumbarton and on to Luss on Loch Lomond. He then visited Arrochar at the head of Loch Long, continuing by way of Glencoe to Cairndow at the north end of Loch Fyne and around the loch to Inveraray. He appears at this point to have turned north through Glen Aray to Cladich, proceeding north along Loch Awe and crossing the loch near its head to sketch Kilchurn Castle. From there he travelled east to Dalmally, to Tyndrum, thence to Crianlarich, proceeding to Killin, along the south shore of Loch Tay to Kenmore, and from there explored Glen Lyon and continued north to, and beyond, Tummel Bridge, turning south-east to Blair Atholl. He travelled south-east through Killiecrankie to Dunkeld and then seems to have proceeded south to Crieff, then west to Comrie, the vale of Earn, and south to Glen Artney. Returning to Comrie and to Crieff, he would have journeyed south to Dunblane and Stirling. Continuing south from Stirling, he then explored and sketched Bothwell Castle, Hamilton,

Lanark, and the falls of the Clyde and then passed through Moffat, crossing the border at Gretna Green on his way to Carlisle and home to London. The sketches he made during this trip are often rapid pencil notations, but he also included watercolour views of Edinburgh and figure studies, a number of them in colour. In addition to these, he made a number of large, finished pencil drawings, the *'Scottish Pencils' (LVIII), prepared while still in Scotland.

THE 1818 VISIT. This third visit took place because of a commission Turner received in advance from *Scott to provide illustrations, mainly of ancient buildings, for his book, *Provincial Antiquities*. Evidence suggests that he went by coach up the east coast from London, crossing into Scotland at Berwick-upon-Tweed, making his first sketches at Dunbar, continuing to North Berwick, exploring and making sketches of Tantallon Castle, then turning south-east to Haddington. From Haddington he seems to have coached directly to Edinburgh, where he made a number of sketches in and of the capital and took several sketching jaunts outside the city, south to Craigmillar Castle and further south to Crichton and Roslin castles, south-east to Borthwick, west as far as Linlithgow, along the shores of the Firth of Forth, and north across the Forth to Rosyth. This visit lasted about two weeks and during that time he filled three sketchbooks (CLXV, CLXVI, CLXVII).

THE 1822 VISIT. On this, Turner's fourth visit, he journeyed by sea from London to Edinburgh and returned by this route, making sketches of the coast during the voyage. Still in Scott's employ, he had come primarily to witness and record the Edinburgh visit of *George IV. The two sketchbooks used on this trip (CC, CCI), which lasted two weeks, record, in the main, the royal celebrations and the architecture of the city associated with them, such as the King's procession with the regalia to Edinburgh Castle.

THE 1831 VISIT. The fifth Scottish visit lasted almost two months and Turner probably filled eleven sketchbooks (CCLXVI, CCLXVII, CCLXVIII, CCLXX, CCLXXI, CCLXXII, CCLXXIII, CCLXXIV, CCLXV, CCLXXVI, CCLXXVII). *Cadell, Scott's publisher, had requested that he illustrate new editions of *Scott's *Poetical* and *Prose Works*. Turner crossed into Scotland at Gretna Green and then proceeded west along the north shore of the Solway Firth to Dumfries, exploring the countryside and making sketches of nearby border castles. From Dumfries he proceeded north-east to Lochmaben, then to Lockerbie and Langholm. From Langholm, he journeyed north to Hawick, where he went south to Hermitage Castle. After returning to Hawick he hired a gig that took him to *Abbotsford. Relatively full documentation exists for his sketching outings during his visit to Abbotsford, when

he was in the company, occasionally, of Scott and always of Cadell, who was also a guest there. Although there is no direct evidence of Turner meeting Scott prior to this visit, the timing of comments attributed to Scott suggests that they probably met in Scotland during the 1818 and 1822 visits.

When Turner left Abbotsford, he departed with Cadell on a sketching tour along the Borders to the east, to Berwick-upon-Tweed, from which point the artist made his way north and west, alone, to Edinburgh. In the capital, Turner met Cadell again and with the aid of maps and guides the publisher provided the artist's route for an extended north-westerly trip and a sketching itinerary for Edinburgh and vicinity. It has been suggested that for this part of his tour he probably had on hand an up-to-date edition of *The Steam-Boat Companion or Stranger's Guide to the Western Isles of Scotland*. The limited amount of documentation that has so far come to light and the fact that several sketchbooks dated to 1831 also include sketches from the 1834 visit, make this part of the tour north and west of Edinburgh difficult to reconstruct. In consequence, the proposed route must remain particularly tentative.

Turner may have begun sketching at Dunfermline and from there journeyed west to Alloa and Stirling. From this point, he possibly travelled north-west to Callander, west to Loch Vennacher, to Loch Achray and Loch Katrine, returning to Loch Achray and then down to Loch Ard. He is likely to have crossed Loch Lomond to Loch Long at Arrochar and from there travelled to Loch Fyne. He possibly took a ferry across Loch Fyne to Inveraray, where he proceeded to Cladich, then north-east to the end of Loch Awe and west along the pass of Brander to Taynuilt on Loch Etive. From there he may have continued further west to Dunstaffnage Castle and then south to Oban, from where he steamed to Mull and, at Tobermory, he boarded the *Maid of Morven* steamer that took him to *Staffa, where he sketched the island and the interior of its celebrated Fingal's Cave. On returning to Tobermory, he seems to have gone back to Oban. From there he probably proceeded to the Isle of Skye. It seems likely that he steamed to Kyleakin, where he disembarked and proceeded to Broadford. He then travelled south-west and south to Elgol, where he probably took a boat across Loch Scavaig to Loch Coruisk ringed by the Cuillin Hills. Having sketched the loch, he may have returned to Oban by sea. From there he would have steamed up Loch Linnhe to Ballachulish, disembarking and travelling a few miles east to Glencoe, which he sketched, and then, retracing his steps, boarded a steamer travelling up Loch Linnhe to Fort William.

It has been proposed that his route to Skye was by land from Fort William to Arisaig, then across the Sound of Sleat

to the island, and back to Fort William. Though this mainly land route cannot be discounted, it would have been much more arduous than the sea voyage from Oban to Skye. From Fort William, Turner proceeded through the Caledonian Canal to Fort Augustus, to the northern end of the Canal, where he disembarked at Inverness. From there he travelled north to Evanton, where he visited his old friend and patron, *Munro of Novar. After this visit Turner returned to Inverness and then journeyed to Elgin, where he made studies of the cathedral ruins. From there he travelled directly to Aberdeen and then coached south to Edinburgh. Finberg suggests that he left Edinburgh for London by sea.

THE 1834 VISIT. Turner's sixth visit to Scotland took place in September 1834, and lasted slightly over two weeks. The evidence for this tour is more limited than for that of 1831 and is obscured by the fact that Turner employed several sketchbooks used during the previous visit. He coached north to Edinburgh and began collecting sketches for three publications, for Scott's *Prose Works*, the projected biography of Scott by J. G. Lockhart, and for a new edition of the Waverley Novels for which in the end he did not provide illustrations. The published designs for all these works, the sketchbooks themselves, and other documentation aid in furnishing some indication of Turner's movements during this visit. Three sketchbooks traditionally dated 1831 were used in 1834: first, the 'Stirling and Edinburgh' Sketchbook (CCLXIX), which seems to date entirely to 1834; secondly, the 'Abbotsford' Sketchbook (CCLXVII), which was employed in both 1831 and 1834; and thirdly, the 'Edinburgh' Sketchbook (CCLXVIII), which again contains sketches that date from 1831 and 1834.

Cadell's diaries furnish evidence that, in addition to short trips south and south-west of Edinburgh (Selkirk and Lanark), and jaunts within the capital itself, Turner also undertook an extended excursion that consumed more than a week of his two-week visit but for which there is, unfortunately, no documentation. This excursion seems to have been mainly to collect sketches intended for the Waverley designs, and this assignment appears to have involved further sketchbooks previously used in 1831. The 'Stirling and West' Sketchbook (CCLXX) seems to have been one of them. Since it is here argued that Turner visited Glasgow in 1834 rather than in 1831, the Firth of Clyde sketches in this sketchbook identified by Irwin probably date to 1834. Wallace-Hadrill and Carolan, who, like Irwin, have provided valuable site identifications in the sketchbooks, have also assumed that the provisional 1831 date assigned to them by Finberg is, on the whole, accurate. Unhappily, this has meant that the careful reconstruction by Wallace-Hadrill

and Carolan of particular segments of Turner's 1831 tour incorporates sequences of sketches that appear to belong to 1834. The following proposed itinerary attempts to identify some of the places Turner visited on this special week-long tour, though the reconstruction of this part of his journey has to be, by necessity, broadly indicated rather than specifically detailed and must still be considered conditional.

The general pattern of his former travels suggests that in 1834 he began sketching in the east, then moving west. He probably headed north across the Forth to Loch Leven where he made a number of sketches of the castle. Sketches are recorded in the 'Stirling and Edinburgh' Sketchbook and the 'Loch Ard' Sketchbook (CCLXXII). The main interest of the castle is that Mary, Queen of Scots, was imprisoned there, an event which is central to the story of Scott's novel *The Abbot*, and which seems almost certainly the reason why Turner wished to sketch it. He then would have proceeded north to Perth to sketch subjects being considered to illustrate the novel *The Fair Maid of Perth*. Sketches of Perth occur in the 'Stirling and Edinburgh' Sketchbook and the 'Loch Ard' Sketchbook. From there he may have made his way down to Stirling, north-west to Callander, west to the Trossachs, for scenes to illustrate *The Heart of Midlothian* and *Rob Roy* (see 'Loch Long' Sketchbook (CCLXXI) and 'Stirling and West' Sketchbook). From there Turner could have made his way south-west to the Clyde which is recorded in the 'Stirling and West' and the 'Stirling and Edinburgh' Sketchbooks. The views of Glasgow Cathedral in this latter sketchbook and of the Clyde and the Firth of Clyde in the former were probably associated with landscapes intended for *Rob Roy*.

Before departing for the south and home, Turner returned to Edinburgh to sketch subjects in and within a day's journey of the capital. Some of the selected scenes were intended to illustrate the *Prose Works*, such as *Edinburgh from St. Anthony's Chapel* (c.1835; Indianapolis Museum of Art; W 1120). Others were proposed for the Waverley Novels, as for example, Heriot's Hospital, which was probably considered as a subject for *The Fortunes of Nigel*. This was Turner's final Scottish visit. GEF

Finley 1980, pp. 51, 54, 93–102, 125–32, 140–1, 179–82, 187–8, repr.
Finley 1981.
Irwin *et al.* 1982.
David Wallace-Hadrill and Janet Carolan, 'Turner North of Stirling in 1831; a Checklist', *Turner Studies*, 10/1 (summer 1990), pp. 12–22; and pp. 25–33, 10/2 (winter 1990).
David Wallace-Hadrill and Janet Carolan, 'Turner in Argyll in 1831: Inveraray to Oban', *Turner Studies*, 11/1 (summer 1991), pp. 20–9.

SCOTT, Sir Walter (1771–1832), Scottish poet, novelist and historian. Renowned as a writer and patriot, Scott seems to have met Turner first in 1818 when the artist was commissioned to prepare watercolours for his *Provincial Antiquities of Scotland* (1818–26). However, Scott, perceiving that Turner was overly concerned with money matters, did not have a favourable impression of him. Still, their business relationship continued. The two appear to have met again in 1822 when Turner came to *Edinburgh to witness the celebrations (stage-managed by Scott) associated with the visit of the recently crowned *George IV. Only four years later, Scott was forced into insolvency, though, gradually, with the aid of *Cadell, his publisher, he removed most of his debt, largely by preparing notes for new editions of his work.

Many of these editions Turner was commissioned to illustrate, notably the *Poetical Works* and *Prose Works* which resulted in the artist, in 1831, coming to Scotland and staying with Scott at *Abbotsford. Despite Scott's initial impression of Turner, and failing health, a sympathy developed between the two, and when Turner later prepared his illustrations, particularly those for the *Poetical Works*, he depicted Scott in one design and alluded to him in others. After Scott died, Turner soon involved himself in the discussions concerning a monument to Scott in Edinburgh which was eventually built in Princes Street in 1840–6, where it remains to this day. GEF

Finley 1980, pp. 25, 55, 103–24, 155–70, 232–9.

SCOTT'S *POETICAL WORKS*, a twelve-volume edition (1833–4). It contains 24 steel-engraved plates after watercolours by Turner and is uniform in size and design with the *Prose Works* (1834–6). *Scott and *Cadell had believed that the addition of illustrations would benefit the author's work, and Turner, as an outstanding landscape artist, was Cadell's choice as illustrator. He persuaded Scott of the value of commissioning him and Turner was asked to come to Scotland in the summer of 1831 to collect sketches mainly, though not entirely, for illustrations for this new edition. Each of the proposed small volumes was to contain two engraved designs, a frontispiece and a vignette. Many of the poetry subjects Turner collected were near and along the Scottish Borders. They were to illustrate *The Bride of Triermain*, *Marmion*, *Rokeby*, *Lay of the Last Minstrel*, *The Minstrelsy of the Scottish Border*, *Sir Tristrem*, and the *Dramas*. Most of these sketches were of ancient architecture in the countryside around *Abbotsford, near Melrose, where Turner had been invited by Scott to stay and where he was joined by Cadell. After this visit, the artist followed a circuitous route travelling east, then north and west to *Edinburgh. There he sketched a view of the city that would illustrate *Marmion*.

From there he headed north-west to the Trossachs for loch views to illustrate *The Lady of the Lake*, and further north and west to the Inner Hebrides for two dramatic subjects with which to embellish *The Lord of the Isles*: an interior view of *Fingal's Cave*, **Staffa* (private collection, USA; W 1089), and, in the Isle of Skye, a view looking down on Loch Coruisk surrounded by the mist-covered Cuillin Hills (National Galleries of Scotland, Edinburgh; W 1088).

Turner did not immediately begin the watercolours after this Scottish visit. He completed twelve designs between late February and mid-March 1832, when they were collected by Cadell, who arranged for them to be engraved on steel, a relatively recent medium of engraving. Steel had been replacing the traditional, softer copper plates since its hardness allowed for the translation of finer detail of the original watercolour and many more high-quality impressions than were possible with copper. Cadell received the last of the remaining watercolours on 2 August, and they too were sent, without delay, to the engravers. Turner's poetry designs are perhaps some of his most significant illustrations because they are the most personal. This was in part the consequence of Turner's stay with Scott at Abbotsford and the artist's growing admiration and respect for his host. In these watercolours he occasionally makes reference to sketching outings with Scott and Cadell. One of these designs, *Bemerside* (private collection; W 1079), for the volume containing *Sir Tristrem*, records the visit of Scott, Cadell, and Turner to this ancient house. Another, the *Vale of Melrose* (National Galleries of Scotland, Edinburgh; W 1080), illustrating the *Lay of the Last Minstrel*, depicts Turner and Cadell enjoying an afternoon picnic above the Tweed with the ruins of Melrose Abbey in the distance. GEF

Finley 1980, pp. 132–40, 145–6, repr.
Lyles and Perkins 1989, pp. 71–3.
Herrmann 1990, pp. 194–201.
Piggott 1993, pp. 53–6, 88, 99.

SCOTT'S *PROSE WORKS*, a 28-volume edition (1834–6), uniform in size and design with the *Poetical Works* (1833–4). This edition contains 40 small frontispiece and vignette steel-engraved designs after Turner. The designs were based on sketches or watercolours that he already had in his possession, on fresh on-the-spot sketches commissioned specifically for the *Prose Works*, or on designs by other artists. These designs were intended to relate to Scott's prose in different ways. Some illustrate the specific places mentioned or alluded to; others depict the district in which a specific event occurred. Still others show landscapes in which the *dramatis personae* of the text are represented or alluded to. Several of the most interesting landscape designs are those that were prepared to illustrate *The Life of *Napoleon Buon-*

aparte. From the planning stage of the *Prose Works*, *Cadell was convinced that illustrations for *Napoleon* should be especially fine since he hoped to launch the edition with this biography. When published, the biography occupied the nine central volumes (8 to 16). Cadell commissioned Turner in 1832 to make fresh sketches in *Paris and its environs of places associated with this historical figure.

In several of the illustrations Turner reinforces and enhances Scott's narrative by introducing into his landscapes Napoleon himself. Although these illustrations and the plates engraved from them, like those for the *Poetical Works*, are very small, the steel plates, because of their hardness, allowed the engraver to translate accurately the remarkable detail that Turner incorporated in his designs. In representing Napoleon, a mere speck, Turner's identification of him hinges most often on the dramatic situation presented in conjunction with the depicted setting. For example, in the watercolour design *Fontainebleau* (*c*.1833; Indianapolis Museum of Art; W 1115), Turner selected a dramatic moment, depicting Napoleon atop the grand entrance staircase of the château and, as has recently been pointed out, immediately before his departure for his future exile on Elba. He is presented by Turner as a tragic yet heroic figure, standing apart from his senior staff in silence. Turner has wrung from these minute figures the high drama and pathos of the event.

In other illustrations for the *Prose Works* Turner does not represent but alludes to notable personalities associated with the text. This is evident in the two vignettes prepared for the *Periodical Criticism* which represent the Rhymer's Glen (*c*.1833; National Galleries of Scotland, Edinburgh; W 1119) and Chiefswood Cottage (*c*.1833; National Galleries of Scotland, Edinburgh; W 1118). In the first he alludes to Scott's presence in this favourite retreat of the author, by showing a rustic seat with an open book near it and a walking-stick. In the second *Chiefswood Cottage*, the summer home of Scott's son-in-law, J. G. Lockhart, is the subject. However, in the left foreground he depicts a desk, stool and inkpot that represent Lockhart's skills as a writer, critic, and especially as editor of the celebrated *Quarterly Review*. GEF

Finley 1980, pp. 189–210, repr.
Lyles and Perkins 1989, pp. 71–7.
Herrmann 1990, pp. 201–9.
Piggott 1993, pp. 56–9, 89, 92, 99.
Warrell 1999, pp. 47–8, 52–8, 82–6.

SCOTTISH PENCILS. Approximately 60 drawings made in *Scotland in summer 1801 (TB LVIII). *Farington, who saw them on Turner's return to London, described their technique (*Diary*, 6 February 1802). The sheets of white paper were first washed by Turner with a solution of 'India ink and Tobacco water', and highlights were added to the pencil drawings with a 'liquid white of his own preparing'. The term 'Scottish Pencils' was first used by *Ruskin, who greatly admired these drawings. They represent a new departure for Turner, who had not hitherto made such large and highly finished monochrome drawings while on tour. Nevertheless they show great assurance in their deployment of pencil techniques such as hatching and shading, and an acute appreciation of light and shade, the coloured paper contributing as much as the white heightening to the tonal effects. The method can be seen as a progression from the monochrome drawings of Richard *Wilson, especially those of Italian subjects made for Lord Dartmouth, but for Turner the drawings evidently served a more private purpose, perhaps as samples of views to show to prospective patrons; of several Inverary subjects, for example, one (LVIII: 11) served as the basis for a finished watercolour commissioned by the Duke of Argyll (Yamanashi Prefectural Museum, Japan; W 349). Though many of the sheets have a feeling of spontaneity, and their execution in the open air cannot be ruled out, they may well have been too large to handle conveniently on the spot, and are often demonstrably reconsiderations of sketches in some of the eight sketchbooks Turner also had with him. Their most likely purpose was intermediate between these and projected finished views. Turner adopted a similar practice on his Alpine tour the following year. DBB

Andrew Wilton, 'Turner in Scotland: The Early Tours', in Irwin *et al.* 1982, pp. 16–19, 32–8.

SCRATCHING OUT is one of many techniques which Turner used to create highlights in watercolours on light-coloured supports (Townsend 1996, pp. 376–80). Some watercolours include only one highly effective scratch in the watercolour paint, for instance the fishing-line in *Near Blair Atholl, Scotland* (*c*.1808; TB CXVII: G). Others include many scratches, made to varying depths, sometimes with a range of tools. *Pembury Mill* (*c*.1806–7; CXVI: O) includes many fine and narrow scratches, which give the effect of a dusty, floury atmosphere seen from the brighter light outdoors. His tools included his own 'eagle-claw of a thumb-nail' (Thornbury 1877, p. 239; see FIRST RATE TAKING IN STORES, A), fine needles which were most likely etching-needles, and ends of brushes, possibly sharpened. Many of the scratches are too fine to have been made with a pocket-knife, unless the blade had been specially narrowed and sharpened. Similar-looking scratches are to be seen in his oil paintings too. Turner also rubbed out areas of watercolour with softer materials, such as blotting paper balled together, or crumbs of stale bread (Farington, *Diary*, 1804, ii. p. 216), as well as washing them out with plain water on a clean brush. JHT

SCUMBLING is the thin or discontinuous application of an opaque paint layer, often with the underlying colour showing through brokenly. Some authors define scumbling as lightening the underlying colour, when the opposite process is known as glazing. Scumbles are always physically thin, and were often applied with thinned paint to which oil of turpentine had been added, which gives the paint an opaque appearance. Turner often applied scumbles, and indeed referred to the effect as 'crumbling layers' in the 'Studies in the Louvre' Sketchbook (1802; TB LXXII: 34). Some of his scumbles are undeniably dark, even black, and their effect is necessarily to darken the layer beneath. They are scumbles none the less, for the paint is opaque, not transparent as it must be in a glaze. Thin, dark scumbles can be seen in the shore in the foreground of *Waves Breaking against the Wind* (c.1835; BJ 457) and in many other unfinished seascapes of this decade. Numerous light-coloured scumbles of localized extent can be seen in sea and sky in *Snow Storm—Steam-Boat off a Harbour's Mouth* (RA 1842; BJ 398). Some scumbles in over-thinned paint dry into a series of spots which follow the line of the brushstroke, and they have been described in the past as having a watercolour medium. This now seems unlikely in those that survive to be viewed today. This does not rule out the possibility that Turner used watercolour medium over oil paint on occasion, but harsh lining treatments in the 19th century could well have removed the evidence. JHT

SEAPIECES. Turner's marines fall into three categories: high-sea dramas, coastal views, and purely atmospheric studies. Together they occupy pride of place in his overall production, the extant seapieces alone numbering nearly one-third of his oils.

Living from childhood near the busy shipping on the *Thames and at times staying on the south coast, Turner must have had a deep need satisfied by observing and depicting the sea and the people that live by it. This need was born, presumably, of the unhappiness at home, caused by his mother's schizophrenic attacks. It may also account for his saying 'That made me a painter' when, after many years, he found himself suddenly confronted again by a mezzotint after the 17th-century Dutch seapainter Willem *Van de Velde the Younger. It represented a single large vessel in a storm, 'bearing up bravely against the waves', as Walter *Thornbury, his first biographer, recorded before concluding: 'That determined his genius to marine painting' (1877, p. 8).

Significantly, after beginning as an architectural and topographical watercolourist who in his boyhood often lodged with an uncle at Margate, his first exhibited oil was *Fisher-men at Sea* (RA 1796; BJ 1). It showed a small open boat off the Needles by moonlight and was hailed at once as the work of a remarkable new talent, one critic even enthusing that 'the undulation of the element' was 'admirably deceiving'. And what seems no less significant is that one of his first commissions was to paint a pendant to a marine by the artist of the mezzotint. Shown in 1801, his *Dutch Boats in a Gale. Fishermen endeavouring to Put their Fish on Board*, or 'Bridgewater Seapiece' (private collection, on loan to National Gallery, London; BJ 14), was warmly welcomed by the press and praised by the President of the Royal Academy as 'what *Rembrandt thought of but could not do'.

To Turner's contemporaries, who in this pre-steam era were generally quite familiar with sea and sail, the picture's attraction was also the obvious collision course of the central vessels. As such, the composition matched Edmund Burke's definition of *Sublimity in his *Enquiry into the Origin of our Ideas of the Sublime and Beautiful* of 1757 as a state of near-catastrophe, producing both awe and a gratifying *frisson*. In *Fishermen upon a Lee-Shore in Squally Weather* of 1802 (Southampton Art Gallery; BJ 16), Turner repeated this type of Marine Sublimity, preliminary studies to which are in his two 'Calais Pier' Sketchbooks (TB LXXXI and LXXI). In fact, a small vessel dangerously crossing the bows of a big ship under full sail became a recurrent compositional ingredient. Each case illustrates his knowledge of the dangers of collision at sea or of being tossed aground on a lee shore when unable to 'claw off' by sail or oar; *Ships bearing up for Anchorage* or 'Egremont Seapiece', also of 1802 (Petworth House; BJ 18), demonstrates by contrast the various phases in a successful anchoring manœuvre.

The British interest in marine painting at the turn of the century may be understood as the Romantic phase in a branch of art which in Britain had grown from the days of the Van de Veldes through nearly a century of maritime conflict with France. After all, from about 1800 until the Battle of Trafalgar, the British lived under the very real threat of invasion by *Napoleon. As a result, the navy was seen as their prime bulwark. In 1802, however, the Peace of Amiens briefly allowed writers and artists to resume cultural contacts. Aged 27 and now a full Member of the Royal Academy, Turner was among the first to cross the Channel.

On his return from the 'Sublime' Alps, he examined Napoleon's looted artworks at *Paris in the Louvre, and the 'Studies in the Louvre' Sketchbook (LXXII) contains some 30 memoranda, both sketched and written, of his impressions. Among these the ones of *Ruisdael's *Coast Scene* (LXXII: 14a–15) are particularly interesting because of the insularity shown in Turner's criticism of the Dutch Master's handling of waves on a lee shore. Back in London, Turner painted

Calais Pier, with French Poissards preparing for Sea: an English Packet arriving (RA 1803; National Gallery, London; BJ 48). Again there is near-collision between a Dutch barge leaving harbour and the English ferry entering. But here Sublimity is set off against the Ridiculous (popularly accepted as being next door to the Sublime). Nothing could indeed be more ridiculous than the scene in the foreground with its inept fishermen struggling to push off from the pier while a *poissarde* ('fishwife') is handing down a bottle. With the Anglo-French war about to erupt again, the picture's anti-French implications are obvious; in 1803 the Dutch were Napoleon's most unwilling allies.

No less political was the message of *Boats carrying out Anchors and Cables to Dutch Men of War in 1665* (RA 1804; Corcoran Gallery of Art, Washington; BJ 52) when England, in short-sighted complacency after maritime successes, seemed to have forgotten 1667 with the disastrous raid on the Medway by a recently defeated but at once refitted Dutch navy.

To 1805 belongs The *Shipwreck* (BJ 54) which was selected for the very first engraving to be published after one of Turner's oils. While Admiral Bowles declared of the equally devastating *Wreck of a Transport Ship* of c.1810 (Fundação Calouste Gulbenkian, Lisbon; BJ 210) that 'No ship or boat could live in such a sea', and the fishing-boat coming to the rescue in the 1805 picture would be definitely overcanvassed for the gale-force wind depicted, it is clear that both compositions were meant to convey the death-defying courage of English sailors.

This courage was exemplified in October 1805 in the battle which brought the tragic loss of Nelson. When followed by the repatriation of the Admiral's body in his flagship, Turner produced a series of meticulous drawings as well as notes. These resulted in 1806 in two major compositions, *The Battle of Trafalgar, as seen from the Mizzen Starboard Shrouds of the 'Victory'* (BJ 58)—as a seapiece a stylistic novelty since it was practically devoid of sky and waves—and *Portrait of the 'Victory' in three Positions passing the Needles, Isle of Wight* (Yale Center for British Art, New Haven; BJ 59). Curiously enough, thirteen years later came the commission from *George IV for another *Battle of Trafalgar* (National Maritime Museum, Greenwich; BJ 252), this time intended as a companion to a historical piece by de *Loutherbourg and, again, unable to please professional mariners.

After 1806 the war at sea became less important since most of the fighting took place on land. Turner continued to paint his beloved subject, but his pictures were no longer full of the earlier drama. Coastal scenes, such as the beautiful *Sun rising through Vapour: Fishermen cleaning and selling Fish* (RA 1807; National Gallery, London; BJ 69) and the arrival at Portsmouth of captured Danish ships in a composition, diplomatically (re)titled for the RA *Spithead: Boat's Crew recovering an Anchor* of 1808 (Turner's gallery 1808, RA 1809; BJ 80), are characteristic of the period.

This shift in interest was first apparent in dozens of documentary sketches and watercolours. But the climax came in 1818 with the brilliant *Dort, or Dordrecht. The Dort Packet-Boat from Rotterdam becalmed* (Yale Center for British Art, New Haven; BJ 137). In its complete contrast of mood with the sombre *Field of Waterloo* (BJ 138) in the same exhibition, it made the two into a striking pair of opposites.

In 1817 Turner had first toured the Whitehall-created 'Kingdom of the United Netherlands' which included Belgium and Luxembourg. His incentive was to collect material for a commemoration of the battle of Waterloo. The outcome of the excursion consisted first of the 'Waterloo and Rhine' and the 'Dort' Sketchbooks (CLX and CLXII), both with many scenes of ships, harbours, and waterways. But the high point was embodied in the oils painted on his return. In fact, if the Rembrandtesque but unashamedly anti-heroic *Field of Waterloo* could be described as representing the Burkian Sublime, the Cuyp-inspired *Dort Packet-Boat* was the Burkian Beautiful. As to his unceasing attachment to ships and the sea, also in 1818 he produced for Walter *Fawkes in one morning the extraordinary watercolour A *First Rate taking in Stores* (Cecil Higgins Art Gallery, Bedford; W 499).

Holland came again to Turner's mind when in 1819 the Bank of England called in all gold coinage in exchange for paper notes. The (now Royal) House of Orange, which while in exile had invested heavily in Britain, found itself facing big losses. Like the coinciding news of the actual shipwreck of a trader carrying oranges, this was duly reported in the press. And so *Entrance of the Meuse, Orange-Merchant on the Bar going to Pieces—Brill Church bearing S.E. by S., Masensluys E. by S.* (RA 1819; BJ 139) showed a big freighter stranded on a—navigationally exactly pinpointed—sandbank with scavengers, in a typical Turner pun, eagerly picking up oranges floating by on the current. The symbolism in the composition may seem over-pessimistic, but the connection between the financial and the maritime disaster is unmistakable; the 'author', as he sometimes liked to call himself, being an avid newspaper reader. In the meantime, Turner painted one marine watercolour after another, many meant to be engraved for publications such as *Cooke's *Picturesque Views of the *Southern Coast* or the *Keepsake*. They not only demonstrate the artist's complete mastery of the medium but also his searching analysis of the behaviour

of winds, waves, and tides with their effect on shipping. This made him feel a special affinity with Dutch marines, not only by Van de Velde but likewise by *Cuyp, Van Goyen, Ruisdael, Bakhuyzen, or Van de Capelle, which increasingly appeared at London auctions and in private collections. Throughout his life, both as a painter and, after 1807, as RA Professor of Perspective (see PERSPECTIVE LECTURES), he paid homage to these predecessors, who at times almost seemed to have become role models—as *Claude and *Poussin were for his landscapes.

In 1827 another stay on the *Isle of Wight made him fill three sketchbooks with impressions of yachting off Cowes, which in turn resulted in several oils recording the still novel racing scene (see COWES SKETCHES; BJ 260–8). But the year's most interesting picture was *Port Ruysdael* (Yale Center for British Art, New Haven, Connecticut; BJ 237), since this port is non-existent, while the composition fully illustrates his debt to Ruisdael, the leading master of the Haarlem School.

In Turner's painting the 1830s saw a further watershed which began as a reaction to the outbreak of the Belgian Revolt against the King of the United Netherlands. This former ally and former refugee, Prince William V of Orange, Whitehall's one-time guest, was now signally left in the lurch. Thus, in 1831, the pro-Dutch Turner exhibited—no doubt ironically—*Life-Boat and Manby Apparatus going off to a Stranded Vessel making Signal (Blue Lights) of Distress* (Victoria and Albert Museum; BJ 336). In the next year followed *Helvoetsluys. The City of Utrecht, 64, going to Sea* (Tokyo Fuji Museum; BJ 345) together with *The Prince of Orange, William III, embarked from Holland and landed at Torbay, November 4th 1688, after a Stormy Passage* (BJ 343). The 64-gun frigate *Stad Utrecht* had been the flagship of one of William III's admirals and the intention of the two pictures was clearly to remind British viewers, at the time of the *Reform Bill's 'stormy passage', of the moral obligations emanating from such past political achievements as the Glorious Revolution and its Bill of Rights.

Then there were the four *Van Tromp pictures, painted between 1831 and 1844. Evocations of the popular Dutch father-and-son combination, Admirals Maarten Harpertszoon Tromp and Cornelis Tromp, in various historically interesting situations begin with the celebratory *Admiral Van Tromp's Barge at the Entrance of the Texel 1645* of 1831 (Soane Museum, London; BJ 339) and end with the exuberant *Van Tromp going about to please his Masters, Ships a Sea, getting a Good Wetting* of 1844 (Getty Museum, California; BJ 410) which—with Wellington's withdrawal from public life imminent—symbolized the importance for public figures of being able, in the national interest, to swallow their pride.

In 1833 Turner's political messages were expressed in a positive sense by *The *Rotterdam Ferry Boat* (National Gallery of Art, Washington; BJ 348) and its companion piece [Antwerp] *Van Goyen looking out for a Subject* (Frick Collection, New York; BJ 350). Together they suggested, in their linking of these great emporia, the desirability of a new departure in Dutch–Belgian relations, based on civilian rapprochement across the waters.

By contrast, in 1839, *The *Fighting 'Temeraire', tugged to her Last Berth to be broken up* (National Gallery, London; BJ 377), profoundly elegiac in its embodiment of the end of the Age of Sail, and Turner's heartbreaking *Slavers throwing overboard the Dead and Dying* of 1840 (Museum of Fine Arts, Boston; BJ 385), both equally grand in conception, may well suggest on a deeper level the forthcoming expressions of the artist's feeling about himself. This goes for both *Snow Storm—Steam-Boat off a Harbour's Mouth making Signals in Shallow Water and going by the Lead* (BJ 398) with the factually questionable subtitle of *The Author was in this Storm on the Night the Ariel left Harwich*, and the moving *Peace—Burial at Sea* (BJ 399). These splendid pictures must be associated with his long, fragmentary poem *Fallacies of Hope* (see POETRY AND TURNER) whose lines, addressed to hope and querying 'where is thy market now?' he added to the RA catalogue entry for *Slavers*.

Indications of the ageing Turner's defiant fear of approaching creative impotence may be perceived in the sombre passage about the sea's demon 'that in grim repose | expects his evening prey' with which he accompanied *The *Sun of Venice going to Sea* (BJ 402) of 1843. In fact, his *Fishing-Boats bringing a Disabled Ship into Port Ruysdael* (BJ 408) of 1844, with its revealing repetition of the fictitious port's name, together with *Ostend* (Neue Pinakothek, Munich; BJ 407), with its central sailing boat desperately gybing to avoid the pier on her lee, may likewise be seen as ambiguous in their implications. For these would seem to point out the hazards of delay in making for a safe harbour—in the case of the 'disabled ship' the safety of a return to the art of a once-venerated Dutch Master.

It can hardly have been a coincidence that, again after a number of awe-inspiring storm-scenes such as *Waves breaking on a Lee Shore* (c.1835; BJ 458), he exhibited in 1845 and 1846 four striking pictures of *whaling subjects (BJ 414, 415, 423, 426), the last of the series actually specifying in its title *Whalers (boiling Blubber) entangled in Flaw Ice, endeavouring to extricate themselves*. Although there were several books on the subject and a number of Dutch pictures, this last painting as exhibited in 1846 was probably prompted by his study of a huge stranded whale made in 1845 on his final visit to France and inscribed 'I shall use

this' (CCCLVII: 6): a fitting conclusion to a survey of the maritime side of an artist whose undying affinity to the sea as the archetypal Romantic emblem has provided invaluable insight into the true potential of marine painting—even where his rendering of marine architecture may occasionally have been somewhat idiosyncratic. AGHB

> David Cordingly, *Marine Painting in England*, 1974.
> Herrmann 1981, pp. 4–18.
> Margarita Russell, *Visions of the Sea*, 1983.

SEAT OF WILLIAM MOFFATT ESQ., AT MORTLAKE, THE. Early (Summer's) Morning, oil on canvas, 36¾ × 48½ in. (93 × 123.2 cm.), RA 1826 (324); Frick Collection, New York (BJ 235).

William *Moffatt lived at The Limes (still surviving as 123 Mortlake High Street) from 1812 until his death in 1831. Turner painted it for him with a companion now in the National Gallery of Art, Washington, *Mortlake Terrace, the Seat of William Moffatt, Esq. Summer's Evening* (RA 1827; BJ 239). Studies for both pictures are in the 'Mortlake and Pulborough' Sketchbook (TB CCXIII).

The pair complement each other: this picture, cool in tonality yet promising a perfect summer's day, and the companion, an evening scene of golden radiance, looking along the Thames in the opposite direction, confirms that promise was fulfilled.

Only the *Literary Gazette* (13 May) noticed the picture, describing it as 'truly attractive, from the lightness and simplicity' whereas the companion, exhibited at the Royal Academy in 1827, was violently abused on account of its yellowness. EJ

SEINE. Turner's set of 40 published views of the River Seine resulted from a much greater familiarity with that river than he had been able to achieve through his brief acquaintance with the *Loire. In a number of cases the viewpoints actually overlap, so that Turner was forced to be inventive with his compositions, for many of which he evolved a vertiginous bird's-eye prospect, looking down on the river. During the 1820s he travelled along the Seine regularly, either on his way southwards, or purely because of his interest in the river as a source of potential subject matter (specifically in 1821, 1826, 1828, 1829, and 1832). As in the case of the Loire, he exhibited only one oil painting showing the river (*Mouth of the Seine, Quilleboeuf*, RA 1833; Fundaçao Calouste Gulbenkian, Lisbon; BJ 353), though it has recently been shown that four of the so-called *Roman oil sketches are based on pencil drawings in the 'Dieppe, Rouen and Paris' Sketchbook used on the Seine in 1821 (see Warrell 1999, pp. 28–30, 119, 169–76, 268, repr. figs. 13, 86, 148, and 152). *Quilleboeuf* is based on one of the watercolour and gouache drawings that he had completed for the 1834

edition of *Turner's Annual Tour*, which were being engraved at the time the picture was first exhibited. This perhaps suggests that Turner hoped it would create interest in the set of images that he and his team were preparing.

There are marked differences between the sets of Loire and Seine images. Those for the Loire are characterized by a limpid tranquility, while the first twenty Seine subjects (published in 1834) repeatedly introduce steamboats to suggest the busy life of the river between the port of Le Havre and Rouen. Technically this set of designs is far more encrusted with brilliantly coloured gouache than its predecessor, most notably in the view of *Rouen Cathedral* (TB CCLIX: 109). This work, with its effects of light dancing across the surfaces of the facade, prefigures Monet's later treatment of the motif. The second group of Seine views (published in *Turner's Annual Tour* for 1835) are painted with a denser, whiter palette that is especially noticeable in the five scenes of *Paris. By this stage in the *Annual Tour* project, Turner's engravers had become familiar with his way of working, and it is significant that less detail is introduced to the preparatory designs, presumably on the understanding that it could be added during the painstaking engraving process (see, for example, the differences between the drawing and finished engraving of *Vernon*, CCLIX: 129 and R 475). In preparing the published scenes Turner produced over 100 related colour studies (CCLIX etc.), and a large group of views executed either in pen and ink (see CCLX) or solely in pencil sketched on the spot (see CCLXI and CCLXII). IW

> Alfrey 1981, pp. 187–93, 327–49.
> Herrmann 1990, pp. 166–7, 171–81.
> Rodner 1997.
> Warrell 1999.

SEINE, WANDERINGS BY THE, see TURNER'S ANNUAL TOUR.

SERRES, John Thomas (1759–1825), English landscape and marine painter and early acquaintance of Turner.

Born in London, he was taught painting by his father, Dominic Serres. After a period travelling abroad, in 1793 he succeeded his father as Marine Painter to the King, *George III. In 1800 he became Marine Draughtsman to the Admiralty, and is also known to have taught drawing at Chelsea Naval School. In 1791 Serres married one of his pupils, Olivia Wilmot, subsequently a landscape painter, but whose reckless and spendthrift behaviour brought him close to financial ruin in later years and led to their permanent separation in 1804. They were living apart as early as 1799, when Serres was reported by *Farington to have moved into lodgings with Turner at 64 Harley Street, where he had the part-time use 'of a parlour & a room on the 2nd floor'. Serres seems to have remained there for some years, possibly until as late as

1808, when he moved to Edinburgh. Such influence as he may have had on Turner during these years is not recorded. However, Eric Shanes has speculated that Turner's oil *The Victory returning from Trafalgar* (*c*.1806; Yale Center for British Art, New Haven; BJ 59), showing a man-of-war in three positions, could have been influenced by the illustrations in *Liber Nauticus* (1805–6), a manual of instruction for marine painters published by J. T. Serres and his younger brother Dominic, which similarly features ships presented in three positions. AL

Eric Shanes, '*The Victory Returning from Trafalgar*, Picture Note', *Turner Studies*, 6/2 (winter 1986), pp. 68–70.

SHADE AND DARKNESS, see LIGHT AND COLOUR.

SHAKESPEARE, William (1564–1616). Turner claimed Shakespeare's *birthday and St George's Day for his own, as if to anticipate Tennyson's accolade (quoted in C. A. Swinburne's biography of the artist, 1902) that Turner was 'the Shakespeare of landscape'; by this Tennyson presumably meant a depth of feeling and ideas, a breadth of range, and a certain poetic universality. Turner made a sketch of Shakespeare's tomb at Stratford into an illustration for *Scott's essay on the Drama (untraced; W 1101; R 524), and was a subscriber to an engraving of Shakespeare's bust published by John *Britton. Turner must surely have seen the great Shakespearian performances of his day close to *Maiden Lane, such as the passionate Shylock of Edmund Kean (1787–1868) at Drury Lane Theatre from 1814; *Coleridge said that watching Kean was 'like reading Shakespeare by lightning'. William Charles Macready (1793–1873) was another famous Shylock; as theatre manager at Covent Garden from 1837 and at Drury Lane in 1841–3 he mounted elaborate scenic productions. *Thornbury tells how Turner, 'rather the worse for grog at Offley's in Henrietta Street' after seeing Macready's *Tempest*, was 'very indistinctly voluble on the subject of Shakespeare and Macready's scenic effects'. Shakespeare on the stage clearly influenced him: the visual memory of fat Falstaff and thin Master Slender led to his reference to them in 1815 when instructing George *Cooke, the engraver, on a 'touched' proof of *Teignmouth* (R 95) to make the contrast in the figures less exaggerated.

Turner's knowledge of Shakespeare was that of reader as well as spectator, as is shown by detailed references, jokes, and wordplay in his letters, especially to his close friends James *Holworthy, George *Jones, and W. F. *Wells: he quotes phrases or alludes to incidents from *Macbeth, Hamlet, King Lear, Twelfth Night*, and *1 Henry IV*. A particularly lively example is the letter to Holworthy of 4 December 1826 when he adapts Malvolio's yellow stockings as a joke about his own predilection for yellow pigments, and further (un-

noted by Gage) makes elaborate wordplay between Holworthy's visits to the 'moors' and Othello the Moor of Venice with a possible later 'ocular demonstration' to be made for Turner himself visiting him there, referring in a gamy way to *Othello*, III. iii. 60–395, where Iago taunts Othello with the 'ocular' proof of seeing Desdemona 'grossly topped' by Cassio. Turner's *perspective lectures quote from *Macbeth*, and use the song 'Tell me where is Fancy bred' from *The Merchant of Venice* to illustrate a point about ephemeral, shallow imagination. The same phrase quoted from *Macbeth* in the lecture, about the earth having 'bubbles', was in his mind again when he composed the epigraph to *Light and Colour* (RA 1843; BJ 405).

Turner surely knew Alderman Boydell's public Shakespeare Gallery of 162 paintings, many of them by his *Royal Academy colleagues, and the engravings made from them for Boydell's edition of Shakespeare (1791–1802); he probably knew the series of illustrations to other editions of Shakespeare by the graceful *Stothard and the frenetic *Fuseli. At the end of the 18th century Shakespearian subjects exhibited at the Academy tended to illustrate the history plays, but by 1830 they were more likely to draw on the comedies; three of Turner's four Shakespeare subjects shown from 1822 to 1837 were from the comedies. The earliest, the small Watteauesque canvas *What You Will!* (RA 1822; private collection; BJ 229), is named after the alternative title given by Shakespeare to *Twelfth Night* and is also most likely a pun on *Watteau. Although Turner adds Olivia and attendants, he shows Act II, Scene v, with Maria, Sir Toby Belch, and Sir Andrew Aguecheek hiding behind garden statuary (sketched by Turner at the Vatican). Scholars have not noticed the diminutive figure of Malvolio distant in the walk at the bottom right. *Jessica (RA 1830; Petworth House; BJ 333) and *The Grand Canal, Venice* (RA 1837; Huntington Art Gallery, California; BJ 368) both have epigraphs from *The Merchant of Venice*. Turner seems to recall a figure at a window on the Grand Canal from his illustration of the Rialto for *Hakewill's *Italy* (untraced; W 700; R 144). The epigraph quotes Shylock's admonition to Jessica to shut the window—hinting tenderly at the pathos of her situation, the locked-up jewel she is in herself and her liberation by Lorenzo. Shylock's cruelty seems to be the common factor of both pictures: *The Grand Canal* shows Antonio on the Rialto remonstrating with Shylock who 'will have his bond', while nuns and a suppliant friar confront him across the water. A *Venetian theatre watercolour of *c*.1833–5 (TB CCCXVIII: 20) shows a woman with a maid at a window and a lover with musician below, which may represent Jessica and Lorenzo. *Juliet and her Nurse (RA 1836; Sra. Amalia Lacroze de Fortabat, Argentina; BJ 365), a Ven-

etian night-piece, with its magnificent view from above of the Piazza San Marco and the carnival beneath with fireworks and starlit sky, seems at first to have little connection with the small scene of Juliet and the Nurse on the roof-balcony, but there are, in the manner of *Hero and Leander* (RA 1837; National Gallery, London, on loan to Tate Gallery; BJ 370), intense emblematical parallels for tragic love written into the scene. When the Revd John Eagles asked in *Blackwood's Magazine* why, 'amidst so many absurdities', the couple are pictured at Venice, *Ruskin was prompted (even before he became an Oxford undergraduate) to eloquent defence. Turner's last Shakespeare subject, the amorous and fantastic *Queen Mab's Cave* (BI 1846; BJ 420), shows the fairies' midwife of Mercutio's speech in *Romeo and Juliet* (I. v), but does not follow Mercutio's imagery—indeed Gage claims that Turner's source is *Shelley. Although the epigraph has the phrase 'Midsummer Night's Dream', it has been suggested that this may be Turner's own phrase from *Fallacies of Hope* (see POETRY AND TURNER); the preceding phrase 'Frisk it, frisk it by the moonlight beam' is not Shakespearian, although the phrase 'moonshine's beams' appears in Mercutio's speech. As well as the Queen Mab passage in *Romeo and Juliet*, Turner seems to have in mind here both Ariel's invitation to the fairies to dance in *The Tempest* (I. ii) and Titania's 'moonlight revels' with fairy dances of *Midsummer Night's Dream* (II. i). A recently discovered sketchbook of Turner's (see Wilton 1986[2]) has 'come unto the yellow sands' written on fo. 3. JRP

W. M. Merchant, *Shakespeare and the Artist*, 1959.
Gage 1987, pp. 50–2, 68, 147, 178, 186.
Wilton 1989, pp. 14–33.
Lyles 1992, pp. 22, 67–8.

SHEE, Sir Martin Archer (1769–1850), portrait painter and *Lawrence's successor as President of the *Royal Academy in 1830. The promotion was thought fairly inevitable by one witty ARA, G. S. Newton (1794–1835), because Shee was one of only two RAs who still powdered their hair. Shee was a fellow student of Turner's in the RA Schools and beat Turner to an Associateship when they were both up for election in 1798; Turner was, however, too young to be eligible. Shee was an elegant and thoughtful writer in his *Rhymes on Art*, 1805, and *Elements of Art*, 1809; Turner made extensive annotations to his copy of the latter. At the RA in 1827 Shee's portrait of John Wilde was a victim of Turner's brightening up the reds in his *Rembrandt's Daughter* (Fogg Art Museum, Cambridge, Mass.; BJ 238), perhaps leading to Shee's unsuccessful attempt in 1830 to reduce the number of *Varnishing Days.

C. R. *Leslie regarded Shee as an 'incomparable' President (1860, i. p. 118) who mounted an eloquent defence of

the RA, including Turner's failure to deliver his *perspective lectures, before a parliamentary committee in 1836. He was a trustee of Turner's Charity, 1844. Turner was acting President of the RA and then Deputy President because of Shee's illness and retirement 1845–9 and 'probably' expected to succeed him as President in his own right (ibid., p. 199). RH

Martin Archer Shee, *Life of Sir Martin Archer Shee*, 2 vols., 1860.
Venning 1982, pp. 40–9.
Venning 1983, pp. 33–44.
Wilton and Turner 1990, pp. 23–8.

SHEEPSHANKS, John (1784 or 1787–1863), art benefactor who gave hundreds of works of art, including Turners, to the nation. Sheepshanks was born in Leeds, the son of a wealthy cloth manufacturer, and was a partner in his father's firm, York and Sheepshanks. His younger brother Richard became a well-known astronomer. Sheepshanks first began collecting copies of Italian Masters, but soon determined to collect pictures by modern British artists.

In 1857 he gave his collection to the nation; in it were 233 oil paintings, 289 drawings and sketches, including works by Turner, *Stothard, Edwin *Landseer, Mulready, *Constable, *Wilkie, *Bonington, Crome, and others. The pictures were housed in the South Kensington Museum (see VICTORIA AND ALBERT MUSEUM) with the intention that they should be used as an education tool for young artists and form the foundation of a National Gallery of British Art. Paintings by Turner included in the Sheepshanks Gift were *East Cowes Castle, the Seat of J. *Nash, Esq.*; *the Regatta starting for their Moorings* (RA 1828; BJ 243) and *Life-Boat and Manby Apparatus going off to a Stranded Vessel Making Signal (Blue Lights) of Distress* (RA 1831; BJ 336), both bought for Sheepshanks by Tiffin at John Nash's sale (Christie's, 11 July 1835); two pictures which may have been commissioned by Sheepshanks, or bought by him at the Royal Academy, *St Michael's Mount, Cornwall* (RA 1834; BJ 358) and *Line-Fishing, off Hastings* (RA 1835; BJ 363); and *Venice, from the Canale della Guidecca, Chiesa di S. Maria della Salute, &c.* (RA 1840; BJ 384), which was commissioned by Sheepshanks. He also gave the museum the watercolour *Hornby Castle, from Tatham Church* (1816–18; W 577). After retiring while still relatively young, Sheepshanks lived in Blackheath, where Constable noted that by 1836 pieces of his Turner oils were already flaking off onto the carpet. He became a Fellow of the Royal Horticultural Society, and later built a house in Rutland Gate, where he lived until his death. TR

SHEERNESS, in Kent, a town which in Turner's time boasted a fort and a naval dockyard, is situated at the confluence of the *Thames and Medway rivers. Just off Sheerness

is the Nore, then 'the busiest naval and merchant-shipping anchorage in Britain' (Shanes 1981, p. 36). Turner made a trip out here in 1805, after Trafalgar, to sketch the *Victory* (Nelson's flagship) and other aspects of the scene. Among the resulting paintings were four featuring Sheerness, all exhibited between 1807 and 1809 (BJ 62, 75, 76, 91), including *Sheerness as seen from the Nore* (Turner's gallery 1808; private collection, Japan; BJ 76). In all four images (and a watercolour of c.1825; W 755) the fishing vessels in the foreground are implicitly protected by securely anchored warships and by the batteries of Sheerness, which, however, appears only as a thin, sunlit strip in the distance. AK

Hemingway 1992, pp. 240–1.
Hill 1993, pp. 143–7.
Egerton 1995, pp. 18, 35, 36, 39, 53, 75.

SHELLEY, Percy Bysshe (1792–1822), poet. Shelley wrote of *Italy (especially *Venice and the *Bay of Baiae) and the *Alps; many comparisons with Turner, mostly large gestures rather than specific 'influences', have been made. The *Athenaeum* for 14 May 1836 compared *Mercury and Argus* (RA 1836; National Gallery of Canada, Ottawa; BJ 367) to Shelley's poetry with its 'rainbow-toned rhapsodies'. From 1842 onwards *Ruskin developed the comparison, quoting Turneresque images from Shelley: in response to landscape and 'mystic sympathy' Turner 'saw things as Shelley and Keats did'; moreover, Ruskin said that he, Turner, and Shelley loved rocks, wild thunder-clouds and 'other forms of terror and power'. A portrait of Shelley figures in *Finden's *Byron illustrations along with Turner's landscapes; S. C. Hall's anthology of 1838, *The Book of Gems*, contained an engraving after Turner and lines by Shelley on Venice. Turner never alludes to Shelley directly, but Gage sees the influence of these lines on Venice in Turner's epigraph to the *Sun of Venice* (RA 1843; BJ 402) and of Shelley's poem *Queen Mab* in *Queen Mab's Cave* (BI 1846; BJ 420). JRP

Ruskin, *Works*, iii. pp. 364, 652; iv. p. 309 n. 2; xiv. pp. 396–7; xxxiv. p. 343.
Gage 1969, pp. 145–7, 186.
Powell 1987, pp. 120–1.

SHERRELL, Francis, see ASSISTANTS.

SHIP AGROUND, A, see FORT VIMIEUX; PETWORTH.

SHIPS BEARING UP FOR ANCHORAGE, oil on canvas, 47 × 71 in. (119.5 × 180.3 cm.), RA 1802 (227); Tate Gallery and the National Trust (Lord Egremont Collection), Petworth House (BJ 18). Signed: 'JMW Turner pinx' lower right. More generally known as the 'Egremont Seapiece', it was probably bought by Lord *Egremont at the Royal Academy in 1802 and was therefore his first purchase of a Turner. He certainly owned it by 1805 when Turner went

through his 'Calais Pier' Sketchbook (TB LXXXI) and inscribed several studies for the picture 'Ld Egremont's P'. The 'Dolbadarn' Sketchbook (XLVI) also contains preparatory drawings and much slighter studies occur in the 'Studies for Pictures' Sketchbook (LXIX), indicating the care Turner took over the composition.

When engraved by Charles *Turner in the *Liber Studiorum* in 1808 (F 10) it was entitled 'Ships in a Breeze'. The print shows marked differences from the original which must account for the change in title.

Professor Bachrach has noticed that the ship at anchor, although much elongated by Turner, resembles the model of a ship owned by Turner (now in the Tate Gallery).

Despite the acclaim accorded to the 'Bridgewater Seapiece' (*Dutch Boats in a Gale*, RA 1801; private collection, on loan to the National Gallery, London; BJ 14) the previous year, this no less magnificent picture was only noticed at the RA by one critic, who wrote: 'That which struck us . . . as the best is a scene with ships bearing up to gain anchorage'.

A survey in German of British painting, published as early as 1808, praised the picture warmly but noted its 'studied neglect of handling'. EJ

Gage 1987, pp. 2, 244.

SHIPWRECK, THE, oil on canvas, 67⅛ × 95⅛ in. (170.5 × 241.5 cm.), Turner's gallery 1805; Tate Gallery, London (BJ 54). Inspired by the recent sinking of the *Earl of Abergavenny* this is, however, a generalized depiction of a shipwreck, unmatched in power at the time of its painting and forerunner of the more dramatic of Turner's works. It may also have been inspired by the successful republication in 1804 of William Falconer's poem *The Shipwreck*. The only known exhibit in Turner's gallery in 1805, it was purchased by Sir John *Leicester for £315 and hung in his London gallery, where it became the first of Turner's oils to be engraved in an etching by Charles *Turner, published on 1 January 1807. On 9 February 1807, the picture was exchanged for *Fall of the Rhine at Schaffhausen* (RA 1806; BJ 61), according to *Thornbury (1862, pp. 266–7) because of a family bereavement at sea; Turner received an extra 50 guineas. Both works, however, appeared in a sale of paintings from the Leicester collection at Harry Phillips on 15 March 1809; perhaps Sir John felt that he had lumbered Turner with an unsaleable picture and decided to help the artist by including it with works from his own collection (see Martin Butlin, 'A Hitherto Unnoticed Sale from the Collection of Sir John Leicester', *Turner Studies*, 11/1 (summer 1991), pp. 30–1). Turner later, c.1810, asked £400 for the picture.

There are composition sketches in the 'Calais Pier' Sketchbook (TB LXXXI: 2, 6, 132–3, 136–7, 140–1) and

slighter sketches probably made from actual wrecks in the 'Shipwreck No. 1' Sketchbook (LXXXVII: 11, 16). MB

Herrmann 1981, pp. 4, 6, 8, repr.

Barry Venning, 'A Macabre Connoisseurship: Turner, Byron and the Apprehension of Shipwreck Subjects in early nineteenth-century England', *Art History*, 8/3 (1985), pp. 303–19.

Whittingham 1986, pp. 25, 28, 29, 35.

Wilton 1988, pp. 29, 31, repr.

SHOOTING. In company with Walter *Fawkes, Turner took part in shooting expeditions in Wharfedale, Yorkshire, principally during the 1810s. Although many of the birds were shot to be eaten, some were also taken as natural history specimens. These supplied feathers for Fawkes's five-volume *Ornithological Collection* and, lying dead, became subjects for watercolours by Turner and other artists, including members of the Fawkes family. Twenty of these studies are in the Leeds Art Gallery; others are in Manchester, Oxford, Indianapolis, the British Museum, and the Tate Gallery (Turner Bequest).

It is unlikely that Turner was as keen or active a shot as he was a fisherman. He recalled in 1850 that 'a cuckoo was my first achievement in killing on Farnley Moor in earnest request of Major [Richard] Fawkes to be painted for the book.' Whereas *fishing is a recurring subject in his painting, he tended to treat shooting with circumspection. He gives it a moral dimension in *Chain Bridge over the River Tees* (?late 1820s; private collection; W 878), depicting a family of grouse separated by a rushing torrent from a predatory gunman. Other treatments, such as *Woodcock shooting on Otley Chevin* and *Grouse shooting* (1813; Wallace Collection, London; W 534 and 535), are more detached. Both of these are direct responses to expeditions from Farnley, as is *Shooting Party on Hawksworth Moor* (1816; private collection; W 610) in which the party, evidently a sizeable one, rests among the marquees awaiting lunch. In *Caley Hall* (c.1816; National Gallery of Scotland, Edinburgh; W 612) we witness the body of a deer being carried back for the pot.

Shooting was part of the everyday life at Farnley that Turner joined into with such gusto. 'On the return from shooting, nothing would satisfy Turner but driving tandem home over a rough way, partly through fields. I need hardly say that the vehicle was soon capsized, amid shouts of good-humoured laughter; and thenceforward Turner was known at his host's by the nickname of "Over Turner"' (Thornbury 1877, p. 237). JH

Hill 1988, pp. 17–22.

Lyles 1988, pp. 37–8, 50–1.

SHORT, Sir Francis (Frank) Job (1857–1945), RA, English etcher and engraver, and one of the most energetic promoters of the *Liber Studiorum* in the late 19th and early 20th centuries. Short trained as an engineer, but took evening classes at the Stourbridge School of Art. In 1883 he came to London, and shortly afterwards abandoned his profession to attend the National Art Training School, South Kensington. With the encouragement of John *Ruskin, J. E. *Taylor, A. Stopford *Brooke and W. G. *Rawlinson, Short taught himself etching and engraving by copying original *Liber* plates. As Martin Hardie observed, the *Liber* was 'the centre and core of his life-work'; Short published 46 mezzotints relating to the series, including a group after drawings catalogued by Rawlinson as unengraved subjects. A distinguished teacher, Short became Professor of Engraving at South Kensington, and succeeded Seymour Haden as the President of the Royal Society of Painter-Etchers and Engravers. Short also used the *Liber* for teaching art, and his engravings after *Liber* subjects were reproduced in the influential 1890 drawing manual popularly known as 'South Kensington Drawing Book'. GF

Martin Hardie, *The Etched and Engraved Work of Sir Frank Short: A Catalogue and Introduction*, 3 vols., 1938–40.

SIGNAC, Paul (1863–1935), French Neo-Impressionist painter. Signac was a follower of Seurat and after him the leading exponent of pointillism, working in oils, lithographs, and watercolour. He visited London in 1898, his main purpose to see the Turners. In the same year Signac published his influential *D'Eugène Delacroix au néo-impressionnisme* in the periodical *La Revue Blanche*, a German translation appearing in *Pan*. In this he cites liberally from *Ruskin, including his comments on Turner's use of broken colour when painting from nature. John Gage (1987, p. 17) gives further instances of Signac's writing about Turner's use of colour and his importance for modern painting. LH

SIGNATURES AND OTHER INSCRIPTIONS appear on relatively few of Turner's works. The earliest signatures noted by Wilton in his catalogue of finished watercolours (1979, p. 300, nos. 5 and 6) are on *Folly Bridge and Bacon's Tower, Oxford* and *Clifton, Nuneham Harcourt, near Abingdon* and are in the form 'W Turner 1787'. Variants on this signature are 'Wm Turner', 'William Turner', sometimes with the suffix 'delin^t' or variants of this for 'delineated' or 'drew', 'pinx^t' for 'pinxit' or 'painted', and 'fe' or 'fec' for 'fecit' or 'made'. Dates were sometimes added between 1793 and 1798, and possibly in 1801 (*The Abbey Pool*, Whitworth Art Gallery, Manchester; see Hartley 1984, p. 34, no. 23). Only one oil painting from the 1790s, *Watermill and Stream* (c.1791–2; BJ 19a), is similarly inscribed 'W. Turner pinxt', and this is on paper.

In November 1799 Turner was elected an Associate of the *Royal Academy. Three watercolours for *Whitaker's *His-

tory of the Parish of Whalley, 1800–1, are inscribed 'Drawn by Wm. Turner A' (W 290, 292, 294). After Turner was elected a full member of the Royal Academy in February 1802 his signature changed more radically, to variants of 'JMW Turner', usually followed by 'RA'. Occasionally a work of the 1790s appears to have been signed in this form (e.g. W 81) but such inscriptions would have to have been added later and were often not made by Turner, as in the case of Westminster Bridge (?1796; University College of Wales, Aberystwyth; W 96). Similarly with oil paintings: *Ships bearing up for Anchorage (RA 1802; Petworth House; BJ 18) is signed 'JMW Turner pinx'. In December 1807 Turner was made Professor of *Perspective at the RA and after this his signatures sometimes included the letters 'PP' after 'RA'. In 1808 two works in his gallery were thus inscribed, *Pope's Villa (Trustees of the Walter Morrison Picture Settlement; BJ 72) and Purfleet and the Essex Shore as seen from Long Reach (private collection, Belgium; BJ 74).

Turner continued to sign, and occasionally to date, his watercolours fairly regularly until the mid-1830s. After this one view on the Rhine of c.1840 is signed (W 1378) and one is actually signed and dated 1840 (W 1380). One of the finished Swiss watercolours is signed and dated 1843 (W 1534), one watercolour sketch is inscribed 'Falls of the Rhein 1841' (National Gallery of Scotland, Edinburgh; W 1460; see Campbell 1993, p. 84, no. 38), while a watercolour of a Storm-Cloud over a River is inscribed on the back in pencil 'Sept. 12/45' (or '6; W 1427). Similarly, Turner occasionally signed and sometimes dated his later oils, as in the case of the *Dort (RA 1818; Yale Center for British Art, New Haven; BJ 137). The last oil to be dated was Dogana, and Madonna della Salute, Venice (RA 1843; National Gallery of Art, Washington; BJ 403), where Turner painted his initials illusionistically on a wall in the lower right-hand corner. Similar illusionistic signatures, and sometimes dates, appear on other works. The inscriptions were usually painted or drawn on the work, though occasionally they were scratched in the paint while it was still wet. Examples of signatures on Turner's oil paintings are reproduced in BJ, pls. 564–5.

In the case of Windsor Castle from the Thames (Petworth House; BJ 149) Turner's full signature is followed by 'RA ISLEWORTH', where Turner lived in *Sion Ferry House in the summer of 1805 (Hill 1993, p. ix). Other inscriptions indicative of place or perhaps patronage occur on watercolours such as Windy Day, Lullingstone Park, Kent ('John Dyke Lullingston'; c.1791; W 22), or label an object in the picture, as in the case of the boat inscribed 'HOPE of Brighton' in Brighthelmstone (c.1796; Victoria and Albert Museum; W 147). Two late watercolour sketches of *whaling subjects are inscribed with titles, 'He breaks away' and 'Hurrah boys' (1845; Fitzwilliam Museum, Cambridge, and untraced; W 1411–12).

More extraordinary are the as yet unexplained letters inscribed in dabs of paint on *Forum Romanum (RA 1826; BJ 233, repr. pl. 562) and those painted on Seascape with Distant Coast (c.1840; BJ 467, repr. pl. 563). On the back of the canvas of Steamer and Lightship (c.1825–30; BJ 279) Turner has drafted some verses in chalk, presumably in connection with his Fallacies of Hope (see POETRY AND TURNER).

MB

SION, or Syon, Ferry House, Isleworth, the Thames-side house on the edge of Syon Park which Turner rented from early 1805 for about 18 months. The house was demolished sometime in the middle of the 19th century, but according to contemporary prints it was an ample double-fronted building under a pitched roof just to the east of Isleworth church, beside the slipway. With two or three reception rooms and three or four bedrooms, it was large enough for a family and became Turner's temporary home during the summer of 1805. It had a riverside garden and a small Gothic summer house. It was here that he spent the summer months drawing and painting from his boat, travelling as far west as Oxford, and, according to *Trimmer, experimenting with oil on canvas in the open air (see THAMES SKETCHES).

In his studies at Isleworth and in the Thames valley Turner looks at the landscape with classical composition in mind, in which art blends with nature. He was developing an art of England in which England could be perceived as a classical source. Beside the house was a classical pavilion which can be seen as a focal point in some of the drawings in the 'Studies for Pictures Isleworth' Sketchbook (TB xc). In this and other sketchbooks in use that summer—including 'Hesperides 1' and '2' (xciii and xciv)—are studies for large-scale compositions which are early stages in the evolution towards such later works as *Dido building Carthage (RA 1815; National Gallery, London; BJ 131). In the 'Isleworth' Sketchbook Turner wrote a list of possible mythological subjects for painting, indicating that he was reading extensively from the classics, or discussing them with friends such as Trimmer.

Turner felt strongly enough about living in Isleworth to add the name to his *signature on Windsor Castle from the Thames (c.1805; Petworth House; BJ 149).

See also HAMMERSMITH. JH

Wilton 1987, ch. 2.
Hill 1993, passim.
Bailey 1997, 89–93.
Hamilton 1997, 88–90, 99.

SIZES AND FORMATS seem to have been significant for Turner, at least for his oil paintings. Between a quarter and a third, about 110 finished works and 64 unfinished, are roughly 3 × 4 ft. (91.4 × 122 cm.), dating from his first exhibit of 1796, *Fishermen at Sea* (BJ 1) to his last four exhibits, the *Aeneas pictures of 1850. Every kind of subject is included, from classical mythology to Thames landscapes; the unfinished works include the larger *Thames sketches of 1805 (BJ 161–76; BJ 160 is on half a 3 × 4 ft. canvas: 24 × 36 in., 61 × 91.4 cm.) and the late oils of the mid-1840s based on *Liber Studiorum* subjects (BJ 509–19). Strangely, this was not a regular colourman's size (see SUPPORTS). Particularly significant is Turner's move away from the standard 3 × 4 ft size used for the three Venetian subjects exhibited between 1834 and 1836 (the surviving oil of the two exhibited in 1833, *Bridge of Sighs, Ducal Palace and Custom-House*, BJ 349, was exceptional, being painted on mahogany, and measures 20³⁄₁₆ × 32⁷⁄₁₆ in., 51 × 82.5 cm.). In 1837 Turner exhibited the exceptionally large *Grand Canal, Venice* (58¼ × 43½ in., 148 × 110.5 cm.; Huntington Art Gallery, California; BJ 368). Then, after a gap until 1840, Turner resumed exhibiting Venetian subjects but on a smaller format, approximately 24 × 36 in. (61 × 91.4 cm.). He continued exhibiting Venetian subjects of this size, mainly in pairs, until 1846 (there was one exception, *Depositing of John Bellini's Three Pictures*, 29 × 45½ in., 73.7 × 113 cm.; RA 1841; private collection; BJ 393). Turner wrote on 23 November 1843, referring to a small Venetian oil, 'I will paint a picture double the size 3 feet × 4 feet—Pastoral landscape or Marine subjects (Venice size being best 2 feet 3 feet)' (Gage 1980, pp. 193).

Turner also had certain favourite larger sizes which he used for series of pictures on similar subjects, though strangely the first picture of each series, often the result of a particular commission or other stimulus, was smaller than the rest. *The Fifth *Plague of Egypt* (RA 1800; Indianapolis Museum of Art; BJ 13), Turner's first picture to be inspired by *Poussin, measures 49 × 72 in. (124.5 × 183 cm.) and led to a series of pictures measuring about 57 × 93 in. (145 × 237 cm.): *The Tenth Plague of Egypt* (RA 1802; BJ 17), *The Deluge* (?Turner's gallery 1805; BJ 55), *The Destruction of Sodom* (?Turner's gallery 1805; BJ 56), *Snow Storm: Hannibal crossing the Alps* (RA 1812; BJ 126), *Apullia in Search of Appullus* (BI 1814; BJ 128), *The *Field of Waterloo* (RA 1818; BJ 138), *The *Bay of Baiae* (RA 1823; BJ 230), and *Forum Romanum* (RA 1826; BJ 233). In the 1830s Turner's format for *Claudian landscapes grew still larger in *Caligula's Palace and Bridge* (54 × 97 in., 137 × 246.5 cm.; RA 1831; BJ 337), *Childe Harold's Pilgrimage* (56 × 97¾ in., 142 × 248 cm.; RA 1832; BJ 342), and *The Parting of Hero and Leander* (57½ × 93 in., 146 × 237 cm.; RA 1837; BJ

370); other examples, *The *Fountain of Indolence* (RA 1834; Beaverbrook Art Gallery, Fredericton, New Brunswick; BJ 354) and *The *Golden Bough* (RA 1834; BJ 355) are smaller, about 42 × 65 in. (107 × 165 cm.).

In 1802 Turner also exhibited a seapiece in the format of *The Fifth Plague of Egypt*. This was *Ships bearing up for Anchorage* (Petworth House; BJ 18), but he had already established a larger and somewhat squarer format for seapieces the year before with *Dutch Boats in a Gale* (private collection, on loan to the National Gallery, London; BJ 14); this, painted as a pair to *A Rising Gale* by Willem *Van de Velde the Younger that measures about 51 × 74 in. (129.5 × 188 cm.), was itself 64 × 87½ in. (162.5 × 222.3 cm.) and in its turn led on to a series of seapieces larger still, approx. 67 × 94 in. (170 × 239.5 cm.): *Calais Pier* (RA 1803; National Gallery, London; BJ 48), *The Battle of Trafalgar, as seen from the Mizen Starboard Shrouds of the Victory* (Turner's gallery 1806; BJ 58), *Spithead: Boat's Crew recovering an Anchor* (Turner's gallery 1808; BJ 80) and *The *Wreck of a Transport Ship* (c.1810; Fundaçao Calouste Gulbenkian, Lisbon; BJ 210).

In 1818 Turner initiated a series of large port scenes with the Cuyp-inspired *Dort* (62 × 92 in., 157.2 × 233 cm.; Yale Center for British Art, New Haven; BJ 137). Again the successors are larger, but in this series slightly more square, about 68 × 88 in. (173 × 223.5 cm.): *Harbour of Dieppe* (RA 1825; Frick Collection, New York; BJ 231), *Cologne, the Arrival of a Packet Boat* (RA 1826; Frick Collection, New York; BJ 232), and the unfinished *Harbour with Town and Fortress*, recently identified as *The Harbour of Brest* (Warrell 1997, p. 175, repr. in colour, fig. 173; c.1826–8; BJ 527). *Entrance of the Meuse* (RA 1819; BJ 139), is larger, 69 × 97 in. (175.5 × 246.5 cm.).

One of the most interesting cases of Turner increasing the scale of one of his compositions is *England: Richmond Hill, on the Prince Regent's Birthday* (RA 1819; BJ 140); this measures 70⅞ × 131¾ in. (180 × 334.5 cm.), Turner's largest picture up to this date, but was preceded by an unfinished canvas of the same view, *Richmond Hill with Girls carrying Corn*, in Turner's normal 58 × 96¾ in. (147.4 × 246 cm.) format (BJ 227). In many ways this is one of Turner's typical Claudian landscapes. The first of these was the small *Aeneas and the Sibyl, Lake Avernus* of c.1798 (BJ 34) but after his first trip abroad Turner painted *The *Festival upon the Opening of the Vintage of Macon* (RA 1803; Sheffield City Art Galleries; BJ 47), measuring 57½ × 93½ in. (146 × 237.5 cm.), more or less the same in size as the series of pictures of Plagues and other biblical disasters. In 1809 Turner combined Claudian elements with features from his series of Thames scenes painted in the 3 × 4 ft (91.4 × 122 cm.)

format, in particular *Pope's Villa at Twickenham (Turner's gallery 1808; Walter Morrison Picture Settlement; BJ 72) and in the unprecedentedly large, for this date, *Thomson's Aeolian Harp, 65⅝ × 120½ in. (166.7 × 306 cm.) (Turner's gallery 1809; Manchester City Art Galleries; BJ 86). In this the stretch of the Thames at Twickenham is ennobled by being seen from the raised viewpoint of, approximately, Richmond Hill and also by a quotation from James *Thomson and, through that poem, an allusion to Antiquity. In 1815 Turner exhibited *Crossing the Brook (BJ 130), another view in England based on Claudian principles but in an upright format, 76 × 65 in. (218.4 × 165 cm.). Both these pictures were out-scaled by England: Richmond Hill, with its allusion to the Prince Regent's Birthday reflecting a desire for royal patronage, and with various details suggesting that it was influenced by the recently exhibited painting by Velasquez of Philip IV of Spain Hunting Boar (71⅝ × 118⅞ in., 182 × 302 cm.; National Gallery, London). Canvases of this new vast size were used for two further 'city' views, *Rome, from the Vatican (RA 1820; BJ 228) and the unfinished Rialto, Venice (c.1820; BJ 245). Turner's largest painting of all, however, was The Battle of Trafalgar (BJ 252) which measures 102 × 144 in. (259 × 366 cm.) and was painted in 1822–4 as a pendant to P. J. de *Loutherbourg's Glorious First of June; (both are now in the National Maritime Museum, Greenwich).

Turner exhibited a number of pictures as pairs from the two Bonneville landscapes of 1803 onwards (see COMPANION WORKS). However, it was not until late in his career that the idea of paired pictures, often of contrasting colour schemes, was accompanied by a switch to matching square, oval, or circular compositions. In 1840 he exhibited Bacchus and Ariadne (BJ 382), a square picture 31 × 31 in. (78.7 × 78.7 cm.); this had no companion. The following year he exhibited Dawn of Christianity (Flight into Egypt) (Ulster Museum, Belfast; BJ 394), a circular composition (though at one stage in its evolution an octagon was envisaged) 31 in. (78.7 cm.) in diameter. Probably as its companion he also exhibited Glaucus and Scylla (Kimbell Art Museum, Fort Worth, Texas; BJ 395); this, painted to the limits of its rectangular wooden support, may also have been first exhibited in a circular frame. The following year, 1842, Turner exhibited *Peace—Burial at Sea and *War. The Exile and the Rock Limpet, both in octagonal frames though, strangely, of different sizes, 34¼ × 34⅛ in. (87 × 86.5 cm.) and 31¼ × 31¼ in. (79.4 × 79.4 cm.) respectively (BJ 528, 529). In 1843 Turner exhibited two more octagonal pictures, *Light and Colour and Shade and Darkness, each about 31 × 31 in. (78.5 × 78.5 cm.) (BJ 404, 405). An earlier version of Shade and Darkness—the Evening of the Deluge seems to have been

painted before Turner had the idea of making such a strong contrast between the colouring of the two paintings (29⅞ × 29⅞ in., 76 × 76 cm.; National Gallery of Art, Washington; BJ 443). Finally in 1846 Turner exhibited Undine Giving the Ring to Massaniello and the apocalyptic The *Angel standing in the Sun, each approx. 31 × 31 in. (78.5 × 78.5 cm.), the one begun as an octagon, the other as a circle but both finished off over the whole square canvas (BJ 424, 425). There are also two unfinished oils on square canvases, Venetian Scene and A River seen from a Hill, again both about 31 × 31 in. (78.5 × 78.5 cm.) (BJ 504 and 532); the fact that the second picture is not a Venetian scene and has a much higher horizon than the other suggests that these were not envisaged as a pair.

Turner being primarily a landscape painter, most of his pictures were in a horizontal format. However, there are a number of upright compositions. As well as those already mentioned there are the two early atmospheric, Wilsonian landscapes, *Morning amongst the Coniston Fells (RA 1798; BJ 5) and his Royal Academy Diploma picture, *Dolbadern Castle (RA 1800; BJ 12). Crossing the Brook is the great example from the second decade of the century. A much later Claudian landscape in upright format is Mercury and Argus (RA 1836; National Gallery of Canada, Ottawa; BJ 367), while other later upright landscapes are the recently re-identified *Banks of the Loire (RA 1829; BJ 328a and 329) and The Grand Canal, Venice, already mentioned. Turner's other important upright compositions are subject-pictures inspired by other artists, including *Rembrandt in Rembrandt's Daughter (RA 1827; Fogg Art Museum, Cambridge, Mass.; BJ 238; see also BJ 333, 346, 436), *Watteau in Boccaccio (RA 1828; BJ 244), *Titian in Venus and Adonis (c.1803–5; private collection; BJ 150), and *Van Dyck in the unfinished A Lady in Van Dyck Costume (c.1830–5; BJ 444). Above all there are the two densely painted but unfinished paintings, *Music at East Cowes Castle (c.1835; BJ 447) and Two Women and a Letter (c.1835; BJ 448).

One should not seek for too much consistency however. As has already been seen, Turner could exhibit a pair of pictures of different sizes, and his two large contrasted Carthaginian pictures, *Dido building Carthage (RA 1815; BJ 131) and The Decline of the Carthaginian Empire (RA 1817; BJ 135), measure 61¼ × 91¼ in. (155.5 × 232 cm.) and 67 × 94 in. (155 × 231.5 cm.) respectively. In decorative schemes, the dimensions were governed by the potential setting: the two views of Plompton Rocks were painted c.1798 for the library at Harewood House (the Earl of Harewood; BJ 26, 27); the four paintings on mahogany covering George IV's visit to Edinburgh in 1822 were painted, presumably for a decorative scheme, in the hope of royal patronage and engraving

(BJ 247–8b); while the famous *Petworth landscapes were designed to be placed below full-length portraits in the dining-room at Petworth House (BJ 288–91), the difference in dimensions of the sketches in the Tate Gallery (BJ 283–7) perhaps being one reason why these were replaced by the slightly more finished pictures. Two other pictures associated with Petworth, *Lord Percy, when under Attainder* and *Watteau Study by Fresnoy's Rules* (RA 1831; BJ 338, 340), owe their dimensions to having been painted on cupboard doors. Other oil paintings by Turner are of all sorts of sizes, for all sorts of reasons, usually unknown. MB

SKETCHBOOKS. Among a mass of paper in Turner's studio at his death there were over 300 sketchbooks. Some had already been broken up by the artist, and others were soon to be dismembered by *Ruskin in his search for exhibitable drawings. A few—only five are traced—escaped into other collections. All that remained in the Turner Bequest (see WILL AND BEQUEST) were sorted, labelled and packaged by Ruskin, and in the first decade of the twentieth century they were catalogued by A. J. *Finberg in his two-volume *Complete Inventory of the Drawings of the Turner Bequest*, 1909. Finberg divided the Bequest into groups consisting either of individual sketchbooks or of sequences of loose sheets, and gave each book or sequence a Roman numeral; that is the system of reference used in this Companion.

The earliest sketchbook is a home-made one that Turner was using in 1789; the latest probably dates from 1845. The period they cover was a time of technical improvement and diversification in artists' materials, and Turner was always quick to avail himself of innovations. Pigments in general, and watercolours in particular, underwent great improvements both in range and in packaging. Supports, too, changed radically. Laid *paper, in use since the 16th century, gave way in the latter part of the 18th century to the more finely and consistently textured wove paper that James Whatman and others were perfecting in their mills. The binding of notebooks and sketchbooks was revolutionized in the early decades of the 19th century.

Turner is thought of as the sort of artist who usually carried a notebook of some kind with him, ready to jot down anything of interest that he happened to see. This was not quite the case. In London, for instance, he seems to have made very few sketches of a casual nature: he occasionally drew buildings of which he intended to produce finished views, but made none of the observations about, say, street life in Covent Garden that Ruskin's famous account of the youthful artist's early inspiration would lead us to expect. Turner, in tune with the times, was a tourist's painter, and his art is often about travelling and the wonders of the for-

eign, the unusual. It was when he was away from his native city that he started to collect information in earnest.

When preparing for a tour, he ensured that he was well supplied with drawing materials and paper. In the late 18th century sketchbooks tended to be heavy, with thick board or calf bindings and brass clasps. These books usually contained leaves of high-quality paper, often Whatman, which was itself a bulky item. Smaller, card-bound books were to be had, and, as noted, Turner occasionally improvised his own, sewing a few sheets together between paper-wrapped card covers. Other kinds of book often came in handy: commercially produced almanacks and account books, which might be bought on the journey from any convenient stationer's. In some circumstances he would also take with him a portfolio of large unbound sheets. So the most important early tours—to the North of England in 1797 or through *Wales in 1798, to *Scotland in 1801, and to *Switzerland in 1802—were recorded in a range of books of which some were substantial in dimensions. Turner's technical resources were extended accordingly: the larger books are more likely to have elaborate watercolour studies, while the smaller ones are mostly filled with pencil or pen sketches.

Regardless of size, some books are prepared with coloured grounds. It is never quite clear on what principle Turner chose to prepare his paper in this way; at first, as in the very small 'Wilson' Sketchbook (TB XXXVII), the suggestion is that he was thinking in terms of the procedure used in oil painting, working from dark to light rather than the dark-on-light of traditional watercolour practice. Later, grand or *Sublime scenery seemed to prompt a need for the immediate tonal flexibility provided by a darker ground. So the *'Scottish Pencils' (LVIII) were executed on a ground of 'India ink and Tobacco water' and the 'St Gothard and Mont Blanc' Sketchbook of 1802 (LXXV) is largely grey-washed. Bower speculates, to explain the fading of some sheets, that Turner's ground may have included indigo as well as the soot-water that contemporary writers specify as appropriate for such uses. Books used at Schloss Eltz about 1841 (private collections; W 1333–5) and in Bavaria in 1840 (the disbound and newly identified 'Passau and Burg Hals' book, CCCXL) are characteristic examples of the occurrence of grey grounds in the latter years of his career.

During the ensuing decades there is a tendency for the sketchbooks to become smaller. Changes in the methods of production allowed a wider choice of sizes, with many quite small or even tiny books available on the market, which suited the wandering Turner well: he could stuff several pocket-sized books into the capacious recesses of his travelling coats. Later, an even more significant revolution oc-

curred: from the late 1810s onwards we find him increasingly using books with stout but flexible paper covers which meant that a reasonably large page-size could be rolled up and pocketed. While the small books that are typical of his tours of the 1810s and 1820s contain mostly pencil notes—sometimes many crammed on to a single spread—the 'roll-sketchbooks' inspired a renewed interest in the use of colour. From 1828 onwards, and especially in the 1840s, Turner used this type of book for a substantial part of his output—though it was nominally for his private reference only. The coloured studies that emerged from his 1836 tour to the *Val d'Aosta, the long sequence of *Venetian views of around 1840, and the great outpouring of *Alpine scenes in the sketchbooks from the 1841, 1842, and 1843 tours, with the postlude of studies made at Dieppe, Folkestone, and elsewhere along both shores of the English Channel in about 1845, constitute a sustained achievement which would itself merit a unique place in the history of landscape painting.

From an early date Turner was in the habit of noting the names of places drawn in his books either on the outside or the inside of the front covers. At some stage, as the sketchbooks accumulated, he also took to numbering them. No one has yet discovered the system behind the numbering, but the titles give a general indication of their contents. Many are therefore identified by the names of the principal places visited on a given tour—'Thames from Reading to Walton', for instance, or 'Milan to Venice'. Finberg, in listing them, frequently abridged or modified Turner's wording: for example the 'Rhine, Strassburg and Oxford' book is 'R. From Strasburg. Oxford' in Turner's notation, and 'from Venice up to Trento' becomes 'Venice to Trient'. Often Finberg invented his own title, to provide a clear point of reference. A large number of leaves from disbound books—usually roll-sketchbooks from the second half of Turner's career—found their way into private collections and are now scattered world-wide; in a few instances these books have been notionally reconstructed by scholars using such evidence as stitch holes along one edge, and given titles indicating the places represented.

But not all the books were employed on tour. There was also the working life of the studio, and the process of transforming rapidly noted observations into finished works of art. Much of that process is to found in books labelled by Turner 'Studies for Pictures' or some such form of words. Here we find composition studies, sequences of ideas for pictures, or developments of particular details. Powell has suggested employing the French terms croquis, esquisse, étude and ébauche to indicate the various functions of these drawings and other works relating to Turner's working process (including watercolour *'Beginnings' and oil lay-ins),

and it is certainly important to be aware of the various functions of the drawings; to distinguish, for example, the studies made on the spot or from life and those done in the process of evolving a finished work in the studio. On the other hand, in the very act of observing the world he was composing pictures. Many of his studies from nature are couched as resolved compositions, and there is not necessarily a clear dividing line between observation and invention. What can be stated categorically is that, with the odd exception from the 1790s, he did not paint finished pictures in his sketchbooks. Even the 'sample' studies of Swiss and other Continental views that he made in the 1840s to enable patrons to choose subjects for commission are not by any means finished works as Turner understood the term. The difference is apparent when they are compared with the great watercolours that he 'realized' from them (in Ruskin's phrase).

At the time of his first success at the Royal Academy, around 1800, Turner self-consciously imitated traditional academic methods in working towards a picture, whether in oil or watercolour. In the 'Calais Pier' Sketchbook (LXXXI), for example, he made composition studies in black and white chalks on blue paper, entirely in the Continental tradition. In the same book and elsewhere there are similar studies in pen and brown ink. Two early tours, to Scotland and Switzerland, prompted books devoted exclusively to figure studies, though in neither were many pages used. He also made studies from the nude model in the 'Academical' (XLIII) and 'Academies' Sketchbooks (LXXXIV), and in the 'Studies for Pictures: Isleworth' Sketchbook (XC) a sequence of grand classical harbour subjects can be seen evolving in parallel with his sketches along the banks of the Thames. Such exercises became less common in the second decade of the century, and for most of his life finished watercolours were developed by means of the 'Colour Beginnings' which occur sometimes on sketchbook leaves but more usually on separate, larger sheets. Nature studies of the type associated with *Constable, notes of the growth and habit of individual trees or plants that might be used for foregrounds or repoussoirs (like the Scots pines in *Crossing the Brook, BJ 130) occur relatively rarely, and are scattered through the earlier sketchbooks fairly randomly. They virtually disappear after about 1828. On the other hand, studies of skies, both in pencil and in colour, occupied Turner quite intensively at different moments throughout his life. The 'Skies' Sketchbook, usually dated to 1818 (CLVIII), is devoted almost entirely to beautiful watercolour notes of clouds and sunsets, with occasional distant horizons; and the recently rediscovered 'Channel' Sketchbook (Yale Center for British Art, New Haven) is largely taken up with sea- and skyscapes,

often sunsets, seen apparently from Margate. This seems to date from about 1845 and is thought to have been the last book that Turner used, though it is hard to believe that he entirely renounced his lifelong habit during the final six years of his career.

Turner often used his notebooks for matters other than drawing, but did not systematically segregate art from business or other concerns. Some books contain notes copied from guidebooks in preparation for tours; some have drafts of poetry, speeches, or letters, some household accounts, recipes, or cures for ailments. Such jottings are usually mixed in with at least some sketches, though a few books are dedicated exclusively to other things. The most famous example is the 'Verse Book' (private collection; see POETRY) in which Turner developed his ideas for poetry connected with paintings like *The Garden of the Hesperides* (see GODDESS OF DISCORD; BI 1806; BJ 57), *Pope's Villa* (Turner's gallery 1808; BJ 72) and *Thomson's Aeolian Harp* (Turner's gallery 1809; BJ 86). In this connection it is worth recording that he also used other books as jotting-places for his poetical thoughts, volumes from his own library that prompted such ideas, or which simply afforded clean pages to write on. AW

Finberg 1910.
Wilton 1986, pp. 9–23.
Wilton and Turner 1990.
Bower 1990.
Cecilia Powell, 'Turner's Sketches: Purpose and Practice', in Joyce H. Townsend, ed., *Turner's Painting Techniques in Context*, 1995.
Bower 1999.

SKETCHES, use of. There are over 19,000 works on paper in the Turner Bequest of which about half are still in Turner's *sketchbooks, the others on separate sheets. This immense body of material provides an unparalleled insight into Turner's working methods but, characteristically, his use of sketches is highly complex and still not fully understood, especially as regards the many works which seem to hover between the status of sketch, abandoned subject, or fully realized picture. A good example of the difficulties attending the distinction between sketch and finished watercolour is provided by the *Rhine subjects Turner derived from a tour of 1817. Turner made pencil drawings of motifs drawn on the spot in sketchbooks (TB CLX, CLXI). These drawings are themselves closely connected with 50 drawings on paper prepared with a grey wash (W 636–77, 679–86) probably made on his return to England, varying from abbreviated notations of architectural and landscape features to quite elaborate designs in watercolour and bodycolour. These he sold to Walter *Fawkes, who considered them finished, but Turner evidently regarded them as

preparation for further development. A few of Fawkes's drawings became the basis for designs in about 1820, some in watercolour on white paper sold to patrons, others closer to the media and technique of the originals for publication by W. B. *Cooke as engravings (W 687–93). Both *Thornbury and *Ruskin believed that Fawkes's drawings had been made on the spot and it is only comparatively recently that scholars have established this more plausible sequence of development (Wilton 1979, pp. 374–80; Powell 1991, pp. 32–8; Powell 1995, pp. 26–8).

These Rhine drawings clearly indicate that the transcription of the original motif was but the starting point for a sequence of further sketches and studies towards the finished picture. If sketching from the motif assembled the raw visual data, the place of the compositional sketch in Turner's practice was almost always to provide an opportunity for technical experimentation such that the original stimulus, whether real or imaginary, was reworked towards the fullest elaboration of its potential as a subject. In distinguishing those works finished for exhibition or sale from their originating sketches Turner seems to have adhered to academic precept as understood in the 18th century. His sketches, therefore, should be seen as providing the motive power for the finished pictures on which he wished to be judged and it is anachronistic to single them out as fully realized statements of creative intent. As Turner's reputation developed, however, he was sometimes disposed to allow selected friends, colleagues, and patrons to acquire sketches from portfolios or sketchbooks, and this practice indicates that he was prepared to countenance a limited dispersal of such work. In like manner, in the 1840s Turner produced a number of 'samples', worked up from Swiss sketches, which were given to his agent Thomas *Griffith to attract interest in a planned series of finished watercolours. Four completed watercolours allowed Griffith to demonstrate how each sample would become fully developed when taken further (W 1523–67). It was in these transactions that a very restricted group of Turner's contemporaries got to see the private, formative side of his creativity. Nevertheless, notwithstanding the formal division between sketch and finished painting, in leaving his sketches to the nation as part of his *will (if indeed he meant to do so), Turner must surely have understood and so intended that the whole of his creative process would become open to more general public scrutiny as well.

Broadly speaking we may distinguish three fundamental types of sketch: those resulting from working from the motif, technical experiments concerning media and handling, and compositional sketches in which imaginative possibilities of subjects were elaborated. All of these sketches, even land-

scape studies, are thus provisional or preliminary, to a greater or lesser extent, valuable chiefly for their potential employment in further development of the subject rather than existing *sui generis*. Sketching for Turner was both a training of the eye and the development of the imagination, and from the outset of his career he was aware of the need to produce a creative response to the motif rather than being enslaved by it. In one of his *perspective lecture manuscripts (*c*.1821) Turner paraphrased *Reynolds in recommending that his students 'mark the greater from the lesser truth; namely the larger and more liberal idea of nature from the comparatively narrow and confined . . . that which addresses itself to the imagination from that which is solely addressed to the Eye' (Shanes 1997, p. 18). Rather than constituting a self-sufficient compendium of picturesque views or antiquarian details most, if not all, of his work in the open air was thus a means of gathering raw material for subsequent transformation in the studio into works of art. A good early example of this is provided by comparing the sketch in the 'Tweed and Lakes' Sketchbook of 1797 (XXXV) with the exhibited oil *Buttermere Lake, with part of Cromackwater* (RA 1798; BJ 7), whose diminutive staffage and soaring rainbow add a poetic register to the original topographical and atmospheric record of the sketch. It is perhaps in the 1810s, when Turner embraced a form of naturalism in his art, that the closest connection between open-air sketch and finished picture can be detected. The oil sketches made variously on the *Thames (BJ 160–94) and in *Devon (BJ 213–25b) explored atmospheric qualities of light and colour which inform work such as *Dorchester Mead* (Turner's gallery 1810; BJ 107) and *Crossing the Brook* (RA 1815; BJ 130) respectively while his 'Skies' Sketchbook (CLVIII) of 1818–22 helps explain the complexity of cloud formations seen in *Entrance of the Meuse: Orange-Merchant on the Bar, going to Pieces* (RA 1819; BJ 139).

When working out compositions for pictures Turner tended to use tinted *paper and black and white chalk, sometimes buying blue-paper sketchbooks, sometimes tinting Whatman paper himself in greys and browns, such as the so-called 'Wilson' (XXXVII), 'Calais Pier' (LXXXI) and 'Studies for Pictures: Isleworth' (XC) Sketchbooks of the late 1790s and early 1800s. Andrew Wilton has noted how the sketches of this period show affinities with oil sketching in their richness of effect (Wilton 1979, pp. 56–60). The sketches included in the 'Academical' Sketchbook (1798; XLIII) are typical of this tendency, combining coloured grounds with different media—pen, chalk, watercolour, and bodycolour— such that a sketch takes on the richness of oil painting and could be further developed as a finished picture either as an oil or a watercolour. If Turner's mature art was largely to

efface the traditional demarcation between oil and watercolour technique, discovering new possibilities for both, these technical experiments in his sketchbooks may be regarded as the necessary preliminaries to such an outcome.

First thoughts for landscape, marine and subject pictures occur throughout the earlier sketchbooks, sometimes grouped together, at other times interspersed with landscape sketches made on the spot, as for instance in the 'Wey, Guildford' (1807; XCVIII) and 'Hesperides' Sketchbooks (*c*.1805–7; XCIII, XCIV). Two of the most important sketchbooks for the gestation of Turner's pictures in his early career are 'Calais Pier' (*c*.1799–1805) and 'Studies for Pictures: Isleworth' (*c*.1804–6), which contain a number of tryouts for *classical subjects and show him developing compositions which respond primarily to the classical literary narrative rather than any artistic tradition. This studious approach to narrative history is a feature of Turner's early maturity, but after the 1820s his sketches for history paintings tend to act more as prompts to the imagination than as exercises in compositional development, and his staffage seems to have been added on canvas in the later stages of completing a picture rather than receiving extensive elaboration in preliminary sketches.

Some of Turner's sketches were of academic value to him as a student of art. The 'Wilson' Sketchbook included copies after Richard *Wilson, and when Turner was in Paris a few years later he studied the pictures deposited by *Napoleon in the Louvre, *Paris. The 'Studies in the Louvre' Sketchbook (1802; LXXII) combines coloured sketches with written annotations on the style, composition, and use of colour of the originals. These sketches provided a storehouse of canonical images and observations which animated his perspective lectures at the *Royal Academy, first given in 1811, as well as several of his *historical subjects. As a student in the RA Schools Turner had made studies of the figure from 1792 to 1799 and he later served as Visitor in the Life Academy on eight occasions between 1812 and 1838. His early studies of the figure, seen, for example, in the 'Dinevor Castle' (XL), 'Academical' (XLIII) and 'Dolbardarn' (XLVI) Sketchbooks of 1798–9 herald a lifelong interest in the human form, and a number of his sketchbooks contain figure drawings ranging from academic poses through naturalistic observation to more intimate and erotic subjects. These investigations allowed him to naturalize the historical narratives of his subject-pictures as well as adding a credible staffage to his landscapes.

When Turner was commissioned to produce series of topographical watercolours for engraving his procedure was to look out the relevant sketchbooks, sometimes recently made, sometimes from decades earlier, and from the sketches

he found there to elaborate the watercolours required. A series of studies might thus be produced, refining the composition before one design was taken forward for completion with the level of finish exhibition and/or engraving necessitated. As Shanes has noted, it is characteristic of Turner's procedure that many of his studies tend to be larger than the resultant finished image, so allowing a freer imaginative exploration of the motif, which exploration could subsequently be disciplined to fit within a smaller compass (Shanes 1997, pp. 12–13). It is worth noting that often it is not his more detailed pencil sketches that provide the basis for work in watercolour but the more abbreviated, cursive drawing style seen most characteristically in his smaller sketchbooks. This suggests that Turner primarily used these smaller sketches to conjure the spirit of the landscape and, as a supplement, referred to more detailed studies for the introduction of accurate topographical information within the overall composition. His sketches, then, were used 'liberally' to engage rather than restrain his imagination.

When working up watercolours Turner is known to have worked in batches, characteristically completing several at once, as noted by John Kay, who saw him working in sequence on four compositions simultaneously, starting with a lay-in of colour and then bringing each to completion by stages (Shanes 1997, p. 23). This seems to have been the procedure noted by Walter Fawkes's children in 1816; they remembered 'cords spread across the room as in that of a washer woman, and papers tinted with pink and blue and yellow hanging on them to dry' (W. L. Leitch, 'The Early History of Turner's Yorkshire Drawings', *Athenaeum* (1894), p. 327). Between pencil sketch and finished watercolour lay several intermediate operations, often including the production of a so-called 'Colour *Beginning' (CCLXIII) to establish the overall composition and/or its chromatic scale and tonal massing. As a consistent practice this seems to have begun with the 1816 commission to provide 120 watercolours for Dr T. D. *Whitaker's *History of *Richmondshire*, published between 1819 and 1823 (Gage 1987, pp. 83–4). Turner's watercolour practice of laying in a composition and returning to it at a later stage finds an echo in his mature practice as an oil painter where canvases might be worked on in series and compositions brought to a finished state on the walls of the Royal Academy or *British Institution on *Varnishing Days.

Turner's late oil studies and unfinished canvases (especially BJ 453–519) demonstrate a close relationship with his late finished pictures in so far as the unexhibited canvases tend to concentrate on those natural forces, atmospheric effects, or chromatic structures which increasingly inform the completed work of the late 1830s and 1840s. Nevertheless, even in his last decade, Turner never envisaged these studies as anything more than preparation, and the paintings he exhibited distilled their spontaneity, lack of structure, and concentration on natural phenomena to produce controlled pictorial explorations suitable for public display. SS

Gage 1969², pp. 22–8.
Wilkinson 1972.
Wilkinson 1974.
Gowing and Conisbee 1980, pp. 32–5.
Chumbley and Warrell 1989.
Butlin 1999.
Reynolds 1999.

SKIES, drawings of. In October 1821 John *Constable wrote a long and informative letter to his old friend Archdeacon John Fisher, in which he told him 'I have done a good deal of skying—I am determined to conquer all difficulties and that most arduous one among the rest . . . That Landscape painter who does not make his skies a very material part of his composition—neglects to avail himself of one of his greatest aids' (Beckett 1968, p. 76). This letter was written at a time when Constable was painting many sky studies, usually in Hampstead, and most of them meteorologically accurate. He was, perhaps, influenced by reading Luke Howard's important book *The Climate of London* (1818–20). Little is known about the relationship between Turner and Constable, but the two artists are likely to have met and spoken quite frequently at the *Royal Academy, of which Constable had belatedly been elected an Associate in 1819. There is no record that Turner owned a copy of Howard's book, but in many of his sketchbooks and some of his finished watercolours there is ample evidence that he too became an eager though less scientific student of the sky in the second decade of the 19th century.

The most notable example of this is the so-called 'Skies' Sketchbook in the Turner Bequest (TB CLVIII), on the label of which Turner wrote '79. Skies', and which is watermarked 1814, but is usually dated to about 1818. In this there are some 60 mostly rapid watercolour studies of a great variety of sky effects, including many sunsets and storms, and most of them probably made out in the open, or looking out from a window, at any rate for the twilight and night skies. In these impressive and often beautiful sketches Turner used a wide variety of techniques, ranging from the very wet to the very dry, and each sheet can be seen as an independent and complete 'picture'. They are not studies for specific use in more complete compositions, but rather a series of jottings made for reference when Turner needed help in composing the sky in a finished painting or watercolour.

It has been suggested that Turner used this sketchbook during his first tour in *Italy in 1819, and it is certainly true

that some of these studies are similar to the skies in the famous watercolours made in *Venice and Como during that visit (CLXXXI). However, they are also comparable with the vivid skies in some of the great series of 50 *Rhine drawings, made immediately after his return from his Rhine tour in 1817. At the end of this journey Turner spent the first two weeks of September travelling in *Holland, and it seems more plausible that the 'Skies' Sketchbook was used at this time to record the huge skies of that flat and open country, which are so often a feature of the work of Dutch 17th-century landscape artists. The theory that the 'Skies' Sketchbook was used in Holland is strengthened by the dramatic and impressive skies of two of the paintings that resulted from this journey, The *Field of Waterloo (RA 1818; BJ 138) and Entrance of the Meuse (RA 1819; BJ 139).

During the same period Turner was including vivid and compelling skies in many of his finished watercolours for engraving, especially in those for *Whitaker's History of Richmondshire, which he made in 1817 and 1818. Here an outstanding example is Simmer Lake near Askrigg (British Museum; W 571), in which the effect of the sky is enhanced by its reflection in the calm waters of the lake. Such impressive skies can also be found in some of Turner's earlier watercolours, as for instance in Weymouth, Dorsetshire (Yale Center for British Art, New Haven; W 448), dating from about 1811 and engraved by W. B. *Cooke for the *Southern Coast series, but they become more usual in later years. This is especially true of the Picturesque Views in *England and Wales series, published between 1827 and 1838. The stormy, wet, and thundery sky in Stamford (c.1828; Usher Art Gallery, Lincoln; W 817) enhances the light effects and adds drama to this lively composition, though it actually records no more than an everyday scene outside a coaching inn in a small Midland town.

From John *Ruskin onwards symbolic meaning has been analysed in many of Turner's skies, and this is certainly true of another England and Wales subject, Stonehenge (c.1827; Salisbury Museum; W 811), which Ruskin described as 'the standard of storm drawing' (Works, iii. p. 413). Many topographical and landscape artists have drawn and painted Stonehenge since the 17th century, but only Turner has succeeded in really dramatizing the scene by marrying the great stones to the sky, in which lightning is flashing, and the fatal effect of an earlier bolt is shown in the foreground, where a dead shepherd and sheep are lying on the ground.

Numerous other such examples could be cited in Turner's later finished watercolours. In addition some of the most striking sheets in the miscellaneous series of some 300 watercolours of the so-called 'Colour *Beginnings' in the Turner Bequest (CCLXIII) are studies of sky effects. In recent

years research by several scholars has led to the identification of some of these Colour Beginnings drawings as studies directly connected with finished watercolours and paintings. One such is Tower on Hill, with Rainbow (CCLXIII: 150), which Ian Warrell has identified as the compositional, colour, and underpainting study for the *Ports of England watercolour of Plymouth (c.1825; Fundaçao Calouste Gulbenkian, Lisbon; W 760), in which the scene is dominated by the vivid rainbow and lowering sky behind it. Unlike the studies in the 'Skies' Sketchbook, these larger drawings were very probably executed in the studio, when Turner was 'thinking' on paper, usually in very wet washes, towards a finished composition. The many beautiful sky impressions among these miscellaneous later watercolours show again how instinctive and vital was Turner's reaction to the ever-changing moods and beauties of the sky as 'a very material part' of his art. LH

Reynolds 1999.

SLAVERS THROWING OVERBOARD THE DEAD AND DYING—TYPHON COMING ON, oil on canvas, 35¾ × 48 in. (91 × 122 cm.), RA 1840 (203); Museum of Fine Arts, Boston, Mass. (BJ 385); see Pl. 27. Accompanied by the lines:

> Aloft all hands, strike the top-masts and belay;
> Yon angry setting sun and fierce-edged clouds
> Declare the Typhon's coming.
> Before it sweeps your decks, throw overboard
> The dead and dying—ne'er heed their chains
> Hope, Hope, fallacious Hope!
> Where is thy market now?
>
> (MS Fallacies of Hope)

Slavers is not only a masterpiece but is also Turner's most famous picture outside the Bequest owing both to its sensational subject and to the praise lavished on it by *Ruskin, who owned it for 28 years. He considered the sea 'the noblest that Turner has ever painted . . . and, if so, the noblest certainly ever painted by man' and asserted: 'if I were reduced to rest Turner's immortality upon any single work, I should choose this.'

The republication of Thomas Clarkson's History of the Abolition of the African Slave-Trade in 1839 recounted the story of the slave-ship Zong in 1783 in which 132 slaves dying of an epidemic were thrown overboard because insurance could be claimed for those drowned but not for any who died of disease. This was Turner's immediate source but there were others: a typhoon is described in 'Summer' in *Thomson's Seasons; Thomas Gisborne's Walks in a Forest (1794) includes an attack on slavery; a biography of William Wilberforce was published in 1839 and his Correspondence in 1840, and the Anti-Slavery League Conference was held

in London during the Royal Academy exhibition, opened by Prince *Albert, so Turner may have hoped to attract royal notice here. All this, as Gage noted, adds up to an extraordinarily wide focus of reading on Turner's part.

The picture was much ridiculed at the RA: *The Times* (6 May) thought it 'impossible to look at without mingled feelings of contempt and pity'; *Blackwood's Magazine* for September conjectured that the object between the ship and the fish was 'a Catholic Bishop, in Canonicals gallantly gone overboard to give benediction to the crew, or the fish, or Typhon . . . The fish claiming their leg-acy is very funny'. *Thackeray in *Fraser's Magazine* for June was undecided whether it was ridiculous or sublime; he considered the slaver throwing its cargo overboard 'the most tremendous piece of colour that was ever seen' and continued 'Ye Gods, what a "Middle Passage"'.

Eventually Ruskin found the subject too painful and, in 1872, sold the picture to America, where it was not well received. Mark Twain saw it in Boston and later wrote 'Slave Ship—Cat having a fit in a platter of tomatoes' and 'What a red rag is to a bull, Turner's "Slave Ship" was to me, before I studied art.'

See also SLAVERY. EJ

Gage 1987, pp. 193–4.

Boime 1990, pp. 34–43.

John McCoubrey, 'Turner's *Slave Ship*: abolition, Ruskin, and reception', *Word & Image*, 14/4 (1998), pp. 319–53.

SLAVERY. The Atlantic trade in slaves began when the Portuguese first brought back slaves from Africa to Europe in 1442. From the 15th until the 19th century 15 million slaves were taken across the Atlantic to the Americas. To begin with the main employment for slaves was on gold mining in South America. This was followed by tobacco, mainly in the West Indies and the southern states of the United States, and from the middle of the 17th century on sugar. Between 10 and 20 per cent died in transit; there was a similar death rate among the crews of the ships that transported the slaves. Insurance could be claimed for slaves who drowned at sea but not for those who died on board ship; this ruling was the basis for Turner's famous painting *Slavers throwing overboard the Dead and Dying—Typhon coming on* (RA 1840; Museum of Fine Arts, Boston; BJ 385).

The movement against slavery began in the 18th century and was fuelled both by the Enlightenment and by the Quakers. In 1772 a test case secured a decision by Chief Justice Mansfield that West Indian planters could not hold slaves in Britain. In the United States the northern states abolished slavery between 1777 and 1804. In Britain opposition to slavery was expressed in the sections on 'Summer' in *Thomson's *Seasons*, 1727, and Thomas Gisborne's *Walks in a Forest*, 1794. Thomas Clarkson's *History of the Abolition of the Slave Trade* was first published in 1808, with a second edition in 1839; the period of Turner's *Slavers* also saw the publication in 1839 of the *Life of William Wilberforce* (he had died in 1833) and in 1840 of his *Correspondence*. Wilberforce had succeeded in getting slavery abolished in Great Britain by an Act of Parliament of 1807. Thomas Fowell Buxton, whose *The African Slave Trade and Its Remedy* was published in 1839–40, carried on Wilberforce's work by helping to steer an Act 'for the abolition of slavery throughout the British colonies' through Parliament in 1833; this came into effect in 1838. In 1839 Buxton founded the Society for the Extinction of the Slave Trade and the Civilisation of Africa, organizing a first anniversary meeting in 1840, just before the international Anti-Slavery Convention of 12 June; Prince *Albert accepted the Presidency of the Society. The French abolished slavery in their territories in 1848. The cause led to the American Civil War of 1861–5 and final emancipation there, while in South America and the West Indies the process took from 1810 until the 1880s.

The degree of Turner's involvement in the abolitionist cause is not altogether clear. In 1828 Turner dedicated Quilley's print of *The Deluge* of about 1805 'To the Right Honourable (the late) Earl of Carysfort', a well-known abolitionist whose name is included in a list of patrons in the 'Academies' Sketchbook (TB LXXXIV: 67v.) as having commissioned a 'Historical' work, perhaps *The Deluge*; the painting includes a prominent figure of a black man supporting a female victim of the flood (BJ 55; see Adele M. Holcomb, review of Wilton 1980, *Turner Studies*, 3/1 (summer 1983), pp. 52–3). *The *Angel standing in the Sun* (RA 1846; BJ 425) may include a reference to the tyranny of American slavery (see Smith 1986, p. 46). *Slavers* reflects, of course, the climax of abolitionist activity in the late 1830s, though whether Turner was emotionally engaged in the cause or merely saw it as an opportunity for a dramatic seascape is arguable. For Jack Lindsay, 'It was characteristic of Turner that he should find a great aesthetic release through an image which concentrated his social thinking and at the same time was deeply embedded in the poetic tradition he so loved' (1996, p. 190). For Boime, 'Turner set the trap by taking a subject whose latent content had been neutralised and revivifying it in pigment and light'; the main social issue of the day had ceased to be slavery and was now the new tyranny of manufacturing industry, on whose leaders Turner relied for patronage in the later years of his life (1990, pp. 39–42). MB

Lindsay 1966, pp. 189–90.

Boime 1990, pp. 34–43.

SMIRKE, Sir Robert (1752–1845). English painter of literary subjects and an early friend of Turner. After receiving Smirke's support in becoming an Associate of the Royal Academy in 1799, Turner presented him with a watercolour view of Richmond, Yorkshire (now lost). Turner's *Fifth *Plague* (RA 1800; Indianapolis Museum of Art; BJ 13) was possibly inspired by Smirke's *The Plague of Serpents* (also RA 1800; now lost; see Gage 1987, p. 114). It has been further suggested that Turner's picture, along with another two 1800 exhibits, *Dolbadern Castle* (Royal Academy; BJ 12) and *Caernarvon Castle* (Tate Gallery; W 263), more generally manifested the influence of Smirke, a known political radical, in adopting liberty as a theme (Shanes 1990³, p. 44).

ADRL

SMITH, John Thomas (1766–1833), topographer, writer, and Keeper of the Department of Prints and Drawings at the *British Museum 1816–33. The son of Nathaniel Smith, a sculptor and printseller, 'Antiquity' Smith was the author of *Antiquities of London and its Environs* (1791–1800) and *Antiquities of Westminster* (1807). He published twenty etchings of ruinous cottages in his *Remarks on Rural Scenery* (1797), which gave great impetus to the movement towards greater naturalism in the work of Turner's contemporaries, particularly Smith's pupil, John *Constable.

Smith's numerous publication projects incurred debts which were partially alleviated by his salary as Keeper of Prints and Drawings. In the Print Room, Smith regaled visitors with tales of his youth and the art world of London, eventually published as *Nollekens and his Times* (1828). Characterizing the sculptor as a miser, Smith recorded one anecdote of his generosity related to him by Turner, to whom Nollekens had given 30 guineas for the *Artists' General Benevolent Institution. Smith drew one of the most intimately revealing portraits of Turner, showing him leafing through a portfolio of prints in the Print Room (British Museum, lithographed by L. Haghe). The posthumous publication of Smith's memoirs as *A Book for a Rainy Day* (1845) led to his present sobriquet, 'Rainy Day' Smith. KMS

Felicity Owen, 'John Thomas ("Antiquity") Smith', *Apollo*, October 1994, pp. 34–6.

SMITH, W. R. (fl. 1819–51). English line-engraver, largely of landscapes, and a favourite with Turner. His first engravings after him were two plates in Dr *Whitaker's *History of Richmondshire* (R 169 and 187). In the 1830s Smith engraved twelve of the ambitious *England and Wales* series, last among them, in 1838, the effective and intricate *Chain Bridge over the River Tees* (R 211, 215, 218, 225, 257, 280, 288–9, 291, 293, 299, 302). Smith's first steel engravings after Turner were three plates for *Rogers's *Italy* (R 351–2, 356). In 1842 he produced the large copper plate of *Dido and Aeneas* (R 652) after the large painting exhibited in 1814 (BJ 129) (see CARTHAGE). LH

SNOW STORM: HANNIBAL AND HIS ARMY CROSSING THE ALPS, oil on canvas, 57½ × 93½ in. (146 × 237.5 cm.), RA 1812 (258); Tate Gallery, London (BJ 126). This is Turner's grandest and most dramatic use of Alpine landscape for a classical subject, Hannibal's crossing of the Alps in 218 BC and his skirmishes with local tribesmen. Turner's verses in the 1812 catalogue, attributed for the first time to his manuscript poem *Fallacies of Hope* (see POETRY AND TURNER), contrasts Hannibal looking 'on the sun with hope' with the warning '"Capua's joys beware!"' Thomas Gray had included the subject in a list of imaginary paintings by artists of the past, in this case Salvator *Rosa: 'Hannibal passing the alps; the mountaineers rolling rocks upon his army; elephants tumbling down the precipices'. The scene was also described in Mrs Radcliffe's *The Mysteries of Udolpho*, 1794. J. R. *Cozens's now lost painting of a later episode, which had passed through the salerooms in 1802, may also have inspired Turner, as may have David's *Napoleon on the St Bernard Pass*, showing *Napoleon as the modern Hannibal, seen by Turner in Paris in 1802. Turner had sketched the subject in the 'Calais Pier' Sketchbook *c.*1803 (TB LXXXI: 38, 39) and another possible inspiration was a storm seen at Walter *Fawkes's Yorkshire home, Farnley Hall, in 1810: 'There, Hawkey,' Turner apparently said to Fawkes' son Hawkesworth, 'in two years you will see this again, and call it Hannibal crossing the Alps.'

*Farington records the dispute, lasting several days from 10 until 15 April 1812, over the best position for the painting at the *Royal Academy. Originally it was placed comparatively high but on the Friday, 10 April, Turner said that 'if this picture were not placed under the line He wd. rather have it back'. Another site across the Great Room injured the surrounding hang and the picture was returned to its original position. The following Monday, 13 April, the picture was moved to the New Room, where it was seen by Turner the following day; he finally agreed to the new position 'provided other members shd. have pictures near it' on the Wednesday (*Diary*, 10, 11, 13, 14, and 15 April). Paradoxically, the low position meant that C. R. *Leslie 'could not see it at the proper distance, owing to the crowd of people'; he added that Washington *Allston 'says it is a wonderfully fine thing: he thinks Turner the greatest painter since the days of *Claude' (letter to his sister, 12 May 1812).

The picture was also well received by the critics. For the *Examiner*, 7 June 1812,

This is a performance that classes Mr. Turner in the highest rank of landscape painters, for it possesses a considerable proportion of that main excellence of the sister Arts, Invention . . . An aspect of terrible splendour is displayed in the shining of the sun . . . A terrible magnificence is also seen in the widely circular sweep of the snow whirling high in the air . . . In fine, the moral and physical elements are here in powerful unison blended by a most masterful hand, awakening emotions of awe and grandeur.

According to the *St James's Chronicle*, 23–6 May, the 'sun is painted with peculiar felicity, and the warm tinting from the great source of light struggling through the blackness of the storm, gives a fine relief to the subject, which is still further improved by the introduction of a corner of cloudless sky on the left.' For Henry Crabb Robinson, the picture 'seemed to me the most marvellous landscape I had ever seen' (diary, 5 May 1812) and he also reported that John *Flaxman 'spoke of Turner's landscape with great admiration, as the best painting in the Exhibition' (15 May 1812). MB

Llynn R. Matteson, 'The Poetics and Politics of Alpine Passage: Turner's *Snow Storm: Hannibal and his Army crossing the Alps*', *Art Bulletin*, 62 (1980), pp. 385–98.

Nicholson 1990, pp. 97–103.

SNOW STORM—STEAM-BOAT OFF A HARBOUR'S MOUTH *making Signals in Shallow Water, and going by the Lead. The Author was in this Storm on the Night the Ariel left Harwich,* oil on canvas, 36 × 48 in. (91.5 × 122 cm.), RA 1842 (182); Tate Gallery, London (BJ 398). One of the boldest of Turner's exhibited pictures. Its title, however, cannot be accepted as an accurate record. No ship called *Ariel* is known to have been involved in a storm around this time nor to have operated out of Harwich. It has been suggested that Turner mis-remembered the name of the *Fairy*, which set out from Harwich on 12 November 1840 and sank with all hands in the storm; Turner could well have witnessed the storm from Margate but can hardly, in the circumstances, have been on board. In addition the story that Turner had himself tied to the mast bears a suspicious resemblance to accounts of the French marine painter Claude-Joseph *Vernet. *Ruskin's account of a conversation between the artist and the Revd William *Kingsley in which Turner said that 'I wished to show what such a sea was like; I got the sailors to lash me to the mast to observe it; I was lashed for four hours, and I did not expect to escape, but I felt bound to record it if I did', is set in Marlborough House, where Turner's pictures were not hung until after his death.

Ruskin also records Turner's hurt reaction to the untraced criticism that the picture was nothing but a mass of 'soapsuds and whitewash'. Similar abuse is found in the *Athenaeum*'s review of 14 May: 'This gentleman has, on former occasions, chosen to paint with cream, or chocolate, yoke of egg, or currant jelly—here he uses his whole array of kitchen stuff. Where the steam-boat is—where the harbour begins, or where it ends—which are the signals, and which the author in the *Ariel*—are matters past our finding out.' However, Ruskin, in *Modern Painters*, described the *Snow Storm*, together with two watercolours, as 'nothing more than passages of the most hopeless, desolate, uncontrasted greys, and yet . . . three of the very finest pieces of colour that have come from his hand.' He also described it as 'one of the very grandest statements of sea-motion, mist, and light that has ever been put on canvas, even by Turner. Of course it was not understood; his finest works never are . . .' (*Works*, iii. pp. 297, 534, 569–71). MB

Gage 1987, pp. 67–8, repr.

SNOWDONIA. Turner's visit to Snowdonia in 1798 and 1799 was his first encounter with high mountains. He approached the North Welsh range from the south-west, on the road from Harlech with its view across the sands of Traeth Mawr towards Y Knicht, Moel Hebog, and Aberglaslyn. He was clearly aware that the region presented him with an unprecedented challenge, for he took with him a supply of whole sheets of Imperial Whatman paper, obviously intending to work on them in colour out of doors. These are the group catalogued by *Finberg as TB LX(a). Some may have been worked up at a later date, but they were all conceived as first-hand studies independent of finished works, and have a unique place in Turner's output. They represent the first climax of his progress as a master of landscape, embodying a wholly new style of painting in watercolour that is precisely at one with its demanding subject matter.

But Turner always needed to demonstrate the part that human life plays in such landscapes. We see him groping towards complex, many-layered subjects in experiments like the atmospheric study or lay-in of Traeth Mawr (XXXVI: U)—experiments implying the existence, actual or proposed, of an ulterior work. Landscape is expressly linked to local history in his painting of *Dolbadern Castle* (RA 1800; Royal Academy, London; BJ 12), with its reference to the medieval Welsh prince Owen Goch in the lines he composed for the Royal Academy catalogue, and in his project, of the same date, for a pair of watercolours illustrating Gray's *The Bard* (LXX: N, Q). AW

Wilton 1984, pp. 17, 24–31, 61, 63–9.

SOANE, Sir John (1753–1837), architect, collector, friend, and fellow Academician of Turner. He was Surveyor to the Bank of England, which he partially rebuilt, and designer of Dulwich College Picture Gallery (1811–14). He was made ARA in 1795, RA in 1802, and Professor of Architecture at the *Royal Academy in 1806. He was knighted in 1831.

Between 1808 and 1824 Soane converted three adjacent houses in Lincoln's Inn Fields, London, to house his substantial collection of works of art, which included antique marbles, the Cawdor vase, architectural drawings, and some 8,000 books. Also in the collection were British paintings and sculpture, including *Hogarth's *Rake's Progress* and works by *Canaletto, *Reynolds, *Fuseli, and Turner. In 1833 Sir John Soane's Museum was established by a private Act of Parliament.

Turner and Soane were friends and correspondents. Turner owned Soane's *Sketches in Architecture* (1793). Frequent references to Turner are contained in Mr and Mrs Soane's diaries between 1803 and 1818. *Finberg (1961, p. 113) quotes a letter from Turner to Soane dated 4 July 1804 discussing the return of several architectural drawings Turner had borrowed from Soane, possibly to assist with the preparation of *The Deluge* (BJ 55) and *The Destruction of Sodom* (BJ 56), both of which may have been exhibited at Turner's gallery in 1805. In return the artist presented Soane with an engraving by F. C. *Lewis of one of Turner's watercolours. They were both on the RA Council in 1803, and Turner assisted Soane with his inaugural lecture at the RA in 1809. The two men may have had a falling out following Soane's suspension from the RA in February 1810, but it was not permanent. Both were Directors of the *Artists' General Benevolent Institution in 1818. Turner was at the presentation of the Belzoni Sarcophagus at Soane's house in March 1825, and seems certain to have known of Soane's plans for a museum by 1826. *Forum Romanum, for Mr Soane's Museum* (RA 1826; BJ 233) was painted for Soane but, probably owing to the limited space at Lincoln's Inn Fields, Soane did not take the picture. He did indicate that he would like a smaller picture, and acquired *Admiral *Van Tromp's Barge at the Entrance of the Texel, 1645* from the RA exhibition in 1831 (Sir John Soane's Museum; BJ 339). Their shared affinities encompassed plans for housing their collections, benevolent work, and a strong *Neoclassical foundation. TR

Gage 1980, p. 285.

Youngblood 1982, pp. 29–32.

Gillian Darley, *John Soane. An Accidental Romantic*, 1999.

SOCIETY OF ARTS. The Society for Promoting Arts, Manufactures and Commerce was founded in 1754; in 1908 it was retitled the Royal Society of Arts. In 1793 Turner was awarded the Society's Greater Silver Pallet, a medal that was conferred in Class 190, 'For the best drawing of a landscape after nature'. Turner had submitted a view of Lodge Farm, near Hambleton, Surrey (untraced, not in Wilton), and in order to prove that it had been created without help, and

that he could draw from memory and/or sketches, he made a further watercolour before the three judges.

The silver medal was shaped like an artist's palette and, in Turner's case, was bordered in gold because he had especially distinguished himself. On the obverse a scroll bearing his name was surrounded by artists' brushes, while the title of the award and that of the conferring body appeared on the reverse.

The medal was last seen publicly in 1923, when its velvet mount and frame were described as being 'not at all faded' (Carey). That condition suggests Turner had always kept the objects hidden.

In 1849 the Society of Arts asked Turner if he would allow them to mount a retrospective exhibition of his work, but he declined 'from a peculiar inconvenience this year'. ES

C. W. Carey, 'Discovery of a New Turner Relic', *Connoisseur*, February 1923, pp. 79–82.

John Gage, 'Turner and the Society of Arts', *Journal of the Royal Society of Arts*, September 1963, pp. 842–5.

SOLUS LODGE, see SANDYCOMBE LODGE.

SOMER-HILL, near Tunbridge, the Seat of W. F. Woodgate, Esq., oil on canvas, 36 × 48½ in. (91.5 × 122.3 cm.), RA 1811 (177); National Gallery of Scotland, Edinburgh (BJ 116). A study for the picture occurs in the 'Vale of Heathfield' Sketchbook (TB CXXXVII) in use in 1810; Turner may have visited Somer Hill, just south-east of Tonbridge in Kent, on the trip that he made to Rosehill Park in Sussex to fulfil a commission for John *Fuller. A sense of recession is achieved by Turner grouping the trees below Somer Hill into a narrowing tunnel which leads up to the house, the focal point of the composition.

Sir George *Beaumont was among those who criticized Turner's pictures at this date for being far too light. He told *Farington that 'Much harm had been done by Turner endeavouring to make his oils appear like water-colours.' This led to Turner and his followers being dubbed 'the white painters', a classification difficult to understand today in front of *Somer Hill*.

Wilton admires 'the sheer breadth of the design and the spell-binding stillness of the scene', while Gage links it to the *Thames sketches and considers it 'Turner's masterpiece of naturalism'. EJ

Gage 1969, p. 24.

Wilton 1979, p. 191.

SOMERVILLE, Mary (1790–1872), mathematician and scientific writer who came to know Turner in the 1820s in the circles of *Chantrey, *Murray, and *Rogers. Somerville was born in Jedburgh, and had studied painting at Alexander Nasmyth's Edinburgh academy, becoming a talented ama-

teur landscapist. This shared interest was one of the bonds between her and Turner, of whom she observed 'no-one could imagine that so much poetical feeling existed in so rough an exterior.' Turner was particularly interested in her research on the magnetizing properties of violet light (1826), speaking of it to *Mayall twenty years later, and owned a copy of Somerville's first book, *Mechanism of the Heavens* (1831), incorporating some of its ideas in *Fountain of Indolence* (RA 1834; Beaverbrook Foundations; BJ 354) and *Rogers's *Italy* illustrations (W 1152–76). Her later books took complex ideas to a wide readership and brought the author international fame. She married twice, secondly to Dr William Somerville, Physician to the Royal Hospital, Chelsea. The Somervilles were widely travelled on the Continent, and for family reasons emigrated to Italy in 1838, where Mary died. Her scientific library is at Girton College, Cambridge. Somerville College, Oxford, was later named after her. JH

Martha Somerville, ed., *Personal Recollections of Mary Somerville*, 1873.

Elizabeth C. Patterson, *Mary Somerville and the Cultivation of Science, 1815–1840*, 1983.

Hamilton 1998, chs. 1, 4, and 7.

Warrell 1999, p. 55.

SOUTH KENSINGTON INTERNATIONAL EXHIBITION, 1862. Turner was handsomely represented by nine oils and 49 watercolours. The oils included *Mercury and Herse* (RA 1811; private collection, England; BJ 47), *The Fifth *Plague of Egypt* (RA 1800; Indianapolis Museum of Art; BJ 13), correctly catalogued as the seventh plague, and *Thomson's Aeolian Harp* (Turner's gallery 1809; City Art Gallery, Manchester; BJ 86), catalogued simply as 'Italy'.

A major lender was Sir Alexander Acland-*Hood, who had inherited Jack *Fuller's *Views in Sussex*, 1816–20, twelve of which were exhibited including *Beauport* (Fogg Art Museum, Cambridge, Mass.; W 434), catalogued as 'Too Late for the Coach'. Acland-Hood also lent *Fishmarket on the Sands—?Hastings* (Turner's gallery 1810; William Rockhill Nelson Gallery, Kansas City; BJ 105); the identification has recently been challenged despite the proximity of Hastings to Fuller's seat, Rosehill Park, in Sussex.

Among other well-known collectors Henry *Vaughan lent *The Reichenbach*, 1802 (National Gallery of Ireland, Dublin; W 361), the basis for the finished 1804 watercolour (Cecil Higgins Art Gallery, Bedford; W 367); John *Allnutt lent *Tivoli* (RA 1818; private collection, England; W 495); and James *Wadmore lent *Negrepont*, engraved for *The Life and Works of Lord *Byron*, 1825 (private collection; W 1218), and *The Cedars of Lebanon* 1832–4, an unused design for *Finden's *Landscape Illustrations of the Bible* (W 1263).

EJ

SOUTH KENSINGTON MUSEUM, see VICTORIA AND ALBERT MUSEUM.

***SOUTHERN COAST OF ENGLAND**, Picturesque Views of the.* Published between 1814 and 1826 the 39 copper engravings of the *Southern Coast* (R 88–127) constituted the first major independent topographical series based on watercolours by Turner. The majority of the plates were engraved by the brothers George and William Bernard *Cooke. It was the latter brother who initiated this series as the first element of a major publication to illustrate most of the coast of England at a time when during the *Napoleonic wars the English were very conscious of the importance of their coastline and the surrounding seas. With a letterpress by William Coombe (Turner's own efforts to provide this having been rejected), the series was to be published over four years in two volumes with sixteen parts of three plates each, and 30 accompanying vignettes designed by other artists. In the event there were constant delays and only 39 plates of the *Southern Coast* were completed, of which the first seven are dated 1814 and the last five 1826, and the larger plan was abandoned. The first eleven parts were published by John *Murray and the final parts by John and Arthur Arch. Throughout the production of this important series Turner was often in dispute with the Cooke brothers, frequently on the question of his own fees, and the engravers also often quarrelled with Murray.

On the other hand Turner took enormous pains in supervising the engraving of his compositions, as is shown by the large number of touched proofs which still exist today, many of them in the outstanding Tweedmouth Collection of *Southern Coast* engravings now in the Tate Gallery. Turner himself began making drawings for this series in 1811 during his tour of Dorset, *Devon, and *Cornwall, and many of the finished watercolours for the *Southern Coast* are among the most impressive that the artist had yet produced. The combination of these outstanding drawings and Turner's careful supervision of the engraving resulted in by far the best copper plates of his work that had been produced so far, and these were the precursors of the many wonderful topographical engravings after Turner published in the 1820s and 1830s. LH

Rawlinson 1908, pp. xxix–xxxv, 44–74.

A. J. Finberg, *An Introduction to Turner's Southern Coast*, 1929.

Herrmann 1990, pp. 76–90.

Shanes 1990[2], pp. 12–13, 41–72, 264–8, 270.

SPECTATOR, THE, a weekly periodical (unrelated to Addison and Steele's *Spectator*), founded in 1828 by R. S. Rintoul, its editor and chief proprietor until his retirement in 1858. The *Spectator*, under Rintoul's firm control, was

pro-*Reform, keenly political, but determinedly non-partisan. Covering news, politics, science, and the arts, its anonymous contributors were knowledgeable, informed, and analytic. The art critics, if perplexed by Turner, were consistently sensitive to his power and originality; more than most, they did not ridicule or censure what they could not understand. The reviewer in 1843 was clearly aware of, even sympathetic to, Turner's experimental investigation of chromatics: *Shade and Darkness* (BJ 404) and **Light and Colour* (BJ 405) were intelligible as illustrations 'of *GOETHE's Theory of Light and Colour . . . but further we cannot follow the painter. There may be some sublime meaning in all this . . . but . . . we see in these two octagon-shaped daubs only two brilliant problems—chromatic harmonies of cool and warm colours' (13 May, p. 451). Presumably the same critic had in 1839 marvelled at the 'dazzling' *Fountain of Fallacy* (see FOUNTAIN OF INDOLENCE; BJ 376), recognizing it as a 'fanciful problem of chromatography' (16 February, p. 163). The reviewers, frequently stunned by his effects of atmosphere and light, were fascinated by what happened when his paintings were viewed from various distances and were curious about the changes that would occur in them over time. There were, of course, criticisms; but typically a reviewer could admire a painting that was 'equally brilliant to the eye and dark to the understanding' (4 May 1850, p. 426). JCI

W. B. Thomas, *The Story of the Spectator, 1828–1928*, 1928.

SPLÜGEN PASS, THE, watercolour, 11⅜ × 18⅛ in. (29.8 × 45.9 cm.), 1842; private collection, USA (W 1523). This watercolour is the first of the renowned set of ten Swiss subjects, painted by Turner in 1842. The set were based on 'sample studies', selected by Turner for his agent Thomas *Griffith, who showed them to prospective patrons to indicate the appearance of the finished works which Turner proposed to execute on commission. The sample study for *Splügen* is TB CCCLXIV: 277.

John *Ruskin considered the finished picture to be 'the noblest Alpine drawing Turner had ever till then made' (*Works*, xiii. p. 480) and 'the best Swiss landscape yet painted by man' (xxxv. p. 309). Ruskin certainly coveted the work but was not able to buy it when it was offered to him by Griffith, as his father, who would have funded the acquisition, was away on business. It was purchased by *Munro of Novar for 80 guineas (the price for each of the 1842 set). Despite protracted attempts to acquire it, Ruskin had to wait until 1878 to own the work when it was sold at Munro's sale at Christie's on 16 April and purchased by a group of his close admirers who presented it to him soon afterwards.

RY

SPOONER, William, see COURTAULD GALLERIES.

STADLER, J. C. (fl. 1780–1820), German-born engraver, mostly in aquatint, who was in London from 1780 to 1820. He was frequently employed by Rudolph Ackerman to provide the aquatints for his illustrated books. His best-known series was the 76 aquatints after the drawings of Joseph *Farington for *An History of the River Thames*, published in two volumes in 1794 and 1796 by Alderman Boydell. In about 1810 Stadler engraved the four large aquatint views in Sussex after drawings by Turner, privately published by Jack *Fuller, MP, of Rosehill (R 822–5). LH

STAFFA, FINGAL'S CAVE, oil on canvas, 36 × 48 in. (91.5 × 122 cm.), RA 1832 (453); Yale Center for British Art, Paul Mellon Collection (BJ 347); see Pl. 23. Signed: 'JMW Turner RA' and exhibited with lines from *Scott's *Lord of the Isles*. Turner left *Abbotsford in August 1831 on a search for spectacular scenery which included a steamship trip from Tobermory round Staffa. Despite stormy weather, Turner explored Fingal's Cave, a place of pilgrimage for *'Romantic' tourists. However, the 'Staffa' Sketchbook (TB CLXXIII) shows Turner concentrating on the sea voyage rather than on the cave itself. The oil shows the sun ringed by a nimbus, a sign of impending rain, a feature owed, as Gage noted, to Turner's discussions in 1831 with Sir David Brewster, an Edinburgh physicist who was investigating such optical phenomena.

Despite being praised at the Royal Academy, *Staffa* remained unsold until 1845 when C. R. *Leslie was commissioned by Colonel James *Lenox of New York to buy a Turner for him. Leslie chose *Staffa*, the first Turner oil therefore to go to America. Lenox initially complained he found it 'indistinct' (see Holcomb and Gage) but later grew to admire *Staffa*, and afterwards bought **Fort Vimieux* (RA 1831; private collection; BJ 341). EJ

Adele M. Holcomb, '"Indistinctness is my Fault": A Letter about Turner from C. R. Leslie to James Lenox', *Burlington Magazine*, 114 (1972), pp. 555–8.
John Gage, 'The Distinctness of Turner', *Journal of the Royal Society of Arts*, 123 (1975), pp. 448–57.

STANFIELD, Clarkson (1793–1867), English painter, regarded as the leading marine artist of his generation. After service at sea he began his career as a theatrical scene painter and took up easel painting in the early 1820s, soon arousing Turner's competitive spirit. In 1826 his failure to finish a picture called *Throwing the Painter* for the Royal Academy was noticed first by *Callcott, who added 'Missing the Painter Rope' to the title of his own *Dutch Fishing Boats* shown that year. Turner completed the joke with his *'Now for the Painter' (Rope)* (RA 1827; City of Manchester Art Galleries;

BJ 236). More angry than amused when Stanfield won a commission for a series of Venetian scenes from Lord Lansdowne, Turner apparently painted his own *Bridge of Sighs, Ducal Palace and Custom House, Venice: Canaletti painting (BJ 349) 'in two days' to overwhelm the first of Stanfield's Lansdowne pictures in the 1833 RA exhibition. Despite this the artists subsequently became friends, often being seen together—for example in a boat with students watching the burning of the Houses of *Parliament, 16 October 1834. Stanfield owned two of Turner's marine drawings and numerous prints. DBB

Peter Van der Merwe, *Clarkson Stanfield*, exhibition catalogue, Sunderland Museum and Art Gallery, 1979.

Stainton 1985, pp. 19–20, 30, 74.

STEAM-BOAT OFF A HARBOUR'S MOUTH . . ., see *SNOW STORM—STEAM-BOAT OFF A HARBOUR'S MOUTH*.

STEAMBOATS. Turner used steamboats both as a means of travel and as a subject for many works. The first steam vessel to appear in one of Turner's works is possibly the paddle steamer in the watercolour *Dover from the Sea* (1822; Museum of Fine Arts, Boston; W 505). The vessel is one which had been converted from sail to steam. This watercolour was made at around the same time as the first iron steamship was constructed, the *Aaron Manby*, built at the Horseley Iron Works, Dudley, in 1821–2. Despite his fascination with steamboats and interest in industrialization Turner never depicted vessels under construction.

From the early 1820s Turner used steamboats regularly to travel around Britain and on the Continent's rivers, including the *Loire in 1826 and the *Seine in 1829. A regular cross-channel steamer service between Dover and Calais became operational in 1821 and by 1826 steamships were a familiar sight on the Thames and on European rivers, particularly the Seine.

One of the most common interpretations given to steamboats in Turner's work suggests that they appear as a symbol of modern life. However, they also appealed to Turner simply for the way they looked. He used their bold blackness to produce striking effects in his landscapes. He also took advantage of the way the black smoke from a steamer's funnel made evident the currents in the air. In a sketchbook of *c*.1808 Turner noted one of the greatest difficulties in painting, 'to produce wavy air, as some call the wind . . . to give that wind he must give the cause as well as the effect' (Bailey 1997, p. 325). This point is demonstrated perhaps most dramatically in *Staffa, Fingals Cave* (RA 1832; Yale Center for British Art, New Haven; BJ 347).

The most controversial of Turner's steamboats is the tug in The *Fighting 'Temeraire'* (RA 1838; National Gallery, London; BJ 377). Judy Egerton presents a detailed discussion of the painting, including Turner's deliberately incorrect positioning of the tug's funnel and foremast. Egerton suggests that Turner has placed the smoking funnel foremost on the tug's deck for compositional reasons, and that it is very doubtful he was making a statement about new technology coming forth to replace the old. However, the painting does show Turner's awareness of change and development in the early 19th century.

As in The Fighting 'Temeraire', Turner frequently juxtaposes steamboats with sailing vessels or historic surroundings. This theme appears most frequently in *Turner's Annual Tour, Wanderings by the Seine*, 1834. This became one of the first publications of its kind to depict this new form of travel, although steamboats had already started to appear in travel guidebooks of the late 1820s. As an individual who travelled constantly himself, Turner knew of the practicality and popularity of steamboats, making it inevitable that this subject is used widely in his work. SET

Egerton 1995.

Rodner 1997.

Hamilton 1998.

STEER, Philip Wilson (1860–1942), British landscape and occasional portrait and figure painter. He ranks as England's leading Impressionist landscape artist, especially in his early and individualistic beach scenes at Walberswick, Suffolk, and Boulogne. His later work became increasingly eclectic, and Turner was one of the artists who influenced him, especially in his fluent and sensitive watercolours. It has been suggested that some of Steer's later landscape compositions were inspired by plates from the *Liber Studiorum*. LH

Bruce Laughton, *Philip Wilson Steer*, 1971.

STOKES, Charles (1785–1853), a wealthy stockbroker, amateur geologist, lithographer, antiquary, and collector who advised Turner financially from the 1820s. The two became firm friends, perhaps introduced by *Chantrey, *Jones, or *Rogers. Stokes was a Fellow of the Society of Antiquaries (1811) and the *Royal Society (1821), and, from 1811, a Fellow, Secretary, and later Vice-President of the Geological Society. While he made his money in the City and on the Stock Exchange (member 1813–45), he spent it on the arts and sciences.

Stokes collected watercolours and Old Master prints widely, but Turner formed the core of his collection. He owned many *Southern Coast and *Loire watercolours and early works, but his collection of Turner prints was unique. In addition to touched proofs of the *Richmondshire and *England and Wales series, Stokes was the first comprehensive collector of *Liber Studiorum engravings, and compiled

its first catalogue. This distinguished between the different states, and aided *Thornbury and W. G. *Rawlinson.

Stokes had interests and social life which crossed easily between the arts and the sciences. He had a large collection of geological and natural history specimens, which he shared and exchanged, and he encouraged makers of scientific instruments. He wrote in *Archaeologia* (1816 and 1845), and encouraged *Hullmandel in the development of lithography. His defining article on this art appeared in the *Encyclopaedia Britannica* (Suppl. V, 1824). The state of his rooms reflected the nature of his interests, exhibiting 'a most picturesque confusion of learned wealth, literary, scientific and artistical'. He was a Director of the *Artists' General Benevolent Institution, 1823, and Auditor, 1824. An obituarist wrote: 'Careless of fame and brimful of benevolence, [Stokes] laboured incessantly, whenever a moment of leisure permitted, to advance science by every means that lay within his power.' JH

Luke Herrmann, 'Turner and Ruskin—A Riddle Resolved', *Burlington Magazine*, 112 (1970), pp. 696–9.

Gage 1980, p. 288.

Forrester 1996, Appendix B and *passim*.

Hamilton 1998, pp. 115–18, 126.

STOLEN WORKS, see LOST, STOLEN, AND DESTROYED WORKS.

STORER, James Sargant (1771–1853), English draughtsman, engraver and publisher. He engraved three of the first plates after Turner, published in *The Copper-Plate Magazine* in 1794 and 1795 (R 1, 2, 6). These attractive topographical views were reissued on a number of occasions, in 1798 as *The Itinerant*, in 1853, and again in 1873. Storer made both the drawings and engravings for a number of series of small topographical plates, and was also the publisher of some of these, mostly working with John Greig. Among these publications were *Select Views of London and its Environs* (1804–5) and *The Antiquarian and Topographical Cabinet*, which appeared in ten volumes with 500 plates between 1807 and 1811. Storer was the engraver of the 1810 *Oxford Almanack view of Balliol College for which Turner's original drawing had been rejected and altered by Hugh O'Neill (R 46). LH

STOTHARD, Thomas (1755–1834), the decorative *Neoclassical painter and illustrator, began his career in the circle of a number of artist friends including John *Flaxman, William Blake, George Romney and Henry *Fuseli. Other influences were the Old Masters, particularly Raphael and *Rubens. It is said that he used to have his hair cut by Turner's father.

By 1815 he was part of the circle around Samuel *Rogers when he was included in the engraving by C. Mottram of one of Rogers's celebrated breakfasts; other notables included were John Flaxman, Walter *Scott, Thomas *Moore, Sydney Smith, William *Wordsworth, Robert Southey, S. T. *Coleridge, Washington Irving, Lord *Byron, Thomas *Lawrence, Thomas *Campbell, and Turner himself. Soon after this he began a series of paintings on subjects derived from *Watteau beginning with *Sans Souci* (RA 1817; Tate Gallery); he had already exhibited a *Scene of Boccaccio's Tales* in 1811. Turner's response can be seen in such works as *What You Will!* (RA 1822; private collection; BJ 229), *Boccaccio relating the Tale of the Birdcage* (RA 1828; BJ 244), and, in a more personal manner, the interiors associated with *Petworth and East Cowes Castle (see NASH).

Rogers commissioned Stothard and Turner together to illustrate the de luxe editions of his *Italy, a Poem*, 1830, and his *Poems*, 1834. According to Rogers, 'I never had any difficulty with Stothard and Turner about the drawings for my works. They always readily assented to whatever alterations I proposed; and sometimes I even put a figure by Stothard into one of Turner's landscapes' (note to the Revd Alexander Dyce, Victoria and Albert Museum, London).

There is a famous anecdote of Stothard, by then nearly deaf, attending Turner's lectures as Professor of *Perspective: 'Sir, there is much to *see* at Turner's lectures—much that I delight in seeing, though I cannot hear him' (Redgrave 1866, 1947 edn. pp. 257–8). Stothard's admiration was reciprocated by Turner: 'If I thought [Stothard] liked my pictures as well as I like his, I should be satisfied. He is the Giotto [possibly a mistake for Watteau] of England', he remarked to C. R. *Leslie on one of the *Varnishing Days in 1828 (Leslie 1860, i. p. 130). MB

Gage 1969, pp. 92, 240 n. 62.

Whittingham 1985, pp. 7–9.

Gage 1987, pp. 143, 147.

Shelley M. Bennet, *Thomas Stothard*, 1988.

STOURHEAD. This famous house and landscape garden in Wiltshire was owned by Turner's early patron, Sir Richard Colt *Hoare (see also SALISBURY). The artist first visited Stourhead in 1795. Two unfinished watercolours (*c*.1797–8), one showing the medieval Bristol Cross (TB XLIV: e) and one looking towards the Temple of Flora and Stourton Church, both underplay the garden's *Claudian and classical qualities, focusing more on atmospheric effects. The latter (XLIV: g) is probably Turner's first attempt to depict the sun rising through mist (compare, as studies of dawn light, *Rembrandt's *Rest on the Flight into Egypt*, then owned by Colt Hoare, and the two images of *Norham Castle of *c*.1798). Very different is the later watercolour, *Rise of the River Stour at Stourhead* (?*c*.1817, RA 1825; W 496), which was painted as a companion to *Landscape:*

Composition of Tivoli (RA 1818; private collection; W 495). Here the effect is unequivocally Claudian and all three of Flitcroft's temples around the lake are shown. Arguably, Turner has portrayed Stourhead in this image as the original 'fountainhead' of his subsequent classical studies. AK

Gage 1974, p. 72.

STRATHMORE, Lord (1769–1820): John Bowes, tenth Earl of Strathmore. He appears to have been a friend or companion of Turner. In the autumn of 1817 when Turner was staying at *Raby Castle, collecting material for a picture of the castle commissioned by Lord Darlington, he travelled on to Co. Durham with Strathmore and painted two water-colours of *Gibside, County Durham, the Seat of the Earl of Strathmore* (Bowes Museum, Barnard Castle; both listed under W 557), for Robert Surtees's *History of Durham*, commissioned by Lord Strathmore. Strathmore's son, also named John, and who did not inherit the title, formed the Bowes Museum. RU

STUDIO, THE—'*The Genius of Turner*'. Published as a special winter number in 1903 by the *Studio* magazine for 5s. Its editor Charles Holme explained in the Preface that it was 'an attempt . . . to gather together from numerous sources a representative selection of the drawings, paintings, and en-gravings of J. M. W. Turner'. It included 124 plates, some in colour, and essays by Robert de la Sizeranne, 'The Oil Paintings of Turner'; Walter Shaw Sparrow, 'Turner's Monochrome and Early Watercolours' and 'The Later Watercolours'; and C. F. *Bell, 'Turner and his Engravers'. By 1903 Turner was firmly established in the critical mind as an 'English Old Master', along with *Reynolds, *Gains-borough, and *Constable. In the 1890s painters such as *Steer had imitated his style, and done much to reawaken enthusiasm for Turner. The *Studio* special number is evi-dence of Turner's status at this time. It is also interesting as one of the first publications to include colour illustrations of his work. RU

STYLISTIC DEVELOPMENT IN OILS AND WATER-COLOURS. In Turner this process is complex, ultimately producing distinctive originality through assimilation and synthesis of other artists and traditions, and from cross-fertilization between his practices in oil and water-based media. Style in Turner is increasingly a matter of *technique as well as form. While even in his mature work conventional origins of composition or *subject matter can be discerned, they are transformed by colouring and handling uniquely his own. Finally, while Turner developed highly original and recognizable characteristics, they are not all-pervasive in his work and it should be seen as showing a range of styles ac-cording to its subject and purpose.

Turner early demonstrated his mastery of an established style, and then his transformation of it, in his first career as a draughtsman and watercolourist. From Thomas *Malton he learnt the essentials of current architectural drawing—clear outline and bright, schematic tinting—and practised them in his first exhibited watercolour, *The *Archbishop's Palace, Lambeth* (RA 1790; Indianapolis Museum of Art; W 10). From this essentially descriptive method he proceeded to the more pictorial, animated, and technically sophisti-cated manner of the best contemporary topographers like *Dayes and Hearne. While necessarily full of detail—a re-quirement of the engravers and publishers for whom their views were often prepared—their work was also enlivened by figures and narrative, or by landscape, and they took their architectural subjects from viewpoints designed to enhance their scale or picturesque effect. By such sleights of hand, and by their technical methods—involving the laying-in of the first pencil outline with underpainting in grey or blue, and then building up the subject with brighter local colour—topographical watercolour had attained, by the 1790s, a distinctive 'house style' that was practised with only relatively subtle variations by its leading exponents. With *Girtin, Turner now produced many of its definitive state-ments, characterized by specially dramatic lighting and soaring perspectives—for example in interiors of *Ely Cath-edral* (?RA 1796 and 1797; private collection and Aberdeen Art Gallery; W 194, 195), before moving to broader, more painterly effects and atmospheric landscaping that signifi-cantly departed from current form. The process was driven by experience of the evocative landscape watercolours of J. R. *Cozens—and of other Old Masters and recent artists—that he shared with Girtin in the *Monro 'Acad-emy'; and, from the mid-1790s, by his experiments with oil.

Having mastered current watercolour practice, by the end of the decade Turner was asserting his individuality by rejecting it—in words as well as art. To *Farington in 1799 he 'reprobated the mechanically systematic approach of draw-ing . . . so generally diffused. He thinks it can produce noth-ing but manner and sameness' (*Diary*, 16 November 1799). Rather than spontaneous improvisation, this implied a more instinctive realization of Turner's pictorial concepts, liber-ated from conventional technical formulas and rooted in the performance of the medium itself. This remained his way, and now the result was a progressively more homogeneous watercolour style, rich and dense in tones which, as in oil, were raised from dark to light through harmonious grad-ations of a related palette, and distinguished by methods of Turner's own—which he exploited with exceptional daring—such as scratching or stopping out highlights. To-gether with the broad generalization of trees or skies that

these methods encouraged, his new manner was the opposite of that of the typical 'tinted' or 'stained' drawing. Expressed, by the turn of the century, on an increasingly grand scale, it proved the perfect vehicle for exhibition watercolours produced in response to the rising status of the medium as a rival to oil.

Turner's first exhibited oil, *Fishermen at Sea* (RA 1796; BJ 1), had owed both its subject and refined handling to Continental, mainly French painting, following technical advice taken from de *Loutherbourg. This was soon repudiated in favour of the more robust, painterly brushwork associated with Richard *Wilson. While this change of direction matched his broadening watercolour practices, it doubtless showed a nascent awareness of the messages and meanings to be conveyed through style; as the Revolutionary wars progressed, an indigenous model may have seemed preferable, while Wilson's expressive touch and underlying current of naturalism was better fitted to the movements of nature that he now wanted to address. Although Turner is said to have copied pictures in *Reynolds's studio before the artist's death in 1792, and may have picked up aspects of his practice from *Hoppner, Wilson proved his most consistent early exemplar as well as being the medium through whom he first approached the classical landscape of *Claude.

Wilson's evocative drawings in black chalk and stump—which Turner knew through Monro and the painter's pupil Farington, and of which he owned at least one example—were probably responsible for a brief but productive phase of monochrome drawing on a large scale after 1800, and for a wider appreciation of the potential of tone as opposed to realistic colour. In *Scotland in 1801 (see SCOTTISH PENCILS) and on an *Alpine tour the next year, he made large drawings in pencil, chalks, and—mainly white—*gouache on *paper prepared with a brownish tint; they spoke through mass and tone rather than outline, and left local colour—if not superfluous—to memory. In both cases these records of summer travels were doubtless intended as sample studies, bases for future commissions, but they must have played their part in developing Turner's faculties of memory and response to the landscapes he now saw on regular summer excursions. In future he relied mainly on smaller pencil or coloured sketches in his *sketchbooks, in which he developed ever more economical shorthands, and did not repeat the particular methods of 1801 and 1802; indeed it may seem paradoxical that the same artist who stimulated his own tonal memory by monochrome drawing in those years could be found in later decades spurring his engravers to tonal variety by gouache drawings of dazzling and varied colour.

The Alpine tour sharpened Turner's awareness of wild nature and of those emotional responses associated with the *Sublime. His finished oils and watercolours made on his return, together with drawings made as he travelled—which included coloured sheets as well as the monochromes—actually show a range of pictorial responses which are sometimes still conditioned by established formulas. He was at first rather thrown by landscape features he found 'broken' or 'bad for a painter', and did not consistently find a fresh voice to declare what he saw. While some—notably sheets drawn around Chamonix or in the *St Gotthard pass in his 'St Gothard and Mont Blanc' Sketchbook (TB LXXV)—abandon all conventional strategies in the thrill of instinctive response, other finished views arrange the mountain scenery according to the geometric rigour of *Poussin or with the Picturesque (see SUBLIME) love of varied form. A certain tension between Art and Nature shows him in transition, juggling the pressures of tradition with overwhelming personal impressions.

The Alpine tour was indeed a preliminary bonus of a visit to the Old Masters in the Louvre (see PARIS, MUSÉE DU LOUVRE) sponsored by his patrons, who valued the gifts for imaginative pastiche already demonstrated in paraphrases of *Van de Velde or Poussin. From 1803, Turner showed a series of grand pictures in the manner of leading Old Masters—Claude, *Titian, *Rembrandt, *Rosa—which uniquely claimed attention by their stylistic self-effacement; his art now became a history of art, as if he were single-handedly creating the national gallery his country—in conspicuous contrast to France—still lacked. Nevertheless, his own personality was evident in bolder colouring and vividly handled natural effects, for example the boiling foam of a rough sea. These striking effects, and a new tendency to luminous atmospherics achieved by subtle gradations in a high and clear tonal key, was observed as Turner's most distinctive feature by about 1805—both by admirers and critics led by Sir George *Beaumont who dubbed him a 'white painter'. Atmospheric abstraction would guide Turner's future development, but was now seen in English pastoral subjects like *Dorchester Mead* (Turner's gallery 1810; BJ 107). Intentionally distinct from the grander subjects shown at the Royal Academy, these were no less old masterly, echoing the vaporous glow of *Cuyp; meanwhile the *Country Blacksmith* (RA 1807; BJ 68) assimilated the new genre style of *Wilkie into rustic narrative in an early example of Turner's habit of acknowledging—whether in jest or evident jealousy—the styles of popular contemporaries as well as his predecessors.

The cooler tones and clarity of the English pastorals owed much to Turner's increasingly luminous handling of

watercolour. Contemporary studies of *Thames subjects made freely with the brush on white paper, for example in the 'Thames from Reading to Walton' Sketchbook (XCV), relate closely to oil sketches, also contemporary, made in thinly diluted paint over pale grounds. In all these Turner aimed at unaffected naturalism, in keeping with new trends in landscape, but other sketchbooks show him projecting classical structures and subjects on to Thames scenery in 'Studies for Pictures, Isleworth' Sketchbook (XC), while an exhibited oil, *Sketch of a Bank with Gypsies* (Turner's gallery 1808; BJ 82), must have appeared a textbook case of Picturesque clichés and of a current fashion promoted by its theorists like Payne *Knight for a self-conscious spontaneity.

If Turner was now displaying his skills both in compositions confected in the studio and in more faithful observation of nature, his *Liber Studiorum* was a celebration of the variety of landscape styles (in which he included marines) without imposing any priorities between them. His interpretations here were largely original, only the 'Pastoral' and 'Epic' or 'Elevated Pastoral' subjects being obviously reworkings of Picturesque or classical prototypes, but even these were transfigured by dynamic treatment of light.

Turner's most important early pictures had been couched in sombre tones, as if they were already matured Old Masters—though not sombre enough for Beaumont. As late as 1815 Turner could still paint *Crossing the Brook* (RA 1815; BJ 130)—which submitted English scenery to the ideal harmonies of Claude—in a palette condemned by Beaumont for its '*peagreen* insipidity', though he had sketched its *Devon landscape sources in bolder oils during the scorching summer of 1813. *Dido building Carthage* (RA 1815; BJ 131) recasts Claude in hues of burnished bronze, but these were a pictorial invention as much as the darker 'historical' colour of his earlier histories. It was not until his first Italian visit in 1819 that Turner dramatically brightened his colour in specific response to observed reality. The azure sky and clear air of *Italy lend verisimilitude to the otherwise very theatrical historicism of *Rome, from the Vatican* (RA 1820; BJ 228) and the Claudian mythology of The *Bay of Baiae* (RA 1823; BJ 230); and a higher colour key was soon applied to subjects north of the Alps, as in *Harbour of Dieppe* (RA 1825; Frick Collection, New York; BJ 231), a work whose very title seems to imply the transfer of a Mediterranean palette and composition, as if Claude had returned to paint his native France as a classic seaport.

Turner was far from outgrowing his dialogue with the Old Masters. A return to Italy in 1828 refreshed his interest in classical subjects and in Claude, whose characteristic compositional structures he now rehearsed in a set of oil sketches on a roll of canvas (see ROMAN SKETCHES); but his

interpretations were transformed by colour and atmosphere, so that familiar structures were diffused and refracted through light and by a fine, broken touch with the brush, as in the gauzy *Regulus* (Rome 1828, BI 1837; BJ 294) or the ethereal *Golden Bough* (RA 1834; BJ 355). In subjects such as the last there can be little doubt that Turner sensed the correlation between the mythical or magical theme and the metamorphoses now displayed in his style and technique— already striking contemporaries as wizardry—but similar processes of transformation were also seen in more literal subjects such as his *Venetian scenes, which began in the idiom of Canaletto before finding their own unique voice. Of *Bridge of Sighs, Ducal Palace and Custom-House, Venice: Canaletti painting* (RA 1833; BJ 349), the *Athenaeum* observed that it 'is more in his own style than he seems aware of; he imagines he has painted it in the Canaletti style; the style is his, and worth Canaletti's ten times over' (11 May 1833).

A major element in Turner's mature style is his use of expanded or multiple perspective, so that the classical rigour and logic of Poussin and Claude is exchanged for more complex journeys into pictorial space. Bernini's arcades and Raphael's loggie in *Rome, from the Vatican* clasp one in an impossible but irresistible embrace, while *Palestrina* (RA 1828; BJ 295) or *The Parting of Hero and Leander* (RA 1837; National Gallery, London; BJ 370) offer divergent vistas from their notional centre. With its high (and once higher) colour key, complex reconstruction of ancient architecture, juxtaposition of history and elemental fantasy, and surreally incandescent sky, *Hero and Leander* presents many key aspects of Turner's later style on an exhibition scale, while springing recognizably from the classical tradition; the right half of the composition even hints at the vortical swirl of sky, sea, and storm that had appeared in early marines like *Calais Pier* (RA 1803; BJ 48), and reached its climax in *Snow Storm—Steam-Boat off a Harbour's Mouth* (RA 1842; BJ 398).

The vortex is compressed into a circular or tunnel-like form in several pairs of late pictures painted on a new and unusual square format (see SIZE AND FORMATS)—for example *Undine giving the Ring to Massaniello* and *The *Angel standing in the Sun* (RA 1846; BJ 424, 425). These, together with other, sometimes initially puzzling pairings, exploited Turner's love of contrast, opposing themes of good and evil, past and present, progress and decay, and pictorial effects drawn from opposite ends of the spectrum; his now famously dazzling brilliance was confronted by its darker counterpart, just as the relative symmetry or stasis of his classical compositions now often yielded to uniquely dynamic principles of composition and execution. Some pictures seemed

almost designed to mystify, and were intentionally unlike anything else—almost self-consuming as figures, birds, ships, or buildings are sucked into a dizzying spin of light, mist, or wave. Turner's own style may be thought to appear here at its most evolved, but he did not always seek such extremes, his last exhibits being strictly classical compositions, retelling the story of Dido and Aeneas (RA 1850; BJ 429–32; see *ÆNEAS RELATING HIS STORY TO DIDO*); only in their ruddy colouring—actually closer to the brick-like palette of Poussin—and in their diffuse brushwork were they distinctly his own variations on Claude. Turner's style could now be defined only by its variety, and its tendency—as with his themes—to invite its opposite; or, as in the diagonal outward thrust of the train in *Rain, Steam, and Speed* (RA 1844; National Gallery, London; BJ 409), it throws up an entirely original solution to a new subject.

Turner's public art was enriched by the repertoire of motifs, effects, and techniques that he tried out in private oil sketches—for example the many beach and wave studies of the 1830s. They informed and liberated his work, to the extent that differences in method and in degree of pictorial resolution between 'finished' and 'unfinished' seem blurred, or, to the modern eye, superfluous in many later oils. The presence of so many private experiments and abandoned canvases, lay-ins, or studies in the Bequest—of a sort which, if made at all by other artists, have not survived or have lost their identity—has perhaps skewed mid-20th-century appreciations of Turner too much towards an instinctive, elemental genius struggling to break the mould of convention (see NEW YORK, MUSEUM OF MODERN ART), and it should be remembered that Turner himself never dropped the distinction between finished and unfinished works in his plans for his posthumous Gallery, while even at the end his exhibited pictures were brought to relatively higher finish or given explicit subject matter. Thus the technical fragmentation of the Dido and Aeneas set is not matched in their composition or narrative elements, which were, by 1850, positively old-fashioned. Even the technique was, in its own way, out of place now that the Pre-Raphaelites were setting the agenda with their realism and high finish. A retrospective, nostalgic inclination is in fact strongly felt in late Turner, not least in a set of canvases whose status is uncertain, the reworkings of *Liber Studiorum* subjects including *Norham Castle* (*c.*1845–50; BJ 512). While certainly not exhibited, they could have been intended to represent his late style at its most luminous and abstracted in his Gallery after his death, and were thus designed for posterity; alternatively they could have been lay-ins of the sort that he took to the Royal Academy for elaboration on *Varnishing Day*. Certainly, while seeming to test the limits of pictorial abstrac-

tion, they remain true to their essentially classical and Picturesque prototypes, thus containing within themselves the opposing poles of tradition and innovation that run throughout his work.

Of Turner's many oil *sketches and studies, only a few directly anticipate specific projects or pictures. His practice in watercolour was different, for since at least the first decade of the century he had laid out the masses or colour harmonies of certain finished watercolours in separate colour studies (see BEGINNINGS), while developing more fluid and transparent handling in separate sketches made directly with the brush. As with oil, variety is the key to understanding his development, and his work in water-based media had branched out into distinctive media and methods according to its purpose, gouache being used for its warmer, more solid properties and watercolour for spontaneity and transparency. Gouache appears particularly in intimate subjects, whether commissioned, as in a set of views of Farnley made for *Fawkes in 1817–18, or personal as in studies of *Petworth or of night scenes in Venice from the 1830s, but also quite freely to enhance the depth of finished topography such as Alpine subjects from 1802 and afterwards. It was often used on a coloured ground, sometimes prepared by Turner as in Italy in 1819 (for example in the leaves of the 'Roman Colour Studies' Sketchbook, CLXXXIX), or commercially available, as in the blue paper used at Petworth or for the views of French rivers. These last, built up with a fine brush dipped in jewel-bright colours into a densely textured mesh of detail, show a style as challenging as it was original. Just as his oils were now brilliantly coloured, so even these subjects intended for engraving in black and white were made in vivid hues to stimulate the engravers to expand their range of tone and flood their prints with shimmering lights. Here technique is again inseparable from the style Turner intended for the finished product, and in developing it he had moved far away from the artificial mannerism of earlier practitioners of gouache like Marco Ricci.

In watercolour also Turner had distanced himself from his early exemplars, exploring the limpid effects and capacity for immediacy he had discovered in his earlier Thames sketches. Combined with some additions of gouache, watercolour was used with a noticeably sketchy touch in the *Rhine views acquired by Fawkes from Turner's 1817 tour; though he sold them, these were markedly looser than earlier finished or commercial subjects. A further breakthrough in his use of pure watercolour came in Venice and *Naples in 1819, when, in parallel with his use of gouache on a grey ground in *Rome, he made sparkling watercolour studies on white paper; many were left unfinished, concentrating on certain key features of a view and suggesting private

communion broken off at the moment of highest rapture. Already evident here are the same sense of when to stop, the tendency towards abstract generalization and the gift for compression that made him, after 1826, the supreme exponent of the vignette. Watercolour was the appropriate vehicle for this open-edged form, dissolving as it should into the page, and Turner made it his own; but whereas the French river subjects were filled with a mass of intricate detail, his vignettes were built around a very few telling images whose symbolic meaning was often enhanced by effects of light or weather—a stormy sky echoing the earthly conflicts at *Carthage or Waterloo (see FIELD OF WATERLOO).

Turner's understanding of the properties of the medium, and his mastery of natural phenomena, combined to distinguish his finished watercolours. His development is best seen in a sequence of large topographical projects where he could display his technical and conceptual grasp over an extended range. The *Southern Coast, *Rivers, and *Ports of England, and finally Picturesque Views in *England and Wales present progressively richer and more detailed panoramas, and execution of unrivalled virtuosity. The breezy coasts and pastorals of the earlier series are realized in delicate stippling; in England and Wales this miniaturist's touch is combined with a broad overall grasp of the total design. The working process was, as noted by those privileged to watch it, swift and dynamic.

Light and colour and consequent effects of atmosphere are, as always, crucial to the impression made by these English subjects, and they are, appropriately, usually cool and naturalistic. In late Continental subjects, a hotter palette is often used, from which light shimmers with a theatrical sparkle. Turner's light now took many forms, white paper reflecting its diffused glow through pale washes or being left untouched in many Venetian watercolours of the early 1840s, or a harder glitter being raised from strong-toned washes by scraping out, or applied with dottings of white gouache. These last methods have affinities with oil painting, where the one-time 'white painter' now shamelessly scattered scumblings of white over his pictures, but the great outburst of watercolours in the 1840s, and their richly varied character, suggests that Turner's central concerns were now being explored on paper. In the case of the last *Swiss watercolours, the results did not always appeal, even loyal patrons being disturbed by their flamboyant handling, restless sense of flux, and atmospherics so overpowering that they obliterated even the most massive mountains. Though some were carefully prepared to commission from quite elaborate 'sample studies', they suggest a spontaneous and continuing process of evolution—no more resolved or predictable than the workings of nature itself. The 'falling-off' remarked by some was probably more the sense of unease that these watercolours can evoke as readily as Sublime rapture, but it is true that nowhere did Turner so completely reject accepted forms of composition, or form a style so uniquely his without reference to past or present. DBB

SUBJECT MATTER, importance for Turner. Since the late 1960s no area of Turner studies has been pursued more assiduously than that of his subject matter, but its importance was not always so unanimously accepted. Even in Turner's lifetime there were many commentators who were unsure about its status, especially in his later work. The word most commonly used to describe his exhibited oils in the 1830s and 1840s was 'gorgeous', implying that his use of colour was ravishing and that this was the main virtue of the works; his meanings, on the other hand, were widely perceived as opaque. The critic of the Art Union, for example, was both admiring and reproachful when he wrote in 1846 that Queen Mab's Cave (BI 1846; BJ 420) was produced 'in all the wantoness of gorgeous, bright and positive colour, not painted but apparently flung upon the canvas in kaleidoscopic confusion'.

The opinion that colour usurped the role of the subject in Turner's work was reiterated and strengthened in the century after his death by a series of influential writers and artists who viewed it not as a weakness but as a principal virtue of his art. They were led not only by their own interests and priorities but also by their knowledge of the unfinished works Turner was reluctant to show in his lifetime. To the *French Impressionists and their supporters he was a consummate painter of light and its effects; the Symbolist writers and artists who later assumed the mantle of the avant-garde described his paintings in opulent prose, the effect of which was often to dissociate Turner's visual splendours from the things he sought to represent; the Neo-Impressionist painter Paul *Signac even went so far as to declare that subject matter itself was discredited in works like *Norham Castle, Sunrise of 1845–50 (BJ 512).

These views must also be seen alongside the development of Modernist theory, which places an exceptional emphasis upon the formal qualities of a painting; subject, incident, and narrative are seen as the proper concern of literature. It also seeks to separate the artwork from its historical and cultural context—those things which render the subject meaningful in the first place. Although it was primarily a theory of modern art, the leading Modernist critic, Clement Greenberg, insisted that Modernist principles offered the best way to read any serious art and thus Turner was co-opted into the Modernist canon as an illustrious precursor. His development even seemed to parallel that of Modernist art

in general, as the pictorial illusions of his early work were superseded by the optical effects of his later output.

The epitome of the Modernist reading of Turner was the exhibition held at the Museum of Modern Art, *New York, in 1966. It attempted to forge connections between his art and that of the Abstract Expressionist painters—particularly Jackson Pollock—whose work was so well represented in the museum's permanent collection. Although its curator, Lawrence *Gowing, was a persuasive and elegant writer, his catalogue essay severed the form from the content of his work. It is ironic therefore that Robert Motherwell, one of the most astute of the Abstract Expressionists, took a broader view of 'content' and 'subject' and was moved by the 'tragic' dimension he found in Turner's paintings.

In the late 1960s Modernism lost ground to other forms of criticism that were more alert to the contexts and connotations of art. As a result the anachronistic image of Turner as a prototypical abstract painter began to change. A key text in this transformation was John Gage's *Colour in Turner*, published in 1969. Where Modernist writing had claimed autonomy for Turner's colour, Gage drew upon a huge range of sources to anchor it within the theory and culture of Turner's own lifetime. In his analyses of works like the *Goethe pictures of 1843 (BJ 404 and 405; see LIGHT AND COLOUR), Gage also demonstrated that questions of colour, subject, and meaning were inseparable.

As the number of studies attempting to place Turner in his own era multiplied, the significance of his subject matter reasserted itself. There are countless reasons why his subject matter continued to absorb him throughout his career: they include his training and education; his professional ambitions; his vision of landscape art as morally and intellectually challenging; his sense of his own place in the great tradition of European painting; his desire to represent as vividly as possible his experience of nature; the curiosity that led him to become a lifelong tourist. Turner was an intensely ambitious man, for although he was the son of a barber he aspired to the social and professional status once enjoyed by Sir Joshua *Reynolds, who became both a social and artistic exemplar. But Turner could only realize his ambitions if he took the precepts and principles of the *Royal Academy into account, among them the unpalatable idea that the subject made the picture. In Academic discourse the various genres of painting were arranged in a hierarchy within which landscape occupied a lowly place beneath history painting and portraiture. It was believed that the 'higher genres' taxed the intellect of both painter and spectator more than landscape art, which was seen as largely a matter of recording natural appearances. Although Turner could not afford to ignore these ideas, neither could he

accept them since they were bound to place a ceiling on his ambitions.

In order to attract the attention of his peers Turner had to distinguish himself from the topographical and architectural watercolourists whose subject matter was determined primarily by commercial, antiquarian, or parochial interests. Watercolour in general was not a medium from which grand statements were expected and, although he made occasional forays into large-scale historical watercolours like *The Battle of Fort Rock*, *Val d'Aouste, Piedmont, 1796* (RA 1815; TB LXXX: G; W 399), Turner's favoured strategy was often to introduce complex meanings into the watercolours he made for publication. *Northampton, Northamptonshire* (1830–1; private collection, UK; W 881) is an example drawn from his *Picturesque Views in *England and Wales*. It contains unmistakable topical references to the unopposed re-election of the Whig peer Lord Althorp, a strong advocate of electoral *reform, an issue with which Turner apparently sympathized. He knew, however, that the arena within which he would gain professional recognition was the annual exhibition at the Royal Academy. His choice of themes between 1796 and 1802 was a calculated and vivid demonstration of his skill, versatility, and lofty ambition. The exhibited oils of these years ranged widely in subjects and effects from the *Fishermen at Sea* of 1796 (BJ 1), simultaneously a night scene and seapiece, to such large historical landscapes as *The Fifth *Plague of Egypt* of 1800 (Indianapolis Museum of Art; BJ 13), whose elevated theme was designed to impress the RA.

Turner's exhibition strategy was successful: he was elected an Associate of the RA in November 1799 and a full member less than three years later. But he did not cease to reflect on the status of landscape, nor to campaign for its parity with history painting. One of the instruments by which Turner sought to achieve this was his *Liber Studiorum*, a series of engravings which was advertised as a 'classification of the various styles of landscape'. The implications of the series for the rest of Turner's output are more profound than this suggests, for although the images are broadly classified according to their subject as 'sub-genres' of landscape art, the manner of their presentation implies that no one category is intrinsically more valuable than another: each is capable of a range of profound meanings.

Within the RA there were few guidelines for ambitious landscape painters who were anxious to challenge the received view of their genre, but Turner learnt a great deal from the writings and portraits of Sir Joshua Reynolds, one of the least dogmatic advocates of the hierarchy of subjects. Reynolds's own forte was portraiture rather than history painting, but in his practice he sought to ennoble his

portraits through a range of literary and pictorial allusions more typical of historical work. The success of his *Garrick between Tragedy and Comedy* (1762; National Trust, Waddesdon Manor, England; repr. Ellis Waterhouse, *Reynolds*, 1973 pl. 31) depends to a great extent upon the associations it invokes in the mind of the spectator with the 'gentle' art of Correggio (Comedy) and the 'serious' Guido *Reni (Tragedy), as well as to the literary theme of the 'Choice of Hercules'. Turner learnt from Reynolds that the association of ideas, if used in his landscape art, might help to undermine the rigid hierarchy of subjects. Like his contemporary, *Constable, he also realized that even the most unpromising subject could be rich in associations.

Turner received more acclaim from the RA for his historical landscapes than for his 'humbler' productions, but he demonstrated time and again that intellectual and moral seriousness were not confined to the grand narrative subjects. In paintings like *Pope's Villa at Twickenham* (Turner's gallery 1808; Trustees of the Walter Morrison Picture Settlement; BJ 72), he transforms a contemporary domestic landscape into a meditation upon the transience of fame, symbolized by the destruction of the poet's house at the command of Countess Howe. A marine subject like the *Fishermen upon a Lee-Shore, in Squally Weather* (RA 1802; Southampton Art Gallery; BJ 16), presents an example of heroic fortitude comparable to those of classical history. As the critic of the *Monthly Mirror* put it, 'We wish to feel it for men, whose necessary and daily occupations of livelihood expose life to such imminent peril.'

Following the advice given in Reynolds's *Discourses*, Turner also alluded to the work of his most celebrated predecessors. Reynolds offered the Old Masters not merely as arbiters of sound taste but also as a means of declaring one's own ambitions. Turner's *Venus and Adonis* (1803–5; private collection, South America; BJ 150) and *Holy Family* (RA 1803; BJ 49), two examples of his early figure paintings, are both unmistakably redolent of compositions by *Titian. *Claude is invoked in the *Festival upon the Opening of the Vintage of Macon* (RA 1803, Sheffield City Art Galleries; BJ 47), where his pictorial qualities are used to signify nature's abundance in a satisfying fusion of style and subject matter. *The Deluge* (?Turner's gallery 1805; BJ 55) invited explicit comparison with one of *Poussin's most celebrated subjects. Turner's originality lay in drawing on the shipwreck imagery of his day to offer an object lesson in the treatment of this *Sublime subject. In none of these cases was the artist mentioned directly, but critics were quick to make the appropriate associations and generally understood that the style or pictorial scheme fitted the subject matter. It was only later, as an older man with an established reputation, that

Turner began to address the past Masters by name, representing episodes from their lives in a series of paintings that will be considered below.

In the first fifteen years of the 19th century, Turner's subject matter was partly determined by the war with *Napoleon. On the one hand he was moved to treat subjects either of patriotic significance or on themes related to the fate of empires; on the other hand he was largely unable to tour abroad and this inevitably limited the range of his subjects. Like many other British artists, he did visit *France and *Switzerland in 1802 during the Peace of Amiens. He may have suspected that the fragile truce would not hold because for all its brevity the tour produced a number of important paintings like *Calais Pier* (National Gallery, London; BJ 48), the *Macon* picture, two oils of *Bonneville* (Yale Center for British Art, New Haven, and Dallas Museum, Texas; BJ 46, 50), all exhibited in 1803, and a number of Sublime *Alpine watercolours. When hostilities resumed he returned from time to time to the sketches he made in 1802 and painted a Swiss subject for exhibition, but the bulk of his work necessarily consisted of domestic landscapes and coastal scenes like *Sun rising through Vapour* (RA 1807; National Gallery, London; BJ 69) and the prosaically titled *Ploughing up Turnips, near Slough* (Turner's gallery 1809; BJ 89). In the context of the Napoleonic blockade and the threat of invasion, these seemingly unambitious subjects might carry strong patriotic sentiments, as did those Turner contributed to W. B. *Cooke's *Picturesque Views of the *Southern Coast of England*. At other times his use of domestic scenery was highly enterprising: the Claudian format and aerial effects of *Crossing the Brook* (RA 1815; BJ 130) beguiled some critics into thinking that Turner's transformation of *Devon scenery was an Italian subject.

It is also notable that the war years were those in which he embarked on a series of genre paintings which included *A *Country Blacksmith disputing upon the Price of Iron* (RA 1807; BJ 68). They permitted Turner to test his command of a genre that was dominated by his rival David *Wilkie. Unfortunately they received scant praise and he was not tempted to return to them in his later career. In the 1810s Turner also created some of his weightiest images, embodying sentiments and ideas that seemed beyond the reach of the history painters of his acquaintance. A number of them are topical, referring directly or indirectly to the *Napoleonic wars. *Snow Storm: Hannibal and his Army crossing the Alps* (RA 1812; BJ 126) implies a parallel between the thwarted ambitions of Hannibal and those still held by Napoleon. The two paintings representing the rise and decline of the Carthaginian Empire exhibited in 1815 and 1817 respectively (see DIDO BUILDING CARTHAGE and CARTHAGE;

BJ 131, 135), are the first of a series of pendants that take as their theme the fortunes of whole empires and cultures. But perhaps one of the most deeply felt oil paintings to emerge from the Napoleonic years is The *Field of Waterloo (RA 1818; BJ 138), a subject that Turner felt called for one of his largest canvases, but which received a very mixed press when shown in 1818. Those who expected an exercise in jingoism were disappointed since Turner depicted, in the words of the radical journal the *Examiner*, the 'carnage after the battle when the wives and brothers and sons of the slain come . . . to look at Ambition's charnel-house'. Unlike the Carthage pictures, which were the outcome of his prodigious reading and imagination, The Field of Waterloo required detailed topographical knowledge. In 1817 Turner travelled abroad for the second time, visiting Belgium, *Holland, and the *Rhine, collecting material not only for his Waterloo picture but also for the exquisite series of watercolours bought by Walter *Fawkes. For the remainder of his career Turner's European travels would provide the subjects of some of his admired works, from the *Rivers of France to the great series of *Venetian oils that began in 1833.

It is beyond the scope of a brief essay to consider the full range of Turner's Continental themes, but particular mention should be made of the paintings he produced as a result of his two *Italian visits of 1819–20 and 1828–9, for on these occasions he was compelled to respond to many of the greatest monuments of Classical and Renaissance culture. In The *Bay of Baiae, with Apollo and the Sibyl (RA 1823; BJ 230) he used his knowledge of *Naples and its coastline to create a historical landscape with the connotations of a *vanitas* picture. As John *Ruskin explained, the Cumaean Sibyl, who was condemned to eternal life without eternal youth, personified 'the ruined beauty of Italy'. The impulse to juxtapose the greatest achievements of the Italian past with a sorry present is also to be found in *Rome, from the Vatican. Raffaelle, accompanied by La Fornarina, preparing his Pictures for the Decoration of the Loggia (RA 1820; BJ 228). In this extraordinary work Raphael is pictured not in High Renaissance Rome, but to all appearances in the *Rome which Turner had recently visited. The work celebrates Raphael's achievements as a painter and architect, but a stone figure to his left that seems to represent the River Tiber is gesturing dismissively towards the modern city, while two infants who may be Romulus and Remus fall from his lap. This sad contrast of past and present is clearer still in the pendants Modern Rome—Campo Vaccino (Earl of Rosebery; BJ 379) and *Ancient Rome. Agrippina landing with the Ashes of Germanicus (BJ 378) shown together at the RA in 1839.

Rome, from the Vatican is also one of the 'pictures about painters' alluded to earlier, which became increasingly important in Turner's later career and invariably contain an autobiographical dimension. He was certainly not alone in this: his most celebrated Continental counterpart was Ingres, whose devotion to Raphael led him to produce a number of images of the artist. But on the evidence of his Apotheosis of Homer (1827; Louvre, Paris) Ingres seems to have felt that truly great art ceased with the death of *Poussin. Turner's sympathies were much broader and so were the meanings he attached to the lives and works of his great predecessors. They included, besides those already mentioned, *Watteau, *Van Dyck, *Canaletto, Giovanni Bellini, and even his friend and rival, Sir David Wilkie. Such works are never solely to do with his forebears: they reflect Turner's concern for his own position in the canon of great European painting, at a stage in his life when he was acutely conscious of his own mortality. These themes of mortality and the judgements of posterity are entwined in *Peace—Burial at Sea (RA 1842; BJ 399), his tribute to David Wilkie, who died on his way home from the Middle East. One of his first two exhibited oil paintings on a Venetian theme, *Bridge of Sighs, Ducal Palace and Custom-House, Venice: Canaletti painting (RA 1833; BJ 349), was a risky and astonishing act of hubris, in which he seems both to identify and to invite comparison with Canaletto. The remainder of his 1833 exhibit at the RA consisted of marine pictures, among them Van Goyen, looking out for a Subject (Frick Collection, New York; BJ 350). In this case we are meant to understand that Turner's seapieces, like those of Van Goyen, were based on authentic, first-hand research. On a number of occasions he even dramatized instances when such research proved perilous. In different ways Calais Pier, *Staffa, Fingal's Cave (RA 1832, Yale Center for British Art, New Haven; BJ 347), and *Snow Storm—Steam-Boat off a Harbour's Mouth (RA 1842; BJ 398) are all purportedly based on specific, life-threatening events.

With its minimal imagery the Snow Storm in particular might seem to imply that the importance of his subject matter diminished as he got older. On the contrary, the extraordinary length of its full title—Snow Storm—Steam-Boat off a Harbour's Mouth making Signals in Shallow Water and going by the Lead. The Author was in this Storm on the Night the Ariel left Harwich—is a sign both of his concern that his contemporaries should understand the picture and of his fear that they will not. It is both a title and an explanation, whose details suggest the desperate plight of a 200-ton coastal steamer without the power to prevent itself being driven ashore.

In works like this the subject retains its importance but it becomes more difficult to read. Much of the painting may be devoid of detail but that which remains is heavily charged with significance. It is a tactic that placed great demands upon his contemporaries, for whom this approach to composition and narrative was virtually unprecedented. From time to time it provoked an angry response, as in the case of *Pilate washing his Hands* of 1830 (BJ 332) which was described as 'wretched and abortive'. The subject itself is unremarkable, one of a handful of biblical figure paintings by Turner; what seems to have created difficulties was the invisibility of Pilate in the chaos of gaudily clad bodies. Turner has deliberately ignored (or perhaps inverted) the Academic precept which required the principal figures in any painting to occupy a prominent position. Instead the audience is left to make sense of the subject for itself.

This may not be a great hardship for a 20th-century viewer used to reading the visual clues in Cubist paintings, but few among Turner's contemporaries were primed to read his pictures in this way. Thus one of his very greatest pictures, *Slavers throwing overboard the Dead and Dying—Typhon coming on* (Museum of Fine Arts, Boston; BJ 385), was badly received when first shown in 1840. The painting, in its theme and overall power, bears comparison with Géricault's earlier and much larger *Raft of the Medusa* (1819; Louvre, Paris). Ruskin, who owned it until the subject became unbearable to him, wrote 'if I were reduced to rest Turner's immortality upon any single work, I should choose this.' In its vigorous denunciation of slavery it now seems to epitomize what Ruskin described as Turner's 'Shakespearian' qualities, but contemporary critics found it ludicrous. The object of their ridicule was not so much his colour and effect, which *Thackeray thought 'the most tremendous . . . that ever was seen', but the local details such as the manacled leg of a drowning slave who is set upon by a shoal of fish. The writers who considered this ill-judged and risible were apparently incapable of grasping the significance of the chains as a metonym for slavery itself.

The incomprehension which greeted Turner's later subjects is not solely due to his unconventional or sparing use of detail: he could also be prodigal in the way he used the association of ideas. In many cases his contemporaries were incapable of making the mental leaps he expected of them. Even today there is no convincing explanation of a work like *The *Angel standing in the Sun* (BJ 425). It is not surprising therefore that when it was first shown in 1846 it defeated even Ruskin, for whom it signified the artist's mental debility. Turner's dense and difficult imagery extends far beyond the quotation from the Book of Revelation upon which the painting is ostensibly based, to embrace various Old Testament stories whose relevance to the main theme is far from clear. Turner was simply over-optimistic in assuming that his audience could follow the train of his associations; with his prodigious memory and unsystematic, self-acquired learning, his was hardly a typical mind.

It is paradoxical that the importance of subject matter to Turner has been compellingly established by a recent study of works which seem at first sight to present little or no subject matter at all: the watercolours grouped together by A. J. *Finberg as Colour *Beginnings. Although many of these present only cursory references to the external world, Eric Shanes has argued that they were not just autonomous exercises in colour and form, but shorthand preparations for subjects Turner had in mind; a stage in the production of an image that would later be more fully elaborated. Some writers, like Ronald Paulson, had previously argued that Turner's subjects compromised what were essentially abstract images. Shanes's research, on the other hand, has demonstrated that there are often close correspondences between the meagre detail of the Colour Beginnings and pre-existing pencil sketches whose subject matter is clearly discernible. It is a strong argument supporting the integrity of form and content in Turner's art.

See also BIBLICAL SUBJECTS; COMPETITION; HISTORICAL SUBJECTS; IDEALISM; TRIBUTES. BV

SUBLIME, Beautiful, and Picturesque, The. In the course of Turner's lifetime these categories came to be grouped together, since they all bear on the ways in which we perceive natural phenomena and render them as art. But they are not coeval. The Sublime had been in use as a category of literary style since Roman times, and began to be analysed in the early years of the 18th century, by Joseph Addison in the *Spectator*, 1712, and by a succession of philosophers such as Hutchinson, Burke, and Kames. These accounts lay emphasis on the power of literature to evoke the grandeur of God, and to exalt the human spirit to levels of awareness above its usual functions. Edmund Burke coupled the Sublime with the Beautiful in his *Philosophical Enquiry into the Origin of our Ideas of the Sublime and Beautiful* (1757). This was conceived in the tradition of John Locke's *Essay Concerning Human Understanding* (1690) as a study in epistemology. Burke argued that our apprehension of external phenomena relates to elemental human responses. Our definition of what is beautiful ultimately refers to what we find sexually attractive; similarly, the Sublime arises from 'whatever is fitted in any sort to excite ideas of pain or danger'. Love and Death, therefore, are at the root of our notions of Beauty and Sublimity. Nature may appeal to either of these instinctual

notions according to whether it is gentle and reassuring, or vast and dangerous.

Before the 18th century the landscape Sublime had been ignored or at least avoided if possible. Now there emerged a new capacity to extract pleasure from wildness and the presence of life-threatening forces. Art provided models. Gray exclaimed on crossing the *Alps in 1739: 'Precipices, mountains, torrents, wolves, rumblings, Salvator *Rosa'. The linking of landscape painting with the appreciation of real landscape assumed great importance. As early as 1719, the Abbé du Bos had associated the term 'pittoresque' with the pleasing arrangement of natural elements in a picture; the idea was further developed when the Revd William *Gilpin published his theories of the Picturesque (originally formulated in the 1740s while visiting the gardens at Stowe) in a series of works beginning with an *Essay on Picturesque Beauty*, drafted about 1776. What is Picturesque, he maintained, is 'that particular quality, which makes objects chiefly pleasing in painting'. Here neither the regular smoothness of the Beautiful was needed, nor the 'hideous rudeness' of the Sublime, but variety, broken textures, and asymmetry, suitably balanced. The landscape paintings and drawings of Thomas *Gainsborough exemplify the practice, derived from this, of assembling natural elements in different permutations to create harmonious compositions. Nature itself required modification in the interests of aesthetics; hence the genesis, and prime relevance, of Gilpin's theories in the field of landscape gardening. Several writers and garden designers contributed to this debate, notably Uvedale Price, Richard Payne *Knight, and Humphrey Repton. A later manifestation of the Sublime, following the aesthetic theories of Kant and building on the writings of Emerson, was Transcendentalism, which in the landscape paintings of mid-19th-century America was to take much of its inspiration from Turner. AW

Wilton 1980.

Morton D. Paley, *The Apocalyptic Sublime*, 1986, pp. 101–21.

Nigel Everett, *The Tory View of Landscape*, 1994.

'SUN IS GOD, THE'. Aphorism supposedly uttered by Turner 'a few weeks before he died', according to *Ruskin (*Works*, xxii. p. 490). If stated, then Turner may have been speaking metaphorically, given his familiarity with a large body of poetry that linked the sun to God (as in *Thomson's 'Soul of surrounding worlds! In whom best seen | Shines out thy maker!': 'Summer', 95–6). But Ruskin emphasized that Turner was speaking literally, being 'a sun-worshipper of the old breed', and that Apollo was genuinely God for him. The artist definitely made a number of representations of the sun-god, most notably in *Apollo and Python*

(BJ 115) and *Chryses* (W 492), both exhibited RA 1811. He may also have linked the sun to Jehovah in late paintings such as The *Angel standing in the Sun* (RA 1846; BJ 425).

Turner was familiar with writings by Alexander Dow and Sir William Jones in which sun-worship was linked to Hinduism. He also knew Richard Payne *Knight's connection of the sun with the generative powers of Priapus (see Gage 1989). The painter may equally have sympathized with Pantheism in the early 1820s, when he referred to the legal trial of a Pantheist and Deist in a print inscription (see POLITICS). Pantheism would certainly have permitted a genuine belief in the sun as God.

A recent suggestion (Hamilton) that Turner said 'The Son is God' seems unconvincing, given the artist's evident lack of interest in Christianity. ES

John Gage, 'J. M. W. Turner and Solar Myth', in J. B. Bullen, ed., *The Sun is God*, 1989, pp. 39–48.

Shanes 1990, pp. 275 ff.

Hamilton 1997, p. 310.

SUN OF VENICE GOING TO SEA, THE, oil on canvas, 24¼ × 36¼ in. (61.5 × 92 cm.), RA 1843 (129); Tate Gallery, London (BJ 402). One of the best-known of Turner's late *Venetian pictures in his standard 2 × 3 ft. (61 × 91.4 cm.) *size. Turner's pessimistic view of Venice is shown in his quotation from his *Fallacies of Hope* (see POETRY AND TURNER), in part based on Thomas Gray's 'The Bard':

> Fair Shines the morn, and soft the zephyrs blow,
> Venezia's fisher spreads his painted sail so gay,
> Nor heeds the demon that in grim repose
> Expects his evening prey.

This was one of *Ruskin's favourite pictures. His diary, 29 April 1844, records a visit to Turner during which he told the artist this and that 'the worst of his pictures was one could never see enough of them'. 'That's part of their quality,' said Turner. The critics in 1843 were somewhat less enthusiastic, perhaps being put off by the verses: 'His style of dealing with quotations is as unscrupulous as his style of treating nature and her attributes of form and colour' (*Athenaeum*, 17 June). The *Art Union*, June 1843, attacked Turner's 'wretched verses' and went on: 'The most celebrated painters have been said to be "before their time", but the world has always, at some time, or other, come up with them. The author of the "Sun of Venice" is far out of sight; he leaves the world to turn round without him . . . such extravagances all sensible people must condemn.' MB

SUN RISING THROUGH VAPOUR; FISHERMEN CLEANING AND SELLING FISH, oil on canvas, 53 ×

70½ in. (134.5 × 179 cm.), RA 1807 (162); National Gallery, London (BJ 69); see Pl. 4. This large, poetic coast scene was offered for sale to Sir John *Leicester in a letter of 12 December 1810 after it had been exhibited for a second time at the BI in 1809 and in Turner's own gallery in 1810, but the sale did not actually take place until 1818; the picture was then exhibited in Leicester's gallery in 1819, after it had been cleaned by W. R. Bigg, perhaps as one of a group of Turner's early pictures that, according to John *Constable, was sent to Bigg 'in a most miserable state of filth' (letter to C. R. *Leslie, 17 January 1832). Turner, writing to Leicester in 1818, described the picture as 'Dutch Boats and Fish Market—Sun Rising thro' Vapour—but if you think dispelling the Morning Haze or Mist better pray so name it', thus emphasizing Turner's interest in the *Claudian atmospheric effects. As in the *Country Blacksmith (RA 1807; BJ 68) the figures reflect the influence of *Teniers and the colour, in this case the red cap of the seated fisherman on the right, seems to have been heightened by Turner deliberately to eclipse *Wilkie's Blind Fiddler, also exhibited in 1807.

Both Richard *Westall and Benjamin *West thought the picture showed a decline in Turner's powers but the newspaper reviews were favourable: 'The general effect . . . is soft, harmonious, and beautiful . . . it has a great deal of very excellent colour' (Cabinet or Monthly Report of Polite Literature, February–June) and 'This picture is without doubt one of the very best Mr. Turner has ever produced' (St James's Chronicle, 9–12 May). The picture was also mentioned in the French publication Magazin encyclopédique for 1807, an early example of a foreign notice of Turner's work.

The picture was bought by Leicester for 350 guineas and bought back by Turner at his sale in 1827 for 490 guineas. In 1831, in his second *will, Turner substituted this picture for The Decline of the Carthaginian Empire (RA 1817; BJ 135) as one of the two works bequeathed to the National Gallery to hang next to pictures by Claude. Later, in the 1840s, Elhanan *Bicknell is reputed to have offered £1,600 for the picture (Bicknell and Guiterman 1987, p. 38).

There is a related sketch inscribed 'Study Calm' and other drawings in the 'Calais Pier' Sketchbook (TB LXXI: 24, 26, 34, 40). Another painting known as The Sun rising through Vapour, probably exhibited in Turner's own gallery in 1809 and sold to Walter *Fawkes, is now in the Barber Institute of Fine Arts, University of Birmingham (BJ 95). The painting also shows shipping and figures preparing fish on the shore but the composition is otherwise different. The much later Fish-Market on the Sands—the Sun rising through a Vapour (RA 1830; destroyed 1956; BJ 335) was similar in mood though with the main elements of the composition reversed. MB

Whittingham 1986, pp. 27–9.
Shanes 1990, pp. 250, 316, 328, repr. in colour, pl. 212.
Egerton 1998, pp. 266–71, repr. in colour.

SUPPORTS, INCLUDING PRIMINGS. The majority of Turner's paintings are on canvas, but a significant minority are not. The supports seem not to have been chosen in relation to the type of image, its intended purchaser, or the size of the work. Turner's father acted as his studio assistant, and must have seen to the supply and preparation of supports. Thornbury quotes Trimmer, who gave descriptions of Turner's methods well borne out by analysis, as saying, 'The old man latterly was his son's willing slave, and had to strain his pictures' (Thornbury 1877, p. 116). During the father's long lifetime, a greater proportion of Turner's paintings are on unusual canvases, reused panels, and muslin stretched over millboard. Afterwards, most were on preprimed canvases from a single supplier, in a narrow range of sizes that were not the standard ones for the time, and must have been specially ordered.

Crack patterns in the paint surface reveal the form of the stretcher when the front is examined in somewhat raking light. Turner's earliest paintings had typical 18th-century stretchers, with diagonal corner bracing. Very large early paintings have a support of loosely woven hessian, since the Turners could not find—or would not pay for, since 18th-century artists had managed to find supplies—canvases wide enough for the purpose. The later purchased canvases had typical 19th-century stretchers, with vertical and then horizontal cross-members added to strengthen the largest ones, only a few of which have survived. A few paintings are on well-seasoned, thick hardwood panels of the type used by other mid-century British artists, and more are on reused, cut-down panels, the survivors of which figured as 'lumber' in the inventory of Turner's house.

All Turner's primings were somewhat absorbent, which allowed his paint to dry fast. About a quarter of the paintings from his father's lifetime have a priming of lead white and whole egg, heavily and unevenly brushed, and presumably applied by him. The others were purchased preprimed with lead white and linseed drying oil. (Preprimed canvases have priming on the margins where the canvas is fastened to the sides of the stretcher.)

Virtually all the primings are white, with lead white, chalk and fillers as the only pigments. Early paintings prior to 1802 tend to have warm red grounds of Mars red. None of the oils has a cool ground. This is found only for *gouaches, where Turner used a blue English-made paper, particularly in the 1820s for many works depicting towns on the Loire (Warrell 1997, appendix B in collaboration with Peter Bower, p. 238).

He had experimented in earlier decades with warm brown or cool grey washes on paper, and one sketchbook of 1801 includes green-washed paper bound into it (the 'Tummel Bridge' Sketchbook, TB LVII), but the majority of watercolours are also on 'white' paper. It can be difficult today to judge how white the paper may have been originally, since exposure to light causes paper to yellow severely, while drastic bleaching treatments (which would not be recommended by the trained conservator) can leave it whiter than it was when new. Turner very rarely used prepared paper with a priming. He generally used well-sized paper because it could better withstand vigorous brushing, rubbing, and scratching while the paper was wet and therefore weak (Bower 1990, p. 13). Almost invariably, he used wove papers, which have a smoother texture than the more traditional laid papers. See also BOARDS AND MILLBOARDS; CANVAS; PAPERS; TECHNIQUES. JHT

J. H. Townsend, 'The Materials of J. M. W. Turner: Primings and Supports', *Studies in Conservation*, 39 (1994), pp. 145–53.

SUSSEX, a southern English county, was the residence of important landed patrons of Turner (see EGREMONT, LORD; PETWORTH; FULLER, JACK) and was also rich in historical and contemporary associations. Thus the untraced watercolour *Battle Abbey—the Spot where Harold Fell* (c.1816; W 423), made for Jack Fuller and engraved in *Views in *Sussex*, alludes to the defeat of the Saxons by the invading Normans at the Battle of Hastings, while *Winchelsea, Sussex, and the Military Canal* (c.1813, possibly intended for *Views at Hastings*, the abortive sequel to *Views in Sussex*; untraced; W 430) shows the road and canal systems which were being constructed as part of the network of defences against the *Napoleonic invader when Turner visited the locality between 1805 and 1807. Soldiers, and the new artillery forts known as Martello towers, appropriately figure in this and in a number of other depictions of the Sussex coast, including *Martello Towers near Bexhill*, a subject engraved for both the *Liber Studiorum* and *Picturesque Views of the *Southern Coast of England* (F 34, 1811, and R 103, 1817). Turner also depicted the town of Hastings several times. The oil *Hastings—Fishmarket on the Sands* (Turner's gallery 1810; Nelson Gallery and Atkins Museum, Kansas City; BJ 105), which was bought by Jack Fuller, is based on 17th-century Dutch beach scenes and follows Joshua Cristall's watercolour of 1808 in excluding evidence of the modern resort. The cliff scenery which made the town more picturesque than *Brighton is seen in *Hastings from the Sea* (British Museum; W 504), 1818, made for *Views at Hastings*. AK

Shanes 1981, pp. 5–6, 8–10, 13–15, 18–21, 27, 32, 39, 42, 46, 152, 155.

Herrmann 1990, pp. 90–4.
Shanes 1990², pp. 10, 22–36, 263.
Hemingway 1992, pp. 171–8.

SUSSEX, VIEWS IN. Group of five watercolours and six line-engravings dating from the 1810s. In 1810 Jack *Fuller, the MP for East Sussex, had hired from Turner four watercolour views (W 432–5) of his own and neighbouring East Sussex properties in order to have them reproduced by J. C. *Stadler as coloured aquatints (R 822–5); subsequently he purchased them. In 1815 he agreed to finance the reproduction by W. B. *Cooke of some of the further watercolours depicting Sussex scenery he had more recently bought from Turner. Four of the prints (R 129–30, 132–3) were ready by 1816 but not until 1820 were they joined by two others and collectively published under the title *Views in Sussex*. One of the further engravings was an emblematic frontispiece that was probably drawn by Turner straight onto the etching plate (R 128). Originally John *Murray had agreed to publish the *Views in Sussex*, but because of W. B. Cooke's tardiness in producing the *Southern Coast* prints he withdrew his support of the engraver in 1819. Cooke then unsuccessfully attempted to market the *Views in Sussex* prints himself.

A sequel to the *Views in Sussex* had originally been planned. This was to be entitled *Views at Hastings and its Vicinity*, and Turner made some six or seven drawings for the project (W 428–31, 438–9, 504). However, the market failure of the *Views in Sussex* prevented the appearance of the *Views at Hastings* and three engravings intended for the latter scheme were begun but abandoned (R 134–6). One of them reproduced a drawing of *Winchelsea* (W 430) that had obviously been diverted by Cooke from the *Southern Coast* series.

Like the four 1810 drawings, all the *Views in Sussex* and *Views at Hastings* watercolours average 15 × 22 in. (38.1 × 55.8 cm.), with the exception of the much smaller Winchelsea view, whose dimensions correspond to those of the *Southern Coast* designs. Stylistically the watercolours demonstrate Turner's arrival at full artistic maturity between 1810 and 1820, for whereas the 1810 drawings are still slightly mannered (as can especially be observed in the renderings of their tree and cloud forms), by 1816 the idealization contemporaneously encountered elsewhere in Turner's art is now very much in evidence. As was becoming fairly common in the *Southern Coast* series during the same period, three of the images—the two views of Battle Abbey (W 435, 423) and the 1816 Vale of Ashburnham design (W 425)—are imbued with ingeniously subtle allusions, respectively to historical and economic aspects of the places represented. ES

Shanes 1981, pp. 5, 8–10, 13–14, 18–21, 42, 152, 155.

Shanes, 1990².

SWINBURNE, Edward, senior (1765–1847), friend of Turner and brother of his patron Sir John *Swinburne, Bt. He is often confused with Sir John's eldest son, Edward Swinburne, jun. (1788–1855). An 'Edward Swinburne', often presumed to be Edward jun., was known to be an accomplished watercolourist; examples of his work are in the Victoria and Albert Museum, the British Museum, and the Whitworth Art Gallery, Manchester. According to Lyles, however, these were certainly the work of Edward sen. It was also Edward sen. who, as a friend of Walter *Fawkes, contributed watercolours to Fawkes's book of birds. In Turner's watercolour decoration for the cover of the catalogue of the 1819 exhibition of Fawkes's collection a list of represented artists is featured on a plinth, with Swinburne's name at the bottom. He made a copy (now in the Yale Center for British Art, New Haven) after Turner's watercolour of *Dunstanborough Castle* (c.1801–2; Laing Art Gallery, Newcastle upon Tyne; W 284). A member of the Swinburne family, possibly Edward sen., commissioned Turner in 1820 to produce some finished watercolours of *Rhine subjects, with views probably chosen from drawings owned by Fawkes (see entry for SWINBURNE, SIR JOHN). *Gainsborough painted Swinburne's portrait in 1785 (Institute of Arts, Detroit). TR

Wilton 1987, p. 88.

Lyles 1988, pp. 28–9, 46 nn. 61, 62, 64, 74.

SWINBURNE, Sir John, sixth baronet (1762–1860), collector and important patron of Turner. Swinburne, of Capheaton in Northumberland, was a close friend of Walter *Fawkes, and Turner may have gained Swinburne's patronage through him. Lady Swinburne's sister, Lady Willoughby *Gordon, was taught drawing by Turner and was herself a collector of Turner's work. In 1809 Turner received a watercolour commission from Swinburne, producing *The Lake of Brienz* (British Museum; W 386) and *The Castle of Chillon* (British Museum; W 390). In February 1813 Swinburne bought *Mercury and Herse* (RA 1811; private collection, UK; BJ 114) from Turner for 550 guineas; it remained in the Swinburne family until after 1862. In 1817 he commissioned the watercolour *Bonneville* (untraced; W 400). Turner worked up some *Rhine subjects into finished watercolours for a member of the Swinburne family in 1820, probably Sir John or his brother Edward *Swinburne, with the views apparently chosen from drawings in Fawkes's collection. Two of these watercolours were exhibited at the Northern Academy of Arts, Newcastle, in 1828 (*Biebrich Palace*, 1820; British Museum; W 691; and *Marksburg*, 1820; British Museum; W 692). According to Finberg (1961, p.

218), Sir John Swinburne sat at Turner's table, with Fawkes and James Ward and several others, at the annual dinner of the Royal Academy on 29 April 1815. Sir John's portrait was painted by *Gainsborough in 1785 (Institute of Arts, Detroit). TR

Wilton 1987, pp. 88, 114, 124, 128, 167.

SWITZERLAND. If *Scotland was a logical extension of Turner's interest in the mountains of *Wales, Switzerland necessarily followed on from Scotland. Circumstances conspired to make a journey there possible in the year following his Scottish tour: the Treaty of Amiens of 1801–2 briefly opened up the Continent and the British flooded across the Channel to take stock. Turner was taken as the companion of a young gentleman, Newbey Lowson, from Co. Durham, to whom he was possibly giving drawing lessons.

They may have met in Paris; they then crossed France to Grenoble and *Geneva, and took in Savoy and parts of the *Val d'Aosta before returning via the Great St Bernard Pass into central Switzerland. They travelled from Martigny to Lausanne and the eastern shores of Lake Geneva, then to Berne and into the mountains of the Bernese Oberland. They visited Lakes Thun, Brienz, and *Lucerne before turning south through the *St Gotthard pass as far as the Devil's Bridge (and perhaps a little further still, to Faido), then returned northwards via Zug to Zurich and up to Schaffhausen. From there they travelled down the Rhine to Basel and re-entered France, continuing their journey back to Paris.

Turner used several sketchbooks on this tour. The largest is the 'St Gothard and Mont Blanc' book (TB LXXV), in which he washed many of the pages with a grey ground, to be worked on in pencil, amplified either with white chalk or with watercolour heightened with white body-colour. These techniques evolved out of experiments he had been making in his larger-scale studies in Wales and Scotland, and he may have drawn particularly on the experience of working in black and white on a grey ground in the so-called *'Scottish Pencils' series (LVIII). As he had done in Snowdonia, he also took some large (Imperial) sheets of *paper to be used on the spot. Some he washed with grey; some are a French self-coloured grey paper. French too is the buff laid paper of the 'Grenoble' book (LXXIV), full of worked up black chalk drawings, often with white and sometimes with watercolour. They are often powerful images, and some were used as the bases of watercolours. On his return to London, Turner broke up both the 'Grenoble' and the 'St Gothard and Mont Blanc' books and mounted many of their pages in an album with slips of paper bearing his own identifications, now alas lost or separated from the sheets to which they referred. The album could be presented to

potential patrons to enable them to select subjects for finished watercolours. The remaining sketchbooks used on the tour contain the usual pencil, and occasionally pen and ink, notes of things seen *en route*. The 'Swiss Figures' Sketchbook (LXXVIII) seems to have been begun in the same spirit as the 'Scotch Figures' book (LIX), as a kind of inventory of local types and costumes, for reference in creating staffage for finished landscapes; but it was not much used. Its subjects are most likely the people Turner saw in the streets of Berne, and its first page, according to Hill, apparently shows a bedroom scene in a Berne brothel.

Switzerland had only recently become a focus of interest for artists. Very few indigenous Swiss had taken up the task of recording its newly fascinating *Sublime topography, and in fact the British were among the earliest in the field. William Pars (1742–82) had made a number of drawings when touring the country with Lord Palmerston in 1770, exhibiting a series of finished watercolours of Swiss views at the *Royal Academy the following year; and John Robert *Cozens (1752–97) had brought his melancholy vision to the scenery of Switzerland on his way to Italy with Richard Payne *Knight in 1776. Francis Towne (1739/40–1816), John 'Warwick' Smith (1749–1831), and a few other artists had also been inspired to make watercolours as they passed through in the years around 1780. It was with these precedents in mind, no doubt, that Turner embarked on a series of ambitious watercolours covering many aspects of his Swiss experience, continuing to finish and exhibit them up until 1815. There were even rarer precursors for his work in oil. The prolific minor artist Edmund Garvey (?1740–1813) had been producing pictures of Swiss and Alpine subjects since 1767, though examples are rarely encountered. Apart from the work of the native Swiss Caspar Wolf (1735–98), and some imaginative mountain scenes by the Alsatian Philippe Jacques de *Loutherbourg, relatively few substantial canvases of Swiss or Alpine subjects had been produced before Turner showed his two views of *Bonneville in 1803 (Yale Center for British Art, New Haven, and Dallas Museum of Art; BJ 46, 50) and in 1806 tackled *Fall of the Rhine at Schaffhausen* (Museum of Fine Arts, Boston; BJ 61). This is an underestimated work. Conceived on a very large scale and in unexpected close-up, it presents the falls as the vast and Sublime backdrop to a trivial human drama, involving local peasants and a frightened horse. The thundering wall of water behind the figures is rendered in a great blur of paint that anticipates the startling grey abstraction of the *Fall of an Avalanche in the Grisons* (BJ 109) that was to appear in Turner's gallery in 1810. Both works foreshadow the astonishing technical liberties of *Snow Storm: Hannibal and his Army crossing the Alps* (RA 1812; BJ 126).

Another canvas to emerge from this first tour, the rather unexpected *Lake of Geneva, from Montreux, Chillion, &c.*, also of 1810 (Los Angeles County Museum; BJ 103), is the first example in oils of the high-viewpoint topographical panorama that he was to experiment with so widely in his watercolours for the *Southern Coast* and other series in the ensuing decades. But the new understanding of mountain scenery that the Swiss tour gave him benefited more than his explicitly Swiss pictures. His mythological subjects too were enhanced by the first-hand experience of Sublime rocks and gorges, as is evident in *The *Goddess of Discord choosing the Apple of Contention in the Garden of the Hesperides* (BI 1806; BJ 57).

When reporting on his tour to *Farington in Paris, he had mixed feelings for the landscape he had seen: 'The lines of the Landscape features in Switzerland rather broken, but there are very *fine parts*' (30 September 1802). He thought

The Grand Chartreuse is fine;—so is Grindelwald in Switzerland. The trees in Switzerland are bad for a painter,—fragments and precipices very romantic, and strikingly grand. The Country on the whole surpasses Wales; and Scotland too . . . He found the Wines of France and of Switzerland too acid for his Constitution being bilious. He underwent much fatigue from walking, and often experienced bad living & lodgings. The weather was very fine. He saw very fine Thunder Storms among the mountains' (Farington, *Diary*, 1 October 1803)

Turner incorporated his impressions of such storms into two watercolours, the *St Huges* of 1803 (Soane Museum, London; W 364; see Pl. 2), and a view of *Lake Thun* from about 1806 (private collection; W 373) that he reused as a plate in the *Liber Studiorum* (F 15). Two views in the St Gotthard pass, one including the Devil's Bridge, reappear in the *Liber* (F 9, 19), where there are also three views of towns, *Basel* (F 5), *Lauffenburg* (F 31), and *Thun* (F 59), of which he did not make separate watercolours.

The most ambitious of all Turner's Swiss watercolours is the *Battle of Fort Rock, Val d'Aouste, Piedmont 1796* (LXXX: G; W 399) which he showed at the Royal Academy in 1815; see ALPS. He made very few watercolours of Swiss subjects in the 1820s, but at the end of the decade he produced the *Fall of the Rhine at Schaffhausen* (City Museums and Art Gallery, Birmingham; W 406), an ambitious composition which was engraved for the *Keepsake* annual in 1833. Rather than anticipating the airy, atmospheric accounts of the country that he was to create in the 1840s, it seems to have been conceived as the Swiss equivalent of the *England and Wales* subjects that he was working on at the time: it incorporates many figures involved in a multiplicity of local activities, while the great fall occupies the position of backdrop to a decidedly topical scene.

The studies that Turner was to make at Schaffhausen on later tours lay very different emphases, with their grey-washed grounds and evocatively scraped indications of spray. They take their place naturally among the highly atmospheric work that Switzerland inspired in the last decade or so of his life, when he revisited the country surprisingly often. His tour with H. A. J. *Munro of Novar in 1836 (see VAL D'AOSTA) heralded a spate of visits to the Lakes and a sequence of watercolours, both studies and finished drawings, of unequalled splendour and range, summing up his development as a watercolourist over a long career. These were to form his most sustained response to the country, and he seems to have been determined to execute them even in the face of considerable discouragement. After his tour of 1841 he proposed to finish four 'specimens', as *Ruskin called them, and to give his agent Thomas *Griffith a group of studies, or 'samples', from which Griffith's clients were to commission further finished drawings, to a total of ten. The subjects included two German views, *Coblenz Bridge* and *Constance* (untraced and York City Art Gallery; W 1530, 1531); the remainder reflected his journey along the Splügen road, back to Zurich and round the shores of Lake Lucerne. Griffith considered the finished pieces 'a little different from your usual style', and orders were slow in coming; only nine were spoken for. Turner finished all ten, giving Griffith the last by way of commission (W 1523-7, 29-33). After his visit to Switzerland the following year he was inspired to make a further ten watercolours, based on studies made on a rather different circuit, which took him from Basel through Lucerne to Locarno and Lugano, then east into northern *Italy and *Austria via the Stelvio pass. In the event only six were ordered (W 1534-9), although they included the great *Goldau* (private collection, USA; W 1537) and the unusual nocturne of *Lucerne: Moonlight* (British Museum; W 1536). Undeterred, he returned to Switzerland in 1843 and again in 1844, making the journey 'little thinking or supposing such a cauldron of squabbling, political, or religious, I was walk-ing over' (Gage 1980, p. 275). In the following year a further group of ten finished watercolours appeared (W 1540-9). They are mainly views round Lake Lucerne, and in them the 'difficult' late manner is intensified, reaching its apogee: they are works of extraordinary, airy breadth in which topography is almost wholly dissolved in atmosphere. Yet others seem to have occupied him later in the decade and it is possible he was still working on Swiss subjects shortly before his death. The very latest examples do perhaps betray some of the 'falling off' that Ruskin lamented, and some are undoubtedly unfinished; but several include the seething crowds that had become a hallmark of his latest work, and they are still remarkably full-blooded evocations of the grandeur of Swiss mountain and lake scenery.

In view of this abundant activity in the field of watercolour it is surprising that, apart from the melodramatic *Snow-Storm, Avalanche and Inundation—a Scene in the Upper Part of the Val d'Aouste, Piedmont* of 1837 (Art Institute of Chicago; BJ 371), Switzerland did not inspire Turner to produce any oil paintings in his later life, with the possible exceptions of two atmospheric but elusive oil sketches, now identified as showing *Lake Lucerne: The Bay of Uri from above Brunnen* and *Sunset from the *Rigi* (c.1840-5; BJ 521, 522; see Warrell 1999², pp. 146-8). After his death, two of the late Swiss watercolours, *Lake of Lucerne from Brunnen* and *Zürich: Fête, Early Morning* (Indianapolis Museum of Art and Kunsthaus, Zurich; W 1547, 1548), were reproduced by two engravers who had enjoyed a long and close association with him, R. *Wallis and T. A. *Prior respectively: the plates were issued in 1854 (R 671, 672). AW

Russell and Wilton 1976.
Hill 1992.
Warrell 1995.
Brown 1998.
Warrell 1999².

SYON FERRY HOUSE, see SION . . . FERRY HOUSE.

TABLEY, Cheshire, the Seat of Sir J. F. Leicester, Bart.: *Calm Morning,* oil on canvas, 36 × 46 in. (91.5 × 116.8 cm.), RA 1809 (146); Tate Gallery and the National Trust (Lord Egremont Collection), Petworth House (BJ 99). Tabley House, near Knutsford in Cheshire, was built by Carr of York in 1761 for Sir John *Leicester's great-grandfather. Turner went there in the summer of 1808 at Leicester's behest in order to paint this picture and a companion showing virtually the same view on a *Windy Day* (RA 1809; Victoria University of Manchester; BJ 98).

Several drawings connected with both paintings occur in the 'Tabley No. 1' and 'Tabley No. 3' Sketchbooks (TB CIII, CV) as well as an oil sketch (BJ 208), cut out from CIII and folded. *Finberg believes that this is because Turner posted it to Leicester for his approval; this may not have been forthcoming, as the sketch lacks the round water-tower which is such a prominent feature of both finished paintings. This suggests that the pictures were scarcely begun while Turner was still at Tabley and bears out Henry Thomson's report that Turner spent more time there fishing rather than painting.

Both pictures were well received at the Royal Academy: the *Repository of Arts* (i. p. 490) wrote that what 'in any other hands would be mere topography, touched by his magic pencil has assumed a highly poetical character'. Their success, despite Tabley itself appearing only in the far distance (Turner was following *Wilson's tradition here), led to similar commissions from Lords *Egremont and *Lonsdale, exhibited the following year. EJ

Finberg 1961, pp. 151, 158–9.

TABLEY, Lord de, see LEICESTER, SIR JOHN FLEMING.

TAFT MUSEUM, Cincinnati, Ohio, which contains the Tafts' extensive collection of paintings, furniture, and ceramics, was opened to the public in 1932. There are twelve works by Turner, all save one bought by Charles P. Taft (1843– 1929) and his wife, Anna, mostly between 1901 and 1914. The exception is an 1817 *Rhine drawing of *Weissen-*

thurm and the Hoch Monument (W 660), bequeathed by Jane Taft Ingalls in 1962.

The two Turner oils are *Europa and the Bull* (c.1845–50; BJ 514), based on the frontispiece to the *Liber Studiorum,* and *Trout Fishing on the Dee, Corwen Bridge and Cottage* (Turner's gallery 1809; BJ 92), which stems from a trip Turner took into *Wales from Tabley in 1808. A third oil, *Old London Bridge* (BJ 553), is a close copy by an unknown hand of the watercolour of 1824 in the *Victoria and Albert Museum (W 514).

The watercolours include two 1809 Swiss views (W 388, 389) from Walter *Fawkes's collection, two illustrations to *Scott's *Poetical Works* (c.1832; W 1072, 1073), one for *Milton's *Lycidas* (c.1834; W 1269), and two vignettes, *The Whale on Shore* (c.1839; W 1307), not engraved, and *Lake Nemi* (c.1835–40; W 1311), engraved for Dr Broadley's *Poems.* Finally, *Lake Thun* (c.1850–1; W 1567), considered by Wilton to be one of Turner's last three watercolours. EJ

TATE GALLERY, London. In October 1889 Henry Tate, the sugar magnate (1819–99, created baronet in 1898), offered to present about 60 of what were then modern English paintings from his collection to the National Gallery. This offer was turned down and Tate then offered to pay for a new gallery to house the collection. There were difficulties over available sites, until in 1892 a new government brought the promise of the land occupied by Jeremy Bentham's model penitentiary on Millbank; Tate's munificence was finally accepted and the new gallery, at first called the National Gallery of British Art, was finally opened by the Prince of Wales on 21 July 1897. Intended as an annexe of the National Gallery for the display of British Art, the Tate became the main home of the *Turner Bequest in 1910, when Sir Joseph Duveen paid for a new suite of galleries to the north-west of the existing building. About 30 oils had already been transferred in 1905, 1906, and 1909, including *Light and Colour* and *Shade and Darkness,* *War, Boccaccio,* some of the *Cowes sketches, a *whaling picture, and the unfinished *Sunrise, with a Boat between Headlands.* In 1910 65 further

oils arrived, and the works on paper from the Turner Bequest were also transferred. In 1912 the first two of the four *Vernon pictures were transferred, as was a painting bequeathed to the National Gallery in 1885 by Mrs E. Vaughan; the other two Vernon pictures had to wait until 1929 and 1949. Oil paintings not wanted for display at the National Gallery continued to be transferred until the Act of 1954 separating the two galleries, and included finished works not required at the National Gallery, works returning from loan to provincial galleries, and unfinished works as they were taken out of store and given acquisition numbers; one batch of these was sensationally discovered by Kenneth *Clark in the cellars of the National Gallery at the beginning of the Second World War (K. Clark, *Another Part of the Wood*, 1974, pp. 276-7). These transfers are recorded in the Reports of the two galleries concerned and, in more summary fashion up to 1953, in Mary Chamot, *The Tate Gallery British School: A Concise Catalogue*, 1953. A number of works on paper were acquired from sources other than the Turner Bequest, including a set of the *Liber Studiorum* in 1925; in 1961 *Palestrina* (painted in *Rome, 1828; BJ 295) was received as a bequest through the National Gallery, and in 1972 an oil was actually purchased, Turner's first exhibited oil, shown at the Royal Academy in 1796, *Fishermen at Sea* (BJ 1).

The disastrous flooding of the Thames in January 1928 endangered the works, particularly drawings, in the lower galleries at the Tate, though luckily the amount of actual damage was relatively small. The works on paper were transferred for safer keeping to the Department of Prints and Drawings at the British Museum, where they remained until the opening of the Clore Gallery in 1987.

After the 1954 Act only fifteen oils remained in the collection of the National Gallery (see Martin Davies, *National Gallery Catalogues: The British School*, 2nd edn., 1959) and by 1998 these were down to nine; even one of these has been, confusingly, on loan to the Tate Gallery since 1986 (Egerton 1998, pp. 260-325).

The opening of the Clore Gallery was preceded by eighteen years of negotiation. In July 1969 the then Prime Minister, Harold Wilson, announced in the House of Commons that by 1975 the site of the Queen Alexandra Military Hospital to the east of the Tate would be available for the Gallery's use. It was a long-cherished, and to begin with secret, dream of the then Director, Sir Norman Reid, that the site should be allocated to Turner. The success of the *bicentenary exhibition of 1974-5 gave further impetus to the idea, though at first this enthusiasm was directed towards Somerset House, a building regarded as unsuitable by the Tate Gallery. A provisional scheme to reuse the exist-

ing hospital buildings emerged in 1977 but this came to nothing and at the end of 1978 James Stirling, Michael Wilford and Associates were appointed to undertake a feasibility study for the total redevelopment of the site. A chance meeting between Lord Hutchinson, a Tate Gallery Trustee, and Mrs Vivien Duffield, daughter of Sir Charles Clore (who had died in July 1979), led to the generous offer of the Charles Clore Foundation to fund a new gallery in his memory. Containing nine main galleries, one for the display of watercolours, three reserve galleries, a study room, auditorium, paper conservation studio, and offices for the Education Department and other staff, the building was opened by the Queen on 1 April 1987. To begin with practically the entire collection of oil paintings, including some lent specially for the occasion by the National Gallery, were on view in either the main or the reserve galleries, while the watercolours and drawings were available in the study room and formed the basis of specialized exhibitions, three or four a year, the detailed catalogues for most of which have provided an outlet for the latest scholarly research. Now, with the resumption of loans, some works may be away from the Tate Gallery. After a shameful period during which the study room was open for only one day a week, opening on three weekdays plus one Saturday a month was resumed in 1997 with a commitment to more opening hours in the future.

From 2000, following the opening of the Tate Gallery of Modern Art at Bankside, re-named Tate Modern, the Turners will mostly remain in the Clore Gallery in the newly titled Tate Britain. The whole collection will continue to be known as that of the Tate Gallery. In the longer term it is likely that the two branches of the Tate will become independent of each other, just as the Tate became independent of the National Gallery.

The presence of so many works by a single artist in one place is unequalled. For just one example of the *influence of this collection on other artists (to say nothing of the general public) one can quote the fact that the American Abstract Expressionist painter Mark Rothko (1903-70), when considering the gift to the Tate Gallery in 1968-9 of the paintings originally intended for the Four Seasons Restaurant in New York, said that the decisive factor which influenced him in the end was the thought that the pictures would be in the same building as the Turner Collection (Ronald Alley, *Catalogue of the Tate Gallery's Collection of Modern Art other than Works by British Artists*, 1981, p. 660). MB

Alan Bowness, intro., *The Clore Gallery: An Illustrated Account of the New Building for the Turner Collection*, 1987.
Jennifer Booth, *Henry Tate's Gift: A Centenary Exhibition*, 1997.

Robin Hamlyn *et al.*, 'The Clore Gallery for the Turner Collection at the Tate Gallery', *International Journal of Museum Management and Curatorship*, 6 (1987), pp. 19–62.

Egerton 1998, pp. 11–17.

Frances Spalding, *The Tate: A History*, 1998.

TATE GALLERY, *Turner* exhibition, 1977. This selection of 'twenty rarely seen paintings' by Turner was planned to coincide with the publication of the first edition of Butlin and Joll; Evelyn Joll wrote the catalogue. It included recently rediscovered works such as *The Devil's Bridge, *St. Gothard* (*c.*1803–4; private collection; BJ 147) and unfamiliar works such as *Grand Junction Canal at Southall Mill* (Turner's gallery 1810; private collection, England, stolen 1991; BJ 101), and a pair of paintings of *Lowther Castle, Westmoreland, the Seat of the Earl of *Lonsdale* (RA 1810; private collection, England; BJ 111, 112). MB

TATTON, Reginald A. (1857–1926), collector, of Cuerden Hall, Preston, Lancs. He owned *Châteaux de St. Michael, *Bonneville, Savoy* (RA 1803; Yale Center for British Art, New Haven; BJ 46) and a considerable number of watercolours including 33 bought *en bloc* from the *Rawlinson collection through *Agnew's in 1917, among them early works such as *The *Archbishop's Palace, Lambeth* (RA 1790; Indianapolis Museum of Art; W 10) and *West Entrance of *Peterborough Cathedral* (RA 1795; City Museum and Art Gallery, Peterborough; W 126), *St. Goarhausen and Katz Castle* (1817; Courtauld Institute of Art; W 645), and a number of late Swiss subjects including *A Scene in the Val d'Aosta* (?1836; Fitzwilliam Museum, Cambridge; W 1430), *William Tell's Chapel, Lucerne* (?1841; Yale Center for British Art, New Haven; W 1480), and *The Red *Rigi* (1842; National Gallery of Victoria, Melbourne; W 1525); he inherited other works from the collection of his great-grandfather Robert Towneley Parker (1793–1879). Thirty-six works were sold from Tatton's collection by his son, Capt. T. A. Tatton, MC, at Christie's, 12–14 December 1928, only twelve of them from the Rawlinson collection, however, leaving a number of other works unaccounted for. TR

TAYLOR, John Edward (1830–1905), British art connoisseur with wide-ranging interests, whose distinguished collection of British watercolours included works by Turner, Blake, J. R. *Cozens, and *Girtin. The son of John Edward Taylor, founder of the *Manchester Guardian*, Taylor became a partner in his father's firm in 1852, and later acted as sole proprietor, exerting an important influence on the newspaper's standards of art criticism. From the 1860s Taylor bought Turner watercolours from *Agnew's, his interest in collecting sketches demonstrating an advanced taste for the period. Taylor's collection of prints after Turner included

significant holdings of *Liber Studiorum* engraver's proofs, and in collaboration with Henry *Vaughan he organized the pioneering *Liber* exhibition at the *Burlington Fine Arts Club in 1872. In 1892 Taylor gave a large group of British watercolours and paintings to the *Whitworth Institute, including 25 works attributed to Turner, followed by a gift to the *Victoria and Albert Museum in 1894. After his widow's death in 1912 Taylor's remaining collection was disposed of at Christie's over twelve days; 101 Turner drawings were sold on 5 and 8 July 1912. GF

Francis Hawcroft, *British Watercolours from the John Edward Taylor Collection in the Whitworth Art Gallery*, exhibition catalogue, Manchester, Whitworth Art Gallery, 1973.

Hartley 1984.

TECHNIQUES IN OIL AND WATERCOLOUR. Turner's working methods in oil paint owe much to his initial experience in watercolour on paper, a medium which he had used for over five years before he began to exhibit oil paintings. Turner's earlier watercolours, with the exception of a few in sketchbooks, were painted on off-white or white paper. His very earliest oil paintings, for example *Morning amongst the Coniston Fells, Cumberland* (RA 1798; BJ 5), were traditionally painted with thick paint (for Turner) on a very warm red ground, yet these early works include telling spots of bright colour which were by then characteristic and innovative in his watercolours. The red ground makes little contribution to the appearance of these paintings, yet when Turner moved on to use white and off-white grounds for oil paintings, after about 1802, he did allow them to make an increasing contribution to surface appearance. For the rest of his life he worked on light grounds for the majority of his oil paintings, only rarely modifying the white with a brown layer when a night subject such as *The *Field of Waterloo* (RA 1818; BJ 138) called for it.

Unfinished works from the decade 1801–10 illustrate Turner's method of applying thinned-down oil paint to a white priming, as though he were painting in watercolour. *Goring Mill and Church* (1805; BJ 138; see THAMES SKETCHES) shows this well. Turner drew lightly in pencil to indicate the mill and some of the trees, then washed in small areas to depict the mill itself, some of the trees and grass, the cows, and their reflections. Isolated pale washes of colour indicate highlights in the river, and the viewer's mind easily fills in the largely blank foreground as the river itself. The sky is similarly unfinished yet a few clouds are suggested by brushstrokes which are modest in themselves. The mixture of brown ochres and thinned Prussian blue used to paint the greener trees and grass is also analogous to Turner's watercolour painting. In Turner's youth there were no bright green pigments available, so he grew skilled in the use of

optical mixtures for greens, greys, and blacks. In fact, the greenness of an area of paint in the early works often owes as much to the colour immediately surrounding the brush-stroke as it does to the colours used for the 'green' area. Unfinished watercolours of this date, such as *Thames River Scene* (c.1805; TB XCV: 47), have a very similar tonal range to *Goring Mill and Church*. He would soon abandon the pencil sketching for both oil paintings and watercolours, except for critical details such as buildings, and proceed to work up an image with coloured washes alone.

Oil paintings which were carried a stage further, with the application of more opaque paint made from lead white and the same colours used initially, include small areas of more intense colour, and few or no areas of unpainted priming. *Shipping at the Mouth of the Thames* (?1805; BJ 175) includes touches of bright red for the sailors' hats and costume details, and bright blue streaks for the sky. All of them were painted over areas of priming that had been reserved for the purpose, so that the colours would appear luminously bright over the white ground. More finished paintings show a greater build-up of paint, and some even include a spot of bright colour—red or blue—applied just where Turner knew it would have most effect, by then over existing paint. In finished works such spots became tiny figures in the foreground, but in the unfinished works they are left as mere suggestions of details that might follow. Throughout his life, Turner abandoned many paintings at this stage. Quite a number he returned to later, and contemporary descriptions suggest that the works which he took to the Royal Academy each year, then completed during the *Varnishing Days which preceded the annual exhibition, were scarcely beyond this stage.

Finished Turner oils may not include a wider palette than the advanced yet unfinished ones, but they do have a greater range of paint texture, and a wide range of modified oil-based paint. Turner modified the paint in order to produce both stiff and soft impasto, and added *megilp to the colours already on his palette, in order to improve the handling properties of pure oil paint. He was not the only artist to do this during the 1820s to the 1840s: the painter's world in England at that time was divided between those who regularly used the delightful substance megilp, and those who criticized it as the immediate or future ruin of all their best paintings. It was not simply that megilp darkened and cracked as it dried, which occasioned problems. Turner used a variety of other mixed media, applying them in layer after layer until the painting matched up to the image in his head. Deep glossy shadows, in landscapes and interior scenes, were made even more glossy and dark when applied in a paint medium prepared from bitumen, drying oil,

mastic resin, and probably beeswax too, and used to glaze the shadows. *Glazes of pure megilps worked well for lighter areas, since they were lighter in colour than bitumen-based paint, while a paint mixed from drying oil and beeswax gave a slightly opaque appearance which Turner used to good effect for morning mist, water, and buildings disappearing into the middle distance. Sometimes spermaceti wax has been found in such paint as well, again modifying both the optical and the handling properties of pure oil paint. Highlights in rivers, such as that in *The *Opening of the Wallhalla, 1842* (RA 1843; BJ 401), may consist only of wax-based paint applied in thin layers over an initial wash of transparent, thinned-down oil paint, but the glossy shadows of the river can include bitumen-rich paint applied on top, now recognizable not only by the depth of gloss, but by the patch of wide cracks which accurately maps the extent of the layer. Sometimes Turner applied megilped paint over such areas, or even applied stiff, unmodified oil paint on top, as can be seen for the fountain in the *Wallhalla*'s foreground.

The outstanding characteristic of Turner's painting technique is variety of application: *Ruskin said, 'Intimately associated with the toning down and correction of colours actually used, is his inimitable power of varying and blending them, so as never to give a quarter of an inch of canvas without a change in it' (*Works*, iii. p. 279). These areas, however, dried at different rates, and often a new layer did not bind firmly to the last, partly dried one. This has led to both cracking and losses, and to many reports by Turner's contemporaries that chunks of paint depicting important elements of some scenes detached themselves and fell off altogether from works only a few years old. It was said of the *Wallhalla* that the surface cracked after eight days in the RA (see BJ 401), which is to say, a mere eight days after Turner finished applying the last brushstroke.

Most of Turner's paint which has been analysed includes linseed oil. This was the oil with the best drying and film-forming properties of all, but it was more prone to yellowing than other oils such as walnut and poppyseed. Many artists chose to grind light-coloured paint in these oils instead, so that white and blue areas would not appear yellow. Turner did not do this habitually. Instead, he used heat-bodied oils (linseed or walnut oil heated for several hours to alter their drying properties) to extend the working time for areas such as skies, which he generally completed last, and oils prepared with driers, both of which were more yellow than pure linseed oil. He must have grown expert in working with a warm-coloured medium, since he used megilps regularly.

A late, finished painting such as the *Wallhalla* gives a good idea of the range of pigments which Turner employed towards the end of his life. The bright details in the fore-

ground, such as the wreath and the eagle standard, include emerald green, ultramarine, Prussian blue, chrome yellow in up to five shades ranging from pale lemon to a deep orange, vermilion, and Mars red. Turner made the most effective use of these bright pigments by applying them over white paint, and by using them either pure, or lightened with lead white, but not mixed with other colours. He habitually applied white paint under yellow areas of the sky. The misty landscape includes ultramarine, madder, pale chrome yellow, and a great deal of lead white, and the water of the river includes Mars orange, yellow ochre, and bone black, as well as small amounts of the colours already listed for the foreground. Ultramarine and chrome yellow were used for the sky, and for many other skies. Practically all of these pigments would have been used by the time the painting was well advanced. Turner rarely introduced different pigments as he worked on the Varnishing Days, the only regular exception being his use of natural ultramarine for finishing skies, over earlier paint which had included the similarly coloured but cheaper smalt. Unfinished paintings practically never include natural ultramarine, which was an extremely expensive pigment.

Turner's studio *pigments have been preserved and analysed, as have a few surviving palettes (Townsend 1993[2], pp. 231–54). The studio pigments included a large number of red organic pigments, based mainly on madder root but occasionally on cochineal (made from insects) or brazilwood (derived from a tree). These were struck onto different bases to form a laked pigment, and the range of bases gave rise to a wide range of colours shading from blue/red to brown/red. Some were more prone to fading than others. Generally at least two or three of these materials can be seen in a finished painting, or even a well-advanced one. Yellow lakes based on flavonoid dyes such as quercitin are also present among the studio pigments. They are harder to spot on the paintings, since they may have faded and become very hard to distinguish from yellowed glazes of megilp or bitumen. Chrome yellow is present in several shades among the studio pigments, as are shades of yellow ochre, umber, and other natural earth colours, and Naples yellow. This last is one of the bright yellows available to him in early years, others being patent yellow and orpiment, which were not, however, among the studio pigments. His deliberate use of bright yellows, and adoption of new ones such as chrome yellow in the very year they were first made, is striking. Turner also used Scheele's green, emerald green, and finally viridian soon after they became available, just as he had cobalt blue in earlier decades. Brighter shades of earth colours, made industrially and known as Mars colours, had become available shortly before Turner first worked in watercolour, and

he used them so regularly that they can be seen in every watercolour which possesses bright orange or red shades, and in every oil painting examined under the microscope, even where their presence is subtle, for example in a warm glaze. The opaque pigments used in oil were soon tried out in watercolour too. There are very few pigments which Turner tried out and disliked sufficiently never to use again: zinc white and synthetic ultramarine, both of which caused drying problems in paint, are the only examples known. Earth colours in a variety of shades, and different qualities of lead white, feature in the paintings as well. These traditional colours were never superseded for Turner by the new ones. Indeed, he rarely failed to reuse a material or an effect of paint application which pleased him, even if he did not return to it for some years.

Another of Turner's techniques which relates directly to his experience as a skilled watercolour artist is his use of absorbent grounds for oil painting. *Paper was available in his era in a wide range of qualities, with different degrees of sizing, which affected the absorbency of the paper. Indeed, the absence of paper made especially for artists encouraged them to seek out a range of papers from stationers, or even directly from the paper mills (Bower 1990, pp. 39–43). In his early years of oil painting several different types of priming (see SUPPORTS) can be recognized, though Turner quickly settled for commercially prepared white ones which were semi-absorbent, or home-made ones made from lead white and whole egg, which were even more absorbent. Turner's father acted as his studio assistant, and presumably made them up and applied them to canvases, for the very last of the egg-primed canvases were painted on in the year or two following the father's death when Turner was already in his 50s. Absorbent primings have two related advantages: they allow the paint to dry fast, clearly a godsend to a fast-working, impetuous artist such as Turner was reported to be, and they shorten the time before the paint reaches its final colour. Both these properties enabled Turner to proceed quickly if the study was going well. Unfinished, advanced, and completed works all have the same type of supports and primings, and any canvas, once begun, had a chance of being finished and displayed in the RA, though on occasion Turner did not finish the work until many years later, sometimes with a change of subject. The painting now known as *The *Hero of a Hundred Fights* (RA 1847; BJ 427) is an extreme example: it was begun c.1800–10 when the subject was related to a sketch of an interior, and reworked for exhibition in 1847 under its present title. The use of absorbent grounds is common to all.

The scope and purpose of Turner's *sketchbooks are discussed elsewhere in detail. It is clear that he never

proceeded in the 'traditional' way, from pencil sketches through to detailed composite pencil sketch, to small oil study, to drawing on the larger canvas, and then to painting and finishing. There are a few unfinished works which clearly resemble earlier versions of finished ones, and some hundreds of watercolour studies have been identified and related to finished works (see BEGINNINGS), but in the majority of cases most of the early working-up is concealed below the finished oil painting or watercolour, and the subject only ever occupied one support. (This is known, because he never discarded sketches, paint, or canvases, and even once used one that was not successful to mix paint on for better images, by turning the front of the canvas to the wall, as in The *Vision of Jacob's Ladder (?c.1830; BJ 435).) Thus, time spent waiting for paint to dry so that he could safely proceed with the next stage was mere frustration, and absorbent primings minimized this. Indeed, the drying cracks visible in a number of his later works indicate that he did not wait until the paint was safely dry, but carried on briskly. Methods were known for minimizing the risk of future paint loss, for example by applying a thin skim of pure oil to the surface before the new paint went on, and then wiping it off, or by passing onion or potato or other materials over the surface to remove the skin of drying oil paint, but all the evidence from examination suggests that Turner never took these precautions.

His methods of applying paint to canvas were inventive and ingenious, and many of them can be related directly to his work in watercolour. When he used opaque *gouache as well as watercolour, Turner could simply add highlights, just as he did in oil. But lights could be achieved in watercolour washes by removing paint with fine and blunter instruments, by rubbing it off with a variety of materials, or by washing off the pigment with fresh water. In oil paint, Turner scratched in lines with his thumb-nail, the end of his brush, or anything else that came to hand. This would reveal the white ground if he scratched deep enough, thereby modifying colour as well as texture in the paint. His brushes would have been round ones (flat ones were not produced until some years after his death) and it can be seen from unfinished paintings (because they have less glazing) that he had a range of brushes with different lengths of hair, and stiffness. Long, soft brushes were used for applying soft impasto, and shorter, stiffer hairs were useful for applying unmodified, buttery oil paint and megilps applied as high impasto. Even on the larger canvases, the brushmarks indicate that he used half-inch (1.4 cm.) brushes, scaling them down somewhat for small works such as the few oil sketches on paper in the Turner Bequest, for example Chevening Park (c.1801; xcv(a): D). He used palette knives shaped like

small trowels to apply thick paint, especially in skies. This is obvious in many unfinished paintings, and in some finished ones where Turner did not glaze skies and thereby conceal the paint texture as much as he did in other areas. *Peace—Burial at Sea (RA 1842; BJ 399) is a good example.

There is less scope to create impasto in watercolour and *gouache, and Turner seems not to have used modified media with these to the extent that he did in oil. The beauty and variety of his watercolour effects are achieved by the superposition of localized washes, and by studied control of the amount of water in the wash, and the wetness of the paper. There are descriptions of Turner working on a group of watercolours, and plunging them successively into water as he worked. Soaked paper gave very soft, even washes which he could enliven with darker ones after the paper was dry. But he did not always use this method, which is simply impossible with the bound sketchbooks he used in travelling and which do have some watercolour painting within. After he had applied washes to dry paper, he proceeded to the creation of lights, through *scratching out. It is easier to see these processes in monochrome works, such as the drawings for the *Liber Studiorum, than in finished watercolours. *Farington described Turner's technique in watercolour very aptly when he wrote in 1799, 'Turner has no settled process but drives the colours about till he has expressed the ideas in his mind' (Diary, IV, p. 1303). Throughout his life, Turner carried out most of his experiments on different colours of priming by applying a coloured wash to paper, or by using blue paper. Many more unfinished watercolours than canvases survive to illustrate this.

Remarkably few examples of original varnishes survive on Turner's oil paintings. Most oil paintings of this age have been cleaned several times, which involves the removal of varnish as well as surface dirt. Turner's few relevant letters show simply that he used a mastic spirit varnish, applied just before he sent a painting off to its purchaser. This was a typical choice for his time. Such varnishes grow yellow within 25 or 50 years of application, which accounts for their deliberate removal from 19th-century paintings. Turner's paintings at the RA would not have been varnished, since the paint was wet when they were displayed, and it is likely that he did not varnish them afterwards, unless they were sold. Nor were his unfinished paintings ever varnished. Those in the Turner Bequest are mostly displayed without varnish (except where later restoration work included varnishing and this has not yet been reversed) and give a good impression of the surface appearance of Turner's paintings during his lifetime.

The most characteristic aspect of Turner's painting techniques is that he was always willing to try out new methods

and materials, to adapt them to the occasion, and to proceed always to new and, to him, potentially better images, by any and every means which occurred to him. JHT

Townsend 1993.

J. H. Townsend, *Turner's Painting Techniques in Context*, United Kingdom Institute of Conservation, 1995.

Hamlyn 1999.

TEMERAIRE, see *FIGHTING 'TEMERAIRE', THE.*

TENIERS, David (1610–90). Son of a painter, David the Younger was active in his native *Antwerp (1623–51), becoming Master of the Guild in 1632, marrying Jan Breughel's daughter Anna in 1637, but moving to Brussels to be Court Painter and Keeper of the picture collection of the Archduke Leopold, Regent of the Austrian Netherlands. Although originally extremely versatile, he specialized in typically Flemish genre scenes of peasant life and rustic interiors. He was very popular in 18th-century England and David *Wilkie was irresistibly attracted to his style.

Turner echoed some of Teniers's small figures in low-life attitudes for his staffage in marines such as *Calais Pier* (RA 1803; BJ 48), in landscapes, and in the odd market or kitchen scene. None the less, in 1810 he composed a satirical ditty about a greatly overpraised Teniers imitation by Edward Bird, reading:

> Came Flattery, like Gipsy came
> Would she were never heard
> And muddled all the fecund brains
> Of Wilkie and of Bird
> When she call'd either a Teniers
> Each Tyro stopt contented
> At the alluring half-way house
> Where each a room has rented ...
>
> (TB CXI: 65a)

It seems ironical that the writer was also the painter of *The Unpaid Bill, or the Dentist reproving his Son's Prodigality* of 1808 (private collection, USA; BJ 81), believed at the time to be a companion to Payne *Knight's Rembrandt but now considered a pendant to his *The Alchemist's Laboratory* (with a similarly cluttered interior), then attributed to Teniers but more recently to his follower Gerard Thomas (1663–1720). AGHB

Clarke and Penny 1982, pp. 184–5.

THACKERAY, William Makepeace (1811–63), novelist, poet, artist, critic, and prolific journalist. Thackeray's art criticism, frequently published under the pseudonym Michael Angelo Titmarsh, was mischievous, witty, urbane, and based on personal knowledge of artists and their world. Fundamentally satirical, Thackeray was none the less sensitive to Turner's complexities, keen to fathom his motives

and effects. Reviewing The *Fighting 'Temeraire'* (RA 1839; BJ 377), 'as grand a painting as ever figured on the walls of any academy', Thackeray (becoming 'politically enthusiastic') considered the fate of the ship: 'But herein surely lies the power of the great artist. He makes you see and think of a great deal more than the objects before you.' Arguing that Turner could soothe, intoxicate, fire, or depress, Thackeray predicted that the *Temeraire*, 'when the art of translating colours into music or poetry shall be discovered, will be found to be a magnificent national ode or piece of music' (*Fraser's Magazine*, 19 (June 1839), p. 744).

Thackeray's descriptions of 'that incendiary Turner', however, could be deliciously provocative. Unsure whether *Slavers* (RA 1840; BJ 385) was sublime or ridiculous, he catalogued its ingredients: 'rocks of gamboge', 'bladders of vermilion madly spirted here and there', 'a flashing foam of white-lead', 'a horrible sea of emerald and purple', and 'horrid spreading polypi, like huge, slimy, poached eggs' (*Fraser's Magazine*, 21 (June 1840), pp. 731–2). His most facetious humour he saved for *Punch* where, in a spoof review (6, 11 May 1844, p. 200), he parodied Turner's poetry and such abstruse titles as *War. The Exile and the Rock Limpet* (RA 1842; BJ 400):

> The DUKE of WELLINGTON and the Shrimp
> (Seringapatam, early suarin).
>
> And can it be, thou hideous imp,
> That life is ah! How brief, and glory but a shrimp!
>
> *From an unpublished poem*

He also invented the wonderful artist's name and title of an imaginary exhibit (see BJ, p. 237):

TRUNDLER RA ...

34. A Typhoon bursting in a simoon over the Whirlpool of Maelstrom, Norway, with a Ship on fire, an eclipse, and the effect of a lunar rainbow. JCI

Gordon N. Ray, *Thackeray: The Uses of Adversity*, 1955.
Gordon N. Ray, *Thackeray: The Age of Wisdom*, 1958.

THAMES AND TRIBUTARIES. In 1804 Turner began renting a summer villa, *Sion Ferry House, on the Thames at Isleworth. In 1805 he toured the Thames and certain of its tributaries, making oil sketches from a boat (see THAMES SKETCHES). A series of related oils were exhibited at his gallery in the period 1806–10, which drew on the associations of the Thames as developed particularly in the poetry of Pope and James *Thomson, both of whom had lived in the Thames valley (see *POPE'S VILLA AT TWICKENHAM*; Turner's gallery 1808; Walter Morrison Picture Settlement; BJ 72). In their works and in later topographical literature, the Thames and the scenery on its banks are figured as a microcosm of Britain, combining rural and urban, culture

and commerce. Indeed, the Thames in a literal sense connected *Oxford (a city of learning), *Windsor (the principal royal seat), and Twickenham (associated with artists, poets, and their noble patrons) with *London, the capital of the British Empire.

The so-called *Thames at Weybridge* (c.1807–10; Petworth House; BJ 204) seems to be very far removed from the naturalistic oil sketches, being an idealized, not to say capriccio-like, view of the river near Sion in the idiom of *Claude; it thus evokes appropriately high-cultural associations (for a more elaborate exercise in this vein, see *Thomson's Aeolian Harp*; Turner's gallery 1809; Manchester City Art Galleries; BJ 86). In *Union of the Thames and the Isis* (Turner's gallery 1808; BJ 70), on the other hand, Turner shows a comparatively featureless landscape, depicting the little River Tame where it flows into the Thames proper. The title, however, refers to the well-known myth which held that the river was really the Isis down to its 'marriage' with the Tame, and that this 'marriage' created the Thames. This seemingly unimportant spot, therefore, is lent a greater significance. Moreover, the painting itself 'was an exercise in the mode of giving aesthetic significance to ordinary landscapes through breadth and atmospheric effect, which . . . was a crucial element in the naturalistic strategy' (Hemingway 1992, pp. 231–2). Because of this management of atmosphere, John *Landseer could describe the work as possessing a '*Claude-like serenity', even though there was little overt reference in it to the master's devices. That there is an essential connection between these more naturalistic images of the Thames and the more overtly mythicizing works is indicated by the new title—*Isis*—given to the *Thames at Weybridge* composition when it was engraved in the *Liber Studiorum* (1819; F 68).

Even modern commerce may be given an air of pastoral tranquillity in these images, as in *Grand Junction Canal at Southall Mill* (Turner's gallery 1810; private collection, until stolen 1991; BJ 101; see also CANALS), which shows the canal just above its meeting point with the Brent, another Thames tributary. Here, a barge negotiates the lock, while the windmill is viewed against a peaceful Claudian sunset, rather than the brooding backdrop seen in the painting's main source, *The Mill*, then attributed to *Rembrandt (Hemingway 1992, pp. 231–2).

See also AGRICULTURE AS SUBJECT MATTER; ENGLAND: RICHMOND HILL, ON THE PRINCE REGENT'S BIRTHDAY; LONDON [FROM GREENWICH]; NEWARK ABBEY; RICHMOND; THAMES ESTUARY; WALTON BRIDGES; WINDSOR AND SLOUGH.

AK

Hemingway 1992, pp. 216–45.
Hill 1993.

THAMES ESTUARY. The estuary of the River Thames abounded in naval and mercantile activities. Turner defined the area in these terms in the oil *Shoeburyness Fisherman hailing a Whitstable Hoy* (Turner's gallery 1809; National Gallery of Canada, Ottawa; BJ 85), where he depicts the interaction of working vessels from both sides of the estuary and includes a naval guardship in the background. The Medway, which flows into the estuary, had its own set of historical, military, and commercial associations. The first engraving to be published after Turner, in the *Copper-Plate Magazine* (1794; R 1), was a picturesque (see SUBLIME) view of the cathedral city of Rochester on the Medway. In a later watercolour of Rochester (1822; British Museum; W 735), made for the *Rivers of England*, the Castle and Cathedral look ethereal compared to the workaday vessels in the foreground, which include a Thames barge carrying hay (its sail blocking much of the view of the town) and a prison hulk. A higher, panoramic viewpoint is used for the two views of the Medway in *Picturesque Views in *England and Wales*. One, *Chatham, Kent* (c.1830; private collection; W 838; R 262), shows the naval base with its fortifications and garrison of marines; Rochester is visible in the distance. The other view, *Rochester, Stroud and Chatham, Medway* (c.1836; destroyed; W 877; R 301), shows the relationship of the old city to the naval base from the opposite direction.

See also FISHING UPON THE BLYTHE-SAND; SHEERNESS; THAMES AND TRIBUTARIES. AK

Shanes 1979, 1990[2].

THAMES SKETCHES, 1805. A distinct body of work on canvas, on veneer, and in watercolour, unusual in Turner's early career for having been painted direct from nature; see Pl. 5. Over the years variously dated between 1804 and 1812, but most recently considered in detail (Hill 1993) to be the product of a single, sustained campaign in 1805 when Turner was living by the *Thames at *Sion (or Syon) Ferry House, Isleworth. The key works are all in the Turner Bequest in the *Tate Gallery. These include a group of eighteen oil sketches of subjects on the rivers Thames and Wey, unique in Turner's œuvre for having been painted on mahogany veneer, later laid on panel (BJ 177–94). In addition there is a group of fifteen canvases of Thames subjects, unusual for having been painted unstretched, probably pinned to a board (BJ 160–8, 171–6). These distinct series relate to a group of five sketchbooks (TB XC, XCIII, XCIV, XCV, XCVIII) datable to Turner's residency at Isleworth. These contain sketches made direct from nature in watercolour as well as in pencil and pen and ink, together with a large number of studies and compositions for classical and literary subjects linked by themes of water, rivers, and sailing. The Thames

subjects have proved to be of particular interest for their freshness, directness, and naturalism, but in the context of the sketchbooks these qualities can be seen to have been developed alongside their antithesis of high artifice and rhetoric.

Turner took a lease on Sion Ferry House late in 1804, and used it in 1805 before moving to the Mall at *Hammersmith in 1806. What prompted him to take it is unknown, but his domestic arrangements with regard to his father, the studio at *Harley Street, and their housekeeper Sarah *Danby and her children, will no doubt all have been factors. The news in 1804 that *Napoleon had a vast army poised at Boulogne ready to invade and march upon London must also have been a consideration. On top of this, fractiousness and rivalry at the *Royal Academy was turning to open hostility, and all-in-all it must have been a relief for Turner to escape to Isleworth after closing his exhibition at Harley Street at the beginning of July 1805.

The five sketchbooks that can be identified with his stay at Ferry House are 'Studies for Pictures Isleworth' (XC), 'Hesperides (1)' (XCIII), 'Hesperides (2)' (XCIV), 'Wey Guildford' (XCVIII), and 'Thames from Reading to Walton' (XCV). A new and much more complete list of contents was published by Hill (1993, pp. 159-71), where relationships between the books were explored, and their relationship to the oil sketches considered. In general, the first four (all bound) sketchbooks contain a mixture of topographical and classical material, as Turner fascinatingly slips between observation and reverie. The pages of the first three have been prepared with grey wash as if he imagined himself to be some grand Old Master setting out to work in the *Campagna. The last is a large roll-sketchbook (one with paper covers that might have been rolled up for easy portability) that was used to make pencil sketches and watercolours on a tour along the whole length of the Thames from Kew up to Oxford.

Subjects overlap from one sketchbook to another. Turner wrote his new address 'Sion Ferry House Isleworth' inside the front cover of 'Studies for Pictures Isleworth', and from there we can trace a sequence of itineraries, starting work in the immediate environs of Isleworth taking views from the house and wharf, and then exploring nearby Brentford and Kew, and later *Richmond and on upstream as far as *Windsor, the course of the River Wey, then finally making trips upstream as far as Oxford and downstream to the estuary and the Nore. A gradual increase in the ambition of these expeditions is apparent, and of the work that he attempted on them. This was dictated by his mode of transportation. We know that he had a small boat at this time, and the sketchbooks contain a number of drawings which give us

some idea of what it was like. In many we see a clinker-built dinghy of perhaps 14 or 16 feet (4.25 or 5 m.), with a single mast. In most we see him considering different arrangements of sail and even measuring up the yardage of canvas that might be required. It seems to have been sensibly cautious of him to have tried out his yachting skills in calm local waters before heading further afield, but eminently characteristic that he should so relatively soon have plucked up enough courage and confidence to hazard the dangers of the Thames estuary.

The key works in the sketchbooks are the numerous watercolours painted from nature. The 'Hesperides (1)' Sketchbook begins with a series of five studies at Isleworth and Brentford painted with the utmost verve and directness (XCIII: 42a, 11, 40a, 39a, 38a). Each is of transient weather effects of dark clouds giving away to glimmering skies. In two the compositions are overarched by rainbows. Each has been painted quickly, often working wet into wet, with bravura skill, control, and improvisation. Also in each are passing figures or boats that give the sketches an extraordinary sense of immediacy, the sensations of experience at their most vivid. These studies are paralleled by nine even larger and more complex watercolours in the 'Thames from Reading to Walton' Sketchbook (XCV: 12, 13, 33, 42, 45-9). Of these, three are unidentified, but the six remaining are all from the same topographical area as those in the 'Hesperides (1)' Sketchbook, that is Kew, Brentford, Isleworth, and Richmond. Likewise they also record passing effects but their mood is more tranquil, even transcendent, and formally suggest a much more leisurely pace of work. One (XC: 48) has been identified by Hill (1993, p. 51) as showing Sion Ferry House itself. In addition to these there is a number of similar-sized sheets outside the Turner Bequest, painted in a similar style and of similar subject matter, which might well be pages from the 'Thames from Reading to Walton' Sketchbook, albeit in most cases worked to a higher degree of finish (see e.g. W 412, 413, 416). Turner's watercolour sketches of Thames subjects culminated in terms of size with a roughly 2 × 3 ft. (61 × 91.4 cm.) study of *Syon House and Kew Palace* from near Isleworth (LXX: L). Despite the large size, the particularity of effect and the comparatively rough yet densely coloured paintwork suggests very strongly that it must have been made out-of-doors rather than in the studio.

The eighteen oil sketches on mahogany veneer in the Turner Bequest were painted on a boat trip from Isleworth to Windsor and then along the Thames tributary, the River Wey via Newark Priory (sometimes called *Newark Abbey) and Guildford to the limit of navigation on the river at Godalming. The same range of subjects is recorded in the 'Wey

Guildford' Sketchbook (xcviii), which must surely have been used on the same tour.

The panels are not prepared artists' materials. They are rough-edged and irregular in shape and size, suggesting that they were off-cuts from some prior purpose, and improvised by Turner as a surface on which he could work. One wonders, indeed, whether they might not have originated in the construction or at least adaptation of his boat. Whatever the case, the boat was important to their use, for painting in oils away from the studio would have required some ready conveyance in which to carry the necessary equipment. To a large extent the whole activity of painting in oils was inherently constrained to the studio before the mid-19th-century invention of collapsible metal tubes for ready-mixed paint. Before that, grinding and mixing oil paint for use was a laborious, studio-based process. In the late 18th century and early years of the 19th, however, colour merchants provided bladders of colour which could be packed in portable paint boxes and used relatively conveniently in the field. One such example of Turner's own can be seen at the Tate Gallery. Even so the handling of the paint, spirit, and oils, cleaning of brushes and palettes, and safeguarding the finished results would have presented quite a challenge, and would have been most straightforward when the artist had some conveyance which was in effect a travelling studio. In this case Turner had his boat.

The panels are all small, the largest measuring about 29 in. (73.5 cm.) wide and the smallest only a few inches, and in effect they provided Turner with a convenient, since readily portable and solid, surface on which to paint, ideal for working out-of-doors. He used some as they were, painting directly onto the wood. Most, however, were prepared with a ground, in some cases a thin coat of white primer, in others a thick chalky ground brushed so thick and dry across the grain that it set immediately, preserving every bristle-mark. All the surfaces were so absorbent that the oil was quickly sucked out of the paint leaving little or no time for adjustment and reworking. Thus every first thought was preserved and the result is a fascinating document of Turner battling with a combination of medium and support which simply did not allow the kind of preplanning and artfulness that he was accustomed to enjoying in the studio.

What prompted Turner's interest in painting direct from nature in 1805 is far from clear. Brown (1991) explores some precedents, in particular the interest of contemporaries such as William Havell and William *Delamotte, who both painted Thames subjects directly in oils at about the same time as Turner. Brown also describes the wider context of Turner's sporadic excursions into oil sketching at *Knockholt in about 1800, and later in *Devon, at *Cowes, and in

*Italy. The obvious comparison is with *Constable, who founded a great part of his practice on painting from nature. Turner never hints at making such a commitment. In the full context of his Thames work in 1805 it seems, rather, more a part of his exploring painting practice across the whole range of possibilities in the equation of nature and art.

The series of fifteen canvases (BJ 160–8, 171–6), all but one roughly 3 × 4 ft. (91.4 × 122 cm.), represents some of the most ambitious painting from nature of Turner's entire career. Eight Thames subjects can be positively identified, painted on a sailing tour up the river from Richmond to the vicinity of Oxford. This is exactly mirrored by the tour represented in the 'Thames from Reading to Walton' Sketchbook (xcv). Four other canvases are unidentified, but are also likely to be Thames subjects; of the remaining three, two are Thames estuary subjects and the other is of Margate. Given the lack of definite links to the 1805 sketchbooks, Hill (1993, p. 174 n. 83) was uncertain whether to date the last three with the rest of the group. In addition two canvases included by Butlin and Joll with the rest of the group (BJ 169, 170) are now thought to be studio works (see Hill 1993, p. 62, pl. 74, p. 128, pl. 187, and p. 174 n. 80).

The Revd H. S. *Trimmer, whose father was a close friend and neighbour of Turner when at Isleworth and Hammersmith, told *Thornbury (1867, i. p. 169): 'From his boat he painted on a large canvas direct from Nature. Till you have seen these sketches you know nothing of Turner's powers. There are about two score of these large subjects, rolled up and now national property.' They have all now been stretched and framed, but they were originally painted as primed but unstretched sheets, which were probably pinned to a board as required and then folded (since most have a prominent central crease) when finished. In the confines of a small boat the attempt to manage such large canvases must be regarded as somewhat ambitious, and it seems at the very least that Turner must have enjoyed a prolonged period of settled weather, as indeed he did in September and October 1805.

One is forced to wonder, however, what was the real purpose of these sketches. In most the paint is used thinly and transparently as if it were watercolour. None, however, seems ever intended to have been viewed as it was. The quality of the paintwork is positively dashed, as if it were conceived as underpainting, done in the knowledge that it would not have to satisfy scrutiny, since it would subsequently be covered by more controlled and presentable finish. The process did, however, allow Turner to capture some exciting particular moments such as the sun lifting from Cliveden Reach in *Barge on the River* (BJ 168), and occasionally to work relatively tightly, as in *Goring Mill and*

Church (BJ 161). Overall, however, one has the clear sense of Turner roughing out compositions for later development. It is possible that some of the many Thames canvases that he exhibited in later years, such as *Union of the Thames and Isis* (BJ 70), might well have begun in this way. Whatever the case, the new naturalism of Turner's practice had a major effect on his work, and he exhibited some of the results. It was not to everyone's taste. When Benjamin *West visited Turner's gallery in 1807 he 'was disgusted with what he found there, views on the Thames, crude blotches, nothing could be more vicious'.

Most reports have been more enthusiastic and, given Trimmer's enthusiasm for the oil sketches, it is remarkable how long they languished among the lumber of the Turner Bequest. It was not until about 1910 that the canvases were unrolled, mounted, and put on display. As *Finberg (1961, p. 137) noted:

They are certainly the most important group of oil paintings which Turner made direct from nature, and with a few examples, they are the only oil paintings of this kind that he ever made. When they were first exhibited, a little more than a hundred years after they had been painted, the public and critics of the day were surprised to find that Turner's realistic rendering of light and atmosphere were not only more truthful and convincing, they were also more instantaneous, more vivid and dextrous, than those of modern artists who had devoted their lives to direct painting in the open air.

Up to the publication of this *Companion*, however, neither series has been exhibited together in its entirety, still less in the context of the sketches. Currently the oil sketches on mahogany are displayed in heavy gilt frames, which suggest a degree of pomposity completely inappropriate to their fresh and fragile spontaneity, while the sketches on canvas are scattered to various rooms of the Clore Gallery. They must surely deserve more focused and sympathetic presentation.

See also OPEN AIR, WORK IN; SKETCHES, USE OF. DH

Gage 1969², pp. 22–6, 39.
Gowing and Conisbee 1980, pp. 32–3.
Brown 1991.
Hill 1993.

THOMSON, James (1700–48), subtle poet of man, landscape, weather, and other natural phenomena. He was the writer closest in spirit to the early Turner, and also influenced his later ideas and images. In his 'Georgics', *The Seasons*, he celebrated clouds, mountains, dawns of 'fluid gold', and the moral influence of Nature on man. For his love of the Thames, *inter alia*, Turner pays him direct homage in *Thomson's Aeolian Harp* (Turner's gallery 1809; City Art Galleries, Manchester; BJ 86): the Seasons dance before a lyre on a pedestal inscribed with Thomson's name, overlooking the *Thames at Richmond; this was shown at Turner's gallery together with a poem by Turner in his catalogue describing Thomson's 'enraptured eyes' responding to the 'resplendent seasons'. *England: Richmond Hill* (RA 1819; BJ 140) adduces lines from *Summer* about the vicinity and the river.

Apart from Turner's own *Fallacies of Hope* (see POETRY AND TURNER), Thomson is the most frequent source of his epigraphs, seven quotations appearing in the *Royal Academy catalogues. Thomson often describes light and the 'penetrative', world-reviving power of the sun; Turner quotes passages to suit weather and the time of day: in 1798 *Dunstanborough Castle* (National Gallery of Victoria, Melbourne; BJ 6) carried lines about dawn after storm; *Buttermere Lake* (BJ 7) a description of a rainbow, 'illumin'd mountains', and 'effulgent' sky before sunset; *Fountains Abbey* (York City Art Gallery; W 238) lines about evening shadows; and *Norham Castle* (private collection or Cecil Higgins Art Gallery, Bedford; W 225 or 226) a favourite passage about the dawning 'King of Day' (quoted again in Turner's *perspective lectures). Misquotations in the epigraphs suggest that Turner quoted from memory. To *Warkworth Castle* (RA 1799; W 256) and *Frosty Morning* (RA 1813; BJ 127) were applied Thomson's lines describing thunderstorm and melting frost. The lines in Turner's first quotation from his *Fallacies of Hope*, the epigraph to *Snow Storm: Hannibal* (RA 1812; BJ 126) about the 'fierce archer of the downward year', are adapted from Thomson's *Winter*, 11. 41–5; the phrase 'fallacious Hope' appears in *The Seasons*.

Thomson describes in *Liberty* the evolution of civilization towards perfection in the British system. Part I, whose subtitle is 'Ancient and Modern Italy Compared', laments the 'melancholy change' of the landscape at Baiae, now desolate with ruins and a nest for serpents, as Turner shows it in *The *Bay of Baiae* (RA 1823; BJ 230). *Liberty*, Part v, describes *Carthaginian decline and fall through luxury. Turner's pairs of paintings of 1838 and 1839 contrasting ancient and modern Rome and Italy reflect, particularly *Modern Italy* (RA 1838; Glasgow Art Gallery; BJ 374), Thomson's contempt for contemporary 'idiot superstition' and his belief that the 'ecclesiastical tyranny' is worse than political tyranny.

*The *Fountain of Indolence* (RA 1834; Beaverbrook Art Gallery, Fredericton, New Brunswick; BJ 354) pictures an allegorical subject from Thomson's mock-Spenserian *Castle of Indolence* where, amid gardens and a Palace of Art and around a fountain spouting the 'drizzly dew of Nepenthe', the sybaritic and indolent escape from reality in 'artful phantoms', steeping themselves in 'sorrowful oblivion', until the Knight of Art and Industry is to come and raze

all to the ground. *Slavers (RA 1840; Museum of Fine Arts, Boston; BJ 385) has a typhoon, sharks, and storm described in Summer, where Thomson eloquently attacks the cruelty of the trade. JRP

Livermore 1957.
Ziff 1964.
Lindsay 1966, pp. 56–64, 104–5, 118–21, 139–41, 189–90, 207.
Gage 1969, pp. 135, 145.
Wilton and Turner 1990, pp. 53–61.

THOMSON'S ÆOLIAN HARP, oil on canvas, 65⅝ × 120½ in. (166.7 × 306 cm.), Turner's gallery 1809 (6); City Art Galleries, Manchester (BJ 86). Exhibited with 32 lines of verse dedicated 'To a gentleman at Putney, requesting him to place one in his grounds'. There are six earlier drafts containing many variations in Turner's verse-book. *Thomson's An Ode on Aeolus's Harp was published in 1748 while other possible sources are Thomson's Summer and William Collins's Ode ocasion'd by the death of Mr. Thomson (1749).

An Aeolian harp, named after Aeolus king of winds and storms, produces sounds when wind blows through its strings. The harp stands on the poet's grave (inscribed 'THOMSON' on the pedestal) which is being decorated by nymphs, while the figures on the right may represent the seasons.

The composition recalls that of the *Festival . . . of Macon (RA 1803; Sheffield City Art Gallery; BJ 47), both deriving from Lord *Egremont's *Claude of Jacob, Laban and his Daughters. Here, however, Claudian elements are fused with a more freshly observed landscape than in Macon and containing recognizable buildings on the Thames at Richmond, where Thomson lived shortly before his death.

James *Morrison (1789–1857) bought this and *Pope's Villa (Turner's gallery 1808; BJ 72) but in what order is not known. EJ

THORNBURY, (George) Walter (1828–76), Turner's first biographer. Although he had studied art, Thornbury became a prolific journalist, author, and poet, who could turn his hand to many subjects. He lived in Gloucestershire and wrote first for the Bristol Journal (1845), latterly becoming art critic for the *Athenaeum, and a contributor to many other periodicals.

By c.1858, when he fixed on Turner as a subject for biography, Thornbury was about 30 and already the author of dozens of magazine articles, many of which he had collected in book form. His early titles include Monarchs of the Main (1855) and Shakspere's England (1856). There is nothing here to suggest an abiding engagement with biography or with Turner himself, whom he does not appear to have had the interest to seek out while he still could. Nevertheless, as

he wrote in the preface to Life and Correspondence of J. M. W. Turner (1862), he asked for *Ruskin's advice and clearance before beginning his task. Thereafter he claimed to have 'let no day pass without some search for materials, some noting down of traditions, some visit to Turner's old friends'. However, he did not have his eye fixed unwaveringly on Turner, for during this same period he wrote widely, with more than 30 long articles in Dickens's Household Words and All the Year Round on miscellaneous subjects, and saw five books through the press. His style of journalism, notable also in his Turner biography, is prolix and patronizing, but is also engaging in its breathless chatter.

That he had genuine regard for Turner and his achievements is clear from the beginning—he referred to 'that great magician Turner' in a letter to John *Pye (?1860; National Art Library, Victoria and Albert Museum, 86.FF.73). As urged by Ruskin, he strove to present a balanced picture of the artist, without masking the 'dark' side, and claimed to have 'no motive whatever to warp me'. Despite Thornbury's assertion that he sought information from many of Turner's contemporaries, including *Griffith, *Jones, *Mayall, *Munro, Pye, and David *Roberts, his Life and Correspondence is riddled with inaccuracies and dubious claims, and suffers greatly from repetition, contradiction, irrelevancies, and poor editing. Clearly, given his other literary endeavours, Thornbury was not sufficiently attentive to his text. As a result, the book was heavily criticized by many of Thornbury's sources, and was hounded by critics and later biographers, from Lady *Eastlake in Quarterly Review (III, 1862, pp. 405 ff.), to *Falk, *Finberg, and *Lindsay. Nevertheless, Life and Correspondence was reissued in 1877, 1897, and 1970, and is one of the few near-contemporary sources for Turner that exists. It is as widely quoted as it is reviled. Following its publication, Thornbury did not venture into art or biography again. JH

Falk 1938, pp. 17–20, 115–16, 234–9.
Hamilton 1997, pp. 333–8.

TIMES, THE, founded in 1785 as the Daily Universal Register, becoming The Times in 1788. Although, like most daily newspapers, it reported the arts only sporadically, favourable notices of Turner are to be found even before 1823 when the paper decided to increase its coverage. Some reviewers found fault, of course. Turner's attempt to paint the sun in Scene in Derbyshire (RA 1827; untraced; BJ 240) was 'as usual, ludicrously unsuccessful' (Supplement, 11 May 1827). Bacchus and Ariadne (RA 1840; BJ 382) represented 'nothing that ever existed in nature, and scarcely anything that the most distorted imagination ever conceived

without it' (6 May 1840). One particularly fine example of that 'kitchen imagery' so prevalent in Turner criticism appeared in a review of *Schloss Rosenau (RA 1841; National Museums of Merseyside, Liverpool; BJ 392): 'Here is a picture that represents nothing in nature beyond eggs and spinach. The lake is a composition in which salad oil abounds, and the art of cookery is more predominant than the art of painting' (4 May 1841). *Ruskin, aware of the 'eggs and spinach' analogy, told Samuel Prout that he wrote *Modern Painters* in response to the 'paid novices' of *The Times* and *Blackwood's* (*Works*, iii. p. 277 and xxxviii. p. 336). But if some reviewers saw only extravagance and absurdities, others saw magic and magnificence, even in Turner's later period: 'To do justice to Turner, it should always be remembered that he is the painter, not of reflections, but of immediate sensations' (6 May 1845). A thoughtful and poignant encomium appeared in *The Times* the day after Turner's funeral (31 December 1851). JCI

TINTERN. The great Cistercian abbey on the banks of the River Wye had been singled out by William *Gilpin as especially Picturesque (see SUBLIME), and throughout the 1780s and 1790s it was the subject of topographical and picturesque views galore. *Wordsworth's 'Lines Written a few Miles above Tintern Abbey' (1800) was soon to associate the ruin with the most intense *Romantic communion with nature. Turner, following *Dayes, Hearne, and others, had drawn it in 1792 and made various versions of a watercolour subject, derived from Dayes, showing the interior of the ruins in a strongly upright format (RA 1794, and c.1794–5; Victoria and Albert Museum, Ashmolean Museum, Oxford, and British Museum; W 57–9; and TB XXIII: A), and another of the west front (c.1794–5; British Museum, and Fundaçao Calouste Gulbenkian, Lisbon; W 60, 61). He revisited Tintern on his way into *Wales in 1798, and a more distant view was finished for Sir Watkin Williams Wynn towards the end of the decade; this is now very badly faded. AW

Wilton 1984, pp. 35, 41.

TITIAN (Tiziano Vecellio, c.1486/90–1576) was an unusually strong influence for an artist primarily known for his landscapes; this influence stresses Turner's determination to place himself in the line of the classical Masters. Nor was it Titian's landscapes that were the primary influence on Turner; rather his colour, figure style, and compositional practices. Turner's first intensive study of Titian is found in the 'Studies in the Louvre' Sketchbook of 1802 (TB LXXII), including both copies and long descriptions of '*Titian and his Mistress*', *The Entombment*, *Christ crowned with Thorns*, and the *Concert Champêtre*. The most important

influence however was that of the *St Peter Martyr*, looted by Napoleon from SS. Giovanni e Paolo in Venice and since destroyed (see PARIS, LOUVRE).

The composition of this, with the figures anchored by the placing of the trees immediately behind them, lay behind both Turner's *Holy Family* (RA 1803; BJ 49) and *Venus and Adonis* (c.1803–5; private collection, South America; BJ 150), an early sketch of the former (LXXXI: 63) sharing the upright composition of the latter; subsequently Turner switched to an oblong format close to Titian's *Holy Family and a Shepherd* then in the collection of W. Y. Ottley and now in the National Gallery, London, and used the upright composition for *Venus and Adonis*.

Turner's visits to Italy in 1819 and 1828 renewed his contacts with works by Titian still in their home country, such as the *Sacred and Profane Love* in the Villa Borghese in Rome. On his second visit to Rome he paid deliberate tribute to Titian in the unfinished *Reclining Venus* (BJ 296), based on the *Venus of Urbino*, which he would have seen in the Uffizi in Florence that September; this may just possibly have been the first candidate for the work painted in Rome for Lord *Egremont in that it also shows features taken from *Hoppner's *Sleeping Venus and Cupid* at *Petworth. On the same visit Turner painted *Vision of Medea* (BJ 293), based on the same compositional formula as Titian's *St Peter Martyr*. Two further paintings painted in Rome in 1828 and influenced by Titian seem to be those now entitled *The Rest on the Flight into Egypt* and, tentatively, *Judith with the Head of Holofernes*, the latter perhaps in *collaboration with *Eastlake (BJ 153, 152, formerly dated ?c.1805 and called 'The Finding of Moses' and 'The Procuress?'; see Wilton 1989, pp. 28–33, both repr.).

In 1840 Turner exhibited another direct tribute to Titian, *Bacchus and Ariadne* (BJ 382), much smaller and lacking the grandeur of Titian's original, by then in the National Gallery, and perhaps a response to Charles Lamb's praise of Titian in an essay of 1833 (see Charles F. Stuckey, 'Temporal Imagery in the Early Romantic Landscape', University of Pennsylvania dissertation 1972, p. 182). The subject matter of three important Titians in England may also have influenced Turner: *The Rape of Europa* now in the Gardner Museum, Boston, on the *Liber Studiorum frontispiece and its late derivative of c.1845, *Europa and the Bull* (Taft Museum, Cincinnati; BJ 514), and *Diana surprised by Actaeon* (Duke of Sutherland, on loan to the National Gallery of Scotland, Edinburgh), and *The Death of Actaeon* (National Gallery, London) on the unfinished *Mountain Glen, perhaps with Diana and Actaeon* of c.1835–40 (BJ 439). MB

Gage 1969, pp. 60–2, 91, 140–2.

Gage 1987, pp. 60, 79–81, 95, 100–1, 114–15, 169.

Powell 1987, pp. 65–7, 70, 143, 158, 193.
Butlin, Luther, and Warrell 1989, pp. 53–5.

TOKYO EXHIBITION, 1986, see BRITISH COUNCIL EXHIBITIONS.

TOMKINSON, Thomas (?1764–1853), sometimes known as Thomas Tomkinson, piano maker in Soho and connoisseur, who collected Turner watercolours from at least 1822. He was a well-known eccentric, often confused with his father, the silversmith and jeweller Humphrey Tomkinson. Tomkinson sen. lived a few doors along Maiden Lane from Turner's father, and Tomkinson jun. liked to relate the story that his father was the first to recognize Turner's juvenile talent. The young Turner had copied a coat of arms from a silver tray, much to Humphrey Tomkinson's incredulity. Thomas Tomkinson also claimed that it was his father who encouraged William Turner to apprentice the young artist to *Malton. Thomas Tomkinson owned an outstanding group of Turner watercolours for *Picturesque Views in *England and Wales*: *Launceston, Cornwall* (private collection; W 792), *Lancaster Sands* (British Museum; W 803), *Malmesbury Abbey, Wiltshire* (private collection; W 805), **Dunstanborough Castle, Northumberland* (Manchester City Art Gallery; W 814), *Cowes, Isle of Wight* (private collection; W 816), and **Windsor Castle, Berkshire* (British Museum; W 829). As these were all exhibited at the *Moon, Boys, and Graves exhibition of 1833, it seems likely that it was here that Tomkinson bought them. He did not own any of the later, unexhibited sheets from the series.　　　　　　RU

TRAINING AND APPRENTICESHIP. Edward *Dayes's assertion that Turner began 'without the assistance of a master' needs substantial qualification, for while he owed his many skills to no single teacher, he benefited from a number of professional contacts, even before his formal studies at the *Royal Academy Schools. His earliest job seems to have been colouring prints for John Raphael Smith at 2*d*. a plate, while his friend J. T. *Smith recorded similar work for the publisher Paul *Colnaghi. While these can have been no more than casual opportunities to earn some money, doubtless encouraged by his father who was keen to foster his son's fondness for drawing, and facilitated by the proximity of his Covent Garden home to London's network of artists and engravers, they nevertheless provided access to the work of more established draughtsmen, and useful introductions.

The nearest Turner received to any formal training as a youth was in the field of architecture rather than art. In 1789 he took a job in the drawing office of Thomas Hardwick (1752–1829)—with whom he shared relatives in business in Brentford—making watercolours of buildings under construction, and progressed later that year to the studio of the architectural topographer Thomas *Malton. Whether or not Turner had originally considered the architectural profession itself, the experience was invaluable for his own practice of topographical watercolour as well as for its insights into how buildings were made. From the end of 1789, when he entered the RA Schools, Turner developed his career as a draughtsman and watercolourist in tandem with his formal studies and, his student status notwithstanding, soon claimed a certain professionalism and reputation. Having assimilated Malton's style, he sought other examples among watercolourists with a less pronounced architectural bias and an interest in picturesque landscape, such as Michael Angelo Rooker (1743–1801), and turned his attention to the recent explosion in topographical publication and its opportunities. His proposal to launch himself as engraver and publisher of twelve of his own views of the River Avon in 1791 showed a grasp of the contemporary market somewhat in advance of his skill, but in 1793 he won the first of a series of topographical commissions from one of the most successful operators in the field, John Walker, in whose *Copper-Plate Magazine* 32 of his views would appear between 1794 and 1798.

Meanwhile with his friend *Girtin he had begun to benefit from the friendship of Dr *Monro, meeting with other artists in his house on Friday evenings to study and copy in a collection that included Old Master drawings and prints, and watercolours by J. R. *Cozens, *Dayes, and other recent and living artists. *Farington recorded their copying activities, Girtin drawing outlines and Turner 'washing in the effects' for which he was paid '3*s*. 6*d*. each night' (*Diary*, 12 November 1798). Although Girtin and Turner developed at first in parallel, from common roots, their styles soon diverged, Turner displaying in the later 1790s an increasingly distinctive style which, as he told Farington, now avoided practices 'generally diffused' that tended to produce 'manner and sameness' (*Diary*, 16 November 1799). Of technical skills older watercolourists like W. F. *Wells could now teach him nothing, but they could widen his horizons in other ways by showing him their collections, as Monro had done. The rich or aristocratic patrons who were already commissioning his watercolours were even more important in this respect, their private galleries supplying the need for study collections in the absence of a public one.

When Turner took up oils in the mid-1790s, he depended largely on his own researches into technique and his examination of other pictures, Academy training then consisting mainly of drawing. Having gained admission on presentation of a drawing after an antique sculpture, students

progressed through a total of six years first in the Antique or Plaster Academy and then in that of Living Models. The associated lectures were biased towards theory, and it was the Professor of Painting himself, James *Barry, who in 1796 declared that the RA was 'but a drawing school'. Turner's studentship coincided with an unhappy phase, Barry's criticisms of his own institution, which led to his dismissal in 1799, being only one symptom of a malaise following the death of *Reynolds; the expulsion and demotion of a number of students, also in 1799, led others to leave in disgust, while the fact that the President, *West, operated his own school, was an indication that the RA could not provide all the instruction required. Students were obliged to fend for themselves, and while there is no evidence for an old story that Turner copied pictures in Reynolds's studio before his death in 1792, he did gain some benefit from Reynolds's own student *Hoppner, and rather more from de *Loutherbourg, whose sound if slick techniques were much admired.

While de Loutherbourg's Continental polish can be seen in Turner's first exhibited oil, *Fishermen at Sea* (RA 1796; BJ 1), the robust, indigenous handling of Richard *Wilson proved most fruitful for his early development as an oil painter. He made a systematic study of his pictures and painted some pastiches; and his Wilsonian investigations, together with an application of Wilson's classicizing composition to his own landscape sketching or studies for pictures can be seen in his 'Wilson' Sketchbook of 1797 (TB xxxvii). Pictures by Old Masters were studied concurrently in patrons' houses or the London salerooms, the Orléans sales in 1796 providing important opportunities. His ambition to emulate the masters was encouraged, and with the Peace of Amiens in 1802, a consortium led by the Earl of *Yarborough funded a visit to the Louvre, the resulting observations filling his 'Studies in the Louvre' Sketchbook (LXXII; see PARIS, LOUVRE).

Turner by now enjoyed high status. He was entering his first maturity as a painter and was widely assessed as the outstanding young artist of his generation. His formal transition from student to professional—in practice already established—was confirmed by his election as ARA in 1799 and full RA in 1802. His success reflected both his high standing, and his assiduous lobbying and cultivation of senior colleagues like Farington. His Diploma picture—the work presented by all new Academicians to the RA—was *Dolbadern Castle* (RA 1800; Royal Academy, London; BJ 12).

DBB

Gage 1969, pp. 18–41.
Gage 1987, pp. 21–37.
Wilton 1987, pp. 20–48.

TRAVEL played an essential part in Turner's life, supplying vital material for his topographical work and nourishing the imaginative processes behind his historical and poetical paintings. With a few notable exceptions—chiefly in the case of commissioned watercolours of *biblical subjects set in the *Holy Land or showing such countries as *Greece and *India—Turner's paintings and watercolours depict places he had actually seen for himself. His belief that first-hand experience was crucial to his profession as a landscape painter led him to be an inveterate and energetic traveller for over 50 years, in fair *weather and foul and taking little heed of dangers and *disasters except to store them in his mind for use in future paintings. From his boyhood in the early 1790s through to his gradual decline in the second half of the 1840s, he regarded the arrival of summer and the closing of the *Royal Academy exhibition as the signal to depart on a sketching tour in order to garner as much material as possible in his *sketchbooks. He would be back in London by early October and from then until the following April he would remain chiefly at home, using his hoard of data to produce works for exhibition and on commission. Only rarely did he deviate from this annual routine and only once did he produce finished paintings while on his travels. In *Rome in 1828 he produced three oil paintings which he then exhibited there, but he then had such difficulty in sending them back to England that he was discouraged from ever repeating the experiment.

Owing to the outbreak of war between France and Britain in 1793, Turner's earliest tours were confined to England, *Wales, and *Scotland; all of these he explored enthusiastically in the 1790s when the vogue for tours in search of the Picturesque (see SUBLIME) was at its height. Like scores of other Britons, he took advantage of the Peace of Amiens of 1802 to make a tour of the Continent that enriched his art in every way. He enjoyed his first experience of the inexhaustible natural grandeur of the *Alps, which was to inspire him all his life, and he spent many hours studying the equally sublime peaks of artistic endeavour in the art collections of *Paris, at this time enriched by all the world-famous treasures which *Napoleon had recently seized from Italy. With the resumption of hostilities in 1803 Turner's movements were once more restricted and he did not cross the Channel again until 1817. Thereafter he was a frequent and wide-ranging traveller to the Continent until 1845, reaching south as far as Paestum in *Italy (1819), north to *Denmark (1835), and east to the capital of *Austria, Vienna (1833 and 1840).

However, Turner also continued to travel within Britain all his life, for work and pleasure, when burdened by domestic anxieties (e.g. over his father's health) or when the

political situation made long journeys inadvisable (e.g. in 1830, a year which saw uprisings and revolts in several parts of Europe). Two patrons who were also friends—Walter *Fawkes (1769–1825) of Farnley Hall in *Yorkshire and the third Earl of *Egremont (1751–1837) of *Petworth House in Sussex—offered Turner an especially warm welcome and a 'home from home'. Besides his well-known sojourns with them, he must have paid many further visits that went unrecorded, and the same may be true of his other friends and patrons scattered throughout Britain such as H. A. J. *Munro of Novar in Scotland, James *Holworthy of Hathersage in Derbyshire, and Sir Willoughby and Lady *Gordon on the *Isle of Wight. During his final years Turner's travels were increasingly hampered by ill health and were confined to visits to Margate, easily reached by boat from London down the Thames, and to Deal and *Folkestone.

Turner was never an enthusiastic or prolific correspondent and his travels seem to have inspired a regrettably small number of letters; there must, of course, have been accidental losses and almost certainly a fair amount of deliberate destruction on the part of both Turner and his correspondents. However, some of the meetings and incidents that occurred on his travels were mentioned or described in letters composed years afterwards, back home in England; the capsizing of his coach in a snow storm on the Mont Cenis pass on 15 January 1820 was vividly recalled almost six years later, in a long and rambling thank-you letter for a Christmas turkey written in January 1826 (Gage 1980, p. 97). During his tours Turner was too busy travelling and sketching (and perhaps simply too disorganized) ever to keep a proper diary. The account of a Welsh tour in the 1790s, once believed to be written by Turner and published with his correspondence (Gage 1980, pp. 10–19), has long been discredited; other, indisputably genuine, attempts at keeping a diary, such as that begun in August 1819 ('Paris, France, Savoy 2' Sketchbook, TB CLXXIII: 1v), petered out almost immediately. Very occasionally Turner summarized his itinerary, with dates, in one of his *sketchbooks (as in the 'Itinerary Rhine Tour' Sketchbook, used in 1817, CLIX: 100r., and 'Rivers Meuse and Moselle' Sketchbook, used in 1824, CCXVI: 270r.) but his sketchbooks and the drawings themselves are very rarely dated.

In the first edition of the first biography of the artist (1862, i. pp. 197–8) Walter *Thornbury attempted a skeleton chronology of Turner's destinations, based on the subjects he exhibited at the RA, but knowledge of Turner's movements has increased dramatically since then, showing Thornbury's list to be deficient in both accuracy and scope: he postulated only about half the number of tours now known to have been made and he had no interest in Turner's itineraries. Scholarship in the late 20th century (see PUBLICATIONS) has gradually built up a much fuller and more detailed picture through a variety of methods and sources: close scrutiny of the notes and drawings in Turner's sketchbooks for help in dating as well as identification of subjects; accounts of *witnesses to his behaviour abroad by friends or strangers; newspaper reports of his arrival or departure in Continental towns where visitors were frequently required to register their name, city of origin, profession, and hotel with the authorities. A summary of Turner's more substantial travels, as currently known, is set out below:

1791	West of England
1792	West of England, South Wales
1794	English Midlands, North Wales
1795	South Wales, Isle of Wight
1797	North of England
1798	Wales
1799	Lancashire, North Wales
1801	Scotland
1802	France, Switzerland, Val d'Aosta
1808	North of England
1811	West of England
1813	West of England
1816	North of England
1817	Low Countries (including Waterloo), Germany (Rhine)
1818	Scotland
1819	Italy (Venice, Rome, Naples, Florence)
1821	France (Paris, Seine)
1822	Edinburgh
1824	Belgium (Meuse), Luxembourg, Germany (Mosel), northern France (Dieppe)
1825	Holland
1826	Northern France (Normandy, Brittany, Loire)
1827	Isle of Wight
1828	Italy (Rome)
1829	France (Paris, Seine)
1830	English Midlands
1831	Scotland
1832	France (Paris, Seine)
1833	Germany, Austria, Venice
1834	Scotland
1835	Denmark, Germany, Bohemia
1836	France, Switzerland, Val d'Aosta
1837	France (Paris, Versailles)
1839	Belgium (Meuse), Luxembourg, Germany (Mosel)
1840	Germany, Venice, Austria
1841–4	Annual visits to Switzerland

1845 Northern French coast
1845–50 Several visits to English coast (Kent)

Turner prepared for his travels very diligently: buying and reading up-to-date guidebooks and phrasebooks and sometimes copying out useful passages from them into his sketchbooks; consulting experienced friends and acquaintances; studying, borrowing, or copying maps and road-books. He owned volumes of historical interest which may well have been pressed on him by learned patrons (e.g. John Henley's *The Antiquities of Italy*, 2nd edn., 1725; Sir Richard Colt *Hoare's *Hints to Travellers in Italy*, 1815) and bought small pocket guidebooks filled with practical information, including Alois Schreiber's *The Traveller's Guide down the Rhine* (1818), H. A. O. Reichard's *Itinerary of Italy* (1818), and Mariana Starke's encyclopaedic *Information and Directions for Travellers on the Continent* (7th edn., 1829). In the 1830s he consulted (and may well have owned) the earliest Continental guidebooks published by John *Murray, those to northern and southern Germany (1836, 1837). Several of Turner's books and maps bear pencil annotations and tiny sketches which can sometimes be related to specific tours. His interleaved copy of Nathaniel Coltman's roadbook, *The British Itinerary or Travellers Pocket Companion throughout Great Britain*, is so crammed with notes and pencil sketches made on the 1811 tour of the West of England (together with historical-cum-philosophical verses on the sites he visited) that it was actually classified as one of the sketchbooks in the Turner Bequest ('Devonshire Coast No. 1' Sketchbook, CXXIII).

Turner always travelled economically and he also travelled light. His sketchbooks usually had flimsy paper covers and the larger ones could be rolled up to fit into his pockets (some were bound in boards with leather spines and corners after his return home). He made himself a tiny paintbox for making watercolours on his travels by sticking cakes of colour into the leather covers of an almanac. He was also the proud owner of an umbrella with a dagger concealed in its handle, a useful travelling accessory in countries like Italy where brigands still prowled near unfrequented roads. But however thoughtful his preparations, he was apparently a rather slapdash traveller. On his 1817 tour to the *Rhine he lost a knapsack containing clothes, books, and vital sketching materials and in 1829 Clara *Wells, who had known him from childhood, maintained that he was the most careless person she knew, invariably losing more than half his baggage on every tour he made. Turner's 300 or so extant sketchbooks may be well short of the total he actually used, and the artist's own carelessness may be the reason for the surprising lack of coloured drawings from tours which

might reasonably be expected to have stimulated some: his 1825 visit to *Holland, for example, and the *German tour of 1835. On several tours he acquired sketchbooks abroad, containing *paper much inferior to what he was in the habit of buying at home; on these occasions he had presumably either miscalculated his needs or failed to take care of his luggage.

Throughout his life many of Turner's tours were financed by his patrons or the bookseller-publishers who commissioned work for engraving, but this was probably not always the case. On some tours he may have travelled like a gentleman, while on others he would have roughed it and passed unnoticed among the crowds. His 1802 tour of France and Switzerland was sponsored by three noblemen including the Earl of *Yarborough, who acted as referee for Turner's first passport and became the first owner of an important work deriving from the tour, *The *Festival upon the Opening of the Vintage of Macon* (RA 1803; Sheffield City Art Galleries; BJ 47); another of the sponsors was the Earl of *Darlington, who provided Turner with a suitable travelling companion who took charge of all the practical arrangements, Newbey Lowson of Witton-le-Wear in Co. Durham. On the whole Turner avoided having *companions on his travels, but he sometimes made exceptions in the case of special friends or patrons. His Continental tours of 1833 and 1836 were both financed by H. A. J. *Munro of Novar, who actually accompanied him on that of 1836, at Turner's own suggestion.

Turner's lifetime coincided with an age that saw a revolution in methods of transport and patterns of travel, with the building of many new roads and *canals and the advent of the *railway and *steamboats. He himself used every available method of conveyance on land and water, recording all manner of carriages and boats and their users in his sketchbooks and often introducing them as a focal point in his paintings. He was an indefatigable walker, even in his later years, and an intrepid sailor but a reluctant horseman (though he did spend seven weeks on horseback exploring Wales in 1798). The laboriously slow pace of 18th-century travel, whether in a horse-drawn vehicle or in a boat gliding slowly on a river, had many advantages, enabling Turner to absorb the essential nature of the landscapes through which he travelled and to make numerous sketches of their ever-changing features as he was carried past them. However, he was fascinated and inspired by the new-found speed of the 19th century in all its guises, evoking it or commenting on it in paintings as diverse as *The *Fighting 'Temeraire', tugged to her Last Berth to be broken up* (RA 1839; National Gallery, London; BJ 377), *Snow Storm—Steam-Boat off a Harbour's Mouth* (RA 1842; BJ 398), and *Rain, Steam, and

Speed—the Great Western Railway (RA 1844; National Gallery, London; BJ 409).

There are many paradoxes in the relationship between Turner's travels and his art. One is that he did not always undertake fresh tours in order to fulfil a topographical commission, but would sometimes make use of sketches he had made years—or even decades—earlier: although the *England and Wales* series of *c*.1825–38 ostensibly provides a portrait of modern Britain, about 30 of the watercolours are actually based on sketches Turner had made on his tours in the 1790s. Furthermore, the amount of time the painter spent in a particular place bore no relationship to the degree of inspiration he found there and the number of works it subsequently stimulated. This is most strikingly shown in Turner's paintings of *Venice, almost as if the act of painting the city in his later years was a sublimation of a passionate desire to see Venice, serving as a substitute for the travels he could no longer make.

In both his own day and ours, Turner's travels have inspired many to follow in his footsteps, whether literally or in spirit. He contributed hundreds of topographical scenes for engraving in a variety of publications, ranging from small 'annuals' and books of poetry and prose to sumptuous volumes designed for the armchair traveller, such as the *Southern Coast of England* or *Hakewill's *Picturesque Tour of Italy*. He thus made a major contribution to the growth of popular travel in the 19th century, stimulating countless Britons to set forth in search of natural beauty and artistic and spiritual enlightenment. The greatest and most influential of these was, of course, *Ruskin. CFP

TRIBUTES TO OTHER ARTISTS. A great many of Turner's works assimilate the imagery, style, and/or technique of other artists but usually we have no way of ascertaining whether such images were intended to double as acts of homage to those predecessors and contemporaries. However, by means of his subjects, titles, and the timing of works Turner did occasionally pay specific tribute to painters of the past and present.

The first of these open acclamations was exhibited at the *Royal Academy in 1820. This was *Rome, from the Vatican. Raffaelle, accompanied by La Fornarina, preparing his Pictures for the Decoration of the Loggia* (BJ 228), which shows Raphael standing next to his mistress, surrounded by paintings and *objets d'art*, and looking up at the ceiling he would so famously adorn. As 1820 was the tercentenary of Raphael's death, we can safely surmise that an act of homage was intended.

Turner exhibited paintings depicting a fictitious 'Port Ruysdael' at the RA in 1827 (Yale Center for British Art,

New Haven; BJ 237) and again in 1844 (BJ 408), obviously in homage to the Dutch painter Jacob van *Ruisdael. *Rembrandt's Daughter* of 1827 (Fogg Art Museum, Cambridge, Mass.; BJ 238) similarly fictionalizes reality, for the Dutchman had no daughter; however, if Turner intended the work to honour *Rembrandt, the homage backfired on him, for one contemporary critic thought the picture 'a joke', and most contemporary observers would probably have agreed with him.

The 1831 *Watteau Study by Fresnoy's Rules* (BJ 340) depicts *Watteau at work and may be considered as paying homage to a forebear from whom Turner declared he 'had learned more . . . than from any other painter' (*Ruskin, *Works*, xxxv. p. 601). And about 1832, in the watercolour of *Château Gaillard* captioned 'Nichola Poussin's Birth-place' (Indianapolis Museum of Art; W 1006), Turner may have paid tribute to another French artist. The work is a vignette showing the Seine at Les Andelys with *Poussin sketching in the foreground, and it may have been intended for engraving in one of the volumes depicting *French rivers.

In the 1833 RA exhibition Turner paid tributes to both Italian and Dutch Masters, by respectively showing them painting or gathering material. In *Bridge of Sighs, Ducal Palace and Custom-House, Venice: Canaletti painting* (BJ 349), we see *Canaletto improbably painting on an easel set up in the open air, while in *Van Goyen, looking out for a Subject* (Frick Collection, New York; BJ 350) the Dutch artist stands in a boat making its way across *Antwerp Roads.

A further overt tribute to another artist was paid in the 1842 *Peace—Burial at Sea* (BJ 399), which shows David *Wilkie's consignment to the deep off Gibraltar in June 1841. Here Turner made the sails of the steamship *Oriental* unrealistically black in order to convey his grief at his friend's death.

Turner's final act of homage may have been his bequest of *Dido building Carthage* (BJ 131), and *Sun rising through Vapour* (BJ 69) to the National Gallery to hang alongside two *Claudes in perpetuity, although equally the stipulation could have ensured an act of *competition with that great forebear. ES

TRIMMER, the Revd Henry Scott (1778–1859). A lifelong friend and confidant, who became one of Turner's executors. He was the eleventh child of the educationalist and writer Sarah Trimmer (1741–1810) of Kew Bridge, Old Brentford, through whom he inherited paintings by *Gainsborough. It is likely that he and Turner met as schoolboys in Brentford and they may have travelled together at this time to Margate. Trimmer was a Classics scholar at Merton College, Oxford (1798–1802), before becoming curate at

Kedington, Suffolk. In 1804 he was inducted as vicar of Heston, Middlesex. Although he and Turner may have renewed contact when Trimmer was at Merton, their friendship flourished when Turner lived near Heston, at *Sion Ferry House, Isleworth, and at *Hammersmith. With their mutual friend *Howard, they went on sketching and *fishing trips, and Turner offered to teach Trimmer to paint in watercolour in exchange for Latin and Greek lessons. Their relationship appears to have been easy and uncomplicated. Trimmer was an observant but largely uncritical admirer of Turner's painting, apparently chiding Turner about an inaccurate detail in the horses' bridles in *Dido and Aeneas* (RA 1814; BJ 129). He greatly admired, and coveted, *Frosty Morning* (RA 1813; BJ 127), which Turner considered giving to him, and reflected that the girl in the painting bore a resemblance to Turner. This led to later speculation that the figure was modelled on Evelina Turner (see CHILDREN). Trimmer's copy of *Perspective Made Easy* by Joshua Kirby (Trimmer's grandfather) was found in Turner's library after his death. Trimmer's heirs destroyed all his papers. JH

Thornbury 1877, 119–28, 223–7.

Gage 1980, pp. 289–90.

D. M. Yarde, *Sarah Trimmer of Brentford and her Children*, 1990.

Hamilton 1997, 16–18, 88, 90, 108, 148–9, 160, 164, 333–6.

TUDOR, Thomas (1785–1855), landscape artist and collector whose unpublished diaries document the collection of Turner's patron B. G. *Windus. Tudor, who lived at Tudor House, Wyesham, exhibited at the Royal Academy 1809–19. In 1840 he lent ten pictures from his collection, including a *Van Dyck, to an exhibition at Monmouth. During a visit to London in mid-1847, Tudor sold *The Fifth *Plague of Egypt* (RA 1800; Indianapolis Museum of Art; BJ 13), through Thomas *Griffith, to George Young. He visited Windus's collection on 21 June and 5 July, and made four visits to Turner's gallery. His diary (Collection Major Probert; photocopy in the National Library of Wales, Aberystwyth) provides valuable corroboration of the works by Turner in Windus's possession at that time. TR

Thomas Tudor 1785–1855, Monmouth Museum exhibition catalogue, 1979.

Whittingham 1987, pp. 30–2.

TURNER, Charles (1774–1857). A highly accomplished British engraver and draughtsman, he engraved a number of mezzotints after J. M. W. Turner, and enjoyed a sometimes turbulent but enduring friendship with his namesake. Apprenticed to the engraver John Jones in 1789, Charles Turner studied at the *Royal Academy Schools from 1795; working primarily in mezzotint, but also in aquatint and stipple, he began to publish his own prints in 1796, and

worked for publishers in London and Scotland. In 1802 he published his mezzotint after John James Masquerier's, *Bonaparte Reviewing the Consular Guards*, to critical acclaim; his success continued throughout his career, and he was elected Associate Engraver at the RA in 1828. The engraver collaborated with J. M. W. Turner on a scheme to publish a large single-plate mezzotint of the latter's picture of *The *Shipwreck* (Turner's gallery 1805; BJ 54; R 751); the plate was published in 1807 with an impressive list of subscribers.

At around the same time the two Turners began to collaborate on plates for the *Liber Studiorum*. It is uncertain whether Charles Turner was the artist's first choice of engraver for the series, and he may have originally intended to work with Frederick Christian *Lewis, but in the event Charles Turner engraved the twenty *Liber* plates which were published in the first four numbers, probably starting in June 1807. J. M. W. Turner acted as publisher for the first part of the series, but evidently found this role irksome, and relinquished the responsibility to Charles Turner. According to one of his later testimonies, the latter 'engraved them [the plates], Published, attended the printing, and then delivered the numbers to the subscribers for only £8.8.0' (Charles Turner to Colnaghi's, 14 February 1852, original untraced, facsimile in private collection), but he soon grew dissatisfied with this remuneration, and the arrangement was discontinued after the publication of the fourth part when the two Turners quarrelled. The circumstances of the celebrated dispute, which probably took place about 1810, have not been established conclusively. Charles Turner, whose recollections are riddled with inconsistencies, claimed that he quarrelled with the artist over the unpublished plate of *Windsor Castle from Salt Hill* (F 74), and that the rift lasted for nineteen years; but the plate could not have been made before 1818, and Charles Turner's engraving after J. M. W. Turner's *Eruption of the Souffrier Mountains, in the Island of St. Vincent* (RA 1815; Liverpool University; BJ 132) as *The Burning Mountain* (R 792) was published in November 1815.

Three *Liber* plates engraved by Charles Turner were published after the quarrel (F 26, 57, 65), but they may have been executed before it took place. The rupture in fact may have been precipitated by the sale of an unauthorized coloured impression of *The Shipwreck* (see Gage 1980, pp. 43–5). In the 1820s Turner engraved five mezzotints after J. M. W. Turner for the *Rivers of England* (R 752, 754, 756, 758, 767). The artist appointed him a Trustee of his proposed Charitable Institution and an executor of his will in 1831, and the two men remained friends until the painter's death. Charles Turner sold his proofs of *The Shipwreck* and

Liber Studiorum plates to Dominic *Colnaghi in 1852 for
over £800. GF

> Charles Turner, Diaries, MS, Osborn Collection, Beinecke Rare
> Book Library, Yale University.
> A. Whitman, *Charles Turner*, 1907.

TURNER, C. W. Mallord (1903–79), collateral descendant
of Turner. Charles Wilfrid Mallord Turner was the son of
Charles Mallord William Turner (1859–1934), who collected
documents related to Turner, as well as books owned or an-
notated by the artist (see Falk 1938, pp. 255–9; Wilton 1987,
pp. 246–7). C. M. W. Turner's parents, William Coham
Turner and Catherine Ann Bartlett, were both descendants
of the artist's uncle John Turner (1742–1818); see FATHER'S
FAMILY. He presented 49 copper plates made for the *Liber
Studiorum* by G. *Harris to the British Museum in 1945 and
was an early member of the Turner Society. His daughter,
Rosalind Mallord Turner, still owns what remains of
Turner's library and contributed to the 1990 Tate Gallery
exhibition *Painting and Poetry: Turner's 'Verse Book' and
his Work of 1804–12*. TR

TURNER, Dawson (1775–1858), antiquary, botanist, and
collector; friend and correspondent of J. M. W. Turner. In
1796 Dawson Turner joined the Yarmouth bank, of which
his father, James Turner (1743–94), had been the head. He
published on antiquities and botany, notably the four-
volume *Natural History of Fuci* (1808–19). He was elected a
Fellow of the Linnean Society in 1797, of the Imperial Acad-
emy in 1800, and of the Society of Antiquaries in 1803. He
had a library of around 8,000 volumes, many of which went
to the British Museum Library. His collection of paintings
by Dutch and Italian artists included a picture by Giovanni
Bellini. He was a patron of John *Crome and John Sell
*Cotman; his wife and four daughters were pupils of Cot-
man, who lived nearby. He apparently approached J. M. W.
Turner through a mutual friend, Thomas *Phillips, RA, also
a Fellow of the Royal Society, hoping to acquire a copy of the
*Liber Studiorum; he did eventually acquire a *Liber* direct
from the artist. He also owned a subscription copy of the
*Southern Coast. He seems to have been encouraged by
Crome's admiration of J. M. W. Turner to buy a Turner
painting, but did not in the end acquire one, refusing
Turner's offer of *Frosty Morning (BJ 127) for 350 guineas in
1818. Dawson Turner gave particular encouragement to the
artist during his late period. Their frequent correspondence
provides valuable insight on the painter. TR

> Gage 1980, pp. 291–2.

TURNER, Mary (1738/9–1804), Turner's mother. She was
born Mary Marshall, the third of four children of William
Marshall, an Islington salesman, and his wife Sarah Mallord.

She met William *Turner about 1770, and married him by
special licence on 23 August 1773 at St Paul's Church,
Covent Garden. The couple had two known children,
Joseph Mallord William and Mary Ann. Nothing is known
of Mary's life before her marriage, and little enough after it.
*Thornbury raises the suggestion that she had landed Not-
tinghamshire connections through her father. She had a
strong personality, that led to reports of 'ungovernable tem-
per', and Thornbury described a lost portrait as having

> a strong likeness to Turner about the nose and eyes; her eyes being
> represented as blue, of a lighter hue than her son's; her nose
> aquiline, and the nether lip having a slight fall. Her hair was well
> frizzed . . . Her posture therein was erect, and her aspect mascu-
> line, not to say fierce. . . . Like her son her posture was below
> average.

It may be that the death of her daughter in 1783 and her ap-
parent inability to cope with daily London life were reasons
for Turner being sent to Brentford in 1785.

Her unhappiness must have deepened over these years,
and propelled her towards lunacy. It is unlikely, however,
that she was considered lunatic until the end of the decade,
for the condition of admission to London lunatic hospitals
was that the patient may not have been considered mad for
more than twelve months. Mary was, however, committed to
St Luke's Hospital for Lunaticks in Old Street in November
1799, on the signature of two parish bondholders, and after
a year she was moved to nearby Bethlem Hospital. Her pa-
pers there were signed by Joshua Turner, her brother-in-law,
and two further parish bondholders who are referred to as
'Friends'. There is no evidence that either her husband or
her son played any formal role in her committal, but neither
did they prevent it. The authorities at Bethlem, senior
among whom was Dr Thomas *Monro, showed a blind eye
to the hospital rules, which stipulated that a patient may
only be 'disordered in her senses' for nine months. Mary
was technically discharged 'uncured' from Bethlem on 26
December 1801, but immediately readmitted to the Incur-
able Department. She never left the hospital, and died there
on 15 April 1804. There is no trace of her burial place. In
1832 Turner erected a memorial to his parents in St Paul's
Church, Covent Garden. The small pencil profile of a
woman in Turner's *Marford Mill* sketchbook (TB xx: 35) is
possibly Mary Turner.

See also FATHER'S FAMILY; MOTHER'S FAMILY; TURNER, MARY
ANN. JH

> Camden and Islington NHS Trust and Royal Bethlem Hospital
> archives.
> Thornbury 1877, p. 4.
> Cecilia Powell, 'Turner's Women: Family and Friends'; *Turner
> Society News*, 62 (December 1992), pp. 10–14.

Bailey 1997, pp. 2–3, 7–8, 11, 14, 31, 35, 44, 51–4, 58, 63, 75, 77, 85, 112, 120, 161, 223, 234, 239, 280, 339, 361, 382.

Hamilton 1997, pp. 5, 7–9, 58–9, 61–3, 87–8, 73, 335–6.

TURNER, Mary Ann (1778–83), Turner's only known sibling. She was baptized at St Paul's Church, Covent Garden, on 6 September 1778, as 'Mary Ann, Daughter of William Turner by Mary his wife'. Her burial is recorded on 8 August 1783, as 'Mary Ann, daughter of William Turner'. A burial entry made on 20 March 1786, 'Mary Ann Turner from St Martin's in the Fields', was long thought to refer to the child, but this is no longer accepted. The 1783 burial entry, recently discovered by Bailey, dissolves the complicated but long-accepted idea that the Turner family somehow moved to the neighbouring parish of St Martin's-in-the-Fields between two periods of living in *Maiden Lane, at numbers 21 and 26. This led to suggestions that Turner was sent to live in Brentford in 1785 to avoid his sister's illness.

See also TURNER, MARY; TURNER, WILLIAM. JH

Bailey 1997, pp. xvii and 8.

TURNER, William (1745–1829), Turner's father. He was born in South Molton, Devon, the third of seven children of John Turner, a wig-maker and barber (latterly a saddler), and his wife Rebecca, née Knight. He left Devon for London around 1770, possibly at the same time as his friend John *Narraway. Following his father's trade, William Turner set up as a barber in *Maiden Lane, Covent Garden. *Thornbury quotes a description of him as

about the height of his son, spare and muscular, with a head below the average standard, small blue eyes, parrot nose, projecting chin, and a fresh complexion indicative of health, which he apparently enjoyed to the full. He was a chatty old fellow, and talked fast; and his words acquired a peculiar transatlantic twang from his nasal enunciation.

This 'twang' may also have been a West Country accent. He married Mary Marshall at St Paul's, Covent Garden, on 23 August 1773.

As a barber William Turner worked hard and was undoubtedly a success. He had chosen his business location with flair and intelligence, placing it at the centre of London's theatrical, legal, artistic, and commercial life. His clientele, whom he variously attended at his shop or at their homes, were professional and well-connected. Their presence in the barber's shop, and William Turner's own natural charm and loquacity, were to become crucial to the pattern of J. M. W. Turner's early recognition and success. Thornbury reported that William Turner displayed and sold his son's watercolours in the shop, and affirmed to customers that 'William is going to be a painter.'

He seems to have left Maiden Lane for *Norton Street about 1800, when his son moved to lodgings in *Harley Street, and Mary *Turner was securely committed to Bethlem Hospital. He may have carried on with his barbering, but his main role in life now was to be his son's studio amanuensis, housekeeper, and 'willing slave', as Thornbury put it. He learnt to stretch and to prepare canvases, and, when *Turner's gallery opened in 1804, he became the gallery attendant. In 1813 he moved with his son to *Sandycombe Lodge, Twickenham, where he kept the house and made the garden.

William Turner kept a close eye on the affairs of his family, particularly after the death of his mother in 1802. He had a litigious streak, and threatened to take his brother Jonathan to court over the provisions in their mother's will. In 1811 he travelled to Barnstaple to settle continuing legal issues.

Turner was very fond of his father, as well he might be, and became concerned in 1815 that the garden at Sandycombe might now be too much for him. Nevertheless, he continued firmly to direct his father's activities, even as late as 1827 when William was 82, urging him peremptorily to send him materials and clothes to East Cowes Castle (see NASH). Turner told *Trimmer that he felt his father's loss 'like that of an only child'. Some years after William's burial in St Paul's, Covent Garden, Turner had a memorial erected there to his parents. JH

Thornbury 1877, pp. 5, 8.

Bailey 1997, *passim*.

Hamilton 1997, pp. 5, 7–9, 12–13, 17, 19–20, 59–69, 71–2, 88, 133–4, 146, 159, 161, 164, 177, 196, 217, 225, 231–2, 245–6.

TURNER, William, 'of Oxford' (1789–1862), landscape artist, mostly in watercolours, and Oxford drawing master. He added 'of Oxford' to his name to distinguish himself from J. M. W. Turner. He studied with William *Delamotte and John Varley, and became an early and active member of the Old Water-Colour Society (see WATERCOLOUR SOCIETIES), where he showed 455 drawings over 55 years. In his later years Turner 'of Oxford' developed a colourful and very detailed manner, and specialized in large panoramic compositions, many of them of scenery in Oxfordshire and the Highlands. LH

C. Titterington and T. Wilcox, *William Turner of Oxford*, exhibition catalogue, Woodstock, London, and Bolton, 1984–5.

TURNER AND THE SUBLIME, 1980–1. This loan exhibition of watercolours, drawings, and prints, selected and catalogued by Andrew Wilton, was shown at the Art Gallery of Ontario, the Yale Center for British Art, New Haven, and the British Museum. A stimulating interpretative exhibition which demonstrated how solidly the concept of the *Sublime, an important 18th-century aesthetic theory stressing

the visual impact of objects and subjects that were daunting and dreadful, and at the same time exhilarating to contemplate, was influential in Turner's formative years, and was entrenched in his work throughout his career. LH

TURNER BEQUEST, see WILL AND BEQUEST; also LONDON, NATIONAL GALLERY; TATE GALLERY.

TURNER BICENTENARY EXHIBITIONS: *Turner 1775–1851*, Royal Academy, London, November 1974–March 1975; and *Turner in the British Museum: Drawings and Watercolours*, British Museum, London, May 1975–February 1976. The first, selected and catalogued by Martin Butlin, Andrew Wilton, and John Gage, included over 180 oil paintings, 330 watercolours and drawings, 78 sketchbooks, and 35 engravings, together with 153 documentary items. High spots were a concluding section on the evolution of Turner's depiction of *Norham Castle from the watercolour of *c.*1798 up to the late oil painting, and a screen of watercolours of the *Rigi of 1841–2. This exhibition, unmatched in its coverage of every aspect of Turner's art, provoked immense interest and led to a new wave of scholarly interest in the artist, the formation of the *Turner Society, and indirectly to the creation of the Clore Gallery for the Turner Bequest (see TATE GALLERY).

The Royal Academy exhibition was followed and supplemented by that at the *British Museum, over 300 watercolours and drawings selected and catalogued by Andrew Wilton. Apart from one item all came from the works then at the British Museum, mainly from the Turner Bequest, but also finished watercolours from the bequests of John *Henderson, George Salting, and R. W. *Lloyd. MB

TURNER DE LOND, William, see FAKES AND COPIES.

TURNER GALLERY, THE, a series of 61 middle-sized steel engravings after well-known paintings, mostly then in the National Gallery, and watercolours by Turner. It was originally published in London between 1859 and 1861 by James S. Vertue. The engravings appeared in parts with texts by Ralph *Wornum. Many of the engravers were men who had been active in producing prints after his work during Turner's lifetime, and under his supervision. Thus the standard remained relatively high, though in the various later editions and reissues, which continued to appear until the 1880s, the plates were often very worn and the quality of the engravings was low. Among the engravers working on the *Turner Gallery* were John *Cousen, Edward *Goodall, William *Miller, and J. T. *Willmore. LH

TURNER IN FICTION. Turner's style and his ability to capture diverse effects of light and weather are so much part of British culture that novelists have long made use of him. The mere mention of Turner's name is enough to evoke a familiar and powerful image in the reader's mind for subjects as diverse as distant Italian hills (D. H. Lawrence, 1922), the rain-swept cliffs of Dover (Nancy Mitford, 1931), and the pyrotechnics of the Blitz (Evelyn Waugh, 1955); the example of these popular writers has been followed by many novelists up to and including the present day. Fictional painters were already taking Turner as a mentor in his own lifetime (Charles Kingsley's *Yeast*, 1848) and have continued to do so. Some novelists have blessed their art-lovers with a Turner in their collections (Soames Forsyte in John Galsworthy's *Forsyte Saga*, 1906–29) while others, including Ford Madox Ford, Kingsley Amis, and Elizabeth Jane Howard, have conjured up entire rooms of imaginary Turners for their characters to savour or even inherit. Around 1900 the Turner rooms in the National Gallery, *London, provided refuge and diversion for a suffering heroine of Henry James (himself a highly perceptive art critic); more recently those in the *Tate Gallery have provided similar sanctuary for characters invented by Sylvia Townsend Warner and the art historian/novelist Anita Brookner. Particular sensitivity to the deeper meanings and beauties in Turner is central to the works of both Thomas Hardy, who shared his sense of the immanent power of nature and light, and Marcel Proust, who imbibed his art through the writings of *Ruskin. Turner's art is frequently there just below the surface of both novelists' work, with no overt references either needed or provided. If one wants a novel overtly based on Turner's life, there is Michael Noonan's *The Sun is God*, 1973, while his erotic drawings (see PORNOGRAPHY) lie at the heart of Nicholas Kilmer's *Dirty Linen*, 1999. CFP

'The Turner Treasury', *Turner Society News*, from no. 47 (1988) onwards.

J. B. Bullen, 'Thomas Hardy and Turner', *Turner Society News*, 50 (1988), pp. 11–14.

TURNER IN SCOTLAND, Aberdeen Art Gallery and Museums, 1982. Important survey of Turner's six tours of Scotland. Principally works on paper, the 103 exhibits included major loans. The catalogue incorporates essays by Francina Irwin, Gerald Finley, and Andrew Wilton, and a report of the weather conditions during the 1801 tour. ADRL

TURNER IN WALES, Mostyn Art Gallery, Llandudno, and Glynn Vivian Art Gallery, Swansea, 1984. Major showing of work relating to the five tours of Wales made by Turner during the 1790s with 104 exhibits drawn mainly from the Turner Bequest. Andrew Wilton's catalogue stresses the richness of the Welsh works and their role in Turner's development. ADRL

TURNER IN YORKSHIRE, York City Art Gallery, 1980. The first exhibition to present a comprehensive survey of Turner's tours around Yorkshire, the art he produced as a result, and the works linking Turner to his Yorkshire patrons. David Hill catalogued and selected this exhibition of 151 works (mostly watercolours) dating from 1797 to 1838. SET

TURNER MEDAL. Turner bequeathed £20,000 to the *Royal Academy, partly for the biennial award of a gold medal for landscape painting. This was to be entitled 'Turner's Medal' and to be worth 'about £20', which in the mid-19th century was equal to a national average annual income.

The medal was designed by Daniel *Maclise and sculpted by L. C. Wyon. It was first awarded in 1857. On the obverse Turner's head is surrounded by his name and dates, while on the reverse a young man reclines with palette and brushes in hand and contemplates some landscapes.

Since 1938 the RA has awarded simply a bronze medal plus £50 cash. Such small financial reward probably explains why the prize receives no publicity today. ES

TURNER MUSEUM, THE, was founded in 1973 in Denver, Colorado, by Douglas J. M. Graham, who had begun to collect Turner prints in 1966. The museum now possesses over 2,200 works 'by and related to Turner' amounting to almost 90 per cent of his entire engraved output. The museum also owns works by the American Thomas *Moran (1837–1926) who, when a young man, was inspired by the gift of a book about Turner to become a landscape painter.

A six-volume catalogue of the collection was published in 1993 and, since then, more than 70 new items have been added by purchase or exchange. There is a programme of regularly changing exhibitions, chosen mainly from the museum's holdings, including *Turner's Cosmic Optimism*, 1990–1, an examination of the *England and Wales* series. The museum also arranges chamber-music concerts combined with gourmet evenings and followed by conducted tours of the collection.

Douglas Graham still runs the museum with his wife Linda. They are now actively looking for larger premises and are prepared to relocate anywhere in the world where the collection will look its best; at present (1999) the collection is in Sarasota, Florida. EJ

TURNER PRIZE. Included here only because of its name, which was given to this *Tate Gallery prize for contemporary art despite opposition at the time of its launching in 1984 from the Tate Trustees. The prize of £20,000 is awarded annually to a 'British artist under fifty for an outstanding exhibition or other presentation of their work in the twelve pre-ceding months'. Winners have included Howard Hodgkin, Gilbert and George, Richard Long, and Damien Hirst. During the Directorship of Nicholas Serota the prize has become increasingly controversial, with an emphasis on the most avant-garde installation and video work. The Turner Prize has succeeded in enormously enlarging the audience for contemporary art in Britain, but has consistently angered traditionalists, as, of course, did Turner himself. LH

TURNER'S ANNUAL TOUR. Three volumes of views of the Rivers *Loire and *Seine produced annually between 1833 and 1835, also known as *Wanderings by the Loire* or *Seine*, and later gathered in one volume under the title *The *Rivers of France*.

These French scenes grew out of Turner's increasing involvement with the popular annuals during the second half of the 1820s, each volume appearing just in time for the Christmas market. The books combined art and literature, although a certain snobbery prevailed about the quality of the latter, which was widely held in low regard, even though the contributions were frequently from notable authors. Charles *Heath was the publisher of *The *Keepsake*, one of the most popular of the genre, to which Turner contributed seventeen designs, beginning with the edition for 1828. Perhaps influenced by the success of the designs for Samuel *Rogers's *Italy* (1830), Heath seems to have proposed that instead of having the effect of Turner's works diluted by comparison with images by other artists in the same volume, they should be promoted in a similar format, on their own. Up until this point, Turner's designs had always appeared in part-works, and frequently in projects that were not illustrated exclusively by him, so this was an important departure.

News about the first volume of this new project was announced in the *Athenaeum in January 1831. This was to be a volume devoted to the River Loire, which Turner had visited almost five years earlier. Turner's designs were to be accompanied throughout the series by letterpress written by Leitch *Ritchie, who was well known for his tales of travel and romance. This dual function of the volumes has always caused some confusion as to how to refer to them, since the spine of the book had Ritchie's name, and his title (*Wanderings by the Loire*, or *Seine*), while the advertisements promoted the item as *Turner's Annual Tour*. The widely held misconception that Ritchie was Turner's travelling companion is now discredited, but this was an idea that he himself encouraged in his text to suggest the hands of artist and writer working as one.

The designs for the first volume must have been completed during the first half of 1831 (see Pl. 19) since payments to the engravers for their completed work began to be paid

out from January 1832, and proofs were available for Ritchie to take with him on his trip to the Loire in the summer of 1832. The team of men who were given the task of working for the first time from the unconventional technique of paintings in watercolour and *gouache on blue *paper, and translating the images into black and white steel engravings, were in many cases already familiar with Turner's work. It is notable that Turner also selected youngsters, such as Robert *Brandard, whom he was able to school in the means of achieving his desired effects. The team remained largely the same throughout the production of the three volumes of *Turner's Annual Tour* and in many cases went on to become closely identified with Turner's later productions. They were as follows (the number of plates each man engraved appears in parentheses): James Baylis *Allen (4); James Charles Armytage (3); Robert Brandard (14); J. *Cousen (5); Samuel Fisher (2); Thomas *Higham (3); Thomas Jeavons (3); William *Miller (7); William *Radclyffe (3 or 4); John *Smith (1); William Raymond *Smith (1); Robert *Wallis (5); James Tibbets *Willmore (9).

The prints for each volume of *Turner's Annual Tour* were available by the end of November in the year preceding that designated for the volume, so that the 1833 Loire subjects had begun to be reviewed in early December 1832, before the book was actually published. This set received an extremely warm response from critics, who were unanimous in hailing it as the best of that year's annuals, with the one reservation that at 2 guineas it was double the price of the rest of the market. The quality of the engravings was especially admired, with the work of Willmore, Radclyffe, Allen, and Miller receiving special attention.

The cost proved to be a problem, however, and Heath was forced to relaunch the 1833 volume in June of that year at 1 guinea per volume. At the same time his advertisements announced that the Loire book was to be the first of a series entitled *Great Rivers of Europe*, or *River Scenery of Europe*, of which the next volume would deal with the Seine. Two volumes of Seine views duly appeared (1834 and 1835), but any plans Heath and Turner had for the series to go on and embrace rivers such as the Rhone, the *Meuse, the *Mosel, and the *Danube, were ultimately to come to nothing. By 1835 Heath was trying to cover his losses by reissuing the French designs in cheaper formats, which culminated in the collected edition of all 61 published views that appeared as *The Rivers of France* (1837). It is remarkable that Turner continued to cherish the *Great Rivers* scheme. Two years after this volume was issued, he created a set of designs based on his travels through the Meuse–Mosel region; this clearly reveals more about his ambitions for his art than the practicalities of print production. IW

Warrell 1997.
Warrell 1999.

TURNER'S GALLERY AND EXHIBITIONS. On 19 April 1804 Joseph *Farington recorded in his diary, 'Turner told me this evening that he shd. be glad to see me at his House [in Harley Street] having opened a Gallery 70 feet long & 20 wide' (*Diary*, vi. p. 2302). The *Royal Academy's annual exhibition, at which Turner showed only two paintings and one watercolour, opened a week later. It seems probable that the 29-year-old Turner, who had been elected a full Member of the Royal Academy in 1802, believed that having his own gallery in central London, as both *Reynolds and *Gainsborough had had, would further enhance his reputation and improve his sales. There were some 20 to 30 paintings and watercolours in the opening exhibition, but, as with most of the exhibitions at Turner's gallery over the coming years, no precise details are known. In 1805, a year in which Turner showed nothing at the RA, the main exhibit was *The *Shipwreck* (BJ 54), of which Charles *Turner's large mezzotint plate was published early in 1807, and did much to enhance the painter's reputation.

The first exhibition of the newly founded *British Institution, at which Turner showed two paintings, was held in 1806, and at the RA that year he was represented by a painting and a watercolour. In his own gallery he definitely exhibited the unfinished *Battle of Trafalgar* (BJ 58), and the other exhibits perhaps included two views of *Walton Bridges (Loyd Collection, on loan to Ashmolean Museum, Oxford, and National Gallery of Victoria, Melbourne; BJ 60 and 63); there were probably also several *Thames views in the selection shown in 1807. In 1806 and 1807 Turner showed only two paintings each year at the RA, and just one in 1808. From then on Turner usually again showed larger numbers each year at the RA.

The first Turner's gallery exhibition about which there is more detailed information is that of 1808, which was reviewed at length by John *Landseer in the second issue of his newly launched and short-lived *Review of Publications of Art* (reprinted in Herrmann 1987, pp. 27–33). There were eight landscape paintings, most of them harmonious Thames views, two mythological subjects, including the large *Goddess of Discord* (BJ 57) previously shown at the BI in 1806, and two marines. Landseer commented that 'the shew of landscape is rich and various'. The 1808 exhibition also included a selection of Turner's drawings for the *Liber Studiorum*, the first Part of which had been published in 1807, and Landseer makes a tantalizing reference to a Prospectus for the *Liber*, which has not survived and may have been available only in manuscript. However, it is clear that Turner used his gallery exhibitions to promote the sale of the prints.

In 1809 Turner exhibited in his gallery eighteen paintings and watercolours, and some of the same paintings were again shown in 1810. The only surviving printed lists of the exhibits are for these two years. The gallery, closed for alterations in 1811, reopened in 1812 and annual exhibitions continued until 1816. Having extended his *Queen Anne Street West and *Harley Street properties, Turner began extensive rebuilding in 1818, and his new gallery was opened for the first time in April 1822, most of the exhibits being unsold earlier works. From then on there is very little, if any, detailed information about Turner gallery exhibitions, though there are numerous records of visits by potential buyers and others to the gallery, which appears to have become increasingly crowded and dirty with paintings stacked against the walls and, in the final years, leaks in the roof. However, the spacious gallery remained an essential element of Turner's plans for the future of his art, for in it he could house and covet the great accumulation which he expected to become a permanent gallery of his work at the centre of 'Turner's Gift', the almshouses for distressed artists which he thought he had provided for in his *will. The only visual record of the interior of Turner's gallery is in two small paintings in the Ashmolean Museum, Oxford, painted from memory in about 1852 by Turner's friend, colleague, and executor, George *Jones, RA. One is of the artist showing his work to two ladies, and the second depicts a group of friends and fellow artists surrounding Turner's coffin lying in state, with the *England: Richmond Hill of 1819 (BJ 140) hanging behind it. LH

TURNER SOCIETY. The initiative for the formation of the Turner Society came from Selby Whittingham, then Assistant Keeper at Manchester City Art Gallery. There was enormous public interest in the Turner Bicentenary exhibition held at the *Royal Academy from November 1974 to March 1975, which attracted 400,000 visitors, an unprecedented number virtually unrivalled until Monet in 1999. Whittingham distributed leaflets to the visitors calling for the formation of a society to represent Turner and honour his wishes. The first public meeting to discuss the creation of the Society was held on 5 April 1975 at the National Liberal Club. The first General Meeting of the formally constituted Turner Society followed on 10 July 1975. This elected the sculptor Henry Moore as the Society's President, and Lord Bruce of Donington, Edward Croft-Murray, Lawrence *Gowing, Victor Pasmore, John Piper, and Graham Reynolds as Vice-Presidents. Allan Pearce was elected as the first Chairman. The first issue of *Turner Society News* was produced the same month, and has been published regularly ever since. It stated the twin aims of the Society: first, to establish a separate art gallery for Turner's works, where the oils from the Tate and the drawings from the British Museum could be seen together, and secondly, to promote the enjoyment and study of Turner. Its campaign for a Turner gallery attracted considerable publicity, with wide-ranging coverage in the media, lobbying of MPs, and the delivery to the government of a public petition. Somerset House became the favoured site for the gallery, but this was eventually ruled out, and in May 1980 the Minister for the Arts Norman St John-Stevas held a press conference to announce the construction of the Clore Gallery at the *Tate Gallery. Both he and Vivien Duffield of the Clore Foundation praised the tenacity and vision of the Turner Society's campaign. The Society continues to thrive with Prince Charles as its patron and Nicholas Horton-Fawkes, a descendant of Walter *Fawkes, as its President. A symposium to mark the 150th anniversary in 2001 of Turner's death is being planned. RU

TURNER STUDIES, This has been the principal journal for the modern study of Turner. Published between 1981 and 1991, it appeared in eleven volumes, each comprising two numbers, appearing twice a year. In 1993 a detailed index was produced (vol. 11, no. 2). Published by the Tate Gallery in association with the Mallord Press, it was an independent journal, edited by Eric Shanes. Its Editorial Board, which decided the content and direction of each issue, comprised Martin Butlin, John Gage, Luke Herrmann, Evelyn Joll, Michael Kitson, and Andrew Wilton. Each issue on its title-page printed the scope of the journal's study: 'It will publish material on the art and life of J. M. W. Turner RA and his contemporaries. In addition it will accept articles or notices on other aspects of the artistic, social and historical background appertaining to Turner's lifetime. It will also include material on the artists who may be deemed to have exercised an influence on him.' In the editorial of the first issue, Eric Shanes explained:

This journal has come into being because it is needed. The sheer scale of Turner's output has paradoxically acted as a barrier to understanding . . . It will bring together the latest researches on both the artist and his relevant contemporaries and will act as a useful forum for debate . . . It will not be doctrinaire but will encompass all shades of opinion. Above all it will aim to enrich the enjoyment as well as the understanding of the pictures.

Turner Studies quickly became the impetus for a renaissance of research into Turner. Articles were published covering all aspects of Turner's *œuvre*, his connection with other artists, both contemporary and Old Master, and a series of invaluable studies of the collectors of his work. Each issue also had one or two short 'Picture Note' articles which shed new light on a specific work, book and exhibition reviews, and a news and sales record. RU

U

ULYSSES DERIDING POLYPHEMUS—*Homer's Odyssey,* oil on canvas, 52¼ × 80 in. (132.5 × 203 cm.), RA 1829 (42); National Gallery, London (BJ 330); see Pl. 17. For *Ruskin this was 'the *central picture* in Turner's career' (*Works,* xiii. pp. 136–9). Although previous artists had treated other episodes from Ovid's account of Polyphemus, Turner seems to have been the first to illustrate this subject from Homer's *Odyssey* in which the escaping Ulysses looks back and taunts the one-eyed Cyclops whom he has outwitted and blinded. Nevertheless the depiction of the giant on the top of the mountain is close to that in *Poussin's *Landscape with Polyphemus* (Hermitage Museum, St Petersburg) which Turner could have known from Baudet's engraving of *c.*1701. Apollo's horses, drawing the sun, may also have been based on a Poussin, *Cephalus and Aurora,* which entered the National Gallery in 1831 but had been exhibited at the British Institution in 1819 and 1821. They also reflect Turner's knowledge of the horses' heads from the Parthenon frieze which entered the British Museum with the Elgin Marbles in 1817.

Turner's first composition sketch dates from as early as about 1807 ('Wey, Guildford' Sketchbook, TB XCVIII: 5). Later, possibly during his stay in *Rome in 1828 (but see ROMAN OIL SKETCHES, and Warrell 1999, pp. 29–30), Turner produced an oil sketch for the painting on a roll of *canvas (BJ 302). The same canvas also contained a sketch including the hollowed-out arches of rock in the background, probably based on those around the Bay of Naples (BJ 303).

Turner must have painted the work in a considerable hurry, having only returned to London earlier in February 1829, three months before the opening of the Royal Academy exhibition early in May. He had planned to show three of the oils he had painted and exhibited in Rome in 1828 but their arrival by sea was delayed. If painted in Rome, the sketch on the roll of canvas could also have been sent by sea or alternatively brought by Turner himself overland; in any case, his memory was such that he would not have needed it actually before him, and he also had the much earlier pen and ink sketch.

Following Turner's second visit to Italy his colouring had become even brighter and, according to the *Morning Herald,* 5 May 1829, this picture

reached the perfection of unnatural tawdriness. In fact, it may be taken as a specimen of *colouring run mad*—positive vermilion—positive indigo, and all the most glaring tints of green, yellow, and purple contend for mastery of the canvas, with all the vehement contrasts of a kaleidescope or Persian carpet . . . truth, nature, and feeling are sacrificed to melodramatic effect.

The *Literary Gazette,* 9 May, protested that 'Although the Grecian hero has just put out the eye of the furious Cyclops, that is really no reason why Mr. Turner should put out both the eyes of us, harmless critics.' However, for the *Athenaeum,* 13 May, although 'The colouring may be violent . . . the poetical feeling which pervades the whole composition, the ease and boldness with which the effects are produced, the hardihood which dared to make the attempt,—extort our wonder and applause.' MB

Gage 1969, pp. 96, 123, 128–32, 143–5.
Nicholson 1990, pp. 273–81.
Egerton 1998, pp. 282–9.

UNDINE GIVING THE RING TO MASSANIELLO, *Fisherman of Naples,* see ANGEL STANDING IN THE SUN.

UPPER JOHN STREET. John and Sarah *Danby and their family lived at 46 Upper John Street, now part of Whitfield Street, in the Portland Estates south of Fitzroy Square. After John Danby died in 1798, Sarah stayed on with her daughters until 1800, when they moved to *Norton Street. JH

Bailey 1977, pp. 55–7.

V

VAL D'AOSTA. Like the *St Gotthard, the Val d'Aosta was a way through the *Alps into Italy, and merited a special detour in 1802. A number of studies in the 'Grenoble' Sketchbook (TB LXXIV) record this phase of the journey, which yielded some important finished watercolours, including the curious historical subject of *St. Huges Denouncing Vengeance on the Shepherd of Cormayer* (RA 1803; Soane Museum, London; W 364); see Pl. 2 and the idyllic mountain panorama of *Mont Blanc from Fort Rock* (?1804; private collection; W 369). This latter, which was based on a study in the 'St Gothard and Mont Blanc' Sketchbook (LXXV), was completely reinvented in 1815 to create another large watercolour, *The Battle of Fort Rock* (LXXX: G; W 399), one of Turner's most important statements on the theme of human ambition and the hostility of nature. It is a recasting in contemporary terms of the theme explored in *Snow Storm: Hannibal and his Army crossing the Alps* of 1812 (BJ 126). This, as Turner's 'M.S.P[oem]' in the Academy catalogue makes clear with its reference to 'Salassian' tribesmen, is also set in the Val d'Aosta, following the contemporary view that Hannibal journeyed by that route.

Turner returned to the Val d'Aosta in 1836, on his tour with H. A. J. *Munro of Novar, and produced numerous powerful colour studies on pages of his 'roll-sketchbooks'. A more substantial result of the trip was the painting *Snow-Storm, Avalanche and Inundation—a Scene in the Upper Part of the Val d'Aouste, Piedmont*, shown at the Royal Academy in 1837 (Art Institute of Chicago; BJ 371). This was to be the last of his Alpine oil paintings (though there exist a few late oil studies which may be based on Swiss subject matter). It is an oddly retardataire exercise, almost a satire on the old *Sublime subjects of his youth, piling catastrophe on catastrophe: a sort of *Götterdämmerung*. Yet for all its virtuoso rhetoric, it lacks the conviction that he was to bring to the great sequence of *Swiss watercolours of the 1840s. AW

VAN DE VELDE, Willem the Elder (1611–93) and **Willem the Younger** (1633–1707). The Elder, born at Leiden in 1611 and son of a barge-skipper for whom he crewed from his tenth year, married in 1631 and fathered Willem the Younger in 1633. They moved to *Amsterdam in 1636 where the Elder soon went on sketching trips afloat with his talented son. The Younger Willem was apprenticed to the seapainter Simon de Vlieger, whose daughter he married in 1652, the year of the outbreak of the First Anglo-Dutch War.

The Elder now developed into a war-artist on a galliot of the Amsterdam Admiralty, flying a special burgee and sketching engagements *in situ*. These he subsequently turned into big pen paintings or *grisailles*: the first battle depictions not based on oral or written accounts and often including his galliot with himself busily drawing on deck.

Painted with remarkable accuracy they, like his individual 'ship-portraits', were a resounding success. In 1658 he joined the Dutch fleet supporting the Danes against the Swedes, charged to record events 'by way of a journal'. In 1660 he drew Charles II embarking at Scheveningen, while soon the battles of the Second Anglo-Dutch War (1665-7) again kept him fully occupied. Then, when in a new war in 1672 combined Anglo-French attacks threatened to spell disaster for large sections of the population, King Charles slyly offered father and son a 'Gracious Declaration' inviting them to settle in England. Partly because of domestic problems the Van de Veldes accepted.

The Elder was appointed by Royal Warrant 'for taking and making Draughts of sea-fights', the Younger 'for putting said Draughts into Colours', which turned him into a singularly effective painter of skies. After the peace of 1674, the King forbade the Elder to take any more risks afloat and so henceforth he drew only peaceful events like the return to Holland of Prince William III with his bride, the Princess Mary, in 1672. Although Charles had given them studio space in the Queen's House at Greenwich, William and Mary did not continue their Royal Appointment, considering both Van de Veldes defectors in wartime.

Undaunted, they continued painting and, apart from producing numerous seapieces for a wide clientele, they also systematically taught pupils the behaviour of ships in all kinds of weather and waters, providing invaluable

instruction sheets (National Maritime Museum, Greenwich). The Elder died in 1693, the Younger in 1707. Among their many followers were Samuel Scott, Peter Monamy, Charles Brooking, Philippe Jacques de *Loutherbourg, and Dominic Serres. By then, after originating in the Netherlands a hundred years earlier, marine painting had become a distinct and legitimate specialization for artists and collectors alike. Only *Ruskin could write of Van de Velde's 'evil influence' on Turner, declaring: 'it is not easily understood, considering how many there are who love the sea . . . that Vandevelde and such others should be tolerated' (*Modern Painters*, i. part 2, p. 146). But then, Ruskin did not know of Turner's exclamation of 'That made me a painter' on rediscovering after many years a mezzotint after Van de Velde which had fired him in his youth.

See also DUTCH BOATS IN A GALE. AGHB

Michael S. Robinson, *The Paintings of the Willem van de Veldes*, 1990.
Michael S. Robinson, *The Willem van de Velde Drawings*, 1997.

VAN DYCK, Anthony (1599–1641), greatest Flemish portraitist of the 17th century. Born in *Antwerp in 1599, he became *Rubens's chief assistant while still a very young man. In 1620 he was induced by the art-loving Earl of Arundel to come to England, where King James I gave him a pension but no engagement as Court Painter. Returning to Flanders after only a few months, he next went to Italy in 1621, where he remained until 1625, working in *Rome, *Florence, *Venice, and Palermo. His most successful stay was at Genoa, where he established himself as a portrait painter with a special style and the reputation of a 'pittore cavalleresco'.

Back in Flanders and endeavouring to obtain the patronage of the Spanish Regent, he still contrived to work for members of the House of Orange. In 1631 he painted Sir Constantine Huygens at The Hague, but from 1632, when he was made 'Principalle Painter in ordinary to Their Majesties', until his death in 1641 he lived in England again. There, although at his most sensitive in Flanders and less forceful than Rubens, he acquired enormous prestige at court, received a knighthood from Charles I, and in 1639 married Mary Ruthven, Lady-in-Waiting to the Queen. In 1640, sensing the approach of civil war, he briefly tried to establish himself in *Paris, but coveted commissions for decorating the Louvre Gallery went to others and, already a very sick man, he returned to England where he still painted the wedding portrait of Stadtholder William II and Princess Mary before his death.

Van Dyck's strength, while leaning heavily on Rubens in religious works, was his elegant portraiture and colouring.

In England his style fixed for ever the outward appearance of Stuart nobility, creating a formula that lasted until the end of the great tradition of British portrait painting and as such only comparable to the effect of Holbein's style before him.

Turner loved the Van Dycks at *Petworth. A small watercolour copy of his Lucy Percy, one of the superb portraits, is in the 'Petworth' Sketchbook (TB CCXLIV: 100) and the figures in his *Lucy, Countess of Carlisle, and Dorothy Percy's Visit to their Father, when under Attainder upon the Supposition of his being concerned in the Gunpowder Plot* (1831; BJ 338) are essentially based on them. Possibly from the same time or slightly earlier dates the curious unfinished *A Lady in Van Dyck Costume* (BJ 444), also inspired by one of the Petworth Van Dycks, and no doubt an exercise intended for the custom of publishing 'pin-up', *Keepsake-style engravings after portraits of society beauties in annuals which would likewise print historical compositions.

In 1802 Turner had drawn and commented on Van Dyck's superb *Cardinal Bentivoglio* (Pitti Palace, Florence) in the 'Studies in the Louvre' Sketchbook (LXXII: 33) where it was simply defined as 'This piece of Nature'. But in his notes on *Opie's *Lectures* of 1809 he praised the English reaction to the light and the power and the 'breadth of colour' of this stunning picture as opposed to the criticism of the French, declaring that 'all our admiration was their astonishment'. As often paraphrased in his own *perspective lectures, to him Van Dyck's royal and noble sitters are depicted as impressive and even formidable while at the same time being approachably human and gracefully elegant.

Although somewhat less so than Rubens, Van Dyck was a typical example of the difference between Flemish and Dutch artists, the former having always enjoyed life on a lavish scale through the patronage of secular and ecclesiastical courts, whereas the latter depended on the private clientele of burghers. One consequence of this was an ever-increasing specialization among Dutch artists, each becoming an expert in a particular genre such as either in portraits, flowers, landscapes, marines, biblical, or historical subjects. Van Dyck started as a painter of religious subjects before finding his strength in portraiture. But in this he remained unsurpassed, not only as a painter but also as a brilliant etcher. AGHB

E. Larsen, *The Paintings of Anthony van Dyck*, 1988.
Anthony van Dyck, exhibition catalogue, Washington, National Gallery of Art, 1990–1.
Wilton 1989, pp. 14–33.

VAN TROMP, Maarten Harpertszoon (1597–1653), and **Cornelis** (1629–91). In the 1830s Turner exhibited at the Royal Academy three marines based on the lives of the two

Dutch Admirals 'Van' Tromp with a further example in 1844. He thus treated as one person the father who was killed in 1653, and the son who died in 1691. The 'Van' was a customary English addition based on the knighthood the elder Tromp received from Charles I in 1643 for escorting his Queen to Holland to pawn the Crown Jewels, and from the baronetcy bestowed on the younger by Charles II in 1674 for eradicating Dunkirk and Barbary pirates.

Turner's *Admiral Van Tromp's Barge at the Entrance of the Texel 1645* of 1831 (Soane Museum, London; BJ 339) depicts the elder Tromp about to board his flagship in the roads of the North Holland island of Texel, where vessels used to assemble in comparative safety. In 1645, on convoy duty, he distinguished himself by saving the Dutch merchant fleet from imminent destruction. The traditional association of his name with the tying of a broom to his mizzenmast to indicate having swept Holland's foes from the seas was still very much alive.

Turner's renewed use of Dutch naval history was no doubt linked to the fact that on the outbreak of the Belgian Revolt in 1830 his government had left the King of the new, British-created United Netherlands completely unsupported (see HOLLAND). In 1832, when *Antwerp had to be surrendered by the Dutch garrison to a French army, Turner painted *Van Tromp's Shallop at the Entrance of the Scheldt* (Wadsworth Atheneum, Hartford, Conn.; BJ 344), a picture with somewhat odd maritime details but composed in the same spirit as the first *Van Tromp*: Antwerp, after all, lay on the mouth of the Scheldt and imaginative reconciliation with the Dutch (cf. *Van Goyen looking out for a Subject*; RA 1833; Frick Collection, New York; BJ 350) would be the logical sequence of the much-desired end of hostilities and the British embargo.

In 1833 followed *Van Tromp returning after the Battle off the Dogger Bank* (BJ 351). Actually, there had been two battles off the Dogger Bank, one in 1652 when the English attacked at sea and started the First Dutch trade war in which, to the English, the elder Tromp became their most popular enemy commander; the other in 1781, fully 128 years after the elder Tromp's death and 90 years after the younger's. Although each time outgunned and outnumbered, both ended in the saving of most of the Dutch ships.

Finally, in 1844, after an interval of eleven years, came *Van Tromp, going about to please his Masters, Ships a Sea, getting a Good Wetting* (Getty Museum, California; BJ 410). Here Turner referred to the younger Tromp's making his submission to the States General in 1673 at the instigation of Prince William III, after being relieved of his command in 1666 for having pursued English warships on his own while failing to come to the aid of his hard-pressed supremo. In the days of

*Wellington's conflict with the British government, the picture's message was clearly that here was a precedent demonstrating that an idiosyncratic military hero need not feel above reconciling himself with his superiors in the interest of his country's need. In his picture Turner succeeds in convincingly rendering the difficult manœuvre of 'going about', that is, changing tack, in a flat-bottomed vessel under full canvas in heavy seas and thereby 'pleasing his masters', unperturbed in their open boat. At the same time the artist displays much poetic licence in dressing Cornelis Tromp in white instead of Calvinist black, having him unceremoniously hanging onto the forestay while waving his hat, and flying from his mainsail a burgee with the initials 'V.T.'—a habit which came into fashion for merchant navy captains only in the 19th century.

Turner's lifelong interest in Dutch maritime art may be traced back to the *Van de Velde marine of which he saw an apparently unforgettable mezzotint in his impressionable youth. Compositionally the four Van Tromp pictures are closely related in that the focus of each is the vessel conveying the Admiral to his flagship, although in the 1832 canvas the little 'shallop' with the Admiral standing upright without support amidships in heaving waves seems as difficult to accept as William III in a similar situation in *The Prince of Orange, William III . . . landed at Torbay, November 4th, 1688, after a Stormy Passage* (RA 1832; BJ 343).

Turner may have derived information about his subject from Basnage's *Life of Cornelis Tromp* of 1697, a copy of which was in the library of William *Beckford, at whose house he had sometimes stayed. And it would only be natural if an initial visual stimulus had been Bakhuyzen's *Embarkation of Van Tromp* at Apsley House, London. The only remaining mystery seems to be his 'Vide Lives of the Dutch Painters' in the exhibition catalogue of 1844. AGHB

C. R. Boxer, *The Journal of Maarten Harpertszoon Tromp in 1639*, 1930.
Cunningham 1952.
Bachrach 1994.

VARNISHING DAYS were set aside by the *Royal Academy for members and Associates to adjust their pictures to the particular circumstances of the very crowded hang at the annual exhibitions. Although the practice was not regulated until 1809 when, at the instigation of Martin Archer *Shee, it was established that there should be a minimum of three Varnishing Days, Turner is known to have indulged in such practices on a small scale as early as 1798. *Farington remarked in 1803 on Turner's behaviour on 'the day appointed at the Academy for varnishing the pictures': *Wyatt reported how Turner had been seen to '*spit* all over his pic-

ture, and, then taking out a box of *brown powder*, rubbed it over the picture' (*Diary*, 13 May 1803). At first Turner used the Days merely to heighten or tone down the colours of his pictures to harm or benefit neighbouring works. From the 1830s, however, he seems to have used the Days to finish off what seem to have been canvases bearing little more than general suggestions of basic colours and forms. A similar practice obtained at the annual exhibitions of the *British Institution.

Turner's first major effort to knock out a picture by a putative rival occurred at the RA in 1807 when he exhibited *A *Country Blacksmith* (BJ 68), much in the manner of *Wilkie's *Village Politicians* exhibited the year before. According to Wilkie's biographer, Allan Cunningham (1843, i. pp. 143–4), Wilkie's *Blind Fiddler*, exhibited in 1807, was 'flung into eclipse by the unmitigated splendour of a neighbouring picture, hung for that purpose beside it, as some averred, and painted into its overpowering brightness, as others more bitterly said in the varnishing time which belongs to academicians between the day when the pictures are sent in, and that on which the Exhibition opens'. *Cunningham's son Peter, in his memoir of Turner (in Burnet 1852, pp. 24–5), describes *A Country Blacksmith* and **Sun rising through Vapour* (National Gallery, London; BJ 69) as 'two pictures which "killed" every picture within range of their effects'.

In 1819, also at the RA, Farington recorded the effect of 'the flaming colour of Turner's pictures' on their neighbours, immediately following this with a reference to 'the pernicious effects arising from Painters working upon their pictures in the Exhibition by which they often render them unfit for a private room' (*Diary*, 2 May 1819). At the RA in 1827 Turner's *Rembrandt's Daughter* (Fogg Art Museum, Cambridge, Mass.; BJ 238) was hung next to Shee's portrait of *John Wilde* in red academic robes; Turner added red lead and vermilion to his picture, a provocation that probably led to Shee attempting to reduce the number of Varnishing Days when he became President of the RA in 1830. Turner's activities seem also to have been responsible for the particularly bad condition of *Rembrandt's Daughter* despite its recent effective restoration.

In 1832 *Constable was the victim. His *Opening of Waterloo Bridge* (Tate Gallery), full of reds, was hung next to Turner's almost monochromatic *Helvoetsluys* (Tokyo Fuji Museum; BJ 345). Constable's biographer C. R. *Leslie described what happened: Constable's picture

was placed in the school of painting—one of the small rooms at Somerset House. A sea-piece, by Turner, was next to it—a grey picture, beautiful and true, but with no positive colour in any part of it. Constable's 'Waterloo' seemed is if painted with liquid gold and silver, and Turner came several times into the room while he [Constable] was heightening with vermilion and lake the decorations and flags of the city barges. Turner stood behind him looking from the 'Waterloo' to his own picture, and at last brought his palette from the great room where he was touching another picture, and putting a round daub of red lead, somewhat bigger than a shilling, on his grey sea, went away without saying a word. The intensity of the red lead, made more vivid by the coolness of his picture, caused even the vermilion and lake of Constable to look weak. I came into the room just as Turner left it. 'He has been here,' said Constable, 'and fired a gun' . . . The great man did not come again into the room for a day and a half; and then, in the last moments that were allowed for painting, he glazed the scarlet seal he had put on his picture, and shaped it into a buoy. (Leslie 1860, i. p. 202)

In 1833 Turner competed with his friend George *Jones, whose *Ghent* hung next to Turner's **Bridge of Sighs, Ducal Palace and Custom-House, Venice: Canaletti painting* (BJ 349). Jones's sky was very blue and, as Jones reported, Turner

joked with me about it, and threatened that if I did not alter it he would put down my bright colour, which he was soon able to do by *adding blue to his own* . . . picture. I enjoyed the joke and resolved to imitate it, and introduced a great deal of white into my sky, which made his look much too blue. The ensuing day, he saw what I had done, laughed heartily, slapped my back and said I might enjoy the victory. (G. Jones, MS 'Recollections', in Gage 1980, p. 5)

At the Academy in 1846 Turner had yet another run-in with a neighbouring picture, in this case by his friend David *Roberts, who had a picture hanging next to Turner's *Undine giving the Ring to Massaniello* (BJ 424). The painter W. P. Frith relates that,

When first placed on the wall, Masaniello's queer figure was relieved by a pale gray sky, the whole effect being almost as gray and quiet as Roberts's picture . . . Both he and Roberts stood upon boxes, and worked silently at their respective pictures . . . 'Masaniello' was rapidly undergoing a treatment which was very damaging to its neighbour without a compensating improvement to itself. The gray sky had become an intense blue, and was every instant becoming so blue that even Italy could scarcely be credited with it. Roberts moved uneasily on his box-stool. Then, with a sidelong look at Turner's picture, he said in the broadest Scotch:

'You are making that varra blue.'

Turner said nothing; but added more and more ultramarine. This was too much.

'I'll just tell ye what it is, Turner, you're just playing the deevil with my picture, with that sky—ye never saw such a sky as that!'

Turner moved his muffler to one side, looked down at Roberts, and said:

'You attend to your business, and leave me to attend to mine'.

And to this hour 'Masaniello' remains . . . with the bluest sky ever seen in a picture, and never seen out of one. (W. P. Frith, *My Autobiography and Reminiscences*, 1887, i. pp. 131–3)

Turner could, however, be unreservedly helpful to his neighbours. In 1826 his *Cologne (Frick Collection, New York; BJ 232) hung between two portraits by *Lawrence making them look very dull. Turner, noticing this, covered the surface of his picture with a wash of lampblack—at least, this is *Ruskin's story, apparently learnt from George Jones, but the story was denied by J. G. Coleridge (letter in *The Times*, 27 December 1951). In 1841 Richard *Redgrave, newly made an Associate, was advised by Henry *Howard that the bosom of the figure in his *Castle Builder* was indecent and that he should paint the dress higher. Turner, seeing what he was doing, said 'Pooh, pooh, paint it lower. You want white.' Redgrave realized that the colour of the dress in his picture

came harshly on the flesh, and no linen intervened. I painted at once, over a portion of the bosom of the *dress*, a peep of the chemise. Howard came round soon after, and said, with a little more warmth, 'Ah! you have covered it up—it is far better now—it will do'. It was no higher however; there was just as much of the flesh seen, but the sense of nakedness and display was gone. (Redgrave 1866, 1947 edn. p. 265)

In 1847 Turner helped Daniel *Maclise, whose *Sacrifice of Noah after the Deluge* (Leeds City Art Gallery) hung next to Turner's *Hero of a Hundred Fights* (BJ 427), an early picture that Turner had worked up 'to such a blaze as to extinguish Noah's rainbow' (*Literary Gazette*, 18 May 1847), by strengthening Maclise's rainbow from his own palette.

Such activities were, however, as nothing in comparison to the way in which Turner completed his own paintings on the RA walls. A tentative beginning was in 1815, when the critic of the *Sun*, 6 May 1815, remarked that when he had first seen *Dido building Carthage (BJ 131) 'the yellow predominated to an excessive degree, and though the Artist has since glazed it down in the water, it still prevails far too much in the sky'.

Turner's major repaintings of his canvases seem to have begun with two of the works painted in Rome in 1828, *View of Orvieto* (BJ 292), re-exhibited at the Royal Academy in 1830, and *Regulus (BJ 294), re-exhibited at the British Institution in 1837. Sir John Gilbert observed Turner at work on the latter:

He was absorbed in his work, did not look about him, but kept on scumbling a lot of white into his picture—nearly all over it . . . The picture was a mass of red and yellow in all varieties. Every object was in this fiery state. He had a large palette, nothing in it but a huge lump of flake-white; he had two or three biggish hog tools to work with, and with these he was driving the white into all the hollows, and every part of the surface. This was the only work he did, and it was the finishing stroke. The sun, as I have said, was in the centre; from it were drawn—ruled—lines to mark the rays; these lines were

rather strongly marked, I suppose to guide his eye. The picture gradually became wonderfully effective, just the effect of brilliant sunlight absorbing everything and throwing a misty haze over every object. (Lionel Cust, 'The Portraits of J. M. W. Turner', *Magazine of Art*, 1895, pp. 248–9)

A small oil by Thomas Fearnley shows the scene (private collection).

Turner's friend Charles *Eastlake, who was with Turner in Rome and advised him on how to wrap his pictures before sending them back to England, reported to *Thornbury, that 'The pictures referred to were in fact not finished; nor could any of his exhibited pictures be said to be finished until he had worked on them when they were on the walls of the Royal Academy' (Thornbury 1862, i. p. 221). In 1830 the critic of the *Morning Chronicle*, 3 May 1830, speaking of *Orvieto* together with *Pilate washing his Hands (RA 1830; BJ 332), wrote, 'We understand that when these pictures were sent to the Academy, it was difficult to define their subject; and that in the four or five days allowed (exclusively, and, therefore, with shameless partiality to A's [Associates] and R.A.'s to touch on their works, and injure as much as possible the underprivileged) they have been got up as we see them.' In 1833 it was reported that Turner only picked on the subject of his *Bridge of Sighs, Ducal Palace and Custom-House, Venice: Canaletti painting on seeing that his friendly rival William Clarkson *Stanfield had a picture of *Venice from the Dogana* in the same exhibition, and completed his picture in two days; this seems unlikely but is supported by the fact that Turner's picture was hung below the line, implying that this was because it was a late addition (see *Morning Chronicle*, 6 June 1833, and *Arnold's Magazine of the Fine Arts*, 3 (1834), pp. 408–9).

In 1835 the exhibition of *The Burning of the House of Lords and Commons 16th October, 1834* at the British Institution (BJ 359) gave rise to the longest and most detailed account of Turner's activities on such occasions, written by E. V. Rippingille:

Turner was there, and at work, before I came, having set-to at the earliest hour allowed. Indeed it was quite necessary to make the best of his time, as the picture when sent in was a mere dab of several colours, and 'without form and void', like chaos before the creation. The managers knew that a picture would be sent there, and would not have hesitated, knowing to whom it belonged, to have received and hung up a bare canvas, than which this was but little better. Such a magician, performing his incantations in public, was an object of interest and attraction. Etty was working by his side and every now and then a word and a quiet laugh emanated and passed between the two great painters. Little Etty stepped back every now and then to look at the effect of his picture, lolling his head on one side and half closing his eyes, and sometimes speaking to some one near him, after the approved manner of painters: but

not so Turner; for the three hours I was there—and I understood it had been the same since he began in the morning—he never ceased to work, or even once looked or turned from the wall on which his picture hung. All lookers-on were amused by the figure Turner exhibited in himself, and the process he was pursuing with his picture. A small box of colours, a few very small brushes, and a vial or two, were at his feet, very inconveniently placed; but his short figure, stooping, enabled him to reach what he wanted very readily. Leaning forward and sideways over to the right, the left-hand metal button of his blue coat rose six inches higher than the right, and his head buried in his shoulders and held down, presented an aspect curious to all beholders, who whispered their remarks to each other, and quietly laughed to themselves. In one part of the mysterious proceedings Turner, who worked almost entirely with his palette knife, was observed to be rolling and spreading a lump of half-transparent stuff over his picture, the size of a finger in length and thickness. As *Callcott was looking on I ventured to say to him, 'What is that he is plastering his picture with?' to which inquiry it was replied, 'I should be sorry to be the man to ask him.' . . . Presently the work was finished: Turner gathered his tools together, put them into and shut up the box, and then, with his face still turned to the wall, and at the same distance from it, went sidling off, without speaking a word to anybody, and when he came to the staircase, in the centre of the room, hurried down as fast as he could. All looked with a half-wondering smile, and Maclise, who stood near, remarked, 'There, that's masterly, he does not stop to look at his work; he *knows* it is done, and he is off'. (Finberg 1939, pp. 351–2, from *The Art Journal*, 1860, p. 100)

In 1838, again at the BI, the American painter Thomas Sully saw Turner at work on *Fishing Boats with Hucksters bargaining for Fish* (Art Institute of Chicago; BJ 372):

Turner was seated on a plank supported by the steps of two step-ladders placed opposite to each other. He was busy engaged in retouching his seapiece. I observed an open Box of water colours by him; but I did not *see* him use them. But whatever he did *not* in the touching, I saw the whole picture toned with a brown liquid before he left it. (MS 'Hints for Pictures', Beinecke Rare Book Library, Yale University, pp. 99 ff.)

Among other pictures on which Turner is noted to have worked during the Varnishing Days are *The *Fighting 'Temeraire'*, exhibited at the RA in 1839 (National Gallery, London; BJ 377), and *Rain, Steam, and Speed—the Great Western Railway* (RA 1844; National Gallery, London; BJ 409). Two pictures for which no such accounts survive, but which seem from their appearance to be extreme examples of Turner's practice, were exhibited in 1848 and 1849. Turner's sole exhibit in 1848, *The Hero of Hundred Fights*, already mentioned, was an early industrial interior largely overpainted in 1848 to represent the breaking away of the mould at the casting of Wyatt's bronze statue of the Duke of Wellington. In 1849 Turner borrowed two early works back from his patron *Munro of Novar, the Titianesque *Venus

and Adonis (c.1803–5; private collection, South America; BJ 150), which he left untouched, and *The *Wreck Buoy* (Walker Art Gallery, Liverpool; BJ 428), an early seapiece of about 1807, which he greatly enhanced in colour, almost certainly adding the rainbow.

In the case of the last two examples Turner worked over finished pictures. An account by the young painter G. D. Leslie's account of Turner's practice late in his career gives us a clue as to what the pictures more usually looked like when Turner brought them into the RA: 'I believe that Turner had for a long time been in the habit of preparing works for future exhibitions . . . He must, I think, have had many works thus commenced laid by in his studio, from which he would take one, from time to time, to send to the Academy for exhibition' (G. D. Leslie, *The Inner Life of the Royal Academy*, 1914, pp. 146–7). The group of late unfinished oil paintings based on *Liber Studiorum* subjects such as *Norham Castle* seem to fit this description. Similarly, as representing the type of works that underlies the exhibited scenes of stormy seas such as *Slavers throwing overboard the Dead and Dying* (RA 1840; Museum of Fine Arts, Boston; BJ 385) and *Snow Storm—Steam-Boat off a Harbour's Mouth* (RA 1842; BJ 398), there is a series of unfinished canvases of stormy seas of the same size, 3×4 feet (91.4×122 cm.), in the Turner Bequest (BJ 454–73).

The explanation for Turner's practice of completing such unfinished works on the walls of the RA or the BI during the Varnishing Days, far beyond anything ever done by his contemporaries, may be purely practical: he liked, as with his watercolours, to work on a number of compositions at once, and he was then able to make a final selection only just before the works were needed for exhibition. On the other hand John Gage has suggested that Turner's intentions were much more positive, being both educative (after the relative lack of success of his lecture-giving as Professor of *Perspective) and an emulation of the antics of the virtuoso violinist Niccolò Paganini who had given concerts in London in the years 1831, 1832, 1833, and 1834. (There is a common passion here with the great Romantic French composer Hector Berlioz (1803–69), who wrote *Childe Harold's Pilgrimage* for Paganini in 1834 and shared Turner's enthusiasm for both *Byron and *Virgil as a source of inspiration.) Fashions in taste vary: at one time it was thought that Turner's finishing off of his canvases was a concession to contemporary taste, whereas now it is realized that he held significant *subject matter to be of the utmost importance. Luckily, with the survival of so many unfinished pictures, we are able to enjoy both aspects of his work.

See also COMPETITION WITH OTHER ARTISTS; SKETCHES, USE OF. MB

Gage 1969, pp. 166–72.
Gage 1987, pp. 89–92, 94.
Townsend 1993, p. 58.
Bailey 1997, pp. 285–303.
Hamilton 1997, pp. 248–50.

VAUGHAN, Henry (1809–99), English art collector. He was born into a Quaker family; in 1828, on the death of his father, a successful hat manufacturer, he succeeded to a large fortune. He spent much time travelling and became a cultivated, enthusiastic, and eclectic collector of works of art, especially of prints and drawings by Turner, with whom he was personally acquainted. He was one of the founders and most active members of the *Burlington Fine Arts Club. Though undoubtedly one of the outstanding English collectors of his time, he appears to have been something of a recluse, whose reputation is largely based on his gifts and bequests to British museums.

In 1886 he presented (anonymously) *Constable's celebrated *Hay Wain* to the National Gallery, *London, and in 1887 he gave five important Michelangelo drawings to the *British Museum. By his will Vaughan distributed his wealth among various medical charities and hospitals, and the bulk of his art collections among museums. Thus the British Museum Department of Prints and Drawings received a further 555 items, including 57 Old Master drawings, over 300 drawings by *Flaxman, *Lawrence, and *Stothard, and, above all, nearly 100 proofs of Turner's *Liber Studiorum* and 23 drawings connected with it. Some of the drawings were transferred from Vaughan's bequest to the National Gallery (the Turners were included in *Finberg's 1909 catalogue of those in the Turner Bequest), which also received various sculptures and Italian and British paintings (the latter now in the *Tate Gallery). To the *Victoria and Albert Museum he assigned his collections of stained glass and carved panels, six Turner watercolours, and the full-scale studies for Constable's *Hay Wain* and *Leaping Horse*, which had been on loan to that museum since 1862. To University College London he bequeathed the remainder of his *Liber* prints, his collection of Constable mezzotints, his *Rembrandt etchings and other prints, and a number of English drawings. The rest of Vaughan's outstanding and scholarly collection of Turner watercolours—he was described by *Ruskin as 'a great Turner man'—was divided between Edinburgh and Dublin. The National Gallery of Scotland, *Edinburgh, received a representative selection of 39 drawings, and a similar group of 31 went to the National Gallery of Ireland, *Dublin. LH

VENETIAN THEATRES, watercolours of. Turner was a great lover of *music, *opera, and ballet. He must have visited theatres on all his visits to *Venice (1819, 1833, 1840) and the unorthodox Venetian setting invented for **Juliet and her Nurse* (RA 1836; Sra. Amalia Lacroze de Fortabat, Argentina; BJ 365) demonstrates his sensitivity to the theatrical qualities of the city itself. The same sensibility underlies 40 highly expressive watercolour and gouache sketches on loose sheets of brown paper (TB CCCXVIII, CCCXIX, originally catalogued simply as 'Venice: Miscellaneous' *c.*1839). These include several of a specifically theatrical nature which were evidently drawn from memory or imagination: the Piazzetta by night with a puppet theatre in the foreground, an open-air theatre by night, the interior of a theatre, lovers at a balcony. The sketches share stylistic traits with some of Turner's *German drawings on identical paper made in 1840, the year of his final visit to Venice.
 CFP

Stainton 1985, pp. 45–7, pls. 11, 20, 21.
Powell 1995, no. 89.

VENICE. Even for the modern visitor 'all the world's a stage' is more true of Venice than of any other European city. The magical and theatrical island city of water, set in its spacious and often dramatically lit lagoon, and with one 'Grand Canal' and numerous narrow, winding, and often dark canals, broad piazzas, and sombre *calle*, and above all with a constant flow of gondolas, boats, and people, was for Turner a source of wonder and inspiration for the last three decades of his life. Though he paid only three—or possibly four—quite short visits to the unique city on the Adriatic, he found there more material for his lifelong study of light and colour than anywhere else, and a theatrical setting of water and imposing architecture, to which he added relatively little human activity, to provide the material for his numerous drawings, watercolours, and paintings of Venice. Taken together these form a highly personal and often visionary view of Venice, which was, as so much of Turner's art, pioneering and ahead of its time.

Turner's first experiences of Venice were at second hand, initially through the still popular views of *Canaletto and his 18th-century contemporaries, and then, slightly more directly, through the drawings of the architect James *Hakewill, who had made numerous topographical pencil drawings during his tour of Italy in 1816 and 1817. Hakewill commissioned Turner to make watercolours for engraving from twenty of these, of which eighteen were published in 1819–20 in Hakewill's *Picturesque Tour of Italy*. The Venetian views among these were the rather stiff and sombre *The Rialto, Venice*, engraved by John *Pye (R 144; W 700, untraced today) and the unpublished *Grand Canal, Venice* (sold at Christie's, 11 November 1999, lot 8, repr.).

It was in part his work for Hakewill that persuaded Turner to undertake his first visit to Italy, in the summer of 1819. He made careful preparations for the journey, receiving much help and advice from Hakewill, who provided Turner with a small leather-bound pocket book (TB CLXXI), filled with information about where to go, what to see, where to stay, distances, costs, and much more. Armed with this little book and another of his own notes and tiny copies of engravings from Smith, Byrne, and Emes's *Select Views in Italy*, published in 1792–6 (CLXXII), Turner left London on 31 July 1819, and reached Venice some six weeks later, probably arriving on 8 or 9 September. He stayed for only a few days, and definitely not more than five. For an Englishman to visit Venice at this period was still unusual, and even more unusual was to make it one of the first cities in his itinerary. Turner had crossed the Alps over the Mont Cenis Pass, visited Turin and Milan, saw something of the Italian Lakes, and then travelled on to Venice via Brescia and Verona.

In 1819 Venice was again part of the Austrian Empire, as it had been for a time after its conquest by *Napoleon in 1797. The rapid decline from being one of the great commercial and cultural centres of Europe, which had overwhelmed the Republic in the 18th century, continued, and at the time of Turner's first visit the city was in economic decline and many of its buildings were decaying. Of its former commercial activities only the glassware industry was still flourishing, and the citizens were burdened by the high taxes imposed on them by their Austrian masters. It had always been popular with British travellers, especially those with cultural and literary interests, and its popularity was greatly enhanced at this time by the Romantic poetry of Lord *Byron. The fourth canto of *Childe Harold's Pilgrimage*, with the famous stanzas about Venice, was published in 1818, and was very probably read by Turner before his visit. Byron's own residence in Venice at intervals between 1817 and 1820 further helped to raise its popularity with British tourists. On the other hand, Venice was not yet a regular port of call for British artists touring in Italy, whose main interest was still focused on *Rome and its surroundings. Turner was in fact one of the first 19th-century British artists to stay in the city, and it was partially his example that led to its growing popularity among artists in the later 1820s and 1830s.

The short first visit in 1819 was a fruitful one, and the large number of rapid and vivid pencil drawings that Turner made prove the immediate impact that the unique Venetian scenery made on him. There are about 135 of these informative and often detailed sketches in two sketchbooks, 'Milan to Venice' and 'Venice to Ancona', in the Turner Bequest (CLXXV and CLXXVI). In addition to the pencil drawings there

are four breathtakingly beautiful watercolours, which capture the shapes, light, and atmosphere of Venice with the greatest economy. Drawn on four consecutive sheets of the 'Como and Venice' Sketchbook (CLXXXI) these have long been considered the outstanding products of Turner's first Italian tour. Their immediacy and convincing rendering of specific light effects—in two cases the luminosity of early morning—make it probable that these masterpieces were executed from nature on the spot, but there is no certainty about this.

Having left Venice, Turner spent another fifteen or so weeks in Italy, many of them in Rome. He was back in London on 1 February 1820, and though it was memories of Rome and classical Italy that predominated in the next few years, he never forgot Venice. Turner's only exhibit at the *Royal Academy in 1820 was the huge and somewhat confusing *Rome, from the Vatican. Raffaelle, accompanied by La Fornarina, preparing his Pictures for the Decoration of the Loggia* (BJ 228). It has only been realized quite recently that another vast, but unfinished, dirty, and badly damaged canvas in the Tate Gallery depicts *The Rialto, Venice* (BJ 245), and was probably the beginning of a Venetian composition conceived as a counterpart to the Roman subject. This shows the Grand Canal through the arch of the Rialto, while a related composition is seen in a large unfinished watercolour of about 1820 in the National Gallery of Ireland, Dublin (W 725). Also dating from about 1820 is the finished and very detailed watercolour of the Rialto, which was among the six Italian views commissioned by Walter *Fawkes (Indianapolis Museum of Art; W 718). This is a more distant and broader view than the Hakewill composition, and is based on one of the most detailed drawings covering two sheets of the 'Milan to Venice' Sketchbook. The second Venetian composition for Fawkes is inscribed 'Venice from Fusina', and dated 1821 (private collection; W 721). In the foreground of this rather dark watercolour Turner has depicted a crowded and vivacious scene of boats and gondolas, making this a real 'souvenir' of the visitor's first impression of Venice, the skyline of which is seen on the horizon across a heavy sea. A third finished watercolour of this time, now untraced, is a view of the Salute from the Grand Canal. As A. J. *Finberg has pointed out, this and the view of the Rialto are full of 'topographical and other licences'. They are the work of a stranger reacting to Venice and recording his impressions

with immense gusto and with touches of pardonable exaggeration. But nearly everything he tells us is strictly true. In these drawings he gives us a mass of shrewdly observed and accurate topography, and all the major elements of the scenes—the play of sunlight on the buildings, on the water, and on the shipping, the movement and the

gay and varied colouring—are presented with consummate skill. (Finberg 1930, p. 72)

Turner's next known Venetian works were two of the vignettes which he produced for engraving as illustrations for Samuel *Rogers's poem *Italy*, published in 1830, and for his *Poems*, which followed four years later. For each volume Turner produced one Venetian subject; *The Ducal Palace* (CCLXXX: 193; W 1162) engraved by Edward *Goodall (R 358) in about 1827 for *Italy*, and *The Rialto: Moonlight* (CCLXXX: 196; W 1190) engraved by William *Miller (R 386) for the *Poems* in about 1832. Both these tiny, minutely detailed, and yet wonderfully atmospheric compositions are based on pencil studies made in 1819, and they show how vivid Turner's memories of Venice still were. He had not visited Venice during his second tour of Italy in 1828, which was spent mostly in Rome, and it is one of the mysteries of Turner's Venetian work that his first two oil paintings of the city were painted *before* his second visit there, and fourteen years after his first visit to the city. Both were among his six exhibits at the RA in 1833, but today only one of these is known. The other, *Ducal Palace Venice* (BJ 352), is lost, but may have been the original of William Miller's 1854 steel engraving entitled *Venice—The Piazetta* (R 674), a rather stiff upright composition somewhat in the manner of *Bonington's Venetian scenes.

The known—very well-known—painting is *Bridge of Sighs, Ducal Palace and Custom-House, Venice: Canaletti painting* (BJ 349), which was purchased by Robert *Vernon and formed part of his gift to the National Gallery, *London, in 1847. As its title implies, this remarkable painting, which is on panel, was conceived as an act of homage to his great predecessor in the depiction of Venice; Canaletto is shown in the left foreground—totally apocryphally—working on a picture in an elaborate gold frame. It was said at the time that Turner completed the painting in two or three days on learning that Clarkson *Stanfield was exhibiting a similar, though much larger, Venetian scene, *Venice from the Dogana* (Marquess of Lansdowne). It was generally thought that Turner's small and colourful composition triumphed in this friendly contest, and its immediate purchase by Robert Vernon confirms that.

Compared with his subsequent paintings of Venice, the *Bridge of Sighs* appears somewhat old-fashioned and stiff—an amalgamation of his own sketches and memories with his knowledge of earlier and contemporary paintings of the city. Though it has been suggested that Turner's second visit to Venice took place in 1832—partially because he exhibited the two Venetian scenes in 1833—it now seems reasonably certain that this second visit did not take place until after the RA summer exhibition, in the late summer of 1833, as has

been convincingly argued by Hardy George (George 1971). That Turner visited Venice again, and for the last time, in 1840 has never been in doubt, but there still remains the possibility that the artist was also in Venice in the intervening years—1835, 1837, and 1839 have all been suggested, though there is no proof of a visit in any of these years. The 1833 visit was again a relatively short one, lasting some ten days in mid-September, during which he made nearly 200 pencil sketches, most of them in one sketchbook—the so-called 'Venice' Sketchbook (CCCXIV). These are mostly very rapid drawings, far more loosely executed and summary than those of 1819, and some of them with identifying inscriptions.

In addition to these drawings a sizeable group of watercolours of Venice are associated with the 1833 visit, though again there is an element of uncertainty as it is difficult to be at all certain about the dating of the 170 or so later watercolour studies of Venetian scenes known today. The bulk of these are in the Turner Bequest, and some 25 are in public and private collections all over the world. In her invaluable *Turner's Venice*, published by the British Museum in 1985, Lindsay Stainton has made a tentative but acceptable division of the drawings between the 1833 and 1840 visits, with the proviso that many of them may have been executed from memory away from Venice, and even when back in England. In the catalogues of the two London 1975 Turner *bicentenary exhibitions, all these Venetian drawings were dated 1840, which is also the 'schematic date' which Andrew Wilton assigns to all the later Venetian drawings not in the Bequest in his pioneering 'Catalogue of Watercolours' (Wilton 1979, nos. 1352–75).

The principal group assigned to the 1833 visit are all on brown *paper, probably cut to size from larger sheets by Turner himself. They are very freely handled, making full use of the dark background, and many of them are night scenes and dark interiors (see VENETIAN THEATRES). Most of them are in the large 'Venice: Miscellaneous' series (CCCXVIII), and a further group of smaller drawings is listed by Finberg under CCCXIX. Most of these very rapid drawings are executed in a mixture of watercolour and body-colour (see GOUACHE), and in many of them white heightening is used to add the final touches. Looked at together these highly individual sketches provide convincing evidence of the strong impact of the scenery, atmosphere, light, and colours of Venice, on the 58-year-old Turner, and it is difficult to think of them as anything other than immediate reactions to specific moments jotted down hastily on the spot.

Lindsay Stainton has made out an excellent case for associating a further group of very impressionistic views in Venice with Turner's 1833 visit, though here she is rather

more tentative than with the brown-paper compositions. These are on off-white paper in CCCXVI (also entitled 'Venice: Miscellaneous') and she points out that 'about twenty-eight of them, however, are the same size, and had clearly once formed the leaves of a sketchbook'. Among the reasons for dating them to 1833 are that several sheets are watermarked 1828, and that many of these daylight scenes are similar in mood to the night-time compositions on brown paper. In some of these drawings the watercolour washes are over slight pencil outlines, and in many of them Turner has used a pen or the tip of a fine brush with red or brown ink or a touch of watercolour to strengthen the outlines. However, the overall effect of most of these wonderfully translucent views of Venice is that water and sky predominate, with buildings, boats, and occasionally people as a link between them. Turner's very personal vision of Venice is at once dreamlike and theatrical; the city provided unique inspiration for his imagery of light and colour.

From 1833 until 1846 there were only two years—1838 and 1839—when Turner did not exhibit one or more Venetian subjects at the RA, and about two-thirds of these canvases were either commissioned or quickly sold. In 1834 one of Turner's five exhibits was the imposing *Venice* (National Gallery of Art, Washington; BJ 356), which was painted for Henry *McConnel. *Keelmen heaving in Coals by Night*, now also in the National Gallery of Art, Washington (BJ 360), which was exhibited at the RA in 1835, was painted as a companion to this, and the contrast between the sunny and restful Venetian view and the bustling night-time scene on the River Tyne is a telling one. The 1835 Venetian exhibit, *Venice, from the Porch of Madonna della Salute*, which is also now in America (Metropolitan Museum, New York; BJ 362), was sold to Turner's major patron H. A. J. *Munro of Novar, who is said by Walter *Thornbury to have financed Turner's second visit to Venice. Though Munro, who had expected a watercolour, is said to have been disappointed with the painting, the critics on the whole approved of it, as they continued to do of most of Turner's Venetian subjects.

The Venetian exhibit of 1836, *Juliet and her Nurse* (Sra. Amalia Lacroze de Fortabat, Argentina; BJ 365), on the other hand, is renowned for the infamous attack on it in *Blackwood's Magazine* by the Revd John Eagles, an amateur artist and conservative critic who was frequently hostile to Turner's work. He called *Juliet* 'A strange jumble—"confusion worse confounded". It is neither sunlight, moonlight, nor starlight, nor firelight . . . Amidst so many absurdities, we scarcely stop to ask why Juliet and her nurse should be at Venice.' This attack infuriated the young John

*Ruskin, who drafted a reply which he sent to Turner, who thanked him for his 'zeal, kindness and trouble' but advised against publication, and asked for permission to send the manuscript to the painting's purchaser, Munro of Novar. Ruskin took the painter's advice, but the remarkably fluent letter—Ruskin was 17 at the time—became the seed which grew into the first volume *Modern Painters*. It is not clear why Turner placed Shakespeare's Juliet in Venice rather than Verona, and when the painting was engraved in 1842 (R 654) the Shakespearian reference was omitted from the title, which became *St. Mark's Place, Venice (Moonlight)*, and was accompanied by four lines from Byron's *Childe Harold's Pilgrimage*. This eerily lit aerial view of the crowded Piazza and the adjoining Grand Canal, dominated by the Campanile set at the golden section of the panoramic composition, is one of Turner's most magical and evocative visions of Venice, 'The pleasant place of all festivity | The revels of the earth, the Masque of Italy', as Byron described it.

In 1837 Turner showed *The Grand Canal, Venice* (Huntington Gallery, California; BJ 368), which was exhibited with a quotation from Shakespeare's *Merchant of Venice*, and was also exhibited as *Scene—a Street in Venice*. This powerful and colourful upright composition shows another very crowded scene, and, as was to be expected, it was again the victim of the Revd John Eagles's harsh invective—'a bold attempt to insult the public taste . . . the execution is as if done with the finger and the nail, as if he had taken a pet against brushes'. An unfinished canvas in the Turner Bequest is also dated to the mid-1830s, and has been identified by Lawrence Gowing (1966, p. 36) as *Venice, the Piazetta with the Ceremony of the Doge marrying the Sea* (BJ 501). In this the main elements of the composition are blocked in, and the painting demonstrates Turner's total understanding of the deep and hot light of Venice on a sunny day in the bold blues of the sky and water.

After a two-year interlude Turner exhibited two Venetian subjects in 1840, a year in which he showed a total of seven canvases, including the controversial and challenging *Slavers*. The somewhat heavy and gloomy *Venice, the Bridge of Sighs* (BJ 383) remained unsold, but the important collector John *Sheepshanks had commissioned the much more attractive *Venice, from the Canale della Giudecca, Chiesa di S. Maria della Salute, &c*, which he presented to the Victoria and Albert Museum with the rest of his collection, including another four Turner oils, in 1857 (BJ 384). This exceptionally well-preserved painting (it has been housed in an airtight frame since 1893) shows Venice in silvery light. These two 1840 exhibits are the first pictures of Venice painted on 2 × 3 ft. (61 × 122 cm.) canvases, a

somewhat smaller size than the earlier Venetian subjects, which from now on Turner used for nearly all his paintings of Venice (see SIZES AND FORMATS).

Turner was back in Venice, now rather more prosperous than in 1819, on his third, or just possibly fourth and certainly final visit, on 20 August 1840, and he left for Trieste on 3 September. Both his arrival and departure are recorded in the city's *Gazetta*, and this visit is also recorded by his much younger fellow artist William Callow (1812–1908), who wrote in his *Autobiography* (1908),

The next time I met Turner was at Venice, at Hotel Europa, where we sat opposite at meals and entered into conversation. One evening whilst I was enjoying a cigar in a gondola I saw in another one Turner sketching San Giorgio, brilliantly lit by the setting sun. I felt quite ashamed of myself idling away the time whilst he was hard at work so late.

As well as making more rapid pencil notations, similar to those of 1833, in three small sketchbooks, CCCX, CCCXIII, and CCCXX, he used larger roll-sketchbooks (which could be rolled up and kept in a pocket) to work in watercolours, very probably on the spot. These late Venetian watercolours, of which some two dozen were removed from the sketchbooks and sold during Turner's lifetime, are among the artist's supreme achievements in the medium of which he was such a complete and unrivalled master (see Pl. 26). Taken as a whole they provide the most engrossing survey of the unique character, atmosphere, and light of Venice; seen individually each one is an outstanding achievement in its own right. Those that 'escaped' are listed by Andrew Wilton, 1979, under nos. 1352–75, and are scattered in public and private collections throughout the world. They were probably sold through Turner's agent, Thomas *Griffith, and six of them were bought by Ruskin, who included three of them in his gift to the University of Oxford. These are now in the *Ashmolean Museum, and one of them, *Venice: The Grand Canal* (W 1363), is among the most ethereal of all Turner's depictions of Venice, wished onto the white paper with the minimum of transparent watercolour and pulled together by the black wash impression of a gondola in the centre. This minor masterpiece and its companions were originally part of the roll-sketchbook listed by Finberg as CCCXV, of which 21 drawings remain in the Bequest. The bulk of the remaining late Venetian drawings are in CCCXVI and CCCXVII, while more are among the various 'miscellaneous' groups listed by Finberg at the end of his Inventory.

Ruskin believed that Turner's Venetian watercolours were sketched 'on the spot', and though some scholars have disputed this, it seems very probable. One argument against this conclusion is that a considerable number of the compositions are topographically inaccurate. On the other hand,

working as rapidly as Turner must have done, accuracy would often have been hard to achieve if the initial marks on the paper did not allow it, for none of these drawings has been abandoned in an unfinished state; they are all as 'finished' as Turner intended them to be. By normal standards, however, and certainly to his contemporaries before the era of Impressionism, they must have seemed little more than preliminary jottings.

It seems probable that Turner hoped to obtain commissions for finished watercolours based on his Venetian studies, as he did a year or two later for some of his *Swiss subjects. However, this did not happen, and surprisingly there are no late finished Venetian watercolours by Turner. However, between 1841 and 1846 Turner exhibited seventeen oil paintings of Venice at the RA, though most of these would certainly have been considered as 'unfinished' by his contemporaries. Three of Turner's six exhibits in 1841 were of Venetian views. The first, *Ducal Palace, Dogano, with part of San Giorgio, Venice* (Oberlin College, Ohio; BJ 390), was painted for Turner's friend, the sculptor Sir Francis *Chantrey, who died later that year. This shimmering panoramic view can be considered as a pair with *Giudecca, la Donna della Salute and San Giorgio* (private collection; BJ 391), which was bought at the exhibition by Elhanan *Bicknell. The third, and larger, canvas was *Depositing of John Bellini's Three Pictures in la Chiesa Redentore, Venice* (private collection; BJ 393), a rather less happy evocation of what is probably an imaginary event, for which Turner was asking 350 guineas, while the *Giudecca* was priced at 250.

While the critics were reasonably enthusiastic about the 1841 Venetian pictures, they were full of warm praise for the two shown in the following year—'Two lovely views of Venice, gorgeous in hue and atmospheric in tone' was the judgement of the *Spectator*. They are indeed an outstanding pair, and both were sold at the exhibition. *The Dogano, San Giorgio, Citella, from the Steps of the Europa* (BJ 396) was bought by Robert Vernon, and was the token painting from his 1847 gift to be hung immediately in the National Gallery, *London, thereby becoming the first painting by Turner to enter a public collection. *Campo Santo, Venice* (Toledo Museum of Art, Ohio; BJ 397) was purchased by Bicknell, and may, indeed, have been painted for him (see Pl. 29). These two calm and vivid scenes must have provided a telling contrast with another of Turner's 1842 exhibits, the dramatic and disturbing *Snow Storm* (BJ 398).

There is something of the same feeling of threat and pessimism in *The *Sun of Venice going to Sea* (BJ 535), one of Turner's three Venetian paintings shown in 1843, the title being accompanied in the catalogue by four premonitory lines from Turner's own epic verses *Fallacies of Hope* (see

POETRY AND TURNER). Ruskin especially admired this work, and also praised the other two Venetian subjects in the 1843 exhibition, *St. Benedetto, looking towards Fusina* (BJ 406) and *Dogana, and Madonna della Salute, Venice* (National Gallery of Art, Washington; BJ 403). In both of these there is something of the vagueness of the 1840 watercolour studies, and in the execution of the late Venetian oils there is often little to distinguish them from his technique in the watercolours. There is rarely a direct connection between the watercolours and the oils, though, as Ruskin first pointed out, there is a close correspondence between the composition of the roll-sketchbook drawing of *The Giudecca, looking towards Fusina* (CCCXV 13) and of the *St. Benedetto*, and there are other cases of considerable similarity.

The three Venetian subjects shown in 1844 are even more diffuse and vague than those of the previous year, and not surprisingly only one of them, *Approach to Venice* (National Gallery of Art, Washington; BJ 412), was sold. The other two (BJ 411, 413) had more specific topographical titles, and their subjects, *Venice—Maria della Salute* and *Venice Quay, Ducal Palace*, are recognizable. However, in 1845 Turner abandoned all pretence at reality, and exhibited a series of four largely visionary compositions which only echoed Venice, but which did feature the four times of day. The titles of two referred to an event in keeping with Venetian ceremonial and festivity, a major element in the life of the city, but were probably more imaginery than actual. They are called *Venice, Evening, going to the Ball* and *Morning, returning from the Ball, St. Martino* (BJ 416, 417), and were painted for specific patrons, but quickly returned to the artist. The other two, *Venice, Noon* and *Venice—Sunset, a Fisher* (BJ 418, 419), were exhibited with the caption 'MS *Fallacies of Hope*', clearly indicating their fanciful and poetic nature. All these four paintings are painted with absolute freedom of technique in a limited colour range of largely yellows and reds, and as a result of this freedom the condition of all of them has deteriorated over the years. There are many similarities in spirit and effect with the late Venetian watercolours, and the same applies to Turner's two 1846 Venetian exhibits, whose titles again refer to the ball, *Going to the Ball (San Martino)* and *Returning from the Ball (St. Martha)* (private collection; BJ 420, 421). This pair was ultimately bought by B. G. *Windus, a major collector of Turner watercolours, but their earlier history is confused. These were Turner's last exhibited paintings of Venetian subjects, and it says much for his high reputation in these late years that such puzzling and difficult paintings should have been competed for, and ultimately found a buyer. The Bequest also includes a number of unfinished 'Venetian Subjects' (BJ 501–8), dated to *c.*1835–45, which were presumably Turner's 'stock' for further Venetian oils.

Turner was a native Londoner, and during his lifetime the Thames with its multitude of shipping played a much more important part in the life of the city than it has done in the last century. He always lived on or within easy reach of the river, and it was clearly an important element in his life. In his travels in Britain and on the Continent, the sea, lakes, and rivers—stretches of water in any form—were a constant feature of his drawings and watercolours. Thus it is not surprising that Venice, in whose appearance and existence water is paramount, provided such wonderful inspiration for Turner. What is surprising is that it took only three quite short visits to Venice for it to become and remain one of the most fruitful sources of subject matter in Turner's work.

For Byron, in *Childe Harold's Pilgrimage*, Venice

> Was as a fairy city of the heart,
> Rising like water-columns from the sea.

For Ruskin, in his *Diary* on 6 May 1841, his first day there, it was 'the Paradise of cities'. Turner did not express himself about Venice in words, but his drawings, watercolours, and paintings show that for him, both as an artist and as a man, it was a supreme experience. Venice played a very central role in his art, and Turner's art, like the words of Byron and Ruskin, has played a significant part in making the city one of the favourite places in Italy for the English. LH

Finberg 1930.
George 1971, pp. 84–7.
Stainton 1985.

VERNET, Claude-Joseph (1714–89), French landscape and marine painter. Born and trained in Provence, he was in Rome 1733–53, with interruptions for visits to Naples; afterwards he lived in France, settling in Paris from 1762. Thought of as an 18th-century successor to *Claude Lorrain, Gaspard *Dughet and Salvator *Rosa combined, Vernet was keenly admired both by fellow artists and by collectors. British Grand Tourists made up about half his patrons during his Italian period, and both *Reynolds and *Wilson met him in Rome in the early 1750s.

It was by this means that Vernet's reputation was carried forward in England almost to the end of the 18th century, although his influence was latterly mediated through the paintings of P.-J. de *Loutherbourg and Wilson, in which form it reached Turner. Turner made a pen and wash copy of a coast scene with a shipwreck by Vernet in his 'Wilson' Sketchbook (TB XXXVII: 104 f.) of 1797. The previous year he had used a cold, hazy moonlight effect borrowed from Vernet as the dominant motif of his first exhibited oil painting, *Fishermen at Sea* (RA 1796; BJ 1). A paler version of

the same effect was repeated in another, smaller marine by Turner shown in 1797, *Moonlight, a Study at Millbank* (BJ 2).

On a different note, it has been suggested by modern scholars that the episode of Vernet's having himself lashed to the mast of a ship in order to observe the effects of a storm at sea (reported in his obituary in 1789) may have been the source of the story that Turner had the same thing done to him before painting *Snow Storm—Steam-Boat off a Harbour's Mouth* (RA 1842; BJ 398). MK

Philip Conisbee, *Claude-Joseph Vernet*, exhibition catalogue, London, Kenwood, 1976.

VERNON, Robert (1774–1849), English collector of British art and patron of Turner. Vernon was the son of a prosperous London hackney man (d. 1801) who collected Old Masters. These were inherited by Robert, whose fortunes rose in 1820 with the acquisition of more stables and a house in fashionable Belgravia. Soon he was buying modern British art. He bought at the de Tabley sale, 1827 (see LEICESTER), including landscapes by *Callcott and James Ward, though it was not until 1832 that he acquired, from the Royal Academy exhibition, his first Turner—*The Prince of Orange . . . landed at Torbay* (BJ 343). At about the same time he acquired his first major British 'Old Master', a landscape by *Gainsborough, and moved to a larger house in Pall Mall which gave him space for a bigger collection.

Vernon's purchase of the great Turner's rendering of an important event in English history was a patriotic gesture which effectively marked the beginning of his campaign to create an unofficial 'national gallery' of British art in the absence of any such collection in the *London National Gallery nearby. Thereafter, Vernon's collection grew rapidly, partly, according to George *Jones, under 'his guidance, suggestion and judgement' (George Jones, R.A., *Sir Francis Chantrey, R.A.: Recollections of his Life, Practice and Opinions*, 1849, p. 209) but now taking account of hitherto unrepresented major living artists who were essential to a survey of the British School. Alongside this, and aware of Francis *Chantrey's ideas for supporting native artists, Vernon planned to create a fund for buying pictures and assisting deserving artists; he also intended setting up artists' fellowships. These initiatives, which came to nothing, find parallels in both Turner's and Chantrey's charitable intentions in their wills as well as John *Sheepshanks's collecting of British art during the same period. In May 1843 Vernon opened his house to the public for the first time, with admission by tickets obtained from Royal Academicians. Turner, together with artist colleagues, attended a celebratory dinner which Vernon held on 3 May (Jenkyns Papers II.3, Balliol College, Oxford).

Vernon owned five paintings by Turner: one of these, *Neapolitan Fisher-Girls surprised Bathing by Moonlight* (Huntington Library and Art Gallery, California; BJ 388; or private collection, USA; BJ 389), he sold in 1842 when refining his collection prior to making it more public. The other four were among the 166 paintings and sculptures (now mostly in the *Tate Gallery) which the Trustees of the National Gallery chose for the nation as a gift out of the hundreds of works which Vernon owned by 1847. By the deed of the gift, signed by Vernon on 22 December 1847, *The Dogano, San Giorgio, Citella, from the Steps of the Europa* (BJ 396) was taken from Vernon's house and put on show in the National Gallery 'in the name of the whole'. It went on public display on 27 December 1847, the first Turner in a public collection and thus of great symbolic importance in the way it signified the artist's (and, by implication, the British School's) by now unassailable position among the Old Masters. In 1849 an attempt to commemorate Vernon and his generosity through the creation of a 'Vernon Medal', to be awarded to meritorious Academy students, was abandoned because of lack of support. The other Turners in Vernon's collection were Turner's first exhibited *Venetian subject, *Bridge of Sighs, Ducal Palace and Custom-House, Venice: Canaletti painting* (RA 1833; BJ 349), and *The *Golden Bough* (RA 1834; BJ 355). RH

Robin Hamlyn and Judy Collins, 'Sir Francis Chantrey: His Bequest in Context', *Within These Shores*, exhibition catalogue, Sheffield, Graves Art Gallery, 1989, pp. 9–26.

Hamlyn 1993.

Egerton 1998, p. 12.

VESUVIUS has shaped the history and destiny of southern Italy for centuries: the eruption of AD 79 destroyed the classical towns of Pompeii and Herculaneum while the awe-inspiring sight of the volcano, brooding over the bay of *Naples, contributes much to the legendary appeal of that city amongst travellers. Both in eruption and at rest, it has been painted by countless artists. Turner's only ascent of Vesuvius was made in 1819 with the young British architect T. L. Donaldson who later recalled that the artist had asked to join his party and had made sketches during the excursion. In two superb watercolour sketches drawn around that time in his 'Naples: Rome. C. Studies' Sketchbook (TB CLXXXVII: 13, 18) Turner showed the bay of Naples with Vesuvius serenely sleeping in the background; the first of these was soon developed into a watercolour for Walter *Fawkes (1820; private collection; W 722). However, Turner's most dramatic depictions of Vesuvius, showing the volcano dazzlingly in eruption, were works of pure imagination, inspired by the paintings of earlier artists such as

*Wright of Derby. The larger and more impressive of these was painted in 1817, two years before Turner visited southern Italy (Yale Center for British Art, New Haven; W 697). Shortly afterwards a much smaller depiction of the same subject (Williamson Art Gallery, Birkenhead; W 698) was commissioned as an illustration for a book on Pompeii. It did not, however, appear there and was ultimately engraved in a much more popular volume, *Friendship's Offering for 1830*, where it provided the boy *Ruskin with his earliest remembered delight in Turner's magical powers. CFP

Powell 1987, pp. 74-5, 78-82.

VICTORIA, Queen (1819–1901), Queen of Great Britain and Ireland, and Empress of India from 1876. Daughter of Edward, Duke of Kent, fourth son of *George III, she succeeded William IV in 1837, and her reign was the longest in English history. She married her first cousin, Prince *Albert of Saxe-Coburg-Gotha, in 1840, and had nine children. It was a very happy marriage, and the Prince Consort exerted a considerable influence on the actions of the Queen, especially in her contacts with the arts and artists. The royal couple took an active interest in the exhibitions of the *Royal Academy, making major purchases from time to time, including Frith's *Ramsgate Sands* in 1854 and Leighton's *Cimabue's Madonna* in 1855. They particularly admired the work of Edwin *Landseer, from whom they bought and commissioned numerous paintings and drawings. However, Turner was not among the artists patronized by them. The lack of royal patronage and recognition certainly upset Turner, whose most blatant attempt to change the situation came soon after the royal marriage with his 1841 RA exhibit *Schloss Rosenau, Seat of H.R.H. Prince Albert of Coburg, near Coburg, Germany* (National Museums and Art Galleries on Merseyside, Liverpool; BJ 392), which, far from buying, the Queen did not even mention in her *Journal* comments on the exhibition. LH

VICTORIA AND ALBERT MUSEUM, London, contains the national collection of British watercolours comprising over 5,600 examples, including 36 by Turner, by 1,600 artists. In its early years it was called the South Kensington Museum.

The five Turner oils all belonged to John *Sheepshanks (1787–1863), as did *Hornby Castle from Tatham Church* (W 577) engraved for *Whitaker's *Richmondshire*, 1822. *East *Cowes Castle, the Regatta starting for their Moorings* (RA 1828; BJ 243) and *Life-Boat and Manby Apparatus* (RA 1831; BJ 336) had both belonged to John *Nash and were bought at his sale in 1835 by Sheepshanks's agent. It is unclear whether Sheepshanks commissioned *St Michael's Mount* (RA 1834; BJ 358) and *Line-Fishing off Hastings* (RA

1835; BJ 363) or bought them at the *Royal Academy exhibitions; he may have bought the former at the RA and then commissioned the latter as a pair to it, both sharing the rather unusual *size of about 24 × 30 in. (61 × 76 cm.). *Venice from the Canale della Giudecca* (RA 1840; BJ 384) appears to have been commissioned by Sheepshanks (Gage 1980, pp. 175–6), although Turner later offered him the choice between it and *Venice, the Bridge of Sighs* (BJ 383) hanging in the same room at the RA; in addition he charged Sheepshanks 250 guineas, thus contradicting his statement quoting 200 guineas for his pictures of Venice 'if painted by commission—250 guineas afterwards'.

The watercolours range in date from c.1793, *St Martin's Priory, Dover* (W 35), to 1848–50, *A Swiss Pass* (W 1565). Highlights include *Abergavenny Bridge* (?RA 1799; W 252), *Warkworth Castle* (RA 1799; W 256), and two of the views of Salisbury Cathedral painted for Sir Richard Colt *Hoare, the former RA 1801 (W 201, 202). There are two outstanding *England and Wales views: *Holy Island, Northumberland* (c.1829; W 819) and *Plymouth Cove* (c.1830; W 835) with sailors dancing in the foreground. Three very small (3½ × 7½ in., 90 × 190 cm.) but brilliant studies of sea and sky (W 1388–90) pose problems of dating as Wilton's ?1830 implies; the same donor (Robert Clarke Edwards) presented *Study of a Gurnard* (c.1840; W 1404). Three exceptional and very late drawings are *Lyons* (W 1555), *The Lauerzev See, with the Mytheus* (W 1562), and *Lake with Hills* (W 1563), catalogued by the museum as *Mountainous Landscape*. EJ

Lionel Lambourne and Jean Hamilton, *British Watercolours in the Victoria and Albert Museum*, 1980, pp. 384–5.

VIEW OF OXFORD FROM THE ABINGDON ROAD, see HIGH-STREET, OXFORD.

VIEWS AT HASTINGS AND ITS VICINITY, see SUSSEX, VIEWS IN.

VIGNETTES, see LITERATURE, ILLUSTRATIONS TO.

VIRGIL (70–19 BC). Turner owned a folio Virgil, quoting from the *Eclogues* in Latin in the 1809 'Perspective' Sketchbook (TB CVIII), but probably studied him in translations by Dryden (as for the epigraph to *Dido and Aeneas*, RA 1814, BJ 129) and Christopher Pitt (whose phrase gave the title to *The *Golden Bough*, RA 1834, BJ 355). In 1819 he sketched Virgil's tomb near *Naples (CLXXXV: 68). Turner admired *Claude Lorrain's landscapes with their Virgilian figures and doubtless knew the veneration felt for Virgil by *Gilpin and other theorists of the Picturesque (see SUBLIME). In the 'Studies for Pictures, Isleworth' Sketchbook, 1804–6 (XC), and the 'Wey, Guildford' Sketchbook, 1807 (XCVIII), Turner

lists subjects and makes sketches from the *Aeneid*. He was fascinated by Aeneas's encounter with the Sibyl (Book VI) and the drama of passion and betrayal between Dido and Aeneas (Book IV) with Dido's dying curse of perpetual hate between Rome and *Carthage. He painted the Sibyl and Lake Avernus three times: in *Aeneas and the Sibyl* (*c*.1798, BJ 34) and 1814–15 (Yale Center for British Art, New Haven; BJ 226), and again in *The Golden Bough*. He depicted the Carthaginian queen in *Dido and Aeneas*, *Dido building Carthage* (RA 1815; BJ 131) showing the tomb of Sychaeus, and *Dido directing the Equipment of the Fleet* (RA 1828; BJ 241). Turner's last exhibits at the Royal Academy (1850) were the quartet of Aeneas pictures (*Aeneas relating his Story to Dido*) from the same obsessive drama of fallacious hope in Book IV (BJ 429–32). JRP

Gage 1974.

Nicholson 1990, pp. 32–5, 234, 276–90.

VISION OF JACOB'S LADDER, THE, oil on canvas, 48½ × 74 in. (123 × 188 cm.), ?*c*.1830; Tate Gallery, London (BJ 435). This was listed in the Schedule of the Turner Bequest (see WILL) as 'Scriptural Subject' but almost certainly shows Jacob's vision of a ladder reaching from earth to heaven and bearing angels ascending and descending (Genesis 28: 10–12).

The picture appears to be an early work overpainted later. The basic landscape resembles that in the *Goddess of Discord* (BI 1806; BJ 57). Ziff suggests that the original subject here was *The First Plague of Egypt* (see PLAGUES OF EGYPT), and Shanes that the underlying picture is the lost *Army of the Medes destroyed in the Desert by a Whirlwind* (RA 1801; BJ 15). Turner then seems to have added the apparition of Jacob's vision, perhaps at about the time of *Vision of Medea* (1828; BJ 293). Gage draws a parallel between Turner's later treatment and a description in the *Annals of the Fine Arts*, 1817, of the *Jacob's Dream*, at Dulwich Art Gallery, at that time attributed to *Rembrandt. Turner may also have been emulating Washington *Allston's picture of the same subject done for Lord *Egremont (RA 1819, BI 1825; Petworth House).

At some time Turner used the back of the canvas as a palette; the dabs of paint were only removed in the 1970s.

MB

Davies 1946, pp. 162, 190.

Ziff 1980, p. 171.

Shanes 1981, p. 46.

Kitson 1988, pp. 9, 19 n. 33, repr.

VISIT TO THE TOMB, THE, see *ÆNEAS RELATING HIS STORY TO DIDO*.

W

WAAGEN, Gustav, Director of the National Gallery in Berlin. A celebrated German art historian, he made several visits to Britain and wrote two classic surveys of art collections in the country, first published in German and then in translation in 1838 and 1854–7. Among his commentaries on contemporary art in Britain were some of the most detailed early accounts of Turner's art as seen through the eyes of a visitor from Continental Europe. In 1835 he saw Turner's *The *Bright Stone of Honour* (*Ehrenbreitstein*) (RA 1835; BJ 361) and *The Burning of the Houses of Lords and Commons* . . . (RA 1835; Cleveland Museum of Art, Ohio; BJ 364; see PARLIAMENT) at the *Royal Academy. Being used to Turner's work through the steel engravings made after them, he was taken aback to find the artist's actual paintings displaying 'such carelessness in handling and such a complete lack of truth'. Waagen added that many of Turner's countrymen saw these works as evidence of the dissipation of a great talent but that 'Many, however, admire the same pictures as being particularly bold and spirited' (Waagen 1838, i. p. 419). Waagen saw Turner's tendencies as symptomatic of a general weakness of sense of form in the British School which he ascribed to its having originated during the 'degenerate' period of the mid-18th century. His views were echoed by other German artists and critics, such as the landscapist Josef Anton *Koch and the painter and historian Johann David *Passavant. In 1854, when Waagen published the updated version of his survey, he included a more sympathetic view. Describing Turner as a wonderful genius, occupying a position in English landscape painting similar to that of *Byron in English poetry, he still censured the later work while praising the early period. Indeed he went so far as to say that he would consider Turner to be the greatest of all landscape painters if only he had known how to finish his pictures properly. Waagen's censure was typical of the generation of Germans whose taste was modelled on classicism and medieval revivalism. WV

Gustav Friedrich Waagen, *Works of Art and Artists in England*, trans. H. E. Lloyd, 3 vols., 1838.

Gustav Friedrich Waagen, *Treasures of Art in Great Britain: Being an Account of the Chief Collections of Paintings, Drawings, Sculptures, Illuminated MSS, etc.,* trans. Lady Eastlake, 4 vols., 1854–7.

Andreas Haus, 'Turner im Urteil der deutschen Kunstliteratur', *J. M. W. Turner. Gemälde, Aquarelle*, exhibition catalogue, Berlin, Nationalgalerie, 1972, pp. 95–107.

WADMORE, James (d. ?1854). In 1828 Wadmore purchased from John *Broadhurst Turner's oils *Guardship at the Great Nore, Sheerness* (Turner's gallery 1809; private collection; BJ 91), **Harbour of Dieppe,** and *Cologne, the Arrival of a Packet Boat* (RA 1825, 1826; Frick Collection, New York; BJ 231, 232). Having tired of them, Broadhurst tried to sell these pictures at auction, but failed to find a buyer. He then took out advertisements, and Wadmore came forward, buying all three for £700. At the time, Wadmore lived in Chapel Street, Edgware Road. All three works were included in his sale at Christie's, 5–6 May 1854, the year he is thought to have died. RU

WALES. Only after the discovery of the aesthetic pleasures of the *Sublime did the mountainous terrain of Wales come into its own as an area for travel for its own sake. New industrial centres springing up in the south of the Principality also beckoned to those interested in modern technology or the visual thrills it gave rise to. In 1776 the topographer Paul *Sandby published a series of aquatints (among the first examples of the medium to appear in Britain) showing views of both landscape and industry in Wales. Thereafter tourism grew steadily and by the middle of the 19th century had become an important part of the Welsh economy.

When Turner visited Wales it was still remote and difficult of access, but its scenery provided a perfect stimulus to his burgeoning conceptual appetite and technical skills. He toured the country four times in the 1790s, and apart from a brief excursion along the Dee valley in 1808 never returned, although he was to draw on the subjects he had gleaned there for the rest of his career. He was particularly conscious of the inspiration that Wales could afford the painter on account of his admiration for Richard *Wilson, whose

'birthplace' he later claimed he had sought 'in the days of my youth' (Gage 1980, p. 307). This has been taken to mean that he visited, or tried to visit, the village of Penegoes near Machynlleth where Wilson was born; but it may simply be a way of saying that he had explored Wales in the consciousness that it was Wilson's homeland.

He first dipped a toe in Wales in 1792, when he was staying with his friends the *Narraways in Bristol. This was a convenient springboard for an excursion into the first mountains he had seen. The River Wye debouched into the Severn opposite Bristol, and to follow its course, past Chepstow, *Tintern, and Goodrich, was to perform the archetypal Picturesque tour as described by *Gilpin in his famous account of 1784. He penetrated along the Wye and into the hills of central Wales only as far as the Devil's Bridge, and seems to have been most stimulated by the scenery of the Black Mountains around Llanthony Abbey and Abergavenny, though he also made an important clutch of views of Tintern (Victoria and Albert Museum, Ashmolean Museum, Oxford, British Museum (two), and Fundaçao Calouste Gulbenkian, Lisbon; W 57–61). A few scenes on rocky coasts, apparently imaginary, seem to have been inspired by his experience of the Welsh coast near Tenby, combined with an admiration for the work of P. J. de *Loutherbourg, and show the beginnings of a sense of the Sublime possibilities of the region. Part of his long Midland tour of 1794 touched Wales, when he strayed in from Cheshire to visit Flint, Wrexham, and Llangollen. A watercolour of *Valle Crucis Abbey* outside Llangollen (TB XXVIII: R) marks an important technical step, with its sombre, romantic presentation of the ruins in a shadowy valley with the hill of Dinas Bran rising ethereally above.

Although a few watercolours resulted in due course from these journeys, he did not produce a substantial body of work on either, and it is worth asking why these very new and eminently picturesque scenes did not stimulate him to greater heights. His next Welsh tour took place in 1795 and was concentrated along the south coast. For this he equipped himself with two sketchbooks ('Small South Wales' and 'South Wales', XXV, XXVI). This time a significant group of finished watercolours resulted. The most important were exhibited at the Royal Academy in 1796 and 1797: *Llandilo Bridge and Dinevor Castle* (RA 1796; National Museum of Wales, Cardiff; W 140), *Landaff Cathedral, South Wales* (RA 1796; XXVIII: A; W 143), and *Trancept of *Ewenny Priory, Glamorganshire* (RA 1797; National Museum of Wales, Cardiff; W 227). Other important subjects are *Aberdulais Mill* (c.1796; National Library of Wales, Aberystwyth; W 169a) and *Newport Castle* (c.1796; British Museum; W 167). Turner seems to have used his experiences on this tour

to develop his technique as a painter of effects of water. A watercolour study of Melincourt Fall in the 'South Wales' Sketchbook is a virtuoso performance, and some shore scenes at Tenby demonstrate sophisticated handling which, translated into oil, is a feature of the first exhibited oil painting, *Fishermen at Sea* (RA 1796; BJ 1), generally believed to show a scene off the Needles, though it has also been thought to show Oxwich Bay in Gower, South Wales.

When he returned to Wales in 1798 it was for a much more extensive survey of the country. He began as usual at Bristol, and followed a route rather similar to the South Wales tour of 1795, but then turned north via Cilgerran with its atmospheric castle ruins to Aberystwyth, Dolgellau, and *Snowdonia. He returned through the Marches from Ruddlan and Denbigh to Powys and Hereford. Outside Hereford he drew the house of his patron Lord *Essex, Hereford Court, which gives its name to the grandest sketchbook of the tour (XXXVIII), full of detailed pencil drawings and fine watercolour studies covering subjects from all stages of the journey. A particularly memorable sheet is the colour study of Llyn y Cau on Cader Idris, interrupted by fine mountain rain, which spatters the page. Turner repeated the subject with more success on the next opening of the book. Other books used are the tiny 'Dinevor Castle' Sketchbook (XL) and the 'North Wales' Sketchbook (XXXIX). There survive a number of loose sheets, with drawings of the Bristol Channel and South Wales subjects, from a rather larger book, 'Cyfarthfa' (XLI), broken up for display by *Ruskin. *Farington noted on 26 September, 'Wm. Turner called on me. He has been in South & North Wales this Summer—*alone* and on Horseback—out 7 weeks—much rain but better for effects—one clear day and Snowdon appeared green and unpicturesque to the top' (*Diary*, iii. p. 1060).

These tours had seen a steady increase in the scale and Sublimity of the scenery that Turner was drawing, and after 1798 he began to make large watercolours which are among the first that he conceived as emulating oil painting in both size and power of effect. The RA in 1799 showed *Abergavenny Bridge, Monmouthshire, clearing up after a showery day* (Victoria and Albert Museum; W 252) and *Caernarvon Castle* (private collection; W 254), which explicitly emulates the *Claude seaports that he admired that year in the collection of John Julius *Angerstein. There were also two substantial oil paintings, *Harlech Castle, from Twgwyn Ferry, Summer's Evening Twilight* (Yale Center for British Art, New Haven; BJ 9) and *Kilgarran Castle on the Twyvey, Hazy Sunrise, previous to a Sultry Day* (National Trust, Wordsworth House, Cockermouth; BJ 11). The catalogue entry for the former included lines from Book IV of *Paradise Lost*, describing the onset of evening. The Kilgarren subject

was also executed as a watercolour (*c*.1798; City Art Gallery, Manchester; W 243).

Encouraged perhaps by the success of these ambitious works, Turner revisited Snowdonia that summer, to concentrate on the most spectacular aspects of Welsh scenery, taking with him a sheaf of large sheets of paper on which he seems to have worked in watercolour on the spot. They constitute an astonishing sequence of masterly studies, in which the medium of watercolour is pushed further than it had ever been taken before. As examples of the watercolour study direct from nature they both anticipate and excel in scale and subtlety the work of many other artists in the ensuing 'decade of naturalism'. The tour gave rise, immediately afterwards, to a large number of preparatory wash drawings, also on a large scale, in which his method of planning and developing a complex landscape motif can be seen evolving. These include serial experiments with bold washes of flat colour, and other sheets remarkable for the application of increasingly dense planes of colour, and the use of unusual earth pigments (or the admixture of flour or some other thickening agent) to create swirling brushstrokes. On the foundation of these explorations a group of finished watercolours was developed for various patrons, among them the Welsh landowner Sir Watkin Williams Wynn, who owned at least two views of Tintern and Dolbadarn Castle.

*Dolbadarn was the subject of an oil painting that Turner showed at the RA in 1800 (BJ 12), and subsequently presented to that body on the occasion of his election as Academician. It was prepared for in a sequence of chalk studies in the 'Studies for Pictures' Sketchbook (LXIX: ff. 103 ff.), and in an elaborate oil study for the whole composition that has recently come to light. The picture was exhibited with verses alluding to the imprisonment at Dolbadarn of the medieval Welsh prince Owen Goch. The lines are thought to be Turner's own composition; another exhibit for which he wrote verses was a second watercolour showing *Caernarvon Castle, North Wales* (RA 1800; LXX: M; W 263). These were the first occasions on which he ventured forth, albeit anonymously, in the RA catalogues as poet in his own right. Like the *Caernarvon Castle* of the previous year the 1800 watercolour was a challenge to Claude, though here it is the Claude of the pastoral subjects rather than of the seaports that is invoked. In the foreground a Welsh bard sings to a group of listeners; the castle is distantly visible in a broad (and clearly modern) landscape. The significance of this work is fully revealed only on consideration of a group of studies in the Turner Bequest (LXX: h and Q) which seem to relate to another part of the Bard's story: the moment immortalized by Gray in his poem *The Bard* of 1757, when the venerable singer, the last of his race, execrates the invad-

ing army of Edward I 'As down the steep of Snowdon's shaggy side | He wound with toilsome march his long array'. These sketches were never brought to completion, but with the pastoral scene that Turner did exhibit in 1800 they testify to a complex historical and symbolic intention that anticipates his paired paintings of the 1840s, notably *War. The Exile and the Rock Limpet* and *Peace—Burial at Sea* (BJ 400, 399).

He made further large watercolours with Welsh subjects soon after these, and some appeared at the RA. In 1801 he showed a view of *St Donat's Castle, South Wales: Summer evening* (private collection; W 279) and *Pembroke Castle, South Wales: thunder storm approaching* (private collection; W 280). This latter has been confused with another, very similar: *Pembroke castle: Clearing up of a thunder storm*, which was exhibited in 1806 (Art Gallery of Ontario, Toronto; W 281). A group of exceptionally large studies in the Turner Bequest testify to even wider experiment stimulated by Welsh themes at this time, notable among them being the beginning of a dramatic view of the gatehouse of Denbigh Castle (LXX: i).

In 1801 Turner toured the Highlands of *Scotland, which can be seen as the next stage in his education as a painter of mountains. The following year he was in the *Alps—a logical progression: 'The Country on the whole surpasses Wales; and Scotland too', he told Farington in October 1802. He had in a sense outgrown Wales. The brief trip along the Dee of 1808, made when he was staying with Sir John *Leicester at Tabley, bore fruit in one picture, *Trout Fishing in the Dee, Corwen Bridge and Cottage* (Taft Museum, Cincinnati; BJ 92), which appeared at Turner's own gallery in 1809. Thereafter, his use of Welsh material was all retrospective. Curiously few *Liber Studiorum* plates have Welsh themes, and those are border subjects, *Chepstow Castle, Raglan Castle*, and the *Junction of the Severn and the Wye* (F 48, 58, 28). But the most substantial call he made on the Welsh material he had gathered in the 1790s was in connection with the *Picturesque Views in *England and Wales*. That series, projected to include 120 plates, made use of many Welsh subjects, some of which he had already treated. His earlier response is often discernible as background, so to speak, to the new image, and although he no doubt worked directly from the pencil drawings he had made on the spot, the *England and Wales* designs can be seen equally as 'revisions' or adaptations of those long since finished works, or as freshly minted views 'from nature', as it were. The subjects are Beaumaris, Caernarvon (adapted from the 1799 watercolour), Carew, Cilgerran (adapted from the painting of 1799), Criccieth, Flint, Harlech, Kidwelly (adapted from a watercolour of about 1797), Laugharne,

Llanberis, Llangollen, Llanthony, Pembroke (a further variant on a theme tackled twice in the first decade of the century), Penmaenmawr, Powis, and Valle Crucis. Some of these, like the *Valle Crucis* and the *Llangollen*, are unexpectedly gentle and pastoral interpretations of material he had previously treated more dramatically. The *Penmaenmawr* and *Llanberis*, by contrast, count among his most powerful inventions, the latter anticipating the expansive studies of light on Lake *Lucerne that he was to make in the 1840s.

Although by the end of his life many years had passed since Turner had visited Wales, he remembered it in the 1840s and paid one last tribute to it in a visionary canvas, *The Junction of the Severn and the Wye from the Windcliff* (Louvre, Paris; BJ 509), which belongs in the series of studies from the mid-1840s that he derived from subjects in the *Liber Studiorum*. AW

Wilton 1984.

WALHALLA, THE. The Walhalla stands overlooking the *Danube a few miles east of Regensburg and is a hall of fame honouring the great German men and women of history. Conceived by Crown Prince Ludwig of Bavaria (later Ludwig I) in 1807, during the period of *Napoleon's crushing victories on German soil and occupation of many parts of Germany, the Walhalla was eventually built between 1830 and 1842. It was designed by Leo von Klenze and takes the form of a Doric temple modelled on the Parthenon in Athens and supported on a substructure of staircases and terraces. Its name comes from that of the dwelling-place of the gods in ancient German mythology and it houses an array of portrait busts carved by the most celebrated German sculptors of the day. Turner visited the Walhalla on his homeward journey from Venice in September 1840 and made sketches both in the sketchbook now named 'Venice; Passau to Würzburg' (TB CCCX) and on loose sheets of grey paper (CCCXLI: 363, 364, 371). He recorded its exterior from many angles, drew diagrams of its ground plan, and, although building work was not yet complete, gained access to its interior and swiftly sketched that also. The vast white marble building is such a dominant feature of this stretch of the Danube that Turner's interest in sketching it in 1840 is not surprising. However, it is hard to know whether he was already planning the oil painting with which he later celebrated its completion, *The *Opening of the Wallhalla, 1842* (RA 1843; BJ 401). CFP

Powell 1995, pp. 68, 70–1, 143, 165–8, 179–80.

WALKER ART GALLERY, Liverpool, see LIVERPOOL.

WALLHALLA, see OPENING OF THE WALLHALLA, THE.

WALLIS, Henry (1804/5–90). Often confused with the painter of that name, he began as a line-engraver but two successive strokes caused him to take up picture dealing. In 1849 he bought *Tummel Bridge* (c.1802–3; Yale Center for British Art, New Haven; BJ 41) at Christie's and at *Windus's sale in 1853 *Gambart and he, presumably in partnership, each bought one of *Going to* and *Returning from the Ball* (RA 1846; private collection; BJ 421/2). In 1854 Wallis bought *Kilgarran Castle* (RA 1799; National Trust, Wordsworth House, Cockermouth; BJ 11) and in 1855 *The Burning of the House of Lords and Commons* (BI 1835; Philadelphia Museum of Art; BJ 359; see PARLIAMENT) but resold it at Christie's in 1860, the year that *Gillott bought Wallis's house at Stanmore to save him from bankruptcy.

In 1867 Wallis took over the lease of the French Gallery in Pall Mall from Gambart and, after Wallis's death, the gallery continued to deal in Turners. EJ

WALLIS, Robert (1794–1878), English line-engraver, trained by his father Thomas, who was himself an assistant of Charles *Heath. Robert engraved twelve plates for the *England and Wales* series, the first, in 1827, that of Lancaster (R 210). Working on steel he contributed plates after Turner to *Rogers's *Italy* and *Poems*, and also to each of the three volumes of the *Rivers of France*. One of his most successful large plates after Turner was the vivid *Hastings*, copied from Turner's large watercolour of 1818 (W 504), and published by *Gambart in 1851 (R 665). In 1859 Wallis exhibited a proof of his steel engraving (R 679) after Turner's 1844 RA exhibit *The Approach to Venice* (BJ 412) at the *Royal Academy. LH

WALTON BRIDGES. The double bridge across the River *Thames and the marshes at Walton, in Surrey, was already a popular subject with artists when Turner sketched it on his Thames excursion of 1805. The bridge features principally in two finished oils of *Walton Bridges*, which possibly form a pair, and were probably exhibited in *Turner's gallery in 1806 (Loyd Collection, on loan to Ashmolean Museum, Oxford; BJ 60) and 1807 (National Gallery of Victoria, Melbourne; BJ 63) respectively. The former, looking downriver, was bought by Sir John *Leicester, and the latter, looking upriver, by the Earl of *Essex. The Loyd picture, in particular, with its golden light and contrasted cattle, recalls *Cuyp river scenes; but both pictures also show the influence of *Claude: 'it is as if Turner had taken us to the bridge in the middle distance of one of Claude's Arcadian landscapes, and shows us that Arcadia is in fact Britain' (Hemingway 1992, pp. 228–9). Indeed, Walton Bridges appear in an ideal composition in the *Liber Studiorum* (1808; F 13), entitled *The Bridge in Middle Distance* and later the

basis for the unfinished oil of *c*.1845–50 (Koriyama Art Museum, Japan; BJ 511). Pastoral activities predominate in these harmonious paintings (albeit with an admixture of commercial barges), while the viewpoint in both pictures excludes nearby houses and the park of Oatlands estate. The Melbourne picture contains a depiction of labourers washing sheep, observed by a mounted farmer and a musing shepherd. *Thomson, in *Summer*, had asserted that this 'simple' activity underlay the 'solid grandeur' of Britain (ibid.).
See also AGRICULTURE; THAMES AND TRIBUTARIES. AK

WANDERINGS BY THE LOIRE/SEINE, see RIVERS OF FRANCE; TURNER'S ANNUAL TOUR.

WAR. THE EXILE AND THE ROCK LIMPET, oil on canvas, 31¼ × 31¼ in. (79.5 × 79.5 cm.), RA 1842 (353); Tate Gallery, London (BJ 400). Exhibited as a contrasting pair to *Peace* (*Wilkie's burial at sea), again with a quotation from the *Fallacies of Hope* (see POETRY AND TURNER) alluding (as *Ruskin, unique in preferring this out of the two paintings, pointed out) to the association of the 'sunset colour with blood' and equating the limpet's 'tent-formed shell' with 'A soldier's nightly bivouac'. As Alfrey suggests, the pairing of the paintings may also reflect the fact that Wilkie's visit to the Middle East coincided with a resurgence of Anglo-French hostility over Mehemet Ali's uprising against the Turkish empire. MB
> Wallace 1979, pp. 107–17, repr.
> McCoubrey 1984, pp. 2–7, repr.
> Alfrey 1988, pp. 33–4, repr.
> Shanes 1990, pp. 23–104, repr. in colour, pl. 86.

WASHINGTON, National Gallery of Art. The nine Turners range from *Junction of the Thames and Medway* (BJ 62), exhibited in Turner's gallery in 1807, to *The Approach to Venice* (RA 1844; BJ 412), described, when first seen by *Ruskin, as 'the most perfectly *beautiful* piece of colour . . . produced by human hands, by any means, or at any period' (*Works*, iii. p. 250).
Uncertainty still surrounds the black dog on the parapet in *Mortlake Terrace* (see MOFFATT; RA 1827; BJ 239). Is it Turner's work or was it stuck on by Edwin *Landseer at the Royal Academy while Turner was at lunch downstairs? *Rotterdam Ferry Boat* (RA 1833; BJ 348) was misidentified as *Van Tromp's Shallop* (RA 1832; BJ 344) until 1951 when that picture was acquired by the Wadsworth Atheneum, Hartford, Conn., and the confusion resolved by C. C. Cunningham (1952, pp. 323–9).
The Manchester cotton merchant Henry *McConnel commissioned the contrasting pair *Venice* (RA 1834; BJ 356) and *Keelmen* (RA 1835; BJ 360). The background to *Pluto

Carrying off Proserpine (RA 1839; BJ 380) was identified as Tivoli by Eric Shanes (*Turner Studies*, 1/2 (winter 1981), p. 46), being a reworking of the *c*.1798 view of *Tivoli* (BJ 44), itself based on a picture by Richard *Wilson.
Until 1965 *Dogana, and Madonna della Salute, Venice* (RA 1843; BJ 403) held the auction record for a Turner when sold in 1927 for 29,000 guineas. *The Evening of the Deluge* (*c*.1843; BJ 443) is an earlier version of *Shade and Darkness* (RA 1843; BJ 404), probably passed over by Turner as an insufficiently strong contrast to *Light and Colour* (RA 1843; BJ 405). This version has gained importance since both Tate 'Deluge' pictures were stolen in 1994 when on exhibition in Frankfurt. EJ
> John Hayes, *The Collections of the National Gallery of Art, Washington Systematic Catalogue: British Paintings of the Sixteenth through the Nineteenth Centuries*, 1992, pp. 261–91.

WATERCOLOUR SOCIETIES. Until the middle of the 18th century, watercolours were kept in sketchbooks, albums, or portfolios and were seldom framed and hung on walls. With the advent of the Free Society and the Society of Artists, exhibiting societies that preceded the foundation of the *Royal Academy in 1768, watercolour painters began to execute works to hang at their annual exhibitions alongside works in oil. Landscape artists like Paul *Sandby and William Pars began to strengthen their compositions and heighten their colours, their watercolours taking on the size and many of the properties of oil paintings. These societies ceased to exist by 1791, when the Royal Academy was the only place where watercolours could be exhibited publicly (Turner exhibited them there regularly from 1790), but watercolours were frequently 'skied' or banned to secondary rooms with the engravings.
In 1799 Robert Ker *Porter, Thomas *Girtin, and Francia founded 'The Brothers', a society for the promotion of historical painting in watercolours, which continued with various members, including the Varleys and *Cotman, for several decades as the 'Sketching Society'. They did not exhibit as a group, however, and in 1804 some of them, including Turner's friend, William *Wells, founded the Society of Painters in Water-Colours specifically to exhibit watercolours only. Their works were for sale and the exhibitions were a great success, but only members could exhibit, so in 1807 a rival group formed the New Society of Painters in Miniature and Water-Colours (also known as the Associated Artists). The exhibitions held by the two societies competed for a dwindling audience until 1821, when the Society of Painters in Water-Colours moved to a small gallery in Piccadilly. But watercolours were exhibited like oil paintings, in elaborate gold frames which came to the edge of the image

or with gold slips, and were hung floor to ceiling in top-lit galleries, frames touching. About this time, the broadly washed landscapes in muted tones of the Varleys and others began to give way to a stronger, more vigorous style in which colour was suffused with light and the paint was worked with the apparent depth and vigour of oil painting. This was largely due to the influence of Turner's watercolours, even though he did not exhibit with these societies—he had continued to exhibit watercolours at the RA, as well as in his own gallery. In 1832 the New Society (from 1863 the Institute) of Painters in Water Colours was formed, again for those who were not members of the original society—henceforth known as the Old Water-Colour Society (OWCS), but their work was full of figures and anecdote and was considered too bright, lacking the freshness, harmony, and depth of the work of artists like Turner. Even after his death, Turner continued to influence the work of these societies, as later owners lent his watercolours to their annual loan exhibitions. KMS

Jane Bayard, *Works of Splendor and Imagination: The Exhibition Watercolour, 1770–1870*, exhibition catalogue, New Haven, Yale Center for British Art, 1981.

Gage 1996, pp. 106–10.

Huon Mallalieu, 'Watercolour Societies and Sketching Clubs', *Dictionary of Art*, 1996, xxxii. pp. 902–3.

WATERLOO, see *FIELD OF WATERLOO, THE.*

WATTEAU, Jean-Antoine (1684–1721), French painter of *fêtes galantes* principally; born and brought up at Valenciennes, then from 1702 resident in Paris. He spent several months of 1719–20 in London in search of artistic patronage and a cure for his TB, and there met the well-known physician and connoisseur Dr Mead, who commissioned two paintings from him. Perhaps because of this visit, Watteau's reputation stayed relatively high in Britain throughout the 18th and early 19th centuries, when most modern French painting was condemned by the British as affected. Both *Reynolds and *Gainsborough greatly admired Watteau, as did *Hazlitt and *Constable a generation later, when the delicacy of his art was particularly appreciated.

Turner may have encountered paintings by Watteau for the first time at Reynolds's house before 1792, and he probably saw others after 1800 in the collections of Samuel *Rogers and John *Soane. Towards the end of the Backgrounds lecture (see PERSPECTIVE LECTURES) he made a passing complimentary reference to Watteau's 'gay materials' and 'taste'. However, it was not until 1818 that Turner began to echo Watteau in his own work. The impetus seems to have come from a *fête galante* exhibited in 1817, entitled *Sans Souci* (Tate Gallery), by Thomas *Stothard, who had

recently taken to popularizing Watteau's style in Britain. Turner's response was none other than **England: Richmond Hill, on the Prince Regent's Birthday** (RA 1819; BJ 140)—a vast panorama in the style of *Claude across the foreground of which he superimposed a chain of fashionably dressed Watteau-esque figures. Turner's source for these figures was evidently *The Enchanted Isle* (Swiss private collection) by Watteau, previously owned by Reynolds and by 1818 in the collection of the watercolourist James *Holworthy, where Turner sketched it (TB CXLI: 26a–27). Turner seized on the fact that the most characteristic features of Watteau's figure style were the expressive back view and the jewel-like colours, especially reds and golds.

Furthermore, Turner's second exhibit at the Royal Academy after his return from Italy in 1820 was not a large Claudian scene, as might be expected, but a small painting still more closely dependent on Watteau. Entitled *What You Will!* (1822; private collection; BJ 229), with an obvious reference in its subject matter to *Shakespeare's *Twelfth Night*, this is reminiscent of Watteau not only in the figures but also in its landscape. (The model was possibly *The Vista, or 'La Perspective'*, now in the Museum of Fine Arts, Boston.) This is the place, therefore, to ask why Turner told his executor, the Revd William *Kingsley, that he had learnt more from Watteau than from any other painter—if, that is, he in fact said such a thing, for neither Kingsley nor *Ruskin, who reported the remark, was noted for reliability. Moreover, Turner is unlikely to have mentioned the topic to Kingsley until the 1840s, some time after Watteau had ceased to be more than a residual influence in his work. Nevertheless, the statement is not implausible and is certainly not without interest, as Selby Whittingham has pointed out.

As is well known, the two or three years either side of 1820 were the period when Turner's transition to a more intense and more transparent style of colouring was at its most forceful: the thin films of pure colour which Watteau used for his figures were precisely what Turner needed. Besides his reds, the French painter's practice of applying numerous fine touches of white on top of the colour, both to act as highlights and to make the surface vibrate and sing, was relevant. Nor was this all, for such a technique served equally well for watercolour as for oil painting, and the dazzle of tiny strokes laid side by side which make up Turner's later finished watercolours may be said to owe their origin partly to Watteau's example.

White is indeed as important as colour in this process, as is shown by Turner's only other painting in which Watteau plays a dominant role: *Watteau Study by *Fresnoy's Rules

(BJ 340). This was exhibited in 1831 with the following quotation:

> White, when it shines with unstained lustre clear,
> May bear an object back, or bring it near.
> (*Fresnoy's Art of Painting*, 496)

This was taken from the English translation by William Mason (1783) of Charles-Alphonse du Fresnoy's 17th-century Latin verse treatise, *De Arte Graphica*, which had explained for painters the rules of pictorial composition, such as how to distribute light and shade and how to organize colour patterns. Other than liking for the artist, Turner's choice of Watteau to illustrate this text is mysterious; nor is the painting Watteau-esque in style, since it shows a domestic interior (which Watteau never represented) with figures reminiscent of Turner's own sketches at Petworth. Only the figure of the artist sketching a couple on the sofa and a small group of paintings, including *Les Plaisirs du Bal* and *Le Lorgneur*, stacked up in the background, are recognizably 'Watteau'. However, the message of the text is made clear through the whites. A barely started canvas whitened by light reflected from its surface 'lies back' in the picture space on account of the dark figure of the artist in front of it, while in the left foreground a piece of white cloth 'comes forward' because of the darker objects behind. Various lesser areas of white in the picture are similarly manipulated. Turner would have known 'Fresnoy's rules' virtually by heart; he also knew better than most other artists how to apply them.

Turner seems never to have forgotten his debt to Watteau, and reminiscences recur in the figures in his later oils and watercolours, such as *Palace de la Belle Gabrielle, on the Seine* (c.1832; private collection, USA; W 1049) and **Juliet and her Nurse* (RA 1836; Sra. Amalia Lacroze de Fortabat, Argentina; BJ 365). MK

Whittingham 1985, pp. 2–24, and 1985², pp. 28–48.

WATTS, Alaric Alexander (1798–1864), English poet and journalist, who had a very varied career, including brief periods as Editor of newspapers in Leeds and Manchester. From 1824 to 1838 he edited the *Literary Souvenir*, the earliest of the many annuals that became so popular. Shortly after going bankrupt through the failure of his numerous journalistic ventures, Watts wrote the very useful 'Biographical Sketch' which was published in 1853 as the opening article of Henry *Bohn's reprint edition of the *Rivers of France, now called the *Liber Fluviorum; or, River Scenery of France* (pp. vii–xlviii). This was only the second biography of Turner to be published, and it is both reasonably accurate and informative. In the *Liber Fluviorum* Watts's piece was followed by the text of Turner's *will and its codicils. LH

WATTS, George Frederic (1817–1904), prolific, eclectic, and varied English allegorical, portrait, and landscape painter, who also produced monumental sculpture in his later years. He himself considered his main achievement the creation of imaginative and idealistic visions in the realm of 'high art', of which the best-known example is *Hope* (private collection; replica in Tate Gallery). Watts was an admirer of Turner's late painting, the influence of which can be seen in some of his own late work. Lionized in his day, Watts was for long neglected in the 20th century, but is now again recognized as a leading figure of the Symbolist movement. Watts is well represented in London at the Tate Gallery and the National Portrait Gallery, and at Compton in Surrey there is the Watts Gallery in his former home. LH

WAVES. Though Turner is usually categorized as a landscape painter, a large number of his most famous and successful paintings feature the sea (see SEAPIECES). In some 150 of the 541 oil paintings catalogued by Butlin and Joll the sea is the predominant subject, ranging from his first exhibited oil painting, **Fishermen at Sea* (RA 1796; BJ 1), to his last exhibited works, the Carthaginian series shown at the **Royal Academy in 1850 (BJ 429–32; see *Aeneas relating his Story to Dido*). The number would be even larger if classical and other harbour scenes and views of *Venice were included. Turner's love of the sea is well recorded, and with that love went a close interest in and knowledge of the infinite variety of the activity of the elements at sea. As a keen inland fisherman Turner had ample opportunity to study the behaviour of water in river and lake, and there can be no doubt that when at sea or on the shore he was equally intent on his studies of the water. Turner lived before the days of sailing at sea purely for pleasure or for sport had become a popular pastime, though the early days of yacht racing resulted in the first *Cowes Regattas in the 1820s, one of which he himself painted in 1827 (BJ 242–3 and 260–8). However, Turner was quite often at sea, crossing the Channel or sailing or steaming to *Scotland and in the northern seas and later from London to Margate. He never undertook a longer sea voyage, as once he had crossed the Channel all his European travels were on land.

In his many marine and sea paintings Turner's depiction of waves was clearly of prime importance. Already in *Fishermen at Sea* the success of the moonlit composition depends on the effective recording of the small boats battling in the waves of a slight swell close to shore. Five years later, in 1801, Turner exhibited **Dutch Boats in a Gale* (the 'Bridgewater Seapiece'; private collection, on loan to the National Gallery, London; BJ 14) at the Royal Academy. Commissioned by the Duke of *Bridgewater as a pendant to his notable Willem

*Van de Velde painting, *A Rising Gale*, this dramatic sea-piece, in which the fishing boats at its centre are on a collision course, became the 'picture of the year'. Turner created a mirror-image of the Van de Velde, and the effectiveness of his composition depends very largely on the powerful painting of the foaming waves in the midst of which the drama of the boats is being enacted. There are a number of rapidly drawn studies for *Dutch Boats in a Gale* in the large 'Calais Pier' Sketchbook (TB LXXXI), in which there are also studies connected with *Fishermen upon a Lee-Shore, in Squally Weather* (Southampton Art Gallery; BJ 16), exhibited in 1802. In this wonderfully naturalistic view of an everyday marine drama, witnessed from just beyond the reach of the waves breaking on the stormy shore, Turner demonstrates his real understanding of the actual circumstances and especially of the formation and force of the breaking wave that the fishermen are fighting against. That understanding is based on a large number of on-the-spot drawings, those already referred to and many more in several other sketchbooks in the Turner Bequest (LIV, LXVII, LXVIII, LXXXII).

This is the most telling early example of Turner's determination to discover the truth and reality of the motion and force of waves as seen from the shore. His determination to do the same for waves experienced from their midst was demonstrated only a year later, when he exhibited his great *Calais Pier, with French Poissards preparing for Sea: an English Packet arriving* (RA 1803; BJ 48), which was based on the artist's own experiences on his first crossing of the Channel in a storm in July 1802; when he at last reached *Calais he had to transfer from the English packet to a smaller boat to be brought ashore. In one of his vivid double-spread drawings in the 'Calais Pier' Sketchbook (LXXXI: 58–9) Turner has recorded this and inscribed the drawing at the side, 'Our landing at Calais—nearly swampt'. It is again the masterly rendering of the waves that emphasizes the drama of the event in the painting. The potential dangers of *Calais Pier* are brought to their logical conclusion in *The *Shipwreck* of 1805 (BJ 54), in which more than half of the surface of the large canvas is filled with the turmoil and confusion of boiling waves at the heart of a storm. The climax of the drama of Turner's early paintings of storms at sea is reached in *Wreck of a Transport Ship* (Fundaçao Calouste Gulbenkian, Lisbon; BJ 210), which dates from about 1810. Even more freely and loosely painted than *The Shipwreck*—some 40 per cent of the surface consists of white paint—this is essentially a painting of waves which totally dwarf, as they would in actuality, the human and material debris of the wreck and the small vessel coming to the rescue.

In the next 20 or 30 years many of Turner's paintings and watercolours of marine subjects feature stormy waves; these include such famous works as *Staffa, Fingal's Cave* (RA 1832; Yale Center for British Art, New Haven; BJ 347), *Slavers* (RA 1840; Museum of Fine Arts, Boston; BJ 385) and *Snow Storm* (RA 1842; BJ 398). The full title of the last in the Royal Academy catalogue was, *Snow Storm—Steam-Boat off a Harbour's Mouth making Signals in Shallow Water, and going by the Lead. The Author was in this Storm on the Night the Ariel Left Harwich*; much has been made by recent scholars of the probable inaccuracy of this lengthy title, but whatever actually happened it does emphasize the fact that the artist wished it to be thought that he had had first-hand experience of the awesome storm depicted, during which he claimed to have been lashed to the mast for four hours. Turner's continued and dedicated interest in the mysterious and infinitely variable motions of the sea is well illustrated by the considerable number of vivid and mostly stormy beach and shore scenes which he recorded in water-colours and in oils on canvas (BJ 453–86) very rapidly and economically in the decade between about 1835 and 1845. These confirm Turner's lifelong enthusiasm for the sea, and it is tempting to think that some of them, even some of the oils, were painted out in the open with the artist relishing the spray from the breaking waves which must have drenched him as he worked. LH

Herrmann 1981, pp. 4–18.

WEATHER DURING TRAVELS. Some of Turner's works show combinations of weather and scenery that he had actually experienced (notably *Messieurs les voyageurs . . . in a snow drift upon Mount Tarrar*; RA 1829; British Museum; W 405) but this is not generally the case. He would sketch and write notes on different phenomena as they occurred, but when he came to depict a place in a painting or watercolour he would feature whatever meteorological effects he felt appropriate to his subject. However, the weather on his travels lingered long in his memory, being precisely recalled in both art and prose years later; the storms round *Staffa of 1831 were described in a letter of 1845 (Gage 1980, pp. 209–10).

Turner's correspondence shows that rain hindered progress on several tours: in *Yorkshire in 1816 ('the year without a summer' after the volcanic eruption of Tambora in Indonesia) he declared he was becoming 'web-footed like a drake' (Gage 1980, p. 67), while his 1844 attempts to cross the Alps were long frustrated and he was 'set back with a wet jacket and worn-out boots' (Gage 1980, p. 203). Turner's ability to endure, depict (and even savour) foul weather led to his nickname 'Mr Avalanche Jenkinson' and he claimed to have been strapped to the mast during the storm shown in *Snow Storm—Steam-Boat off a Harbour's Mouth* (RA

1842; BJ 398). Paradoxically, he does not seem to have enjoyed the blazing heat he evoked so well in his art. In September 1828 he was completely 'knocked up' by travelling in the south of France and needed a plunge in the sea at Marseilles to restore himself (Gage 1980, p. 119). CFP

WEDMORE, Sir Frederick (1844–1921), author and art historian. Wedmore was the author of numerous books on art and artists. These were principally devoted to French art, and included studies of Nattier, Chardin, Fantin Latour, Ribot, and Boudin. However, Wedmore also wrote about British art, publishing books about *Whistler, contemporary British etchers, and a general survey, *Studies in English Art* (1876). In 1900 he published his two-volume *Turner and *Ruskin: An Exposition of the Work of Turner from the Writings of Ruskin*. For more than 30 years Wedmore was a newspaper art critic, working principally for the *Standard*. He also published volumes of fiction and poetry, and in 1912 his autobiographical *Memories*. RU

WELLINGTON, Arthur Wellesley, Duke of (1769–1852), English field marshal and statesman; the hero of the *Napoleonic wars. After long service in *India he became Allied commander in the Peninsular War (1808–14), defeating the French, and then at the Battle of Waterloo (see FIELD OF WATERLOO, RA 1818; BJ 138) on 17 June 1815, which resulted in Napoleon's final defeat. He re-entered politics, became a Tory cabinet minister in 1818, and was Prime Minister 1828–30. He remained at the centre of politics and served in the governments of Sir Robert *Peel. Turner's *The *Hero of a Hundred Fights* (RA 1847; BJ 427) records the breaking away of the mould at the casting of M. C. Wyatt's vast equestrian statue of Wellington in 1845. LH

WELLS, Clara [Clarissa] (1787–1883), elder daughter of W. F. *Wells. Lively and attractive in her youth, she became a close friend and sketching-companion of Turner from c.1800 when her parents lived at Mount Street, York Buildings, and *Knockholt. Turner was able to reveal himself to her, and as a consequence she could write for *Thornbury an observant account of his early manhood and of the beginnings of *Liber Studiorum*. Clara was a lifelong confidante of Turner, being aware as much of his foibles as his strengths. She showed concern, too, about his father's well-being. Clara entertained Turner frequently, particularly after her marriage in 1817 to the surgeon Thomas Wheeler of Gracechurch Street, nephew of James Rivington *Wheeler. She was one of the organizers of a river expedition to Richmond in 1813 which included tea at *Sandycombe Lodge. She showed special insight into Turner's painting, writing with feeling about *The Loretto Necklace* (RA 1829; BJ 331).

Turner left her £100 in his *will. Her pencil portrait was drawn by her father. JH

Thornbury 1877, pp. 234–6.
Rawlinson 1906, pp. xii–xiii.
Finberg 1961, pp. 69, 126–9, 236, 313, 319, 364–5, 391, 398, 424.
Gage 1980, pp. 293–5.
Robert Yardley: 'Picture Notes', *Turner Studies*, 4/1 (summer 1984), pp. 58–9.
Yardley 1986, pp. 51–60.

WELLS, Emma (1793–1871), third daughter of W. F. *Wells, whom Turner had known from her childhood. She lived with her parents until they died, and subsequently with her sister Clara *Wells (Mrs Wheeler) at Sundridge, Kent. Emma was one of the children who entranced Turner as a young man, and whom he entertained when he stayed with the family in Mount Street and *Knockholt. She never married. Four letters to her from Turner survive (the latest 1842), their tone suggesting easy friendship and concern. Turner left her £100 in the 1849 codicil to his *will. JH

Gage 1980, pp. 85, 165–6, 188–9.

WELLS, William Frederick (1762–1836), watercolourist, etcher and drawing master, who was an early professional friend and valued mentor of Turner. It is likely that they met at the *Royal Academy c.1792, and in the following years Turner stayed frequently with Wells and his family, in Mount Street, *Knockholt (where he moved in 1801), and latterly New Road and Mitcham. Their hospitality was particularly welcome, as Clara *Wells records, when life for Turner was difficult at *Maiden Lane. From Knockholt Wells took Turner and others on sketching expeditions.

Wells exhibited at the RA from 1795 and the Old Water-Colour Society (see WATERCOLOUR SOCIETIES) from 1804. As a young man he had visited Norway and Sweden, and talk of such extensive Romantic travel may have confirmed and encouraged Turner in his belief in the importance of foreign travel to an artist. Perhaps his greatest service to Turner was to persuade him to embark on his *Liber Studiorum in 1806.

Wells became Master of Civil Drawing at the East India Company's Military College at Addiscombe, Surrey, in 1813, where he worked alongside another of Turner's friends, the geologist John MacCulloch. In his 1829 and 1831 *wills Turner named Wells as an executor and trustee of his Charitable Institution. Clara recorded that Turner 'loved my father with a son's affection', and on Wells's death Turner declared that he had lost 'the best friend I have ever had in my life'. Turner seems also to have been fond of Wells's wife Mary (d. 1807). He noted 'There is not a quality or endowment, faculty or ability which is not in a superior degree

possest by women. Vide Mrs Wells Knockholt. Oct.' ('Derbyshire' Sketchbook, TB CVI: 67v.). JH

Thornbury 1877, p. 236.
Finberg 1961, pp. 69, 115, 119, 126–9, 234, 265–7, 281, 315–16, 330–1, 364.
J. M. Wheeler, *The Family and Friends of W. F. Wells*, 1970.
Gage 1980, pp. 295–6.
BJ 1984, pp. 25–8.
Hamilton 1997, pp. 41, 98, 147, 207, 246, 288.

WEST, Benjamin (1738–1820), American-born history painter and President of the *Royal Academy, 1792–1805 and 1806–20. Amazingly (to us), Archer *Shee described him as 'the greatest historical painter . . . since the days of the Caracci' (minutes of Evidence before the Select Committee on Arts and Principles of Design 1836, para. 1916), though he was important to the development of the British School. He painted a great range of subject matter and often showed real originality in his treatment of it (notably *The Death of General Wolfe*, 1770). He also encouraged many younger artists, including John *Constable. In his Presidential Discourses West made clear his belief in a pursuit of perfection in art through the observation of 'nature and truth', with a concern to prevent 'the ruin of harmony and aerial perspective' (John Galt, *The Life of Benjamin West*, 1820, ii. p. 139). This stance undoubtedly guided his hostile reaction to Turner's early adventurousness, ranging from his comment in 1798 that his (and *Girtin's) drawings were 'manner'd' (Farington, iii. p. 1004) up until 1807, when West both felt that he had 'run wild with conceit' (Farington, viii. p. 3007) and was 'disgusted' by what he saw then in Turner's gallery, in particular the *Thames views (perhaps BJ 63–7), 'crude blotches' and 'vicious' (Farington, viii. p. 3038). Where West shared some common ground with Turner, as he presumably did in 1801 with *The Army of the Medes* (untraced; BJ 15), he was complimentary.

Turner, for his part, in 1804 criticized West for the 'incorrectness in the detail' of his figures (Farington, vi. p. 2299). Later he was to thank West for his 'kind attention' towards him during his career (Turner to West, 11 July 1816; Gage 1980, pp. 66–7) and in 1829 he regretted not buying West's *The Cave of Despair* at auction. Turner's *Death on a Pale Horse* (c.1825–30; BJ 259) must have taken some inspiration from West's own renderings of the subject which he would have seen in West's own gallery or at *Petworth. RH

Helmut von Erffa and Allen Staley, *The Paintings of Benjamin West*, 1986.

WESTALL, Richard (1765–1836), subject painter in oil and watercolour. Elected an RA in 1794, he voted for Turner's election as an RA in 1802 (Farington, *Diary*, 10 February 1802). Farington also reported (7 April 1807) that Westall thought that A *Country Blacksmith* (BJ 68) was 'very clever' though he also felt that *Sun rising through Vapour* (National Gallery, London; BJ 69) was 'inferior' to Turner's earlier pictures. One of Westall's patrons was Richard Payne *Knight and his acquisition of Westall's *Flora Unveiled by the Zephyrs* (RA 1807) was part of Knight's plan of forming an important collection of English paintings; this embraced the commissioning of Turner's *Unpaid Bill* (RA 1808; private collection, USA; BJ 81). Westall's highly finished and acclaimed watercolours of historical subjects, which he exhibited from the 1790s, anticipated the challenge to the supremacy of oil which watercolourists mounted in the early 1800s (see WATERCOLOUR SOCIETIES). As a colourist Westall was often criticized, but Turner owned one work by him. RH

Gage 1969, p. 97.
Clarke and Penny 1982.
Richard J. Westall, 'The Westall Brothers', *Turner Studies*, 4/1 (1984), pp. 23–38.

WETHERED, William (fl. 1840–63), tailor and woollen draper, collector and art dealer, of King's Lynn. His collection included oriental china, bronzes, virtu, and British paintings, among them works by Etty and Linnell. In December 1843 he was seeking advice from *Ruskin about collecting Turner; therefore, the identification by *Finberg (1961, p. 408) of Wethered with 'Wetherall', the first owner of *Pluto carrying off Proserpine* (RA 1839; National Gallery of Art, Washington; BJ 380), is doubtful. Ruskin suggested several works to Wethered, including *Slavers* (RA 1840; Museum of Fine Arts, Boston; BJ 385) and *Rockets and Blue Lights* (RA 1840; Clark Art Institute, Williamstown, Mass.; BJ 387). A letter in York City Art Gallery from Wethered to William Etty provides proof of Wethered's ownership of *Approach to Venice* (RA 1844; National Gallery of Art, Washington; BJ 412). He may have commissioned the work, or possibly bought it at the Royal Academy in 1844, subsequently commissioning another *Venice subject from Turner, *Venice, Evening, going to the Ball* (RA 1845; BJ 416); this was painted for Wethered, but he apparently returned it to Turner as it formed part of the Turner Bequest (see WILL). Confusion also surrounds another possible commission: indications are that Wethered contemplated buying one of the two Venice pictures exhibited in 1846, *Going to the Ball (San Martino)* (RA 1846; private collection; BJ 421) or *Returning from the Ball (St Martha)* (RA 1846; private collection; BJ 422). The first seems to have been sent to him after the close of the RA exhibition and rejected. In Wethered's recorded sales at Christie's (7–8 March 1856, 27 February 1858), the only work by Turner was a proof set of 'Tour in France'

(*Turner's Annual Tour), included in the 8 March sale (lot 84). TR

 Gage 1980, pp. 297–8.

WHALING. Turner's first known depiction of a whale is in *The Whale on Shore* (c.1837; Taft Museum, Cincinnati: Eric Shanes, *J. M. W. Turner: The Foundations of a Genius*, exhibition catalogue, Taft Museum, 1986, pp. 62–4, no. 54, repr. in colour). This small watercolour, formerly known as *The Great Whale* (W 1307), illustrates a scene from Sir Walter *Scott's novel *The Pirate* (1822). A large right whale has been stranded behind a sand bar on the island of Orkney. Turner depicts the whale in the act of breaking free from villagers who have tethered him to the shore, his massive body upending a small boat as his upright tail snaps the cable by which he is anchored. Turner evidently created this image to be engraved in the 1837 volume of the *Landscape— Historical Illustrations of Scotland and the Waverley Novels*, which, however, illustrates the passage from *The Pirate* with the work of another artist.

Turner's most significant treatments of the subject of whaling are the four large oil paintings shown at the *Royal Academy in 1845 and 1846. The 1845 titles were both simply *Whalers* (BJ 414) and *Whalers* (Metropolitan Museum, New York; BJ 415); the latter canvas is generally known as *The Whale Ship*. These were followed in 1846 by '*Hurrah! for the Whaler Erebus! another Fish!*' (BJ 423) and *Whalers (Boiling Blubber) entangled in Flaw Ice, endeavouring to extricate Themselves* (BJ 426). Each of the 1845 oils appeared with a caption referring to a specific page of Thomas Beale's *Natural History of the Sperm Whale . . . to which is added, a sketch of a South-Sea Whaling Voyage* (1839). Those pages were both from Beale's chapter on the 'Chase and Capture of the Sperm Whale'. Turner's caption for '*Hurrah! for the Whaler Erebus! another Fish!*' refers more generally to 'Beale's Voyage'.

Beale's *Natural History* provided Turner with visual, scientific, industrial, and narrative information about the sperm whale whose chase, capture, and industrial processing provides the narrative foundation for the sequence of paintings. In *Whalers* the whalers in several small boats are about to strike the hump of a rising sperm whale at the moment a storm approaches through a sun-struck sky. In *The Whale Ship* a stricken sperm whale upends several whaleboats in foreground action beneath the white sails of the whale ship, whose sidelong image fills the middle ground. The next stage of the chase and capture is seen in '*Hurrah! for the Whaler Erebus! another Fish!*', where whalers are cutting into the body of a whale alongside the ship in the mid-distance. Suspended above them in the spars is the dis-

tinctive shape of a sperm whale's head, facing the sun that floods the entire scene with a copper warmth. In *Whalers (Boiling Blubber)* the smoke rising from the whale ship represents the final stage of the industrial process; as whalers boil the blubber into oil they are themselves 'endeavouring' to 'extricate' themselves from ice.

Whales and whaling were unlikely subjects for the RA in 1845, and the exhibition of two more paintings on the same subject a year later did not enhance the reception of the earlier pair. Turner, with the emphasis on 'whalers' in the titles as well as the action of these paintings, makes a significant tribute to the life of the industrial worker. The 1845 paintings appear to have been commissioned by Elhanan *Bicknell, Turner's patron, who had made his fortune in the Southern Sperm Whale fishery. Bicknell was evidently dissatisfied with the paintings, for he failed to purchase them. Three of the four whaling oils remained unsold in the painter's private gallery, with only *The Whale Ship* finding a buyer in Turner's lifetime.

Although the 1845 paintings did impress a few reviewers, they also drew some of the most stinging ridicule to which Turner's work was subjected. *Punch* wrote memorably of 'those singular effects which are only met with in lobster salads and in this artist's pictures'. Not surprisingly, one of the whaling oils the next year was rechristened as 'Hallo there!—the oil and vinegar,—another lobster salad'. Together, the two were seen as 'ticketed with strange titles having no apparent connexion with the heaps of colour before us'. Even John *Ruskin found the 1845 pair to be 'altogether unworthy' of Turner (*Works*, iii. pp. 251–2). Barry Venning in 1985 was the first critic to address the sequence of four paintings as being worthy of sustained imaginative attention.

Contemporaries of Turner who did admire the whaling oils perceived virtues for which his late style remains highly valued in our own day. The *Literary Gazette* in 1845 saw 'splintered rainbows', not 'lobster salads', in Turner's 'astonishing' effects. The *Times praised his gift for rendering 'immediate sensations', one year praising a 'mass of white spray, which so blends with the white clouds of the sky, that the spectator can hardly separate them', in the next year celebrating the 'magnificent' treatment of a 'blaze of light' in which 'the spectator looks full against the sun'. *Thackeray captured the essence of Turner's late style when he wrote of being 'mesmerised' by a painting that, at first, he had thought merely careless. 'That is not a smear of purple you see yonder, but a beautiful whale . . . and as for what you fancied to be a few zigzag lines spattered on the canvas at hap-hazard, look, they turn out to be a ship with all her sails'.

The purely prismatic effects of the whaling oils are much deepened by an understanding of Turner's use of Beale. A viewer's instinctive sympathy for the whale whose wounded black head stains the sea in *The Whale Ship* is deepened by Turner's reference to Beale's account of a massive sperm whale whose body had sunk out of sight after its life was taken. The irony of this situation is intensified when one sees that the vague grey shapes hanging amidst the white sails in the painting are pieces of a whale that has already been captured and cut into. The most poignant detail of this kind in the sequence of four paintings is the severed head of the sperm whale whose elevated shape faces the sun from the spars of the ship in the ironically titled *'Hurrah! for the Erebus! another Fish!'*

Beale was useful to Turner visually as well as narratively and industrially, for the severed head in the *Erebus* painting is clearly modelled on one of several accurate engravings of the sperm whale's head in Beale's book. Some of Beale's illustrations had been drawn by William Huggins, whose painting *A Whaler in the South Sea Fishery* (c.1830–5) provided the compositional structure for *The Whale Ship* (see Bicknell 1985). Comparing the two paintings offers a remarkable demonstration of the prismatic strength and liquid ease of Turner's late style.

Beale and Huggins both endeavoured to depict whaling voyages into the South Seas, but neither provided a precedent for the field of ice beneath the frontal sun in one of the 1846 oils. Turner was in this case drawing upon the discovery of Antarctica by HMS *Erebus* and *Terror* during their South Sea explorations of 1839–43. The captain of the exploratory voyage, James Clark Ross, was one of Turner's fellow members of the *Athenaeum Club, as was Turner's friend Dawson *Turner. Dawson Turner's nephew J. D. Hooker was assistant surgeon to Captain Ross on the *Erebus*, and sent back visual and verbal depictions of Antarctic ice fields, solar effects, and whales to which Turner would have had access through Dawson Turner. Turner created his own South Seas narrative by fusing Beale's whaling voyage and Ross's exploring voyage in the 'furnace of his imagination' (a phrase from the 1846 journal of Elizabeth Rigby, later Lady *Eastlake).

The Antarctic discovery ships did not chase whales for industrial profit, but they did capture whales for scientific study, making possible the treatise 'On the Cetaceous Animals' published in 1846 as part of the *Zoology of the Voyage of H.M.S. Erebus and Terror* by J. E. Gray (another member of the Athenaeum). The 1845 volume on 'Fishes' from the *Zoology* of the same voyage was in Turner's personal *library; J. D. Hooker's 'Summary of the Voyage', first published as part of the *Zoology* in 1844, is the probable source for the

'whalers' who are 'endeavouring' to 'extricate' themselves from the ice in which they have been 'entangled' in Turner's 1846 painting (and its title). The sailors on Ross's voyage who brought whale specimens back to J. E. Gray at the British Museum also captured a variety of whales in words. In published and unpublished writings they attended closely to the sperm, finback, and humpback whales they saw in Antarctic waters near mountains of ice lit by a polar sun and animated by volcanic eruptions.

Such observations from the Antarctic appear to be the inspiration for two watercolour vignettes that Turner drew of whales among ice in about 1846. In *Ship, Ice, and Eruption* (private collection; W 1309; formerly called 'Ship and Iceberg') the whales are visible by the tips of their fins in a pool of deep blue water surrounded by icebergs beneath a volcanic eruption. In *Sails, Whales, and Icebergs* (private collection; W 1310; formerly 'Ship among Icebergs') two large finner whales pass near a full-sailed ship in a windblown sea full of bergs. Each drawing corresponds to verbal depictions in Hooker's journals and in his 'Summary of the Voyage' as well as in Ross's *Voyage of Discovery and Research*, published in 1847 by John *Murray, yet another member of the Athenaeum. Turner's drawings may possibly have been considered for this project (whose published illustrations, however, were engraved after drawings by Hooker and J. E. Davis, his counterpart on the *Terror*).

Turner's own sketchbooks of c.1845 contain a number of drawings by which he prepared himself for taking on the subject of whaling in oils. Two large-scale drawings evoke the space and the drama of the chase. On one, now at the *Fitzwilliam Museum in Cambridge, Turner wrote of the whale, 'He breaks away'. On another, in the 'Ambleteuse and Wimereux' Sketchbook, he wrote 'I shall use this' (TB CCCLVII: 6). Other drawings, some of them in the 'Whalers' Sketchbook (CCCLIII), depict such subjects as the boiling of blubber, a whale-like cloud, a finner whale breaking the surface of the sea, and a whaling scene near an erupting volcano. The 'Channel' Sketchbook, which surfaced at Sotheby's in 1986 (10 July, lot 37; now Yale Center for British Art, New Haven; see A. Wilton, A 'Rediscovered Turner Sketchbook', in *Turner Studies*, 6/2 (winter 1986), pp. 9–23), contains several additional whales or whaling scenes.

Turner's depictions of whales illustrate the evolution of his style in the ten-year period from *A Whale on Shore* to the 1846 oils. Turner expressed sympathy for a struggling whale in the small watercolour inspired by *The Pirate*, but his emotional depth and imaginative range had expanded immensely by the time he exhibited *The Whale Ship* in 1845 and *'Hurrah! for the Whaler Erebus! another Fish!'* in 1846. The empathy with which he depicts the agony of a fellow

mammal in the one work, and the silhouette of its severed head in the other, has a certain humanistic precedent in Beale's *Natural History*, but Turner gives such emotion a new expressive force. One expects that he may have been feeling the fate of the whale as a metaphor for his own artistic situation by 1845, the year in which he turned 70, during a decade in which his deepest artistic explorations were drawing increasingly hostile ridicule.

Several years after Turner's death, R. *Brandard engraved one of the whaling oils for *The *Turner Gallery* (1859). Working without Turner's supervision, Brandard got the suspended head of the sperm whale all wrong in *Whalers—'The Erebus'* (R 750). More than a century, it turned out, was to pass before Turner's whaling subjects could begin to be appreciated fully for their narrative cohesion as well as their prismatic flair, for their industrial accuracy as well as their imaginative fancy, for their personal symbolism as well as their ecological empathy.

A writer of Turner's own day who found comparable inspiration in the subject of the whale was Herman Melville, whose novel *Moby-Dick* was published in London two months before Turner's death in 1851. Melville had visited London in November and December 1849. It is not known whether he met Turner himself, but he did meet such close associates as Samuel *Rogers, John Murray, and C. R. *Leslie, and he would have heard about the four whaling oils whether or not he saw them in person. Back in America in July 1850, having imported Beale's *Natural History* as the primary scientific source for his own treatment of the sperm whale, Melville wrote on its title-page, 'Turner's pictures of whalers were suggested by this book'. Turner's powerful aesthetic of the indistinct is a strong presence throughout Melville's novel, beginning with the description of an oil painting in which 'a long, limber, portentous, black mass of something in the centre of the picture' turns out to be an 'exasperated whale'. It was 'a boggy, soggy, squitchy picture truly, enough to drive a nervous man exhausted. Yet was there a sort of indefinite, half-attained sublimity about that fairly froze you to it, till you involuntarily took an oath with yourself to find out what that marvellous painting meant'.

In 1896 *The Whale Ship* was acquired by the *Metropolitan Museum in New York, initiating the kind of extended public exposure it had never before received. The other three whaling oils, belonging to the *Tate Gallery, have all been consistently on view since the creation of the Clore Gallery in 1987, but as yet there has been no exhibition of all four of the whaling oils together. These works offer a rare narrative sequence of four paintings on a single theme painted by Turner at the peak of his visionary power, and they would gain greatly by being seen as an ensemble. In combination with the watercolours and sketches that Turner made of whaling scenes, and in the context of the diverse sources he drew upon in creating them, these four canvases memorably exemplify his 'wonderful range of mind'—his ability to absorb, condense, and transfigure information and perceptions from a wide range of exterior and interior spaces.

On 23 June 1845 Elhanan Bicknell wrote these words about Turner to John *Pye: 'Pray fasten your hook into him before he fairly takes water again or he may get so far and so deep that even a harpoon will not reach him' (Gage 1980, p. 240). Turner did get away for more sketching and fishing that summer, but of course he came back again, too, like the whale who must surface to breathe, ready to expose two new whaling oils to ridicule, yes, but always also to the possibility of enlarged comprehension. RKW

Barry Venning, 'Turner's Whaling Pictures', *Burlington Magazine*, 127 (1985), pp. 75–83.

Peter Bicknell, 'Turner's *The Whale Ship*: A Missing Link?', *Turner Studies*, 5/2 (winter 1985), pp. 20–3.

Robert K. Wallace, 'The "sultry creator of Captain Ahab": Herman Melville and J. M. W. Turner', *Turner Studies*, 5/2 (winter 1985), pp. 2–19.

Robert K. Wallace, 'The Antarctic Sources for Turner's 1846 Whaling Oils', *Turner Studies*, 8/1 (summer 1988), pp. 20–31.

Robert K. Wallace, 'The Antarctic Vignettes', *Turner Studies*, 9/1 (summer 1989), pp. 48–55.

Robert K. Wallace, *Melville and Turner: Spheres of Love and Fright*, 1992.

WHEELER, James Rivington (1758–1834), important patron of English watercolourists, whose collection included six works by Turner. Wheeler, a lawyer, inherited £10,000 from his uncle William Lowe Wheeler (d. 1776) and amassed a large fortune. A regular patron of the Society of Painters in Water-Colours (see WATERCOLOUR SOCIETIES) from 1809, he owned important works by Thomas Heaphy, Joshua Cristall, Ramsay Richard Reinagle, John *Glover, John Varley, and others. Varley's pencil and chalk portrait of Wheeler (c.1813; Victoria and Albert Museum) is inscribed 'J. Wheeler, collector of Drawings'. He housed his collection at his London residence, 26 Gloucester Place, New Road, where it was widely known and visited. *The Annals of the Fine Arts* for 1819 compares his collection with those of Sir John E. *Swinburne, Walter *Fawkes, John *Allnutt, and Sir Richard Colt *Hoare. He and Turner probably met through their circle of mutual friends, and by c.1820 he had commissioned the watercolours *Cologne* (private collection, Japan; W 689a), *Rafts on the Rhine* (Bolton Art Gallery; not in Wilton) and its pendant *The Val d'Aosta* (British Museum; W 403). Other commissions included *Vessels off the Coast* (c.1822, now called *Off St Albans Head*;

Harrogate Art Gallery; not in Wilton) and its pendant *View on the Brent* (private collection; W 417). Turner gave him *Antiquities of Pola*, engraved as the frontispiece to Thomas Allason's *Picturesque Views of the Antiquities of Pola, in Istria* (*c*.1818; private collection; not in Wilton). The artist refers to Wheeler in a note in the 'Hints River' Sketchbook (TB CXLI). TR

Yardley 1986, pp. 51–60.

WHISTLER, James Abbott McNeill (1834–1903), American-born artist. Walter Greaves said that in the 1870s Whistler told him he 'reviled Turner' (E. R. and J. Pennell, *The Life of James McNeill Whistler*, 1908, ii. p. 178). However, there may have been an element of bravado in this, for Whistler shared certain pictorial interests with Turner: the effects of sea and sky, the Thames, and Venice. The expression of his Nocturnes may in some ways be considered to follow Turner's idiom. Whistler was well aware of Turner's work; in 1857 he visited the *Manchester *Art Treasures* exhibition, and must have seen the Turners shown there. Around 1854 he had made a highly worked-up watercolour copy of the chromolithograph of *Rockets and Blue Lights* (R 850; see Margaret F. Macdonald, *James McNeill Whistler: Drawings, Pastels and Watercolours: A Catalogue Raisonné*, 1995, no. 176). Macdonald considers that this work 'shows he was influenced by Turner's technique and subject-matter, and studied it deeply. The technical expertise that he achieved was never forgotten, and he applied it to his own paintings in later years' (ibid.). Whistler lived just a short distance from where Turner had in Chelsea. Comparisons between Whistler and Turner were made at the *Ruskin trial, when Frith was questioned about *Snow Storm—Steam-Boat off a Harbour's Mouth* (RA 1842; BJ 398).

In the 1890s, the Pennells reported, Whistler insisted on Turner's

inferiority to the *Claudes, so amazingly demonstrated in Trafalgar Square, where Turner had invited the comparison disastrous to him . . . As he compared the pictures of the two artists which hang side by side . . . he said 'Well, you know, you only have to look. Claude is the artist who knows there is no painting the sun itself, so he chooses the moment after the sun has set . . . But Turner must paint nothing less than the sun—and he sticks on a blob of paint . . . and there isn't any illusion whatever.' (Pennell, *Life of Whistler*, ii. p. 178) RU

WHITAKER, Dr Thomas Dunham (1759–1821), of Holme in Cliviger near Burnley, Lancashire, clergyman, antiquarian, and planter of trees. He was a landed gentleman who devoted himself to the study of the history and topography of *Lancashire and *Yorkshire. His first book, the *History of Whalley*, was published in 1800–1, with ten of the plates, all

engraved by James *Basire, based on drawings by Turner (R 52–61). The artist had visited Dr Whitaker in 1799 to make the studies for his watercolours, and during his stay he met several other local landowners, including Thomas Lister *Parker and Walter *Fawkes. Though Turner stayed with Dr Whitaker at Holme, the cleric thought of him as merely a 'draftsman' and the Whalley plates are, in fact, old-fashioned and uninspired. In 1805 Whitaker published his *History of Craven* without any illustrations after Turner, who did, however, provide one plate for the second edition in 1812 (R 77). For Whitaker's third topographical work, *Loidis and Elmete* (History of Leeds), 1816, Turner provided earlier drawings for five illustrations: engraved views of Harewood House and Gledhow, and three etched scenes at Farnley Hall, the seat of Walter Fawkes (R 83–7).

Dr Whitaker had become Vicar of Whalley in 1809, and then Rector of Heysham in 1813. It was at about this time that he conceived the bold plan for a *General History of the County of York*, to be published by *Longman's, in seven folio volumes, for which, according to *Farington (*Diary*, 17 May 1816), Turner was commissioned 'to make 120 drawings of various kinds . . . for which he was to have 3000 guineas'. Only the *History of *Richmondshire* was actually completed and published before Dr Whitaker's death in 1821, with twenty plates after Turner, issued between 1818 and 1823 and produced by some of the best engravers of the day, including John *Landseer, John *Pye, and Samuel *Middiman (R 169–88). Turner was paid 25 guineas for each of his watercolours (W 559–80), which he completed in 1817 and 1818, having made an extensive preparatory tour, mostly in bad weather, in the summer of 1816 (see Pl. 13).

Dr Whitaker and a 'committee' of local gentlemen chose the subjects for these plates, which are among the most attractive and successful of the numerous topographical engravings after Turner. *Ruskin, who at one time or another owned six of the original watercolours, claimed that the Richmondshire drawings showed 'the state of Turner's mind in its first perfect grasp of English scenery, entering into all its humblest details with intense affection, and shrinking from no labour in the expression of this delight' (*Works*, xiii. pp. 429–33). The rivers, streams, lakes, and waterfalls of Yorkshire feature in many of these plates, and the series includes several beautifully observed skyscapes. One of the most effective compositions is *Simmer Lake near Askrigg* (R 180), the watercolour for which is in the British Museum (W 571), as is the watercolour for the wonderful and dramatic *Weathercote Cave when half filled with Water* (W 580; R 188). LH

Warburton 1982.
Hill 1984.

Herrmann 1990, pp. 19–21, 99–105.
Shanes 1990², pp. 10–11, 76–7, 79–97, 269–70, 272–3.

WHITE'S *VIEWS IN INDIA*, *Chiefly among the Himalayan Mountains* . . ., published by Henry Fisher in monthly parts, 1836, and in book form with text by Emma Roberts, 1838: 'the most splendid mountain scenery which can be found throughout the world'. (The plates were reissued in Fisher's publications on India and anthologies of engravings.) Turner worked up seven drawings (W 1291–7; R 606–12) from sketches by Lieutenant George Francis White, 31st Regiment. *Stanfield, *Roberts, Thomas Allom, and Henry Warren also contributed. Turner obviously relished 'improving' vast prospects, 'snowy ranges', waterfalls, and the broad Ganges; White's original sketch *Jubberah* (Tate Gallery) by comparison highlights Turner's perspective and atmosphere in the finished watercolour (Blackburn Art Gallery, Lancs.; W 1294; R 609). Foreground details of travellers, huntsmen, tents, and a man with telescope distinguish *Part of the Ghaut at Hurdwar* (City Art Galleries, Leeds; W 1291; R 606) which shows a sacred fair with a Nawab in a palanquin. In 1836 Turner was with *Munro in Italy; this commission may have contributed to their 'half-resolution' to visit India. JRP

Herrmann 1990, pp. 213–14.
Lyles 1992, pp. 74–5.

WHITECHAPEL EXHIBITION, *J. M. W. Turner, R.A., 1775–1851*, 1953. The first serious attempt after the war to provide a comprehensive survey of Turner's work, selected from public and private collections by Bryan Robertson, the director of the Whitechapel Art Gallery in the East End of London.

The exhibition contained 71 prints from the *Liber Studiorum*, 30 paintings including *Frosty Morning* (BJ 127), the *Dort* (BJ 137), The *Evening Star* (BJ 453), and The *Opening of the Wallhalla, 1842* (BJ 401), and 120 watercolours drawn mainly from the *Fitzwilliam Museum, the *Ashmolean Museum, *Manchester City Art Gallery, and the *Whitworth Art Gallery, as well as the Turner Bequest and the private collectors Gilbert Davis and L. G. Duke. EJ

WHITLEY, William T. (1858–1942), writer. Following early ambitions as a painter, Whitley turned to art-historical research. He discussed Turner in *Artists and their Friends in England, 1700–1799* (1928), *Art in England, i. 1800–1820* (1928), and *Art in England, ii. 1821–1837* (1930). He also wrote *Thomas Gainsborough* (1915). The original writer of the *Morning Post* column 'Art and Artists', Whitley contributed to numerous publications including the *Burlington Magazine*, 22 ('Turner as a Lecturer', January 1913, pp. 202–8; February 1913, pp. 255–9) and the *Connoisseur*, 88 ('Relics of Turner', September 1931), p. 198. TR

WHITWORTH ART GALLERY, Manchester, formally the Whitworth Institute, with 3,500 works, can claim to be the major collection of watercolours in Britain outside London. It has 52 Turners, 21 from the collection of J. E. *Taylor (1830–1905), proprietor of the *Manchester Guardian*, eight from James Worthington of Sale, bequeathed by his widow in 1904, and eight bought from a fund presented by the Guarantors of the 1887 *Manchester Royal Jubilee Exhibition*.

Of the 52, 25 date from before Turner's first journey abroad in 1802, including *The Chapter House*, *Salisbury Cathedral* (c.1799; W 199), *St Agatha's Abbey, Easby* (c.1798–9; W 273), *Conway Castle* (c.1801–2; W 271), and, somewhat faded, the romantic *Coniston Fells* (c.1801; W 261).

Petworth Park (c.1828; W 909) is one of only seven drawings outside the Turner Bequest from the famed *Petworth series of 123 drawings on blue paper. Equally notable are the dramatic although faded *Fire at Fennings Wharf* (c.1836; W 523), *A Conflagration, Lausanne* (c.1836; W 1455), *The Lake of Lucerne, Moonlight* (c.1841; W 1478), *Storm in the Pass of *St. Gothard* (1845; W 1546), *Sunset at Sea with Gurnets* (c.1840; W 1396) and the brilliant *Sunset on Wet Sand* (c.1845; W 1415). EJ

Hartley 1984.

WILBERFORCE, William, see SLAVERY.

WILKIE, Sir David (1785–1841). Scottish genre, portrait, and historical painter. After moving to London in 1805 his narrative pictures won immediate success. Turner painted The *Country Blacksmith* (BJ 68) in response to Wilkie's new style; hung alongside Wilkie's *Blind Fiddler* (Tate Gallery) in the 1807 Royal Academy exhibition, it stole some of its thunder. A protégé of Sir George *Beaumont, who bought the *Fiddler*, Wilkie was at first in the opposition camp to Turner, but became an admirer by about 1808. While Turner assimilated elements of Wilkie's genre style, he regarded it as meretricious and repetitive, criticizing Wilkie and his follower Edward Bird, in a poem of about 1811, for having 'stopt contented | At the alluring half-way house | Where each a room hath rented' (TB CXI: 65a). There is no evidence that Turner visited Wilkie's one-man show at 87 Pall Mall in 1812, and he did not visit him at home until 1821. By this time Wilkie's art had evolved, tending towards historical subject matter and assimilating a wider range of Old Masters than the Dutch and Flemish 'low-life' painters who had first inspired him. In Paris with his close friend *Haydon in 1814, and in Antwerp after visiting the field of Waterloo in 1816, he studied *Rubens. His

masterpiece, *Chelsea Pensioners* (Apsley House, London), commissioned by the Duke of *Wellington and showing the arrival of the Waterloo dispatch at the Royal Hospital, showed a new ability to incorporate national events into a familiar situation, and by its immense success in the 1822 RA set standards of popularity unmatched by Turner. That year Wilkie and Turner were both in Scotland to document *George IV's visit, the ceremonial for which was devised by their mutual friend Walter *Scott. Following a breakdown in 1825, Wilkie travelled extensively on the Continent, his experience of Masters such as Correggio and Velasquez substantially changing his later style, while his inclination towards serious historical subjects was also developed.

Though they were never intimate, Turner by now regarded him with respect. Wilkie had become an establishment figure, appointed Painter in Ordinary to George IV on the death of *Lawrence in 1830 and knighted in 1836. Despite this, and the pressure of official commissions not always sympathetic to him, he retained a capacity to reinvent his art. In 1835 he visited Ireland in search of new subjects and in 1840 left for the *Holy Land, planning biblical subjects researched from authentic sources—a journey he recommended to Turner in 'an oft-repeated joke' (Cunningham 1843, iii. p. 443). His death off Gibraltar on his way home moved Turner to paint *Peace—Burial at Sea* (RA 1842; BJ 399); Turner told *Stanfield he wished he could have painted the ship's sails blacker to match his sorrow. DBB

Cunningham 1843.

William Chiego, Hamish Miles, and David Blayney Brown, *Sir David Wilkie of Scotland*, exhibition catalogue, Raleigh, North Carolina Museum of Art, and New Haven, Yale Center for British Art, 1988.

WILL AND BEQUEST. Ever since his death, controversy has surrounded Turner's will and the treatment of what has become known as the Turner Bequest. 'A very stupid Will', Lady *Eastlake called it. Within a month of the death, Turner's cousins, with whom he was not on close terms, sought a court decree that he was of unsound mind and incapable of making a valid will. Their action failed. A grant of probate was issued on 6 September 1852. Then, they argued in court that the will was technically void in attempting to establish a charity for destitute artists. A compromise, reached after three years of litigation, was made effective by a court decree on 19 March 1856. Turner's intentions were frustrated by this compromise: his main charitable scheme was not carried out; his relatives received his engraved works, properties, including the *Queen Anne Street gallery, and most of his investments; a modest bequest to the *Royal Academy was increased to £20,000; his testamentary gift of 'finished pictures' to the National Gallery, *London, was en-

larged to include 'all the Pictures, Drawings and Sketches by the Testator's hands without any distinction of finished or unfinished'. The National Gallery thus became entitled to all the artist's own works, but not engraved works, still in his possession at his death—and this body of work is usually called 'the Turner Bequest'. Subsequent debate has focused on Turner's desire that his pictures should be kept together and housed in a room or rooms to be called 'Turner's Gallery'. These issues were examined by a select committee of the House of Lords in 1861, and have been considered in books, articles, and letters to newspapers, from then until now. Successive attempts by governments, galleries, and curators to honour Turner's wishes and work (as they would put it) or fulfil the nation's obligations (as critics would say) have met mixed receptions. This story is unlikely to be over yet.

Turner's first will was executed on 30 September 1829, the day after his father's funeral. Modest legacies and annuities were given to relatives and the *Danby family, £500 to the *Artists' General Benevolent Institution, and a fund to the Royal Academy to provide a Professorship of Landscape Painting and a *Turner Medal. The residue was to found a charity for 'decayed English artists (Landscape Painters only) and single men' to be built on Turner's land at Twickenham (see SANDYCOOMBE LODGE) and contain a picture gallery. Two paintings—*Dido building Carthage* (BJ 131) and *The Decline of the Carthaginian Empire* (BJ 135)—were to go to the National Gallery, opened just five years earlier, to hang next to works by *Claude. The 1829 will was replaced by a more carefully prepared one, drawn up by the solicitor George *Cobb, and executed on 10 June 1831. It was this, varied by codicils, that was admitted to probate after Turner's death. There were five codicils dated 10 June 1831, 20 August 1832, 29 August 1846, 2 August 1848, and 1 February 1849, but the third was revoked.

It was for Turner's executors to see that his will was carried out. Altogether, ten executors were named: W. F. *Wells, the Revd Henry *Trimmer, Samuel *Rogers, George *Jones, and Charles *Turner in the will itself, Thomas *Griffith, John *Ruskin, Philip Hardwick, and Henry *Harpur in the 1848 codicil, and H.A.J. *Munro of Novar in the 1849 codicil. Of these, the Revd Henry Trimmer, George Jones, Charles Turner, Philip Hardwick, and Henry Harpur proved the will. Wells had died in 1836. Munro reserved power to come in later as an executor. Rogers, Griffith, and Ruskin formally renounced their appointment, although Ruskin later sorted and numbered the works on paper, dismantling sketchbooks, selecting items for exhibition, mounting and encasing many, and destroying certain erotic drawings.

Cash gifts to Turner's father's two surviving brothers (£50 each) and specified cousins (£25), and modest annuities to Hannah Danby, Sarah Danby, and her daughters, Evelina and Georgiana (who died in 1843), were all revoked in 1848. Annuities of £150 each were directed in 1849 to Hannah Danby and Sophia *Booth. The daughters of W. F. Wells—Clara Wheeler (see WELLS, CLARA), Emma *Wells and Laura Wells—were given £100 each in 1849. No other individuals were named by Turner, but each executor was to receive 19 guineas 'for a ring'.

Turner left £1,000 for a monument in St Paul's Cathedral 'where I desire to be buried among my Brothers in Art'. This desire was fulfilled, Turner's body resting in the crypt close to the tombs of *Reynolds and *Lawrence. The marble statue of Turner, by Patrick MacDowell, RA, stands on the south side of the nave under the dome (see MONUMENTS TO TURNER).

In the second will of 1831, as in the earlier will, two pictures were specifically bequeathed. This time, *Sun rising through Vapour (BJ 69) and *Dido building Carthage (BJ 131) were left to the National Gallery, on condition that they were always to hang between Claude's Seaport and Mill (i.e. Seaport with the Embarkation of the Queen of Sheba and The Marriage of Isaac and Rebecca). Barring brief intervals, the four pictures have hung there together ever since.

The scheme of the will for the remainder of Turner's estate, including his other pictures, was straightforward: the executors were to sell everything and invest the proceeds to endow the intended charity for 'poor and decayed male artists being born in England and of English parents only and lawful issue'. However, Turner certainly never intended this dispersal of pictures. In 1832 an unwitnessed codicil (pace Cummings, this was validated by a subsequent codicil)—which it is generally supposed he drew up himself and which may have been influenced by a similar complex at Dulwich—directed that the charity was to be carried into effect by using part of his investments for the erection of

the Gallery to hold my Pictures and places, Houses or Apartments for one two or three or more persons according to circumstances or means which my executors may find expedient keeping in view the first objects I direct namely is to keep my Pictures together so that they may be seen known or found at the direction as to the mode how they may be viewed Gratuitously I leave to my executors and that the Building may for their reception be respectable and worthy of the object which is to keep and preserve my Pictures as a collection of my works.

That the preservation of the collection for viewing together was indeed Turner's first object was further emphasized by a provision in the 1832 codicil which catered for the eventuality that it would be found impossible to establish the

charity. In that case, all the pictures and property in Queen Anne Street were to be kept 'intire and unsold' with Hannah Danby retained as custodian for life 'with the object of Keeping my works together and to be seen under certain restrictions which may be most reputable and advisable'.

By 1848, doubtless influenced by Robert *Vernon's 1847 gift of modern British pictures to the National Gallery, Turner had decided on a different home for, at least, his 'finished Pictures'. The codicil of that year gave these to the National Gallery in addition to Dido and Sun rising 'provided that a room or rooms are added to the present National Gallery to be when erected called "Turner's Gallery" in which such Pictures are to be constantly kept deposited and preserved'. He directed that until this condition was met, the pictures should remain at Queen Anne Street, with its lease being renewed if necessary by his executors

to the intent and purpose that such pictures may always remain and be one entire Gallery and for the purpose of regulating such Gallery it is my wish that so many of the Pictures as may be necessary shall be seen by the public gratuitously so that from the number of them there may be a change of pictures either every one or two years as my said Trustees shall think right.

He also directed what should happen if this fallback plan failed because the lease at Queen Anne Street could not be renewed: in that case the pictures were to be sold. By a short codicil added on the same date in 1848, he gave the National Gallery a time limit for carrying out his conditions, failing which his gift would be void. This time limit was changed by the final, 1849, codicil to a term of ten years after his death.

Turner's residuary estate—investments and cash—was to be used to found his charitable institution, which was to go by the name of 'Turner's Gift'. In the 1832 codicil he dealt with the destination of the residue should the charity not be brought into being within five years after his death. In that event, it was to pass to the Royal Academy subject to their holding an annual dinner on his birthday and—if funds permitted—establishing a professorship of landscape or a 'Turner's Medal' for landscape painting, to be awarded every two years. Should the RA not accept these conditions, residue was to go to Turner's daughter, Georgiana. Nothing in the later codicils disturbed these provisions for dealing with residue.

At the time of Turner's death the law forbade gifts by will for charitable purposes unless the intended bequest had been registered in the Court of Chancery and the relevant deed had been delivered to the intended trustees at least a year before the donor's death. Turner's unexplained failure to comply with the latter rule opened the way for his relatives' second challenge to his will and brought about the collapse of his intended charity.

In the summer of 1854, while litigation was proceeding, Turner's works were transported from Queen Anne Street to the National Gallery for safe keeping, and following the court decree the Gallery's Trustees took legal possession on 25 September 1856. This year is accordingly usually given as the accession year of Bequest items. The finished oil paintings given by Turner's will numbered 100 (including the two bequeathed specifically), but in addition the Gallery received under the decree 182 oils regarded as unfinished and over 19,000 watercolours and drawings. A list of the oil paintings included in a Schedule of 21 June 1854, with notes of modifications made on 19 March 1856, is included in Davies 1946, pp. 185–91. Display space was a problem. Initially, a selection was hung in rooms at Marlborough House, then in use as an annexe of the National Gallery; and in 1859 103 oils and 97 drawings were displayed at the South Kensington Museum (see VICTORIA AND ALBERT MUSEUM). By 1861 attention had been drawn to the risk that the National Gallery might forfeit the Bequest through failing to meet the will's condition about building 'Turner's Gallery' within ten years of his death. The Trustees had thought they took the Bequest under the decree free of any such condition, but they bowed to the opinion of the former Lord Chancellor, Lord St Leonards, who had always argued that the condition still applied. The matter was debated in the House of Lords, and the government appointed a select committee 'to consider in what manner the conditions annexed by the Will of the late Mr. Turner RA to the bequest of his pictures to the Trustees of the National Gallery can best be carried out'. The Trustees submitted evidence:

The Trustees and the Director are of opinion that having undertaken the Care and ordering of these Pictures under the decree of the Court of Chancery, and by virtue of the Powers assigned to them by the Legislature, they are bound to the Extent of the Powers committed to them to see that Provision is made for their Custody, Preservation and Exhibition according to the Intentions of the Testator, unmistakably evinced by the Language of his Will. They apprehend those Intentions clearly to have been that the Works of the Artist should be exhibited to the Public in proximity to and in immediate Connexion with the other Pictures forming the National Gallery . . . The Trustees . . . would submit . . . that, whether that Trust be considered as created by the Will itself, or by the Decree of the Court of Chancery, or as dependent upon the combined authority of both, these Pictures are held by them under an Obligation, binding alike on legal and moral Grounds, to see that the undoubted Object of the Testator is fulfilled.

The committee concluded that

the nation ought . . . to carry out the conditions annexed to the gift in like manner as the conditions annexed to the gift of the two pictures now between the two Claudes have been complied with . . . Turner died in December 1851 and . . . no further delay should take place in providing a room or rooms for the reception and exhibition of his pictures and drawings, now the property of the nation, in connexion with the National Gallery, to be called 'Turner's Gallery'.

What actually happened was that the largest room in the Gallery was designated 'Turner's Gallery' and crammed with most, though not all, of his finished oils; while selections of watercolours and drawings were exhibited at the National Gallery, South Kensington Museum, and, after 1869, museums outside London. An 1883 Act of Parliament permitted the National Gallery to lend to other public galleries 'pictures which can be spared' and some Turner oils were immediately sent to the provinces. In 1905 it proved convenient to move 'surplus' oils to the *Tate Gallery, and by 1910, amid public debate and protest, most of the Bequest was moved there and shown in the newly built Duveen wing, leaving at Trafalgar Square a small 'representative sample'. In 1954 legal ownership of the Bequest was split, legislation vesting in the Tate Gallery the works situated there. Following the 1975 bicentenary exhibitions, the newly formed *Turner Society and others campaigned for the establishment of an independent 'Turner Gallery' to house the entire Bequest in accord with the artist's aims. Instead, the National Gallery retained its works from the Bequest, while the Tate kept its works, recovered the watercolours and drawings that had since 1931 been housed in the *British Museum, and opened in 1987 yet another newly built wing, the 'Clore Gallery', as a home for its 'Turner Collection'. Here, the vast majority of Turner's Bequest has received an unprecedented level of conservation, care, scholarly attention, and public exposure.

The Bequest was initially catalogued by court-appointed assessors, *Eastlake and J. P. *Knight, whose task was to identify works by Turner's own hand. Although no single published catalogue of the Bequest as such exists, all works on paper are listed in *Finberg 1909 and all oils are discussed in BJ. A not implausible attempt by Whittingham at estimating its monetary value in 1992 reached a total of £500,000,000. However, the Bequest is unique and truly priceless. NRDP

Thornbury 1862, pp. 620–33, with reprint of will.

Finberg 1961, pp. 441–55.

Turner Society, *The Case for a Turner Gallery*, n.d. [1979], with reprint of will.

Cummings 1986, pp. 3–8.

Selby Whittingham, *An Historical Account of the Will of J. M. W. Turner, R.A.*, 1989.

Selby Whittingham, *The Fallacy of Mediocrity*, 1992.

Bailey 1997, pp. 402–16.

WILLMORE, James Tibbits (1800–63). English line-engraver, who was born near and trained in Birmingham,

under William *Radclyffe. In his early 20s he moved to London and worked for three years under Charles *Heath. Willmore engraved thirteen of the copper plates in the *England and Wales series, the first of Okehampton in 1828 (R 226). He also engraved a considerable number of steel plates after Turner, especially for the *Rivers of France, to which he contributed eight plates. His outstanding engravings after Turner were large single plates such as the luminous Ancient Italy (R 657), after the RA exhibit of 1838 and published in 1842. In 1843 a proof of this print was Willmore's first exhibit at the *Royal Academy, and he was elected an Associate-Engraver that year. In later years he exhibited several other engravings after Turner; the last, in 1860, was *Childe Harold's Pilgrimage (R 680), an *Art Union print published in 1861. LH

WILSON, Richard (1713/14–1782). Welsh landscape painter, admired by Turner and his generation as the first British artist of substance to devote himself to landscape, and as a paradigmatic exponent of the classical tradition derived from *Claude. After training as a portraitist he concentrated on landscape during seven years in Italy from 1750. Under the influence of Zuccarelli and Joseph *Vernet his style moved from that of the Venetian rococo to an eclectic, but distinctive and atmospheric fusion of earlier masters in which Claude and, to a lesser extent *Dughet, were predominant. This, together with a classical education that matched if it did not actually exceed that of the aristocratic Grand Tourists of the time, ideally suited him for the depiction of the classical sites and scenic beauties of Italy for British visitors to *Rome such as Turner's future patron William *Lock of Norbury, or the second Earl of Dartmouth, for whom he painted oils including Rome: St Peter's and the Janiculum (Tate Gallery), and made 68 monochrome drawings of Roman scenes in 1754.

Wilson's Italian subjects ranged from Arcadian pastorals to historic landscapes with narratives or mythology chosen to enhance their settings, while he was also a master of more abstract subjects in which invented landscapes played host to the drama depicted, as in The Destruction of the Children of Niobe, c.1759–60 (Yale Center for British Art, New Haven), long regarded as the epitome of the historical 'Grand Style' in landscape—though *Reynolds, in his fourteenth Discourse to the Royal Academy, considered Wilson's pictures generally 'too near common nature' to admit such exalted narratives. Turner's picture of Wilson in his 'Backgrounds' lecture in his own *perspective series, casting him—like Wilson's painted hero Cicero—in a tragic role as an example of thwarted achievement and disappointment, was excessively coloured by hindsight. During the

1760s, following his return from Italy, Wilson's reputation stood high. He was a founder member of the Incorporated Society of Artists and of the *Royal Academy, and his output and sensibilities widened to include not only recollections of Italy but also English and Welsh landscapes and country house-portraits, which at times were subordinated to the elevating influence of his classical taste, at others showed a distinctly naturalistic feel, which, when expressed in his broadest, most painterly handling, put them far ahead of their time. Negative recollections of Wilson stemmed from the early 1770s and beyond, when his career went into reverse with a decline of patronage and his descent into alcoholism; before retiring to Wales he was rescued from paupery by a post as RA Librarian.

After his death Wilson's reputation was kept alive by his former pupils including Turner's associates *Farington and Hodges, and underwent significant reappraisal in the 1790s when, as the former noted, his more expressive and naturalistic characteristics were most appreciated. While Turner admired his fusion of landscape and history, his robust technique offered an appropriately 'British' alternative to the Continental slickness he had learnt from his first exemplar in oil painting, de *Loutherbourg. Studying and copying oils by *Wilson, both on canvas and in his 'Wilson' Sketchbook (TB XXXVII) was crucial to his development as an oil painter from the mid-1790s, and the status of various Wilsonian oils in the Turner Bequest (BJ 43, 44, 545, 546, 547)—whether copies, pastiches or reworked originals—remains debatable. Turner may also have made some additions of his own to the otherwise characteristic example of Wilson's 'black chalk and stump' drawings that entered his collection (CCCLXXX: 19). Lock owned many Wilson drawings, and their techniques informed Turner's *'Scottish Pencils' in 1801 (LVIII) and monochrome studies made on the Continent in 1802. Meanwhile Turner's tour of *Wales in 1798, including a visit to Wilson's birthplace of Penegoes (Powys), had been a pilgrimage to the painter, while views of Welsh castles, for example *Kilgarran Castle on the Twyvey, Hazy Sunrise, previous to a Sultry Day (National Trust, Wordsworth House, Cockermouth; BJ 11), were both tributes and creative advances on his style. While the compositional simplicity, atmospherics, and broken paint of such pictures were important inheritances, above all Wilson trained Turner's eye for Claude, and his recollection of both painters 'which ever way he looked' in Italy in 1819 was approvingly noted by both Farington and *Lawrence.

DBB

Brinsley Ford, The Drawings of Richard Wilson, 1951.
Constable 1953.
Solkin 1982.

Andrew Wilton, *J. M. W. Turner: The 'Wilson' Sketchbook*, 1988.

WINDSOR AND SLOUGH. Windsor, as the site of a royal residence, had the most august associations of any location on the Thames up stream from *London (see also RICH-MOND; THAMES AND TRIBUTARIES). 'Majestic Windsor lifts his princely brow' (*Thomson) in one of the most elevated of Turner's Thames pastorals, *Windsor Castle from the Thames* (c.1805; Petworth; BJ 149). In a rectilinear, *Poussinesque composition, the castle, embowered in stately trees, presides over a very broad-looking river, and staffage which includes barges, boatmen, and graceful female shepherds in quasi-classical garb. The painting was bought by Lord *Egremont: such a classicizing image would have fitted in with works by *Claude and Gaspard *Dughet at Petworth.

In *Ploughing up Turnips, near Slough* (Turner's gallery 1809; BJ 89), Windsor Castle again presides, though this time as a more distant silhouette, over a scene of productive activity. In contrast to the atmosphere of timelessness in the previous painting, an emphatically contemporary activity is shown here—the winter harvesting of turnips, a practice central to improved agriculture, since the turnips will serve both as fodder, and prepare the ground for the next crop. *George III, the Castle's resident, was known for his interest in farming. However, the inefficient use of horses in the plough teams and the evident disinclination of the labourers to toil unremittingly do not suggest an unambiguous celebration of agricultural improvement (see Hemingway 1992, pp. 230–1, and AGRICULTURE AS SUBJECT MATTER).

The towers of Eton are visible on the right of the above painting, beyond the agricultural scene. Although educated at Westminster, Lord *Egremont bought two subjects which refer to the school, the 'first . . . in the British Empire' (William Combe, quoted in Hemingway, p. 233). *Near the Thames' Lock, Windsor* (Turner's gallery 1809; Petworth; BJ 88), with its schoolboys playing in the foreground, was exhibited with lines from Gray's *Ode on a Distant Prospect of Eton College*, in which the poet recalls his happy childhood at Eton, and laments its passing. *The Thames at Eton* (Turner's gallery 1808; Petworth; BJ 71) also seems intended to recall the poem, showing, as it does, the towers of Eton's chapel at twilight, a time favourable to melancholic reflection.

Windsor and Eton also feature in *Picturesque Views in *England and Wales* (c.1829; British Museum and private collection, W 829 and 830 respectively). In *Eton College, Berkshire* (W 830), the schoolboys relax on the right, while fishermen trap eels in the left foreground. Turner frequently juxtaposes different social classes in his work for this series,

but it may be that he intends no social critique in his contrast of work and leisure in this image—there are similar contrasts in his apparently affectionate images of *Oxford.　　　AK

Hemingway 1992.

Hill 1993.

WINDUS, Benjamin Godfrey (1790–1867), major collector of Turner's works. B. G. Windus owned probably the largest collection of Turner watercolours in Great Britain. His collection also contained drawings by other artists, notably *Stothard and *Wilkie. Although a coachmaker by profession, with an office in Bishopsgate, London, he seems to have made his fortune selling 'Godfrey's Cordial', an opium-based concoction marketed as a throat remedy. He inherited from his father a house at Tottenham Green, then on the outskirts of London. He added several rooms, including a library where he displayed many of his Turner watercolours. The house was open to the public, albeit a select group, every Tuesday, allowing Windus's collection to become widely known. *Ruskin studied it, maintaining that its open access allowed him the means to write *Modern Painters*. An important record of the collection exists in John Scarlett Davis's 1835 watercolour, *The Library of Tottenham, the Seat of B. G. Windus, Esq.*, showing his Collection Turner Watercolours (British Museum). In a letter to his friend J. M. Ince (quoted in Finberg 1961, pp. 352–3), Davis remarked that the room contained some 50 pictures by Turner; 31 are depicted.

It is not known exactly when Windus began collecting Turner's work, but he lent a watercolour, *Margate from the sea: whiting fishing* (1822; private collection; W 507), to George *Cooke's 1823 exhibition. Windus was the second biggest lender, with sixteen works, to the exhibition of Turner's watercolours held by *Moon, Boys and Graves in Pall Mall, London, in 1833. The core of Windus's Turner collection consisted of about 36 drawings from *Picturesque Views in *England and Wales*; twenty *Southern Coast drawings were known to be in his possession by 1840, and he owned 67 Turner drawings for *Cadell's edition of the *Works and Life of Sir Walter *Scott. William Robinson, in his 1840 catalogue, said that approximately 70 Turner drawings hung in the library, with the remainder in portfolios. Several of these may have been painted for Windus; however, he did not as a rule buy directly from artists or give commissions. In 1841 he turned to collecting Turner's oil paintings, although he continued to acquire drawings as late as 1845. The artist Thomas Tudor, in his 1847 diary, reported that Windus at that time owned three oil paintings: *Calais Sands, Low Water, Poissards collecting Bait* (RA 1830; Bury Art Gallery and Museum; BJ 334), *Dawn of*

Christianity (Flight into Egypt) (RA 1841; Ulster Museum, Belfast; BJ 394), and *Glaucus and Scylla* (RA 1841; Kimbell Art Museum, Fort Worth, Texas; BJ 395). The first was possibly sold in 1849; the latter two appeared in Windus's sale at Christie's, 20 June 1853. Not mentioned by Tudor but also in the 1853 sale were *Approach to Venice* (RA 1844; National Gallery of Art, Washington; BJ 412) and the pair *Going to the Ball (San Martino)* and *Returning from the Ball (St. Martha)* (both RA 1846; private collection; BJ 421–2). Windus sold his Wilkie collection in 1842 (Christie's, 1–2 June), and he had parted with much of his Turner collection before he died. A list of watercolours known to have belonged to him is given in Whittingham 1987. In the 1850s Windus became an important patron of the Pre-Raphaelites. TR

Gage 1980, pp. 299–301.

Whittingham 1987, pp. 29–35.

Selby Whittingham, 'Windus, Turner and Ruskin: New documents', in *J. M. W. Turner, R.A.*, 1993, no. 2, pp. 69–116.

WITNESSES TO TURNER ABROAD make a major contribution to our knowledge of the artist's many tours. There are few extant letters written by Turner about his travels and reports of his comments after his return home are equally scarce. Fortunately other people were more communicative and their accounts, by and large, have the ring of truth. They usually show him hard at work, avoiding unwanted expenses or company (such as that of the Revd Thomas *Judkin), but many also show him at relaxed and sociable moments. Most testimonies come from travelling Britons; Turner was not fluent in any foreign languages, mixed little in local society on most of his travels, and would usually have passed unrecognized. An innkeeper in the Jura told a friend who came looking for him that he was a rough, clumsy man. He made a poor impression on Eugène *Delacroix when he called on him in Paris in 1829 or 1832: the urbane French painter recalled Turner in 1855 as looking just like a farmer and being rather coarse, with big shoes and a hard, cold manner.

An invaluable witness of Turner's first visit to Paris in September–October 1802 was Joseph *Farington, who recorded in his diary not only their meetings and conversations in France but also Turner's subsequent pronouncements on his first venture abroad. Turner's behaviour in *Italy in 1819 was described by several Britons: the poet Tom *Moore recorded their visit to the *Roman Academy of St Luke in a British group led by the sculptor *Canova and an occasion on the Tower of the Capitol when Turner's umbrella was blown inside out in a violent gust of wind; John *Soane's son described in a letter to his father how Turner rudely declined an invitation in *Naples to go out

sketching in company; the architect T. L. Donaldson recalled their ascent of *Vesuvius and Turner's purchase of a white evening waistcoat at a second-hand clothes dealer in Naples when invited to dine with the British Minister. Turner's behaviour in Italy in 1828–9 was described by several correspondents including his host in *Rome, Charles *Eastlake; the watercolourist James Holland, who recalled Turner bargaining at a marine store shop for a large coil of old cable which he then painted yellow and used to frame the pictures in his Roman exhibition (*View of Orvieto, painted in Rome*, BJ 292; *Vision of Medea*, BJ 293, now shown at the Tate Gallery in a rope frame reconstructed by Lawrence *Gowing; and *Regulus*, BJ 294); and a correspondent of the painter Thomas Uwins, who shared a carriage with Turner and described him continually popping his head out of the window to sketch the passing view and becoming angry with the conductor for not waiting while he sketched a sunrise.

Accounts by Turner's rare *companions on his travels are usually far more penetrating than the brief comments resulting from chance sightings by comparative strangers. H. A. J. *Munro of Novar furnished Turner's first biographer Walter *Thornbury with an account of their 1836 travels to the *Val d'Aosta, including precious descriptions of Turner at work—absorbed and sometimes fretful. In *Venice in 1840 the watercolourist William Callow spotted Turner hard at work in a gondola sketching a sunset and was impressed by his energy. A few years later, probably in 1843, William Lake Price was on board the same steamer as Turner on Lake Como and was fascinated to see him scribbling away in a minuscule sketchbook, recording all the changing combinations of shoreline and mountains as they passed.

There are fewer witnesses to Turner in northern Europe than in the south, partly perhaps because of the sheer popularity of Switzerland and Italy with Britons and the many opportunities these countries provided for shared experiences. An unidentified British watercolourist travelling in Germany claimed that he once accepted Turner's invitation to a splendid evening on the *Mosel, when they wined and dined and happily discussed the beauties of the scenery. The following morning he discovered to his consternation that Turner had risen at crack of dawn to go sketching, leaving him to foot the entire bill. CFP

WOOLNER, Thomas (1825–92), sculptor and Royal Academician; admirer of Turner and collector of his work. At various times Woolner owned *Newark Abbey on the Wey* (?Turner's gallery 1807; Yale Center for British Art, New Haven; BJ 65), *Neapolitan Fisher-Girls surprised bathing by Moonlight* (RA 1840; Woolner seems to have owned both

versions, Huntington Museum, California, and private collection, USA; BJ 388 and 389; one of these he lent to the Royal Academy in 1875 (261); see REPLICAS AND VARIANTS), and *Whalers* (RA 1845; Metropolitan Museum, New York; BJ 615). Among the watercolours he owned were *Malmesbury Abbey* (*c*.1793; private collection; W 36), *Trancept of *Ewenny Priory, Glamorganshire* (RA 1797; National Museum and Gallery, Cardiff; W 227), *Evening Landscape, with Castle and Bridge* (*c*.1798–9; Yale Center for British Art, New Haven; W 250), and *Hammerstein, below Andernach* (1817; Johannesburg Art Gallery; W 664). A reference to *The *Fighting 'Temeraire'* (RA 1839; National Gallery, London; BJ 337) appears in his *Life and Letters*, ii. pp. 260–1. Woolner is believed to have taken Turner's death mask (National Portrait Gallery, London), which originally came from his studio. TR

Amy Woolner, *The Life and Letter of Thomas Woolner R.A.*, 1903.

WORDSWORTH, William (1770–1850). Wordsworth addressed poems to Sir George *Beaumont and to B. R. *Haydon (on the high calling of both the poet and the artist, whose brush is 'pregnant with ethereal hues') and moved in circles hostile to Turner. Wordsworth was in some ways temperamentally akin to Turner in his response to landscape, as recognized by *Ruskin, who in *Modern Painters* took epigraphs from *The Excursion* and gave many 'illustrations' to Turner by lines from Wordsworth (*Works*, iii. pp. 307, 347, 353–4, 363). Wordsworth visited and wrote about many British and Continental sites pictured by Turner, both the famous and the less well-known, and called the *Alps the 'types and symbols of Eternity'. Although Wordsworth in the 1835 edition of *A Guide through the District of the Lakes* refers to Turner's 'fine drawing' of the waterfall at Hardraw Scar (Fitzwilliam Museum, Cambridge; W 574; R 182), Crabb Robinson said that Wordsworth 'did not even spare Turner when condemning modern painters'. At the *Royal Academy in 1830 with William Jerdan, he 'growled' at *Jessica* (Petworth House; BJ 333): 'Did you ever see anything like that? It looks to me as if the painter had indulged in raw liver until he was very unwell.' Turner must have been aware of Wordsworth—for example the publisher John Macrone dedicated the edition of *Milton illustrated by Turner to Wordsworth and Southey—but no response or stimulus from his poems is known. JRP

W. Jerdan, *Autobiography*, 1852–3, vol. iv.

WORNUM, Ralph Nicholson (1812–77), art critic and Keeper of the National Gallery, *London. Destined for the law, he went to University College London, but then studied painting under Henry Sass before travelling in Europe for six years to visit the major art galleries and museums. On returning to London in 1839 he practised briefly as a portrait painter but also began writing on art, especially, from 1846, for the *Art Journal*. In 1851 he won the *Art Journal*'s prize for the best essay on 'The [*Great] Exhibition of 1851 as a Lesson in Taste'. In 1847 he compiled a model official catalogue of the National Gallery, which was edited by Sir Charles *Eastlake, who, when he became the first Director of the gallery in 1855, recommended Wornum for the post of Keeper, of which he was an exemplary incumbent. Thus it was Wornum who was responsible for arranging the reception of the paintings and drawings of the Turner Bequest (see WILL AND BEQUEST), a large selection of which were finally exhibited in Trafalgar Square in 1861. At this time Wornum provided the text for the various parts of the *Turner Gallery*, published between 1859 and 1861. LH

WRECK BUOY, THE, oil on canvas, 36½ × 48½ in. (92.7 × 123.2 cm.), RA 1849 (81); Walker Art Gallery, Liverpool (BJ 428). Originally painted *c*.1807, it was acquired sometime afterwards by *Munro of Novar, who brought it down to London so that Turner could alter it for the 1849 RA exhibition, thus showing that by then he was short of new ideas. *Thornbury records Munro anxiously watching Turner for six days while he repainted it; this probably includes the two buoys as well as the rainbows which were described in the *Spectator* (12 May) as 'shaped no better than the vault of an ill-built wine cellar'. However, 'it came out gloriously', although it has certainly darkened since.

Gage associates the rainbows with the bubbles forming the rainbow in *Light and Colour* (RA 1843; BJ 405) which are emblems of fallacious hope and thus considers it a pessimistic work indicating that Turner had ceased to believe in the possibility of redemption. EJ

Gage 1969, pp. 232–3.

WRECK OF A TRANSPORT SHIP, oil on canvas, 68 × 95 in. (172.5 × 241.2 cm.), ?*c*.1810; Fundaçao Calouste Gulbenkian, Lisbon (BJ 210); see Pl. 6. When lent by Lord *Yarborough to the Royal Scottish Academy in 1851, this was entitled: *The Wreck of the Minotaur, Seventy-four, on the Haack Sands, 22nd December 1810*. This appears specific enough but Turner's accounts show that he received £300 for the picture in May 1810 from the Hon. Charles Pelham (1781–1846), later first Earl of Yarborough, and therefore several months before the *Minotaur* was wrecked. Furthermore there are two studies in the 'Shipwreck No. 1' Sketchbook of *c*.1805 (TB LXXXVIII) which were afterwards used for the picture.

The foaming cauldron of the sea and the vortex-like composition foreshadow the stormy seascapes Turner painted

30 years later. Admiral Bowles, who saw the painting in 1849, said: 'No ship or boat could live in such a sea.' EJ

Burnet and Cunningham 1852, pp. 27, 28, 44, 75, 77–8.

WRIGHT OF DERBY, Joseph (1734–97), painter of landscapes, portraits, and subject pictures, whose work was influential on Turner in his early career. Born of a legal family in Derby, Wright trained under the portraitist Thomas Hudson in London where, in the 1760s, he made his reputation with subjects of scientific experiment set by candlelight or lamplight. The influence of Wright's moonlight landscapes—in particular a fondness for contrasting the cold natural light of the moon with the warm glow of a man-made light source such as a lantern or firelight—can be seen in Turner's watercolour *Llanstephan Castle by Moonlight* (1795; TB XXVIII: D) and in his first exhibited oil, **Fishermen at Sea* (RA 1796; BJ 1). In its smooth paint and adoption of glazes, the latter also reflects the 'Continental' manner of de **Loutherbourg and Claude-Joseph **Vernet, a style which Wright—amongst all his English contemporaries—had come closest to perfecting. Turner would also have been aware of Wright's example when painting volcanic eruptions (e.g. *The Eruption of the Souffrier Mountains* (RA 1815; University of Liverpool; BJ 132) and the 1817 watercolours of Vesuvius for **Hakewill (Yale Center for British Art, New Haven, and Williamson Art Gallery, Birkenhead; W 697–8), which recall Wright's own oils of Vesuvius), and when treating industrial subjects (e.g. *Dudley*, *c*.1832, Port Sunlight, Liverpool; W 858, which has distant echoes of Wright's famous oil *Arkwright's Cotton Mills by Night*, private collection). Wright was elected ARA in 1781, but distanced himself from the Royal Academy after a quarrel. He died in Derby, the first important British painter to have pursued a successful career outside London. AL

Benedict Nicolson, *Joseph Wright of Derby, Painter of Light*, 2 vols, 1968.

Judy Egerton, *Wright of Derby*, exhibition catalogue, London, Tate Gallery, 1990.

WRIGHT OF UPTON, Thomas (d. ?1845), the owner of two Turner oils, *Walton Bridges* (Turner's gallery 1806; Loyd Collection, on loan to Ashmolean Museum, Oxford; BJ 60), acquired from Sir John Leicester sometime before 1819, and *Hurley House on the Thames* (*c*.1807–9; private collection; BJ 197), commissioned by Wright himself. His sale was held at Christie's, 7 June 1845, the year he is thought to have died. RU

WYATT, James (1747–1813), highly sought after architect. Turner provided drawings for him during the late 1790s and helped vote him in as President of the **Royal Academy in 1805; his brother Samuel Wyatt and nephew Lewis William Wyatt were also architects, as were other members of the family. Wyatt and Turner were possibly introduced by Richard Colt **Hoare in 1796, when Wyatt was working on Salisbury Cathedral; for a time they were near neighbours in Queen Anne Street. A drawing by Turner of Wyatt's **Fonthill Abbey (Yale Center for British Art, New Haven; W 333) was exhibited at the Royal Academy in 1798 under the architect's name. Wyatt was subsequently present during Turner's three weeks at **Fonthill in 1799. Other Wyatt buildings depicted by Turner include the Brocklesby Mausoleum (destroyed; W 330), the **Pantheon, Oxford Street (TB IX: A; W 27), and Belvoir Castle (private collection; see Yardley p. 61, repr.). ADRL

Susan Morris, '"Two Perspective Views": Turner and Lewis William Wyatt', *Turner Studies*, 2/2 (winter 1983), pp. 34–6.

Edward Yardley, 'Picture Notes', *Turner Studies*, 4/2 (winter 1984), p. 61.

Price 1987.

WYATT, James (1774–1853), printseller, art dealer, carver, and gilder (which is how Turner addressed his letters); mayor of Oxford 1842–3; curator of paintings at Blenheim Palace. Perhaps introduced to Turner by William **Delamotte (1775–1863) who owned **Kilgarran Castle (RA 1799; National Trust, on loan to Wordsworth House, Cockermouth; BJ 11). Wyatt commissioned *View of the **High-Street, Oxford* (Turner's gallery 1810; Loyd collection, on loan to the Ashmolean Museum, Oxford; BJ 102) in 1809–10 to be engraved and, following its success, a companion *Oxford from the Abingdon Road* (RA 1812; private collection; BJ 125). It is clear from their correspondence that Wyatt monitored the progress of the paintings closely and felt free to suggest alterations and additions to Turner.

In 1846 the young Millais went to Oxford, where he met Wyatt, later becoming a frequent guest at his house. Millais described Wyatt as 'A remarkable man in many ways and one of nature's gentlemen', and painted the family portraits, one of which is now in the Tate Gallery (J. D. Millais, *Life and Letters of Sir J. E. Millais*, 1899, i. pp. 34–42).

Wyatt's sale at Christie's in 1853 contained a full-size copy of the *High-Street*, an early Turner watercolour of St Mary Magdalen, Oxford (untraced), and many etchings and proofs of both the commissioned pictures. EJ

Finberg 1961, pp. 169 ff., 186–9.

Gage 1980, pp. 35–42, 301–2.

YACHT APPROACHING THE COAST, oil on canvas, 40¼ × 56 in. (102 × 142 cm.), *c*.1835–40; Tate Gallery, London (BJ 461). One of the most richly textured and coloured of Turner's late unfinished pictures, similar in size and perhaps painted as a light-toned pair to *Stormy Sea with Blazing Wreck* (BJ 462). It has been suggested that the heavily worked surface covers the forms of gondolas and that this was originally conceived as a Venetian subject such as the similarly unfinished *Procession of Boats with Distant Smoke, Venice* (*c*.1845; BJ 505). At the same time the composition, though not the mood, is remarkably similar to that of *Slavers (RA 1840; BJ 385).

Interestingly, this picture, not even given an inventory number by the National Gallery until the early 1930s but regarded as one of the peaks of Turner's achievement by such critics as Lord *Clark, Sir Lawrence *Gowing, and Sir John *Rothenstein, is almost totally neglected in the recent literature.

MB

YALE CENTER FOR BRITISH ART, New Haven, Connecticut. Major gallery and study centre at Yale University devoted to British art. It was founded in 1968 with gifts made to the university by Paul *Mellon, and opened in its impressive building designed by Louis Kahn in 1977. The basis of the Center's extensive collection is that formed by Paul Mellon, begun in the 1930s and becoming a 'dominant interest' in the late 1950s. This was the foundation of a 'nearly encyclopaedic survey of the pictorial arts in Britain from Elizabethan times to the mid-nineteenth century'. Recently the collections have been extended to include later 19th- and 20th-century British art. As well as paintings, drawings, prints, and rare books, there is a small group of sculptures. A fine Print Room and an extensive library combine with the permanent galleries, temporary exhibitions, lecture and seminar programmes to make the Center the principal place for the study and appreciation of British art on the American East Coast.

The collection of paintings, drawings, and prints by and after Turner is one of the Center's strong points, only ri-valled by similar holdings of the work of George Stubbs and John *Constable. The fourteen Turner oil paintings range from the small 1797 *Limekiln at Coalbrookdale* (BJ 22) to two outstanding late sea paintings (BJ 476 and 482) and the lovely *Inverary Pier* (BJ 519), based on a *Liber Studiorum* subject, of the later 1840s. The group includes some famous masterpieces, among them *Dort, or Dordrecht* (RA 1818; BJ 137), and *Staffa, Fingal's Cave* (RA 1832; BJ 347). The representation of Turner's watercolours and drawings is also extensive and impressive, and includes over 50 finished watercolours. *Glacier and Source of the Arveron* (RA 1803; W 365), originally bought by Walter *Fawkes, is an early example of Turner's revolutionary development of watercolour technique, which culminated in the late Swiss watercolours, magnificently represented at Yale by *The Lake of Lucerne* of 1845 (W 1541), which was first bought by *Munro of Novar and then John *Ruskin. Like the collection of watercolours, that of Turner prints is the largest in America, and includes the working collection of W. G. *Rawlinson, acquired in 1976 with that of S. L. *Courtauld, which also provided an outstanding representation of the *Liber Studiorum*. All this material, supported by an excellent library, makes the Yale Center the major place outside London for the study of Turner. An additional factor is that the artist can be seen in an ideal context at Yale, housed in the same building as fine collections of the work of his British predecessors, contemporaries, and successors.

LH

Christopher White, *English Landscape 1630–1850*, exhibition catalogue, New Haven, 1977.
Malcolm Cormack, *Concise Catalogue of Paintings in the Yale Center for British Art*, 1985.

YARBOROUGH, Charles Anderson Pelham, first Baron Yarborough (1749–1823). One of Turner's earliest patrons, Yarborough was a Whig MP, elevated to the peerage. In 1798 Turner went to Brocklesby Hall, near Crowle in Lincolnshire, to make drawings of the Mausoleum; designed by James *Wyatt, it had been raised in 1792 to Yarborough's

wife Henrietta. Turner made seven studies in his 'Brocklesby Mausoleum' Sketchbook (TB LXXXIII), a large watercolour (CXXI: U) and eventually a large watercolour of the interior for use in his *perspective lectures (CXCV: 130). He also made a finished watercolour of the Mausoleum for Yarborough (c.1799; W 330), but this was destroyed by the fire at Brocklesby in 1909; it is known now only from the aquatint by F. C. *Lewis of c.1800 (R 812). In 1804 Yarborough bought The *Festival upon the Opening of the Vintage of Macon (RA 1803; Sheffield City Art Gallery; BJ 47) from Turner for the then enormous sum of 400 guineas. Yarborough was a subscriber to The *Shipwreck print (R 751) in 1805, and was also said, 'with two other noblemen', to have financed Turner's 1802 Continental tour (Manchester *Art Treasures* exhibition, 1857, Provisional Catalogue, p. 111); he submitted a reference for Turner's passport for this journey. Yarborough also possessed a collection of Old Masters at Brocklesby. Works by *Cuyp, *Claude, *Poussin, Joseph *Vernet, and Salvator *Rosa were inherited from his father-in-law in 1801, but *Farington judged them 'very indifferent' (*Diary*, 7 May 1805), though the Claude is a fine example. Nevertheless, Yarborough also owned Bernini's *Neptune and Glaucus*, which he bought at the *Reynolds sale in 1794. RU

YARBOROUGH, Earl of: Charles Pelham (1781–1846), first Commodore of the Royal Yacht Squadron at *Cowes, succeeded his father as Baron Yarborough in 1823, and was created first Earl of Yarborough in 1837. He inherited from his father Turner's *Brocklesby Mausoleum* (c.1799; W 330; destroyed) and *The Festival upon the Opening of the Vintage of Macon* (RA 1803; Sheffield City Art Gallery; BJ 47). He clearly shared his father's enthusiasm for Turner, as he too was a subscriber to The *Shipwreck (R 751) and in 1810 he purchased or commissioned from the artist *Wreck of a Transport Ship* (c.1810, Fundaçao Calouste Gulbenkian, Lisbon; BJ 210). RU

YORKSHIRE. Turner first visited this northern English county in 1797. He made sketches of the Harewood estate, near Leeds, in connection with commissions from its owners, the *Lascelles family, before beginning an extensive tour of the North of England, including Yorkshire, which was gradually becoming more popular with artists and Picturesque (see SUBLIME) tourists. Turner concentrated most on the county's ruined abbeys and castles. A *Rembrandtesque view of the interior of Kirkstall Abbey (Soane Museum; W 234) and an evening view of Fountains Abbey (York City Art Gallery; W 238) were included amongst his ambitious *Royal Academy entry of 1798 (see also LAKE DIS-

TRICT; NORHAM CASTLE). He next sketched in Yorkshire in 1801, *en route* to Scotland. In 1808, he stayed for the first time at Farnley Hall, near Leeds, the seat of Walter *Fawkes. He was to stay there almost every year until Fawkes's death in 1825. Among the results of the 1808 trip were two watercolours depicting the sublimities of the limestone scenery: one of Malham Cove (c.1810; British Museum; W 533) and the other of Gordale Scar (1809; now lost), which, to judge by the surviving study (TB CLIV: O), anticipated James Ward's famous painting (1814; Tate Gallery) in its evocation of natural terrors.

Turner made several watercolours of the towns of Whitby (W 752, 903, 905) and Scarborough (W 527–9, 751) on the east coast. Turner's views of Scarborough tend to emphasize the picturesque foreground staffage of shrimpers, fishermen, and their boats, and the castle on its promontory in the background, rather than the features of the modern resort (for example, *Scarborough Town and Castle: Boys catching Crabs* (?RA 1811; private collection, England; W 528). However, a view of Leeds (1816; Yale Center for British Art, New Haven; W 544), then the textile manufacturing centre of West Yorkshire, is an impressive depiction of an early industrial city. Probably made for T. D. *Whitaker's *Loidis and Elmete* and rejected because of its modernity, the watercolour shows new factories adding their smoke to the sunlit vapours over the city and competing with the churches for prominence, while straggling suburbs develop along the roads. In the foreground are clothworkers, masons, and a milk carrier. Kirkstall Abbey, on the outskirts of Leeds, provided Turner with another index of change. In *Kirkstall Lock, on the River Aire* (c.1824; CCVIII: L; W 745; see also CANALS), painted for the *Rivers of England, the building work and road and canal infrastructure, associated with the expansion of Leeds, combine to push the Abbey into the background, in contrast with the quieter, more conventionally picturesque treatments of the Abbey in the same series (c.1824; CCVII: M; W 741), and earlier (e.g. W 224 of 1798). None the less, Bolton and Rievaulx Abbeys and their immediate surroundings continued to be depicted as havens of rural (not to say piscatorial) tranquillity, as the views made c.1825 for *Picturesque Views in *England and Wales* attest (Lady Lever Art Gallery Port Sunlight and private collection; W 788 and W 785 respectively).

See also FROSTY MORNING; RICHMONDSHIRE; WHITAKER, DR THOMAS DUNHAM. AK

Hill *et al.* 1980.

Hill 1984.

S. Daniels, 'The Implications of Industry: Turner and Leeds', *Turner Studies*, 6/1 (summer 1986), pp. 10–17.

Hill 1996.

Z

ZIEM, Felix (1821–1911), French landscape and marine painter. His colourful, boldly and fluently painted later work is often reminiscent of Turner and also, suspiciously, resembles Hand A (see FAKES AND COPIES). This applies especially to his numerous paintings and drawings of *Venice, which he visited frequently from 1842 onwards. Largely self-taught, he travelled widely in Italy and the Near East, and established his studio at Martigues in Provence, where there is now a Ziem Museum. He visited London in 1892. Ziem enjoyed a considerable reputation during his lifetime, and among his artist admirers was Vincent Van Gogh. LH

ZURICH. Turner made two important panoramic views of Zurich for his late *Swiss sequences of watercolours, one in 1842 (British Museum; W 1533), the other in 1845 (Kunsthaus, Zürich; W 1548). They are very similar, and it may be that the second was done at the behest of B. G. *Windus after he had seen the first, which had been acquired by H. A. J. *Munro of Novar. Both show the town in bright morning light from a high vantage point, looking towards the lake, and are crowded with people, like his late paintings of The *Opening of the Wallhalla or *Heidelberg (BJ 401, 440). The first shows the October vintage festival, and tables are laid in the streets with gingham cloths, while citizens clamber up trellises arranging vines, and soldiers and citizenry march in procession. The event depicted in the second view is another fête. The pair illustrate Turner's late love of huge crowded spaces, the Schillerian, or Beethovenian 'seid umschlungen, Millionen' of a great master including all humanity in his art. AW

ZÜRICH KUNSTHAUS, *Turner und die Schweiz,* 1977. A loan exhibition with three oils and 94 drawings and watercolours shown in the winter of 1977 to coincide with the publication by the De Clivo Press, Zurich, of *Turner in Switzerland* by John Russell and Andrew Wilton. The exhibition made a considerable impact, and was well received by the Swiss. Its climax was provided by four of the ten famous 1842 *Swiss watercolours, and three of the series completed in 1843. *Zürich: Fete, Early Morning* (W 1548) of 1845, originally commissioned by B. G. *Windus and lent by the London gallery Leger's, was acquired by the Kunsthaus. LH

· BIBLIOGRAPHY ·

This is a select bibliography that also gives full references for works referred to in an abbreviated form under individual entries. Fuller bibliographies can be found in Butlin and Joll 1984, Gage 1987, and Herrmann 1990.

Alfrey 1983: Nicholas Alfrey, *Turner en France*, see Paris 1983, pp. 35–41.

Alfrey 1988: Nicholas Alfrey, 'Turner and the Cult of Heroes', *Turner Studies*, 8/2 (winter 1988), pp. 33–44.

Armstrong 1902: Sir Walter Armstrong, *Turner*, 1902.

Ashby 1925: Thomas Ashby, *Turner's Visions of Rome*, 1925.

Australia 1996: Michael Lloyd, ed., *Turner*, exhibition catalogue, Canberra, National Gallery of Australia, and Melbourne, National Gallery of Victoria, 1996.

Bachrach 1974: A. G. H. Bachrach, *Turner and Rotterdam, 1817, 1825, 1841*, n.d. [1974].

Bachrach 1981: A. G. H. Bachrach, 'Turner, Ruisdael and the Dutch', *Turner Studies*, 1/1 (summer 1981), pp. 19–30.

Bachrach 1994: A. G. H. Bachrach, *Turner's Holland*, exhibition catalogue, London, Tate Gallery, 1994.

Bailey 1997: Anthony Bailey, *Standing in the Sun: A Life of J. M. W. Turner*, 1997.

Beckett 1962–8: R. B. Beckett, ed., *John Constable's Correspondence*, 6 vols., 1962–8.

Bell 1901: C. F. Bell, *A List of Works Contributed to Public Exhibitions by J. M. W. Turner, R.A.*, 1901.

Bicknell and Guiterman 1987: Peter Bicknell and Helen Guiterman, 'The Turner Collector: Elhanan Bicknell', *Turner Studies*, 7/1 (summer 1987), pp. 34–44.

Boime 1990: Albert Boime, 'Turner's *Slave Ship*: The Victims of Empire', *Turner Studies*, 10/1 (summer 1990), pp. 34–43.

Borch 1980: Agnes von der Borch, *J. M. William Turner, Köln und der Rhein*, exhibition catalogue, Cologne, Wallraf-Richartz-Museum, 1980, German text.

Bower 1990: Peter Bower, *Turner's Papers: A Study in the Manufacture, Selection and Use of his Drawing Papers 1787–1820*, exhibition catalogue, London, Tate Gallery, 1990.

Bower 1999: Peter Bower, *Turner's Later Papers: A Study in the Manufacture, Selection and Use of his Drawing Papers 1820–1851*, exhibition catalogue, London, Tate Gallery, 1999.

Brown 1991: David Blayney Brown, *From Turner's Studio: Paintings and Oil Sketches from the Turner Bequest*, exhibition catalogue, London, Tate Gallery and tour, 1991.

Brown 1991²: David Blayney Brown, *Oil Sketches from Nature: Turner and his Contemporaries*, exhibition catalogue, London, Tate Gallery, 1991.

Brown 1992: David Blayney Brown, *Turner and Byron*, exhibition catalogue, London, Tate Gallery, 1992.

Brown 1998: David Blayney Brown, *Turner in the Alps 1802*, exhibition catalogue, London, Tate Gallery, and Martigny, Switzerland, Fondation Pierre Gianadda, 1998.

Burnet 1852, 1859: John Burnet, *Turner and his Works*, 1852, 2nd edn. 1859.

Butlin 1981: Martin Butlin, 'Turner's Late Unfinished Oils: Some new evidence for their late date', *Turner Studies*, 1/2 (winter 1981), pp. 43–5.

Butlin 1999: Martin Butlin, 'Studies, Sketches or Beginnings?—Finished and Unfinished in Turner's Work', see New York 1999, pp. 81–94.

Butlin and Joll 1977, 1984: Martin Butlin and Evelyn Joll, *The Paintings of J. M. W. Turner*, 2 vols., 1977, 2nd edn. 1984.

Butlin, Luther, and Warrell 1989: Martin Butlin, Mollie Luther, and Ian Warrell, *Turner at Petworth*, 1989; French edn., *Turner: Les Années Egremont: chefs d'œuvre inédits*, 1989.

Campbell 1993: Mungo Campbell, *A Complete Catalogue of Works by Turner in the National Gallery of Scotland*, 1993.

Chapel 1986: Jeannie Chapel, 'The Turner Collector: Joseph Gillott, 1799–1872', *Turner Studies*, 6/2 (winter 1986), pp. 43–50.

Chumbley and Warrell 1989: Ann Chumbley and Ian Warrell, *Turner and the Human Figure: Studies of Contemporary Life*, exhibition catalogue, London, Tate Gallery, 1989.

Clark 1949, 1996: Kenneth Clark, *Landscape into Art*, 1949, 2nd edn. 1996.

Clarke and Penny 1982: Michael Clarke and Nicholas Penny, *The Arrogant Connoisseur: Richard Payne Knight 1751–1824*, exhibition catalogue, Manchester, Whitworth Art Gallery, 1982.

Clifford 1982: Timothy Clifford, ed., *Turner at Manchester: Catalogue Raisonné Collection of the City Art Gallery*, 1982.

Constable 1953: W. G. Constable, *Wilson*, 1953.

Cormack 1975: Malcolm Cormack, *J. M. W. Turner, R.A. 1775–1851: A Catalogue of Drawings and Watercolours in the Fitzwilliam Museum, Cambridge*, 1975.

Croal and Nugent 1996: Melva Croal and Charles Nugent, *Turner Watercolours from Manchester*, exhibition catalogue, U.S. tour and Manchester, Whitworth Art Gallery, 1996.

Cumming 1986: Robert Cumming, 'The Greatest Studio Sale that Christie's Never Held?', *Turner Studies*, 6/2 (winter 1986), pp. 3–8.

Cunningham 1843: Alan Cunningham, *Life of Wilkie*, 1843.

Cunningham 1852: Peter Cunningham, 'The Memoir' in Burnet 1852, 1859.

Cunningham 1952: C. C. Cunningham, 'Turner's Van Tromp Paintings', *Art Quarterly*, 15 (1952), pp. 323–9.

Davies 1946, 1959: Martin Davies, *National Gallery Catalogues: The British School*, 1946, 2nd edn. 1959.

Davies 1992: Maurice Davies, *Turner as Professor: The Artist and Linear Perspective*, exhibition catalogue, London, Tate Gallery, 1992.

Egerton 1995: Judy Egerton, *Making and Meaning: Turner, The Fighting Temeraire*, 1995.

Egerton 1998: Judy Egerton, *National Gallery Catalogues: The British School*, 1998.

Falk 1938: Bernard Falk, *Turner the Painter: His Hidden Life*, 1938.

Farington: Joseph Farington, *Diary*, MS in Royal Library, Windsor; complete edn., ed. Kenneth Garlick and Angus Macintyre (vols. i–vi), and Kathryn Cave (vols. vii–xvi), 1978–84; index by Evelyn Newby, 1998.

Finberg 1909: A. J. Finberg, *The National Gallery: A Complete Inventory of the Drawings of the Turner Bequest: with which are included the Twenty-three Drawings bequeathed by Mr. Henry Vaughan*, 2 vols, 1909.

Finberg 1910, 1968: A. J. Finberg, *Turner's Sketches and Drawings*, 1910, reissued with introduction by Lawrence Gowing, 1968.

Finberg 1924, 1988: A. J. Finberg, *The History of Turner's Liber Studiorum with a New Catalogue Raisonné*, 1924; reprinted 1988.

Finberg 1930: A. J. Finberg, *In Venice with Turner*, 1930.

Finberg 1939, 1961: A. J. Finberg, *The Life of J. M. W. Turner, R.A.*, 1939, 2nd edn. 1961.

Finley 1980: Gerald Finley, *Landscapes of Memory: Turner as an Illustrator to Scott*, 1980.

Finley 1981: Gerald Finley, *Turner and George the Fourth at Edinburgh 1822*, 1981.

Finley 1997: Gerald Finley, 'The Deluge Pictures: Reflections on Goethe, J. M. W. Turner and Early Nineteenth-Century Science', *Zeitschrift für Kunstgeschichte*, 60 (1997), pp. 530–48.

Finley 1999: Gerald Finley, *Angel in the Sun: Turner's Vision of History*, 1999.

Forrester 1996: Gillian Forrester, *Turner's 'Drawing Book': The Liber Studiorum*, exhibition catalogue, London, Tate Gallery, 1996.

Gage 1969: John Gage, *Colour in Turner: Poetry and Truth*, 1969.

Gage 1969[2]: John Gage, *A Decade of English Naturalism 1810–20*, exhibition catalogue, Norwich Castle Museum and London, Victoria and Albert Museum, 1969.

Gage 1972: John Gage, *Turner: Rain, Steam and Speed*, 1972.

Gage 1974: John Gage, 'Turner and Stourhead: The Making of a Classicist?', *Art Quarterly*, 37 (1974), pp. 59–87.

Gage 1980: John Gage, ed., *The Collected Correspondence of J. M. W. Turner*, 1980.

Gage 1981: John Gage, 'Turner and the Greek Spirit', *Turner Studies*, 1/2 (summer 1981), pp. 14–25.

Gage 1983: John Gage, 'Le roi de la lumière', see Paris 1983, pp. 43–55.

Gage 1984: John Gage, 'Turner's Annotated Books: "Goethe's Theory of Colours"', *Turner Studies*, 4/2 (winter 1984), pp. 34–52.

Gage 1986: John Gage, 'Further Correspondence of J. M. W. Turner', *Turner Studies*, 6/1 (summer 1986), pp. 2–9.

Gage 1987: John Gage, *J. M. W. Turner: 'A Wonderful Range of Mind'*, 1987.

Gage 1996: John Gage, 'Turner: A Watershed in Watercolour', see Australia 1996, pp. 101–27.

George 1971: Hardy George, 'Turner in Venice', *Art Bulletin*, 53 (1971), pp. 4–7.

Goldyne 1975: Joseph R. Goldyne, *J. M. W. Turner: Works on Paper from American Collections*, exhibition catalogue, Berkeley, University Art Museum, 1975.

Golt 1987: Jean Golt, 'Beauty and Meaning on Richmond Hill: New Light on Turner's Masterpiece of 1819', *Turner Studies*, 7/2 (winter 1987), pp. 9–20.

Gowing 1966: Lawrence Gowing, *Turner: Imagination and Reality*, exhibition catalogue, New York, Museum of Modern Art, 1966.

Gowing and Conisbee 1980: Lawrence Gowing and Philip Conisbee, *Painting from Nature: The Tradition of Open-Air Oil Sketching from the 17th to 19th Centuries*, exhibition catalogue, Cambridge, Fitzwilliam Museum, and London, Royal Academy, 1980.

Guiterman 1989: Helen Guiterman, ' "The Great Painter": Roberts on Turner', *Turner Studies*, 9/1 (summer 1989), pp. 2–9.

Hamilton 1997: James Hamilton, *Turner: A Life*, 1997.

Hamilton 1998: James Hamilton, *Turner and the Scientists*, exhibition catalogue, London, Tate Gallery, 1998.

Hamlyn 1993: Robin Hamlyn, *Robert Vernon's Gift: British Art for the Nation*, exhibition catalogue, London, Tate Gallery, 1993.

Hamlyn 1999: Robin Hamlyn, ' "Sword Play": Turner and the Idea of Painterliness as an English National Style', see New York 1999, pp. 117–30.

Hardy 1988: William Hardy, *The History and Techniques of the Great Masters: Turner*, 1988.

Hartley 1984: Craig Hartley, *Turner Watercolours in the Whitworth Art Gallery*, 1984.

Hemingway 1992: Andrew Hemingway, *Landscape Imagery and Urban Culture in Early 19th-Century Britain*, 1992.

Herrmann 1968: Luke Herrmann, *Ruskin and Turner*, 1968.

Herrmann 1975: Luke Herrmann, *Turner: Paintings, Prints and Drawings*, 1975.

Herrmann 1981: Luke Herrmann, 'Turner and the Sea', *Turner Studies*, 1/1 (summer 1981), pp. 4–18.

Herrmann 1987, 1987²: Luke Herrmann, 'John Landseer on Turner: Reviews of Exhibits in 1808, 1839 and 1840', *Turner Studies*, 7/1 (summer 1987), pp. 26–33, and 7/2 (winter 1987), pp. 21–8.

Herrmann 1990: Luke Herrmann, *Turner Prints: The Engraved Works of J. M. W. Turner*, 1990.

Hichberger 1983: Joany Hichberger, 'Captain Jones of the Royal Academy', *Turner Studies*, 3/1 (summer 1983), pp. 14–20.

Hill 1984: David Hill, *In Turner's Footsteps through the Hills and Dales of Northern England*, 1984.

Hill 1984², 1985: David Hill, ' "A Taste for the Arts": Turner and the Patronage of Edward Lascelles of Harewood House', *Turner Studies*, 4/2 (winter 1984), pp. 24–33, and 5/1 (summer 1985), pp. 30–46.

Hill 1988: David Hill, *Turner's Birds: Bird Studies from Farnley Hall*, 1988.

Hill 1992: David Hill, *Turner in the Alps: The Journey through France and Switzerland in 1802*, 1992.

Hill 1993: David Hill, *Turner on the Thames: River Journeys in the Year 1805*, 1993.

Hill 1996: David Hill, *Turner in the North: A Tour . . . in the Year 1797*, 1996.

Hill, Warburton, and Tussey 1980: David Hill, Stanley Warburton, and Mary Tussey, *Turner in Yorkshire*, exhibition catalogue, York City Art Gallery, 1980.

Hofmann 1976: Werner Hofmann *et al.*, *William Turner und die Landschaft seiner Zeit*, exhibition catalogue, Hamburger Kunsthalle, 1976, German text.

Holcomb 1974: Adele M. Holcomb, 'The Bridge in the Middle Distance: Symbolic Elements in Romantic Landscape', *Art Quarterly*, 37 (1974), pp. 59–87.

Irwin 1982: Francina Irwin *et al.*, *Turner in Scotland*, exhibition catalogue, Aberdeen Art Gallery and Museum, 1982.

Joll 1983: Evelyn Joll, 'Catalogue des peintures', see Paris 1983, pp. 58–151.

Joll 1999: Evelyn Joll, 'Who bought Turner's Late Pictures and How Were These Received?', see New York 1999, pp. 105–111.

Jones 1980: George Jones, 'Recollections of J. M. W. Turner', MS, Ashmolean Museum, Oxford, *c*.1857–63, printed in Gage 1980, pp. 1–10.

Kitson 1964: Michael Kitson, *J. M. W. Turner*, 1964.

Kitson 1982/3: Michael Kitson, 'Turner and Claude', *Turner Studies*, 2/2 (winter '1983' for 1982), pp. 2–15.

Kitson 1988: Michael Kitson, 'Turner and Rembrandt', *Turner Studies*, 8/1 (summer 1988), pp. 2–19.

Krause 1997: Martin Krause, *Turner in Indianapolis*, exhibition catalogue, Indianapolis Museum of Art, 1997.

Leslie 1860: C. R. Leslie, *Autobiographical Reflections*, 1860; reprinted 1978.

Lindsay 1966: Jack Lindsay, *J. M. W. Turner: His Life and Work, a Critical Biography*, 1966.

Lindsay 1966²: Jack Lindsay, *The Sunset Ship: The Poems of J. M. W. Turner*, 1966.

Lindsay 1985: Jack Lindsay, *Turner: The Man and his Art*, 1985.

Livermore 1957: Ann Livermore, 'J. M. W. Turner's Unknown Verse Book', *The Connoisseur Year Book*, 1957, pp. 78–86.

Lloyd 1984: Mary Lloyd, *Sunny Memories*, 2 vols., 1879 and 1880; part reprinted as 'A Memoir of J. M. W. Turner, R.A., by "M.L." ', *Turner Studies*, 4/1 (summer 1984), pp. 22–3.

Lyles 1988: Anne Lyles, *Turner and Natural History: The Farnley Project*, exhibition catalogue, London, Tate Gallery, 1988.

Lyles 1989: Anne Lyles, *Young Turner: Early Work to 1800; Watercolours and Drawings from the Turner Bequest 1787–1800*, exhibition catalogue, London, Tate Gallery, 1989.

Lyles 1992: Anne Lyles, *Turner: The Fifth Decade; Watercolours 1830–1840*, exhibition catalogue, London, Tate Gallery, 1992.

Lyles and Perkins 1989: Anne Lyles and Diane Perkins, *Colour into Line: Turner and the Art of Engraving*, exhibition catalogue, London, Tate Gallery, 1989.

Maas 1975: Jeremy Maas, *Gambart Prince of the Victorian Art World*, 1975.

McCoubrey 1984: John McCoubrey, 'War and Peace in 1984: Turner, Haydon and Wilkie', *Turner Studies*, 4/2 (winter 1984), pp. 2–7.

McCoubrey 1986: John McCoubrey, 'Time's Railway: Turner and the Great Western', *Turner Studies*, 6/1 (summer 1986), pp. 33–9.

Macleod 1996: Dianne S. Macleod, *Art and the Victorian Middle Class: Money and the Making of Cultural Identity*, 1996.

Marks 1981: Arthur S. Marks, 'Rivalry at the Royal Academy: Wilkie, Turner, and Bird', *Studies in Romanticism*, 20 (1981), pp. 333–62.

New York 1999: *exploring late Turner*, exhibition catalogue, New York, Salander-O'Reilly Galleries, New York, 1999.

Nicholson 1990: Kathleen Nicholson, *Turner's Classical Landscapes: Myth and Meaning*, 1990.

Omer 1975: Mordechai Omer, *Turner and the Poets*, exhibition catalogue, London, Marble Hill, 1975.

Omer 1979, 1981: Mordechai Omer, *Turner and the Bible*, exhibition catalogue, Jerusalem, Israel Museum, 1979, and Oxford, Ashmolean Museum, 1981.

Omer 1985: Mordechai Omer, *Turner: Landscapes of the Bible and the Holy Land*, 1985.

Paris 1981: Maurice Guillaud, ed., *Turner en France*, exhibition catalogue, Paris, Centre Culturel du Marais, 1981, French text.

Paris 1983: *J. M. W. Turner*, intro. John Gage, exhibition catalogue, Paris, Grand Palais, 1983, French text.

Paulson 1982: Ronald Paulson, *Literary Landscape: Turner and Constable*, 1982.

Payne 1991: Christiana Payne, 'Boundless Harvest: Representations of Open Fields and Gleaning in Early Nineteenth-Century England', *Turner Studies*, 11/1 (summer 1991), pp. 7–16.

Perkins 1990: Diane Perkins, *Turner: The Third Decade; Turner's Watercolour 1810–1820*, exhibition catalogue, London, Tate Gallery, 1990.

Piggott 1993: Jan Piggott, *Turner's Vignettes*, exhibition catalogue, London, Tate Gallery, 1993.

Powell 1982/3: Cecilia Powell, 'Picture Notes', *Turner Studies*, 2/2 (winter '1983' for 1982), pp. 56–8.

Powell 1983: Cecilia Powell, 'Turner's Vignettes and the Making of Roger's "Italy" ', *Turner Studies*, 3/1 (summer 1983), pp. 2–13.

Powell 1987: Cecilia Powell, *Turner in the South: Rome, Naples, Florence*, 1987.

Powell 1991: Cecilia Powell, *Turner's Rivers of Europe: The Rhine, Meuse and Mosel*, exhibition catalogue, London, Tate Gallery, and Brussels, Musée d'Ixelles, 1991.

Powell 1992, 1993: Cecilia Powell, 'Turner's Women: The Painted Veil', *Turner Society News*, 62 (December 1992), pp. 10–14, and 63 (March 1993), pp. 12–15.

Powell 1995: Cecilia Powell, *Turner in Germany*, exhibition catalogue, London, Tate Gallery, Mannheim, Städtische Kunsthalle, and Hamburger Kunsthalle, 1995.

Price 1987: Curtis Price, 'Turner at the Pantheon Opera House, 1791–2', *Turner Studies*, 7/2 (winter 1987), pp. 2–8.

Pye and Roget 1879: John Pye and John Lewis Roget, *Notes and Memoranda Respecting the 'Liber Studiorum' of J. M. W. Turner R.A.*, 1879.

Rawlinson 1878, 1906: W. G. Rawlinson, *Turner's* Liber Studiorum: *A Description and a Catalogue*, 1878, 2nd edn. 1906.

Rawlinson 1908, 1913: W. G. Rawlinson, *The Engraved Work of J. M. W. Turner R.A.*, i, 1908; ii, 1913.

Redgrave 1866, 1947: Richard and Samuel Redgrave, *A Century of British Painters*, 2 vols., 1866; ed. Ruthven Todd 1947.

Reynolds 1969: Graham Reynolds, *Turner*, 1969.

Reynolds 1969²: Graham Reynolds, 'Turner at East Cowes Castle', *Victoria and Albert Museum Year Book*, i, 1969, pp. 67–79.

Reynolds 1999: Graham Reynolds, 'Turner's Late Sky Studies', see New York 1999, pp. 17–22.

Ruskin *Works*: *The Works of John Ruskin*, ed. E. T. Cook and Alexander Wedderburn, 39 vols., 1903–12.

Russell and Wilton 1976: John Russell and Andrew Wilton, *Turner in Switzerland*, 1976.

Sayers 1996: Andrew Sayers, 'Turner and the Origins of Landscape Painting in Australia', see Australia 1996, pp. 202–15.

Shanes 1979: Eric Shanes, *Turner's Picturesque Views in England and Wales 1825–1838*, 1979.

Shanes 1981: Eric Shanes, *Turner's Rivers, Harbours and Coasts*, 1981.

Shanes 1984: Eric Shanes, 'New Light on the "England and Wales" Series', *Turner Studies*, 4/1 (summer 1984), pp. 52–4.

Shanes 1990: Eric Shanes, *Turner's Human Landscape*, 1990.

Shanes 1990²: Eric Shanes, *Turner's England*, 1990.

Shanes 1990³: Eric Shanes, 'Dissent in Somerset House: Opposition to the Political *Status-Quo* within the Royal Academy around 1800', *Turner Studies*, 10/2 (winter 1990), pp. 40–6.

Shanes 1997: Eric Shanes, *Turner's Watercolour Explorations, 1810–1842*, exhibition catalogue, London, Tate Gallery, 1997.

Smiles 1987: Sam Smiles, 'Turner in Devon: some additional information concerning his visits in the 1810s', *Turner Studies*, 7/1 (summer 1987), pp. 11–14.

Smiles 1989: Sam Smiles, 'The Devonshire Oil Sketches of 1813', *Turner Studies*, 9/1 (summer 1989), pp. 10–25.

Smiles and Pidgley 1995: Sam Smiles and Michael Pidgley, *The Perfection of England: Artist Visitors to Devon c.1750–1870*, exhibition catalogue, Exeter, Royal Albert Memorial Museum, 1995, pp. 99–103.

Smith 1986: Sheila M. Smith, 'Contemporary Politics and "The External World" in Turner's *Undine* and *The Angel Standing in the Sun*', *Turner Studies*, 6/1 (summer 1986), pp. 40–50.

Solender 1984: Katherine Solender, *Dreadful Fire!*, exhibition catalogue, Cleveland Museum of Art, 1984.

Solkin 1982: David H. Solkin, *Richard Wilson: The Landscape of Reaction*, exhibition catalogue, London, Tate Gallery, 1982.

Stader 1981: K. H. Stader, *William Turner und der Rhein*, 1981, German text.

Stainton 1985: Lindsay Stainton, *Turner's Venice*, 1985.

Stainton 1985²: Lindsay Stainton, 'Ducros and the British', *Images of the Grand Tour: Louis Ducros 1748–1810*, exhibition catalogue, London, Kenwood, Manchester, Whitworth Art Gallery, and Lausanne, Musée Cantonal des Beaux-Arts, 1985, pp. 26–30.

Stuckey 1981: Charles Stuckey, 'Turner's Birthdays', *Turner Society News*, 21 (April 1981), pp. 4–6.

Thornbury 1862, 1877: Walter Thornbury, *The Life of J. M. W. Turner, R.A.*, 2 vols., 1862; 2nd edn. 1877.

Townsend 1993: Joyce Townsend, *Turner's Painting Techniques*, exhibition catalogue, London, Tate Gallery, 1993.

Townsend 1993²: Joyce Townsend, 'The Materials of J. M. W. Turner: Pigments', *Studies in Conservation*, 38 (1993), pp. 231–54.

Townsend 1996: Joyce Townsend, 'Turner's "Drawing Book": The *Liber Studiorum*: Materials and Techniques', pre-prints of 11th triennial meeting of Icon-CC, Edinburgh, 1996.

Upstone 1989: Robert Upstone, *Turner: The Second Decade; Watercolours and Drawings from the Turner Bequest 1800–1810*, exhibition catalogue, London, Tate Gallery, 1989.

Upstone 1993: Robert Upstone, *Turner: The Final Years; Watercolours 1840–1851*, exhibition catalogue, London, Tate Gallery, 1993.

Venning 1982, 1982²/3, 1983: Barry Venning, 'Turner's Annotated Books: Opie's "Lectures on Painting" and Shee's "Elements of Art" ', *Turner Studies*, 2/1 (summer 1982), pp. 36–46; 2/2 (winter '1983' for 1982), pp. 40–9; and 3/1 (summer 1983), pp. 33–44.

Walker 1983: Richard Walker, 'The Portraits of J. M. W. Turner: A Check-list', *Turner Studies*, 3/1 (summer 1983), pp. 21–32.

Wallace 1979: Marcia Briggs Wallace, 'J. M. W. Turner's Circular, Octagonal and Square Paintings 1840–1846', *Arts Magazine*, 55 (April 1979), pp. 107–17.

Warburton 1982: Stanley Warburton, *Turner and Dr. Whitaker*, 1982.

Warrell 1991: Ian Warrell, *Turner: The Fourth Decade: Watercolours 1820–1830*, exhibition catalogue, London, Tate Gallery, 1991.

Warrell 1995: Ian Warrell, *Through Switzerland with Turner: Ruskin's First Selection from the Turner Bequest*, exhibition catalogue, London, Tate Gallery, 1995.

Warrell 1997: Ian Warrell, *Turner on the Loire*, exhibition catalogue, London, Tate Gallery, 1997.

Warrell 1999: Ian Warrell, *Turner on the Seine*, exhibition catalogue, London, Tate Gallery, 1999.

Warrell 1999²: Ian Warrell, 'Turner's Late Swiss Watercolours—and Oils', see New York 1999, pp. 139–52.

Warrell and Perkins 1988: Ian Warrell and Diane Perkins, *Turner and Architecture*, exhibition catalogue, London, Tate Gallery, 1988.

Wedmore 1900: F. Wedmore, *Turner and Ruskin*, 2 vols., 1900.

Whittingham 1985, 1985²: Selby Whittingham, 'What you Will; or some notes regarding the influence of Watteau on Turner and other British Artists', *Turner Studies*, 5/1 (summer 1985), pp. 2–24, and 5/2 (winter 1985), pp. 28–48.

Whittingham 1986: Selby Whittingham, 'A Most Liberal Patron: Sir John Leicester, Bart., 1st Baron de Tabley, 1762–1827', *Turner Studies*, 6/2 (winter 1986), pp. 24–36.

Whittingham 1987: Selby Whittingham, 'The Turner Collector: B. G. Windus', *Turner Studies*, 7/2 (winter 1987), pp. 29–35.

Wilkinson 1972: Gerald Wilkinson, *Turner's Early Sketch Books, 1789–1802*, 1972.

Wilkinson 1974: Gerald Wilkinson, *The Sketches of Turner, R.A., 1802–20: Genius of the Romantic*, 1974.

Wilkinson 1975: Gerald Wilkinson, *Turner's Colour Sketches, 1820–34*, 1975.

Wilson 1987: John Human Wilson, 'The Landscape Paintings of John Hoppner', *Turner Studies*, 7/1 (summer 1987), pp. 15–25.

Wilton 1979: Andrew Wilton, *The Life and Work of J. M. W. Turner*, 1979.

Wilton 1980: Andrew Wilton, *Turner and the Sublime*, exhibition catalogue, Toronto, Art Gallery of Ontario, New Haven, Yale Center for British Art, and London, British Museum, 1980.

Wilton 1982: Andrew Wilton, *Turner Abroad*, 1982.

Wilton 1984: Andrew Wilton, *Turner in Wales*, exhibition catalogue, Llandudno, Mostyn Art Gallery, and Swansea, Glynn Vivian Art Gallery, 1984.

Wilton 1986: Andrew Wilton, 'Turner at Bonneville', *Essays in Honor of Paul Mellon*, ed. John Wilmerding, 1986, pp. 402–27.

Wilton 1986²: Andrew Wilton, 'A Rediscovered Turner Sketchbook', *Turner Studies*, 6/2 (winter 1986), pp. 9–23.

Wilton 1987: Andrew Wilton, *Turner in his Time*, 1987.

Wilton 1988: Andrew Wilton, 'Turner and the Sense of Place', *Turner Studies*, 8/2 (winter 1988), pp. 26–44.

Wilton 1989: Andrew Wilton, 'The "Keepsake" Convention: *Jessica* and Some Related Pictures', *Turner Studies*, 9/2 (winter 1989), pp. 14–33.

Wilton 1990: Andrew Wilton, 'Picture Note', *Turner Studies*, 10/2 (winter 1990), pp. 55–9.

Wilton and Turner 1990: Andrew Wilton and Rosalind Mallord Turner, *Painting and Poetry: Turner's Verse Book and his Work of 1804–1812*, exhibition catalogue, London, Tate Gallery, 1990.

Woodbridge 1970: Kenneth Woodbridge, *Landscape and Antiquity: Aspects of English Culture at Stourhead, 1718–1838*, 1970.

Yardley 1986: Edward Yardley, 'The Turner Collector: "That Munificent Gentleman"—James Rivington Wheeler', *Turner Studies*, 6/2 (winter 1986), pp. 51–60.

Youngblood 1982: Patrick Youngblood, 'The Painter as Architect: Turner and Sandycombe Lodge', *Turner Studies*, 2/1 (summer 1982), pp. 36–46.

Youngblood 1982²/3: Patrick Youngblood, ' "That house of art": Turner at Petworth', *Turner Studies*, 2/2 (winter '1983' for 1982), pp. 16–33.

Youngblood 1983: Patrick Youngblood, 'Three Mis-Identified Works by J. M. W. Turner', *Burlington Magazine*, 125 (1983), pp. 615–19.

Ziff 1963: Jerrold Ziff, ' "Backgrounds: Introduction of Architecture and Landscape". A Lecture by J. M. W. Turner', *Journal of the Warburg and Courtauld Institutes*, 26 (1963), pp. 124–7.

Ziff 1963²: Jerrold Ziff, 'Turner and Poussin', *Burlington Magazine*, 105 (1963), pp. 315–21.

Ziff 1964: Jerrold Ziff, 'Turner on Poetry and Painting', *Studies in Romanticism*, 3 (1964), pp. 193–215.

Ziff 1965: Jerrold Ziff, 'Copies of Claude's Paintings in the Sketch Books of J. M. W. Turner', *Gazette des Beaux-Arts*, 65 (1965), pp. 51–64.

Ziff 1980: Jerrold Ziff, Review of Butlin and Joll 1977, *Art Bulletin*, 62 (1980), pp. 166–71.

Ziff 1986: Jerrold Ziff, 'William Henry Pyne's "J. M. W. TURNER R.A.": A Neglected Critic and Essay Remembered', *Turner Studies*, 6/1 (summer 1986), pp. 18–25.

Ziff 1988: Jerrold Ziff, 'Turner as Defender of the Art between 1810–20', *Turner Studies*, 8/2 (winter 1988), pp. 13–25.

· CHRONOLOGY ·

Note: Between 1796 and 1850 Turner exhibited 189 oils at the RA and the BI, but only a selection of key works is listed below. Asterisks indicate an entry in the main text.

TURNER'S LIFE		PAINTING, ARCHITECTURE, MUSIC, AND LITERATURE		OTHER EVENTS IN BRITAIN AND ABROAD

1775–1790

1775	Joseph Mallord William Turner born in London at 21 *Maiden Lane, Covent Garden, to William *Turner, barber and wig-maker, and his wife Mary *Marshall, probably on 23 April. Baptized on 14 May at St Paul's, Covent Garden.	1775	Thomas *Girtin born. Robert Adam working at Osterley. Jane Austen born.	1775	American War of Independence. Alexander Cumming patented the water closet. Wedgwood perfected his jasperware invention.
		1776	John *Constable born. *Reynolds, *Omai*. Adam Smith, *Wealth of Nations*. Gibbon, *Decline and Fall of the Roman Empire*—completed 1783.	1776	4 July, American Declaration of Independence.
		1777	James *Barry, *Progress of Human Culture* for the Great Room of the Society of Arts—completed 1783.	1777	General Burgoyne surrendered at Saratoga.
1778	Mary Ann, Turner's sister, born.	1778	*Hazlitt born. Copley, *Brook Watson and the Shark*.	1778	Death of Pitt the Elder.
		1779	Reynolds completed the two 'Society of Dilettanti' groups. Copley, *Death of Chatham*—completed 1780. *Callcott born.	1779	Samuel Crompton perfected his spinning mule. Siege of Gibraltar.
		1780	Zoffany, *Tribuna*. Richard *Wilson, *Tabley House*. Ingres born.	1780	Gordon Riots in London. The Derby first run at Epsom Downs.
		1781	Reynolds, *The Three Ladies Waldegrave*. *Fuseli, *The Nightmare*. *Wright of Derby, *Sir Brooke Boothby*. Rousseau, *Confessions*. Kant, *Critique of Pure Reason*. *Chantrey born.	1781	British surrender at Yorktown. Walter Scott born.
		1782	*Gainsborough, *Madame Bacelli*. Reynolds, *Captain Tarleton*. de *Loutherbourg exhibited the Eidophusikon in London. Death of Wilson.	1782	James Watt developed the first rotary steam engine. Home Office established.

TURNER'S LIFE		PAINTING, ARCHITECTURE, MUSIC, AND LITERATURE		OTHER EVENTS IN BRITAIN AND ABROAD	
1783	Death of Mary Ann just before her fifth birthday.	1783	William *Gilpin's first *Picturesque Tour* published.	1783	Treaty of Versailles: France and Britain recognized American Independence. Pitt the Younger became Prime Minister.
		1784	Reynolds, *Mrs Siddons as the Tragic Muse*. John *Opie, *A School*.	1784	Pitt's India Bill.
1785	Turner stayed with his maternal uncle, a butcher, at Brentford, Middlesex.	1785	Gainsborough, *Mr and Mrs William Hallett* ('The Morning Walk'). *Wilkie born. Mozart, *Marriage of Figaro*.	1785	Cartwright invented power weaving. First Channel crossing by balloon.
1786	Turner sent to stay at Margate where he made his earliest surviving drawings (W 1–4).	1786	Reynolds, *Duchess of Devonshire and her Daughter*. George *Jones born. Sir William Chambers's Somerset House completed. Richard Payne *Knight, *An Account of the Remains of the Worship of Priapus*. William *Beckford, *Vathek*.	1786	Impeachment of Warren Hastings.
1787	First signed and dated drawing (W 5). His work displayed in the window of his father's shop.	1787	Mozart, *Don Giovanni*.	1787	American Constitution signed.
		1788	*Byron born. Death of Gainsborough. The *Times* appeared for the first time.	1788	Trial of Warren Hastings began. First steamboat built. Linnean Society founded in London. British colony founded at Botany Bay, Australia.
1789	Stayed with an uncle at Sunningwell near Oxford. Employed as a draughtsman in the office of the architect Thomas *Hardwick. By the end of the year working with Thomas *Malton and admitted to the *Royal Academy Schools after a term's probation.	1789	*Lawrence, *Queen Charlotte*. Blake, *Songs of Innocence*. Gilbert White, *The Natural History of Selborne*.	1789	French Revolution—storming of Bastille. Mutiny on HMS *Bounty*. George Washington inaugurated as first President of the United States of America.
1790	Family moved across Maiden Lane to Hand Court, no. 26. Exhibited first watercolour at the RA: *The *Archbishop's Palace, Lambeth* (W 10).	1790	Burke, *Reflections on the Revolution in France*. Mozart, *Così fan tutte*.	1790	Death of Adam Smith.

1791–1800

1791	Two watercolours at the RA (W 12, 14). Stayed with the *Narraways, friends of his father, at *Bristol and from there went on his first sketching tour visiting Malmesbury and Bath.	1791	Boswell, *Life of Johnson*. Michael *Faraday born. Haydn in London 1791–2, 1794–5.	1791	Louis XVI's flight to Varennes.

TURNER'S LIFE		PAINTING, ARCHITECTURE, MUSIC, AND LITERATURE		OTHER EVENTS IN BRITAIN AND ABROAD	
1792	Admitted to the life class at the RA; W 27, 28 shown there. Met *Soane and W. F. *Wells. Again stayed with the Narraways and then made a sketching trip into South Wales.	1792	Death of Reynolds. *Shelley born. Raeburn, *Sir John and Lady Clerk*. Thomas Paine, *The Rights of Man*. Mary Wollstonecraft, *A Vindication of the Rights of Woman*.	1792	France declared war on Austria.
1793	Awarded Great Silver Pallet by the *Society of Arts for a landscape drawing. Summer tour of Hereford and *Tintern and visited Kent and Sussex in the autumn. First contact with Dr Thomas *Monro and probably first attempts at painting in oils.	1793	Godwin, *An Enquiry Concerning Political Justice*.	1793	Britain and France declared war. Execution of Louis XVI and Marie Antoinette. Marat assassinated by Charlotte Corday.
1794	Five watercolours at the RA attracted favourable press comments. First Midland tour in the summer and then on into North Wales. Began to take pupils for drawing lessons and also to work regularly on Friday evenings for Dr Monro copying drawings by J. R. *Cozens and others in company with his fellow pupil Thomas *Girtin.	1794	Lawrence, *Richard Payne Knight*. *Soane's Bank of England completed.	1794	Admiral Howe defeated the French on the 'Glorious First of June'.
1795	Eight watercolours at the RA. Toured South Wales in June–July and the *Isle of Wight in August–September with commissions from the engraver John *Landseer. Also received commissions from Viscount Malden (see *Essex) and Sir Richard Colt *Hoare.	1795	Keats born. Humphrey Repton's *Sketches of History on Landscape Gardening* encouraged growth of 'picturesque' landscaping.	1795	The future King George IV married Princess Caroline of Brunswick.
1796	First oil at the RA: *Fishermen at Sea*, a view off the coast near the Needles, Isle of Wight. Summer, may have visited Brighton, perhaps to recover from an illness.	1796	Corot born.		
1797	Two oils, four watercolours at the RA. Tour of the North of England and the Lake District. Visited Harewood to execute commissions from Edward *Lascelles.	1797	Death of Horace Walpole.	1797	Naval mutinies at the Nore and Spithead.
1798	First year that lines of *poetry were allowed to be appended to titles of pictures exhibited at the RA.	1798	Malthus, *Essay on the Principle of Population*. *Wordsworth and *Coleridge,	1798	Edward Jenner demonstrated first vaccination against smallpox.

TURNER'S LIFE		PAINTING, ARCHITECTURE, MUSIC, AND LITERATURE		OTHER EVENTS IN BRITAIN AND ABROAD	
	April, three-day sketching tour of Kent with the Revd Robert *Nixon and Stephen Rigaud. Tour of *Wales, where he visited Richard *Wilson's birthplace. November, competed unsuccessfully for Associateship of the Royal Academy but was in any case below the minimum age permissible.		*Lyrical Ballads.* Haydn, *Creation* and *Nelson Mass.* *Delacroix born.	Pitt introduced income tax. Nelson destroyed French fleet at the Battle of the Nile.	
1799	April, recommended to Lord Elgin to accompany him to Greece as his draughtsman but Elgin found Turner's terms too stiff. Visited *Beckford's London house to see the Altieri *Claudes recently arrived from Italy. August–September, working for Beckford at *Fonthill. November, elected ARA and moved to 64 *Harley Street, sharing studio accommodation with J. T. *Serres. First *Oxford Almanack* engraving by James *Basire published. Sarah *Danby became Turner's mistress.	1799	Thomas *Campbell, *Pleasures of Hope.*	1799	*Napoleon appointed First Consul. Death of George Washington.
1800	Sat to George Dance for his *portrait. Among RA exhibits *The Fifth *Plague of Egypt* bought by Beckford for 150 guineas. Commissioned by the Duke of *Bridgewater to paint a seapiece as a companion to the Duke's *Van de Velde, the price to be 250 guineas. 27 December, his mother admitted to Bethlem Hospital for the insane where Dr Monro was physician.	1800	Girtin, *The White House.* J.-L. *David, *Madame Recamier.* Macaulay born.	1800	Royal Institution for encouraging applied science established in London. Britain acquired Malta.

1801–1810

| 1801 | Two oils and four watercolours at the RA, including *Dutch Boats in a Gale* which both *West and *Fuseli considered superior to *Rembrandt. June–August, first tour in *Scotland returning through *Lake District and Chester. | 1801 | John Henry Newman born. Bellini born. | 1801 | Nelson's victory off Copenhagen. Union with Ireland. First National Census held. |

Turner's Life		Painting, Architecture, Music, and Literature		Other Events in Britain and Abroad	
	Most likely date for the birth of Evelina, Turner's elder daughter by Sarah Danby.				
1802	Elected full RA; *signature changed from 'W. Turner' to 'J. M. W. Turner RA'. *Ships bearing up for Anchorage at RA acquired there or soon after by Lord *Egremont. July–October, first trip to Continent during Peace of Amiens. His journey sponsored by Lord *Yarborough, Walter *Fawkes, and probably also Lord *Darlington, as Newbey Lowson, a neighbour in Co. Durham, accompanied Turner. First sight of Swiss *Alps, which were to inspire him for the rest of his life. Spent three weeks in *Paris studying the pictures in the Louvre.	1802	Death of Girtin. *Bonington born.	1802	Peace of Amiens with France. First stock exchange opened in London.
1803	Member of the Academy Council and also on the Hanging Committee. *Festival upon the Opening of the Vintage at Macon, his first Claudian oil at the RA. Sir George *Beaumont, among other Academicians, criticized Turner's works for 'lack of finish'.	1803	John *Crome presided at first meeting of the Norwich school of artists. Berlioz born.	1803	War resumed with France. Louisiana Purchase.
1804	15 April, death of Turner's mother, probably in Bethlem Hospital. 18 April, opened his own gallery on the corner of *Harley Street and *Queen Anne Street where he could exhibit between 20 and 30 works.	1804	Society of Painters in Water-Colours (later the Old Water-Colour Society) founded in London.	1804	Napoleon Emperor of the French.
1805	No exhibit at the RA. First record of Turner at *Sion Ferry House, Isleworth, where he had a boat on the Thames. The *Shipwreck exhibited at his gallery; it was his first oil to be engraved, attracting 130 subscribers. December, sketched the Victory as she sailed up the Medway on returning from Trafalgar.	1805	Beethoven, Fidelio.	1805	21 October, Battle of Trafalgar. 2 December, Battle of Austerlitz. Napoleon crowned King of Italy in Milan.
1806	Exhibited two oils at the *British Institution's first exhibition and one at the RA. Showed Battle of Trafalgar at his own gallery.	1806	Wilkie, Village Politicians. *Canova, Napoleon (Apsley House).	1806	Deaths of Pitt and Fox. 14 October, Battle of Jena. J. S. Mill born.

TURNER'S LIFE	PAINTING, ARCHITECTURE, MUSIC, AND LITERATURE	OTHER EVENTS IN BRITAIN AND ABROAD
Stayed at *Knockholt in Kent with W. F. Wells, who persuaded Turner to embark on the *Liber Studiorum*. Towards the end of the year took a house at 6 West End, Upper Mall, *Hammersmith, which he kept until 1811.		
1807 Bought a plot of building land at Twickenham. Showed Thames views at his gallery, described as 'crude blotches' by West. *Sun rising through Vapour* and A *Country Blacksmith* at the RA. 11 June, first number of the *Liber Studiorum* published. 2 November, elected Professor of *Perspective at the RA, so now sometimes added P.P. to his signature. First independent French notice of Turner in *Magazin Encyclopédique*.	**1807** Ackerman's *Microcosm of London*.	**1807** Act passed for the abolition of the slave trade.
1808 Long review by John *Landseer in *Review of Publications of Art* identifies twelve oils in Turner's gallery (four bought by Lord Egremont) together with *Liber Studiorum* drawings. Summer, stays with Sir John *Leicester at Tabley Hall in Cheshire to paint two views of the house. From Tabley made a trip into Wales to sketch on the River Dee. Later visited his patron Walter Fawkes at Farnley Hall, his home in Yorkshire not far from Leeds.	**1808** *Scott, *Marmion*. Goethe, *Faust*.	**1808** Beginning of Peninsular War.
1809 Two views of Tabley at the RA and sixteen oils at his gallery, including *Thomson's Aeolian Harp*. Summer, visit to *Petworth House in Sussex, home of Lord Egremont. August, sketching tour in the North of England and visit to Cockermouth Castle, Cumberland, of which Egremont, as the owner, had commissioned a picture.	**1809** Constable, *Malvern Hall*. *Hoppner, *Sir George Beaumont*. *Flaxman's monument to Nelson placed in St Paul's. Tennyson born. Charles Darwin born.	**1809** W. G. Gladstone born.

TURNER'S LIFE		PAINTING, ARCHITECTURE, MUSIC, AND LITERATURE		OTHER EVENTS IN BRITAIN AND ABROAD
1810	London address changed to 47 Queen Anne Street West. Ten oils at his gallery including *View of the *High-Street, Oxford* and *Dorchester Mead*. Three oils at the RA. Visited Sussex to make drawings for Jack *Fuller at Rosehill. August at Farnley; he became a regular visitor there until 1824.	1810	Callcott, *Morning* (Diploma Work). Deaths of Hoppner and Zoffany.	

1811–1820

1811	7 January, first series of six *perspective lectures began. 8 January, proposed that a Professorship of Landscape be established at the RA. July–September, toured West Country in search of material for W. B. *Cooke's *Southern Coast*, his first major series of topographical engravings to be issued in parts. Met his father's relations at Barnstaple and Exeter. November–December, at Farnley.	1811	Constable, *Dedham Vale*. Jane Austen, *Sense and Sensibility*. *Thackeray born.	1811	Invention of tin cans for food storage. George, Prince of Wales, becomes Prince Regent. Luddites attacked textile machinery.
1812	January–February, six perspective lectures at the RA. Began building *Sandycombe Lodge at Twickenham, which he had designed himself. Turner's gallery reopened. *Snow Storm: Hannibal and his Army crossing the Alps* at the RA accompanied by the first quotation from *Fallacies of Hope* (see *poetry and Turner).	1812	Raeburn, *Colonel Alastair MacDonell of Glengarry*. Dickens born. *Byron, *Childe Harold* (Cantos i and ii). John *Nash began to remodel central London. Edward Lear born. Robert Browning born.	1812	*Napoleon invaded Russia. War of 1812 between Britain and USA. Spencer Perceval assassinated in the lobby of the House of Commons. Retreat from Moscow. Cylinder printing press invented and adopted by *The Times*. Lord Liverpool became Prime Minister.
1813	Visitor at the Academy Schools. *Frosty Morning* and *Deluge* at the RA. Sandycombe Lodge completed and occupied. *Constable sat next to him at the RA dinner and was impressed by his 'wonderful range of mind'. Summer Tour: *Devon with *Eastlake, Ambrose *Johns, and Cyrus Redding; he made on-the-spot oil sketches in their presence.	1813	Wilkie, *Blind Man's Buff*. Verdi and Wagner born. Jane Austen, *Pride and Prejudice*. Robert Owen, *A New View of Society*.	1813	October, Battle of Leipzig.
1814	First instalments of *Picturesque Views of the *Southern Coast of*	1814	Soane's Dulwich Picture Gallery opened to the public one day a	1814	End of Peninsular War. –1815 Congress of Vienna.

TURNER'S LIFE		PAINTING, ARCHITECTURE, MUSIC, AND LITERATURE		OTHER EVENTS IN BRITAIN AND ABROAD	
	England issued. Submitted *Apullia in Search of Appullus* to the British Institution's landscape competition after the closing date—almost certainly on purpose. It was disqualified but was exhibited. First notices of Turner by William *Hazlitt.		week, England's first public art gallery. Scott, *Waverley*.		
1815	*Dido building Carthage* and *Crossing the Brook* at the RA. November, exhibited *Bligh Sands* and *Jason* at Plymouth. *Canova visited Turner's gallery with *Haydon and called Turner 'un grand génie'.	1815	*Canova, *Three Graces*. Nash rebuilt Royal Pavilion, Brighton, completed 1818. Trollope born.	1815	18 June, Battle of *Waterloo. Sir Humphrey Davy invented miner's safety lamp. Corn Law passed.
1816	Chairman of Directors and Treasurer of *Artists' General Benevolent Institution. July–August, travelling in Yorkshire to gather material for Dr *Whitaker's History of *Richmondshire.	1816	Lawrence, *John Julius Angerstein*. *British Museum bought the Elgin marbles. Coleridge, *Kubla Khan*. Rossini, *The Barber of Seville*.		
1817	*Decline of the Carthaginian Empire* at the RA. *Cotman failed to interest Turner in collaborating on a publication on the scenery of Normandy. August–September, visited Belgium, *Holland, and the *Rhineland from Mainz to Coblenz. On return went to *Raby Castle to fulfil a commission from Lord *Darlington. Later at Farnley where, on arrival, he sold Fawkes a series of 50 views of the Rhine.	1817	John *Martin, *The Bard*. Death of Jane Austen.	1817	Potato famine hit Ireland for the first time. Death of Princess Charlotte, daughter of the Prince Regent.
1818	Made drawings for *Hakewill's *Picturesque Tour of Italy*. The *Field of Waterloo, *Dort, and *Raby Castle* at the RA. October–November, visited Scotland to discuss illustrating *Scott's *Provincial Antiquities of Scotland*.	1818	Lawrence went to Aix-la-Chapelle and then to Vienna and Rome in 1819 to paint the Allied victors over *Napoleon, Pope Pius VII, and Cardinal Consalvi. These paintings now in the Waterloo Chamber, Windsor Castle.	1818	Karl Marx born.
1819	Member of the RA Council. Last *Liber Studiorum* plates published. March, eight oils shown at Sir John Leicester's new gallery in *Hill Street, London, and in May–June 60 watercolours shown at Fawkes's London	1819	John *Ruskin born. John Martin, *The Fall of Babylon*. Keats, 'Ode to a Nightingale'. George Eliot born. Byron, *Don Juan*, completed 1824.	1819	*Peterloo massacre. Queen *Victoria born. USA bought Florida.

Turner's Life		Painting, Architecture, Music, and Literature		Other Events in Britain and Abroad	
	house in *Grosvenor Place, an exhibition Turner himself frequently visited.				
	August, first visit to *Italy, where he stayed for six months mainly in *Rome but he also went to *Venice and *Naples and as far south as Paestum, returning via *Florence and Mont Cenis.				
	November, elected to honorary membership of the *Roman Academy of Saint Luke through Canova's good offices.				
1820	Back in London 1 February. April–June, Fawkes's exhibition open again. *Rome, from the Vatican at the RA. June, inherited cottages at Wapping which he converted into the 'Ship and Bladebone' tavern. Also busy enlarging the Queen Anne Street house, adding a second gallery.	1820	March, death of Benjamin *West; Lawrence becomes President of the RA. Gericault's *Raft of Medusa* exhibited at the Egyptian Hall, London. Constable, *Stratford Mill* ('The Young Waltonians').	1820	Death of *George III. Accession of *George IV. Cato Street conspiracy.

1821–1830

1821	Most unusually nothing at the RA, nor in 1824. April, W. B. Cooke's exhibition of modern British engravings included many Turners, mostly *Southern Coast* views. Eight watercolours for Scott's *Provincial Antiquities* completed and bought by Scott, who hung them together in one frame at *Abbotsford. September, travelled to Paris, Rouen, and Dieppe in preparation for a series of engravings of the *Seine.	1821	Francis *Danby, *Disappointed Love*. Constable, *The Hay Wain*. Klenze's designs for the *Walhalla approved by Ludwig of Bavaria. Death of Keats. 30 December, death of *Farington.	1821	Death of Napoleon. Greek War of Independence began. Cobbett set out on his Rural Rides.
1822	February, Cooke's watercolour exhibition in Soho Square included 24 Turners. *What You Will!* (private collection, BJ 229) at the RA. Turner's new gallery opened with an exhibition of mainly earlier, unsold works. August, travelled by sea to Edinburgh to record *George IV's ceremonial visit to the city. By the end of the year commis-	1822	Thomas de Quincey, *Confessions of an English Opium Eater*. Shelley drowned in Italy. Matthew Arnold born. Royal Academy of Music founded.	1822	Castlereagh committed suicide. *Sunday Times* first appeared.

TURNER'S LIFE		PAINTING, ARCHITECTURE, MUSIC, AND LITERATURE		OTHER EVENTS IN BRITAIN AND ABROAD	
	sioned by the King, on *Lawrence's advice, to paint *The Battle of Trafalgar* for St James's Palace.				
1823	*Bay of Baiae* at the RA. March–April, *Rubens's *Chapeau de Paille* exhibited in London, Turner made a pencil copy of it (TB CCV-p. 44). June, first *Rivers of England* engravings published. Busy working on the enormous *Battle of Trafalgar*.	1823	Death of Raeburn. Charles Lamb, *Essays of Elia*.	1823	Daniel O'Connell formed the Catholic Association in Ireland. President Monroe's message to Congress (Monroe Doctrine).
1824	Auditor of the RA accounts. Summer, sketched in East Anglia for a projected series of views on the east coast of which, however, only a few plates were engraved. 10 August–mid-September, visited Belgium (*Meuse), Luxembourg, Germany (*Mosel), northern France (Dieppe). December, last visit to Farnley.	1824	Death of Byron at Missolonghi. National Gallery established in *London with the acquisition of the *Angerstein collection. Beethoven, Choral Symphony. Wilkie Collins born.	1824	Royal Naval Lifeboat Institution established by Sir William Hillary. Royal Society for the Prevention of Cruelty to Animals (RSPCA) founded.
1825	*Harbour of Dieppe* at the RA. Began work on his most ambitious project for engraving: 120 watercolours for the series *Picturesque Views in *England and Wales*. August, toured the Low Countries. 25 October, death of Walter Fawkes.	1825	Constable, *The Leaping Horse*. Lawrence, *Charles William Lambton* ('The Red Boy'). Death of Fuseli. Manzoni, *I promessi sposi*, completed 1827.	1825	The Stockton to Darlington railway opened.
1826	*Cologne* and *Forum Romanum* at the RA. Samuel *Rogers commissioned Turner to illustrate his poem *Italy*. Sandycombe Lodge sold; first *Ports of England* engravings published. Visited northern France (Normandy, Brittany, *Loire). This year probable date for Turner making the twelve mezzotints known as the *Little Liber*.	1826	*Landseer, *The Hunting of Chevy Chase*. Weber's *Oberon* and his death. Royal Scottish Academy of Painting, Sculpture, and Architecture, Edinburgh, founded.	1826	University College London, founded to provide non-sectarian higher education. Royal Zoological Society founded.
1827	*'Now for the Painter' (Rope)* and *Port Ruysdael* at the RA. 7 July, at the Lord de Tabley (formerly Sir John Leicester) sale Turner bought back the *Country Blacksmith* and *Sun rising through Vapour*.	1827	Lawrence, *Sir Walter Scott* and *John Nash*. B. R. *Haydon, *The Mock Election*. Death of Blake.	1827	Treaty of London. Turkish fleet defeated at Battle of Navarino.

TURNER'S LIFE		PAINTING, ARCHITECTURE, MUSIC, AND LITERATURE		OTHER EVENTS IN BRITAIN AND ABROAD	
	Late July–early September, stayed with John *Nash at East Cowes Castle on the *Isle of Wight to paint two views of the castle which he combined with the Cowes Regatta. October, at *Petworth.				
1828	January–February, last series of perspective lectures given although Turner retained the Professorship until 1837. Visited Petworth to paint four pictures to hang in panels in the dining-room. The first quartet (now Tate Gallery) was rejected by Egremont but Turner then painted a new set still at Petworth. August, second visit to Italy, reaching Rome in early October where he shared lodgings with *Eastlake at 12 Piazza Mignanelli. In December he exhibited *Regulus and Orvieto, later joined by Medea, in the Palazzo Trulli, where they were much derided.	1828	Danby, *Opening of the Sixth Seal*. Bonington, *Coast Scene*; his death later that year. Lawrence, *Sir John Soane*.	1828	Death of Lord Liverpool. *Wellington became Prime Minister. Thomas Arnold became headmaster of Rugby School.
1829	Early February, returned from Italy; his diligence overturned en route in a snowdrift on Mont Tarare. *Ulysses deriding Polyphemus at the RA. June–July, Charles *Heath exhibited some 40 Turner watercolours, mostly *England and Wales* subjects, at the *Egyptian Hall, Piccadilly. August–September, visited Paris, Normandy, and Brittany in connection with his illustrations of the Seine. 21 September, death of Turner's father. 30 September, made his first *will providing for a Professorship of Landscape at the RA and a Turner Gold Medal for landscape painting.	1829	Millais born. Mendelssohn's rough crossing to Staffa inspires 'Fingal's Cave' overture, performed in London in 1832, the year Turner's *Staffa was shown at the RA.	1829	*Catholic emancipation granted in Britain. Metropolitan Police Act passed; first 'Peelers' went on the beat in London. First university boat race; Oxford beat Cambridge at Henley. George Shillibeer introduced three-horse omnibus, Paddington to the Bank.
1830	7 January, death of Lawrence; Turner painted a large watercolour from memory of the funeral at St Paul's, later shown at the RA.	1830	Delacroix, *Liberty Leading the People*. Constable, *English Landscape Scenery*.	1830	Accession of William IV. July Revolution in France; accession of *Louis Philippe. William Huskisson killed by Stephenson's Rocket at the

TURNER'S LIFE		PAINTING, ARCHITECTURE, MUSIC, AND LITERATURE		OTHER EVENTS IN BRITAIN AND ABROAD
	*Jessica at the RA bought by Egremont, his twentieth and last Turner oil. July, publication of Samuel *Rogers's *Italy.* August–September, tour of the Midlands to gather more material for the *England and Wales* series. Resigned from the Artists' General Benevolent Institution after disagreements over the use of funds.			opening of the Liverpool-Manchester railway.

1831–1840

1831	*Life-Boat and Manby Apparatus* at the RA. June, signed second will exchanging *Sun rising through Vapour* for the *Decline of Carthage* in his bequest to the National Gallery. July–August, travelled to Scotland to stay at *Abbotsford with *Scott. Extensive tour gathering material to illustrate *Scott's *Poems,* often accompanied by Robert *Cadell, Scott's publisher. Later that year Cadell invited Turner to illustrate another volume, *Rogers's *Poems.* Christmas at Petworth.	1831	Constable, *Salisbury from the Meadows.* Bellini, *Norma.*	1831	Belgium became an independent kingdom. Declaration of Greek Independence. Faraday's experiments discovered electromagnetic current. Law Society founded.
1832	*Childe Harold's Pilgrimage* and *Staffa* at the RA. March, *Moon, Boys, and Graves exhibited twelve watercolours for Scott's *Poems.* June, member of committee to discuss space to be allotted to the RA in the new National Gallery building in Trafalgar Square. September–October, in France to collect material for *Rivers of France* and Scott's *Life of Napoleon.* Probably also visited *Delacroix at his studio. December, at Petworth and then Christmas with Nash at East Cowes Castle. By now a regular visitor to Mrs *Booth's lodgings at Margate.	1832	Constable, *The Opening of Waterloo Bridge.* Deaths of Goethe and Walter Scott. Darwin began publishing *Narrative of the Surveying Voyages of HMS Adventure and Beagle.*	1832	First *Reform Bill. Cholera epidemic reached London. British Medical Association founded.
1833	*Quilleboeuf* and first two oils of	1833	Death of William Wilberforce.	1833	*Slavery abolished throughout

TURNER'S LIFE	PAINTING, ARCHITECTURE, MUSIC, AND LITERATURE	OTHER EVENTS IN BRITAIN AND ABROAD
Venice at the RA. June, Moon, Boys, and Graves exhibited twelve Scott drawings and 66 *England and Wales* subjects. 30 June, Turner bought back thirteen lots of drawings by or attributed to him at Dr Monro's sale. September, long Continental tour including Berlin, Dresden, Prague, Vienna, and Venice. December, publication of **Turner's Annual Tour: Wanderings by the Seine*. Mrs Booth's husband, John, died during the year.	Carlyle, *Sartor Resartus*.	the British Empire. First steamship crossing of the Atlantic. The Oxford Movement inaugurated by Newman and Keble. Falkland Islands formally annexed.
1834 March, first instalments of **Finden's Landscape Illustrations of the Bible* issued. The **Golden Bough* at the RA. July, visited Oxford. Turner's illustrations to *Byron exhibited at *Colnaghi's. 16 October, sketched the Houses of Parliament on fire from a boat on the Thames. December, four early oils shown at the Society of British Artists.	1834 William Morris born. Berlioz, *Harold in Italy*. Death of Coleridge.	1834 New Poor Law Act. Burning of the Houses of *Parliament. Tolpuddle Martyrs sentenced to seven years' transportation. Charles Babbage designed 'analytical engine', a digital computer; proved too complex to manufacture.
1835 One painting of *The Burning of the House of Lords and Commons* shown at the BI and the other at the RA with *Keelmen and three others. Summer, visited *Denmark, *Germany, and Bohemia gathering material to illustrate Thomas *Campbell's *Poetical Works* commissioned by *Moxon.	1835 Death of Nash. Donizetti, *Lucia di Lammermoor*. Death of Bellini.	1835 Municipal Reform Act. Samuel Colt invented the revolver.
1836 Last RA exhibition at Somerset House; showed three oils including **Juliet and her Nurse*, which received virulent criticism in **Blackwood's Magazine* from the Revd John Eagles. August, tour of France, Switzerland, and the Val d'Aosta with his patron *Munro of Novar, who had bought *Juliet*. October, *Ruskin wrote a defence of Turner refuting the *Blackwood's* review but Turner advised against publication. December, Turner persuaded	1836 William Witherington, *Petworth Park 9th June 1835*. Dickens, *Pickwick Papers*, completed 1837.	1836 Marriage Act; weddings in nonconformist chapels legalized. London Working Men's Association founded by William Lovett.

TURNER'S LIFE	PAINTING, ARCHITECTURE, MUSIC, AND LITERATURE	OTHER EVENTS IN BRITAIN AND ABROAD
the RA to hold a farewell dinner at Somerset House before the move to Trafalgar Square. During the winter Turner was in poor health.		
1837 *Hero and Leander* at the RA. Turner on the Hanging Committee. Lord Francis Egerton lent *Dutch Boats in a Gale* to the old master exhibition at the BI together with its pendant by Van de Velde. July–August, travelled to France: Paris and Versailles. October, at Petworth. 11 November, death of Lord Egremont. 28 December, resigned Professorship of Perspective. Publication of Thomas Campbell's *Poems* with twenty illustrations by Turner.	1837 Constable, *Arundel Mill and Lock*. Carlyle, *The French Revolution*. J. G. Lockhart, *Memoirs of the Life of Sir Walter Scott*. Deaths of Constable and Soane. George Basevi built *Fitzwilliam Museum at Cambridge.	1837 Accession of Queen *Victoria. Euston Station, London's first railway terminus, opened.
1838 *Modern Italy* and *Ancient Italy* at the RA, both bought by Munro. Last *England and Wales* plates published; the series had run into financial difficulties with only 96 out of the 120 plates completed. 6 September, Turner, on his way back from Margate, saw the *Temeraire* being towed up the Thames to be broken up.	1838 The National Gallery in Trafalgar Square by William Wilkins completed.	1838 First electric telegraph. Anti-Corn Law League established by Richard Cobden. People's Charter published.
1839 *The Fountain of Fallacy* exhibited at the BI, having been altered after being shown at the RA in 1834 as The *Fountain of Indolence*. The *Fighting 'Temeraire'* at the RA. August, travelled to Belgium (Meuse), Luxembourg, and Germany (Mosel). 42 watercolours from Fawkes's collection exhibited at the Music Hall, Leeds. A codicil to Turner's will revoked annuities to Sarah Danby and his two daughters.	1839 Landseer, *Van Amburgh and his Animals*. Sir Charles Barry began to rebuild the Houses of *Parliament, completed in 1852 with Pugin's assistance. Dickens, *Nicholas Nickleby*.	1839 *Chartist riots. Opium War began with China. First Grand National steeplechase, Aintree.
1840 *Slavers throwing overboard the Dead and Dying* at the RA. 22 June Turner met *Ruskin for the first time at Thomas *Griffith's house.	1840 Wilkie, *The Irish Whiskey-Still*. Nelson's Column erected in Trafalgar Square.	1840 Queen Victoria married Prince *Albert of Saxe-Coburg-Gotha. Penny post introduced by Rowland Hill. Bradshaw's *Railway Companion*

TURNER'S LIFE	PAINTING, ARCHITECTURE, MUSIC, AND LITERATURE	OTHER EVENTS IN BRITAIN AND ABROAD
August–September, visit to Venice, travelling via Rotterdam and the Rhine and returning via Munich and *Coburg, where he sketched Schloss Rosenau, Prince *Albert's birthplace. Eastlake's translation of *Goethe's *Farbenlehre* published this year; Turner owned a copy.		provided first timetables.

1841–1851

1841	*Schloss Rosenau* and three Venetian views at the RA. 1 June, death of David *Wilkie at sea on his way back from the Middle East. August–September, tour of Switzerland including Schaffhausen, Constance, Zurich, Splugen Pass, and especially Lucerne. 25 November, death of Sir Francis *Chantrey, one of Turner's closest friends.	1841	Thomas Webster, *The Boy with many Friends*. *Punch* founded. The London Library founded.	1841	Royal Botanic Gardens at Kew opened to the public. Talbot Fox patented calotype process. Peel became Prime Minister. Edward VII born.
1842	*Peace (burial of Wilkie) and *War together with *Snow Storm—Steam-Boat off a Harbour's Mouth at the RA. Painted a series of ten watercolours—mostly Swiss scenes—for his agent Thomas Griffith to offer to selected patrons. Griffith managed to sell nine, taking the tenth as his commission. August–September, again visited Switzerland, going over the St Gotthard Pass to Bellinzona and Como.	1842	George Jones, *The Burial at Sea of Sir David Wilkie*. *Illustrated London News* started. Verdi, *Nabucco*.	1842	Income tax reintroduced. Ashley's Mines Act: children under ten and women not to work underground.
1843	The two 'Deluge' pictures (*Shade and Darkness and *Light and Colour) and The *Opening of the Walhalla and *Sun of Venice at the RA. Painted a second series of ten Swiss watercolours but Griffith could place only five. May, the first volume of Ruskin's *Modern Painters* published.	1843	Wagner, *Flying Dutchman*. George Borrow, *The Bible in Spain*. Wordsworth succeeded Southey as Poet Laureate. Ruskin, first volume of *Modern Painters*.	1843	Opening of Brunel's Rotherhithe–Wapping tunnel under the Thames. The *Economist* founded. Christmas cards introduced by Sir Henry Cole.
1844	*Rain, Steam, and Speed among seven oils at the RA. *Bicknell and *Gillott each bought eight oils during the	1844	Deaths of Callcott and William Beckford.	1844	The American Samuel Morse invented his code for transmitting telegraph messages.

TURNER'S LIFE		PAINTING, ARCHITECTURE, MUSIC, AND LITERATURE		OTHER EVENTS IN BRITAIN AND ABROAD	
	year, probably encouraged by *Modern Painters*. 24 July, Turner signed over his land at Twickenham to a group of Trustees for the establishment of almshouses 'for the Relief of Decayed and Indigent Artists'. The document was not implemented so the scheme came to nothing. Late summer, a final tour of Switzerland. 8 October, Turner saw *Louis-Philippe land at Portsmouth on a visit to Queen *Victoria.				
1845	20 February, appointed Acting President of the RA during Martin Archer *Shee's illness. On Shee's resignation in June Turner appointed Deputy President until December 1846. Two *whaling subjects and four Venetian views at the RA. James *Lenox of New York bought *Staffa* on the advice of C. R. *Leslie, the first Turner to go to America. September–October, last trip abroad to Dieppe and coast of Picardy. Dined with Louis-Philippe at his Château at Eu.	1845	Disraeli, *Sybil*. Edgar Allan Poe, *Tales of Mystery and Imagination*.	1845	Sir John Franklin's abortive expedition to find the North-West Passage. Irish potato famine.
1846	*The *Angel standing in the Sun* and *Undine giving the Ring to Masaniello* at the RA. Autumn, or earlier, moved with Mrs Booth and her son, Daniel Pound, into 6 Davis Place, Cremorne New Road, Chelsea (see *Cheyne Walk) close to the Thames. 30 December, last Council Meeting as Deputy President. Health now declining.	1846	Edward Lear, *Book of Nonsense*. Robert Browning married Elizabeth Barrett.	1846	Repeal of the *Corn Laws.
1847	*The *Hero of a Hundred Fights*, a work of *c*.1798 much repainted, at the RA. The American photographer J. J. E. *Mayall acquired a studio in London where Turner was a frequent visitor. December, Robert *Vernon bequeathed part of his collection to the nation and *Dogano . . . from the Steps of the Europa*	1847	Thackeray, *Vanity Fair*, completed 1848. Emily Brontë, *Wuthering Heights*; Charlotte Brontë, *Jane Eyre*.	1847	Thousands emigrated from Ireland on 'coffin' ships. Factory Act; restricted hours worked by women and children.

TURNER'S LIFE	PAINTING, ARCHITECTURE, MUSIC, AND LITERATURE	OTHER EVENTS IN BRITAIN AND ABROAD
became the first Turner painting to hang in the National Gallery.		
1848 Nothing at the RA for the first time since 1824. This year hired a young artist, Francis Sherrell, as a studio *assistant. A new codicil to his will referred to the Bequest and exhibition of 'finished pictures', providing for a change of display every two years.	1848 The Pre-Raphaelite Brotherhood founded. Marx and Engels, *The Communist Manifesto*. Macaulay, *History of England* (vols. i and ii).	1848 Year of revolutions in Europe. Cholera epidemic in England; 14,000 deaths in London. Gold discovered in California. Chartist movement collapsed.
1849 Asked by the Society of Arts if he will permit a retrospective exhibition of his work to be arranged; declined 'from a peculiar inconvenience this year'. Repainted an early picture, loaned by Munro, and exhibited it at the RA as The *Wreck Buoy* together with *Venus and Adonis* of *c.*1804. 24 December, in a letter to Hawksworth *Fawkes, admitted that his health was 'much on the wane'.	1849 Holman Hunt, *Rienzi*. Dickens, *David Copperfield*, completed 1850. Ruskin, *Seven Lamps of Architecture*.	1849 Rome declared a republic under Mazzini.
1850 Exhibited his last four pictures at the RA, their subject being the story of Dido and Aeneas. 19 August, death of Shee; succeeded as President of the RA by *Eastlake.	1850 Rossetti, *Ancilla Domini*. Millais, *Christ in the House of his Parents*. Death of Wordsworth; Tennyson became Poet Laureate. Wagner, *Lohengrin*.	1850 Refrigerator invented by Twining and Harrison. Restoration of Catholic hierarchy in England.
1851 No picture at the RA but attended Varnishing Days, Private View, and the Academy Banquet. 7 May, present at an Academy Club dinner for the last time. October, took to his bed in Chelsea looked after by Mrs Booth, with regular visits by a surgeon, Mr Bartlett, and Dr Price from Margate. 19 December, Turner died at 10 a.m. 30 December, buried in St Paul's Cathedral.	1851 Melville, *Moby Dick*. Holman Hunt, *The Hireling Shepherd*. Millais, *Return of the Dove to the Ark* and *Mariana*. Joseph Paxton, the Crystal Palace for the *Great Exhibition in Hyde Park. Ruskin, *The Stones of Venice*, completed 1853. Verdi, *Rigoletto*.	1851 Australian Gold Rush began in New South Wales. 2 December, Louis Napoleon's *coup d'état* led to the establishment of the Second Empire exactly a year later.

· PUBLIC COLLECTIONS WITH WORKS BY TURNER ·

(Only those museums and galleries with larger groups of paintings, watercolours, or prints, or with particularly important individual works, are listed. Museums and galleries with an entry in the *Companion* are marked with an asterisk.)

Australia

Melbourne, National Gallery of Victoria; three paintings, including *Walton Bridges* (BJ 63) and *Val d'Aosta* (BJ 520); three watercolours, *Linlithgow Palace* (W 321), *Okehampton, Devonshire* (W 802), and *The Red Rigi* (W 1525).

Sydney, Art Gallery of New South Wales; one watercolour, *High Force, Fall of the Tees* (W 564); a fine set of the *Liber Studiorum* given by A. A. Allen.

Canada

Ottawa, National Gallery of Canada; two paintings, *Shoeburyness Fisherman* (BJ 85) and *Mercury and Argus* (BJ 367); three watercolours (W 161, 165, and 705).

Québec, Musée du Québec; *Near Northcourt in the Isle of Wight* (BJ 269).

Eire

*Dublin, National Gallery of Ireland; 36 watercolours and drawings, 31 of them bequeathed by Henry Vaughan in 1900, including *Edinburgh from below Arthur's Seat* (W 361) and three late Venetian scenes (W 1356–8).

France

*Paris, Musée du Louvre; one painting, *Landscape with a River and a Bay in the Distance* (BJ 509); one watercolour, *St. Germain-en-Laye* (W 1045).

Germany

Munich, Neue Pinakothek; one painting, *Ostend* (W 407).

Japan

Koriyama Museum of Art; *Calder Bridge* (BJ 106); *Descent of the St. Gothard* (W 1552).

Shizuoka Prefectural Museum of Art; the very late watercolour *Pallanza, Lago Maggiore* (W 1556).

Tokyo, Fuji Art Museum; *Seascape with a Squall coming up* (BJ 106).

The Netherlands

Amsterdam, Rijksmuseum; one watercolour, *Farnley Hall, from above Otley* (W 613).

Portugal

Lisbon, Fundaçao Calouste Gulbenkian; two paintings, *Wreck of a Transport Ship* (BJ 210) and *Mouth of the Seine, Quille-Boeuf* (BJ 353); two watercolours, W 61 and 760, *Plymouth*.

United Kingdom

Aberystwyth, National Library of Wales; newly discovered oil sketch for *Dolbadern Castle* (RA 1800), acquired in 1998.

*Bedford, Cecil Higgins Art Gallery; nine watercolours, including *The Great Fall of the Riechenbach* (W 367), *A First Rate Taking in Stores* (W 499), and *Loss of an East Indiaman* (W 500), acquired in 1997.

*Birmingham, City Museums and Art Gallery; *The Pass of St. Gothard* (c.1803/4; BJ 146); seven finished watercolours, including *Snowstorm, Mont Cenis* (W 402), *Lancaster Sands* (W 581), and *Blenheim House and Park, Oxfordshire* (W 846).

Blackburn, Museum and Art Gallery; six watercolours, five of them bequeathed by E. L. Hartley, including *Cascade of Terni* (W 701).

Burnley, Townley Hall Art Gallery and Museums; four watercolours, three of them illustrations for Dr Whitaker's *History of the Parish of Whalley* (W 286, 292, and 294).

Bury, Art Gallery and Museum; *Calais Sands* (BJ 334) and four watercolours, including *Bridport, Devonshire* (W 465) and two views of *Ehrenbreitstein* (W 687 and 1051). Bury also has a complete set of the *Liber Studiorum*.

Cambridge, *Fitzwilliam Museum; three early paintings (BJ 35a and b, and 38); 55 watercolours, nearly half of them given to the University by John Ruskin in 1861. The museum purchased the *Vale of Pevensey* (W 432) in 1979; a considerable collection of Turner prints, including the *Liber Studiorum*.

*Cardiff, National Museum and Gallery; five paintings, all late sea paintings (BJ 474, 478, 480–1, and 484); sixteen watercolours, including three 1817 Rhine drawings (W 638–9 and 669) and several late Swiss drawings.

*Edinburgh, National Gallery of Scotland; the painting *Somer-Hill, near Tunbridge* (BJ 116); over 70 watercolours, principally 38 from the Henry Vaughan Bequest of 1900 and twenty vignette illustrations for Campbell's *Poetical Works*, acquired in 1988.

*Leeds City Art Gallery; one small Devon painting (BJ 225); ten watercolours, including two late Swiss views (W 1498 and 1522).

Liverpool, University of Liverpool; *The Eruption of the Souffrier Mountains* (BJ 132); five watercolours, including *The Vale of Ashburnham* (W 433) and *Bolton Abbey, Yorkshire* (W 531).

*Liverpool, National Museums and Art Galleries on Merseyside, incorporating the Walker Art Gallery; five paintings, four of them from the George Holt collection, including *The Wreck Buoy* (BJ 428); seven watercolours, including the 1802 *Fall of the Clyde* (W 343) and *Richmond Terrace, Surrey* (W 879).

London, *British Museum, Department of Prints and Drawings; over 100 watercolours and drawings, notably from the Salting Bequest of 1910 and the Lloyd Bequest of 1958, which includes the finest extant collection of finished watercolours. The Print Room also houses the largest existing collection of Turner prints, with an exceptional representation of the *Liber Studiorum*.

London, *Courtauld Galleries, Somerset House; seventeen watercolours, mostly from the Stephen Courtauld collection, including the evocative *Dawn after the Wreck* (W 1398).

*London, National Gallery; the two paintings specifically bequeathed by Turner, *Sun rising through Vapour* (BJ 69) and *Dido building Carthage* (BJ 131), and seven canvases from the Turner Bequest, among them *The Fighting 'Temeraire'* (BJ 377) and *Rain, Steam, and Speed* (BJ 409).

London, Sir John *Soane's Museum; *Admiral Van Tromp's Barge at the Entrance of the Texel* (BJ 339); two early exhibition watercolours (W 234 and 364).

London, *Tate Gallery; all the paintings from the Turner Bequest, except for the small selection in the National Gallery, London; all the drawings, watercolours, and sketchbooks from the Turner Bequest, and a few further watercolours; a representative, recently formed, collection of Turner prints, including the *Liber Studiorum*. This material is usually housed in the Clore Gallery, where the prints and drawings are available in the Study Room.

London, *Victoria and Albert Museum; five paintings, including *Life-Boat and Manby Apparatus* (BJ 336) and *Venice, from the Canale della Giudecca* (BJ 384); over 40 drawings and watercolours, many of them pre-1802, including a group of Monro School drawings and two views of Salisbury Cathedral (W 201–2); among the later works several Swiss watercolours (W 1562–3 and 1565) from the Henry Vaughan Bequest; a representative collection of Turner prints, including the Mummery Collection of late and posthumous prints.

London, Wallace Collection; four watercolours of Yorkshire scenes (W 527, 534–6).

*Manchester City Art Gallery; *Thomson's Aeolian Harp* (BJ 86) and *'Now for the Painter'* (BJ 236); over 30 watercolours and drawings, including *Malvern Abbey and Gate, Worcestershire* (W 834), *Heidelberg: Sunset* (W 1376), and the 1843 *Kussnacht, Lake of Lucerne* (W 1534); a large group of *Liber Studiorum* plates and a selection of other prints after Turner.

Manchester, *Whitworth Art Gallery; over 50 drawings and watercolours, many from the collection of J. E. Taylor; these include an exceptional group of early watercolours, including *St. Anselm's Chapel, Canterbury Cathedral* (W 55) and a strong representation of late Swiss drawings, among them *Lake of Lucerne, Moonlight, the Righi in the Distance* (W 1478) and the 1845 *Snowstorm in the Pass of St. Gothard* (W 1546).

Oxford, *Ashmolean Museum; three paintings on long-term loan from the Loyd Collection, *Walton Bridges* (BJ 60), *Whalley Bridge and Abbey, Lancashire* (BJ 117), and *View of the High-Street, Oxford* (BJ 102); some 100 watercolours and drawings, 67 of them presented by John Ruskin, including 23 *Rivers of France* drawings and three Venetian scenes (W 1363, 1364, and 1366); a good

group of *Liber Studiorum* prints and other Turner engravings.

Portsmouth City Museum; *Gosport, Entrance to Portsmouth Harbour* (W 828), acquired in 1997.

Port Sunlight, Lady Lever Art Gallery (see *Liverpool); one painting (BJ 510); seventeen watercolours, among them three *England and Wales* subjects (W 786, 788, and 858—*Dudley, Worcestershire*) and two late Swiss subjects (W 1515 and 1529).

Sheffield City Museum and Mappin Art Gallery; *The Festival upon the Opening of the Vintage of Macon* (BJ 47).

Sheffield, Graves Art Gallery; six watercolours, including a large early view of Edinburgh (W 347a).

Southampton Art Gallery; *Fishermen upon a Lee-Shore* (BJ 16).

United States

Baltimore, Walters Art Gallery; one painting, *Raby Castle* (BJ 136). Baltimore Museum of Art; one watercolour, *Grenoble Bridge* (W 404).

*Boston, Museum of Fine Arts; three paintings, *Fall of the Rhine at Schaffhausen* (BJ 61), *View from the Terrace of a Villa at Niton, I.O.W.* (BJ 234), and *Slavers* (BJ 385); ten watercolours, among them two studies for the *Little Liber* (W 774 and 777); an outstanding collection of Turner prints, especially the *Liber Studiorum* from the Francis Bullard Collection, bequeathed in 1913, with many touched proofs.

Cambridge, Mass., Fogg Art Museum, Harvard University; one painting, *Rembrandt's Daughter* (BJ 238); nine watercolours, including *Devonport* (W 813) and the very late *Simplon Pass* (W 1566).

Chicago, Art Institute of Chicago; two paintings, *Snow-Storm, Avalanche and Inundation—a Scene in the Upper Part of the Val d'Aouste* (BJ 371) and *Fishing Boats with Hucksters* (BJ 372); two late Swiss watercolours (W 1436 and 1471).

Cincinnati, Ohio, *Taft Museum; two paintings (BJ 92 and 514); ten watercolours, including two 1809 Swiss drawings (W 388–9), several vignettes, and the very late *Lake of Thun* (W 1567).

Cleveland, Ohio, Museum of Art; the RA 1835 *The Burning of the Houses of Lords and Commons* (BJ 364); one watercolour, *Fluelen* (W 1549).

Hartford, Conn., Wadsworth Atheneum; *Van Tromp's Shallop, at the Entrance of the Scheldt* (BJ 344).

*Indianapolis Museum of Art; four paintings, including *The Fifth Plague of Egypt* (BJ 13); some 40 drawings and watercolours, largely from the Pantzer Collection, among them *A View of the Archbishop's Palace, Lambeth* (W 10) and *Oberhofen, Lake Thun* (W 1557); some 3,000 Turner engravings, including numerous *Liber Studiorum* prints.

Los Angeles County Museum, California; *Lake of Geneva* (BJ 103).

Malibu, California, Getty Museum; *Van Tromp, going about to Please his Masters* (BJ 410) and two watercolours, *Conway Castle* (c.1800; W 270) and the celebrated *Longships Lighthouse, Land's End* (c.1835; W 864).

New Haven, Conn., *Yale Center for British Art; fifteen oil paintings, including *Dort, or Dordrecht* (BJ 137) and *Staffa, Fingal's Cave* (BJ 347); a large collection of drawings and watercolours, with over 50 finished watercolours such as *Glacier and Source of the Arveron* (W 365) and *The Lake of Lucerne* (W 1541); the largest collection in America of Turner prints, centred on the working collection of W. G. Rawlinson.

New York, *Frick Collection; an outstanding group of five paintings, including *Harbour of Dieppe* and *Cologne, the Arrival of a Packet Boat* (BJ 231–2).

New York, *Metropolitan Museum; three paintings, including *Venice, from the Porch of the Madonna della Salute* (BJ 362); three watercolours, including *Lake of Zug, Early Morning* (W 1535).

Oberlin, Ohio, Peter Allen Memorial Art Museum; *Ducal Palace, Dogano* (BJ 390).

*Philadelphia Museum of Art; two paintings, including *The Burning of the House of Lords and Commons* (BJ 1835; BJ 359).

Poughkeepsie, New York, Vassar College Art Gallery; four watercolour vignettes (W 1140, 1156, 1222, and 1226).

Providence, RI, Museum of Art, Rhode Island School of Design; ten watercolours, including *Wharfedale, from the Chevin* (W 615) and *The Lake, Petworth Park* (W 911).

San Marino, Calif., *Huntington Art Gallery; two paintings, *The Grand Canal, Venice* (BJ 368) and *Neapolitan Fisher-Girls surprised bathing by Moonlight* (BJ 388); some ten watercolours and drawings, including *St. Goarhausen* (W 676); a selection of Turner prints.

Toledo, Ohio, Museum of Art; *Campo Santo, Venice* (BJ 397); *Schaffhausen: The Town and Castle* (W 1540).

*Washington, DC, National Gallery of Art; nine paintings, including three Venetian scenes (BJ 356, 403, and 412) and *Keelmen heaving in Coals by Night* (BJ 360).

Williamstown, Mass., Sterling and Francine Clark Art Institute; *Rockets and Blue Lights* (BJ 387); *Brunnen, from the Lake of Lucerne* (W 1545).

Worcester, Mass., Worcester Art Museum; *The Banks of the Loire* (BJ 329, identified in 1998, previously wrongly catalogued as BJ 328a).

· PICTURE ACKNOWLEDGMENTS ·

Jacket illustration © Bury Art Gallery & Museum, Lancashire
Frontispiece © Tate Gallery, London 2001
 1 Aberdeen Art Gallery and Museums
 2 By courtesy of the Trustees of Sir John Soane's Museum, London
 3 © National Gallery, London
 4 © National Gallery, London
 5 © Tate Gallery, London 2001
 6 Calouste Gulbenkian Museum, Lisbon
 7 © Tate Gallery, London 2001
 8 © National Gallery, London
 9 © Tate Gallery, London 2001
10 Private Collection
11 Yale Center for British Art, Paul Mellon Collection
12 Private Collection
13 The Courtauld Gallery, London
14 © Tate Gallery, London 2001
15 © Tate Gallery, London 2001
16 Copyright The Frick Collection, New York
17 © National Gallery, London
18 © Copyright The British Museum
19 Ashmolean Museum, Oxford
20 © Tate Gallery, London 2001
21 © The Cleveland Museum of Art, 2001, Bequest of John L. Severance, 1942.647.
22 © Tate Gallery, London 2001
23 Yale Center for British Art, Paul Mellon Collection
24 © 2001 Board of Trustees, National Gallery of Art, Washington/Widener Collection
25 By courtesy of the Trustees of Sir John Soane's Museum, London
26 © Copyright The British Museum
27 Courtesy, Museum of Fine Arts, Boston, reproduced with permission. © 2001 Museum of Fine Arts, Boston. All Rights Reserved/Henry Lillie Pierce Fund
28 National Gallery of Victoria, Melbourne/Felton Bequest, 1947
29 The Toledo Museum of Art, Ohio/Gift of Edward Drummond Libbey
30 © Tate Gallery, London 2001
31 © National Gallery, London
32 Private Collection